A World History of Art

Margaret Morgan.
December 1984.

A WORLD HISTORY OF ART

Hugh Honour
John Fleming

MACMILLAN

In memory of John Calmann

The Authors:

Hugh Honour was educated at the King's School, Canterbury, and St Catharine's College, Cambridge. In 1961 he published *Chinoiserie: the Vision of Cathay* and in 1965 *The Companion Guide to Venice*. He organized the 1976 bicentennial exhibition 'The European Vision of America' for the National Gallery, Washington, and the Cleveland Museum of Art. His *Neo-classicism*, first published in 1968 in the Pelican 'Style and Civilization' series (of which he is editor, with John Fleming), was followed in 1979 by *Romanticism*. He collaborated with Nikolaus Pevsner and John Fleming in *The Penguin Dictionary of Decorative Arts* (1977). He is now working on a study of the image of the black in Western art up to the early 20th century.

John Fleming was educated at Rugby School and Trinity College, Cambridge. In 1961 he published *Robert Adam and his Circle in Edinburgh and Rome,* which was awarded the Bannister Fletcher Prize and the Alice Davis Hitchcock Medal. He collaborated with Nikolaus Pevsner and Hugh Honour in *The Penguin Dictionary of Decorative Arts* (1977). He is also the editor, with Hugh Honour, of the 'Style and Civilization' and other series published by Penguin.

The cover illustration shows a bronze head of the Emperor Augustus (27 B.C.-14 A.D.) in the British Museum. Photo: Fotomas Index.

First published in the United Kingdom 1982 by Macmillan Reference Books
First published in paperback in the United Kingdom 1984 by
PAPERMAC
a division of Macmillan Publishers Limited
4 Little Essex Street London WC2R 3LF
and Basingstoke

Associated companies in Auckland, Dallas, Delhi, Dublin, Hong Kong,
Johannesburg, Lagos, Manzini, Melbourne, Nairobi, New York, Singapore,
Tokyo, Washington and Zaria

Published in the United States of America under the title *The Visual
Arts: A History* by Prentice-Hall, Inc

ISBN 0 333 37185 2

This book was designed and produced by
John Calmann and Cooper Ltd 71 Great Russell Street London WC1B 3BN

Filmset by Keyspools Ltd, Golborne, Lancs
Printed in Hong Kong by Mandarin Offset Ltd

Contents

Acknowledgements

The authors, the publishers and John Calmann & Cooper Ltd. wish to thank the museums, galleries, collectors and other owners who have kindly allowed their works to be reproduced in this book. In general museums have supplied their own photographs; other photographers are listed below.

ACL, Brussels: 10:8. Aerofilms Ltd, London: 5:30a. 8:11. 9:30. 13:36. Agraci, Paris: 15:13. Alinari, Florence: 4:23d. 5:14;18;36;39;47. 7:5;6. 9:40;42;43;48;54. 10:4;6;7;12;14;15;16;17;20; 22;23. 11:17;22;26;38;40;44. 13:1;8;9;21. American Museum of Natural History, New York: 18:1. Anderson, Florence: 4:23b;49;50. 5:4a;4b;37. 7:7;10b;17b. 10:10a;10b;13;19. 11:14;27;34;39. Wayne Andrews, Grosse Pointe, Michigan, USA: 14:2. 15:16. 17:26;27. 19:30. Archaeological Survey of India, New Delhi: 6:6. 12:36. Archives of American Art, Smithsonian Institution, Washington D.C. (David Smith Papers): 21:11. Asukaen, Nara, Japan: 6:45. Bauhaus Archiv, Berlin: 19:31. Raffaello Bencini, Florence: 7:18. 8:15;16. Charlotte Benton, London: 20:16. Bergerhausen Fotostudio, Mannheim: 15:26. Kunst Dias Blauel, Munich: 13:11. Lee Boltin, Croton-on-Hudson, New York: 4:33;37;38;39. E. Boudot-Lamotte, Paris: 2:37. 3:20;31;32;33. 6:15;21;22;23;24;25. 9:59. 12:23. Bridgeman Art Library, London: 14:19;20. 15:17. 16:3. 17:19. British Museum, London: 12:2;12. Brogi, Florence: 11:15. Bulloz, Paris: 9:15. Caisse Nationale des Monuments Historiques et des Sites, Paris: 1:4. 9:28. 10:11. Leo Castelli Gallery, New York: 21:14;16. Janet Chapman/Michael Holford, London: 12:7. China Features, Peking: 6:35. Colorific, London: 19:7. Conway Library, Courtauld Institute of Art, London: 9:36. *Country Life*, London: 14:11. Courtauld Institute of Art, London: 13:18a;18b;22. De Antonis, Rome: 12:45. Detroit Institute of Arts: 12:24;25. Deutsches Archaeologisches Institut, Athens: 4:7. Deutsches Archaeologisches Institut, Istanbul: 5:1; 2. Deutsches Archaeologisches Institut, Rome: 4:54. 5:7;9;35;38;46. Dumbarton Oaks Center for Byzantine Studies, Washington D.C.: 7:35. 9:41.

Eliot Elisofon/Colorific, London: 6:33. William Fagg, London: 12:13. Dr Felbermeyer, Rome: 5:19. Fogg Art Museum, Harvard University, Cambridge, Mass.: 12:38. Werner Forman Archive, London: 3:7;37. 4:12. 6:26;42;54;46. 9:2. 12:5;9;46, Fototeca Unione, Rome: 4:56. 5:23;30b;31;32;41. Alison Frantz, Princeton, New Jersey: 2:38. 4:8;16. Frobenius Institut, Frankfurt: 1:10. Foto Fürböck, Graz, Austria: 4:41. Gallimard, Paris: 2:12;13. 3:16 (detail). Giraudon, Paris: 2:5;21. 3:21;15. 4:42. 6:4;5;10; 12;20. 7:34. 8:2. 9:20;56;57;58. 10:25;11;45. 13:25. 15:8. 17:1. 19:2;3;12. Verlag Gundermann, Wurzburg: 11:6. Sonia Halliday, Weston Turville, U.K.: 7:22. 8:5. 9:21;22. Hamlyn Group Picture Library, London: 13:37. Robert Harding Associates, London: 2:9. 3:28. 6:36. 12:29. Hedrich-Blessing, New York: 20:19. 21:18;19. Lucien Hervé, Paris: 21:20. Colorphoto Hans Hinz, Allschwil, Switzerland: 1:6. 18:25. Hirmer Fotoarchiv, Munich: 2:18a;18b;25;30;32;33;35; 36. 3:8;22;24. 4:1;2;3;5;11a;11b;13;14a;14b;18; 20;21;23a;24;26;27;28. 5:3;4c;10;15. 7:8;12b;23. 14:12. Michael Holford, London: 3:34. 9:11. 11:43. 13:16. Musée de l'Homme, Paris: 18:4;8. Angelo Hornak, London: 8:10. 11:1;36. 14:9. 20:17. India Office Library and Records, London: 6:1. Information Service of India: 21:21. Istituto Centrale per il Catalogo e la Documentazione, Rome: 5:43. 7:41. Sidney Janis Gallery, New York: 20:1. *The Japan Architect*, Tokyo: 21:24. Japan Information Centre, London: 12:56;58. Charles Jencks, London: 16:2. Maggie Jencks, London: 16:42. A. F. Kersting, London: 1:17. 2:20. 3:13. 9:18;26;33;34. 12:35. 15:15. G. E. Kiddersmith, New York: 5:42. Landesbildstelle, Berlin: 15:14. Landesmuseum, Trier: 5:44. Islay Lyons, Siena: 7:2. Macquitty International Collection, London: 3:10. 6:13;19. Bildarchiv Foto Marburg, Marburg: 2:19;22;24. 4:30;31. 7:30. 9:3;7;19;24;27;29;32;35;37. 11:2. Kunstverlag Maria Laach, Maria Laach, W. Germany: 9:25. Ampliaciones y Reproducciones MAS, Barcelona: 8:17. 9:13. 11:3. 12:21;22. 13:2. 15:4. Phyllis D. Massar, New York: 11:33. Arlette Mellaart, London: 1:13. Metropolitan Museum of Art, New York (Egyptian Expedition): 3:11. Photo Meyer, Vienna: 5:24. 7:27. 8:25. 10:28. 11:30;42. 13:20.

Museum of Modern Art, New York: 19:19. 20:6; 20. The National Trust, London: 13:15. Novosti, London: 13:19. 17:8. Orion Press, Tokyo: 6:47. Penguin Books Ltd, London: 17:20;21;22;25a; 25b. Ann & Bury Peerless, Birchington-on-Sea, UK: 6:17. Philadelphia Museum of Art: 15:29. Photoresources, Dover: 1:15;16. Pontificia Commissione di Archeologia Sacra, Vatican: 7:3. Josephine Powell, Rome: 1:14. 2:34. 3:1. 5:40. 6:3b. 7:19;29;36. 8:18;19. 9:47. Prestel Verlag, Munich: 8:20;21. 10:3. 12:30. 19:11. Albert Renger-Patzsch, Wamel: 14:4. Alfred Renz: 12:37. Réunion des Musées Nationaux, Paris: 1:3. 2:1. 3:16. 6:30;58. 9:46. 11:12;13;20. 14:21. 15:1; 2;5;7;20;21. 17:2;12;13;29. 20:4b;5. Rheinisches Bildarchiv, Cologne: 9:1;4. Roebild, Frankfurt: 7:42. Rollin R. La France: 21:22. John Ross, Rome: 2:17;27;28. 3:6;23. The Royal Pavilion, Art Gallery and Museums, Brighton: 17:28. Sakamoto Photo Research Laboratory, Tokyo: 6:55;56;59. 12:61. Oscar Savio, Rome: 5:34. Scala, Florence: 1:11. 2:4;10;11. 3:2. 4:4;25a;25b; 45;47;48. 5:13;16;20;21;22;25;29. 7:9;13;14;15; 16;33. 8:24. 9:5;6;10;12;51;52;53;55. 10:1;2;26a; 26b;29;30;31;36;39;42. 11:24;25;28;29;32;35. 13:6. 14:15. Helga Schmidt-Glassner, Stuttgart: 5:27. 9:38. Sheridan Photo-Library, London: 4:29. 5:17;28. 7:21;24. 9:9. 12:31. Professor W. Kelly Simpson, Boston Museum of Fine Arts: 3:9. Éditions d'Art Albert Skira, Geneva: 8:6;7;9. Soprintendenza alle Antichità dell'Etruria Meridionale: 4:53. Soprintendenza alle Antichità delle Province di Napoli: 6:3a. Soprintendenza alle Gallerie di Milano: 11:11. Alex Starkey, London: 12:28. Stedelijk Museum, Amsterdam: 20:13. Thames & Hudson Ltd, London: 6:50. 9:49;50. Unesco/Mireille Vautier, Paris: 6:27. University Museum, University of Pennsylvania, Philadelphia: 12:3. Leonard von Matt, Buochs, Switzerland: 4:46. 5:26;33. 11:18. 13:17. Professor William Watson, London: 12:44;49. Roger Wood, Jo Harrison Library, London: 8:12. K. Woodbridge: 14:10. Yale University Art Gallery, New Haven, Conn. (Dura Europos Collection): 7:4. Yan, Toulouse: 1:5;7. The Zauho Press, Tokyo: 6:51;57;61. 12:48;53;54;55. Zefa, London: 18:23.

Preface

We have been indebted to many friends for help and encouragement in writing this book, above all to the late John Calmann without whom we should never have had the temerity to embark on it. His death, when it was little more than half finished, deprived us of a warm friend and an outstandingly gifted publisher. Since then all possible assistance has been given to us by his sister Marianne and by his loyal staff. To Sarah Riddell's meticulous editorial skill we owe a very great deal, as also to Elisabeth Ingles and Dr. I. Grafe whose careful reading of the text has saved us from many errors. Susan Bolsom-Morris was indefatigable in searching for the photographs we wanted. And the book, in its final form, owes much to the patient cooperation and visual sensibility of the designer, Harold Bartram.

For guidance and information either on specific points or more general issues we have importuned a number of scholars, several of whom have kindly read whole chapters or sections and have given us the benefit of their specialized knowledge. They include James Ackerman, Bruce Boucher, Richard Brilliant, J.F.Cahill, Lorenz Eitner, Nicholas Gendle, Oleg Grabar, Ian Graham, Michael Grant, Francis Haskell, Howard Hibbard, Derek Hill, Robert Hillenbrand, John Dixon Hunt, Charles Jencks, Alastair Laing, Sherman E.Lee, Norbert Lynton, M.D.McLeod, Margaret Medley, Patricia Phillips, Alex Potts, Martin Robertson, Michael Rogers, Aaron Scharf, Dorota Starzecka, William Watson and Sarah Jane Whitfield. To all of them we are deeply indebted, as also to the authors of books and periodical articles, too few of whom are recorded in our necessarily very brief bibliography (p. 627), and of course to many librarians especially those of the London Library and the Kunsthistorisches Institut in Florence.

For help in connection with photographs and other problems we are most grateful to Naomi Caplin, Peter Carson, Françoise Chiarini, John and Thekla Clark, Anne Distel, Aastrid Fischer, Michael Graves, Andreina Griseri, Anne d'Harnoncourt, John Harris, Carlos van Hasselt, John Irwin, Arata Isozaki, Margaret Keswick, Islay Lyons, Henry P. McIlhenny, Dominique de Menil, John H.Morley, John Ross, Laurence Sickman, William Kelly Simpson, Nikos Stangos, Mary Tregear, Hermione Waterfield, and William Weaver. And, finally, we must also thank, most gratefully, the friends who have helped us in more personal ways—Noel and Giana Blakiston, Milton Gendel, Nicholas and Susanna Johnston, Ornella Francisci Osti, Donald Richard, Richard Sachs, Gary Schwartz and Sebastian Walker.

Hugh Honour John Fleming
November 1981

A compromise between American and English spelling has been agreed by our publishers. In the transliteration of Greek and non-European names and terms we have adopted the most widely accepted spellings, using for Chinese the Wades-Giles rather than the new Pinyin system. The Christian calendar is used throughout. Dates in brackets refer to the birth and death of artists and writers and to the reigns of rulers (emperors, kings and popes).

Introduction

In writing this outline history our aims have been exploratory rather than critical. We have preferred exposition to interpretation and evaluation, in so far as they are separable. And we have tried to shed assumptions about art being intended primarily for aesthetic enjoyment, often in alliance with social prestige, assumptions determined largely by the art market and art collecting and themselves, in turn, responsible for current Western conceptions of what 'art' is. It is not always easy to bear in mind that these conceptions are peculiar to the West and, even there, relatively recent. Until the nineteenth century few, if any, great works of art were made to be seen in museums or art galleries. Most were made in the service of religion or magic or of some secular ideal or, more rarely, to fulfil the private longings of the artist. So this book seeks to explore the different ways in which men and women have given visual expression to perennial human impulses and concerns—to the appetite for sensual gratification and the need for self-knowledge and self-mastery, to exalted dreams and demonic passions, to beliefs and convictions about the ends of life and about the human environment and the supernatural powers, to hopes and fears of the beyond.

Confronting so vast a horizon in both time and space, we have been obliged to focus attention on the historically salient periods and areas, which are also those of most general interest. Chapters are arranged chronologically across a wide geographical panorama in order to allow crucial events in world history (which affected artists as much as other human beings) to stand out clearly—the aggregation of hunters and gatherers into pastoral and agricultural communities, for instance, the emergence of urban cultures with stratified social structures, the expansion and dissolution of empires, the spread and transformation of world-wide religions, the rise of industrialized states—and to permit, within these and other great historical transitions, some detailed and instructive confrontations. Juxtapositions of the 'civilized' and 'barbarian' cultures of the ancient Greeks and their neighbours in the fifth century BC, or of the works of contemporaries as dissimilar (though in some ways comparable) as Michelangelo and Koca Mimar Sinan, or of the cult of natural beauty and its expression in landscape painting in China, Japan and Europe in the sixteenth and seventeenth centuries—parallels of this kind are not only mutually illuminating but sharpen awareness of the meaning and purpose of art in general. Above all, we have tried to illustrate and discuss works of art in their original contexts, dissociating them as far as possible from the museum surroundings in which they are nowadays so often confined, without, on the other hand, trying to find in them any evolutionary pattern.

In every human society, art forms part of a complex structure of beliefs and rituals, moral and social codes, magic or science, myth or history. It stands midway between scientific knowledge and magical or mythical thought, between what is perceived and what is believed, and also between human capabilities and human aspirations. As a means of communication it is akin to language, with the aim of making statements of a didactic or morally instructive nature; but at the same time it is often a means of exerting control, akin to magic, with the aim of imposing order on the physical world, of arresting time and securing immortality. Within the social group, whether it be a single village or a vast and ramifying empire, motifs, themes or subjects are drawn from a common stock. The manner of the representation is restricted by the availability of materials and tools, by the skills passed on from one generation to the next and by what can only be called 'tribal' conventions, though they are often of great sophistication. Yet art is constantly regenerated like the living organisms of social and cultural structures which are always subject to modification, as a result either of internal growth or of external pressures. In stable societies, or those which seek stability, artistic changes often take place so gradually as to be barely perceptible. Even in more dynamically expansive societies artistic change may take place at one level while continuity is maintained at another. Western ideas of 'progress' have tended to distort our view of the art of the world.

The illusion of progress and pictorial representation
Throughout the world, delineation, whether incised, drawn or painted, has been a means of attaining one of the prime aims of pictorial art: the isolation of an object from the array of coloured patches the eye sees

in nature. The earliest known paintings, in French and Spanish caves (see p. 15), are outlines of animals unrelated to earth or sky, and associated with one another mentally rather than visually. Composite groups came later and the defined image field later still, with the invention of framing devices. Even in some of the most sophisticated forms of two-dimensional art the images are all that count, the field on to which they are projected being generally no more than part of an undefined ground, not a background in the Western sense. In ancient Egypt it was often covered with hieroglyphs, in China with inscriptions. Colour was added to set off images, fill in their outlines and distinguish their parts.

Colour has been used to define forms without drawn outlines only since the sixteenth century in Europe and, more rarely, in China (where such paintings are said to be in the 'boneless manner'). In the West the adoption of a 'painterly' technique was the response to the peculiarly European conception of a picture as a 'window' on to a real or imaginary world. It was connected with the development of linear perspective, to relate objects in space seen from a single viewpoint, of *chiaroscuro*, the manipulation of light and shade to mold form, of aerial perspective, the subtle gradation of tones to suggest distance, and also the refinement of the distinction between the actual colours of objects (local colour) and those they take on by reflection. Although these devices enable a painter to trick the spectator's eye, *trompe l'oeil* or illusionism was seldom pursued as an end in itself. They led, however, to the creation of a uniquely Western art form, the framed easel picture—a painting on panel or canvas intended to be hung on a wall and admired for the skill with which the visual world was captured and conveyed and also, additionally, for harmonies and contrasts of colour, delicacy or bravura of brushwork, simplicity or complexity of composition. The development of this naturalistic form of painting, which became the central theme of histories of art from the sixteenth to the nineteenth century, coincided with the Renaissance cult of 'beauty' and together they dominated the practice as well as the theory of Western art. A sense of progressive achievement was induced—of painters advancing ever closer towards a goal of visual truth—and only began to be seriously questioned by artists in the nineteenth century. Meantime, the rise of the easel picture as the predominant art form in the West had a marked effect on the relationship between the artist, the work of art and the public. The easel picture was intended for no specific location but simply became part of the furnishing of a house or an exhibit in an art gallery. 'The picture hook is the ruination of painting', Picasso said. 'A painting is done for as soon as it is bought and hung on a wall.' It becomes a form of decoration.

Context: meaning and function

If all great works of art were created for a purpose, whether religious, social, political or, exceptionally, to express the artist's inner vision, few man-made objects have been created without some regard for aesthetic qualities. An almost universal and possibly innate demand for symmetry and patterning can be felt in the simplest household objects made by craftsmen. Yet their decorations are never purposeless. They answer two basic human urges, to impose order on nature and natural forms and to assert individuality by marking the differences between one human being or group and another. Objects are made and decorated in accordance with preferences for certain forms and colours developed within a social group as part of its traditional way of life. Shields are a case in point. They are found in all cultures throughout human history. Yet despite their simple unitary purpose, they differ far more widely in shape (round, ovoid, hexagonal, etc) than can be explained by function or medium—modes of combat or types of material used. A particular shape of shield could be used and read as a distinguishing mark for a group or tribe or clan. Colour was often similarly used—or to indicate the bearer's rank—and so were figurative designs such as the coats of arms of European heraldry. But they often had an additional, magically protective purpose. Thus a shield shown in a sixth-century AD mosaic at Ravenna bears a Christian symbol (see p. 228). The painting on a shield from the Trobriand islands in Melanesia (p. 562) is more difficult to interpret, but almost certainly had a magical significance. Many other types of painting and also of sculpture were similarly apotropaic—intended to ward off evil—the great *lamassu* of Assyrian palaces (p. 74), for instance, or the gargoyles that leer out from Gothic churches. In them art and magic are very closely integrated. But the visual arts also served other magic purposes, to encourage fertility, to control the elements and support the after-life of the dead.

Works of art cannot be fully understood unless related to the circumstances in which they were created. Context is all-important in art as it is in language. Iconography, the study of the meaning of visual images, seeks to elucidate the original significance of works of art by setting them in their general cultural ambience. In many works there are, however, superimposed levels of meaning, which cannot always be recovered. For meanings have been conveyed visually in a variety of interconnected

ways—from the most direct (in representations of gods or rulers) to the symbolic (by the use of conventional colours and of non-representational signs such as haloes) and the allegorical (by the personification of abstract ideas).

Pictorial devices used to enforce these meanings are so familiar that they can often be taken for granted, symmetry to suggest a stable order, for instance, asymmetry dynamism or violent emotion. Scale can be similarly used to emphasize a figure's importance, often together with a central position as in the groups of three which recur in the art of the world—the Buddha flanked by two smaller Bodhisattvas, Christ between two saints, a ruler with two attendants. The central figure is normally posed frontally, looking straight ahead, while those on either side may be in profile. When symmetry is avoided, as in narrative art, and figures are scaled naturalistically, the protagonists are distinguished more subtly by placing them against a blank area or arranging the scene so that the spectator's eye is directed to them by the dominant lines of the composition.

Sculptors used similar devices to point up meaning, especially when working in low relief or high relief (that is to say with figures at least half in the round). In ancient Egyptian art there is little distinction between wall paintings and reliefs which were shallow and coloured: the same conventions were observed in both. The materials of sculpture might have significance, too. Precious metals, bronze and types of hard stone, which demand great expenditure of labour in carving, often reflect the importance of the subject represented. Their durability was expressive in its 'intimation of immortality'. Marble statues and 'the gilded monuments of princes' were intended to last for ever. Similarly, sheer size could denote superhuman power, large-scale sculpture generally being reserved for religious and political imagery—closely related as in ancient Egypt and imperial Rome. The third dimension gives sculpture a tangible presence and in many cultures statues were regarded as receptacles for a human or divine spirit and thus became objects of veneration, if not of worship. Hence the very strict rules which governed their forms and sometimes the processes by which they were made. Hence, too, the ban placed on them by more than one religion.

Size and media are no less demonstrative in architecture than in sculpture. A building larger than its neighbours or raised on a platform declares an importance which might be further emphasized by the use of distinguishing materials. The size of houses and their exterior decoration have often been regulated by laws according to social class. The need for shelter is no

more than a point of departure, and in most societies and cultures architecture has been concerned mainly with the creation of an environment for human activities and thus involves the manipulation of space as well as mass, answering a need for a defined spatial frame within which human actions can both literally and metaphorically 'take place'. The lay-out of a settlement corresponds to its inhabitants' conception of their relationship with one another and with exterior forces. Order is established by planning and a gridiron or chequer-board plan was often adopted in absolutist states where land-ownership was vested only in the ruler and portions were parcelled out among subjects (although it also came to be adopted simply as a convenience for new towns in ancient Greece and colonial America). Strong axes or paths control movement towards a goal or outwards from a central point. Very often and in many different parts of the world, individual buildings and whole cities have also been oriented on astronomical phenomena (sunrise and sunset or the movement of the stars) to maintain harmony between life on earth and the heavens above. The west-east axis of a Christian church has a cosmic significance combined with the symbolism of the believer's path from initiation to salvation and eternal life. Such spatial organization provides, as it were, the grammar of an architectural language. Symbolic meanings are spelled out by forms and motifs. Domed roofs, for instance, usually reserved for regal and religious structures, reflect the hemisphere of the firmament, as is often made explicit by the decoration of their interiors. Articulation of mass, that is to say the simultaneous division and integration of inter-dependent parts, creates such effects as those of processional movement along a horizontal path or of aspiring verticality. In this way a building is given architectural expression or character within the spatial field which it dominates or helps to define.

Art as craft

Art, craftsmanship and technology are three terms which seldom have meanings as distinct as those they have acquired in the West since the sixteenth century. The creation of an artifact is dependent on both manual skill and technical knowledge. A pottery vessel, no less than a temple, a painting or a statue, demands the coordination of ideas of form and decoration with dexterity in handling raw materials and mastery of the techniques which ensure its permanence. In all but the very simplest buildings and utensils, however, there is a tension between ends and means, between the 'idea' and the skills needed to express it and give it form. And this tension gives art, as

we understand it, a history different from that of craftsmanship or technology. Methods of construction, carving or painting do not supersede one another as they do in technology, one mechanical invention rendering an older device obsolete. They often have a significance apart from their practical purpose—seen most obviously in the interplay between structural and stylistic developments in architecture, including that of our own time.

There are two basic systems of building: with posts which support horizontal members or lintels, and with walls pierced by openings. Ancient Egyptian and Greek temples are the most prominent examples of post-and-lintel architecture: their walls are merely fillings between uprights. Both the Egyptians and the Greeks were, nevertheless, also practitioners of wall architecture. At an early date, and in different places, it was discovered that spaces could be completely enclosed by projecting each horizontal course of a wall slightly over that below to form a vault or dome. This system was further developed by the ancient Romans, whose exploitation of round arches and invention of concrete enabled them to span areas of an extent that was unprecedented and for many centuries remained unequalled. For the practice of building with concrete was abandoned in the Early Christian period, although other elements of Roman architecture, the columns taken over from Greece and the round arch, were retained.

Sculpture also has two basic techniques: modelling and carving. As one depends on building up clay or other malleable material and the other on reducing a piece of stone or wood, they are called additive and subtractive processes. Carvers are restricted by the natural characteristics, shape and consistency of their materials and the efficiency of tools with which to fashion them. The cylinder of a tree-trunk, like an invisible cage, encloses a statue carved from a single piece of wood. the rectangularity of a block of stone hewn in the quarry similarly determines the form of a figure, most obviously when a carver begins work by marking outlines on its four faces. The hardness or brittleness of stone dictates the degree of delicacy with which it can be worked. Iron chisels and drills, which came into use in the West in the first millennium BC, greatly lightened the carver's task and opened up new possibilities, especially in undercutting, though they resulted mainly in increased production. Without their aid, however, some of the most finely worked statues had been carved out of the hardest of stones in ancient Egypt. In wood, effects of the greatest intricacy and delicacy were often obtained with the simplest implements—no more than flakes of stone and

seashells in Melanesia (see p. 552).

The properties of clay and other malleable media likewise restrict modellers. No form that extends far beyond the lump into which it naturally subsides can be held together without a skeleton or armature of wood or metal. Clay figures are impermanent unless baked hard in an oven, the heat of which must be controlled to avoid fragmentation. In the second half of the third millennium BC it was discovered in Mesopotamia that a durable metal version of a clay statue could be made by the lost wax or *cire perdue* (see Glossary) method of bronze casting. As shells of cast bronze are considerably lighter in weight than equivalent pieces of stone (especially marble and other close-grained stones favoured by sculptors of all cultures and periods) and also have some resilience, the medium permits a wider range of formal effects. Stone sculptures must be columnar, cubic or pyramidal if they are to stand upright—the legs of a standing figure cannot be placed wide apart unless a third support is provided. Bronze figures, on the other hand, may be delicately, even precariously, balanced. Effects of amazing naturalism have been achieved in clay and bronze sculptures in many parts of the world, and carvers often attempted to rival them by modelling forms in clay and then copying them in stone. The production of lifelike statues involves, nevertheless, much more than the meticulous imitation of forms and surfaces, and although intermittently achieved, this has rarely been regarded as the principal aim of sculpture.

The only comparable technical problem confronting painters is simply that of fixing pigments to a ground, by the use of coloured stains which are absorbed (as in fresco and watercolour) or by mixing coloured powders with an adhesive binding agent (egg yolk for tempera, various oils for oil painting). There are usually three layers to a painting: a film of pigments, a prepared ground and a support which may be a rock-face, a wall or some piece of transportable material such as wood or canvas. The various types of support and ground, as well as the range of available pigments, their properties and the consistency of the binding agent, all condition the painter's art. Figurative mosaics and woven tapestries impose greater restrictions and were for centuries, in the West, more highly valued than paintings. Each of the processes of print-making—from carved wood-blocks, from engraved or etched metal plates or from drawings on stone (lithography)—has its own possibilities and limitations. But, significantly, only in its use for scientific illustration does print-making have a progressive history, like technology. Copper-plate engrav-

ings with their fine, even lines superseded woodcuts for maps and for the detailed, accurate illustration of plants and animals in books on natural history in sixteenth-century Europe. For imaginative work, on the other hand, artists preferred etching, which permits greater freedom and gives the effect of pen-and-ink drawing. And in the nineteenth century there was a revival of the woodcut and the inventon of lithography as art forms of expressive power.

Until the present century, the projection of three-dimensional images on a two-dimensional surface, either conceptually (according to what the mind knows) or perceptually (according to what the eye sees at a particular moment), has been the traditionally accepted aim of painters and draftsmen. A conceptual image can, in theory, record the salient characteristics of any object, sometimes by taking it apart and reassembling it—front, back and sides—so that all are visible. A perceptual image is an attempt to record the 'truth' of visual appearances, though in practice it is inevitably influenced by what the painter knows not only about the properties of the subject in question, but also about the ways in which it has previously been depicted. The style in which a subject is depicted (or sculpted) depends as much on traditional modes of expression as on individual ways of seeing, as much on the materials and techniques available as on a particular artist's skill in handling them.

Style and the individual artist

The word 'style' is derived from *stylus*, the writing instrument of the ancient Romans, and was first applied metaphorically to the manners of public speaking appropriate for different occasions. In an artistic sense. a style is a visual language with a vocabulary of forms or motifs and a syntax governing their relationship. Stylistic changes, which include reversions to earlier styles (a prominent feature in both Chinese and Western art) and the adoption of alien styles, sharply distinguish the history of art from that of technology and the sciences. They are the outcome of a perennial struggle with materials and meanings. For although styles reflect in varying degrees the assumptions, beliefs, philosophies, moral codes, political and other ideals of the society or culture to which they belong, they are also the creation of individual painters, sculptors, architects and crafts-men, the mark of whose personal 'handwriting' they inevitably bear.

The study of styles can illuminate works of art by relating them to others and sometimes also to the literature and music of the period and place in which they were produced. Styles indicate the range of possibilities open to artists in choice of materials and subject-matter, as well as in the means of expression. An artist's preferences, whether for the conceptual, or the linear or painterly, for symmetry or asymmetry, for compositions that are static or dynamic, 'closed' or 'open', that is to say those that isolate the subject and those that present it as part of a world which the spectator is invited to enter, all these and many other similar factors may contribute to the formation of a style. Different styles may, however, coexist and be adopted for different purposes even in a small social group—one being reserved for religious art, for instance.

In some communities practically every man and woman is a part-time artist. Whole-time painters and sculptors are found only in the more complex, stratified societies, where their standing was rarely superior to that of other craftsmen. Architects have generally been ranked higher, partly because their art required mathematical and other scientific skills and knowledge, partly because they were also organizers of teams of labourers and craftsmen. Until very recently the writing of artists' and architects' biographies has been limited mainly to China and the West. Most of the art of the world is anonymous—though it must be stressed that this does not imply any suggestion of impersonality. Visual works of art have always been unique creations by individual men and women and artistic styles are likewise the creation of individuals, though often in response to shared circumstances.

In some respects the history of art is comparable with that of literature. There is continuity and change in both, progressive improvement in neither. Both are punctuated by masterpieces which transcend circum-stantial limitations, with a timeless appeal independent of, and sometimes even at odds with, the intentions of their creators. The history of art is, however, entirely dependent on the survival of physical objects, even in the present age of mechanical reproduction. Yet it has had a much longer time-span than that of literature. For many ages we know of humanity's aspirations and attempts to come to terms with its predicament only through visual works of art. Great works of art are more than aesthetically pleasing objects, more than feats of human skills and ingenuity: they deepen our insight into ourselves and others, they sharpen our awareness of our own and other religious beliefs, they enlarge our comprehension of alternative and often alien ways of life—in short, they help us to explore and understand our own human nature. The history of art is an essential part of the history of the human race.

Part 1 Foundations of art

1 Before history

The history of the manual techniques which have enabled the human race to dominate its environment began in east-central Africa more than two million years ago, when pebbles were first made into rudimentary tools by breaking off part of the surface to form a working edge. These first artifacts were made by man-like creatures, sometimes identified as *Homo habilis* (able or handy man), a species of the zoological genus of hominids. By chipping flakes from the opposite faces of a stone to give it a cutting edge, a more efficient tool was being made about a million years ago in Africa and about half a million years ago in Asia and Europe by *Homo erectus*. Members of this species in China had also learned the use of fire, indicating a further advance in cognitive capacity. After another quarter of a million years, choppers and multi-purpose tools called hand-axes were being flaked and smoothed into more or less regular shapes, sometimes even into roughly symmetrical shapes. Awareness of form and function and the connection between them on which tool-making depends had been heightened. In the process, the first step towards the making of art had been taken.

Neanderthal man—*Homo sapiens neanderthalensis*—who was living in Europe and west Asia from about 125,000 years ago, made a great variety of implements. Members of this sub-species coloured their bodies with red ochre. Their thoughts seem to have extended beyond the immediate, physical world, for they buried the dead in graves with funeral gifts of food and weapons and, in at least one instance (at La Ferrassie in France), a kind of monument—a large stone from which pairs of concave cup-like marks had been pecked out. It is impossible to be certain about this, of course, but if the markings on the stone had a commemorative, magical or at any rate non-utilitarian purpose, the second step towards the making of art had been taken. These were the millennia of the last Ice Age, broken by slightly warmer 'inter-glacial' periods,

during the last of which, around 40,000 BC, Neanderthal man vanished and another sub-species, the only one to survive and that to which we belong, made its appearance in Asia and Europe: *Homo sapiens sapiens*, as we are zoologically designated. In every essential respect, including brain capacity, these people were like ourselves. Before the final stage of the Ice Age (see p. 15), they had carved the earliest known objects which can be called works of art.

Unfortunately, the stone carvings which survive from this remote age cannot as yet be dated with enough precision to reveal a sequence. The earliest can only be dated to within 5,000 years—a period as long as that which separates us from the beginning of history. We know nothing of the predecessors they almost certainly had in such perishable materials as wood and unbaked clay. So the curtain goes up on the history of art some time after the play has begun. Nor can we tell how far surviving carvings are typical of the culture that produced them. They have been found over an enormous area in Europe and southern Russia. And they are, of course, very rare in comparison with the tools and implements, of which a considerable number have survived.

The art of the hunters

The little figure of a woman, no more than $4\frac{1}{2}$ inches (11.5cm) high, found at Willendorf in Austria, is the most striking and famous of these first works of art (1, 1). It is between 25,000 and 30,000 years old, carved out of limestone, and seems originally to have been covered with pigments, of which traces remain. The exaggerated rotundity of the body has a yielding fleshiness, felt rather than seen. The hands resting on the breasts, the arms and the lower legs are no more than sketchily indicated and the woman has no face. Tiny curls of hair cover her entire head. There can be little doubt that she was carved as an image of fertility, probably as some kind of magic charm, perhaps to be

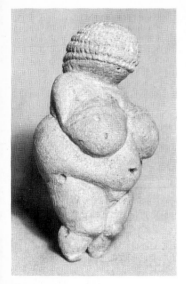
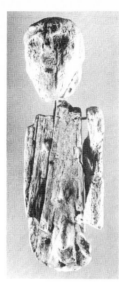

1, 1 *Above left* Woman from Willendorf, Austria, c. 30,000–25,000 BC. Limestone, 4½ins (11.5cm) high. Naturhistorisches Museum, Vienna.

1, 2 *Above right* Man from Brno, Czechoslovakia, c. 30,000–25,000 BC. Ivory, 8ins (20.3cm) high. Moravian Museum, Brno.

held in the hand. Other female figures which are dated slightly later (in millennial terms!) similarly emphasize the breasts, belly and buttocks, and in one instance, the remarkable Woman from Lespugne (Musée de l'Homme, Paris), they are almost completely abstracted into an organic geometry of cones, ovoids and spheres. Sometimes only part of the body is represented—the breasts in ivory carvings found at Dolní Věstonice in Czechoslovakia (now in the Moravian Museum, Brno); well-defined belly and thighs in a stone carving from Tursac in the Dordogne, France; and numerous vulvae engraved on rock-faces in the Dordogne in about 25,000 BC. In a strange sandstone figure of about the same date, found at Chiozza in Italy, the female form, again without feet, is combined with a faceless head like the tip of a phallus as if to unite the generative organs of the two sexes into a single image (Museo Civico, Reggio Emilia). Sex and art would seem to have been closely allied from the very beginning.

A badly damaged ivory statuette of a man, which seems originally to have stood some 17 inches (43cm) high, dates from the same period as the Woman from Willendorf (1, 2). It was found at Brno in Czechoslovakia in the grave of a man evidently of some importance, for he was buried wearing a head-dress or necklace made of cut and polished beads of mammoth tooth, bone roundels and some 600 pieces of shell. To judge from the present damaged state of the statuette,

the body was schematically represented and the carver's attention concentrated on the naturalistically rendered head with close-cropped hair and deep-sunk eyes. Whether it was intended as a portrait, a symbol or the image of a supernatural being cannot, of course, be known. But its place of discovery reveals that it was used in a ritual of burial, which implies some form of religious belief.

The objects found with the Man from Brno were clearly used for personal adornment—another human impulse closely involved with the visual arts—though we cannot tell whether they were selected for their aesthetic or magic properties or a combination of the two. A little ivory head from Grotte du Pape reveals that women dressed their hair in braids even at this very remote period (1, 3). Other small ivory and bone carvings show signs of having been handled and worn as pendants or carried about the person in pouches, perhaps as charms. They include some remarkably well-observed animals, found with others equally fine in baked clay, in the Vogelherd Cave (now Tübingen Institut für Vor- und Frühgeschichte). Like the Woman from Willendorf and the Man from Brno, they are naturalistic. This is one of the most extraordinary of all the extraordinary features of prehistoric art and it becomes even more evident in cave paintings of animals. They are visualized, not conceptualized; that is to say that, unlike children's drawings and other so-called 'primitive' attempts at visual representation, they are based on what the eye sees and not on what the mind knows. It can only be supposed that their original purpose, whatever it may have been, was in some way

1, 3 Woman's head from Grotte du Pape, France, c. 22,000 BC. Ivory, 1⅓ins (3.4cm) high. Musée des Antiquités Nationales, St-Germain-en-Laye.

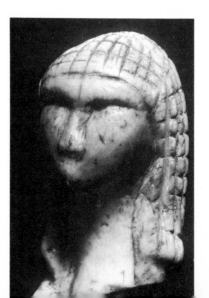

linked with their lifelikeness. What is still more extraordinary is that a conceptual art of symbols was practiced in the same area at the same time (see p. 17 below).

The period is termed Upper (or late) Paleolithic. In the nineteenth century, when people first became aware of the vast tract of time preceding the earliest written records (i.e. before the third millennium in the Near East, later elsewhere), a system already in use for classifying artifacts was applied chronologically to the early history of the human race, dividing it neatly into three: Stone Age, Bronze Age and Iron Age. The Stone Age was then subdivided into Paleolithic, Mesolithic and Neolithic (old, middle and new) and each was again split up into cultures named after places where important finds of stone implements were made. This general system based on technological criteria was also used to categorize non-literate cultures still extant in Africa, Australasia and America—to the great confusion of both anthropological and prehistoric studies. For it can at best provide only a relative chronology within geographically limited areas. More recently, the radiocarbon method of dating (see Glossary) and other scientific tests have made it possible to date even the most ancient artifacts much more accurately. Nineteenth-century terminology is still used, none the less.

The Woman from Willendorf and the Man from Brno are products of an Upper Paleolithic culture which flourished in an area extending from present-day France to southern Russia and is called East Gravettian. Their makers lived on the edge of an ice-cap in a landscape like that of modern Greenland or the Canadian barrens. They subsisted by hunting a variety of animals—mammoths, reindeer, wolves, horses, arctic foxes, arctic hares and willow-grouse. For some part of the year, presumably the long and very cold winter, they gathered in settled communities of perhaps a hundred or slightly more people. These villages were usually sited near a spring and some were inhabited for several centuries. Huts were built of mud and other materials, including stone and mammoth bones. Each had at least one hearth, some as many as five. There were also workshops in which implements were made of stone, bone and ivory, and clay was modelled and baked—all suggesting the emergence of specialized craftsmen.

Cave art
Sculpture precedes drawing and painting in the archeological record—though it should be remembered that we know nothing of what may have been painted on perishable surfaces, including the human

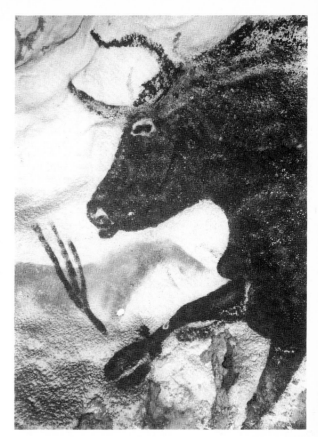

1, 4 Bull's head, c.16,000–14,000 BC. Paint on limestone rock, total length of bull 16ft (4.88m). Lascaux, France.

body. In south-western France before about 25,000 to 20,000 BC animals were incised in bold outline on the walls of caves. From about 18,000 BC red, black and yellow pigments were also being used, especially for stencil impressions of hands, many of them with disturbingly mutilated fingers. Such 'drawings' hardly prepare us, however, for the cave paintings. They began, so far as is known, some three millennia later in the so-called Franco-Cantabrian triangle, which extends from the north coast of Spain to south-western France and has its northern apex in the valley of the Dordogne. Although human beings were still comparatively 'rare animals', this appears to have been the area most densely populated by them immediately after the Ice Age (18,000–15,000 BC). They subsisted by hunting the large herds of animals which had been driven south by the cold, and as the ice retreated they seem to have made summer forays into northern Europe. They were expert workers of flint and evolved a wide range of weapons of standardized forms to kill

the beasts on which they lived.

The earliest paintings in the most famous of the caves, Lascaux, seem to date from about 15,000 BC. During the following 5,000 years or so, cave painting continued with unchanging consistency, apart from slight local variations. For sheer vitality, freedom of hand and sureness of touch, the best of these paintings have rarely been excelled. The bulls at Lascaux (1, 4), for instance, or the bison at Altamira or the shaggy horses at Niaux (1, 5) beautifully catch an essential 'animality', suggesting not only form and texture but also gait and physical presence with an astounding economy of means. They are among the most vivid of all paintings of animals. When the first examples were found at Altamira in northern Spain in 1879 most archeologists dismissed them as a hoax perpetrated by an artist friend of the caves' owner: few were able to believe that they could be prehistoric. Subsequent discoveries, especially those at Lascaux made by accident in 1940, left no doubt that they are Paleolithic, and scientific methods of dating have now established their approximate age. Their technique has also been analyzed. The pigments were derived from natural minerals—reds, yellows and browns from ochre and hematite; black, dark brown and violet from various types of manganese. These substances were ground to powder and applied directly on to the damp limestone walls and ceilings of the caves. First, the outlines were painted with pads of fur or moss, with primitive brushes of fur, feather or chewed stick, or simply with a finger, and then the outlines were filled in by spraying

powders through bone tubes. (Such tubes with traces of colour have been found in the caves.)

The caves extend for several hundred yards underground, and the paintings are mainly in their inner and deeper recesses, far beyond the entrances with natural light and other areas which might have been used for habitation. At Niaux the most elaborately painted chamber is 870 tortuously winding yards (800m) from the entrance. Visitors to the main chambers at Bédeilhac must crawl on their stomachs through a long, low, narrow passage.

The natural formation of the cave surfaces was exploited by the painters, but not at all consistently. For instance, advantage was taken of the unusually large chamber at Lascaux, the 'great hall', to paint vast bulls, each 16 feet (5m) long (1, 6); elsewhere the larger chambers sometimes have very few paintings. Similarly, the natural formation of the rock-face seems sometimes to have suggested to the artist the form of animal depicted and surface irregularities were also exploited visually, as at Pech-Merle in France, where a rock-edge serves as the outline for a horse's head; but they were just as often ignored. Whether cave painting originated in this way, in seeing animal images in the fissures and veins, the bumps and hollows of the cave surfaces—just as we sometimes see pictures in the random stains on a damp wall—cannot be known. But it is tempting to speculate on the possibility that cave art began by some Stone Age hunter recognizing the shape of an animal lurking, as if by magic, in the rock-face and then marking what he had divined so that others could see it too.

The subject-matter of cave painting is limited almost exclusively to animals. Very few men and no women

1, 5 Wild horse, c.14,000–12,000 BC. Paint on limestone rock, length of horse 28ins (71cm). Niaux, Ariège.

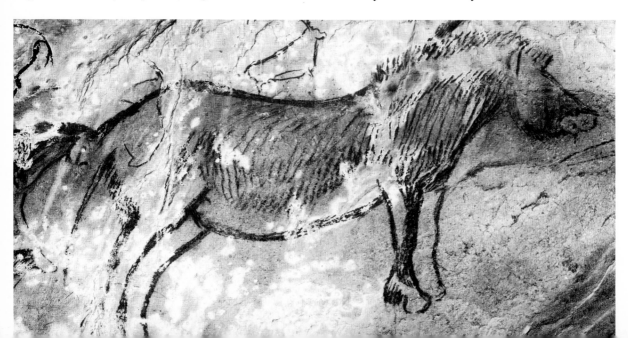

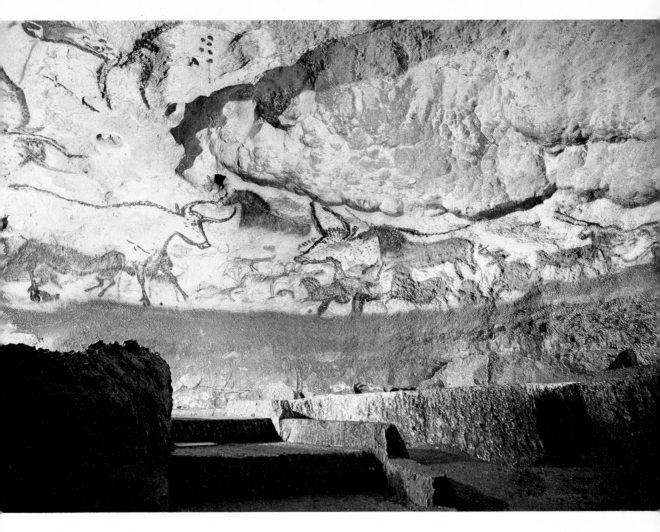

1, 6 General view of cave chamber at Lascaux.

appear. The choice of animals is also somewhat surprising, for it was not confined to those which were hunted and eaten. Reindeer initially provided these people with their staple food and also with skins, antlers, bones and tendons, all of which were utilized. As reindeer gradually moved north with the retreating ice, their place was taken by ibex. Reindeer are, however, very rare in cave painting (though they were quite often engraved on small pieces of bone), and ibex are less numerous than bison and horses, which seem rarely to have been eaten. Mammoths, lions and woolly rhinoceros (now extinct) were more frequently depicted than creatures more commonly encountered, such as hares, birds and fishes.

That it is possible to identify all these animals, even extinct species, testifies to the skill of the cave painters in naturalistic representation. The animals are rendered with amazing fidelity to optical fact. Indeed, their lifelikeness is such that one can almost hear the thunder of the hooves as the bulls stampede across the ceiling of the 'great hall' at Lascaux. Yet when the cave painters depicted a human being, they resorted to the most rudimentary of conceptualized images—a box with sticks for legs and arms. Nor were they unaware of signs and symbols. For alongside the naturalistic depictions of animals are often found strange geometrical configurations, some of which have been interpreted as male and female sexual symbols.

The naturalism of cave painting, however, may be misleading. Paleolithic artists, like those of later ages down to our own time, worked within a conscious or unconscious set of visual conventions. They painted from memory, but their memories held both images of things seen and of other images. Traditions or systems

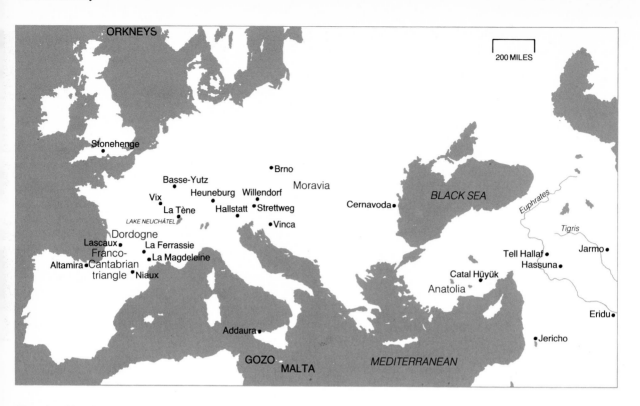

Map of prehistoric Europe.

of representation developed, specifically for different species of animal. Horses, mammoths and bison, for instance, are almost invariably shown in profile, while deer turn their heads to look behind them or to confront the spectator. The regularity of such conventions is such that we can often recognize a whole animal from a single flowing line, which defines only a part—the domed head and trunk of a mammoth, for instance, or the hump of a bison. However, the experience of later art, which helps us to read this kind of shorthand almost unthinkingly, probably hinders us in other respects.

The animals were painted on to the rough stone surfaces of the caves as if on to an unprepared ground, a neutral area on which the images were imposed but which did not, like the backgrounds of later paintings, form part of the image. The Paleolithic artist worked on a field with no set boundaries and with an irregular surface which shows through the paintings. To this, doubtless, part of their power for us is due. We take for granted the artist's canvas, board or other defined field, forgetting how artificial it is. For it corresponds to nothing in nature or mental imagery, where the phantoms of visual memory come up in a vague unbounded void—just as they do in cave painting. No framing devices were used by cave artists to mark off the pictorial field. There are no backgrounds, no ground lines even. We are given no clue as to whether the outstretched legs of a horse indicate that it is in a flying gallop or lying dead on the earth, for instance; nor can we assume differences in size to indicate distance or the confrontations and juxtaposition of animals (as in the 'great hall' at Lascaux) to have symbolic or other significance. Such visual ambiguities seem dreamlike and compelling. But it is impossible for us to see cave paintings as cave men saw them. We should remember, however, that originally only a very limited area of wall or ceiling was ever visible at a time—only as much as could be lit by resinous torches or small stone lamps burning animal oil or fat.

That the cave artist never thought of the rough surface on which he worked as a distinct 'ground' is shown by his practice of painting one image over another almost as if the earlier image was invisible to the viewer. Some ceilings, such as that at Trois Frères, seem at first sight to be no more than a tangle of lines and only on closer inspection do animals begin to start out of them—firmly drawn outlines of horses and bison and deer intersecting each other in higgledy-piggledy confusion. Similarly superimposed outlines appear on engraved pebbles. Various suggestions have been made to explain this, the most widely accepted

being that the act of drawing an animal had some ritual or magic significance and was repeated on the same area of wall as a fire might be lit year after year, on the same hearth over past embers. Whether the superimpositions had themselves any ritualistic, seasonal significance is not known, but it has recently been demonstrated that on many bone and ivory carvings lines previously assumed to be decorative were, in fact, incised at regular intervals. Such carvings seem to have been used as tally sticks of some kind and a remarkably high proportion of them have marks corresponding with the days in a lunar month—intimating, perhaps, some concern with time for other than purely practical purposes.

Attempts to plumb the inner meaning of Paleolithic art are as numerous as they are diverse. It was generally assumed, at first, to have been decorative, made to satisfy the perennial human desire for adornment. But this could not be maintained after the discovery of cave paintings, mostly in the deeper recesses of the caves unused for habitation. More elaborate theories have subsequently been propounded, and support for them has been drawn from the arts and rituals of surviving tribes of hunters and gatherers in America, Africa and Australia—although perhaps the most important lesson to be learned from ethnography is that interpretations based solely on visual appearances are often very wide of the mark.

Since some, though not very many, of the bison and other animals appear to be wounded with arrows, a connection with sympathetic magic—rites to ensure successful hunting—has been suggested. Fertility symbols have been descried in the genitals of male animals and in a few apparently pregnant mares, as well as in the abstract signs already mentioned. A cosmic interpretation has been based on the connection between the migration of herds and the seasons of the year. The animals have been identified as mythological beings and also as the totems of different Paleolithic groups or families. The caves themselves have been thought to be religious sanctuaries, temples or the locales of initiation rites. A recent structuralist analysis suggests that they may illustrate a mythology—a cultural construction of the Paleolithic hunters' relationship with the world—for a wholly unexpected consistency has been revealed in the placing and juxtaposition of the animals, even when repeatedly superimposed on each other, bovines being nearly always given the best locations and almost invariably accompanied by horses. If their precise meaning remains as dark as ever, cave paintings were clearly more complex than was at first supposed.

The paintings owe their preservation to the very

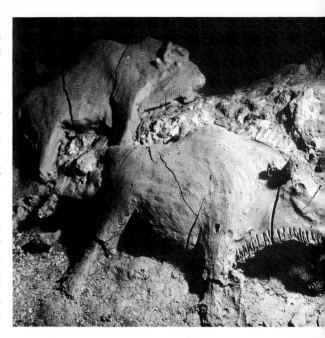

1, 7 Bison, after 15,000 BC. Modelled clay, 25 and 24ins (63.5 and 61cm) long. Tuc d'Audoubert, Ariège.

peculiar atmospheric conditions of the limestone caves in which they were sealed for thousands of years. (Many have deteriorated in the short time since their discovery and access to some, notably Lascaux, is no longer allowed.) Few examples of sculpture have been found in the deep galleries. The most notable exceptions are two pairs of bison, one larger than the other and each with a male following a female, modelled in clay from the floor of a chamber some 750 yards (700m) from the cave's entrance at Tuc d'Audoubert (1, 7). They are in high relief and are rendered as naturalistically as those in the paintings. Sculpture in the cave entrances and the open air has fared less well. Here women make their appearance in reliefs, notably two reclining nudes about life-size at the entrance to the cave at La Magdeleine, near Penne (Tarn). There are several reliefs of animals, one of which includes a life-size horse on a limestone terrace above a river at Cap Blanc in the Dordogne. Whether these weatherbeaten works originally had the vitality of the paintings inside the caves is hard to tell. But some small animal carvings in bone are remarkable both for their sharply observed naturalism and for an almost 'streamlined' elegance. They form part of objects generally described as spear-throwers—devices to give a hunter's arm leverage to propel his spear with additional force and steadier aim—though the most delicately carved were probably symbolic rather than

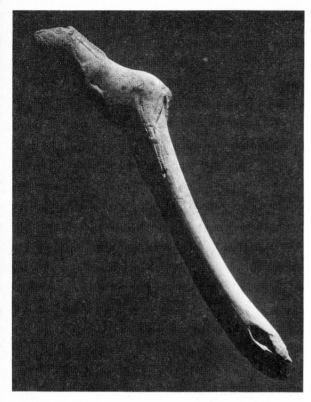

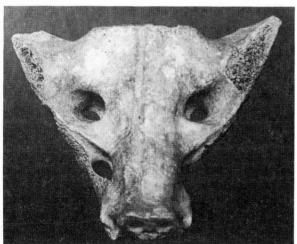

1, 8 *Left* Spear-thrower carved with leaping horse, from Montastruc, France, c.12,000 BC. Bone, 11ins (28cm) long. Bétirac Collection, Montauban.
1, 9 *Below left* Coyote head, from Tequixquiac, Mexico, c.10,000 BC. Bone, 7ins (17.8cm) wide. Museo Nacional de Antropologia, Mexico City.

about the same date but from a very different part of the world (1, 9). It was found in Mexico and—fashioned from the sacrum (part of the pelvis bone) of an extinct species of llama—is the earliest recorded American work of art. (Neatly chipped flint instruments testify to man's presence in America from about the thirtieth millennium.)

The coyote head is a reminder of how fragmentary our knowledge of Paleolithic art is. The little we know comes from chance survivals and discoveries. Paintings of mammoths, for instance, have recently come to light in the Kapovaya cave in the southern Urals, far to the east of Moscow. They are not unlike those in the Dordogne. Similarly, engravings of animals on rockfaces in the Sahara, including a rhinoceros more than 26 feet (8m) long and giraffes and an elephant superimposed (1, 10), have many of the characteristics of southern French and northern Spanish cave art. They are probably later, though they must antedate the climatic changes which transformed this area into a desert about 2000 BC. Whether there is any direct

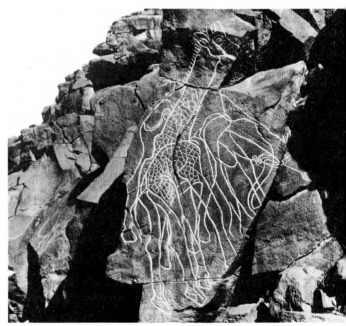

1, 10 Two giraffes and an elephant superimposed, c.8000–5000 BC. Rock engraving. Wadi Bergiug, Fezzan, Libya.

utilitarian (French archeologists call them *bâtons de commandement*). One has an endearing young·ibex poised on its tip, as if hesitating to take a leap, another terminates in a galloping horse (1, 8). So perfectly is the form integrated with the medium that it is impossible to tell whether bones were carefully selected in order to carve predetermined shapes or whether the animals were suggested by the natural formations of the bones. The same could be said of the head of a coyote, of

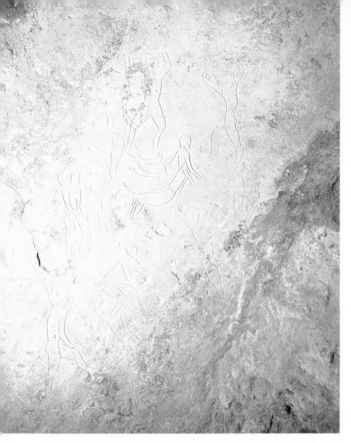

relationship between all these works remains a mystery.

A kind of unity can, however, be discerned in Paleolithic art, a generic similarity between the animals painted or engraved on stone and between the carved figures which have been found in many widely separated places. On the other hand, it is not possible to trace in them any lines of development such as may be seen in the increasingly subtle working of flint arrow-heads and hand-axes. This is perhaps significant. The magic or other, more than merely decorative or utilitarian, function of the paintings and figurative artifacts seems to have in some way immobilized, without having devitalized, the artistic impulse.

A great change in climate and environment took place in Europe around 8000 BC: the ice-cap finally reached its present limit, new water-levels created many modern geographical divisions (for example, separating the British Isles from the mainland of Europe c. 6000 BC), forest spread across the continent and hindered man's mobility, and the animals on which Paleolithic hunters had preyed died out or moved to pasturage further north. This marks the beginning of the Mesolithic period, during which dogs were domesticated, bows were made for hunting and dug-out canoes for travel. So far as the arts are

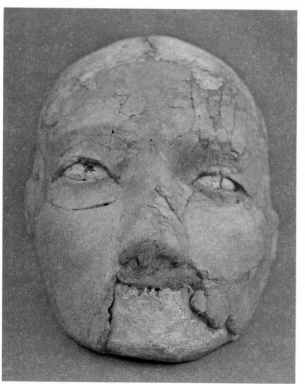

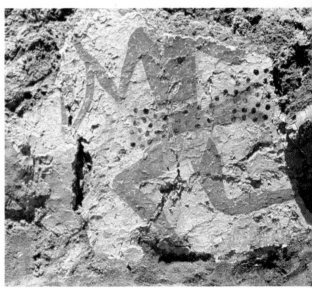

1, 11 *Above left* Group of figures, c. 8000 BC. Engraving on rock, figures 10–15ins (25–38cm) high. Addaura, Monte Pellegrino, near Palermo, Sicily.
1, 12 *Left* Head from Jericho, Jordan, c. 7000–6000 BC. Human skull, coloured plaster and shell. Amman Archeological Museum, Jordan.
1, 13 *Above* Dancer, c. 6000–5500 BC. Wall-painting in main room of shrine A.III.1. Çatal Hüyük, Turkey.

concerned, the most important changes took place in the Mediterranean area which was least affected by the variation in climate.

On a rock-face at Addaura in Sicily there are outlines of animals dating from about 8000 BC or shortly after. They are not unlike those of the Paleolithic period, but they are accompanied by nude human figures, each from 10 to 15 inches (25–38cm) high, and engraved with the same degree of naturalism as the animals (1, 11). These nudes are athletically lithe, firmly drawn in pure outline in such a way as to suggest both muscularity and movement. No human figures as anatomically correct or as graceful are found in earlier art and very few until the beginning of the historical period. Furthermore, three standing men wearing animal masks and two bound men at their feet are clearly related to one another in a group with narrative content, although we can only guess at its meaning; an initiation rite, an execution and a dance with acrobats have all been proposed.

Narrative art of a type more easily read emerged in eastern Spain by about 5000 BC. In mountainous country above the Mediterranean coast at Vallitorta, Remigia and several other neighbouring sites, paintings have been found in shallow overhung shelters lit by natural light. They differ from cave paintings not only in location but also in technique, style and subject-matter. (They are preserved under veils of stalagmite, can be clearly seen only when splashed with water and, unfortunately, cannot be satisfactorily photographed.) Animals are outnumbered by small (1–8 inches, 2.5–20cm, long) human beings busily engaged in a range of activities, mainly hunting and—a subject never depicted in earlier Paleolithic art—fighting one another. Some of the scenes which must be among the latest, though probably painted before 2000 BC, include domesticated cattle and horses led by men, testifying to a new pastoral and agricultural, rather than a hunting and gathering, way of life. Cattle also began to appear at about the same date in rock engravings in the Sahara.

The art of the farmers

Increasing population probably encouraged the domestication of livestock and the cultivation of cereals to supplement food obtained by hunting and foraging, and this initiated what is often called the 'Neolithic revolution'. The great change brought about by the introduction of agriculture, which led to land ownership, to the formation of urban communities and eventually to states as well as to great technological advance, is certainly one of the major turning-points in the history of mankind. It is recorded in innumerable myths and folk-tales. But it took place gradually and at different periods in different parts of the world. Farming began in the middle of the eighth millennium in Palestine and western Iran, later in Egypt; in about the sixth millennium in Greece and the Balkans, but not for another two or three thousand years in northern Europe and, it would seem, in China. Some tribes in Australia and central South America have precariously maintained the old manner of subsistence to the present day. So Neolithic is sometimes used, rather tendentiously, as a cultural as well as a chronological term.

The adoption of agriculture was naturally accompanied by more permanent settlements, even if homesteads were often moved as soon as the land was exhausted by primitive methods of farming. The earliest known settlements of any size and permanence were at Jericho in Jordan, Çatal Hüyük in Anatolia and Jarmo in Iraq, only recently partially excavated. In about 8000 BC Jericho was a considerable town of oval, mud-brick dwellings on stone foundations and by about 7500 BC it was surrounded by formidable masonry fortifications of up to 12-foot-high (3.5m) walls and at least one 30-foot-high (9m) tower. Even more impressive than the fortifications are the sculptured heads found there (1, 12). These appear to have been placed above graves, the body being buried and the head preserved or, as it were, brought back to life in this way. For the heads were made by refashioning human skulls, the flesh being restored with tinted plaster and the eyes with seashells. The modelling is amazingly skilful and sometimes displays a most sensitive awareness of flesh and bone. So subtle, indeed, is the handling and so individual are the features (one has a painted mustache) that some conscious attempt at portraiture may perhaps be presumed, as must certainly some commemorative, if not animistic, purpose. The sculptures and wall paintings discovered at Çatal Hüyük are much later. This settlement was occupied from the mid-seventh millennium onwards for about 800 years by people who still hunted wild animals but also grew cereals, peas and vetches, bred sheep and cattle and traded in seashells and mirrors of polished obsidian, a hard volcanic stone. Inside many of their rectangular mud-brick dwellings, which could be entered only from the roof, were shrines beneath which the dead were buried and in these shrines and other rooms some remarkable painted and sculptured decorations have been found. The most notable is a large-scale composition of men and women painted in strong colours in silhouette, though very naturalistically, indeed with some feeling for bodily weight and movement (1, 13). Unlike

paintings from earlier Paleolithic times, these are on a prepared ground, an evenly coloured area of smoothly plastered wall, and not a natural surface. The figures are still depicted as if in a void, without ground lines, let alone a background, but a sense of enclosure within a rectangular field is given by the shape of the wall. A momentous step had been taken towards the conception of a picture within a defined 'image field'. It is impossible to tell how widespread paintings of this type may have been. Çatal Hüyük is unique and its discovery in the early 1960s was a wholly unexpected revelation of Neolithic life in Asia Minor. Nothing of the kind has been found at a settlement of about the same period at Hacilar, also in Anatolia.

Apart from polished stone implements, from which the New Stone or Neolithic Age takes its name, the artifacts most closely associated with the early farmers' new way of life are pottery vessels. Clay had been modelled and baked into animal forms much earlier, as we have seen (p. 14), and rough, cord-marked (*jomon*) pots were made in pre-agricultural Japan at least as early as the seventh millennium. But pottery was not widely used until the rise of stable communities—and not always then, for the first inhabitants at Jericho had vessels of stone but none of clay. Nevertheless, although not all early potters were peasants and not all early peasants were potters, it may be said that pottery first developed in south-west Asia among agricultural communities of sedentary habit. At Jarmo in the Zagros mountains of northern Iraq, a village of some 25 households whose inhabitants grew cereals and had flocks of sheep and goats by about 6500 BC, storage pits were lined with clay baked *in situ*. Early in the sixth millennium pottery vessels and figurines of clay were also being made there and at other settlements in the same region, notably Hassuna, which has given its name to a class of simply shaped, thick-walled, buff-coloured wares sometimes with burnished surfaces, sometimes with painted or incised geometric patterns—the earliest example known of what seems to have been a purely decorative art. Pots produced somewhat further south (called Samarra ware) were being decorated with paintings of birds, fish, animals and human beings before the beginning of the fifth millennium. Shortly after 5000 BC motifs which almost certainly had symbolical significance—a bull's head, a double-axe and a Maltese cross—appear on vessels of fine thin hard ware found at Tell Halaf on the frontier of modern Turkey and Syria. It is unlikely that any of these pots were the work of whole-time potters: women in the house may well have made some of them. The clay was shaped by coiling and hand-molding and fired in small kilns. The specialist craftsman appeared with

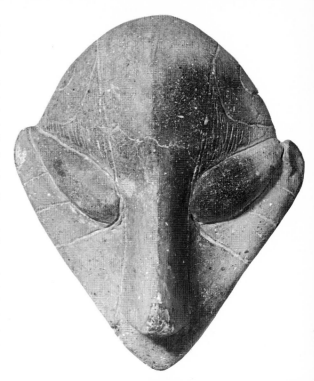

1, 14 Head from Predionica, Yugoslavia, c. 4500–4000 BC. Clay, 7ins (17.8cm) high. Kosovo i Metohija, Yugoslavia.

the potter's fast wheel, that is about 3400 BC in Mesopotamia, in the course of the next thousand years in China, and not before 2400 BC in south-east Europe.

Clay continued to be used for modelling statuettes, which were baked as hard as pots and pans and have survived in far greater quantities than any earlier works of sculpture. At one site, Vinca on the Danube in Serbia, more than 1,500 statuettes dating from the late fifth and early fourth millennia have been found. Most of them were in the remains of houses, not in graves. Some represent animals, domestic and wild, many are of men and women sometimes so sharply characterized that they might almost be taken to be portraits. Very different are the heads found only slightly further south at Predionica: here the features are reduced to a simple design formula—inscrutable, impersonal, with long noses and staring eyes of feline detachment (1, 14). Yet another type appears in a pair of figures, a man and a woman, from Cernavoda on the lower Danube. Despite their small size (only 4½ inches, 11.5cm high) they have a bold monumentality and the man seated on a stool and holding his head in his hands might well be called the first 'thinker' in the history of art (1, 15). It would be difficult to represent with greater economy and force this highly expressive pose.

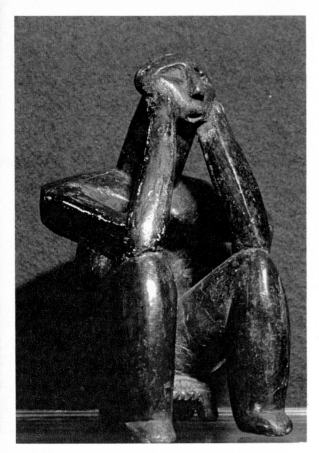

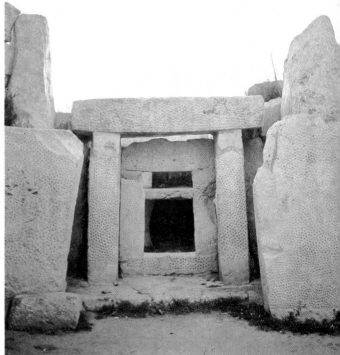

1, 15 *Above* Man from Cernavoda, Romania, c. 4000–3500 BC. Clay, 4½ins (11.5cm) high. Museum of Antiquities, Institute of Archeology, Bucharest.
1, 16 *Above right* Entrance to temple, Mnaidra, Malta, c. 3000–2000 BC.

More stable conditions of life also led to the development of architecture. Hunters and foragers had seasonally inhabited man-made as well as natural shelters from a very early period, as we have seen (p. 15), and at Jericho dwellings and fortifications were constructed to simple, regular plans. At the beginning of the fourth millennium a new type of building appeared in southern Mesopotamia: the temple set apart from habitations both in siting and in form. A small shrine of this period, discovered under many subsequent layers of religious structures at Eridu, already has the internal niche in one wall and the offering table, which later became the most important elements in the temples of the Sumerians (see p. 34) and, indeed, in those of many later cultures. It was constructed of mud-brick, the only building material readily available in the area. Stone was not used either here or in Egypt until much later, after it had been used for temples on Malta and the megalithic tomb chambers of the European Atlantic coastline.

The temples on Malta and on the adjacent island of Gozo were begun before 3000 BC and abandoned by about 2200 BC. They are the earliest known free-standing buildings of stone. There are at least 16, constructed of huge blocks resting on one another without mortar. The façade of the largest, Ggantija on Gozo, has a base of fairly regularly shaped slabs of limestone, each one about 12 feet (3.5m) high, supporting smaller and rougher stones in courses, which seem originally to have risen to a total height of some 50 feet (15m). Interior spaces are rounded, the most important being on a trefoil (three-leafed) plan; others are roughly oval, and some seem to have been roofed with wood. Much of the stonework is dressed (i.e. smoothed to a regular surface) and some of it decorated overall with little hammered pits, which give a mottled effect (1, 16). At Tarxien, the most elaborate of the temples, there are even carved spiral vine-scroll motifs of a type later found throughout the Mediterranean. Here also a fragment of a larger than life-size statue of a seated woman was discovered. The only

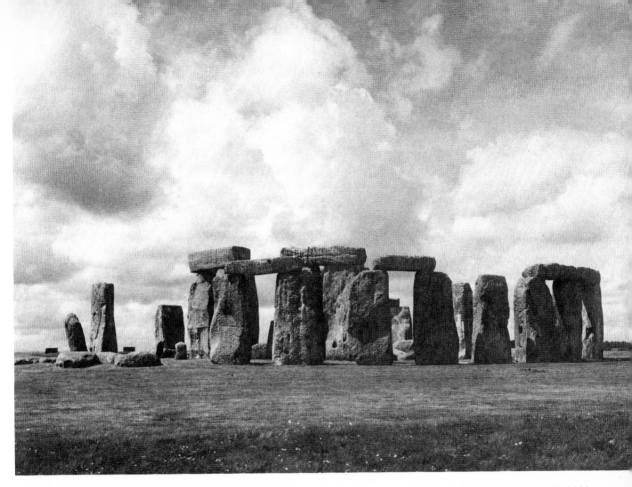

1, 17 Stonehenge, Salisbury Plain, England, c. 2100–2000 BC.

other surviving sculptures are stone and clay statuettes of obese women rendered with considerable naturalistic skill.

The simple post-and-lintel system used for doorways in the Maltese temples—one large horizontal stone placed on top of two uprights—had already been adopted by the builders of megalithic tombs in western and northern Europe. (The word 'megalith' simply means large stone.) Long passages were built in this way, the stones being subsequently covered with earth to form artificial hillocks. Somewhat surprisingly some of the earliest, dating from about 4000 BC, in Brittany, are among the most elaborate technically, with their main tomb chambers roofed by placing thin slabs of stone on top of one another and slightly overlapping so that the uppermost meet to form a corbelled dome (see Glossary). Distinct types of tomb seem to have been evolved independently in different areas, conditioned mainly by the availability of materials. The rectangularity and fine corbelling of tombs in the Orkneys, for instance, are due largely to the peculiarities of a local stone which breaks neatly into straight-sided pieces. Some types of stone may, on the other hand,

have acquired special significance. This would explain why in Britain, about 2100 BC, 19 large pieces of bluestone (spotted dolerite), each between 6 and 8 feet (180 and 240cm) high, were hauled from the mountains of Wales to Salisbury Plain 190 miles (300km) away to be set up in the extraordinary monument known as Stonehenge (1, 17).

The function of Stonehenge remains a mystery, despite numerous attempts to solve it. The most that can be said with certainty is that it was an important cult centre and that stones were carefully aligned on various points on the horizon: where the sun rose on midsummer day, where it set on midwinter day, and also the most northerly and southerly points of the moon-rise (in the second millennium BC that is to say; there has been a slight shift in the relative position of the earth and the sun since then). Such moments which marked the passage of the seasons had, no doubt, both practical and religious importance for a pastoral population. It has recently been shown that the stones could have been used for more sophisticated solar and

lunar observations to predict solstices and eclipses through a 300-year cycle. Whether they were is another question. So far as the history of art is concerned, Stonehenge is notable for the quite remarkable precision, symmetry and unity of its conception and the technical abilities of its builders, despite their lack of metal tools.

To transport to the site and erect the tall 'sarsens' or Wiltshire sandstone blocks of the concentric circle at Stonehenge (a century or so after the bluestones) was an organizational, if not a technical, feat. It has been estimated that it would have taken 1,100 men 5½ years to shift them from Marlborough Downs some 20 miles (32km) away. The stones were dressed with stone hammers so that they are smoother on the inside than the outside and have outlines slightly tapering towards the top after a central bulge. The preparation of the lintels, which originally ran right round the circle, was still more remarkable. Not only were holes hollowed out of them to fit exactly over projecting tenons on the uprights, but they were curved horizontally as segments of a circle and carefully levelled on top. Most extraordinary of all are the optical corrections or 'refinements', as they are called in later architecture (see p. 106): the faces of the lintels are cut so that they incline outward by about 6 inches (15cm) and thus appear to be vertical when seen from the ground. It seems possible, therefore, that the bulging profiles given to the sarsen stones were similarly intended. Small wonder that in the Middle Ages Stonehenge was believed to have been conjured up by magic. The presence of a skilled mason from the Aegean was later invoked to account for the technical ability it displays. But radiocarbon dating has revealed that megalithic buildings were being erected in northern Europe long before the first stone structures on Crete, and Stonehenge must be understood simply as the most complex product of this northern Stone Age tradition.

The Stone Age persisted in northern Europe for some time after it had given way in the south-east and Mediterranean and long after it had been superseded in the Near East by the Bronze Age, during which metal implements replaced those of stone. In the Near East native copper (nuggets found on the surface of the earth) had been hammered into small objects before the beginning of the sixth millennium. Gold was similarly worked. As both copper and gold are softer than stone they were never used for implements. A time-lag of 3,000 years intervened before it was discovered, again in the Near East, that a much harder substance could be obtained by alloying copper with tin to make bronze. It used to be assumed that this discovery was then transmitted to China (see p. 60) and to Europe, where bronze implements make their first appearance in the Balkans in about 2500 BC. There is, however, a strong possibility that bronze was invented independently in both China and Europe (as was certainly the case in South America in about AD 1000). In any event, by the second millennium great skill had been attained in south-eastern Europe in both the casting and ornamentation of bronze objects, which were quickly diffused to other parts of the continent. Axe-heads and swords were decorated with incised spiral motifs of a type to be elaborated much later in Celtic art. They mark the beginning of a new phase in European prehistory, but by then the early civilizations of the Near East, the Indus Valley, Egypt and China had already emerged.

2 The early civilizations

It is unfortunate that the word 'civilization' has acquired such strong qualitative overtones. For the first so-called 'civilized' cultures were not necessarily and in every way superior to those of the hunters and subsistence farmers which had preceded them. The transition from pre-civilized to civilized societies depended first of all on the production of a surplus, that is on farmers producing enough food to permit a substantial section of the population to engage exclusively in other, non-productive activities—trade, administration and, of course, warfare. The development of specialized crafts led to improved agricultural methods such as artificial irrigation and the control of floods, the use of the wheel and the plough, which, in turn, made possible the growth not only of large urban communities but also, eventually, of states. Clearly stratified social structures emerged more or less simultaneously with administrative organizations requiring permanent records, hence the invention and development of writing. New ways of paying for goods and labour by a standard medium of exchange were also introduced. Thus, a 'natural economy' based on barter was replaced by a money economy, which facilitated the storage and manipulation of wealth. This process was repeated with only slight variations as each of the early civilizations began to evolve in different, widely separated parts of the world—in the great river basins of the Tigris and Euphrates in the Near East, of the Indus in Pakistan, of the Nile in Egypt and of the Yellow River in China.

Mesopotamia

The Near East, the vast area spanning much of Asia and Africa and comprising present-day Israel, Jordan, Lebanon, Syria, Turkey, Iran and Iraq, was the cradle of the first such evolution. Neolithic cultures had flourished there, especially on the pastoral uplands around Sialk near modern Tehran, for example, and at Susa further south. To judge by the pottery, a high

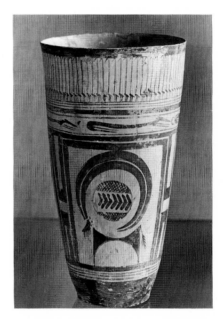

2, 1 Painted beaker, from Susa, c. 5000–4000 BC. 11¼ins (28.5cm) high. Louvre, Paris.

degree of technical skill was attained. The walls of some of their pots are quite amazingly thin and delicate—finer, in fact, than anything produced by their immediate successors—and the painted decorations foreshadow later developments. A beaker from Susa is painted boldly and fluently with schematic yet remarkably lively animals in pure silhouette: a frieze of very long-necked birds at the top, a band of running dogs and, below, an ibex with huge horns (2, 1). These animals are distorted expressively, the elongation of the dogs, for instance, suggesting speed of movement. They also imply a highly developed sense of design, with curves and straight lines echoing those of the vessel itself and integrating surface decoration with form. What is more, the birds

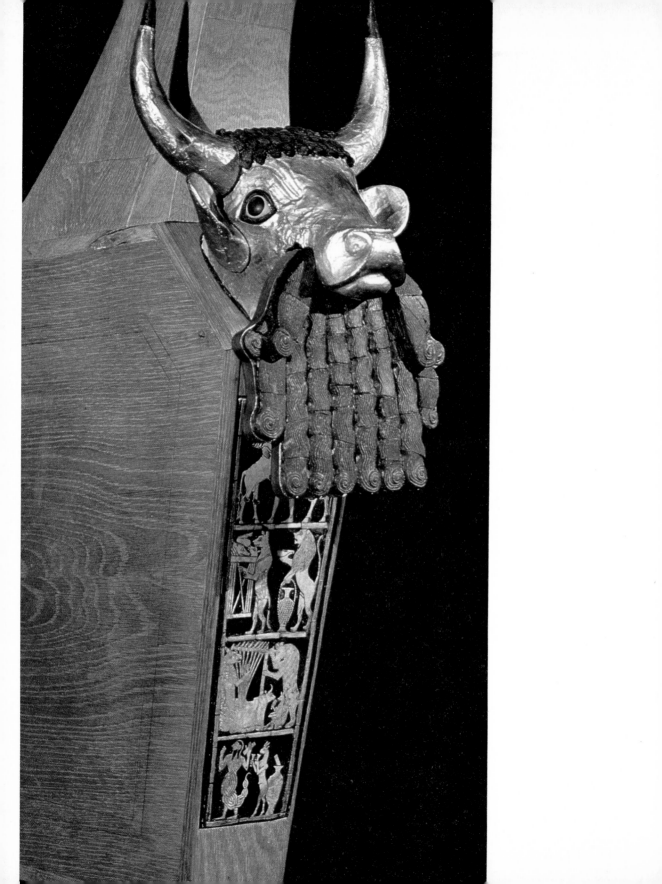

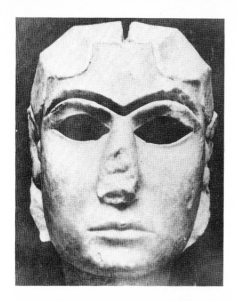

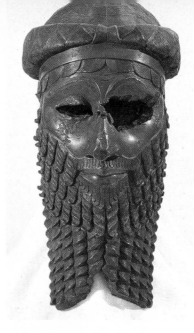

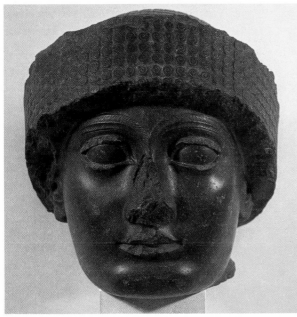

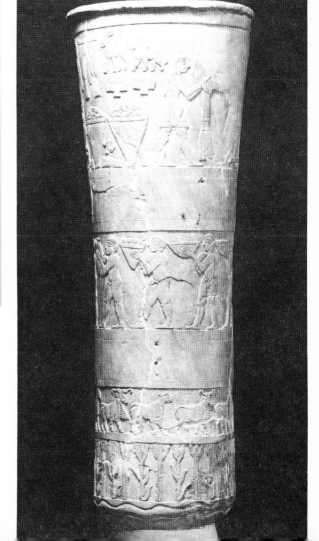

2, 2 *Opposite* Soundbox of a harp, from Ur, c. 2685 BC. Gold, lapis lazuli and shell inlay, about 17ins (43cm) high. University Museum, Philadelphia.

2, 3 *Top left* Female head from Uruk, c. 3500–3000 BC. Marble, 8ins (20.3cm) high. Iraq Museum, Baghdad.

2, 4 *Top right* Head of an Akkadian ruler, from Nineveh, 2300–2200 BC. Bronze, 12ins (30.5cm) high. Iraq Museum, Baghdad.

2, 5 *Above* Head of Gudea, from Telloh, c. 2100 BC. Diorite, 9⅛ins (23.2cm) high. Louvre, Paris.

2, 6 *Right* Vase from Uruk, c. 3500–3000 BC. Alabaster, 36ins (91.4cm) high. Iraq Museum, Baghdad.

and ibex stand on, and the dogs skim over, firmly marked ground lines, which provide the lower edges of frames enclosing regular 'image fields'. In this way the image acquires, for the first time, a definite space of its own—in striking contrast to cave painting. This invention preceded that of writing, it should be noted, although its enormous possibilities for the arts of representation do not seem to have been recognized until later (see below, p. 31).

The civilization which developed about 4000 BC emerged not on the high plateaus favoured by the Neolithic cultures of the Near East but on the flat, low-lying plains of Mesopotamia (Greek for 'land between the rivers') formed by the Tigris and Euphrates, whose waters the new settlers learnt to control. They were able to turn the formerly unproductive and probably uninhabited flat lands into an enormous oasis, often called the 'fertile crescent', stretching some way north of the rivers' swampy confluence at the head of the Persian Gulf.

The settlers called it Sumer. Where they came from is unknown; their language is unrelated to any other known tongue. They lived in mud-brick settlements, which gradually grew to the size of towns and cities, eleven or more, including Uruk (the Biblical Erech and present-day Warka), Eridu, Ur, Larsa and the recently discovered Tell Habuba in the Upper Euphrates region. Independent and sometimes at war with each other, yet sharing one language and culture, they all held a common belief in a pantheon of gods personifying the creative and the destructive forces of nature. Each city was under the protection of one of these gods, to whose service its entire population was dedicated. The god was, in fact, believed to be its owner and divine sovereign, the human rulers his earthly stewards and priests. The form of government thus evolved has been described as 'theocratic socialism' and it certainly has elements of the welfare state. Administration was in the hands of the priests, who alone could direct the population and keep reserves of implements and draught animals. They controlled the pooling of labour for communal enterprises, such as the all-important irrigation ditches and flood channels. They also collected and distributed food to craftsmen and others not engaged on work on the land, and they stored grain against periods of famine. It was in this context that a numerical system was first evolved. Similarly, picture-signs were developed into a standardized cuneiform script, so-called from the angular, wedge-shaped form of its several hundred characters, which were impressed on clay tablets with a split reed—the oldest known writing in the world. It was used from the third to the first

millennium for a number of Near Eastern languages— Sumerian, Akkadian, Elamite, Hittite and others. The earliest examples are of no later than about 3000 BC, recently discovered at Tepe Yahya in south-eastern Iran, a large fourth-millennium urban centre of some complexity. Tepe Yahya, together with other, widely separated urban or proto-urban sites in the Near East, has raised some as yet unsolved problems, notably that of the primacy of Sumer. Was Sumer the cradle of civilization in this area? Or was the development of urbanization multilinear over a wide area? There is increasing evidence to support the latter view, i.e. that about 3000 BC urban centres from Mesopotamia to the Indus Valley and from the Persian Gulf to Baluchistan and Turkmenistan were interrelated and interdependent. Development did not radiate out from one generating centre. (Similar conclusions are to be drawn from another important and recently excavated site, Ebla [Tell Mardikh] in northern Syria, though of a later date. With the discovery there of more than 15,000 cuneiform tablets of 2400–2250 BC, northern Syria has been established as a cultural entity independent of Babylonia and Assyria.)

The Sumerians, however, had a literature and a literature of some quality, for it includes *The Epic of Gilgamesh*, which still, after more than 4,000 years, has the power to enthral and move. It is the world's first

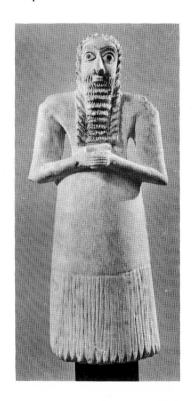

great poem. Although it antedates the Homeric epics by 1,500 years, its heroes Gilgamesh, Enkidu and Huwawa belong to the same universe as the gods and mortals of the *Odyssey*. Nothing comparable in quality to *The Epic of Gilgamesh* has come to light as yet among the visual works of art of the Sumerians. It was a predominantly religious art and among the earliest survivals are some tall alabaster vases, more than 3 feet (90cm) high, from the temple at Uruk. They date from what is called the Proto-literate period, i.e. the last centuries of the fourth millennium, when writing was invented. The finest records the festival of the New Year (2, 6). On the top band of carving a man presents a basket to a woman, either the mother-goddess Inanna or her priestess, behind whom other gifts are piled up, more baskets, vases and a ram supporting clothed statuettes or figures of a man and a woman. Beneath this there is a procession of men carrying more gifts; they are naked, as men were usually represented when approaching the gods. Alternating ewes and rams fill the lowest register above a frieze of date palms and ears of barley.

This is the earliest instance of an artist exploiting the possibilities of the defined 'image field', in which figures stand on a firm ground line in an area that could be understood as representing space. It is significant that it accompanied the invention of writing. The regularity of direction, spacing and grouping so evident in the Uruk vase, corresponds to that of writing, as may also the use of parallel bands to create a tiered composition, with one row of scenes above another—a system which was to be used for the next 5,000 years, especially for narrative illustration. On the Uruk vase the sequence is hierarchical rather than chronological. Each frieze is a continuous procession without beginning or end, perhaps expressing the eternal significance of the ritual which marked the beginning of the year and the renewal of the cycle of the seasons.

The artistry displayed in the carving is akin to that of cylinder seals, little cylinders of hard stone rarely as much as 2 inches (5cm) high, incised with abstract or figurative designs so that, when one is rolled across wax or damp clay, it leaves a relief impression, usually as a mark of ownership. Free-standing sculpture was also being carved before the end of the fourth millennium, although only fragments survive. A life-size white marble face of a woman found at Uruk is the finest (2, 3).The carving is of extraordinary delicacy and sensitivity, especially in the subtle, unemphatic transitions from the cheeks to the nose, upper lip, and firm, sensual mouth. The deep incision below the forehead was probably filled originally with eyebrows of lapis lazuli, the eye-sockets with some other coloured material, perhaps shell for the eyeballs and obsidian for the pupils, and the head would have been covered with hair of gold or copper. Drill holes in the flat back appear to have been intended for attaching the mask to a statue, presumably a wooden cult figure.

Priests and other worshippers standing before a cult figure are the subject of several statuettes found in the temple of Abu, the god of vegetation, at Tell Asmar. They are carved in white gypsum, a soft easily worked marble, which may partly explain the cylindrical or conical form. Their hair and beards are rendered with black bituminous paint, their huge staring goggle eyes with lapis lazuli or black limestone set in white shell (2, 7). Tell Asmar was a small town some way from the main Sumerian cities, and these statues are artistically inferior to the head from Uruk, suggesting provincial workmanship. They reveal, nevertheless, that many of the conventions of religious art in the Near East (later to be passed on to Europe and also to the Far East) were already present. All of them look straight ahead,

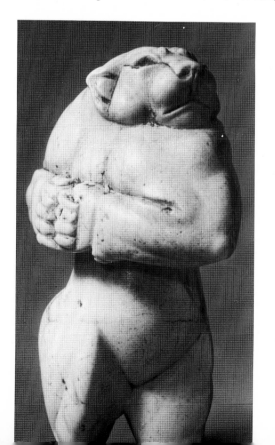

2, 7 *Opposite* Statuette from Tell Asmar, c.3000 BC. Gypsum, 11¾ins (29.8cm) high. Metropolitan Museum of Art, New York, Fletcher Fund, 1940.
2, 8 *Left* Female monster, c.3500–3000 BC. Crystalline limestone, 3½ins (8.9cm) high. Brooklyn Museum, New York, courtesy Mr & Mrs Robin B. Martin.

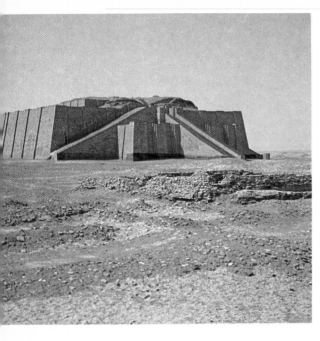

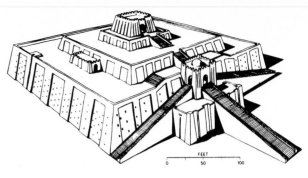

2, 9 Ziggurat at Ur, c. 2100 BC.
Above Drawing of a ziggurat, reconstruction.

2, 10 *Below* Seals from Mohenjo-Daro, c. 2400–2000 BC.
Steatite, about 1½ins (3.8cm) square. National Museum of
India, New Delhi.
2, 11 *Right* Bust from Mohenjo-Daro, c. 2400–2000 BC.
Limestone, 6⅞ins (18cm) high. National Museum of India, New
Delhi.

standing or kneeling in rigidly symmetrical poses with their hands clasped just below their chests. Differences in size appear to denote hierarchical importance.

Inscriptions reveal that to the Sumerians a statue was not simply a representation: it was believed to have a life of its own. The god was present in the cult image, as was the mortal in the statuette standing in permanent awe-struck adoration before it. This primitive animistic sense is strongly felt in earlier works, even when they are on a relatively small scale, as in one of the most powerful to be unearthed so far (2, 8). This is a tiny carving in crystalline limestone of a monstrous female creature whose powerful mis-shapen body and terrifying head and claws confront us with all the incomprehensibility of evil and man's helplessness before it in a hostile universe.

Many of the finest third-millennium works of art were discovered in the royal cemetery at Ur, where Sumerian kings and queens were buried in all the finery of their gold and jewelry, together with their attend-ants and courtiers, who were killed so that they could accompany them into the next world. They include palace or temple furnishings of an unprecedented and rarely equalled richness and elaboration of workman-ship. A harp, for instance, has a sound-box terminat-ing in a wonderfully realistic head of a bull of carved lapis lazuli and modelled gold (2, 2). Lapis lazuli, the intensely blue stone greatly prized by the Sumerians, who imported it from its only source some 2,000 miles (3,200km) away in northern Afghanistan, was used for the bull's horn-tips, the hair between the horns, the eyelids and pupils, and the human beard (presumably a ritual adornment). The panel beneath is very delicately inlaid with shell and gold leaf to depict four scenes, delineated with a clarity that makes the obscurity of their meaning all the more tantalizing. They are at once so sophisticated and so naive that we cannot tell how, or how seriously, these strange little pictures of animals impersonating humans were intended to be taken, or whether they illustrate myths or fables. They have the magnetizing poetry of fairy-tales, which suspend disbelief while they are being told. The motif of the man embracing two human-headed bulls on the top register is one that recurs in the art of the ancient Near East (it is sometimes called the Gilgamesh motif, although no such scene is exactly described in the epic). His curious twisted pose, frontal above the waist but in profile below, was being used about the same time in Egypt (see p. 45).

Akkadian art
Towards the beginning of the third millennium, if not earlier in some places, war leaders replaced high priests as the rulers of Sumerian cities, without, however, modifying the theocratic system of government. A greater change came about 2350 BC, when Akkadians who had infiltrated the area from the north-east—they spoke a Semitic language quite different from Sumerian—gained complete control. Their first king, Sargon, incorporated the cities into a single state spreading over northern Mesopotamia and into Elam (see below, p. 35); his grandson Naramsin extended the realm to the west and about 2250 BC conquered Ebla (see p. 30). The expansionist policy of the Akkadians may partly account for a new emphasis placed on the person of the ruler as an individual leader and conqueror and not simply as the servant of the local god. Life-size statues of kings were produced, and from one of them a superb bronze head with braided hair and neatly curled beard survives—displaying complete mastery of the techniques of metalwork (2, 4). It is at once naturalistic and hieratic, the image of a ruler with a commanding aspect, which must have been intensified and made to seem almost superhuman when eyes of precious stone flashed from the now empty sockets. The Akkadian concept of godlike sovereignty could not have been more forcefully expressed.

Naramsin himself appears on a stele carved to celebrate a victory over an Iranian frontier tribe (2, 12). He is shown nearly twice the size of his soldiers, as gods (here represented only by their symbols in the sky) had previously been distinguished from mortals. Perhaps to emphasize the actuality of a single moment, the sculptor abandoned the usual system of superimposed bands of figures and treated the whole surface as a single dramatic composition. The location in mountainous country is indicated by the climbing postures of the soldiers and also by trees and a conical hill—landscape, in fact, for the first time in the history of art. Naramsin's commanding position, treading on the bodies of two slain tribesmen and with his arm poised to dispatch another, records the moment of victory. There was originally no inscription (the writing on the hill is a later addition); the meaning of the scene was expressed in purely visual terms. Every line of the composition suggests the climax of the action, with the upward movement of the Akkadians from the left balanced by the fallen and falling tribesmen and the survivors begging for mercy on the right. Naramsin stands at the top, at the dramatic peak of the composition, related to the other figures by their gestures and glances and yet isolated from them by the empty surface of stone which surrounds him. Nothing quite like this stele is to be found in the art of the Near East for another 1,500 years.

Akkadian rule collapsed about 2180 BC. Only one city survived, Lagash (modern Telloh), where literature and the visual arts flourished in an oasis of peace under the *ensi* or ruler Gudea. Although Gudea followed Akkadian practice and set up life-size statues of himself, they present a very different conception of kingship. He styled himself the 'faithful shepherd' of his people, the servant of Ningirau, the god of irrigation and fertility. His clean-shaven face has a delicate, almost adolescent sensitivity, and he is always shown in a piously reflective mood (2, 5), in one instance holding in his lap an architectural plan, probably for temple precincts. A very hard stone was used for these statues, chosen perhaps less for its rich colour than its durability—its power to preserve an immutable record of royal piety.

Temples had been built in Mesopotamia since the mid-fourth millennium BC (see p. 24). They were small mud-brick structures and not intended for communal worship—access may well have been limited to priests and the priest-kings—but raised on platforms which

gave them prominence. These platforms were soon transformed into squat stepped pyramids called ziggurats, conceived as holy mountains, which brought the priests nearer to the gods, if not into their actual presence. (Moses was to climb Mount Sinai to receive the Tablets of the Law from the Lord.) For the plain-dwelling Sumerians, mountains had a further significance as the source of the waters which flowed down to the valleys, and also as a symbol of the whole earth and the life-bringing force of vegetation beneath it. They called their mother-goddess Ninhursag, 'Lady of the Mountain'. So the mountain imagery, which the Bible later spread all over the Western world, probably originated in southern Mesopotamia. According to the Book of Genesis, Abraham was a native of Ur, where the ziggurat still partially survives (2, 9). It was built shortly after the city became the capital of a revived Sumerian state in 2125 BC. The plan is oblong, oriented with its corners pointing north, south, east and west, and the walls slope inwards as they rise, their monotonously blank faces relieved by non-functional

2, 12 Victory stele of Naramsin, c. 2300–2200 BC. Pink sandstone, about 80ins (203cm) high. Louvre, Paris.

2, 13 Stele of Hammurabi, from Susa, c. 1760 BC. Basalt, 88ins (223.5cm) high. Louvre, Paris.

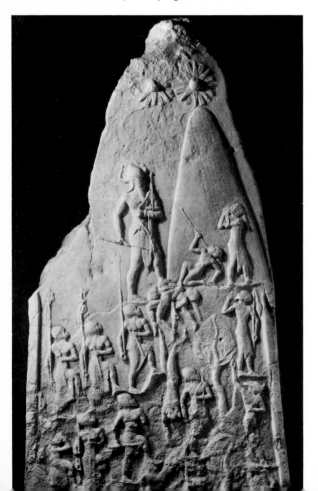

2, 14 Head of an Elamite, from Azerbaijan (?), c. 2000 BC. Copper, 13½ins (34.3cm) high. Metropolitan Museum of Art, New York, Rogers Fund, 1947.

buttresses. On the north-east side, long straight staircases lead up to a gatehouse more than 40 feet (12m) above the ground. Originally there were two further stages, crowned by a temple.

Babylon

A new period in Mesopotamian history began with the rise to pre-eminence of Babylon early in the second millennium BC. Under Hammurabi, who ruled from 1792 to 1750 BC, it became the capital of an empire extending from Mari and Nineveh to the Persian Gulf. Hammurabi is of great historical importance as the author of the oldest surviving code of laws. Its declared aim was to 'cause justice to prevail in the land, to destroy the wicked and the evil, that the strong might not oppress the weak', although, in fact, one of its chief concerns was to protect money-lenders from defaulting borrowers, for whom rigorous penalties were prescribed. This code is inscribed on a stele under a relief of Hammurabi standing before the enthroned sun god at the summit of a holy mountain or ziggurat—a perfect illustration of the semi-divine status of the priest-king, to whom the god, himself in human form, delivers the laws (2, 13). That the stone takes the form of a phallus, an obvious symbol of male dominance, is perhaps no coincidence.

The empire ruled by Hammurabi's successors was gradually eroded and Babylon itself was sacked about 1600 BC by Hittites from Anatolia (see p. 64). Attacks came also from the opposite direction, and in the late second millennium the steles of Naramsin and Hammurabi were carried off to Susa, the capital of Elam, the agriculturally productive region extending north-east from the lower Euphrates (present-day Khuzestan). The complexities of the political and artistic relationship of Elam with the cities of Mesopotamia and farther east are hard to unravel. Their civilizations seem to have followed parallel courses. Well before the end of the fourth millennium, Elamites had developed a pictographic script similar to that of Sumer but adapted to their own language (tablets in proto-Elamite script of c.3200 BC have recently been found at Tepe Yahya, south of Kirman). Later, cylinder seals were carved in Elam, again similar to those of Sumer, though differing in subject-matter. Among the few surviving large-scale works of Elamite sculpture there is a very fine head of cast copper (2, 14), which recalls the bronze head of an Akkadian ruler (2, 4). The modelling of the face is, however, softer and more sensitive and the treatment of the beard and bands round the hair broader. Elamite civilization seems to have reached its height towards the end of the second millennium. An impressive, though unfortunately headless, bronze statue of Queen Napirasu from Susa dates from about 1260 BC (Louvre, Paris). Elam's most imposing remains, only recently brought to light, are at Haft Tepe, south of Susa, where the royal tombs have some remarkably assured brick vaulting of about 1500 to 1300 BC. The ziggurat at Choga Zanbil, near Haft Tepe, is larger than those of earlier Mesopotamia and differs also in other respects, being faced with green and blue bricks and incorporating three temples. Built about 1250 BC, it was originally five stories high. Elam was finally conquered by the Assyrian Assurbanipal (see p. 74) about 640 BC.

The Indus Valley

There is evidence of interchange of goods between Sumerian Mesopotamia and the cities of the Indus Valley (modern Pakistan) by way of the island of Bahrein in the Persian Gulf, and figurative carvings and other material recently discovered at Tepe Yahya in south-eastern Iran (see above) are strikingly similar to those of the Indus Valley. It seems likely, therefore, that the Indus Valley civilization, which emerged between 3000 and 2500 BC and vanished some thousand years later (to be totally lost and forgotten until its rediscovery in the 1920s), formed part of that great upsurge of fourth-millennium urbanization in Asia to which we have already referred. It could hardly have been more different from the civilization of Sumer, however, for it produced no great temples, no

royal tombs, palaces or dynastic monuments of any other kind. The area it covered was much greater than that even of the Akkadian empire—its two outposts at Lothal and Rupar are more than a thousand miles apart as the crow flies, and much farther by passable routes skirting the mountains. But the vast majority of artifacts found at different sites and archeological levels (which indicate relative age) are so similar as to suggest a tight cultural unity lasting for a millennium. They give no indication of any incursions from without or of disruptions within. A form of writing was in use, quite distinct from Sumerian picture-signs and from cuneiform, but it is known only from seals used to impress marks of ownership with brief inscriptions, which still remain to be deciphered. There is thus no literature to tell us of the history or the beliefs of this people. Weights and measures were standardized but, once again, according to a system different from that of the Sumerians.

So far as may be judged from the archeological record—and there is no other source of information—the Indus Valley civilization was essentially urban and mercantile. There seems to have been no dominant class of priests or warriors. Weapons were rudimentary. So, too, were the agricultural implements of the farmers, who continued to live in small rural communities, though it is known from terracotta models that they had wheeled carts (much like those still used in Sind in present-day Pakistan), presumably to transport their produce to the urban centres. The great achievement of this civilization was its cities, Harappa and Mohenjo-Daro. Nothing remotely like them had been seen before or was to be seen again for a thousand years or more. They were regularly planned with wide streets and thoroughfares for traffic. Various public services were systematically provided. And there were no fortifications, presumably because there was no need for them. Each had a citadel, however, raised on an artificial mound of mud-bricks, like a one-story ziggurat, and surrounded by a thick wall.

Harappa was the bigger and more important city, but its remains were largely destroyed by nineteenth-century British railway builders. More survives of Mohenjo-Daro. It was originally on the west bank of the Indus river (later to shift its course), into which platforms were built to control flood-waters. The large living and working area, about a mile across, was laid out on a grid plan with wide streets running from north to south to benefit from the prevailing winds. Public services included piped fresh water and drains to draw off household waste as well as rain and flood-water. Houses, workshops and merchants' stores were much of the same size. All were built of brick, fire-burnt (not sun-dried as in Mesopotamia) and regularly bonded—i.e. laid alternatively with their ends and long sides on the outer face of the wall. Staircases reveal that there were upper floors of wood. No decorative features survive except narrow pointed niches in interior walls. Public buildings, on the citadel, would appear to have differed from others only in size. There was a large hall or assembly place with a roof supported on many columns (a type of construction later developed in Egypt and called *hypostyle* by the Greeks), a vast granary, an asphalt-lined bath probably for ritual washing and, nearby, a structure with many small cells, like a college or monastery, though we can only guess at its purpose.

The inhabitants of the cities had fine but undecorated beaten copper vessels. Most of their pottery was of an equally utilitarian plainness, though some fairly large storage jars of a dignified form are decorated with geometrical and leaf motifs and an occasional animal in black on red, burnished to a high gloss. Clothing was made from patterned cotton, which was being cultivated and woven in the Indus Valley by about 2500 BC (a few centuries later than in America; it is first recorded in central Mexico c. 3000 BC). Jewelry was made of gold and silver with beads of semi-precious stones—lapis lazuli from Afghanistan, turquoise from Iran or Tibet, and jade from central Asia. There was even a bead factory in the small town of Chanhu-Daro.

All surviving works of art are small and seem to have been personal possessions. There is no trace of large-scale public art. Terracottas are numerous, ranging from rather crude figures of men and, more often, women with broad hips and emphatically marked sexual organs—probably cult objects—to naturalistic animals and groups of models, like those of carts already mentioned, which may have been made as toys for children. Of greater artistic interest are the seals of steatite (an easily cut gray or greenish stone), which were given a lustrous surface by a gentle firing, presumably in a potter's kiln, after they had been carved (2, 10). They are incised with figures of men, fabulous beasts and real animals on flat rectangular faces, which precluded the narrative effects developed on the cylinder seals of Mesopotamia from the Sumerian to the Assyrian period (see p. 31). Designs reveal great feeling for the relationship between the image and the shape of the stone, and the carving has a delicate precision unsurpassed in the whole history of the gem engraver's art. Despite their small size—never more than 2 inches (5cm) square—they are packed with compressed vitality and capture the essential characteristics of the animals represented, especially

the humped ox, which was a favourite subject.

Stone carvings in the round are also extremely small and are, with two notable exceptions referred to below, limited to male heads and half-figures with strange Asiatic slit eyes, flat thick lips and fringes of beard. The best is carved in a whitish limestone originally overlaid with red paste and is so imposing that, from a photograph, it might be thought to be a monumental over-life-size sculpture (2, 11). It is, in fact, not quite 7 inches (18cm) high. The disposition of the robe over the left shoulder is distinctive and has led to the supposition that a priest or shaman is represented. In feeling it is remote from anything found in Mesopotamia despite some superficial similarities — the trefoil design on the robe, for example, the arrangement of the hair and of the beard, with shaven upper lip, and the hard mask-like smoothness of the carving. There was a deep dissimilarity between the arts of Mesopotamia and those of the Indus Valley, which can be felt more strongly in two male torsos carved in limestone, one in a dancing posture (2, 15), the other standing upright (2, 16), both of which have lost their heads, arms and legs.

Although barely 4 inches (10cm) high, there is nothing of the miniature, nothing toy-like, about these extraordinarily accomplished sculptures. The texture of firm, youthful flesh, the softness and warmth of its swelling roundness, have seldom been more sensuously suggested. Broad, convex planes melt and merge into one another so smoothly that the gently protuberant bellies and bottoms seem essential to a sculptural form intended to be seen and admired from many different viewpoints. They are conceived fully in the round. The dancing figure displays, moreover, a grasp of three-dimensional movement rare in the arts until much later periods. It is held in a sinuous three-bended twisting pose familiar from countless examples in later Indian art from the second century BC onwards and called the *tribhanga* pose (see p. 179); here it is combined with a gentle diagonal twist, which accentuates its sensuality. The figure catches the rhythm of a dance, perhaps one performed as part of a religious ritual, as in many other cultures. Both torsos treat the human figure as a living and moving organism and not, as in Mesopotamia and Egypt, the symbol of some immutable ideal of divinity or semi-divine kingship. So extraordinary are they, in fact, that their early date has been questioned. Not only the technical accomplishment, but also the sophistication in the working out of a highly contrived sculptural composition with such apparent naturalism and balance, with such freedom and ease of movement, make it difficult to believe that they were created in the third or second millennium BC. Yet both were found at

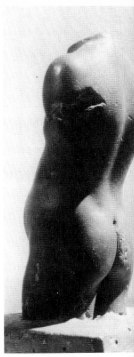

2, 15 Dancing figure from Harappa, c. 2400–2000 BC. Limestone, 3⅞ins (9.8cm) high. National Museum of India, New Delhi.
2, 16 Male torso from Harappa, c. 2400–2000 BC. Limestone, 3½ins (8.9cm) high. National Museum of India, New Delhi.

Harappa, with other surviving products of the civilization of the Indus Valley. One can do no more than speculate as to why so few and relatively small examples of the figurative arts have been recovered from these large, efficiently planned and well-built cities on the Indus. Did their culture lack those eternalizing impulses that lie behind the creation of so much of the monumental arts of Mesopotamia and Egypt? Did their religion call for no imposing cult figures and their social system demand no images of political power?

Ancient Egypt: Predynastic

Ancient Egyptian civilization, like the civilizations of Sumer and the Indus Valley, grew up along a great river which provided irrigation for agriculture and also a thoroughfare for the transport of men and materials — wood, stone and, of course, agricultural produce. The pressures which brought about the great step forward from Neolithic life to that of organized communities were probably much the same here — flood control and irrigation. The impetus that they gave to communal effort must have been as crucial in Egypt as in Mesopotamia. But there were important

differences. Unlike Sumer, where great cities developed in mutual rivalry and were frequently at war with one another, ancient Egypt evolved as a single, unified, far-flung rural community without any local centres and under the control of an absolute monarch. This probably came about largely through natural causes. For when the African deserts began to form in the fourth millennium, the Nile valley increasingly enjoyed the protection of these great natural barriers and the community was ever more closely bound together by the single, life-giving river which united it—and later by the central authority of the kings or pharaohs, as the Bible calls them. The Nile, together with the sun, also shaped their essential beliefs. The Nile (or rather the Nile in flood) was worshipped as the god Hapy, while the sun was revered as Re (or Ra), the father of the gods, a visible presence in Egypt, welcomed at dawn, feared at midday, honoured at dusk when he fell below the horizon.

The Nile, however, passes through two distinct environments: the narrow and sometimes cliff-confined valley of Upper (southern) Egypt and the wide alluvial plain, which opens into the huge delta of Lower (northern) Egypt. Farming began before the middle of the fifth millennium in the delta, where silt carried down by the river provided a richly fertile terrain. Upper Egypt was settled by nomads from further south and west, and was linked with the Neolithic cultures of the Sahara. This is probably the only region in the world where an unbroken thread of continuity may be traced from Stone Age rock art to the painting and sculpture of a literate people.

Animals like those engraved on rocks in the Fezzan

2, 17 Fragment of painting from Gebelein, c. 3500–3200 BC. Linen. Museo Egizio, Turin.

(1, 10) were painted on the pottery made in Upper Egypt in the Predynastic period (from c.4000 to c.3200 BC). Painted pottery seems, however, to have declined before the end of the fourth millennium. The most notable Predynastic vessels are those of marble or diorite, which already reveal great technical accomplishment in drilling, carving and polishing hard stone, even though the only metal tools available were of copper (bronze was not cast here until the beginning of the second millennium). Small figures of men and women were modelled in clay for burial with the dead. Usually they represent servants and indicate the early growth of belief in an immortality which prolonged indefinitely the pleasures of mortal life and which, in its developed form, promised a happy eternity to every good man—the belief which underlies and inspires the vast majority of surviving ancient Egyptian works of art. From about the same date paintings appear in tombs, on the wall of one at Hierakonpolis (now in the Egyptian Museum, Cairo) and on fragments of a linen cloth in another (2, 17). Both depict life on the Nile: there are hippopotamus and boats with deck cabins and many oars manned by tawny figures on the linen panel. Everything is rendered in flat silhouette, floating in unbounded space, as in Paleolithic cave painting and rock art. But in subject-matter and location (tombs) they break away decisively from the prehistoric past. Thus the basic elements of ancient Egyptian culture were already nascent before Upper and Lower Egypt were united about 3200 BC by Narmer, the first king of the first dynasty.

Narmer is represented on a votive palette of carved schist (a crystalline rock) (2, 18). Many of the formal characteristics which were to distinguish ancient Egyptian art for the next 3,000 years make their appearance here. On the front, the entwined necks of two monsters frame a recess for the cosmetic paint used to colour the eyes of a cult image in a ritual, probably to celebrate a victory. The creatures stand on firmly marked ground lines, from which figures in ancient Egyptian paintings and relief carvings were henceforth to be allowed to stray only very rarely. They are no longer scattered images floating in an unbounded void, as on the linen fragment (2, 17), nor are they rendered as flat, unarticulated silhouettes. Above them Narmer, wearing the red crown of Lower Egypt, inspects the place of execution of captives, who are shown, decapitated, on the right; in the lower register he is symbolized as a bull triumphing over a man, whose stark nudity implies inferiority. The reverse side shows Narmer wearing the White or Cobra crown of Upper Egypt, standing in a pose to be repeated thousands of times down the ages, his right

2, 18a & 18b Palette of Narmer, from Hierakonpolis, c. 3200 BC. Slate, 25ins (63.5cm) high. Egyptian Museum, Cairo.

2, 19 Stele of Djet, from Abydos, c. 3000 BC. Limestone, 21$\frac{5}{8}$ins (54.9cm) high. Louvre, Paris.

arm raised in a ritual gesture to smite a captive. Size denotes importance and Narmer is more than twice the height of the attendant, who carries his sandals and stands on his own detached ground line. Narmer is also distinguished by the carefully cut musculature of his legs, probably as a sign of strength. The bird to his right is a hawk, symbol of the sky god Horus, who was also the god of Upper Egypt, holding on a tether the symbol of Lower Egypt, incorporating six heads of papyrus. Every element of the composition has a specific meaning which can be deciphered from later usage.

The tiered composition recalls the somewhat earlier vase from Uruk (2, 6). On the palette, however, there is an ambivalence between realistically conceived figurative groups (the king and the captives, or the fleeing men below them) and pictorial symbols (those indicating the entrance and exit of the procession of men carrying banners, on the face, and the emblems of Upper and Lower Egypt on the reverse), an ambivalence only partly resolved by the carver's ability to unite them artistically. The palette was intended to be 'read' as a factual statement of Narmer's power to overcome his enemies. But, like so much ancient Egyptian art, it is also symbolic. The ancient Egyptians were less concerned with recording man's temporal

affairs in a transitory world than with the 'eternal present', and that called for an occult language of signs and symbols.

The stele from the tomb of Djet the 'Serpent King', one of the early monarchs of the first dynasty, is entirely symbolic (2, 19). It consists simply of a crisply carved falcon for the god Horus, incarnated in the person of the king, a serpent as the king's name-sign, and the façade of a building, presumably his royal palace (the word 'pharaoh' originally meant great house or palace). Hieroglyphs, the signs used in picture-writing, were being systematized at about this time, mainly for inscriptions on royal monuments (not for administrative purposes, as in Sumer, where the earliest forms of writing had been evolved for temple accounts and so on). In Egypt cursive script more suitable for writing on papyrus was developed from hieroglyphs only after the mid-third millennium. But hieroglyphs continued to be used for inscriptions in tombs, on monuments and in temples until ancient Egyptian religion was itself suppressed in the fourth century AD. They retained their pictorial character to the last, just as representational images retained their semantic significance.

Self-sufficiency and consistency, conservatism and an almost obsessive concern for permanence and continuity, an inflexibility quite impervious to change, these characteristics became evident very early and persisted with extraordinary tenacity throughout the entire course of ancient Egyptian art. In the fourth century BC, Plato remarked that there had been no change in Egyptian art for 10,000 years. It had not been lawful to introduce novelties, he said. These were exaggerations, of course, but only an art of a very well-marked character could have provoked them. And, despite periodic mutations and innovations, ancient Egyptian art always retained a strong and immediately recognizable flavour—to a degree unmatched by that of any other civilization, except perhaps the Chinese.

Attitudes to life and death peculiar to the ancient Egyptians, and still not fully elucidated, determined the form of almost all their art from well before and until long after the pyramids. The pharaohs were regarded as gods and not, like the rulers of Sumer, merely the stewards or representatives of the gods. Yet the immortality which they, and also their faithful subjects, could attain was dependent on the preservation of their mummified mortal remains. (The practice of embalming the body and preserving its entrails separately was mastered by the mid-third millennium BC.) There is one instance, in the first dynasty, of a princess being buried with her servants, slaughtered to accompany her into the next world, a gruesome funerary custom shared by many cultures (see p. 33). But we do not know how common it was in Egypt and to what extent, if at all, the demand for sculptured and painted figures in tombs was due to it. More important for the sepulchral art of the ancient Egyptians were their notions about the relationship between the body and the spirit, notions unique to them and developed early in the Dynastic period. In general terms, it may be said that they believed there to be three distinct but closely related emanations of the spirit. The *Ka*, which was part of the life-force of the universe, accompanied the body in life and death, though its full potentialities could be realized only after death. The *Akh* was the 'effective personality' of a man and also the soul, which left the body at death to dwell in the heavens. The *Ba* was more like a ghost which could move back and forth from the dead body. The presence of these beliefs is felt not only in their sepulchral art, but behind every aspect of culture. Nothing more effectively sets ancient Egypt apart from all other civilizations. Their visual arts were largely dedicated to providing suitable dwellings for these spiritual emanations—statues were perpetual bodies for the *Ka*, or some portion of it, to inhabit for ever; reliefs depicting the pleasures of this life ensured their prolongation in the next, those depicting historical events guaranteed the everlasting power of Egypt; even the portrayal of religious rites was intended to ensure the eternal well-being of the gods.

'The Egyptians say that their houses are only temporary lodgings, and their graves their houses', wrote the Greek historian Diodorus Siculus in the first century BC. Two distinct methods of burial had been customary in prehistoric Egypt. In the delta the dead were interred in the villages, sometimes beneath its houses, whereas in the south they were buried in graves dug in the desert (where the dry sand preserved their bodies) and provided with food, drink, clothing, weapons and implements. After Narmer's conquest of Lower Egypt, which united the two realms, the idea of building a house for the dead developed in the south. The mound of sand which had previously covered a grave was replaced by a low rectangular structure of bench-like form, nowadays called a *mastaba* (from the Arabic word for bench), built of mud-brick. With the growth of prosperity, the size of these *mastabas* and the complexity of the chambers beneath them increased. Eventually, stone was introduced, not for structural purposes but to cover floors and walls and for relief carvings—the stele of Djet, for instance.

Old Kingdom architecture
An ancient tradition ascribes the 'invention' of

2, 20 Sphinx and pyramid of Khufu, c.2650 BC. Giza.

building in stone to Imhotep, a high priest of Heliopolis, who was later venerated as a god — not only the earliest but one of the very few named architects of ancient Egypt. Imhotep is a semi-mythical figure, but there are substantial remains at Saqqara of the mortuary complex he is said to have built for King Zoser, founder of the third dynasty (2780–2180 BC), which initiated the period known as the Old Kingdom. Many of its peculiarities may be due to lack of experience in the use of stone, but it set a precedent for much in later Egyptian architecture, notably the 'step pyramid'. This seems to have developed from the *mastaba*, that at Saqqara being a *mastaba* enlarged by adding units of decreasing size until it reached a height of some 200 feet (60m) and formed, in effect, a ziggurat without a temple on top. Its purpose was to mark and protect the underground tomb chamber 90 feet (27m) below.

Around the pyramid stood single-story buildings and courtyards enclosed by a 30-foot-high (9m) wall of limestone, imitating the mud-brick walls of Zoser's palace in both construction and design. Neatly trimmed blocks of ashlar were used just as if they were mud-bricks, and the exterior was articulated with niches, like those of the buildings on the stele of Djet (2, 19). Stone was, in fact, used throughout the complex as a substitute for less durable materials: stone columns in the form of bundles of papyrus stems, such as were used to support flimsy primitive shelters; half-columns like vast single stalks of papyrus (perhaps also symbolic). Posts and rafters were expertly carved in stone and coloured to simulate wooden posts and rafters. Most extraordinary of all, in the underground chambers, there are false doors with blue-green tiles imitating rolled-up reed matting of the kind used to the present day for curtains in the Near East (2, 27). This might seem to be a highly sophisticated form of illusionism or *trompe l'oeil*. But it was not intended in this sense at all. Whereas to us illusionistic art provides a deceptive image of the 'real thing', the reverse was true for the ancient Egyptians. For them the precinct of King Zoser was the 'real thing', the royal palace it imitated the ephemeral earthly substitute, subject to the laws of change and decay. Their relationship parallels that between the spirit and the mortal body. The doors in these underground chambers are of solid stone, through which the *Ba* could pass. In one of the courtyards of the precinct, 'chapels' dedicated to each of the local gods of Egypt were no more than façades with false doors, which the mortal eye could see but only the spirit could penetrate.

False doors and stone papyrus columns recur throughout ancient Egyptian architecture. But the oblong plan and stepped form of Zoser's pyramid were gradually modified. Three pyramids built for Sneferu, founder of the fourth dynasty (c.2680–2565 BC), had approximately square plans and one, at Dashur, comes near to the classical smooth-faced form that was finally attained by his successors Khufu (Cheops) and Khafra (Chefren) for the biggest of all, at Giza just outside modern Cairo (2, 20). The form seems to have been adopted from the cult image, known as the *benben*, in the temple of the sun god at Heliopolis — a stone with a pyramidal or conical top, the ancestor of the obelisk.

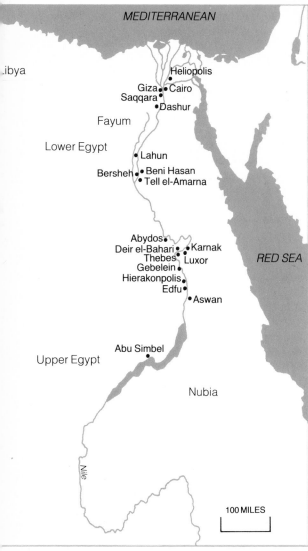

Map of ancient Egypt.

rising position, the point of observation and its setting position). So far as can be discovered, the stones which form the core of the pyramid were hauled up banks or ramps, which were increased in height as it rose and then were gradually demolished as the surface was covered with more finely cut stone, working from the top downwards. Skilled masons must have been employed to cut the stone lining the galleries leading to the burial chambers in the heart of the pyramid. The large work-force needed to haul the stone to the site is said to have been conscripted. It probably operated only in the period from late July to late October each year when the Nile was in flood, the land could not be cultivated and the majority of the population was idle. This was the normal period for building. The Nile flood also facilitated the transport of stone from Upper Egypt by boat. According to the fifth-century BC Greek historian Herodotus, the pyramid of Khufu took 20 years to build—a relatively modest outlay when it is remembered that the pyramid ensured the eternal welfare of the king, on which the future prosperity of the state was believed to depend.

Later pyramids were smaller, but otherwise varied only in the arrangement of interior passages leading to the burial chambers—and others intended to mislead intruders. Each pyramid was approached through a funerary precinct laid out for ceremonies and rituals, though little survives of Old Kingdom precincts apart from the Valley Temple at the beginning of the processional way to the pyramid of Khafra at Giza—a construction of massive monolithic piers and lintels carved and placed with perfect rectangular precision. Nearby, a knoll of living rock left by the quarrying of stone for the pyramids was hacked and carved into the form of the Great Sphinx, probably to represent Khafra as the sun god at the western horizon, guarding the Gates of Sunset (2, 20).

Although the pyramids of the Old Kingdom have proved the most enduring of man's large-scale monuments, they ironically failed in their main purpose of preserving the mummies, statues and furnishings of the dead, who were buried beneath them. All were broken into and robbed. Devices to prevent violation were used to no avail—until much later in the New Kingdom. But the treasure from the deeply buried tomb of Queen Hetepheres I (the mother of Khufu) fortunately survives. It includes a portable pavilion supported on wooden posts covered with sheet gold, two arm-chairs, a bed, a sedan chair and caskets inlaid with gold and ebony (2, 28), as well as jewelry of turquoise, lapis lazuli and carnelian set in silver (a metal rarer and more highly valued than gold in ancient Egypt). The furniture is as remarkable for

The pyramid also recalls the effect made by the sun shining down on the earth through a gap in the clouds—and it was on the rays of the sun that the dead king was said to mount to heaven.

The pyramid of Khufu is some 450 feet (137m) high on a square base occupying 13 acres (5.25 hectares) (it covers approximately twice the area of St Peter's in Rome), its regular sides being equilateral triangles. The precision with which it was laid out is remarkable, the sides being aligned on the cardinal points of the compass to within one tenth of a degree (true north seems to have been determined by sighting a star on the northern horizon and bisecting the angle between its

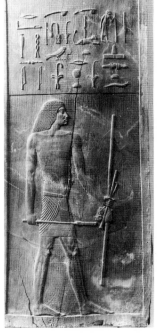

2, 21 Scribe, from Saqqara, c. 2600 BC. Painted limestone, 21 ins (53.3cm) high. Louvre, Paris.

2, 22 *Above left* Portrait panel of Hesira, from Saqqara, c. 2700 BC. Wood, 55½ ins (141cm) high. Egyptian Museum, Cairo. *Above right* The 'Canon' of ancient Egyptian art (after E. Iverson, *Canon and Proportions in Egyptian Art*).

the simple refinement of its design as for the exquisite precision of its craftsmanship. These pieces may have been made expressly for burial, but they resemble those shown in daily use in contemporary paintings and reliefs and thus provide some indication not only of the treasures which must have been buried in other royal tombs, but also of the elegance of the Old Kingdom palaces, of which no trace now remains.

Old Kingdom sculpture and painting
Apart from the mummy itself, the most important object in a tomb was the statue of the deceased, his 'other self', in which his *Ka* or part of it might dwell. By the beginning of the fourth dynasty, sculptors were carving such statues with a realism wholly unprecedented in the arts of the world. Several are most convincing portraits, speaking likenesses, such as those of Prince Rahotep (a son of Sneferu) and his wife Nofret, which still retain their colouring in all its original freshness (2, 30). So persuasive is the rendering of the faces that the rather summary treatment of the hands, legs, thick ankles and outsize feet tends to be overlooked. The somewhat later court official portrayed as a scribe (literacy was confined to priests and

government officials), with ochre-painted flesh and twinkling eyes of polished stone, is less formal and also more sensitively modelled (2, 21). Although less than 2 feet (60cm) high, this figure is even more astonishingly lifelike than the statues of Rahotep and Nofret. Such illusionism was not, of course, intended as a display of technical virtuosity—it was simply the means of embodying the human spirit in stone or wood. Accuracy of portrayal was necessary if the statues were to fulfil their immortalizing function and many are inscribed as 'carved from the life'. They were no more intended to deceive than were the rolls of modelled and glazed matting over the doors in Zoser's funerary precinct. No mortal eyes would see them once they had been immured in the tombs.

By no means all statues were, however, walled up in tombs. Many were carved to stand in the temples, where rites of a dead king were expected to be celebrated in perpetuity by a well-endowed priesthood. Mycerinus, the penultimate king of the fourth dynasty, commissioned a whole series (perhaps as many as 42) for the Valley Temple at the beginning of the processional way to his pyramid at Giza. In one he is accompanied by his wife Khamerernebty (2, 23). These

imposing figures are (unlike Rahotep and Nofret) integrated into a single sculptural group by the rhythmical arrangement of form (strong verticals counterbalanced by the horizontals of the king's belt and the queen's left arm, for instance), as well as by their close physical contact and the invincibly confident gaze with which they both stare into eternity. The lower part of the group is unfinished, but this lack of finish would have been very much less apparent under the paint, of which only traces survive. All ancient Egyptian statues were painted or partly painted. (The beautiful hard stones from which they were often carved were chosen for durability rather than for their colour or texture.) So, the group of Mycerinus and his wife must originally have looked very different. In its present monochrome state, however, it reveals all the more clearly the rigid framework of conventions which controlled sculpture from the time of the Old Kingdom onwards.

Statues were invariably carved and placed to be seen

2, 23 *Below* Mycerinus and his queen, from Giza, c. 2600 BC. Slate, 48⅞ins (124.1cm) high. Museum of Fine Arts, Boston.
2, 24 *Right* Entrance to tomb of Mereruka, c. 2400 BC. Saqqara, Egypt.

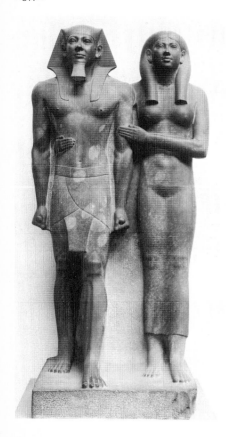

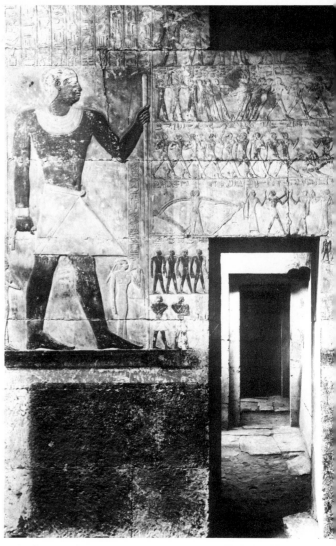

only from a frontal viewpoint. The range of postures was strictly limited. Figures either stand with the left leg slightly advanced or sit bolt upright—kings and queens on thrones, such court officials as scribes and physicians squatting cross-legged. (Large-scale sculpture in the round was reserved for royalty and the court.) This inflexibility has been ascribed to peculiarities in sculptural practice, and especially to the use of rectangular blocks, which are said to have determined the four-square rigidity of the statues. The reverse might equally well be true—that it was the limited conception of sculptural form which led to the blocks being cut to rectangular shape in the quarries, so that sculptors might draw on their surfaces the outlines of the four, and never more than four, envisaged aspects of a statue: front, two sides and back (often left plain).

The latter explanation is inherently the more likely. But whatever its ultimate origin—craft traditions or sense of form—may have been, nothing was left to chance in the carving of a statue. The sides of the block were marked with a measured grid of lines which determined the 'correct' size of every part of the body (see below). A figure could encapsulate the spirit and thus fulfil its essential purpose only if it observed established conventions.

Similar conventions which regulated the allied arts of painting and low-relief sculpture are already evident in a masterly carved wood relief of Hesira, a court official of King Zoser (2, 22). The sensitively carved head is that of an individual, not a generalized type; the way in which the left hand clasps the staff of office could hardly be more naturalistically observed; the knees and calf muscles are lovingly, almost tenderly, defined. Yet the pose is most unnatural, if not anatomically impossible—shoulders to the front, head and legs to the right—and the figure appears to have two left feet, for only the inner side is visible of what ought to be the right—there are no little toes! The kilt is shown frontally, while the legs stride off to the right.

This strangely contrived posture is the hallmark of ancient Egyptian art and the most obvious example of its essentially intellectual or conceptual, as distinct from purely visual, nature. Ancient Egyptian artists wanted, above all, to convey what they knew and not just what they saw. They therefore laid out the human figure to show its distinguishing features as fully as possible, much as a botanist lays out and presses flat a plant or flower to display its essential parts. So the pose is no mere convention: it was most carefully devised as a means of combining in a single image all the salient features of the subject, which were, so to speak, taken apart and recomposed. Thus, the head shows the fullness of the eye as well as the line of the forehead, nose and chin, and the thick hair brushed back. The placing of the legs, with the one furthest from the spectator (usually the left) extended forward, was a means of displaying the sex, whether of a man or an animal, as well as the whole structure of the leg from the hip and buttocks downwards—which could not have been done frontally. (The figure is to be read as moving not to the right or the left, but out of the wall towards the spectator.) This pose very soon became accepted as the 'correct' mode for human representation. A slight deviation would have been the equivalent of a spelling mistake; a major deviation would change the meaning of the figure and transform, for instance, a court official into a peasant or a captive (for whom less strictly formalized modes were thought appropriate).

The standard Egyptian pose was intimately connected with a no less strictly observed system or canon of bodily proportions. Like most other people, the ancient Egyptians based measures of length on parts of the human body—their main unit, the small cubit, corresponded to the length of the arm from elbow to thumb-tip, which equalled 6 hand-breadths or 24 finger-breadths. In nature, of course, these lengths differ from person to person, but the Egyptians noted that the relationship from one to another is almost invariable—that, for instance, the foot is three times the width of the hand (as we instinctively recognize when we measure the size of sock we need by wrapping it around a clenched fist)—and from this observation they created the canon which laid down the proportional ratios between every part of the body. To ensure its observation an Egyptian painter or relief carver drew on the surface of the wall a grid of squares, each one the size of the feet of the figure to be represented, and divided the body into 18 units from the sole of the foot to the hair-line of the forehead (p. 43). A fixed number of units determined the length of arms and legs, the breadth of shoulders (so clearly and measurably shown by the twisted pose in paintings), the distance between the feet and so on. Traces of several such grids survive from the Old Kingdom. Merely by altering the dimensions of the unit, figures could be enlarged or reduced without departing from the canon. Size in ancient Egyptian art always indicates the relative importance of figures and not their distance from the spectator. The system was, in fact, entirely intellectual and made no allowance for the natural muscular extension of limbs in movement, let alone the visual effects of foreshortening or perspective.

The fidelity and regularity with which the canon was observed had artistic results, perhaps unintended. To it is due much of that sense of controlled balance and repose, which can be felt throughout ancient Egyptian painting and sculpture, as well as their stately monotony, which can exert a strange, almost hypnotic charm. All these solemnly, silently gesturing figures, rank upon clean-limbed rank of narrow-waisted men and slender women delicately holding lotus flowers in their long, lean fingers, have the effect of repeated phrases in a poetic incantation. Such comments and interpretations, however, would have been considered entirely irrelevant by the ancient Egyptians—to whom, in any case, the aesthetic response of the living was of little or no importance.

Nothing more clearly reveals the intellectual rather than visual or sensual basis of ancient Egyptian art than the intermixture of hieroglyphic signs with

images. On the panel from Hesira's tomb, hieroglyphs are confined to the upper section (2, 22), but often they surround a figure, indicating that what we tend to regard as a background of space was conceived by the ancient Egyptian artist as a surface, onto which images were projected. Sometimes there is little or no direct connection between the meaning of the words and the explicit subject-matter of the figurative groups with which they are juxtaposed. This disjunction perhaps partly explains the inconsistency between the acutely observed naturalism of details and the extremely artificial way in which they are combined.

The function of tomb paintings and low-relief carvings was to furnish the deceased's 'eternal castle' with eternally durable effects and also to establish the status he had attained in life (fully spelt out in the inscriptions) and hoped to enjoy still more intensely in the hereafter. A funeral banquet is usually shown, together with, in one royal tomb at Giza, the cooks preparing it in the kitchen. Women appear only as wives, daughters, servants, for a wife was regarded as a possession, 'the fruitful field of her lord' as she was sometimes termed. As the tombs not only of kings but

also of courtiers grew larger, so the elaboration of their paintings increased, with numerous records of the everyday activities of the family and servants of the deceased in one chamber after another (2, 24). Under the fifth dynasty (c.2565–c.2420 BC) the range of subject-matter widened. Country scenes became more prominent, with the deceased enjoying boating trips through thickets of papyrus or hunting on the verge of the desert. Such pictures were intended to evoke for the dead the life-giving power of the sun god Ra (or Re). But they were outnumbered by scenes of seasonal work on the land, scenes which recorded the farms the deceased owned, and provide us with amazingly vivid glimpses of daily life in Egypt 4,000 years ago, as in those from the tomb of Ti at Saqqara which fully exemplify the principles of ancient Egyptian painting (2, 25). The water of the Nile is represented by the wavy band at the bottom. Men driving a flock of sheep in the upper register are in a pose which, to indicate movement, departs slightly from the standard form, but the inferior farm-hands below, one walking beside a cow and the other bending under the weight of the calf he carries, depart further, being rendered almost as naturalistically as the wonderfully lively animals. Degrees of naturalism would seem to correspond to the strata of the social order.

2, 25 Cattle fording a river, c.2450 BC. Painted limestone, tomb of Ti, Saqqara.

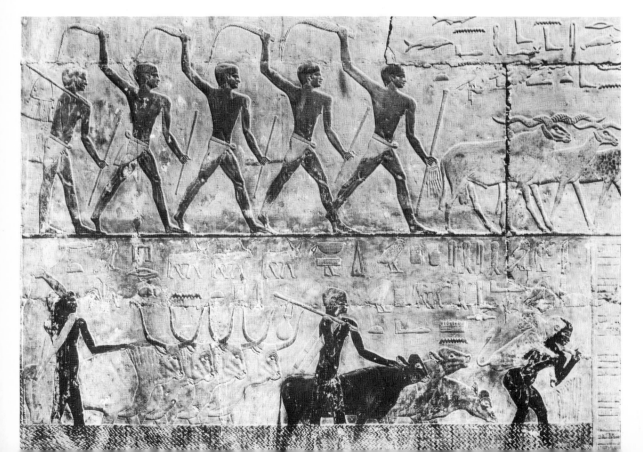

Middle Kingdom

In about 2258 BC the central authority of the kings broke down, the country disintegrated into feudal states and was not reunited until Mentuhotep, ruler of Thebes, initiated the Middle Kingdom about 2134 BC. The most important outcome of the intermediary period between the Old and Middle Kingdoms was the so-called 'democratization of the hereafter'. In the Old Kingdom, only the king was destined to become a god and the afterlife of his subjects depended on his favour. Local rulers now appropriated this divine right, which was further extended to all those who could afford to have the appropriate rituals performed at their funerals and their coffins inscribed with the magic spells previously used for the royal apotheosis. This 'democratization' was accompanied by new cults (notably that of Osiris) and the questioning of old beliefs. Moral and semi-philosophical problems were taken up—including suicide in *The Dialogue of a Pessimist with his Soul*—but this outburst of intellectual activity had no parallel in the visual arts. Rather the reverse, in fact: and it was not until the Middle Kingdom that a delayed response can be discerned, especially in painting.

Essential principles remained the same in Middle Kingdom painting, but colour was now used more freely and subtly, as on the outer coffin of Djehutynekht from Bersheh (2, 29). Shading and other naturalistic effects were attempted here, notably on the dove's plumage rendered with delicate gray and black strokes over white, through which a suggestion of rose colour permeates up from the cedar-wood ground. The range of subject-matter was also expanded. Historical events were depicted, such as Mentuhotep's victory over Asians, and subsidiary figures were given more attention. Hundreds of pairs of wrestlers grapple with one another on the walls of tombs at Beni Hasan, with an occasional (perhaps misleading) suggestion of foreshortening. Rural scenes have more of an open-air feeling. Beneath a fishing scene on the Nile hieroglyphs declare: 'Boating in the papyrus beds, the pools of wild-fowl, the marshes and the streams, spearing with the two-pronged spear he transfixes thirty fish; how delightful is the day of hunting the hippopotamus.' It is a vivid statement of the Egyptians' love of life, implicit in their urge to perpetuate its pleasures after death—a corrective to any facile assumption that their art of the tomb was morbid. 'May I be cool under the sycamores', runs one of their prayers, 'May I bathe in my pond; May my spirit not be shut in; May I tend my acres in the field of Iaru.' Likewise, in Middle Kingdom sculpture, a new and more relaxed feeling for life can sometimes be sensed. A hint of a smile, very

2, 26 A princess, 1929–1892 BC. Green chlorite, $15\frac{5}{16}$ ins (38.9cm) high. Brooklyn Museum, New York, Charles Edwin Wilbour Fund.

rare in ancient Egyptian art, hovers around the enigmatic lips of an unnamed princess, her cheeks still touched with the bloom of youth (2, 26). Formal patterning of eyebrows and hair beautifully sets off the naturalistic rendering of meltingly smooth planes of flesh in this masterpiece of delicately subtle portraiture.

The most grandiose architectural monuments of the Middle, as of the Old, Kingdom continued, of course, to be those erected for the kings. But at Lahun in the Fayum there are remains of a whole town built to accommodate the workers, artisans and others engaged on the pyramid of Sesostris II (1897–78 BC). This is the earliest town of which traces survive in a country where most people lived in agricultural villages strung along the Nile. And the reason for its construction is no less significant than the rigid social stratification which its foundations demonstrate. It was laid out on a square grid plan (more regular than that of the earlier cities of the Indus Valley, see p. 36) about 1,300 feet (400m) across. Such a plan was probably adopted, as in later times, mainly as a convenient means of apportioning land. A stout north-south wall divided it into two parts. In the eastern part the houses of higher

officials, some with as many as 50 rooms, flanked wide streets leading to the palace of the governor (perhaps used also for royal visitors) raised on an artificial platform. The much smaller western part was crammed with blocks of back-to-back houses of three or four rooms apiece for the workers.

What of these workers? They took no part in the official religious cults centred on the pharaoh. The religio-political system condemned them to toil in this world and the next. They appear frequently in tomb paintings and reliefs and also as little free-standing figures called *shabti* (later *shawabti* or *ushabti*), whose role in the hereafter is made explicit in hieroglyphics, such as: 'When I am called to tend the land, then you, *shabti*, give ear and answer "Here I am".' Another reads: 'Take up your mattocks, your hoes, your yokes and your basket in your hands as any man does for his master.'

Artists and craftsmen (there was no distinction) were, of course, included among this vast body of servants of the great and as such they, too, figure on the walls of tombs. Little is known of them as individuals. Architects appear to have occupied a fairly elevated status as court officials. One named Nekhebu, who worked for a king of the fifth dynasty, stated in his epitaph (Museum of Fine Arts, Boston):

> His majesty found me a common builder. His majesty conferred upon me the successive offices of journeyman builder, master builder, and master of a craft. Next his majesty conferred upon me the successive offices of Royal Constructor and Builder, Royal Attaché, and Royal Constructor and Architect ... His majesty did all this because his majesty favoured me so greatly.

This unique glimpse into the workings and structure of the building profession in ancient Egypt unfortunately tells us nothing of the buildings Nekhebu designed. A sculptor named Iritsen, who lived in the reign of Mentuhotep, was less self-effacing in the inscription of his funerary stele (Louvre)—by far the earliest recorded statement by an artist. 'I was a man skilled in my art and pre-eminent in my learning', he wrote. 'I knew how to represent the walking of a man and the carriage of a woman ... the poising of the arm to bring the hippopotamus low and the movements of a runner.' He boasted of his accomplishment in handling various, mainly precious, materials. But he clearly took most pride in his arcane knowledge of 'the secrets of the divine words', of 'the prescriptions regarding the rituals of festivals' and 'one of every kind of magic'. Though surprisingly articulate, Iritsen should not be understood as implying by these remarks any artistic

independence. His claim to know 'how to represent' a human figure refers strictly to his knowledge of accepted conventions, those 'rules' which enable an image to fulfil its ritual, religious or magic purpose and which underlay all ancient Egyptian art and architecture. So tightly were the visual arts integrated into the religio-political structure of the state that they declined sharply whenever its balance was upset, as in the first so-called Intermediate period and the much longer second Intermediate period (1786–1570 BC) after the disintegration of the Middle Kingdom. That they revived after each of these interruptions attests to the resilience and strength of their traditions. (For later developments see p. 65.)

The Aegean

Late in the third millennium BC, about the time the Middle Kingdom began in Egypt (p. 47) and Akkadian rule collapsed in Mesopotamia (p. 34) and two or three hundred years after the foundation of the cities of the Indus Valley (p. 35), another civilization emerged on the island of Crete in the Aegean, or eastern Mediterranean, about 350 miles (560km) north-east of the Nile delta. It had contacts with Egypt and with Mesopotamia (through intermediaries in the Levant), but was an autonomous growth, differing in many respects from the others. They were river-valley civilizations—as was to be that of China, as we shall see. This was a sea-faring, island culture. Whereas the others controlled and were sustained by vast territories, this was confined to a relatively small geographical area, Crete being only some 150 miles (240km) long and 36 miles (56km) across at its widest. The island enjoyed, however, a temperate climate, without the droughts and floods which plagued the others, and was more than self-sufficient agriculturally, producing grain, wine and enough olive oil to export—and probably enough wool as well. It was much more fertile then than it is today. The sea, which provided the means of communication for trade in raw materials and artifacts, also protected Crete from foreign invasion, though for little more than 500 years (c.2050–1450 BC). Practically nothing is known of its history except that its buildings were destroyed about 1730 BC, probably by an earthquake, and were very soon reconstructed. A second disaster at the beginning of the fifteenth century BC, perhaps the result of a volcanic eruption, was followed by an invasion from the mainland of Greece.

Minoan Crete

The origins of this Minoan civilization—so called after a mythical king Minos of Crete—are difficult to trace,

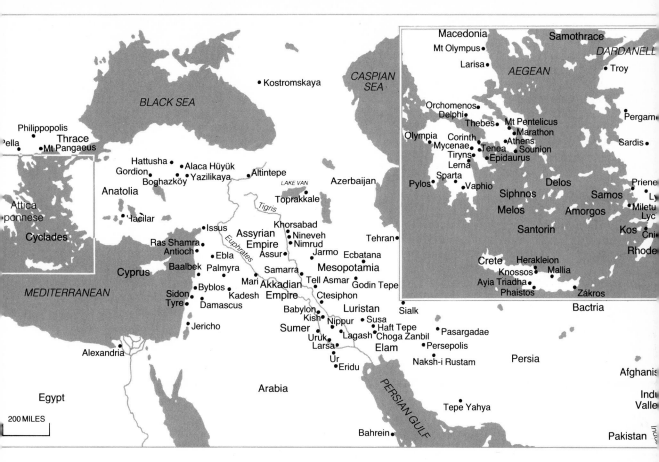

Map of the ancient Near and Middle East.

however, and its emergence seems to have been as sudden as its collapse and disappearance. Recent excavations have brought to light evidence of an advanced Neolithic culture, which had merged into a Bronze Age culture by 3200 BC and extended throughout the Aegean islands, up the east coast of Greece and as far north as Troy on the opposite shore. This seems to have provided the material background from which civilization sprang up independently of outside influence on the agriculturally rich island of Crete.

Although the Aegean culture of the third millennium used bronze implements, its only notable works of art were produced by Neolithic techniques: statuettes of hard white marble carved with obsidian blades and rubbed smooth with emery (2, 31). They seem to have originated in the islands of the Cyclades, where these materials were readily available. Ranging in size from a few inches to almost life-size in very rare instances, they represent nude human figures, generally female and rendered with the utmost schematic

simplicity. A few are in more lifelike poses with some three-dimensional feeling, though in almost tubular form. The majority are of women with strange expressionless shield-shaped faces and wedge-like noses, tiny breasts and arms tightly folded beneath, pubic triangles sharply incised and legs held close together. Heads are tilted back and feet are extended in line with the shins so that the figures seem to be lying down (they cannot be displayed upright without a support). The human body has almost been transformed into geometric shapes (triangles, rectangles,

Overleaf
2, 27 *Top left* False door, south tomb of Zoser group, subterranean area, c.2700 BC. Saqqara.
2, 28 *Top right* Portable pavilion and furniture of Queen Hetepheres I, c.2650 BC. Wood and gold leaf. Egyptian Museum, Cairo.
2, 29 *Left below* Detail of outer coffin of Djehuty-nekht from Bersheh, c.1860 BC. Paint on cedar wood. Total height of panel 44ins (111.8cm). Museum of Fine Arts, Boston.
2, 30 *Far right* Rahotep and Nofret from Medum, c.2580 BC. Painted limestone, 47$\frac{1}{4}$ins (120cm) high. Egyptian Museum, Cairo.

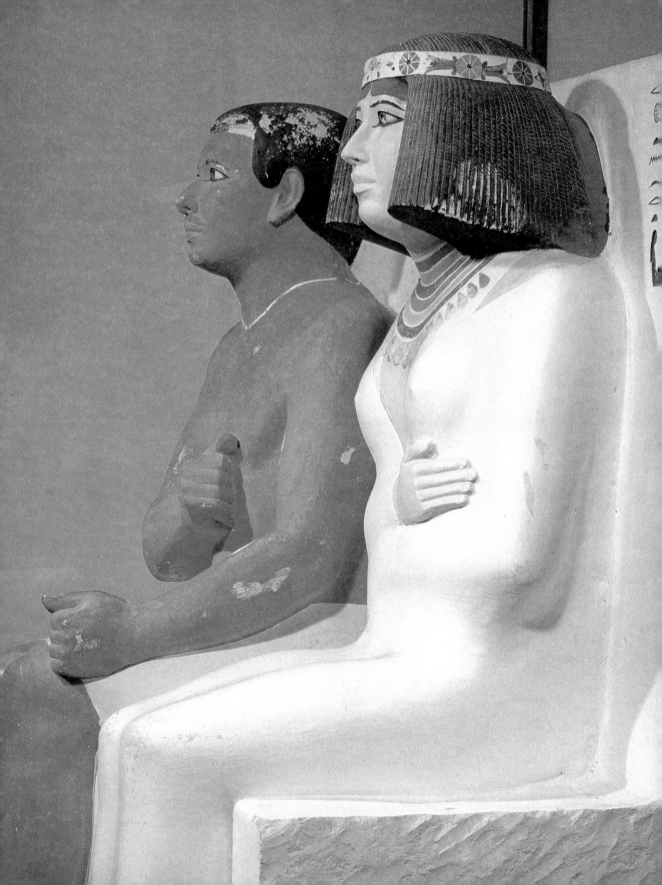

ovals) but the stylized effect this now gives may have been less pronounced before the colouring had worn off—the eyes were painted, also various necklaces, bracelets, and other ornaments. Examples have been found mainly in tombs, but it is impossible to tell whether they were cult figures or companions of the dead (like the Egyptian *shabti*, see p. 48)—goddesses or concubines. There is something curiously innocent about them, a purity of crystalline form as if they had been washed clean of all gross matter. They make a very striking contrast with the plump fleshy images of fertility or motherhood produced by other prehistoric cultures—and also with most of the works of art found in the Cretan palaces.

Cretan civilization was centred on the palace rather than the temple (as in Sumer), the town (as in the Indus Valley) or the tomb (as in Egypt). There were no large temples: religious shrines were in domestic buildings or scattered through the countryside, in caves, by springs or on hill-tops. Towns were simply unplanned conglomerations of small dwellings without fortifications such as surrounded the settlements on the Cyclades and also Troy (where the sixth of a series of

2, 31 Cycladic figure from Amorgos, c. 3000 BC. Marble, 30ins (76.2cm) high. Ashmolean Museum, Oxford.

towns built one on top of another is approximately contemporary with those on Crete). The Cretans buried their dead collectively in communal ossuaries. The few more elaborate tombs, like those at Knossos and Isopata which seem to have belonged to a ruling family, are stark and modest by Egyptian standards. But the palaces at Knossos, Phaistos (each of which covered between 3 and 4 acres—about 1 to 1.5 hectares), the somewhat smaller ones at Mallia, Ayia Triadha and Zákros, and the several neighbouring 'villas', lacked for nothing in richness of decoration and furnishings.

Whether these palaces belonged to different families of rulers or to a single one is not known. There may even have been a transition from a confederation of princes to a unified monarchy. All that is certain from archeological evidence is that Minoan Crete had a clearly stratified social structure, that the economy functioned by a process of redistribution (without money) and that government was effective enough for towns and individual buildings to do without massive fortifications. The palaces were built near the richest agricultural land and their vast storage areas reveal that they were centres for the collection and redistribution of the four main products: wool, grain, wine and olive oil (the latter used for lighting, cleansing the body and as a base for scent as well as for cooking). In a single store at Knossos there were more than 400 huge pottery jars, presumably for oil, with a total capacity of some 20,000 gallons (91,000l). It was in this context, intermediate between barter and commerce, that Minoan writing developed for the palace accounts. Inventories of goods were inscribed on clay tablets in the later of two scripts, called Linear B. The language was a primitive form of Greek.

The palaces were curiously irregular—what today would be called 'informal' or 'open'—in plan, with rectangular rooms varying greatly in size grouped around a large, paved central courtyard. Stores were on the ground floor, larger apartments and colonnaded terraces above. The centre of each palace could be reached from several directions, through a succession of spaces and along sharply turning corridors, which may well have given rise to the myth of the minotaur's labyrinth. Comfort seems to have been a factor of major importance: parts of the buildings were open to catch cool breezes in the summer, others were planned so that they could be closed and heated with braziers in the winter. Baths and latrines (with wooden seats) were provided. There was an excellent drainage system.

Decoration was evidently no less important than comfort. Façades of buildings seem to have been

brightly coloured, and inside the palaces and villas courtyards were paved as were rooms and other covered areas. Columns used to form colonnades and porticoes were all of wood, usually tapering towards the base. Plastered walls were painted red, blue or yellow above dados of gypsum. In the more important rooms there were also figurative paintings and occasionally stucco reliefs. Unfortunately, only fragments remain. Larger and sometimes very much better preserved wall paintings of about 1550 BC have recently been discovered at Akrotiri on Thera (Santorin) in the southern Cyclades, a Minoan colony culturally if not politically. They seem to have decorated living-rooms in private houses (though a priestess is depicted in one of them) and include several human figures in what might be described as scenes from daily life—notably two boys boxing and fishermen carrying their catch ashore (2, 33). They are painted in flat colours, with here and there some indications of modelling.

Perhaps the best idea of the style of wall paintings in palaces and houses, and the general effect they originally made, can be obtained from a small sarcophagus found at Ayia Triadha in Crete, even though it dates from the very end of the Minoan period and, being a tomb painting, is untypical. It is, however, complete and exceptionally well preserved. A single scene is depicted on each side, a funerary ritual on that illustrated here (2, 32). At the far right the dead man stands in front of his tomb and at the other end a woman (perhaps his widow) pours a libation into an urn placed between columns topped with double axes—a symbol of unknown significance, which appeared much earlier on pottery in Mesopotamia (see p. 23) and recurs in Minoan art. As in Egyptian and Mesopotamian art, all the figures have their feet flatly placed on a single ground line and their eyes are depicted frontally. The three men carrying offerings of animals and a boat to the tomb are in the twisted Egyptian pose. But the dead man, the lyre-player and the two women are in pure profile. There are other notable differences from Egyptian paintings. The scene is framed by bands, setting off the pictorial field, which is conceived as a shallow stage with a recessed background. There is, in fact, an attempt to catch the visual appearance of figures moving in a defined space, and this may account for some curious inconsistencies, especially in the relationship between the woman pouring the libation, the urn and the two columns. In comparison with ancient Egyptian art, the figures are crudely drawn, yet they have a suppleness and ease of movement rare in Egypt before the New Kingdom (see p. 47). It is this delight in movement and the flowing

lines and free forms expressive of it that give Minoan art its air of buoyancy and vivacity.

Minoan art is seen at its best in small and usually precious objects, probably the products of palace workshops. No large-scale sculpture is known apart from some life-size and lifelike stucco reliefs of men and bulls which were combined with wall paintings at Knossos. Unfortunately, only fragments survive, perhaps dubiously reassembled. Cult images of a bare-breasted goddess holding snakes in her hands are little more than 12 inches (30cm) high, sometimes less. Two are made of the glittering, glassy substance produced by firing a mixture of sand and clay so that the surface vitrifies (invented in Egypt or Mesopotamia in the fourth millennium BC and misnamed 'faience' by archeologists). Life-size bare-breasted female figures in clay, fragments of which were recently discovered on the island of Kea in the Cyclades, would appear to have been not unlike the small snake goddesses in form. They were all found together in what may have been a temple, the only instance as yet discovered of such a building in the Aegean at this period.

Apart from the snake goddesses, there are few explicitly religious images in Minoan sculpture or painting. Nor is there any historical scene, nor even a single portrait which can be identified as that of a ruler. In these respects the contrast with both Mesopotamia and Egypt could hardly be more striking. The subject-matter of Minoan art was derived mainly from the natural world. The sea provided many motifs: underwater plants float and sway languidly, octopus extend their tentacles with decorative rather than menacing effect, and dolphins play happily on little gold cups and large pottery vases. Birds, beasts and plants enlivened the painted walls of the palaces. On the island of Thera one house had a room entirely painted with flowers springing from hillocks and with birds flying above (now National Museum, Athens). These are the earliest pure landscapes anywhere, certainly painted before 1500 BC, although fragments suggest that there may have been others like them in the palaces and villas of Crete itself. Indeed, flowers bloom everywhere in Minoan art, on ewers and storage jars, to which they were often applied in relief, and on tiny pieces of gold jewelry together with delicately wrought insects.

The animals most prominent in Minoan art are bulls, represented in every available medium, incised on seals, modelled in clay, wrought in gold and silver, cast in bronze, carved in hard stone, painted on walls and on pottery. Rhytons—vases from which libations were poured to the dead or to the gods—often took the form of bulls' heads: one is carved of steatite with

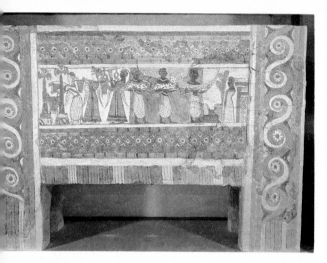

2,32 *Top left* Sarcophagus from Ayia Triadha, Crete,
c.1450–1400 BC. Limestone with surface plastered and painted,
Herakleion Museum, Crete.
2,33 *Above* Fisherman, from Akrotiri, Thera (Santorin), c.1550
BC. Wall-painting, 53ins (109cm) high. National Museum,
Athens.
2,34 *Above left* Bull's head rhyton, c.1500 BC. Steatite with
mother-of-pearl, jasper and rock crystal, head 12ins (30.5cm)
high. Herakleion Museum, Crete.

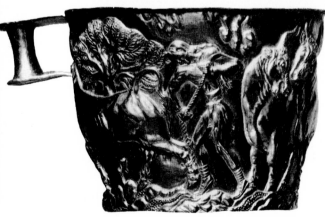

2, 35 *Top* Detail of Harvester Vase, from Ayia Triadha, c.1500 BC. Steatite, about 5ins (12.7cm) wide. Herakleion Museum, Crete.

2, 36 *Above* Cup from Vaphio, c.1500 BC. Gold, about 3½ins (8.9cm) high. National Archeological Museum, Athens.

mother-of-pearl inlaid around the nostrils and also in the whites of the eyes, which have irises of red jasper and pupils of rock crystal (2, 34). These bulls evidently had some religious significance, but precisely what remains mysterious. Though less benign than their Sumerian predecessors (2, 2), they can hardly have been intended to embody dark supernatural forces. Perhaps they were connected in some way with the bull-leaping practiced by youths and girls, either as a ritual or a sport or a combination of the two, of which many representations survive. Fragments of a wall painting at Knossos show a prancing bull whose horns are held by a girl while a youth turns a somersault over its back. Acrobats also appear independently and probably without any ulterior meaning.

The sprightliness, the joyful carefree buoyancy which distinguishes the art of Minoan Crete from that of ancient Egypt or Mesopotamia is very apparent in perhaps the finest of all surviving Minoan works of art, a small stone libation vase carved with a continuous procession of farm labourers carrying sheaves and winnowing forks, singing as they march to the sound of

a rattle held aloft by an older man (2, 35). It may well represent a ritual of some kind, though nothing could be less solemn than this exuberant celebration of uninhibited physical well-being. The broad-shouldered, wasp-waisted men are shown in the 'Egyptian' pose—like those on the Ayia Triadha sarcophagus (2, 32)—jostling one another, pulsating with spontaneous human vitality. A sense of the third dimension, of movement through space, is rendered in this small masterpiece to a degree very rare in the art of the second millennium.

Similar mastery is displayed in the exquisitely wrought repoussé (see Glossary) reliefs of bull-catching scenes on two little gold cups (2, 36). Muscular force is vividly suggested by a youth with a rope attached to the bull's hind leg. The bull nuzzling at the cow set to decoy him displays a command of foreshortening which is unprecedented. These cups were, however, found in a grave at Vaphio, near Sparta, in the Peloponnese, and whether they were made there or in Crete is much disputed. The same problem is raised by other pieces of metalwork found on the mainland. A bronze dagger blade from a grave at Mycenae is decorated with a leopard chasing ducks among lotus plants—an exotic scene of a type popular in Minoan painting. But nothing similar has been found in Crete, nor were the dead buried there with rich 'grave goods' until after invasions from the mainland about 1450 to 1400 BC.

Mycenae and the mainland

The early civilization of mainland Greece is generally called Mycenean, though this is something of a misnomer and archeologists now prefer Helladic (a term also used for the earlier prehistoric culture). It flourished in a number of small 'states' or kingdoms extending across the Peloponnese from Mycenae and nearby Tiryns in the east to Pylos on the south-west coast and included Vaphio, Orchomenos and Lerna, all of which seem to have been independent of, and sometimes at war with, one another. They shared, nevertheless, a common background and language (an early form of Greek, which belongs to the so-called Indo-European group), had similar buildings and weapons, and the same burial customs. There is reason to think that this civilization initially followed a path parallel to that of Minoan Crete. As bronze was increasingly used for weapons and implements, as larger and more strongly defended towns were built and the land was more productively cultivated, a redistributive economic system evolved. Helladic rulers accumulated the surplus necessary to build palaces and support artists working in such costly materials as gold from Nubia in southern Egypt, ivory from Africa or India by way of Syria, and amber all the way from the shores of the Baltic.

This mainland civilization differed in many respects from that of Minoan Crete. Its massive fortifications, numerous weapons and other remains suggest a fiercer and more aggressive people. Local chieftains or kings of the first half of the second millennium were buried with grave goods which, though modest in comparison with those of the kings of Ur (p. 33) or the pharaohs of Egypt (p. 42), are of an opulence unprecedented in the Aegean world and give some indication of their material wealth and power. There can be little doubt that by this date the Helladic states were already moving towards the stratified social system recorded in Linear B inscriptions at Pylos—a pyramid with the chieftain or king, sometimes assisted by a leader, at the top; then a 'nobility', who held land on a feudal footing in return for agricultural produce and service in war; then the artisans and land-workers, followed at the lowest level by slaves.

Little is known about the early buildings at Mycenae contemporary with the first shaft graves, which, it has recently been argued, may be as early as 1850 BC. They were probably of mud-brick and wood, not of stone. The surviving remains of the city and citadel appear to date back to about 1700 BC, with the royal palace on the hill-top isolated in the centre of a roughly triangular area enclosed by a massive stone wall following the contour of the hill. A few houses and a granary (also the shaft grave circle) lay just outside the citadel wall. The mass of the population lived below in a conglomeration of houses of varying size, simply constructed of sun-dried brick, with flat roofs and beaten earth floors. None of these houses is still standing, but unearthed fragments suggest that some of them had painted decorations. In times of danger the people presumably moved up to the citadel. The same general system (similar to that established earlier at Troy) was followed at Tiryns with variations conditioned by the nature of the site. The contrast between these forbidding hilltop fortresses and the very lightly defended cities and palaces of Minoan Crete could hardly be more striking. Similarities with the Hittite fortifications at Boghazköy in Anatolia, on the other hand, are quite evident (see p. 64).

The citadel walls, especially, are overpoweringly impressive—obviously intended to look, as well as be, impregnable. Built of earth and rubble, they were faced with massive rough-hewn blocks later called Cyclopean because they seemed to have been set in place by the mythical one-eyed giant Cyclops. The main gate at Mycenae is constructed of three giant

megaliths—i.e. a trilithon, as at Stonehenge (see p. 25)—with a carved panel filling a relieving arch above (a false arch made by corbelling the blocks of the wall to relieve the lintel stone of the trilithon from the weight of the superstructure) (2, 38). As bold and forceful as the building it adorns, this carving is the most imposing example of Mycenean sculpture to survive; but its precise significance is unknown. The central column could be either a dynastic or a religious symbol, and although the two headless creatures heraldically posed on either side are usually described as lions, they may well have been sphinxes or griffins with human or bird heads of bronze, coloured stone or some other medium. (The heads were attached separately.) Originally the effect must have been much harsher than appears today.

In comparison with the gigantic monumentality of the walls, the palaces seem small. The main room in each was a megaron, at the most 40 feet (12m) square. In Greek the word means simply 'large room', but it is now used technically to describe one of a specific form: a square or oblong chamber with a central hearth and usually four columns to support the roof, the lateral walls projecting forward beyond the entrance wall to form the sides of a porch, which is usually columned. Sometimes a second entrance wall, with a single opening like the first, is added to form an anteroom between the porch and the inner chamber; and store-rooms might be added at the back, but always within the same lateral walls. Neolithic dwellings in northern Greece were approximately of this form, but the regular megaron is first found at Troy in the middle of the third millennium. (It does not appear to have been used on Crete before the conquest of the island and the two so-called 'megarons' at Knossos are simply 'large rooms'.)

The Mycenean, or Helladic, civilization seems to have exploited Minoan art just as it did the Minoan syllabary for the Linear B script. But sometimes it did more, developing and transforming Minoan forms, most notably in tholos tombs (see Glossary). As we have seen (p. 25), tombs with corbelled roofs or 'false domes' had been built as early as the fifth millennium in northern Europe. But neither they nor the tholoi of Crete prepare one for the geometrical precision and grandeur of the royal tombs at Mycenae. This type of tomb, consisting of a passage dug into the side of a hill and terminating in a chamber of beehive shape, was adopted from the late sixteenth century BC onwards for royal burials at Mycenae, where the remains of a dozen survive—and there are a few more elsewhere.

The 'Treasury of Atreus' or 'Tomb of Agamemnon' at Mycenae is by far the finest. It is approached along a

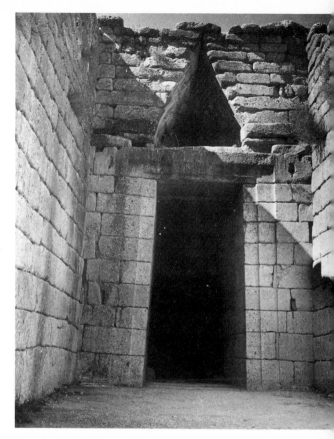

2, 37 Treasury of Atreus, Mycenae, c. 1300 BC.

passage (technically called the *dromos*), the sides of which are lined with rectangular, hammer-dressed blocks of a dark-gray stone. An entrance slightly tapering towards the top, with a massive lintel weighing about 120 tons (122,000kg) and a relieving triangle above, leads into the tomb (2, 37). Originally this entrance façade was decorated with engaged columns of green limestone slightly tapering downwards and crisply carved with ornament—zigzags, beading, fluting and Minoan spiral patterns. The relieving triangle was filled by carved panels of dark-red, pink and green stone. The tomb chamber is now very austere but bronze nails indicate that it, too, had some form of applied decoration. Simply as a piece of engineering this great domed space is remarkable, for each of the massive stone blocks of which it is constructed must have been very carefully shaped according to precise calculations, to resist the pressure of those above and on either side as well as to provide a perfectly smooth interior surface. Measuring $47\frac{1}{2}$ feet (14.5m) in diameter and 43 feet (13m) in height, it is the

largest unsupported covered space built anywhere before the erection of the Pantheon in Rome about a millennium and a half later. But it is more than just a technical feat: it is a work of architecture of imposing nobility and dignity. This great monument is a reminder that the Mycenean civilization should not be dismissed—as it sometimes is—simply as a postscript to the Minoan. Whether it can be hailed as a prelude to that of Classical Greece presents a more difficult problem.

The economic system on which Mycenean civilization was based began to break down by about 1300 BC. A change in climate affecting agriculture may have been the initial cause, but before the end of the thirteenth century BC there was an invasion by people from the north, named Dorians in later literature. This was part of a major movement of population which caused havoc throughout the whole of the eastern Mediterranean, bringing about the fall of the Hittite civilization in Anatolia as well as threatening Egypt (see p. 65). A massive wall seems to have been built across the isthmus of Corinth, but this final monument of Helladic architectural engineering was unable to stem the tide of invaders and prevent the devastation of the Peloponnese. Cities were sacked, palaces destroyed. Civilization was snuffed out and with it the art of writing. But the ruins of the great Helladic citadels survived, inspiring myths and legends which have come down to us in the form of poetry, the greatest epics ever written, the *Iliad* and *Odyssey* of Homer composed in the eighth and seventh centuries BC, the *Odes* of Pindar and the supreme masterpieces of

2, 38 Lion Gate, Mycenae, c.1500–1300 BC. Limestone relief, about 9½ft (289.5cm) high.

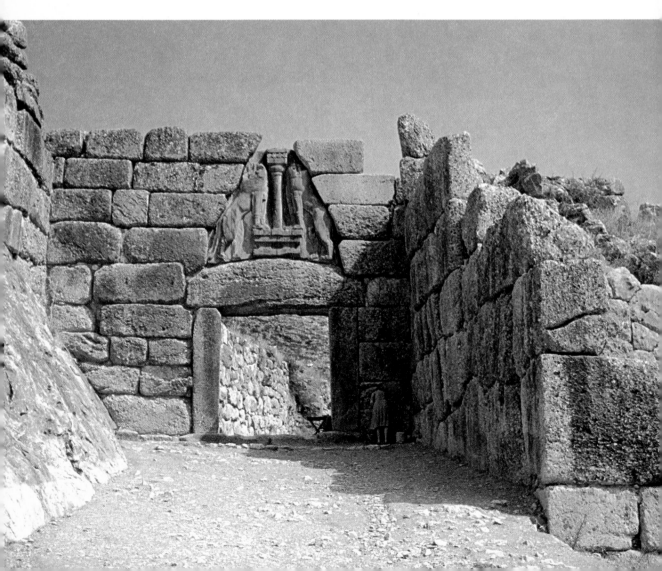

Classical Greek drama by Aeschylus, Sophocles and Euripides of the fifth century BC.

China

Only one of the Bronze Age civilizations—that of China—can be clearly recognized as having been the first stage in a long process of cultural evolution which has continued without a single significant break up to the present day. Chinese civilization has withstood both revolutions inside the country and invasions from outside. Time and again conquerors have found themselves engulfed and eventually overcome by it. For nearly 4,000 years Chinese art has retained its characteristic forms, its distinctive virtues and qualities and its unique and immediately recognizable flavour. This is not to suggest that it was rigidly monolithic, like that of ancient Egypt. From a very early stage it has shown great flexibility—like the bamboo which Chinese sages admired for bending without breaking (they also praised jade for breaking without bending). Tradition and innovation counterbalanced one another in an art whose history is marked by frequent revivals of past forms and by the no less frequent absorption and transformation of new and sometimes foreign styles and techniques.

The Neolithic cultures of China made fine pottery at least as early as the fourth millennium: rotund bowls and vases with incised or painted decorations, the latter sometimes figurative, have been found over a wide area of central China. It is comparable to the prehistoric pottery of the ancient Near East, Indus Valley, Predynastic Egypt and Japan. (Some Japanese pottery is earlier and, dating from the eighth millennium BC, possibly the earliest in the world: a process of modelling slabs of worked clay into vessels and firing them was practiced from that date.) Neolithic Chinese pieces include vessels of complex form, notably jugs resting on three bulbous feet like inverted pears. From the late third or early second millennium bowls were made on the fast wheel, either introduced from the West or invented independently—the device enabling a potter to shape a vessel by throwing a lump of clay on a spinning turntable, which provides the centrifugal force to raise it into a bowl.

Jade carving was also mastered in prehistoric times, when flat rings of unknown purpose or significance were beautifully cut with perfectly circular centres within almost, but not quite perfectly, concentric rims. They are doubly remarkable as the stone is so hard that it can be worked only with abrasives and is not found in China but had to be imported from central Asia or, more probably, Siberia. Millennia later jade rings in the form of *pi* (see p. 85) were taken as symbols of the

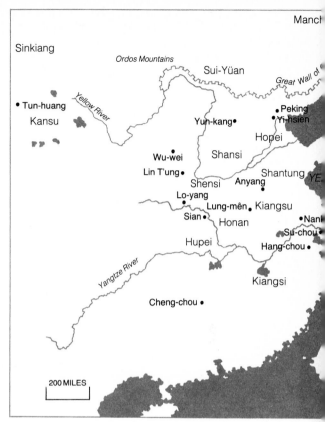

Map of ancient China.

sky and prescribed as instruments of royal sacrifice to heaven. Their origin may go back to these prehistoric jade rings. Certainly the love of jade as a substance, which provoked an almost mystically reverent passion later to develop into a kind of lyrical ecstasy peculiar to the Chinese, began with these Neolithic carvers of the fourth millennium living in village communities of farmers and land workers. They maintained for several thousand years the same peasant way of life and methods of work.

Shang dynasty

According to the traditional history of China as formulated in the second century BC, dynastic rule began in the valley of the Yellow River with the Hsia 'emperors', who were succeeded by the Shang. Of the former little trace survives, though some recently discovered sites such as the Erh-li-t'ou (or Erlitou) complex are thought to be Hsia rather than early Shang. The Shang were assumed to be mythical until about 50 years ago, when the remains of a large city were discovered and excavated at Anyang in Honan on a tributary of the Yellow River. This discovery

confirmed the existence of a Bronze Age civilization of the Shang dynasty. More recently the remains of another city have been found under modern Cheng-chou and, in addition, more than a hundred other Bronze Age sites of the second millennium BC extending over a very wide area from north of the Yellow River to south of the Yangtze. The relationship between all these places has yet to be determined. There can be little doubt, however, that the city of Cheng-chou from about 1600 BC and that at Anyang from about 1300 BC were capitals of a realm which flourished until 1027 BC under rulers who claimed divine descent and the ability to mediate between the heavens and their people, thus setting the pattern for the future Chinese empire.

The two cities were laid out on rectangular grid plans oriented north, south, east and west, surrounded by walls of pisé (earth and gravel rammed between planks which could be subsequently removed), about 20 yards (18m) thick at Cheng-chou, very much less at Anyang. While Cheng-chou was more than a mile across, Anyang was much smaller and seems to have been less a population centre than an administrative capital. Buildings were rectangular, constructed of timber columns and beams with walls of pisé and gabled thatched roofs, the more important—palaces and temples—raised on platforms of rammed earth and set apart from ordinary dwellings. At Cheng-chou the potters, jade carvers, metalworkers and other craftsmen occupied distinct quarters of the city. Royal tombs at Anyang, large pits with stairs or ramps leading down to them from the points of the compass, were opulently furnished with jewelry and precious objects of jade and bronze, as well as with the chariots, weapons and other possessions of the deceased. Human beings were slaughtered to accompany a dead ruler: the skeletons of 22 men and 24 women have been found in a single tomb together with those of 16 horses and numerous dogs, surrounded by small pits contain-ing another 50 human skulls.

Further light is thrown on the Shang period by bones (usually ox shoulder-blades) engraved or inscribed with symbols, many of which are early forms of the Chinese script still in use to this day. These 'oracle bones', of which more than 100,000 survive either whole or in fragments, were used for divination and the sentences written on them ask questions about such topics as the health of the ruler, the weather, auspicious moments for hunting or warfare, and perhaps most important of all, what sacrifices should be made to the ancestors, from whom the ruling class derived its authority. Thus it seems that writing was first used in China not for temple or palace accounts

(as in Mesopotamia and the Aegean) nor for monu-mental inscriptions (as in ancient Egypt), but for communications with the other world. And this may well have influenced the later development of Chinese calligraphy as an art form, to which almost super-stitious reverence was paid, another constant and distinguishing feature of Chinese civilization.

No Bronze Age civilization is more appropriately named than that of Shang China. Bronze, from which vessels were made for the rituals of ancestor-worship, had a significance both religious and social. Except for a few marble sculptures, all its finest surviving works of art are in this metal. Other materials were used and with great skill, but without the demonic creative power concentrated on bronze. Shang tombs have also yielded jade carvings, especially ritual knives with turquoise-studded handles, paintings of which very slight traces now remain, woven silks known only from the impressions left on objects wrapped in them, and some very handsome glazed pottery vessels (of stoneware, the predecessor of porcelain, see pp. 208–9). For the most part the bronzes are ritual vessels used in sacrifices to royal ancestors and both the technical process by which they were made and the artistic forms are peculiar to China at this date.

Bronze had been made in China well before the end of the second millennium BC and although it was more extensively produced in the Near East, the Balkans and the Aegean, there is very little likelihood that the technique was transmitted across Asia. The necessary metals for the alloy (copper and tin) were readily available to the Chinese, who had also developed kilns for firing pottery and thus had the technical means at hand for smelting. And whereas metalworkers of the West and Near East fashioned their bronzes by hammering, by casting in packed sand or, for more delicate effects, by using the lost-wax or *cire perdue* process (see Glossary), the Chinese adopted the much more laborious method of piece-molding, in a peculiar form combining ceramic and metallurgical techniques. It was rapidly brought to an astonishing degree of refinement. From a technical point of view, no more accomplished bronze casting has ever been achieved than in Shang dynasty China. A model of the ritual vessel with the bolder forms of the desired decoration was first made, probably of clay cut and carved as if it were stone. Negative impressions of this were taken by pressing slabs of clay on to the model, piece by piece. After further and more delicate decorations had been incised on them, these piece-molds were fired, in itself a tricky undertaking if the precision of the relief was not to be lost. They were then assembled to form a whole mold, into which the molten alloy was poured. The

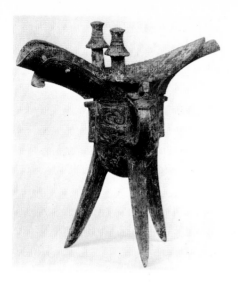

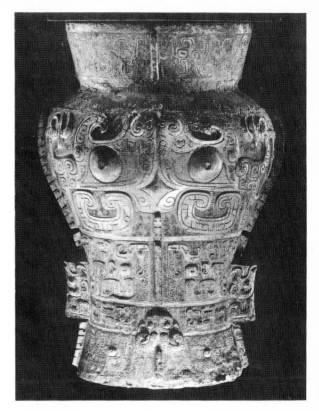

2, 39 *Above* Ritual goblet or *chüeh*, 1122–947 BC. Bronze, 9⅞ins (25cm) high. Metropolitan Museum of Art, New York.
2, 40 *Above right* Ritual wine vessel or *hu*, c.1300–1100 BC. Bronze, 16ins (40.6cm) high, 11ins (27.9cm) wide. Nelson Gallery–Atkins Museum, Kansas City.

vessel was finished by replacing the spillage of metal at the seams of the mold with vertical flanges, which also have a decorative effect.

The shapes of these vessels were basically derived from household utensils in other media, usually pottery, but elaborated to exploit the potentialities of metal. There were about 30 types ranging in size from 6 inches or so (15cm) to more than 4 feet (120cm) and weighing up to some 2,000 pounds (900kg). Each had a specific purpose in ritual sacrifices of food and wine to ancestors. One, called a *ting*, was for food, and inscriptions on oracle bones include such proposals for sacrifice as: 'Third, in a *ting* vessel a dog. Fourth a pig', and so on. A *ting* might be either a kind of three-legged cauldron or a massive rectangular trough on four stumpy cylindrical legs. There were dishes for ritual ablutions, vases, cups and ewers for hot black millet wine. Perhaps the most remarkable in its combination of dignity with fierce, almost animal vitality, is the *chüeh*, a libation cup which developed from a somewhat gawky early version found at Cheng-chou into a form of wonderful poise which seems almost to dance on its three pointed feet (2, 39).

In the shape and, even more clearly, in the surface decoration of these extraordinary vessels a peculiarly Chinese, or rather Shang, sense of form is felt very strongly. Form is interpreted in terms of rounded rectangles, everything following this morphological principle. There is complete consistency and inner coherence, as if these strange shapes had been produced by some primitive organic process such as created the regular, but never exactly repetitive, markings on the carapaces and horny skins of certain reptiles. Flat and essentially linear, Shang forms have, nevertheless, great visual weight and solidity. They are never inert or flaccid—an inner tension is felt as if something suppressed was about to break through the surface and disrupt the solemn rhythms of the slowly unfurling patterns. As far as is known, this peculiar and very distinctive sense of form occurs nowhere but in Chinese art—and in early American art, a coincidence that may not be quite as odd as it might seem at first sight, as we shall see.

The decoration on these ritual vessels had a significance which has been very variously and sometimes contradictorily interpreted by Chinese writers from the third century BC onwards and by sinologists of our own time. A kind of dragon mask later called a *t'ao-t'ieh* or *taotie* with two large round eyes staring out of the vessel is a prominent motif and has been described as a storm god, a wind god, a monster who attempted to devour mankind, an emblem of fecundity and a warning against gluttony. It might seem, at first, to be the face of a monster

combining features of the pacific ox or water-buffalo with those of a ferocious tiger (2, 40). Closer inspection reveals, however, that it can be read in an entirely different way: as two dragons in profile confronting one another, nose to nose, each with a single leg and clawed foot. Yet these two creatures are so perfectly symmetrical that they may alternatively be read as the two sides of a single dragon split lengthwise from head to curling tail (2, 41). The almost uncannily similar 'fearful symmetry' of very much later carvings and paintings by the Indians of north-west America and the Maori of New Zealand are certainly to be understood in this way, as conceptual renderings of animals or human faces in two profiles (see Chapter

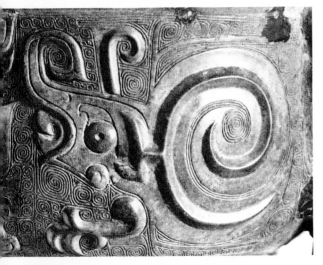

18). And this coincidence, combined with the even stranger and even more striking affinities in their sense of form, mentioned above, has led to theories about some common origin or some direct contact between early China and North America.

Whatever the cause of these affinities and whatever the original significance of the Shang bronze vessels, their relief decoration reveals an astonishing ability to create forms with a life of their own. Chinese artists did not simply graft naturalistically rendered human and animal members on to one another to create compound images, like the Egyptian sphinx (p. 42) or the winged bulls of Assyria (p. 74). They produced far more complex hybrids by integrating claws, beaks, wings, scales and fur to create what might be termed a mythozoology. Sometimes whole vessels were cast in the form of such monsters with dragons and reptiles swarming over their bodies. A wine-mixer, for instance, with eyes in the horns on its head, has linear representations of crocodiles and dragons on its sides and, on the top, the body of a snake joined to the three-dimensional head. Similar equivocal creatures carved in stone include one with tiger-like jaws and paws found in a tomb near Anyang. Despite a certain squat solidity, it has a contained muscular force, the ferocity of a real animal, although resembling none (2, 42). This quality is no less evident in bronze and stone figures of real animals, though few date from before the end of the Shang period in the late eleventh century BC (see p. 84).

Vitality rather than verisimilitude or illusionism was always to be a prime aim of Chinese artists. A myth records that a great Chinese painter drew a horse with such vigour that his drawing jumped off the paper. The story of the ancient Greek painter who depicted cherries so illusionistically that even the birds were deceived and came to peck at them, neatly expresses an essential difference between attitudes to the arts in the East and West.

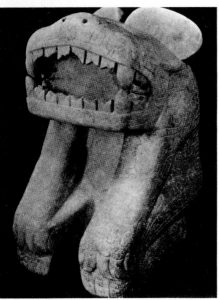

2, 41 *Above left* Detail of *kuei*, 12th–11th century BC. Bronze. Ashmolean Museum, Oxford.
2, 42 *Left* Tiger-headed monster, from Hai-pei-kang near Anyang, 1400–1100 BC. People's Republic of China.

3, 1 *Opposite top* King Tudhaliyas IV protected by a god, Yazilikaya, Turkey, 1250–1220 BC. About 7ft (213cm) high.
3, 2 *Opposite bottom* Royal Gate, Boghazköy, Turkey, c. 1400 BC.

3 Developments across the continents

The Hittites

'But, my brother, please send me a sculptor. As soon as he has finished the statues I will send him back and he will be with you again. Have I not sent back the previous sculptor? Have I not kept my word? My brother, do not deny me this sculptor.' So wrote Hattusilis III, ruler of the Hittite kingdom in Anatolia from 1275 to 1250 BC, to the Kassite king of Babylon, a thousand miles away. What these sculptors did is unknown and they are as anonymous as all artists were to remain for several centuries (with a very few Egyptian exceptions). The letter is of interest for the light it throws on their position as valued royal servants and for the evidence it provides of cultural contacts in the Near East around the middle of the second millennium BC. It also implies some degree of discrimination—if only between the work of sculptors available in Anatolia and that of the Babylonians. The

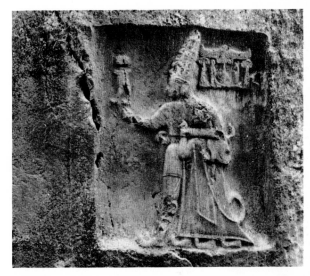

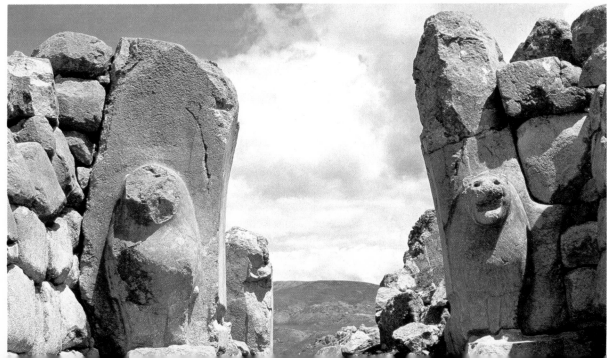

letter comes from a royal archive of cuneiform tablets which contains a great deal of diplomatic correspondence between the Hittite kings and their 'brothers' (as they were politely addressed), the rulers of Babylon, Assyria and Egypt.

The Hittites, a people who spoke an Indo-European language, infiltrated Anatolia from the east early in the second millennium BC. About 1600 BC a Hittite king advanced down the Euphrates and sacked Babylon (see p. 35), but then withdrew again to the rocky plateau of Anatolia. By the mid-fifteenth century BC the Hittites had become one of the major powers in the Near East, with much of Syria under their sway. After a great battle at Kadesh in 1286–5 BC between Hittites and Egyptians a treaty was drawn up defining, in prophetically modern terms, their respective zones of influence either side of a line running through Syria.

Some of these foreign contacts were reflected in the culture of the Hittites. Although they had their own pictographic script, they took over cuneiform from Mesopotamia and, for official communications, wrote in Akkadian as the diplomatic language (rather as Latin was to be in medieval Europe). In the visual arts, influences from ancient Egypt are apparent in motifs such as the sphinx and winged solar disc (see below p. 69), as well as from Babylon and neighbouring Syria. Indeed, there is some doubt as to whether some small objects are of Hittite or Syrian origin. Hittite art has a very distinctive character of its own, nevertheless.

The capital city, Hattusha, near the present-day Turkish village of Boghazköy, was founded about

3, 3 *Below* Banquet, from tomb of Netamun, Thebes, c. 1400 BC. Painted stucco, 25ins (63cm) high. British Museum.
3, 4 *Below right* Figure of a god, Royal Gate, outer jamb, Boghazköy, Turkey, c. 1400 BC.

1600 BC over the charred ruins of an earlier, partly Assyrian, settlement destroyed about 1700 BC. From the beginning it seems to have had an axial plan and regular rectangular houses separated by paved paths. Foundations of five temples have been found. Each had an interior courtyard surrounded by many small rooms with windows on the outer walls. Their general effect must, therefore, have been very different from that of the closed and inward-looking temples of Mesopotamia and Egypt. The most impressive remains at Boghazköy and other Hittite sites are, however, the massive walls, built about 1400 BC, of coarse masonry with rubble filling and an upper level of sun-dried brick forming casemates and parapet walks. This defensive architecture is in some ways akin to that of Mycenae and Tiryns (see p. 56). At Boghazköy there was also a no less massive inner wall surrounding the citadel on a rock dominating the city. Emphasis was laid on defence and long underground passages led from the centre of the city to sally ports, from which a besieging army could be attacked. Yet the fortifications also had symbolic features.

The exterior faces of the monolithic jambs of the main entrances—themselves of an unusual parabolic or half-oval form—were carved in such a way that huge sphinxes or lions seem to be protruding out of them, in a strange combination of relief and sculpture in the round (3, 2). They are far more intimately joined to the structure than are the guardian figures in ancient Egypt and Mesopotamia. In fact, there are no precedents for these semi-engaged sculptures. And the idea of making them form part of a building, later to be taken up with great effect in Assyria, also seems to have originated with the Hittites. At Boghazköy, the outer jamb of the 'royal gate' is carved in such a high relief

that the sturdy muscular figure of Teshub, the weather god, might well be described as a half-statue. The face is free for more than half its depth (3, 4). Carved orthostats (slabs of stone set upright at the base of a wall) similarly made their first recorded appearance in Hittite architecture and were also later adopted and much elaborated by the Assyrians (see p. 75).

In the religious texts surviving on tablets from the royal archive, the Hittites frequently referred to their 'thousand gods', among whom the most important seems to have been the weather god or storm god—as befitted the inhabitants of this high, windswept country. Their most important shrine is less than 2 miles (3.5km) from Boghazköy, at Yazilikaya, where a natural outcrop of rock was converted into an extraordinary open-air sanctuary. There were buildings here (of which only traces remain), but they must have been dwarfed by the peaks of surrounding rock. The grandeur of the natural setting does not, however, diminish the power of the relatively small reliefs carved on the rock-face, which suggest, despite their being framed within reserved panels, the supernatural forces latent within. Two long rectangular panels represent gods and goddesses apparently walking in procession. One of the best preserved carvings is in a cleft or chamber of the rock and shows King Tudhaliyas IV (c.1250–1200 BC) protected by a god wearing a long robe and tall, horned hat (3, 1). Egyptian influence is apparent here in the winged disc which crowns the hieroglyphs meaning 'My sun, my Great King' and which, as in ancient Egypt, signified an aspect of the solar deity associated with kingship. Both god and king stand in the so-called 'Egyptian pose', which was, of course, common throughout the Near East. (The procession of goddesses in pure profile at Yazilikaya is among the few exceptions.) Yet in its general effect this sculpture is markedly different from ancient Egyptian reliefs; it has none of their elegant linearity. In the sturdy, big-boned robustness of its forms it is much more like sculpture in the round. There is, too, a different sense of spirituality in this image of divine protection, something at once solemnly religious and almost tenderly natural in the way the god holds his arm around the neck and clasps the up-raised wrist of the king, who was also his priest. This carving in a mountain cleft, where the king's remains may have been buried, has reminded more than one modern traveller of the words of the Psalmist: 'Yea, though I walk through the valley of the shadow of death, I will fear no evil: for thou art with me; thy rod and thy staff comfort me.'

With their vigorous relief sculptures and massively walled cities, the Hittites made notable contributions to the visual arts in the Near East. They also exploited bronze and the natural alloy electrum for animal statuettes. In the perspective of world history, however, these achievements are overshadowed by a technological innovation of an importance hard to exaggerate: the working of iron. Iron was being produced in Anatolia at least as early as the fifteenth century BC. Iron differs from bronze in that it is a pure metal, not an alloy, and in that its ores are very widely distributed throughout the world. Few of the Bronze Age civilizations had large enough supplies of both copper and tin to make the alloy (bronze) without importing one or both of them. As foreign trade was a royal prerogative and mines were also monopolized by rulers, the supply of bronze implements and weapons could be controlled. But to make iron all that was needed were the ubiquitous ores, a simple charcoal furnace—and the knowledge that the spongy mass to which the ore was reduced under heat could be compacted into bars by hammering and then wrought into sickles and ploughshares, lances and swords. Armies could thus be equipped much more easily than hitherto, and those of the civilized states lost the great advantage which bronze weapons had given them. Iron also had the important military advantage of breaking less easily than bronze on impact. The Hittites do not, however, appear to have exploited the new material in the visual arts, though it made available a new range of tools for builders and sculptors. Nor did iron weapons prevent the disintegration of their empire, about 1200 BC, during the period of unrest and population movement in which Helladic civilization was snuffed out in Greece.

The New Kingdom in ancient Egypt

In the period known as the New Kingdom (1570–1085 BC), under pharaohs of the eighteenth, nineteenth and twentieth dynasties, ancient Egypt rose to the summit of its power and wealth and the arts were more lavishly patronized than ever before, or after. It began with the expulsion of people from Asia, later called the Hyksos, who had settled in Lower Egypt during the later years of the Middle Kingdom and seized power in the delta about 1670 BC. As soon as the Hyksos had been driven out, about 1570 BC, Egypt embarked on an aggressive expansionist policy. Nubia with its gold mines was almost immediately annexed. Before 1500 BC the Egyptians advanced west into Libya and east into Asia, as far as the Euphrates on one occasion, creating an empire of tributary states even larger than that of the Hittites in the north.

Imperial expansion brought Egypt into closer contact than before with the Bronze Age civilizations

of the Aegean and Near East. In the visual arts a few foreign motifs made their appearances, notably that of horses with both forelegs in the air drawing two-wheeled chariots, as in relief carvings at Mycenae. The important innovations in the arts of the New Kingdom seem, however, to have been generated within Egypt itself, notably in tomb paintings, which now showed the deceased in scenes of daily life more freely painted than before.

Banquets were a favourite theme of the eighteenth dynasty, depicted with great liveliness and even abandon. A fragment of a painting from a tomb at Thebes shows a group of musicians and two sinuous naked girls performing a dance (3, 3). Above there is the text of a spring-song:

> The earth-god has implanted his beauty in every body
> The Creator has done this with his two hands as balm to his heart.
> The channels are filled with water anew.
> And the land is flooded with his love.

3, 5 *Right* Ostracon with coloured drawing of a tumbler, c. 1180 BC. Limestone, 6⅝ins (16.8cm) long. Museo Egizio, Turin.
3, 6 *Below* The brother of Ramose and his wife, c. 1370 BC. Limestone relief in the tomb of the Vizier Ramose, Thebes.

An inscription from another tomb develops the theme of awareness of death as an invitation to enjoy the pleasures of this life:

> Follow thy desire as long as thou shalt live,
> Anoint thy head with myrrh and put fine linen on thee,
> Perfume thyself with the genuine marvels of divine oils!
> Enjoy thyself as much as thou canst . . .
> For a man cannot take his property with him,
> For of those who depart not one comes back again.

The mood of such texts is beautifully caught in paintings of banqueting scenes in the tomb chambers, where relatives of the deceased assembled for rituals—including anniversary banquets. Since they were intended to be seen by the living, artists were free to diverge from the rules and formulae on which depended the semi-magical power of painted and carved figures made for burial with the dead (see p. 44). In the scene illustrated here, for instance, two of the musicians are full-face and we are even shown the soles of some of their feet! A sketch of a female acrobat on a flake of stone (called an ostracon—used for sketches, notes, etc. in lieu of papyrus) reveals the degree of naturalism eventually reached (3, 5).

The rather crumbly stone into which private tombs were dug in the necropolis near Thebes, the capital of the New Kingdom, was poor material for sculpture and paintings greatly outnumber relief carvings. Tombs were usually plastered to provide a surface for painting. However, the tomb of Ramose (vizier to Amenhotep III, 1417–1379 BC) was of harder rock and the ante-chamber is adorned with exceptionally fine reliefs. Ramose's brother and sister-in-law with their exquisitely modelled features are rendered with a rare combination of tenderness and sophisticated elegance (3, 6). The way in which the almost transparently diaphanous garments are carved to reveal the contours of the body beneath—a device which seems to have originated in the New Kingdom—suggests that the sculptor may have been influenced by paintings.

Other reliefs of the period are carved in a different technique, almost unique to ancient Egypt, which originated in the Old Kingdom but was widely practiced only in the New Kingdom—that of sunk relief. Outlines are incised in the stone and the figures cut back behind the surface so that they seem to be sunk into the block (3, 7). Much used for large-scale architectural work intended to be seen in the open air, this technique exploited the strong shadows cast by dazzling sunlight to emphasize the image and to convert the inherent weakness of an essentially linear style of relief into its strength. For it is doubly effective—in simple bold outline when seen at a distance and with full, delicately modelled detail when seen close up. (It was also labour-saving, for it freed the sculptor from the necessity of working over the whole background to reduce it.) The combination of boldness and massive simplicity in general conception with the utmost refinement and delicacy of detail characterizes all art of the New Kingdom, in sculpture in the round as in sunk relief.

New Kingdom architecture

A great change came over architecture in the New Kingdom. There were no more pyramids. As security against robbers, the pharaohs were now buried in rock-cut tombs hidden away in the Valley of the Kings in the western desert opposite Thebes, sometimes tunnelled as much as 500 feet (150m) into the hillside. Even so, only Tutenkhamun's tomb was to survive with its contents intact (see p. 70). Mortuary temples were detached from them, prominently sited as manifestations of royal power overlooking the Nile on the west bank. The largest and best preserved is that of Queen Hatshepsut, the daughter of Thutmosis I (third king of the eighteenth dynasty) and the wife of Thutmosis II, on whose death she took power, which she retained even after the male heir, her stepson, came of age. Reigning alone from 1503 to 1482 BC, she was the earliest female monarch of whom any record survives. The design of her mortuary temple is credited to her steward and adviser Senmut, formerly a soldier in her father's army, but he may well have been the general supervisor of the undertaking rather than an architect, in the modern sense of the word.

Queen Hatshepsut's temple was sited almost adjoining an earlier Middle Kingdom mortuary complex of Mentuhotep I and was similarly built on terraces (3, 8). But its sculptured decorations were richer and a still

3, 7 Queen Hatshepsut, c.1480 BC. Sunk relief on fallen obelisk, Karnak.

more dramatic use was made of the spectacular site beneath the cliffs of the gorge, through which the Nile flows at this point. Indeed, the relationship between man-made and natural architecture—the one echoing the other—is very striking. Whether this was consciously intended cannot, of course, be known, but it is surely no coincidence that the temple is exactly on axis with that at Karnak, five miles (8km) away across the river. A monumental gateway at the edge of the valley opened into a court with a ramp flanked by painted sphinxes leading up, above a colonnade, to a large terrace planted with myrrh trees, sacred to Amun. This terrace was closed by a deep colonnade backed with walls, on which events from the life and reign of the queen were illustrated in relief carvings. (Unfortunately, these very fine carvings cannot be photographed satisfactorily.) From the first terrace a ramp led up to the second with a long portico, which originally had a statue of the queen in front of each of its columns. Behind this was a court surrounded by a double colonnade and on its far side the granite entrance to a rock-cut sanctuary of Amun. The 200 or so statues of Hatshepsut which stood in various courts and chapels were removed and defaced after her death, probably by order of Thutmosis III, her stepson, nephew and son-in-law, whom she had so long kept from the throne.

The dramatic design of Queen Hatshepsut's temple was not repeated. But it was under the eighteenth dynasty that the ancient Egyptian temple was given its definitive form—inward-looking and enclosed within tall forbidding perimeter walls, with a processional sequence of colonnaded courts and many-columned halls, creating an architecture of inhuman, impersonal and still daunting monumentality. These temples had no specific funerary function. The first were dedicated to Amun (or Amon or Amen), the 'local' god of Thebes, who was united with the sun god Re and, as Amun-Re, elevated to the position of Egyptian national deity. His shrine at Karnak on the east bank of the Nile, just outside the city of Thebes, was gradually enriched, especially with the spoils of war, until it became an institution of immense wealth (by the early twelfth century BC it owned 86,486 slaves, nearly 1,000,000 head of cattle, more than 500,000 acres (200,000 hectares) of land, 65 cities and towns, 9 of them in Syria, not to mention vast quantities of gold and silver). The original building was gradually enlarged into one of the most imposing of all temples in the ancient world, 1,220 feet (370m) long and 338 feet (100m) wide in a sacred enclosure covering nearly 62,000 acres (25,000 hectares). A second temple, only slightly less grandiose, was built some two miles (3.5km) to the south at Luxor,

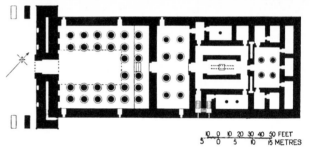

3, 8 Funerary temple of Queen Hatshepsut, Deir el-Bahari, c.1480 BC.
Plan of the temple of Khonsu, Karnak.

dedicated to Amun, his wife and their son Khonsu (3, 21). This was subject to fewer alterations than the temple at Karnak and the hypostyle hall, with its huge papyrus columns built under Amenhotep III (1417–1379 BC), survives almost intact.

The temples at Karnak and Luxor were joined by an avenue of sphinxes, of which hundreds are still in place, and also by water. On the god's great annual festival the image of Amun was taken by barge from Karnak to 'visit his harem' at Luxor. Like all ancient Egyptian temples, they were designed primarily as settings for ritual and the architects' attention was concentrated exclusively on the interiors to which, it should be remembered, only the privileged few had access. Exteriors present no unified view—sometimes nothing but blank walling, more than a mile in circumference at Karnak. The only prominent feature was the entrance through a twin-towered gateway called a pylon, which made its first appearance in stone in the New Kingdom, though the few well-preserved examples are very much later (3, 13). A pylon, often called the 'horizon of heaven', was usually built with its outer

face to the west so that the pharaoh could make his ceremonial appearance through the great doorway, above which the sun was seen as it rose between the towers. The temple interior was planned with strict bilateral symmetry as a succession of colonnaded courts and halls gradually ascending to the innermost chamber. To those who moved slowly up the narrow path through the progressively constricted space, with ever lower ceilings and dimmer light, the effect must have been overwhelming.

The system of construction is of the simplest post-and-lintel kind (though the few surviving ancient Egyptian brick buildings show that other techniques had been mastered: there are brick barrel vaults with a span of over 13 feet, 4m, at Thebes). Huge horizontal slabs were supported on massive columns simulating bundles of papyrus stems bulging out from the base and, as it were, tied at the neck, or slightly tapering cylinders spreading out into palm-leaf capitals placed so closely together that they seemed to form an unbroken wall, discouraging any deviation from the straight path between them. (The entrance could be seen only from the main axis.) The structural load-bearing function of such columns was not emphasized. Indeed, it might almost seem to have been denied by horizontal bands of sunk-relief carvings and hieroglyphs. There were also reliefs on the walls, no doubt highly coloured. Lavish use of gold and paint must originally have given these interiors a spectacular opulence. They were not created for the living, however, any more than the statues in tombs. Many of the carved images and inscriptions in the temples can never have been clearly seen and some must have been all but invisible, so dim was the light. Their purpose was to declare the piety of the pharaoh to the god whose incarnate son he was and on whom the prosperity of the realm depended; hence the massive-ness of these great structures. Durability was essential. Amenhotep III described a temple he built as 'an everlasting fortress of fine white sandstone, wrought with gold throughout; its floor is adorned with silver, all its portals with electrum; it is made very wide and large, and established for ever . . . Flag-staves are set up before it, wrought with electrum; the pylon resembles the horizon in heaven when Re rises therein.'

Akhenaten

During the reign of Amenhotep III a new cult, devoted to the Aten or disc of the sun, gained in importance and was officially adopted by his son and successor Amenhotep IV, who changed his name to Akhenaten, 'pleasing to the Aten' (1379–62 BC). Akhenaten declared the Aten to be the only god and after a clash with the priesthood proscribed the worship of Amun and other state gods. This conversion from polytheism to monotheism also brought with it the conception of a non-anthropomorphic god. For the new cult centred on the visible disc of the sun, the giver of light, heat and life. The Aten was represented as a sunburst with rays terminating in human hands. But the spirit of the cult is better reflected in hymns said to have been composed by Akhenaten himself. In at least one there are quite striking parallels, both in thought and structure, with the Hebrew Psalms composed six or seven centuries later; and some contact between Atenism and Hebrew religion has been supposed, though this can be no more than speculative. The famous *Hymn to Aten*, however, is certainly the first truly monotheistic composition in the literature of the world, its theme being the all-embracing love of god for everything he has made.

The cult of the Aten was necessarily celebrated not in dark interiors but in open-air temples, the largest of which was laid out in Akhenaten's new capital, Akhetaten, at a place now called Tell el-Amarna, more than 200 miles (320km) down the Nile from Thebes. It consisted of a series of great courts, with pylons giving access from one to another, covering more than 50 acres (20 hectares). A luxuriant garden city was built around it, with an official and a residential palace for the royal family and spacious houses for courtiers. (Separate quarters on a grid plan were provided for the workers.)

There is no clearer indication of how completely subservient the arts of ancient Egypt were to the

3, 9 Akhenaten, head of colossal statue from Karnak, c.1375 BC. Sandstone, 61ins (153cm) high. Egyptian Museum, Cairo.

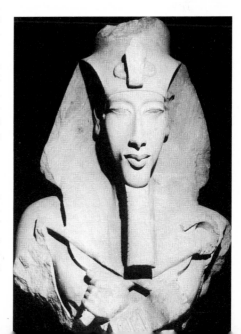

monarchy than that provided by the paintings, sculpture and architecture from the brief 17-year reign of Akhenaten. Although a tendency towards greater naturalism had been evident in the earlier art of the New Kingdom, the patronage of Akhenaten effected its speedy culmination. Portraits of the pharaoh are alone enough to demonstrate what a radical break had been made with the art of the past. The colossal statues of him, more than double life-size, from the temple of Aten at Karnak are most revealing (3, 9). There is nothing heroic about these extraordinary royal icons. Individual features, the long lean face with thick lips, heavy-lidded eyes and protruding chin, the narrow chest and weak arms, the slack muscles, pot belly and soft, almost feminine hips, are all rendered with such realism that a medical diagnosis has been made to account for his physical peculiarities (a glandular disorder known as Fröhlich's syndrome). The thoughtful, over-refined, even effete countenance is disturbingly enigmatic, at once dreamily introspective and warmly sensual, far more expressive than the bland masks of earlier—and, for that matter, later—Egyptian pharaohs, yet no less hierarchically aloof and remote from the world of ordinary mortals. For these are complex images blending the real with the formal, psychological depth with conventional stylization. In relief carvings in tombs and on altars found at Amarna his features are almost caricatured. Sometimes he is shown in intimate groups, dandling his youngest daughter or caressing his wife Nefertiti, although always within the religious aura of the symbol of the Aten.

No less remarkable are the several sculptured portraits of members of the royal family found in the studio of Akhenaten's chief sculptor, Thutmosis, at Amarna. They include what is justly one of the most famous of all ancient Egyptian works of art, the painted limestone head of Queen Nefertiti—ideally beautiful, yet strangely naturalistic in her elegant, worldly affectation, head held regally high with lowered eyelids, skin manipulated and cosmetically coloured to a uniform soft smoothness and subtle pliability of flesh over bone, but with slight creases at the corners of the mouth, tell-tale indications that she had already begun to lose the first bloom of youth (3, 22). The carving is a masterpiece of sculptural form, a daring essay in 'precarious balance' with head and high-spreading head-dress perfectly poised on the slender column of the neck, reaching out obliquely from the shoulders, in such a way that it seems only momentarily to have come to rest. Yet this masterly portrait, the most immediately arresting and memorable of all images of a highly sophisticated type of untouchable female beauty, was almost certainly carved as a trial piece or model and not intended as a finished work. The final version would probably have been less naturalistic. The same studio had in it unfinished statues and heads of harder stone (including some unfinished, unpainted heads of Nefertiti), as well as models in clay and casts from life and death masks, fascinating for the light they shed on the sculptor's practice, but more than a little misleading as regards ancient Egyptian art, which always sought to transcend reality.

The pictorial style developed at Amarna may be illustrated by a wooden panel carved in very low relief and still retaining its original gilding and bright colouring (3, 24). It shows Tutenkhamun, Akhenaten's son-in-law and successor, enthroned and anointed by his wife beneath the symbol of the Aten. Posed without the strict formality that had previously been obligatory in portrayals of the pharaohs, the two slender adolescent figures seem almost relaxed, despite their vast crowns; there is even a hint of human tenderness in their physical proximity. But the relative freedom from conventions, which permitted this increase in naturalism, was accompanied by a loosening in technique. The carving lacks the crisp precision of, for instance, the reliefs in the tomb of Ramose dating from little more than two decades earlier (3, 6).

This panel forms the back-rest of the throne buried in Tutenkhamun's tomb, together with numerous other furnishings, which afford us an uniquely vivid glimpse of the luxurious splendour surrounding the pharaohs of the eighteenth dynasty. (No other pharaonic tomb has been found with its contents undisturbed.) Tutenkhamun, who succeeded to the throne in 1316 BC, was persuaded by the priests to restore the old polytheistic religion of Egypt, to take (as a mark of devotion to Amun) the name by which we know him, and to move the capital back to Thebes. The open-air temples and other buildings at Amarna were demolished. A reaction had set in. And its effect on the visual arts can be seen very clearly in, for example, his mummy-case mask, in which he has been given the attributes of the resurrected Osiris, king of the afterworld (3, 23). In this impassive, almost impersonal, image of divine royalty barely a trace remains of the subtle and sensitive naturalism introduced under Akhenaten.

Ramesside art

The succeeding period witnessed a further and more radical reaction, a conscious return to the formality of pre-New Kingdom traditions. Seti I, who came to power in 1304 BC and founded the nineteenth dynasty,

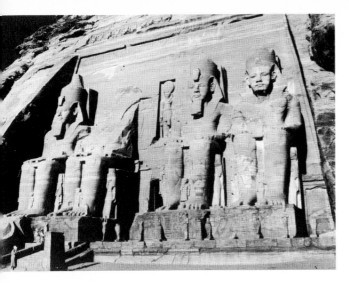

3, 10 Temple of Ramesses II, Abu Simbel, c.1257 BC. The colossi are about 60ft (18.3m) high.

had reliefs of himself piously worshipping the gods carved inside the temples at Karnak and Abydos and, on the exterior at Karnak, reliefs showing him victorious in warfare, winning back territories lost in Asia while Akhenaten immersed himself in religious questions. Seti's departure for battle, scenes of the enemy fleeing in confusion at his approach, his triumphant return and dedication of spoils to Amun, are all recorded in a revived 'Old Kingdom' style. Partly as a result of Akhenaten's heresies, the pharaohs of the nineteenth and twentieth dynasties seem to have felt a need to celebrate their martial prowess in images of conquest, often carved on the outer faces of pylon gateways for all to see. For the same reason, the scale of both temples and statues increased—to assert the imperious power of an absolute monarchy.

At Abu Simbel, Ramesses II (1304–1237 BC) had a vast temple hacked out of the living rock, dedicated to Amun the god of Thebes, Re-Horakhte the sun god of Heliopolis, Ptah the creator god of Memphis—and himself. It was given the traditional temple plan, tunnelled 180 feet (55m) into the cliff. The façade was treated as a vast pylon, the central door being flanked by four seated statues of Ramesses some 65 feet (20m) high with smaller, though still well over life-size, figures of his family standing between his gigantic legs (3, 10). Inside there were 30-foot-high (9m) statues of Ramesses II and also reliefs recording in great detail his battle with the Hittites at Kadesh in Syria (see p. 64). The temple is, in fact, a monument to Ramesses, but since he was himself regarded as an incarnate god, no secularizing or irreligious intentions are implied by

this act of self-glorification. (In 1968 the whole temple was cut out of the cliff and moved some 600 feet, 180m, up the rock-face to save it from being submerged by the new Aswan dam.)

The grandiloquence of Abu Simbel may seem a little hollow. And, indeed, before the end of the long reign of Ramesses II the power of Egypt had begun to decline. Ramesses III (1198–1166 BC) was the last pharaoh to build on a colossal scale. The only victory of which he could boast in relief carvings was that of about 1170 BC against 'peoples of the sea', who tried to invade Egypt from the north—an extension of the migratory movement which had overrun Helladic Greece (see p. 58) and wiped out the Hittite empire only a few decades earlier. Ramesses III also had to fight off invasion from Libya. Henceforth Egypt was on the defensive, a prey to marauders. This deteriorating political situation may be reflected indirectly in tomb

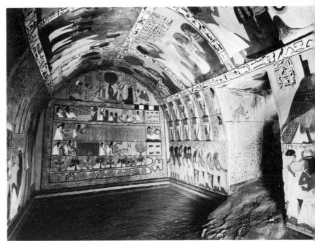

3, 11 Tomb of Sennedjem, Deir el Medineh, c.1150 BC.

painting, which now lost its joyous, light-hearted spirit (3, 3). The tomb of a man called Sennedjem of the late Ramesside period at Deir el Medineh (a village occupied by artists and artisans employed on the tombs in the vast nearby necropolis of Thebes) illustrates the change. No longer is the owner of the tomb the dominant figure, eternally standing and watching in serene detachment (2, 24). Sennedjem and his wife are dwarfed by the images of the gods, while they themselves are shown labouring in the fields of Osiris after their journey through the netherworld, during which their souls would have been weighed in the balance (3, 11).

Collections of spells, incantations and prayers assembled to form a guide to the afterworld (called a

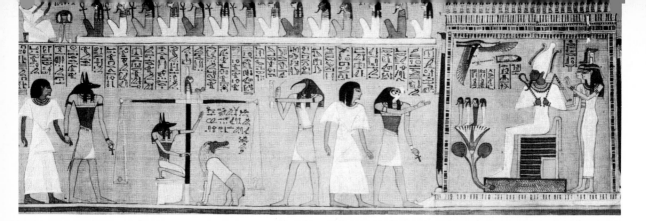

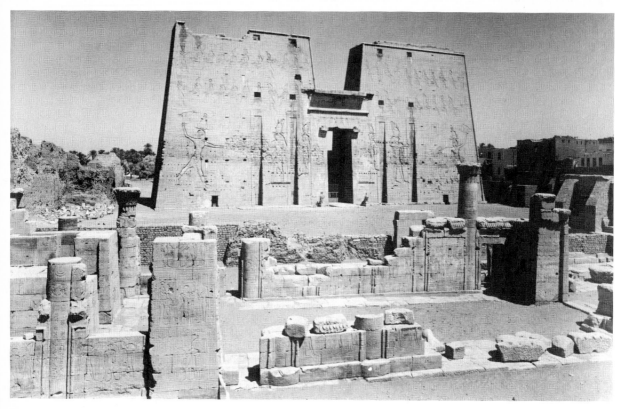

3, 12 *Top* Last Judgement before Osiris, from *The Book of the Dead* of Hunefer, c.1300 BC. Painted papyrus, 2¾ins (7cm) high. British Museum, London.
3, 13 *Above* Temple of Horus, Edfu, 237–212 BC.

Book of the Dead by scholars in the 1840s) often illustrate this scene (3, 12), which was to reappear in Christian images of the Last Judgement, millennia later. A *Book of the Dead* was inscribed on papyrus or leather and placed in a casket with a statuette of Osiris or slipped into the sarcophagus or into the mummy-wrappings of the deceased to enable him to salute the

sun with hymns, identify with Osiris, conquer his personal enemies, kill the crocodile and the serpent or escape the fisherman's net. The illustrations were usually continuous, not separate images, as in later books in codex form (see p. 240). A papyrus roll might be some 30 to 35 feet (9 to 10.5m) long, composed of the pith of the papyrus plant, flattened, thin-shaved and glued together to form a sheet.

During many centuries of slow decline, when Egypt was conquered and subjugated by a succession of foreign invaders—by the Assyrians in 670–664 BC, by the Persians in 525 BC and finally by Alexander the Great in 332 BC—the visual arts survived almost

unchanged. Such peculiarly Egyptian forms as the cube- or block-statue, for instance, or the pylon gateway in architecture, seem to have been quite impervious to outside influence. In cube- or block-statues the figure is seated with knees drawn to the chin, hands spread on top of them and with only the head and feet protruding from the block of stone. Their precise significance is uncertain, although they seem to have been originally associated in some way with the cult of Osiris. (Purely formal interpretations in terms of releasing the figure imprisoned within the block are misleading.) But they went on being made long after Egypt had been occupied. Similarly in architecture traditional forms prevailed. There is no better preserved example of an ancient Egyptian temple than that dedicated to Horus at Edfu (3, 13). The traditional plan with a strong longitudinal axis from the entrance, through a wide court and columned halls to the dark innermost sanctuary, was adopted intact. The pylon gateway façade is of the type developed early in the New Kingdom, and among the figures rendered in sunk relief there is one, at the left, that harks back some 3,000 years to King Narmer, founder of the first dynasty. This extraordinary longevity of artistic forms was due not simply to the persistence of the religious cults which they were largely created to serve, but to the ancient Egyptians' preoccupation with the immutable and eternal, which lay behind their whole civilization.

Assyria and Babylon

Assyria takes its name from a Mesopotamian god, Assur or Ashur, after whom a city on the Tigris (some 60 miles, 100 km, south of present-day Mosul) was also named. This city of Assur is first recorded in the third millennium BC as a frontier post of the Akkadian empire (see p. 33). But it was not until the second half of the fourteenth century BC that Assyria began to emerge as an independent power. At the end of the second millennium BC the Assyrians briefly extended their rule as far as the Mediterranean, and in a renewed effort at expansion during the reign of Assurnasirpal II (883–859 BC) they embarked on the conquest of a vast empire, which eventually stretched from the Caspian to the Nile and from the Taurus to the Persian Gulf, covering modern Iraq, Syria, Jordan, Lebanon, most of Palestine and part of southern Turkey and northern Egypt. For about 300 years—until 612 BC when they were overrun by the combined forces of the Medes and Scythians—Assyrians were the dominant power in the Near East, with a terrorizing reputation for the brutality and ruthless efficiency of their troops armed with iron weapons. Dominant, but rarely stable or

secure, they lived in a state of almost perpetual warfare and their history is that of a series of military campaigns, first to acquire and then to defend their sprawling empire.

Assyrian art was produced in these special circumstances and for a limited but related purpose: the promotion and glorification of Assyrian power and military strength. It was exclusively public, official and even, it might be said, propagandist. The figurative arts were devoted mainly to the exploits of Assyrian kings and their armies. Many of the scenes of slaughter, whether of men or animals, may seem to our eyes repetitive and degrading—but it led to the invention of the first true narrative art to be found anywhere. Earlier artists had recounted legends and recorded historical events, but they had done so in scenes which read as disconnected sentences (e.g. in New Kingdom Egypt at Beni Hasan and tombs in the Valley of the Kings). The Assyrians devised means to show how one incident ineluctably led to the next, as in a well-told story—or the chronicle of a military campaign. Warfare may even have sharpened the awareness of time and space on which narrative art depends, as well as providing its subject-matter.

Many of the salient characteristics of Assyrian art appear before the end of the second millennium BC. Much was taken over from Sumer (see p. 30), though significantly transformed. Ziggurats built at Assur differed from those in southern Mesopotamia in that they had no monumental exterior stairways, so that the upper stages, reached from the roof of a nearby temple or a special stairway building, must have seemed even more remote from the workaday world. The gods of Sumer were still worshipped, but they seem to have withdrawn themselves from mankind. On two surviving carved reliefs they are represented only by their hands reaching down from heaven. When they appear together with kings they are shown not as living beings but as statues set on pedestals. Assyrian literature reveals that the king alone had direct access to the gods, whose place he took, so far as the community at large was concerned. There was, however, a lesser order of supernatural beings: genii and demons, who lurked everywhere and were frequently represented on seals and protective amulets.

Seals are the most interesting as they are also from a technical point of view the finest Assyrian works of art of the late second millennium BC. Their compositions have a liveliness rarely found before. Sharply incised figures of men, supernatural beings and animals move briskly round the cylinders. On one, a deer skips light-hooved over the ground between two trees. A lion and a winged horse rear up on their back legs to confront

each other. A winged demon in a flowing robe pursues an ostrich and its young, which turn their heads back as they run (3, 14). A tensely muscled nude man aims his spear at a rampant lion accompanied by a bounding deer and an ostrich striding forwards. These seals date from about 1250 BC and already indicate the ability to create dramatic situations by careful disposition of the figures, as well as the talent for vigorous depiction of animals, which distinguish later

3, 14 *Below* Winged demon chasing an ostrich, c.1250 BC. Impression from cylinder seal. Pierpont Morgan Library, New York.
3, 15 *Bottom Lamassu* from Khorsabad, c.720 BC. Limestone, about 13ft 10ins (421cm) high. Louvre, Paris.

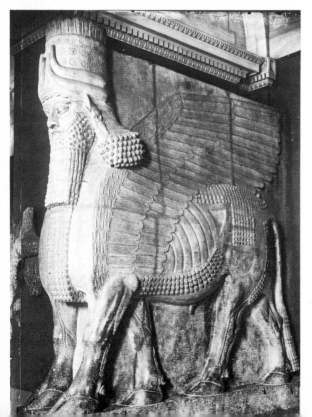

and much larger relief carvings from the palaces of Assyrian kings.

Each of the major Assyrian kings of the early first millennium BC enlarged an old palace or built an entirely new one to celebrate and display his power: Assurnasirpal II (883–859 BC) at Nimrud (present-day Calah), Sargon II (721–705 BC) at Dur Sharrukin (present-day Khorsabad), Sennacherib (705–681 BC) at Nineveh (present-day Kuyunjik) and Assurbanipal (669–626 BC) also at Nineveh. That of Sargon II, completed only shortly before his death and then abandoned, has been more systematically excavated than the others. It stood within a citadel enclosure on the perimeter of a walled city, built at the same time and about a mile across. The material was mainly mud-brick, but the bases of the walls were faced with stone slabs, called orthostats, which are a distinguishing feature of Assyrian architecture. In plan the palace conformed to a peculiar system, which had appeared at Assur in the thirteenth century BC. Courts and groups of rooms were aligned not axially but diagonally, so that one monumental space succeeded another off axis. From the large, approximately 300-foot-square (90m) first court a doorway near the corner led into the corner of the second oblong court, with the throne room on the nearer of its long sides. Symmetry was, however, observed in the design of individual units, most notably monumental entrances.

Huge carvings of human-headed winged bulls called *lamassu*—genii believed to ward off evil spirits—guarded each of the entrances, through which foreign ambassadors, vassals and petitioners were obliged to pass on their way to the throne room (3, 15). Similar *lamassu* kept stony watch on entrances to other palaces. Massively overpowering, yet carved with meticulous attention to detail—the curls of the beard, the feathers of the eagle wings and the muscles and veins of the legs—they are impressive examples of architectural sculpture. The earliest, sometimes with lion instead of bull bodies, were found at Nimrud and date from the early ninth century BC (British Museum, London). As we have already seen (p. 64), the Hittites had earlier incorporated lions and sphinxes in monumental gateways very much in this way, and they had also faced buildings with carved orthostats. Assyrian practice probably derives from them, although the archeological record is as yet so far from being complete that cross-currents of influence in the Near East at this period cannot be traced with any certainty.

Some of the Assyrian *lamassu*, however, have a striking peculiarity not found elsewhere. Seen head-on they stand stock still, seen from the side they pace

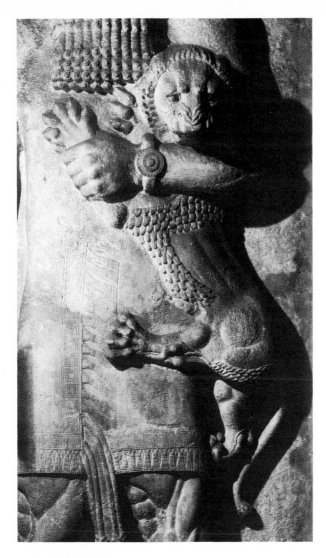

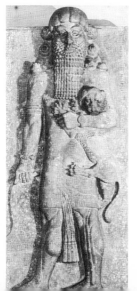

slowly forward: and as an awkward consequence an oblique view reveals five legs. Clearly, they were not conceived in the round but as two reliefs joined at right-angles. High reliefs of genii carrying holy-water buckets and sprinklers or, as at Khorsabad, supermen with lion cubs, who accompany the bull-men, are ungainly in another way (3, 16). Above their heavy beards they stare straight out of the wall and their torsos are also rendered frontally. But their stocky legs with bulging calves move disjointedly to left or right in the Egyptian way. The stiffness of their poses is emphasized by the naturalism of hands, wrists and other details, especially the lion cubs, alive in every inch from twitching tail and scratching claw to puckered muzzle, struggling to escape the brawny grasp of these brutal figures, which have sometimes been identified as the Sumerian hero Gilgamesh.

Narrative relief

Assyrian orthostat reliefs range in date from the reign of Assurnasirpal II (883–859 BC) to that of Assur-banipal (669–626 BC). The earliest known are from the throne room of the palace at Nimrud (now British Museum), panels of gypsum rather more than 7 feet (2m) high, some carved with large figures but the majority divided horizontally into two registers by a central band of inscriptions. These slabs provided sculptors with immensely long continuous strips, on which the king's military campaigns were recorded in an easily read continuous narrative with one episode following another. The same system was adopted in the later palaces and the subject-matter was little changed—a story of unrelieved violence, city after city besieged, stormed and sacked, prisoners slaughtered or led off to captivity, the king engaged in the ritual killing of lions and bulls. Only in a few scenes where docile vassals pay homage are there brief moments of respite from the chronicle of carnage. The general effect is not, however, monotonous: the variety and vitality of the many thousand figures are extraordinary. And in the course of two and a half centuries techniques of representation were modified.

Even in the earliest there were significant departures from the traditions of both Mesopotamia and ancient Egypt. Images were no longer projected on to the wall but seem rather to emerge out of the background, which forms an integral part of each 'picture'. Figures in a single section are of the same size, whether in the foreground or on the towers of a distant city, and the

3, 16 *Left* Man with lion cub, and *above*, detail of the cub, from Khorsabad, c. 720 BC. Limestone, 15ft 5ins (470cm) high. Louvre, Paris.

Assyrian king is no larger than his soldiers or even his foes. Difference in size ceases to indicate rank. There are even some instances of scale being used to suggest recession when one figure overlaps another, that behind being slightly smaller. The importance of a figure, usually the king, was more subtly marked by his position, often at the edge of a scene towards which he looks and aims his bow, and by a blank area surrounding him and his personal attendants like an aura. Figures stand in the Egyptian pose, but in the later reliefs pure profiles become increasingly common. At the same time motifs denoting landscape settings grow less conventional and are more strongly particularized. On orthostats carved for Tiglathpileser III (745–727 BC) a nearly realistic rendering of figures in space was achieved. One shows the population of a conquered city being deported for settlement elsewhere as, according to the *Second Book of Kings*, Shalmaneser 'carried Israel away into Assyria' (3, 17).

This relief should be read as a map with the officer and scribes in the centre of the composition, standing in the midst of the various activities. But the sloping ground line of the hooves of the cattle in the upper right-hand corner suggests an elementary rendering of perspective. If that was the sculptor's intention, it was unprecedented. The effect may be merely accidental. But a later, mid-seventh-century BC relief of yet another captured city clearly shows soldiers moving downhill from its gate, along a path which gradually widens as if to record a purely visual effect. Yet these experiments with perspective—if they can be so described—were to lead nowhere.

3, 17 Booty from a city taken by Tiglathpileser III, from Nimrud, 745–727 BC. Limestone, 40ins (101.6cm) high. British Museum, London.

The most impressive Assyrian reliefs are, in fact, those which show figures ranged in a single plane, rather more widely apart than those in Egyptian carvings, with a suggestion of air circulating round the bodies, greater attention to naturalistically rendered detail and a heightened sense of drama. Those of Assurbanipal killing lions are perhaps the finest of all. (They should not, as they often are, be described as 'hunts', for the beasts had been captured and were then released to be slain by the king in what seems to have been partly a sport and partly a ritual display of royal power.) One panel shows the king in his chariot speeding round an arena and leaving in his wake a shambles of dead and dying animals. A dying lioness transfixed with arrows, agonizingly dragging her rear limbs, is justly famous as a masterpiece of animal portraiture. But the pity that it moves in the modern observer can too easily encourage the misapprehension that Assyrian artists shared this feeling for pathos. That they were fully conscious of the drama they depicted seems, on the other hand, beyond doubt. The lions are by no means cowed, and in some scenes the odds appear to be fairly evenly distributed between man and beast—as they had to be if royal prowess and courage were to shine forth.

Such dramatic effects would have been impossible without the invention of continuous narrative and this led to even more sophisticated developments. A culminating scene is depicted in split-second moments of action—almost as in a film-strip—so that the excitement of watching the animal in movement is caught. Already in the thirteenth century BC the Assyrians had compressed a sequence of actions into a single pictorial space. Still earlier, Minoan and Helladic artists had sometimes shown single figures in

a succession of movements (the bulls on the Vaphio cups, for instance, p. 56). But Assyrian sculptors of the seventh century BC took this technique much further. A relief carved for Assurbanipal at Nineveh provides one of the clearest examples (3, 18). It shows one lion released from a cage, hit by an arrow as it bounds forward, and then making a desperate leap towards its antagonist. The figures of the king and his attendant, holding a shield, are shown in two distinct moments in the narrative: the king draws his bow as the animal is released, the attendant begins to plunge his spear into its heart as it pounces. To read the relief correctly entails the separation, mentally, of its three sequential layers. No such effort is, however, necessary to experience the thrill of the action from the moment when the door of the cage is lifted and the snarling lion prowls out. The animal is rendered with extreme sharpness of observation and with as much feeling for its weight and muscular strength as for the texture of its

3, 18 Lion released and killed, from Nineveh, c. 650 BC. Limestone, about 27ins (68.6cm) high. British Museum, London.

Assyrian sites are generally believed to be of Phoenician workmanship. Some are clearly derived from Egyptian prototypes, others reflect Assyrian influence. Most notable are several carvings of animals—a cow suckling her calf, for instance—hardly less naturalistic than those on Assyrian reliefs, though very different in their sweet, almost sentimental, tone. Even violent subject-matter was treated gently and decoratively, almost playfully, as in two little reliefs of a lioness mauling a young Nubian (3, 30). The figures are conceived more fully in the round than are those on all but the finest Assyrian reliefs, though they have none of the latter's sense of vigorous life. The emphasis is on delicacy and refinement. The background of stylized Egyptian flowers is inlaid with gold, red 'faience' and lapis lazuli, the boy's kilt is of gold leaf and his curly hair is composed of minute gilt-topped pegs of ivory. This work is of interest not only as an exquisite piece of craftsmanship but also as an example of the internationalism of its period—ivory probably from India, lapis lazuli from central Asia, Egyptian flowers, a

pelt. It is perhaps significant that these wonderful reliefs, in which the art of pictorial narrative was brought to its height, were carved for Assurbanipal, who was also the owner of a library of cuneiform tablets which preserved the masterpieces of Mesopotamian literature, including the *Epic of Gilgamesh* (see p. 30).

The reliefs were almost certainly coloured and the palaces which they adorned had also painted decorations (of which only fragments have been preserved) and appropriately rich furnishings. Tablets from the royal archives refer to ivory stools, beds and thrones received as tribute from Damascus and the Phoenician cities in Lebanon, on the Mediterranean coast, which formed part of the Assyrian empire from about 743 BC. Very few pieces have survived intact. A number of ivory carvings found at Nimrud and other

Nubian boy, a Phoenician carver and an Assyrian patron. It dates from the beginning of the seventh century BC, when, as we shall see, Greece and Italy were being drawn into the cultural orbit of the Near Eastern civilizations. (Phoenician syncretism made their art the main intermediary, though it had a character of its own, especially in metalwork. The remarkable Phoenician chambered tombs at Ras Shamra/Ugarit in Syria are of Aegean type with excellent masonry.)

Assyrian power suddenly began to falter immediately after the death of Assurbanipal. Medes and Scythians, who had for some time been attacking the eastern and northern frontier, penetrated the empire and sacked Nineveh in 612 BC. They were allied with Nabopolassar, a former Assyrian army commander, who established himself as king of Babylon, which now

became the capital of most of the former Assyrian territory and, once again, the centre of Mesopotamian civilization, though for little more than 70 years (until 539 BC, when Cyrus the Great of Persia took possession). Nabopolassar and the succeeding kings of Babylon called themselves the 'faithful shepherds' of the city god Marduk, but they seem to have been just as aggressive as the Assyrians—two of the tribes of Judah were taken off into captivity by Nabopolassar's more notorious son Nebuchadnezzar. The arts which flourished during this brief 'Indian summer' were marginally indebted to Assyria, yet essentially different: theocentric, static and revivalist. Sculptors adopted the pure profile of figures in the later Assyrian reliefs, but reverted to the rather soft rounded forms and motionless compositions of the steles carved for Hammurabi nearly a thousand years earlier.

The difference between the arts of Assyria and Babylon is most clearly seen in architecture and architectural decoration, though unfortunately nothing survives of the temples and ziggurats apart from the foundations of the largest (the Biblical Tower of Babel). The royal palace in Babylon was almost as large as the Assyrian palaces, but lacked their overpowering monumentality. It consisted of numerous, relatively small rooms ranged around five courtyards and in one corner, presumably, the famous hanging gardens said to have been created by Nebuchadnezzar. There seem to have been no reliefs or other representations of royal triumphs, no vast *lamassu* glowering menacingly out from the entrances. The walls of the throne room and of the processional way leading to the Ishtar Gate were decorated with lions and monsters in raised and molded brick, coloured and glazed (a technique first found in Kassite buildings of c.1200 BC), but they are staid creatures in comparison with the beasts of Assyria. Each one is identical with all the others of its species, shown not in movement but as if frozen in the slow stride of a ritual march. They form, nevertheless, the most impressive surviving example of Neo-Babylonian art (3, 29) — long-necked dragons sacred to Marduk in white with yellow details, bulls sacred to the weather god Adad in yellow with blue hair, on backgrounds of dark blue. Rank upon rank, 575 of them in all, they covered the whole exterior of the ceremonial gateway and a further 120 white and yellow lions lined the walls of the processional way leading from it to the main group of temples.

Iran

Mesopotamia was protected by no great natural barriers like those which had secured the integrity of Egyptian civilization for so long. It was constantly vulnerable to attack from people living in the surrounding areas, bounded on the west by the Mediterranean and on the south by the Arabian desert, but open to the north between the Black Sea and the Caspian, and to the east across the great central Asian plateau. The history of its art is that of the régimes strong enough to resist pressure from outside, usually by counter-aggression. To the north and west the civilization of Urartu flourished in the area now occupied by the Kurds and from about 825 to 750 BC challenged the military might of Assyria, while accepting its artistic influence. The principal sites, containing important architectural remains, are Van, Toprakkale and Altintepe (Turkey), Bastam (Iran) and Arin-berd (USSR). Their metalwork is of high quality and seems, in fact, to have been (together with that of the Phoenicians, see p. 77) one of the main vehicles by which Assyrian and Oriental motifs were transmitted to Greece and Etruria. At about the same time bronzes of a very different kind were being produced in the area known as Luristan, in which Mesopotamian motifs are much less prominent than those derived from the prehistoric cultures of central Asia.

3, 19 Finial from Luristan, c. 750 BC. 14¼ins (36cm) high. Musées Royaux d'Art et d'Histoire, Brussels.

Undecorated metal tools and weapons had been made in Luristan since the mid-third millennium BC. But these intricately wrought bronzes, cast by the *cire perdue* process, date from between the ninth and seventh centuries BC. Although most of them correspond with what has been called 'nomad's gear'—such easily portable objects as cauldrons, cups, costume ornaments, enrichments for chariots and trappings for horses—they were the work of sedentary craftsmen and made for a people whose chiefs lived in permanent dwellings on the plains of Luristan. The most interesting of these bronzes are sculptures in the round, which clearly had no utilitarian purpose and are generally called finials or standards—they have either a spike or a socket at the base (3, 19). They may have had some supernatural function, perhaps to ward off evil spirits. The combinations of human and animal forms of which they are composed vary from piece to piece; but the top usually consists of two curving members flanking a firm vertical, sometimes a human figure, whose face with beaky nose and large round eyes is repeated below, up to three times. In the example illustrated here the figure is male, his sex being indicated beneath a second head and belt, but the legs are combined with the hindquarters of animals, which sprout dragon heads. These finials reveal an astonishing power to create seemingly organic forms merging into—or, perhaps one should say, emerging like spectres out of—one another in a kind of self-generating continuum, a morphological ferment with affinities with that which produced the earlier hybrid images of Shang China (see pp. 61–2). The culture that created the Luristan bronzes was, however, absorbed into that of Iran in the seventh century BC.

Achaemenid art

Iran takes its name from a nomadic people of the steppes—Iranians or Aryans (the original meaning of this much-misused term)—who moved into the central Asian plateau shortly before the end of the second millennium BC. They spoke an Indo-European language related to Sanskrit, Greek, Latin and nearly all the modern European languages. But they did not constitute a homogeneous group. Tribes arriving independently of one another settled in vaguely delimited areas, Medes to the south of the Caspian Sea, advancing into Luristan in about 650 BC, Scythians and Cimmerians to the west and Persians further south. The Medes were the best organized and they, in alliance with the Scythians, brought about the fall of the Assyrian empire in 612 BC. Cyrus the Great (d. 530 BC) was one of their vassals until about 550 BC, when he and his Persian followers rebelled, sacked the Median

capital Ecbatana (present-day Hamadan) and brought the whole of Iran under his rule, which he then extended to east and west. The empire Cyrus founded was the largest the world had yet seen: by the end of the sixth century BC it reached from the Oxus and Indus rivers to the Danube and beyond the Nile, incorporating all the former Assyrian territory, as well as all Anatolia, what is now Turkey in Europe, Bulgaria and much of northern Greece, Egypt and Libya. The Achaemenid dynasty, named after Cyrus's ancestor Achaemenes, continued to reign over most of this vast area until it was conquered by Alexander the Great in 332 BC.

In this way the Near East, or rather the whole civilized area of western Asia, came under the control of a tribe of nomadic or semi-nomadic horsemen—with the surprising result that civilization was not destroyed but enhanced. Cyrus imposed peace on kingdoms which had for centuries been at war with one another. Unlike all previous, and most later, conquerors he respected the religious and other traditions of the people he overcame. Multilingual inscriptions were used, for example. He even had the tribes of Judah repatriated from Babylonian captivity and, according to the Bible, ordered the rebuilding of the temple in Jerusalem: 'Thus saith Cyrus king of Persia, the Lord God of Heaven hath given me all the kingdoms of the earth, and he hath charged me to build him an house at Jerusalem, which is in Judea' (II, *Chronicles*, 36, 23). Thus the art of the Achaemenid empire reflected both the diversity of its subject states and the unifying ambition of its rulers. Darius I (521–486 BC), in an inscription on his palace at Susa, itemized the provenance from various parts of his dominions of all the materials used in the buildings and went on to declare:

> The stone-cutters who wrought the stone were Ionians and Sardians. The goldsmiths who wrought the gold were Medes and Egyptians. The men who wrought the baked brick were Babylonians. The men who adorned the walls were Medes and Egyptians.

The Persians themselves are not mentioned, but it was they who effected this cosmopolitan synthesis of styles and probably contributed elements from their own tradition.

The finest artistic achievement of the Achaemenid dynasty was in architecture. They greatly advanced on the mud-brick architecture of the Medes, though deriving from them such prominent features as the huge, rectangular, many-columned or hypostyle hall (prefigured in eighth- to sixth-century BC Median citadels at Godin Tepe and Tepe Nushi-i Jan, near

Hamadan). There were no large Achaemenid temples, for the gods were worshipped at fire altars in the open air even before the monotheistic creed of Zoroaster (628–551 BC) became the official cult of Iran (probably after the Achaemenid period). Cyrus the Great was buried in a free-standing stone-built tomb on a high stepped podium or platform at Pasargadae. Other important tombs were cut into cliffs, their fronts enriched with rock-carvings of figures and with pilasters and entablatures which are decorative and sculptural rather than functional and architectural (3, 32). The most imposing, sometimes called the Tomb of Darius, is at Naksh-i Rustam near Persepolis, crowned by a relief of a king standing bow in hand before a fire altar. Large-scale sculpture seems to have been limited almost exclusively to work in relief and to architectural ornament such as bull's head capitals. The recently discovered free-standing and over life-size statue of Darius from Susa is unique. Carved some time between 500 and 490 BC, it is unfortunately headless (Archeological Museum, Tehran).

Cyrus the Great established his capital at Pasargadae in a wide and fertile plain in the modern province of Fars. The name means 'camp of the Persians' and the palace built by Cyrus was like the encampment of a nomad chief transformed into stone, with several buildings loosely grouped and placed independently and at some distance from one another in a vast enclosure of parkland and gardens surrounded by a 13-foot-thick (4m) wall, entered through a monumental gatehouse. Much use was made of tall columns, some with lion-headed capitals in stone, both for porticoes and to support the roofs of large hypostyle halls, which may have been partly inspired by ancient Egyptian precedents (see p. 68) as well as by those of the Medes (see p. 79), though they are square in plan, with no dominant axis in any direction. Since the columns carried beams of strong cedar-wood from the Lebanon, and not stone lintels, they could be much taller, slimmer and more widely spaced than those in Egypt, making the interiors correspondingly lighter and airier. Black and white limestone slabs were used decoratively in alternation with telling effect and with extremely precise stereotomy (see Glossary). So the general effect must have been quite unlike that made by ancient Egyptian temples or by Mesopotamian palaces with their long, narrow rooms—even though such carved decorations as winged bulls at the entrances and reliefs of winged demons or genii were derived from Assyria.

Persepolis

Darius I, who succeeded Cyrus's son Cambyses II (the conqueror of Egypt) in 521 BC, moved the capital to the former Elamite city of Susa. The palace he erected there was apparently inspired by that of Babylon, built round large interior courtyards. Babylonian lions, bulls and griffins in molded, glazed brickwork paraded along the walls, more richly coloured than in their homeland and now augmented by figures of archers from Darius's famous royal guard—the thousand 'immortals' as they were called. Here again there was an audience-hall of grandiose proportions with 72 columns about 65 feet (20m) high. The palace was burnt down some time between 465 and 425 BC and little has survived standing. Much more remains of that at Persepolis, begun by Darius I in 518 BC and completed under his son Xerxes and grandson Artaxerxes I some 70 years later (3, 31).

The lay-out of Persepolis recalls Pasargadae, for although the buildings are closer together, they are again disposed loosely as separate entities in irregular open spaces as in an encampment. The lowest slope of a mountain behind the site was levelled and extended forwards to make a vast terrace nearly 1,500 by 1,000 feet (460 by 300m), faced by a retaining wall some 40 feet (12m) high of massive, finely cut rectangular blocks of stone. Wide flights of steps, shallow enough for horsemen to ride up them, led to the terrace where the main buildings were set on a platform approached up further flights of steps. There were two huge hypostyle halls, the 250-foot-square (76m) and 60-foot-high (18m) audience-hall (or *apadana*) and the still larger Hall of the Hundred Columns or throne-hall. The king received the Persian and Median nobles in the former, delegates of tributary states in the latter. The columns in these halls were of unique form: slightly spreading bell-shaped bases, slender fluted shafts and complex capitals with down-curving motifs somewhat like palm leaves, volutes and impost blocks (see Glossary) composed of the forequarters of two lions, bulls or human-headed bulls (3, 33).

Even stranger than the form is the construction of the columns. Although there were mud-brick curtain walls and some brick vaulting, stone was used at Persepolis to an extent unprecedented in Asia—and it was handled in a very peculiar way. The drums of which the columns are composed, for example, are of unequal height and the joins between them do not coincide with the decorative divisions. Similarly, the windows in the residential palace were not constructed of separate vertical and horizontal elements, of posts, lintels and sills. Either a single block of stone was cut and carved to make a whole window frame in one piece; or, if two or more blocks were used, the pieces were likewise carved and then placed on top of one

another rather than being joined at the angles. Flights of steps were composed not of separate slabs, one for every tread, but of large blocks, each carved to form several steps and a corresponding section of the parapet. Such a practice cannot, obviously, have derived from a tradition of timber or mud-brick construction. It may have originated in their custom of hewing flights of steps out of the living rock, as adopted at an Urartian site on Lake Van. In fact, the architect of Persepolis seems to have aimed at combining this rock-like permanence with the spacious lightness of the large tents of a nomadic chieftain's encampment.

Susa was the Achaemenid administrative capital; Persepolis was an imperial symbol, the spectacular setting for ceremonies, when tribute from every part of the empire was brought to the 'Great King, King of Kings, King of Persia'—as Darius I and his successors were titled. Architectural ornamentation symbolized the extent of his dominion—the royal winged discs of Egypt, for instance, and the human-headed winged bulls of Assyria. Every one of the hundreds of columns was composed of diverse national elements—the fluted shaft and voluted capital of the Ionian Greeks, foliage from the Nile, bulls and lions from Mesopotamia—all welded in a new imperial unity. But impressive as Persepolis is as an expression of Achaemenid imperial ambitions, it may well have had a further dimension of meaning. Various details of the sculptural decorations suggest that it was the ritual centre of the Achaemenid world, notably the repeated and prominently placed image of the lion slaying the bull, which has been connected with the conjunction of the zodiacal signs of Leo and Taurus at the vernal equinox. Persepolis may have been conceived as a kind of sermon or prayer in stone representing and re-enacting eternally in sculpture the rites of the Persian New Year, the Now Ruz, when the world was believed to be threatened by the evil forces of chaos and had to be conquered and created anew, initially by a god and later symbolically by the king. The figurative relief carvings on the terrace walls, originally coloured like the glazed brickwork of Susa and Babylon, probably perpetuate the annual ceremonies performed here—line upon line of alternating Medes and Persians with their distinguishing headgear, ranks of soldiers, bevies of servants carrying dishes to the banquet preceding the enthroning of the Great King, with which the festival ended, and the long procession of representatives of subject peoples, the Bactrian with his camel, the Babylonian with a humped ox, Syrians bearing pieces of metalwork (3, 20), in honour of the auspicious beginning of a new year and the continuance of the Achaemenid world

3, 20 Subjects bringing gifts to the king, relief on the stairway to the audience hall, Persepolis, Iran, c. 500 BC.

order. All move to the same slow, regimental march, all have equally expressionless faces, all are carved in the same stylized, almost uniform, manner.

These figures follow artistic conventions established nearly 3,000 years earlier in Sumer and Egypt. Whether they are shown in pure profile or with their torsos twisted to the front, their feet are always placed in a single plane and cemented to the inflexible ground line of ancient Near Eastern art. Sometimes inspiration may have been drawn from Assyrian reliefs, though their nervous energy and dramatic intensity have been lost. That heads and heavily draped bodies are rendered with a fuller sense of three-dimensional form may be due to Ionian Greek sculptors, who are known to have been sent to the Persian court. But there could hardly be a more striking contrast than that between these regimented figures and the athletic horsemen in the Panathenaic procession carved for the Parthenon in Athens just two decades after Persepolis was completed (4, 22). Each Greek is an independent being and moves freely in a logically conceived space beyond the frontal plane. The figures at Persepolis remain bound by the rules of grammar and syntax of a visual language which the Mediterranean world had already begun to reject by this date.

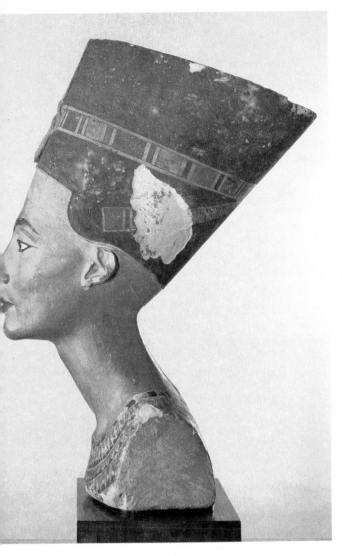

3, 21 Temple of Amun-Re, Luxor, 1417–1379 BC.
3, 22 *Above* Nefertiti, c.1360 BC. Painted limestone, about
19ins (48cm) high. Egyptian Museum, Berlin.
3, 23 *Above right* Tutenkhamun, mask from mummy-case from
Thebes, c.1340 BC. Gold inlaid with enamel and semi-precious
stones, 21¼ins (54cm) high. Egyptian Museum, Cairo.
3, 24 *Right* Back rest of throne from the tomb of Tutenkhamun,
c.1355–1342 BC. Carved wood with gold inlaid with Egyptian
'faience', glass paste, semi-precious stones and silver. Egyptian
Museum, Cairo.

Chou China

For some 800 years after the fall of the Shang in the eleventh century BC the greater part of China from Manchuria to south of the Yangtze—an area very much larger than that of any of the contemporary empires of the Near East—was ruled by kings of the Chou dynasty, though no more than nominally after 771 BC (see below). The Chou came originally from the north-west, established their capital near modern Sian in the early eleventh century and deposed the last Shang king in 1027 BC. As the Chou had already been subject to Shang cultural influence for some time there was no break in continuity. Shang institutions were elaborated rather than replaced. Craftsmen seem at first to have been little affected by the dynastic change, but Chinese art gradually underwent the first of the many transmutations which were to modify, without essentially altering, its character throughout its long history.

No trace of stone sculpture of the kind which adorned Shang buildings (2, 42) has as yet been found at Chou sites and, though Chou artists were certainly capable of modelling figures naturalistically in the round, early bronzes indicate the stylized and decorative direction of their artistic sense. The bronze tiger illustrated (3, 25) is one of a pair intended as supports (the holes in their backs are sockets for a superstructure, presumably of wood), so its function was primarily ornamental. The scrolls covering its shoulders and haunches are conceived simply as surface patterning, more elegant, more linear, more sophisticated perhaps than those on Shang bronzes, but quite without their organic vigour (2, 40). They are no longer part of the object but superimposed. The harshness of Shang forms has also been smoothed out. Their aggressive jutting and jagged flanges have disappeared into evenly enriched surfaces and rounded, continuous contours. A more refined art, perhaps, it is also a more purely decorative one. Even

3, 25 Tiger, 9th century BC. Bronze, $9\frac{7}{8} \times 29\frac{5}{8}$ ins (25 × 75.2cm). Freer Gallery of Art, Smithsonian Institution, Washington DC.

the *t'ao-t'ieh* or dragon mask (p. 61) tended to be fragmented into separate elements and lost the sense of primitive, magical power.

The change may have been partly due to increasing secularization: indeed, the long inscriptions recording the circumstances in which ritual vessels were cast often suggest it. That on an early eighth-century BC *ting* (a type of ritual cauldron) describes in colourful detail how an official was given a royal mandate to govern a town and in commemoration commissioned vessels in which to sacrifice to the spirits of his parents 'to solicit tranquillity of heart, piety, pure blessing, steady salary and long life ... to enjoy a myriad years and the bushy eyebrows of old age.' The cauldron was, he said, to be cherished and used by his sons and grandsons. Such bronze vessels had evidently become symbols of status for members of the ruling class.

Ancestor-worship, which encouraged conservatism in life and art, was an expression of political and social as well as religious ideas. The Chou were a clan who claimed descent by direct male line from a single mythical ancestor, the relative importance of its members being determined by genealogical proximity to the main line of primary sons by primary wives in each generation. The king, styled 'the Son of Heaven', reigned in the capital and princes of the blood were sent to govern provinces, where they established independent lineages with ever more distant ramifications. Allies and court retainers were also given grants of land, which passed to their descendants. While the authority of the king remained absolute, this feudal system provided a unifying structure of government, reflected in the arts by a predominant metropolitan style. But in 771 BC people from the Ordos regions of the north invaded and sacked the capital, killing the king, whose successor set up his court further east at Lo-yang, which became the capital of the eastern Chou kingdom. As royal power declined in the following centuries, the holders of fiefs became more independent and the country was gradually divided into warring states, after which the period from 475 BC to reunification under the first Ch'in emperor in 221 BC is named. (The period from 771 to 475 BC is called that of the Spring and Autumn Annals.) Yet, somewhat surprisingly, this turbulent period was one of rapid economic, technological and social advance—notably in irrigation, agriculture and metallurgy. Similarly in art, a proliferation of regional styles in the eighth and seventh centuries BC, sometimes influenced by the nomads of central Asia (p. 122), was followed during the Warring States period by an efflorescence in which Chinese inventive genius manifested itself in decorative works of the highest artistic order. Conventionalized

natural forms usually become decorative formulas, but these remain intensely, tremulously alive. No other artists have been able to bring artistic forms to such a pitch of stylistic generalization and abstraction without loss of energy or vitality. It was during this troubled period, also, that scholars and philosophers first acquired the influence they were to exert throughout subsequent Chinese history. The founders of the two great philosophies, Confucianism and Taoism (pp. 200–1), lived at this time.

Jade had been prized in China from a very early date, but decorated only with incised linear designs. Now the exacting art of carving it in subtle relief by grinding away the hard and brittle stone was perfected. Some jade ritual objects are masterpieces both of technical virtuosity and controlled vitality in design (3, 26). The regularity of the surface decoration balances the free, but always supremely elegant, forms of the dragons along its edge. It is precisely this held tension between the designer's intellectual control and the artist's more instinctual responses that gives Chou art its peculiar and very powerful quality. This can be seen at its finest in lacquer, a new medium which calls for as

3, 26 *Top* Pierced disc or *pi*, c. 400 BC. Jade, 8⅝ins (21.9cm) high. Nelson Gallery–Atkins Museum, Kansas City.
3, 27 *Above* Lacquer box, c. 400 BC. Diameter about 8ins (20cm). John Hadley Cox Collection, Washington DC.
3, 28 *Right* Mask and handle from Yi-hsien, Hopei, c. 400 BC. Bronze, length of mask and retaining bar 18ins (45.5cm). People's Republic of China.

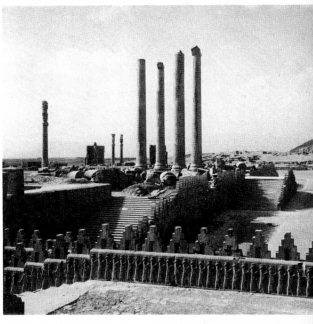

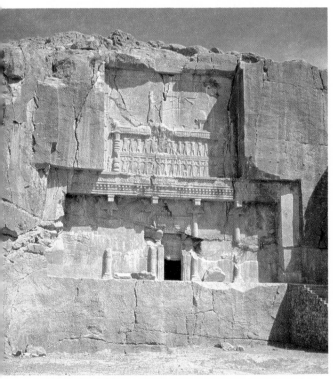

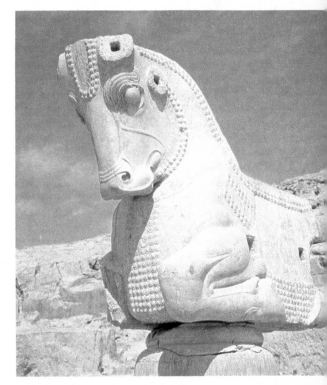

3, 29 *Left* Ishtar Gate, from Babylon (restored), c. 575 BC.
Glazed brick. Staatliche Museen, East Berlin.
3, 30 *Top* Lioness mauling a Nubian boy, from Nimrud, c. 700
BC. Ivory, gold, coloured paste, 2¾ins (7 cm) high. British
Museum, London.
3, 32 *Above* Tomb at Naksh-i-Rustam, Iran. c. 500 BC.

3, 31 *Top right* Persepolis, Iran, c. 500 BC.
3, 33 *Above* Bull capital, Persepolis, Iran, c. 500 BC.

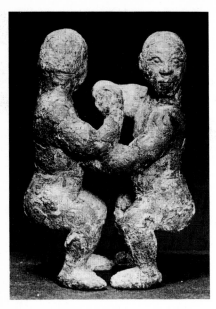

3, 34 Acrobats or wrestlers, c. 400 BC. Bronze, 6ins (15.2cm) high. British Museum, London.

much technical dexterity as jade. The sap of the lac tree— *Rhus verniciflua*—had previously been used for waterproofing clothes and also possibly for inlays on bronze vessels. About the fifth century BC it was discovered that brilliantly coloured caskets and plates, resistant to damp and heat, could be made by applying successive coats of lacquer to a wooden or cloth core. The process was extremely laborious as each coat had to be left to harden before the next was applied, and designs painted in lacquer coloured with other substances had to be repeated at each stage. Decorative effects of the greatest sophistication were achieved, however, as on the lid of a casket with peacocks in shades of vermilion red on a lustrous black ground (3, 27). The strutting birds, each one with its tail feathers overlapping the wing of the next, make a pattern of perfectly integrated intricacy set off by the abstract decoration of the outer rim, which echoes the spacing, rhythm and accents of the central medallion.

Iron came into use in China in the fifth century BC, long after its revolutionary effect had been assimilated in the West (p. 65), but probably as a result of an independent discovery. (Implements were forged in the West and not cast until the fourteenth century AD: the sequence was reversed in China.) On the other hand, the lost wax or *cire perdue* process of casting bronze used in the late Chou period to supplement the traditional and peculiarly Chinese technique of casting from piece-molds (p. 60) may have been transmitted across Asia. A mask and handle with many undercut projections could have been cast in no other way (3, 28). It was found in a tomb, where it had probably been attached to a door, to ward off evil spirits as well as to demonstrate the wealth and status of the deceased. On the mask there is a reminiscence of the *t'ao-t'ieh*, but elaborated into bold complexity by the addition of lifelike serpents, dragons with scaly bodies and a central phoenix. Supple forms seem to be in perpetual motion, writhing smoothly in and out of one another within the tight symmetrical pattern. On the suspended ring, dragons arch back their heads like those on the upper corners of the mask, visually uniting the two parts.

Alongside this purely decorative art a number of late Chou (or Warring States period) sculptures manifest an extraordinary naturalism new to China and of a kind not to be reached (or perhaps attempted) for several centuries in painting. Statuettes of stocky horses and vessels in the form of rhinoceroses would seem to have been modelled from life. Human figures are usually rendered with less vitality, but a small group of acrobats or wrestlers, knees bent as if about to leap into action, is in every way exceptional (3, 34). The figures are entertainers and the group seems to have been intended quite simply to give visual pleasure (i.e. it had no ritual function nor was it intended for burial with the dead). But few works better exemplify the rigorous co-ordination of parts into a single artistic unity, which characterizes all Chinese art of this time. Like the finest works of Chou decorative art, it derives its force from a tension between free visual rhythms and the controlling intelligence which gives structural unity. Expressive rather than descriptive, an embodiment of energy rather than thought, and in no way an idealization of the human form, it makes a striking contrast with the statues of athletes which, as we shall see, were being produced in Greece at exactly the same moment.

America and Africa

There are arresting similarities between the arts of ancient America and those of China and the ancient Near East—artificial mounds like ziggurats in Mexico, carvings which recall the reliefs on Shang dynasty bronzes in Peru—but quite as many, more fundamental, differences reflecting attitudes to life at variance with those of the rest of the world. Early stages of social evolution were much the same. In about the seventh millennium hunting and foraging were supplemented by the cultivation of maize, which gradually became, and still remains, the staple food of Meso-America (i.e. present-day Mexico, Belize, Guatemala and Honduras). By about 1500 BC there

were settled agricultural villages in the uplands of Mexico, and before the end of the second millennium these had been aggregated into some form of state with large cult or ceremonial centres, which presuppose organized religion and a ruling class of priests. Improvement in the quality of domesticated maize by a process of selection seems to have had an effect akin to that of irrigation in Mesopotamia, providing the surplus of food necessary to support a social super-structure. But no cities were built until a thousand years later (Teotihuacán appears to have been the first, see Chapter 12), and the economic developments which usually accompany urbanization hardly took place at all. Priests acquired the mathematical ability to calculate in millions, discovered and understood the concept of zero and learned how to measure the length of the solar year with scientific precision; but no standard system of weights, measures and currency was devised. The people who laid out vast temple precincts and produced some of the world's most imposing monumental sculpture were slow to develop metallurgy and never grasped the principle of the

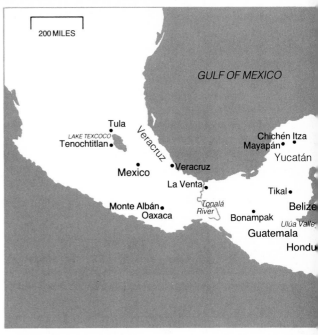

Map of ancient Meso-America.
3, 35 *Left* Statuettes from Xochipala, c.1300 BC. Terracotta, $5\frac{1}{3}$ and $4\frac{1}{3}$ins (13.5 and 11cm) high. Art Museum, Princeton University.
3, 36 *Below* Wrestler, from S Maria Uxpanapan, before 400 BC. Basalt, 26ins (66cm) high. Museo Nacional de Antropologia, Mexico City.

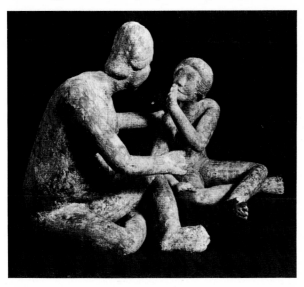

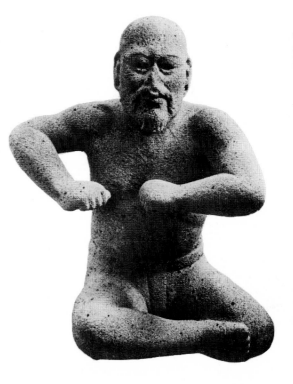

wheel, on which so much technology is based. Their genius tended towards the immaterial and impractical with a corresponding indifference to the realities of everyday life, sometimes to life itself—and this is very clearly reflected in their art.

A gap of some 8,000 years in the archeological record intervenes between the prehistoric carved coyote head from Tequixquiac (1, 9) and the beginning of a recoverable sequence of works of art. Near Xochipala, some 60 miles (100km) inland from the Pacific coast in the modern Mexican province of

3, 37 *Left* Colossal monolithic head from S Lorenzo,
Tenochtitlan, before 400 BC. Basalt, 70⅞ins (180cm) high.
Museo Regional de Veracruz, Jalapa, Mexico.
3, 38 *Above* Stone knife or celt, before 600 BC. Jade, about
12ins (30.5cm) high. British Museum, London.

The Olmecs

The great Olmec sites are on the opposite coast of
Mexico in the provinces of Veracruz and Tabasco,
where occupation can be dated back to before 1200 BC.
(The word Olmec means 'dweller in the land of rubber'
and was originally given to an entirely different people
inhabiting the same area of the Gulf Coast at the time
of the Spanish conquest.) Most works of art found in
the region are stone sculptures and cannot be dated
precisely since stone resists scientific dating tests.
However, they are probably much later than the
figures found at Xochipala, though the remarkable
naturalism of the latter persists and is, indeed, brought
to a far more sophisticated level in the finest of all
Olmec sculptures, the bearded athlete known as The
Wrestler, which may well be a portrait (3, 36). (Beards
are rare among the mostly hairless indigenous people
of America.) Controlled inner energy is felt to an
extraordinary degree in the firmness of muscle and
slow, flexing movement of the spiralling pose, as well
as in the steady concentration of the face. Moreover,
the continuous flow of curved surfaces can be fully
appreciated only when it is seen, as it must have been
conceived, in the round. Other surviving Olmec
sculptures are entirely different, rigidly frontal and

Guerrero, have been found a number of clay statuettes
dating from about 1300 BC, but modelled with a
sureness of hand, a sensitivity to three-dimensional
form and a liveliness which suggest a well-established
tradition. Two of them form a group, earnestly
engaged in conversation, seated in easy poses, with
expressive faces and eloquent gestures, the middle-
aged corpulence of the one almost touchingly con-
trasted with the adolescent slenderness of the other (3,
35). Like many later Meso-American figures, they are
of puzzlingly indeterminate sex. Others are of youths
dressed for the ball-game—a religious ritual as well as
a sport (like ancient Greek athletics). These Xochipala
figures are the earliest works of art that can be
associated with the Olmecs, whose formative influence
on the civilizations of ancient America is comparable
with that of the Sumerians in the ancient Near East.

individuals, by small groups or by a majority of the community—tyranny, oligarchy or democracy (we owe these terms to the Greeks, of course, as also the word 'politics' itself, from *polis* or 'the self-governing state'). Yet the Greeks, or Hellenes as they called themselves, were highly conscious of possessing a single culture—what Herodotus called in the fifth century BC 'our being of the same stock and the same speech, our common shrines of the gods and rituals, our similar customs'. He might well have added 'the visual arts', for anyone travelling round the northern Mediterranean in his time would have encountered temples, statues, paintings, pottery vessels, jewelry,

4, 1 *Opposite left* Early Corinthian *olpe*, c. 600. BC. 11$\frac{7}{16}$ins (29cm) high. British Museum, London.
4, 2 *Opposite right* Exekias amphora from Vulci, 540–530 BC. 24ins (60.7cm) high. Vatican Museum, Rome.
4, 3 *Below Kore*, c. 510 BC. Marble, 21$\frac{1}{2}$ins (54.6cm) high. Acropolis Museum, Athens.
4, 4 *Right* Charioteer, from the Sanctuary of Apollo, Delphi, c. 478 or 474 BC. Bronze, life-size. Archeological Museum, Delphi.

arms and armour, all in much the same style in every Greek city.

Hellenes called those who did not speak Greek as their native language barbarians—because their speech was unintelligible and seemed to them to be little more than a succession of grunts, 'bar-bar-bar'. Many Greeks thought themselves to be not only different from, but superior to, the rest of mankind—including the highly civilized Egyptians, Mesopotamians and Persians as well as the less sophisticated, but by no means uncouth, nomadic tribes of Thracians and Scythians, whom they encountered on the borders of their states. Such was the thrust of their self-confidence that they even managed to impose this view on others. Romans and later inheritors of the Greek tradition came to believe that a standard of excellence, to which all art should aspire, had been set by Greek masterpieces. But with their emphasis on simplicity and structural clarity in architecture, their preoccupation with visual appearances in painting and with the convincing rendering of an idealized male nude in sculpture, the canon of beauty the Greeks created was very peculiar, much more peculiar than Europeans were subsequently able to realize.

Archaic Greece

The period after the destruction of the Helladic palaces about 1300 BC by invaders from the north (see p. 58) is generally called the Dark Age. The country lapsed into total illiteracy, until about 800 BC, when an entirely different script was developed from the Phoenician alphabet. Nor was there any architecture, painting or large-scale sculpture until about the same date. Only two arts survived from the Helladic past: those of the bronze-worker and potter, the former engaged for the most part in producing weapons and the latter mainly simple utilitarian wares, roughly decorated, if at all, with motifs handed down from an earlier period. (Of some 70 Helladic vase forms only 10 continued to be made.)

In the archeological record, which is our only source of information, signs of recovery begin to appear during the last century of the first millennium BC with the introduction of iron technology. The most interesting artifacts of this period are pottery vases made in Athens—then a small town which had had a citadel on the Acropolis in Helladic times but only now began to gain a leading position. The word 'vases' is perhaps misleading, for they were all strictly utilitarian—cups, jugs and mixing-bowls for wine and water—and never intended for ornamental purposes, though they were sometimes placed over graves. Technically they are as fine in quality as any previously made in Greece or Crete, wheel-thrown, boldly and symmetrically shaped with an even surface texture. But the lively free-hand painted decoration of natural forms and scrolls on earlier vessels (2, 35) has given way to very severe patterns of lustrous black bands and lines and concentric circles on a buff ground: the bands and lines were painted by holding a brush against the surface while the vessel was rotated on a wheel, the circles by brushes attached to a pair of compasses. Decoration thus echoes both the form of the pot and the process by which it had been made—hinting at a precocious development of that rationalizing mentality later to be expressed in the words inscribed on the entrance to Plato's Academy: 'Let no one enter here who is ignorant of geometry.'

Such vases are called 'Proto-geometric' and precede the much more elaborately painted 'Geometric' vessels found at Athens and elsewhere on the Greek mainland and the Aegean islands. On Geometric pottery the spaces between the horizontal bands are filled with lozenges, checkers, chevrons, the squared scroll of the Greek fret pattern (later used extensively in architectural decoration) and sometimes men and animals. The finest example is nearly 6 foot (2m) high—a virtuoso display of ceramic craftsmanship, for so large a vase had to be constructed in horizontal sections and fitted together. It has a frieze of grazing deer just below the top, another of seated deer at the base of the neck and panels with human figures circling the belly between the handles. The animals are schematically rendered and those on each band are so exactly like one another that they seem almost to have been painted through a stencil. Human figures are only slightly less stereotyped. They are represented conceptually in a short-hand reduction of the 'Egyptian' pose—blobs for heads with slight excrescences to denote the chin, simple triangles filled in for frontal torsos and extended upwards to indicate arms bent at the elbow. The figures conform to the regularity which Greek artists were always to favour and are likewise arranged with strict symmetry. On the front they mourn a corpse laid out on a central bier: on the other side similar figures are shown in the same traditional attitude of lamentation with their hands on their heads (4, 5). The figurative scenes thus express the purpose of the vase, which was one of several used to mark graves in the Dipylon cemetery at Athens.

The practice of burying the dead with elaborate 'grave goods', like those of Mycenae (see p. 56), had by this date been abandoned. But great importance was attached to the ritual of burial, which enabled the spirits of the dead to pass into the other world, and to the setting up of some kind of memorial. In the

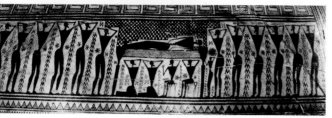

4, 5 Details of Dipylon Vase, Attic Geometric amphora, 8th century BC. National Archeological Museum, Athens.

Odyssey, the shade of an unburied companion of Odysseus pleads: 'Burn me with all my arms and build me a grave mound upon the gray sea's shore so that the future may learn of luckless me; on it shall be raised the towering oar I used to ply while I saw the light.' Similarly in funerary art the focus shifted from the afterlife (about which Greek notions were very vague) to the world of the living. Greek religion and philosophy henceforth were to concentrate on the here and now—how to confront death rather than what might happen afterwards.

Geometric pottery was not exclusively funerary: nor was art confined to pottery. Bronze statuettes of stiffly posed men, wearing nothing but very tight belts, and equally wasp-waisted centaurs and horses survive from the eighth century BC, plastic versions of the men and animals on Geometric vases. The bronze figure of a helmet-maker is in a different class aesthetically—a tiny masterpiece no less remarkable as the image of a craftsman wholly absorbed in his work than as a representation of the human figure in an entirely natural, unconventional and uncontrived pose of great three-dimensional subtlety (4, 6). That metalwork was the most highly regarded form of art or craft (the Greeks did not distinguish between the two) is evident from descriptions in the Homeric epics, which were given their final form at this time, notably the famous description of Achilles' shield. This is almost certainly fanciful, but that of Agamemnon's may correspond with one Homer had actually seen: 'Big enough to hide a man, intricately worked, mighty, a beautiful shield; around it there were ten circles of bronze, and on it were twenty raised bosses of white tin, in the middle of which was one of dark enamel. And wreathed around in the very centre was the grim face of the Gorgon, glaring terribly, and around it were Terror and Fear.' The few surviving examples of eighth-century BC armour are a good deal less extravagant. Significantly, perhaps, a silver vase said in the *Iliad* to have 'surpassed all others on earth by far' was made at Sidon on the coast of the Lebanon—'skilled Sidonians

had wrought it well, and Phoenicians had carried it over the misty sea.' Significantly, because shortly before the end of the eighth century BC luxury articles made in the Assyrian empire, then at the height of its power, began to exert an animating influence on Greek art; and thus Greece was drawn briefly into a Near Eastern current.

Motifs derived from the Near East had occasionally been incorporated into the decorations on Geometric pottery—the two friezes of deer on the funerary vase illustrated here, for instance (4, 5). But in the seventh century BC they predominate on vessels in what has, as a result, been termed the Orientalizing style. This is especially evident on pottery made at Corinth, which now emerged as a rival to Athens in pottery production. A jug painted with monstrous beasts of Oriental breed is typical (4, 1). It differs from Geometric pieces on account not only of the Oriental motifs but also of the red, black and buff colour scheme, the greater size of the animals in relation to the vessel and the use of incised lines to suggest the form and texture of their bodies. No pottery exactly like this is known to have been made in the Near East, and the Corinthian painter must have taken his motifs from Near Eastern works in other media, probably metal and perhaps also textiles.

Influences from the East are also apparent in carvings of the human figure, but here they are more complex and seem to have been more quickly assimilated into a new and unmistakably Greek idiom. An ivory carving of a kneeling boy found on the Aegean island of Samos—originally perhaps part of the decoration of a lyre—seems to be Syrian or

4, 6 Helmet-maker, c. 700 BC. Bronze, 2ins (5.1cm) high. Metropolitan Museum of Art, New York, Fletcher Fund, 1942.

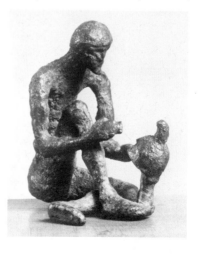

4, 7 Kneeling youth from Samos, c. 600 BC. Ivory, 5¾ins (14.6cm) high. Vathy Museum, Samos.

Phoenician in its refinement of carving and minute elaboration of detail, but not in the boy's nakedness, which is accentuated by the intricate belt, the carefully dressed hair and the head-band (4, 7). Male nudity is rare in Near Eastern art. Its peculiar appeal and significance for the ancient Greeks—and the enormous effect this was to have on the visual arts—will be discussed later. It was, however, connected in some no less mysterious way with their avoidance of female nudity until well into the fourth century BC. The Phoenician mother goddess and goddess of fertility, Astarte, usually nude in her homeland, was clothed by the Greeks when they transformed her into Aphrodite. A marble goddess from the island of Delos, influenced by the images of Astarte, is one of the earliest large-scale Greek statues to survive, carved in the rudimentary style called Daedalic (after Daedalus, the legendary founder of the art of sculpture, who was said to have worked in Crete) (4, 8).

Despite its battered condition and the loss of colouring, which would no doubt have helped to articulate the flat drapery, this statue from Delos has a dignified presence. A larger than life-size (and probably slightly later, early fifth-century) limestone head of a woman from Olympia, with an enigmatic smile on her lips, is still more imposing (4, 9). Whether it comes from a sphinx or, as some archeologists believe, a statue of Hera, wife of Zeus, the most powerful of the gods, it represents a figure apart from the ordinary world of mortals. She has, rather, the air of some Eastern goddess or queen. The way in which the hair on the forehead is carved persisted in marble

statues of *korai* (usually translated as 'maidens') for about a hundred years (4, 3). But everything else changed in the masterpieces of the so-called Archaic style. This term is used to distinguish works of the late seventh to early fifth centuries BC from those of the succeeding period known as the Classical period. These Archaic *korai* are at once more delicate and more human than any earlier statues. Jewelry and neatly pleated dresses give them an almost modish elegance, not entirely uninfluenced perhaps by such luxury objects as ivory carvings from the Near East. All this finery is, however, worn with an air of happy innocence, lending the statues a tender poignancy as new to art as that of Sappho's epigrammatic poems to young brides (written c. 600 BC) had been to literature.

From an early stage the Greeks had a trading station on the Syrian coast at Al Mina (in present-day Turkey). In the mid-seventh century BC they established another in the delta of the Nile. Syria provided a repertory of exotic motifs, but Egypt may have contributed a stronger stimulus to the independent development of Greek art. In Egypt the Greeks encountered monumental sculpture and architecture in stone, and although they copied neither in detail, they seem to have learned from both. They almost certainly took over Egyptian techniques of working in hard stone—a trickier process than that of carving wood or even limestone—and adapted them to their native types of marble. In these they were extraor-

4, 8 Goddess from the Artemision of Delos, c. 650 BC. Stone, 68⅞ins (175cm) high. National Archeological Museum, Athens.

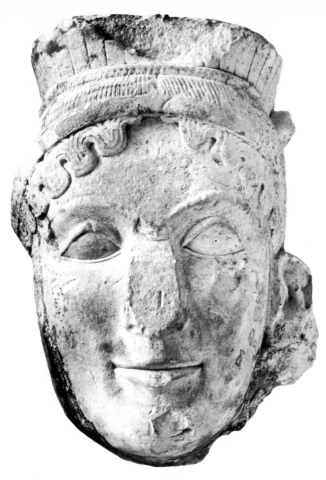

4, 9 Head from Olympia, c. 600 BC. Limestone, 20½ins (52cm) high. Archeological Museum, Olympia.

is completely undressed—which it seldom was in ancient Egypt—this may well have resulted from the Greek demand for male nudes.

The overwhelming majority of free-standing Archaic statues are of nude youths, generally known as *kouroi*, which quite simply means 'youths'. More than a hundred survive, either whole or in large fragments, ranging in height from an average 5 feet (150cm) or so to an exceptional 11 feet (335cm) (the *kouros* of Sounion, National Museum, Athens). Examples have been found in most parts of the Hellenic world, but mainly in Greece itself. All stand in the same stiff attitude, head held high, eyes to the front, arms hanging down with fists clenched. Emphasis is placed on breadth of shoulders, athletic development of pectoral and calf muscles, narrowness of waist, hardness of knee, roundness of thigh and buttock. Facial expressions vary from an impassive, rather loutish, stare to an all too knowing, and sometimes slightly pert, alertness (4, 10).

Two such statues, slightly over life-size and perhaps among the earliest, are known to record the legend of the dutiful brothers Cleobis and Biton, who died in their sleep after their mother—a priestess whose chariot they had drawn to a religious festival—prayed that they might be rewarded with what was best for mortals. The original significance of the other *kouroi* is, rather surprisingly, obscure. Many were placed in sanctuaries as votive offerings, beside their fully clothed female equivalents, the *korai*; others served as funerary monuments, and not necessarily for those who died young. They have been described as images either of the youthful god Apollo or of mortal athletes (though obviously not intended as portraits). To give them, however, such precise meaning is perhaps to misunderstand them. Greeks never distinguished between the physical features of men and gods. Nor did they (like the Mesopotamians and Egyptians) invest statues of either with the spirits of those whom they represented: there is nothing animistic about Greek sculpture. *Kouroi* and *korai*, caught at the moment when the body is just on the point of reaching maturity, in the first bloom of that youthfulness which mortals possess briefly and only the gods enjoy eternally, are at once human and divine. And this duality may account for the increasing care devoted to the rendering of anatomy. It may also, paradoxically, underlie the tendency to avoid characterization by deriving from individuals a highest common factor of physique—in other words, it may contribute to that unique combination of naturalism and idealism which became, when fully developed in the Classical period, the great and enormously influential contribution of

dinarily fortunate, for Parian marble and that from other Aegean islands and from Mount Hymettus and Mount Pentelicus near Athens are most beautiful, almost golden in colour and gently luminous.

The Egyptian method of preparing a block by drawing the outlines of the statue on its faces (see p. 44) also seems to have been taken over. Archaic Greek sculpture has the same limited number of viewpoints—sometimes only two, front and back. Archaic statues are posed with their weight distributed equally on two legs, one of which is slightly advanced. Of the many that survive, however, only one conforms to the strict Egyptian canon of proportion, which was based on an abstract numerical system. From the beginning Greek sculptors seem to have preferred a more empirical approach to the human figure, and since the disparity between the Egyptian canon and a normally proportioned body becomes more obvious when the figure

the Greeks to Western art. *Kouroi* may thus have been intended as images both of the gods and of their human worshippers—those naked athletes who took part in the games at Olympia and elsewhere, which were, of course, primarily religious festivals of a type wholly peculiar to Greece.

To explain their practice of disporting themselves naked in the games—which has always seemed odd to members of other civilizations—the Greeks told the story of a runner at Olympia who dropped his loin-cloth and won the race. Its true origin probably lies deeper, somewhere between the earlier association of nudity with the act of worship (as in Sumer, see p. 31) and later symbolism of the naked soul as a body divested of its earthly trappings. The athletes were also soldiers, it should be remembered, and belonged to a superior caste on whom the safety of their *polis* or state depended. They came from the richer or upper ranks of citizens who were bound to serve in the infantry (as hoplites) or, if they were very well-to-do, in the cavalry. The work-force consisted of second-class citizens and slaves who left these favoured young men free to

devote themselves to athletic training when they were not fighting. The *kouroi* thus reflect a distinctly élitist view of youth. Their air of blithe self-confidence, their obvious pride in the bodies they so freely display, form part of it. They symbolize the upper echelon of a male-dominated society, which relegated women to the home, smiled on pederasty and seems never to have doubted the superiority of men, in beauty as well as in strength.

Kouroi and *korai* vary greatly in anatomical accuracy and attempts have been made to date them almost by decade on the assumption that their sculptors were constantly striving towards greater naturalism. Regardless of whether this attempt at a chronological classification is sound, a more natural-istic style does seem to have begun to emerge in the early fifth century BC. This can be seen from the statuary which was pulled down when the Persians, under Xerxes, sacked the Athenian Acropolis in 480 BC. These statues (later buried in new foundations and thus preserved) include a number of Archaic pieces and also the greater part of a statue in an entirely

4, 10 *Kouros* from Tenea, c. 570 BC. Marble, c. 60ins (152cm) high. Staatliche Antikensammlungen und Glyptothek, Munich.

4, 11 *Kritios Boy*, c. 480 BC. Marble, c. 34ins (86cm) high. Acropolis Museum, Athens.

different style, which seems to have been carved not very long before the disaster: the *Kritios Boy* (so called because of its similarities with statues by Kritios, the fifth-century Athenian sculptor, whose works are unfortunately known only from later copies). The rigidity of the Archaic *kouros* is relaxed in this outstandingly beautiful and calmly passionate tribute to the Greek cult of the youthful male nude (4, 11). The right leg is slightly bent at the knee, the boy's weight being shifted mainly to the left, while his head—which originally had eyes of glass or coloured stone—is turned to the right, very slightly but just enough to send a current of animation through the whole figure. What is perhaps still more notable is that the torso is no longer conceived as a kind of chart or diagram of separate anatomical figures (as in most Archaic *kouroi*), but as a single, organic form in which muscular rhythms find their natural balance. It is carved with a controlled sensuality which gives the marble something of the quality of firm young flesh. Even in its damaged state, the statue seems so amazingly alive that one hardly notices the liberties the sculptor has taken to avoid the deadness of a simulacrum. The ripple of muscle over the pelvis, for instance, is exaggerated partly to link the thighs with the torso and effect a smooth transition from the front to the back of the figure—a device used by nearly all Greek sculptors and their imitators in subsequent periods. Emphasizing the shift in balance, these muscles lead the eye round the figure so that the four main viewpoints begin to merge fluidly into one another and the figure itself acquires the potential of movement.

Sculpture was normally coloured and thus more closely related to painting than is nowadays apparent; indeed, there seems to have been a symbiotic relationship between the two arts. Until later in the sixth century BC painters continued to render figures in the conceptual Egyptian manner. A terracotta panel, probably torn down when the Persians sacked the Acropolis, depicts a warrior exactly according to the Egyptian convention: the spear in his left hand seems to pass behind his back, so that prominence is given to what is most important (4, 12). Much more attention was paid to visual appearances by the carver of reliefs of boys shown wrestling and playing various games. A passionate delight in the human body, in watching the play of muscle beneath the skin, in catching the fleeting rhythms as it passes from one position to another, inspired this masterpiece of early Greek art. So enthralled was the sculptor by the beauty of what he saw that he tried to present the human body from every angle—back, front and sides—and in order to show it

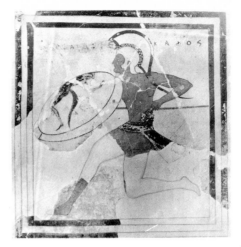

4, 12 Warrior, late 6th century BC. Painting on terracotta, 16 × 15ins (40.6 × 38cm). Acropolis Museum, Athens.

as it actually appeared he confronted the problem of foreshortening. The left foot of the boy on the right (4, 13) is seen frontally and not aligned with the base, as it would have been in Egypt or the ancient Near East. It is a small detail. But the difference between the way in which the Greek artist rendered it and the visual convention previously accepted by artists is a crucial one.

A similar process can be observed in vase painting. The same delight in bodily movement is evident from many sixth-century vases, on which figures run and leap, dance and fight, ride horses and drive chariots. On a vase, probably painted about 540 BC, Ajax and Achilles are shown at rest, concentrating on a table-game, but with a great animation and sense of drama (4, 2). Here the practice of arranging scenes in strips has been abandoned and a single moment in the story, very economically delineated, fills the whole area available for figurative painting. The composition is delicately balanced on a central axis with just enough deviation from bilateral symmetry to give it life—the helmet worn by Achilles, for instance, is counterpoised by that hung up over the shield behind Ajax. No attention was, however, paid to the relationship between the painting and the curvature of the vessel. The composition seems to have been worked out on a flat surface, although whether it was derived from a larger painting, on a panel or wall, cannot be known.

Behind Ajax a prominent inscription reads, *Onetorides kalos*— 'Onetorides is beautiful'—referring to the youth who was presumably given the vase by an admirer. Such 'love-names', nearly always male, appear on numerous cups and vases of this period, some of which are decorated with paintings of

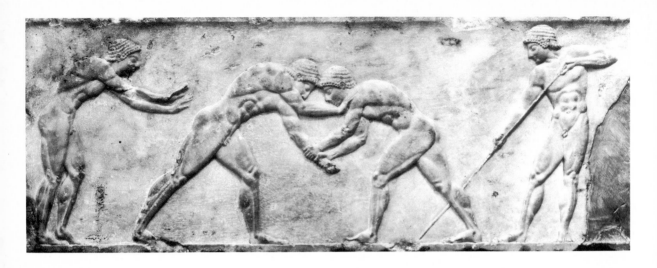

4, 13 Ball Game, from a statue base, c. 500 BC. Marble, 12½ins (31.8cm) high. National Archeological Museum, Athens.

handsome young athletes (4, 14), and others are still more explicitly homo-erotic. They are of interest for the light they shed on a prominent aspect of life in ancient Greece. But there are other inscriptions on the Achilles and Ajax vase. One around the mouth records: 'Exekias painted me and made me', and Exekias also wrote his name in the background of the figurative panel. Such signatures appear quite frequently, though by no means consistently, on vases made at Athens—rarely elsewhere—during a limited period from the mid-sixth to the mid-fifth century. Why only these should have been signed is a mystery.

Artists' signatures have been found on a few earlier Egyptian relief carvings but on no works of art outside the Hellenic world until much later periods (in about the eighth century AD in China). Already in the seventh century BC a Greek sculptor, of whom nothing else is known, signed the base of a statue in the sanctuary of Apollo on Delos: 'Euthykartides the Naxian made and dedicated me'. Later sculptors often signed the statues which their patrons dedicated to the gods. Greek painters are known to have signed their works, though none survives; also engravers of gems and dies for coins. Yet the significance of these signatures has never been satisfactorily explained. Were they expressions of pride in artistry or simply a means of advertisement? Were they applied with the consent, or at the bidding, of patrons? Is it a mere coincidence that they make their sudden appearance at a moment when artists were beginning to assert their individuality? And has this anything to do with Greek democracy? These questions must remain unanswered; but it is significant that they can be asked. They simply do not arise in connection with the products of any earlier civilization.

The distinctive characteristics of Greek art became evident at about the same time as did those of the no less distinctly Greek political unit: the *polis* or self-governing state. Before the end of the Dark Age, kings or hereditary chieftains had been eliminated from the various communities of the Greek mainland (apart from Sparta, which remained the exception) and power passed into the hands of leading families. In other words, monarchy gave way to aristocracy—a word which originally meant rule by the 'best' people in terms of riches and birth. The same system of aristocratic government was initially adopted in the Hellenic cities, which, from the mid-eighth century BC, were established in Italy, Sicily and elsewhere overseas, partly for trade but much more to relieve population pressure at home (it is misleading to call them colonies, for they were wholly independent of the states from which their founders had emigrated). Subsequent developments varied from place to place. In Athens, a city of the greatest importance in the history of the arts, the famous constitution drawn up by Solon at the beginning of the sixth century created a status hierarchy based on wealth—reckoned in terms of agricultural produce—and for the first time gave a role in government, albeit a minor one, to a middle class of fairly prosperous farmers, merchants, shippers and craftsmen. Despite a period of tyranny from 545 to 510 BC—which was, in fact, more like constitutional monarchy than the word tyranny suggests nowadays—this system survived to become the basis of a democratic state in which all free citizens could participate directly in government.

The Athenian *polis* was a very small state by modern standards. It occupied an area of some 1,000 square miles (1600 sq. km)—the size of the Grand Duchy of Luxembourg today and rather less than Rhode Island in the US—with a population which rose at its height in the mid-fifth century BC to no more than a quarter of a million people, about a third of whom lived in the city itself. Other *poleis* were still smaller: Corinth seems to have had a population of around 90,000, Argos about half that, and many had 5,000 or less, yet contrived to remain independent. Both the proliferation and the small size of these 'city-states' (misleadingly so-called, for most were, in fact, agricultural communities) may well have conditioned artistic developments more than the various political systems they adopted— aristocracies and tyrannies being more usual than democracies. Each one had its temples decorated with sculpture and paintings, and each had a comparatively rich and leisured upper class. Artists (like poets) were free to travel from one to another in search of patronage. Their products, especially metalwork and pottery, were also exported to the Greek cities overseas, whence they might be traded with Etruscans in Italy and Scythians in southern Russia (see p. 122).

The potential market for works of art in the Hellenic world may thus have been larger than in the incomparably vaster empires of ancient Egypt, Assyria and Iran, for in them patronage was concentrated at the top of a single social pyramid. But if the patrons of Greek artists were more numerous, they were much less wealthy. They could afford to give few opportunities for work on the grand scale. Significantly, the largest and showiest of Greek temples were built by tyrants, on the island of Samos and at Syracuse in Sicily. The main demand seems to have been for statues rarely more than life-size, for panel paintings rather than great decorative schemes, for small pieces of finely wrought gold jewelry and for pottery vases, which were, of course, of slight intrinsic value. A premium was thus set on artistry. Artistic experiment was quite evidently not discouraged and the artists themselves, perhaps for the first time in history, seem to have competed with one another in attempts to improve on their predecessors' efforts. Competition was a great feature of Greek life, not only in athletics: the fifth-century BC Greek tragedies were first performed in poetical competitions. Perhaps artists were also fired by that love of independence which enabled the Greeks to defeat the massive Persian invasion of 480 BC.

The Classical period: fifth century BC

Two historical events, the Persian war of the early fifth century BC and the temporary unification of Greece by Philip II of Macedon in 338 BC, stand at either end of what has for long been called the Classical period of Greek civilization. In 490 BC a Persian invasion of Greece—as a reprisal for Athenian support of an insurrection of Greek cities in Asia Minor which had been absorbed into the empire of Darius I (see p. 80)— was repulsed on the plain of Marathon. A second invasion in which Athens was taken and sacked was initially more successful, but the Persian fleet was destroyed at the battle of Salamis in 480 BC and their army routed at Plataea in the following year. Nothing could have more effectively convinced the Greeks of their superiority to 'barbarians', however numerous and well-equipped. The final victory was achieved by a very exceptional co-operation between Greek states. But Athens, which with Sparta had played a leading part in the war, took most of the credit and all of the profit, immediately emerging as the dominant power in the Aegean, where the islands were virtually reduced to the status of colonies.

The Athenian hegemony was not uncontested. Only a brief spell of peace followed the defeat of the Persians; thereafter Athens was almost constantly fighting with one or other of her neighbours and in 404 BC was herself defeated by Sparta at the end of the disastrous 27-year-long Peloponnesian War. Nor were the following decades any less disturbed by dissensions

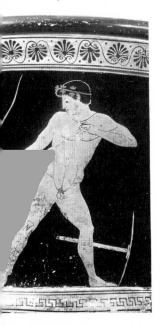
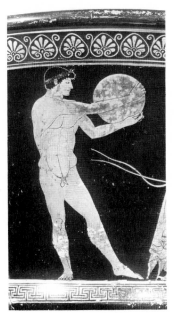

4, 14 Kleophrades Painter, details from a calyx-krater, 500–490 BC. 17¾ins (45cm) high. Museo Nazionale Tarquiniese, Tarquinia.

between the Greek states. Yet the period was marked by the most extraordinary flowering of artistic and intellectual activity the world had ever seen. From fifth-century Athens date the tragedies of Aeschylus, Sophocles and Euripides, which explored and expressed in sublime poetry the depths of human passion, the comedies of Aristophanes, which exposed with no less sublime ridicule the absurdities of human behaviour, and the teachings of Socrates, which probed the complexities of man's predicament and revealed for the first time the full capacity of the brain for abstract reasoning. All retain their vital force undimmed to the present day, after nearly 2,500 years. The visual arts also flourished and were similarly focused on human concerns, but time has treated them less well.

It is more than likely that the fifth-century works of literature which have been preserved are those which were most highly regarded in their own time. The reverse could be said of the visual arts. The large statues of ivory and gold which were believed by the ancient Greeks to be their greatest masterpieces of sculpture have all vanished. Buildings survive but in ruins and they have lost most, and sometimes all, of the decorations for which they were renowned. Bronzes were melted down; marbles were burnt and converted into lime; of the vast number of bronze and marble statues described by ancient writers only a very few still exist. Rather oddly, more Greek sculpture remains from the Archaic than from later periods. Thus our knowledge of the most famous fifth-century works of art comes largely from written descriptions and Roman copies—made sometimes as much as seven centuries later—whose fidelity to the originals cannot be assessed. It is as if, to revert to a literary parallel, we knew Shakespeare's plays only from the comments of critics and French nineteenth-century translations! Enough survives, nevertheless, of architecture to justify the claim that the visual arts of the fifth century BC were comparable with its literature. It was a Classical period in the sense that its products belonged to a superior class (the original meaning of the Latin word *classis*) and provided models of excellence, free equally from the artless simplicity of earlier and the sophisticated over-elaboration of later works—although all this could not, of course, be recognized until long afterwards.

Of surviving monuments, none characterizes this Classical moment in Greek art better than the Parthenon, which still dominates the city of Athens and the surrounding country for many miles (4, 15). Bold in outline, delicate in detail, majestically imposing, yet built to a scale of proportion so carefully

regulated by the physical and mental capacities of humanity that it is not at all overpowering, the Parthenon is so designed that all the parts are intimately adjusted in scale and size to one another and to the whole. It is a product of that rare combination of abstract thought and sensual feeling which typifies the Greek achievement. Though sadly damaged (mainly by the explosion of a Turkish powder-magazine in 1687) and robbed of most of its sculpture (now in the British Museum), it still retains the timeless quality which Plutarch ascribed to the buildings on the Acropolis some 500 years after their erection. 'They were created in a short time for all time,' he wrote. 'Each in its fineness was even then at once age-old; but in the freshness of its vigour it is, even to the present day, recent and newly wrought.' The significance of this extraordinary group of buildings cannot, however, be fully understood without reference to the circumstances in which they were erected and the earlier history of Greek architecture.

The first temple of the goddess Athena on the Acropolis seems to have been built between 570 and 560 BC. But even before the Persians demolished it another more grandiose temple had been begun on an artificial platform raised above the summit of the hill. After the defeat of the Persians the first building task for the Athenians was, naturally, the repair and reconstruction of dwelling-houses and the city's fortifications. Nothing is known as to what efforts were made to repair the damage to the Acropolis and although it is possible that work was resumed on the Parthenon in the 460s, the building we know today was not begun until 447 BC. Its structure was completed in 438 BC and the sculpture set in place in the pediments in 432 BC. Two architects are recorded: Callicrates and Ictinus (author of a long-lost book about the building). Phidias, who created the colossal chryselephantine—i.e. gold and ivory—statue of Athena placed inside the temple, is said to have supervised all the sculptural work.

The promoter of the whole undertaking was Pericles, an aristocrat by birth who won the support of the poorer classes, gave Athenian democracy its definitive form and led the state from 460 until his death in 429 BC. His ostensible and closely related aims were to glorify the city of Athens and to honour its divine protectress. To finance it he diverted funds subscribed by the allies and subject-states to Athens for mutual defence against further Persian aggression. This was denounced at the time as dishonest, especially as the Parthenon was one of a number of public works initiated by Pericles as a means of providing well-paid employment for the class on which he relied for

political support—the *demos* or majority of the population. It is, however, likely that some of the men were slaves hired out by their owners.

The Parthenon is the supreme example of the Doric temple, a type of building evolved in the course of the preceding two centuries—and one made so familiar by later imitations throughout the Western world that its original purpose and peculiarities are too often overlooked. Greek temples were not designed for ritual. Religious ritual was focused on the open-air altar where sacrifices were made to the gods, not on the temple which stood behind it. Other altars proliferated in public and private places, in town and in the country. The temple was built to enshrine the statue of the deity to whom it was dedicated—a statue which could be seen through its open doors and was sometimes carried outside. Essentially a show-piece, the temple testified to the piety, and also to the wealth and power, of the city which lavished funds on it— Greek writers record the great importance attached to the mundane value of objects dedicated to the gods. It was a static type of architecture: the visitor passed round and into, not through, a Greek temple. Emphasis was placed on its exterior rather than—as in Egypt—its interior.

Greeks learned the technique of building with posts and lintels, or rather stone columns and entablatures,

from Egypt. But to answer their own needs they turned the Egyptian temple inside out, using columns mainly to support the outer framework of the roof, which was also carried by the walls of the chamber or cella, with further columns inside only when necessitated by width. (In form it may possibly have derived from the megaron, see p. 57). The sequence in which a Greek temple was built is instructive. First a stepped platform of stone was laid out, then the columns (composed of drums held together by central pegs) were erected and the blocks of the entablature set on top of them. Only then did work begin on the walls of the cella.

The origin of the embellishments of the Doric order is more than a little obscure. In Roman times it was stated that they were derived from the tradition of building in wood, that the tapering column followed the natural shape of a tree-trunk and the concave grooves of fluting repeated its rough shaping with an adze, that the triglyphs of the frieze represented the ends of planks bound together to serve as rafters, and that the guttae beneath them acted as pegs to keep them in place (see Glossary under Order). In fact, however, there is no evidence that wooden columns were roughly fluted with an adze; triglyphs do not appear in a Doric temple where rafters would end in a wooden building, nor indeed is it conceivable that beams would ever have been cut into planks and then joined together again. Nevertheless, these elements of a Doric temple were obviously derived in some way from

4, 15 Parthenon, Athens, from the north-west, 447–438 BC.

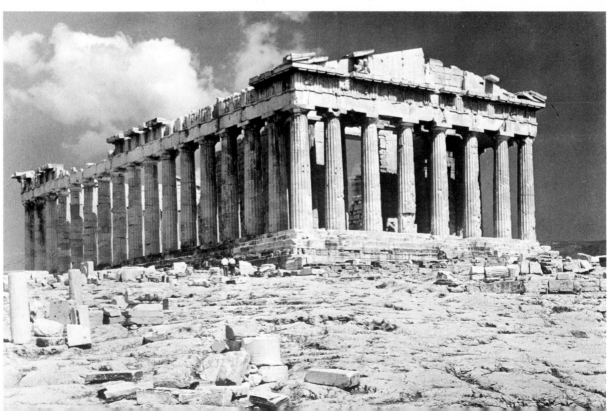

Plan of the Parthenon.

carpentry, and it seems likely that they were used quite deliberately to give visual intelligibility and an appearance of structural soundness and coherence to buildings in what was, for Greece, a new medium. For Doric is quintessentially stone architecture, conditioned by the potentialities and limitations of blocks resting on one another without mortar (concealed metal clamps were used to resist lateral thrusts). The decorative elements have only an apparent functional significance, though they soon became the distinguishing features of the style.

Little survives of the earliest known Doric temples built about 650 BC, at Corinth, but that at Paestum in southern Italy of a century later shows how robust and massive they were. By the early fifth century BC a more athletically trim version had been developed in Attica, facilitated perhaps by the fine local marble which needed no stucco coating to give a smooth, sharp finish but permitted effects of great delicacy and precision. Much of the beauty of the Parthenon derives from the wonderful bloom and texture of the marble, though it must have looked rather different when the moldings were brightly painted.

The Doric temple, especially when seen obliquely—the lay-out of sanctuaries reveals that the oblique view was that envisaged by the architect—appears to be perfectly rectilinear and regular (4, 15). This is a carefully contrived illusion. The lines are not straight nor are the columns equally spaced. Appreciating that true verticals appear to slope and true horizontals to sag in the middle, Greek architects introduced what are called 'optical refinements' to compensate for what might have been disturbing visual effects (though doubts have been expressed as the precise intentions of the architects). The optical refinements of the Parthenon are so effective that they pass unnoticed until they are pointed out. The whole platform, for example, is very gently curved down from the centre—like the tip of a vast dome. The sides of the platform and the steps beneath are concave curves (the centre of each long side is about 4 ins, 10cm, higher than its ends).

This line is repeated, but with the curve slightly reduced, in the entablature. The columns all slope inwards, though by no more than $2\frac{1}{2}$ ins (6cm); those at the angles are also a couple of inches thicker than the others to allow for apparent diminution when silhouetted against the sky. To compensate for another optical illusion the columns are shaped on the principle of *entasis* (see Glossary) so that they do not taper directly to the top but bulge out very slightly (by $\frac{2}{3}$ of an inch, 1.7cm) about two-fifths of the way up the shaft. Above them the entablature slants slightly inwards. The columns also appear to be spaced regularly, but the three at each corner are closer together than the rest and the six in the centre of the front and back are wider apart than those down the sides.

These optical refinements are by no means peculiar to the Parthenon: they were employed with variations only in degree in all Greek temples of the fifth century BC. They do not, however, seem initially to have been worked out, as it were, on the drawing-board. (It is not known, of course, how Greek temples and other buildings were designed, but plans and sections and elevations must have been drawn in some way, either on papyrus or other material or in a sand-tray.) The stages by which a temple was erected allowed a fairly wide margin for improvization while the work was in progress. And this may account for variations from regularity which can hardly have been accidental, which cannot have been intended to correct optical illusions, but do, in fact, give the Parthenon an elasticity, a vitality, the very slightest shimmer of movement, conspicuously lacking in its imitations. There is a free-hand element in the building, as in the sculptures that adorn it. The main proportions are very simple and the entirely satisfying relationship in size between the various parts seems to have been determined not by mathematics but by rule of thumb—or rather, rule of eye. A theorist of the first century AD, Heliodorus of Larisa, may have reflected the attitude of Ictinus and his contemporaries when he remarked:

The aim of the architect is to give his work a semblance of being well-proportioned and to devise means of protection against optical illusion so far as possible, with the object, not of factual, but of apparent equality of measurements and proportion. (Heliodorus, *Optica*, tr. A.W. Lawrence)

As soon as the structure of the Parthenon was complete a ceremonial entrance-way, the Propylaea, to the sanctuary on the Acropolis was begun, but never finished as work was interrupted by the Peloponnesian War. For an awkward sloping site the architect

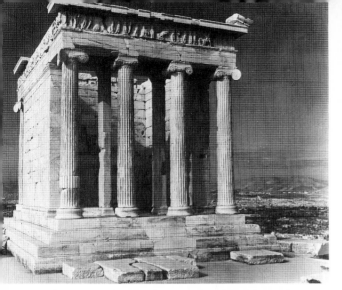

4, 16 Athena Nike Temple, Athens, 427–424 BC.
4, 17 Fallen Warrior, from the Temple of Aphaia, Aegina, early
5th century BC. Marble, 62½ins (158.8cm) long. Staatliche
Antikensammlungen und Glyptothek, Munich.

Mnesicles devised a complex building with two Doric
façades like the fronts of temples linked by an Ionic
colonnade. Two later buildings on the Acropolis were
wholly Ionic—the exquisite little temple of Athena
Nike or Victory (4, 16) and the Erechtheum. As its
name suggests, the Ionic style originated in the Greek
cities on the coast of Asia Minor and the islands of the
eastern Aegean which came under their cultural
influence. Greek civilization owed much to this area. It
was much richer in natural resources than mainland
Greece and this may be reflected in an architecture less
austere than the Doric and characterized by delicately
carved moldings, slender columns and volute capitals.

Little is known about the earliest Greek temples in
Ionia. But some eighth- or seventh-century BC capitals
found at Larisa and elsewhere in Anatolia are of the so-
called 'Aeolic' type, composed of curling members or
volutes. Similar capitals were carved for Persepolis
about 500 BC by craftsmen from Ionia, which was then
part of the Persian empire (see p. 80). By this time the

Ionic capital, which may derive from the 'Aeolic' (the
point is disputed), had already been given its definitive
form. Despite their decorative effect, both these types
of capital are more truly functional than the square
slab of the Doric order, for they spread the bearing
surface of the column in line with the horizontal
member it supports (see Glossary under Order). In
Ionic architecture the emphasis is, however, on
ornament which elaborates structure. The frieze,
uninterrupted by triglyphs, provided the field for a
continuous band of figurative relief, as in the temple of
Athena Nike. Sometimes columns were replaced by
statues as on the Siphnian Treasury at Delphi and the
Erechtheum on the Athenian Acropolis. In Doric
temples, on the other hand, sculpture seems to have
been applied to, rather than to have formed part of, the
structure—for example, rectangular reliefs in the
metopes and groups of figures in very high relief or
carved in the round to fill the pediments. As all this
sculpture was placed far above eye-level it called for
treatment entirely different from that of Egyptian,
Assyrian and Persian reliefs.

The earliest substantial groups of pedimental
sculpture come from the temple of Aphaia on the
island of Aegina near Athens. They date from two
periods, before and after the Persian invasion of 480
BC. Both groups represent Homeric battle scenes with
figures in similar poses—much more varied than in any
other sculptures of the time—but markedly different in
handling. A fallen warrior from the earlier pediment
has the stiffness of a *kouros* who has been toppled over,
while his opposite number is shown in a far less
awkwardly contrived manner (4, 17). Similarly, the
body of the former is schematically rendered and
retains a kind of stoniness; that of the latter seems
almost to be of flesh and blood. Moreover, an
expressiveness in the face of the second warrior, a
suggestion of thought and feeling, links him with the
world of the great fifth-century BC tragedies.

The second of the Aegina pediments probably dates
from the same years as the bronze *Charioteer* at
Delphi, cast to record a victory in the games of 474 or
478 BC—one of the finest and best preserved of all
Greek statues and one of the very few which can be
firmly dated (4, 4). Here there is no violent movement
and the boy's regularly handsome face seems at first to
be almost expressionless; yet the figure has an
animating inner vitality; an ideal of moderation or the
'golden mean'—'nothing in excess', the famous dictum
inscribed in the temple at Delphi—was surely the
guiding principle of the creator of the *Charioteer*. The
statue reveals its breathing life in only very slight
deviations from regularity. The folds of the lower part

of the robe, which at first sight might seem as rigid as the fluting of a Doric column, are ruffled by a gentle tremor; creases in the clinging drapery of the sleeves are nearly, but not quite, symmetrical; though looking straight ahead, the upper part of the charioteer's body and his head are turned just a little to the right. Again, although the figure's stance is motionless, the spectator feels drawn to move round it. From every angle it reveals a different but equally clear-cut outline, a pattern of three-dimensional forms modelled with such an acutely developed appreciation of the effects of light and shade that nothing is blurred and nothing over-emphasized. (The same could be said of a Greek temple.) Once it has been seen from a succession of viewpoints, the face also takes on intensity and depth, a look of concentrated thought with the eyes unselfconsciously trained on the horse.

The subtlety of the modelling of the *Charioteer*, the extreme refinement and sensitivity of his strong, highly-bred hands and feet would all have been lost in a statue placed high up in a pediment. The heroic-scale *Apollo*, which originally stood some 50 feet (15m) above ground level on the temple of Zeus at Olympia, for instance, was carved to be seen from a distance and from only a limited number of viewpoints (4, 18). The subtleties of the *Charioteer* would have been out of

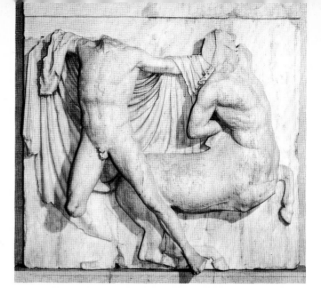

4, 19 Lapith and centaur, metope from the Parthenon, c. 438–432 BC. Marble, 56 ins (142.2cm) high. British Museum, London.

place here. The gesture is bold, the turn of the head emphatic, the body is rendered in broad flat planes. Standing in the centre of the pediment, quelling a struggle between drunken centaurs and lapiths (members of a mythological Thessalian tribe) raging on either side, this Apollo seems to symbolize divine order—the triumph of light over darkness and, perhaps, culture over savagery. Victory is gained simply by his radiant presence as a perfect embodiment of the Greek ideal of physical beauty at its simplest and severest. The figure has all the sublime imperturbability, the remote aloofness and arrogant self-assurance that we associate with the word Olympian.

The *Apollo* at Olympia retains, nevertheless, traces of an Archaic hardness of form and rigidity of pose which were eliminated from sculptures carved little more than two decades later for the Athenian Parthenon. A few are still in place, but the majority, often called the 'Elgin Marbles', were removed in 1799 by the Earl of Elgin and sold to the British Museum in 1816. Comprising free-standing statues from the pediments, several high-relief metopes and a long low-relief frieze, from the exterior of the cella, this group of works illustrates the mastery attained by Attic carvers in all three categories of sculpture. In conception and style they seem to reflect a single artistic personality and Phidias, the leading Attic sculptor of the time, has been named, but without evidence. Whether the figures are shown in action or at rest they are all at ease—too much so, perhaps, in the metopes where lapiths battle against centaurs, gods against giants, Greeks against Amazons, without overstraining a muscle or ever falling into an inelegant posture (4, 19).

4, 18 Apollo from the Temple of Zeus, Olympia, 468–460 BC. Marble, over life-size. Archeological Museum, Olympia.

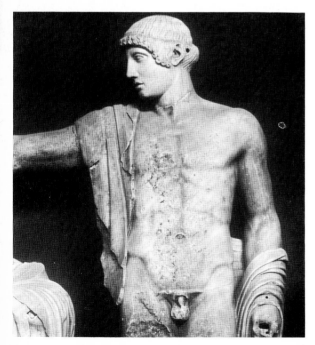

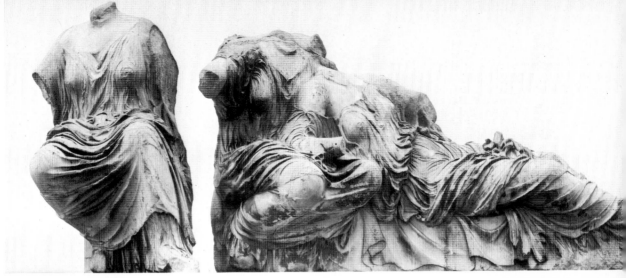

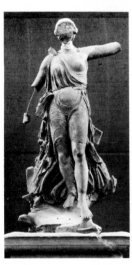

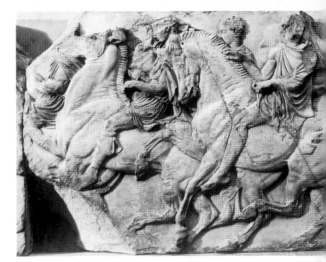

4, 20 *Top* The Fates, from the east pediment of the Parthenon, c. 438–431 BC. Marble, over life-size. British Museum, London.
4, 21 *Above left* Nike from Olympia, c. 420 BC. Marble, 85ins (216cm) high including base. Archeological Museum, Olympia.
4, 22 *Above right* Parthenon frieze (detail), 447–432 BC. Marble, about 43ins (109.2cm) high. British Museum, London.

The frieze depicts the Great Panathenaia, the most important Athenian religious festival, celebrated in July every fourth year with a great procession from the city to the Parthenon. Here it is commemorated as an eternal, rather than a temporal, event in the living presence of the gods, who are represented over the main entrance. Originally 524 feet (160m) long (of which about a fifth has perished), the frieze includes several hundred figures, all idealized, yet quite as individual in their poses as in the variety of their clothing or lack of it. (Comparison with the only very slightly earlier processions in low-relief at Persepolis is revealing, see p. 81.) There are no exact repetitions throughout the whole length of the frieze. The vast composition is rhythmically composed with a quiet beginning at the west end of the building, where men are shown preparing to set off, rather more movement rising to crescendos along the side walls and a slow, solemn finale above the entrance at the east end. The figures seem to determine the pattern, to create rather than follow the rise and fall of this great composition (4, 22). Prominent among them are young men in perfect control of the spirited horses they ride, recalling lines from the *Oedipus at Colonus* of Sophocles:

Every bridle flashes
And each man gives his horse its rein, as onward
The whole troop surges, servants of Athena,
Mistress of horses. . . .

The technical problems involved in the naturalistic

representation of men and animals in movement on a shallow stage, with one overlapping the other, have been completely mastered even when complicated, as they were here, by optical distortions due to the siting. The spectator's angle of vision, looking up from the colonnade, had to be taken into account and compensation made for it in the carving. The heads, for instance, are cut in higher relief than the feet and the backgrounds slant inwards. The imposing figures from the pediments were similarly designed to be seen from below, though in much brighter light. As a means of heightening their plastic expressiveness—their tactile sense of form—the sculptors developed a new technique for the carving of drapery, using what are now called 'modelling lines'.

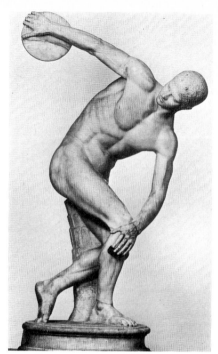

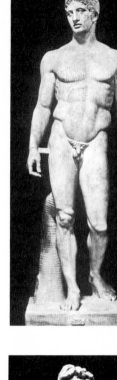

Whereas the cloak over the shoulder and round the left forearm of the *Apollo* at Olympia looks as if it had been ironed flat, the garments of the Parthenon statues are carved in ridges and deep furrows, which catch the light and hold the shade. No cloth naturally rumples in this way. The effect is entirely artificial. These gossamer-like draperies must have given the pediments a shimmering vitality and—what was far more important—they revealed, rather than concealed, the forms of the bodies beneath them. In the group of the *Fates* (4, 20) the soft fullness of the breasts is emphasized by gently swirling lines, the firm roundness of the arms by tight gatherings across them, the robustness of the thighs by the broad diagonals of deeper folds. Sometimes the concentric lines describe forms almost with the precision of a volumetric diagram. Greek sculptors now realized also that drapery running counter to the direction of the body could indicate movement as well as form. The torso of Iris from the Parthenon is an early instance of this, but a slightly later statue of Nike at Olympia illustrates better their quickly attained mastery of the technique (4, 21). The goddess of victory is seen in flight with her dress swirling out behind her and the drapery pressed close to her front so that those parts which it covers seem fuller and rounder than those left naked.

Naturalism and idealization

The use of modelling lines was no mere trick of the trade. It marks a turning-point in the history of European sculpture comparable with that of foreshortening in two-dimensional art (see p. 101). A new attitude to the statue, as a visual equivalent and not a reduplication of its subject, had emerged out of attempts to invest marbles and bronzes with the appearance of life. Socrates (d. 399 BC) is reported as saying of statues that 'the quality of seeming alive has the strongest visual appeal'. But shortly before the

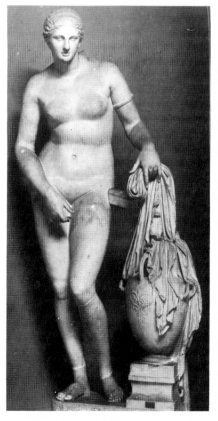

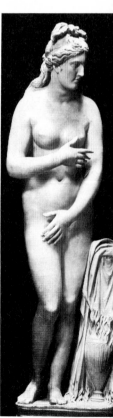

middle of the fourth century BC his follower Plato (?427–347 BC) condemned further developments towards naturalism, drawing a distinction between 'the art of producing a likeness and the art of producing an appearance', with a reactionary preference for the former. 'Artists nowadays care nothing for truth', he complained; 'they incorporate into their images not proportions that really are beautiful, but those that appear to be so.' In another passage he praised the Egyptians, who did not allow painters and sculptors 'to make innovations or to create forms other than the traditional ones'.

The *Nike* at Olympia is by Paeonius of Mende, but he does not seem to have been very highly regarded by his contemporaries. It is, however, the only surviving fifth-century BC statue by a named sculptor. The works of the more famous artists are known to us only from descriptions, some of which may have been written towards the end of the fourth century BC, although the form in which we have them dates from the first century AD. It is, to say the least, difficult even to imagine the appearance of Phidias's *Athena* and his still more celebrated *Zeus* at Olympia, some 40 feet (12m) high, covered with ivory, gold and coloured glass, and incorporating a great deal of ingeniously wrought figurative relief work on the throne and robe. Copies of less famous statues by other fifth- and fourth-century BC sculptors have, however, been identified from descriptions in later literature, notably the earliest extant account of Greek art which Pliny the Elder (who died in AD 79) appended to a work on natural history, and a fascinating guide to Greece written by Pausanias in the second century AD. These copies were made between the first century BC and the third century AD, mainly for Roman patrons, whose tastes they must to some extent reflect. Many are marble versions of bronze statues and although some have considerable artistic merit, they probably give little more than a general idea of the originals, in many cases little more than the pose. So they may confuse as much as they illuminate the history of Greek sculpture.

Several Roman versions survive of a lost *Discobolus* or discus-thrower by Myron of Eleutherae, who is said to have worked in the mid-fifth century BC (4, 23a). The differences between them indicate how far they may all

4, 23a *Top left* Discobolus, imperial Roman copy. Marble, 60ins (152.4cm) high. Museo Nazionale Romano, Rome.
4, 23b *Top right* Doryphorus, imperial Roman copy. Marble, 78ins (198cm) high. Museo Archeologico Nazionale, Naples.
4, 23c *Bottom left* Aphrodite of Cnidus, imperial Roman copy. Marble, 80ins (203.2cm) high. Vatican Museum, Rome.
4, 23d *Bottom right* Capitoline Aphrodite, imperial Roman copy. Marble, 73½ins (187cm) high. Museo Capitolino, Rome.

depart from the original, for example in the rendering of muscles and bones, especially the ribs. They reveal, nevertheless, that Myron's statue—in bronze and without the tree-stump that supports the figure and spoils the effect in the marble copies—must have been an outstanding example of the compositional quality which the Greeks called *rhythmos*, with the limbs balancing one another in a complex pattern of forms. It is an essay in equilibrium, for the figure is shown not in movement but eternally poised between two actions. According to modern athletes the attitude is not one that would be naturally adopted by a man throwing a discus. Yet it vividly suggests both the winding and unwinding torsion of the body, as well as the trajectory of the discus. Movement—or rather the idea of movement—has rarely been more effectively expressed in static terms. And the original statue in polished bronze with coloured eyes must have looked almost startlingly alive, especially when it was seen in the company of the more usual types of athlete statues standing upright. Myron was famed in antiquity for his naturalism, and there are no fewer than 36 surviving neatly turned Greek epigrams devoted to the unpromising subject of his deceptively lifelike bronze statue of a cow (of which no copy or other record survives).

The composition of the *Discobolus* is confined to a single plane, as if it had been conceived as a high relief. Polyclitus of Argos, on the other hand, who worked between 452 and 417 BC, took account of multiple viewpoints. His statues are similarly known only from Roman marble copies of varying quality after the bronze originals. The most famous is the *Doryphorus* or spear-bearer, striding slowly forward with his weight almost entirely on his right leg, his left arm holding a spear, his head turned slightly to the right— changes in direction which send a tremor of life through the figure (4, 23b). This statue is said to have been modelled to illustrate the sculptor's theories about bodily proportions and it became very influential in Roman times when it was called and had the authority of 'the Canon'.

These copies are of interest mainly as records of the poses invented by fifth-century sculptors. They show very little of the subtlety of modelling and amazing naturalism in handling and in the treatment of detail which characterize the very few surviving contemporary bronze statues (none of which can be securely attributed to a named artist). One dredged from the sea off the coast of southern Italy in 1972 has eyes of bone and glass paste, eye-lashes, lips and nipples of copper and bared teeth of silver (4, 25). His hair is rendered with the most minute delicacy. And yet, the general effect could hardly be more different from that of in

some ways comparable Egyptian figures (2, 30). Greek sculptors appreciated that the human figure cannot be simply 'reproduced', as in a cast from a living model: they saw that it must be, as it were, 'translated' not only into marble or bronze but also into the medium of art and the tension held between idealization and naturalism in a delicately balanced equilibrium—those creative life-giving qualities lost in marble copies. The muscular bronze warrior is at once an ideal male figure and a wholly convincing image of a man in the prime of life. Another bronze (found in the sea near Marathon) is of later date and the balance between idealization and naturalism has been tipped towards the former to catch that mood of adolescent dreamy melancholy which first appears in Greek art in the fourth century BC (4, 27). It is the product of a world quite different from that of heroic extrovert *kouroi*, athletes and stalwart warriors.

The sturdiness and air of serene detachment so marked in Classical Greek sculpture began to give way to stylish elegance of form in the mid-fourth century. The sculptor mainly associated with this was Praxiteles (fl. 375–330 BC), of whom very little is known. Classical archeologists disagree as to whether the famous statue of *Hermes* at Olympia is his original or a very good

4, 24 *Below* Hermes and Dionysus, c. 340 BC. Marble, about 84ins (213.4cm) high. Archeological Museum, Olympia.
4, 25 *Right* Warrior, 5th century BC. Bronze with bone, glass-paste, silver and copper inlaid, 78⅜ins (200cm) high. Museo Nazionale, Reggio Calabria.

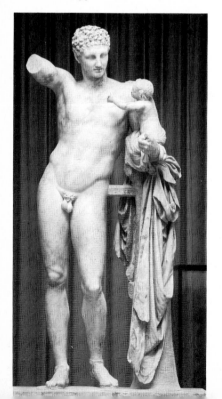

copy (4, 24). Certainly, it has a subtlety of soft modelling conspicuously lacking in the 49 surviving copies of his most famous statue, that of Aphrodite (whom the Romans called Venus) carved for the city of Cnidus on the coast of Asia Minor (4, 23c). None has more than a hint of the sensual quality ascribed to the original by poets and other writers of the first two centuries AD. They all lauded it as the perfect embodiment of female beauty, supremely and deceptively lifelike. One visitor was so overcome that he leaped on to the plinth to embrace her.

Surprising as it may seem, in view of the innumerable nude male statues, the *Aphrodite of Cnidus* is the first completely nude female in ancient Greek sculpture. (Literary sources mention none earlier, and the supposed pre-fourth-century BC origin of two known from Roman copies, in the Louvre and the Museo dei Conservatori in Rome, is by no means certain.) As we have already seen, when the Greeks adopted the Syrian fertility goddess Astarte, and renamed her Aphrodite, they immediately clothed her naked form (4, 8). The proximity of Cnidus to Syria may partly account for the nudity of the statue carved by Praxiteles, but for no more. For with this figure he virtually created the classic Western image of the beautiful female nude, an image which was to appear again and again in the art of Europe and which also encapsulates some of the fundamental differences between European and other cultures. As in the nude male statues that proliferated in ancient Greece, naturalism and idealism are combined. Moreover, the stance is in effect an adaptation in reverse of that used for statues of young athletes—Aphrodite's weight being on her right leg, with left knee slightly advanced and left foot withdrawn. The only significant modification is in the thighs, held tightly together, and in the general emphasis given to the dimpling roundness and softness of the limbs. Unlike the brazen male nudes, however, she seems slightly shy of her nakedness. Her eyes are averted and the gesture with which Astarte had boldly pointed to her sex has been transformed by a slight shift of the hand into one of protective concealment. By raising the other arm in front of the breasts, in a statue of about 300 BC, an anonymous sculptor effected the most significant change made to the image, creating one of the great prototypes in European art with a long subsequent history, when it was known as the 'pudic Venus' or Venus of modesty—a figure whose erotic attraction was, of course, enhanced by her modest gesture (4, 23d).

A conjunction of social and aesthetic concerns may account for the rarity of female nudes in the earlier periods of Greek art, as well as the particular form they

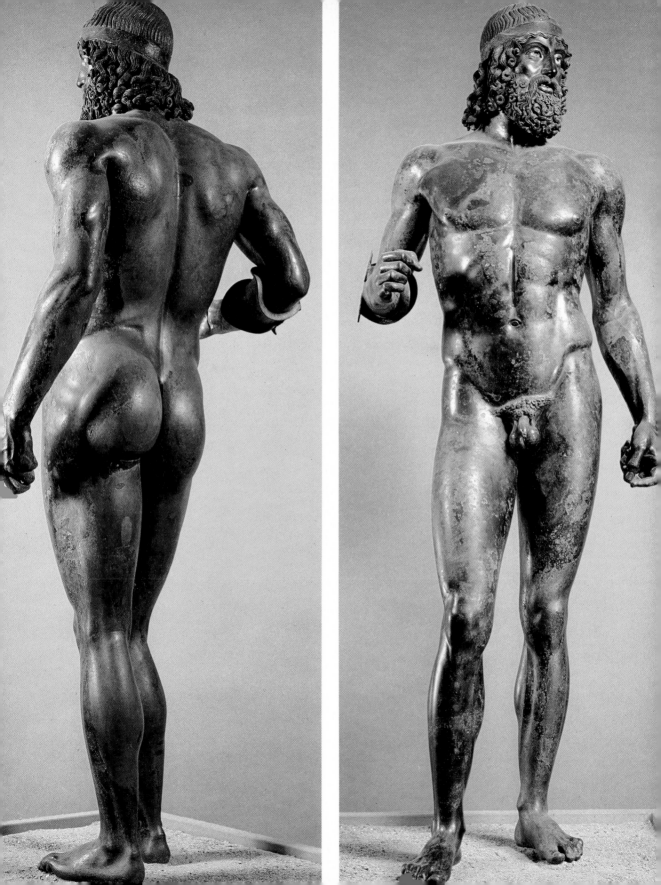

took when they eventually appeared in the fourth century. Few civilized societies have been so completely male-dominated as that of ancient Greece. Laws make this abundantly clear: adultery, for example, was defined one-sidedly as intercourse between a married woman and a man who was not her husband, rape as an offence against a woman's husband, father or guardian, not herself. Regarded and guarded as possessions, upper-class wives were kept at home and confined to child-rearing and household maintenance, while their husbands sought emotional, physical and intellectual stimulus elsewhere, either with members of their own sex or among the *hetairai* or *porne* (common prostitutes). The latter were depicted naked, in a variety of seductive poses, on sixth- and fifth-century vases, usually in brothel scenes, which are pornographic in the strictest meaning of the word. To have included a nude female among the statues of male athletes which crowded the sanctuaries would have seemed extremely odd.

Idealization is an art of the possible rather than the probable. It springs from an urge to transcend everyday reality. Early in the fourth century BC, Xenophon reported a conversation in which Socrates remarked to the painter Parrhasius: 'When you are painting figures, as it isn't easy to come across one single model who is beyond criticism in every detail, you combine the best features of each one of a number of models, and so convey the appearance of entirely beautiful bodies.' Much later, Cicero recounted how Zeuxis—another Greek painter active in the fifth century BC—had employed five different girls as models for a single picture of Helen, 'for he did not believe that it was possible to find in one body all the things he looked for in beauty, since nature has not refined to perfection any single object in all its parts.' Both accounts assume that a work of art could improve on nature without being unnatural. The impulse to idealize was held in check by a need for verisimilitude. It is hardly a coincidence that the same two painters were the subject of a story told by Pliny the Elder—that Zeuxis 'depicted some grapes with such success that the birds flew up to them' and that Parrhasius, in a competition, 'depicted a linen curtain with such truth' that Zeuxis asked for it to be drawn aside!

There can be little doubt that it was the Greek painters of the Classical period who developed both the ideas and the techniques which were to differentiate the arts of Europe from those of all other civilizations—their predominant naturalism, above all. The painters were, it must be remembered, just as famous in their own day as the sculptors. But whereas we know something about the work of the sculptors, even if only at second- or third-hand, we know absolutely nothing about the work of the great ancient Greek painters. Descriptions, however, testify to their naturalistic skills in representing spatial recession and movement. Socrates, according to Xenophon, urged artists to go beyond mere representation and express character and emotion at their finest and noblest. Aristotle, writing in the fourth century BC, suggests that already by that date painters had evolved what we would call idealization, caricature and realism ('Polygnotus represented men as better, Pauson represented them as worse, and Dionysius represented them as they are'). How far any of them succeeded cannot, of course, be known since all their works have vanished. Not a scrap remains of those which hung in a building attached to the Propylaea on the Acropolis at Athens, of the hundreds in other Greek sanctuaries and the many taken to Rome.

Paintings of the Classical period are known to have been copied in Italy and probably provided models for scenes depicted on the walls of houses at Pompeii (see p. 148). But there is no means of telling how faithful the copyists were or whether their work gives more than a very general impression of the original compositions. The only other visual evidence we have is that provided by the decorations on Greek pottery. These naturally differ from wall and panel paintings in several important respects, notably in scale. But they illustrate the development of those techniques of representation to which the literary sources refer.

Most Greek pottery painting is on useful wares (made for the toilet or for drinking parties, etc.), although some vases were intended for funerary or ceremonial purposes (e.g. for presentation at the Panathenaic games). Basic shapes both elegant and practical had been devised by the sixth century BC for the tall two-handled *amphora* with swelling body for wine, the three-handled *hydria* or water jar, the wide-mouthed *krater*, in which wine and water were mixed (as was customary), the small jug called an *oinoche* for pouring the mixture, and the wide, shallow cups, *kylix* and *kantharos*, from which it was drunk. The subject-matter of the figurative scenes depicted on them was usually mythological—very similar, in fact, to that of contemporary dramatic poetry and of such large-scale paintings as are recorded. A preference for stories about men and fabulous beasts rather than the immortals on Olympus is evident, although Dionysus, the god of wine, with his female followers the maenads attacked by libidinous satyrs, appears quite frequently. Also depicted are numerous scenes from daily life: artists and craftsmen at work, women engaged in

4, 26 Detail of vase by Meidias, c. 410 BC. British Museum, London.

household chores, athletes exercising in the gymnasium, drinking parties and theatrical performances. Love-making both heterosexual and homosexual is represented with extreme candour. Indeed, these vases reflect more clearly than any other surviving works of art the Greek preoccupation with their own world, the here and now.

In the sixth century BC figures were usually shown in black on a light orange-red ground. This so-called 'black-figure' process was a Greek invention which called for great technical skill. After a vessel had been formed (on a fast wheel by hand), allowed to dry and then burnished smooth, it was brushed over with a very thin coat of refined and diluted clay known as 'slip' (sometimes misleadingly called a glaze). When dry, it provided the ground on which decorations were painted, also in slip. The chemical properties of the clay used for the slip were such that when the pot was fired, and the heat of the kiln carefully controlled in three stages, the undercoat took on an orange-red colour and the decorations a glossy black. Before the beginning of the fifth century BC the reverse 'red-figure' process was introduced as an alternative. The background of the composition was painted in with black slip, which was also used for adding details on the figures 'reserved' on the red undercoat. As the same type of local clay and the same method of firing were used in both processes, some potters 'showed off' by painting one side of a vase in black-figure, the other in red-figure. Red-figure gradually replaced black-figure,

which, from the early fifth century onwards, was used only for certain traditional types of vessel, notably those filled with oil and awarded to the winners in the Panathenaic games.

Black-figure was essentially an art of silhouette. The details that indicate the modelling of the body are picked out in red lines (or rather are incised through the black slip to the ground colour) and make little visual effect. The red-figure process had to be used in order to transform these shadowy forms into light-illuminated figures and this led, in turn, to a departure from the purely conceptual image. On black-figure vases eyes, for instance, had to be shown frontally, even when the head was in profile, as it almost invariably was (the silhouette of a full face being insignificant). Foreshortening appears for the first time on red-figure vases.

It is more than likely that the development of red-figure was inspired by a desire to emulate the effects achieved by painters working on a large scale and with a much less restricted palette. Red-figure vase painters could delineate figures in a far wider range of postures than before; they could indicate (if not quite express) emotion and character in their features; they could even suggest recession in space. The influence of Polygnotus has been detected in a vase made (and perhaps also painted) by Meidias (4, 26). Draperies are

agitated, horses turn their heads as they canter along, Hilaeiria, who is carried off in the chariot of Polydeuces, has an expression of almost caricatured despair on her face, some wispy branches of olive hint at a landscape setting. The potentialities of finely drawn lines to suggest form as well as movement have been brilliantly exploited. This vase is, indeed, a virtuoso performance, though one that betrays signs of striving after effects which could be fully realized only on a much larger scale by mural or panel painters.

The achievements of such artists as Parrhasius and Zeuxis may be more faithfully reflected on vessels decorated by a process closer to that of panel painting: the white-ground *lekythoi*. These relatively small jugs of supremely elegant form were made to hold oil for cleansing the body and many were specifically intended for use in burial rites and subsequent interment with the dead. They were entirely covered with white slip and after firing were decorated in tempera colours (see Glossary), which would soon

4, 28 *Lekythos*, late 5th century BC. 19¼ins (49cm) high. National Archeological Museum, Athens.

4, 27 Boy from the Bay of Marathon, detail, c. 340–300 BC. Bronze, full height 51¼ins (130.2cm). National Archeological Museum, Athens.

have rubbed off vessels in frequent use. Indeed, they have all but vanished from most that survive. The figure drawings that remain, however, are no less astonishingly free than they are expressive (4, 28). Nothing quite like them is to be found in European art for another 2,000 years. A few bold lines suffice to indicate a limb or a garment, a broad splash a shock of hair, two or three slight brush-strokes give emotional expression to a mouth or an eye. What is even more remarkable is that outline is used not merely to define

silhouette, as in black-figure and red-figure vases, but to indicate volume. It is a kind of visual shorthand that can be employed only by an artist who has already solved the problems of graphic representation, and one that can be 'read' only by those familiar with its conventions.

Several of the finest *lekythoi*—including the one illustrated here—were buried with Athenians who fell in the Peloponnesian War. Few memorials of the dead are simpler or more poignant. Two figures, probably friends or relations, stand on either side of a soldier, who is seated before his tomb or, on some examples, with eyes open as if to catch a last lingering look at 'the warm precincts of the cheerful day'. There are no heroic gestures, the mourners strike no attitudes of grief and the soldier seems to confront the inevitability of extinction with a mixture of resolution and regret. Love of life counterbalances the fatalistic outlook summed up in the famous dictum 'Call no man happy ere he die, he is at best but fortunate' (attributed by Herodotus to the law-maker Solon, but also used by Sophocles).

Graves were often marked by stone monuments—that is, by stone 'reminders' or 'memorials'—without the religious or magic properties that invested the sepulchral art of most other civilizations. Greek monuments emphasized life rather than death—the memory of the dead in the minds of the living. They were usually upright slabs called *stelae* carved in relief.

4, 29 Theatre, Epidaurus, begun c. 350 BC.

Earlier examples rarely had more than one figure, but the type devised in the mid- or late fifth century BC shows two or more framed by a kind of pedimented porch. The relationship between the figures gives these works a sombre dramatic power, all the more effective for being underplayed. A husband takes leave of his wife, tenderly but without any demonstration of emotion; similarly a son says farewell to his aged father, and a father to a son who died in youth. More than one *stele* shows a pensive seated woman, the subject of the monument, with a standing woman—a slave or daughter—holding a casket (4, 30). Repetitions make it clear that these cannot have been portraits (though portraits of distinguished men had begun to appear in Greek art by the early fourth century BC).

Not only the rich were commemorated by such *stelae*. Several record humble craftsmen with their tools. At least one is of a slave girl, presumably set up by her master or mistress. None has the grandiose pretensions of monuments to rulers such as were then being created on the fringes of the Hellenic world in Asia Minor (e.g. that of Mausolus of Caria from whom the word 'mausoleum' derives). Fear of the dire consequences of *hubris* or arrogance may partly account for this. Similarly, they make no reference to an afterlife; they have no 'magic' function. Because of their scale and simple human subject-matter, they are perhaps more directly and immediately appealing than statues and reliefs of divinities behind which there always lurk those irrational beliefs prominent in Greek

literature, but which nowadays seem remote and difficult to comprehend.

In the ancient world *stelae* were not regarded as major works of art. The Romans seem rarely to have robbed them or to have had them copied. Pliny and Pausanias passed them by. Yet, doubtful though it is whether any are by leading sculptors, they sometimes possess in the sensitivity of their carving the very qualities that are lacking in the copies by which the work of celebrated sculptors is known. The majority, however, seem to have been almost mass-produced. The similarities between some examples are so close as to suggest that they had been roughed out with the help of some kind of pointing apparatus (see Glossary) from a single model: and in them and others we can follow the development of such techniques of working in marble as that of the running drill to cut deep furrows (introduced in the early fourth century BC). *Stelae* also reflect the main stylistic trends in Greek sculpture from the severity of the early Classical period, in the years immediately after the Persian wars, to the serenity of the mid-fifth century and the more highly worked elegance and greater expressiveness of the fourth. As very few are dated, this stylistic sequence can, of course, provide no more than a rough chronological framework. Some sculptors of the fourth century BC—and vase painters too—may well have harked back to earlier styles in response to those who, like Plato, distrusted change in art as in politics. Tradition played as important a part as innovation in Greek art and, especially, in architecture.

The fourth century BC is often described as a period of artistic decline: it was certainly one of change. New tendencies in architecture are most clearly apparent in two buildings at Epidaurus: the theatre and the *tholos*, a circular structure of unknown function. Both are in the sanctuary of Asclepius, the god of healing who was also credited with the power of resurrecting the dead and whose cult became very popular in the fourth century. Offerings from many devotees who sought his protection provided the funds for the buildings. The theatre is among the most spectacular of all ancient Greek constructions and one which seems to crystallize an ideal of architecture as pure geometrical form (4, 29). It could hardly be simpler—a vast auditorium 387 feet (118m) in diameter, composed of 55 tiers of marble benches rising round rather more than half the circular orchestra platform or dancing space for the chorus (not for musicians), beyond which there was a long, narrow structure for the stage. The form regularized and embellished the earliest type of theatre, which had been simply a natural hollow in a hill adapted for rituals connected with the cult of Dionysus. It was out

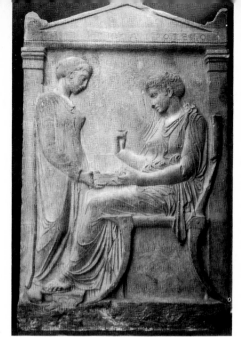

4, 30 Grave stele of Hegeso, c. 410–400 BC. Marble, 59ins (150cm) high. National Archeological Museum, Athens.

of these rituals that drama as we know it evolved. In Athens the theatre where tragedies and comedies were first performed in the fifth century BC had been a fairly simple affair in a cleft of the rock below the Acropolis, with wooden benches in an auditorium hemmed in by buildings on either side. (The extant remains date from a later remodelling.) At Epidaurus space was unlimited in the open country and the theatre could therefore take its 'natural' geometrical shape, which also enabled more than 20,000 spectators to see and hear the performers—a feat of acoustics that still amazes audiences today. The theatre was, however, built after the great creative period of Greek drama had come to an end. Whereas in fifth-century Athens only new works had been given—three tragic trilogies and five comedies each year—now there were revivals of the most popular of those 'classics' from which Aristotle was soon to draw the rules of dramatic poetry. It was not only the architectural form of the theatre but Greek drama itself which had been regularized.

The *tholos* at Epidaurus is said to have been designed by the same architect as the theatre, Polyclitus (not to be confused with the slightly earlier sculptor of the *Doryphorus*), but it was strikingly different in style, with much carved decoration. Corinthian capitals, first devised in Athens in the fifth century but little used before the middle of the fourth, are prominent and characterize a new tendency in Greek architecture. With their curling tendrils and acanthus leaves they were not only more decorative than Ionic capitals but also, since all four faces were alike, avoided the

awkward effect which the latter made when seen from the side (as at the angle of a building). They perfectly answered new demands for both embellishment and regularization (4, 31).

Similar tendencies were apparent also in domestic architecture. Demosthenes, the great orator and leading opponent of Philip II of Macedon (see p. 120), declared that luxurious houses had made their first appearance in Athens in his lifetime (he was born c. 384 BC). There is an interesting signed floor mosaic in a house in Athens, but little else survives. At Olynthos near the coast of Thrace in north-east Greece—a town laid out about 430 BC and destroyed in 348 BC— excavations have revealed that the larger houses already had figurative mosaic pavements in the main room (the *andron* used for entertaining male guests). Olynthos was built on a regular grid, a type of planning not used in central and southern Greece, except for the rebuilding of the Athenian port of Piraeus (c.460–445 BC) to the design of Hippodamus of Miletus, who was called in by Pericles. Athens itself was a maze of narrow winding streets and alleys. Its centre of daily life, market-place and meeting place, the *agora* (literally 'field'), remained an irregular space with a simple *stoa* or long portico to provide shelter from the weather, until order was imposed on it in the second century BC (see p. 146).

Further evidence of a taste for luxury indulged by the ruling classes in northern Greece is provided by gold vases found in a tomb near Philippopolis, the capital founded by Philip II of Macedon (present-day Plovdiv in Bulgaria). They are of an extraordinarily sophisticated elegance (4, 32). Figures which had become either tired or overwrought on painted pottery vases in the south here exude a new vigour. Contact with 'barbarians' may have been responsible. The

4, 31 Corinthian Capital from the tholos at Epidaurus, c. 350 BC. Archeological Museum, Epidaurus.

4, 32 Amphora from Panagyurishte, Bulgaria, c. 350–300 BC. Gold, 10ins (25.4cm) high. Archeological Museum, Plovdiv.

handles have the same animal vitality as the ibexes that serve the same function on Achaemenid vessels, although here they have been metamorphosed into lively young Greek centaurs.

Some of the finest examples of ancient Greek goldsmiths' work were, in fact, made for the Scythians of southern Russia. No gold ornament of any period or country is more exquisitely wrought than a pectoral intended to be worn on the breast of some nomadic chief and buried with him near the Dneiper River (4, 33). Animals are rendered with a vitality and naturalism that makes the griffins of the lower register no less credible than the extremely sharply observed horses, cattle, sheep, dogs, hares and even a couple of grasshoppers. Four men are incorporated, one milking an ewe, another holding an amphora and two in the centre stitching a shirt out of animal skin. The contrast between the simple pastoral way of life represented by these figures and the highly developed technical accomplishment of the goldsmith who made them is not, however, stressed. The Scythians are neither caricatured nor idealized. Not until much later, in Roman times, did these people come to be regarded as 'noble savages', preserving the innocence and moral qualities which 'civilized' man had lost.

Before the end of the Classical period numerous examples of Greek artistry had found their way far beyond the frontiers of the Hellenic world: gold ornaments, bronze vessels, painted pottery vases and, much more widely, coins. The idea of fashioning

4, 33 Detail of pectoral from Ordzhonikidze, Russia, 4th century BC. Gold, 12ins (30.6cm) diameter. Historical Museum, Kiev.

precious metals into small pieces of uniform size, weight and value originated, like so much else, in Asia Minor. Bean-shaped lumps of electrum stamped with devices were minted in Lydia shortly after the middle of the seventh century BC. But within a hundred years the Greeks had regularized the shape to a disc modelled in relief with the emblem of the city which issued it—at Athens, for instance, the head of Athena on the front and the owl sacred to her on the back (4, 34a). As their designs were frequently modified and changed, coins provide a miniature history of Greek art from the Archaic to the Hellenistic period. On the earliest, profile heads have frontal eyes and animals are schematized. Later they reflect the naturalistic ideals of the Classical period, none more beautifully than those of Syracuse in Sicily, which bear the firmly modelled head of Arethusa surrounded by dolphins (4, 34b), and in the later fourth century BC a tendency towards greater delicacy and intricacy becomes apparent (4, 34c).

The most widely diffused coins were those issued by Philip II of Macedon after 356 BC, when he acquired the gold mines of Mount Pangaeus in Thrace. The gold *stater* (a piece weighing 8.6 grams) became an item of international currency and continued to be issued in Macedonia for a long time. It was subsequently imitated by central and northern Europeans ignorant of the significance of its emblematic designs. The process by which such designs were slowly de-naturalized and transformed into non-figurative patterns is very instructive. The head of Apollo, for instance, was gradually reduced to an assembly of disjointed facial features, and the two-horse chariot on the reverse of this coin—which probably referred to Philip's racing victories in the Olympic games—was

4, 34a *Left* Attic tetradrachm with head of Athena and owl, c. 479 BC. Silver, 1 in (2.5cm) diameter. British Museum, London.
4, 34b *Centre* Decadrachm from Syracuse, 413–357 BC. Silver, 1⅜ in (3.5cm) diameter. British Museum, London.
4.34c *Right* Didrachm from Herclea, 370–281 BC. Silver, ⅞ in (2.2cm) diameter. British Museum, London.

completely dissolved into abstraction (4, 35). The power of Greek art to reassert itself is forcefully demonstrated by the coins we use today with their idealized heads and naturalistically rendered symbols. Coins provide a chain—the only one which has never been broken—linking the arts of the modern world with those of ancient Greece.

Barbarian alternatives: Scythians and the Animal style

Herodotus who, in the mid-fifth century BC, went to Olbia on the northern shore of the Black Sea to gather information about the Scythians, noted that they were 'a people without fortified towns, living in wagons which they take wherever they go, accustomed, one and all, to fight on horseback with bows and arrows, and dependent for their food not upon agriculture, but upon their cattle.' He set down what he could find about their origins, believing them to have come from further east, described their customs and gave a vivid account of the gruesome rites performed for the burial of a dead king. Although he did not admire them, he was bound to admit that 'they have managed one thing, and that the most important in human affairs, better than anyone else on the face of the earth: I mean their own preservation. For such is their manner of life that no one who invades their country can escape destruction, and if they wish to avoid engaging with an enemy, that enemy cannot by any possibility come to grips with them' (*The Histories, IV*). They are hardly less elusive, in a different way, to the modern observer. Numerous Scythian artifacts have been dug up in various parts of Russia—fascinating, beautiful but baffling. Archeologists have been continually foiled in attempting to reconstruct their history.

The Scythians are the most prominent of a number of groups of mounted nomads with related cultures who thinly populated the vast area of steppe or treeless grassland stretching from the Danube to the Gobi desert in Mongolia—a distance roughly double that from one coast to another of north America. All that is known about these peoples derives from their artifacts, almost invariably found in tombs, and from the records of the neighbouring literate societies of the Mediterranean, the Near East and China, to whom they were an ever-present menace from the second millennium BC until well into the European Middle Ages. The Great Wall of China was begun in the late third century BC to keep them out.

The territory occupied by these nomads lay between the great northern forests, inhabited by hunters and fishers, and the temperate fertile regions, where agriculture was highly developed and cities had been established. They have often been described as living in a state of arrested development between the two. But this is to misunderstand them. Nomadism sprang not directly from Stone Age hunting and gathering but from mixed farming—with the domestication of horses—as a means of obtaining the maximum yield of food from land which was unsuitable for permanent pastoral or agricultural settlement. It was based on the careful breeding of different species of animals to make the most of grazing possibilities: cattle that graze well on long grass, sheep and goats that crop close. Climatic conditions necessitated constant movement from wide areas that provided fodder in spring and summer to the more restricted pastures, where the flocks could survive the winter. Nomads exploited for their own purposes the technologies developed in the cities, the

4, 35 Progressive stylization of imagery in 2nd-century BC Celtic coins, imitating the gold stater of Philip II of Macedon. Drawings.

working of bronze and then of iron, the use of wheeled vehicles. They created a form of society which was to outlive the ancient civilizations of the Near East and the Classical world (which, indeed, they helped to destroy). Their way of life was, in fact, a parallel development to that of urban civilization: an alternative with its own set of values. The art conditioned by it similarly provides an alternative to that evolved in the Mediterranean, and the conflict between the two determined much of the subsequent history of painting and sculpture in Europe.

As we have seen, Scythians clearly valued Greek craftsmanship. Many of the finest examples of Greek goldsmiths' work were preserved in the tombs of their kings (4, 33). So too were bronze and pottery vessels, including a fifth-century BC amphora, which had originally been made as a prize for a victor in the Panathenaic games. Egyptian artifacts have also been found in these tombs. Fine objects from Achaemenid Persia and Chou dynasty China were buried with nomads of the eastern steppes and Altai mountains. But the so-called 'Animal' style developed by the cultures of the steppes differs almost as much from Persian and Chinese art as from ancient Egyptian and Greek. A gold plaque of a stag wrought to decorate an iron shield or breast-plate is a characteristic example (4, 37), modelled in relief but with extraordinary feeling for full-bodied form, simplified, schematized and contracted into a tight pattern, yet mysteriously alive with animal vitality.

The origins of the Animal style are obscure. So too are those of the Scythians, who established themselves to the west of the Volga and on the northern shores of the Black Sea in about the eighth century BC, displacing another group of nomads known to the Greeks as Cimmerians (who retreated into Asia Minor and sacked Greek cities on the coast). Excavations have revealed traces of a succession of pre-Scythian cultures in the southern Caucasus—a famous tomb dating from the late second millennium at Maikop and several tombs of the early first millennium have yielded some notable bronzes of animals, but these are closer to the arts of Assyria and Anatolia than to that of the Scythians. A more likely connection would be with the bronzes of Luristan (see p. 79). But the latter include numerous human figures, which are very rare in Scythian art. Also the animals of Luristan often merge into one another by what is known as the 'zoomorphic juncture'—the tail of one creature being fashioned like the head of another of different species—a device which does not seem to have been adopted by Scythian craftsmen until a relatively late period. The arts of Shang and Chou China (pp. 59, 84), at the other end of

the steppes, probably contributed to the formation of the Animal style, but here influences seem to have been reciprocal and are, therefore, very hard to disentangle. Works in perishable materials, of which we now know very little or nothing at all, may also have played a part—not least the tattooings with which the nomads decorated their bodies.

Whatever its origins the Animal style as we know it seems to have first emerged on the western steppes in the seventh century BC. It is found almost exclusively on small objects, mainly metal—bronze or, quite often, gold enriched with coloured glass paste—to be attached to clothing, arms and armour, chariots and the harness of horses. The animals from which it takes its name were wild (not those bred by the nomads), usually various species of deer, wolves and large felines although fabulous monsters also appear. Single animals are rendered with a sharp-edged compactness that gives them an almost monumental quality, despite their small size. A stag's antlers are rendered as a series of scrolls running the length of the back; the legs are folded together beneath him (4, 37). The slim body of a feline, probably a snow-leopard, is coiled into a circle, schematized with ruthless concision but given a tensely flexed muscular vitality. But what do they signify? They can be read in more than one way. Is the stag bound for sacrifice and, therefore, a symbol of man's mastery of the animal world—or was the reverse intended? Is the stag in full flight, escaping capture by its fleetness and superior muscular force, wound up like a hard metal spring?

Another animal, usually identified as a panther, is shown on the prowl (4, 38). Its paws are fashioned like curled felines, which are repeated along the tail, a device probably intended to compress the force of many animals within a single image. Similar superimpositions occur on many other pieces, including bronze finials for poles. The significance of the animals themselves remains, none the less, mysterious. Clearly they are more than merely decorative in intent. But their 'meaning' remains obscure, just as their form resists analysis. It is impossible to say more than that the extraordinary contortions and involutions of this art sprang from a culture and sense of form totally distinct from that of the Mediterranean world.

Numerous attempts have, of course, been made to explain or interpret these works of art. They have been associated with the rites of hunting magic, for the nomads are known to have hunted wild beasts as well as bred the tame. They may have represented supernatural beings. Later peoples of the steppes are known to have believed that stags transported the dead to the other world. They have also been explained as

totems venerated by the various clans of nomads as ancestors. Their transformation into clan symbols would have followed naturally and easily. The heraldic beasts of medieval chivalry, which include many deer and felines like those on the British royal coat of arms, may certainly be traced back to emblematic devices of later barbarian tribes from central Asia.

Animal style art was essentially aristocratic, intended for the adornment of the person and possessions of the rulers, their families and perhaps some of the more important mounted warriors. (Kingship seems to have been hereditary among the royal Scythians of the west.) The vast majority of examples come from tombs in which the riches and power of the deceased are very clearly displayed. Herodotus described in chilling detail how a dead king was embalmed and taken in a chariot around his dominions, accompanied by an increasing crowd of mourners, to the burial place. There the corpse was placed in a pit together with a selection of royal treasures. One of his wives, his butler, cook, groom, steward and chamberlain were strangled and buried with him, as were a number of horses who had been clubbed to death. A mound of earth was heaped over the tomb and a year later 50 youths and 50 of the finest horses were killed, stuffed with straw and stationed round it. Several tombs excavated in the Kuban region to the east of the Black Sea have confirmed the substantial accuracy of this account, notably one at Kostromskaya, containing the dead man's armour, a gold plaque of a stag (4, 37), leather quivers, bronze arrow-heads, copper and iron horse-bits. Thirteen human skeletons without any adornments lay in the compacted earth above. Outside the main area the remains of 22 horses were found, apparently buried in pairs.

A still more extraordinary group of tombs, rather more elaborate than those of the Scythians and constructed partly of stone, is located far to the east at Pazyryk in the Altai mountains of Mongolia (near the present-day frontier between the USSR and China). Here the peculiar climatic conditions preserved their contents deep-frozen in solid ice, allowing us a unique close-up glimpse of the life-style and art of the nomads of the steppes some 2,400 years ago. The body of a king or chieftain has been found, strongly marked with tattooing in the Animal style — a tantalizing indication of the role which decorations on the human skin, now totally lost and unknown to us except for this one chance survival, may well have played in the development of drawing and painting from a very early period. Also deep-frozen were fabrics with their colours still bright and fresh, including a magnificent Persian pile carpet (the earliest known), delicate Chinese silks and

panels of *appliqué* work in felt, which were presumably local products. A particularly fine felt saddle-cover is decorated with dragon masks and fighting griffins and goats, motifs derived respectively from Chinese ritual bronze vessels and the arts of the ancient Near East, but transformed and incorporated into a richly luxuriant version of the Animal style of the steppes (4, 39). Such objects as pole-tops made of wood and leather reveal a mastery of complex three-dimensional form: one is fashioned like the head of a plumed griffin holding a deer's head in its jaws, another as a deer with antlers of exaggerated magnificence. That nothing quite like these pieces has been found at the western end of the steppes may well be due simply to climatic conditions less favourable to survival.

There were other related cultures of the steppes, notably that of the Sarmatians, a nomadic people from south Russia who moved into Scythian territory in about the third century BC and then pressed on towards Europe. Sarmatian art reveals contacts with both China and Persia and is notable mainly for metalwork, especially gold and the early development of *cloisonné* enamelling (see Glossary). The Sarmatians were eventually absorbed into the 'empire' of the Huns from central Asia, whose art forms yet another variant of the Animal style.

Examples of Animal style art may well have reached central and northern Europe long before the mounted nomads from Asia. One of the finest of all, probably dating from the fifth century BC, was found in a hoard of treasure at Vettersfeld in Germany (some 50 miles, 80 km, from Berlin); how it got there remains a mystery. This is a relatively large electrum plaque in the form of a fish embossed with a shoal of fish on its belly and animals on its back, with its tail terminating in rams' heads — a good example of the zoomorphic juncture (4, 36). An electrum plaque of a stag, of about the same period, in exactly the same pose as the stag from Kostromskaya (4, 37), was found in Hungary on the frontier between the nomadic world of the steppes and agrarian Europe. How far work in the Animal

4, 36 Fish, from Vettersfelde, Germany, early 5th century BC. Electrum, $16\frac{1}{8}$ ins (41 cm) long. Antikenmuseum Staatliche Museen Preussischer Kulturbesitz, Berlin.

4, 37 *Above* Recumbent stag, shield plaque, from
Kostromskaya, south Russia, late 7th to early 6th century BC.
Gold, 12½ins (31.7cm) long. State Hermitage, Leningrad.
4, 38 *Above right* Panther, shield or breast-plate plaques, from
Kelermes, south Russia, late 7th to early 6th century BC. Gold
with inlays, 12¹³⁄₁₆ins (32.6cm) long. State Hermitage, Leningrad.

style influenced European art at this time is, however,
impossible to determine.

Hallstatt and La Tène

The history of art in Iron Age Europe of the first
millennium BC is divided by archeologists into two
overlapping phases, the earlier named Hallstatt after a
lakeside village near Salzburg in Austria, the later
(beginning in the second half of the sixth century BC)
called La Tène after the place where a group of votive
objects were found at the east end of Lake Neuchâtel in
Switzerland. In the course of the first period the
peoples later known as Illyrians, Celts and Germans
settled, respectively, in the south-eastern, central and
northern regions of Europe, from which they were to
make their first appearance in written history. They
were farmers with an upper, warrior class. Burials
suggest a change in the social structure in about the
seventh century BC. The so-called Urnfield cultures
(those of people who placed the ashes of the dead in
pottery vessels and interred them in communal
cemeteries) gave way to those in which individuals
were, like the Scythians, buried in tombs richly
furnished with bronze arms and armour, articles of
personal adornment and riding equipment. A sixth-
century BC king or chieftain was buried in a cave in
Moravia with his chariot, jewelry, table-wares and
some 46 companions—a rare instance in Europe of the
Eastern practice of immolating the living to accom-
pany the dead.

Hallstatt Iron Age culture anticipated by many
centuries the confrontation of northern with southern

4, 39 Saddle-cover from Pazyryk, Altai region, Russia, 5th
century BC. Felt, leather, fur, hair and gold, 46⅞ins (119cm)
long. State Hermitage, Leningrad.

(Mediterranean) art which marks the much more accomplished Scythian work, especially in gold. By far the most remarkable instance of this at Hallstatt is a seventh-century BC bronze group usually called a 'cult-wagon' or 'ritual car'—though its original significance is unknown—found in a tomb at Strettweg near Graz in Austria (4, 41). A female figure, probably a goddess, stands in the centre holding a bowl on her head. She is surrounded by four warriors on horseback, a woman and a man with erect penis wielding an ax and, at either end of the chariot, two stags flanked by naked, but curiously sexless, figures. They are all uniformly schematized to a degree that is best appreciated by comparing the stags—rigid, spiky, antlered—with the much more vital, compact, supple creatures of the Scythians.

Like the central goddess, the warriors and especially the horses, these stags are much closer to the 'Geometric' art of ancient Greece. The piece may well

4, 40 *Left* Flagon from Basse-Yutz, France, early 4th century BC. Bronze, coral and enamel, $15\frac{1}{4}$ins (38.7cm) high. British Museum, London.
4, 41 *Top* Cult-wagon from Strettweg, Austria, 7th century BC. Bronze, height of goddess $8\frac{3}{4}$ins (22.2cm). Steiermärkisches Landesmuseum, Johanneum, Graz.
4, 42 *Above* Krater from Vix (detail), c. 550–500 BC. Bronze, $64\frac{1}{2}$ins (163.8cm) high. Musée Archéologique, Châtillon-sur-Seine, France.

have been made by a bronze-worker who had learned his craft in Greece, if not by a Greek. For although the general effect is distinctly northern, with possible antecedents in Scandinavia, the Strettweg chariot is perhaps best understood as the product of a European Iron Age Culture, from which Greece was only just beginning to diverge at this moment.

Celtic chieftains of the La Tène period evidently

valued Greek art no less than did the Scythians. By far the largest extant Greek bronze vessel, a sixth-century krater more than five feet (150cm) high, was found in the tomb of a princess or priestess at Vix, near Châtillon-sur-Seine in central France. There is reason to believe that it was made in the Peloponnese and intended for export; the frieze round its top represents Greek soldiers, chariots and horses in the best style of mid-sixth-century BC Archaic sculpture (4, 42). Many other Greek works have been found in northern graves, even cups which still retained traces of resinated southern wine, as if they had just been emptied and put down after the funeral feast. One chieftain at Heuneburg on the Upper Danube employed southern engineers to fortify his citadel in the Greek fashion (but only on the side facing a friendly settlement, whose inhabitants he evidently wished to impress).

La Tène art might seem, nevertheless, to have been only marginally influenced by the Greeks, as also by the Scythians—only marginally because these influences were completely assimilated. Decorative elements on a magnificent bronze ewer unearthed in a tomb at Basse-Yutz in Lorraine can be traced to both eastern and southern sources (4, 40). The lithe wolf-like animal which serves as a handle and the two animals seated on the rim have a recognizable Asian ancestry. Their ears are drawn, rather than modelled, with continuous scrolled lines and their joints are rendered by spirals as in some wood-carvings from the Altai mountains. The idea of making a handle in the form of an animal, on the other hand, probably derives from Iran by way of Greece and Etruria. The form of the vessel is basically Greco-Etruscan, although it has been given greater angularity and a more attenuated elegance. Just above the base a Greek wave pattern (later called Vitruvian scroll, see Glossary) is neatly incised in the bronze. The plaited pattern around the foot is also of Greek origin (technically called a *guilloche*, see Glossary) and the decoration beneath the spout also seems to derive from Greek motifs, but the geometricality of the prototypes has been lost in the process of rendering them with insets of enamel and pieces of coral. The ewer is as typically Celtic in its coiling linearity and nicely balanced asymmetry as in the very distinctive use of colour and the schematization of the handle, which merges into a bearded human face with goggle-eyes of coral.

Celts rejected as much as they took from the arts of other cultures, and the motifs they adopted tended to be increasingly broken down into linear patterns of scrolls and flourishes. Their art is at once non-representational and yet organic. Many of its qualities are evident in a bronze openwork ornament found in Czechoslovakia (4, 43). No explanation of the original purpose of this extraordinary piece is entirely convincing and it may owe some of its strange effect to its separation from the object, probably of wood or leather, of which it originally formed part. A head with curiously sad human eyes and an animal snout peers out of an intricate network of curves flowing naturally into a highly complex three-dimensional pattern. Although the lines cannot have been geometrically determined, their torsion is rigorously controlled so that they echo and balance one another in a perfectly self-contained composition. Like the Basse-Yutz flagon and many other examples of La Tène art, this bronze has a refinement of craftsmanship and elegance of form hard to reconcile with what is known of the tribal society for which it was created.

Celtic tribes swept down the Italian peninsula and burnt Rome in about 390 BC, Rome being then only one of several small city-states in Italy which had grown up alongside those of the Etruscans (see p. 129). Other Celtic tribes made periodic raids into Greece and in 279 BC sacked Delphi. In the course of the following centuries they were gradually driven back and most of their territories were eventually occupied by the Romans. But the art which made its first appearance in the La Tène period had an enduring vitality and survived, as we shall see (p. 245).

4, 43 Openwork ornament from Brno-Malomerica, Czechoslovakia, 3rd century BC. Height of animal head $2\frac{1}{3}$ins (6cm). Moravian Museum, Brno.

Iberia and Sardinia

There were several other European cultures of the first millennium which the Greeks dismissed as barbarian and which the Romans were to suppress by force. At the far western end of the Mediterranean, on the south coast of Spain, the Iberian civilization developed from the mid-sixth century BC under Phoenician as well as Greek influence. It had a literate class using a script derived mainly from Greek, but their language has so far resisted translation. Several of its cities are known to have been extensive, although little remains of them. But a number of carvings have survived, including one, the *Lady of Elche*, which is a masterpiece of European sculpture. (It was found at Elche, near Alicante, in 1897.) This is the upper part of an over-life-size statue of a woman, goddess, priestess or princess (4, 45). The sensitively modelled face is extraordinarily expressive—aloof, detached, with a hint almost of melancholy introspection. The carving of the mouth and nose and exquisitely tender eyelids might suggest the influence of Greek sculpture, although no Greek would have placed such a strong emphasis on the costume. It is this which sets the *Lady of Elche* so obviously apart from Classical sculpture. The dressing of the hair in great wheels set with wires and precious stones or pearls, the pendants dangling from the concealed ears, and the heavy jewelry on the breast give the work an exotic opulence closer in feeling to the art of the ancient Near East than to that of Greece. Comparison between it and, for instance, the approximately contemporary *Aphrodite of Cnidus* (4, 23c) illustrates an almost antithetical development from the same tradition.

The relationship of another Mediterranean culture, that of Sardinia, with the civilization of Greece and the Near East is difficult to define. Its most conspicuous relics are the defensive round towers called *nuraghi*, of which there are some 6,000 remains. The earliest date from the mid-thirteenth century BC, and they continued to be built until the Romans conquered the island a thousand years later. Of cyclopean masonry, sometimes with mortar, they form truncated cones two or more stories high. The rooms inside them had corbelled false domes. Sometimes a number of towers are connected by walls with corbelled passages in their thickness. Underground chambers were built on the same principle around wells and springs, which evidently had some religious significance. Houses were built in a similar fashion, and the foundations of a whole village have been unearthed around the *nuraghi* at Barumini. It is generally assumed that the technique of construction was learned from Minoan Crete or Helladic Greece. But unlike the *tholoi* of Mycenae, the

4, 44 Man from Sardinia, 800–500 BC. Bronze, 7¼ins (18.4cm) high. Museo Nazionale, Cagliari.

nuraghi towered above ground-level as free-standing buildings.

Their small-scale sculpture was equally distinctive. Several hundred bronze statuettes, mainly of human figures, survive and are believed to have been made between the eighth and sixth centuries BC. The lost-wax process (see Glossary) by which they were cast must surely have been transmitted from the eastern Mediterranean at about the same time that it was taken up by the Greeks (see p. 60). Subjects include warriors, women with flowing robes who might represent goddesses, musicians playing double-pipes, a shepherd carrying a sheep on his shoulders, wrestlers and so on, many of them probably made as votive objects to be placed in shrines. Typical is a small male figure, rudimentarily schematized and with arms reduced to simple bent rods, yet vividly alive (4, 44). He speaks or shouts as he gesticulates. This little bronze captures the character as well as the appearance of a well-known and happily still flourishing Mediterranean type.

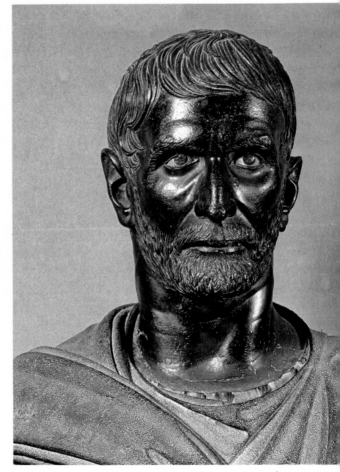

The Etruscans

Soon after the Greeks founded their first colonies in southern Italy in the mid-eighth century BC they encountered an Iron Age culture not so very different from their own: that of the people who called themselves Rasenna, but were later known as Etruscans. The Etruscans were beginning to transform their small agricultural settlements into cities and were becoming the best organized inhabitants of the peninsula, the only ones who were to be a match for the Greek invaders. During the next hundred years or so their materially rich civilization rivalled that of Archaic Greece. Their language, preserved in many thousand inscriptions, was not of the Indo-European group and is still little understood. It set them apart from the other peoples of Italy, who spoke dialects closely related to one another, including a primitive form of Latin. It has been suggested that they were themselves relatively recent arrivals in Italy, probably from west Asia, as Herodotus stated, but this can neither be proved nor disproved.

Although they shared a common language and

4, 45 *Top left Lady of Elche*, 5th to 4th century BC. Stone, 22ins (55.9cm) high. Prado, Madrid.
4, 46 *Top right* Painting in Tomb of the Triclinium, Tarquinia, c. 500 BC.
4, 47 *Bottom left* Interior of the tomba delle sedie, Cerveteri, c. 600 BC.
4, 48 *Bottom right* 'Brutus', c. 300 BC. Bronze, 12⅝ins (32cm) high. Palazzo dei Conservatori, Rome.
4, 49 *Above* She-wolf, c. 500 BC. Bronze, 33½ins (85cm) high. Museo Capitolino, Rome.

religion, the Etruscans were not a political unit. Their independent city-states (traditionally said to be 12), at first monarchical and later republican, were somewhat similar to the Greek *poleis*, though much less frequently at war among themselves. From cities on the coastal plain between the Tiber and the Arno, they expanded inland as far as the Apennines, occupying the area of modern Tuscany and Umbria, rich in minerals which they exploited. Later they spread north into the fertile valley of the Po and south nearly as far as Naples. Rome itself was ruled by Etruscan kings until 510 BC. Their influence stretched further and by the end of the sixth century BC they seem to have dominated the whole peninsula apart from the areas colonized by the Greeks. Their fleet, perhaps the most powerful in the Mediterranean, protected their widespread commercial interests.

Cultural relations between Etruscans and Greeks were complex. Before the end of the eighth century BC the Etruscans adopted an alphabet like that of the Greeks (though an independent derivation from the Phoenician has been proposed), but they wrote from right to left. They bought Greek artifacts on a large scale, notably pottery painted with scenes from Greek myths and legends and statues of Greek deities, some of whom they adopted for their own pantheon, as, for example, Apollo and Artemis. From the seventh century BC onwards Greek artists are known to have been working in Etruscan cities. Yet Etruscan culture was not simply an offshoot from that of Greece. It sprang quite independently from similar Iron Age origins. Significantly, the Greeks and later the

Hellenized Romans regarded the Etruscans as people apart.

The Etruscans left no literature from which we might gain some insight into their thought, feelings, way of life or their history. We know them only from the probably biased comments of Greek and Latin writers and from the material remains of their culture, found mainly in tombs and susceptible to a bewildering range of interpretations. They have been described by ancient and modern authors as a people obsessed by death and as one wholly devoted to the pleasures of living, as deeply religious and as amorally licentious. Their art has been condemned for its lack of originality and praised for its vital spontaneity. Etruscan bronze work is known to have been prized in Athens in the fifth century BC, that is at the height of the Greek Classical period. At least one surviving work fully justifies this estimate—the famous *She-Wolf* of the Capitol (4, 49), for centuries the totem of the city of Rome and a masterpiece of bronze casting and chasing. It is also, of course, quite unlike any Greek animal sculpture. The extraordinary realism of the tense, watchful stance—ears pricked, brow furrowed, jaws snarling, hackles rising—epitomizes at its finest and most vividly factual the unidealized, down-to-earth quality of Etruscan art.

The frontier between the arts of the Greeks and the Etruscans is less easily defined than that between the arts of the Greeks and the Scythians, Celts and Iberians. Controversy among archeologists and scholars has raged around the numerous objects found in the cities and cemeteries of Etruria. There are literally thousands of Etruscan tombs with painted and sculptured decorations, cinerary urns, sarcophagi and 'grave goods' ranging from the simplest household equipment to lavish and even sophisticated works of art. Yet much remains obscure. The objects themselves have been variously attributed to Greek or Etruscan artists, all too often by highly subjective criteria. It is for this reason rather more difficult to define the art than the artistic taste of the Etruscans.

Greek 'Geometric' pottery (see p. 96) of the early eighth century BC has been found in tombs at Veii (a few miles north-west of Rome). But the majority of imported objects in Etruscan tombs of the eighth and seventh centuries are in Near Eastern styles: pieces of 'faience' from Egypt, Phoenician bronze-work and ivory carvings and also Greek 'Orientalizing' bronzes and painted vases. They provide evidence of a substantial luxury-loving upper class in each of the main Etruscan cities. It was for their own use or pleasure, it should be noted, that rich Etruscans bought bronze cauldrons of a type made by the Greeks

exclusively for dedication to the gods.

Among the many objects in 'Orientalizing' styles there are some which are generally agreed to have been made in Italy, presumably by Etruscan craftsmen. They include ivory arms with long-fingered hands, probably handles for mirrors or fans, their sleeves decorated with prowling lions, which no inhabitant of Italy at this date is likely to have seen for himself and which must have derived ultimately from Assyrian art. Lions also appear prominently on one of the finest examples of Etruscan gold jewelry, a large fibula or clasp from a very rich and perhaps royal tomb at Caere (modern Cerveteri) (4, 50). The maker of this piece derived from the Near East not only decorative motifs but also techniques of working gold which he elaborated into a feat of virtuoso craftsmanship. The five lions on the upper part are cut out and applied to the ground. Lines indicating their manes are composed of minute granules of gold; so, too, are the lines of the wreaths that surround them and the zig-zags on the bars joining the two parts of the fibula, soldered to the surface by an exceptionally tricky process. On the lower part six rows of winged lions are outlined by granulation and here there are also tiny ducks

4, 50 Fibula, 7th century BC. Gold, 12⅝ins (32cm) long. Vatican Museum, Rome.

modelled in the round. Etruscans clearly loved such work, on which wealth was conspicuously displayed both by the precious nature of the material and, still more, by the lavish expenditure of time and skill.

The 'Orientalizing' style of the seventh century BC drew the Etruscan cities onto the periphery of a cultural world that had its centre in Assyria, then the dominant power in the Middle East (see p. 73). It was carried throughout the Mediterranean not only by Greeks but also by Phoenicians. This great maritime trading nation had settled in the Lebanon and about 800 BC established at Carthage a colony which became their new capital, from which they gradually expanded along the coasts of north Africa and southern Spain. The Etruscans were to be closely involved with the Phoenicians, or Carthaginians as they came to be called, until both were conquered by Rome. In the sixth century BC they were allied against the Greek cities of the Western Mediterranean. It was, none the less, to the Hellenic world that the Etruscans turned for works of art.

The Archaic Greek style which, as we have seen (p. 98), followed the 'Orientalizing' style in sixth-century Greece, was introduced to Etruria by imports and also by Greek artists, many of whom were probably refugees from Asia Minor after the Persian conquest of Ionia in 548–7 BC. Most of the more notable surviving works of art made for the Etruscans—whether by Greek or local artists—are in this style. A magnificent and unusually well-preserved bronze-covered processional chariot found in a tomb near Spoleto is a case in point (4, 51). Both the subject-matter and the style of the decorations are Hellenic. On the front Achilles receives his armour, a helmet and a shield with grimacing gorgon mask, from his mother Thetis. One of the side panels shows Achilles battling with Memnon, the other the apotheosis of Achilles. Scenes from the story of the Trojan War as recounted by Homer were, of course, often painted on Greek pottery at this period, sometimes with great narrative ability. But here the compositions are so crowded that the artist's aim seems to have been merely one of enrichment.

Etruscan love of adornment found its most striking expression in bronze mirrors and caskets engraved with figurative designs of great vivacity and elegance. An early example shows an embracing couple animated in a jerky dance (4, 52). Comparison with contemporary Greek vase decoration is illuminating. On an Archaic Greek vase the figures are depicted with the utmost clarity, almost as if they were a frieze of silhouettes (4, 2). Here they are placed together in such a way that the design is at first sight difficult to 'read'.

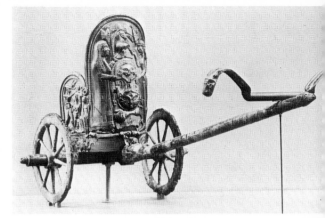

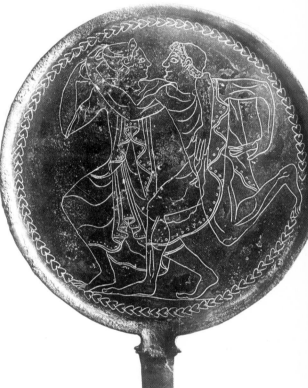

4, 51 *Top* Chariot from Monteleone di Spoleto, 550–540 BC. Bronze and wood, 51½ins (131cm) high. Metropolitan Museum of Art, New York, Rogers Fund, 1903.
4, 52 *Above* Engraved mirror, c. 500 BC. Bronze, 5¾ins (14.6cm) diameter. Staatliche Antikensammlungen und Glyptothek, Munich.

They are to be understood as facing one another, with the youth's right arm around the girl's shoulders. Apparent similarities between the arts of the Greeks and Etruscans are often deceptive. They overlie differences which go much deeper. For instance, a Greek statue of the late sixth or early fifth century BC,

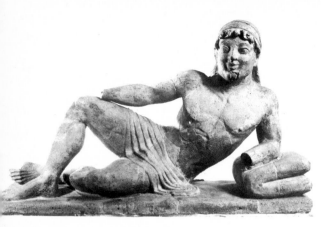

4, 53 Reclining youth, 500–480 BC. Terracotta, length of base 35½ins (90cm). Museo Nazionale Cerite, Cerveteri.

like those of the warriors on the temple at Aegina (4, 17), may have provided the model for the figure of a youth on the cover of an urn found at Caere (4, 53). But there is a world of difference between them. The heroic idealization of the Greeks has been brought down to earth. The Etruscan figure is much more descriptive, much more factual—almost the portrait of an individual caught in a casual moment, a banqueter resting his elbow on a cushion, with a cloth thrown lightly over his loins.

A different kind of deviation from the Greek ideal is apparent in the *Apollo of Veii*. This famous Etruscan statue has the face, the braided hair and even the enigmatic smile of a *kouros* (4, 54). The motif on the pier which serves as a support between the legs is lifted straight from Greek architectural ornament. The drapery which seems to have been ironed into pleats and folds is also Greek, though imitated from a *kore* since male figures in Greek sculpture were usually nude. But this Apollo with his heavy limbs and somewhat lumbering gait has none of the poised elegance of Greek statues. And it differs still further from the Greek in two other respects. It is of molded terracotta, not of marble, which was very rarely used for sculpture in Etruria (not until much later did the Romans exploit the quarries at Carrara, see p. 159). And it was one of a group of figures which stood outlined against the sky along the roof-ridge of a temple, giving the latter a very different aspect to that of its Greek prototype.

The earliest Etruscan temples seem to have been simple rectangular huts built of timber and mud-brick with decorations of molded and painted terracotta. Although the building materials remained the same, this basic form was amplified under Greek influence

before the end of the sixth century, when temples began to be set on high plinths or podia and provided with columns, pitched roofs and triangular pediments, later filled with sculpture. Very little survives apart from foundations and fragments of terracotta, but the descriptions by Roman writers enable us to reconstruct their general form (which was to influence later Roman architecture, see p. 158). In contrast to Greek temples, the cella was often divided into three compartments for different cult figures and seems never to have been completely surrounded by columns. There was a deep porch in front and sometimes colonnades on either flank, but not at the back. The podium had steps only at the front. Thus, whereas the Greek temple was intended to be seen from an angle, the Etruscan was designed to be approached along its axis and this determined the symmetrical plan of its forecourt. Etruscan temples were much smaller than the great Doric structures of the Greeks but very much more richly decorated—with figurative acroteria on the pediments, antefixes along the eaves, as well as statues on the roof ridge. Painted terracotta was

4, 54 *Apollo of Veii*. c. 500 BC. Terracotta, 69ins (175.3cm) high. Museo Nationale di Villa Giulia, Rome.

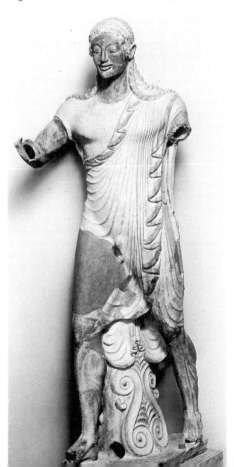

Plan of an Etruscan temple.

extensively used both to protect the impermanent building materials and for ornamental effect.

Symmetrical planning and rich plastic decoration similarly marked their domestic architecture. Our knowledge comes mainly from tombs, which were conceived as habitations for the dead (like those of ancient Egypt) and reproduce the interior architecture and even the furniture and furnishings of the now vanished cities. The wooden columns, door-posts, lintels and decorative details of Etruscan houses are simulated in roughly carved tufa (4, 47). Foundations show that the larger houses, though built only of mud-brick and timber, had spacious rooms and often a central courtyard or atrium open to the sky. By Athenian standards they were luxurious. Figurative paintings on the tomb walls, larger than any that survive from Greece, similarly reflect their interior decoration. The earliest known, in a tomb at Veii, date from the second quarter of the seventh century BC and are of ducks painted directly on the tufa without a prepared ground. They were followed slightly later by paintings of creatures from the semi-fabulous bestiary of 'Orientalizing' art. Shortly after the mid-sixth century BC human figures made their appearance in the tombs of Tarquinia, painted on a prepared ground of clay plaster. (Most of the surviving tomb paintings are at Tarquinia.)

The Archaic Greek style of these Tarquinian tomb paintings is so similar to that of recently discovered paintings of about the same date in Asia Minor (notably at Gordion and in Lycian tombs) that there can be little doubt of its having been introduced by Ionian artists. Subjects include hunting and fishing scenes, athletic contests, riding exercises, wild ecstatic dancing and occasional illustrations of Greek myths and legends. A decorative scheme or program, often repeated from about 500 BC, shows banqueters reclining on one wall of a tomb chamber and, on the other three, musicians and dancers in an outdoor setting amongst trees and birds (4, 46). Whether these depict funeral banquets, as in Egypt, is hard to say. Much in Etruscan tomb paintings is foreign to Italy.

But as indications of the wealth of the families who commissioned them they are certainly effective. They vividly reflect the worldly pleasures of members of a moneyed upper class, who loll on their couches listening to the music of lyre and pipes while watching the gyrations of dancers and the contortions of acrobats. The Etruscans appear, in fact, as spectators and not as participants in the Dionysiac dances and athletic sports with which the Greeks honoured the gods.

It seems likely that Greek art had in Etruria the value of what would now be called a status symbol. This may partly account for the persistence there of the Archaic Greek style, which had been introduced when the Etruscan cities were at the height of their wealth and power. Schematically drawn figures in a limited number of poses, with heads and legs in profile and frontally rendered torsos, went on being painted on the walls of Etruscan tombs long after they had been superseded by more naturalistic representations on Greek pottery. Often they have great linear grace and convey a sense of exuberant, rhythmical movement. The youthful lyre-player illustrated here is a good example, his body drawn nude, partly covered with the drapery which Etruscans demanded and the outline then filled in with bright colour without any modelling (4, 46). No attempt seems to have been made to follow the Greeks along the path towards greater naturalism. Indeed, any departure from well-established conventions seems to have met with disapproval from Etruscan patrons. Similarly in architecture, once the form of the temple (adapted from Greece, as we have seen) was established it remained unchanged until Etruria was swallowed up by Rome.

In sculpture, too, the Greek Archaic style lived on, barely influenced by fifth-century developments in Greece. The closest approximation to the Classical style is seen in the famous life-size statue known as the *Mars of Todi* (4, 55): but this is in every way an exceptional work, the only surviving large-scale bronze of Etruscan workmanship dating from before the second century BC. It was found, carefully buried in a sarcophagus, in the ruins of a temple at Todi, just outside the territory of the Etruscan cities. An inscription written in a mixture of Etruscan and Latin characters records that it was dedicated by a man named Ahal Trutitis. As on many Greek bronze statues, the lips were originally inlaid with copper and the eyes filled with coloured material (a helmet, which is lost, was cast separately and attached to the head). In craftsmanship it is as skilful as the best Hellenic work of the same late fifth- or early fourth-century date. Yet it could hardly be mistaken for a Greek statue. The

slightly awkward pose as well as the armour which conceals the torso set the *Mars of Todi* apart. His features are idealized, but according to an ideal altogether different from that of the Greeks: burly rather than athletic, with an expression of blunt assertion rather than inward self-confidence. There is, furthermore, a disturbing incongruity between the delicacy of the hands, the feet and the undergarment (especially its ruffled collar) and the lack of articulation in the thick neck and gross, swollen, rather than muscular, thighs. As in so many other Etruscan works, the naked flesh is treated summarily without any hint of that obsessive attention to the underlying structure of bone and muscle which marks the art of Greece. Nudity is rare in Etruscan art, in sculpture as in painting, where it usually indicates the inferior status of paid performers, servants or slaves.

Etruscan art was focused less on images of the gods or of men displaying godlike physique with the bloom of eternal youth, than on mortals. Even in the tomb the emphasis was on the here and now (at any rate until a late period). Their funerary art is, therefore, bafflingly paradoxical. The dead were normally cremated and cremation suggests a distinction between spirit and body. Yet belief in a material link between the two is implied by the Etruscan practice of providing the dead, whether cremated or buried, with the necessities and luxuries of the living. These apparently contradictory ideas lie behind the peculiar form taken by the containers in which the remains of the dead were placed.

Cinerary urns of the seventh century BC, found mainly in the cemetery of Clusium (modern Chiusi), have covers in the form of heads, sometimes with torsos and arms as well. They seem to have been evolved by a process of reification—the opposite of abstraction—from urns with helmet-shaped lids made for ashes by the early Iron Age people who preceded the Etruscans in north-central Italy (called Villanovans after an archeological site near Bologna). The impassive countenances with tightly closed lips and, usually, lowered eyelids are too alike to be described as portraits, although they were presumably intended as representations of the dead. In the tombs they were placed on chairs and later the whole urn was sometimes fashioned like an enthroned figure. For bodies which were inhumed, rather than cremated, a type of sarcophagus was developed in the sixth century BC in the form of a rectangular couch, on which a figure (or a couple) reclines (4, 56). This was probably inspired by Carthaginian sarcophagi, which combined the mummy-case of ancient Egypt with the rectangular coffin of the Near East. The same general form was adopted also for cinerary urns. Stylistically the figures derive from Archaic Greece and, as we have already seen, at least one of them is a distant relative of the warriors from Aegina.

What is new and distinctive about Etruscan sarcophagi and urns is that the figures are shown alive and apparently enjoying the pleasures of the table. From the fourth century onwards they were also modelled with almost caricatured individuality as if to preserve their physical identity. Curiously, however, the introduction of this more realistic style of representation coincided with a sharp increase in references to a terrifyingly dark afterworld—in tomb

4, 55 'Mars of Todi', early 4th century BC. Bronze, 55⅛ins (140cm) high. Vatican Museum, Rome.

4, 56 Sarcophagus from Caere (Cerveteri). c. 520 BC. Terracotta, about 79ins (200cm) long. Museo Nazionale di Villa Giulia, Rome.

paintings as well as in sarcophagi and urns. Two figures with strongly characterized faces and attenuated bodies on an urn from Velathri (modern Volterra) may represent either a none too happily married couple or a man accompanied by a demon of death.

A similar, if more restrained, naturalism is apparent in bronze heads. The finest, probably from a' whole-length statue, is that traditionally said to portray Lucius Junius Brutus (fl. 509 BC), the supposed founder of the republic, who roused his fellow Romans to expel the last Etruscan king, Tarquinius Superbus, from their city (4, 48). Whether or not the identification is correct, this rugged face with piercing eyes, aquiline nose and sternly set jaw surely records an individual, and one with an unbending sense of purpose. Hair and short beard are rendered with all the accomplishment for which Etruscan bronze-workers were renowned. As an example of skill in casting and chasing, it surpasses the *She-wolf* of the Capitol (4, 49) and confirms the survival of these skills into a later period.

The Etruscans, although they had shown themselves so strangely impervious to later developments of the Greek Classical style, were drawn into the cultural orbit of the Hellenistic world towards the end of the fourth century BC. So, too, were the Romans, soon to become the dominant power in the Itàlian peninsula. One by one the cities of Etruria fell to Rome and by the beginning of the first century BC the Etruscans had been absorbed into the composite population of Italy. Before long, the Roman poet Propertius was to write his famous lament:

Veii, thou hadst a royal crown of old,
And in thy forum stood a throne of gold.
Thy walls now echo but the shepherd's horn,
And o'er thine ashes waves the summer corn.
(Propertius IV, X, 27, tr. G. Dennis)

But enough survived above ground for other Roman writers, notably the architectural theorist Vitruvius, to record and discuss. One Etruscan temple built about 500 BC, with a cult statue of Jupiter by Vulca of Veii, the only named Etruscan sculptor, survived in the heart of Rome itself until 83 BC. It was then burnt down. Only the plan was preserved in the rebuilding. Otherwise the new temple was completely Hellenistic in style. It neatly illustrates the complementary legacies of Etruscan and Hellenistic culture in the formation of the art of the Roman empire.

5 Hellenistic and Roman art

A sumptuously sculptured and coloured sarcophagus found at Sidon, the former Phoenician city on the coast of present-day Lebanon, is a masterpiece of technical accomplishment in the handling of marble (5, 1). The workmanship is Greek and the amazing skill with which the material is chiselled, undercut, drilled and finished to present varying surfaces of subtly contrasted textures bespeaks a long tradition of carving, gradually and laboriously refined since the beginning of the Classical period (see p. 103). Figures, especially the athletic nudes, the riders and their horses, lucidly arranged on a shallow stage, recall those on the frieze of the Parthenon, and not only as ideal 'types'. They all have that organic unity of structure which was fundamental to Greek art and its naturalistic bent.

5, 1 *Alexander Sarcophagus*, c. 310 BC. Marble, 76½ins (194.3cm) high. Archeological Museum, Istanbul.

And yet, the work as a whole differs radically from anything previously produced in the Hellenic world.

Sarcophagi had rarely been made in Greece, least of all in Athens, where the dead were either cremated or buried in simple, unpretentious receptacles and commemorated by laconic, though often very beautiful, *stelae* (4, 30). Greek attitudes to the afterlife and

form of the sarcophagus itself, therefore, but also iconographical and other elements reflecting attitudes to the afterlife, mark the re-entry into Greek art of influences from other cultures, which had been rare since the much earlier Orientalizing period. By the time this sarcophagus was carved, Greek civilization was, in fact, no longer limited to the shores of the Mediter-

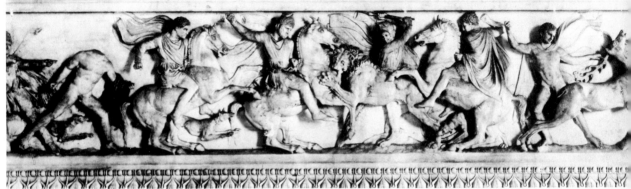

5, 2 *Top* Detail of plate 5, 1.
5, 3 *Above* Silver tetradrachm of Lysimachus of Thrace, 306–281 BC. 1⅛ins (3cm) diameter. British Museum, London.

aversion to any idea of personal apotheosis were unfavourable to the development of sculptural glorifications of the dead. As an art form the sarcophagus had Oriental, ancient Egyptian and Etruscan antecedents. Often shaped like a house with a pitched roof, it provided a dwelling-place for the deceased and implied beliefs about the hereafter rather different from those held by the Greeks. But it was to become the predominant art form in funerary sculpture from the late fourth century BC throughout the Hellenistic and Roman eras right down to early Christian times.

In the example illustrated here, the so-called *Alexander Sarcophagus*, the reliefs show Greeks and Persians. On the front, they are fighting one another. On the back they join in a hunt in one of the big-game preserves which were a Persian specialty, the lion recalling those on Assyrian reliefs (5, 2). Not only the

ranean. Philip II of Macedon (382–336 BC), who united the city-states of Greece and robbed them of their independence, was succeeded by his 20-year-old son Alexander the Great (356–323 BC). As soon as he had firmly established control of the Greek mainland, Alexander led his army across the Hellespont into Asia. The Persians, the traditional enemies of the Greeks, were soon defeated and with astonishing speed Alexander made himself master of their entire empire and more. He conquered all Asia Minor, Syria, Egypt, Iran, Bactria and then passed beyond the Indus into the Indian sub-continent.

The battle on the front of the *Alexander Sarcophagus* records one of his first victories, possibly that over the Persian king Darius at Issus in 333 BC. Alexander is shown on the far left, clearly recognizable from his facial features as portrayed on coins (5, 3). Near him in each scene there is the same much older figure in Persian costume, almost certainly the man for whom the sarcophagus was carved—the satrap of Sidon, who had prudently surrendered to Alexander and became his vassal. Portraiture had rarely been practiced by the Greeks, but became increasingly important from the fourth century BC onwards. Alexander is not simply portrayed, however; he is all but deified by the emblems he wears on his head—the lion-skin of the deified hero Hercules, with whom he was often compared, and the horn of the Egyptian ram god Amun, whose 'son' he was claimed to be after his

conquest of Egypt. He thus appears as the first in a long line of European emperors and kings who were accorded—like Oriental monarchs—the worship that the Greeks had hitherto paid only to the gods.

The meeting and intermingling of different cultures, so clearly visible in the *Alexander Sarcophagus*, is one of the essential aspects of both Hellenistic and Roman art. The interpenetration of Oriental and Occidental, of primitive and advanced ideas from East (Persia) and West (Etruria) reanimated and made more fluid the Greek inheritance and thus brought about the creation of a great new art for the enormously expanded, cosmopolitan world of the succeeding era.

The Hellenistic period

The term 'Hellenistic' refers to a period of some three centuries from the death of Alexander the Great in 323 BC. Babylon was to have been the capital of Alexander's vast Hellenized Near Eastern empire, but when he died, aged only 32, his conquests devolved upon his generals, known as the diadochi or successors, who set themselves up as absolute monarchs. Ptolemy took over Egypt and southern Syria, including Judea. The rest of the empire in Asia fell to Seleucus; Macedon was taken by the successors of Antigonus; other Hellenistic kingdoms were smaller.

5, 4a *Medici Venus*, 1st century AD. Marble, 60¼ins (153cm) high. Uffizi, Florence.
5, 4b *Apollo Belvedere*, 2nd century AD. Marble, 88ins (223.5cm) high. Vatican Museums, Rome.
5, 4c *Venus de Milo*, c.150 BC. Marble, 82ins (208cm) high. Louvre, Paris.

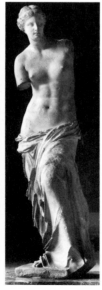

In Greece and the Aegean islands the city-states recovered some of their independence during the third and second centuries BC, but they had lost their power and importance; and Athens was now little more than a centre of culture and learning. The end of the Hellenistic period cannot be as precisely dated as its beginning. In the mid-third century BC the Seleucids were driven out of Iran by Parthian nomads from the steppes, who pressed on to occupy Mesopotamia in 141 BC. During these same years the Roman republic (see p. 147) became the dominant power in the Italian peninsula and eventually in the whole Mediterranean area (see p. 154).

The rulers of the Hellenistic kingdoms were of Greek (strictly Macedonian) descent, and so, too, were most of their administrators. The official language was a form of Greek called *koiné*—the Greek of the New Testament—spoken and written from Sicily to the Hindu Kush, from the shores of the Black Sea and the Caspian to the cataracts of the Nile. Greek culture spread over the same area. What had previously been confined to a few, relatively small independent communities now became the artistic language of half the civilized world. Cities were built or rebuilt on the pattern of the Greek *polis*, each with its temple, assembly hall, theatre, gymnasium, stoa and agora all conforming to the Greek orders of architecture and adorned with sculptures embodying the Greek ideal of the beautiful human form. The capital cities grew into large and wealthy centres of trade, industry, learning and artistic activity: Alexandria in Egypt, Seleucia on the Tigris, Antioch near the coast of Syria and, later, Pergamum in Asia Minor. And their influence extended to the Greek cities of the Western Mediterranean, to Etruria and to Rome.

Small, tightly knit, heroically competitive societies have given way to vast, amorphous, cosmopolitan urban centres, predominantly commercial and manufacturing. Their history has sometimes been described, and often dismissed, as a confused and unhappy epilogue or degenerate sequel to the Classical Age. But they made important contributions to civilization. The two most widely influential philosophies of life in the ancient world were Hellenistic: Stoicism, which held virtue to be its own reward, and Epicureanism with its belief in virtue as the prerequisite of happiness. Both were philosophies of withdrawal, reflecting a shift in emphasis from problems of human relations—man as by nature a 'political animal' in Aristotle's famous definition, i.e. a citizen of a free *polis*—to those of the inner life of the individual.

Aristotle (384–322 BC), who had been tutor to Alexander, began his long domination of scientific

thought and method, and nearly all the major achievements of the ancient world in science and mathematics date from the Hellenistic period: Euclid's *Elements*, the discovery of specific gravity and the invention of the water-pump by Archimedes, the calculation of the diameter of the earth to within a few hundred miles of the correct figure by Eratosthenes.

In the visual arts the influence of the Hellenistic world was to be equally pervasive. The Greek sculptures admired and collected by the Romans included such Hellenistic works as the *Medici Venus* and *Apollo Belvedere* (5, 4a and 5, 4b). The *Medici Venus* is the best of 33 surviving copies or versions of a lost original presumed to be of the third or second century BC. It owes a debt to the *Aphrodite of Cnidus* by Praxiteles (4, 23c), but the rendering is less idealized—more fleshy and malleable—and there is a hint of self-conscious coquetry in the turn of the head and almost alluringly defensive gesture. The arms held in front of the body also emphasize the third dimension and lend the whole figure a gyrating movement. The *Apollo Belvedere* is a second-century AD Roman copy or version of a lost original usually presumed to have been a late fourth-century BC bronze, although it is at least equally likely that the statue was based on more than one original and is a pastiche. With its almost dancing posture, effeminate physique, elaborately dressed hair and heartlessly beautiful face, the *Apollo Belvedere* makes a very striking contrast with surviving male statues from fifth-century BC Athens. Although neither the *Medici Venus* nor the *Apollo Belvedere* was as famous in its own time as it became when rediscovered a thousand or more years later (in the late fifteenth and mid-sixteenth century respectively), they illustrate very well certain formal tendencies of the period. Sensuous delight in the handling of marble, equally characteristic of Hellenistic sculpture, can be seen in the *Venus de Milo* (5, 4c). The material here might almost seem to have been caressed rather than chiselled and rasped into the texture of soft, warm flesh, complementing an air of rather precious worldly elegance and sophisticated self-awareness.

It was in late fourth- or early third-century BC Alexandria that the first histories of art (as distinct from criticism and aesthetic theory) seem to have been written. They have all perished, as have most Hellenistic prose writings, but passages survive, sometimes as direct quotations, embedded in the works of such later writers as the elder Pliny and Pausanias. From these fragments it can be deduced that they were conceived in terms of a linear progression from crude beginnings in the distant past to a high point of achievement in the later fourth

century BC—neatly coinciding with the rise to power of the Macedonian dynasty. Praxiteles and Lysippus, Alexander's court sculptor, were claimed to have excelled all their predecessors, and Alexander's court painter, Apelles, was said by Pliny to have 'surpassed all those who were born before him and all those who came later'.

The notion of a 'norm' towards which art aspires was first put about in this way by Hellenistic writers. To them also is due the idea of a 'Classical moment' or high point, when the summit of achievement is reached and after which it declines. They located this apogee in the late fourth century BC, it should be noted, and not in the fifth century BC. (The idea that Greek art and culture reached its height under Pericles came later.)

Artists were, for the first time, placed in history and came to see themselves as living in the aftermath of a great period. Hence the strong conservative 'Classicistic' tendency in Hellenistic art, for which a philosophical rationale could be found in Plato's contention that works of art should, like everything else, ideally conform to some absolute standard. As we have already seen, he praised the Egyptians for permitting no artistic innovations. His theory was, however, criticized by Aristotle, who propounded a more commonsensical and relativist doctrine. Whereas Plato believed the works of man to be at best but pale imitations of heavenly prototypes or 'Ideas', Aristotle approached the problem empirically and tried to identify the various 'causes' governing the generation of any man-made object and thus giving it its form. The form an object took depended, according to him, not on some fixed 'Idea' to which it approximated but on who made it, what it was made of and, above all, on its purpose or 'final cause'. In this way began one of the great debates in the history of Western aesthetics—and to it the expanding range of Hellenistic art was largely due.

For Aristotle's teaching opened the door (in theory at any rate) to expressiveness and the cultivation of the artist's individuality, even to eclecticism and to the notion that an artistic style might be appropriate in certain circumstances and not in others. His relativism in this sense is most explicit in his discussion of rhetoric. A speech in the public assembly should, he said, be like *skiagraphia* or shadow-painting (probably a style of painting using strong contrasts of light and shade to give an illusion of the third dimension). Bold outlines and broad handling were therefore desirable. In the law-courts, on the other hand, a finer and more intricately and subtly constructed speech would be appropriate. By analogy, styles in the visual arts might be regarded like literary genres—epic, tragic, comic,

lyric, elegiac—each with its own rules, laid down in Aristotle's *Poetics*.

The emergence of such ideas signals a profound change in attitudes to the arts. Statues, paintings and even temples gradually came to be thought of as 'works of art' rather than as images, whether animistic or merely ritualistic. Increasingly they were seen as the creations of individual artists, working for individual patrons. And this process of secularization was taken a stage further with the rise of art-collecting in the Hellenistic period, leading to the 'promotion' of famous artists. That the first histories of art should have appeared at the same time was no coincidence, more especially as they seem to have been written by practicing artists. But other, non-artistic factors may also have been involved. Propagandist overtones may be detected occasionally in the praise accorded to artists of Alexander's time. How far the motivating impulses for this entire intellectual structure were political, and how far aesthetic, is by no means clear. There can, however, be little doubt that the artistic style of the late fourth century acquired political significance, visually associating Hellenistic rulers with Alexander and his legacy of prestige and power.

This was obviously the intention of the satrap of Sidon in commissioning his sarcophagus (5, 1). Here Alexander appears as the superhuman victor and hero, taking the place of a god watching over the fate of men in earlier Greek battle reliefs or paintings. The sculptor clearly intended Alexander to be symbolic—but also a portrait. The youthful clean-shaven face (Alexander drove beards out of fashion) is recognizably that of the same person in several other representations which probably go back to contemporary likenesses. And this naturalism extends to the other figures, whose heads are so strongly individualized as to suggest that they, too, are portraits. The costumes and physiognomy of the Persians are recorded as in the generically similar Alexander mosaic (5, 16), with an ethnographic fidelity rare in Greek art except occasionally in vase paintings of Africans and, more notably, the fourth-century pectoral made for a Scythian chief (4, 33). In the sarcophagus naturalism is combined with symbolism to generalize and give eternal significance to historical events. Thus some of the Greeks are heroically nude, perhaps to symbolize the triumph of Greek intelligence over barbarian brute force, which enabled Alexander to rout armies greatly outnumbering his own. The composition is complex enough to give an impression of action and yet sufficiently formal to suggest that order is being brought out of confusion. The figures are posed to echo and counterbalance one another within a carefully devised pattern of diagonals.

The carving is still as sharp and crisp as it was when the sarcophagus was placed in the tomb chamber which protected it from the elements for over 2,000 years. It even retains some of the pigments with which it was painted, enough to show that the colours were naturalistic and not, as on Archaic Greek sculpture, conventional. Flesh was given a yellow wash, slightly darker for the Persians than for the Greeks, and hair, eyes, lips and garments were picked out in shades of brown, red, violet and blue. Because of its almost unique state of preservation there are very few other works in marble with which the *Alexander Sarcophagus* can be compared. But the same sophisticated taste for virtuoso displays of craftsmanship, for the most subtle and sensuous handling of the material, is seen in surviving metalwork of the late fourth century BC. On a magnificent krater found at Derveni in Macedonia—a masterpiece of bronze casting, chasing and repoussé hammering (5, 5)—Dionysus is shown in

5, 5 *Derveni Krater*, c. 350–25 BC. Bronze and silver, $3\frac{1}{2}$ins (9cm) high. Archeological Museum, Thessalonika.

a wonderfully relaxed, yet elegant, pose of erotic abandon, resting his right thigh on the lap of Ariadne. With this sexually symbolic gesture of casual dalliance the grand passions of the ancient gods are tamed and refined.

Statuettes of bronze and other materials had, of course, been produced in Greece for centuries, usually, it seems, as votive offerings; only now did they begin to appear as independent decorative works of art. One of the finest is a statuette of a dancer, apparently a professional mimer (5, 6), quite clearly not the Muse of Dancing nor one of the worshippers of Dionysus who had appeared in ecstatic poses in so many early vase paintings. Clutching at drapery tightly drawn across her body, her right foot slipping out from beneath her long dress, she seemingly sways to some slow rhythm. Both the structure and the movement of the form beneath the clothing are rendered with a naturalism which could have been achieved only by close observation. The figure is also a *tour de force* of three-dimensional form which demands to be examined from every viewpoint and seems to have been modelled quite simply in order to be admired. A whole series of complicated changes of direction are beautifully contrasted and balanced and held together in a continuous sweeping but subtly restrained rhythmic phrase. But statuettes of much less attractive subjects were also produced: grimacing dwarves, emaciated youths, crippled hunchbacks begging for alms. Whether such images of lower-class poverty and misery had already acquired the sinister charm that they later held for rich upper-class art-lovers is impossible to say.

According to Aristotle, an imitation is in itself pleasurable, and looking at it delights the eye. Things which repel in everyday life may please when represented in art, he wrote. This is as diametrically opposed to Plato's contention that all imitations are false and therefore morally harmful as it is to Socrates' demand that artists should concentrate on representing the 'good' and 'beautiful', terms which are interchangeable in ancient Greek. Little distinction was made by the Greeks between physical and moral beauty: all Homer's heroes are handsome, all his villains ugly or deformed; the fat men occasionally depicted on vases are invariably figures of fun. But Socrates, himself snub-nosed and short of stature, had begun to evolve a more subtle and profound conception of the outer and inner man and the relationship between them. This and similar currents in Greek thought, coinciding with the rise of naturalism in the visual arts, modified very notably the traditional Greek conception of beauty. Nobility, if not beauty, of soul might now be discerned

5, 6 Dancer, c.225–175 BC. Bronze, 8⅛ins (20.6cm) high. Metropolitan Museum of Art, New York, Walter C. Baker, 1972.

within an unprepossessing exterior. No longer was the clean-limbed young athlete the sole and exclusive ideal. (By this date, prize athletes were no longer aristocratic amateurs but professional performers, and this may not be irrelevant.) This modification was to have enormous and profound consequences for the visual arts and was felt immediately in the sudden development of lifelike portraiture in the last decades of the fourth century and first of the third.

The contrast between weakness of body and strength of soul was very clearly expressed in a statue of Demosthenes—that vociferous opponent of both Philip II of Macedon and Alexander—and also in the words inscribed on its base: 'If your strength had equalled your resolution, Demosthenes, the Macedonian war-god would never have ruled the Greeks.' Surviving copies reveal how the frail, lean body was animated and ennobled by the indomitable spirit shining through the stern, forthright expression on his face (5, 7). It was a posthumous portrait set up by the Athenians in 280 BC and there may be a touch of idealization in the head. But there is none whatever in the several images of Socrates and later philosophers (again known only from copies), which might almost be thought to emphasize their physical peculiarities. One of the few which can be dated to the third century BC is perhaps of Hermarchus, the chief follower of Epicurus, an unflattering but none the less endearing figure of an old man, bearded head slightly bent, loose

141

flesh on his chest, toga gathered around a pot-belly, and shrunk shanks held rather wide apart (5, 8). Even the rulers of the Hellenistic world were portrayed with surprising frankness—Philetaerus of Pergamum, who had been accidentally castrated in childhood, is shown on coins with the heavy bloated features of a eunuch, and Euthydemus, who usurped the Bactrian throne in 230 BC, might almost seem to have gloried in his bottle-nosed brutality (5, 9).

Sleeping figures appear for the first time in Hellenistic sculpture, notably a famous Ariadne and a sleeping faun slouched back in sensuous indolence, both expressive in their uncontrolled movements and gestures of a new awareness of man's instinctual nature. Their unconscious bodily responses betray a temporary disjunction of body and mind. An exceptionally fine bronze beautifully catches the complete

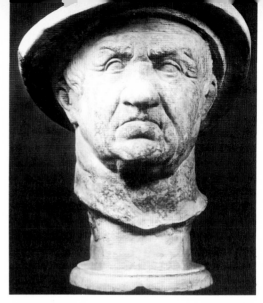

5, 7 *Far left Demosthenes*, Roman copy of an original, probably by Polyeuctes, c. 280 BC. Marble, life-size. Vatican, Rome.
5, 8 *Left Hermarchus* (?), mid-3rd century BC. Bronze, 10⅜ins (35cm) high. Metropolitan Museum of Art, New York, Rogers Fund, 1910.
5, 9 *Above Euthydemus of Bactria*, c. 200 BC. Marble, 13¾ins (35cm) high. Villa Torlonia, Rome.

relaxation of a tired child in deep sleep, legs apart, one arm thrown across the body, and faithfully renders the appearance of loose, dimpled infantile flesh (5, 11). As the wings with ruffled feathers reveal, however, this is no ordinary child. He is usually identified as the god of love, Eros, son of Aphrodite, though why he should be sleeping is something of a mystery. (Deities were usually shown in characteristic attitudes and actions.) Does he represent the tranquillity attained, so the Stoics believed, when desires are laid to rest? Is he one of the brothers Hypneros and Thanatos—sleep and death—who were visualized as winged children? Is he some other personification reflecting that shift in emphasis, to which we have already alluded in connection with Hellenistic thought, towards the inner life and introspection and philosophies of withdrawal? Or is he simply a decorative figure? It is impossible to give a certain answer: but it is indicative of the expanding range of Hellenistic art that it should pose such questions.

It is in this context that allegory, which means literally 'saying something else', first occurs in European art. By the second century BC the Greek gods had lost much of their credibility as inhabitants of a superior world influencing the life of mankind below. In Hellenistic art they tend increasingly to become personifications—of love, death, wisdom, courage, and even of such abstractions as opportunity, luck, strife and forgetfulness, which had not been previously

deified. Lysippus carved a statue of *Opportunity*, running on tip-toe with winged feet, a razor in the right hand, the proverbial forelock in front of the face, the back of the head bald to indicate that he cannot be caught from behind. Such statues were intended to be 'read'.

The Greek statue of a deity, hero or athlete had been self-sufficient, a thing in itself. In the Hellenistic world such figures might acquire allegorical significance from their contexts. One of the major masterpieces of Hellenistic art is a case in point: the *Nike* or 'Victory' set up about 190 BC by the inhabitants of the small north Aegean island of Samothrace to commemorate a naval victory (5, 10). Here the context redefined the meaning of an old image and so reanimated it, as comparison with the late fifth-century *Nike* at Olympia reveals (4, 21). Whereas the earlier figure flutters atop a high column, the *Nike of Samothrace* lightly 'touches down' as if in a sudden gust of wind on the prow of a ship, which was originally set in a fountain with boulders emerging from the water in the foreground. Although both were made in connection with historical events, the former is generalized, with the goddess Victory shown as if ready to descend where she will, while the latter is quite specific in representing the victory off the coast of Samothrace. The difference in meaning is reflected in the form, even in the handling of the marble. On the *Nike of Samothrace* drapery is rendered as thick wind-swept cloth rather than as a

5, 10 *Below left Victory of Samothrace*, c.190 BC. Marble, 96ins (244cm) high. Louvre, Paris.
5, 11 *Below Sleeping Eros*, 250–150 BC. Bronze on marble, $33\frac{3}{4} \times 30\frac{3}{4}$ins (85.7 × 78cm). Metropolitan Museum of Art, New York, Rogers Fund, 1943.

diaphanous, almost insubstantial membrane. The structure of her well-built form is, none the less, apparent beneath the rich folds and furrows of billowing material, which, with complex rhythms of light and shadow, heightens the figure's dramatic impact.

A taste for the small and exquisite was combined with a love of the vast and grandiose, both extremes becoming typical of Hellenistic art and contrasting very strongly with the aims of fifth-century Greek artists and their ideal of the 'golden mean' (see p. 107). Lysippus was renowned for his ability to work on either scale. One of his masterpieces is said to have been a little bronze Hercules he made to stand on Alexander's table, another was a colossal bronze Hercules some 58 feet (18m) tall set up in the Greek city of Taras (present-day Taranto) in southern Italy. His

pupil, Chares of Lindos, nearly doubled this height in his famous Colossus of Rhodes.

The over-life-size figure poses problems of structure and also of proportions, for it cannot be simply a mathematical enlargement. The optical distortions, due to the spectator's viewpoint, would make any simple enlargement appear grotesque. It may well have been in this context that Lysippus is said to have boasted that where his predecessors had represented men 'as they really were', he represented them 'as they appeared to be'. He is credited with a complete revision of the Polyclitan canon of proportions (see p. 111), which had been based on actual measurements of the human form. Although none of his reputed 1,500 works survives, and very few are known even from copies, numerous Hellenistic statues are based on the scale of proportions associated with him, which involved mainly a slight reduction in the size of the head and a corresponding extension of the limbs, thus producing an appearance of greater height.

One of the finest of the Lysippic statues is a slightly more than life-size male nude, an original Hellenistic bronze variously dated between the early third and the late second century BC (5, 13). There is a characteristically Hellenistic combination of naturalism and rhetorical allegory in this work. The traditional walking posture is given a more vivid sense of lively movement by the wider spacing of the feet and the placing of the arms in a bold spiral curve. Somewhat overdeveloped broad-shouldered muscularity con-

5, 12 *Altar of Zeus*, from Pergamum, c.175 BC. Marble, reconstructed and restored. Staatliche Museen, East Berlin.

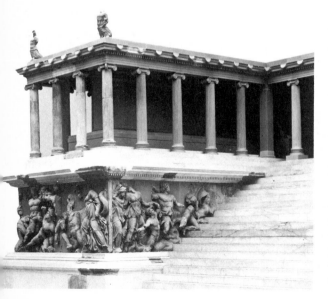

forms to a new ideal of physical vigour, which stresses strength and weight rather than the nimble, light-foot agility of earlier Greek athletes. Yet the face is anything but idealized and would seem to be that of an individual, a portrait head, in fact. This type of portrait statue—the 'ruler portrait', as it is called, with only the head as a likeness—was a Hellenistic invention. The physical perfection which, in Archaic and Classical Greece, athletes had shared with the gods was now attributed to the ruler, to whom divine honours were paid.

Many of the qualities which differentiate Hellenistic from Classical Greek art reach their apogee in the great *Altar of Zeus* from Pergamum in north-western Asia Minor (5, 12). It was by far the largest sculptural complex created in the ancient world, a work so grandiose and imposing that the author of the Biblical Book of Revelation later called it 'Satan's seat'. Erected as a memorial to the war which, ironically, established Rome as the dominant power in the eastern Mediterranean, it commemorates in more ways than one the beginning of the end of the Hellenic world. Pergamum had been a kingdom of minor importance until 230 BC, when its king Attalus I defeated an invading force of Gauls from the north and briefly made himself master of Asia Minor. The event was celebrated in a series of statues of dead or dying Gauls, now known only from later copies (5, 14), which reveal the emergence of a distinctive Pergamene style responsive to the highly 'civilized' demands of its patrons. For in this remarkable sculpture the defeated is endowed with dignity, even nobility, and those introspective, spiritualizing trends in Hellenistic thought, which held that the body is the prison of the soul, found their classic expression. The spirit persists while life slowly drains away from the body of the *Dying Gaul*. Comparison between him and the *Fallen Warrior* from Aegina (4, 17) shows how much had been gained in expressiveness—and how much lost in purely sculptural power.

The *Altar of Zeus* was erected some 50 years later. It stood on a 20-foot-high (6m) platform, surrounded by an Ionic colonnade. The approach was from the back, so that only after walking round the building did the great flight of steps leading up to the altar come into view. Running round the base was a sculptural frieze (which only partly survives) some $7\frac{1}{2}$ feet (2.3m) high and, in all, more than 300 feet (90m) long. On the interior wall of the colonnade at the level of the altar a second frieze, of which a good deal less has been preserved, runs for some 240 feet (73m); it is about 5 feet (1.5m) high. (The remains of the building were dismantled after excavation in the late nineteenth

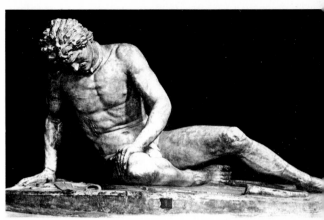

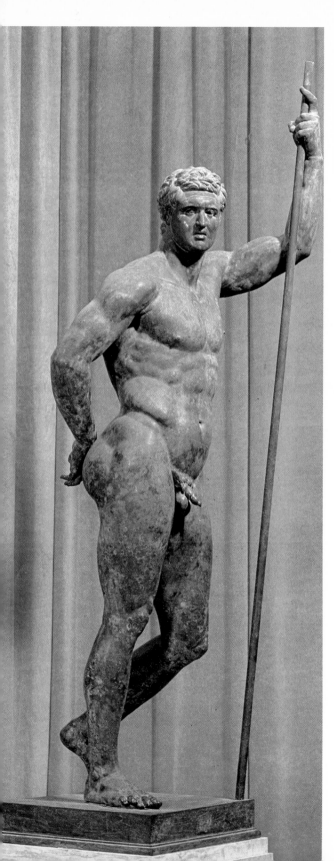

5,13 *Left Hellenistic Ruler*, c.150–140 BC. Bronze, 87⅜ins (222cm) high. Museo Nazionale Romano, Rome.
5,14 *Above Dying Gaul*, Roman copy of a bronze original of c.230–220 BC. Marble, life-size. Museo Capitolino, Rome.

century and re-erected in the Berlin Museum in about 1900.) The first and larger frieze is devoted to a battle between gods and giants, the gods being the full height of the relief slabs and the giants even bigger, only their huge menacing torsos being visible. Muscles swell in great hard knots, eyes bulge beneath puckered brows, teeth are clenched in agony. The writhing, overpowering figures seem contorted, stretched, almost racked, into an apparently endless, uncontrolled (in fact, very carefully calculated) variety of strenuous, coiling postures to which the dynamic integration of the whole composition is due. Rhythmic sense is felt very strongly—a plastic rhythm so compelling that the individual figures and complex groups are all fused into a single system of correspondences throughout the whole design. Deep cutting and under-cutting produce strong contrasts of light and dark which heighten the drama and seem to echo in abstract terms the great cosmic conflict between Olympians and earth-bound giants. The effect, in fact, is painterly rather than sculptural in its dramatic use of *chiaroscuro*—the stone is carved so that effects of light and shade suggest forms without describing them in full—and in its extreme naturalism, which is taken to such lengths that some of the figures break out of their architectural frame altogether and into the spectator's space. One of the giants leans out to kneel on the steps leading up to the altar. The upper frieze is quite different with figures smaller than life, subtly carved in low relief, and intended to be examined closely—a contrast recalling Aristotle's description of the various contrasting oratorical styles (p. 139).

Likewise, in the structure as a whole, a sculptural

145

5, 15 Interior of the Temple of Apollo, Didyma, near Miletus, Turkey, begun 313 BC.

conception of architecture as mass in space—rather than space regulated by mass—was taken to its furthest extreme. Yet the classic virtue of a clear relationship of parts to the whole might be said to have culminated here. For the continuous band of sculpture makes a wonderfully rich, almost a colour contrast with the base below and colonnade above, giving by its complexity a peculiar value to the cool lucidity and elegance of the Ionic columns. The interior—always of less importance than the exterior in ancient Greece—has been eliminated altogether. The whole building is nothing but a façade.

In urban planning, too, some very significant departures were made at Pergamum from former Greek practice. On its rocky acropolis the *Altar of Zeus* was only one of several structures, including a temple of Athena, a library, large theatre, royal palace and stoa, all visually related to one another and placed so as to take full advantage of the terraced hill-top site. Such an interest in the monumental effects obtained by careful siting, grouping and the creation of vistas first becomes apparent only in Hellenistic times. In Athens itself at the end of the fourth century BC, the agora was still simply an irregular open space bordered by a number of detached and unrelated buildings. All this was changed in the second century BC by, significantly enough, Attalus II of Pergamum. Two long stoas were built on the south and east sides, thus creating a unified spatial composition out of the previously amorphous area.

The history of Hellenistic architecture is, however, hard to trace. We know less about it than about earlier, Classical Greek architecture, for much less has survived. Nothing remains in the three great capital cities: Alexandria and Antioch were both entirely

rebuilt by later inhabitants, Seleucia on the Tigris was deserted and left to crumble away after the Parthian occupation. The *Altar of Zeus* from Pergamum (5, 12) and the huge Corinthian temple of Olympian Zeus at Athens (begun 174 BC, but not completed until about AD 130) are almost the only major buildings of which more than the foundations are visible, although enough survives at Didyma on the west coast of present-day Turkey to indicate the dramatic effects sometimes achieved in planning (5, 15). The central doorway of this great dipteral temple, approached through gigantic Corinthian columns over 64 feet (19.5m) high, led from an antechamber to a great flight of steps descending into an open, sunlit interior court, where an elegant small Ionic temple contained the cult statue. Similarly inventive planning has been revealed by excavations in temple precincts (sanctuary of Asclepius on the island of Kos, third century BC) and in whole urban areas (e.g. Priene); but our knowledge of ancient urbanism is very limited. (The name of Hippodamus, the fifth-century BC Milesian architect credited by Aristotle with the systematization of regular street patterns of the gridiron type, has been associated with Priene; and regular, usually rectangular, street-planning goes back to the seventh century BC in the Aegean and much further in ancient Egypt, Mesopotamia and the Indus Valley; see pp. 47 and 36.) However, excavations show the new importance given in Hellenistic cities not only to prominent civic buildings but to monumental effects in their disposition—and to an increase in the size and decorative richness of private houses with painted walls and elaborate pebble-mosaic pavements (at Pella in Macedonia, the birthplace of Alexander, and on the island of Delos, an important centre for trade in slaves). If little remains from the period itself, it seems almost certain that the opulent architectural style elaborated in Asia Minor and Syria under Roman rule, especially at Baalbek and Palmyra, derived from Hellenistic prototypes and reflects Hellenistic aspirations and achievements.

Hellenistic and Roman painting and mosaics

Wall paintings and floor mosaics which decorated town and country houses in Italy in the last two centuries BC and the first AD are mainly in the pictorial style developed in the Hellenistic kingdoms, and some were the work of artists from the eastern Mediterranean. They are geographically, rather than culturally, Italian—like much of the earlier pottery, metalwork and paintings in Etruscan tombs (see p. 133). But they date from the period when Rome had already gained control of a large part of the Hellenistic world

and also of territories to the north and west. By the beginning of the second century BC, the Romans had made themselves masters not only of the whole Italian peninsula, Sicily, Sardinia and Corsica, but also of the former Carthaginian colonies in the south of France and Spain. They subdued Carthage and its north African territories in 151 BC, annexed Greece three years later and the kingdom of Pergamum in 131 BC. The Ptolemaic kingdom of Egypt came under Roman 'protection' early in the first century BC and was constituted a Roman province in 30 BC. Roman power and influence were, however, military, political and economic. The Roman upper class had absorbed Hellenistic culture. As Horace (65–8 BC) put it, 'When Greece had been enslaved she made a slave of her rough conqueror and introduced the arts into an uncultivated Latium [the province of Rome, present-day Lazio].' The territories amassed by the Roman republic were more tightly organized under the Emperor Augustus (27 BC–AD 14), whose reign initiated a century and a half of peace—the *pax romana*—throughout the whole Mediterranean area. The Roman empire grew still larger under Augustus's immediate successors, the Julio-Claudian emperors and the Flavian dynasty (69–98), reaching its greatest extent—from the Euphrates to the Atlantic, north Africa to Scotland—under Trajan (117–138) and the Antonines (138–192). This vast expansion of the empire geographically, ethnically and in other ways, raises almost insuperable problems in defining Roman art (see p. 166).

The sculpture, paintings, mosaics and other works of art from Pompeii and Herculaneum, smothered under lava and ashes from Vesuvius in August AD 79 and not uncovered until the eighteenth century, illustrate the problem. The most impressive of the mosaics represents Alexander's victory over the Persians, the battle of Issus, and is as Hellenistic in style as in subject-matter (5, 16). Its composition is almost certainly derived from a late-fourth-century BC painting, perhaps by Philoxenus of Eretria, whom Pliny credits with such a scene. There is also a tantalizing reference to a picture of this subject by Helen, daughter of an Egyptian named Timon, one of several women artists mentioned as working in the Hellenistic period. (They were the first women artists, or at any rate the first professional women artists, so far as is known. None is recorded in Classical Greece.) The mosaic is carried out in the limited range of four colours—black, white, red and yellow with their intermediate tones—to which some Greek painters of the fifth and fourth centuries are known to have restricted their palettes.

As we have already seen, the battle of Issus is possibly represented on the *Alexander Sarcophagus* (5, 1). In the relief the subject is elevated to universal significance by generalization—the warriors are all given equal prominence, though three Greeks, each with an expiring Persian at his feet, stand out in the *mêlée*—whereas in the mosaic everything is particularized. The artist concentrated on the vividness of the scene, which is shown as it was thought to have really happened. An actual incident appears to be depicted, the vital moment when the battle turned into a rout as the Persians took to their heels, though, of course, this is an imaginary reconstruction. A bare-headed Greek youth, Alexander, advancing from the left and spearing a cavalryman, faces the Persian King of Kings Darius, who turns towards him with a helpless gesture and expression, while his charioteer raises his whip to lash his horses into a galloping retreat. There are no nudes or symbolical elements, except perhaps for the blasted tree, which balances the head of the defeated Darius. Emphasis is laid on the drama of the moment, registered by the movement of the ranked spears—a brilliantly effective visual device.

Map of Italy showing Etruscan and Roman sites.

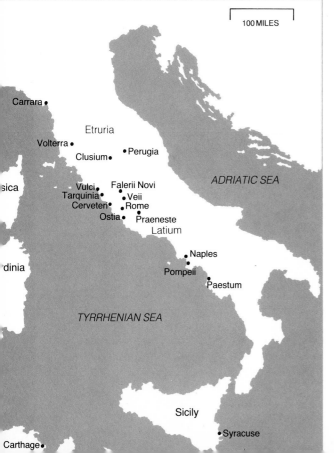

5, 16 *Battle of Issus*, 2nd to 1st century BC. Mosaic, 8ft 11ins × 16ft 9½ins (272 × 513cm). Museo Archeologico Nazionale, Naples.

Figures in the mosaic are robustly modelled with shading to give them weight and substance; they move through clearly lit space, casting shadows on the ground. Indeed, light is rendered as in no surviving earlier work with reflections and highlights glancing off bared swords and glittering on armour. All the pictorial devices learned in the Classical period (so the ancient literary sources tell us) have here been exploited to give an appearance of movement in three dimensions. Figures are shown in a great variety of natural attitudes and from as many viewpoints—the head of one is turned away and his terrified face reflected in a polished shield. Rearing, shying, bolting horses are delineated with complete command of foreshortening, most notably that to the right of centre, seen from behind and held by a Persian groom, who gazes apprehensively towards Alexander.

So skilful is the execution of this mosaic that some impression of the fluid brushwork of the original painting can even be recaptured in the mind's eye. The picture is built up from tiny *tesserae* or cubes of carefully graded naturally coloured stone, by a technique which seems to have been invented in the third century BC (previously figurative mosaics had been composed of small pebbles). Small mosaic pictures, called *emblemata*, were produced as works of art independently of the usually less subtly coloured and more broadly treated ornamental mosaics set in floors and wall surfaces. Their origin is unknown. They may have been imported ready-made from the eastern Mediterranean. All that is certain is that they reflect artistic tastes which upper-class Romans shared with the upper class of the Hellenistic kingdoms.

Pompeii and Herculaneum were provincial cities and not major centres of wealth and artistic patronage in any way comparable with Alexandria or Rome. They may, therefore, give a somewhat misleading impression of Hellenistic and Roman painting, though we necessarily depend on them for much of our visual knowledge of it. Very rarely do paintings from Pompeii and Herculaneum equal the technical accomplishment of the battle of Issus mosaic. Relatively few rise above the level of rapidly daubed hack-work. A painted room in a large country house known as the Villa of the Mysteries, just outside Pompeii, is altogether exceptional (5, 17). There has been much discussion about its authorship (Greek or South Italian) and also whether it was copied from an earlier prototype. For although the composition is so carefully adapted to the size and shape of the room that it might seem to have been determined by it, individual figures are in poses which occur in Hellenistic sculpture.

The subject of this painting—still not completely elucidated—seems to be some form of initiation. Prominent are the ritual flagellation of a woman and the toilet of a bride under the gaze of a seated priestess, perhaps the mistress of the villa. One wall is given up to immortals with Ariadne reclining in the lap of Dionysus, symbol of the eternal bliss of the initiate who espoused the god. Dionysus, son of Zeus, was a god of the fertility of nature, a suffering god who died and came to life again; he was also the god of wine who inspired music, dance and drama. His cult had been introduced from the Near East to Greece and thence to Italy (where he was called Bacchus) as had other, more esoteric cults in the westward migration of Oriental spiritualism during the last two centuries before Christ.

There is nothing orgiastic about this painting, none of the delirious intoxicated frenzy of the devotees of Dionysus as depicted on Greek vases. Both mortals and immortals look distinctly cool and collected—apart from one apparently terrorized figure, though even she maintains her statuesque deportment. They are represented a little less than life-size, standing on a simulated stage or platform which runs round the room so that they seem to move in a shallow extension of the real space, giving the impression almost of a *tableau vivant*. Furthermore, they look across the real space of the room, with some rather complicated and sophisticated results, as when the flagellator raises her whip to strike the woman kneeling on the adjoining wall. Anyone coming into the room is given an embarrassingly vivid sensation of having intruded into a religious ceremony, of interrupting some solemn and arcane ritual.

If the ritual scene in the Villa of the Mysteries is a unique survivor, the illusionism of the architectural framework in which it is set is characteristic of painting in Italy at this period. Ambitious—spatial and not flat—decorative schemes appeared early in the first century BC, visually enlarging the space of rooms with columns, entablatures and other architectural elements. Figurative scenes were often incorporated, as if they were panel pictures hanging on or set in the walls. Later, a further step was taken by visually opening the wall, sometimes completely, sometimes with make-

5,17 *Dionysiac mystery cult*, c.50 BC. Wall-painting, 63¾ins (162cm) high. Villa of the Mysteries, Pompeii.

believe windows, to disclose vistas of colonnades stretching into the far distance. In the first century AD this imaginary architecture was treated with increasing fantasy to conjure up buildings of a more insubstantial elegance than any that could be erected on earth. Recession was indicated by a perspective system apparently devised for theatrical scenery, probably in the Hellenistic East, though it may have Italian origins as well, with orthogonals or lines of perspective projection slanting towards a central axis (not towards a single vanishing point, see p. 319).

These various types of painting are usually categorized as the Pompeiian Styles I, II, III and IV, though there is, of course, no reason to suppose that they followed one another in strict sequence. The development was additive, not sequential. Nor did they originate at Pompeii, though by far the largest number of examples have survived there. One room in the house of evidently prosperous merchants combines all four illusionistic systems or styles—a dado of simulated panels of rare marbles; pictures hung on or set in the wall and surrounded by frames which seem to project forwards; windows opening on to views of airy structures; and, above, statues placed on top of the wall, beyond which fanciful buildings may be glimpsed in space (5, 18). Sometimes the 'pictures' were of fruit, dead fish and game and glass vessels half full of water (the earliest known still lifes), themselves exercises in eye-deceiving illusionism or *trompe l'oeil*, creating a complex and sophisticated play with levels of reality— illusionistic paintings of *trompe l'oeil* pictures set in walls which were given the appearance of having relief decorations and also openings on to the world beyond! Deception in art is pleasurable, wrote the late Roman man of letters Philostratus the Younger about AD 300. For, he asked rhetorically, 'to confront objects which do not exist as though they existed and to be influenced by them, to believe that they do exist, is not this, since no harm can come of it, a suitable and irreproachable means of providing entertainment?' Mythological scenes such as those in the House of the Vettii (5, 18) may, however, have had for those who commissioned them greater significance than meets the modern eye. The Roman house was a shrine and place of sacrifice as well as a human habitation. Its main living rooms were under the protection of different deities, who might be represented on their walls, Bacchus in the *triclinium* or dining-room, Venus in the *cubiculum* or bedroom. Paintings might also indicate cultural and social status: Greek subject-matter for educated upper-class taste, decorative profusion and opulence for the parvenu—an appearance of wealth, sometimes a doubly deceptive one. Accelerated social mobility in

5, 18 Ixion Room, House of the Vettii, Pompeii, 1st century AD.

the Italian cities of the first century BC had created an increasingly complex social structure, which made visible indications of social standing desirable. But aesthetic factors must also have been involved. Decorations on walls and ceilings were by no means limited to paintings and mosaics. Some of the most elegantly refined of all are in stucco.

Landscapes, or rather figurative compositions in landscape settings—airy little country scenes with trees, rustic buildings, a few pensive figures and sometimes a herm—were often incorporated in decorative schemes. The finest surviving examples, from a house in Rome, illustrate eight scenes from the *Odyssey*, framed by simulated pilasters (5, 20). Their artist created evocative atmospheric effects of cool Mediterranean water and warm still air with the headlands of a bay shimmering in a slight haze. Distance is suggested and the forms of boats and rocks only vaguely defined, but the painting opens the wall surface on to the crystalline dream-world of poetry. Some of the energetic little figures are labelled with their names in (not always correct) Greek lettering and it is assumed that the artist was of Greek origin, though it is impossible to say for certain whether his work was original or copied from an earlier composition, a

painting on the inner wall of a stoa, perhaps, or even an illustrated manuscript. But here we stand on the frontier, or rather the overlap, of Hellenistic and Roman art.

Pliny ascribed to an artist of the Augustan period named Studius Ludius or Spurius Tadius—the manuscripts give different readings, but he must have been Italian if not strictly Roman—'that most delightful way of painting walls with representations of villas, porticoes and landscape gardens, woods, groves, hills, ponds, channels, rivers and shores—any scene in short that took the fancy'. The same artist, he wrote, painted the walls of open galleries with views of seaside towns 'producing a charming effect at minimal cost'. A room in the villa outside Rome believed to have belonged to Livia, wife of the Emperor Augustus, might illustrate this style of work (now Museo Nazionale Romano, Rome). Flowering plants and trees of several types with brightly feathered birds perching on their branches completely encircle it, bringing permanently indoors a luxuriant garden of the type which was frequently integrated into the planning of larger Roman palaces and villas (5, 22). Beyond a narrow strip of grass, which visually extends the real space of the room, the world of nature is tantalizingly fenced off—as if to suggest the paradise of the 'Islands of the Blessed', where eternal summer reigned, as described by Horace in a poem written at about this time.

Freshness and freedom of handling distinguish the finest of these Pompeiian and Roman decorative paintings. This can best be appreciated in isolated details, which often display quite extraordinary mastery and bravura (5, 19). Such sophisticated delight in dexterity is much less evident in portraiture, however, an art form greatly cultivated by the Romans, especially in sculpture (see p. 165). Pliny refers to lifelike portrayals of gladiators as having been 'for many generations the highest ambition of painting'. His remark may be sarcastic, but, in fact, portraits of relatively humble sitters are among the most arresting of the many paintings found at Pompeii. One, from the wall of a shop, is of a man and woman traditionally called the 'Baker and his Wife' and probably a wedding picture (5, 21). The features of the swarthy man are anything but patrician: he seems to be an ordinary tradesman (though he has been identified with Terentius Neo, a law student). The woman with her carefully dressed hair and pale complexion might seem to have higher social ambitions, the writing tablet and the stylus which she presses against her chin perhaps indicating literary interests. In the gesture of her hand there is a touch of affectation made more obvious by the plain candid style of the painting itself. This and other equally direct and vivid portraits, some scenes of contemporary life—a riot in the amphitheatre, for instance—and grotesquely erotic caricatures on the walls of a brothel suggest that a vigorous popular art coexisted with the upper-class and rather high-flown paintings in the richer houses and public buildings.

Pompeii and Herculaneum show that by AD 79 every type of painting (every genre as they were later to be called) was being practiced and patronized—history-painting, figure-painting, portraiture, landscape and still life. A system of perspective had been devised to give a sometimes illusionistic appearance of recession in space. Various pictorial styles had also been developed, ranging from hard linearity with flat areas of colour to an impressionistic rendering of form with rapid flicks of the brush. When Pompeii and Herculaneum were at their heyday, however, Roman writers were already lamenting that the art of painting was in a bad way. The architectural theorist Vitruvius (active 46–30 BC) and later Pliny thought painting a 'dying art': it was said to be 'completely dead' by Petronius,

5, 19 Detail of a wall-painting from the Temple of Isis, Pompeii, 1st century AD. Museo Archeologico Nazionale, Naples.

5, 20 *Above Ulysses in the land of the Lestrygonians*, late 1st century BC. Wall-painting, about 60ins (152cm) high. Vatican Museums, Rome.

5, 21 *Left Baker and his wife*, from Pompeii, 1st century AD. Wall-painting, $19\frac{1}{4} \times 16\frac{1}{8}$ins (48.9 × 41cm). Museo Archeologico Nazionale, Naples.

Below Plan of a Pompeiian house.

arbiter of elegance at the Emperor Nero's court and author of the brilliant bawdy novel *Satyricon*, in which a 'picture gallery with a marvellous collection of all kinds of painting' consisted exclusively of Greek and Hellenistic works:

> I saw a work by the hand of Zeuxis which was not yet worn away with the injuries of age, and I beheld not without a certain awe the sketches of Protogenes which were so real that they vied with nature herself. And when I came upon the work of Apelles ... I actually worshipped it. For the outlines of the figures gave a rendering of natural appearances with such subtlety that you might believe even their souls had been painted. ... (Petronius, *Satyricon*, AD 83, tr. J. J. Pollitt)

It was, perhaps, to give the effect of such a collection that rooms like that in the House of the Vettii at Pompeii were painted.

Livy, the great historian of the Roman republic, declared that paintings robbed from the temples of Sicily in 211 BC initiated 'the craze for works of Greek art'. Such paintings were at first placed in public buildings as trophies of conquest. But private collectors appeared on the scene in the first century BC. One paid for a single fourth-century BC picture as much as 36,000 *denarii*, an enormous sum at a time when a capable slave cost 500 and a free labourer was paid around 250 a year. This collecting of Greek and Hellenistic 'Old Masters' by very rich Romans stimulated a demand for copies to grace the walls of those who could not obtain originals. Only now, significantly enough, did the conception of an 'original' and its corollary, a 'copy', first arise. Once it had, the copy was despised. Quintilian dismissed copies as 'bastards'. The influential Stoic philosopher Seneca (tutor to the young Nero) made a point of distinguishing between the divinely inspired artists of the past and the artisan copyists of his own day. Such views might be justified philosophically; yet one may question how far they were the cause and how far the effect of the high commercial value then being placed on originals in the 'Old Master' market.

Art collecting may also have played a part in transforming attitudes to artists and their work in other ways. Pictures which had been dedicated to the gods in a Greek sanctuary necessarily lost much, if not all, of their religious significance once they were removed to private residences in Italy. They were transformed into collectors' pieces, objects of luxury and status symbols. As a result, the rather occult aura which seems to have surrounded artists in earlier times was dimmed. Both Cicero and Seneca excluded

painting from the 'liberal arts', the latter classifying painters simply as 'agents of extravagance'. That Nero dabbled in painting was often mentioned: but not as one of his virtues.

In the vast body of Latin literature there are few references to, and fewer words of praise for, contemporary painters. Not even their names would be known were it not for Pliny, and his remarks are extremely brief. (They end before AD 79, for he died while watching the fatal eruption of Vesuvius.) Although Romans were fascinated to the point of obsession by their political history, they wrote no histories of their

5, 22 Atrium and peristyle, House of the Silver Wedding, Pompeii, mainly 1st century AD.

visual arts. Very little is recorded about the artists who worked in Rome itself, let alone those in the provincial cities. It is not known whether they were of Italian or eastern Mediterranean origin, freemen or slaves. They were classed simply as artisans, beneath the attention of writers. In ancient Greece disdain had sometimes been expressed for *banausoi*, a word which originally meant 'blacksmiths' but came to include all who worked with their hands, and this attitude hardened in Rome. Sculptors were as little regarded as painters or, for that matter, carpenters. The versatile writer Lucian (c. AD 120–200) described a sculptor as 'no more than a workman, doing hard physical labour ... obscure, earning a small wage, a man of low esteem, classed as worthless by public opinion, neither courted by friends, feared by enemies, nor envied by fellow citizens, but just a common workman, a craftsman, a face in a crowd, one who makes his living with his hands' (*Dream* 9 [13]). This may be an exaggeration, but even the greatest artists of the past were downgraded by the Romans, despite the prices and the praises commanded by their works. 'No gifted young man upon seeing the Zeus of Phidias at Olympia ever wanted to be Phidias', wrote the great moralist and biographer Plutarch (c. AD 46–120). 'For it does not necessarily follow that, if a work is delightful because of its gracefulness, the man who made it is worthy of our serious regard.'

Unlike painting and sculpture, architecture was regarded by Cicero as one of the liberal arts, that is to say one in which a free man (*liberalis*) might engage without loss of status. Vitruvius, himself a practicing architect as well as a theorist, declared that 'persons can justly claim to be architects only if they have from boyhood mounted by the steps of their studies and, being trained generally in the knowledge of arts and sciences, have reached the temple of architecture at the top.' An architect, he demanded, 'should be a man of letters, a skilful draftsman, a mathematician, familiar with scientific thought, a diligent student of philosophy, acquainted with music, not ignorant of medicine, knowledgeable about the opinions of jurists, and familiar with astronomy and the theory of the heavens.' How often these requirements were fulfilled is, of course, impossible to say. But there can be no doubt that the buildings which were to be Rome's greatest and most enduring contribution to the visual arts of the West were designed by men who not only combined artistic sensibility with great expertise in engineering, but also had the freedom of mind to break away from traditional methods of construction and accepted canons of judgement. They created an entirely new concept of architectural mass and space.

Roman architecture

The Romans' artistic genius was most fully expressed in architecture, the art in which their extraordinary gifts for organization and planning could find a natural outlet. They excelled in urban design and in new systematized construction methods, which facilitated large-scale programs for utilitarian and civic structures—roads, drainage systems, bridges, aqueducts, vast apartment blocks and public buildings of various kinds. Temples and other religious edifices, so prominent hitherto in the history of architecture, now became relatively unimportant. It was essentially the same practical, managerial gifts which, in other fields, enabled the Romans to make their finest contributions to Western civilization—first Roman Law, that supreme expression of ancient probity from which Western legal codes derive; and secondly the *Pax Romana*, that century and a half's display of continuously expert and energetically efficient administration initiated by Augustus, which brought stability and peace to an empire covering the whole of Europe as far north as Scotland, the whole Mediterranean area and much of the Near East. The phenomenon was to be unique in world history.

The unity and centralized power of the Roman empire at its height was nowhere more strongly felt than in town-planning. Whether in north Africa, Palestine, the Rhineland or Britain, their settlements were usually laid out in the same regular manner based on a military encampment (or *castrum*)—a square divided into equal quarters by two main streets crossing at right angles in the centre. One ran north-south (called the *cardo*), the other east-west (called the *decumanus*), and the *forum* or civic centre, colonnaded and closed to traffic, was sited just off the crossing. The four quarters were subdivided into square blocks and any structure or open space conformed by being a multiple of these squares. The strict uniformity of this planning was, of course, a concomitant of administrative efficiency, but in Italy it was not always adhered to, notably in Rome itself, in Ostia and in the two cities which have accidentally but quite substantially survived, Pompeii and Herculaneum.

No other sites provide so copious a record of an ancient city as a living organism conditioned by and conditioning the daily life of its inhabitants. Nearly all the various types of ancient Roman buildings and all the methods of construction from mud-brick wall and post-and-lintel to concrete vaulting are represented at Pompeii (Herculaneum has been only partially disinterred). A covered market, a warehouse or granary, a triumphal arch, a *comitium* where municipal elections took place, and a *basilica*—the most characteristic

building type developed by the Romans, comprising a covered hall with aisles and usually, though not at Pompeii, an apse, and used for the transaction of business and the administration of justice—all stand round the forum, which was the rigidly rectangular, axially planned heart of this as of every other Roman city. There are also three public baths, two *palaestrae* for gymnastic exercises and sports, two theatres, an amphitheatre for gladiatorial combats and other spectacles (the earliest example known), barracks for gladiators, and so on. Remains of similar structures survive elsewhere, of course, scattered over the whole vast area ruled by Rome, and many of them have greater architectural merit. But it is rarely possible to see so clearly as at Pompeii the urban texture, the relationship of public buildings to each other and to private dwellings, built for single families of varying degrees of wealth and social standing, which cover the greater part of the ground within the city walls.

The building history of Pompeii and Herculaneum came to its catastrophic end at the very moment when Rome and the major provincial cities of Italy were in the throes of urban renewal. The single-family house or *domus* was everywhere being torn down and replaced by many-storied tenement blocks or *insulae*, which were needed to accommodate a steadily increasing middle- and lower-class population, the latter flocking to the cities as landowners went over to farming with slaves (imported in quantity as prizes of colonial wars). Simultaneously, the richer families were moving out of the congested areas to live in suburban or country villas. Had the fatal eruption of Vesuvius been delayed for a few decades, it is more than likely that much of Pompeii and Herculaneum would also have consisted of huge regular pullulating *insulae* uniformly built of concrete faced with brick and stucco, similar to those whose foundations have been found elsewhere, notably at Ostia. Eventually, by the fourth century, almost 90 per cent of the population of Rome was to be housed in *insulae*, built to the maximum legal height of five stories (about 70 feet [20m] high) with communal latrines and other facilities. Some of the larger houses in Pompeii had already been converted into such apartments by AD 79. But the city still contained a wide variety of domestic architecture with the homes of bankers, merchants, tradesmen and artisans in close proximity to inns, brothels, bakeries, or evil-smelling dye-works, perhaps reflecting a looser social structure than that which was to follow in later imperial times.

The Pompeiian house was inward-looking with an unimpressive exterior often given over to single-room shops (*tabernae*), which had no connection with the

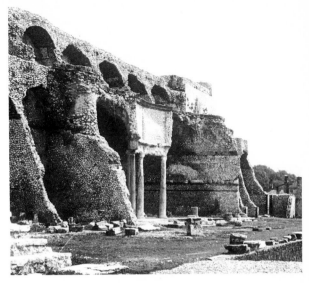

5, 23 *Top* Sanctuary of Primagenia, Praeneste (Palestrina), Italy, c.80 BC; and *above*, plan of the sanctuary.

rest of the building. From the street a narrow passage led into the main interior space called the *atrium*, a courtyard surrounded by small rooms, which were covered with tiled roofing sloping inwards to a rectangular opening. The word atrium is of Etruscan origin and the type of house planned round it seems to have been peculiar to Italy. In the earliest and simplest the owner's bedroom was in the centre of the side opposite the entrance and beyond it lay a small high-walled garden. Later in larger houses the garden was sometimes extended and surrounded by a covered

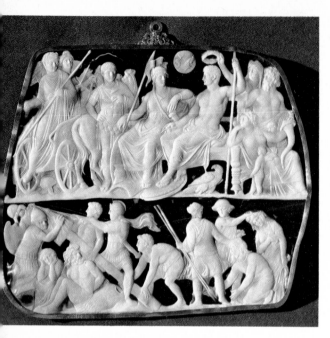

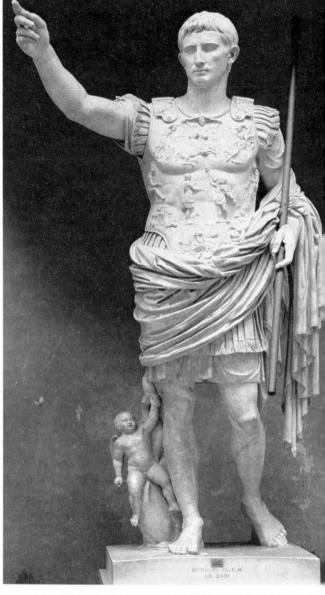

5, 24 *Above Gemma Augustea*, early 1st century AD. Onyx, 7½ × 9ins (19 × 23cm), Kunsthistorisches Museum, Vienna.
5, 25 *Right Augustus of Primaporta*, early 1st century AD. Marble, 80ins (203cm) high. Vatican Museums, Rome.
5, 26 *Opposite* Equestrian statue of Marcus Aurelius, AD 161–180. Bronze, over life-size. Piazza del Campidoglio, Rome.

colonnade called a peristyle—a Greek word recalling its Hellenistic origin.

From this combination of Etruscan and Hellenistic elements a new type of domestic architecture evolved in Italy. Planned with a regard for axial symmetry, unusual in the Hellenistic East, one space flows harmoniously into the next in orderly sequence. From the outside a Pompeiian house is a featureless, solid block; but its interior reveals that preoccupation with the molding of space—also expressed in the illusionistic wall paintings—which distinguishes Roman from Greek architecture. Contrasts of light and shade were often exploited, as in the house illustrated here, with its dim cool atrium (the roof has been restored so that the original effect can be recaptured) giving on to a sun-drenched peristyle garden, where there were flowering plants, statues and fountains (5, 22).

Suburban and country villas were sited to take full advantage of prevailing breezes and wide views over land and, sometimes, water, but also to be seen, to make an impression of many-columned opulence. A portico was an essential feature: one type of villa resembled a Hellenistic stoa and consisted simply of a single row of rooms behind a long colonnade. Others had more elaborate plans, including that in Tuscany owned by Pliny the Younger (AD 61/2–c. 113), whose description of it in a letter vividly conveys the highly civilized taste for which the architects of such luxurious houses had to cater. Besides dwelling lovingly on its many rooms, interior courtyards, terrace and formal garden, Pliny describes the south-facing colonnade, which caught the full strength of the sun, and such features as the pool beneath his bedroom window, 'a pleasure both to see and hear, with its water falling from a height and foaming white as it strikes the marble'. Outside the formal gardens there were meadows no less 'well worth seeing for natural beauty',

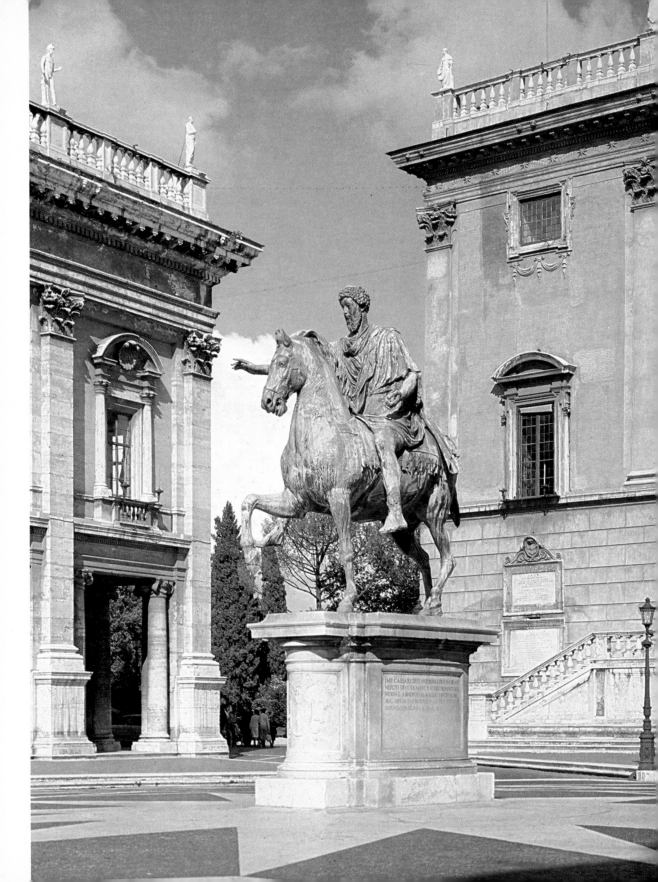

he wrote; 'then fields and many more meadows and woods'. His dining-room looked on to a terrace, 'the adjacent meadows and the open country beyond'—a great spreading plain 'ringed round by mountains, their summits crowned by ancient woods of tall trees'. Ornamental gardens had been laid out much earlier in Egypt, but the park merging into the natural landscape seems to have been a Roman invention.

Similarly, although the siting of Roman temples and sanctuaries was determined by religious rather than aesthetic considerations, as in Greece, a heightened sense of the relationship between architecture and landscape is evident in their design. That dedicated to *Fortuna* or fate at Praeneste (present-day Palestrina, south-east of Rome) must have been the most impressive by far, with seven wide terraces steeply rising up, one above the other, to a theatre framed by a semicircular colonnade and crowned by a round temple (5, 23). The acropolis at Pergamum (a Roman possession from 133 BC) provided a recent precedent for the use of colonnaded terraces on a rocky site (see p. 146). But whereas the temples and other buildings simply crown the hilltop at Pergamum and are informally related to one another, at Praeneste the whole hillside was transformed into architecture. This molding of space into a unified composition of strict axial symmetry—combined with massive scale and boldness of conception—marks Praeneste as one of the first masterpieces of specifically Roman architecture.

As we have already seen (p. 132), the Etruscans had modified the Doric temple by heightening the base and by doing away with the steps on three of its sides, pushing the cella back at the same time to make way for a deep frontal porch. The Roman temple, like the Roman house, evolved by skilful and inventive blending of Etruscan and later Greek elements. The

5, 27 Maison Carrée, Nîmes, France, 1st century BC.

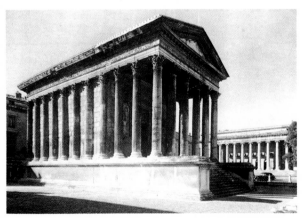

Maison Carrée at Nîmes (Roman Nemausus) in the south of France, which is the finest surviving example, might at first sight be taken for a peripteral temple set on a high Etruscan podium (5, 27). It is, in fact, a new and typically Roman invention, partly dependent for its effect on illusionism—hence its technical description *pseudoperipteral*—for the columns along the flanks are not free-standing, as they might seem to be, but engaged. They are purely decorative and have no supporting function. In this way Greek post-and-lintel construction was harmoniously combined with the wall architecture developed by the Romans. So perfect was the join that hardly any variations were introduced, except for increasing refinement of the non-figurative carved ornament from the late second century BC (Temple of Fortuna Virilis, Rome) until Roman religion itself was suppressed.

In Roman architecture, however, the temple was much less conspicuous than in the architecture of Greece or even of the Hellenistic kingdoms. Temples were not invariably the largest structures in a Roman city. Despite the Romans' love of magnitude, none of the temples they built before the second century AD exceeded in size the largest raised by the Greeks in the fifth and fourth centuries BC. Even so, Cicero questioned the expenditure of public funds on them rather than on utilitarian structures—harbours, aqueducts or some other of 'those works which are of service to the community'. The remark is a complete denial of the belief cherished by all earlier civilizations that no work could be of greater service to the community than a temple to its gods.

Politics played a greater part than religion in the development of Roman architecture. Rome of the early republic had been little more than a conglomeration of villages among the seven hills, rebuilt without plan after it had been sacked by the Gauls in the early fourth century BC. At the beginning of the second century the city itself was still a confused mass of mud-brick buildings divided by narrow winding streets, its forum an irregular space surrounded by both private and public buildings. In about 200 BC, so the historian Livy tells us, visitors from Macedon were shocked by its squalid appearance, for 'it was not yet made beautiful in either its public or its private quarters'. This began only in the first century BC with the great public works and building programs initiated partly, if not mainly, for propaganda purposes by the succession of ambitious men (notably Sulla and Julius Caesar) who made bids for absolute power, plunging the republic into civil war, and then by Augustus and the early emperors. Julius Caesar planned a complete reorganization of the heart of the city and some new

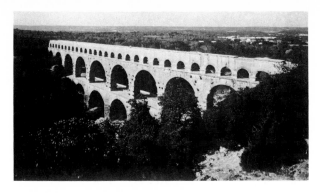

5, 28 Pont du Gard, near Nîmes, France, 1st century BC.

buildings were begun in his time (49–44 BC). But the transformation of Rome into a monumental imperial capital was left to his great-nephew and adopted son Octavius, who in 30 BC restored peace after 14 years of civil war. In 28 BC he was hailed by the Senate as Augustus (a word implying both divine appointment and individual ability) and thus became the first Roman emperor, ruling with undisputed authority until his death at the age of 76 in AD 14.

Augustus carried through the building program initiated by Julius Caesar and in addition gave Rome another new forum, several temples and other imposing buildings. Public works of a more utilitarian kind—such as a huge new warehouse, aqueducts and sewers—were sponsored by Augustus' right-hand man and, so to speak, political manager Marcus Agrippa, who also built a pantheon (see p. 163), a basilica and the first of the magnificent *thermae* or public baths, which were to be perhaps the most splendid and lavishly equipped of all the great public building types invented by the Romans. Even the poorest citizens could frequent them and enjoy their luxurious 'facilities'—cold baths, cool baths, hot baths, steam baths, dressing-rooms, recreation rooms, lecture halls, restaurants, libraries, gymnasiums and gardens. More obviously, perhaps, than other Augustan buildings they were at once emblematic of imperial power and popular in their appeal to the middle and lower classes, on which the regime relied for support.

Towards the end of his life Augustus claimed to have 'found Rome a city of brick and left it a city of marble'. For the Romans, marble was a symbol of magnificence. Vitruvius, who had been employed by Julius Caesar and dedicated his architectural treatise to Augustus, wrote of an early first-century temple in Rome: 'If it had been of marble, so that besides the refinement of art it had possessed the dignity which comes from magnificence and great outlay, it would be reckoned among the first and greatest works of architecture.' Extensive use of marble was made possible by the opening of quarries in the Apuan Alps a few miles inland on the north-west coast of Italy (near present-day Carrara), whence it could be easily transported by sea to Rome or indeed to any part of the empire. Employed mainly for cladding and decorative purposes, to give a smooth clean surface to buildings constructed of concrete or brick, it transformed the drab, predominantly mud-brick and terracotta face of Rome. Nearly all this marble facing vanished during the Middle Ages and later. The interior of the Colosseum, for instance, was clad throughout in marble, none of which survives. In fact, the only large-scale surviving example is the interior of the Pantheon (see p. 164).

Far more important than marble, however, was concrete. The development of this building material by the Romans and especially their use of it in conjunction with the arch and vault revolutionized architecture. Neither concrete nor the arch and vault were Roman inventions. Numerous ancient Egyptian prototype arches and vaults in brick were available and it might seem rather surprising that the true arch (constructed of wedge-shaped stone voussoirs) was not developed earlier. It first appears in the fifth or fourth century BC. Etruscan arched city gateways, dating from shortly after 300 BC, survive at Perugia and Volterra and a few decades later the Romans were building neatly constructed semicircular arches, for example, the gateways in the city walls at Falerii Novi (present-day S Maria di Falleri). The potentialities of arched construction were soon realized and put to use in causeways, bridges and aqueducts, of which none is more impressive than the Pont du Gard in the south of France (5, 28), commissioned by Marcus Agrippa to carry water some 30 miles (48 km) across the plain and valley of the river Gardon to Nîmes. Built entirely of dressed stone, it is a masterpiece of engineering by any standards ancient or modern, and has proved astonishingly durable. The graceful proportions of its seemingly light structure are eminently simple, the width of the arches at the top being multiplied six times for the total height, four times for the span of the great central arches, three times for those at either end. Its majestic simplicity is also due partly to the systematized construction methods adopted by the Romans. The Pont du Gard was substantially prefabricated, the huge voussoirs of the arches being fully dressed before erection, and it was to facilitate this that all measurements were made standard and all profiles strictly semicircular. (The voussoirs were laid out on the ground as a preliminary check and lettered and

numbered, some of these markings still being visible.)

The arch became the essential element in Roman architecture, emphasizing the strength and massiveness of the masonry structure as if to symbolize the sustaining power of the empire itself—most obviously in the triumphal arches erected in honour of emperors (see p. 169). Arches enframed by engaged columns and entablatures—used from early in the first century BC— were a dominant motif in the imperial period. The exterior of the great Flavian amphitheatre, known since the eighth century as the Colosseum, is entirely composed of them in arcades which integrate the units of the design by rhythmic horizontal and vertical repetition (5, 30b). The orders follow the ascending sequence established by the Romans for multi-story buildings—Doric-Ionic-Corinthian. (The sequence is purely aesthetic, the Doric being visually the heaviest and strongest and the Corinthian the lightest.) Although several such permanent arenas for gladiatorial combats and other spectacles had been built elsewhere, somewhat surprisingly this was the first in the city of Rome, where 'games' had previously been held in the Forum or in temporary structures. With a seating capacity estimated between 45,000 and 55,000, the rapid entrance-exit problem for filling and emptying the vast seating space was formidable. It was brilliantly solved by an ingenious arrangement of stairways and corridors all leading down to the continuous ground-floor arched openings. The Colosseum was begun as a shrewd bid for popularity by Vespasian, the first emperor of the Flavian family, who came to power in AD 69 as the result of a mass uprising against Nero, the last of the dynasty established by Augustus. To fulfil its purpose it had to be built quickly: the enormous structure, which is on an elliptical plan measuring 615 by 510 feet (188 by 155m) externally and 159 feet (48m) high, was completed in no more than a decade. Various materials were used, concrete for the 25-foot-deep (7.5m) foundations, travertine (a fine local limestone lighter in weight and less strong than marble, easily cut when first quarried, but hardening with exposure to air) for the framework of load-bearing piers, tufa and brick-faced concrete for radial walls between the piers, travertine for the exposed dry-jointed stonework held together by metal clamps (most of which have gone), and marble (of which no trace remains today) for the interior. A giant awning to protect spectators from the sun was supported on wooden poles projecting inwards from the top and manipulated by ropes tied to bollards on the pavement surrounding the building (5, 30a).

The Colosseum is a masterpiece of Roman engineer-

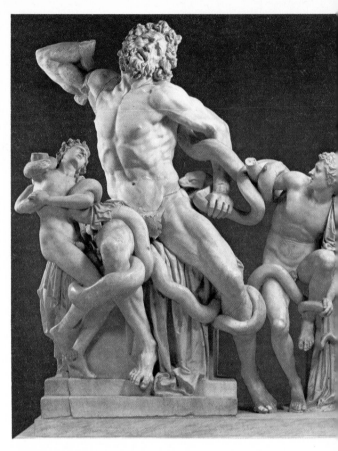

5, 29 *Above* Hagesandrus, Polydorus and Athenodorus, *Laocoon and his Two Sons*, 1st century AD. Marble, 96ins (244cm) high. Vatican Museums, Rome.
5, 30 *Right* Colosseum, Rome, c. AD 70–82. Aerial view and exterior view.

ing as well as of architecture. In both design and structure it was, however, conservative. Concrete was used simply for foundations and walls, as it had been in many earlier buildings, including, for example, the sanctuary at Praeneste. Roman concrete (*opus caementicum*) was a combination of mortar and pieces of aggregate (*caementa*) laid in courses—unlike modern concrete, which can be mixed and poured. Its unique strength and durability derived from the binding agent, a mortar made of lime and volcanic sand, first found at Pozzuoli near Naples and thus called *pozzolano*, used as early as the third century BC. Exposed walls of this concrete were usually faced with another material, an irregular patchwork or neatly squared pattern of stone and later, under the empire, brickwork. The full potentialities of the material were, however, only gradually discovered. In early examples the cement evidently dried out quickly so that each

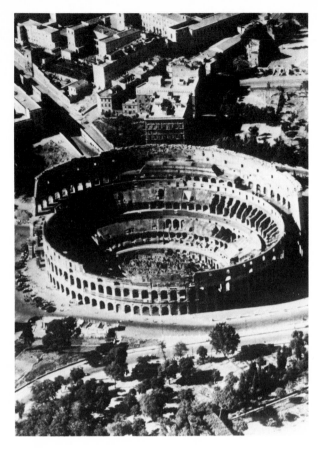

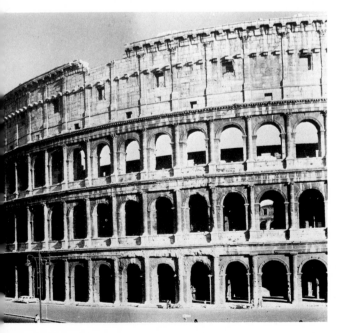

layer formed a single horizontal band like an enormous stone slab. But the development, about the time of Augustus, of a slow-drying mortar, probably made with volcanic sand found near Rome, produced a concrete core which hardened into an inert homogeneous mass. This revolutionized architecture, for when combined with the arch and vault, it enabled the Romans to cover, without any interior support, spaces far larger and of far greater flexibility of form than had ever been possible before. Ancient Egyptian, Mesopotamian and Greek architecture had been essentially an art of composition in mass. Space was simply what was left over or left between the solids. This negative conception was now replaced by that of an architecture of space. A building was conceived as a shell molding space into whatever shape the architect or his patron desired.

The earliest building in which the possibilities of using concrete for this new 'spatial' conception of architecture are known to have been explored is the 'Golden House' designed for the Emperor Nero (AD 54–68) by an architect named Severus. Of the parts that remain, the most interesting is a group of rooms which, although divested of all their surface decorations apart from some traces of delicate stucco-work, reveal a truly revolutionary originality (p. 162). An octagonal space covered by a rather shallow dome is surrounded on five sides by rectangular vaulted rooms, one of which terminated in an ornamental cascade of water. Lighting, unusually bright and even for a Roman interior, was provided by a circular opening or *oculus* in the centre of the dome and, very ingeniously, by clerestory windows high up on the walls of the radial rooms. The inner surface of the dome was probably decorated with mosaics, which must have given an almost magically insubstantial effect. And the views through the wide square openings of the octagon from one room to another and on to the garden to the south may well have seemed to realize architectural prospects of the type that Pompeiian painters had feigned. For here the walls really had been broken and bent to permit free spatial flow and to give the appearance of an unending series of opulent chambers. From no single point would it have been possible to grasp and resolve the visual complexities and ambiguities of this highly sophisticated interior.

The surviving ruins are no more than a small part of the 'Golden House', in which, Nero remarked, he could 'at last begin to live like a human being'. His biographer Suetonius (AD 69–140) described the main banqueting hall, which 'constantly revolved, day and night, like the heavens'. The remark is tantalizingly brief, but it is usually assumed that the ceiling—not the

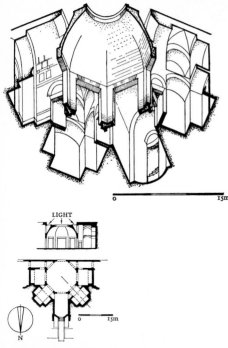

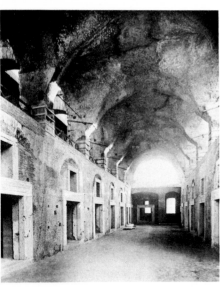

5, 31 *Above* Trajan's Market, Rome, c. AD 98–117.
Top Nero's Golden House, Rome. Octagonal hall: axonometric view from below, section and plan.

room itself—revolved and was constructed in the form of a vast wooden dome decorated with stars or astral symbols, a kind of planetarium beneath which the emperor entertained his guests at the very centre of the cosmos, as it were. The idea of placing such a cosmic canopy over a ruler with pretensions to universal

authority probably derived from the royal tents and canopies of Achaemenid Persia. It would certainly have appealed to Nero: and it may well lie behind the domes which became such a prominent feature of imperial Roman architecture. The development of the concrete dome may even have been stimulated by the symbolism of the textile or wooden cosmic canopies of the East.

The Emperor Domitian (AD 81–96), whose palace on the Palatine Hill in Rome exhibits similar flexibility of planning, used the new technology to provide an appropriate setting for his imperial role. Trajan (AD 98–117), who ruled for the 20 years during which the Roman empire reached the peak of its power and its greatest extent, was more concerned with public works. The most notable were public baths, of which unfortunately little survives, and a new commercial quarter known as Trajan's Market, created by cutting away the slope of the Quirinal Hill. Trajan's Market is one of the most fascinating of all surviving Roman structures, at once logical and complex, utilitarian but possessing an austere monumental beauty. One hundred and fifty or more shops and offices on three different levels connected by streets and steps are combined with a great covered market hall (5, 31). Built for a city most of whose inhabitants were engaged exclusively in working for, buying from and selling to one another, it had a social importance hard to exaggerate. The concave main façade was articulated with pilasters, but the rest of the exterior and the interiors were severely simple, of brick-faced concrete with travertine surrounds to rectangular doors and windows. A better idea can be obtained from them than from the numerous but much less well preserved remains at Ostia and elsewhere of the architectural form and appearance of Roman multi-story construction. At street level there are shops with small windows above giving light and·air to timber-floored mezzanines or garrets approached from within the shops by timber ladders. The main horizontal divisions, however, are concrete barrel vaults between the party walls, and access to the upper stories is by concrete stairways. (Concrete was made compulsory for floors and stairways after the great fire of AD 64.) Great ingenuity was applied to the planning. The architect's aim was eminently practical: to provide the maximum space, well lit and aired, for the various activities connected with buying and selling within a limited area on an extremely awkward sloping site. The result is a masterpiece of volumetric organization, an autonomous structure of interlocking curved corridors, straight streets and passages, and vaulted rooms of different sizes. Nowhere else—except in the

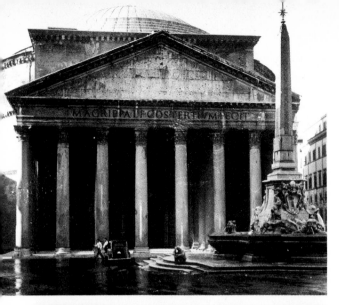

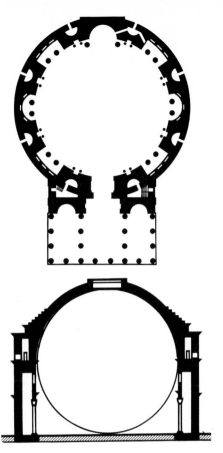

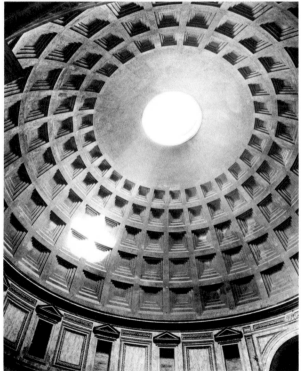

5, 32 Pantheon, Rome, c. AD 118–125.
5, 33 Pantheon, interior, dome.
Above right Plan and section of Pantheon.

Pantheon—can the characteristically Roman genius for molding space be better experienced.

The Pantheon was built under Trajan's successor, the Emperor Hadrian (AD 117–138), on the site of an earlier temple, which had been of an entirely different design but similarly dedicated to all the gods by

Marcus Agrippa (see p. 159), whose name is boldly recorded on the façade (5, 32). It consists of two parts, a traditional rectangular temple-front portico with massive granite columns, and an enormous domed rotunda of a size made possible by the development of slow-drying concrete. The awkwardness of the join between these two parts would have been much less evident originally, when the building was not free-standing as it is today, but was approached on axis through a colonnaded forecourt, which screened all but the portico. The ground level was much lower also, so that five wide marble steps had to be mounted to reach floor level. Yet the contrast—or unresolved conflict—between the rectangularity of the portico and the circularity of the rotunda, between the exterior architecture of mass and the interior architecture of space, must have been even sharper because largely concealed, and the visual excitement and feeling of sudden elation experienced on passing through the door must have been even more overwhelming. One passes from a world of hard confining angular forms into one of spherical infinity, which seems almost to

have been created by the column of light pouring through the circular eye or *oculus* of the dome and slowly, yet perceptibly, moving round the building with the diurnal motion of the earth (5, 33).

This exhilarating interior space is composed, as Vitruvius had recommended for a rotunda, of a drum the height of its own radius and a hemispherical dome above—diagrammatically a sphere half enclosed in a cylinder, the total height of 144 feet (44m) equal to the dome's diameter. The effect is not, however, that of geometrical solids. The lower part of the drum wall is pierced by niches which suggest continuity of space beyond; the columns screening them have lost even the appearance of being structural supports: they seem more like ropes tying down the dome, which floats above. The surface of the dome is broken by five rings of coffers very ingeniously molded to give the illusion that they are rectangular and that although they diminish in area, all are of equal depth. To achieve this effect, account had to be taken of the dome's curvature—which presented a tricky geometrical problem, for no straight line can be drawn on it—as well as of the shadows cast by light from above and of the spectator's angle of vision from the ground. Originally, these coffers probably had gilded moldings around their edges and enclosed gilt bronze rosettes.

Minor changes were made to the interior in about 609, when, as the reigning Pope Boniface IV put it, 'the pagan filth was removed' and the temple converted into a Christian church—to which, of course, its extraordinary and unique preservation is due. In the 1740s the attic zone (i.e. the band of wall immediately beneath the dome), which had fallen into disrepair, was insensitively stuccoed and provided with over-large false windows. Otherwise the interior is substantially intact. The various types of marble, mainly imported from the eastern Mediterranean and used for the pattern of squares and circles on the pavement, for the columns and the sheathing of the walls—white veined with blue and purple (*pavonazzo*), yellowish-orange (*giallo antico*), porphyry and so on—still reflect and colour the light which fills the whole building.

That the Pantheon should eventually have been made into a place of worship for monotheistic Christians was not wholly inappropriate. It was built at a moment of religious speculation and exploration, when faith in traditional beliefs was giving way increasingly to Eastern mystery cults, and its design marks a break with the traditional form of Roman temple, which, as we have seen, harked back to Etruscan and Greek prototypes (p. 158). Less than a century after its completion the historian Dio Cassius (c. 135–c. 235) pondered its significance, remarking

that it was called the Pantheon 'perhaps because it received among the images which decorate it the statues of many deities, including Mars and Venus; but my opinion of the name is that, because of its vaulted roof, it resembles the heavens'. He appreciated that the images of individual gods were of less importance than the building itself, within which the supreme god, so often associated with the sun, was immanent, visible yet intangible in the light streaming through the *oculus* and moving over the surface of the dome. It was, in fact, not so much the temple of a specific religious cult as an attempt to express the very idea of religion, of the relationship between the seen and the unseen, between mortals and the inscrutable powers beyond their ken. Domes had previously been decorated to symbolize the heavens, but no single building embodied this idea more effectively and on a grander scale than the Pantheon. Nor did any exert greater influence on subsequent developments in the religious architecture of the West. Domes and half-domes as symbols of heaven had become essential features of Christian churches long before the Pantheon itself was converted into one.

Roman sculpture

The Pantheon is quintessentially Roman. But the Emperor Hadrian, to whom its design has sometimes been attributed, displayed more eclectic tastes in his enormous, rambling imperial residence outside Rome—Hadrian's Villa near Tivoli. A philhellene who spoke Greek better than Latin and preferred Athens to Rome, Hadrian furnished the villa throughout with Greek statues. Several hundred, perhaps as many as a thousand, survive in fragments now scattered among the museums of the world. They are mainly copies or variants of Classical Greek or Hellenistic figures or groups. The only original works seem to have been portraits of Hadrian himself and his favourite Antinous, a youth from Asia Minor who was mysteriously drowned in the Nile in AD 130 and promptly numbered among the gods. Images of Antinous, set up all over the empire, were, however, more often than not pastiches in which earlier statues of Hermes, Dionysus or other gods were combined with heads portraying the youth's sultry and often rather sulky good looks.

In his obsession with Greek sculpture Hadrian followed a long and well-established tradition. Romans had begun to collect Greek statues before the end of the third century BC, and after Greece was absorbed into the Roman empire as the province of Achaia in 146 BC the flow of Greek sculptures westwards was continuous. The sanctuary at Delphi

alone is said to have been robbed of some 500 statues. Even so, the demand in Rome far exceeded the supply. In letter after letter Cicero, for example, implored a friend who was living in Athens to procure sculpture for him. He was building a country house near present-day Frascati, a few miles outside Rome, and needed some sculpture to adorn it. A great deal of sculpture was bought in this way as 'furniture pieces' and was doubtless produced specifically for this market—hence the proliferation of copies and imitations and their usually rather poor quality. (It is on these shaky foundations, it should be remembered, that much of our knowledge of Classical Greek sculpture rests.) They were mostly produced in Greece—either in Athens itself, the Greek islands or the Greek cities on the coast of Asia Minor—or by immigrant Greek artists in Rome. Sometimes these sculptors seem to have worked from casts with the aid of pointing apparatus (see Glossary). But they had no respect for either medium or scale. Bronzes were reproduced in marble, with the addition of unsightly supports as a result, and scale was adjusted arbitrarily to suit the decorative demands of the purchasers. Statues were even copied in reverse to make up pairs. A mid-fourth century BC statue by Skopas, which, Pliny tells us, was 'worshipped with extremely sacred ceremonies at Samothrace', was duplicated in this way to fill balancing niches in a Roman house of the imperial period. There could hardly be a more telling instance of the transformation of a Greek devotional image into a luxury ornament.

It is seldom known how faithfully a marble of the imperial period reproduces an earlier original (the caryatids from Hadrian's Villa and from the Forum of Augustus are the only Roman copies which can be compared with the still surviving originals), and there is reason to believe that some were essays in earlier styles rather than copies—including two of the most famous of all, the *Apollo Belvedere* (5, 4b) and the *Laocoon* (5, 29). The latter depends stylistically from the relief of similarly straining muscular figures with tortured faces on the frieze of the *Altar of Zeus* at Pergamum (5, 12) and was for long regarded as a copy after a lost work of that period. That it is an original work of the first century AD is strongly suggested by the recent discovery (at Sperlonga, south of Rome) of very similar groups signed by the three sculptors to whom Pliny attributed the *Laocoon*, and almost certainly carved expressly for a grotto used as a banqueting hall by the Emperor Tiberius (AD 14–37). The incident represented by the *Laocoon* is not recorded in Greek literature in just this form: the earliest known source for it is the greatest of all Latin poems, Virgil's

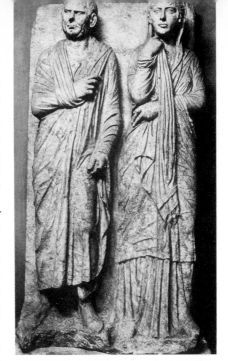

5, 34 Roman husband and wife, 1st century AD. Marble, 6ft ⅞ins (185cm) high. Museo Capitolino, Rome.

patriotically Roman *Aeneid* (written *c.* 27–20 BC), where Laocoon appears as the Trojan priest who warned his fellow countrymen against admitting the wooden horse of the Greeks into their city. While he was sacrificing a bull to Poseidon, Virgil relates, two serpents swam out of the sea, coiled round him and his sons and killed them. As the Romans believed themselves to be descended from the Trojans, the heroic suffering of Laocoon had special significance for them. The priest and his sons are at once figures from the mythical prehistory of Rome and symbols of human fortitude in a struggle against malign, incomprehensible supernatural forces. In turning to Hellenistic art for inspiration, however, the three sculptors, who came from Rhodes, introduced a declamatory sensationalism, both technical and emotional, which ill accords with the dignity, restraint and gravity of the *Aeneid*.

If Roman cultural dependence on Greece was evident even in a major original work like the *Laocoon*, which stood in the imperial palace when Pliny saw it, it became quite blatant in their practice of making full-length portrait statues by the simple expedient of adding a portrait head to a body copied direct from a Greek original. The bodies were produced independently and could be bought, as it were, from stock. A variety of poses and types and sizes were available to choose from, each with a socket in the neck so that a portrait head could be attached. How prevalent the

practice was—and how indifferent the Romans were to its demeaning implications—is shown by its use for prominent imperial portraits, though sometimes, it is true, with such latitude that the resulting image has the force of an original conception. The statue of Augustus, which originally stood outside the imperial villa at Primaporta near Rome, is the best known of these (5, 25). For it the famous *Doryphorus* (4, 23b), an accepted exemplar of ideal male proportions, was treated more freely than usual, almost, in fact, as if it were a tailor's dummy. Not only the portrait head but a Roman general's costume was added as well, including the cuirass crisply carved with allegorical figures probably alluding to the diplomatic victory over the Parthians in 20 BC. Adjustments were also made to the pose, notably by raising the right arm to a speaking gesture. By these means a highly idealized statue of an anonymous nude athlete was transformed into an image of imperial power personified by Augustus, a Greek model into what seems to be a characteristically Roman work of propagandist art—though it may well have been carved by a sculptor of Greek origin.

Towards a definition of Roman art

This statue raises the peculiar and peculiarly complex problem of how to define Roman art. What criteria should be applied?—geographical? chronological? ethnic? stylistic? None is very satisfactory. It is sometimes suggested that the Romans leaned so heavily on the figurative arts of earlier times that their own has no definable identity—that they produced no body of works in the visual arts (except in architecture) comparable with their literature. Roman literature, though most of it was written by men who were not strictly speaking Roman, can be defined linguistically. Moreover, the Latin language was itself the creation and vehicle of a culture to so marked a degree that its use alone conferred distinctive 'Latin' or 'Roman' qualities, even on imitations of and translations from the Greek (e.g. the plays of Terence, a slave of Libyan stock). A comparable unifying visual language is lacking in Roman art, especially in the imperial period, when Rome was the capital of an ethnically mixed empire, including Greece and the eastern Mediterranean, where Hellenistic traditions survived almost intact. The term Roman may, of course, be used for all works of art produced in territory under Roman rule, but such a geographical definition would necessarily embrace very diverse and stylistically heterogeneous works. Attempts at an ethnic definition founder on our ignorance of the artists and their origins. In the fluid conditions prevailing in so vast a multi-racial empire

the identification of any supposedly national tendencies (Italic or Greek, for instance) must be very speculative. The *Pax Romana* permitted great mobility to artists and their works: statues carved in Greece and the eastern Mediterranean were shipped to Rome, imperial portraits were diffused from Rome to the furthest corners of the empire. Nor can any consistent process of artistic development be traced, though there were many and important changes in direction during these centuries. Political history provides no more than a series of convenient date brackets, of dubious stylistic significance, for periods named after the emperors. Markedly different styles, ranging from a crude realism to a refined Greek Classicism, were practiced simultaneously or recurrently revived, usually to accord with subject-matter and to satisfy ideas of appropriateness or 'decorum'.

Yet certain characteristics or qualities commonly associated with ancient Rome can be recognized in their major works of art and in many others as well, as the mention of so essentially Roman a concept as that of 'decorum' already suggests. A funerary portrait of an upper-class couple of the late republican period, for example, epitomizes the straightforward republican virtues so eloquently extolled by Cicero (5, 34). The woman with her distinctly superior expression recalls, no doubt intentionally, statues of *Pudicitia*, personifying female modesty. Her grim unsmiling husband is every inch a Roman, the embodiment of dignity, moral rectitude and gravity. Many other portraits of the same period are of elderly men with equally stern, heavily wrinkled, businesslike countenances, quite unassuming in their ordinariness and plainness. None could be described as amiable. Yet the marks of age may not have been thought unsightly. To Romans, especially of the republic, fullness of years implied success in life. The patrician became not simply an old man but an honoured elder, as well as a *pater familias*, the sovereign ruler of his unmarried daughters, sons, grandsons and their wives, and the sole legal owner of all his family's property.

Figures on the *Ara Pacis Augustae*—the altar of Augustan peace—are equally stern and grave and no less realistic, though carved with greater refinement and set in a structure of complex allegory. The *Ara Pacis* was set up to mark the return of Augustus to Rome in 13 BC, after a lengthy absence in the western provinces, and also to celebrate the peace that followed the civil wars, which had convulsed the dying republic. Its form—an altar on a podium surrounded by a rectangular walled enclosure—is Greek, probably derived from the fifth-century BC Altar of Pity in the Athenian agora. On the outer walls, above exquisitely

chiselled panels of foliage ornament, there are figurative reliefs of mythological subjects (Tellus, the Roman earth goddess, and Aeneas, the legendary founder of Rome and ancestor of Augustus), and two long processions, one of senators, the other of Augustus' family (5, 36). These processional reliefs differ as much from those on the Parthenon (4, 22) as from those at Persepolis (3, 20), being neither of idealized youths nor of expressionless, regimented types all marching in step. Informally grouped, they appear, from their glances, to be in quiet, civilized conversation with each other and they are all recognizably portraits. Augustus (unfortunately damaged) leads as high priest and *pater familias* of his own family and, by implication, of the entire Roman empire. The prominent man in the centre of our illustration is probably Agrippa, his son-in-law and right-hand man. Unlike earlier processional reliefs, those on the *Ara Pacis* record and commemorate a specific moment in time, the dedication of the altar itself. And this emphasis on actuality reinforces the cool realism of the carving and hence the truth of the, in fact rather tendentious, claims it makes for the beneficence of the new Augustan regime.

If the message of the *Ara Pacis* is emphatically Roman, the visual language in which it is expressed remains Hellenistic. The same can be said of a cameo known as the *Gemma Augustea*, whose carver almost certainly came from the Hellenistic East, where the exacting technique of working semi-precious stones to exploit their natural veins of colour had been developed into a fine art by the second century BC (5, 24). Romans greatly prized such virtuoso feats of craftsmanship—technical accomplishment was,

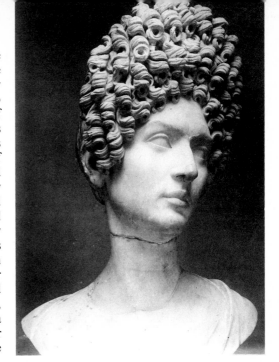

5, 35 Portrait bust of a Roman lady, c. AD 90. Marble, life-size. Museo Capitolino, Rome.

indeed, the only artistic quality of which they wrote. But the *Gemma Augustea* is more than merely decorative. On the upper register Augustus is shown deified with the personification of *Oikoumene* (the whole inhabited earth) placing a crown on his head and the goddess Roma enthroned beside him: the youthful figure descending from a chariot on the far left is probably Tiberius, who succeeded him as emperor. Below, Roman soldiers are setting up a trophy of captured arms after a victory over barbarians, four of whom are shown as prisoners awaiting their fate. Such a mingling of allegorical and historical figures, abstract ideas and hard facts, is a recurrent feature in the official art of the empire.

It was their preoccupation with actuality, above all, that enabled Roman artists to enlarge their range, as can be seen very clearly in portraiture. A high degree of verisimilitude had been attained by Etruscan and Italic sculptors (4, 56), and there are equally vivid and penetrating characterizations in Hellenistic portraiture—sometimes in a sophisticated and worldly vein, sometimes extremely matter-of-fact in a 'warts-and-all' style (5, 9). But the finest Roman portraits surpass them in unflattering directness. A wide cross-section of society is represented, from craftsmen and tradesmen to government officials and courtiers, whose features, unique even in their ordinariness, speak for single individuals caught at a single moment.

The portrait bust was the most notable Roman

5, 36 Detail of frieze of the *Ara Pacis Augustae*, 13–9 BC. Marble, about 63ins (160cm) high. Rome.

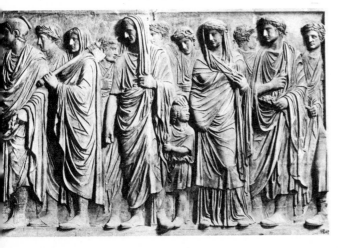

contribution to sculptural form. Up to now portraits had been either full-length statues or herms (square pillars terminating in heads originally of Hermes but later of famous men). The portrait bust, comprising head, neck and a portion of the torso, was introduced by the Romans probably as an off-shoot of their practice, dating back to very early republican times, of making wax masks of their ancestors. This was a jealously guarded privilege of the patrician class—indeed it was restricted by law to them alone. The wax portraits were piously preserved in the *atria* of aristocratic homes, to be brought out only for family funerals. An early first-century AD statue shows a Roman patrician proudly holding two such busts of ancestors, which must have been of light-weight material, wax or plaster. Most surviving busts are, however, in marble or bronze. One of the finest is of an unknown but clearly very fashionable and high-ranking lady of the court (5, 35). From this period onwards busts of the emperors were made in large numbers for distribution throughout the empire and were set up in public places to be looked on with religious awe. Every Roman citizen had to burn incense in front of the emperor's bust in token of his loyalty and allegiance. It was because of their refusal to do this that the persecution of the early Christians began.

There can be little doubt that behind these customs lay some residue of the ancient belief that the likeness preserves the spirit—a belief already encountered in ancient Egypt and Etruria—and, of course, the more lifelike the portrait, the more efficacious the icon. However, the imperial image transmitted throughout the Roman world in busts and statues and, of course, on coins had to be both a recognizable likeness and a symbol of the head of state. Thus, Augustus was always portrayed as a man in the prime of life with a serious open expression, large frank eyes and a serene, unfurrowed brow, which makes him seem almost boyish. His is the unageing face of the man who made himself master of the Roman world when no more than 33 years old. He is shown in his various roles, as military commander (*Imperator*), first citizen of Rome (*Princeps*) and chief priest (*Pontifex Maximus*)—never as an absolute ruler, as were the Hellenistic kings. The image may originally have been intended to mark the new epoch of peace and prosperity he brought, but it persisted unchanged throughout his long reign. His short-back-and-sides hair-style set a model for later imperial portraits, including those of the bald Caligula. Only Nero broke away to have himself portrayed with a charioteer's or gladiator's fringe—'he did not take the least trouble to look as an emperor should', the

historian Suetonius caustically remarked.

Hadrian was the first Roman emperor to make a radical break with tradition and have himself portrayed with neatly curled hair and a beard in Greek fashion. He may have done this partly to indicate his Hellenism, but he must also have been influenced by Roman theories of physiognomy, which gave great importance to hair and hair-styles as an indication of character. A rich profusion of hair on the head and face marks the Antonine emperors, who succeeded Hadrian, notably the Stoic philosopher emperor Marcus Aurelius (161–180), of whom the most famous portrait is that on the Capitoline Hill in Rome (5, 26). It is the only survivor of more than 20 bronze equestrian figures of various emperors and generals to be seen in the city at the end of the imperial period. The naturalism evident in both the rider and the horse, with its bulging eyes and loose skin creased at the neck, is such that one is hardly aware of the completely artificial discrepancy in scale between them. An impression of calm authority and magnanimity is powerfully conveyed—an impression which may well have been even more compelling originally, when the figure of a captive barbarian chieftain (now lost) cowered beneath the horse's raised hoof.

Similar messages were spelt out by many other works of art. The most frequently used vehicle for visual propaganda was the triumphal arch—another

5, 37 Arch of Titus, Rome, AD 81.

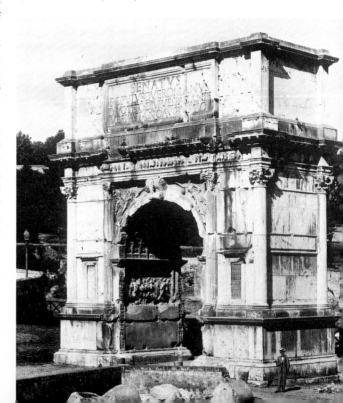

Roman invention—half sculpture, half architecture. The origin of these structures, which were set up in all parts of the empire, is surprisingly obscure. Monumental entrances to cities, temple precincts and palaces had, of course, been embellished with sculpture by the Hittites, Assyrians, Babylonians and Myceneans. In Egypt, as we have seen (p. 40), entrances to temples sometimes bore hieroglyphic inscriptions and carved reliefs referring to the pharaohs who commissioned them. Etruscans, too, built monumental gateways to their cities, of which one survives from the second century BC at Perugia. But the Roman triumphal arch is essentially different. It is free-standing and purely ornamental. Its only function was to carry and display visual propaganda. It might also serve as a monumental entrance to a forum or a city; but it was not necessarily the entrance to anything. Usually it stood across a thoroughfare—one type, the *quadrifrons* arch, spanned a crossroad and was designed as part of a regulated flow, to be passed through, not round.

The earliest surviving triumphal arches date from the time of Augustus. The first recorded was built in Rome at the beginning of the second century BC with spoils from the war against the Carthaginians. Their precise connection with the triumphal processions with which victorious generals were honoured is unknown, but the bronze groups which originally crowned them were of figures riding in chariots drawn by two or four horses, as in a procession. Coins show such a group above the arch erected in the Forum Romanum in 19 BC—to celebrate Augustus' purely diplomatic victory over the Parthians—which seems to have set the pattern for subsequent imperial arches: a rectangular block with a round-headed opening framed by pilasters and entablature with a large panel for an inscription above.

The Arch of Titus in Rome is one of the finest examples, built of concrete faced with honey-coloured marble from Mount Pentelicus in Greece (5, 37). Its columns are of the Composite order, combining Corinthian and Ionic elements, invented by Augustan architects. Winged figures of Victory, descended from those of Greece, hover in the spandrels. But the Roman preoccupation with actuality asserts itself in the reliefs on either side of the passageway. These represent the triumph which Titus shared with his father Vespasian in AD 71, when, to celebrate the suppression of a Jewish revolt, treasures looted from the temple in Jerusalem were paraded through Rome. Even in their damaged state these reliefs convey an astonishingly vivid illusion of space and movement—the men and horses eternally accompany whoever passes through the arch. Titus had died (AD 81) before the work was completed, and his apotheosis is shown in the centre of the vault, borne up to heaven on the back of an eagle. In the attic an inscription in very finely cut, originally gilded letters reads: 'The Roman Senate and People to Deified Titus, Vespasian Augustus, son of Deified Vespasian'. Romans placed enormous importance on such monumental inscriptions. They were the first to discover their artistic possibilities. Clear and simple lettering, in which the form of every letter and the equally important spacing between them was made to conform to the laws of architectural structure, thereby enhancing the authority and dignity of the words, was one of the greatest Roman inventions. It was certainly their most influential and lasting contribution to the arts, for it has never been excelled and remains the basis of all our lettering, including that in which this book is printed (but see also p. 248). In its boldness, clarity and compactness, in its total rejection of any kind of decorative flourish, it perfectly reflects the Roman sense of dignified restraint and disciplined order. Most ancient Greek inscriptions are quite formless in comparison.

If triumphal arches were conceived as historical statements, so, too, were the tall commemorative columns set up in Rome—another and even more peculiar Roman invention than the triumphal arch. The first was Trajan's Column (5, 39), entirely covered by a marble band of figurative carving winding up its shaft and originally topped by a gilded statue of the emperor (replaced in 1588 by a statue of St Peter). It commemorates his campaigns in Dacia (present-day Romania) in AD 101 and 105–6, the main events of which are depicted in chronological sequence from bottom to top. As the column originally stood between two libraries founded by Trajan, it has been suggested that the cylindrical helix of the carving was inspired by the scrolls on which all books were then written. To read this figurative history from end to end, however, was not as simple a matter as unrolling a parchment scroll. The reader must walk round the column no less than 23 times with eyes straining ever further upwards! The scale increases slightly towards the top, but the upper registers are hard to see and impossible to appreciate and must always have been so, even when the figures were picked out in bright colours and gilding. Evidently, the artist's concern was with a very generalized conception of posterity.

The entire strip of carving, more than 600 feet (183m) long if it could be unfurled and including some 2,500 figures, was composed as a continuous narrative, a manner of visual story-telling which had first appeared in Assyria and later in Egypt and on the

upper frieze of the *Altar of Zeus* at Pergamum. There are 150 episodes, each merging into the next without any vertical break to interrupt the flow of the composition and the sequence of events—save for an allegory of history marking the interval between the two campaigns. Trajan's victory over the Dacians is thus presented as an irresistible historical process, but one rendered less in the style of a dry chronicle than in that of an epic poem with much colourful detail. The many different scenes of warfare could, however, be accommodated and represented legibly only by renouncing the spatial logic of such earlier reliefs as those on the *Ara Pacis* (5, 36) and on the Arch of Titus (5, 37). On Trajan's Column the ground is tilted and space is rendered schematically almost as on a map: realistic scale is similarly abandoned so that distant figures stand above those in the foreground without any diminution. Men are larger than the horses they ride, the boats in which they cross the Danube and even the citadels they build and storm.

Narrative relief was further developed on a similar column set up some 65 years later to commemorate the victories of Marcus Aurelius over the Germans and other barbarian tribes on the north-eastern frontiers of the empire (5, 38). Its designer—for it must, like Trajan's Column, have been conceived by a single mind, even if it was executed by several hands—attained greater legibility by reducing the number of scenes and figures in them and by cutting away the background more deeply to give higher relief. Stronger emphasis is placed on the emperor, easily distinguished by his central position in every scene in which he appears and also by the frontal pose, which had by this date come to be reserved for gods and incipiently divine rulers (as yet the emperors were not deified before they died). Other figures are vividly character-ized, with ruthless determination on the faces of the Roman soldiers, terror on those of the barbarians, who are being butchered or herded off to slavery. The forms seem to have been brusquely hacked out. In the process of carving, too, drills were more extensively and obviously used than before, leaving dark pits and channels which play as important a part in the composition as highlighted surfaces. Voids were, in fact, used pictorially to suggest substances as well as space—a technique known as 'negative modelling', much exploited in later Roman sculpture.

The carvings on the Column of Marcus Aurelius have a harsh realism which sometimes recalls the

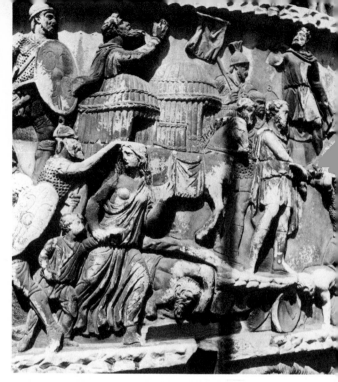

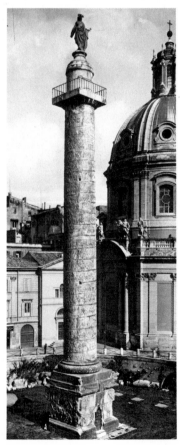

5, 38 *Above right* Captive women and children, relief on the Column of Marcus Aurelius, Rome; c. AD 181.
5, 39 *Right* Trajan's Column, Rome, AD 113.

unflattering portraits of the republican period (5, 34) and even Etruscan tomb effigies. A native Italic tradition of sculpture had, perhaps, begun to reassert itself. The column signals the coming renunciation of Greek and Hellenistic ideals with their emphasis on logical clarity, physical beauty and elegant urbanity. It was erected at the close of the golden age of the Antonines and the *Pax Romana*. Yet intimations of the hieratic, schematized and often illogical art which emerged in the subsequent period, reflecting the aspirations and fears of a new era, are already felt in this last monumental expression of Roman imperial power.

Late Antique art

A huge carving on a rock-face at Naksh-i-Rustam in Iran is a kind of 'barbarian' reply to such pieces of Roman propaganda as the Columns of Trajan and Marcus Aurelius (5, 40). It shows the Sassanian king Shapur I triumphing over two Roman emperors, who had vainly fought against him—Philip the Arabian (244–9), who had been obliged to buy Shapur off with money, kneels in homage, and Valerian (253–60), who ended his days in captivity, is forcibly held by the hand. Lest there be any mistake about the meaning of this and other reliefs of the same subject (one at Nishapur in Iran includes the Emperor Gordian III lying dead beneath the hooves of Shapur's horse), Shapur had trilingual inscriptions carved nearby, giving an account of the war significantly different from (and perhaps more accurate than) those by Roman historians. The narrative technique, by which three distinct events—with 16 years between the first and last—are condensed into a single image, derives from an ancient tradition going back to the palette of Narmer. And yet the carving, with its suggestion of spatial depth, albeit shallow, and its sense of harmonious human proportions, clearly owes a debt to Roman sculpture, whose influence, by this date, could be felt far beyond the frontiers of the empire—as far as India, as we shall see.

Cracks had begun to appear in the fabric of the Roman empire before the death of Marcus Aurelius in AD 180. With the benefit of hindsight we can see that the three-centuries-long process of Rome's declining power had already begun, but whether there was any immediate reflection of it in the visual arts is questionable. There is certainly no hint of any lack of confidence or sense of ebbing authority in the architecture of the late second and third centuries, either in Rome or the provinces. Many of the largest and, originally, most richly ornamented of all Roman buildings date from this period. The theatre at

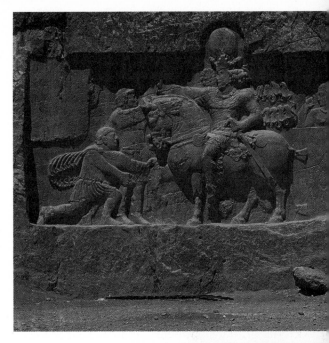

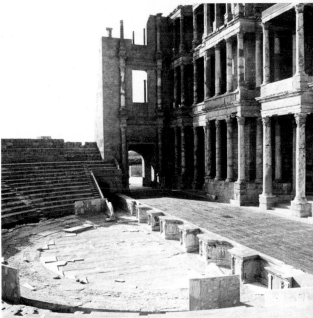

5, 40 *Top* Triumph of Shapur I, Nishapur (Fars), Iran, late 3rd century AD.

5, 41 *Above* Theatre (largely restored), Sabratha, Libya, late 2nd century AD.

Sabratha on the coast of Tripolitania (present-day Libya), for instance, still gives an overwhelming impression of the magnificence of a prosperous, but not very large, provincial city, not even a provincial capital (5, 41). It also demonstrates how the logical and straightforward Greek language of architecture had been elaborated by the Romans into a richly articulated vocabulary for decorative display. On the *scaenae frons* or permanent stage set, Corinthian columns of various types of marble, some plain-shafted, others fluted, a few with spiral fluting, are used without any structural function, apart from that of supporting entablatures to carry yet more columns. Advancing and receding, they provide an openwork screen in front of the great sustaining wall, originally marble-clad, which is itself hollowed out into three semicircular apses.

Similarly opulent buildings with grossly inflated decorations rose up all over the vast empire, but especially in the eastern Mediterranean—in Egypt, Syria and Asia Minor—where Hellenistic architectural forms were reorganized according to Roman ideals of axial symmetry and logical sequence. Individual buildings, temples, basilicas, public baths and long colonnaded streets at Baalbek and Palmyra have far closer affinities with Pergamum than with Rome, although the way in which they are deployed is Roman in its formal monumentality. At Baalbek the huge

5, 42 Temple of Bacchus, mid-2nd century AD. Baalbek, Lebanon.

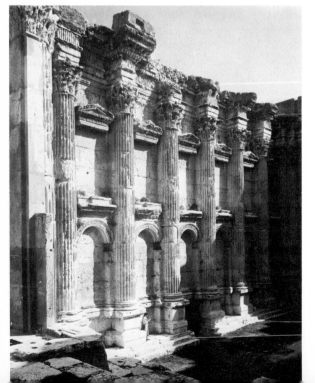

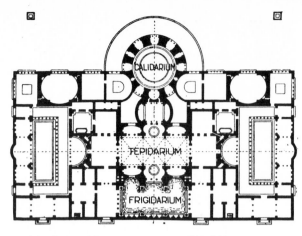

Plan of the Baths of Caracalla, Rome, AD 212–216.

peripteral temple of Jupiter—the Near Eastern storm god Ba'al had been equated with the presiding deity of the Romans—set on a massive 44-foot-high (13m) podium, was begun in the mid-first century AD and was provided some 200 years later with a daunting system of approaches, which made it appear still larger. A flight of steps about 100 yards (90m) wide led up to the tower-flanked portico of the propylaea, giving access to the effectively constricted space of an hexagonal court, from which the worshippers entered a wide colonnaded courtyard in front of the temple. Magnitude was further enhanced by richness, the dramatic management of space by spectacular elaboration of surfaces. In the interior of the nearby temple of Bacchus, which is better preserved, Corinthian columns alternate with pedimented and arched niches, somewhat oppressively compounding the columnar architecture of Greece with the wall architecture of Rome (5, 42). Concrete, the great liberating invention of Roman engineers and architects, was seldom used in the eastern provinces of the empire. Columns continued to reign supreme there—literally thousands of them at Palmyra, where they still stand like sentinels of a rearguard in the desert.

Although the centre of gravity, both politically and economically, had begun to shift towards the East, the emperors continued to promote their most lavish building projects in Rome itself. The Baths of Caracalla (AD 212–216), for example, dwarfed all earlier *thermae*. The main building alone covered more than five acres (two hectares) within a 50-acre (20-hectare) enclosure. Decorations were of unprecedented lavishness. There were numerous free-standing statues, some appropriately colossal—the 10-foot-high (3m) 'Farnese Hercules' being one of them (now Museo Nazionale, Naples). Floors were paved

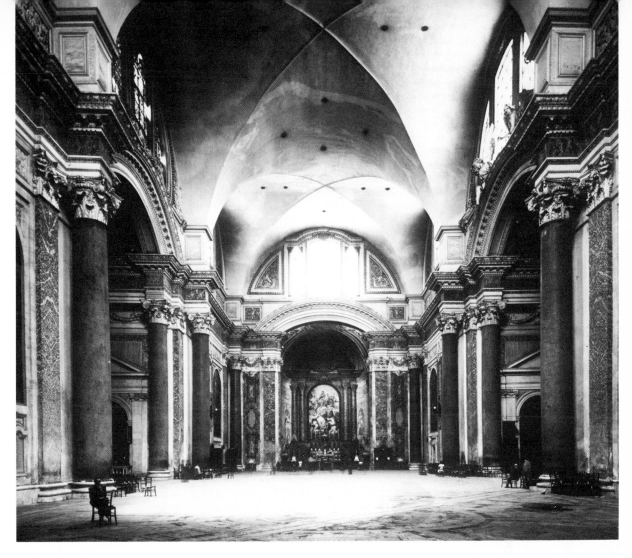

5, 43 Tepidarium of the Baths of Diocletian, Rome, c. AD 298–305. (Converted by Michelangelo and others into the church of S Maria degli Angeli.)

with black and white marble in both figurative and geometrical designs, walls veneered with coloured marble, vaults lined with painted stucco or mosaics. Within a tight symmetrical plan the architect ingeniously integrated rooms of all the different shapes and sizes made possible by the development of concrete construction—rooms covered by barrel vaults, groin vaults, domes and half-domes. Even among the ruins of the concrete core stripped bare of its marble cladding and carved enrichments, it is still just possible to experience some of its spatial effects, to glimpse views from one enormous enclosed space into another and to sense the contrasts in cubic volume, which must have been hardly less exhilarating and relaxing than the differences in temperature between the lofty

rectangular *frigidarium* (cold room), the much lower and narrow *tepidarium* (warm room) and the circular domed *caldarium* (hot room).

A better impression of the grandiose monumentality of the *thermae* may be gained from the *tepidarium* of the later, larger (nearly double the size), but similarly planned Baths of Diocletian (5, 43). The proportions of this vast hall were spoiled by raising the floor some 7 feet (2m) after it was converted into a church; the wall and ceiling decorations of marble and mosaic, which originally reflected and coloured the light pouring through the high windows, were also largely replaced by paint and plaster; and the great openings which afforded vistas of magnificence into adjacent rooms were closed. But the great vault spanning an area of some 200 by 80 feet (60 by 24m) remains: three bays of equal size visually upheld by 50-foot-high (15m) monolithic columns of Egyptian granite. It rests, in

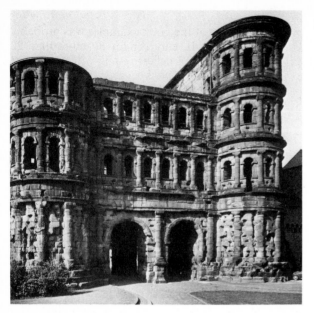

In the half-century between the assassination of the last of the Severans in 235 and the advent of Diocletian in 284, no fewer than 21 men had borne the title of emperor: less than three years was the average duration of a reign. They were no longer elected by the senate, but proclaimed by the army, usually some provincial army of barbarian troops. Indeed, they were often barbarians themselves. None had the time, let alone the taste or resources, to indulge in artistic patronage. Instability within the empire was accompanied by repeated attacks from without. Significantly, the most notable architectural undertaking of these years was a 10-mile-long (16km) fortified wall round the city of Rome itself, built under Aurelian (270–5) after barbarians from the north had invaded Italy and penetrated as far as the Po valley. The

5, 44 *Left* Porta Nigra, Trier, Germany, early 4th century AD.
5, 45 *Below* Seasons Sarcophagus, c. AD 220–230. Marble, 35½ins (90cm) high. Metropolitan Museum of Art, New York, Joseph Pulitzer Bequest, 1955.

fact, on eight huge concrete piers. Like the Pantheon and the similar and equally massive Basilica of Maxentius completed by Constantine (306–313), the last great Roman building in Rome, it powerfully displays not merely engineering skill but unquestioning self-confidence in the Roman's ability to shape and organize his environment, in Roman power to order the world. And, indeed, the Baths of Diocletian were built partly to demonstrate that a strong-minded man had restored imperial authority after a period of near-anarchy.

Roman empire had been put on the defensive. Fortifications, especially city gates, were none the less designed to overawe as well as to repel assailants. The Porta Nigra at Trier (ancient Augusta Trevirorum)—the city in western Germany which was for a while the administrative capital of the empire—is the best preserved survivor (5, 44).

Verisimilitude in portraiture and narrative clarity in relief carving had been the prime aim of Roman sculptors—or the demands of their patrons—ever since republican times. But in the third century

5, 46 Sarcophagus from Acilia, AD 260–270. Marble, about 60ins (152cm) high. Museo Nazionale Romano, Rome.

emphasis began to shift from outward appearances to inner thoughts and feelings, from the body to the soul and from actions to reactions. On sarcophagi the pagan gods and their votaries—uninhibited devotees of Bacchus revelling in the pleasures of the flesh (5, 45)—give way to more intellectual, more spiritually dignified, sometimes nervously introspective figures. Pagan myths (of Orpheus and Eurydice or Alcestis, for example) and such images as that of Aion (personifying the cycle of cosmic time) are drawn on to symbolize the passage from life to death and the translation of the soul, sometimes even suggesting, it might almost seem, the concept of eternity. Others symbolize, with figures of philosophers or Muses draped and holding scrolls, a virtuous, disinterested life, which rises beyond the world to a higher realm of values. In this way educated Romans sought to evade oblivion by being remembered as devotees of philosophy or poetry, and perhaps comforted themselves with the thought of an afterlife

with lofty spirits who had cultivated the undying truths of the mind. One of the finest examples was probably made for Gordian II, emperor for no more than 22 days in AD 238 (5, 46). A delicate youth with a poignant expression of anxiety on his large-eyed, beardless face—perhaps Gordian III, who succeeded at the age of 13 and was murdered six years later—is surrounded by older men who look like philosophers, though they may be senators. One points towards him but they all turn their heads away, sunk in their own thoughts and suggesting the utter loneliness of individuals confronting death. Bodies are swathed in voluminous togas, creating a slow rhythmical pattern of folds, behind which it is difficult to distinguish one from another: only the pensive heads are differentiated, only their incorporeal thoughts seem to matter. We have moved into a world as far away from that of the *Ara Pacis*, where each figure was a self-confident physical presence, engaged in a public, religious ritual (5, 36), as from that of republican tomb effigies, who stare at us with such hard-headed self-assurance in their own materialist values (5, 34).

Amid the disasters afflicting the empire in the third century, the more thoughtful Romans averted their minds from harsh mundane realities in order to contemplate the pure realms of thought. Increasing numbers of converts were drawn either to Neoplatonism or to Christianity. Plotinus (204–270), the founder of Neoplatonism, was the last great philosopher of the ancient world. A Greek-speaking native of Upper Egypt, he studied in Alexandria under the same teacher as the Christian theologian Origen (c. 185–c. 254), joined an expedition of Gordian III against the Persians in the hope of learning something of Oriental thought, and in about 245 settled in Rome, where he expounded a mystical philosophy to a circle which included the emperor Gallienus (260–8). His dialectical method and many of his ideas derived from Plato and Aristotle, but he showed no interest whatever in their political theories or in Aristotle's scientific writings. He was exclusively concerned with fundamentals, with the source of all existence and values, which he identified as 'the One' and 'the Good'. All modes of being, material and mental, temporal and eternal, were, according to Plotinus, an expansion or 'overflow' of this immaterial and impersonal force, of which beauty also was an emanation. From these premises he originated a new aesthetic.

Plotinus rejected the then current definition of beauty as 'proportional correspondence of parts to each other and to the whole coupled with pleasing colour', since this implied that only measurable compounds and no incommensurable single entities

(sunlight, for instance) could be beautiful. In his view progression from unity to plurality involved a decline from the perfect to the imperfect. He also denied that art was necessarily limited to imitation of the visible, material world.

When someone looks down upon the arts because they are concerned with imitating nature, it must first be replied that also the things of nature, too, imitate other things; then you must know that artists do not simply reproduce the visible, but they go back to the principles in which nature itself had found its origin; and further, that they on their part achieve and add much, whenever something is missing [for perfection], for they are in possession of beauty. Phidias produced his *Zeus* according to nothing visible, but he made him such as Zeus himself would appear should he wish to reveal himself to our eyes. (*Enneads*, V,8,1, tr. E. Panofsky)

Thus the artistic 'Idea' acquired a completely new importance and lost the rigidity of Plato's conception of it. The Idea beheld by the mind became the living 'vision' of the artist. This did not, however, lead Plotinus to revalue the visual arts—rather the reverse.

5, 47 Reliefs from the Arch of Constantine, Rome. Medallions AD 117–138, frieze early 4th century AD. Marble, frieze about 40ins (102cm) high.

For, he argued, the artist's vision or idea of beauty, imparted from 'the One' to the artist's soul, could never be more than imperfectly expressed in material which was inherently ugly and evil. Although works of art might, like nature, afford glimpses of an unrealizable 'intellectual beauty', they hindered true enlightenment in so far as they persuaded a spectator to mistake the earthly illusion for the heavenly reality—as Narcissus was beguiled by his own reflection in the water. Plotinus is said to have been ashamed of his own body and refused to sit for a portrait. It could be no more than an image of an image, he thought.

The contemporary renown of Plotinus as a teacher is enough to indicate how well his philosophy answered the spiritual needs of intellectual Romans as well as of students who flocked from Egypt, Syria and Arabia to sit at his feet. What, if any, immediate impact his aesthetics had on artistic practice is, of course, impossible to determine. (His later influence, after Neoplatonism had been absorbed into Christian theology, is easier to trace, as we shall see, p. 292). The sculpture of the late third and early fourth centuries tends, however, to discard or disregard Classical Greek notions of physical beauty, the accepted 'canon' of bodily proportions. Naturalism was no longer pursued; portraiture declined. Yet how far this was deliberate and consciously willed and how far it was due to extraneous factors, to what extent the Classical tradition was renounced in order to create a new style expressive of the spiritual turmoil of the time, may be questioned. The problem is posed in very clear terms by the reliefs on the Arch of Constantine erected in Rome in 313–315 to commemorate Constantine's assumption of sole imperial power in 312—which was immediately followed by the Edict of Milan, proclaiming the toleration of Christianity.

The Arch of Constantine might almost have been designed to stand as an epilogue to the 600-year-long history of Hellenistic and Roman art. The structure is of traditional, characteristically Roman, triumphal arch form, but its lavish sculptural decoration is a patchwork of old and new. This is unprecedented; and whatever the cause may have been, the effect is to emphasize by contrast the radical change which had come over Roman sculpture in the late third century. In one panel, for instance, two Hadrianic roundels

representing a boar hunt and a sacrifice to Apollo are inset above the frieze of Constantine delivering a public oration, one of several similar Constantinian reliefs on the arch (5, 47). The roundels are elegantly suave examples of the Hellenized art favoured by the Emperor Hadrian, delicately cut, naturalistic, vivacious and graceful. In comparison, the relief of Constantine is crude in its simplicity, as if it were a throwback to a less civilized, less highly skilled level of culture. All the hardly-won technical knowledge for creating spatial depth and other naturalistic illusions has been abandoned. There is no foreshortening, no indication of movement: space is flattened, scale is ignored and gestures and poses are repeated without variation, almost mechanically. Uniformly squat and sturdy figures, with heavy oversize heads of regular unvarying features, stand in rows—all in profile except for those of the statues of Hadrian and Marcus Aurelius at either end of the rostrum and that (now missing) of Constantine himself, frontally posed and looking straight ahead.

Ever since republican times a popular Italic style, sometimes termed plebeian, though it was patronized by the middle, rather than the lower, classes (p. 151), had coexisted with that favoured by the more highly educated and consequently more strongly Hellenized patricians. The relief of Constantine belongs to this popular Italic tradition. But the blunt simplicity and directness characteristic of the style are accompanied here by a new consistency in conception—a consistency and thoughtfulness also evident in the choice of earlier sculptures for use on the arch. They were all taken from monuments erected by the 'good' emperors with whom Constantine wished to associate himself: Trajan, Hadrian and Marcus Aurelius. Their new function and new meaning arise simply from the architect's act of choice. In this way the idea behind the work of art acquired greater importance than the work itself; and all the naturalistic skills cultivated in Classical Greece, the Hellenistic kingdoms and the Roman empire came to seem irrelevant to the main purpose of art. The sculptor or sculptors of the Constantinian reliefs must almost certainly have carved sarcophagi for Christians—patrons for whom 'meaning' rather than 'form' was always foremost and who demanded a richly symbolic art to express their otherworldly ideals.

6 Buddhism and Far Eastern art

A slender 34-foot-high (10m) smooth-shafted mono-
lithic column, crowned by a crouching lion in
sandstone, which stands near the village of Lauriya on
the vast plain of the Ganges in north-eastern India, is a
monument of manifold artistic, political and religious
significance (6, 1). At first sight it might seem to have
strayed from Persepolis, more than 2,000 miles
(3,200km) to the west (3, 33). Both its capital, in the
form of a lotus flower, and the lion on top, recall
Achaemenid sculpture. It is, in fact, quite close in date,
being only about a century later. The inscription on the
shaft declares that it was set up by Asoka (272–32 BC),
grandson of the founder of the Mauryan dynasty who
had begun to build the first Indian empire. Asoka had
several such columns erected in various parts of his
empire (6, 2), which extended over most of the Indian
sub-continent from the Himalayas to the Deccan
mountains in the south (covering all present-day
Pakistan, Bangladesh and most of the Republic of
India). They may owe their origin partly to the
columns which had an ancient religious significance in
India as symbols of the cosmic pillar or axis of the
universe, and partly to the inscribed stones which from
a very early period had recorded the conquests and
territorial claims of west Asian rulers, such as the stele
of Naramsin (2, 12). The message of Asoka's
inscriptions was, however, entirely unprecedented: a
declaration of non-violence and adherence to the
teaching of the Buddha. On one column he states that
he had been moved to remorse, had 'felt profound
sorrow and regret because the conquest of a people
previously unconquered involves slaughter, death and
deportation', and that he had learned from the Buddha
to consider 'moral conquest the only true conquest'.
Another records that Asoka had sent missionaries to
preach Buddha's pacific doctrine to all the Hellenistic
rulers in the West, 'to where the Greek king Antiochus

6, 1 Lion column at Lauriya Nandangarh, Nepal, 243 BC.

dwells, and beyond that Antiochus to where dwell the four kings severally named Ptolemy, Antigonus, Magas and Alexander'.

There is no reference to these emissaries in Classical sources, but Buddhist missionaries certainly reached the West and went on doing so—they are known to have been active in Alexandria around the first century AD—though it is unlikely that much heed was paid to them. Links between India, the Hellenistic kingdoms and, later, the Roman empire were mainly commercial. Works of art passed along the trade routes, perhaps more frequently from West to East than the other way though Chinese textiles were being imported into the Mediterranean world in Classical times. The art of India and the ideas it expressed were, however, deeply foreign to Europeans.

An ivory carving, which had reached Pompeii before the city was destroyed in AD 79, is an isolated example of Indian art in Roman Europe (6, 3a). The minutely detailed workmanship reveals considerable technical skill in handling the medium, certainly the equal of any comparable Roman work, though lacking the extraordinary accomplishment and exquisite sensuality of second-century AD Indian ivory carving (6, 3b). The

6, 2 *Below left* Lion capital, from an Asokan column, 3rd century BC. Sandstone, Sarnath Museum.
6, 3a *Below centre* Andhran mirror handle, pre-AD 79. Ivory, 9⅞ins (25cm) high. Museo Nazionale, Naples.
6, 3b *Below right* Detail of Kushan plaque from Begram, pre-AD 241. Ivory, Kabul Museum, Afghanistan.

proportions of the figure from Pompeii, with her over-large head, and the two attendants on either side, no taller than her hips, indicate the East's indifference to any ideals of human beauty of the kind evolved by the Greeks. Dressed only in jewelry, which frames and sets off the sexual organs, she displays just those parts of the body which the gesture of the *Venus pudica* hides (4, 23d). Yet this ivory has none of the grossness of the many erotic Pompeiian sculptures and paintings.

The ivory served originally as the handle of a mirror and the subject is usually identified as a courtesan. She is closer, however, to a *yakshi* or nature spirit such as that carved on a gate to the Great Stupa at Sanchi, in a similarly alluring state of bejewelled undress with a necklace hanging down between her large and sexually provocative breasts, a belt round her hips and bangles on her arms and legs (6, 4). Holding on to the branches of a banyan tree, the *yakshi* sways with rhythmical *déhanchement*—there is no English word for this bending of the body from the hips—in the Indian *tribhanga* (literally 'three bends') pose which obsessed Indian artists for centuries and provided the sinuous three-dimensional curves which pervade their sculpture, even when it is purely decorative and non-representational. The figure seems to be composed entirely of soft malleable flesh without any hard bone structure. Yet this gives it, paradoxically, a strangely ethereal quality, exemplifying the combination of sensuality and spirituality which distinguishes the arts of India from those of all other civilizations. It forms

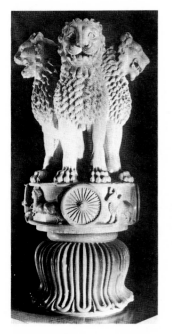

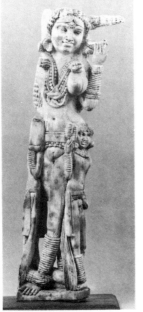

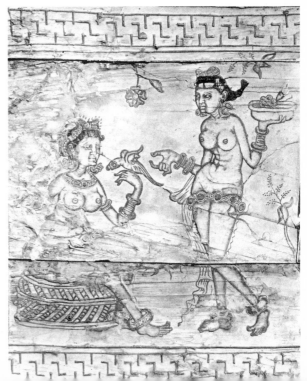

part of the exterior of one of the holiest shrines dedicated to the Buddha, who taught that the pains and sorrows of existence stemmed from attachment to self and to the ephemeral pleasures of the senses.

Yakshis belonged to the complex religious beliefs which preceded, coexisted with and were destined to outlast Buddhism in India. As spirits of the trees and streams they were worshipped by the Dravidians, who had peopled India before Aryan invaders arrived from the North in the second millennium BC. Aryans brought with them a pantheon of 'higher' deities not unlike those of the Greeks, personifying the great elemental forces worshipped without images or temples, notably Indra, god of the atmosphere and thunder, and Surya, the sun god—cousins, as it were, of Zeus and Apollo. These gods were celebrated in the famous Vedic hymns, composed between about 1500 and 800 BC in Sanskrit, a language akin to the dialects of the Greek, Celtic and German peoples who moved into Europe also in the second millennium BC. Both Dravidian and Aryan beliefs contributed to the religion, or rather to the group of magic practices, religious cults and philosophies of life known in the West as 'Hinduism', a word with no precise equivalent in the Indian languages. The metaphysic expounded in the early *Upanishads*, composed between about 800 and 600 BC as commentaries on the Vedic hymns, was focused, however, less on easily visualized anthropomorphic deities than on elusive abstract ideas: *Brahman* the universal spirit or world-soul, *Atman* one eternal human soul, *Maya* the cosmic flux which animates all things. The aim of religious exercises was not, as in other contemporary civilizations, to propitiate or coerce the supernatural powers but to achieve the absorption of the *Atman* into the *Brahman* and thus liberate the soul from the retributive principle known as *Karma*, the endless succession of reincarnations in human or animal form determined by conduct.

Belief in *Karma* had social as well as ethical significance. For it was generally held to justify the caste system, which provided a structure of classes: Brahmins or priests, Kshatriyas or warriors, Vaisayas or cultivators, and Sudras or serfs. Brahmins alone were credited with the power to escape from the cycle of rebirth by means of asceticism and by sacrifices according to a ritual known only to them. (Others could hope to attain this goal by leading exemplary lives and practicing self-denial, which might be rewarded by reincarnation as a Brahmin.) Their absolute spiritual and temporal authority was questioned by the founders of Jainism and Buddhism, the two great religious movements which emerged in the

sixth century BC. The former was destined to remain a relatively small sect confined to India. But Buddhism revolutionized the thought and art of the whole of East Asia.

Buddhist art in India
The word 'Buddha' signifies 'the enlightened one', and the aim of Buddhism is release from the sufferings of existence not by ritual sacrifice and extreme asceticism, but through enlightenment attained by the obliteration of all desires and, finally, of the self through concentrated meditation or yoga. Buddhism opened the way to salvation to all who followed the Eightfold Path of right knowledge or understanding, right motive, right speech, right deeds, right way of life, right effort, right self-mastery and right meditation. Its founder Siddhartha Gautama (c.563–483 BC) was born into the warrior caste as a prince of the Sakya family—he was often called Sakyamuni, 'Sage of the Sakyas'—on the border of Nepal in north India. He withdrew from the world, studied under Brahmins who advocated self-mortification, but renounced their asceticism and achieved the enlightened cosmic consciousness known as Buddhahood as the result of

6, 4 *Yakshi*, detail of east gate, Great Stupa, Sanchi, 1st century BC.

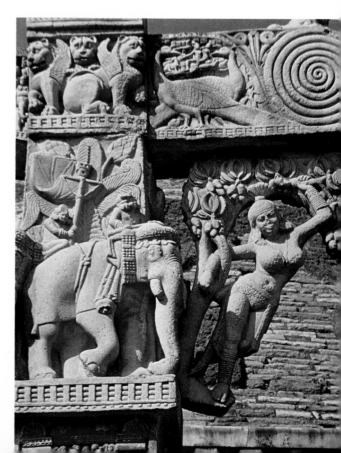

meditations under the Bodhi Tree or Tree of Wisdom at Gaya. The rest of his life was devoted to preaching his message to members of all castes in northern India. After he died or, in Buddhist terminology, attained *Nirvana* (which originally meant extinction), his work was carried on by an ever-increasing band of followers. In the mid-third century BC, as we have seen, Buddhism was adopted by Asoka as the official religion of the greater part of India.

The early development of religious art in India is a direct consequence of the spread of Buddhism. Brahmins had had no need for temples and little desire for images to make the mysteries of religion accessible to the laity. Although images were almost certainly made in perishable media for the cults of the non-Aryan population, there are no sculptures or paintings to set beside the works of religious literature composed in the millennium after the disappearance of the Indus Valley civilization (see p.35). The first great Buddhist ruler, Asoka, was also the first major patron of the arts in India. In addition to setting up inscribed columns (6, 1), he is known to have had mounds or artificial hills, called stupas, built to enshrine the bodily relics of the Buddha, which he distributed to the principal cities of

6, 5 Great Stupa, Sanchi, 1st century BC.

his empire as a means of 'moral conquest'. No stupa of his time survives, but the essential form—derived initially from the mounds raised over the dead, especially Brahmins and members of ruling families—is preserved in the Great Stupa at Sanchi in central India (6, 5). Although it dates mainly from the first century AD, it is probably an enlargement of a stupa founded by Asoka.

This is a symbolic structure, at once a visible manifestation of the Buddha—the contemplation of his natural remains enabling the worshipper to think of the Buddha as an immanent reality—and an architectural diagram of the cosmos, precisely oriented and designed according to an elaborate system of proportional relationships with mystical significance. It consists of a solid hemisphere, typifying the dome of heaven, levelled at the top to carry a square superstructure with a central mast to represent the world axis extending from the infra-cosmic waters to the skies. Three parasol-like forms called *chattras* on the mast signify the heavens of the gods, with that of Brahma at the top, and perhaps also the Three Jewels of Buddhism—the community of monks, the Law and the Buddha. From their resemblance to the parasols carried over the heads of earthly potentates, they also declare the Buddha to be the universal ruler.

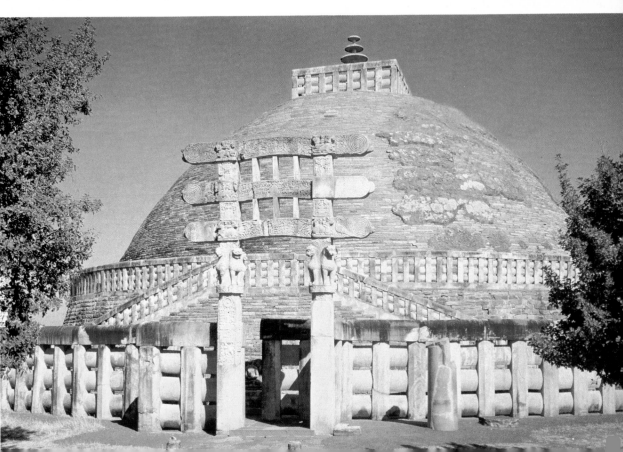

A palisade encircles the mound; it is built of stone but in the form of a wooden fence. Carefully dressed stones were fitted together as if they were stout posts and thick bars. The four gateways called *toranas* are similarly constructed in stone to simulate wood with their horizontal beams carved so that they appear to pass through the uprights—the spirals at their ends suggesting the rings in the section of a tree-trunk and perhaps symbolizing the vegetative stem of life. Why wooden prototypes should have been followed so closely despite the technical difficulty of treating heavy stone in such a way is a mystery—the same pheno-menon is found in other cultures, for example, ancient Egypt, Greece and, less obviously, in imperial Rome (see p. 105). There can be no doubt that the form of the palisade at Sanchi, especially of the gates, had some earlier symbolical significance perhaps connected with the temporary open-air fire-altars on which the sacrificial ritual of the Brahmins was centred. The very careful orientation of the gates to the cardinal points of the compass, and the walls behind them obliging visitors to turn left on entering and thus walk round the stupa following the course of the sun, certainly reflected the Brahmins' cosmological preoccupations. But on all Brahminical sacrificial implements or-namentation was—and still is—avoided. The *toranas* at Sanchi and other stupas, on the other hand, are entirely covered with carvings. There are animals and Dravidian *yakshis* (6, 4) as well as symbols of the Hindu gods and scenes from the Buddha's life on earth—though without his image. (The anthro-pomorphic Buddha image was not created until later, see p. 184).

Whatever their previous significance may have been, the *toranas* acquired a special meaning for Buddhists. As they passed through the gate and walked round the stupa, contemplating the holy relic buried at its heart, they moved from the world of the senses to that of the spirit, from the temporal to the eternal, approaching the enlightenment of cosmic consciousness. They also passed from the diverse beliefs of the earlier religions of India to the all-embracing unity of Buddhism. As a whole the Great Stupa at Sanchi thus demonstrates how a new art emerged out of the Buddhist integration of the metaphysical content of the *Vedas* and *Upanishads* with animistic pre-Aryan beliefs, which had remained the religion of the masses.

Emphasis placed by the Buddha on the supreme importance of the contemplative life encouraged an increasing number of his followers to withdraw into monasteries, called *viharas*. They seem to have lived at first in very simple buildings of wood or thatch or, like earlier holy hermits of India, in natural caves. From the third century BC more elaborate groups of cells and halls were cut into the living rock of hillsides or gorges. One of the largest and most impressive of these is the *chaitya*-hall (the word *chaitya* means simply 'place of worship') at Karli (6, 6). Its façade, with a huge ogee arch (see Glossary) like the gable of a thatched roof, is carved to imitate the elements of wooden structures. So, too, is the interior, divided into a nave and aisles by rows of closely set columns. Strictly speaking, this is sculpture rather than architecture; it is not constructed but excavated and carved. A passage was first tunnelled into the rock-face, the ceiling with its simulated beams was then carved, without any need for scaffolding, and work proceeded downwards until the space around the columns and the small stupa in the apse at the end of the hall was cut away and the floor smoothed.

The hall provided a setting for the stupa which the devout could approach directly or, more usually, walk round by passing along the passage between the columns and wall, thus performing the rite of *pradaksina* or circumambulation. Light, filtering through a large window above the main door, is focused on the stupa. Glimpsed from the dark aisles, through the narrow gaps between the columns, the interior appears to be radiant with ethereal light emanating from the stupa. Seen from the nave, the stupa seems to be the only reality in an infinite void of primal darkness, held back by the half-lit columns along either side. Decoration is restricted to these columns, each with a base carved like a water-jar (perhaps an allusion to the waters beneath the cosmos), a 16-sided shaft, a bell-shaped capital and, above, a pair of elephants bearing male and female figures looking into the nave, and paired horses facing

6, 6 Interior of *chaitya*-hall, Karli, c. AD 50.

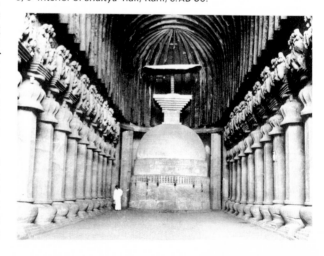

the aisles. There is much more figure sculpture on the façade, including reliefs of *yakshis* and their male equivalents *yakshas*. But a clearer impression of the entrance to a rock-cut temple is given by a later and richer example at Ajanta (6, 10). Here, however, the carvings include images of the Buddha, which had made their first appearance in the first or early second century AD.

The early Buddhists revered Sakyamuni as a mortal teacher who attained enlightenment and finally *Nirvana*—the release of the spirit from its incarnations. This consummation could for them be expressed visually only by abstract forms, such as that of the stupa. There was no means by which his person could be represented. 'For him who (like the sun) has set, there is no longer anything with which he can be compared', declares one of the earliest Buddhist texts. But a religion with the steadily growing popular appeal of Buddhism called for icons as visual aids to doctrine, and stupa gateways were carved with reliefs illustrating his life as early as the late second or early first century BC. A fine example from the stupa at Bharhut in north-central India depicts the visit paid to the Buddha by a king (6, 9). It is a strange mixture of the conceptual and the naturalistic, for while some figures are taller than the columns of buildings by which they stand, elsewhere a remarkable degree of illusionistic skill in carving is displayed—as in the two oxen which trot forwards drawing the royal chariot on the right and are shown head on; and in the hind-quarters of a horse passing through a *chaitya*-arch gateway on the left and, above, a mahout trying to prevent his elephant from pulling down the branch of a mango tree. Altogether a surprising amount of descriptive detail is given. Yet the Buddha himself is represented only symbolically, by a wheel above his flower-strewn throne. The wheel, which had been associated in west Asia with the solar disc, the supreme deity and knowledge, acquired in India additional significance as the multiple symbol of birth, maturity and death and of the great cosmic revolutions in the unending cycle of reincarnations. It also had a more specific Buddhist meaning as the *Dharmacakra*, the Wheel of the Law (or Doctrine) set in motion when the newly enlightened Buddha preached his first sermon, which, like the wheel of the sun, illuminated all quarters of the earth, giving spiritual light to all beings. In other early relief carvings the Buddha's ineffable presence is indicated by the horse he rode when he made the great renunciation and left his father's house, or by the Bodhi Tree beneath which he meditated, or by an empty seat or simply by his footprints.

A momentous change came about with a new school

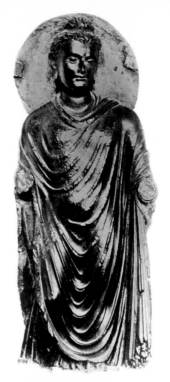

6, 7 *Left* Standing Buddha from Hoti-Mardan, 1st–2nd century AD. Formerly Guides' Mess, Hoti-Mardan, Pakistan (present location unknown).

6, 8 *Right* Gold coin of Kanishka showing the Buddha, late 1st to early 2nd century AD. Formerly Museum of Fine Arts, Boston, Seth K. Sweetser Fund.

of Buddhist thought called by its adherents the *Mahayana* or Great Vehicle (of Salvation) to distinguish it from the earlier *Hinayana* or Small Vehicle. *Hinayana* Buddhism had been a literally 'atheistic' philosophy derived from the Buddha's teaching and especially his final injunction that his disciples should work out their own salvation for themselves. It encouraged withdrawal and the contemplative life of a monastery. The *Mahayana*, however, conceived the Buddha not as a mortal teacher whose precepts and example were to be followed, but as a god who had existed eternally, like Brahma or Jehovah, without beginning or end. In this form Buddhism became more easily reconcilable with other religious beliefs both in India and, as we shall see, China and Japan. From a transcendental viewpoint, the historical Buddha came to be seen as an illusion in an illusory world; this paradoxically permitted him to be represented by images, for all images are illusory too. At a lower intellectual level the *Mahayana* opened the door to the worship of a Buddhist pantheon of deities visualized anthropomorphically like, and sometimes together

6, 9 *Below* King Prasenajit visits the Buddha, detail of a relief from the Bharhut stupa, early 2nd century BC. Red sandstone, 18⅞ins (67cm) high. Freer Gallery of Art, Smithsonian Institution, Washington DC.
6, 10 *Right* Exterior of cave temple at Ajanta, 4th century AD.

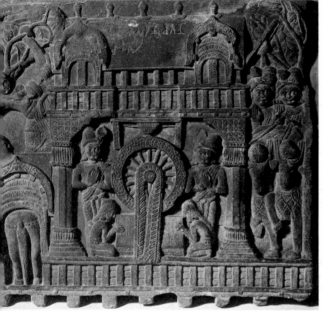

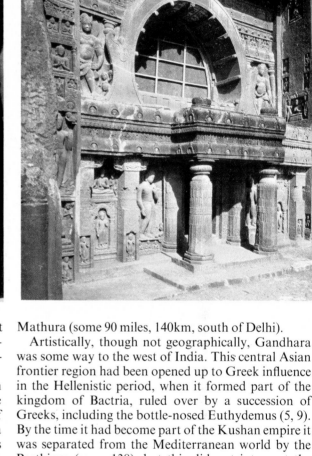

with, the deities of other religions. Most important among them were the Bodhisattvas or Buddhas-in-the-making, who, for the salvation of humanity, renounced the *Nirvana* they were capable of attaining.

An image of the Buddha in human form appears on coins issued by Kanishka I, a follower of the *Mahayana*, who, probably in AD 78, became ruler of the Kushan empire, which extended from the Aral Sea through Afghanistan and south-eastwards as far as Benares on the Ganges (6, 8). This tiny figure incorporates many of the distinguishing features of later Buddha images, for instance the *ushnisha*, a cranial protuberance indicating superior spiritual knowledge, ear-lobes greatly elongated by the heavy jewelry he had worn in his gilded youth as a prince, right hand raised in a gesture of reassurance or benediction, a monastic robe, and haloes of sanctity behind his head and body. There must surely have been precedents for these features, either in sculpture or painting. But none of the early surviving Buddhas can be more than approximately dated. They are in two distinct styles, one developed at Gandhara in the north (around Peshawar in present-day Pakistan), the other at the southern extremity of the Kushan empire at

Mathura (some 90 miles, 140km, south of Delhi).

Artistically, though not geographically, Gandhara was some way to the west of India. This central Asian frontier region had been opened up to Greek influence in the Hellenistic period, when it formed part of the kingdom of Bactria, ruled over by a succession of Greeks, including the bottle-nosed Euthydemus (5, 9). By the time it had become part of the Kushan empire it was separated from the Mediterranean world by the Parthians (see p.138), but this did not interrupt the flow of works of art and, almost certainly, of artists as well from Rome's eastern provinces. The result was an art owing as much or more to Rome as to India, a miscegenation of two deeply antipathetic ideals. Yet it was from this strange artistic cross-fertilization that the first great Buddha images were to come, some of the most serene and spiritual of all works of art. To express the idea of divinity in human form Gandharan sculptors turned to statues of Greek and Roman gods, as artists were to do some two centuries later when Christians demanded visual images of Christ (see p. 218). The haloes placed behind the heads of both the Buddha and Christ probably share a common origin (see p. 226). But the sculptors of Gandhara derived

more than iconographical devices from the West.

One of the earliest Gandharan Buddhas is also among the most Classical, in a European sense (6, 7). Drapery hanging in loose folds, but indicating the form and movement of the body beneath, is like that on contemporary statues of deified Roman emperors or, more appropriately, of the Muses, who brought to humanity the purifying power of poetry and divine wisdom (5, 36; 5, 46). The pose has an enlivening twist typical of Late Antique sculpture and the head recalls a Greek Apollo. Wavy hair conceals the *ushnisha*, and only the *urna*, a tuft of hair between the brows, and elongated ear-lobes remain as distinguishing marks of the Buddha. For the elevated but gentle expression of a heart at peace so eloquently conveyed by this noble figure there was, however, no precedent in the art of the West. In another, probably later, Buddha head Greek symmetry, balance and repose are again combined with the peculiarly sensual spirituality of India to create a sublime image of Eastern serenity, an Orientalized Apollo (6, 11). The meeting of East and West in the art of Gandhara brought forth a new type of human beauty, which was to haunt not only the Indian image of the Buddha but also, and perhaps more strongly, the Chinese.

In contrast, the Mathura Buddha images are purely Indian, as exemplified by an imposing high relief in the red sandstone of the region (6, 14). Here the Buddha, or rather, as the inscription reveals, Sakyamuni before he achieved enlightenment, sits in the cross-legged yoga posture, meditating beneath the Bodhi Tree. Royal status is indicated by the lion throne and the two attendants with fly-whisks, spiritual power by the

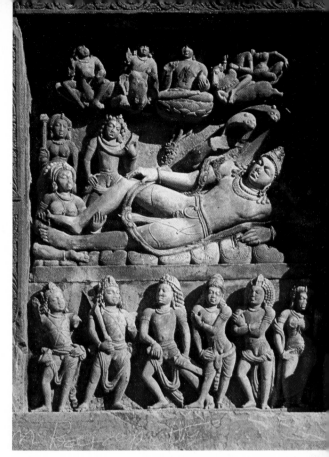

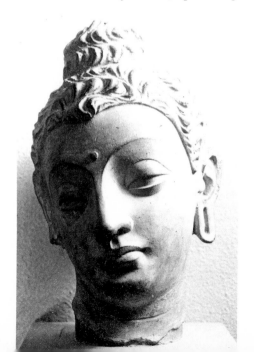

6, 11 *Left* Head of Buddha from Gandhara, 3rd century AD. Lime composition, 16$\frac{1}{10}$ins (41 cm) high. Victoria & Albert Museum, London.
6, 12 *Top* Vishnu on Sesha, Vishnu temple, Deogarh, 5th century AD.
6, 13 *Above* Sanctuary of the lingam, Trimurti Cave, Mamallapuram, early 7th century AD.

heavenly beings hovering above and by the distinguishing marks on his body, including wheels incised on the palm of his hand and the soles of his feet. The torso with distended skin has the same somewhat pneumatic quality of the *yakshis* at Sanchi (6, 4) or even of the very much earlier Indus Valley statuettes (2, 15).

Images of this type influenced the sculptors of Gandhara. They appear, for instance, on a Gandharan frieze (6, 16) surrounded by figures which would not look out of place on a Roman sarcophagus of about the same date—one man appears to be wearing a toga and another, Classically posed beside him, is in a state of stark nudity rare in Indian art even in the most uninhibited erotic scenes. But the sculptor had evident difficulty with the Indian yoga pose, for which the arts of the West provided no model. (The folded legs look like a bolster beneath the torso and the upturned right foot has been transformed into a swirl of drapery.) The frieze depicts the Buddha's birth, his meditation under the Bodhi Tree and, in the part illustrated here, his first sermon in the Deer Park (symbolized by the wheel between the two deer on the throne) and his death, with the last disciple meditating in front of the bed. Difference in scale indicates relative importance. The Buddha on the Mathura relief also is much larger than his attendants: they are no more than shadowy presences beside the living teacher, who bends forwards slightly with a compassionate expression on his face, as if to address the spectator. On the Gandhara frieze, the small subsidiary figures are full of vitality and jostling movement, while the Buddha is withdrawn in static detached monumentality, like an heroic-scale statue surrounded by living worshippers. He is, in fact, represented as a god, far removed from the joys and sorrows of humanity, as he was to be in later Buddhist art.

The arts of both Gandhara and Mathura contributed to the formation of what is generally called the 'Classical' style in Indian art. It reached maturity in the three-century-long Gupta period named after Chandra Gupta I, who was crowned king of kings in the old Mauryan capital of Pataliputra in AD 320. A high relief of the Buddha preaching his first sermon is among the masterpieces of this style and, indeed, of the religious art of the world (6, 17). The superb technical accomplishment of the carving may perhaps derive from Gandharan practice, but has been further refined by an exquisite precision of detail and by a sensuously subtle definition of form unlike anything in the West.

Gandharan sculptors had represented the Buddha as an anthropomorphic god, almost as in the West. In the Gupta statue he appears as a divine essence, pure

6, 14 Seated Buddha from Katra, Mathura, 2nd century AD. Sandstone, 27¼ins (69.2cm) high. Government Museum, Mathura.

spirit purged of all earthly matter, light without heat. Such a figure seems to be a product of the meditation it was intended to stimulate, transcending the senses among which Indians include the intellect. Essential symbols from earlier representations of the subject have been assimilated and subjected to the general effect—the heavenly beings, the wheel, the deer (sadly damaged) and the disciples. The Buddha's exquisitely expressive hands, in one of the *mudras* or gestures which constitute an esoteric sign language, turn the Wheel of Doctrine, the *Dharmacakra*. Yet the statue derives its silencing religious aura, the spiritual potency of non-violence, as much from its form as from its symbolism. Otherworldly serenity is suggested by perfect symmetrical equilibrium and the combination of the simplest and most self-contained of geometrical figures. The great circles of the halo are echoed in the lines which indicate the creases of the neck, the waist and the drapery beneath the legs. Two triangles intersect, one enclosing the body from the

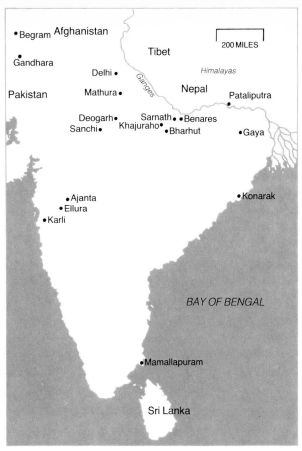

Map of India.

6, 15 *Left* Great Bodhisattva, wall painting in Cave I, Ajanta, 7th century AD.

6, 16 *Below* Details of relief from Gandhara showing the First Sermon in the Deer Park and the death of the Buddha, Kushan, late 2nd–early 3rd century AD. Dark gray-blue slate, $26\frac{3}{8}$ ins (67cm) high. Freer Gallery of Art, Smithsonian Institution, Washington, DC.

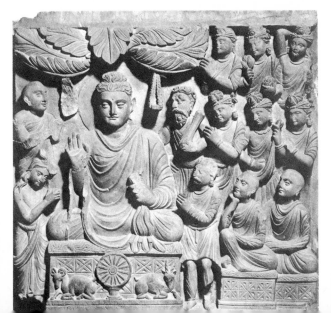

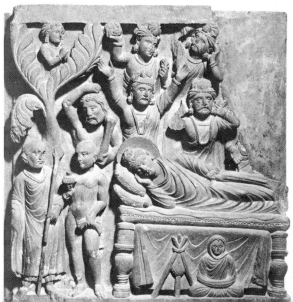

crown of the head to the knees, the other expanding along the lines of the narrow-waisted, broad-shouldered torso to the heavenly beings who hover on the edge of the halo. The head is oval, an allusion maybe to the Indian idea of the egg-shaped cosmos, and the sharply cut lines of eyebrows and eyelids repeat its curves. It is a mark of the sculptor's genius that so severely abstract a configuration could be fused so apparently naturally and effortlessly with an image of such gentle humanity, one which is supernatural without being in any way unnatural.

Like many Indian statues, the figure is under life-size. In pursuing an inner spiritual reality, a pursuit which immunized them from the Western obsession with naturalism and the lifelike, Indian sculptors often, and perhaps most effectively, worked on a small scale, though they occasionally went to the opposite colossal extreme. They also evolved a canon of bodily proportions designed to give heroic stature even to small-scale figures, but based on mathematical ratios and thus more closely akin to that of ancient Egypt than to that derived from visual appearances in Classical Greece. (The distance between the chin and the top of the forehead provided the module, multiplied nine times for a full-length figure.) Careful observance of this intellectually conceived canon did not, however, preclude sensuous handling when the subject-matter demanded it—to indicate, for instance, the nature of a Bodhisattva. Physical beauty attracted the eye but also disposed the mind to meditate beyond the range of the senses and the intellect. A red sandstone torso, probably later than the Gupta period but maintaining the same high standard of technical accomplishment, illustrates the extreme sensitivity with which the velvet-soft but firm flesh of a lithe athletic youth could be rendered, bulging slightly above the belt and set off by sharply cut jewelry and the scarf of antelope skin (6, 18). Here again, as at Sanchi (6, 4), full-blooded life and provocatively swaying movement are suggested by the *tribhanga* pose.

That pictorial art was as highly developed as sculpture in the Gupta period is demonstrated by wall paintings in the rock-cut temples known as the Ajanta 'caves', very poorly preserved though they are. One of the most impressive, and least badly damaged, is of a Bodhisattva rather larger than life-size and very much larger than the numerous figures around him (6, 15). In technique it is akin to fresco: the rock-face was covered with a mixture of clay and other materials, this was coated with lime which was kept moist to absorb pigment, outlines were painted in red then filled in with colour and the whole surface finally burnished to a lustrous gloss. Outlines define forms with an occa-

sional use of shadows and highlights to suggest solid modelling, not to record the effect of light (the bridge of the Bodhisattva's nose is paler than the rest of his skin and there are shadows on both sides of it).

A visionary harmony, a sense of universal well-being, pervades this great painting. Although it teems with figures, they are all so much at their ease that there is not the slightest sense of overcrowding. It suggests not so much *horror vacui* (dislike of emptiness) as a positive delight in fullness. An amorous couple, royal or divine, reclines to the left of the Bodhisattva: a dark-skinned woman with richly jewelled head-dress stands

6, 17 *Below* Teaching Buddha from Sarnath, Gupta, 5th century AD. Sandstone, 62ins (157.5cm) high. Sarnath Museum.
6, 18 *Above right* Torso of Bodhisattva from Sanchi, post-Gupta (?), 5th century AD. Sandstone, 34¼ins (87cm) high. Victoria & Albert Museum, London.
6, 19 *Above far right* Descent of the Ganges, Mamallapuram, early 6th century AD.
6, 20 *Below right* The Dharmaraja rath and other rock-cut temples, Mamallapuram, AD 625–674.

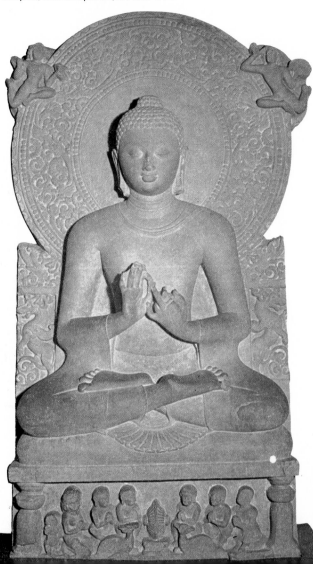

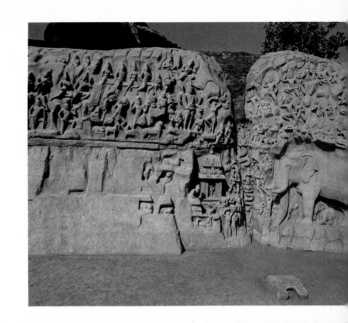

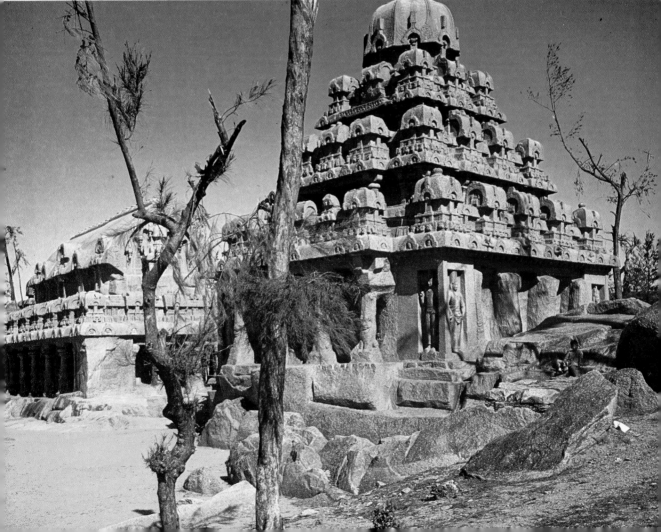

on the other side. There are monkeys, peacocks and fabulous creatures among the trees in the background, or rather at the top of the wall, for the painting should not be 'read' in a Western way as an illusion of figures in space. The figures, immersed in their own intimate thoughts, must be examined individually by a similarly meditative spectator. They look straight out of the wall, since Indian artists avoided the profile almost as studiously as did the Egyptians and Greeks the full face. There is no composition in the European sense, no comprehensive controlling pattern to which the parts relate. Forms seem to have drifted together like clouds, giving the work its visionary or dreamlike quality. It differs as profoundly from European painting as does Indian from Western music.

The Bodhisattva stands in the *tribhanga* pose, gazing with an expression of thoughtful tenderness. His features recall, no doubt intentionally, the similes by which supernatural beauty was evoked in Buddhist literature—brows curving like an Indian bow, eyes like lotus petals and so on. A jewelled tiara, a pearl necklace with sapphire clasp, and the strand which Brahmins wear across their chests woven of seed pearls, all indicate princely status. The symbolically blue lotus flower in his hand identifies him as Avalokitesvara ('the being capable of enlightened insight') Padmapani, one of the most important figures in *Mahayana* Buddhism, who was to be worshipped in China as Kuan-yin and in Japan as Kwannon (see pp. 208, 215). He is the potential Buddha, eternally teaching the doctrine of enlightenment to all creatures on earth. His regalia refer to his role as a heavenly prince and also to the historical Buddha's youth as an earthly prince. As a personification of divine mercy and compassion for humanity, he satisfied devotional and emotional needs better than the remote figure who had attained *Nirvana* and had come to be seen less as a teacher than a symbol of the redemptive power latent in every soul. He was also much more like the ever-present deities of traditional Indian religious cults. His lotus links him with the pre-Aryan Lakshmi, and also with Vishnu and Brahma.

By the seventh century, when this painting was executed at Ajanta, *Mahayana* beliefs were, in fact, beginning to draw Buddhism in India back to its origins. After the Islamic invasion, which began in the early eleventh century, it was entirely extirpated in the north (hence the scarcity of surviving monuments) and completely reassimilated into Hinduism in the south, where the Buddha was eventually regarded as an avatar or incarnation of Vishnu. The subsequent history of Buddhist art thus lies mainly outside India (see p. 196).

Hindu art

During the first millennium of the Christian era Buddhism, Jainism and Hinduism developed side by side without friction, submitting to the same influences, exchanging ideas and insights. Buddhists and Jains may not always have practiced the non-violence they preached—any more than Christians did. But they did not persecute, nor were they persecuted by adherents of the manifold and undogmatic religious and philosophical beliefs which comprise Hinduism. The arts inspired by these religions, therefore, differ less in style than in iconography. Hinduism has remained to this day the religion of the vast majority of Indians, and its artistic heritage is incomparably richer than that of Indian Buddhism or of Jainism (which has always been a relatively small sect). Its iconography is also much more complex, incorporating numerous figures with multiple significance.

Nearly all the main members of the Hindu pantheon are gathered together in a fine relief of the Gupta period on a temple at Deogarh in central India (6, 12). Vishnu, to whom the temple is dedicated, has pride of place. The world and all its creatures are often referred to as figments in the dream, or nightmare, of Vishnu. He is here shown asleep, resting on the coils of the giant serpent called *Ananta* (endless), who dwells in the cosmic waters which give life to all beings, divine as well as terrestrial. The god and the serpent, which raises its nine heads to form a canopy over him, are both manifestations of the single divine cosmic substance: the energy underlying the inhabiting all forms of life. Vishnu's right leg is held and caressed by his wife Lakshmi, in origin one of the nature spirits worshipped by the pre-Aryan inhabitants of India. (The serpent may also be connected with Dravidian water-spirits called *nagas*). In the centre of the upper register a figure in the yoga posture might be mistaken

6, 21 Siva Mahadeva, Siva temple, Elephanta. Stone, 17ft 10ins (5.44m) high.

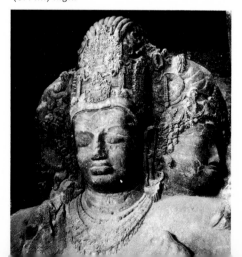

for the Buddha were it not for his four heads which reveal him to be Brahma. He is enthroned on a lotus blossom said to grow from Vishnu's navel (though this is not directly indicated in the carving at Deogarh). Flanking him on the left is Indra riding his elephant; on the right Siva and his consort are mounted on a bull. Five men and one woman at the base of the relief, in busy attitudes which contrast with the atmosphere of eternal somnolence above, are terrestrial incarnations of other gods. Their story is associated with Vishnu's avatar as Krishna, related in the *Bhagavad gita*, the enormously influential religious poem which was composed in about 200 BC and marks the emergence of popular theistic Hinduism out of the esoteric Vedic religion of the Brahmins. In the context of Indian religious history, it is interesting to note that the relief at Deogarh gives second place to Brahma—the world soul of the Brahmins—but only alludes to Krishna, whose cult later became, as it still remains, the most widespread in India.

The orthodox Hindu trinity is composed of Brahma, the creator of the universe, Vishnu, its preserver and supporter and Siva, its destroyer. But as they are identical in substance, their roles are interchangeable and each may be credited with those of all three. Siva is shown as a trinity himself in the rock-cut temple dedicated to him on the island of Elephanta, some six miles out from Bombay harbour. A more than 17-foot-high (5m) bust with the three heads seemingly rises out of the ground within a dark recess opposite the entrance (6, 21). A stern virile mustached profile crowned with a cobra and death's head on the left is balanced, on the other side, by that of a female counterpart, softly modelled with voluptuous lips and delicately dressed hair. They indicate respectively the male and female, destructive and creative, principles which proceed from the divine essence or Absolute represented by the sublimely aloof androgynous central countenance. As a whole this overpowering image—so different from the simply conceived and, one might say, naively anthropomorphic deities of the ancient West—gives concrete form to the mystery of the unfolding of the Absolute into the dualities of phenomenal existence. It was not, however, the main object of worship in the temple. An inner shrine, a holy of holies with four entrances, enclosed a stone lingam or phallus as a symbol of cosmic creative energy. Such a lingam shrine is found in every temple to Siva and there is a better preserved example at Mamallapuram (6, 13). Worship of the lingam may well have originated in prehistoric fertility cults—numerous realistically modelled phalluses have been found among the remains of the Indus Valley civilization.

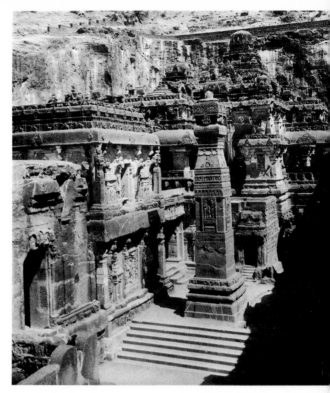

6, 22 Kailasanath temple, Ellura, c. AD 750–850.

That it had been invested with an entirely different, transcendentally supranatural significance in Hinduism is evinced by the austere, almost geometrical, form given to the symbol. Abstraction could be taken only one step further: the faithful go to a temple at Chidambaram, south of Madras, to worship the *Akasalingam*, an invisible lingam of ether.

To the Western mind the idea of an invisible symbol is contradictory. But neither Indian art nor the religious philosophy with which it is so closely integrated is susceptible to rational analysis. Both are suprarational. A work of Indian sculpture is not an illusory imitation—in the Platonic or Aristotelian sense (see p. 139)—but part of a visible world which is itself entirely illusory. No distinction is made between the real and the ideal, the naturalistic and the symbolic.

Nor is any distinction drawn between what the West calls space and solid matter. According to Indian cosmology our visible world is composed of an all-pervading radiant substance, *akasa* or ether, a small part of which condensed to form air. By a similar process fire was formed from air, water from fire and solid earth from water. Air is as much a substance as the other elements, there is no empty space in the cosmos and thus the problem of creating an illusion of

space in reliefs (or paintings), which perplexed and obsessed European artists for so many centuries, simply did not arise. The Indian sculptor shaped figures, often out of the living rock, by a process analogous to that by which ether condensed into tangible substance under the creative influence of the supreme divine being.

The force of these ideas and their effect on the forms taken by Indian art can be seen quite clearly in an extraordinary carving on a huge granite boulder at Mamallapuram, south of Madras on the east coast (6, 19). The subject is the myth of the descent of the River Ganges to earth through the locks of Siva's hair. More than a hundred large figures of deities, humans, half-humans and animals, including life-size elephants, stand on either side of a natural cleft, up which the king and queen of the *nagas* float. The whole surface, some 20 feet (6m) high and 80 (24m) long, seethes with life as if it were fermenting and this effect must have been heightened when, on special occasions, sparkling water flowed down the fissure from a cistern above. Individual figures, especially the animals, suggest that the relief depicts a single episode in the myth: the moment when the Ganges descends from the heavens to make the earth fertile. But earlier events are also recorded, meshed into the composition rather than strung out in narrative sequence. Two yogis meditating by a temple just to the left of the cleft belong to the very beginning of the story. Two Brahmins, immediately beneath them, are figures who seem to come from the sculptor's own world and time: one dries himself after

6, 23 Temple of the Sun, Konarak, 13th century.

bathing in the sacred stream which washes away sin. The descent of the Ganges to water the north-east Indian plain is a perpetually miraculous phenomenon: and different episodes in the myth can therefore be shown simultaneously. The art which ignored Western ideas of space also transcended temporality. There is no sense of continuity or sequence. All time is eternally present in this carving, for—to quote T. S. Eliot—'the end and the beginning were always there before the beginning and after the end'.

Other natural boulders at Mamallapuram were carved into free-standing statues of elephants, lions and oxen and other outcrops of granite into five monolithic *raths* or sanctuaries (6, 20). As we have already seen (p. 182), the earliest surviving Indian temples and monasteries were burrowed into cliffs. But temples were also cut in the round out of the living rock by a complementary process of separating and molding the elements of earth and air. At Ellura, a place of immemorial sanctity where both Buddhist monks and Brahmin ascetics lived and worshipped, an entire slope was excavated to leave a richly sculptured shrine, the Kailasanath, which measures nearly 100 feet (30m) from base to cupola-shaped crown (6, 22). It is similar in form and decoration to contemporary and slightly later temples constructed, rather than hewn out, of stone but more vividly illustrates the Indian preoccupation with an architecture of mass which is not inert but alive.

Both the forms and the ornamentation of these temples are, of course, richly symbolic. That at Ellura is dedicated to Siva as the Lord of Kailasa, referring to a mountain in northern India regarded as the earthly

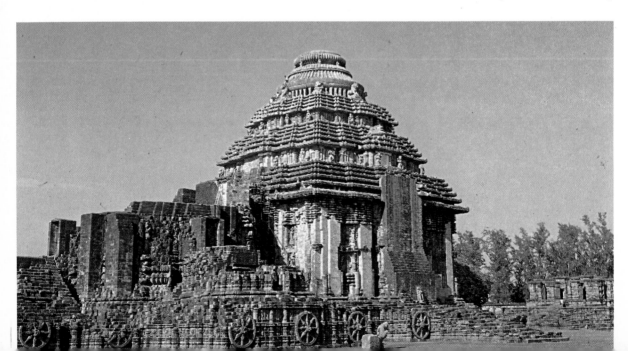

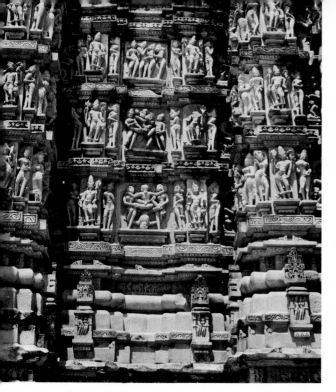

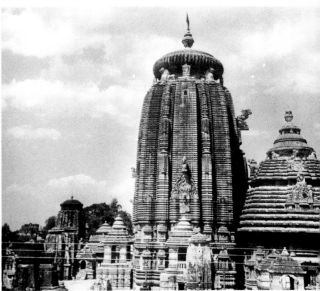

counterpart of Mount Meru, the vertical axis of the universe. Originally it was painted white like a snow-covered Himalayan peak. A beehive-shaped tower, the most prominent feature in many Indian temple complexes, as at Bhuvanesvar in the north (6, 25), is called a *sikhara*, which means 'peak'. Every measurement in these buildings was determined by a very elaborate scale of mathematical proportions related to the mystical numerical basis of the cosmos. An Indian temple is, in fact, a microcosm or scaled-down replica of the structure of the universe. But it is also a dwelling-place for the god, infinitely richer and larger than that of any mortal ruler. In its decoration, motifs derived originally from the mundane architecture of brick, wood and thatch are multiplied. Lintel is piled upon lintel, roof upon roof, in seemingly endless succession, the basic form of the building is repeated again and again, sometimes whole façades are tiered one above another, to indicate the magnitude of the god. Large numbers have always fascinated the Indians. A single incarnation of Indra, king of the gods, is said to last 306,720,000 human years, that of Brahma 1,103,760 times longer, according to popular doctrine. The human soul can, however, transcend this temporality and escape the cycle of birth and rebirth, to which even the gods are subject, by attaining union with the Absolute. And this potentiality is symbolized by the crowning member of a *sikhara*, shaped like a bubble which bursts into non-being or like a lotus bud which

opens to release pure essence.

Another type of religious building was given the form of a triumphal car, the god's vehicle. The most notable is that at Konarak on the north-east coast, a temple dedicated to the sun god Surya and built to resemble the chariot on which he traverses the sky, with huge wheels carved on its plinth and sculptured horses prancing in front (6, 23). This is some centuries later in date than the temples at Bhuvanesvar, and its sculptural decoration is much richer in figures. Couples in every posture of love-making described in the *Kama sutra* cavort over the whole surface, twisting lithe limbs round one another in delirious abandon. Similar exhibitions of eroticism appear on a temple at Khajuraho in central India, and others may have been destroyed by prudish Muslims (6, 24). Though much discussed, the precise significance of these amorous couples remains mysterious. They have been described as metaphors for the ecstasy of the human soul united with the divine. They have been associated with Tantric teaching that the female principle is the dominant force in the universe, without which the male force cannot be stimulated to action—a doctrine which emerged in the seventh century, influencing Buddhism as well as Hinduism and encouraging meditation to resolve the sexual duality within the microcosmic soul. It has also been suggested that the carvings at Konarak owe their origin to orgiastic rites actually performed in the temple and later suppressed by orthodox Brah-

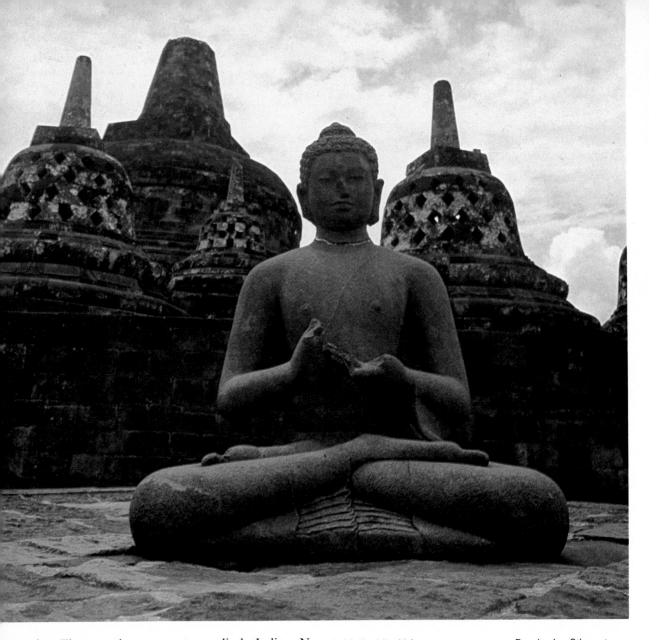

mins. They are, in any event, peculiarly Indian. No other civilization in the world has given such prominence to overt eroticism—nor, paradoxically, laid greater stress on ascetic spirituality.

As that extraordinarily frank and curiously unprurient account of the art of love, the *Kama sutra* (written in Sanskrit some time between the fourth and seventh centuries AD), is alone enough to demonstrate, Hinduism was far from denying the pleasures of the flesh. In religious art, however, sensuality is mainly a means of enforcing spiritual ideas. 'The divinity draws near if images are beautiful', a Hindu text declares. A cult image could fulfil its purpose as a *yantra*—a tool or

6, 26 Buddha Vairocana, upper terrace, Borobudur, 8th century.

instrument of worship—only if it bridged the gulf between the physical and spiritual realms, the yogi and the object of his meditation. It had, therefore, to subsume the multifarious aspects of divinity incorporated in a single avatar, the relationship between the image and the god being the same as that between the god and the Absolute.

Four arms are necessary to express the manifold powers and attributes of Siva Nataraja—Siva Lord of the Dance—one of the most popular subjects for bronze statuettes made in southern India especially

which all other elements are created, in his upper left hand there is a tongue of flame for the fire with which the universe will be destroyed. Creative and destructive powers are thus balanced. His lower right hand is in a gesture which means 'fear not'. It is addressed to the devout, whose attention is drawn by the lower left hand to the upraised foot, which symbolizes escape from the illusions of the world embodied in the demon crushed beneath Siva's other foot. His long hair, an attribute of asceticism, streams out on either side of his head enclosing on the left a little figure of Ganges (see p. 192). The encompassing ring of flames is said to signify the vital processes of the universe in the dance of nature, the informing energy of all matter, and, simultaneously, the light of transcendental wisdom. There is neither arrest nor movement in this wonderful composition, or perhaps one should say there are both—with the impassive face of the god at the still point to which the worshipper aspires, where past and future are gathered.

An Indian cult image was the product of ecstatic meditation similar to that which it was intended to assist. 'Let the imager establish images in temples by meditation on the deities who are the objects of his devotion', one of the many Indian craft treatises stipulates. 'For the successful achievement of this yoga the lineaments of the images are described in books, which are to be dwelt upon in detail. By no other means, not even by the direct or immediate vision of an actual object, is it possible to be so absorbed in contemplation as by this meditation in the making of images.' The artist's individual vision of both the natural and supernatural was thus directed and circumscribed by tradition. Individuality was, and still is, alien to Hindu thought except in so far as it refers to the individual manifestation or avatar of a god—Siva as Lord of the Dance, for instance, or Vishnu appearing on earth as Krishna. Human beings were regarded as types of their caste, occupation, sex or age. Artists were no exception. Their vocation and training were entirely hereditary and they constituted a kind of sub-caste with its own immemorial and carefully maintained traditions of craft practice as well as imagery. Hence the strong sense of continuity in Indian art from at least the time of Asoka and possibly from the Indus Valley civilization more than a millennium earlier. For artists seem to have preserved some of the aura surrounding the shaman or magician. Craft treatises enjoined them to work 'in solitude or with another artist present, never before a layman'. They were the agents of the deity from whom the mystical power of an image derived.

Indian art is almost exclusively religious—very few

6, 27 Bayon, Angkor Thom, early 12th century.

during the Chola period (ninth to thirteenth centuries). The symbolism goes beyond the legend of the dance of Siva (*nadanta*) to express the whole Indian concept of life as an eternal becoming. In the cycles of creation, according to Hindu cosmogony, nothing ever ends or is ever lost or can be lost, all things are interchangeable. Siva personifies the forces and powers of the cosmic system, the universal flux of energy, the dynamic process of perpetual disintegration and renewal. In his upper right hand he holds a small drum to connote sound, associated with the ether from

secular works from before the sixteenth century survive. Its history, therefore, follows very closely that of religion: the development of Buddhism, the interactions between Buddhism and Hinduism, the spread of Tantric teaching and the periodical re-emergence of indigenous pre-Aryan cults. Numerous works of sculpture and architecture and the few paintings that have been preserved seem to reflect something of the intensity and profundity of Indian religious thought. There was, however, a marked decline in quality from about the eleventh century. Sculptural traditions of sensitive handling and even of sound craftsmanship lapsed. On temples profusion of carving seems often to have been pursued as an end in itself. This can partly be explained by the Islamic invasion and the slow spread of the Mughal empire, which commanded the services of the most notable artists (see Chapter 12).

Buddhist and Hindu art in south-east Asia

Indian artistic styles spread to south-east Asia and to the Indonesian islands in the wake of Indian religious beliefs. Buddhism was the first proselytizing religion, the first to offer salvation to all mankind and to break away from the worship of local and tribal deities. As we have already seen (p. 178), the Emperor Asoka sent missionaries to preach its pacific doctrine to the Hellenistic kingdoms of the West. With much greater success, he despatched his son to propagate Buddhism in Ceylon (modern Sri Lanka), where it was soon accepted as the established faith in the early *Hinayana* form, which has survived there (as also in Burma) to the present day. Further expansion was facilitated by the development of *Mahayana*, with its Bodhisattvas, while the Hindu cults of Vishnu and Siva, which united simple piety with transcendental metaphysics, were also diffused in the same direction. There is, however, no hint of provincialism in the Buddhist and Hindu sculpture and architecture of the regions often designated as 'Greater India'. Styles which had originated in India acquired fresh vigour and were developed quite independently, especially in Java and the territory of the Khmer empire.

Borobudur in central Java is, in fact, one of the greatest masterpieces of Buddhist art. It was begun in about 825, when the island was ruled by the Sailendra dynasty, who were probably of Indian extraction, and it may have been directly influenced by the stupas in north India which were destroyed by Muslims. As its nine terraces were built round the solid core of a natural hill, there is no 'interior' apart from a sealed chamber in the crowning stupa, originally enclosing a statue of the Buddha. Borobudur measures about 360

Plan of Borobudur temple.

feet (110m) across the base and is 115 feet (35m) high, but emphasis was placed less on grandeur of scale than on intricacy of detail. The form of a Buddhist stupa was multiplied rather than magnified. There are 72 small bell-shaped stupas, encircling the main one, on the upper terraces; and lower down there are still more, some cut in half to provide niches. All contained statues of the Buddha seated in the yoga pose and differing from one another only in the *mudras* or significant gestures of the hands. Indeed, the name Borobudur (or Barabudur) probably means simply 'many Buddhas'.

The plan of the building, composed of four concentric circles inscribed within squares which break forward in the centre of each side, resembles a *mantra* or diagram used in Tantric Buddhism at first as an aid to meditation, later as a kind of magic spell. Its form, essentially a truncated pyramid surmounted by a cone, combines the symbolism of the cosmic Mount Meru with that of the stupa—earth and heaven, existence and *Nirvana*. Relief carvings which line the walls of the rectangular terraces are more simply and overtly

6, 28 Siva Nataraja, Chola, 12th to 13th centuries. Bronze, $13\frac{1}{16}$ ins (33.5cm) high. Nelson Gallery–Atkins Museum, Kansas City.

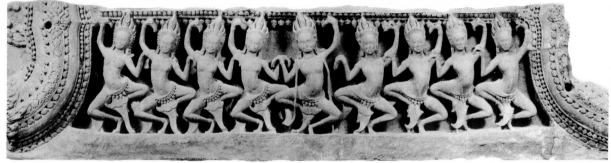

6, 29 *Top* Scene from the legend of the Buddha, Borobudur, 8th century.
6, 30 *Above* Relief from Angkor Wat, 12th century. 23⅝ins (60cm) high. Musée Guimet, Paris.

didactic, providing a kind of Buddhist pilgrim's progress from the illusory world to the ultimate reality. Those at the lowest level illustrate scenes from human life subject to *Karma*, the cycle of birth and rebirth. They were, however, completely closed from view by a massive outer wall, perhaps built as a last-minute structural reinforcement for the upper terrace and not, as is sometimes claimed, to symbolize the 'underworld'. In the first gallery above this basement the reliefs are devoted to scenes from the popular *Jataka* stories recounting the Buddha's previous incarnations and episodes from his life, which are continued on the second gallery. As the pilgrim climbed to the third gallery he left the *Hinayana* for the *Mahayana*. A series of reliefs is devoted to Maitreya, the Buddha of the Future who will eventually descend to earth. The next level, spiritual as well as physical, expounds the teaching of Asanga, founder of Tantric Buddhism, preparing the devout for ascent to the eternal sphere of the symbolically circular upper terraces, where ethereal Dhyani Buddhas, transcendental saviours, sit in sublimely composed meditation beneath perforated stupas (6, 26).

Despite the Indian origin of their subject-matter, their symbolism and some of their forms, the carvings at Borobudur could hardly be mistaken for Indian work. Javanese facial features alone would set them apart. But differences which are more than skin-deep are apparent in such a panel as that of the young Buddha cutting his hair in preparation for the ascetic life (6, 29)—as the *Jataka* recounts: 'He thought, "These locks of mine are not suited to a monk; but there is no one fit to cut off the hair of a Future Buddha, so I will cut them off myself with my sword." Grasping a scimitar with his right hand, he seized his top-knot with his left hand, and cut it off, together with the diadem.' He should, of course, be called Siddhartha at this stage of his life, and he is shown in the relief as a slender youth, not as an ageless sage. But the scene has been conceived imaginatively rather than 'transcendentally' and rendered not so much symbolically as sacramentally. The incident has been formalized into a ritual, attendants have been included, to carry the tiara and shorn curls, as well as four spectators with hands clasped in prayer (the *Jataka* text mentions only the horse on which Siddhartha left his father's house and the heavenly beings who carried away his hair and head-dress). The composition is logical. Figures are consistent in size and, furthermore, rendered as three-dimensional forms in space rather than as manifestations of the *Maya* bursting out of the stone (see p. 180). Foreshortening is used to mirror visual appearances. The carving seems, in fact, to be further removed from Indian than from Western art, notably reliefs depicting Christian themes of about the same date, or even earlier, although this must be a pure coincidence.

武帝 司馬炎

In Cambodian sculpture the links with Indian art were equally residual as in the extraordinary combination of two Hindu gods (Vishnu and Siva) in the lithe figure of Harihara (6, 32). But a great change was brought about in the eighth century after the Khmer from the north occupied the whole Indo-Chinese peninsula. Khmer rulers alternated between Buddhism and Hinduism, sometimes from one reign to the next, but as they put both to the same political use, a single artistic style sufficed. Each ruler claimed to be a Devaraja or god-king, the incarnation of a Bodhisattva or the avatar of a Hindu deity, an idea wholly alien to Indian thought.

Regimentation is one of the hallmarks of Khmer art. Identical features were carved in relief or in the round by the hundreds. Rank upon rank of marching soldiers appear in some reliefs. *Apsaras*—spirits of the sky and members of Indra's seraglio—were made to dance in unison. A relief from Angkor Wat catches a group of them in frantic eurhythmic movement (6, 30). Twisting their lissom bodies into erotic postures, they have all the sensual allure, but none of the spirituality, of Indian *yakshis*.

The major artistic achievements of the Khmer were the great temples erected by and dedicated to the Devarajas. They originally towered above cities built of less durable materials, now vanished without trace in the depths of the jungle. Angkor Wat (the name means 'temple of the capital') is the grandest of them

6, 31 *Top* Yen Li-pen, detail from *Portraits of the Emperors*, 7th century. Horizontal scroll, ink and colour on silk, 8¼ins (21cm) high. Museum of Fine Arts, Boston, Denman Waldo Ross Coll.

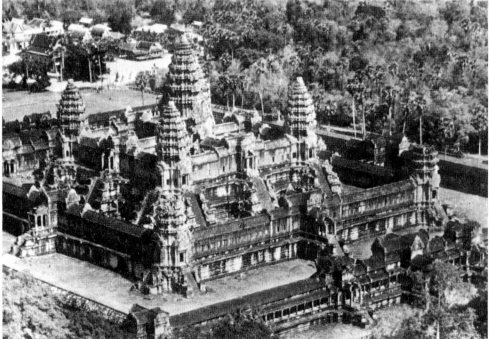

6, 32 *Opposite below left* Harihara from Prasat Andet, 7th century. 76½ins (195.3cm) high. Museum. Phnom Penh.
6, 33 *Opposite below right* Angkor Wat, aerial view from the north-east, early 12th century.
6, 34 *Above* Ku K'ai-chih, detail from the *Admonitions of the Instructress to the Court Ladies*, late 4th–early 5th century AD. Horizontal scroll, ink and colour on silk, 9¾ins (24.8cm) high. British Museum, London.

and is probably the largest temple in the world, a mountain of carved stone rising to a height of some 200 feet (60m), surrounded by covered passageways and a moat nearly 2½ miles (4km) in circumference (6, 33). It was constructed without mortar, the vast stone slabs being held together by iron clamps, and the roofs of the galleries were corbelled and thus rather narrow, as the technique of true vaulting was unknown.

The plan, consisting of crosses within rectangles, was of cosmic significance and the form of the central block is, once again, a stepped pyramid crowned by a spire, derived ultimately from the Indian *sikhara*, repeated in diminishing scale at the corners of the platform and (originally) of the whole enclosure. Indian tendencies towards multiplication of single elements were here extended as far as they would stretch. But Angkor Wat was designed with a logical coherence entirely lacking in such a temple complex as that at Bhuvanesvar (6, 25). It seems to have been intended not so much to honour a god, still less to express an abstract idea of divinity, but mainly to overawe mortals. An impression of vast extent is enhanced by the immensely long closed galleries and of height by the very steep flights of steps which lead to the upper platforms. Its builder was Suryavarman II (1112–52), a devotee and self-styled avatar of Vishnu. A later Devaraja, Jayavarman VII (1181–1219), was a Buddhist and the temple he built has numerous spires,

from which his face, with the attributes of a Bodhisattva, looks out over the luxuriant landscape (6, 27). Here we are a far cry indeed from the column and stupas erected by the pious Emperor Asoka and the otherworldly humility of the early Buddhists. The ideal of divine beauty created by sculptors in Gandhara in the first century AD survives, nonetheless, in these gigantic yet strangely gentle, almost smiling countenances. And the whole vast temple complex took to its grandiose conclusion the Indian conception of religious architecture as a microcosm of the universe.

Confucian, Taoist and Buddhist art in China

The teaching of the Buddha reached China in the first century AD, at a moment of great prosperity and national self-confidence hardly propitious for the introduction of a religion both otherworldly and alien. After a long period of internal warfare which followed the disintegration of the Chou empire (see p. 84), the country had been reunited with ruthless efficiency during the brief reign of the first emperor of the Ch'in dynasty (c.221–209 BC). Under the succeeding Han dynasty, which ruled from 209 BC to AD 220, China enjoyed one of the most brilliant epochs of its history. Peace was maintained throughout the land and barbarian tribes were steadily driven back from the frontiers until the empire extended, at the height of its power, from the Pacific to the Pamirs, from Korea to south-east Asia. Looking back, the Chinese of later

6, 35 Archer from tomb of Emperor Ch'in Shih Huang-ti, c.221–209 BC. Terracotta, life-size. Shansi Provincial Museum.

6, 36 Flying horse from Wu-wei, eastern Han dynasty, 2nd century AD. Bronze, $13\frac{1}{2} \times 17\frac{3}{4}$ins (34.3 × 45cm). People's Republic of China.

times were often to call themselves the 'Sons of Han'. It was during the next four centuries of instability, when much of northern China once more came under foreign rule, between the fall of the Han dynasty and the rise of the T'ang in 617, that Buddhism began to win widespread acceptance, though not without rivalry from Confucianism and Taoism.

Confucius (551–479 BC), the founder of Chinese philosophy, was an almost exact contemporary of the historical Buddha (563–480 BC). Several centuries passed, however, before the sayings of Confucius were formulated into a consistent philosophy as Confucianism. This was a product of the Han period and, despite shifts in emphasis, it has endured as an underlying structure for Chinese thought ever since. From the Han period onwards, Chinese education was almost exclusively Confucian and had the explicit aim of preparing young men for the competitive written examinations (already established in the mid-second century BC) which opened the door to government service. Confucianism as a philosophical system might almost be said to have exalted the virtues of the conscientious civil servant into a moral code. Deeply concerned with conduct and the interrelated duties of ruler and ruled, parents and children, old and young, employers and employees, it stressed conformity and tradition. The social order was conceived as a reflection of the moral order of the universe. Virtue was understood by Confucians simply as the right and proper way of doing things and thus provided a comprehensive rule of life—and of art. As a ninth-century writer declared, 'Painting promotes culture and strengthens the principles of right conduct. It

penetrates completely all the aspects of the universal spirit.' Painting (but not sculpture or architecture, which, like the crafts, were too closely associated with manual skills) and the closely allied art of calligraphy formed part of the official educational program, which thus trained the largest class of amateurs of the arts produced by any civilization. Every educated man was a connoisseur of painting and calligraphy, and many were very able practitioners, including several emperors.

Confucianism was not a religion, although it encouraged from the beginning the piety towards spirits of ancestors which was traditional in China. Taoism was much more deeply concerned with the spiritual and the supernatural. Also formulated in the Han period, Taoism derived mainly from the teaching of Lao-tzu, an elusive mystical philosopher who is said to have lived in the sixth century BC. But it took over popular beliefs in dragons, celestial and infernal spirits, and the power of magicians. However,

6, 37 Two Officials, detail from lintel and pediment of a tomb, late 1st century BC—early 1st century AD. Hollow ceramic tiles, 29 × 94⅘ins (73.8 × 240.7cm). Museum of Fine Arts, Boston, Ross Coll

Taoism—like Hinduism and Buddhism—was accessible at more than one intellectual level. The *Tao*, as understood by Taoists, is an irrational life-force beyond the grasp of the conscious human mind and submission to it means the liberation of natural instincts without regard for social conventions or even moral imperatives. The ultimate attainment is an Inward Vision (*ming*), in which all distinctions between 'self' and 'things', between 'inside' and 'outside' are lost in a lyric, almost ecstatic, acceptance of the universal laws of nature. Taoists looked back to a golden age when man lived in absolute harmony with his surroundings, when life was as effortless as the passage of the seasons and the two vital, female and male, principles of all nature—the Yin and Yang—worked together and not in opposition. Their ideal was the recluse who abandoned all worldly ambition to cultivate inner powers and inner happiness.

Confucianism encouraged conformity, moderation, logical thought; Taoism individuality, passion, imagination. Yet the two are not so much antithetical as complementary. 'We are socially Confucian and individually Taoist,' the modern Chinese writer Lin Tung-chi has remarked. Buddhism introduced an altogether different system of intellectual and spiritual values, focused on a belief in salvation which looked beyond the life of men and women in society, with which the Confucians were mainly concerned, and the Taoist preoccupation with the interior life of the individual. A monk living in a religious community exemplifies a Buddhist ideal. Buddhism reached China as a fully developed religious system with its holy scriptures, priests, monks, images and rituals. In the course of time it was influenced by and marginally influenced Confucianism and Taoism, yet always remained somewhat alien to China, despite the following it gathered between the fifth and twelfth centuries and the many great works of art it inspired.

In the tombs from which our knowledge of Han art is almost entirely derived, Taoist and Confucian elements appear side by side. Indeed, a meeting between Confucius and Lao-tzu is shown in one relief carving. Entrances are guarded by fabulous beasts endowed with the power to ward off evil spirits. Figures from the traditional and Taoist pantheon appear in the decorations of burial chambers and the adjacent rooms in which offerings to the spirit of the occupant were placed by his pious descendants. Little models of buildings and statuettes of attendants and animals hark back to the ancient practice of immolating the living to accompany the dead into the afterlife. The megalomaniac first Ch'in emperor, an implacable enemy of the Confucians, had been buried in 209 BC

6, 38 *Below* Altar with Maitreya Buddha, AD 524. Gilt bronze, 30¼ins (76.8cm) high. Metropolitan Museum of Art, New York.
6, 39 *Right* Kuan-yin as the Guide of Souls, from Tun-huang, 10th century. Painting on silk, 31½ × 21ins (80 × 53.3cm). British Museum, London.
6, 40 *Opposite* Kuan-yin, 11th to early 12th century. Polychromed wood, 95ins (241.3cm) high. Nelson Gallery–Atkins Museum, Kansas City.

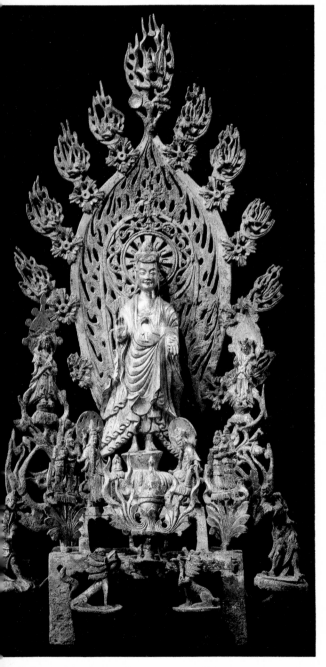

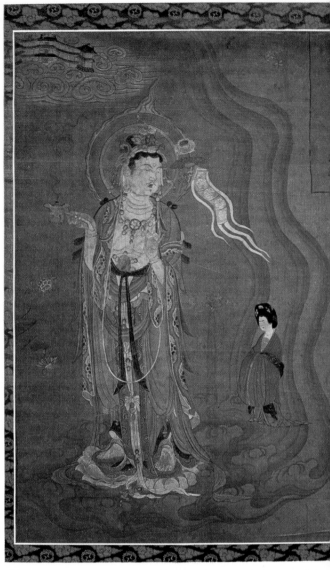

with a vast bodyguard of clay warriors, of which more than 500 with 24 horses were brought to light in 1974, when one of the gateway chambers of his tomb at Lin T'ung, Shensi, was excavated (6, 35). Partly cast and partly modelled—the detachable heads and hands were modelled individually—these life-size figures in unglazed terracotta stand at the beginning of a long tradition of human and animal tomb art. In their emphasis on human personality rather than on human form they typify perennial Chinese concepts and attitudes. But greater artistry was displayed in small figures from Han tombs, such as the bronze 'flying horse' found at Wu-wei in Kansu (6, 36). Perfectly

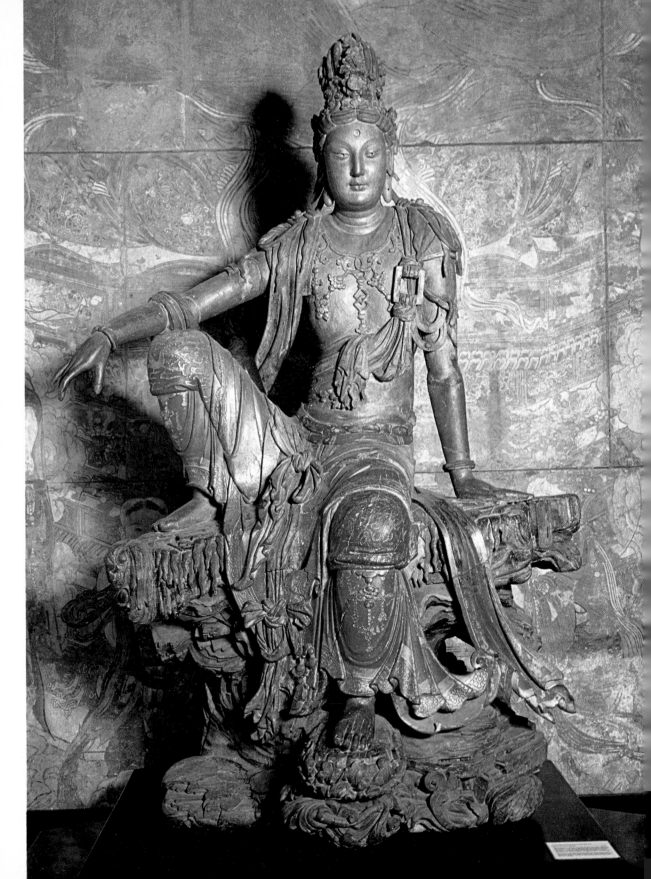

balanced on the one hoof which rests without pressure on a flying swallow, it is a masterpiece of three-dimensional form and of animal portraiture with the head vividly expressing mettlesome vigour. The horse belongs, in fact, to the 'celestial' or 'blood-sweating' breed which had been introduced into China from Ferghana in central Asia about 100 BC and became a kind of status symbol. The same tomb contained many other statuettes of horses of this prized breed, a clear indication of the high standing of the provincial governor with whom they were interred.

Worldly importance is stressed in most tombs of the Han period. Government officials and their retinues were a favourite subject for paintings, the figures moving with the decorous solemnity on which Confucius had insisted. Other subjects are specifically moral in a Confucian sense, including illustrations to such collections of improving stories as the *Gallery of Devoted Sons* (written 79–78 BC). Some were engraved on stone in a technique peculiar to Han China, whereby the silhouettes of the figures were polished smooth and the background hatched. Tiles either painted or modelled in relief also adorned the walls of tomb- and offering-chambers. Two officials on one of the tiles seem to exemplify a Confucian ideal of social

relationships, so very courteously commanding is the one, so exquisitely deferential his inferior (6, 37). They are rendered in outline with some colour but no shading, yet a sense of three-dimensional form is vividly conveyed, as well as of character. Unlike the sharp outlines of Greek vase painting or of Indian painting (at Ajanta, for instance), the assured, flexible Chinese brush-strokes modulate in response to the weight and consistency and movement of the forms they describe—now thick and fat, now sharp and tight, now trembling with the lightest possible flick of the brush. They have the same highly expressive quality as Chinese calligraphy. On relief tiles, form is shown in silhouette. In one the varied attitudes of the figures (6, 41)—reapers in the lower part and archers above—imply close study of the human figure in movement. Fish are depicted rather schematically, as if on the surface of the water, but the leaves of the lotus and their seed-pods are rendered with a sensitivity to actual appearance, which distinguishes them from the symbols of the same plant in Indian art. Although they are the work of provincial craftsmen, such tiles probably reflect the art of the imperial capital, none of which survives, for the fondness of the Han emperors for paintings had the unfortunate result that all the masterpieces they assembled were destroyed in AD 190, when their capital was sacked.

No examples of Han court art survive from before the fourth century. The earliest surviving court painting is a silk hand-scroll painted by or after Ku K'ai-chih (c. 344–406), who worked at the court of Nanking. Entitled *Admonitions of the Instructress to the Court Ladies*, it consists of a series of figurative scenes separated from one another by columns of edifying text (6, 34). A bedroom scene illustrates the passage: 'If the words you utter are good, all men for a thousand leagues around will make response to you. But if you depart from this principle, even your bed-fellow will distrust you.' That it is not entirely clear who is distrusting (or responding to) whom indicates the subtlety of the depiction, in which the confrontation of the lady's profile and the man's three-quarter face suggests some complex psychological relationship. Ku K'ai-chih was renowned as a portrait-painter able to catch not merely the appearance but also the character and spirit of his subjects. He is known to have been a Taoist who cultivated eccentricity and perhaps had some reservations about the worldly Confucian morality of the text he illustrated. A later scroll attributed to Yen Li-pên, the most celebrated artist of the T'ang court in the seventh century, is devoted to imaginary portraits of 13 notable emperors (6, 31). The figures have much greater substance and an

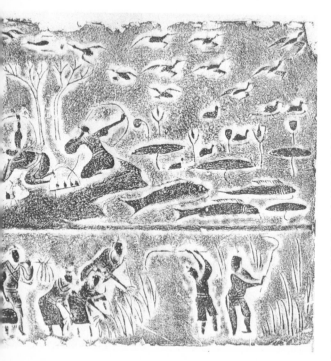

6, 41 Duck-shooting and rice-reaping, 2nd century AD. Rubbing of a tomb tile, 16½ins (42cm) high (from R. C. Rudolph, *Han Tomb Art of West China*, 1951).

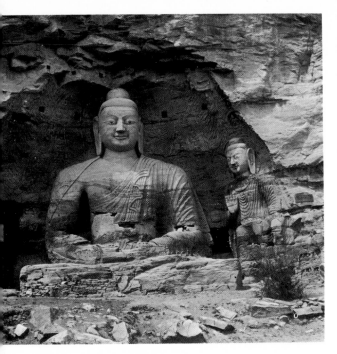

6, 42 *Above* Colossal Buddha at Yün-kang, Shansi, 5th century. Natural rock, 45ft (13.7m) high.

imperturbable self-assurance and, despite their small scale, the compositions are monumental and the whole scroll, as it is unrolled, reveals a pageant of imperial pomp.

Styles of painting, sculpture and architecture foreign to China were introduced with Buddhism by way of the great trans-Asian caravan trails—the so-called Silk Road—along which an ever-increasing quantity of Chinese silk was borne in the opposite direction to India, Iran and Europe. Beginning at Tun-huang, these routes passed through what is now Sinkiang, the vast western province of the People's Republic of China bordered in the north by the USSR and in the south by Tibet. In the first century AD it was an area peopled mainly by nomadic tribes but with a number of city-states under the cultural influence of India and the West. There was a last outpost of Gandharan art (see p. 184) at Miran, only 300 miles (480km) west of Tun-huang, where second- or third-century paintings of Buddhist subjects are signed by an artist whose name, Tita or Titus, suggests that he came from one of Rome's eastern provinces. To the north-east the small state of Kucha on the Tarim river became an important Buddhist centre in about the fourth century with extensive free-standing and rock-cut temples and monasteries. The splendours of this and other central Asian cities were celebrated by Chinese travellers from the fifth to the seventh century. All were destroyed and Buddhism was extirpated as a result of the Muslim invasions in the eleventh century, but fragments survive to reveal the existence of a highly developed monumental Buddhist art, quite independent of India.

The most notable early surviving Chinese Buddhist images, apart from wall-paintings in cave-temples at Tun-huang, are in sculpture—an art form excluded from the Confucian syllabus. A small bronze inscribed with a date equivalent to AD 288 is the earliest (Asia Art Museum, San Francisco). Few others survived a violent persecution of the Buddhists and wholesale destruction of their temples in AD 444. A period of intense artistic activity was, however, initiated in 452 on the succession of a Buddhist to the throne of the northern Wei 'empire' (one of the three realms into which the country was divided at this date). Between 460 and 494 a sandstone cliff at Yün-kang in Shansi, not far from the Great Wall, was transformed into the most spectacular of all groups of rock-cut temples, lined with images large and small similarly carved from the living rock. These extraordinary man-made caves must have been inspired by the *viharas* and *chaitya*-halls of India and their colossal figures by two famous statues, 120 and 175 feet (37 and 53m) high, hewn out of a cliff at Bamiyan in Afghanistan in the second or third century AD. By their huge dimensions such statues symbolized the more-than-mortal nature of the universal Buddha, the equivalent to the cosmos itself. The rich intricacy of the interiors and style of sculpture seem, however, to derive more immediately from Kucha. One of the temple façades has fallen away to reveal a 45-foot-high (14m) statue of the Buddha, originally flanked by two Bodhisattvas forming a trinity which must have looked still more mysteriously overwhelming when it could be seen only at uncomfortably close quarters in a dimly lit cavern (6, 42). Pose and raiment recall the preaching Buddha from Mathura (6, 14), but all naturalism has been eliminated from the colossus at Yün-kang. The face has become an inscrutably smiling mask. The *ushnisha* and the elongated ear-lobes have been so conventionalized that they look like detachable pieces of regalia.

Small images were made in bronze. As we have already seen, the art of bronze casting had been mastered in China at a very early period; but a shrine made in 524 (6, 38) could hardly be further in feeling from either Shang ritual vessels, with mysterious dragon forms lurking on their surfaces (2, 40), or the much more recent, vividly naturalistic figures of animals from the Han dynasty tombs (6, 41). The central figure of the Buddha, the tiny Bodhisattvas below his feet, and the *Apsaras*—'angels' of the Hindu

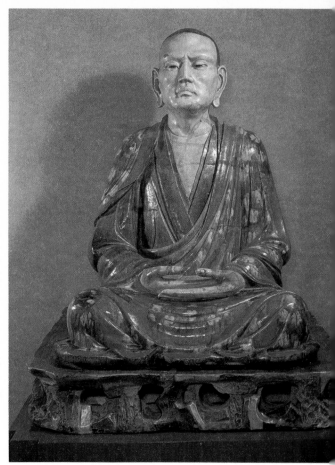

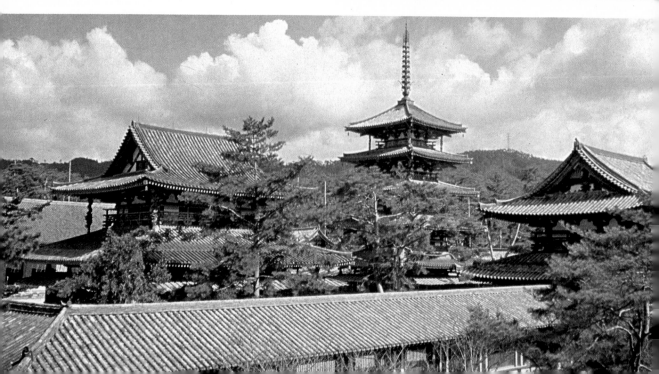

6, 46 *Left* Pagoda of Yakushiji, Nara, 8th century.
6, 47 *Below* Unkei, *Mujaku*, 1208. Wood, 75½ins (191.8cm) high. Kofukuji Temple, Nara.

as well as the Buddhist heavens—fluttering their draperies on the edge of the halo, all derive from Indian models. These elements have, however, been skilfully worked into a cogent linear composition. The whole piece flickers with lambent life, recalling the legend that Sakyamuni's body emerged unburnt from his funeral pyre and metaphorically suggesting the elevation of the spirit. Symbols have, in fact, been integrated into a devotional image of more profound significance than the sum of its parts.

Sculptors and painters of devotional images of all cults are usually bound by iconographical rules to ensure religious efficacy. In the representation of

6, 43 *Opposite top left* Ju ware vase with copper rim, Sung dynasty, 12th century. Porcelain, 9¾ins (25cm) high. Percival David Foundation of Chinese Art, London.
6, 44 *Opposite top right* Lohan, 10th–13th century. Three-colour glazed pottery, 40ins (101.6cm) high. Nelson Gallery–Atkins Museum, Kansas City.
6, 45 *Opposite* Horyuji temple, Nara, Japan, AD 607.

devotees Buddhist artists were allowed a freer hand, as the relief of a pious empress and her attendants demonstrates (6, 48). In contrast to the static, almost geometrically solid Buddhas and Bodhisattvas—some on a colossal scale—which remain in the cave at Lung-mên from which this relief came, the figures are at once naturalistic and insubstantial, intentionally so perhaps to mark the distinction between eternal verities and transient illusory appearances. Clad in garments which fall naturally from their shoulders, the wraith-like empress and her ladies are grouped informally, with a suggestion of recession in space, and move as if drifting on the lightest of breezes. The ability of Han dynasty painters to create form by a few deft brush-strokes, which also develop a rhythmically linear pattern with a life of its own, has here been transferred to sculpture without any loss of subtlety or delicacy and infused with the emotional spirituality which Buddhism had brought to China.

Under the first emperors of the T'ang dynasty

(618–906) a reunited China enjoyed another period of peace at home and prestige abroad. The arts flourished as never before during the reign of Ming Huang (713–56), founder of the Imperial Academy of Letters, which still survives. In 715, however, Chinese Turkestan was lost to Muslims advancing from the west and an internal rebellion followed, weakening the imperial administration. A period of decline set in. By this date a Chinese version of *Mahayana* Buddhism had become almost if not quite the national faith and it was blamed by Confucians and Taoists for the drain of wealth to temples and of man-power to the unproductive celibate life of monasteries. In 845 the reigning emperor proscribed all 'foreign' religions, especially Buddhism. Some 4,600 temples and 40,000 shrines were destroyed and 200,000 monks sent back to work on the land. The ban was later relaxed and, in fact, there was a Buddhist revival not long afterwards. But there was no economic or political recovery and in 907 China disintegrated into a state of confusion known as the period of the Five Dynasties.

In this later phase of Chinese Buddhism a figure who answered emotional rather than intellectual needs moved to the centre: Kuan-yin, the Bodhisattva of Mercy. He had been called Avalokitesvara in India (see p. 190), but no trace of an Indian origin survives in

such a painting as that in which he manifests himself swathed in the finest, lightest, most delicately patterned Chinese silks (6, 39). Invoked by an exquisite little lady, presumably the donor of this votive image, he has floated down from the celestial mansion in the upper left corner, one of the several humanly desirable heavens which had all but replaced the remote ideal of *Nirvana*. Distinctions between the divine and the human have been blurred and Kuan-yin is represented, larger in size but no less naturalistically than his devotee, as if he were an earthly prince. What theologians might regard as a naive conception of divinity is, nevertheless, rendered with the utmost sophistication, and the whole composition with its softly curving lines and gently vibrant colours is pervaded by an atmosphere of compassionate tenderness.

Kuan-yin, who is here shown with a mustache and imperial beard, was later to be transformed into a female figure associated with the traditional Chinese mother goddess. Bodhisattvas are sexless (like angels), possessing the spiritual virtues of male and female, and able to manifest themselves in either form. The fusion is vividly suggested in a statue of the Sung period (6, 40). (The Sung came to power in 960, reunited China but lost the north to the Jurchen from Manchuria in 1127 and moved the court south of the Yangtze to Hangchow, where an extremely sophisticated southern Sung culture flourished, 1127–1279.) The sexual organs and other physical features, which the Greeks had combined in their hermaphrodites, have here been ignored in order to create an image of androgynous love which transcends sexuality. The idea of the pure distilled spirit of humanity is embodied in this sensuously carved figure. The ornaments, drapery and fluttering scarves play a major part in the composition of delicately molded forms, no less subtle than intricate, with asymmetry enhancing the impression of life and movement.

Naturalism merges into down-to-earth realism in a glazed pottery statue dating from the same period but inspired by a different form of Buddhism and made, far from the elegant world of the Sung court, in Li'ao-occupied Manchuria (6, 44). With the vividness of portraiture from the life, it represents one of the *lohans*, followers of the *Hinayana* who achieved enlightenment by their own meditative efforts without supernatural aid. This work stands at the end of a tradition, however. Naturalistic pottery sculpture had first appeared in the Ch'in period in tomb figures (6, 35) and was further developed in the Han and T'ang periods, when it was sometimes wholly or partly covered with coloured glazes (similar to those used on domestic

6, 48 *Above* Empress as Donor with Attendants, from the Pin-yang cave chapel at Lung-mên, Honan, c. AD 522. Limestone with traces of colour, 6ft 4ins × 9ft 1ins (193 × 276cm). Nelson Gallery-Atkins Museum, Kansas City.
6, 49 *Opposite top* Landscape with figures, AD 984–991. Wood engraving, Fogg Art Museum, Harvard University, Cambridge, Mass.
6, 50 *Opposite bottom* Mu-ch'i, *Six Persimmons*, 13th century. Ink on paper, 14¼ × 15ins (36.2 × 38.1cm). Daitokuji, Tokyo.

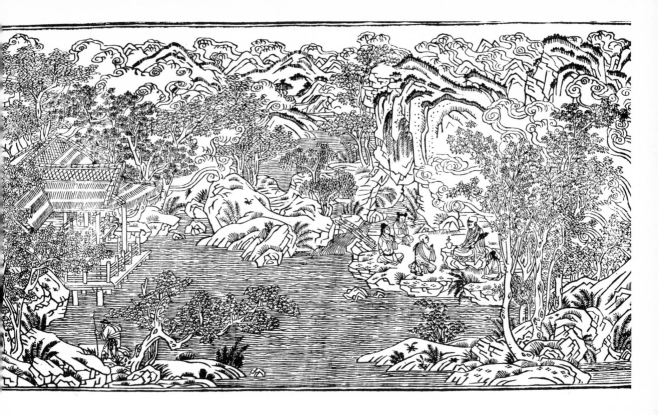

wares). A large number of T'ang statuettes survive, but they give a misleading impression of T'ang art and of Chinese ceramics in general. Statuettes were never rated highly by the Chinese. The pure forms and smooth cool jade-like textures of bowls, vases and other vessels in porcelain, first made in the T'ang period and brought to perfection under the Sung, were preferred. Nor was large-scale figure sculpture to be prominent in the later art of China; its importance declined with the Buddhist faith which had introduced it.

Increasingly influenced by Tantric doctrines which infiltrated from Tibet and came direct from India, Buddhism gradually became a popular cult in seventh-century China with much emphasis on esoteric rituals and magic spells. This had one consequence of revolutionary importance, or rather potentiality: the invention of wood-block printing. A demand for huge numbers of amulets and images was answered in the seventh century by impressing ink-impregnated wood-blocks on woven silk or paper (also Chinese inventions, dating from the Shang and Han periods respectively). The next step, towards the printing of illustrated texts, was taken well before 868, the date of the earliest surviving printed scroll (the *Diamond Sutra*, a Buddhist text in the British Library, London).

In the following century a collection of Buddhist texts was printed in 5,000 volumes and also the 'classics' of Chinese literature in 130 volumes. By the twelfth century, printed books included encyclopedias, dynastic histories and also such illustrated works as a *Materia medica* and catalogues of art collections. And yet printing made a far less forceful impact on China than on Europe, where it was introduced or re-invented several centuries later. The nature of Chinese script with some 20,000 different characters ruled out the development of movable type, which was to enable European printers to produce books that were infinitely cheaper than manuscripts. Moreover, the Chinese preoccupation with the artist's touch discouraged recognition of the figurative wood-cut as an art form in its own right. One of a set of early prints of landscapes with Buddhist sages surrounded by disciples reveals the possibilities of the medium (6, 49). But they were not exploited. The majority of prints produced before the sixteenth century were either technical diagrams or popular religious images which circulated only among the lower strata of society.

Another development in Buddhism had a more direct influence on the arts: the emergence of the Ch'an sect (known as Zen in Japan, see p. 217), founded in 520–7 but achieving little prominence before the ninth century. Its members declared that there was no Buddha save the Buddha in man's own nature, that all rituals, acts of worship and study of texts were worthless. They strove in meditation for communion with the Absolute or First Principle—a communion vouchsafed in rare flashes of blinding illumination. This transcendental experience could never be described in words but might be evoked by a work of art, by a painting —of a plant, a wild landscape or just six persimmons (6, 50)—which expressed the inner life of things and which could, in turn, assist the viewer's quest for enlightenment. Imaginary portraits, not necessarily of holy men, were among the subjects. With a dozen rapid brush-strokes of spontaneous inspiration Liang K'ai (c.1140–1210), who called himself 'Liang the Fool', summoned up the spirit of the bibulous, free-living eighth-century poet Li Po (6, 51). An almost uniquely aniconic religious art was thus created (see pp. 421–2). But Ch'an ideas are remarkably close to those of Taoists, who found in landscape painting a means of expressing their apprehension of the workings of the cosmic spirit. And as neo-Confucian philosophy, founded in the Sung period, developed in the same direction towards an intuitive communion with the natural world, the art of landscape painting acquired in China an importance it has been given by no other civilization.

Buddhist art was essentially public: images made for domestic shrines were small-scale versions of those displayed in temples. But Chinese landscape painting is deeply private and, furthermore, an élitist art—an art made by a few highly cultivated artists, especially gentlemen amateurs (professionals were less highly regarded) for an intimate circle of congenial spirits. Only initiates could fully understand the six enigmatic principles distinguishing a 'good painting'—indeed they can be no more than very roughly translated: (i) animation through spirit consonance; (ii) structural method in the use of the brush; (iii) fidelity to the object

6, 51 Liang K'ai, *The Poet Li Po*, 13th century. Ink on paper, $42\frac{7}{8} \times 13$ins (78×33cm). Tokyo National Museum.

6, 52 Li Ch'ing, *Buddhist Temple in the Hills after Rain*, C. AD 950. Ink and slight colour on silk, 44 × 22ins (111.8 × 55.9cm). Nelson Gallery–Atkins Museum, Kansas City.

in portraying forms; (iv) conformity to kind in applying colours; (v) proper planning; (vi) transmission of the experience of the past in making copies. Enunciated by Hsieh Ho in the early sixth century, these principles constitute the foundation of Chinese art theory. Significantly, the first refers to a quality unattainable by mere technical skill or by rational analysis. The last alludes to that respect for 'Old Masters' and the practice of copying them which gives such consistency to Chinese painting over nearly a millennium and a half—as well as bedevilling its study by Westerners.

In early Chinese literature there are many references to T'ang landscape painters, including some extreme individualists who adopted unorthodox procedures. One is said to have applied the ink with worn-out brushes and his bare fingers; when asked how he learned this technique he replied: 'Outwardly, nature has been my teacher, but inwardly I follow the springs of inspiration in my heart.' These stories were to influence later generations of artists (see Chapter 12), but no examples of such painting survive. Indeed, very few T'ang landscapes are known at all, even from copies. The earliest surviving paintings which reflect to some extent T'ang ideas date from the tenth century. One of the finest is a hanging scroll, *Buddhist Temple in the Hills after Rain*, which was in the Sung imperial collection (6, 52). It has been attributed to, and is almost certainly in the style of, Li Ch'êng (fl. 940–67), a prime representative of the Chinese ideal of the artist: a man of good family, well educated, wholly devoted to painting and scorning the nobles and careerist officials who clamoured for his work. An eleventh-century biographer records that his only ambition was to lead a quiet life and that, as an artist, 'his inspired versatility was the quintessence of the spiritual, very far beyond normal human capacities'. The scene is imaginary, as are most Chinese landscape paintings, but rendered with an intimate understanding of nature such as comes only from observation as sharp-eyed as it is loving. Artists roamed the countryside; many of them are known to have sketched what they saw, and their landscapes thus bear a strong likeness to the real scenery, though only a generic one, for they were painted indoors and were intended to represent the essence of nature and not simply views of natural beauty. A landscape is called in Chinese *Shan-shui*, a 'mountain-water' picture, and this work exploits the relationship of the two elements spiritually as well as visually. 'The wise men find pleasure in waters; the virtuous find pleasure in mountains,' Confucius had remarked. For Taoists water had a special significance exemplifying the *Tao*, and their basic text celebrated

the place where streams from the mountain are gathered.

Buddhist Temple in the Hills after Rain is painted on silk in black ink with only a few touches of colour. Such artists as Li Ch'êng shunned the bright colours favoured by ungentlemanly and unscholarly professionals for merely decorative work. They preferred the ink used for calligraphy (generally regarded in China as the highest form of art, though it is the least accessible to Westerners) and thus bound landscape painting in technique as well as subject-matter to the learned literary tradition. It was from the practice of calligraphy, which demanded vitality of line, structural strength in each character and firm control over the composition of the whole page, that these artists derived much of their skill and sensibility. The effect is not, however, linear in a Western sense: washes and dabs of ink are freely used and long brush-strokes have no hard confining uniformity. Nor is there any composition in the Western sense: no framing devices enclose the view. Li Ch'êng's painting has a strong vertical axis, or rather three, ascending in height and receding in depth from left to right almost like three long-drawn-out musical chords. Distance is indicated by clearly defined planes separated by banks of mist, against which the nearer objects are silhouetted. Unlike the hand-scrolls, which gradually revealed landscapes as they were unfurled inch by enthralling inch, this hanging scroll was intended to be seen as a whole, but to be pored over no less minutely. The viewer's eye is invited to wander with the pilgrim in the left foreground, across the bridge to the rustic huts and pavilions where people are eating, drinking and talking, to climb up among the autumnal trees to the temple and to scan the remoter distances. But the eye is simultaneously held on the surface of the painting by the amazing delicacy and deftness of the brush-strokes indicating texture as well as form, and by the expressive dabs of ink with which the rocks are modelled.

A later, southern Sung landscape is in a different style, softer and more atmospheric (6, 53). It is part of a long scroll entitled *Twelve Views from a Thatched Cottage* by Hsia Kuei (c. 1180–1230), painter-in-attendance to the emperor. Unrolled, from right to left of course, it reveals a mountain range and then a wide lake with boats on the water and fishing nets on the shore. Inscriptions entitle successive sections, such as: 'Distant Mountains and Wild Geese', 'The Ferry Returns to the Village in the Mist', 'Fisherman Playing the Flute in the Quiet Dusk', 'Anchoring at Evening on the Misty Bank', as well as many others. Time as well as space is taken into account in this scroll, which

moves from far to near, from misty daylight to dusk. And the effect of scanning it is akin to that of listening to music or reading a poem—one passage lingers in the memory and reverberates there as the eye passes on to the next. Transitions are so subtle that they are hardly noticed until they are gone. Although the mood is one of uninterrupted reverie, monotony is avoided by subtle transitions from soft washes to firm brush-strokes, from diaphanous suggestions of form to sharply focused details. Much of the silk is left blank. Only a gentle diagonal (a device often used) indicates how the lake widens out and the far shore vanishes from view. A few perfectly placed blobs and lines of jet-black ink suffice to conjure up a boat and also the expanse of still water on which it floats. The art of pictorial suggestion could hardly be taken further.

In China a landscape painting was understood as a depiction of reality. Wholly fantastic scenes were ruled out and merely conventional views were despised. But it was also—and this was more important—a reality in its own right, as a manifestation of the cosmic spirit working through the hand of the artist and in perfect harmony with it. Li Ch'êng was, in fact, criticized by a contemporary for giving too great importance to visual appearances and especially for painting buildings from a single viewpoint and not 'from the angle of totality'. Objects should be correctly delineated but their 'essence' could be lost in overparticularization.

The building in the centre of *Buddhist Temple in the Hills after Rain* is of great interest now, however, in that it records a type of structure known from very few surviving examples of the period in China. Buddhism had introduced not only the rock-cut temple but also free-standing stone architecture. A few early stone or brick temple towers, known in the West as pagodas (from a Portuguese word of uncertain origin), survive. One at Ch'ang-an was erected for the abbot of a monastery who had made a pilgrimage to India, but it owes almost as much to Han dynasty watch-towers (known from pottery tomb-models) as to any Indian structure (6, 54). Its eaves are supported on brick corbels simulating the wooden brackets normal in China. The architecture of Buddhism was naturalized much more quickly than its sculpture and completely transformed in the process of adaptation to Chinese methods of construction in wood. A new style was evolved, far more remote from Indian architecture than the latter had been from its wooden prototypes. And this was exported with Buddhism to Japan, where the earliest and finest examples survive.

Shinto and Buddhist art in Japan

The Buddhist monastery called Horyuji, in the south

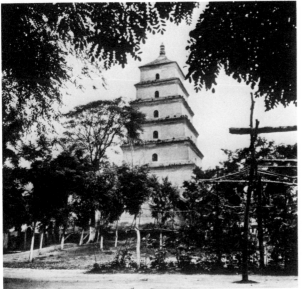

6, 53 *Above* Hsia Kuei, *Twelve Views from a Thatched Cottage* (detail), c.1200–1230. Hand scroll, ink on silk, 11ins (28cm) high. Nelson Gallery–Atkins Museum, Kansas City.
6, 54 *Left* Great Gander Pagoda (Ta-yan-t'a) of the Tz'u-en-ssu temple, Ch'ang-an, c.AD 700.

China evolved an architecture differing from that of any other nation in that it gave to the roof the major visual importance that the Greeks had given to the column. Japanese architecture developed similarly. The earliest known Japanese hut was a rectangular pit covered by a pitched roof of thatch supported by strips of bamboo on a framework of diagonally intersecting spars and a ridge-pole. The same type of roof covered dwellings and also Shinto shrines with interiors at ground-level or raised on stilts. (The term 'Shinto' came into use in the seventh century to distinguish indigenous religious cults from Buddhism.) Shrines are known to have been built in this way as early as the third century AD. The original form of the most famous, at Ise, has been preserved to the present day by the custom of building, every 20 years, a new shrine next to and exactly like the old one, which was then demolished—a religious ritual in itself and also a means of maintaining pristine purity. Depending for their effect on the logical simplicity of structure and materials—thatch and wood carefully selected for its grain, which remains visible as it is dyed with persimmon juice, not painted—these shrines already suggest that love of rusticity which was eventually developed by the Japanese into the most sophisticated of aesthetic cults.

A new type of timber roof-frame was introduced with Buddhism from China. Its basic principle is post-and-lintel, but the horizontal members or beams are tenoned into or pass through the tops of columns (6,

of the main island (Honshu) of the Japanese archipelago, is the earliest surviving example of Sino-Japanese architecture (6, 45). Founded in 607, it was rebuilt after a fire in 670 and subsequently modified only by the addition of further subsidiary structures (notably the tenth-century lecture hall to the right of the large building in the view illustrated here). Buddhism had been introduced into Japan in 552 and adopted by the ruling family in 588 together with the architectural style evolved for it on the Asian mainland.

Wood was the main Chinese building material for both secular and religious buildings, stone and brick being reserved mainly for fortifications. As a result,

213

45). The joins were reinforced both structurally and visually by brackets often of an ingenious complexity, which take the place of the capitals in a European Classical order, but appear to be purely functional, not ornamental. The length of available timbers conditioned the distance between uprights, but the width of a building could be increased by a simple process of repetition (the entrance was beneath the slope of the roof, not at the gable end, as in a Greek temple). To increase depth and height further pairs of taller columns in the interior were needed. The roof-covering, of shingles or tiles for the grander buildings, was supported on purlins (see Glossary) carried by the beams and could thus be given the concave profile that is such a distinguishing feature of Sino-Japanese architecture. Eaves were wide, originally no doubt to protect the walls from torrential rain and to provide shade, but it was for aesthetic rather than practical reasons that corners were turned up, especially on hipped roofs. To support wide eaves, elaborately carpentered brackets were cantilevered out from the columns. Beneath these great roofs there were no load-bearing walls, only partitions. Buildings were held together by their vertical and horizontal timbers.

In a palace complex the most ceremonial building was, of course, the throne room and this provided the design for the temple in which statues of the Buddha and Bodhisattvas were enthroned like an emperor and his courtiers. No such building survives in China earlier than that of the mid-ninth century. The form had, however, been fully developed before it was introduced to Japan, where it was called a *kondo* or 'golden hall'. That at Toshodaiji is the largest and finest survivor from the Nara period (645–784, named after the city then the capital). It enshrines a group of statues up to 18 feet (5.5m) tall and occupying most of

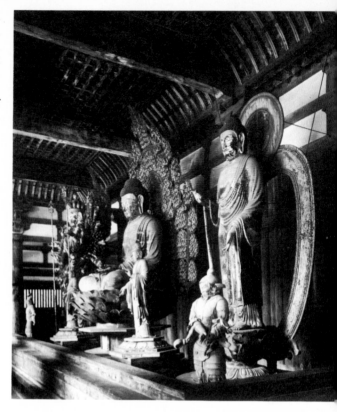

6, 55 Kondo at Toshodaiji, Nara, 8th century (interior from the east).

the floor space (6, 55). The ceiling is suspended from the huge hipped roof, which is the main feature of the exterior.

The pagoda is the only exclusively religious building type evolved by the Chinese and Japanese. It is a purely symbolic structure, a signal of faith in the greatness of the Buddha, towering above the sacred relics buried in its foundations. In Japan the pagoda provided the focal point in a group of monastic buildings with which it was perfectly integrated, not only by materials and method of construction. For its vertical accent complemented rather than contradicted their horizontal emphasis, composed as it was of roofs similar to theirs but which seemed to have taken wing, hovering one above another.

Chinese precedent was followed closely in the earliest surviving Japanese pagoda at Horyuji. But Japanese architects soon began to evolve types of their own, as at Yakushiji (6, 46). Originally one of a pair of pagodas, this building has its main tower set in a wider base and roofs of alternating size, which lend it an almost calligraphic character. Great importance is given to the brackets, supporting eaves and balconies,

Drawing of the Chinese beam-frame system.

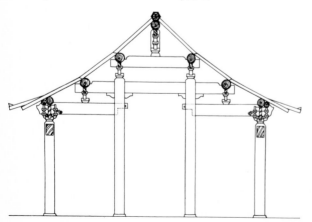

composed of blocks and bars of cleanly cut wood locked together, apparently with as much regard for abstract sculptural form as for function.

In the Fujiwara or late Heian period (898–1185) an architectural style with a still stronger Japanese flavour developed. The breakdown of the formerly close diplomatic and commercial relations with China cut Japanese artists off from developments on the mainland and encouraged the growth of a style reflecting the nationalistic and aristocratic tone of the court. The first great—some would say the greatest—work of Japanese fiction was written at this time: *The Tale of Genji* by the Lady Murasaki (c. 980–1030), as was the *Pillow Book* by Sei Shonagon (b. 965).

The palaces and court buildings of the Fujiwara period in which these stories are set have vanished. They are known to have been similar architecturally to Fujiwara temples of which the finest example is the Hoodo (Phoenix Hall) of the Byodoin temple at Uji near Kyoto (6, 56). Despite an almost rakish elegance, it retains a mood of dreamy quietude. Roofs with dashingly uptilted corners seem to float above the horizontal lines, giving the whole fabric a mirage-like quality, as if it were no more substantial than its own reflection in the still waters of the lake. Nor was this effect accidental. The temple was built to enshrine an image of the Buddha Amida, Lord of Boundless Light. By faith in Amida and repetition of his name, devotees of the Pure Land sect believed that they would be admitted to the western paradise with its jewelled trees, lotus ponds and palaces of celestial beauty, which the Hoodo prefigures. With its 'Easy Way' to salvation this Buddhist sect had a strong appeal for hedonistic courtiers in Japan and inspired some of the most exquisite, if least spiritual, of Buddhist works of art.

Large-scale sculpture had also been introduced into Japan with Buddhism. The only earlier sculptures were *haniwa*, usually about 2 feet (60cm) high, dating from the fourth to the sixth century and peculiar to Japan: terracotta tubes surmounted by human heads, whole-length human figures or animals made to stand in palisades surrounding burial mounds (6, 58). Smoothly modelled in simple, mainly geometrical forms, with slits for eyes and mouths, they are expressionless and yet curiously expressive. Tradition states that they were substitutes for the living beings who had previously been slaughtered at the funeral of a chieftain—like the figures the Chinese placed inside their tombs at the same period. But little is known about early Japanese religious beliefs. There were no images of indigenous deities until Buddhist ideas were incorporated into Shintoism. Japanese sculptors then took up new techniques as well as new iconographical

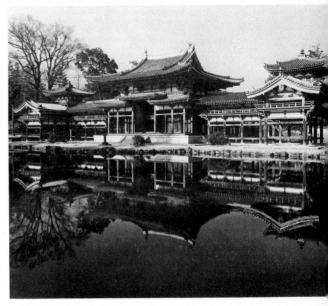

6, 56 Hoodo (Phoenix Hall), Byodoin Temple, Uji, near Kyoto, 11th century.

patterns. Both came from China, initially by way of southern Korea. Korean artists as well as Korean paintings and sculptures are known to have reached Japan in the sixth century and the first notable Japanese sculptor, Tori Busshi (fl. 600–630), was the grandson of an immigrant metalworker. But as so few Chinese and still fewer Korean large-scale sculptures survive from this period it is impossible to tell how far early Japanese sculptures derive from them. An ethereally slender statue of the Bodhisattva Kwannon—as Kuan-yin (6, 39) is called in Japan—is generally believed to be of Japanese workmanship (6, 60). The pierced copper crown, the very delicate detail on the flame-like halo and the fluent carving of the bands of drapery which lend the figure a sense of levitation, as if it were slowly ascending to the heavens, all bespeak great technical accomplishment.

In the Nara period of the late seventh and eighth centuries inspiration came direct from T'ang China. Buddhist priests who crossed from China sometimes brought artists with them. A style of solemn and sometimes rather heavy monumentality developed, as can be seen in the *kondo* at Toshodaiji (6, 55). These figures are carved out of single pieces of wood, the usual medium for sculpture in Japan, though at the end of the hall (barely visible in the illustration) there is a huge Thousand-Armed Kwannon made by the Chinese dry-lacquer process (see p. 88).

A style owing less to China emerged in the Fujiwara period, typified by a small, brightly painted statue of

6, 57 *Left* Unkei, *Nio*, 1203. Wood, 26ft 6ins (8m) high. Todaiji Temple, Nara.
6, 58 *Centre* Haniwa figure, c. AD 300–600. Terracotta, c. 2ft (61cm) high. Musée Guimet, Paris.
6, 59 *Right* Kichijoten, 12th century. Polychromed wood, 34⅞ins (88.6cm) high. Horyuji, Nara.

the goddess of felicity, Kichijoten (6, 59). Comparison with the nearly contemporary Chinese statue of Kuan-yin (6, 39) reveals how different Japanese aesthetic ideals had become. There is no sense of the ideal and unattainable—or of the ambiguous—about the buxom Kichijoten. She is a very solid down-to-earth manifestation of a goddess, clad not in fluttering gauze-like draperies but in a robe as rich as it is heavy. Were it not for her lotus pedestal, she might easily be mistaken for a very superior lady of the court, such as the Lady Murasaki could have described.

Other aspects of Fujiwara art and religion appear in a number of fans printed from wood-blocks with passages from the Buddhist *sutras* and the outlines of genre scenes, coloured by hand and further decorated with little squares and specks of gold (6, 61). Their combination of sacred text with a wittily drawn glimpse of everyday life in a composition of highly sophisticated elegance is uniquely Japanese. These fans are among the earliest manifestations of the Japanese genius for decorative design, but at this date the finest paintings were, like the finest sculptures, devotional images.

Japanese sculpture reached maturity in the Kamakura period (1185–1333). After a series of civil wars, the country came under the military dictatorship of the shoguns and their samurai (warriors), with a new capital at Kamakura, some 200 miles (320km) north of Kyoto, which, nevertheless, remained the cultural centre. The rule of a few immensely rich, highly cultivated and pleasure-loving aristocratic families gave way to a more broadly based feudal regime. Vigorous, virile simplicity was the new order of the day, and no artist expressed this more forcibly than the leading sculptor Unkei (d. 1223). His most famous work is the pair of colossal wooden statues of Buddhist guardian deities flanking the entrance to the Todaiji temple at Nara (6, 57). With fiercely glowering eyes, tensed muscles and swirling draperies, they are gigantically demonic to the tips of their extended fingers. Despite the huge scale—and also the number of different sculptors who worked on them under Unkei's direction—they have an almost unique intensity of vigour, as of some explosive volcanic force.

But Unkei's true genius was of a different tenor. He was one of the most deeply human of all artists and his

most tender and penetrating insights were conveyed in portraits or imaginary portraits. That of Mujaku, one of the ancient teachers of *Mahayana* Buddhism, called Asanga in India, is a profound work of religious sculpture—the figure of a man of unexceptional physical appearance, set apart from others by no esoteric symbolism, and yet endowed with an extraordinary spirituality. Holiness is made visible in this serene countenance (6, 47). It is the image of a great religious teacher and at the same time a statement of faith in the belief that every human being has the power of soul to transcend the human condition, the doctrine which was first enunciated by the Buddha and transformed every aspect of life throughout Asia. But Unkei's are perhaps the last great works of Buddhist art. For although Buddhism has never ceased to be a living force, its power to inspire artists declined after the thirteenth century—with the notable exception of the Zen sect (see p. 210). In Japan, especially, the subsequent history of art was to be predominantly secular.

6, 60 *Left* Kwannon, AD 623. Gilded wood, 77½ins (196.9cm) high. Horyuji, Nara.
6, 61 *Below* Fan decorated with printed *sutras* and genre scene, hand-coloured, 12th century. Paper, engraved and painted, 9¼ins (23.5cm) high. Shitennogi Temple, Osaka.

7 Early Christian and Byzantine art

In the opening years of the second century AD, the great Roman historian Tacitus referred to:

> A class of persons hated for their vices, whom the crowd called Christians. Christus, after whom they were named, had undergone the death penalty in the reign of Tiberius, by sentence of the procurator Pontius Pilate, and the pernicious superstition was checked for a moment only to break out once more, not only in Judea, the home of the disease, but in the capital itself, where everything horrible or shameful in the world gathers and becomes fashionable (*Annales*, XV, 44).

Such was the view of a prominent senator, consul and colonial governor. At this date Christianity was as yet no more than a fairly small and scattered sect composed mainly of the underprivileged, so far as we can tell—small shopkeepers, artisans and so on. To an

7, 1 *Chi-Rho* monogram, detail of a sarcophagus, c. AD 340. Museo Pio Cristiano, Vatican.

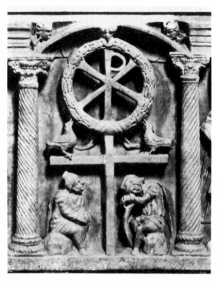

outsider it might well have seemed to differ little from other Oriental mystery cults, which held out hopes and promises of a life beyond the grave. But there were features which made Christianity potentially dangerous to the state, notably its believers' proselytizing zeal, combined with an inflexible monotheism and intolerance of all other religious beliefs, which precluded even token allegiance to the state cult, including the emperor cult. Refusal to make obeisance to imperial images was tantamount to treason. Yet, despite a permanent ban—with the death penalty for all who confessed to being Christians—and intermittent campaigns of persecution, the faith spread with increasing vigour during the second and third centuries, not only across the empire but up its social structure. The discovery that the army had been infiltrated prompted the last persecution, under Diocletian in 305. This was less than a decade before Christianity was legalized by Constantine's Edict of Milan (313).

The beginnings of Christian art

Ironically, a caricature roughly scratched on a wall of the house of the imperial pages in Rome in the second century may be the earliest surviving visual image of Christ's death on the cross. It shows a man gazing at a crucified figure with an ass's head and is inscribed in Greek: 'Alessameno worships god'. Christians themselves adopted the sign of the cross, but for long eschewed explicit representations of the crucifixion— the humiliating punishment meted out to common criminals. They also hesitated to depict Christ directly until the late third or early fourth century (though there were exceptions). The central doctrine of the Incarnation, that God became Christ, raised the problem of the desirability, and even the possibility, of his portrayal, which was argued with mounting vehemence during the next 500 years.

Initially, the natural prudence of a persecuted sect

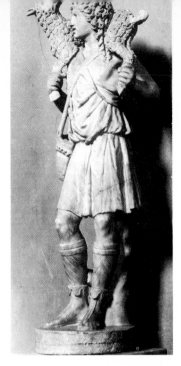

7, 2 *The Good Shepherd*, c. AD 300. Marble. Vatican Museums, Rome.

may also have encouraged the creation of an arcane imagery intelligible only to the initiated. The first symbols invented by the early Christians were semantic rather than representational and some were purely verbal—for the word outlives the flesh and thus pertains to eternity. The Chi-Rho monogram, for example, was simply a combination of the first two letters of *Christos*—XP—in Greek, the language of early Christianity (7, 1). A fish was adopted as a rebus for Christ's name because the word fish in Greek provided the initials for the formula: 'Jesus Christ Son of God Saviour'. Other symbols were based on literary metaphors; the lamb, for instance, on St John the Baptist's description of Christ as 'the Lamb of God, which taketh away the sins of the world'. Christ's own words, 'I am the good shepherd: the good shepherd giveth his life for the sheep', lent particular significance to a figure which had been used to symbolize benevolence or philanthropy in pagan Classical art (7, 2). Such figures acquired new meaning only from their context (Christian tombs). They were not, of course, supposed to represent Christ. As we have seen (p. 183), the development of Buddhist imagery had run a parallel course, an image of the Buddha in human form being evolved only in the second century.

The earliest Christian symbols appear among the paintings in Roman catacombs. These underground cemeteries, running up to five galleries deep beneath the cheap land outside the city, were adopted at least as

early as the second century by Christians (also by Jews and others), who shunned places for inhumation dedicated to pagan deities. Because of their belief in the resurrection of the body, the early Christians insisted on burial and objected to cremation, normal for the lower classes in Rome. Their symbolism referred primarily to salvation from death—crosses, Chi-Rho monograms, fishes, anchors of hope and figures of the Good Shepherd—all painted on the low ceilings and the very limited wall spaces between recesses for coffins in these subterranean corridors and chambers.

Some of these paintings seem to have been deliberately left open to more than one interpretation, so that they have multiple layers of meaning. That of men and women at table with bread and wine might be understood simply as an *agape* or early Christian 'lovefeast' (7, 3). On the other hand, it could refer to two of Christ's miracles, the transformation of water into wine at the wedding feast at Cana and the feeding of the five thousand with five loaves and two fishes, with, in addition, an allusion to the Last Supper and its

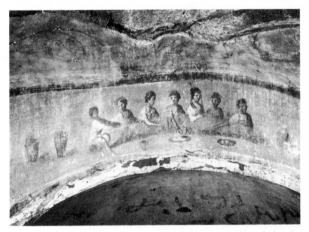

7, 3 *The Breaking of Bread*, late 2nd century AD. Wall painting in the catacomb of Priscilla, Rome.

commemoration in the simplest form of the sacrament of the Eucharist and perhaps also to the reunion or banquet of the faithful in heaven. Incidents from the Gospels are, however, greatly outnumbered by Old Testament subjects prefiguring Christian salvation: Noah, Abraham sacrificing Isaac, Jonah and the whale, the three Hebrew children in the fiery furnace and Daniel in the lions' den. To the initiated they were a reminder of how the New Testament fulfilled the old. Greek and Roman mythology also provided subjects if they could be given a Christian interpretation—Cupid and Psyche as an allegory of body and soul, for instance. The best of these paintings were clearly by professional artists, not necessarily Christian, who

were otherwise engaged in enlivening the walls of private houses with briskly sketched figures of gods, fauns and nymphs of the kind we have seen at Pompeii. Catacomb paintings were rarely as vivid and they mark no new stylistic departure. In Rome Christians took over the artistic, as well as the literary, language of pagans, changing only the meanings with which they invested its images.

Christian paintings, in a different style and on a larger scale than was possible in the cramped conditions of the catacombs, have been found in Syria at Dura Europos, a trading station and frontier town garrisoned by the Romans from 165 to 256, when it was abandoned. The Good Shepherd, Adam and Eve in the Garden of Eden, David slaying Goliath and two of Christ's miracles (walking on the water and healing the paralytic man) were depicted. They are too badly damaged to be legible in reproduction but are similar stylistically to the comparatively well-preserved wall paintings in the nearby synagogue of the Jewish community (7, 4). At this time the Mosaic prohibition of 'any likeness of any thing that is in the heavens above, or that is in the earth beneath' was freely interpreted (only the image of God being totally banned) and the scriptures were illustrated also in Hebrew manuscripts, which Christian artists were soon to use as models.

7, 4 Synagogue from Dura Europos, view of north-west corner, c. AD 250. National Museum, Damascus.

The painters of the Dura Europos synagogue disregarded all the naturalistic techniques developed by Hellenistic and Roman artists. No attempt was made to break the surface of the wall or to create an artificial space. Scenes are arranged without any visual relationship to one another or to the design of the room as a whole. Figures are flatly painted without modelling or shadows, frontally posed and placed motionlessly side by side. They have no reality, only significance. Wall paintings in other buildings at Dura Europos are similarly schematic—the temples of Zeus, the Persian god Mithras (whose cult was widespread in the Roman army) and the Mesopotamian god Bel (worshipped since Sumerian times). It is impossible to know whether painters in this provincial outpost of the empire ignored illusionism because of their non-materialist, religious ideals or simply because they had been trained in a schematic tradition more closely allied to Persia or even farther East than to Rome and the West. In this small town there were no fewer than 16 different cult buildings, erected mainly for Roman troops—vivid testimony to the spiritual turmoil of the late second and third centuries.

The Christians' place of worship at Dura Europos—the earliest to survive anywhere—was not built as such. It was an ordinary private house in a poor district. A central courtyard was surrounded by rooms, two of which had been united to make an assembly hall for some 50 people, and another—with mural paintings—was provided with a large basin or font, surmounted by

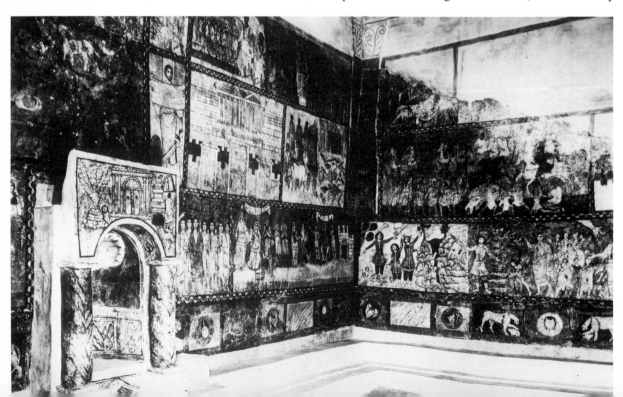

a canopy, for the all-important initiatory rite of baptism. There may have been a room for the celebration of the Eucharist on the upper floor. During the centuries of persecution Christians normally congregated in such a building. It was called a *domus ecclesiae* from the Latin word for a private house and the Greek for an assembly. Churches built after the legalization of Christianity in 313 kept the external plainness of their predecessors (the only architectural feature to be retained being the atrium, see p. 155, enlarged to serve as a forecourt), but for the increasingly large congregations spacious interiors were needed. The traditional Roman temple rarely allowed much space for communal worship in its cella, which was reserved for cult statues, and for this reason, and to mark a decisive break with paganism, its form was not taken over by Christians. Prototypes for the first great churches built under the patronage of Constantine were found in public secular architecture (i.e. basilicas) mainly, no doubt, for practical reasons, but also in order to symbolize the alliance he had forged between Christianity and the empire.

The promotion of Christianity by Constantine (c. 274–337) invites comparison with that of Buddhism by Asoka in India more than five centuries earlier (see p. 178). Irrespective of their personal convictions, both found religion to be a most effective aid to political unification. This was the main aim of Constantine's career. He succeeded his father as ruler of the north-western provinces in 306, obtained control of Italy in 312 and in 324 subdued the rich eastern provinces, where he founded his new capital Constantinople. Long before he came to power the ideological base of the empire had begun to disintegrate. The old Roman religion, of which the emperor was high priest, had lost its appeal to a variety of 'foreign' cults including Christianity, and during the political upheavals of the second century the idea of the 'god-emperor' had become irretrievably tarnished. Christians refused to pay it so much as lip-service. But their objections were removed at a stroke by Constantine, when he placed himself at the head of their Church as the vicegerent of Christ, whose *Chi-Rho* monogram was inscribed on his standards. Although he was not baptized until shortly before his death, he felt himself to be the 'servant of God' in a special sense and strove throughout the Arian controversy for unity, presiding at Church councils, including that which promulgated the Nicene creed—still the basic declaration of faith of most Christians today. (A united empire needed a united Church to support it.) The position he had assumed and passed on to his successors was neatly summarized in a fourth-century military manual, written after

Christianity had become the one official religion of the empire: 'When the emperor has received the name Augustus, loyalty and obedience are due to him as to a present and incarnate deity. For in peace and in war it is a service to God to adhere loyally to him who rules at God's ordinance.' By a complementary process, the simple rites of the early Church were elaborated into ceremonies resembling those of the imperial court—with momentous consequences for Christian art.

In 313 Constantine gave the Christian community in Rome an imperial palace for its bishop and a piece of land on which to erect a church. Foundations of the latter, beneath S Giovanni in Laterano, which is still the cathedral of Rome (i.e. the church containing the bishop's throne or *cathedra*), reveal that it was a type of building called in Latin a *basilica* (p. 154). The Roman basilica varied quite considerably both in function and form. It might be an imperial throne-room, a court of justice or simply a covered market, money-exchange or drill-hall. Usually it took the form of a large hall with aisles, and sometimes galleries above them, flanking a central space, covered with concrete vaults or timber roofs. One wall was generally broken by a semicircular or rectangular apse. Its public character was indicated by a statue or bust of the emperor, before which oaths were taken. From this variety of building types the

Isometric reconstruction of the Lateran Basilica, Rome, as in AD 320.
Bottom Plan of Old St Peter's, Rome.

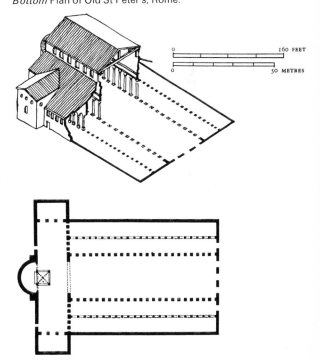

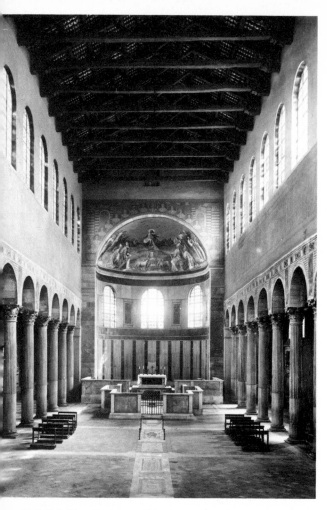

7, 5 S Sabina, Rome, AD 423–432.

architect of the church at the Lateran selected the elements which were to make up the Christian basilica: an oblong timber-roofed hall divided by columns into a nave, well lit from large clerestory windows, and flanking aisles giving a strong longitudinal axis from the entrance door to the apse. In a Roman throne-room or law-court the apse contained the emperor's or magistrate's throne flanked by seats for courtiers or assessors, and this became the apse with bishop's throne and benches for celebrating clergy (the *synthronon*), as in S Sabina in Rome, one of the best-preserved early examples of a Christian basilica (7, 5). (The columns and capitals are Roman, probably from a pagan temple.)

A variation of the basilican plan was adopted for the much larger church dedicated to St Peter, which was built on the Vatican hill in Rome in the 320s with funds supplied by Constantine. Excavations under present-day St Peter's have revealed that the rear wall of the basilican hall, with its central apse, had been moved back to create a transverse space or transept (see Glossary) to accommodate large congregations of pilgrims. The interior was, in fact, divided into two parts marked off at the end of the nave by a huge arch. On this there was a mosaic of Constantine accompanied by St Peter presenting a model of the church to Christ with the inscription: 'Because under Thy leadership the world rose up triumphant to the skies, Constantine, himself victorious, has founded this hall in Thy honour.' The division indicated this church's special and dual purpose of *martyrium* and burial-place. St Peter's was primarily a *martyrium* (i.e. a church built on a site bearing witness to the Christian faith, in this instance the shrine which had long been venerated as the tomb of St Peter). It was also a covered cemetery, where Christians could be buried near the shrine, with the customary rituals of the period including funerary feasts. The transept was reserved for the shrine: nave and aisles provided a burial-place.

The shrine was the focal point of St Peter's, backed by the apse and, when seen from the entrance, framed by the arch—a very ancient architectural symbol of heaven and perhaps also recalling the triumphal arches of imperial Rome. A *ciborium* or canopy, similar to those held over imperial thrones, was placed above it, supported on spiralling 'barley-sugar' columns sent from Greece by Constantine, but later believed to have come from Solomon's temple. It was, of course, to St Peter that Christ had said: 'Thou art Peter, and upon this rock I will build my church.' He was the founder of the Christian community in Rome and its first bishop, from whom all subsequent bishops of Rome derived their authority—as Popes—over not only the city but all Christendom. The plan of the church which Constantine had built in his honour therefore acquired symbolical significance.

Constantine founded churches also in his new capital at Constantinople and in the Holy Land. Very little survives of them, but it is known that the Holy Sepulchre outside Jerusalem, where Christ's body was believed to have been placed after the crucifixion, was enshrined in a circular building with a dome supported on 12 pairs of columns (corresponding to the number of the apostles). The circle was a religious symbol of immemorial antiquity in many cultures. As we have seen, the hemispherical Buddhist *stupa* symbolized the cosmos (see p. 181); Greeks and Romans also built round temples for their gods and a centralized (often circular) plan had been usual for tombs and shrines of

deified or semideified heroes (mortals who had become immortal by their deeds). The form now entered Christian architecture as a *martyrium*, the building on a site which was either hallowed by an event in Christ's life or the tomb of a Christian who had borne witness to the faith (the meaning of the word 'martyr'). It was used for the Holy Sepulchre in Jerusalem, for the tomb of Constantine's daughter Constantia in Rome, now the church of S Costanza (7, 6), and, later, for St Simeon the Stylite at Qal'at Si'man in Syria (7, 22).

The terms 'Late Antique' and 'Early Christian', as applied to the art of the fourth and fifth centuries, are both equally appropriate for the church of S Costanza, which beautifully illustrates how pagan form coalesced with Christian meaning. Its dome rises from 12 pairs of granite columns with crisp Corinthian capitals, almost certainly removed from some earlier pagan building. On the vault of the ambulatory surrounding the central space there are mosaics which might also seem to have come from some ancient Roman palace or temple—geometrical designs above the entrance and then, on either side, panels of rambling vines with children joyfully engaged in the vintage. They may derive from earlier mosaics, but have Christian significance as a metaphorical symbol of Christ's saying: 'I am the true vine, and my Father is the husbandman.'

Originally in the bay opposite the door, above the

7, 6 S Costanza, Rome, c. AD 350.

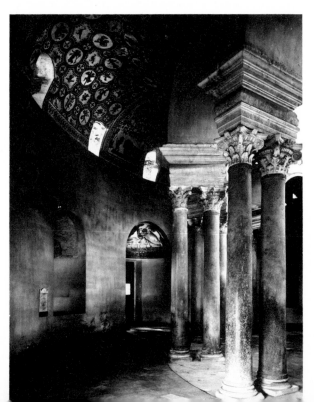

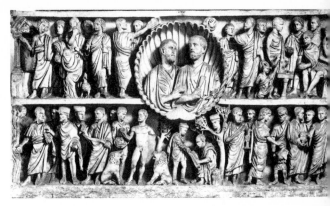

7, 7 Sarcophagus of the 'Two Brothers', c. AD 330–350. Museo Pio Cristiano, Vatican.

niche in which stood Constantia's richly carved imperial porphyry sarcophagus (Vatican Museum), there had originally been a mosaic of paradise with the apostles symbolized as lambs, and in the dome Old Testament scenes separated from one another by gilded caryatids with panthers at their feet. All this has now vanished. The effect must have been one of bejewelled opulence in sharp contrast with the roughly painted tomb chambers in the catacombs only half a century or so earlier.

The image of Christ

When Christianity ceased to be an underground religion the need arose not only for a new architecture with a richness of decoration to reflect its imperially sponsored status, but also for a new visual language—a language less cryptic and allusive than that of the catacombs. Large Biblical scenes painted on the walls of the church at the Lateran and in St Peter's were probably the first attempts to answer this need. Unfortunately, little is known of their appearance and it would be hazardous to suppose there were any parallels between them and the paintings in the church and synagogue at Dura Europos (7, 4). Relief carvings on sarcophagi provide the best surviving evidence of the first steps in the creation of a specifically Christian art. The earliest are so similar to the friezes on the Arch of Constantine that they might seem to have been products of the same workshops. Soon afterwards there was a reversion to older and more Classical types of sarcophagus—to those which had, in fact, assisted the sculptors of Gandhara in their quest for a visual language of Buddhism some 200 years before (see p. 184). Several figures on the Early Christian sarcophagus of the 'Two Brothers', for instance, were directly copied from Classical prototypes of this kind, most obviously an athletic male nude (7, 7). But they

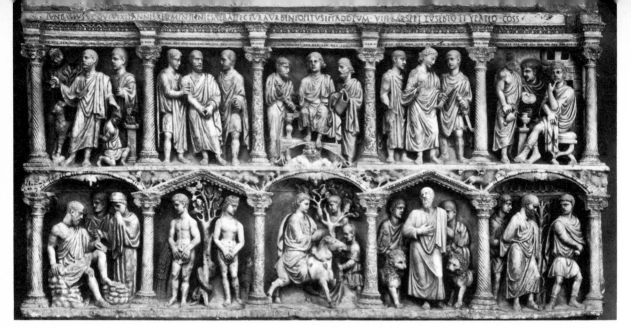

7, 8 Sarcophagus of Junius Bassus, AD 359. Grottoes of St Peter, Vatican.

are huddled together on two registers to illustrate a number of incidents, juxtaposed without divisions in no narrative sequence, unlike the traditional sarcophagus with one frieze devoted to a single scene. In the upper register, for instance, Christ raises Lazarus from the dead and prophesies that St Peter will deny him, Abraham prepares to sacrifice Isaac, and Pontius Pilate washes his hands. Below, St Peter is apprehended by Roman soldiers, who stand next to Daniel in the lions' den.

The sarcophagus of Junius Bassus, a prefect of the city of Rome who died in 359, is a more elaborate and accomplished work with figures well proportioned and delicately carved in the Classical spirit (7, 8). But the same need to say as much as possible in a limited space is evident. Even the spandrels of the lower arcade are filled with lambs enacting such scenes as the Hebrew children in the fiery furnace, the baptism of Christ and the raising of Lazarus. Here again the scenes follow no narrative sequence but are set on separate stages, flanked by colonnettes so that attention can be focused on each in turn, and arranged in thematic relationship to one another. At either end of the lower register, for instance, the afflicted Job and St Paul led off to martyrdom are parallel instances of redemption through suffering, which also allude to Christ's humiliating flagellation and crucifixion—neither of which was directly represented at this time. Christ is, moreover, no longer a figure barely distinguishable from the others (as on the sarcophagus of the 'Two Brothers'), but is given the central place in the composition as in the doctrine of redemption, which it

illustrates. He is shown in the middle of the lower register riding into Jerusalem on Palm Sunday—his moment of triumph on earth—and, immediately above, enthroned between St Peter and St Paul. The seated figure flanked by two standing attendants is an image of authority, which was taken over from imperial Roman art and also occurs in Buddhist art (the Buddha between Bodhisattvas). Christ's feet rest on a canopy supported by the Roman sky god Coelus to indicate that he is enthroned above the firmament, 'ascended into the heavens'.

On the sarcophagus of Junius Bassus, Christ is dressed not in a Roman toga but the Greek pallium, which had come to be associated in Italy with philosophers and teachers. He is not, however, bearded like a philosopher but has a fresh adolescent face. The sculptor seems to have taken a youthful Apollo as his model. This image of eternal youth recurs in Early Christian art, but gradually takes on a more ritualistic cast. In a mosaic at Ravenna the beardless Christ, wearing a pallium of imperial purple cloth, stands with arms outstretched to bless the loaves and fishes, carried by symbolically shorter disciples, whose hands are covered, as was usual at this time for subjects bringing tribute to their ruler (7, 9). (A priest celebrating a Catholic mass still makes the gesture of Christ as in this mosaic and, until very recently, the deacon carried the paten for the consecrated bread in veiled hands.) This youthful Emmanuel ('God with us') figure continued to be used for Christ until well into the Middle Ages.

An entirely different image of Christ, lean-faced, long-haired and bearded, first appears in a fourth-century catacomb painting. He is shown in this way on

a sarcophagus probably carved about 390 in Milan, then an important centre of Christianity and the western capital of the Roman empire (7, 10a). Here Christ stands with the apostles (also symbolized by sheep below) before the entrance to the heavenly Jerusalem, confiding the New Law to St Peter, as God had handed down the tablets of the ten commandments to Moses. Clearly, a more mature appearance than that of a beardless youth had been thought appropriate for Christ the law-giver, one that associated him with God the Father. The artist had, therefore, looked to the father of the pagan gods, Zeus or Jupiter, for inspiration. A still more authoritative, awe-inspiring image was evolved and given canonic form in such mosaics as that in S Pudenziana (7, 10b) or that of the early sixth century in SS Cosma e Damiano in Rome. The bearded image was, of course,

the one destined to become familiar throughout Christendom, although several centuries were to pass before it was invested with the pathos of the Man of Sorrows. At this early date Christ was represented almost exclusively as either the miracle-working healer, or the great teacher, or the law-giver. Scenes of his passion always stopped short of depicting his humiliation and the crucifixion was generally avoided as in the earliest surviving cycle of Gospel subjects of c.490 in S Apollinare Nuovo, Ravenna. The cross was rendered as a symbol not of suffering and death but of triumph and resurrection, sometimes fashioned in gold and studded with precious stones.

The two entirely different images of Christ which coexisted in the minds of early Christians were evolved against a background of theological questioning. Hatred of pagan idolatry, which Christians shared with Jews, led some to a total condemnation of representational art. The writer and polemicist Tertullian (c.160–c.225) claimed that the devil created

7, 9 *The Miracle of the Loaves and Fishes,* c. AD 504. Mosaic, S. Apollinare Nuovo, Ravenna.

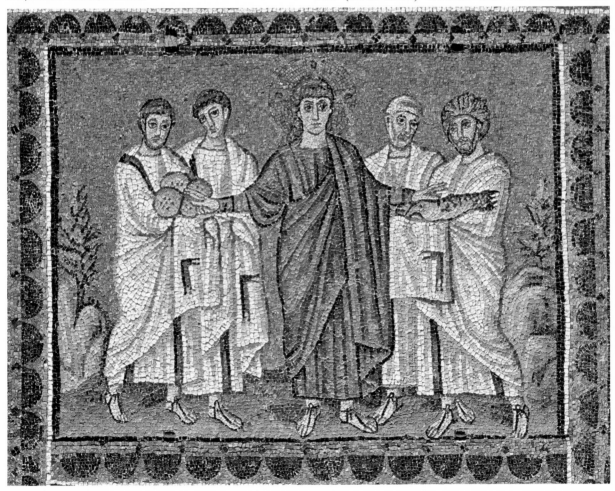

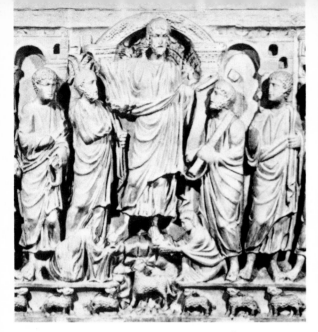

7, 10a Detail of sarcophagus, c. AD 390. S Ambrogio, Milan.

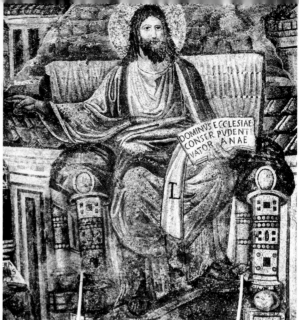

7, 10b Detail of apse mosaic, AD 402–17. S Pudenziana, Rome.

'sculptors, painters and producers of all kinds of portraits'. The absolute Mosaic ban on images of God was strictly observed—not until the twelfth century was he to be represented by more than a hand reaching down from heaven (7, 24; 7, 44)—and sometimes extended to Christ. When the sister of the Emperor Constantine applied to a bishop for a portrait of Christ she was said to have been sharply rebuked for displaying a tendency towards idolatry. And before the end of the fourth century Epiphanius (d. 403), bishop of Salamis, in a letter to the Emperor Theodosius, asked: 'Which of the ancient Fathers ever painted an image of Christ and deposited it in a church or private house? Which ancient bishop ever dishonoured Christ by painting him on door curtains?' Images of saints were equally objectionable, he went on, since painters habitually 'lied' by depicting them 'according to the whim' sometimes as old men, sometimes as youths and so on. 'Wherefore', Epiphanius entreated the emperor to have all such paintings removed or whitewashed over and 'let no one paint in this manner henceforth. For our fathers delineated nothing except the salutary sign of Christ both on their doors and everywhere else'.

Nevertheless, theological support could be found for the widespread desire for images. The original version of the Nicene Creed, formulated in 325, had stated that Christ was 'of one substance with the Father' and 'for us men and our salvation came down and was made of flesh, and became man'. It followed that he could be represented as a man and, indeed, to deny it implied adherence to a heresy prevalent among

Gnostics of the third century—that Christ's appearance on earth was visionary. Thus the image of Christ eventually came to be seen as an affirmation of orthodoxy, especially later in connection with the fifth-century heresy of the Monophysites, who held that the divine nature of Christ subsumed the human. Images made explicit the doctrine defined at the Council of Chalcedon in 451 that Christ was 'of one substance with the Father as regards his Godhead, and at the same time of one substance with us as regards his manhood; like us in all respects, apart from sin.'

The imperial Roman art on which Christians drew for their sacred images continued to furnish models for secular work as well. There are figures from pagan mythology—cupids not yet converted into angels—on a magnificent silver plate made in 388 to celebrate the tenth anniversary of the accession of the Emperor Theodosius (7, 11). But the general effect is most un-Classical. The emphasis has shifted. The corporeal has given way to the incorporeal, verisimilitude to symbolism. Theodosius is enthroned in front of a pedimented arch of a peculiar form, which had acquired symbolic significance from its imperial use. His head, an idealized portrait, is surrounded by a halo, which probably derives from Sassanian and Hellenistic images of sacred monarchy but later came to indicate the divine aura—of the Buddha (6, 8) and of Christ and his saints. Without so much as a glance towards the official to whom he hands a document, Theodosius stares straight ahead, his eyes fixed on the source of his divine power in heaven. Scale indicates

status, descending from Theodosius to his co-emperors and the dwarfed soldiers of his bodyguard. Christ was frequently depicted in exactly the same way, at the centre of a symmetrical composition. Thus secular and religious meanings interfused with and reinforced each other in the art of an empire governed by a divinely appointed Christian ruler.

Many upper-class citizens, however, clung tenaciously to the old gods, even after Theodosius proscribed all non-Christian cults in 392. There were artists who went on working for pagan as well as Christian patrons—sometimes in a style that must at this date have been self-consciously 'Classicizing'. Two late fourth-century ivory panels, for example, one pagan and one Christian in subject, quite clearly came from the same workshop, probably in Rome. The border ornamentation of palmettes is identical on both (7, 12a; 12b). In one, carved for a member of an ancient senatorial family called Symmachi, who were promoters of a pagan revival, a distinctly patrician

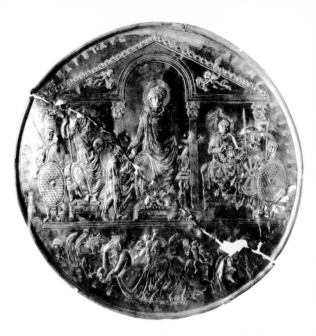

7, 12a *Below left Priestess performing pagan rites*, c. AD 400. Ivory, 11⅝ × 4¾ins (29.5 × 12cm) high. Victoria & Albert Museum, London.
7, 12b *Below right Holy Women at the Tomb*, c. AD 400. Ivory, 14⅜ × 5³⁄₁₀ins (37 × 13.5cm). Castello Sforzesco, Milan.

7, 11 Missorium of the Emperor Theodosius, AD 388. Silver, 29ins diameter. Real Academia de la Historia, Madrid.

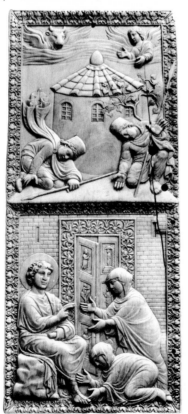

priestess sacrifices to Bacchus or Jupiter. The other panel shows the holy women visiting Christ's sepulchre on the morning of the resurrection and originally formed part of a diptych (i.e. two hinged leaves with blank inner sides on which to write the names of those for whom prayers were to be said at the Eucharist). It differs from the pagan panel by illustrating not a single scene but two successive incidents. Above, the guards are stunned by the angel arriving to remove the stone from the sepulchre. Below, the angel tells the holy women that Christ has risen from the dead. Symbols of two of the evangelists who recorded the event are placed in the upper corners. The panel is, nevertheless, carved with as much delicate precision as that of the pagan priestess, the same attention to the natural fall of draperies and to the build and flexibility of the bodies beneath them, and the same feeling for form and space. The lucid and also sensuous language of the Classical tradition has been most tactfully and sensitively adapted to express a Christian message. It was about this time, it should be noted, that St Augustine (354–430) was forging out of Cicero's precise and elegant Latin a literary style in which to expound the intricacies of Christian theology—hitherto written mainly in Greek—and St Jerome (c. 348–420) was translating the Bible into a plainer style of Latin, closer to common speech, a style which was to become the unifying language of Western

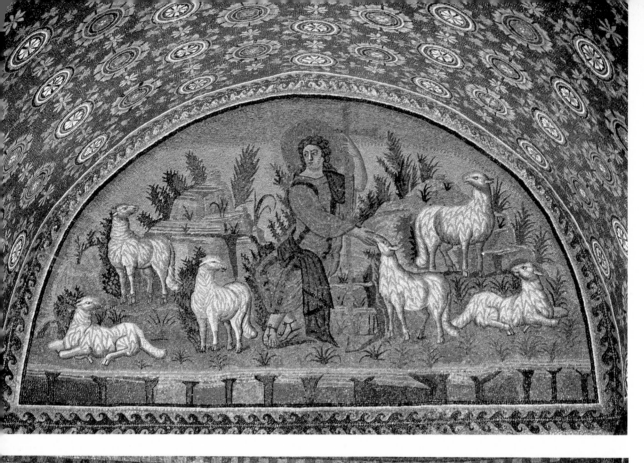

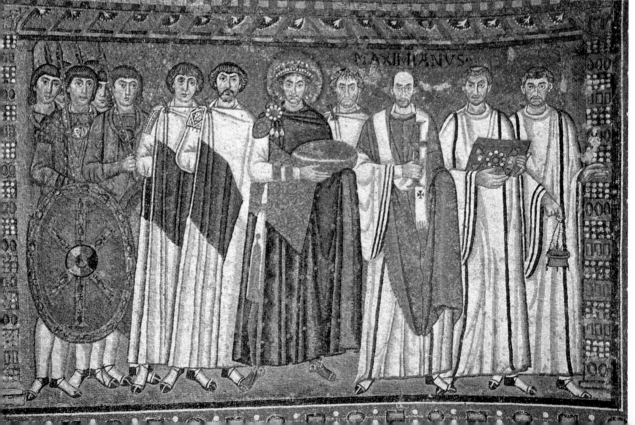

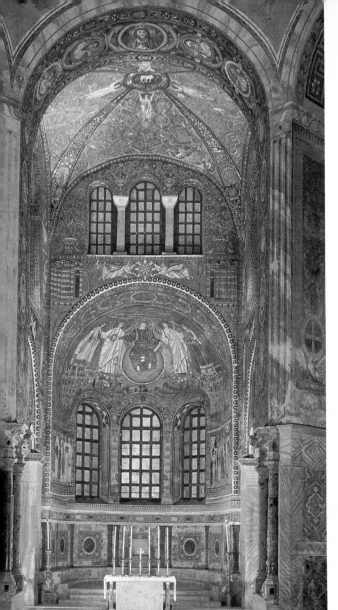

began to disintegrate under attack from the peoples of central and northern Europe. Rome was sacked by the Visigoths in 410—three days of mourning were ordered in Constantinople but nothing more was done. It was sacked again and more seriously by the Vandals in 455. In 476 it came, with the rest of Italy, under the rule of a barbarian king, Odoacer, later overthrown by Theodoric (d. 526), king of the Ostrogoths.

Yet, surprisingly, the visual arts flourished throughout this troubled period. Church building was promoted in Rome in the fifth century as never again until the seventeenth. The standard form of Christian basilica was finally established (e.g. S Sabina, 7, 5), and at S Maria Maggiore, completed in 440, the Roman Church began to aspire to the splendour of the city's imperial past. The bishops of Rome, who now called themselves 'popes', put forward claims to universal authority. Sixtus III, the founder of S Maria Maggiore, is described in the bold dedicatory inscription above the apse as *episcopus plebi dei*—bishop of God's people. Nearby, in a mosaic, Solomon's temple was given the form of the ancient *Templum urbis* in the Forum, dedicated to the goddess Roma, as if to suggest that Rome was the new Jerusalem.

There are many reminiscences of ancient Roman art in the mosaics at S Maria Maggiore. Their designers

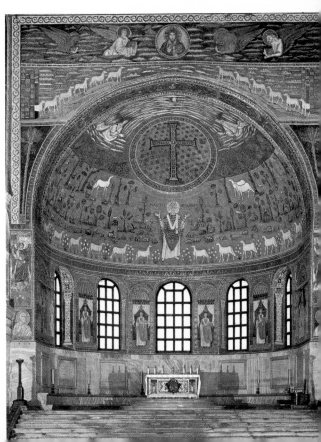

7, 13 *Left above The Good Shepherd*, mosaic, Mausoleum of Galla Placidia, Ravenna, c. AD 425.
7, 14 *Left below Justinian and his retinue*, c. AD 547. Mosaic in apse of S Vitale, Ravenna.
7, 15 *Above* S Vitale, Ravenna, c. AD 540–547.
7, 16 *Right* S Apollinare in Classe, Ravenna, c. AD 547.

Christendom for more than a millennium, and of the Roman Catholic liturgy until the mid-twentieth century.

After the death of Theodosius in 395 the incipient rift between the eastern and western parts of the empire was deepened by their political division between his two sons. The eastern empire remained prosperous and intact, but the western, already impoverished,

were evidently as familiar with second-century Roman narrative relief sculpture as with more recent sculpture and painting, notably that in illustrated Bibles and Classical texts (7, 17a). One of the panels beneath the clerestory windows depicts the children of Israel on their way to the Promised Land threatening revolt against Moses and then, below, stoning Moses, Aaron and Joshua, who are protected in a cloud sent by the Lord (7, 17b). The story is told dramatically, much as on the Column of Marcus Aurelius (5, 38), with a similar disregard for scale and concentration on emphatic expressions and gestures.

The walls of the earliest churches in Rome had been covered with paintings. The more durable medium of

7, 17a *Below Dido sacrificing*, illustration to Virgil's *Aeneid*, early 5th century AD. Biblioteca Apostolica, Vatican. Ms. lat. 3225. f. 33 v.
7, 17b *Bottom Israelites threatening revolt* and *The Stoning of Moses*, AD 432–440. Mosaic in the nave of S Maria Maggiore, Rome.

mosaic was more expensive and so less often used. The technique of making decorative patterns and figurative scenes or *emblemata*, as mosaic pictures were called (the origin of our word 'emblem'), out of small tesserae of stone had been highly developed in Hellenistic times, mainly for pavements (see p. 146). About the first century AD the introduction of light-weight squares of glass together with that of a new type of cement, in which they could be fixed, greatly facilitated the use of mosaics on walls and ceilings. Glass also increased the colour range and could be made refulgent with gold-leaf backings. By setting the pieces at a slight angle to the surface to catch the light a shimmering effect could be created. Design did not, however, keep pace with these technical advances. Mosaics went on being conceived as pavements, so that those in the ambulatory of S Costanza, for example, look rather like carpets laid out over the ceilings (7, 6). Not until the fifth century was the medium fully exploited for wall and vault decoration in churches in Rome, Milan and, most notably, Ravenna, the most important city in Italy from 402 until the mid-eighth century (capital of the western emperors until 455, then of the Ostrogothic conquerors and the Romanized court of Theodoric and finally the see of Byzantine viceroys after the reconquest of Italy by Justinian's armies in the sixth century).

The so-called Mausoleum of Galla Placidia is the earliest building in Ravenna to preserve its full complement of mosaics. It was originally attached to a church founded by Galla Placidia, daughter of Theodosius and, as mother of the Emperor Valentinian III, empress of the West from 425 until her death in 450. It follows a cruciform plan recently recommended as symbolically ideal for a church by St Ambrose, the great theologian and bishop of Milan. Over the main door a mosaic lunette shows the Good Shepherd in a landscape strongly reminiscent of Pompeiian paintings (7, 13). Schematic rocks at the front place the scene beyond the frame and provide a solid base. Spatial recession is indicated by the foreshortened sheep, the twisting pose of the Good Shepherd and the pale-blue sky gently darkening towards the zenith. Conceived in the tradition of *emblemata*, it is so placed as to suggest an opening on to the exterior from inside a tent or awning of imperial richness. Above the crossing the vault is transformed into a starry night sky with a gold cross gleaming at its centre, symbolizing the kingdom of heaven in which the souls of the victorious faithful would shine like stars. But the illusionistic devices of Hellenistic and Roman painting, so brilliantly put to Christian use in this building, were soon to be renounced. Figures have

already begun to lose their solidity, standing against plain gold backgrounds in ambiguous spatial relationships, in the sumptuous mosaic decorations of S Apollinare Nuovo, built on a basilican plan as Theodoric's palace church around 490. Gospel scenes—the earliest extant cycle—are here rendered not as parts of a narrative but as static ritual moments symmetrically composed (7, 9).

Emblemata gave way to emblems a century later, when the chancel of the church of S Vitale was encrusted with some of the most beautiful of all mosaics. Every square inch sparkles with colour, green and gold predominating, cool blues, occasional touches of scarlet and purple, and very telling use of white. The designs, intricate but never fussy, are so perfectly integrated with the structure of the building that the mosaics and architecture, surfaces and forms, seem to have been conceived together. The general effect is of great, though controlled and unostentatious, magnificence. Yet S Vitale was not intended simply to charm the eye. Every motif is symbolic—vines of Christ, peacocks and doves of the immortal soul and so on. For the figurative scenes, the eucharistic sacrifice provides the unifying theme, with the Lamb of God in the centre of the vault. These wonderful mosaics were executed shortly after 540, when Ravenna with the rest of Italy was won back from the Ostrogothic king, Theodoric, and they have perhaps political overtones.

In the centre of the half-dome or conch of the apse, a youthful and beardless Christ is flanked by angels. On the far right stands Bishop Ecclesius, founder of the church of S Vitale, of which he holds a model (7, 15). St Vitalis is on the far left. The scene is set in the flowery meadows of paradise with its four rivers, issuing like twists of blue hair just beneath Christ, and its golden sky. Christ is, however, seated on the orb of the world, suspended in space. He is dressed in the purple robe of an emperor and hands a crown to St Vitalis without so much as a turn of the head—just as Theodosius was shown handing a diploma to an official (7, 11). All the figures are posed frontally, looking directly at the spectator and communicating with each other only by gestures.

On the lower walls of the apse we move from the court of heaven to that of the Byzantine emperor Justinian (527–65) and his empress Theodora, depicted with attendants carrying offerings to the altar. Justinian, with a halo, is accompanied by his bodyguard, carrying a shield with the *Chi-Rho* monogram, officials and three ecclesiastics including Maximianus (identified by name), bishop of Ravenna when the church was completed (7, 14). The vivid

characterization of the heads suggests portraiture from the life. And, at first sight, the panel might seem to be a straightforward representation of visual appearances in the tradition of *emblemata*. But the illusion of figures standing in space was created only to be denied. Justinian's feet are behind, but his cloak is in front of, the bishop. Although all the figures stare straight ahead, the gesture of the acolyte carrying a censer reveals that they should be read as moving in procession to the right, towards the centre of the apse.

Shortly after the completion of S Vitale, the apse of the church of S Apollinare in Classe (at the port of Ravenna) was decorated with mosaics hardly less fine (7, 16). Here illusionistic devices were retained only for the bishops of Ravenna standing in curtained niches between the windows, in what constitutes the terrestrial zone of this great cosmic conception. In the lower part of the conch the garden of paradise, its little trees planted so carefully that they never overlap one another, is depicted quite flat, without any suggestion of recession, for in this eternal sphere where there is no time there can be no space. St Apollinaris, the first bishop of Ravenna, his hands raised in the traditional gesture of prayer (*orans*) and wearing the eucharistic chasuble of an officiating priest, stands in the centre, with six sheep on either side, representing the twelve apostles. Three more sheep are placed at the top of the landscape to symbolize St Peter and the brothers St John and St James witnessing the Transfiguration. The Gospel according to St Matthew states that Christ took them up to a high mountain 'and was transfigured before them: and his face did shine as the sun, and his raiment was white as the light. And, behold, there appeared unto them Moses and Elias talking with him.' In the mosaic the two prophets are shown emerging from the clouds and the blinding glory of Christ is symbolized by a jewelled cross set in a dark-blue star-studded disc. At the very top of the apse the hand of God the Father reaches down through the clouds. Iconographically the whole scheme is quite unprecedented, nor was it to have any progeny.

S Apollinare in Classe and S Vitale were both begun during the reign of Theodoric, with funds donated by a local banker, but neither was completed until after 540. Columns and carved capitals for both were imported from the eastern Mediterranean. But whereas S Apollinare in Classe is a basilica of the Early Christian type—one of the best preserved examples—S Vitale is in a new style developed in the East. It is possible that Bishop Ecclesius, who went on an embassy to Constantinople shortly before 525, brought back plans for S Vitale, or even an architect. The central octagon with upper galleries (for women) may perhaps have

been derived from the chapel of the emperor's palace at Constantinople. In any event, the simple clarity of the basilica or of the circular or cruciform plans used by Early Christian builders was renounced in favour of a design which, by the subtle interplay of solids and voids, of brightly lit and shadowy spaces, creates in S Vitale a sense of mystery and awe. In this, its affinities with contemporary buildings in Constantinople are so evident that it may be regarded as Byzantine. In this way, too, it reflects the changed political situation. For after the reconquest by Justinian's armies, Italy became no more than a province in an empire whose ruler resided at Constantinople and no longer spoke Latin.

Byzantine art

The foundation of Constantinople in 330, on the site of the old Greek city of Byzantium, had far-reaching consequences. Constantine's intention had not, however, been to divide the empire: rather the reverse.

7, 18 Anthemius of Tralles and Isodorus of Miletus, Hagia Sophia, Istanbul, built AD 532–537.

Constantinople, overlooking the narrow waterway which separates Europe from Asia, was at the empire's centre of economic gravity. Nor was his move the decisive gesture it was later to seem. It had been said much earlier that 'where the emperor is, there is Rome', and from the beginning of the third century this was rarely Rome itself. Imperial residences and administrative centres were established under Diocletian in various strategically placed garrison cities, Milan, Trier and Nicomedia in Asia Minor. None of these cities was as populous and prosperous as Rome or, in the East, as Antioch and Alexandria, which were also commercial and cultural centres of great importance. But when, in the course of the fourth century, Constantinople became the emperor's usual place of residence it swiftly grew into the richest city in the empire and the main centre of artistic patronage.

Hardly any traces survive of the buildings erected for Constantine in Constantinople, and eye-witness descriptions which praise their magnificence are imprecise. One church seems to have been a basilica. Another, dedicated to the holy apostles and intended

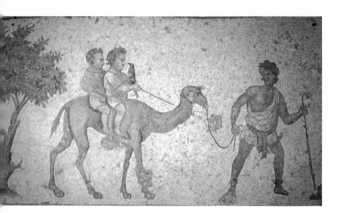

7, 19 *Left Pastoral scene*, 7th century AD. Floor mosaic from the peristyle of the Imperial Palace, Istanbul.
7, 20 *Below Rebecca and Eliezer*, from the Vienna Genesis, 6th century AD. Pigment on parchment, 335 × 250mm. Oesterreichische Nationalbibliothek, Vienna.
7, 21 *Bottom The Transfiguration*, c. AD 550–565. Apse mosaic in Church of the Monastery, Mount Sinai, Egypt.

as the emperor's mausoleum, was more original, having a large central space for the imperial sarcophagus and four naves—a combination of a centrally planned *martyrium* and a cruciform church. Foundations of two late fourth- or early fifth-century palaces have been unearthed, both with concave semicircular façades and rooms of varied shapes, either circular or indented with large niches. This use of deep

niches had the effect of masking or concealing the structure—a feature which became characteristic of Byzantine architecture.

Substantial ruins of the fifth-century churches have survived elsewhere in the eastern empire. The most imposing are at Qual'at Si'man in northern Syria, where the famous ascetic St Simeon the Stylite (c. 390–459) spent the last decades of his life on a platform atop a 60-foot-high (18m) column, from which he gave spiritual instruction to people who came from far and wide to consult him. After his death pilgrims continued to crowd to the place in large numbers and the column was enshrined in the octagonal centre of a vast cruciform church (7, 22).

Other buildings extended over several acres. (Groups of hermits had begun to form monastic communities in Egypt and Palestine in the fourth century, but this is one of the earliest surviving complexes of monastic buildings.) Finely dressed ashlar, which had never been displaced by Roman concrete in the East, was used for walling, and timber for the roofing of the church. Decorative details were derived from the Classical repertory of ornament with only such variations as had been made in the eastern Mediterranean since Hellenistic times. Bold string courses divided the walls horizontally and framed windows and doors. Interior spaces were clearly defined and marked off from one another with the four arms of the cross as double-aisled basilicas, that at the east terminating in three apses. Over the central octagon there may perhaps have been a dome of wood sheathed in metal, a type of dome that originated in the Near East and was later used extensively in Byzantine architecture as a manifold symbol of the cosmos, the heavens, death and resurrection. Indeed, the whole conception of the church of St Simeon the Stylite, like that of holy apostles in Constantinople, to some extent foreshadowed in embryonic form the 'quincunx' or cross-in-square plan of fully developed Byzantine

7, 22 *Left* S Simeon Stylites, Qal'at Si'man, Syria, south façade, c. AD 480–490.
7, 23 *Below* Hagia Sophia, view from the galleries showing capitals, built AD 532–537.

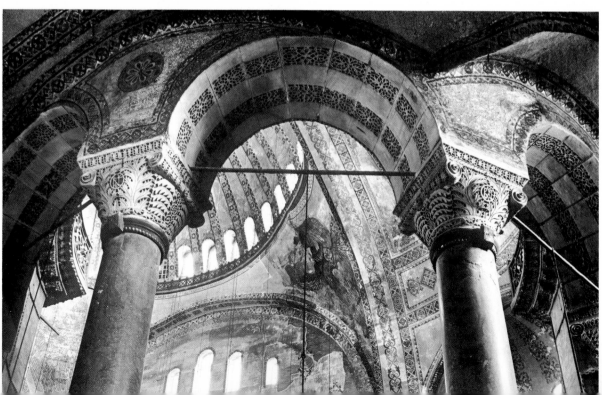

architecture (see p. 243).

One of the first indications of the new direction Byzantine architecture was to take is provided by the capitals of columns. Builders of early churches in Rome had been able to obtain these costly items ready-made from abandoned pagan temples (see p. 222). When new capitals had to be carved, especially in the East, those of the Corinthian order, traditionally reserved for important public buildings, were usually copied with variations that became increasingly pronounced. Stiffly curving leaves of acanthus were ruffled, volutes were replaced by human and animal heads, Christian symbols were sometimes incorporated. A sequence of such capitals would illustrate the disintegration of Classical form as the naturalistic elements used by the Greeks were gradually schematized and deprived of their visual logic (see p. 118). The Classical ideal of regularity and uniformity was modified. A new type of capital was evolved and perfected by the early sixth century—a type which allowed great variation in detail. For diversity was now prized, as in the carving of the intricate patterns of stylized spikey leaves in the capital illustrated here (7, 23). The function of the capital was masked—in a way that was to be very typical of Byzantine architecture generally. The richly carved three-dimensional acanthus foliage of a Corinthian capital has been replaced by flat lacy open-work patterns, deeply undercut by drilling, so that the sustaining core is left darkly indeterminate. The effect of these so-called 'basket capitals' is of an almost weightless piece of starched lace veiling the structurally all-important join between vertical and horizontal. They provide an almost exact counterpart in decoration of the spatial effects Byzantine architects were to achieve with structure. The mysterious and insubstantial has taken the place of the self-explicit and sustainingly solid.

What has been called a 'dialectical principle of statement and denial' underlies much Byzantine architecture. It is most notable in the design of its greatest monument, the church of Holy Wisdom, Hagia Sophia, in Constantinople (7, 18). 'Through the harmony of its measurements it is distinguished by indescribable beauty', wrote Justinian's court historian Procopius, who witnessed its erection. 'A spherical shaped tholos standing upon a circle makes it exceedingly beautiful.' Mathematics was at the time regarded as the highest of the sciences and the two architects of Hagia Sophia, Anthemius of Tralles and Isidorus of Miletus, were known primarily as mathematicians. The former described architecture as the 'application of geometry to solid matter'. And the impression given by Hagia Sophia is that it was applied

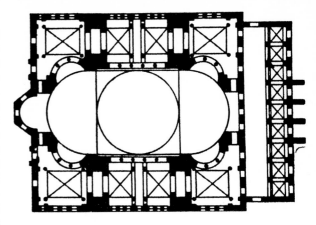

Plan of Hagia Sophia.

to conceal the solidity of matter. In this vast and inspiring space the eye cannot assess the niceties of its geometrically calculated proportions or penetrate to the defining boundaries of the plan. Volumes are not clearly marked off, as in the Pantheon, for instance, but interpenetrate one another. The air of mystery and splendour must have been further enhanced originally when the dome, brightly lit by the windows around its circumference, was inlaid with a plain gold mosaic. 'It abounds exceedingly in gleaming sunlight', wrote Procopius: 'You might say that the space is not illuminated by the sun from the outside, but that the radiance is generated within.' Another contemporary, Justinian's court poet, Paul the Silentiary, described in 563 how 'to the east there open the triple spaces of circles cut in half, and above, upon the upright collar of the walls, springs up the fourth part of a sphere; even so, above his triple-crested head and back does a peacock raise his many-eyed feathers.'

Hagia Sophia was built at the command of the Emperor Justinian with the specific aim of outshining all other religious buildings. When it was consecrated in 537, only five years after the foundations had been laid, he is said to have remarked: 'Solomon, I have outdone thee.' It was very much bigger than any church in Rome and remained for many centuries by far the largest church in Christendom. The moment was propitious for such an ambitious undertaking, politically as well as artistically. Justinian was set on reviving the glory of the empire, and establishing his own autocratic power—he had savagely put down the popular insurrection in which an earlier church of Hagia Sophia (the second on the site) was destroyed. At his instigation a new code of laws had been drawn up and an all but incorruptible civil service created. A strengthened army under the command of brilliant

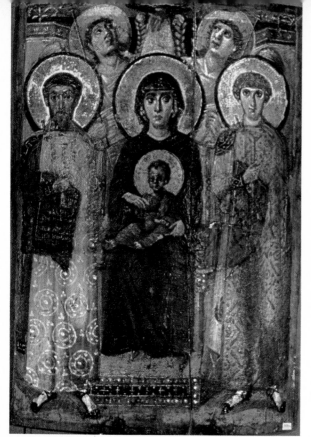

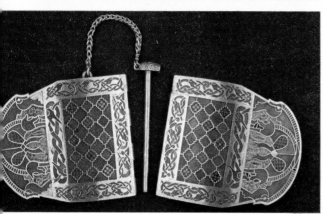

7, 24 *Top The Virgin and Child enthroned between St Theodore and St George*, 6th century AD. Panel painting, 27 × 18⅞ins (68.6 × 47.9cm). Monastery of St Catherine, Mount Sinai, Egypt.

7, 25 *Above right* Carpet page with cross from the Lindisfarne Gospels (fol. 2v), before AD 698. 13½ × 9¾ins (34.3 × 24.8cm). British Library, London.

7, 26 *Above* Hinged clasp from the Sutton Hoo ship burial, 7th century AD. Gold decorated with garnets, mosaic, glass and filigree. British Museum, London.

7, 27 *Right Saint John*, from the Coronation Gospels (fol. 178v), late 8th century AD. 12¾ × 10ins (32.4 × 24.9cm). Weltliche Schatzkammer, Vienna.

7, 28 *Far right* Incarnation Initial from the Book of Kells (fol. 34), early 9th century AD. 13 × 10ins (33 × 25cm). Trinity College Library, Dublin.

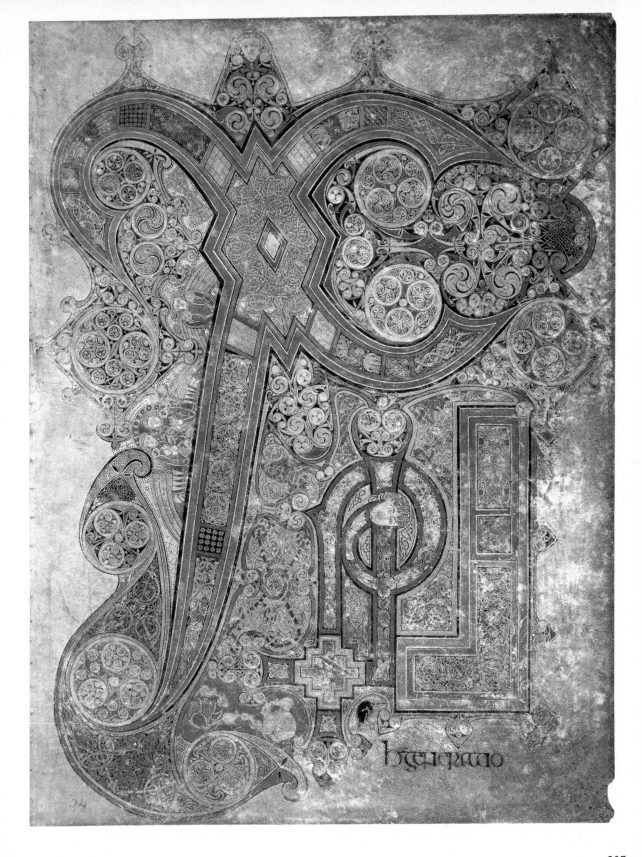

bgeneratio

generals such as Belisarius had begun to win back western territory lost to the barbarians in the previous century. That a new architecture should have been brought to sudden maturity at the same moment is hardly a coincidence. And the two architects of Hagia Sophia, who came from quite outside the tradition of Roman master-builders, had the courage as well as the inventive genius to design a structure of unprecedented form.

The plan is surprisingly simple: a large rectangle enclosing a square space, at the corners of which there are huge piers to carry the dome. It looks as if the

7,29 *Below* Hagia Sophia, view looking east. (The minarets have been removed from this photograph.)
7, 30 *Bottom* Hagia Sophia, interior view through doorway.

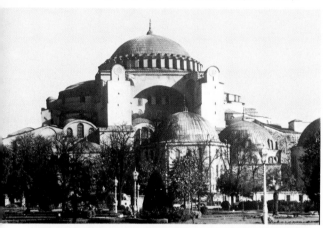

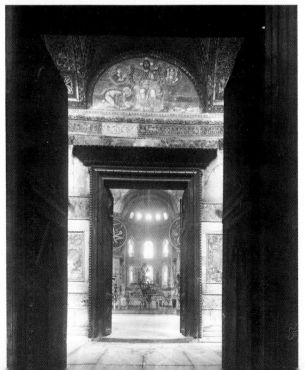

halves of a church with a central octagon (like S Vitale at Ravenna) had been pulled apart and a domed area placed between them. The dome is, however, the dominant feature of the whole structure. Of a type originated in the Near East, it rests not on a drum (like that of the Pantheon) but on four spherical triangles or pendentives, which rise from the piers and are structurally the skeletal remains of a lower and larger dome, from which the crown and four semicircular arches have been notionally cut away. (The origins of the pendentive dome have been variously traced to Armenia and Iran, but this method of covering a very large space was perfected by Byzantine architects and constitutes their main contribution to structural engineering.) To the (liturgical) east and west of the central dome, swelling out from the great arches, there are half-domes of the same diameter, and below them smaller half-domes.

In materials as well as in form Hagia Sophia differs from the concrete domed structures of ancient Rome. The piers are of ashlar; walls and vaults are of rather thin brick set in mortar. The use of brick for roofing such a vast area was a daring innovation, rather too daring as it turned out. The dome collapsed in 558 and had to be replaced by one slightly higher, completed in 563. Other alterations had to be made to steady the structure at the same time and also later. The exterior of Hagia Sophia is, in fact, the product of a long succession of expedients to buttress the dome rather than of architectural design (7, 29).

Hagia Sophia is a building without a façade, in the usual sense of the word: it is the skyline, not the entrance front, that commands attention. Here again, the difference from Italian practice is very striking. Domes had been given very little prominence in the architecture of pagan Rome—that of the Pantheon was barely visible behind the pediment of the façade. On Early Christian churches they were boxed in and concealed behind brick walls, being intended only for their interior effect. They symbolized the dome of heaven. But in Asia, from Syria to Buddhist India (see p. 181), the hemispherical exterior was equally important as a symbol of the cosmos.

Hagia Sophia, built on a high ridge, crowned the city of Constantinople and its dome could be seen from far away. Few people were allowed to see any more of it. The breathtaking view that greets the modern visitor walking through the central door was for the privileged few only (7, 30). Hagia Sophia was the church of the imperial court. It was not, like the Early Christian basilicas in Rome and elsewhere, intended for ordinary communal worship, but as a setting for rituals of quintessentially Byzantine complexity. The great nave

under the dome and half-domes was a processional space, through which the clergy passed to the chancel and the emperor and his court to their enclosure in the south aisle. The congregation, accommodated in the aisles and galleries, men on one side and women on the other, could see only parts of the church and of the rite, most of which was celebrated in the chancel. It was, however, in the most prominent place, beneath the eastern rim of the dome, that patriarch and emperor exchanged the kiss of peace immediately after the eucharistic consecration. At this solemn moment the two earthly representatives of God stood together as if in an aura of divine light. The theocratic basis of the Byzantine empire could not have been more clearly displayed.

Justinian's patronage of architecture was a direct expression of his ambition to create a monolithic state with one set of laws, one religious creed and one ruler, the earthly representative of the one almighty God. Procopius, probably at his command, devoted an entire volume to the religious and other buildings which he founded, rebuilt, restored or embellished. They were scattered throughout the empire to demonstrate his far-reaching power, in the Balkans, Palestine, north Africa and Italy, even on the barren slopes of Mount Sinai.

The church he built there is of interest mainly for its exceptionally well preserved mosaics, among the finest of their period and probably the work of artists and craftsmen from Constantinople (7, 21). In the conch of the apse medallion heads of the apostles, 16 prophets and King David frame a representation of the Transfiguration—Christ transformed in glory and conversing with Moses and Elias. The subject was particularly appropriate for the place as it was here that the God of the Old Testament had appeared in a burning bush to Moses, an incident illustrated on the arch above the niche and commemorated in an open-air *martyrium* beyond the apse. Two epiphanies, or manifestations, of the one God were thus combined.

As we have already seen, the Transfiguration was also represented at about the same time in the apse of S Apollinare in Classe (7, 16). On Sinai, however, Christ and the three disciples are depicted as men, not as symbols. They and the two prophets are, indeed, quite substantial, boldly modelled forms, though they seem to hover above, rather than to stand on, the strip of ground reduced to three bands of dark green, light green and yellow, which merge into the gold background. Landscape has been eliminated and the figures appear as real, but remote, presences, quite literally out of this world and also isolated from one another in the golden glow of the heaven above the heavens, infinite

7, 31 *Seated goat-herd,* AD 527–565. Silver plate. Hermitage, Leningrad.

and eternal. In the centre, Christ is clad, as the Gospels say, in raiment 'white as the light', accentuated by the almond-shaped aureole or mandorla in four shades of blue, darkest in the centre like the sky. From the cross that crowns the niche a ray of light bearing the hand of God shines down and seems to be refracted into the seven beams emanating from Christ, flickering across the mandorla and the gold vault, filling the whole composition with divine radiance.

A huge floor mosaic laid in the imperial palace in Constantinople at about the same time is in an entirely different style (7, 19). Pastoral scenes with naturalistically posed men and animals, trees and small buildings are depicted in gradations of colour as subtle as had ever been achieved in the medium. Without any apparent symbolical significance, they maintain Classical traditions, kept alive in Constantinople in a secular art no less sumptuously sensuous than that produced in the Hellenistic kingdoms at their height (5, 17). Satyrs and nymphs continued to dance and the old Greek gods to display their athletic figures on silver vessels until well into the seventh century. Both the art and the bucolic poetry of ancient Greece and Rome were evoked, sometimes with a gravely retrospective note, as in a magnificent silver plate delicately wrought with the figure of a shepherd, or rather, goat-herd— emphatically not the Good Shepherd (7, 31).

Most works of art that survive from the reign of Justinian are, however, religious. Many of the finest

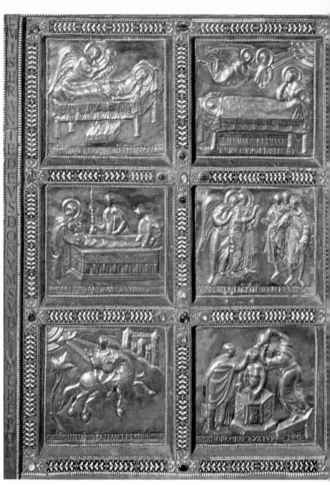

7, 32 *The Crucifixion and Resurrection of the Saints*, c. 820–830. Ivory on book-cover of the *Pericopes* of Henry II, early 11th century AD. Gold, enamels, gems and pearls, $16\frac{2}{3} \times 12\frac{1}{2}$ins ($42.3 \times 31.5$cm). Bayerische Staatsbibliothek (Ms. Clm. 4452), Munich.

7, 33 Scenes from the *Life of St. Ambrose*, c. AD 850. Silver, partly gilt, whole panel $33\frac{1}{2} \times 86\frac{1}{2}$ins ($85 \times 220$cm). Sant'Ambrogio, Milan.

are on a small scale, including exquisitely carved ivories and illuminated manuscripts. It was during this period that miniature painting—book illustration so called from minium, a red pigment used to outline figures—first became an important art form. The book or codex, consisting of single sheets of parchment or vellum bound together and protected by a cover, had been introduced towards the end of the first century AD and gradually superseded the scroll. A codex was very much easier to read and less easily damaged than a scroll (usually some 30 feet, 9m, long). Its flat pages also provided a better ground for paintings, as we have seen (7, 17a). The importance of the book to Christians, who set such store by the Holy Scriptures and included readings from the Gospels and Epistles in their liturgy, need not be stressed. To call Christianity

a 'religion of the book' is no mere figure of speech.

Fragments of three magnificent sixth-century examples survive, two Gospels and one Genesis. Their texts are written in gold and silver letters on parchment, coloured with the purple dye that was reserved for imperial use and indicates that they were made for presentation by the emperor. Illustrations delicately painted in bright colours have great prominence. On one page of the Genesis manuscript the story of Rebecca and Eliezer, the servant of Abraham who was sent to find a wife for Isaac, is told verbally and pictorially (7, 20). Rebecca 'very fair to look upon' is shown twice, on her way to the well and then giving water to Eliezer. Heads of ten camels (numbered in the Bible) are clearly indicated, but with only a few bodies and legs. Both the walled city and the

fountain nymph symbolizing the well seem to have been copied from Classical sources—neither would look out of place on the Column of Trajan. But the relationship between text and illustration has been reversed. Here the words explain the image, which was intended as an aid to meditation on the all-important inner meaning of the story. Rebecca, the wife of Isaac and mother of Esau and Jacob, was seen as a precursor of the Virgin Mary, and her meeting with Eliezer construed as an Old Testament parallel to the angel's annunciation to Mary that she was to be the mother of Jesus.

Icons and Iconoclasts

The distinction between an image that was an aid to thought or prayer and one that was in itself an object of veneration was somewhat blurred in the course of the sixth and seventh centuries. Small portable pictures of Christ, the Virgin and Child or the saints, nowadays called icons (from a Greek word which originally signified a much wider variety of 'likenesses' or 'images') were increasingly demanded throughout the Byzantine world. They had a stronger emotional appeal than the intellectually conceived symbols and doctrinal allegories of earlier Christian art. In 692 this move away from symbolism was officially sanctioned by the Trullan Council of the Church, which ordained that 'the human figure of Christ our God, the Lamb, who took on the sins of the world, be set up even in the images instead of the ancient lamb. Through this figure we realize the height of the humiliation of God the Word and are led to remember His life in the flesh, His suffering and His saving death and the redemption ensuing from it for the world.' To achieve this aim painters reverted to a more naturalistic style, as in a panel painting of the Virgin and Child flanked by two saints and two angels with the hand of God reaching down from the top (7, 24). The heads of the two angels are foreshortened with the skill of a Hellenistic painter, the Virgin and Child have substance and weight, the two saints, especially the lean St Theodore on the left, might almost be portraits of ascetics. The picture is composed hierarchically, but the figures staring straight at the spectator seem to have been intended as more than aids to meditation. They invite a face-to-face meeting with the holy persons depicted. And devotion was paid to such icons as if they were themselves holy relics. This example is among the few to escape the fury of the Iconoclasts, which broke loose in the early eighth century against the, as they thought, idolatrous tendencies such icons were arousing.

An edict issued by the Emperor Leo III in 730 ordered the destruction of all images that showed Christ, the Virgin Mary, saints or angels in human form. It brought into the open a smouldering conflict which raged for the next 113 years between Iconoclasts (image-breakers) and, as they styled their opponents, Iconodules (venerators of images) throughout the Byzantine empire. (The edict was repudiated by the Pope in Rome and by western Christendom.) No controversy about works of art has ever aroused such violent passions, polarizing sentiments on other religious, political, social and economic issues as well. Any Iconodule discovered harbouring an icon could be punished by flogging, branding, mutilation or blinding. Religious images survived openly only in those parts of the earlier Byzantine empire that had been overrun by 'barbarians'—the word is poignant in this context.

Iconoclasts were not, however, opposed to art as such. While they were in control, churches were richly adorned with mosaics of jewelled crosses and leafy gardens of paradise (e.g. the Blachernae Palace church

7, 34 *Emperors hunting*, late 8th or 9th century AD. Silk compound twill. Staatliche Museen, Berlin.

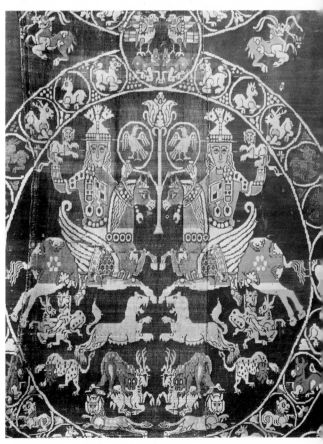

in Constantinople known from descriptions). Palaces were still more opulently decorated. Ambassadors from the court of T'ang China to Constantinople noted with admiration the abundance of wrought glass, crystal, gold, ivory and rare woods, as well as 'a human figure of gold which marks the hours by striking bells'. They also admired ingenious devices to keep rooms cool in summer. None of these wonders has survived, though some examples of Byzantine silks of this period have, finely woven with heraldically stylized patterns of men and beasts (7, 34). Their designs are strongly influenced by Persian textiles, a reminder that Byzantium had by now become more Asian than European, even though all the eastern territories of the empire, save Asia Minor, had been lost to the forces of Islam (see p. 252). It should be mentioned, however, that there seems to be no direct connection between Iconoclasm and Islamic abhorrence of religious images.

The Triumph of Orthodoxy

The defeat of Iconoclasm was officially proclaimed in 843, on the first Sunday in Lent, which is still celebrated in the Eastern Church as the festival of the Triumph of Orthodoxy. From this time onwards orthodoxy was to be the key concept in Byzantine art—though the doctrinal differences between the Orthodox Church of Constantinople and the Catholic Church of Rome did not develop into a schism until the eleventh century. So far as the arts are concerned, the most important outcome of the controversy was the formulation of a doctrinal statement on the value of images of Christ, the saints and angels. They were recommended:

> For the more frequently they are seen by means of painted representation the more those who behold them are aroused to remember and to desire the prototypes and to give them greeting and worship-of-honour, but not the true worship of our faith, which befits only the Divine Nature. (Mansi, *Concilia*, XIII, 377B–E, 397C)

Elsewhere in this document mosaics as well as paintings are specified, but not statues, which were never to be approved by the Eastern Church. Byzantine sculpture is practically non-existent.

For a century after the triumph of Orthodoxy, in a period of uninterrupted political and economic stability, mosaicists were engaged on the slow work of covering the vaults of the larger churches with figurative compositions. In a sermon preached in Hagia Sophia in 867 Photius, patriarch of Constantinople, was able to extol the recently finished

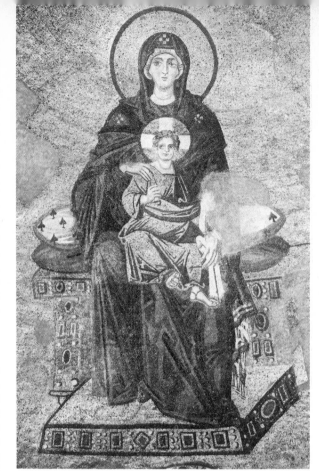

7, 35 *The Mother of God*, late 9th century AD. Detail of apse mosaic, Hagia Sophia, Istanbul.

mosaic of the Virgin and Child above the apse (7, 35). That this should have been the first of the new mosaics is not surprising, for the mystery of the Incarnation was, as we have seen (p. 226), the main theological justification for images of Christ.

The Virgin had gained increasing importance in Christian thought since 431, when the Council of Ephesus declared her to be the Mother of God. She came to be regarded as the great intercessor for mankind and, from the sixth century, was sometimes given the prominence hitherto reserved for Christ alone by being represented with the Child in the conch above a high altar (the earliest surviving example is of c.550 at Poreč, Yugoslavia). After the Iconoclastic period this became normal in Byzantine churches. Similarly, the tradition was established of placing the image of Christ *Pantocrator* (ruler of all things) in the central dome, 'looking down from the rim of heaven', as a Byzantine writer described him. The largest, set in the previously plain gold dome of Hagia Sophia in the late ninth century, was destroyed when the church was converted into a mosque. But one of the most

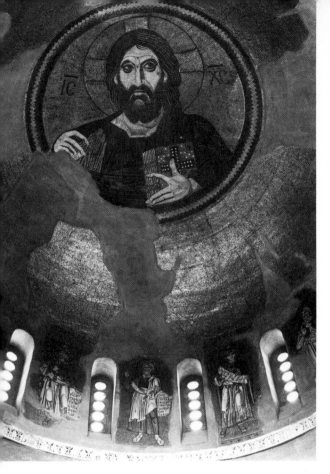

7, 36 *Christ Pantocrator*, c. AD 1020. Mosaic in dome of church at Daphni, near Athens.

impressive examples still dominates the little monastic church at Daphni near Athens, as humbling an image of divine omnipotence as has ever been depicted (7, 36). He is the ruler and judge. The Virgin in the apse is the intercessor, represented as the Queen of Heaven enthroned on the cushions of Byzantine royalty.

The emperor was the living symbol of divine power, Christ's viceregent on earth. A mosaic over the central door of Hagia Sophia shows Leo VI (886–912) prostrate before Christ (7, 30), and a poet of the time imagined an emperor in this position saying: 'It is Thou who hast appointed me lord of Thy creatures and master of my fellow slaves, but having proved to be the slave of sin, I tremble before thy scourge, O Lord and Judge' (Joannes Mavropous, *Poems*, tr. C. Mango). All who approached the emperor were required to prostrate themselves in this way, and when they looked up they might see his throne elevated by a mechanical contrivance (Liutprand, bishop of Cremona, described this astonishing spectacle in 949). The sacred status of the ruler was displayed to a wider public by the coinage. Justinian II (685–95) had

Christ's head stamped on one side of coins and his own image holding a cross on the other (7, 37a, b). The practice was abandoned during the Iconoclastic period but was resumed immediately afterwards. A slightly later coin showed the emperor and his son holding a patriarchal cross on the front and Christ enthroned on the reverse (7, 37c, d). Emperors might, nevertheless, be regarded as no more than symbols, to be discarded and mutilated without damage to the idea they represented. In Byzantine life, as in art, divine ideas were far more important than earthly realities.

In accordance with the concept of orthodoxy, Byzantine artists of the post-Iconoclastic period began by looking back for models to the sixth century. And orthodoxy governed the subsequent development of Byzantine art, which is insistently symbolic and regulated by strict conventions. The figure of a saint had to face the spectator in order to act as a channel for prayer to his or her prototype in heaven. Biblical scenes had to conform to established iconographical norms. Gestures and perhaps even colours acquired inalienable meanings. In centuries of declining wealth the size of new churches was greatly reduced, leading to the quincunx or cross-in-square plan with a small central dome and sometimes four subsidiary ones over the corners. But a uniform system of decoration was evolved to express a Byzantine church's threefold significance: as a microcosm of the celestial and terrestrial worlds, as a setting for Christ's life on earth and for the sequence of festivals in the Christian year. The conch of the apse usually signified the cave of the Nativity in Bethlehem and thus bore an image of the Virgin *Theotokos* (Mother of God). The Pantocrator, as we have seen, looked down from the central dome.

This art exerted continuing influence throughout Christendom. The full iconographic program was, however, limited to those regions which looked to Constantinople rather than to Rome for doctrinal authority. Orthodox Christianity became the official state religion of Bulgaria in 864 and of Russia in 988. Vladimir, prince of Kiev (980–1015), who formed his Russian kingdom on the model of the Byzantine empire, sent to Constantinople for priests to teach and baptize his subjects and for architects, mosaicists and

7, 37a *Left* Solidus of Justinian II (first reign AD 685–717); 7, 37c,d *Right* Solidus of Basil I (AD 869–879). British Museum, London.

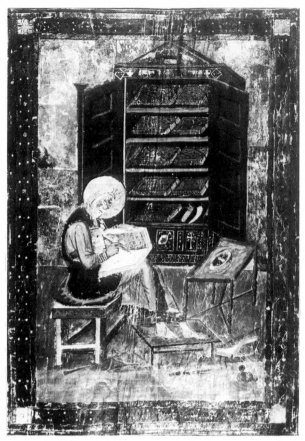

7, 38 *The Prophet Ezra rewriting the Sacred Records*, from the *Codex Amiatinus* (fol. Vr). Jarrow, early 8th century AD. c. 14 × 10ins (35.6 × 25.4cm). Biblioteca Medicea Laurenziana, Florence.

painters to build and decorate churches. A local variant of the Byzantine style was subsequently developed in Kiev, and others emerged in the Balkans and the outlying regions of the empire itself. Despite the rigidity of its iconographical conventions and its essentially self-generating character—from an unbroken tradition stretching back to the Classical world—Byzantine art continued to develop, with a great final flowering in the late thirteenth and early fourteenth centuries (see p. 302). Constantinople held its position as a metropolis of Christian scholarship and of the arts throughout the European Middle Ages and remained the greatest and most magnificent city on the continent until, and even after, it fell to the Turks in 1453.

Christian art in northern Europe

In the depths of the so-called 'Dark Ages' of western Europe—the 500 years or so of confusion as migrant peoples from the East swept across the continent after the collapse of Roman power in the early fifth century—there was a sudden flowering of Christian art in Ireland and in various remote and isolated islands off the coasts of north Britain. Although its origins can be traced in the history of religion and of art, nothing quite prepares us for the brilliance and suddenness of this phenomenon on the outer fringe of the world known to the Greeks and Romans. The style that was created has been called Celtic, Irish and Hiberno-Saxon, but the more general term 'Insular', which also suggests its isolation, may be preferred. Its most notable surviving products are illuminated manuscripts, among the most intricately beautiful ever painted, with a unique quality summed up by the twelfth-century writer, Giraldus de Barri, who was shown one of them in Ireland, perhaps the *Book of Kells* (7, 28). 'Examine it carefully and you will penetrate to the very shrine of art', he wrote. 'You will make out intricacies so delicate and subtle, so concise and compact, so full of knots and links, with colours so fresh and vivid, that you might think all this was the work of an angel, not a man.'

Christianity, which had been introduced into England during the Roman occupation, did not long survive the withdrawal of the last legions in 407 and the subsequent invasions by Angles, Saxons, Jutes and Frisians across the North Sea. About the same time, however, the conversion of Ireland began and was largely effected before the death of the great missionary St Patrick (the traditional date is 461). Christianity was spread among a large rural population from monastic communities in the open country, like those of Syria and Egypt, on which they may have been modelled. In the sixth century similar monasteries were established by Irish monks elsewhere as missionary stations, from the island of Iona off the west coast of Scotland, right across Europe to Bobbio in Italy. In 634 monks from Iona were given the island of Lindisfarne, which was to become one of the most important centres of religious thought and art in Britain.

In the meantime a mission sent direct from Rome in 597 had begun work in the Anglo-Saxon south of England, and gradually moved towards the north. Since the Irish Church had developed practices different from those of Rome, a clash was inevitable when the two groups of missionaries met. The schism was resolved at the Synod of Whitby (644), after which all England came under the spiritual rule of Rome, and the effect on every aspect of monastic life, including art and architecture, was soon felt. St Benedict Biscop,

7, 39 Latchet, 2nd century AD. Bronze, length 5ins (13cm). National Museum of Ireland, Dublin.

who founded two monasteries at Jarrow and Wearmouth in County Durham in 674 and 682, called in stone-masons from France 'to build him a church of stone after the Roman fashion which he always loved'—as his pupil the Venerable Bede tells us. Parts of both buildings survive with massive walls and small round-headed windows set rather high. Bede also records that Biscop brought back many paintings from Rome, 'in order that all men who entered the church, even if they might not read, should either look (whatsoever way they turned) upon the gracious countenance of Christ and His Saints, though it were but in a picture; or might call to mind a more lively sense of the blessing of the Lord's Incarnation.' However, this Mediterranean Classical influence did not penetrate very deeply; the *Codex Amiatinus* illuminated at Jarrow (7, 38) is the only surviving example. Native artistic traditions were too strong. Indeed, they took on a new lease of exuberant life in the great Insular style illuminated manuscripts, the first of

which were produced in the late seventh century.

When St Columba was asked whether Irish poets should be allowed to go on composing ballads in the vernacular, he agreed that they should. Similar licence seems to have been given to metalworkers, the most notable artists of the time, who went on using ornamental motifs which had formerly been—and perhaps still were—credited with supernatural powers. A local variant of the Celtic 'La Tène' style (see p. 126) lived on in Ireland. A latchet for fastening clothes, cast in bronze and originally inlaid with enamels, illustrates the skill of Irish craftsmen (7, 39). The main motif on the disc is one much favoured in Celtic art, a *triskele*: three 'legs' issuing from a single point, each one curling round and bifurcating into spirals, the larger of which terminates in a bird's head, the smaller in a kind of comma.

Similar spiralling lines, sometimes ending in animal heads, embellish the capital letters of the earliest known Irish manuscripts dating from about 600 (e.g. the *Cathach of Saint Columba*, Royal Academy, Dublin). They also appear in more elaborate manuscripts in the mature Insular style, such as the *Lindisfarne Gospels* (7, 25). On the page illustrated here the border is composed of strange birds knotted together by ribbons, which pass from the wing feathers of one to the neck of the next. More knots are within the frame, each in a square compartment, also arrangements of squares and panels in a stepped pattern. In the layout of this page there may be some reminiscence of the mosaic pavements in Romano-British villas, some of which incorporated crosses and other Christian symbols in their designs. But the general effect is closer to jewelry made for the migrant peoples who flooded into Europe from the east as the Roman troops withdrew. A gold bracelet inlaid with garnets (from India) and coloured glass (perhaps from Syria) has, like the pages of the *Lindisfarne Gospels*, panels of rectangular stepped patterns surrounded by intertwined creatures, which seem, in turn, to be remotely derived from the prehistoric Animal style of central Asia (see p. 121) (7, 26). This remarkable object was found at Sutton Hoo on the east coast of England, in a ship buried under a mound as a memorial to some East Anglian king of the mid-seventh century. Gold coins minted by the Merovingian kings of Gaul and many pieces of silver including a large Byzantine bowl were also found at Sutton Hoo—an indication that northern Europe was by no means cut off from the rest of the world at this date. In a burial of the same period at Helgö in Sweden a bronze statuette of the Buddha was found (National Museum, Stockholm)!

Various origins have been proposed for the knot-

7, 40 Animal head from the Oseberg ship burial, c. AD 825. Wood, approx. 5ins (12.7cm) high. Universitetets Oldsaksamling, Oslo.

has been suggested that it may have been a charm against evil spirits credited with a human desire to unravel the knots. Nowhere was it used to better artistic effect, however, than in Insular manuscripts. A single strand may be followed as it winds its way backwards and forwards all round a page of the *Lindisfarne Gospels*, weaving a kind of seamless fabric with no loose ends. To paint such a design, clearly indicating at each of several thousand points the over-and-under passage of the thread, was an exercise in patience as demanding as the more physically strenuous feats of endurance which monks imposed on themselves for the mortification of the flesh and the benefit of the soul. The immense expenditure of time and skill on each decorated page and on the meticulous copying of the Gospel text was an act of service to God.

The scribe and illuminator of the *Lindisfarne Gospels*, Eadfrith, bishop of Lindisfarne (698–721), must have taken his text from an Italian manuscript illustrated with images of the evangelists similar to those so carefully copied at Jarrow (7, 38). But Eadfrith ignored all the illusionistic devices of these pictures when he came to his evangelist portrait pages, reducing his figures schematically almost to patterns of flat colours. He lavished attention on the abstract decoration of the so-called carpet-pages placed before each Gospel (7, 25). These pages, on which the sign of the cross is elaborated and set in a no less rich background with all the convolutions and near repetitions of a Gregorian chant, are peculiar to Insular manuscripts. The earliest known are those in the *Book of Durrow* dating from about 680 (Trinity College Library, Dublin). They are not illustrations but, like book-bindings embellished with precious materials, earthly pointers to the other-worldly, spiritual beauty and significance of the text.

The other innovation made by Insular manuscript illuminators was the elaboration of capital letters into configurations of labyrinthine complexity, which culminated in the *Book of Kells*, inscribed and decorated by monks of the Iona community very shortly before the island was sacked by Vikings in 807 or immediately after they found refuge in central Ireland. An enriched capital letter marks the beginning of each brief passage of the four Gospels, setting off one or more verses for meditation and study. There are more than 2,000 in all, differing widely in the ways they are formed, coloured, gilded and filled with interlace. At the opening of St Matthew's account of the Nativity a whole page is devoted to the *Chi-Rho* monogram (7, 28). This is a far cry from the austere symbol of Early Christian art (7, 1). It appeals to the eye and to the senses as well as the intellect, whereas the other had

work or interlace pattern which fills so many pages of the *Lindisfarne Gospels* and other Insular manuscripts. Similar devices are found in the arts of Coptic (i.e. Christian) Egypt from the fifth to the ninth century, and there may well have been a direct connection. (Bowls made in Alexandria were buried in non-Christian graves in England: and Irish monks seem to have had direct contacts with Egyptian monasteries.) But interlace occurs in the arts of many cultures, especially in the north, where it was as pervasive as leaf ornament in the Mediterranean. In Scandinavia, patterns of plaited and coiled ropes and thongs were applied to grave-stones, jewelry, weapons and the carved prows of the ships from which the Vikings— 'people of the inlets'—harried the coasts of northern Europe from the eighth to the eleventh century (7, 40). The contrast between the interlace pattern and the form it decorates is often very striking, as here or when carved on stone crosses set up in Ireland, Scotland and the north of England (e.g. Bewcastle, Cumberland). Whether interlace had any meaning is not known; it

7, 41 Three saints, c. 770. Stucco reliefs, over life-size. S Maria in Valle, Cividale.

engaged the mind alone. The eye is enthralled by the impenetrable subtleties of tight scrolls, intricate knots and whirling triskeles within the expansively sweeping curves of the design. The attention is caught by angels on the outer face of the great X, by a man's head in the P, and surprised by vividly depicted animals at the base, an otter with a salmon and a group of cats and mice. The page celebrates the Incarnation with a painting as rich as the finest goldsmiths' work, perhaps conceived as the artist's equivalent to the precious gifts brought to the Christ child by the Wise Men from the East. There is, indeed, something almost Orientally luxuriant about it. Yet it is essentially Northern, the masterpiece of a style which provided a valid alternative to the Classical still being promoted by the Church in Rome.

Christian art in western Europe

Christian art in continental Europe had remained bound to its Classical origins. The art of the Teutonic peoples who swept across the former western empire in the Migration Period—as the fifth and sixth centuries are sometimes called—adopted Italian and Byzantine prototypes after they settled and were converted to Christianity. Under the Franks, who occupied Gaul (later called France after them), the style established for church-building in Roman times was continued without a break, fostered no doubt by the many ecclesiastics who were descended from the old imperial aristocracy; similarly in Spain, under the Visigoths, who ruled Spain from the early sixth century until they were overcome by the Arabs in 711 (see p. 255). In Italy local traditions persisted, though often modified by influence from Byzantium. As we have already seen (p. 230), some of the finest buildings at Ravenna date from the years when the city was the capital of the Ostrogothic king, Theodoric. The peninsula was won back for the eastern empire between 535 and 563 but was again invaded in 568 by the Lombards, another Germanic people, who set up a kingdom with its capital at Pavia in the Po valley, not far from Milan. Churches continued to be built under their rule, but they were small in size, for here, as in the rest of Europe, funds were limited. Decorations were, perforce, executed in stucco and paint rather than the more expensive and durable media of marble and mosaic. Only because it was walled up for centuries has a stucco frieze been preserved intact in the little church of S Maria in Valle, Cividale, probably built between 762 and 776 (though later dates have sometimes been proposed). Six larger than life-size figures of female saints of a truly Classical serenity and a severe elegance flank an arch springing from debased Corinthian columns and decorated with interlace (7, 41). They are lonely survivors from the Dark Ages in Italy. How far they were typical is impossible to say. (Recently discovered frescoes at Castelseprio, near Milan, may date from as early as the eighth century and are Byzantinizing in style.)

The survival of a basically Classical language of Christian art was, perhaps, connected with the retention of Latin as the language of the liturgy and theological writing, even though it became increasingly foreign to the vast majority of Christians north of the Alps. In the course of more than three centuries the corruption of Latin was aggravated and not until after Charlemagne (c. 742–814) had become king of the Franks in 771 was any serious effort for reform initiated.

The Carolingian renovatio

Charlemagne inherited a realm which covered, in modern terms, much of Germany, most of the Netherlands, the whole of Belgium and Switzerland

7, 42 Palatine Chapel of Charlemagne, Aachen, AD 792–805.

and nearly all France. To this he added the Lombard kingdom of Italy, as far south as Rome, further territory in Germany and Austria, and rather less on the borders of Islamic Spain. Essentially a man of action, Charlemagne nevertheless patronized scholarship and the arts on a lavish scale unprecedented in northern Europe. Although his native language was German, he recognized the value of Latin for official as well as for religious use throughout his dominions, and he learned to speak it fluently. He also came to appreciate the value of literacy. He tried to learn to write, his friend and adviser Einhardt tells us: 'He tried very hard, but had begun too late in life and made little progress.' From Italy and elsewhere he gathered to his court many of the most learned men of the day with the main purpose of schooling a civil service of clerics— priests and monks, who were also clerks in the modern sense. At his instigation they restored Latin as a literary language, purged it of barbarous usages, revised its spelling and devised a beautifully clear script in which official documents could be written. This

involved the study and copying of Classical texts and it is to the Carolingian scribes that we owe the preservation of a very large proportion of Latin poetry and prose, including Vitruvius' treatise on architecture (see p. 154). When the manuscripts were rediscovered some six centuries later (i.e. in the early Renaissance), the script in which they were written, technically known as Carolingian minuscule, was revived and adopted by printers for lower-case letters—the lower-case type that we still use to this day, as in this book. (The ancient Roman alphabet had consisted of capital letters only.)

The restoration of Latin to its Classical clarity and elegance was accompanied by an attempt to reform the visual arts. This is often described as a renaissance of Classical antiquity; but the word used in Charlemagne's circle, *renovatio*, implied the renovation of a surviving tradition rather than the rebirth of one that had died out. Thus it was S Vitale in Ravenna, with its domed octagonal central space, that seems to have provided the model for the Palatine (imperial palace) Chapel at Aachen, Charlemagne's favourite residence in his later years (7, 42). Polished granite and marble columns with finely carved Corinthian capitals were brought to Aachen from Italy, some of them from Ravenna. Yet there are some striking differences between the two buildings.

The Palatine Chapel, designed by a Frankish architect, Odo of Metz, has little of S Vitale's spatial subtlety and air of mystery. It is more massive: space is constricted and the vertical axis is felt more strongly than the horizontal. The sturdiness of the piers supporting the dome is emphasized and columns are used decoratively rather than structurally (most obviously those fitted rather awkwardly into the openings of the upper gallery). Some of the differences between the two buildings are due simply to the technique of construction, rubble faced with marble for the piers and solid stone for the vaults instead of the light brick and terracotta used at Ravenna. Others were determined by function. Charlemagne's throne was placed in the first gallery above the door and looked down across the central space to the main altar in a small square apse (later replaced by a Gothic choir). This part of the building was strongly marked externally by what is called a westwork, a porch at ground level surmounted by a large recessed window and flanked by towers enclosing staircases for access to the galleries. The westwork, one of the most influential innovations in Carolingian church architecture, perhaps derived from Roman city gateways, which had come to symbolize imperial authority—e.g. Trier less than 100 miles (160km) south of Aachen (5, 44). An

example of 873–85 survives in relatively well-preserved form at Corvey-on-the-Weser.

The Palatine Chapel is the only great Carolingian building to have been preserved, but the important developments made to the basilican form in Charlemagne's monastic foundations are known from descriptions and other records, notably those of the abbey church of Centula (St Riquier, France) of 790–99. This was a revolutionary building in both plan and elevation, having a westwork, nave and aisle, transepts, a chancel and an apse, with towers over the west and east crossings flanked by round towers, some impression of which can be obtained only from later buildings. A plan of about 820 for the monastery of St Gall, Switzerland, followed the basilican innovations at Centula, but is of greater significance for the systematic and orderly manner in which the monastic buildings are laid out according to St Benedict's rule— very different from the higgledy-piggledy arrangements at earlier monasteries in Egypt and Ireland. It was to be very influential.

While the Palatine Chapel was being built Charlemagne was crowned emperor by Pope Leo III in St Peter's in Rome, on Christmas Day 800. He was recorded in lists of emperors as the 68th in succession from Augustus. (Not until much later was he to be seen as the first ruler of a new Holy Roman Empire.) He assumed the guardianship of the Roman Church and, on at least one occasion, intervened in the controversies of the Eastern Church. When in 787, during a lull in the Iconoclastic controversy (see p. 241) a council summoned by the Byzantine emperor and the patriarch at Nicea worked out a guarded formula permitting images to be honoured, Charlemagne protested at what had been 'arrogantly done in Greece'. His theologians were instructed to draw up a counter-statement, the 'Caroline Books', denying that images could be more than reminders 'of things that have happened'.

Of several manuscripts contemporary with Charlemagne, the most interesting is the *Coronation Gospels*—so-called because it was used from the eleventh century onwards at the coronation of Holy Roman Emperors. The text is written in gold and silver on parchment coloured with the purple dye reserved for imperial use in the East. A Greek name, possibly that of the scribe or illuminator, appears in one of the margins; but the four 'portraits' of evangelists, which are its only figurative decorations, have little in common with Byzantine art. The artist responsible for the St John (7, 27) had clearly studied illustrated manuscripts like the early fifth-century Virgil (7, 17a) or the sixth-century original of the *Codex Amiatinus* (7,

38). He even indulged in a little illusionistic trick, projecting the footstool in front of the substantially modelled frame.

Were it not for his halo, St John might be mistaken for some staid Roman writer pondering his next periphrastic sentence. An entirely different impression is given by the image of St Mark in a Gospel manuscript made for Ebbo, imperial librarian and, from 816 to 835, archbishop of Reims (7, 43). The furniture is more obviously Roman, with a lion monopod support for the throne, but it has been wrenched out of all semblance of perspective. The head is fully modelled with effective use of shade and highlights, but the expression is ecstatic. As he dips his pen in an ink-well, the evangelist gazes anxiously towards his symbol, tense with emotion that makes his hair bristle and vibrates through the trembling folds of his clothing. Behind him the landscape heaves up as if in sympathy. The solid and tranquil Classical ideals so eloquently expressed in the *Coronation Gospels* have been completely abandoned in the quest for a more vividly expressive visual language. Similar tendencies

7, 43 *Saint Mark*, from the Ebbo Gospels (fol. 18v), between AD 816–835. Approx. 10 × 8ins (25.4 × 20.3cm). Bibliothèque Municipal, Epernay.

were noted in literature. In the 830s Lupus of Ferrières, one of the greatest Classical scholars of the time, lamented to Einhardt that writers had begun to 'stray from that dignity of Cicero and the other classics which the best of Christian writers sought to imitate'.

The *Coronation Gospels* illustrate Carolingian art at its most Classical. But perhaps the clearest indication of the desire to recapture the purity of Early Christian art is provided by ivory carvings modelled on those of the late fourth century, which (as we have seen, p. 227) reverted to the style of earlier pagan art just when St Augustine was striving to emulate the gravity of Ciceronian prose. Because of this there has been much controversy as to whether certain ivories date from the late fourth or the late eighth century. An exceptionally large panel inset in a book-binding (7, 32) is framed by bands of acanthus ornament as delicate and crisp as any carved in ancient Roman times; but the subject-matter and the expressiveness of the figures indicate a later date. At the top the hand of God reaches down from heaven between Apollo and Diana in their chariots symbolizing the sun and moon. The crucifixion is shown below, then the visit of the holy women to the sepulchre, and in the lowest register the resurrection of the saints, which, according to St Matthew, followed the Crucifixion—'and the graves were opened and many bodies of the saints which slept arose'.

The Crucifixion, which had been rare in Early Christian art, dominates this panel and others of the period. Why it now assumed the importance that it was to have in later European art is a question that permits no simple answer. In the earliest known examples (e.g. on the wooden door of S Sabina, Rome, 432–40) Christ's head is erect and his eyes are open. There is no suggestion of agony, or even of death. On the Carolingian ivory, on the other hand, the body is racked and the head slumped on the shoulder. These two types coexisted, the one emphasizing Christ's victory over death, which had dominated the thought of the early Christians, the other his suffering for the sins of mankind, which gradually acquired equal importance, especially in the Western Church, where the fear of sin overshadowed that of death. In the East images of the suffering Christ were always to be more ritualistic than those in the West, due to differences between Eastern and Western attitudes to religious art. Pope Gregory I (590–604) wrote to a bishop who had destroyed images to prevent them from being worshipped idolatrously: 'To adore images is one thing; to teach with their help what should be adored is another.' And he went on: 'What scripture is to the educated, images are to the ignorant, who see through

them what they must accept; they read in them what they cannot read in books.' His letter, which was frequently quoted in later periods and underlies the 'Caroline Books', provided the basis of a predominantly didactic theory of religious art in the West distinct from the beliefs of both the Iconodules and the Iconoclasts in the East. Western art thus became increasingly illustrative. The aim of such an ivory as that of the Crucifixion was to assist the believer in visualizing the event. Surrounding figures vividly express the tragic pathos of the scene, and below we sense the wonder of the holy women learning of Christ's resurrection, the joy of the saved leaping from the grave. In the eleventh century the relief was set in the book-binding and surrounded with Byzantine enamel plaques of Christ and the apostles staring straight ahead to act as intermediaries between their heavenly prototypes and the worshipper. The two entirely different purposes of Christian images, illustrative and devotional, Carolingian and Byzantine, could hardly be more clearly contrasted.

The need for reminders, rather than objects of devotion, set a premium on narrative. Visual story-telling had, of course, an additional importance for a

7, 44 The Lothar Crystal, AD 865? Crystal, diameter 4⅛ins (10.5cm). British Museum, London.

laity that was almost entirely illiterate (unlike that of Byzantium or the early Church in Italy). Charlemagne is known to have encouraged the painting of Biblical scenes in churches for didactic purposes, though only a few damaged fragments survive. Narrative illustrations were given increasing prominence in Bibles. They were included even in a manuscript of the Psalms, which have themselves no narrative content (Psalter, c.830, Utrecht University Library). They were executed in all available media. The Biblical story of Susanna falsely accused and finally vindicated was illustrated with tiny, vivaciously gesturing figures engraved on a disc of rock-crystal for King Lothar II of Lotharingia (modern Lorraine in France) (7, 44). Nor was the subject-matter of religious art any longer limited to the Old and New Testaments. Scenes from the lives of more recent saints were also represented, the earliest surviving example of a complete cycle being that devoted to St Ambrose on the back of the magnificent gold and silver altar in S Ambrogio in Milan (7, 33).

In the course of the ninth century, however, artists began to abandon the logical construction of their Classical models in favour of a new pictorial language of gestures and poses, one that gave greater importance to inner emotions and permitted the expression of profound spiritual ideas within a formal or decorative idiom. This was to be their major contribution to the later art of western Europe. In the feverish penmanship of the *Ebbo Gospels* (7, 43) and the exquisite engraving on the Lothar crystal (7, 44) the solid forms of Classical art almost seem to be dissolving into the intricate abstract embellishments of Insular manuscripts. But this spiritualizing tendency did not find release in great works of art on a large scale until after Europe had emerged from another century of conflict, which marked the end of the Dark Ages.

In the great hall of the Palace at Ingelheim, completed for Charlemagne's son Louis the Pious, one wall was painted with images of Cyrus, emperor of Persia, Romulus and Remus, founders of Rome, Alexander the Great and Hannibal. On the other side, so a description of 825–6 tells us, were the emperors Constantine, Theodosius, and Charlemagne with his father and grandfather. It is in this context that Charlemagne is best understood, as the last great ruler of the ancient world. The empire he built was less like the Holy Roman Empire it was to become in the later Middle Ages, with its elaborate structure of vassalage, than that of Alexander—and it fell apart nearly as quickly. In the history of art the Carolingian period similarly marks the end of the ancient world, the swan-song of the Classical tradition. But Charlemagne had succeeded in shifting the centre of Western culture and civilization from the Mediterranean to the triangle bounded by the Rhine, the Loire and the North Sea— where it was to remain for the next 600 years, until the Italian Renaissance.

8 Early Islamic art

The Arabic words from which 'Islam' and 'Muslim' are derived mean 'submission' and 'one who has submitted' — to the will of Allah, the One and Only God, as revealed by the Prophet Muhammad (d.632) in the *Qur'an*, or Koran as it is usually rendered in English. To the inhabitants of the Near East and the southern shores of the Mediterranean in the seventh century, Islam also meant submission to the armies which had precipitately burst out of the Arabian peninsula—an area less barren in prehistoric times but now an enormous desert—and from there conquered with amazing rapidity a very large section of the Hellenized Orient. Architects, painters and craftsmen in this huge area, formerly part of the Roman, Byzantine and Sassanian empires, were obliged to submit to the demands of Arab patrons, for whom a new artistic style was gradually evolved out of conflicting Near Eastern, Hellenistic and Roman traditions.

Early Muslim attitudes to the visual arts were indeterminate, conditioned as much by opposition to those of other religious faiths as by any positive desire to find artistic forms to embody their own beliefs. In contrast to all others, theirs was to be a religious art entirely without holy images. Even visual symbols were avoided—the crescent moon was a very late introduction, an heraldic device adopted by the Turks in the sixteenth century, which only later acquired religious significance, mainly in the eyes of non-Muslims. The only specifically religious elements in Islamic art are inscriptions, and Islamic art became, partly for this reason, essentially an art of signs and not of symbols or images. Calligraphy itself was more highly cultivated in Islam than anywhere outside China and Japan, and it determined more than just the fluid linearity of Islamic decoration. Yet the inscribed texts, which appear on buildings and all manner of objects in metalwork, ivory, glass, pottery and textiles as well as in manuscripts of the holy book itself (8, 1), constantly remind the faithful that the word of God is

the only reality in an ephemeral world and, by implication, that all the works of man, including works of art, are vain.

Islam has been described by the French anthropologist Claude Lévi-Strauss as the third of mankind's 'major religious attempts to free itself from persecution by the dead, the malevolence of the beyond and the anguish of magic'. Like Buddhism and Christianity in their early stages, it was a great liberating force. Each of these religions transformed a body of locally held beliefs and customs into a coherent spiritual and ethical system with a promise of salvation. Buddhism was the least, and Islam the most, strictly codified. To this day there are fewer essential differences between the various sects of Muslims than between those of Buddhists and Christians. A complete and comprehensive guide for the inner and outer life of the individual and also for the 'constitution' of the Islamic state is provided by the Koran, which Muslims believe

8, 1 Koran page written in Kufic script, Iraq or Syria, 8th or 9th century. Parchment, 8½ × 13ins (21.6 × 32.5cm). Museum für Islamische Kunst, West Berlin.

to have been dictated by God to the Prophet. The Koran was given canonical form immediately after Muhammad's death and has never been altered (no translations or paraphrases were officially permitted until fairly recently).

Muhammad made no claim to be divine—in this respect, if in no other, he was like the Buddha. His

and ancestor-worship to a form of monotheism around holy leaders called *hanifs* or *hunafa*. Foreign religions also found adherents in Arabia. In the north there were followers of the Persian Zoroaster. Elsewhere colonies of Jews, whose ancestors had fled from Palestine, were settled in several towns. There were also many Christians both orthodox and

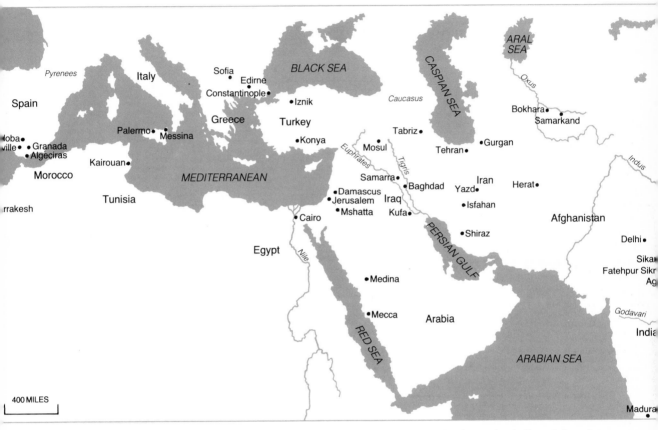

Map of the Islamic world.

mission was to save his fellow men—at first his compatriots, later all mankind—from eternal damnation by recalling them to the worship of the One God—the God of Abraham, from whom he and other Arabs believed themselves to be descended. Muhammad was born about 570 into an impoverished branch of the main merchant family in the trading city of Mecca, an important junction of caravan routes, along which products of the Arabian peninsula, especially incense, were carried to the Mediterranean. At this time Arabia was occupied by fiercely independent groups of nomads on the heights, agriculturalists in the valleys and merchants in the few scattered towns. A variety of local religious beliefs were held, ranging from animism

heretical—Monophysites, who believed that there was only one 'nature' in the person of Christ, and Nestorians, who maintained that he united two distinct 'persons', human and divine, in one body. All these people had, in Muhammad's view, strayed from the path of true monotheism. Although he never doubted the authority of the first books of the Old Testament and accepted both John the Baptist and 'Jesus Son of Mary' as divinely inspired prophets, he questioned Jewish practices and completely rejected the complexities of Christian doctrine, especially the doctrine of the Trinity. His teaching was dominated by the concept of a last judgement, which would determine eternal salvation or damnation—heaven or hell—for every individual. No religion is more exclusively monotheistic than Islam, based as it is on

the direct relationship between the individual and God without the intercession of saints in heaven or the mediation of priests on earth. Every individual stands alone before God. As there is no priesthood, so there is virtually no ritual in Islamic worship to distract from the prayers which the faithful are bound to say five times a day and which are usually said alone, except on Fridays. The duties required of Muslims are simple: prayer, fasting during the month of Ramadan, abstinence at all times from strong drink and some foods (notably pork, but not all the others forbidden to Jews), almsgiving, a once-in-a-lifetime pilgrimage to Mecca—and, of course, faithful observance of the moral code contained in the Koran.

Muhammad was a social, as well as a religious, reformer. All believers were equal, he declared. The idea of a brotherhood of the faithful, which is still very strongly felt to this day, began with him. But the injustice and materialist greed of the upper merchant class of Mecca—especially their practice of usury—fell under his censure, and the hostility this aroused led to his *hegira* (exodus or emigration) with his family and a few followers in 622, the year that was to mark the beginning of the Muslim calendar. Settling some 300 miles (480km) to the north in the town of Yathrib, later called Medina—the City (of the Prophet)—he took on that dual role of political and military leader which most strikingly distinguishes him from the founders of Buddhism and Christianity. Within a decade he had united the greater part of Arabia under his spiritual and temporal leadership. In Medina he initiated the practice of praying while facing towards Mecca, which fell to his army only after stubborn resistance. And in the last year of his life, 632, he led the first Islamic pilgrimage (*hajj*) to the Ka'ba in Mecca, the ancient shrine associated with Abraham.

Muhammad himself lived and worshipped in surroundings of extreme simplicity. His house at Medina was built of mud-brick, palm trunks for columns and palm leaves coated with mud for partitions and roofing. It consisted of a number of small rooms opening on to a partly shaded courtyard with a shelter for his poorest followers at one end. He seems to have been sublimely indifferent to his surroundings and is said to have declared that 'nothing so much wastes the substance of a believer as architecture'. Another statement attributed to him is that 'the angels will not enter a house in which there is a picture or a dog', and this has always been interpreted by some groups of Muslims as an outright condemnation of figurative painting. However, these remarks come not from the Koran but from the Hadith, a collection of traditional sayings which have

8, 2 Palace of Chosroes, Ctesiphon near Baghdad, Iraq, mid-6th century. (From a 19th-century photograph; much less survives today.)

less authority. Apart from calling idols 'an abomination', the Koran mentions neither sculpture nor painting. So the arts have been regulated less by the letter than by the spirit of Islam.

Muslim prayers can be said anywhere, in the home, in the fields or in the workshop; even for the weekly act of communal worship on Fridays, when the faithful are addressed by their *imam* or leader, no more is strictly necessary than space in which all can prostrate themselves together. As there are neither rituals nor priests there are neither ritual vessels nor vestments. Teaching is based exclusively on the word of God, not on the life of the Prophet, hence no didactic images are needed (another contrast with Christianity, which has laid such stress on the life of Christ and the saints). Nor were elaborate ceremonial manuscripts of the Koran required, for the holy words were learnt and recited by heart. In fact, art seems to have been regarded as at best an embellishment, at worst a mere distraction, and it is hardly surprising that early Islam evolved no aesthetic theory.

Long before the birth of the Prophet, however, Arabia had been open to artistic as well as religious influence from neighbouring civilizations. Remains of pre-Islamic architecture and sculpture in provincial versions of Hellenistic, Byzantine, Iranian, Ethiopian and other styles of 'the age of ignorance', as Muslims later referred to it, survived in various parts of the peninsula. After Islam began to expand under the caliphs, who succeeded Muhammad as temporal and spiritual leaders, Arabs were confronted with not only far more but far more sophisticated works. In Palestine and Syria they found magnificent stone-built Early Christian and Byzantine churches. In Mesopotamia and Iran they saw the spectacular structures erected under the Sassanian dynasty, who had ruled the area

since the third century. The palace at Ctesiphon near Baghdad, probably dating from the mid-sixth century, is the most impressive of those that still partly survive today (8, 2). With its huge *iwan* or hall opening beneath a gently pointed arch and its stucco panels of flower and leaf motifs (8, 3), this building was to exert great influence on the development of Islamic architecture and decoration—though not for a century or more after the Muslim annexation of Mesopotamia in 640.

The Islamic state expanded with a rapidity that has never ceased to astonish. By 647 its armies had conquered Iraq, Palestine, Syria, Egypt, Iran, Cyrenaica and Tripolitania. Two years later they had reached the Indus in present-day Pakistan. North-west Africa fell to them in 670. In 710 they crossed into Europe, conquered the Visigothic kingdoms of Spain and passed over the Pyrenees as far as Poitiers in France, where they were finally checked in 732 by Charles Martel (grandfather of Charlemagne). For

8, 3 Sassanian relief ornament from Ctesiphon, 6th century. Stucco, 40 × 40½ins (102 × 103cm). Museum für Islamische Kunst, West Berlin.

places of worship in all these lands Muslims took over whatever buildings were conveniently available, whether Christian churches or Zoroastrian temples. So long as it contained no idol, any building could become a mosque, a word derived from the Arabic *masjid*, which means simply 'a place where one prostrates oneself'.

Umayyad art and architecture

In the early years of Islamic expansion mosques were built or laid out only where, as in new garrison towns, no existing structure was large enough to be taken over and used. The earliest were not even roofed: a space surrounded by a fence sufficed. At Kufa in Iraq in 638 a large square was marked off by a ditch, and two rows of columns taken from nearby buildings were set up to form a covered colonnade on its south side—i.e. that facing towards Mecca. In Jerusalem, which fell to the Arabs in 637, no more elaborate mosque was erected than that still in use some 30 years later, when a Christian pilgrim described it as 'a quadrangular place of prayer, which they have built rudely, constructing it by setting great beams on some remains of ruins: this house can, it is said, hold 3,000 men at once.' Not until about 685 did work begin on the first major monument of Islamic architecture, the Dome of the Rock in Jerusalem, built near the site of Solomon's temple at the command of the caliph Abd al-Malik of the first dynasty of Islam—the Umayyads, who were descended from a companion of the Prophet (8, 5). It was, however, conceived as a special sanctuary, not as an ordinary place of worship. Its design—an octagon with two concentric ambulatories surrounding a central space covered by a dome—was derived from Early Christian *martyria*, of which the most famous was that enshrining the Holy Sepulchre on the other side of Jerusalem.

The natural outcrop which the Dome of the Rock surrounds had been venerated by the Jews as the tomb of Adam and also as the place where Abraham prepared to sacrifice Isaac. According to Muslim tradition, it was the place from which Muhammad ascended into heaven on the night journey described in the Koran, though it is not known to have been identified as such until after the Dome was built. The rock itself seems to have provided little more than a pretext for this spectacular departure from earlier Islamic architectural practice or non-practice. A tenth-century writer declared that Caliph Abd al-Malik, 'seeing the greatness of the *martyrium* of the Holy Sepulchre and its magnificence was moved lest it should dazzle the minds of the Muslims and hence erected above the Rock the Dome, which is now seen

there'. The caliph's aim was to create a prominent monument which would outshine the Christian churches of the city and even, perhaps, the Ka'ba in Mecca, then in the hands of a rival caliph. It is unlikely that he was inspired by, or even aware of, the ancient cosmic symbolism of the dome.

Although the brilliant spectacle which greets the modern visitor to Jerusalem is largely the result of later redecorations (notably the glazed pottery tiles replacing exterior mosaics), the original effect made by the building must have been very similar and no less arresting, with mosaics in gold and many colours glittering on the walls beneath the gilded dome. Much of the seventh-century decoration survives inside, panels of variously coloured marble cladding piers and walls, sheets of gilded metal worked in relief, and mosaics of glass and mother-of-pearl with flower and leaf motifs surrounding vases and crowns (8, 6). Here there are also long inscriptions of passages from the Koran addressed specifically to Christians. 'O ye People of the Book', one of them begins. 'The Messiah Jesus Son of Mary is only an apostle of God, and His Word which he conveyed into Mary, and a Spirit proceeding from Him. Believe therefore in God and his apostles and say not "Three". It will be better for you. God is only one God. Far be it from his glory that He should have a son.'

The Dome of the Rock was clearly intended to 'dazzle the eyes' of Christians as well as to distract those of Muslims from the splendour of Christian churches. So, too, was the Great Mosque, built between 706 and 715 by Abd al-Malik's son and successor Caliph al-Walid in Damascus, then the capital of Islam. This is the earliest mosque of which a substantial part survives (even though it has been sacked several times and all but burnt down) and also the first known to have had any pretensions to grandeur in form or decoration. It exerted great influence on nascent Islamic architecture. Artists and craftsmen employed on it were, however, predominantly non-Arab and probably non-Muslim; and a considerable element of improvization entered into its creation.

The site was the rectangular walled *temenos* or precinct of a pagan temple, which had been converted into a Christian church in the late fourth century. When the Muslims took Damascus in 635 they adopted part of the *temenos* as an open-air mosque, which served their needs for some 70 years. In 705 al-Walid acquired the church, demolished it and set about building the largest mosque in Islam. All that was allowed to survive of the original fabric was the Roman wall with its four corner towers, which were

converted into minarets from which the faithful could be called to prayer—the first in the history of Islam. Columns and capitals of various types (mostly Corinthian) were taken from earlier buildings to support an arcade running round three sides of the *sahn* or courtyard. The fourth side of the *temenos* was filled by the sanctuary or prayer hall, a covered structure deriving from a Christian basilica with three equal naves divided by arcades. The effect, however, on entering is unlike that of a Christian church, one of indeterminate breadth rather than length. Just as there is no altar to provide a focal point, so there is no strong axis from one end to the other. This plan enabled the maximum number of men (women were relegated to a separate place) to pray, shoulder to shoulder, immediately facing the *qibla* wall (i.e. that on the side facing Mecca), the importance of which was marked by three shallow niches called *mihrabs*. Whereas the Christian basilica reflects the hierarchical structure of the Church—laity, priests, a bishop enthroned in the apse—the mosque no less clearly expresses the Islamic conception of the brotherhood of believers, all equal before God, to whom each has direct and equal access through prayer.

8, 4 Marble window grille, Great Mosque, Damascus, c. 715.

8, 5 *Above* Dome of the Rock, Jerusalem, late 7th century.
8, 6 *Left* Detail of mosaic decoration, Dome of the Rock, Jerusalem, 691–692.

Early accounts of the Great Mosque of Damascus attest to the splendour of its decorations, most of which have perished by sack or by fire (the last and most serious in 1893). Few traces remain of the coloured marble panelling which encased the piers and lower walls. But six windows still have their marble grilles, carved probably by Egyptian craftsmen with interlace designs strikingly similar to the carpet pages of manuscripts, which were being painted at exactly the same time far away in the north-west of Europe (8, 4). Both derived, in all probability, from the same Coptic sources. Fragments of the mosaics which glittered in the courtyard—in the spandrels of the arcades, on the undersides of the arches and on the upper parts of the walls—have also been preserved (8, 9; 10). Among the most accomplished of all mosaics, they are almost certainly the work of Byzantine craftsmen. The panoramic views especially, like that illustrated here, with numerous buildings rendered in the Hellenistic landscape tradition, recall mural decorations painted some seven centuries earlier at Pompeii and Rome. Only in one respect do they differ: the palaces, houses and gardens at Damascus are all

257

8, 7 Floor painting from Qasr al-Hayr al Gharbi, Syria, c. 730.
Fresco, National Museum, Damascus.

eerily uninhabited. There has been much discussion as to the possible symbolical meaning of these mosaics and whether they might have been intended to represent a specific place (the environs of Damascus), the vision of a peaceful Islamic world, or paradise. But it seems rather more likely, in view of the negative and somewhat cursory way in which Western artistic conventions were adapted, that they were conceived simply as decorative backgrounds, as palatial and opulent settings for life in the courtyard of the Great Mosque.

Mosaics in a similar style have been found on the floors of palaces built in the open country for the Umayyad family and their supporters, who had been granted lands vacated by Christians. Here there were also figurative paintings, both on walls and floors, confirming the absence of an absolute ban on images outside a religious context. Most of these paintings derive, like the mosaics, from Hellenistic prototypes. But one of the most spirited, with figures of musicians standing under arches and a mounted horseman hunting gazelles, recalls Sassanian art and may well have been inspired by an Iranian model (8, 7). On stone

reliefs from the most famous of the Umayyad palaces, that at Mshatta in Jordan, lions, birds and fabulous beasts from Sassanian and earlier Near Eastern art are entangled in luxuriant growths of vine, which can be traced back to Coptic Egypt (8, 8). The general effect is, nevertheless, quite new and this great band of carving, which went right across the façade of the palace just above eye level—a zigzag forming triangles each with a huge rosette in the centre—may be thought to be the earliest example of an art distinctively Islamic, derivative though every individual motif may be. It is purely ornamental and unrelated to the structure of the building (from which it was removed in the nineteenth century) and seems to have had no symbolical or other meaning whatever. It was merely a sign indicating the grandeur and importance of the palace. In design each triangle is so tightly integrated that neither the foliage nor the animal motifs dominate. Geometrical and organic forms are combined and balanced. Motifs recur from one triangle to another and, although they are subtly varied, an effect of rhythmical repetition prevails, as in later Islamic decorative art and also in Arabic music and literature.

Mshatta, which was left unfinished in about 744, was the last of the great Umayyad palaces. Traces of some 50 others survive (notably at Khirbat al-Mafjar in Jordan), sited far from cities, not, as is sometimes thought, to satisfy nostalgia for the wide open spaces, but in order to be at the centre of farmland and hunting country (now all desert). In their splendour and luxury they seem a world apart from the tents of the central Arabian nomads and also from the simple mud-brick courtyard house in which the Prophet had lived and died at Medina, little more than a century earlier. The larger Umayyad palaces were symmetrically planned and each was provided with a mosque, an audience hall and numerous private apartments, latrines (at Mshatta they were in the towers, which had no defensive purpose) and hot baths of the Roman type, later called Turkish. These palaces mark the end of the first stage in the history of Islamic architecture, and also the end of a single unified Islamic state.

The empire ruled from Damascus by the Umayyad caliphs extended from central India to the Atlantic, covering most of the countries which have remained Islamic to the present day. Its spread had been effected not only by the force of arms. Muslims proved to be tolerant overlords and in the course of two or three generations very large numbers of the conquered peoples adopted the religion of their masters, either out of conviction or to avoid paying a poll-tax imposed on non-Muslims. Many Christians responded to the uncomplicated theology of the Koran. But in due

course discontent arose among converts and their descendants, who tended to be treated, in defiance of the Koran, as second-class Muslims in an empire ruled by and for an Arab élite. From 661 the Arabs were divided among themselves by a dispute over the succession to the caliphate, which widened into a schism between orthodox Muslims or Sunnites and the more mystical and philosophical Shi'ites. The schism polarized doctrinal issues, and has continued to split Islam. In the 740s the Shi'ites joined with other malcontents in a revolt which broke out in Iran and in 750 overthrew the reigning Umayyad caliph in Damascus, whose relatives were massacred with the exception of one who escaped to Spain. He became the

8, 8 Detail of frieze from Umayyad palace at Mshatta, Jordan, c. 743. Limestone, height about 114ins (290cm). Staatliche Museen, East Berlin.

emir of Cordoba and from that date the western part of the empire developed independently (see p. 264).

Abbasid art and architecture

The Abbasid dynasty of caliphs, who succeeded the Umayyads, was descended from Abbas, an uncle of the Prophet. Arabic remained the legal as well as the religious language throughout Islam (necessarily, as translation of the Koran was prohibited), but power began gradually to pass out of the hands of Arabs and into those of officials of other ethnic origins. At the same time the empire evolved into independent states, which rarely acknowledged the caliphs as more than spiritual leaders, while its eastern territories were slowly eroded by the advance of the Mongols, who finally, in 1258, drove the Abbasids out of Asia altogether. They retreated to Egypt. The 500-year-long Abbasid period is, nevertheless, generally regarded as the 'Classical' age of Islamic culture. The court of the reigning caliph was a brilliant centre of luxury, poetry and learning. The most famous was that of Harun-al-Rashid (d. 809), a contemporary of Charlemagne, with whom he corresponded, well known in legend from *The Arabian Nights*. The visual arts, music and literature all flourished. So, too, did the sciences, in which Islamic men of learning made a major contribution by reanimating Greek ideas and preserving Greek texts—it was the Muslims, not the Christians, who were the direct inheritors of those parts of the Greek tradition which the eastern empire had kept alive. In addition, they developed algebra from India, chemistry and alchemy from China and initiated the scientific study of optics and astronomy. Above all, their culture was unified and well-integrated. Omar Khayyam (fl. c.1100) was both poet and mathematician. It is instructive to consider some of the words we owe to Arabic—algebra, alembic, alkali, azimuth, zenith—and to remember that it is to Islam that we are indebted for the transmission from India of what are called 'Arabic' numerals, the numerals we still use (as in this book) and without which the advance of mathematics and all related and dependent sciences would have been impossible.

In 762 the second Abbasid caliph, al-Mansur, transferred his capital from Damascus to the banks of the Tigris, where he founded Madinat as-Salam—the City of Peace—better known as Baghdad. It was a decisive shift away from the Mediterranean world—preceding by only a few decades Charlemagne's establishment of a new centre of power in northern Europe. Perhaps significantly, Baghdad was laid out not on the rectangular grid, ubiquitous throughout the Roman empire, but on a circular plan which had a long

history in the ancient Near East. Astrologers determined the date on which the foundations should be laid, and the whole concept may reflect the influence of Persian cosmology and indicate that the new city was the hub of the universe. A simple scale of proportions was used throughout: bricks one cubit (about 15 inches, 38cm) square, the outer wall with a total circumference of 16,000 cubits (rather more than 5 miles, 8km), the palace 400 cubits square, the mosque 200 cubits square, and so on. The throne-room of the palace was in the very centre, a cube (20 cubits) with a domed ceiling, surmounted by another room of the same size crowned by the famous Green Dome, which dominated the city. It was approached through an *iwan* as at Ctesiphon (8, 2), another instance of the increasing Iranian influence, which also determined court ritual under the Abbasid caliphs. The palace, the large mosque attached to it and the administrative buildings were all in a vast enclosure more than a mile

8, 9 Detail of mosaic decoration, Great Mosque, Damascus, c. 715.

(1.5km) across, a city within the city, encircled by a massive wall with four gates, from which vaulted galleries about 300 yards (275m) long led to monumental gateways in the outer wall, each with an audience hall covered by a gilded dome over the entrance. The ordinary population of the city was crammed into this narrow ring—only 300 yards (275m) across but some 5 miles (8km) long. The inconvenience to the inhabitants of such an arrangement is a striking instance of how Abbasid Baghdad embodied the Islamic ideal of submission to one absolute spiritual and temporal ruler, successor to the Prophet of the One God. Early accounts state that engineers, craftsmen and artists from all parts of the Islamic world were assembled to build and decorate the new capital.

However, Baghdad soon burst out of its tight, ideal, circular plan to grow and sprawl into one of the richest, most densely populous and famous cities in the world, celebrated in the reports of travellers from East and West and, of course, in a whole series of stories in *The Thousand and One Nights*. The palace enclosure was a 'paradise' in the ancient Persian sense of the word, a game reserve, in which gardens surrounded numerous pavilions. Affluent court officials built only slightly less magnificent palaces in the suburbs, which spread far beyond the walls. In contrast to the rigid formality of the original city plan, these buildings seem to have been informally related to one another, establishing a precedent for later Islamic palace architecture—the Alhambra at Granada, for example, and Topkapi Saray at Istanbul. It seems likely that they kept alive Sassanian architectural forms and methods of decoration, which were to re-emerge so brilliantly in later buildings in Iran (see p. 400). Similarly, their settings among lawns and canals and circular pools, flowers and fruit-trees maintained a tradition of garden design probably derived from ancient Roman villas and palaces but invested with the imagery of the Islamic paradise and passed on to Iran and Mughal India (see p. 410). But the extent of their influence is impossible to estimate, for practically no visible trace of the city of the Abbasids survived its remorseless destruction in 1258, when the last of the Abbasid caliphs was put to death by the Mongols, along with 800,000 of the inhabitants of Baghdad. The loss is irreparable and our knowledge of Islamic art necessarily incomplete as a result.

At Samarra, a little more than 60 miles (96km) up the Tigris from Baghdad, excavations have revealed the remains of a second Abbasid capital with a vast palace, which was built in 836–8 by a son of Harun al-Rashid. Here, too, artists from all parts of the Islamic

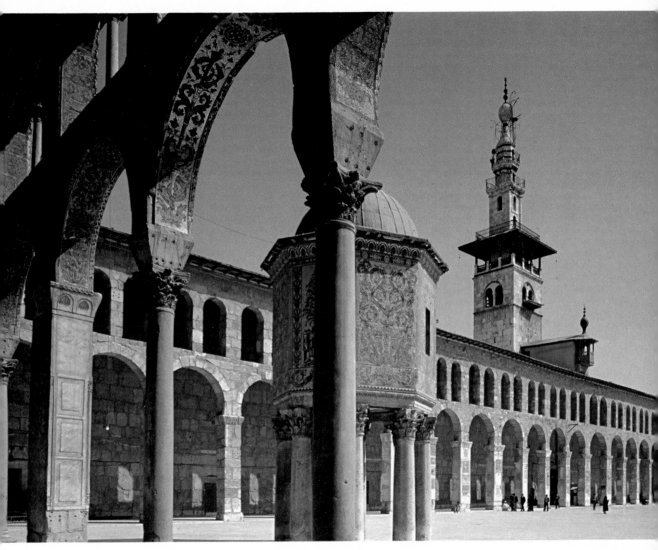

8, 10 Great Mosque, Damascus. Courtyard looking west, 715.

world were employed and some of their signatures have been found, written in Greek, Syriac and Arabic characters. Fragments of abstract stucco decoration and figurative wall paintings reveal the influence of Chinese and European as well as Persian art, and the general effect must have been, perhaps intentionally, cosmopolitan. The richest and finest of them appear to have been reserved for the harem, for the exclusive enjoyment of the caliph and his wives. Here a desire for art as an embellishment of aristocratic life was reconciled with the religious conception of art as vanity—albeit accompanied by a salutary awareness of life's transience. In Muslim palaces, as at Samarra, the pleasure pavilions were always most highly prized and

often seem to have been deliberately fragile structures with a kind of built-in evanescence, owing much of their effect to the precious objects and richly coloured and patterned textiles displayed temporarily, just for the occasion.

Very different indeed in its conception was the mosque. That at Samarra was the largest in the world, 784 by 512 feet (240 by 156m) and capable of accommodating 100,000 people. Of the vast prayer-hall, reminiscent of the hypostyle halls of Persepolis (see p. 80), barely a trace survives of the 216 square brick piers which supported the roof. But the minaret still stands (8, 11), recalling even more directly the spiral towers of Iran.

The main factor conditioning the structural development of the mosque was the need to provide

sufficient free space, at least partly under cover, for the whole male population of an area when they assembled for communal prayers on Fridays. The relatively small enclosures, which had sufficed for the conquering Arabs in the early decades of Islamic expansion, were quite inadequate for the more settled populations of their descendants, let alone for the growing number of converts. Increased space was obtained either by piecemeal additions or by wholesale demolition and rebuilding, yet almost invariably with conservative respect for pre-Islamic local traditions. The Great Mosque at Kairouan (8, 12), for instance, was begun about 724, when the governor of the city obtained the caliph's permission to enlarge an early mosque by expanding into an adjacent garden, and adding a sturdy, square minaret. All but the minaret was demolished and rebuilt in 772–4 and again in 836. Alterations were made in 862–3, when a wooden dome was raised over the bay in front of the *mihrab*, reserved for the governor. At the same time the *mihrab* was redecorated with lustred faience tiles imported from Iraq and beside it a wooden *minbar* was placed—the pulpit from which the *imam* addresses the faithful and leads the Friday prayers (8, 13). A decade or so later the prayer-hall was extended on one side and towards the courtyard, where a second dome was placed over the central entrance. Although Kairouan was sacked and deserted after the massacre of its population by the Berbers in 1054–5, enough survived of the mosque for it to be restored with only minor modifications in the late thirteenth century. It is a remarkable record of tenacious adaptability and artistic conservatism. A Christian church would never, during these centuries, have been enlarged and rebuilt again and again with such unchanging stylistic consistency.

As it stands today, the Great Mosque of Kairouan is thus the work of many periods and the typological history of its various parts goes back to pre-Islamic times. The basic unit of construction is a round arch slightly compressed to swell out into a horseshoe shape, first found in fifth-century Christian churches in Syria, and resting on columns with capitals of Corinthian type. There are 7 of these arches in each of the 16 arcades running in the direction of the *qibla* wall. Monotony was avoided, perhaps fortuitously, by using columns of greatly varying size and type of marble, some with bases to bring them up to uniform height, others without, and all presumably removed from earlier buildings, either Christian or ancient Roman. Yet no adaptation was attempted. No modifications in style were introduced to disturb the atmosphere of harmony prerequisite for prayer. Despite its long building history, the whole mosque is remarkably

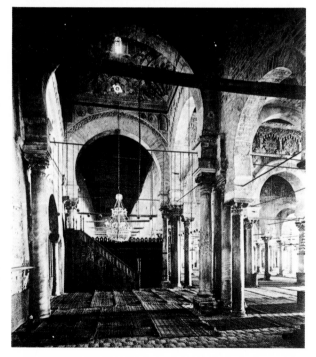

8, 11 *Top* Minaret and Great Mosque of al-Mutawakkil, Samarra, Iraq, c. 848–852.
8, 12 *Centre* Aerial view of Great Mosque, Kairouan, Tunisia, c. 772–863.
8, 13 *Bottom* Interior of Great Mosque, Kairouan, Tunisia, c. 862–3.
8, 14 *Right* Arcade of Mosque of Ibn Tulun, Cairo, c. 877–879.

homogenous, and despite the disparate origins of the elements used in its construction, it remains quintessentially Islamic.

The enlargement of an existing mosque did not always provide a solution to the problem of space for the Friday prayers, however. New mosques had to be built as well. And perhaps the finest of all mosques, that of Ibn Tulun in Cairo, was one of these. Designed and built between about 877 and 879 and never subsequently enlarged or altered, it is an almost unique instance of the completely realized architectural conception in early Islamic architecture. Its patron was Ahmed Ibn Tulun, born at Samarra in 835, the son of a Turki slave taken there from Bokhara. He attracted the attention of the caliph, who had him educated, and swiftly rose in the service of the caliphate, always open to talent. In 869 he was appointed governor of Egypt, which he and his descendants ruled as a semi-independent state until 907. His mosque was built with brick piers instead of columns, perhaps because of shortage of materials and, according to legend, because of his refusal to rob Christian churches of the 300 or so columns needed for the very large building he envisaged (the quarrying of marble had long since ceased in Egypt). He may also have wished to emulate the Great Mosque at Samarra, which he had known as a boy (8, 11). The minaret (later rebuilt in its present form) seems to have been inspired by that at Samarra. The piers in both mosques have simulated columns at their corners, those in the mosque of Ibn Tulun emphasizing visually their massive strength and lending the great arcades a grandeur and gravity fully equal to that of the finest ancient Roman buildings. If ever a building could be called 'big-boned', it is the mosque of Ibn Tulun (8, 14).

At Samarra the piers had directly supported a flat ceiling; at Cairo, however, they carry arches. Furthermore, the arches are pointed, not round or horseshoe-shaped. Gently pointed arches had been used much earlier in Christian and Islamic buildings in Syria, but those in the mosque of Ibn Tulun are much bolder and their form is accentuated by bands of relief decoration. They are also repeated in the 'windows' above each pier, an unusual feature, inserted, it has been suggested, to save building material, to lessen the load on the piers, or simply to allow more light to pass through the interior.

Islamic Spain

It may have been partly for the same reason—to increase the light in a wide prayer-hall—that the architect of the mosque in Cordoba devised a unique system of double arches. The columns available for use were of various types, smooth and fluted, varying from

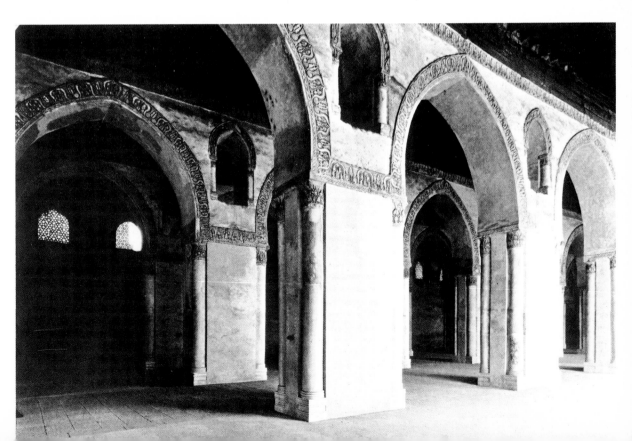

14 to 17 inches (36 to 43cm) in diameter, and some can have been no taller than the 9 feet 9 inches (3m) to which the others were reduced. Had they been used to support simple arcades in the normal way, the effect would have been murkily cavernous. Impost blocks were, therefore, set on the capitals to carry arches (constructed of wedges of red bricks alternating with stone voussoirs) and also the 6-foot-high (182cm) stone piers, from which the segmental upper arches spring. This device, introduced at Cordoba with the earliest part of the mosque in 786, was so successful that it was repeated with only slight variations as the prayer-hall was gradually enlarged by piecemeal addition of one block of aisles after another until, in 987–8, it reached its present enormous extent, some four times its original area.

Cordoba—originally a Roman city—had been chosen as the Islamic capital of Spain after the Arab conquest of the peninsula in 710–11. Here in 755 one of the Umayyads, who had escaped the general massacre of his family in Syria (see p. 259), found refuge and was accepted by the Muslim population as emir or military governor. The title was retained by his descendants until the early tenth century, when they began to style themselves caliphs, in open rivalry with the Abbasids in the east and the Fatimids, descendants of the Prophet's daughter, who had established a second caliphate in north Africa. Under the despotic, but generally benevolent, rule of the Umayyads, Cordoba

8, 15 *Below* Interior of Great Mosque, Cordoba, c. 961–976.
8, 16 *Right* Dome above the *mihrab*, Great Mosque, Cordoba, c. 961–976.

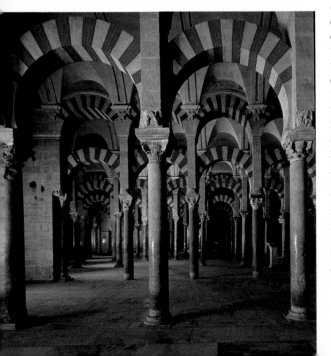

grew to be by far the most prosperous city in western Europe, second only to Baghdad in Islam. There are said to have been no fewer than 3,000 mosques and 300 public baths within its walls. The mosque that survives was the most important, attached to the palace by a bridge across a street so that the caliph could enter it without passing through the congregation. It was, in fact, a kind of Islamic equivalent to the great court churches of Christendom—Hagia Sophia in Constantinople (7, 18) and the Palatine Chapel in Aachen (7, 42)—though the Great Mosque at Cordoba is much larger, even, than Hagia Sophia (8, 15). Great attention was lavished on its decoration, especially of the *qibla* wall and the area in front of it, which date from the 960s. The *mihrab* is unique in that it consists of a small, domed chamber entered through an arched doorway of the pronounced horseshoe shape that the Muslims of Spain particularly favoured. Around the opening there are bands of carving in stone, as delicate as work in ivory, as well as mosaic patterns of leaves and, above, inscriptions from the Koran in gold and coloured-glass mosaic executed by craftsmen from Constantinople (and presumably, therefore, Christian). The area in front of the *mihrab* is divided off from the rest of the prayer-hall by columns supporting arches which burst into multilobed life, crossing one another in intricate, regular patterns created as if by some complicated process of multiplication and division (8, 17). Above there is the richest of the mosque's three domes, similar feats of Islamic skill and precision in geometry (8, 16). Each dome is constructed on 8 intersecting arches. By this date there were two main methods of erecting masonry domes over rectangular bases: one with arches, technically called squinches, across and projecting over the corners; the other with spherical triangles or pendentives, like those at Hagia Sophia. The former method was adopted by Islamic architects, who developed it in conjunction with a framework of ribs of the kind used to reinforce ancient Roman concrete domes. But whereas the Romans had concealed the framework inside the fabric, Islamic architects displayed the whole structural system and its complex patterns of symmetrical arcs—regular geometric patterns and linear grids of a kind which greatly appealed to Muslims with their interest in mathematics and astronomy. Indeed, it was probably at least partly for this reason that squinches with ribs were introduced, for they are of an intricacy that is often quite gratuitous structurally. Islamic domes are seldom of any great span and could have been constructed by simpler methods long in common use.

Basic differences in aesthetic attitudes are revealed

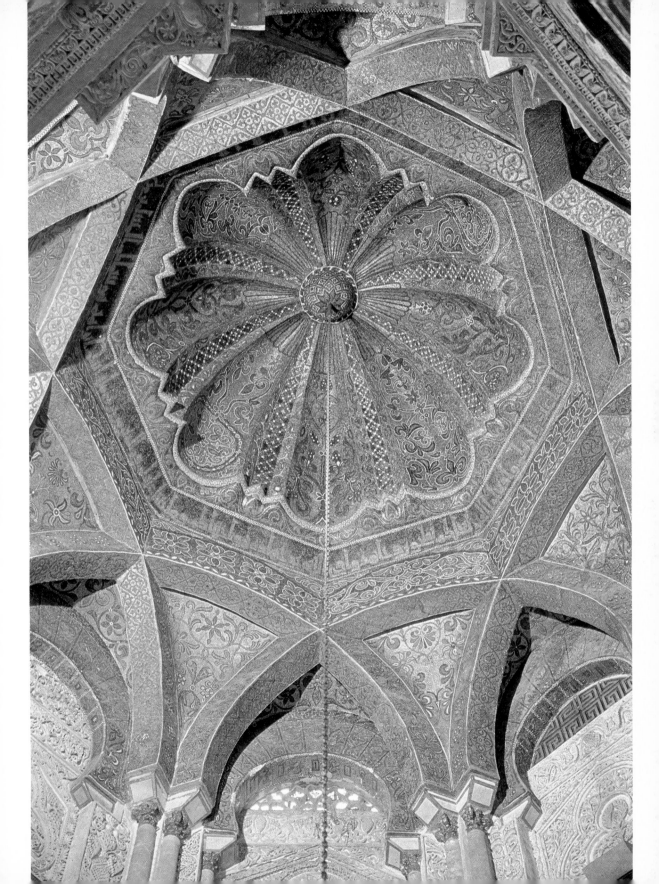

by a comparison between the vaulting systems at Hagia Sophia (7, 18) and the Great Mosque at Cordoba (8, 16). The former conceals its structure, at enormous cost in labour and technical ingenuity for, ultimately, transcendental reasons; the latter exposes it partly as a display of technical virtuosity, partly just for the intricate decorative beauty of the geometric interlaces it forms. Moreover, early Islamic architects did not exploit their technical feats. Nor did they go on to vault large areas with a structural system of vaults. That was left for Christian architects to do some centuries later, quite independently (pp. 289–90). It was as if early Islamic architects, having mastered and perfected a vaulting system and having demonstrated the extreme structural and decorative elegance that could be attained in it, were quite content to leave its practical exploitation to others, just as they did with the pointed arch. Their interest in structural problems would seem to have been primarily intellectual; their appreciation of architecture to be focused on the decorative and ornamental.

Height was hardly necessary for 'a place where one prostrates oneself', and early mosques emphasized the horizontal. A vertical accent was supplied externally by the minaret. As we have already seen, the first minarets were those of the Great Mosque at Damascus, originally towers at the corners of the pagan temple *temenos* from which it was adapted. Of minarets built as such, the earliest survivor is that at Kairouan, 103 feet high (31m) (8, 12). Its ostensible purpose was, of course, to provide a place from which the *muezzin* could call the faithful to prayer. But, above a certain point, height begins to diminish, rather than increase, the range of the human voice, and the function of the tall minaret must have been as much, if not more, visual than auditory, to mark the location of the mosque in a crowded city. Tall towers had similarly been erected on or alongside Christian churches, sometimes, but not always, as bell-towers. The Kairouan minaret derived from this source and in turn provided the model followed throughout north Africa and Spain. There is a very handsome twelfth-century example at Marrakesh in Morocco, decorated with panels of arcading carved to such an elaboration of texture that they look like fabrics hung on its walls (8, 18). A similar minaret was built at about the same time in Seville and needed little alteration when it was transformed into the bell-tower of the cathedral after the Christian conquest of the city—a rare example of a structure being returned to its typological origin!

Samanid and Seljuk architecture

Meanwhile, an architectural variant was being devel-

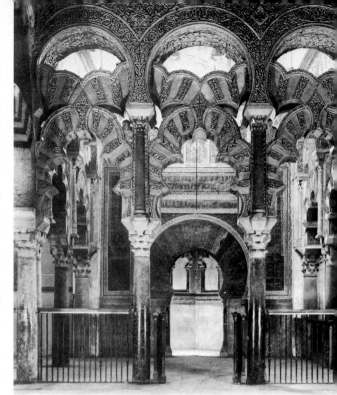

8, 17 *Mihrab* in the Great Mosque, Cordoba, c. 961–976.

oped contemporaneously at the other end of the Islamic world, in the vast plains on either side of the River Oxus in central Asia (now the Soviet Republics of Turkmen and Uzbek). Its patrons were members of an ancient Iranian aristocratic family, the Samanids, who had been converted from Zoroastrianism to Islam in the eighth century and ruled from 874 to 999 as emirs virtually independent of the caliphate. A mausoleum erected at Bokhara for one of these emirs—perhaps Isma'il, who died in 907—is its most notable surviving monument and, despite its small scale (only 36 feet, 11m, wide), one of the most remarkable buildings of its time anywhere (8, 20). The form is probably derived from a Zoroastrian fire temple with four columns supporting a domed roof, but its decorative elaboration seems to have had no precedents. Brick was the material used for both construction and, with the addition of a few panels of terracotta, decoration. By laying them vertically, diagonally and in circles as well as horizontally an extraordinary variety of surface patterns was created. Structure and ornament were, in fact, completely integrated, but in a most unusual way, for the former was not expressed by the latter. The columns at the corners have no structural function— not even visually, like those engaged in the piers of the mosque of Ibn Tulun (8, 14). The impression given is

not that of a solid, weighty mass of brick and mortar so much as of a temporary pavilion woven out of wickerwork and draped with fabric. Some of the interwoven patterns are, in fact, taken from basketry. Unlike most funerary monuments, from the pyramids onwards, this mausoleum suggests transience and impermanence, perhaps reflecting in this way Muslim attitudes to death.

The Koran prescribed that the dead should be buried with the greatest simplicity, and the Hadith attributed to Muhammad a ban on buildings over graves. But the impulse to commemorate and perpetuate was too deeply rooted, especially in ruling families, to be resisted for long. Abbasid caliphs succumbed before the Samanids. More prominent monuments were built by the Seljuks, a dynasty of rulers of a Turkish people from the eastern steppes, who were converted to Islam, took over Iran and spread into Mesopotamia, where, in 1055, the Abbasid caliph surrendered most of his temporal power to their leader—retaining only his spiritual authority. Thus, the Seljuks became the first sultans to have more than regional authority. Seljuk tombs were given the form of lofty towers dominating the landscape for miles around, lasting testimonies to Seljuk power. One of the earliest and most imposing tomb towers, the Gunbad-

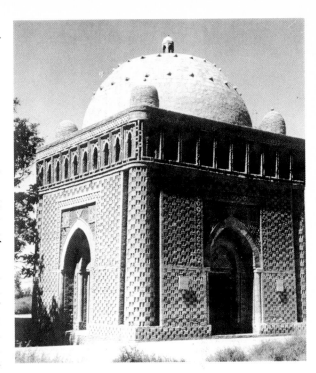

8, 20 Samanid Mausoleum, Bokhara, USSR, pre-943.

8, 18 *Below left* Minaret of Kutubiya Mosque, Marrakesh, Morocco, 1196.
8, 19 *Below right* Tomb of Qabus near Gurgan, Iran, c. 1012.

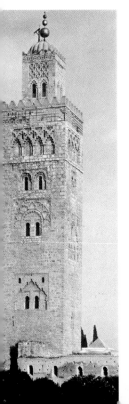

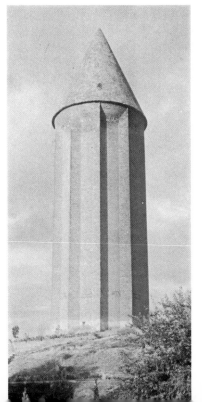

i-Qabus (tomb of Qabus, a prince who died in 1012), near Gurgan in north-eastern Iran, tapers to a height of 190 feet (58m) (8, 19). It is a masterly composition of contrasting sharp-edged and smoothly rounded forms. The 10 pointed buttresses have the clean-cut elegance of a polished steel instrument. There is no ornamentation or decoration of any kind, apart from two slender bands of lettering.

But brickwork patterns, reminiscent of those on the Samanid mausoleum at Bokhara, were to be much used on later Seljuk architecture, which soon lost its original austerity. Later buildings are exuberantly decorated, especially in Anatolia, where the Seljuks established the sultanate of Rum on territory won from Byzantium in the eleventh century. No more opulent example survives than the façade of the Ince Minare madrassa (a college for related religious and legal studies) in their capital at Konya (8, 21). Here the basic design follows that of the entrance to a Christian church, with a doorway recessed in a tall niche and flanked by engaged columns, but it has been elaborated almost out of recognition. The effect is, in fact, of a structure swathed in very thick and very heavy textiles. At the top the stone seems to be gathered up into a kind of valance, from the centre of which two bands of inscriptions fall and are twisted

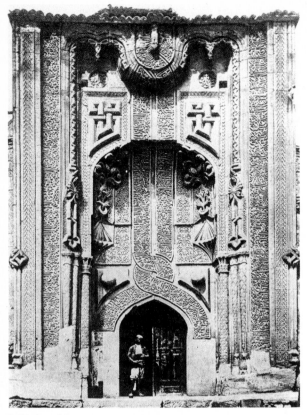

8, 21 Ince Minare madrassa, Konya, Turkey, 1258.

evident in ornament and surface decoration, widely and quickly diffused by itinerant craftsmen and by trade in such luxury objects as metal vessels and panels of silk. Yet, even in ornament, many motifs were derivative and the initial impact of Islam was negative, marked by the absence of religious symbols and, in religious art, of animal and human figures. The first explicitly Islamic feature was Kufic lettering.

Calligraphy was the art most highly regarded by Muslims, and its practitioners—both professional scribes and amateurs, who included several viziers or ministers of state—are practically the only artists to be named in early literary sources. Kufic (so called from an erroneous belief that it originated at Kufa in Iraq) was a ceremonial script. It was not used for day-to-day business but was developed mainly for manuscripts of the Koran, which, since illustrations were out of the question, could be given appropriate dignity only by fine penmanship and an occasional panel of abstract ornament (8, 1). The page illustrated here begins: 'On the Day of Judgement, the faith of those who shall have disbelieved shall not avail them.' As these early Korans were intended to be pored over by several of the faithful at a time their pages are wide with few boldly written lines only—they were not intended, as were the Christian Gospels, for the eyes of priests alone. The same style, thick and heavy but rapier-sharp, was used extensively for monumental inscriptions usually in long frieze-like bands, where its strong visual rhythm—so different from that of Roman lettering—was either adapted to, or inspired by, the foliage ornament which often accompanied it,

into a knot over the door. To trace this style back to the tents of nomads is, perhaps, no more than fanciful, for it did not mature until its patrons had long since been urbanized. But the crafts of weaving had been expertly practiced by the peoples of central Asia since prehistoric times (see p. 36), and the Seljuks initiated the production of knotted carpets in Anatolia—the source of the world-famous Turkish carpet of later times. The prominent rectilinear knots above the niche on the Ince Minare madrassa façade are very reminiscent of motifs which recur on carpets. This building also takes to its logical—or illogical—extreme that tendency to overlay, almost to hang, panels of ornament like pieces of fabric on wall surfaces, a tendency already evident at Mshatta five centuries earlier.

Islamic decoration
Although Islam's major contribution to the arts of the world was in architecture, Islamic buildings are seldom very original structurally, despite the ingenuity and inventiveness of Islamic architects, for example, in vault construction. A distinctively Islamic style is more

8, 22 *Below left* Ivory casket made in the workshop of Khalaf, Madinat az-Zahra, near Cordoba, c. 965–970. Height 6½ins (16cm). Hispanic Society of America, New York.
8, 23 *Below right* Bowl with Kufic inscription, from Nishapur, Iran, 10th century. Height 7ins (17.8cm), diameter 18ins (45.7cm). Metropolitan Museum of Art, New York.

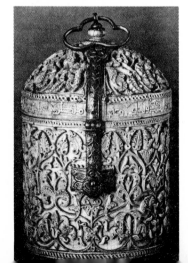

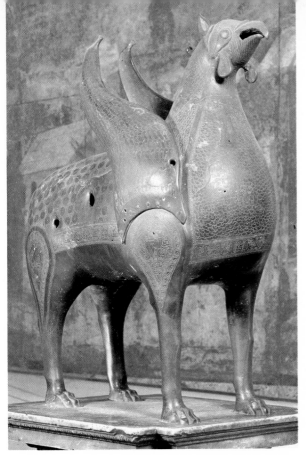

beauty, a kind of proto-porcelain. Slightly later, true porcelain was invented. It was importations of Chinese stoneware and porcelain into Iran and Iraq in the Abbasid period that sparked off the sudden development of Islamic ceramics.

Since the type of clay (kaolin) essential for making true porcelain was unavailable in the Near East, a new type of pottery was invented, probably in Baghdad—tin-glazed earthenware (also called faience or maiolica) with an equally glossy pure white surface,

8, 24 *Left* Griffin, 11th to 12th century. Bronze, height c. 40ins (101.6cm). Museo dell'Opera della Primaziale, Pisa.
8, 25 *Below* Coronation mantle of Roger II, 1134. Silk with pearls and gold embroidery. Schatzkammer, Vienna.

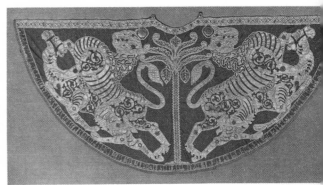

as on the *mihrab* arch in the Great Mosque at Cordoba.

Kufic inscriptions were also prominent in the decoration of such luxury objects as ivory caskets. The inscription on one made near Cordoba reads: 'The sight I offer is the fairest, the firm breast of a delicate girl. Beauty has invested me with splendid raiment, which makes a display of jewels. I am a receptacle for musk, camphor and ambergris' (8, 22). In striking contrast with this 'vanity-box' are pottery plates of an austere beauty which have no decoration other than inscriptions of pious wishes and such wise saws as 'patience in learning is first bitter to the taste but its end is sweeter than honey' (8, 23). Here the decorative potentiality of Kufic was fully exploited—to such a degree that it was often imitated and used as abstract ornament by artists unable to read it.

These plates, dating from the ninth and tenth centuries, are of interest from another point of view, as the earliest surviving examples of Islamic art clearly intended neither for the mosque nor the palace. Pottery had long been regarded, in the Near East as in Europe, as a 'humble' medium suitable for common utensils. In China, of course, a different attitude prevailed and artists of the T'ang period (see p. 209) had refined pottery into a substance of exquisite

which provides an excellent ground for painted decorations in colour. It was also discovered that this pottery could be given a wonderfully iridescent metallic surface by coating it before a second firing with lustre pigments (invented a little earlier in Egypt for use on glass). These developments were to transform not only household utensils and table-wares but also architecture. As we have already remarked, the *mihrab* of the Great Mosque at Kairouan was adorned with lustred tiles in 862–3 (they are, in fact, the earliest datable examples). Subsequently, tiles with inscriptions, geometrical patterns and leaf ornament in a range of cool colours—black, white, various blues and greens—were to become as much a distinguishing feature of Islamic architecture as are the orders of Classical architecture or the roof-carpentry of Chinese and Japanese. In the sixteenth century they replaced mosaics on the exterior of the Dome of the Rock.

Officially, the making of solid gold or silver vessels was prohibited; and although the ban (like that on figurative representations) was often violated, it stimulated refinement of craftsmanship in base metals. Here again, as with the invention of tin-glazed earthenware, it was probably Muslims of the merchant or middle class who were the instigating patrons,

rather than the upper-class élite of viziers and court officials, who could probably obtain porcelain from China and also gold and silver. The most famous centres of production were Herat (Afghanistan) and Mosul (now northern Iraq), where, from the Seljuk period until the late fifteenth century, magnificent ewers and basins for ablutions at home and in the mosque, handsome bronze candlesticks and other decorative objects were made of bronze or brass, often inlaid or partly coated with gold or silver. Surfaces were entirely covered with delicately incised ornament—geometrical, plant and animal motifs in addition to the ubiquitous Kufic inscriptions. Equally fine work was produced in Egypt especially under the Fatimid caliphs (990–1171) and in Spain. The finest surviving example is a bronze griffin said to have been taken to Italy by the crusader king of Jerusalem, Amalric I (1162–73). It is as near as any Muslim artist ever went towards sculpture in the round (8, 24).

Islamic art was appreciated and admired in Christian Europe almost from its beginning, and pottery, silks and metalwork were imported from all the main centres of the Islamic world. Commercial relations were never seriously interrupted—neither by the wars in Spain, for example, nor by the crusades, which regained the Holy Land for Christians in 1099 and held it for nearly two centuries. Since no religious symbols were used in their decoration, Islamic artifacts were as acceptable to Christians as to Muslims. In Sicily, for instance, Muslim craftsmen went on working in their own style long after Messina had been conquered by the Normans in 1061. The finest surviving example of Islamic textile art was, in fact, produced in Palermo for King Roger II: a mantle of scarlet silk embroidered with gold thread and pearls (8, 25). A lion attacking a camel, a motif which goes back to the very beginning of art in the Near East, is duplicated on either side of a Persian tree of life. Around the edge an Arabic inscription in Kufic lettering expresses fulsome good wishes to the wearer and is dated, according to the Muslim calendar, 528 (i.e. AD 1133–4). This superb robe was used from the sixteenth century onwards as the coronation mantle of the Holy Roman Emperors.

Islamic art raises a number of general questions about the nature of art, and in particular it poses the problem of artistic style and its causes. As we have seen, a consistent, well-marked and easily recognizable 'Islamic style' can be felt almost from the beginning— even in works which, as is not infrequent during the early centuries of Islam, can be shown to be largely composed of heterogeneous elements drawn from other cultures and civilizations. No one, for instance, could fail to identify the Dome of the Rock as a Muslim building, even though it derives quite directly in structure and form from a Christian prototype. This phenomenon is evident all over the Islamic world, covering a tremendous range in time and space—from Spain to India for a period of more than 1,000 years— involving many different peoples of varying cultural and ethnic origins. Geographical and racial traditions are, therefore, inadequate as explanations and unilluminating generally in this context. Islamic art is not comparable to, say, Mexican art or Spanish art or Eskimo art. Religion, too, must be discounted as an explanation or cause in any simple, direct sense: for many Islamic works of art have quite obviously little or nothing to do with the faith which was, in any case, unconcerned with the visual arts, except negatively. Moreover, many typically Islamic works of art are known to have been made either by or for non-Muslims, as for instance the mantle of Roger II. To this extent, therefore, it would be as unhelpful and misleading to compare Islamic art with Buddhist or Christian art as it is to compare it with any of the national styles. Nevertheless, the few salient features distinguishing Islamic art—notably its non-figurative and non-symbolic nature—arise directly or by implication from the Koran or the Hadith. And, more positively, the basic impulse behind Islamic artistic creativity may be traced, if not to the Prophet's teaching, then to his message in a wider and perhaps deeper sense. A ninth-century Muslim mystic described the tones of a flute as 'the voice of Satan crying over the world because he wants to make it outlive destruction; he cries over things that pass; he wants to reanimate them, while God only remains. Satan has been condemned to hold to things that pass and this is why he cries.' To the Muslim, God is the only reality. The world of the senses—of sight and touch—is transient and vain. Its beauty is evanescent, but all the more poignant and exquisite and desirable, all the more passionately to be cultivated and enjoyed. It might be said that Islam inspired no religious art— only an art that just stopped short of being irreligious.

9 The European Middle Ages

A crucifix in Cologne Cathedral (9, 1) dates from about the same decade of the tenth century as the *mihrab* in the Great Mosque at Cordoba (8, 17). Nothing could be further removed from the ideals of Islam or, indeed, of any of the other great religions of the world than this harrowing image. The degraded, humiliated, suffering god in human form is a peculiarly Christian conception. It reflects aspects of Christian thought which did not, however, become central until the Middle Ages. The early Christians had depicted Christ as healer, teacher, law-giver or judge (7, 9; 10). For them, the cross was a symbol of triumph over death, and the Crucifixion was seldom represented even in cycles of New Testament subjects (see p. 225). Byzantine artists sometimes depicted it after the Iconoclastic period, but always with a restrained and dignified, often rather ceremonial, remoteness stressing its sacramental significance rather than the painful actuality. Nor did they depart very far from Greek ideals of physical beauty in representing the incarnate deity.

There is no precedent for the stark and anything but idealized figure in Cologne Cathedral, a Christ exhausted by physical pain and torment, chest strained to the limits of endurance, stomach bulging, head slumped forward with eyes closed and mouth very slightly open. It was carved for Gero, archbishop of Cologne (969–76), and is the earliest known instance of that preoccupation with Christ's agony which originated in northern Europe and was to become a distinguishing feature of Western Catholic, as opposed to Eastern Orthodox, Christianity. No image other than that of Christ on the cross was appropriate for a church, Bernard of Angers declared in about 1020. Only in the West was it believed that the miraculous reproduction of the stigmata—the five wounds in Christ's hands, feet and side—on the body of a living man or woman was a gift of divine grace. They were received by St Francis of Assisi in 1224 (see p. 300) and later, with the pain but without the visible signs, by St

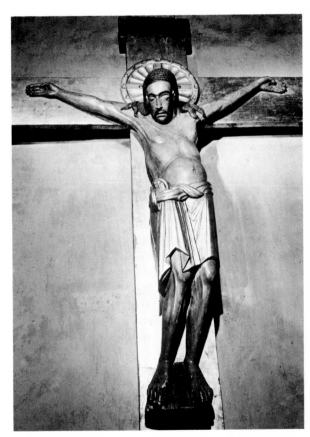

9, 1 Cross of Gero, 969–976. Oak, height 73⅝ins (187cm). Cologne Cathedral.

Catherine of Siena. Only in the West did lay confraternities of flagellants whip themselves in public, so that, according to an early thirteenth-century writer, onlookers 'shed floods of tears as if they saw before their own eyes the very Passion of the Saviour'. To present events of the Gospel story, and especially the Passion, so vividly that spectators might feel they

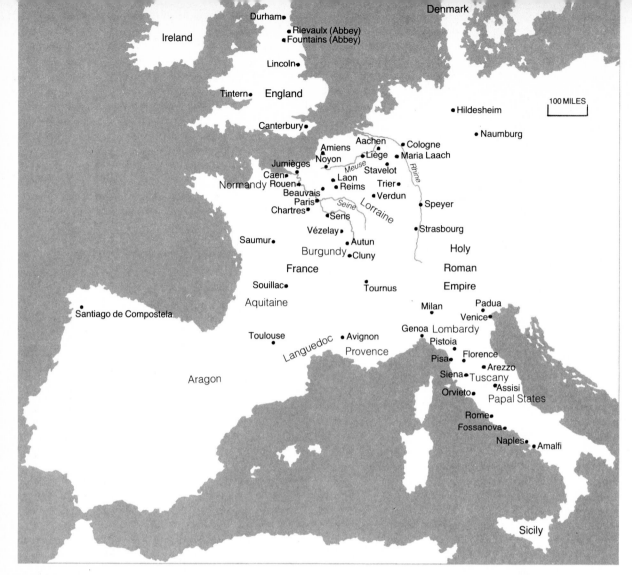

Map of Europe in the Middle Ages.

were participants was to be one of the prime aims of western European artists throughout the Middle Ages, setting their imagery ever further apart from that of Byzantium.

A different image of Christ appears on a large boulder carved between 965 and 985 at Jelling in Denmark (9, 2). He is here shown bound in toils of interlace. Such patterns of twisted and knotted ropes and thongs had been painted on Insular manuscripts two centuries earlier (see p. 244), but at Jelling they seem to evoke a Christ already absorbed into a Nordic world of elemental gods and magic charms. The stone was carved at the command of King Harald Bluetooth, who, so the runic inscription claims, 'conquered all Denmark and Norway and made the Danes Chris-

tians'. For more than 100 years these people—called Danes and Norsemen in England, Normans in France—had been feared as remorseless pagans in Christian Europe. 'From the fury of the Norsemen, Good Lord deliver us', was a phrase inserted into many ninth-century litanies. Harald Bluetooth's attempt to impose Christianity on his subjects was a failure and led to his deposition. The conversion of Denmark and Norway was not effected for another century, and Sweden held out still longer. But Northern artistic traditions of intricate flat patterning were to contribute much to the creation of medieval art in Western Christendom.

Very different in spirit and significance, though only a little later in date, is a magnificent gold cross in the Palatine Chapel at Aachen, studded with emeralds, amethysts, rubies and pearls in exquisite gold filigree

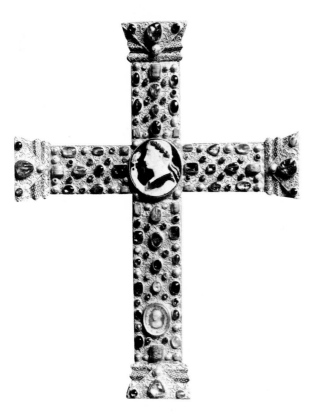

mounts (9, 3). Whenever funds permitted, crosses, liturgical vessels and reliquaries were encrusted at this period with precious stones, like those of which, according to the *Apocalypse*, the heavenly Jerusalem will be built. Sometimes antique gems were used, despite the pagan subjects incised on them. One, of the three Graces, is set on its side in the cross at Aachen. But the most prominent gems were chosen carefully and with intent: in the centre an ancient Roman cameo of Augustus with imperial insignia and, lower down, a rock-crystal intaglio with the head and title of Lothar II, king of Lorraine (855–69), a great-grandson of Charlemagne (see p. 251). The idea of such a *crux gemmata* or jewelled cross goes back to the emblem adopted by Constantine, the first Christian emperor. And this spectacular example was made for the Holy Róman Emperor Otto III (983–1002), who was possessed by the ambition to recreate the empire in the west. The victory of Christ—*Christus triumphans*—is symbolized by the imperial Classical imagery. On the reverse side, however, there is an engraving of the dying or dead Christ, closer to Byzantine formality than to Archbishop Gero's crucifix, with the hand of God the Father reaching down from above and holding a wreath which encloses the dove of the Holy Spirit—so that the three Persons of the Trinity are represented. When displayed in the ritual of imperial coronations, this side faced the clergy, the other the emperor. In this way the cross as a whole symbolized the union of Church and State under an emperor anointed and crowned by the Pope, a union passionately sought throughout the Middle Ages but rarely achieved.

The complexities of early medieval civilization—of which the cross of Lothar is so eloquent an emblem— reflect its origin in the turbulent centuries following the death of Charlemagne in 814. His empire had begun to crumble internally a decade before then and very quickly disintegrated into anarchy within the three areas nominally ruled by his descendants—roughly corresponding with present-day Germany, France and a central strip running from the Netherlands to Switzerland. It also came under constant attack from outside. Muslims from Spain marauded southern and central France in search of loot and slaves. Vikings harried the northern and western coastlands and sailed up the rivers to the interior—Cologne, Rouen, Nantes, Orléans and Bordeaux had all fallen to them before 888. Then a new menace appeared: Magyars from central Asia swept into Europe, penetrating as far as Pavia in Italy by 899 and southern France by 917. Not until 924 were they forced to withdraw to Hungary and lead a more settled life.

9, 2 *Top* Rune stone, 965–986. Jelling, Denmark. Granite, height 96ins (244cm) (presumed colouring restored).
9, 3 *Above* Cross of Lothar, c. 1000. Gold, filigree, precious stones and cloisonné enamel, height 19½ins (49.8cm). Aachen Minster Treasury, Aachen.

In 911 the king of the western Franks granted territorial rights to a Viking band who had settled in what was later called after them Normandy, their leader being titled a duke and baptized a Christian next year. The Normans were to play a very important part in medieval Europe, especially in the long struggle between Popes and Holy Roman Emperors. By 1053 a group of Norman adventurers had moved into southern Italy, where they took possession of the last Byzantine colony in the west and went on to oust the Muslims from Sicily, while Duke William effected the conquest of England in 1066.

If the century that followed the death of Charlemagne was perhaps the most turbulent in the history of Europe, it was also the period in which the foundations of its medieval civilization were laid. Germany and France began to take shape under their own ruling houses and to develop individual cultures. Within them new social structures were built up from the complex relationships binding vassal to lord, in chains which extended from peasant to king—what is now called 'the feudal system', though there were several kinds of feudalism and none was systematic. Similarly, monasticism developed organically, gradually acquiring the importance of a supranational force. But not until the tenth century did the arts begin to revive.

Ottonian art

Recovery from the century of terror came first in Germany with the re-establishment of stable government by King Henry (919–36), consolidated by his son Otto I (936–73), who was crowned by the Pope in Rome in 962 as the first of a new line of Holy Roman Emperors. Ottonian art, named after Otto I and his descendants who ruled Germany and northern Italy until 1056, was in some respects a conscious revival of the Carolingian style, with strong imperialist overtones. The abbey church of St Pantaleon in Cologne, financed by Archbishop Bruno, youngest brother of Otto I, harked back in plan to Carolingian churches (e.g. St Riquier, see p. 249), with a westwork that remained little altered when the rest of the church was reconstructed in later centuries (9, 4).

Imposing westworks, such as that at St Pantaleon, are typically Ottonian—not least in being Carolingian in origin, the interior incorporating an upper-floor chapel looking down the nave to the high altar at the other end, as did Charlemagne's throne in the Palatine Chapel. But although Ottonian art, like the Ottonian

9, 4 *Above left* St Pantaleon, Cologne, c. 980.
9, 5 *Left* San Miniato al Monte, Florence, begun 1018.
9, 6 *Right* St Mark's, Venice, begun 1063.

imperium, derived inspiration from Carolingian precedents, it was by no means backward-looking. There is a new boldness in the massing of solids in the westwork of St Pantaleon and a new feeling for interior space at, for instance, St Michael's, Hildesheim. St Michael's has two chancels, two transepts and two apses, that at the west being raised above a semi-basement chapel or crypt. Different areas are thus clearly articulated, yet held together by a controlling mathematical scheme based on equal squares. The nave consists of three squares with piers at the corners and columns in between, a system of alternating supports for arcades which was to be widely followed in Germany for a century or more. It is a complex plan and breaks decisively away from the Early Christian basilica's monotonous procession of columns on either side of the straight path from west door to apse. At St Michael's the interior was conceived as an encompassing space and the main entrances were placed in the south flank so that the aisles into which they opened served as a narthex at right angles to the main axis with its balanced focal points. (The church was all but destroyed in the Second World War and has been rebuilt.)

The patron and, almost certainly, the architect of the church was the bishop of Hildesheim, St Bernward (c.960–1022, canonized 1193), formerly tutor to Otto III (grandson of Otto I), whom he accompanied to Rome in 1001—which suggests that the departure from the basilican plan must have been quite deliberate. His contemporary biographer described him as 'foremost in writing, experienced in painting, excellent in the science and art of bronze founding and in all architectural work'. He may, therefore, have done more than merely commission the great works in bronze for St Michael's. One is a 12-foot-high (3.65m) column with a spiral band of relief obviously inspired by the columns of Trajan and Marcus Aurelius in Rome (see pp. 169, 170), but illustrating scenes from the life of Christ and originally surmounted by a large crucifix (destroyed in 1544). A pair of bronze doors survives intact, about 15 feet (4.5m) high, each apparently cast in a single piece with figures in bold relief, some heads being almost in the round (9, 7). There are eight scenes on each door, from the Book of Genesis on the left reading down from the top, from the Gospels on the right reading in the reverse direction. This arrangement made it possible to confront subjects from the Old and New Testaments: the temptation of Adam and Eve is paired with the Crucifixion, for instance, to contrast the fall with the redemption of mankind. These subjects, though often depicted before in manuscript illustrations, which the

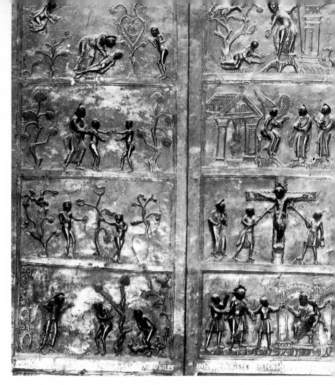

9, 7 Detail of bronze doors, with scenes from the Old and New Testaments, c. 1015. Hildesheim Cathedral.

designer probably consulted, had never been rendered with such common humanity and dramatic expressiveness. The sharpness of focus is such that each incident appears as if freshly imprinted on the artist's mind in a sudden flash of vision. Naked figures owe little or nothing to the Classical tradition of heroic nudity. They have a kind of natural gaucherie, a heaviness of trunk and weakness of limb suggestive of the frailty of the spirit within the flesh. Adam and Eve, meeting one another for the first time, seem tremulously shy. They gain self-confidence in the scene of the temptation, but after they have eaten the forbidden fruit and God points an accusing finger, they cringe with shame, Adam passing the blame on to Eve, who points to the dragon-like serpent at her feet.

Similarly in painting, a desire for greater emotional expressiveness is now increasingly felt and found an outlet in a new type of liturgical book which came into use during the Ottonian period, the *Pericope*. In this texts were cut up and arranged according to liturgical usage. There was no place for 'portraits' of evangelists, which had prefaced each Gospel in Carolingian manuscripts, and incidents from the life of Christ, commemorated in the festivals of the liturgical year, were depicted instead. Inspiration for them was initially derived from Byzantium (close connections between the Ottonian court and Constantinople were

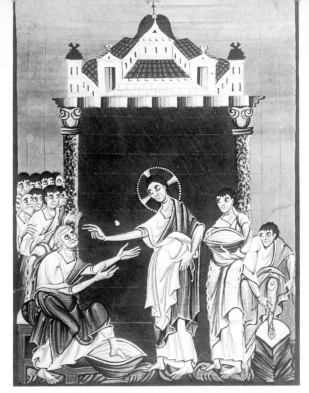

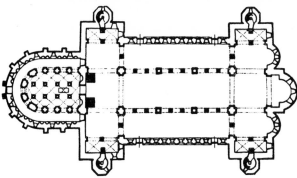

9, 8 *Christ washing the Apostles' feet*, from the Gospel Book of Otto III, c. 1000. Illumination. Bayerische Staatsbibliothek, Munich.
Plan of Hildesheim Cathedral.

cemented by the marriage in 972 of Otto II to a Byzantine princess). But distinctive styles were soon evolved.

A group of outstandingly fine manuscripts has been associated with the Abbey of Reichenau (on an island in Lake Constance), though there is no evidence that they were produced there. An illustration from the Gospel book of Otto III epitomizes the style (9, 8). It represents Christ preparing to wash the feet of the disciples, an act of humility annually commemorated in Constantinople by the Byzantine emperor and in Rome by the Pope (who, to this day, ceremonially washes the feet of 12 men the day before Good Friday). Here there are elements derived from Classical

antiquity by way of Byzantium but used out of context, almost like the engraved gems embedded in a reliquary or cross. A Hellenistic statue of an athlete provided the distant model for the disciple undoing his sandal on the right. The figure of Christ, beardless as in Early Christian art, harks back to still earlier Roman relief carvings of a physician healing a patient, here replaced by St Peter. Christ and St Peter are hierarchically larger than the other figures: Christ's right arm is greatly lengthened to emphasize the gesture of benediction, while St Peter similarly speaks with his hands in the dumb-show soon to be conventionalized as a visual language throughout medieval Europe. The buildings at the top also have a Roman origin in stage scenery and mural paintings (5, 18), but the sense of perspective recession has been lost and they have all been flattened into a symmetrical motif crowning a frame filled with gold. They should be read as the earthly Jerusalem in front of, not above, the pure gold space of heaven within the frame, distinguished from the atmospheric mundane space in which the disciples move.

In this characteristically Ottonian miniature all sense of Classical rationalism has been lost. Instead a solemn monumentality is combined with a vibrant inwardness, an unworldly, visionary quality with sharp attention to actuality, surface patterns of flowing lines and rich bright colours with passionate emotionalism. Such conjunctions and syntheses typify the art of the Ottonian period and of the centuries that immediately followed. With the crucifix in Cologne Cathedral and the bronze doors at Hildesheim, this miniature signals the beginning of a new period in the history of European art.

Romanesque architecture in Italy

By 961–2 Otto I had moved into Italy and restored relative political stability after more than 100 years of internal anarchy, aggravated by the attacks of the Magyars and the Saracens (as Muslims from north Africa were known in Italy, from the late Latin name for Arabs). This created conditions propitious not only for economic recovery but also for the rise of the communes or city-republics—the most important event in Italian history since the fall of the Roman empire and one that was to affect every aspect of political and cultural life in the peninsula for centuries.

About the year 1000, so the monk Raoul Glaber wrote a few decades later, 'it befell almost throughout the world, but especially in Italy and Gaul, that the fabrics of churches were rebuilt, although many were still seemly and needed no such care; but every nation in Christendom rivalled with the other, which should

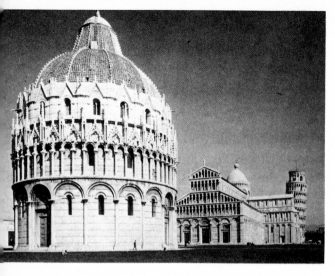

9, 9 *Above* Baptistery, cathedral and campanile, Pisa, 1053–1272.

worship in the seemliest buildings. So it was as though the very world had shaken itself and cast off her old age, and was clothing herself everywhere in a white garment of churches.' In Italy this outburst of church building and rebuilding in the late tenth and early eleventh centuries led to no immediate change in style. Conservatism was the order of the day. Early Christian plans and decorative schemes were revived, especially in Rome, where one church, S Clemente, completely rebuilt after 1084, was later mistaken for a fourth-century basilica. Church builders in Lombardy reverted to a style of brick architecture, with brick and rubble vaulting, which had been first introduced about 800 (there is still much doubt about the date of some churches in and around Milan, variously assigned to the early ninth or the eleventh century). In Tuscany, too, they adhered to traditional plans but evolved a distinctive Classicizing style for the exterior elevations, most notably in Pisa and Florence. It is sometimes called the Tuscan 'Proto-Renaissance'.

The church of S Miniato al Monte overlooking

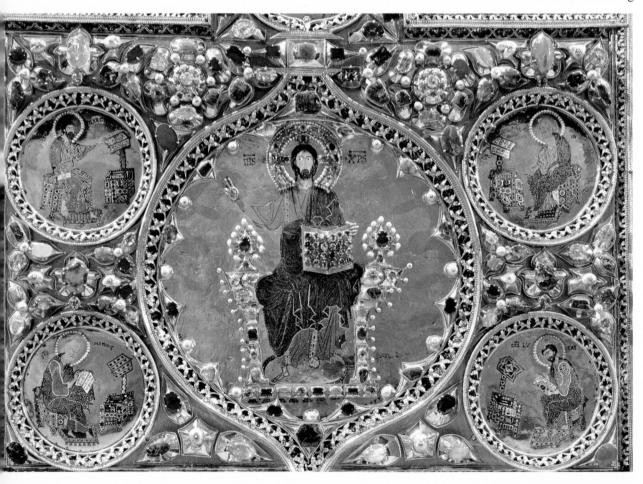

Florence is probably the earliest surviving example, begun in 1018 (9, 5). In general outline, the façade emphasizes the basilican form of the interior with a tall nave flanked by aisles. But its lower register (probably completed by 1062) is a shallow arcade with Corinthian columns framing three real and, for symmetry, two false doorways. The later (twelfth-century) upper part was designed as a Classical temple front, with the un-Classical insertion of a simulated arcade between the entablature and the pediment. The whole surface is clad in white and green marble in geometrical patterns of taut, clean elegance, lending it the dignified restraint and intellectual sharpness characteristic of later Tuscan art. The same style was adopted for the exterior of the most important religious building in Florence itself, the Baptistery, dedicated to the city's patron St John the Baptist. Both buildings date from the years when Florence was winning its way to acceptance as an independent republic.

At Pisa, on the coast only 50 miles (80km) west of

9, 10 *Below left Christ in Judgement and the Four Evangelists*, detail from the Pala d'Oro, 1105. Enamel and gold, $7\frac{1}{2} \times 4\frac{3}{4}$ins (19.5 × 12cm). St Mark's, Venice.
9, 11 *Above The fleet sails*, detail from the Bayeux tapestry, c. 1073–83. Wool embroidery on linen, height 20ins (50.8cm). Musée de l'Evêché, Bayeux.
9, 12 *Below* St-Sernin, Toulouse, c. 1080–1120.

Florence, churches were built on similarly traditional plans, but decorated externally in an increasingly divergent style. The monk Raoul Glaber's remark about the 'white garment of churches' is nowhere more vividly brought to mind than in the Piazza del Duomo or Cathedral Square of Pisa (9, 9). Clad in white marble with thin horizontal lines of black, which give a gently shimmering effect, the cathedral, the Baptistery, the leaning tower or campanile, and the walled cemetery still have a brilliance that is almost blinding on a sunny day. The cathedral was begun in 1063 to the design of an architect whose sarcophagus is embedded in the wall and inscribed in Latin: 'Unequalled is the temple of snowy marble which was in very truth made by the talent of Buscheto'. Buscheto must have been responsible for the remarkable decorative scheme of very shallow, elegantly attenuated arcading, with windows and lozenges of coloured marbles alternating in the arches, which was maintained when the nave was extended to the west and the present façade built (completed in 1162). It was also adopted for the 'ground floor' of the Baptistery (begun 1152) and the campanile (begun 1173)—the famous leaning tower, whose foundations began to shift in the course of construction.

The idea of sheathing buildings in marble came, of course, from ancient Rome (see p. 159), and Pisans were able to obtain the material from nearby quarries used since the time of Augustus. Marble dignifies a building, as do columns; and at Pisa columns were used equally lavishly, no longer attached to the wall but free-standing and supporting open galleries or loggias on the cathedral façade, apse and campanile. The profusion of columns, rank above rank, on church fronts became the hallmark of a style which spread inland (though not as far as Florence) and appeared wherever Pisan influence was felt, in Sardinia and Corsica and the far south of Italy (e.g. at Troia in Apulia).

Pisa, formerly an important imperial Roman naval base, so prospered from trade with the eastern Mediterranean that at the beginning of the eleventh century it was recognized as a free republic. In alliance with the Genoese and later the Normans in southern Italy, the Pisans waged war on the Muslims, and it was loot from Muslim ships, taken at a battle in the bay of Palermo in 1062, that provided the funds to begin Pisa Cathedral. According to a contemporary chronicler, the Pisans 'declared with unanimous consent that a splendid temple should be erected worthy of the Divine Majesty, and also such as to command universal admiration'. Ninety years later they celebrated a victory over Amalfi, a rival (Christian) maritime

republic in southern Italy, by building the Baptistery. These great buildings in the Piazza del Duomo are, therefore, direct reflections of the thrusting expansion and prosperity of the Pisans, much augmented at the beginning of the twelfth century, when they were shipping crusaders to the Holy Land at considerable profit. They are, in a sense, both civic and religious, rather as ancient Greek temples had been—monuments of a proud republic. Perhaps significantly, at a time when it was usual to state that a building had been erected 'by' the patron who commissioned it—emperor, king, pope or bishop—the Pisans recorded the names of the individual architects in inscriptions on the fabric: Buscheto, Rainaldo, who began the cathedral façade, Diotisalvi, who designed the Baptistery.

These buildings at Pisa, and also S Miniato al Monte and the Baptistery at Florence, are usually called 'Romanesque'. Originally meaning 'debased Roman', the term was invented in the early nineteenth century to categorize medieval architecture which retained the column and round arch, before the adoption of the pointed Gothic arch. It thus embraces architectural styles (and by extension painting and sculpture) still more widely divergent than the Pisan and Florentine—those of the great abbey churches of Germany and France, for instance, and the buildings of Norman Sicily, which owe as much to Islam as to Rome. But early medieval Venetian architecture is generally excluded.

S Marco in Venice is essentially Byzantine, designed by a Greek architect about 1063 and closely modelled on the Church of the Holy Apostles in Constantinople (tenth century, but destroyed 1469), with a quintessentially Byzantine 'quincunx' or cross-in-square plan with five domes, one over the centre and one over each of the arms (9, 6). It was built as a chapel attached to the palace of the Doges, the elected leaders of the Venetian republic, and had functions akin to those of Hagia Sophia in Constantinople and the Palatine Chapel in Aachen. As such, it was, still more obviously than Pisa Cathedral, a monument to the power of the state. Although few church interiors create a more deeply spiritual atmosphere than this, with its dim light, mysterious spaces and the lean faces of ascetic saints staring out of the gleaming gold mosaics on wall and roof, none was more inspired by temporal, non-religious ideals.

Venice was founded in the fifth century and soon came under the rule of the eastern (Byzantine) empire, to which it long remained attached—though only nominally after the end of the ninth century, when it became a virtually independent state (called a republic,

but oligarchic rather than democratic) and grew rich from trade between northern Europe and the Near East. Venetians acknowledged their dependence on Constantinople only when it suited them, but S Marco was built between 1063 and 1094 under three pro-Byzantine doges, one of whom was married to a sister of the Byzantine emperor. Shortly after its completion, the Pala d'Oro—the gold altarpiece on the high altar—was enlarged by the addition of cloisonné enamel plaques (see Glossary) either imported from Constantinople or made by Byzantine artists in Venice (9, 10). These panels are among the finest Byzantine works of art of their time, of a superbly sophisticated elegance of line and colour.

Much of the present appearance of S Marco (and its Pala d'Oro) is the result of later workmanship and of later events in Venetian history. In 1204 the Venetians turned the tables on Byzantium by diverting a crusade from fighting the Muslims and leading it instead to sack Constantinople, after which they became for a time rulers of the eastern empire. In the following centuries, as Venice grew still richer by supplying Eastern merchandise to northern Europe, the interior of S Marco was gradually transformed with mosaics in non-Byzantine styles. Windows were filled in to provide additional wall space, thus dimming the light to which Byzantine architects gave such importance (see p. 235). S Marco symbolizes the rise of the Venetian republic to international importance and, by implication, its independence even from the Papacy. In fact, the bishop's church, the Cathedral of Venice, is a quite modest structure in comparison to S Marco and stands in a part of the city remote from the Doges' Palace and the centre of power.

Romanesque art and architecture in northern Europe
The flowering of Romanesque art and architecture in late eleventh-century France came after a long, bleak period. France suffered more from the disintegration of Charlemagne's empire than Germany; many towns had been devastated by Vikings, Muslims and Magyars, and recovery was slow. In 987 the west Frankish nobles (they can hardly be called French as yet), who ruled a patchwork of independent duchies and counties, elected as king the undistinguished Hugh Capet. But the territories under his direct control and that of his immediate successors, in the Ile de France around Paris, were poorer and less extensive than those of his more important nominal vassals—including the dukes of Normandy, who became kings of England in 1066 and ruled an exceptionally well organized state on both sides of the Channel. The Church, which held more land than any single lay

ruler, was the only unifying institution, overlying and touching at many points the secular structure. Some bishops were, in fact, great feudal lords, and many bishops and abbots were members of the ruling families. It was, nevertheless, from French monasteries—first Cluny, then Cîteaux—that two major movements for religious reform radiated out to the rest of western Christendom, with momentous consequences in the visual arts, especially architecture expressing both temporal and spiritual authority.

In 910 the duke of Aquitaine bequeathed a large tract of land to establish a monastery at Cluny, with the unusual condition that it should be exempt from ecclesiastical, as well as secular, interference. This differentiated it from the many monastic houses in France which had come under lay control (to the detriment and sometimes extinction of contemplative religious life), and also from those in Germany, which Otto I had made into imperial foundations. Benefiting from his unique situation, the second abbot of Cluny, St Odo (879–942), founded a kind of monastic empire by uniting under his authority a number of houses, from which a reformed Catholicism generated the militancy of the Church in the eleventh century. (Pope Gregory VII, who humbled the German emperor Henry IV at Canossa in 1077, and Pope Urban II, who summoned Europe to the first crusade in 1095, both began as monks at Cluny.) The first monastery at Cluny was already proving too small by 955, when

9, 13 Cathedral of Santiago de Compostela, c. 1120.

work began on a new church vaulted with stone and surrounded with cloisters, dormitories, refectory, farm buildings and so on, all laid out on a clear rectangular plan. Before the end of the century more buildings were needed and a third and greater church was begun in c. 1085. It remained for long the largest in the world. (Only the southern end of the transept survived destruction in 1810.)

The Cluniac Order set new standards for religious life and monastic organization, and also for churches whether of their own or other orders—large fabrics of imposing magnificence, boldly planned, solidly constructed with great stone vaults. It did not, however, initiate a new architectural style so much as accelerate developments that had already begun elsewhere at about the time of the Order's foundation. St-Sernin, Toulouse, contemporary with the third church at Cluny, though much smaller, derives from the same origins and its form was determined by similar structural possibilities, functional needs and spiritual ideals (9, 12). Proportions were conditioned by the use of stone vaulting—a single great tunnel vault along the nave, strengthened with diaphragm arches—instead of the flat timber ceiling with which church naves had been covered during the earlier Middle Ages and often still were, as at Pisa. Many French churches with wooden roofs had been burnt out in the troubles of the ninth and early tenth centuries; but it was not solely in order to lessen the risk of fire—a hazard even in times of peace—that efforts were now being made to recover the ancient Roman art of large vault construction. Stone gave a nobler and more solemn effect and also provided better acoustics for the sonorous Gregorian chant, which had become an essential part of religious services, especially in monastic churches.

Externally the emphasis at St-Sernin is placed firmly

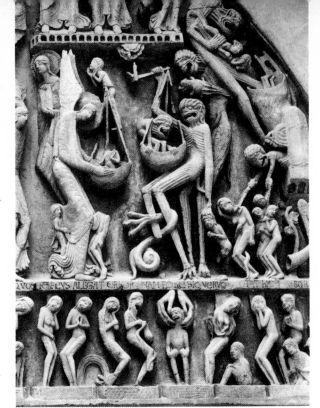

9, 15 Gislebertus, *Last Judgement*, c. 1130. Detail of the tympanum, Autun Cathedral.

on the east end, enclosing the choir and the high altar (the west end with its twin towers is unfinished). From the large apse and also from the east walls of the transept small apses project, presenting a bold grouping of rounded masses crowned by the great octagonal tower rising above the crossing (heightened in the thirteenth century by the addition of two upper stages, not shown here). St-Sernin was the church of a house of Augustinian canons (priests who lived a communal life according to a rule less strenuous than that St Benedict had prescribed for monks). The little apses enclose chapels with altars so that several priests could say mass at the same time. Church plans of this type, incorporating numerous small chapels into a unified organic structure, had been evolved in the course of the previous 100 years or so in response to the relatively new practice of daily celebration of the mass by every priest. The daily mass and the increased number of priests in monastic houses were among the more conspicuous results of the great religious reform movement of the mid-tenth century. But the apsidal chapels in St-Sernin were also used to display relics, which could be seen from the ambulatory dividing them off from the choir. The long nave and wide transepts with galleries above the aisles were intended to accommodate pilgrims. For St-Sernin was one of

9, 14 Initial Q from St Gregory's *Moralia in Job*, 1111. Detail of illuminated manuscript. Bibliothèque Municipale, Dijon (MS 170, folio 41).

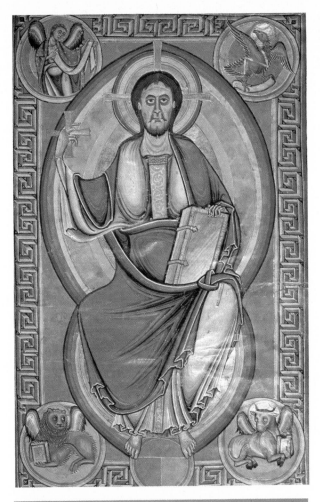

the many 'pilgrimage churches' built on the roads leading across France to the shrine of St James at Santiago de Compostela, in the north-western corner of Spain.

The Cathedral of Santiago de Compostela is more grandiose than St-Sernin, with perhaps the most impressive of all Romanesque interiors (9, 13). An enormous tunnel vault is supported on square stone piers with four attached half-column shafts, which divide the space into its component parts and, visually as well as structurally, bind it into a coherent whole. One shaft is extended the entire 68 feet (21m) height of the nave to carry a transverse arch, that on the other side carrying an arch of the aisle. The other two support the stilted round-headed arcade and seem to be continued within the stonework to re-emerge in the double arcade of the gallery. Lighting in the nave is indirect, filtered from the outer windows of the aisles and galleries, but at the crossing it is direct and floods the central area with sunlight, emphasizing the stable bulk of walls and piers. Masses of almost unbroken masonry, squared and rounded blocks of brown granite, define the geometrically simple volumes of this great interior space. Solid, dignified, inflexibly self-assured, it is a masterpiece of the Romanesque style. Here can be felt, more strongly than anywhere else, the style's origins, not so much in ancient Roman basilicas and temples as in Roman engineering and utilitarian architecture. In grave serenity it rises above the tumults of the Middle Ages, recalling the words of the Lord to Zachariah: 'Turn you to the stronghold, ye prisoners of hope.'

'The word pilgrim may be understood in a broad and a narrow sense', wrote Dante Alighieri in *La Vita Nuova* ('The New Life', c.1292). 'In the broad sense anyone is a pilgrim who is outside his fatherland: in the narrow sense only the man who travels to or from the sanctuary of St James.' From the beginning of the eleventh century increasing crowds of men and women trudged sometimes more than 1,000 miles (1,600km) along the roads of France and through the unfriendly landscape of northern Spain to Santiago de Compostela. Why it should have attracted more pilgrims than any other shrine is difficult to say: relative inaccessibility may, paradoxically, have been in its favour at a time when Jerusalem was too remote and the road to Rome seemed almost too easy. Pilgrimages to Compostela were, in any event, aided by the Augustinian and other religious orders, whose houses became

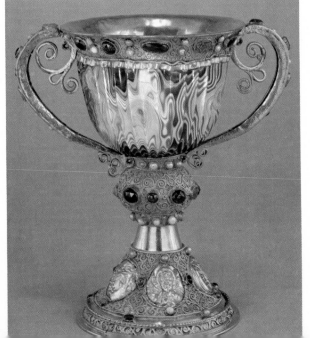

9, 16 *Above left Christ in Majesty*, page from the Stavelot Bible, 1093–7. Illuminated manuscript. British Library, London.
9, 17 *Left* Chalice, c. 1140. Agate and silver gilt. National Gallery of Art, Widener Collection, Washington DC.

hostels along the way and sometimes profited greatly from offerings. People went for a variety of reasons — in thanksgiving for divine favours received, to benefit from prayer at the end of the journey, and often as acts of penitence, to relieve the sense of sin that permeated religious thought in western Europe (see p. 250). Pilgrimages were a binding force in medieval life, bringing together clergy and laity, rich and poor, of different regions and languages, and quickening the diffusion of secular, as well as religious, culture.

Secular, almost as much as religious, art and culture depended on Church patronage. Leading churchmen used the knowledge of Classical Latin acquired in the cloister to write not only pious hymns and lives of saints but also poems in the manner of Ovid, recalling with ill-feigned regret the pleasures of wanton youth, when, as one recalled, 'my mind did stray, loving with hot desire'. At the same time, however, French vernacular poetry began to blossom in the charming *chansons de toile*, love songs for ladies to sing as they sewed, and the epic *chansons de geste* recounting the deeds of chivalry. The latter poems have a visual counterpart with a similar narrative structure in the Bayeux Tapestry (not a true tapestry with a woven design, but a 240-foot-long, 73m, strip of linen embroidered in coloured wools). In words and pictures it records the events leading up to the Norman Conquest of England in a sequence of separate scenes, each dominated by a few figures (9, 11). Emphasis is placed on actions with abrupt, stiff-limbed, but expressive, gestures and close attention to details of contemporary costume, armour, arms, horse-trappings, carts and boats. Although much is conventionalized, rudimentary naturalistic effects were attempted: figures in each group are approximately the same size and not scaled according to rank; boats in the distance are appreciably smaller than those in the foreground. Other figurative hangings are known to have been made about the same time, but none has been preserved. Nor are there many surviving examples of the secular works of art which are recorded as decorating the lodgings of abbots and priors, as well as feudal castles in the eleventh century.

The growing riches of the monasteries, especially Cluny, and the increasingly luxurious way of life adopted by abbots and priors, prompted a new call for monastic reform. In 1098 the stricter Cistercian Order was founded at Cîteaux some 15 miles (24km) south of Dijon. Here, as the old rule of St Benedict prescribed, the waking hours of the monks were divided between work and prayer. Work included the illumination of manuscripts, sometimes with scenes from daily life as well as religious imagery. Two of the brethren in ragged habits, indicating their avowed poverty, are, for instance, shown splitting a tree-trunk and composing the letter Q in a commentary on the Book of Job (9, 14). But even such innocent irrelevancies were frowned on by St Bernard of Clairvaux (1090–1153), the severest critic of monastic abuses who took command of the Cistercian Order in 1134. In a letter of 1127 denouncing the secular tone that had crept into monasteries, especially those of the Cluniac Order, he provided the most vivid description ever written of their carved decorations:

> In the cloisters, under the eyes of the brethren engaged in reading, what business has there that ridiculous monstrosity, that amazing mis-shapen shapeliness and shapely mis-shapenness? Those unclean monkeys? Those fierce lions? Those fighting warriors? Those huntsmen blowing their horns? Here you behold several bodies beneath one head: there again several heads upon one body. Here you see a quadruped with the tail of a serpent; there a fish with the head of a quadruped. There an animal suggests a horse in front and half a goat behind; here a horned beast exhibits the rear part of a horse. In fine, on all sides there appears so rich and so amazing a variety of forms that it is more delightful to read the marbles than the manuscripts, and to spend the whole day in admiring these things, piece by piece, rather than in meditating on the Law of God (St Bernard of Clairvaux, *Apologia ad Will-elmum Abbatem Sancti Theodorici*, tr. E. Panofsky).

When St Bernard wrote this denunciation the art of French Romanesque sculpture was at its height. Large-scale carving in stone had been little practiced anywhere in Europe since the fall of the Roman empire; now several different local styles developed almost simultaneously in central and southern France, like a spontaneous flowering after a long winter. It was limited almost exclusively to the capitals of columns and the main exterior entrances to churches. The Romanesque portal, consisting of a large semicircular tympanum carved in relief and resting on a lintel above the doorway, which usually had further carvings on its jambs, was given its characteristic form by about 1100. Christ was almost always shown in the centre, dwarfing all the other figures, and the favourite subject was the Last Judgement. The worshipper entered the church under the stern gaze of the all-seeing judge. That above the west door of Autun Cathedral in central France is prominently signed by Gislebertus, one of the few named Romanesque sculptors whose work has survived and master of a style which combines sophisticated delicacy of line with great

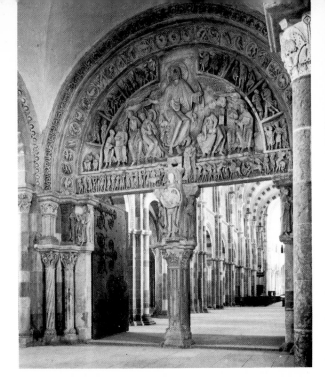

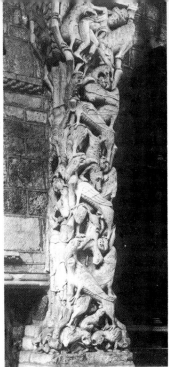

9, 18 Central portal of La Madeleine, Vézelay, 1120–32.

9, 19 Trumeau of the portal, abbey church, Souillac, Périgord, c. 1125.

dramatic intensity. On Christ's left hand, the souls of the dead are shown as they are weighed in the balance (9, 15)—a scene which had been depicted in ancient Egyptian art (3, 12). Little figures hide behind and clutch at the immaculately pleated robes of ethereally slender angels with faces and gestures of the utmost gentleness, while demons, open-jawed, claim the souls of the damned. In another part of the huge composition there are pilgrims among the saved, one wearing the cockle-shell badge (symbol of St James) to show that he has been redeemed by a visit to Santiago de Compostela, another wearing a cross to indicate the benefit of a visit to Jerusalem. Equally significant is the miser among the damned—a victim of the deadly sin of avarice, which inhibited gifts to the Church.

More robustly carved are the sculptures over the entrance from the narthex to the nave of the Cluniac abbey and pilgrimage church at Vézelay (9, 18). Christ is seated in majesty in the centre, sending the apostles forth on their mission to convert the heathen, heal the sick and cast out devils from the possessed—all of whom are shown on the lintel and inner archivolt (see Glossary). On the semicircle of the outer archivolt there are figures of men engaged in the 'Labours of the Months' and also the signs of the zodiac, in which the pagan gods lived on throughout the Middle Ages, here signifying Christ's rule over the cycle of the year. At the very top a man has twisted his body into a perfect

circle—an image of uncertain significance going back to Minoan gems. Among the many small figures of the unregenerate there are men with the heads of dogs (to the left of Christ's head) and men with huge wing-like ears (at the right end of the lintel), dwellers in distant lands, who had been described by Pliny and entered the medieval imagination through the encyclopedic writings of the seventh-century archbishop, Isidore of Seville. Here, however, they seem to illustrate a passage in Isaiah, which had come to be read as a prophecy of the apostolic mission and also, in the early twelfth century, of the 'liberation' of the Holy Land by the crusaders (in 1099). The integration of Old Testament, New Testament and topical concerns is very characteristic of medieval art and thought.

The sculptor of this great tympanum obviously learnt much from manuscript illuminations—the calligraphic swirl of drapery on Christ's left knee, for instance—yet the figures have considerable three-dimensional substance. The manuscript illuminator's conventional seated posture with knees bent has been adapted in such a way that Christ seems to be materializing out of the stone. His head breaks the inner archivolt, just as that of St John the Baptist standing on the trumeau breaks through the lintel. The semicircle of the arch conditioned, without confining, the composition of the tympanum so that it remains part of the fabric of the building visually, though it has,

285

in fact, no structural purpose or function. (It needs a special central member, the trumeau, to support it.) A tympanum exists solely in order to provide a field for relief sculpture, its only precedents being the painted or mosaic lunettes and conches of apses in Byzantine churches (7, 14; 21). The similarity of effect must have been striking when tympana still retained their painted surfaces, for they were brightly coloured as were all medieval carvings. Like an apse mosaic, the tympanum presents an image of heaven, linking the building with its prototype in the celestial Jerusalem. The idea of carving it in stone and placing it on the exterior to draw the attention of pilgrims and other visitors seems to have been conceived in France.

The trumeau supporting the lintel of the tympanum

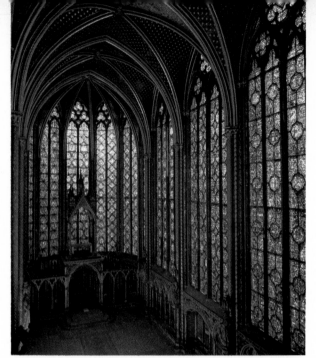

9, 20 *Right* Ste-Chapelle, Paris, 1243–48.
9, 21 *Below* Scene from the life of St. Eustace, north aisle, Chartres Cathedral, c. 1210. Detail of stained glass.
9, 22 *Far right* Rose window, north transept, Chartres Cathedral, France, c. 1230. Stained glass, diameter 42ft 8ins (13m).

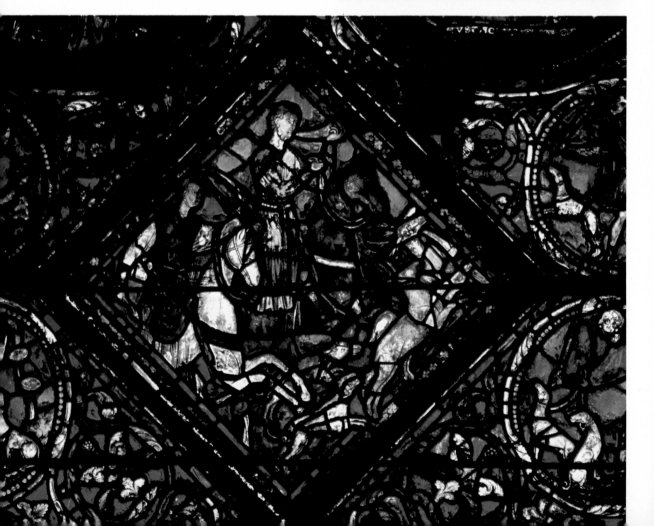

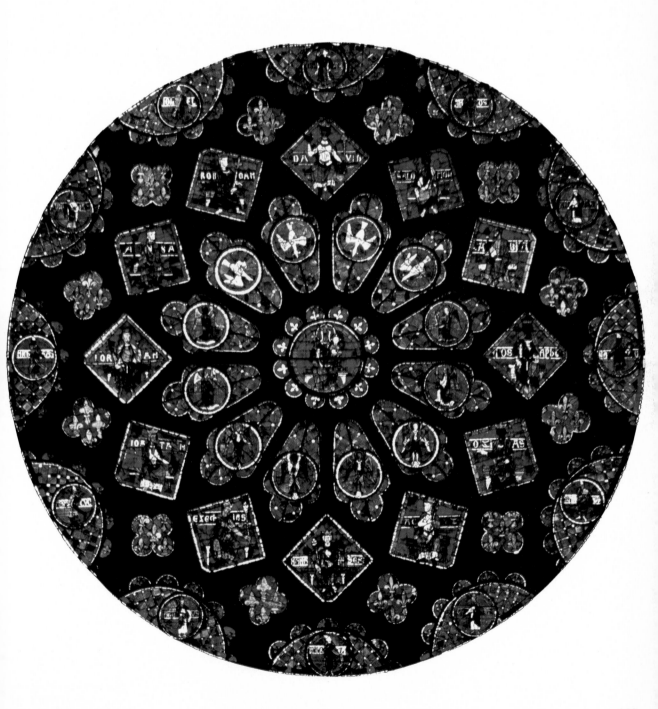

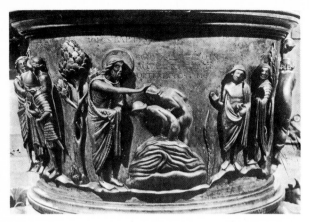

9, 23 Rainer of Huy. Detail of baptismal font, 1107–18. Bronze, height 25ins (63.5cm). St. Barthélémy, Liège, Belgium.

was also richly carved, never more strangely than at Souillac in south-western France (9, 19). Monstrous birds with heads twisted back, their huge beaks grabbing at suspended animals, clamber over one another to the top of the column, where one attacks a naked man. They are fiercer than the creatures in the margins of Insular manuscripts (7, 25), and personify the evil spirits which prey on human souls, as described by Marbod, bishop of Rennes (c. 1035–1123). It was carving of this kind, on the capitals of columns in churches throughout southern France, that aroused St Bernard's disapproval.

An entirely different type of sculpture made a sudden appearance about the same time on a bronze font cast at Liège (Belgium) in the prosperous valley of the Meuse, then on the north-eastern frontier of the Holy Roman Empire (9, 23). The font was inspired by Biblical accounts of the forecourt of Solomon's temple in Jerusalem, where a huge basin described as a 'molten sea' was supported on 12 oxen. Christ's baptism by St John and four other baptismal scenes are shown with figures so fully conceived in the round that they seem like statuettes detachable from the surface. In bodily proportions, poses, gestures and garments, they recall Classical models far beyond Byzantine, Carolingian or even Early Christian art. Their partly nude bodies have the sleek athletic flesh and even the hairstyle of ancient Greek youths. The contrast between them and the nude Adam on the doors at Hildesheim (9, 7) or the figures in French Romanesque tympana is very striking. It would seem extremely likely that the sculptor of the Liège font, traditionally identified as Rainer of Huy, had seen ancient Greek statues. Perhaps he was among the many crusaders from the Mosan region in Godfrey of Bouillon's army, which passed through Constantinople in 1096 on its way to the Holy Land. Constantinople was the one place where numerous examples of ancient Greek sculpture were still to be seen. (Very few remained above ground in Rome by this date.) The almost literal Classicism of his figures is unique in early medieval art.

Although there is nothing comparable in manuscript illumination of about this date in the Mosan region, a similar tendency towards monumentality is sometimes evident, as in the miniature of Christ in Majesty in a Bible from the rich and important monastery of Stavelot (Belgium) (9, 16). Modelling is bolder, lines are more firmly drawn than before with nervous touches only on the ruffled hem of the robe. Moreover, Christ seems to project beyond the frame, overlapping the roundels with symbols of evangelists that partly cover the sharply rectilinear fret of the border. The design is made up of separate elements, like plaques of embossed or enamelled metal superimposed on the ground. And it may well owe a debt to the metalwork, especially champlevé enamelling (see Glossary), for which the Mosan region was known at this date.

Innovations in Romanesque architecture

Architectural developments of great importance, which took place at the end of the eleventh century in both Germany and France, were at least partly

9, 24 Interior of the cathedral of Speyer, Germany, c. 1082–1106.

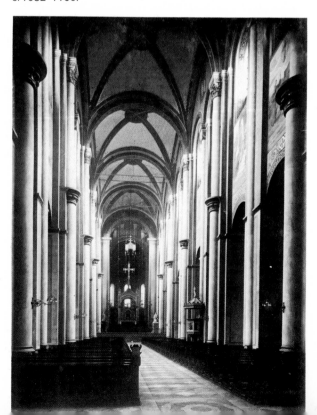

inspired by similar demands for greater unity of effect. The technical knowledge and skill required for stone-vaulting on a large scale had been recovered by the mid-century, as we have seen (p. 282), naves of churches being covered with simple tunnel vaults or with a series of tunnel vaults placed transversely. The transverse system, an ingenious alternative, survives at St Philibert, Tournus, vaulted shortly after 1066 with such a variety of different types that it might almost seem to have been an experimental workshop. It was probably in the course of developing these two main systems, the tunnel and the transverse, that the potential advantage of the groin vault—half one and half the other—became apparent (see Glossary). In a groin vault the weight is carried by the four corner points instead of by the whole wall—hence the greater difficulty in construction. Groin vaults were first used to span a wide nave at Speyer in the Rhineland, where the great, gaunt imperial cathedral, begun about 1030 with a flat timber ceiling, was remodelled between 1082 and 1106 (9, 24). The nave is 45 feet (14m) wide and 107 feet (33m) high—i.e. wider and higher than Cluny (40 feet, 12m, wide and 98 feet, 30m, high) and little short of the highest Gothic nave, at Beauvais. Grand and austere, as befitted the dynastic pantheon of the Franconian emperors, Speyer has all the defiance and assurance of German Romanesque. Lining the nave are huge piers with alternate engaged shafts forming blind arcades very reminiscent in their stern solemnity of a Roman aqueduct. They probably derive from the exterior elevation of the Roman basilica at Trier, less than 100 miles (160km) away. Unfortunately, the exterior of Speyer Cathedral has been much altered, but its originally splendid display of towers— octagonal, round and square—of double transepts and double chancels can still be seen on a smaller scale at the contemporary abbey church of Maria Laach, near Coblenz (9, 25).

Although the great vaults at Speyer were not formed by a true interpenetration of tunnel vaults, substantial transverse arches being needed to strengthen them, a very significant step had been taken. Even more significantly, projecting diagonal ribs—that is ribs constructed before filling in the intervening triangular webs and not imbedded in them, as ancient Roman ribs had been—followed only a few years later in widely separated locations in England, Italy and France. At Durham Cathedral they seem to have been intended from the start (1093); they were completed by about 1095 in the chancel aisles, by about 1104 in the chancel and by 1130 in the nave (9, 26). At S Ambrogio, Milan, they were probably built shortly after 1117 and at St-Etienne, Caen, between 1115 and

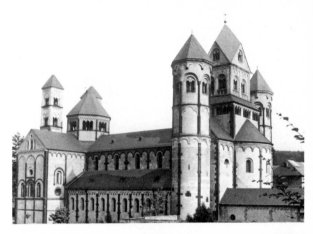

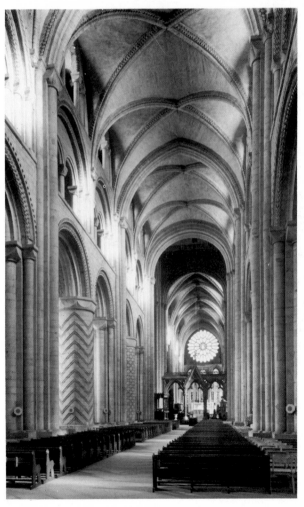

9, 25 *Top* Church of Maria Laach, Germany, late 11th century.
9, 26 *Above* Nave of Durham Cathedral, England, begun 1128.

1120, but here they were rebuilt in the seventeenth century (9, 27).

The introduction of ribbed groin vaults brought the medieval architect's quest for lofty, well-lit, fire-proof and aesthetically unified interior spaces close to a solution. And it raises the question of how far the evolution of vaulting was determined by aesthetic preferences. The notion that its development was due simply to the need for improved technical means for spanning wide naves now seems a nineteenth-century misinterpretation, important though structural considerations clearly were. Aesthetic motives must have been involved as well, as we have seen (p. 282); indeed, they were inseparable, except in retrospect.

Tunnel vaults were unsatisfactory not only because the massive stone piers and thick, unbroken walls needed to take their weight and outward thrust were both costly and cumbersome, but also because they accounted for much of the characteristic heaviness of Romanesque architecture. In addition, they tended to exclude light. Light could reach the chancel and nave only through the tribunes and galleries above the aisles, as at Santiago de Compostela (9, 13). Groin vaults, by spreading their weight, allowed space for clerestory windows above the tribunes; but groin vaults were difficult to form, required a great deal of woodwork for centering to support them while they were being built, and sometimes produced disturbing effects of double curvature. Rib vaults had the practical advantage that the ribs formed the supports and were built first, the webs between them being filled

9, 27 Interior of the abbey church of St-Etienne, Caen, early 12th century.

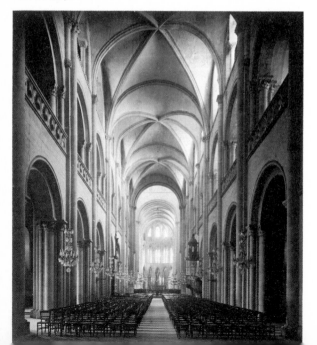

in later with lighter stone or other material, thus obviating the gigantic wooden frameworks formerly needed during construction. No less important, however, was the visual effect. The ribs integrated each bay (or double bay) into clearly defined units, while creating a firm rhythm that binds them all together and gives the whole interior space a lighter, less stern and forbidding appearance. Indeed, ribs may have been introduced initially for aesthetic rather than structural reasons, as their predecessors in the Islamic world had been. In Islamic architecture projecting ribs had been used from at least as early as the tenth century in domes and domical vaults where there was no real structural need for them at all, as in the Great Mosque at Cordoba (8, 16).

The rib vault was the most important structural device by which the inert masses of Romanesque architecture were gradually reduced and lightened, both in fact and in appearance. Its visual effect was emphasized, however, by combination with tall, thin shafts attached to the piers. These shafts, found separately at Notre-Dame, Jumièges (1037–66), rise from ground level up to the roof, and at Speyer, Durham, Caen and elsewhere appear to fan out across the vault as ribs, drawing the eye upwards so that it tends to overlook the solidity of wall and roof. At Caen a further and more daring refinement appeared for the first time, the sexpartite vault (9, 27). Created by adding a second transverse rib, cutting across the vault from side to side and splitting it into six compartments, the sexpartite vault greatly increased the unified effect of the interior space, especially when, as at Caen, it was used with a double-bay vaulting system. At Durham there was a third and perhaps more important innovation, the combination of rib vaults with pointed arches (9, 26). This might almost seem to herald Gothic effects of aspiration and upward growth. But Durham remains essentially Romanesque. The great bare round arches, block capitals and moldings of uniformly blunt simplicity, the sheer size of the massive piers with their deeply cut zigzags and other bold geometrical ornamentation, convey an overwhelming impression of absolute power and authority. Durham is the most forceful of all the noble expressions of that proud moment in medieval Christianity at the end of the eleventh century, when reform had triumphed at Rome and initiated the last great flowering of monasticism at Cîteaux, when the supremacy of the Papal tiara over the imperial crown had been asserted at Canossa with the humiliation of the Emperor Henry IV by Pope Gregory VII and the knights of Europe set out to recover the Holy Land in the first crusade (1095).

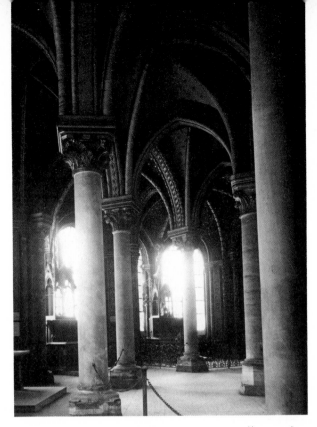

9, 28 Ambulatory of the abbey church of St-Denis, near Paris, 1140–44.
Plan of the *chevet* of St-Denis.

Gothic art and architecture

The ambulatory of the abbey church of St-Denis, now a northern suburb of Paris, holds a position of unique importance in the history of European architecture (9, 28). It is all that remains of the *chevet*, or east end, completed after only four years of work in 1144 as the first major part of any building in the Gothic style (the choir which it originally surrounded was replaced a century later). The ancestry of every subsequent Gothic church in the world—including the Episcopalian Cathedral in Washington DC, still in course of construction—can be traced back to it. Whether the builders realized the import of what they had done is, however, very doubtful. There is no hint that they did in either of the two detailed accounts of its con-

struction and decoration written by Suger (1081–1151), abbot of St-Denis, who initiated and directed the whole enterprise. Nor is the architect responsible for the epoch-making design named, though one must certainly have been employed.

No individual element in St-Denis was, in fact, completely new. Apses with radial chapels had been built much earlier, as at St-Sernin (9, 12), though they had not been planned so that space could flow round them uninterrupted by walls. Pointed arches and ribbed vaults—the most obvious characteristics of a Gothic interior—had also been used before, but not so consistently as to transform a Romanesque architecture of massive load-bearing walls into another (Gothic) one of slender supports with no inert matter, only active, thrusting energy. The architectural revolution effected at St-Denis was one of structural relationships rather than forms. It is in many ways analogous to the developing intellectual movement known as Scholasticism, which, without introducing original ideas, created a new and enduring structure of thought from a systematically dialectical reconciliation of the truths of reason and faith, philosophy and theology, Aristotle and the Bible. What was new, and strikingly so, at St-Denis was the way in which well-established techniques of construction were combined to create an interior of wholly unprecedented clarity. As Suger himself remarked, by virtue of the ambulatory chapels the whole church shone 'with the wonderful and uninterrupted light of most luminous windows, pervading the interior beauty'.

Although Suger wrote, and may have understood, little of architectural practice, his writings abound in remarks which reveal his purpose and suggest the crucial role he played as patron. In his account of the consecration of the *chevet* on 11 June 1144, for instance, he recorded how 5 archbishops and 14 bishops celebrated mass at the new altars in the choir, ambulatory and crypt beneath:

so festively, so solemnly, so diversely and yet so concordantly, and so joyfully that their song, delightful by its consonance and unified harmony, was deemed a symphony angelic rather than human; and that all exclaimed with heart and mouth: 'Blessed be the glory of the Lord from His place, Blessed and worthy of praise and exalted above all be Thy name, Lord Jesus Christ. . . . Thou uniformly conjoinest the material with the immaterial, the corporeal with the spiritual, the human with the Divine . . .' (E. Panofsky ed., *Abbot Suger on the Abbey Church of St-Denis*, Princeton 1979, p. 121).

The last words in particular might equally well refer to

Gothic architecture. Indeed, they indicate its essence most succinctly.

One source of Suger's inspiration for St-Denis is known. The monastic library owned a manuscript of writings attributed to 'Dionysius' (later called the pseudo-Areopagite), an important theologian who lived in Syria about 500 but was mistakenly identified with St Dionysius or Denis (the French form of the name), believed to have evangelized France. However, confusion could not have been more happily confounded. From Dionysius, who had fused the philosophy of Plotinus (see p. 175) with Christian theology, Suger derived the idea of God as the 'superessential light' reflected in 'harmony and radiance' on earth. The new *chevet*, 'pervaded by the new light', as Suger wrote, was thus designed to illustrate the Neoplatonic theology of the saint to whom it was dedicated. The brightly coloured gems with which Suger had the high altar, the great cross and liturgical vessels encrusted (9, 17) also reflected divine light 'transferring that which is material to that which is immaterial' and, he declared, transporting him 'from this inferior to that higher world in an anagogical manner'.

But the church had a political as well as a religious role. St-Denis was a royal abbey which enshrined the relics of the patron saint of France and, from Hugh Capet onwards, had been the burial-place of French kings. Suger himself had close ties to the royal house and was perhaps more active in the political than in the religious sphere. When he was elected abbot at St-Denis in 1122, the fabric was in a sad state of disrepair, the monastery's extensive estates were mismanaged and the morals of its monks were said to be lax. A contemporary called it a 'synagogue of Satan'. Suger was to reform all this. He began to raise funds for rebuilding in 1124 and continued while he was promoting the re-establishment of royal power in France as first minister to Louis VI (1108–37).

St Bernard of Clairvaux (see p. 284), a sharp critic of the monastery at the time of Suger's election, felt bound to congratulate the abbot on its reformation five years later. It is impossible to say how far, if at all, he inspired the design of the new church. But, about 1130, the archbishop of Sens, who had come under his spell, began to rebuild the *chevet* of Sens Cathedral with piers for vaulting similar to that at St-Denis (begun later but finished sooner). Ascetic, high-born, high-minded St Bernard was quite unlike the humbly born but rather worldly Suger with his devotion to royalty, his love of pomp and ceremony, his infectious delight in objects made of precious substances (9, 17). Yet both contributed to the creation of the nascent Gothic style.

Like Suger, St Bernard was deeply influenced by Neoplatonism, but in a very different way. In a typically Neoplatonic image he described the union of the soul with God as 'immersion in the infinite ocean of luminous eternity'. This spiritual, indeed mystical, view led him to join his voice to the mounting criticism of the mundane splendour of Cluniac churches, their vast size, their 'costly polishings, the curious carvings and paintings which attract the worshipper's gaze and hinder his attention'. Monks should, he thought, renounce 'all precious and beautiful things for Christ's sake . . . all things fair to see or soothing to hear, sweet to smell, delightful to taste, or pleasant to touch'. The abbey of Fontenay (1139–47), built while he was abbot, is in a kind of expurgated Romanesque. In this way the Cistercians created a version of the Gothic style that expressed their ascetic ideals. And they made it mandatory for all their houses—525, including nunneries, by 1200. Their churches with flat-ended choirs (no apses), slender Gothic windows and inspiring lofty vaults rely for effect solely on the well-cut precision of masonry and perfect balance of simple proportions. The many that survive (if only as ruins like Rievaulx, Fountains and Tintern in England) remind us that the effect of St Bernard's attack on Cluniac architecture was not negative. It directed attention away from ornament and decoration to form and structure.

The aim of Cistercian and other contemporary movements for monastic reform was a return to primal simplicity and purity, and this may partly account for some striking analogies between the essential principles of Gothic architecture and ancient traditions of timber construction. In northern Europe wood was plentiful and had always been the normal building material—as stone was in the south and mud-brick in the Near East. The basic unit of construction was that of the great barns on country estates: four upright posts joined at their tops by beams, which also support the sloping rafters of a pitched roof (in section a rectangle inscribed in a triangle). There can be little doubt that this skeleton was the origin of the 'bay system', which divides a nave into a sequence of equal compartments and distinguishes such northern churches as St Michael's, Hildesheim (see p. 276) or Santiago de Compostela (see p. 283) from Italianate basilicas. Clearer reminiscences of the primitive wooden skeleton reassert themselves in Gothic architecture, which, significantly, originated in the Ile de France, where timber construction was in general use.

Within two decades of the consecration of St-Denis, three great Gothic cathedrals were begun in the Ile de France: those of Noyon (c. 1150), Laon (c. 1160) and

Notre-Dame in Paris (1163). Soon afterwards the Gothic style is found elsewhere. When the choir of the monastic and cathedral church of Canterbury was burnt out in 1174 the monks engaged an architect, whom they called 'William', from Sens (see p. 292). One of the Canterbury brethren, Gervase, who chronicled the rebuilding, summed up the merits of the new style in what is the only known contemporary comparison of 'Romanesque' and 'Gothic':

> The pillars of the old and new work are alike in form and thickness but different in length. For the new pillars were elongated by almost twelve feet. In the old capitals the work was plain, in the new one exquisite in sculpture. There the circuit of the choir had twenty-two pillars, here are twenty-eight. There the arches and everything else was plain, or sculptured with an axe and not with a chisel. But here almost throughout is appropriate sculpture. No marble columns were there, but here are innumerable ones. There, in the ambulatory, the vaults were plain, but here they are arch-ribbed and have keystones. There a wall set upon pillars divided the crosses from the choir, but here the crosses are separated from the choir by no such partition and converge together in one keystone, which is placed in the middle of the great vault which rests on the four principal pillars. There, there was a ceiling of wood decorated with excellent painting, but here is a vault beautifully constructed of stone and light tufa (R. Willis, *The Architectural History of Canterbury Cathedral*, London 1845, pp. 58–60).

High Gothic

The amazing achievement of French architects in the early twelfth century was to create a system in which structure, construction and visually expressive form became indistinguishable in the Gothic cathedral—the building-as-symbol of an all-embracing religious faith. The system was, moreover, so flexible that it not only permitted variations in planning but also seems to have stimulated dynamic evolution as detail and carved decoration quickly reassumed importance. The early Gothic of St-Denis and Sens matured extremely quickly into what is called 'High Gothic' in three still more imposing cathedrals of northern France: Chartres, begun in 1194 and completed 1220; Reims, begun in 1212, and Amiens, begun in 1220. Jean d'Orbais (fl. 1212–29), the architect of Reims, had clearly learned much from the anonymous master of Chartres; and Robert de Luzarches, who designed the nave of Amiens Cathedral, was indebted to both. Masons and master-masons or architects travelled

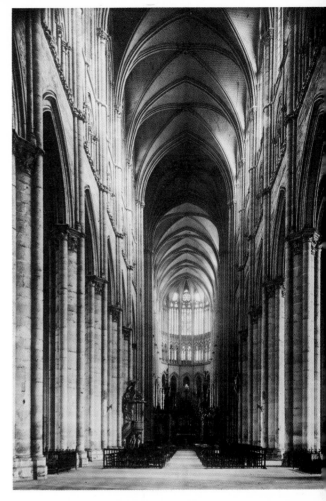

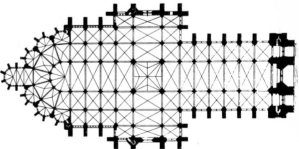

9, 29 Nave of Amiens Cathedral, France, c. 1220–36. Plan of Amiens Cathedral.

widely and it is more than likely that many made drawings of features of buildings that caught their attention. Villard de Honnecourt (fl. 1225–35), author of the only surviving architect's sketchbook of this period (9, 31), drew details of plans, structures and

decorations at Laon, Chartres, Reims and elsewhere, as far afield as Hungary.

The High Gothic interior reached its apogee at Amiens (9, 29). All reminiscences of Romanesque mass and weight have been obliterated in this huge, soaring interior space, three times as high as it is wide. In plan, too, it goes beyond its predecessors. The nave and chancel with an almost centrally placed transept, as at Notre-Dame in Paris and at Chartres, create a wonderfully smooth and limpid spatial rhythm. It is no longer split up, as in Romanesque churches, into numerous separate units which must be combined visually in order to grasp the totality, but is concentrated into a few, in fact, only three units—the transept acting as the centre of the balance. But the general and compelling momentum is vertical—one of long, upward, finely ruled lines yielding at their summit to the reserved grace of Gothic arches and weaving, as it were, the whole spatial envelope into a seamless garment of stone. Piers are no longer conceived as isolated supports like Classical columns, punctuating and therefore interrupting the horizontal flow, but rather as bundles of circular shafts, with those on the inner side reaching right up to the clerestory, where they branch out into the ribs of the vaults. Bays of vaulting are no longer square (and static) but oblong. The arches of the arcade are narrower than before and separated from tall clerestory windows only by a low triforium—an arched screen in front of a narrow passage—so there is nothing to hinder the eye's upward flight. In this way the impetus of the nave piers is accelerated vertically. It is also quickened horizontally in the apse, where the arcade becomes narrower, the arches more acute and the wall behind the triforium is replaced by windows, thus greatly strengthening the traditional axis from west to east, from entrance door to altar. This combines with the new and insistent verticality to direct the eye and mind heavenward, ever onward and upward. An exhilarating sensation of ascent is induced, as well as of propulsion along the nave, by the rapid succession of aspiring arches. And it is the precarious balance between these two axes that gives the interior its vibrant life and almost elastic tension, held together visually by lines as taut as the strings of a well-tuned musical instrument.

The interior of Amiens Cathedral beautifully exemplifies the lucidity of Gothic architecture, in which all the parts are related to each other and to the whole, both in form and proportions. This visual logic was originally raised to an even higher, transcendental plane by the unearthly light filtered through stained-glass windows and suffusing the whole space with immaterial colour. Church windows had often been filled with coloured glass since the fourth century (no crystal-clear glass was made until much later) and early theologians had endowed it with Neoplatonic significance. At least as early as the eleventh century the window sometimes incorporated figures composed like translucent mosaics from pieces of variously coloured glass overpainted in black to indicate details. It was at St-Denis that figurative stained-glass windows (only fragments of which survive) were first given the importance they were to retain for some four centuries in northern Europe. Suger saw in them a double symbolism, that of their subject-matter irradiated by the *lux nova*, or new light, of the Gospel. 'Miraculous' was the word he used for the light admitted by these 'most sacred windows'.

Chartres Cathedral still preserves most of its original stained glass, conceived as the source of both spiritual and physical illumination. Figures in each window or group of windows are theologically related to one another and to the doctrines illustrated in the whole series. Many are devoted to the cult of the Virgin Mary, centred on Chartres Cathedral, which cherished as its holiest relic the tunic she was believed to have worn when she gave birth. The Virgin with the Christ Child on her knee is in the centre of the great rose window of the north transept (9, 22). Around her, panels are arranged in symbolical twelves: angels, archangels and four white doves representing both the Holy Spirit and the Gospels, then in squares, the kings of Israel named by St Matthew as the ancestors of St Joseph, with prophets on the outer rim. Every element of the design points towards the Virgin and Child in an intricate network binding the Old Testament to the New. Other windows at Chartres illustrate scenes from the lives of saints (9, 21), reflecting a less strenuously intellectual and more popularly accessible tendency in religious thought, which was soon to inspire Jacobus de Voragine (c.1230–98) to collect all the colourful stories of saints into the *Legenda Aurea* or Golden Legend.

It is often said that windows such as those at Chartres constituted the 'Bible' of the poor and illiterate, although whether they could ever have been understood without the aid of the inscriptions identifying the figures seems doubtful. The mystical significance of the light they transmit may well have been equally difficult for the unlettered layman to comprehend, but the essential meaning of these jewel-like windows could hardly be missed. They create an atmosphere far removed from that of the everyday world outside. From the predominant blues and reds the light takes on a violet tone, which floods into the

church from every side and diffuses softly a unearthly glow and glimmer. It is, however, of low intensity, and very large areas of stained glass were needed. As Gothic architecture developed, masonry walls were gradually replaced by windows filling the spaces between ever more slender supports. Eventually, in such buildings as the Ste-Chapelle in Paris, the chapel of the kings of France, the interior becomes one single tall space with, except for a low dado zone, walls entirely of glass (9, 20). The stonework dividing one panel of glass from another (still fairly prominent at Chartres) is reduced to a lacy mesh of tracery more conspicuous from the outside than from within. (Tracery was a Gothic invention and its development towards ever greater dissolution of the wall—from 'bar tracery' to 'plate tracery'—can be followed stage by stage from Chartres to Reims and from Reims to Amiens and beyond.) The desire for light and immateriality complemented the Gothic quest for ever greater height. Clerestory windows grew steadily taller, pushing up the vaults to 120 feet (37m) at Chartres, 125 feet (38m) at Reims, 140 feet (43m) at Amiens and a dizzying 157 feet (48m) at Beauvais (1230–40). But at Beauvais the architect overreached himself. Only the apse survived the collapse of the choir in 1284 and although the choir was rebuilt, the nave was never even begun.

These lofty vaults required external support and this led to another Gothic invention, 'flying buttresses' as

9, 30 Chartres Cathedral, aerial view, mainly 1194–1220.

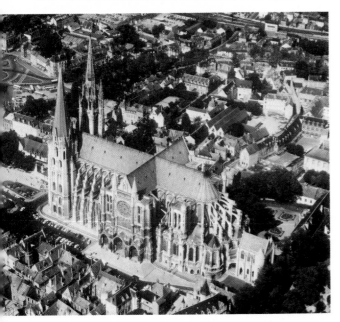

9, 31 Villard de Honnecourt, page from notebook, c. 1235. Ink on vellum, 9½ × 6⅜ins (24 × 16cm). Bibliothèque Nationale, Paris.

at Chartres, where they completely surround the apse (9, 30). Their structural purpose is well illustrated in a drawing by Villard de Honnecourt, which shows how their arms stretch out to resist the outward thrust of the vaulting (9, 31). A similar system of buttressing had been used in Romanesque architecture, but was concealed beneath the roofs of the tribune galleries above the aisles. To admit more light, Gothic architects did away with the tribune galleries, exposed the buttresses and pared them down to slender skeletal supports no less aesthetically satisfying than functional. They also had them carved and topped with little spires so that they contribute to the general upward force of the building, entirely concealing, indeed contradicting visually, their structural function of resisting the building's lateral spread. Flying buttresses help, in this way, to integrate the interior and exterior of a High Gothic church into an organic whole. The same can be said of the main façades, which repeat the horizontal divisions (arcade, triforium, clerestory) of the interior elevations of the nave. That of the Cathedral of Notre-Dame in Paris also states very clearly the geometrical system on which the design of the whole building was based (9, 32). This is a rationalization of the still Romanesque façade of St-Etienne, Caen, and St-Denis, which already had what seems to have been the first rose window in its centre.

Later, at Amiens and Reims, the residual Romanesque horizontality of Notre Dame was muted, much greater emphasis being placed on verticals.

None of the High Gothic cathedrals has its full complement of towers and spires as envisaged by the architects. Chartres was to have had eight. (Of its two existing towers, one predates the 1194 fire and the other is a sixteenth-century addition.) Building work at a cathedral normally began with the choir, moved along the nave and then up the façades, which were rarely finished before money ran out. For the building of cathedrals was a major financial undertaking and, according to some historians, seriously affected the economic stability of France. Funds were raised from a variety of sources. Revenues from the vast agricultural estates owned by the Church and the taxes levied by bishops as temporal lords naturally provided considerable sums. Suger set aside annually a proportion of the St-Denis estate income to meet the cost of building. At Chartres the canons of the cathedral (its governing body) are said to have foregone their stipends for three years from 1194 so that construction work could begin. Offerings made by pilgrims and the local population contributed much, especially for adornment of the fabric—probably more than donations from kings and noblemen. The wealthy seem, in fact, to have preferred to subscribe to specific undertakings to which their names could be attached, e.g. stained glass. The north transept windows at Chartres (9, 22), for instance, were given by Queen Blanche, mother of the sainted crusader Louis IX. Others were the gift of guilds, the associations which regulated the religious and social as well as the working lives of medieval craftsmen and tradesmen. Butchers, bakers and other local guilds donated the great windows in the *chevet*, the most important of all. In fact, whether directly by gift or indirectly through taxes, the inhabitants of Chartres, though they numbered no more than 10,000, contributed a large proportion of the funds to build the cathedral, which dominated, and still to this day dominates, the town. Their lives revolved around it. Justice was administered at its door. The great fairs or markets, on which the mercantile prosperity of the town depended, took place in neighbouring streets and squares owned by and under the jurisdiction of the cathedral chapter. Wine-sellers were even allowed to transact business in the crypt. So the cathedral became almost as much a civic as a religious building. And it was a great financial asset to the town in that it attracted a constant flow of pilgrims. For these reasons, perhaps, the thirteenth-century citizens of Strasbourg shouldered the financial responsibility for constructing the nave and façade of

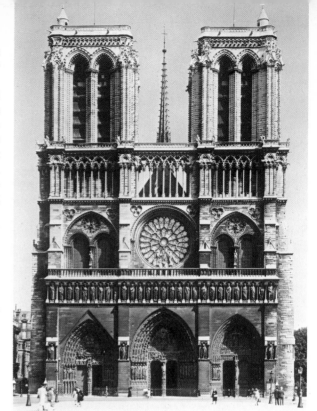

9, 32 Façade of Notre-Dame, Paris, 1163–1250.

their cathedral, taking it out of the hands of the bishop and chapter, with whom they were at loggerheads.

The architects who designed and directed these great undertakings are often recorded by name, but very little else is known about them. As personalities, Robert de Luzarches at Amiens and Jean d'Orbais at Reims are no less shadowy than the three anonymous masters whose individual touch can be detected in successive stages of the building at Chartres. Like other medieval architects each had doubtless risen from the ranks of masons after having served an apprenticeship in a quarry, where stone was cut, and having earned the title of 'master' by carrying out some technically difficult piece of work or 'masterpiece'. His expert knowledge of construction, architectural draughtsmanship, geometry and the rules of proportion were acquired through the jealously guarded traditions of the masons, handed down from one master to another in the 'lodges' or workshops, which often became permanent fixtures at the great cathedrals in order to maintain the fabric. Work was, however, always carried out in close consultation with the bishop, who initiated the project, or with one or more members of the chapter, who administered the finances.

In view of the architect's training as a mason, it is hardly surprising that carved stonework should be so prominent in Gothic buildings. Moldings become steadily more complex in section, and figure sculptures proliferate (at Chartres there are some 1,800), yet carved decorations have greater uniformity in early and High Gothic than in Romanesque churches. Already in the ambulatory of St-Denis (9, 28) capitals of the type condemned by St Bernard are replaced by sharply carved wreaths of naturalistic leaves, which set a pattern later followed over the whole of northern Europe. They are similar to one another but, significantly, not identical. The design of a Gothic church left room for variation in details and it was this that invested the intellectual geometry of its conception with throbbing yet disciplined life.

St Thomas Aquinas (c. 1225–74), or a close follower, defined beauty as 'a certain consonance of diverging elements'. He was the greatest theologian of the Middle Ages, author of the *Summa theologica*, which set out to provide a systematic exposition of all Christian doctrine but was left unfinished—in this respect, as in others, like the great Gothic cathedrals. For in the closely woven fabric of medieval thought a church was a microcosm of the all-embracing Catholic Church, personified by the Virgin Mary, to whom the cathedrals of Chartres, Paris, Reims and many others were dedicated. With its spires, which strove to pierce what an English mystic called 'the cloud of unknowing', its stained-glass windows radiant with divine light shining through them as the Holy Spirit penetrated the body of the Virgin and illuminated the Church, the Gothic cathedral was at once a symbol and an exposition of Christian faith. One translucent layer of

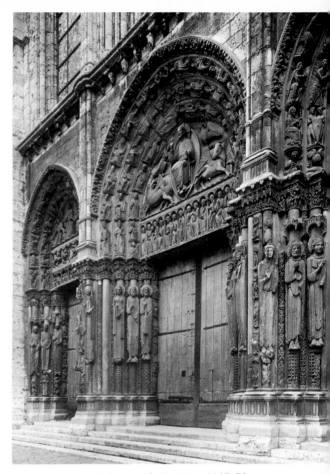

9, 34 West portal of Chartres Cathedral, c. 1145–70.

9, 33 Vine-leaf capital in chapter-house of Southwell Minster, England, c. 1290.

meaning was superimposed on another. Vine leaves or oak leaves might be specific symbols; but they also declared that, in the words of the 24th Psalm, 'The earth is the Lord's and all that therein is: the compass of the world and they that dwell therein.' Every detail in these great buildings proclaimed the glory of God and the wonder of his creation (9, 33). The worst heresy of the period—that of the Albigenses or Cathars, who were ruthlessly persecuted in the early thirteenth century—was the dualistic belief that all matter was evil and only spirit good. So a cathedral was not only a *Summa theologica* but also an encyclopedia of divinely ordered creation.

As all living things came to be seen as a manifestation of the divine, a great impetus was given to naturalism in the figurative arts, especially sculpture. On the west or royal portal of Chartres, which was carved in the 1140s and survived the fire of 1194, columns are still decorated with geometrical patterns,

while the Old Testament kings and queens, attenuated and columnar, have already begun to separate themselves from the architectural background (9, 34). On the south transept portal of about 1215–20 they are projected further forwards and given more strongly marked individuality. The process was completed on the west portal of Reims, carved about 1225–45, where heroic-scale saints and angels are wholly detached from the building and conceived not as reliefs but as statues in the round (9, 35). Despite their grandiose scale and withdrawn expressions and poses, either sunk in meditation or in silent commune with one another, they are essentially human figures occupying the same space and apparently breathing the same air as the spectator.

The Visitation at Reims (in the centre of our illustration) may be interpreted as a quiet colloquy between the gravely dignified expectant mothers of Jesus and St John the Baptist. Weight, both physical and moral, is suggested by the substantial gathered folds of their garments. Like Nicholas of Verdun, a few decades earlier and not far away (see p. 300), the sculptor at Reims must have known and studied ancient Roman statues, for the draperies are carved in a technique not known to have been practiced for some 900 years. The pose of each figure, with one knee bent, also harks back to the Classical past. But the sculptor took all this over from antiquity in the same spirit as Scholastic theologians adopted arguments or 'modes of reasoning' from Aristotle. He used it afresh for his own purposes. His statues have a new warmth and a new human sympathy.

The Virgin in the Annunciation group, to the left of the Visitation, was carved by another sculptor in a slightly different, though no less remarkable way, with draperies apparently studied from life, falling smoothly and clearly revealing the form of her firm young breasts. The smiling angel on the far left is the work of a third hand and was probably placed originally on another part of the façade. It may be a little later in date. Here the draperies are clearly realized as quite independent of the body beneath, but they are arranged with great attention to decorative effect. And the pose of the Visitation figures has been both anatomically corrected and eased into the gentle spiral which recurs in later Gothic art—in an exquisite ivory statuette of the Virgin and Child, which was for long in the Ste-Chapelle in Paris, for instance (9, 46). The three sculptors at Reims had moved as far from Romanesque conventions as the architect of the cathedral façade on which they stand. Their naturalism complements his structural lucidity.

All the visual arts were involved in the construction and decoration of the great cathedrals of the late twelfth and thirteenth centuries, and Gothic was soon established as the norm not only for architecture. On a page in the Psalter of St Louis an edifice with pinnacled buttresses, pointed arches and rose windows forms the background for Abraham receiving the three angels and (in the right half) entertaining them under the gaze of his wimpled wife peeping from behind a curtain (9, 45). The whole page is rendered with the same strong outlines and broad areas of glowing colour as a stained-glass window. The angel on the left, furthermore, bears a family resemblance to the statue on the west front of Reims Cathedral (9, 35). Behind both there lies that desire to visualize the scene in human terms which so sharply differentiates Gothic from Romanesque art. The allegorical significance, which had formerly been stressed, remains important but now takes second place to dramatic presentation.

English and German Gothic

As we have already seen, the style was transmitted in its formative stage to England. Here, even before the twelfth century was out, local variations were introduced and were further developed at the very moment

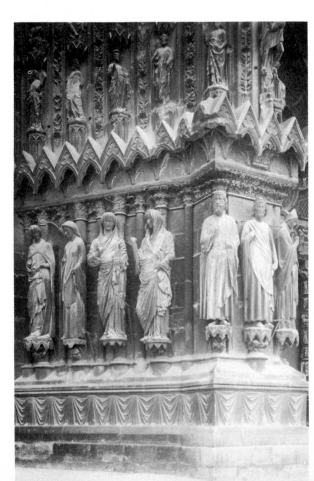

9, 35 *Left* Detail of west portal, Reims Cathedral, c. 1225–45.
9, 36 *Above* Nave vault, Lincoln Cathedral, England,
c. 1240–50.
9, 37 *Above right* Nicholas of Verdun, *The Prophet Jonah*,
detail from the Shrine of the Three Kings, c. 1182–90. Gold,
enamel and precious stones, Cologne Cathedral.
9, 38 *Right Ekkehart and Uta*, c. 1250–60. Naumberg Cathedral.

when a sense of national identity was beginning to
grow (English was first used as an official language in a
mid-thirteenth-century document). In the vaulting of
the nave of Lincoln Cathedral, for instance, ribs are
multiplied by running one along the centre and
splaying out subsidiary ribs to join it, creating a
pattern of stars which wilfully sacrifices logic to
decorative effect (9, 36). The so-called 'Decorated
Style', with much use of double-curving ogee arches
and bars of window tracery twisted and turned into
intricate networks of stone, was developed in England
in the later thirteenth century, long before the
equivalent 'Flamboyant Style' appeared in France.
The same delight in fantasy and elaborate curvilinear
ornament is felt in the richly elaborate vestments,
which were among the finest works of art produced in
England at this time (9, 44). Embroidery was an
English speciality and was prized all over Europe,
where it was known as *opus Anglicanum* (English
work).

Until the end of the twelfth century Germany clung
to the Romanesque style so closely associated with the

Holy Roman Empire, and intimations of a coming change are felt first in small-scale works. A reliquary shrine of the Three Magi made by Nicholas of Verdun (c.1140–c.1216) for Cologne is architecturally Romanesque in its round arches and short columns, but the high-relief figures anticipate by some two decades the statues on the cathedral at Reims less than 200 miles (320km) away (9, 37; 35). The pliant loose draperies of the silver figures, following both the form and the movement of the body beneath, resume a style which had passed from Greece to Rome, while their strongly characterized thoughtful heads have the spirituality of Gothic sculpture. The naturalism of such works was taken to its furthest extreme in Germany, most notably in two of the quite extraordinarily lifelike statues of the founders of Naumberg Cathedral—the burly Margrave Ekkehart, hand on sword, and his elegant, worldly wife Uta, drawing the collar of her cloak across her cheek (9, 38). When Gothic architecture was introduced into Germany it expanded in both scale and richness. Cologne Cathedral, probably inspired by Reims, was begun in 1248 as the tallest and longest of all Gothic churches—though it was not to be completed until the nineteenth century and is substantially a nineteenth-century building.

Italian Gothic

Gothic architecture was introduced into Italy by the Cistercians, whose abbey churches (e.g. Fossanova, south of Rome, of 1187–1208) look as if they had been bodily transported from France. S Francesco at Assisi, begun in 1228 when St Francis was canonized, substantially completed by 1239 and consecrated in 1253, is quite different (9, 39). Although there are curious and unexplained affinities with early Gothic churches built in western France nearly a century before, all it has in common with the great High Gothic cathedrals are rib vaults and pointed traceried windows. The aims of its architect were not only different from, but almost contrary to, those of his French contemporaries. Their soaring ecstasies of yearning for the infinite are replaced by something equally noble, if less rarefied. The plan is of emphatically rectilinear simplicity: a Latin cross with a five-sided apse. Horizonals and verticals are exactly balanced, creating a wonderfully self-confident and self-contained effect in the upper church (the exceptionally high crypt below is called the lower church). The broad and aisleless nave, evenly lit and airy, is a clearly defined space unassertively articulated into bays by attenuated columns bunched into piers that cling to the walls. There are no carvings apart from inconspicuous capitals. Surfaces are uniformly

9, 39 *Above* Nave of San Francesco, Assisi, 1228–1253.
9, 40 *Right* Bonaventura Berlinghieri, *St Francis*, 1235. Panel, about 60 × 42ins (152 × 107cm). San Francesco, Pescia.

smooth, emphasizing the massiveness of the walls. The whole church has a solidity and volumetric clarity typical in medieval Italy, as we shall see, not only of architecture but of painting and sculpture as well.

S Francesco was a new type of church, designed to meet the needs of a religious order founded by St Francis of Assisi (c.1181–1226) to recall people of all conditions to faith and penitence. Its dimensions and form were determined by the size of the congregations which flocked to hear Franciscan sermons, its decoration by the demand for a direct, non-allegorical exposition of Christian doctrine focused on the life of Christ and the Christ-like founder of the order. St Francis renounced all worldly goods to 'wed Lady Poverty', as he put it, and although he was not a priest, he and eleven companions obtained in 1211 Papal sanction to be wandering preachers. These first friars, who called themselves *Fratri minori* or lesser brethren, practicing the humility they preached, soon attracted a large following of men and women—including St Clare (c.1194–1253), founder of the sister order of nuns—similarly vowed to absolute poverty and subsisting on what they could obtain by menial work or begging for alms. St Francis intended that they should not own even corporate property, though this restriction was relaxed to enable them to build churches and communal houses, as at Assisi. But he attacked the worldliness of the Church only by example—he was not censorious. (Arnold of Brescia, less than a century earlier, had been outspoken about 'priests who have estates, bishops who hold fiefs, and monks who possess property'. He was burnt at the stake.) Yet St Francis's views on otherworldly monks

who lived in richly endowed seclusion were obvious enough to provoke reaction from the Cistercians, who did their damnedest to have the Franciscans suppressed.

Another order of mendicant preachers was founded at the same time by the Spaniard St Dominic (1170–1221) as a task-force to battle against the heresy of the Albigenses (see p. 297). Dominicans later staffed the dreaded Holy Office or Inquisition. Like St Francis—and unlike St Bernard of Clairvaux—St Dominic was primarily concerned with the spiritual life of the laity, and nearly all the most learned men of the thirteenth century were drawn to one or other of the two orders, Dominican (Black Friars) or Franciscan (Grey Friars). Albertus Magnus (1206–80), for instance, and his pupil St Thomas Aquinas (see p. 297) were Dominicans: Duns Scotus (c. 1265–1308), who

opposed reliance on deductive reasoning, was a Franciscan.

Both orders had houses in all the main university cities. But however influential among the educated laity, they were even more active among the unlettered and poor. Their sermons were given in a plain, vigorous, unerudite style which all could understand and were full of lively, topical descriptions, especially of incidents from the lives of saints held up as exemplars. In Italy, where Latin remained the written language, these sermons in the language of common speech stimulated the growth of a vernacular literature, which blossomed astonishingly quickly in the work of one of the greatest European poets, Dante Alighieri (1251–1321). The influence of their sermons on the visual arts was no less strong. They created a demand for vivid and easily read imagery.

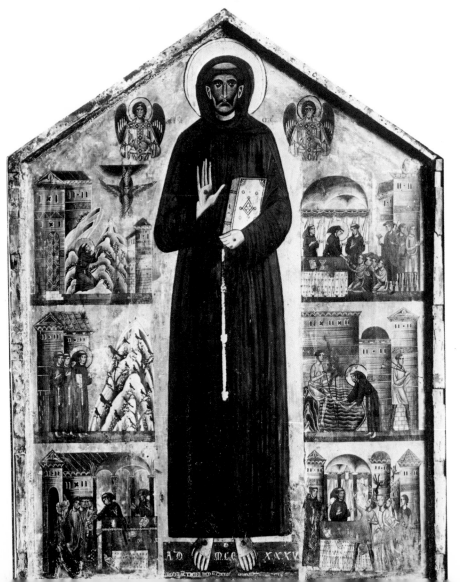

Italian literature virtually begins with St Francis's *Cantico delle creature* (Canticle of all created things), a hymn which owes its poignancy to the unaffected directness of its invocations and the concrete simplicity of its images. God is praised for brother sun and sister moon, for sister water, 'greatly useful and humble and precious and chaste', brother fire, 'beautiful and joyful and vigorous and strong', our sister, mother earth, who 'brings forth diverse fruits and coloured flowers and grass' and finally for 'our sister bodily death, from whom no living man can escape'. Similarly in the visual arts, it might almost be said that Italian painting—as distinct from late Roman and Byzantine—begins in S Francesco at Assisi with frescoes ascribed to Cimabue (on the upper walls) and, less certainly, to Giotto (see p. 306).

A painting of St Francis by Bonaventura Berlinghieri (fl. 1228–35) dates from only nine years after the saint's death and may well record memories of his actual appearance (9, 40). But, despite its spiritual force, this image is not a portrait so much as a kind of identikit assemblage of remembered characteristics— coarse, gray-brown habit and rope girdle with three knots symbolizing poverty, chastity and obedience, hands and feet marked with the stigmata, lean, ascetic, lightly bearded face and tonsured head. Six little scenes on either side are similarly informative rather than expressive, telling or reminding the spectator how St Francis received the stigmata (upper left), preached to the birds who 'rejoiced in wondrous fashion', ministered to the poor and ailing, and (lower right) rid the city of Arezzo of evil spirits. The panel was painted as an altarpiece to rise from the back of an altar—a type of picture peculiar to Catholic Europe. (Altarpieces came into being as the result of a liturgical change at about this date, when priests celebrated the mass with their backs to the congregation.) Figures and architectural backgrounds are, nevertheless, depicted according to time-honoured Byzantine conventions. Indeed, one of the artist's aims seems to have been to integrate the recently canonized saint into the Eastern icon tradition.

This was the 'Greek style' (*maniera greca*) from which, as Renaissance writers were to claim, Giotto liberated Italian art. In fact, Byzantine artists had preceded him in relinquishing their ancient hieratically stiff manner. During the second half of the twelfth century compositions became more complex, figures more dynamic, and draperies more agitated, in the great decorative schemes carried out by Greek mosaicists not only in the eastern Mediterranean but also in Italy (mainly in Venice) and in Norman Sicily. A further change took place in wall painting during the thirteenth century. Boldly modelled figures, outlined by sweeping brush-strokes and richly coloured, were set in front of landscape or architectural backgrounds in which a new feeling for solidity of form and hollowness of space is felt. The apostles painted in the monastic church of Sopoćani in Yugoslavia seem like giants and express gigantic grief as they cluster round the bed of the dying Virgin Mary, their forceful heads and bodies animated and yet controlled as if by vast reserves of interior energy (9, 47).

The use of wall paintings to supplement the far more expensive mosaics was probably due to the sharp economic decline during the half century after 1204, when the crusaders sacked Constantinople, placed a puppet Latin emperor on the throne and carved up the eastern empire among themselves. In the following period of partial recovery and cultural revival, sponsored by the Greek emperors of the Paleologan dynasty, the greater freedom of handling and the expressiveness developed by painters was transferred back to mosaics. The finest of these are in the church of

9, 41 Funerary chapel, St Saviour in Chora, Constantinople, c. 1303–20.

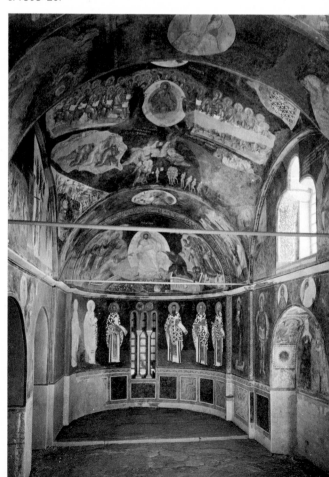

St Saviour in Chora (or Kariye Djami), Constantinople. Still more remarkable, however, are the paintings in the attached funerary chapel (9, 41). Here the old Byzantine style survives only in the saints, posted like sentries around the walls and constrained by heavy vestments. On the ceiling, figures are charged with energetic life, especially in the *Anastasis* depicted in the conch of the apse, where Christ drags Adam and Eve from their tombs in limbo. That paintings of a similarly dramatic intensity began to be produced in Italy at the same time is more than a coincidence.

It is perhaps significant that the only documented work by Cimabue (fl. 1272–1302), revered as the founder of the Italian school of painting, should be in mosaic (apse of Pisa Cathedral, 1301–2)—the medium most closely associated with Byzantium. But his reputation rests, ironically, on a stanza in Dante's *Purgatorio*—written c. 1315 as the second part of the Divine Comedy—where he is mentioned as an instance of the vanity of all human endeavour:

> Of painters, Cimabue deemed his name
> Unrivalled once; now Giotto is in fashion;
> And has eclipsed his predecessor's fame.
> (Tr. I. Grafe)

No specific works were, however, attributed to Cimabue until some 200 years after his death. His name is, in fact, little more than a convenient label for a closely related group of panel and wall paintings.

Of the paintings assigned to Cimabue by modern scholars the most impressive is an unusually tall altarpiece with a larger than life-size image of the Virgin and Child (9, 42). It is no more than 50 years later than Bonaventura Berlinghieri's *St Francis* (9, 40), but marks a radical change in style. The composition is tightly controlled in form and colour, the all-over symmetry being broken only by the Christ Child, who thus immediately attracts attention. Figures, held in tense immobility, have incisive contours and are modelled in soft gradations of tone giving some sense of corporeality—the two foremost angels and the Virgin have their feet flat on the platforms (not suspended in space like those of St Francis). Recession is indicated by the architecture of the throne rising up in stages and surrounded, not merely flanked, by angels. Everything is immersed in the golden light of heaven, which flickers along the folds of drapery and glistens on the haloes. The four half-length prophets below are bound into the composition by colour and expression, but the artist's inability to render space is revealed all too clearly in the arches—are they three arches, or two arches and an indentation?

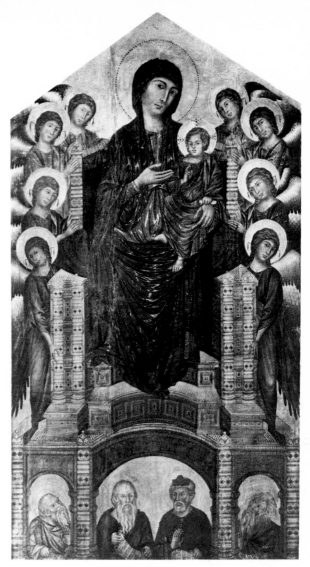

9, 42 Cimabue, *Madonna Enthroned with Angels and Prophets*, c. 1280–90. Tempera on wood, 12ft 7ins × 7ft 4ins (384 × 224cm). Uffizi, Florence.

The Virgin Mary, known in Italy as the Madonna (My Lady), had been venerated throughout Christendom since the fourth century, and in the thirteenth she began to occupy in the minds of the faithful a position almost equal to that of Christ himself. In the West her cult was greatly encouraged by the Franciscans. Duns Scotus formulated the doctrine that she was free from original sin, which was to be given official recognition by a Franciscan Pope, Sixtus IV, in the fifteenth century, but not promulgated as the dogma of the Immaculate Conception until 1854. It was a thirteenth-century Franciscan who wrote what was to become

one of the most popular of all hymns to the Virgin, beginning 'Stabat mater dolorosa/ Juxta crucem lacrimosa'—the sorrowful mother stood weeping beside the cross—and emphasizing the need to visualize. 'Who would not weep', it goes on, 'if he were to see the Mother of Christ in such great suffering?' Such poems were a challenge as well as an inspiration to sculptors and painters, as may be seen by comparing two reliefs of Christ's Passion, both great works of art but separated by almost exactly 100 years (9, 43; 52).

The Deposition by Benedetto Antelami (fl. 1178–96) is a masterpiece of restraint and makes a solemn impact akin to that of the slow rhythm of Gregorian chant. Emotion is contained by the austere geometry of the composition with its sequence of dignified figures, among whom the Virgin takes her appointed place. The effect is sacramental. A human tragedy of agony and loss has become a solemn rite and symbol of atonement. Very different indeed is the Crucifixion panel on the pulpit by Giovanni Pisano (fl. 1265–1314). The emphasis here is on vivid visualization of the actual events—as in the *Stabat Mater* and, probably, the sermons preached from this and many other pulpits at that time. Christ's emaciated body, abdomen contracted, rib-cage bursting, hangs on the cross, his arms forming a V, which has the effect of a loud cry to heaven—'My God, my God, why hast thou forsaken me?' And the eye is caught and finally held by the

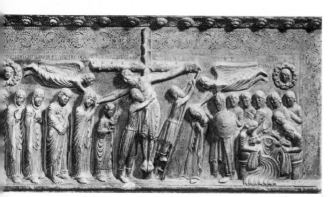

9, 43 *Above* Benedetto Antelami, *Descent from the Cross*, 1178. Relief, Parma Cathedral.
9, 44 *Opposite top left* Butler-Bowdon Cope (detail), 1335–6. Embroidery in silver and silver-gilt thread and silks on red velvet, with pearls, green beads and gold rings, full width 11ft 4ins (345cm). Victoria & Albert Museum, London.
9, 45 *Opposite top right Abraham and the Three Angels*, page from the St Louis Psalter, 1253–70. Illumination. Bibliothèque Nationale, Paris.
9, 46 *Opposite bottom left Virgin and Child*, c. 1300. Ivory with some gilding, height 16ins (40.6cm). Louvre, Paris.
9, 47 *Opposite bottom right Dormition of the Virgin* (detail), 1258–64. Fresco, Church of the Trinity, Sopoćani, Yugoslavia.

figures on earth: St John, to the left of the cross, bursting into tears, the men on the right cowering in terror and, above all, the Virgin collapsing in a convulsive faint.

Giovanni Pisano's father, Nicola Pisano (fl. 1258–78), had absorbed Classical culture at the court of the Holy Roman Emperor Frederick II Hohenstaufen (1212–50), who lived mainly in the south and in Sicily. From a close study of antique sculpture he evolved what might be called a sculptural 'proto-Renaissance' style with numerous direct quotations from Roman sarcophagi, including the male nude (as on his pulpit in the Baptistery, Pisa). Giovanni, who is first recorded in 1265 as assisting his father on the magnificent pulpit in Siena Cathedral, acquired his technical mastery from him but also came under the spell of northern art. The Gothic arches supporting Giovanni's Pistoia pulpit are distinctly French and the tall figures standing between the reliefs have the graceful contrapposto of statues on the façade of Reims Cathedral, though there is no precedent in France or anywhere else for the dramatic intensity of the reliefs themselves. He proudly, if somewhat boastfully, signed it with an inscription describing himself as 'the son of Nicola and blessed with higher skill'. He had created a new visual language in which to express the religious ideals of the day.

The influence of Giovanni Pisano was pervasive throughout the early fourteenth century in central Italy, for instance in the reliefs by Lorenzo Maitani (c. 1275–1330) on the façade of Orvieto Cathedral. The damned are rendered so vividly that they arouse our compassion, like the sinners in Dante's *Inferno*— whatever the intention of either the poet or the sculptor may have been (9, 48). The new visual language created by the Pisani helped painters as well as sculptors, and Nicola's Classicism may have contributed as much as Byzantine art to the monumentality of Cimabue's altarpiece (9, 42). The same could be said of the main panel of the *Maestà* (or Virgin and Child enthroned in majesty) painted by Duccio di Buoninsegna (fl. 1278–1318) for the high altar of the cathedral in his native Siena. Here the statuesque, centrally placed Virgin towers above angels and saints hierarchically ranked on either side of her. The small scenes originally above and below and on the back of the altarpiece are less rigid (it consisted of some 70 panels, several of which were lost when it was dismembered in the eighteenth century). There are reflections of the latest developments in Byzantine art here, and individual figures are so close to those in the mosaics of St Saviour in Chora, Constantinople (see p. 302), that they must surely derive from some common source. But Duccio's

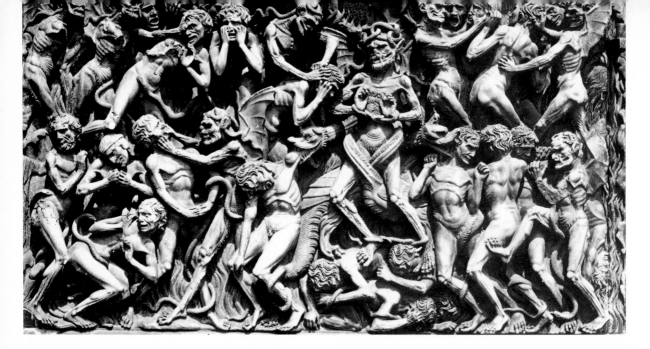

narrative ability and sharpened sense of space owes
more to Giovanni Pisano, who worked in Siena from
1285 to 1297.

In one of the Passion scenes from the back of the
altarpiece the old convention of showing an interior by
removing one wall is maintained (9, 49). The room is,
however, a clearly defined cubic space and, despite the
rudimentary perspective, provides a visually effective
stage-like setting for the religious drama. It is the third
of the panels in which Duccio illustrated with
increasing tension the last verses of the 26th chapter of
the Gospel according to St Matthew. Blindfold but
dignified, Christ stands in the centre, mocked by the
men who crowd round him. On the right the high priest
and elders darkly plot his fate. But the eye is drawn to
St Peter, who, like the spectator, stands outside the
room and exemplifies the predicament of every
Christian torn between denial and affirmation of his
faith.

When the great altarpiece was completed in June
1311, it was carried in procession through Siena to the
sound of trumpets, pipes, and castanets and the ringing
of church bells. Duccio signed his name on the base of
the Virgin's throne. Yet, despite all this, he had been
hired by the Cathedral authorities as a wage labourer.
They supplied the paints and other materials and paid
him by the day. And he was soon all but forgotten.

The fame of the slightly younger Florentine painter
Giotto di Bondone (c. 1267–1337) was to overshadow
Duccio's completely—owing partly, perhaps largely,
to the local patriotism of Florentines, who wrote the
first histories of Italian art. That Giotto was, in every

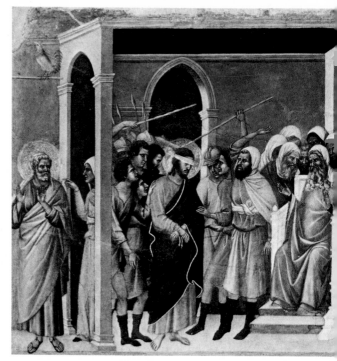

9, 48 *Top* Lorenzo Maitani, *The Damned*, detail from the Last
Judgement relief, 1310–30. Marble, Orvieto Cathedral.
9, 49 *Above* Duccio, *The Third Denial*, 1310–30. Panel, about
$19\frac{1}{2} \times 21\frac{1}{4}$ ins (49.5 × 54cm). Museo dell'Opera del Duomo,
Siena.
9, 50 *Right* Giotto, *Feast at Cana, Raising of Lazarus,
Lamentation* and *Noli me tangere* (details of fresco decoration),
c. 1304–13. Scrovegni Chapel, Padua.

sense, a success there can be no doubt. Documents record his financial prosperity, his houses in Florence and Rome, his agricultural estates and his hiring out of looms—a method of investing money to yield as much as 120 per cent per annum without infringing the Church's ban on usury. Not for him the asceticism and self-denial of St Francis. As for his contemporary renown as a painter, we have already mentioned Dante's testimony and before the mid-fourteenth century an historian of Florence listed him as the only artist among the great men of the city. But only one work by him is mentioned, a mosaic in St Peter's in Rome, of which very little now survives. Paradoxically, he has been obscured by his own fame. He became the subject of fables previously told about ancient Greek artists. Writers eulogized him with phrases copied out of Pliny. And, of course, his name was attached to a large number of heterogeneous paintings. In his lifetime Assisi was mentioned as a place where he had worked and a century later he was

said to be the author of the scenes from the life of St Francis in S Francesco—whether he did paint them or not is still disputed. No surviving work nowadays attributed to him is fully documented.

His authorship of the frescoes in the Scrovegni (or Arena) Chapel in Padua, however, need not be doubted; and they mark a turning point in the history of Western art and of artistic patronage. Hitherto major works of religious art had been commissioned by rulers, churchmen and civic authorities. Enrico Scrovegni, who had this chapel built next to his grandiose palace (demolished, but originally on the site of the ancient Roman arena), was a private citizen, albeit one of the wealthiest in the republican city-state of Padua, the son of a money-lender so notorious that Dante placed him in the *Inferno*. Scrovegni declared that he built the chapel 'in honour of the cult of the Virgin Mother of God and to honour and adorn the good city-state and commune of Padua'. The honour of his own family was also involved, for the chapel was

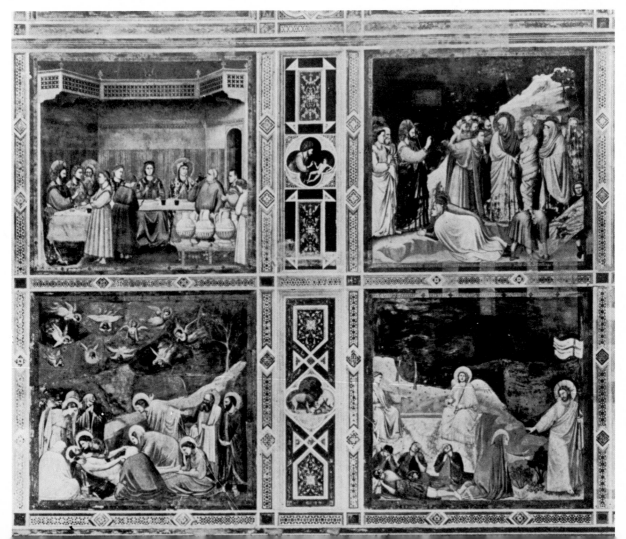

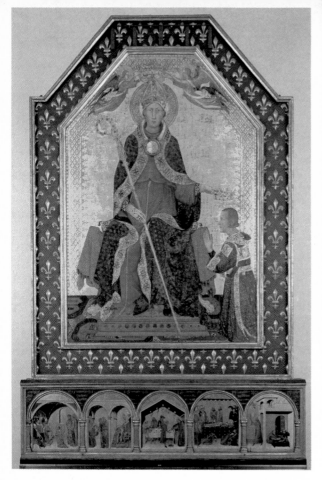

decorated with a lavishness quite unprecedented for a private foundation and, as the paintings reveal, he sought thereby to expiate the sins of his father. In Giotto's large *Last Judgement* over the entrance door damned usurers are balanced by the very prominent figure of Enrico Scrovegni presenting a model of the chapel to the Virgin. There are three registers of figurative paintings on the other walls, of scenes from the life of the Virgin and of Christ. Below them is a dado with single grisaille figures of virtues and vices, where, it is worth noting, Avarice, the sin of the rich, is omitted to make room for Envy, a failing ascribed mainly to the poor! As a whole, the cycle of paintings answers to the demands of Bishop Sicardo (c.-1155–1215), who wrote in a treatise on the liturgy that images should not merely be suitable as decorations for a church, but should serve to remind the laity of 'things past (stories and visions) and direct their minds to those of the present (virtues and vices) and the future (punishments and rewards)'.

The paintings in the Scrovegni Chapel are the earliest securely attributed to Giotto. They are, nevertheless, the work of a fully mature artist who had

9, 51 *Above left* Simone Martini, *St Louis of Toulouse crowning Robert of Anjou King of Naples*, 1317. Panel 78¾ × 54¼ins (200 × 138cm), predella 19¾ × 68¾ins (50 × 174.6cm). Museo di Capodimonte, Naples.
9, 52 *Above* Giovanni Pisano, Pulpit, begun 1297. Marble, Sant'Andrea, Pistoia.

completely assimilated influences from Cimabue, Early Christian art in Rome, the shadowy Roman painter Pietro Cavallini (fl. 1273–1309), and the Pisani (Giovanni Pisano carved a statue of the Virgin and Child for the chapel). Although Giotto borrowed iconographical patterns from earlier art, he revised them almost out of recognition, omitting irrelevancies so as to give each scene a compelling and totally coherent simplicity. Indeed, he carried the elimination of everything inessential to the furthest point attainable. Those reproduced here represent the Marriage Feast at Cana, where Christ miraculously changed water into wine, the Raising of Lazarus, the Lamentation of the dead Christ, and the Resurrection (9, 50). So clearly are the Gospel stories presented that there is no need for demonstrative emphasis, for contorted features or violent gestures, to stress their meaning. It emerges quite naturally. With only the

gentlest movement of the hand the risen Christ says to St Mary Magdalen: 'Touch me not' (*Noli me tangere*). Every figure is similarly expressive, even those squatting on the ground with their backs to the spectator in the Lamentation. All are solemnly posed, yet seemingly endowed with the capability of motion within the space that surrounds them. Draperies fall in natural folds according to their different textures, all carefully rendered, and contribute to the disciplined formal construction that gives to the whole conception of the chapel's decoration so extraordinary a sense of gravity and weight and eternal stillness. The unity of the whole is felt in every part. Individual scenes are related to one another not only thematically, as hitherto, but also compositionally: the Raising of

9, 53 Giotto, *Lamentation*, detail of Plate 9, 50.

Lazarus being linked directly with the Resurrection and also diagonally by the line of the hill with the Lamentation. Above them all there is the same cloudless blue sky, which also spreads across the vault of the chapel and binds the scheme together—just as the doctrine of the Redemption unites the various subjects.

Each group stands on a shallow but logically constructed stage. Interiors are depicted according to the ancient Roman tradition of 'wide-angle' perspective, which Giotto used more systematically than Duccio. But the aims of both artists were the same. Both transformed the flat picture-plane, from which solidly modelled figures projected, as in low relief, into a kind of transparent window, beyond which scenes from the Gospel are brought vividly to life. Some figures are partly cut off by the frame; the risen Christ

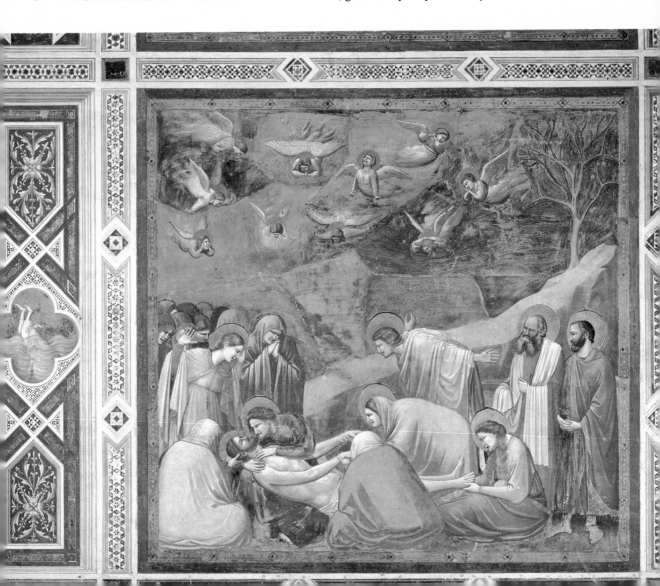

is shown as if about to move out of the spectator's field of vision altogether. Giotto was, however, quite as much concerned with inner states of mind as with outward appearances. In the Lamentation, where each figure is individually and uniquely expressive, the Virgin clasps her dead son and gazes at his closed eyes, creating an unforgettable image of the desolation of bereavement, made all the more poignant by the rigorous, one might almost say Stoic, control with which it is rendered (9, 53).

There are, however, two levels of reality—or unreality—in the Scrovegni Chapel: religious and mundane, or poetic and prosaic. While the narrative scenes elevate the mind, their frames trick the eye with simulated inlays of porphyry, lapis lazuli and other semi-precious stones, and the dado imitates marble panelling with inset carvings. Paint was, in fact, being used here as a *trompe l'œil* substitute for more expensive materials. Up to this period figurative wallpainting had usually been regarded as an inferior alternative to mosaic, which was both costly and slow to execute (18 men worked for 10 months without completing the apse mosaic in Pisa Cathedral). Venice seems to have been the only Italian city rich enough to afford extensive schemes of mosaic decoration (9, 6) and, doubtless for this reason, was almost the only one to produce no school of mural painters in the Middle Ages. Franciscans preferred painting partly because it *was* a humbler medium—no mosaics and only a very limited quantity of stained glass were permitted in their churches. S Francesco, Assisi, has very extensive painted decoration (9, 39).

True frescoes—the word fresco is often misused for all forms of mural painting—are almost as durable as mosaics. They were painted on fresh (*fresco*) damp plaster, with which the soluble earth pigments unite chemically as it dries, fixing the colours and lending them a unique transparency. Pigments which could not be absorbed into the plaster in this way but had to be mixed with an adhesive could be added *a secco* after the surface had dried, though only for finishing touches in the Scrovegni Chapel. These pigments were the same as those used for such panel paintings as Duccio's *Maestà* (9, 49), applied in layer after layer on the dry gesso (a kind of plaster) ground with which the wood panel was coated. Whether painting on walls or on panels, artists at this period normally worked with groups of assistants. But the difficult fresco technique set a premium on the virtuosity of the master, demanding great swiftness and sureness of hand as well as a grasp of the total composition, which had to be finished patch by patch. No more plaster was laid at a time than the artist could paint in one session. This

might vary, of course. In the Scrovegni Chapel Giotto sometimes painted a whole group of figures in a single session, sometimes only a head. His increasing reliance on assistants for his later wall paintings (in S Croce, Florence) was, significantly, accompanied by more extensive use of pigments applied *a secco*.

The poet Petrarch (1304–74) wrote of a *Virgin and Child* by Giotto, which he owned, that its beauty would not be understood by the ignorant but would astound all those with knowledge of the arts. Some years were to pass before any painter took the full measure of Giotto's genius (see p. 321). His immediate followers in Florence, including those who probably began their careers as his assistants, like Taddeo Gaddi (fl. 1330–63), did little more than imitate aspects of his work. The most interesting Italian painters of the next generation were Sienese, notably Simone Martini (fl. 1315–44), a personal acquaintance of Petrarch, who commemorated him in two of his exquisitely phrased and delicately cadenced sonnets. But with Simone we move out of the austere world of Dante and Giotto into a more courtly ambience.

Secular and International Gothic

Within a century of the death of St Francis of Assisi the fervent but simple pieties of the early friars were being overlaid and sometimes compromised by concessions to secular demands. A large altarpiece painted in 1317 by Simone Martini for the French (Angevin) king Robert of Naples might almost be read as an illustration of this process, for the rough brown Franciscan habit of the saint is sheathed and all but concealed by richly embroidered ecclesiastical vestments (9, 51). St Louis of Toulouse, the king's elder brother, had joined the 'Spiritual' branch of the Franciscan Order, which strictly observed the founder's rule of poverty, chastity and obedience, unlike the larger 'Conventual' branch, whose members were often said to be too lax in observing their vows. In 1296, the year before he died, Louis had reluctantly accepted the archbishopric of Toulouse.

Two angels bearing a heavenly crown hover above St Louis while he holds a smaller but otherwise identical earthly crown over the strongly characterized head of his brother Robert, in whose favour he had renounced the Neapolitan kingdom. Scenes from his life and a miracle he had worked after his death are depicted in the predella. King Robert commissioned the picture in the year of St Louis's canonization, which he had eagerly promoted to endorse his own divine right to the throne and as a move in a complicated political game to establish Angevin supremacy in central Italy. Heraldic lilies, the French

royal emblem, are prominent on the frame as well as on the 'heavenly' gold background of the main panel. Beneath its serene surface, therefore, Simone Martini's altarpiece attempts to reconcile religious and political, eternal and temporal, concerns that might well seem discordant if not irreconcilable.

There are reminiscences of courtly Byzantine art in the hierarchically scaled and ceremonially posed figures. Just so, the Emperor Theodosius had been shown handing down a scroll to an official more than 900 years before (7, 11). The painting has an Eastern opulence, which must originally have been heightened by the glitter of precious stones (now lost) set in the surface. But the textiles, which contribute so much to the rich effect, are painted in a wholly un-Byzantine manner. Velvets, brocaded silks, embroideries with gold thread, and a knotted carpet—evidently of Turkish or Persian manufacture—are rendered almost illusionistically. And despite the rigid formality of their full-face and profile poses, the figures have three-dimensional substance and are placed in a space clearly defined by the foreshortened pattern of the carpet. Still more remarkable are the five scenes in the predella, with their architecture depicted in perspective from a

9, 54 The Doges' Palace, Venice, c. 1345–1438.

single central viewpoint so that we see only the left part of the vault above the scene on the left, the right wall of the house of that on the right. In this logical organization of space from a precisely determined viewpoint, Simone Martini completely rejected the *maniera greca* of Bonaventura Berlinghieri (9, 40) and went some way beyond Cimabue (9, 42) and even his own master, Duccio (9, 49).

Another Sienese artist, Ambrogio Lorenzetti (fl. 1319–47), made a further advance towards a natural-istic vision in his large mural paintings in the town hall in his native city (9, 55). Emphasis is firmly placed on the here and now in this enormous panoramic view of town and country, based on Siena and its surrounding hills—perhaps the first convincing cityscape ever painted. Buildings of many types are shown, shops with open fronts, palaces of the rich (with masons still at work on one), some with towers for defence which had been erected in earlier times of civil war. They are clearly detached from one another, and men and animals pass in the space that flows between them. Trade prospers and a note of happy harmony is struck by a group of girls in the centre foreground, dancing rather sedately to the tinkle of a tambourine, their silk dresses rustling as they gyrate. The right half of the painting depicts a well cultivated agricultural land-

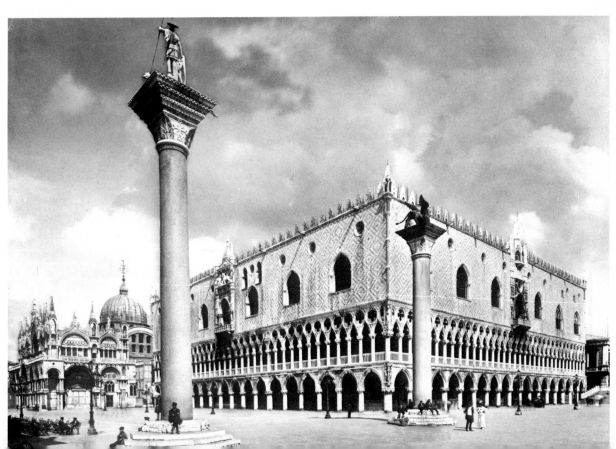

scape. Facing this peaceful vision, on the opposite side of the room, there is (or rather was, for little survives) another view of the same city and landscape devastated by war. Personifications of justice, wisdom, peace, the Christian virtues and the Sienese commune itself, holding a shield with an image of the Virgin and Child, are painted on the third wall, facing that with windows opening onto the real landscape. It was in this room that the nine magistrates who governed Siena from 1292 to 1355 held their meetings—surrounded by the paintings which were originally entitled 'Peace' and 'War' (not 'Allegories of Good and Bad Government'), visual reminders of a political theology specifically directed to maintaining peaceful stability.

Ambrogio Lorenzetti presented a realistic, not to say materialistic, view of the Tuscan countryside, which provided his home town with food and the raw materials for manufacture (Siena was a centre of the cloth trade). In the Palace of the Popes at Avignon, on

the other hand, a woodland scene becomes an idyllic but totally unproductive setting for elegantly mannered sportsmen (9, 58). A whole room was transformed into the likeness of a forest glade, with streams, many different trees and singing birds, of a type described by Virgil and Ovid in phrases that had inspired poets throughout the Middle Ages, thus linking the decoration across the centuries with that of similar painted rooms in ancient Rome (5, 18). The Papal court had moved out of Rome, mainly for

9, 55 *Below* Ambrogio Lorenzetti, *Allegory of Peace*, detail, 1339. Fresco, Palazzo Pubblico, Siena.
9, 56 *Right* The Limbourg Brothers, *September*, page from the *Très Riches Heures du Duc de Berry*, 1413–16. Illumination, approx. $8\frac{1}{2} \times 5\frac{1}{2}$ins (21.6 × 14cm). Musée Condé, Chantilly.
9, 57 *Far right* Claus Sluter, *Moses Fountain*, 1395–1403. Figures about 72ins (183cm) high. Chartreuse de Champmol, Dijon.
9, 58 *Right below* Bird-Catchers, 1343. Fresco, Chambre des cerfs, Papal Palace, Avignon.

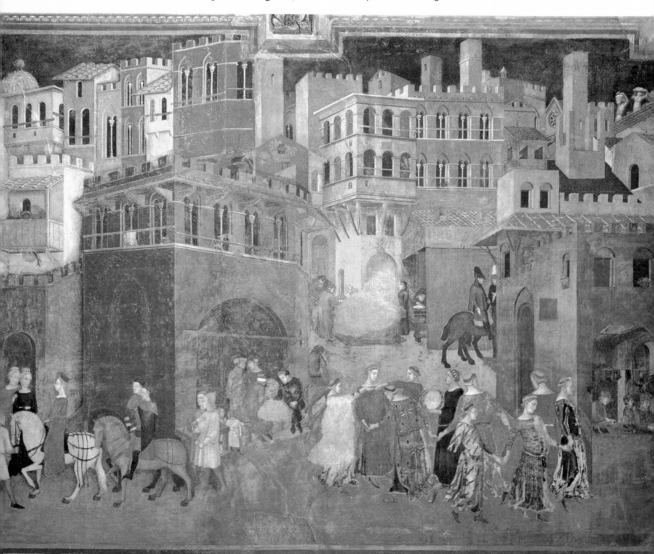

political reasons, and in 1309 settled at Avignon in the south of France (on territory of the Angevin king of Naples), remaining there until 1376. Several Italian artists went there, notably Simone Martini, and the unknown painter of the frescoed room was probably one of them. It forms part of the palace built and decorated for Clement VI (1342–52), a French aristocrat who had spent most of his career in royal service in Paris and became the most luxury-loving of the Popes who ruled from Avignon.

In 1348 Europe suffered the greatest natural calamity in its history: the bubonic plague known as the Black Death, which many contemporaries believed to have been sent as divine punishment for the profligacy of the Church and especially the Papal court. At least a third of the population died in a single summer. The long-term effects of the disaster are, however, hard to estimate and often seem contradictory. Many changes that had gradually been taking place, most notably in the feudal structures of obligation (service in return for protection), were abruptly brought to a head. No longer was there a shortage of land and food, or a surplus of manpower; but attempts to exploit the scarcity of labour were suppressed so that wealth came to be more than ever concentrated in the hands of increasingly exclusive land-owning and mercantile classes. There was a wave of popular religious fervour, marked by heightened emotionalism and public acts of penitence, for example by flagellants who scourged their backs as they walked in processions. But the proximity of death could, and often did, sharpen the appetite for earthly pleasures.

Although many artists must have died in the plague (Ambrogio Lorenzetti probably among them), there was no more than a brief hiatus in artistic activity in Italy. Major building projects were carried forward without any change in plan or in style. In Venice, for instance, work continued almost uninterrupted on the Doges' Palace, which had been begun in the 1340s (9, 54). Its main function was to provide a vast hall for the *Maggior Consiglio*, the elective assembly of the republic as constituted in 1297, when an oligarchic system was adopted—a system destined to endure for five centuries. Whereas the civic buildings of Florence and Siena were fortresses designed to protect the administrators, the Doges' Palace has an openness which reflects the tranquillity of Venice. The two rows of loggias and damask-like brickwork above give it an almost insubstantial appearance. The style is a uniquely Venetian version of Gothic, somewhat influenced by Islamic architecture and developed mainly for the palaces of its powerfully rich merchant class. But Venetians were, none the less, susceptible to the charm of the International Gothic style in painting and sculpture.

Strong currents of artistic influence had passed from France to Italy in the thirteenth century. In the fourteenth they began to flow also in the opposite direction, partly as a result of Italian artists working at the Papal court at Avignon. The so-called 'International Gothic Style', fully developed by about 1400, was the product of this confluence of two traditions. It is distinctly courtly, the creation of artists working for the interrelated but jealously competitive ruling families of Europe. Elegance of line, delicacy of colour and a jewel-like sharpness of definition were prized above all. Pol de Limbourg (fl. 1400–16) and his brothers, Herman and Jean, were among its most accomplished practitioners. Born at Nijmegen (then in the Duchy of Burgundy), and working in France, they drew much inspiration from Italian art—one of their works derives from a fresco in Florence by Giotto's pupil Taddeo Gaddi. Their masterpiece is the *Très Riches Heures* (the Very Rich Book of Hours) illuminated for John, duke of Berry, a younger son of John II, king of France.

The *Très Riches Heures* opens with 12 calendar pages, one for each month with an appropriate scene and the signs of the zodiac in a semicircle above. Thus, *September* shows the vintage in front of the duke's castle of Saumur on the Loire (9, 56). Although the perspective is anything but scientific, the precision with which every separate detail is represented lends the whole scene a poetic truth which suspends disbelief. It is, of course, a highly idealized vision of peace and plenty. It was, in fact, painted in the midst of the Hundred Years' War, which devastated northern France. Moreover, it is a view not only of but, as it were, from a castle, both literally and metaphorically looking down on the peasants. As ungainly as they are natural, these are among the first of the semi-comic 'rustics' who figure as foils to courtly elegance in European paintings, and in literature as well. For the *Très Riches Heures* is, above all, a masterpiece of the exquisite and the refined. There is, significantly enough, no reference whatever to religion: the vines, for instance, are not symbolic, as they had always been in earlier medieval art.

A Book of Hours was a compilation of passages from scripture and the Golden Legend, arranged to be read by the laity through the year—hence the prefatory calendar. One may question whether the duke of Berry was as interested in the text as he was in the Limbourgs' calendar. He was perhaps the most notable art collector of his time, the owner of Italian paintings, antique coins and engraved gems (including the

Gemma Augustea, 5, 24), and a passionate bibliophile. The *Très Riches Heures* is one of the very few great medieval works of art made for a private patron's delectation. (Many devotional images and other religious works of art were, of course, created for private patrons throughout the Middle Ages, e.g. Giotto's Scrovegni Chapel, 9, 50; 53, but in them the artistic intent is not the same.)

Some of the last great medieval works of religious art were commissioned by the duke of Berry's younger brother, Philip the Bold of Burgundy. The dukes of Burgundy were probably the most powerful rulers in northern Europe around 1400 and it was for the monastery Philip founded at Champmol, just outside his capital city of Dijon, that the Netherlandish sculptor Claus Sluter (fl. 1379–1404) created his masterpiece, the Moses Fountain. Only the base survives intact (9, 57). The Crucifixion group which it supported is now known only from fragments (9, 59). That the central mystery of the Christian faith should have formed, or rather should have been made to form,

part of a fountain is a conceit typical of the period—the sacrifice of Christ as the fountain of life. But the sense of human dignity and tragic intensity which Sluter brought to the conception and execution of this great work raises it far above all other examples of International Gothic, however exquisite and sophisticated some of them may be. Moreover, the personality of the artist is now very strongly felt, as of a sovereign master. Little more than a decade, it should be remembered, divides Sluter's masterpiece from the early works of Donatello (see p. 328).

Old Testament prophets—the six men whose words, inscribed on the scrolls they carry, had predicted the Passion—meditate on the meaning of that terrible event (9, 57). Their life-size figures recall the sculptures on Gothic portals (9, 34; 35) but go beyond them in their boldly realistic rendering of detail and in their sheer corporeality. The heads are so sensitively carved that they might well be mistaken for portraits: and so overpowering is the sense of weight and bulk of their great forms under the swelling draperies that they seem to expand into the surrounding space. They must have been almost unnervingly lifelike when they still had all their original colouring (partly by Jean Malouel, uncle of the Limbourg brothers). Jeremiah wore brass spectacles made by a Dijon goldsmith. But Sluter's fascination with the specific and the tangible would seem, from the surviving fragments, to have given way to something much more impressive in the main group. The head of Christ, torn with pain and still bearing the twisted crown of thorns in which he had been mocked and humiliated, is an entirely new image, as noble and tragic in its humanity as it is sublime in its withheld divinity. Remote both from the idealized Christs of Byzantium (7, 36) and the abject images of suffering of the early Middle Ages (9, 1), this masterpiece combines the spirituality and the realism, the mysticism and the logic that had inspired, in varying degrees, all the greatest works of Gothic art and architecture.

9, 59 Claus Sluter, *Head of Christ* from the *Moses Fountain*, 1395–1403. Musée Archéologique, Dijon.

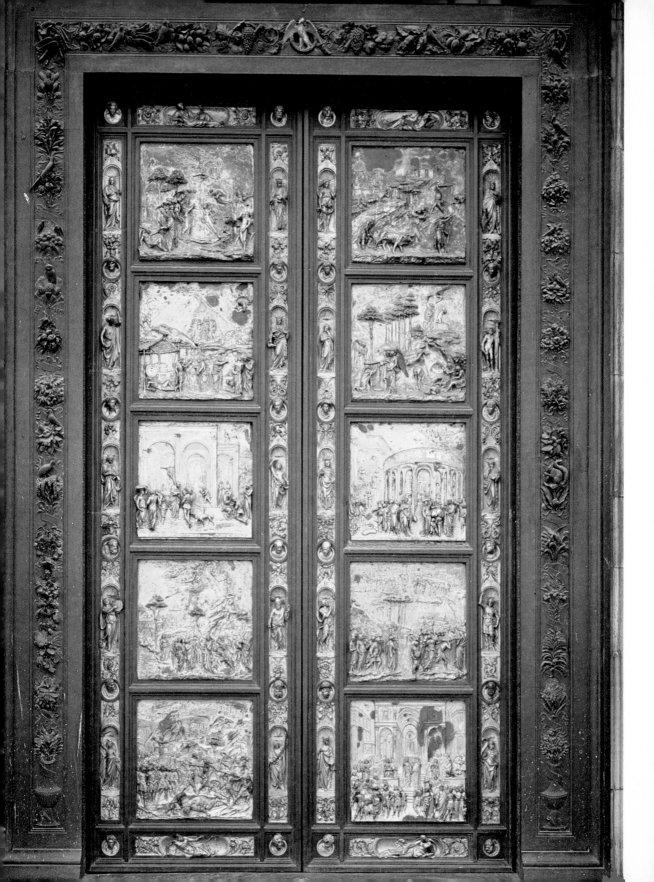

10 The fifteenth century in Europe

Gothic artists did not know that they were Gothic, or even medieval, but the Renaissance artist was well aware that he was different. No previous movement in Western art had been so self-conscious. The whole idea of a Renaissance or 'rebirth' of Classical culture, with dark Middle Ages intervening between it and the fall of the Roman empire, was largely a myth propagated in the late fourteenth and fifteenth centuries by Italian Classical scholars—humanists in the original meaning of the word. 'When the darkness breaks, the generations to come may contrive to find their way back to the clear splendour of the ancient past', wrote the poet Petrarch (1304–74) shortly before the middle of the fourteenth century. Less than a hundred years later the architect Leon Battista Alberti (1404–72) recognized among his Florentine contemporaries several artists who were 'not to be ranked below any who was ancient'—he named Brunelleschi, Donatello, Ghiberti, Luca della Robbia and Masaccio. Soon afterwards a Roman humanist, Lorenzo Valla (1405–57), somewhat complacently remarked that he did not know why the arts 'had been so greatly in decline and had almost died out altogether; nor why they have revived in this age, and so many good artists and writers have appeared and flourished.' This, in a nutshell, was how the Renaissance saw itself.

In fact, as we have seen, the Classical heritage survived throughout the Middle Ages. Greek as well as Latin literature continued to be read. There were many medieval artists who were neither blind to the beauty of Classical art nor indifferent to Classical legends and history. But the humanists of the Renaissance differed from medieval theologians and others who had studied Aristotle, Cicero and the Neoplatonists. The human-

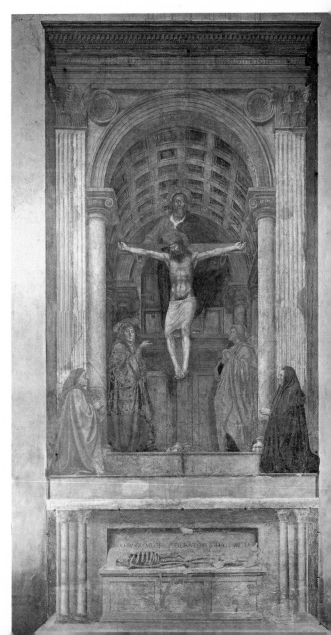

10, 1 *Left* Lorenzo Ghiberti, *Porta del Paradiso*, 1424–52. Bronze parcel-gilt, approx. 17ft (5.2m) high. Baptistery, Florence.
10, 2 *Right* Masaccio, *The Holy Trinity*, 1425. Fresco, S Maria Novella, Florence.

ists found in Classical antiquity absolute standards by which cultural and, indeed, all human activities could be judged. They created, or re-erected, a structure of values different from that on which medieval ideals of chivalry and nobility were based—one in which birth, for example, counted for less than individual prowess and intellectual ability. Humanism was nurtured in the Italian city-states, which could trace their history back to ancient Roman times and, with their republican (not clerical or aristocratic) governments, epitomized the new ideals of self-reliance and civic virtue—civic and mundane, not chivalric or contemplative.

The growth and spread of humanism is pre-eminent in the intellectual history of the fifteenth century; but its relationship with the visual arts is complex and sometimes ambiguous. Although humanists were not initially anti-clerical, still less anti-Christian, they were preoccupied by problems of the here and now rather than of the hereafter. The visual arts, on the other hand, remained largely religious both in Italy and northern Europe. For the fifteenth century was the golden age of Flemish as well as Florentine painting, and only towards its end did Italian art acquire international prestige—at least partly because of its association with humanist thought.

The beginnings of the Italian Renaissance

The Pazzi Chapel in Florence (10, 5) and the choir of St Lorenz in Nuremberg (10, 3) are almost exactly contemporary, though they might seem to belong to different worlds and different centuries. The difference is not due solely, or even mainly, to the fluted pilasters with Corinthian capitals of the one and the hexagonal piers and pointed arches of the other: it is more profound. The architects of the choir of St Lorenz developed the High Gothic style of, for instance, Amiens Cathedral (9, 29) to create a space of great complexity and apparent freedom, one that is by no means easy to comprehend. Although the plan is symmetrical and mathematically determined, a series of subtly differing patterns of lines soaring up to the intricate tracery of the vault is presented from every viewpoint. In the Pazzi Chapel there are no mysterious depths or soaring heights, no sense of the beyond. Space is precisely defined in cubes, half-cubes and hemispheres. Horizontal and vertical axes are held in balance and the effect is supremely simple, lucid and static. It is almost severely tectonic, a construct without any suggestion of organic growth. Human figures in the glazed terracotta reliefs by Luca della Robbia are confined within circles so that temporal life seems to be set in the pure and eternal geometry of the spheres. (A curiously different, visionary effect is made

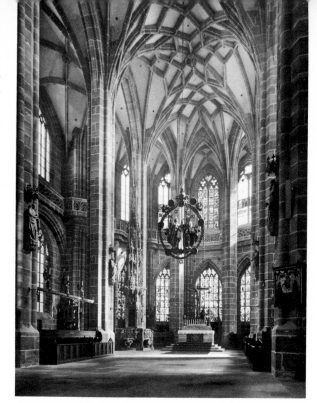

10, 3 K. Heinzelmann and K. Roriczer, choir of St Lorenz, Nuremberg, begun 1439.

by the later Annunciation group suspended in St Lorenz, the work of Veit Stoss, see p. 354.)

Renaissance churches are sometimes thought to be unspiritual. But the attitude to Christianity which they embodied was no less intensely devout for being predominantly cerebral. Divinity is revealed in them by equilibrium and the harmonious relationship of the parts to one another and to the whole—as in the human body, created by God in his own likeness—rather than by mystery and aspiration towards the otherworldly. The Pazzi Chapel is ascetic and spiritual in its renunciation of superfluous ornament and in its concentration on the purity of geometrical volumes. Simple proportional relationships, mathematically determined and emphasized by the articulation of the walls and even the grid of the inlaid marble floor, have metaphysical significance, reflecting the perfection of God and the divinely ordered cosmos. As one of Brunelleschi's Florentine contemporaries, Gianozzo Manetti (1396–1459), declared, the truths of the Christian religion are as self-evident as the axioms of mathematics.

A finite expression of infinity, the Pazzi Chapel also answers to the definition of beauty which Alberti derived from Vitruvius (see p. 159)—'a harmony and concord of all the parts achieved in such a manner that

nothing could be added or taken away or altered except for the worse'. Such perfection could, of course, be realized only by an exceptional architect, and the Pazzi Chapel has, since the late fifteenth century, been ascribed to Filippo Brunelleschi (1377–1446). In 1429 Andrea Pazzi, the head of a noble Florentine family enriched by trade and banking, commissioned Brunelleschi to design an addition (chapter-house and family chapel combined) to the monastery of S Croce. Relatively little had been constructed before Brunelleschi died, however, and the intervention of another hand has been surmised, especially for the exterior. The chapel thus raises a problem of attribution of a type seldom encountered in medieval architecture, a problem created by the new (Renaissance) attitude to architecture and the distinction drawn between artist and craftsman, between architect and builder. For although the two architects responsible for the choir of St Lorenz are recorded—Konrad Heinzelmann (d.1454) and Konrad Roritzer (d.c.1475)—it would not be possible to attribute parts of the building to them on stylistic grounds. They are little more than names. Brunelleschi's character and accomplishments, on the other hand, are well known to us.

Brunelleschi was the first of a new type of architect, one who had served no apprenticeship in a masons' lodge (see p. 296). The son of a well-to-do Florentine notary, he was given a liberal education. In 1418 he and the sculptor Lorenzo Ghiberti (see p. 321) jointly provided a model for the construction of the dome of Florence Cathedral by an ingenious engineering system which did away with centering (see Glossary), an amazing technical feat. Before work on the cathedral was under way, however, he was commissioned in 1419 to design the Foundling Hospital in Florence, usually cited as the first Renaissance building, and in 1421 he began the sacristy of S Lorenzo, Florence. With its Corinthian pilasters and pure geometrical space (a cube surmounted by a hemispherical dome with pendentives, a Byzantine form in origin), this prefigured the design of the Pazzi Chapel and of later Renaissance buildings on centralized plans.

Brunelleschi was praised in the fifteenth century both for his engineering skill and his revival of antique architectural forms. The architect and theorist Filarete (Antonio Averlino, c.1400–69) 'blessed' him for reviving 'in our city of Florence the ancient style of building in such a way that today in churches and private buildings no other style is used'. But why did this occur? Filarete suggests that it was quite simply because the ancient style was 'correct' and an architect who adopted it did 'exactly the same thing as a man of letters who strives to reproduce the classical style of Cicero and Virgil'. Brunelleschi certainly went to Rome early and may well have been the first architect or artist since ancient times to go there to study its ancient monuments. However, the causes leading to the fifteenth-century revival of antique forms and motifs may have been more diverse than Filarete supposed—as were its sources. (Brunelleschi, for instance, found in Tuscan Romanesque architecture a system for making the structural skeleton visible on the surface of the building.)

The Gothic style was associated with the north and at the very beginning of the century the independence of the Florentine republic had been threatened from the north by the Milanese Giangaleazzo Visconti, an ally of the Holy Roman Emperor in Germany. His death in 1402 not only removed the peril of conquest, but also enabled the Florentine republic to expand to the Mediterranean coast and transform itself from a city-state to a region-state. At this buoyant moment Florentines looked back with pride to their supposed origin as a colony of republican Rome. 'I believe that this is why it has been and is true that of all peoples the Florentines appreciate liberty most and are the greatest enemies of tyrants,' wrote the humanist and historian Leonardo Bruni (c. 1370–1444). 'Other peoples were founded by fugitives or exiles or peasants or obscure strangers,' he went on. 'But your founder is the Roman people, conqueror and lord of all the world' (*Laudatio florentinae urbis*, c. 1403–4). Northern European royalty and nobility might trace their lineage to the Gothic chiefs who had vanquished Rome; the leaders of the mercantile republic of Florence found nobler ancestry in ancient Rome itself. In this context Brunelleschi's rejection of Gothic and his return to the Roman column, the round arch and the rectangular window have more than just an aesthetic significance.

Brunelleschi's contemporaries credited him with another achievement of equally great and far-reaching effect: the invention of linear perspective. Various devices had previously been used to suggest distance in pictures and drawings, but Brunelleschi worked out a system by which it could be rendered in a scientifically measurable way. Assuming that visual rays are straight lines subject to the laws of geometry, he seems to have been the first to realize that if a picture is regarded as a window between the viewer and what he sees, the objects on it can be made to obey the same laws. The key to his system lay in the observation that all parallel lines running into space at right angles to the 'window' will seem to converge on a central vanishing-point at the viewer's eye-level. These lines, called orthogonals,

opened the door—not to say window—to the idea of a picture as an illusionistic representation of objects in space seen from a fixed viewpoint. More important, it seemed to impose order—a rational order—on the visible world.

The architectural style and the system of perspective developed by Brunelleschi were very quickly taken up by other artists, notably by Masaccio (1401–28) in his fresco of the Holy Trinity, commissioned as a memorial to a prominent Florentine family (10, 2). In the foreground a skeleton lies on a tomb beneath the inscription: 'I was what you are, and what I am you shall be'. Above, the painting's donor in the scarlet costume of a *gonfaloniere* (the highest civic office of the

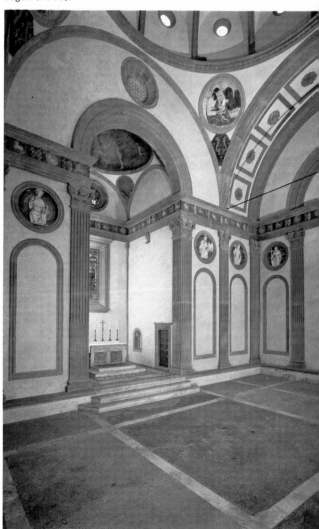

10, 5 Filippo Brunelleschi, Pazzi Chapel, S Croce, Florence, begun c. 1440.

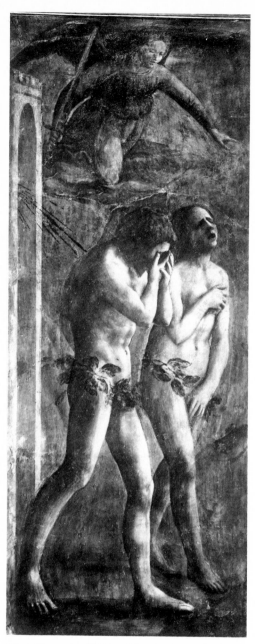

10, 4 Masaccio, *The Expulsion from Paradise*, c. 1427. Fresco, Brancacci Chapel, S Maria del Carmine, Florence.

provide a geometrical network defining pictorial space. Brunelleschi demonstrated his system in two paintings (now lost), but his friend Alberti codified and probably elaborated on it in his treatise on painting (1435). The enthusiasm with which Brunelleschi's discovery was greeted can hardly be exaggerated. At a stroke it had raised the art of painting to a science. It

republic) kneels with his wife at the entrance to a chapel in which the Virgin and St John stand on either side of a crucifix supported from behind by God the Father. In a medieval painting the donors would have been much smaller than the sacred figures. Here they are slightly larger. For with the aid of the new system of perspective Masaccio painted all the figures to scale and set them within a single unified space. Thus the tomb is 'read' as a projection into the church, and the chapel as a view through the wall. The chapel with its coffered vault is depicted with such care that a measured ground plan can be drawn of it. Otherwise, however, the perspective system is rather less simple than it may at first appear.

The Virgin and St John are foreshortened to show that they stand beyond the two columns, and the Virgin gazes down on the spectator, whose attention she directs with a gesture to the figure of Christ. But the Trinity is depicted from a much higher, literally supernatural viewpoint, without any foreshortening. Two levels of reality, temporal and eternal, are thus indicated; and in the temporal sphere past and present are visually detached yet spiritually linked with one another and with the world without end.

Masaccio's major achievement, however, was to revitalize the human figure with the robustness it had had in the frescoes of Giotto (9, 50) and to create an illusion of tangibility by means of *chiaroscuro* (the manipulation of light and shade). Although he died when only 27, Masaccio completed one great cycle of frescoes in which this tangibility endows the figures not only with solidity and weight, but also with a new sense of dignity and independence, of flesh-and-blood vitality (10, 4).

'Progress' in sculpture

Mastery of perspective was assumed to evince progress and thus set the new men of the early fifteenth century apart from their immediate predecessors. The idea of artistic 'progress', implicit in Pliny's account of the history of art (see p. 139), was both revived and revised during the Renaissance, influencing artists as well as historians and encouraging painters and sculptors to vie with one another. The Florentine Baptistery doors illustrate the effect this notion of progress had in practice.

Andrea Pisano (c.1290–1348) had made for the Baptistery a pair of bronze doors with gilded figures in relief, still distinctly Gothic in style, in 1300–30. In 1401 sculptors were invited to compete in making trial reliefs for a second pair of doors. (This seems to have been the first public competition of the kind in the history of art.) The winner was Lorenzo Ghiberti

(1378–1455), who maintained Andrea Pisano's scheme of 28 Gothic quatrefoils enclosing narrative scenes or single figures. But he gave greater depth, both real and apparent, to the individual scenes, and in the process of modelling them seems gradually to have abandoned Gothic grace in the pursuit of a more robust naturalism and a more dramatic narrative. On completing these doors in 1424 Ghiberti was promptly commissioned to make another pair for a third portal. He had improved on Andrea Pisano and now set out to surpass himself—as Florentines of the day agreed he had succeeded in doing when his second pair of doors was completed in 1452 and given the place of honour in the portal facing the Cathedral—known as the Porta del Paradiso (10, 1).

On Ghiberti's second pair of doors the reliefs are fewer, larger and gilded overall. A single scale of proportions is used throughout so that the foreground figures are of the same size in all the scenes. Leonardo Bruni (see p. 319) had worked out the program, though Ghiberti himself may have modified it in the course of the work. Ghiberti certainly exploited the Old Testament subjects to display not only his consummate skill as a craftsman, in the exquisitely refined modelling and finishing of every detail, but also as an artist in the representation of human figures—whether nude or elaborately clad, at rest or caught in gently lilting movement—as well as in the use of linear perspective. In the two central scenes, indeed, he seems to have incorporated buildings, one on a rectangular and the other on a circular plan, just to show how well he could represent them. 'I strove to imitate nature as clearly as I could, and with all the perspective I could produce, to have excellent compositions with many figures', Ghiberti wrote.

In his *Commentaries* (c.1450–55), Ghiberti included both a history of ancient art, derived from Vitruvius and Pliny, and an account of art in Tuscany from the time of Giotto to the mid-fifteenth century. The idea of 'renaissance' is nowhere more clearly expressed than in his parallel description of the birth and rebirth of painting and sculpture. An enthusiastic student and collector of ancient Roman art, Ghiberti was on friendly terms with the Florentine humanists who were studying Classical texts. But his account of the revival of the arts, elaborated by later writers (notably Giorgio Vasari, see p. 357) into the history of a movement originating in Florence and gradually spreading to the rest of Italy—rather as Christianity had spread from Jerusalem—is misleading. Italian Renaissance art is multifarious, if only because it was the product of individuals (patrons as well as artists) more acutely conscious than ever before of their individuality.

The work of the Sienese sculptor Jacopo della Quercia (c.1374–1438) provides an antidote to the Florentine version of the Renaissance. Little if at all influenced by the humanists, hardly affected by Brunelleschi's rationalization of pictorial space, no more than marginally interested in antique art, della Quercia evolved a new style intuitively. Yet it has all the steady poise and controlled naturalism of the new age. Even when set in Gothic niches, his saints seem to be unaware of them, so deeply are they immersed in themselves (10, 6). Though not, in fact, free-standing, they appear to be detached in both senses of the word. Della Quercia's attention focused on the human figure, sometimes to the exclusion of almost all else, as in the reliefs he carved on two pilasters flanking the main doorway of S Petronio in Bologna (10, 7). In the *Expulsion from Paradise* three figures fill the entire panel, which has a tragic intensity lacking in Ghiberti's conception of the same subject. As in Masaccio's *Expulsion* (10, 4), Eve derives her pudic gesture ultimately from an antique statue of Venus (4, 23d), but della Quercia's and Masaccio's distraught figures evince an internal anguish quite foreign to ancient art. And della Quercia's Adam is still more remarkable, a powerful image of man's nobility in defeat, defiantly confronting the archangel with a twist of his muscular torso as he struggles to resist divine judgement.

A new style in Flanders

By the mid-fifteenth century Italy and Flanders—the two most densely urbanized areas in Europe—had emerged as the two great centres of European art. There were both economic and cultural links between them and although Florence was nominally a republic, while Ghent, Bruges and Ypres, the three leading Flemish cities of the time, formed part of the duchy of Burgundy (which was to pass by marriage to the Austrian Habsburg monarchy in 1477), this difference was not as great as the political labels might suggest. Both areas were prosperous, though they suffered from the general economic depression of fifteenth-century Europe.

While the Florentines were working out theories and systematic rules for the representation of three-dimensional space, the Flemish discovered linear perspective by trial and error and went on to experiment in the same empirical spirit with aerial perspective (the subtle gradation of tones suggesting distance in a landscape). This distinction is fundamental. Flemish artists were not of a theorizing turn of mind. But, despite this and their lack of interest in antiquity, the break they made with their immediate predecessors was no less strongly marked.

10, 6 *Left* Jacopo della Quercia, *St Lawrence* (detail of Trenta altar), 1416–22. S Frediano, Lucca.
10, 7 *Right* Jacopo della Quercia, *The Expulsion from Paradise*, c.1430. Istrian stone, 34 × 27ins (86.4 × 68.6cm). Detail of main portal, S Petronio, Bologna.

In Flanders, of course, there had previously been little if any large-scale painting. There were magnificent, richly glowing stained-glass windows. But the great contribution Flemish painters were to make to Western art—the development of easel or panel painting—owed more to the tradition of manuscript illumination. And to obtain on panels effects as bright and lustrous as those of the Limburg brothers (9, 56), for instance, called for a medium more luminous than tempera. It was in this context that oil painting was developed.

From at least as early as the tenth century various oils had occasionally been used as media to bind powdered pigments. (In tempera painting the pigments are bound with egg yolk.) Not until early in the fifteenth century and in Flanders, however, did artists begin to exploit the potentialities of pigments mixed with oil (usually linseed) in applying translucent films of paint over opaque colours to give an appearance of depth beneath a hard enamel-like surface. Whereas artists using tempera, which dries in a matter of

minutes, were obliged to work quickly across the surface of a panel, piece by swiftly painted piece, those using oil could build up a picture slowly. The new process permitted and encouraged the great precision of detail which is perhaps the most immediately appealing feature of fifteenth-century Flemish painting. (Of course, media were often mixed, e.g. oil colours applied over tempera.)

The Flemish artists who developed this technique, which revolutionized the art of painting in Europe and, with linear perspective, led it ever further away from that of the rest of the world, are shadowy figures. No biographies were written of them nor were their works so much as listed by contemporaries. Only in Italy were artists deemed worthy to appear in collections of lives of famous men and, significantly, the earliest account of Jan van Eyck (c.1390–1441)—to whom the 'invention' of oil painting was for long ascribed—was written in 1455–6 at the court of the king of Naples, who owned a triptych by him. Its author, Bartolomeo Fazio, called him 'the leading painter of our time' for his technical accomplishment, his truth to nature and—here speaks the Renaissance humanist—his rediscovery of pigments known to Pliny and other ancient authors. Van Eyck's skill in handling oil paint is indeed extraordinary. The transparency of the pigments gives his paintings a unique jewel-like quality to which no reproduction can do justice. They seem to emit light from within. He developed the medium to give form the palpable solidity of, for example, the Adam and Eve on the great altarpiece in Ghent Cathedral (begun by his brother Hubert). These almost disturbingly lifelike figures owe their impact also to his mastery of perspectival foreshortening— they are seen as if from below, the under-side of Adam's toes being visible, and his right foot seems to stick out over the edge of the frame (10, 8). Strikingly naturalistic, they are nevertheless quite uninfluenced by Classical sculpture, to which Italians habitually turned when painting nude figures. Their warm, breathing, flesh-and-blood quality is contrasted by Van Eyck with the simulated relief carvings of the sacrifice and murder of Abel directly above them.

Jan van Eyck also rivalled his Italian contemporaries in rendering space. In the *Madonna of Chancellor Rolin* (10, 25) both the volume of the room and the extent of the view through the triple arches at its end are convincing. The landscape is indeed so convincing that attempts have been made to identify it. The room might also seem to be in a real building, though the architecture is of a type (basically Romanesque with Gothic details) developed by van Eyck to depict the New Jerusalem. For this is a celestial audience-

10, 8 Jan van Eyck, *Adam and Eve*, completed 1432. Tempera and oil on panel, St Bavo, Ghent.

chamber in which the Queen of Heaven receives the chancellor of Philip the Good, duke of Burgundy. Practically every one of the exquisitely painted details has a symbolic meaning. Yet all the learned symbolism remains unobtrusive. For the more naturalistically van Eyck and other Flemish painters depicted the visible world, the more intensely did they saturate it with spiritual significance. Their naturalism was far from being profane, since to them everything could be a symbol. God is diffused in all visible objects, which are, to quote St Thomas Aquinas, 'corporeal metaphors for things spiritual'. So total a sanctification of the visible world is now difficult to comprehend and often these religious paintings seem to be no more than scenes from contemporary life in a Flemish town. The simplest everyday household furnishings could have meaning in a universe which shone with 'the radiance of delightful allegories'—a candlestick symbolizing Our Lady, a brass ewer her purity, and so on. In the *Madonna of Chancellor Rolin* the river might be the Meuse—or the 'pure river of the water of life, clear as crystal', described in the Book of Revelation. The garden is such as might be found adjoining a palace—

but it is planted with roses, lilies and irises, attributes of the Virgin, and so becomes the Garden of Paradise. The earthly and the heavenly are fused in this painting, where the Virgin, over whose head an angel hovers with a crown, and the Child with the creased skin of a mortal baby are no less vividly perceived and depicted than the rock-faced, proud and unscrupulous Nicholas Rolin kneeling before them.

Jan van Eyck was one of the first great European painters of portraits, descriptive rather than interpretative in their sharp concentration on physical individuality. The slightly younger Rogier van der Weyden (1399/1400–64) approached his sitters with less attention to detail than to general effect. The refinement of his delicate modelling and gently felt contours give to nearly all his sitters an aristocratic air. The unknown young lady in one of his best portraits is very obviously well born to the tips of her exquisitely manicured fingers (10, 9). Her eyes are demurely cast down so that she avoids our gaze, but the fullness of the lips and the tenderness of the delicate clasped hands beautifully convey nervous sensitivity. She is depicted in the three-quarter view which Rogier van der Weyden

10, 9 Rogier van der Weyden, *Portrait of a Lady*, c.1455. Oil on panel, $14\frac{1}{2} \times 10\frac{3}{4}$ins ($36.8 \times 27.3$cm). National Gallery of Art, Washington DC (Andrew W. Mellon Collection).

and other fifteenth-century Flemish artists preferred. This pose introduces a sense of movement, the sitter turning and, as it were, advancing from the pictorial space into the real space occupied by the spectator, with whom a *rapport* is thus established.

Jan van Eyck and, still more, Rogier van der Weyden set the pattern for north European painting until the first decades of the sixteenth century. They created standards rarely achieved and never excelled by their immediate successors in the Low Countries, many of whom were artists of great ability—Petrus Christus (d.1472–3), painter of quiet religious scenes and shy portraits; Dirc Bouts (c. 1415–75), whose sad figures stand in landscapes of exquisite beauty; the more dramatic and mystical Hugo van der Goes (d.1482). During this period Flemish art was exported to all parts of Europe: to Germany, England, Scotland, France, Spain, Portugal and even to Italy, where it was valued by Italian patrons and painters until late in the fifteenth century. Then the current of influence from north to south began to turn. Flemish painters were, however, always admired mainly for their technical accomplishment in the exploitation of oil paint. The arts of the two countries came closest to one another in portraiture. Even here, however, there are as many differences as similarities. Italians favoured

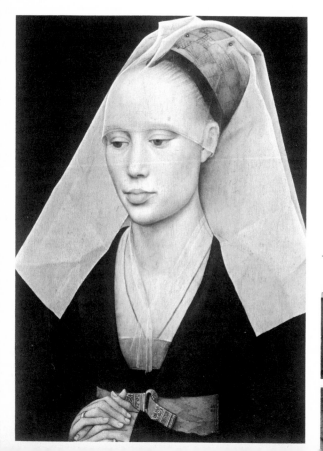

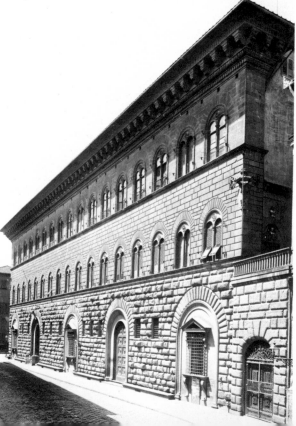

pure profiles, which dissociate the subject from the spectator and were reminiscent of heads on antique coins. Even at its most naturalistic, Italian fifteenth-century art was more conceptual than that of Flanders. Artists of both countries claimed to imitate nature but, to use a distinction of the period, the Flemish were preoccupied largely with *natura naturata* (the created world), the Italians with *natura naturans* (the creative force behind it). And in the north the new artistic impulse found an outlet only in painting; sculpture was little affected and architecture not at all.

Architecture in Italy

Palazzo Medici, which set a pattern for Florentine town houses, is sober and severe, even a little forbidding. On the exterior, windows are simple and regular and the design makes its effect largely by very carefully adjusted variations in texture, massive blocks for the ground floor, smooth rustication (see Glossary) above and a flat wall-surface on top, overshadowed by a massive spreading cornice (10, 10a). There is a greater elegance, but little more ornamentation, in the interior courtyard's composite columns supporting round arches with circular reliefs above (10, 10b). All is rigidly integrated and controlled—in striking contrast to the house of another wealthy financier being built in

ous, while the other is lavishly Gothic with whimsical touches (illusionistic figures leaning out of simulated windows, innumerable carvings alluding to the owner's name).

Both patrons must have played a role in determining the designs, Jacques Coeur's house giving an impression of extravagant opulence, Cosimo de Medici's one of ample, solid wealth. Head of the Medici bank and the richest man in Florence, Cosimo was the first citizen of the republic and took his civic responsibilities seriously. His palace was intended to be both a dwelling and an ornament to his city, a model of 'decorum', which implied more than good taste. He is said to have rejected a design by Brunelleschi because it was too ostentatious and turned to Michelozzo di Bartolomeo (1396–1472), whose art and, if we are to believe Vasari, life were regulated by prudent economy. This may well have recommended him to Cosimo. Significantly, the name of Jacques Coeur's architect is not recorded. Not that an architect was any less important for a Gothic building than for one in the Renaissance style, but in fifteenth-century Florence the role of the architect underwent a fundamental

10, 11 House of Jacques Coeur, Bourges, 1443–51: interior courtyard.

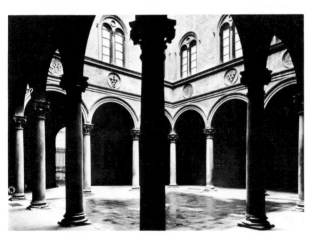

10, 10a *Left* Michelozzo, Palazzo Medici-Riccardi, Florence, begun 1444.
10, 10b *Above* Michelozzo, Cortile of Palazzo Medici-Riccardi, Florence.

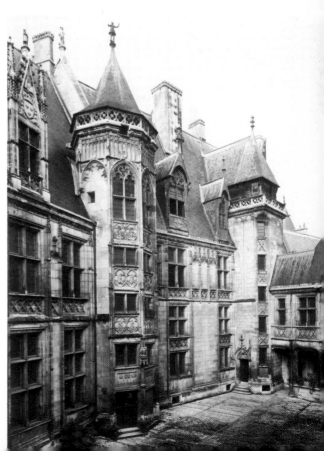

France during the same years (10, 11). Although similarly ranged round a central courtyard, Jacques Coeur's house sprawls with rooms of varying shape added to one another horizontally and vertically according to function or fancy. Similarly in decoration, one is gravely Classical and solemnly decor-

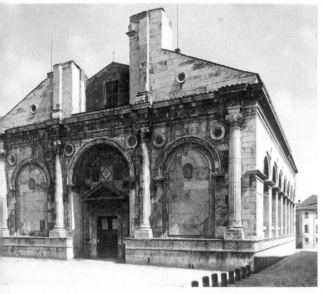

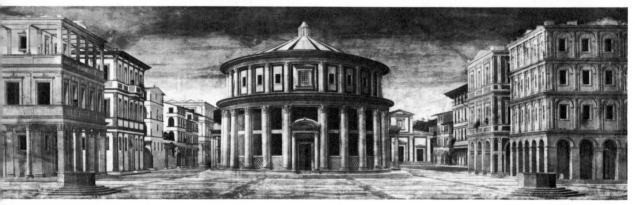

10, 12 *Top left* Leon Battista Alberti, S Francesco, Rimini, begun 1450.
10, 13 *Top right* The Loggia, Palazzo Ducale, Urbino, late 15th century.
10, 14 *Above* Circle of Piero della Francesca, *An Ideal Town*, mid-15th century. Panel painting, 79 × 23½ins (200.6 × 59.7cm). Galleria Nazionale delle Marche, Urbino.

change (as already mentioned, p. 319), due almost entirely to one man: Leon Battista Alberti (1404–72).

Alberti might be said to have created the ideal of the complete man of the Renaissance in his own image. Moralist, lawyer, poet, playwright, musician, mathematician, scientist, painter, sculptor, architect and aesthetic theorist, his range was extraordinary and his knowledge profound. No one did more to enhance the status of the visual arts and, consequently, of artists. To him we owe the basic idea of an all-embracing Renaissance style. In his treatises on painting (1435, published 1540), on architecture (1452, published

1485) and on sculpture (c.1464–70, published 1568), he developed a rational theory of beauty based on the practice of the ancients and what he called the 'laws of nature'.

The illegitimate son of a noble family exiled from Florence, Alberti was given a classical education and began to develop an interest in architecture only after joining the Papal civil service in Rome in 1431. Inspired by antiquity, he evolved a style more massively plastic than that of Brunelleschi and also more archeologically correct. Although his columns, for example, are often used decoratively rather than structurally, they are always combined with architraves, not arches. One of his greatest and most influential achievements was, in fact, to adapt the elements of the Classical post-and-lintel temple, in which the wall is conceived as no more than a filling between upright supports, to an architecture of walls pierced by openings. Another innovation was his self-

promotion to professional status. He took no part in construction, but limited himself exclusively to design.

One of the first to ask Alberti for designs was Sigismondo Malatesta, the prototypical Renaissance prince, who at the age of 14 seized the lordship of Rimini from his uncle and his brothers and soon emerged as a daring military commander, a ruthless ruler and a patron both of humanist scholars and of artists. In 1450 he decided to transform the medieval church of S Francesco into a monument to his own glory as the burial-place for himself, his mistress Isotta degli Atti and various luminaries of his court. It was subsequently called the Tempio Malatestiano (10, 12). Alberti designed a marble case for the old church, the front freely based on a Roman triumphal arch symbolizing triumph over death, the side walls pierced by deep arched niches containing austerely plain sarcophagi intended for poets and philosophers (one contains the bones of a Byzantine Neoplatonist, Gemistos Plethon, snatched from Mistra in the Peloponnese as if they were the relics of a saint). Here the early Renaissance style in architecture came of age. There are no reminiscences of Romanesque (as in so many Florentine buildings): all is magnificently Roman, yet derived from no specific ancient building. So perfectly had Alberti mastered the Classical language of architecture that he was able to compose in it with original imaginative potency. But like other Renaissance projects, initiated by those whose ambitions outran their means, it was never completed. It lacks the intended dome and in its unfinished state fortuitously resembles a ruin. Although the finely chiselled half-columns, the beautiful clean lettering of the inscription and the wreaths of bay which encircle the windows all hark back to ancient Rome, this building is the reverse of a ruin: it is rather a symbol of aspirations towards a new ideal, of faith in the future as much as veneration for the past.

A townscape painted a decade or so later neatly expresses the ideal towards which Italian architects and their patrons aspired (10, 14). A circular building stands in the centre of a marble-paved piazza surrounded by buildings of varying size and character, yet all designed with the logical geometry as well as the Classical detailing of the early Renaissance style. Order is not so much imposed as accepted in a framework which permits individuality so long as it is kept within the limits of decorum. The airy lightness and spaciousness, which differentiate this view from that of a medieval city (9, 55), make it a symbol also of the Renaissance ideal of civic humanism.

The unknown painter was obviously influenced by Piero della Francesca (see p. 334), who worked for

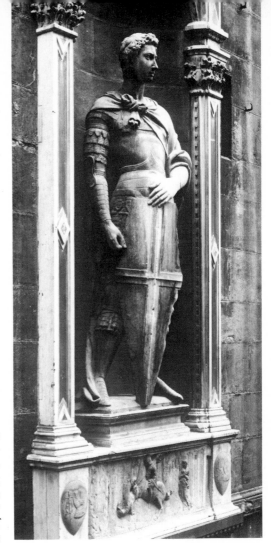

10, 15 Donatello, *St George*, c.1415–17. Marble, approx. height 82 ins (208cm). Or San Michele, Florence.

both Sigismondo Malatesta at Rimini and for his great antagonist Federico da Montefeltro at Urbino, and it may well have been painted for the latter. Federico, lord of the tiny dukedom of Urbino, was another condottiere and discerning patron of both artists and Classical scholars. His architectural activities were concentrated on the palace built to house his court, which became a curious combination of military academy and institute of Classical studies. The vast building was erected slowly, probably as money became available, to the designs of a succession of architects. Throughout, the emphasis is on the delicate adjustment of proportions and the refinement rather than the prodigality of carved decorations even more exquisite than those of the slightly earlier Palazzo Medici in Florence; they were limited mainly to corbels

and the surrounds of doors and fireplaces, sharply carved with Classical ornament.

The richest room must always have been Federico's *studiolo*. But this study and the adjoining loggia, both intimate in scale, were intended not for public display but for the duke's personal delectation (10, 13). From the loggia he could survey the rugged countryside; in the privacy of the *studiolo* he kept his most precious possessions, his library of manuscripts, many of them written out by the 20 or 40 scribes he employed, comprising numerous theological works, all the medical treatises then available, Greek texts including the plays of Sophocles and the poems of Pindar, a section devoted to Dante, Boccaccio and other Italian writers, not to mention original works and translations by contemporary humanists. The manuscripts are now in the Vatican but the room is still lined with the cupboards of *intarsia* work, tiny segments of wood skilfully inlaid to form pictures. Above this inlaid woodwork were painted portraits of famous men and allegories of the liberal arts. If the ideal townscape symbolizes one of the aspirations of the early Renaissance, this room and its loggia epitomize some of its human achievements.

Sculpture in Italy

Passion for antiquity inspired sculptors as well as architects, and none more so than Donatello (Donato Bardi, c.1386–1466). He began as an assistant on Ghiberti's first bronze doors for the Florentine Baptistery and very soon emerged as an independent artist, one who revitalized almost every form of sculpture from free-standing monuments to the low relief. His first statues were, like those of medieval sculptors, intended for architectural settings, usually for niches. But the Gothic niche he designed for his St George is so shallow that it projects the figure forward away from the building and into the spectator's world (10, 15). It is, in effect, almost a free-standing figure— and has been exhibited as such since the late nineteenth century, when it was removed to a museum and its place taken by a copy.

Because of the cost of materials, a sculptor was necessarily limited to the commissions he received, and those for large free-standing figures were rare in early fifteenth-century Italy. So there can be little doubt that Donatello welcomed the commission for a bronze equestrian monument in Padua which gave him a chance to rival the famous antique statue of Marcus Aurelius in Rome (5, 26). Its subject was to be the condottiere Erasmo da Narni, nicknamed Gattamelata, who died in 1443 after serving the Venetian republic for many years as captain-general of its

10, 16 *Top* Donatello, *Equestrian Monument to Gattamelata*, 1445–50. Bronze, c.11 × 13ft (3.4 × 4m). Piazza del Santo, Padua.
10, 17 *Above* Donatello, *Lamentation over the Dead Christ*, 1460–66. Bronze, S Lorenzo, Florence.

10, 18a *Left* Pisanello, Domenico Malatesta medal, c.1445.
Bronze, diameter 3⅜ins (8.5cm). Victoria and Albert Museum,
London.
10, 18b *Right* Pisanello, Leonello marriage medal, 1444. Bronze,
diameter 4ins (10.2cm). Victoria and Albert Museum, London.

armies. In modelling the horse Donatello seems to
have kept in mind that ridden by Marcus Aurelius and
also the four even earlier bronze horses on the façade
of S Marco in Venice, though he gave to his charger a
new sense of controlled vigour (10, 16). Gattamelata
wears a Roman breastplate, but is otherwise dressed in
contemporary costume with a long sword, armour on
his legs and his feet in stirrups (unknown in ancient
Rome). Donatello made other innovations. The head
of Gattamelata is not modelled (like that of Marcus
Aurelius) to be seen at eye-level. The features are
daringly distorted to make the maximum effect when
the statue on its high plinth is seen from the ground.
The work is, in fact, an attempt to surpass antiquity.

Likewise in the reliefs modelled for the church of S
Antonio, beside which the Gattamelata monument
stands, Donatello vied with antiquity by displaying his
mastery of linear perspective (conspicuously lacking in
antique reliefs) and of pictorial narrative as prescribed
in Alberti's treatise on painting. In his last reliefs,
however, modelled for the two pulpits in the church of
S Lorenzo in Florence, all technical accomplishment
was subordinated to the expression of fervently felt
religious convictions. There is emotional violence in
these profoundly moving scenes from the Passion.
They convey a spiritual message with an almost
brutally physical realism. In that of the Lamentation
(10, 17) the distraught grief of Christ's mother and
followers is felt not only in expressive features and
gestures, but also in the composition as a whole, in the
absence of logic, in the agonized confusion of the
group of mourners, in the strange way in which the
sharp diagonal of the ladder and the bodies of the two
thieves are severed by the frame. Foreshortening
devices and distortions which enable the scene to be
'read' from below are so effective as to be unobtrusive.
Similarly, borrowings from antiquity—the Maenad-

like dress of the figure below the right cross, the nude
horseman in the left background—have been as-
similated fully, but again quite unobtrusively. Only the
relief of cupids in the frieze owes an obvious debt to
antiquity.

This frieze is largely by Donatello's pupil and
assistant Bertoldo di Giovanni (c.1420–91), later to be
the master of Michelangelo (see p. 362) and thus the
link between the two greatest Renaissance sculptors.
His independent works are on a small scale, notably
medals and bronze statuettes. However, it is in such
works that Renaissance ideals can be most clearly seen
in concentrated form. Medals went back directly to the
imperial coinage of ancient Rome ('medal' originally
signifying a coin out of circulation); but like the
portrait bust, which had a similar ancestry in ancient
Roman art and reappeared in the fifteenth century (10,
21), they are examples of rebirth rather than revival.
Pisanello (Antonio di Puccio Pisano, before
1395–1455), a distinguished painter and exquisite
draftsman, was the first artist to make a speciality of
them and created a virtually new art form. Each of his
medals has on the front a profile portrait, more
strongly characterized and also more boldly modelled
than the heads of emperors on ancient coins. Usually
there is an allegorical device on the back. That of
Domenico Malatesta Novello (younger brother of
Sigismondo Malatesta, see p. 327), for instance, has on
its reverse a scene incorporating an armoured knight
kneeling before a crucifix and a horse, the latter
represented with amazing economy of means (10, 18a).
Another, commemorating the marriage of Leonello
d'Este to Maria of Aragon, has the charming device of
Cupid teaching a lion (Leonello) to sing (10, 18b).
Medals became increasingly popular in humanist
circles as vehicles for transmitting personal fame with
delicately contrived devices, often ingeniously ab-
struse. Intensely private works of art, which could be
fully understood only by an erudite élite, they were
intended to stimulate philosophical thought, just as
religious images inspired devotion.

Bronze statuettes are also essentially private and
reflect even more clearly the same secular tastes, being
intended purely as works of art. Whereas medieval
statuettes had been devotional (9, 46), these were often
quite overtly pagan. Their appearance in fifteenth-
century Italy was prompted partly by descriptions in
Latin literature. 'What precision of touch, what daring
imagination the cunning master had, to model a table
ornament, yet to conceive such mighty forms', the first-
century AD poet Statius (a writer popular with
humanists) had remarked of a statuette of Hercules.
The same words could be applied to a group of

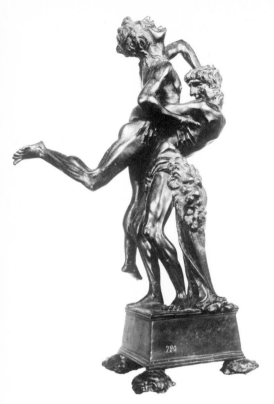

10, 19 Antonio del Pollaiuolo, *Hercules and Antaeus,* c. 1475. Bronze, height approx 18ins (46cm). Museo Nazionale del Bargello, Florence.

Hercules and Antaeus by Antonio del Pollaiuolo (1433–98), in which not only an antique form but an antique aesthetic attitude was reborn (10, 19). Formal artistic problems to which Alberti had alluded in his treatise on sculpture, in connection specifically with Hercules and Antaeus, were brilliantly solved by Pollaiuolo. The bronze must be handled and turned round so that it can be seen from multiple viewpoints, being centrifugally composed and at the same time perfectly balanced. The energy of the male nude in action, which Pollaiuolo extolled in paintings and in an engraving of a battle between naked men, is here condensed into an image of dramatic intensity.

The bronze may, nevertheless, have had an allegorical significance for its original owner, probably Lorenzo de' Medici (the Magnificent). He would have been aware of the medieval conception of Hercules as a prototype of the Christian knight and how, by restoring him to his pagan context, the humanists had transformed him into a symbol of 'Renaissance Man', the mortal who achieves immortality by his own efforts. Further philosophical meaning could be read into the story of his overcoming Antaeus, a giant who

remained invincible only as long as he was in contact with the earth. But bronze statuettes were, of course, also prized simply as highly sophisticated and exquisitely refined works of art and some of the finest, for instance those by Piero Jacopo Alari Bonacolsi appropriately named Antico (d.1528), had no ulterior meaning or purpose at all (10, 28). The mercurial hedonism of such works seems almost provocative when, as sometimes happened, the same 'antique' skills were lavished on figures of Christ and the saints.

There is a dichotomy rather than a conflict in Renaissance thought between Christianity and the

10, 20 Desiderio da Settignano, *Monument to Carlo Marsuppini,* begun c.1453. Marble, $19\frac{3}{4} \times 11\frac{3}{4}$ft (6.01 × 3.58m), S Croce, Florence.

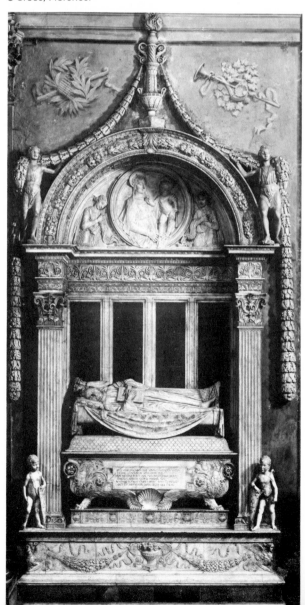

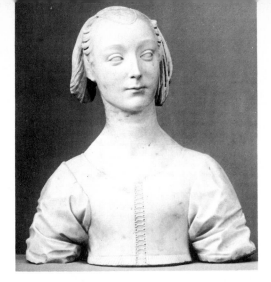

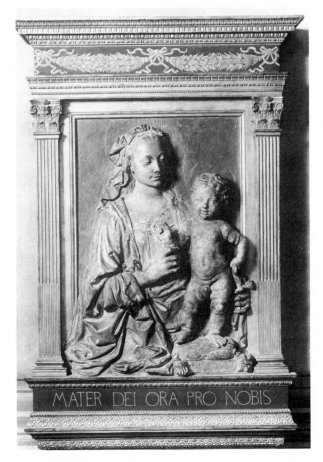

humanism which encouraged the enhanced view of the dignity of man and the beauty of the physical world implicit in such works of art. This becomes evident in humanist tombs, such as the monument by Desiderio da Settignano (c.1430–64) to Carlo Marsuppini, a Classical scholar, the first translator of Homer into Italian verse and, from 1444 until his death, state chancellor of Florence (10, 20). Marsuppini is shown lying in state with a book under his lifeless hands, probably as at his funeral, which was one of unprecedented pomp. Beneath him there is a sarcophagus standing on a plinth, both carved with Classical ornaments which combine springing vitality with incisive precision. On either side stand slender naked boys carrying shields, winged but very obviously mortal children rather than angels. The Latin inscription on the sarcophagus reads: 'Stay and see the marbles which enshrine a great sage, one for whose mind there was not world enough. Carlo, the great glory of his age, knew all that nature, the heavens and human conduct have to tell. O Roman and Greek Muses, now unloose your hair. Alas, the fame and splendour of your choir is dead.' There is not so much as a hint in all this of Christian beliefs or even of Christian virtues. The monument is, however, crowned by a relief of the Virgin and Child flanked by angels, as beautifully carved as the rest. Christianity and humanism are thus visually detached from one another, yet each has its appropriate place within a framework of early Renaissance architecture.

The head of Marsuppini with high brow and prominent cheekbones was probably a likeness, not a generalized image of the kind usual on medieval tombs. Significantly, Desiderio da Settignano is known to have been one of the Florentine sculptors who carved the first portrait busts since ancient Roman times. It was the idea rather than the form of these busts that derived from antiquity, much more of the chest and arms being shown than in ancient Roman examples. Some, of local notabilities whose names are inscribed on them, are products of that cult of fame which found expression also in medals (see p. 329). Several, including one of the finest, variously attributed to Antonio Rossellino (1427–79) and Desiderio, represent the daughters of Florentine patricians and appear to have been commissioned simply for personal and aesthetic reasons as enduring records of individual beauty (10, 21). But portrait busts were rare in comparison to other types of sculpture.

Reliefs of the Virgin and Child were the stock-in-trade of Florentine sculptors in the mid- and late fifteenth century. (In painting the demand was so great that a special class of painter called *madonnieri* arose to

10, 21 *Top* Desiderio da Settignano, *Bust of a Lady*, c.1460–64. Marble, height 20⅜ins (52.5cm). Staatliche Museen, Berlin (West).
10, 22 *Above* Andrea del Verrocchio, *Madonna and Child*, c.1470–80. Terracotta partially painted, 33⅘ × 26ins (86 × 66cm). Museo Nazionale del Bargello, Florence.

satisfy it.) Many are still to be seen in Florence, in churches, civic buildings, private houses and, enshrined in tabernacles, in the streets; others are now scattered among the art collections of the world (the Victoria and Albert Museum, London, alone has more than 60). They are usually rectangular, though sometimes circular, and show the Virgin half-length, often life-size. Iconographically they derive from paintings rather than sculptures, and, as they were almost invariably coloured, suggest a demand for images more lifelike than had previously been available. The majority of surviving examples are in stucco, apparently molded from terracotta or marble originals, and were probably within the reach of buyers who could not afford works in marble or bronze. A rare documented example in painted terracotta is by Andrea del Verrocchio (1435–88), the master of Leonardo da Vinci, a work as remarkable for tenderness in feeling as for its boldness and plasticity in modelling (10, 22).

Reliefs of the Virgin and Child were also made in what was a new medium for sculpture, terracotta coated with coloured enamel glazes (previously used only for plates, jugs and other domestic utensils), first developed by Luca della Robbia (1399/1400–82) and exploited by his nephew Andrea (1435–1525), whose sons continued to use it until after the mid-sixteenth century. One of the select band of artists praised by Alberti in 1435 (see p. 317), Luca della Robbia was a highly accomplished sculptor who had worked in marble and bronze before he turned to glazed terracotta in about 1440. This new medium seems to have been taken up partly as a cheap alternative to marble and bronze, partly for its texture and colour.

10, 23 Guido Mazzoni, *Lamentation*, 1477–80. Terracotta, life-size. S. Giovanni Battista, Modena.

The roundels in the Pazzi Chapel (10, 5) have the effect of painted rather than sculptured elements, but the later *Madonna and Child* (10, 29) combines what were at the time regarded as the chief merits of sculpture and painting—form and colour. Luca della Robbia did not strive after illusionism. The meditative serenity which emanates from his reliefs is achieved by a uniquely simple idealization. Colours are often limited to a background of beautiful sky-blue, to flowering plants and fruits, the figures with their Classically modelled draperies being left white so that they diffuse a celestial radiance.

There was, however, a tendency towards the illusionistic in much fifteenth-century Italian sculpture outside Florence. Guido Mazzoni (d.1518) of Modena was one of the first and most gifted of a number of sculptors who modelled life-size and disturbingly lifelike figures enacting scenes from the Gospels— usually groups of the Nativity and the Lamentation (10, 23). The figures are dressed in contemporary costume and must resemble quite closely the actors who took part in the sacred dramas, which, like the miracle plays of medieval England, were performed in the open air at religious festivals and were intended to bring home the meaning of the Bible story to large and mainly illiterate audiences. Their extreme naturalism gives them the same sense of actuality as these dramatic performances must have had. But whereas the miracle plays, and the Gothic manuscript illuminations related to them, often indulged in a strain of grotesquerie, all inessentials have been eliminated in Mazzoni's groups.

Italian painting and the Church

There were three reasons why religious images were introduced into churches, a popular Franciscan preacher remarked in the mid-fifteenth century:

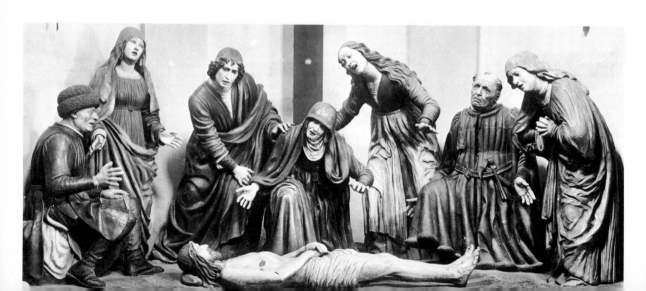

First, on account of the ignorance of simple people, so that those who are not able to read the scriptures can yet learn by seeing in pictures the sacraments of our salvation and faith ... Second, on account of our emotional sluggishness; so that men who are not aroused to devotion when they hear about the histories of the Saints may at least be moved when they see them, as if actually present in pictures. For our feelings are aroused by things seen more than by things heard ... Third. Images were introduced because many people cannot retain in their memories what they hear, but they do remember if they see images. (Fra Michele da Carcano, *Sermones Quadragesimales*, 1492, tr. M. Baxandall)

This is an elaboration of a passage in a thirteenth-century theological dictionary which similarly provides both a justification and a program for religious paintings, intermittently under attack for their lack of reverence in the depiction of sacred subjects. In 1450 the pious archbishop of Florence condemned such apocryphal matter in pictures as 'midwives at the Nativity' and all 'things that do not serve to arouse devotion but laughter and vain thoughts—monkeys, and dogs chasing hares and so on, or gratuitously elaborate costumes'. He clearly looked askance at much Gothic art.

The fifteenth century was a period of reform movements within the Church—reformations before the Protestant Reformation—led mainly by ascetic monks and friars who tightened up the rules of their own orders and never ceased to exhort the laity to more intense devotion. It was to culminate in the 1490s with Savonarola, the Dominican preacher who denounced the Medici and their artists, poets and philosophers in a spirit of extreme puritanism. But before Savonarola, a new note of austerity had been struck in Italian religious art, counterbalancing yet also complementing the contemporary revival of antique forms.

The demand for religious paintings both memorably clear and emotionally and spiritually stimulating was answered by Fra Angelico (Guido di Pietro, d. 1455). He entered the Dominican Order before 1423. All his work is religious, much of it painted for the Dominican friary at Fiesole, of which he was prior for three years, and its daughter house, the friary of S Marco in Florence, where, with a number of assistants, he frescoed the walls of the cloister, the chapter-house, the corridor on the upper floor and 41 cells.

In each of these little square rooms a fairly large fresco (usually about 6 feet, 1.8m, high) was painted beside the window, so that the wall seems to have two openings, one to the spiritual and one to the physical world. That of the Annunciation is one of the most beautiful and revealing in its extreme simplicity (10, 30). The scene is set in a cloister with columns of the kind beloved by Brunelleschi and Michelozzo, but the ornamental capitals are almost entirely obscured by the angel's wings, the only highly coloured part of the painting. In other paintings of the same subject Angelico showed the Virgin reflecting on the angelic salutation: here she kneels in submission, a sublime model of humility and obedience for the friar who lived in the cell. All the technical developments which enabled painters to give logical cogency to depictions of the physical world are here applied to an austerely spiritual end. The figures are shown 'as if actually present', just beyond the cell's wall.

Paolo Uccello (1397–1475) seems to have been more concerned with visual realities than with their spiritual significance. *The Flood*, painted as a lunette below the vaulted ceiling of the cloister of S Maria Novella, Florence, vividly expresses the horror of the Biblical cataclysm with figures struggling for survival. Two young horsemen in the left foreground brandish weapons at one another, though their mounts are almost submerged. One man clings to the ark, another tries to break into it. Two figures swim frantically, others find temporary refuge with wolves and dogs on a tiny island of dry land. There are also such gruesome details as a drowned baby with distended stomach and a crow picking the eyes out of a corpse (10, 31). In the tradition of continuous narrative, the lunette embraces two incidents: on the left the ark is floating and on the right has come to rest, with Noah looking out of the window. The two moments in time are, however, united in space by the strong compositional pattern and also by an unusual system of perspective, which gives the painting much of its mysterious power.

Uccello was obsessed by the problem of representing solids in space. The strange objects on the head of the seated girl in the foreground and around the neck of the youth beside her are *mazzocchi* (multi-faceted rings of wood or wicker used as foundations for a type of head-dress), which were so difficult to draw accurately that they were used as tests in perspective exercises. In *The Flood* they prominently display the scientific precision with which Uccello rendered every element of the composition, despite the contradictory scale of the foreground figures. Dissatisfied with Brunelleschi's and Alberti's simple scheme of pictorial perspective, based on a single vanishing-point, Uccello experimented with a more elaborate system. In *The Flood* he used it to imaginative and expressive, rather than illusionistic, effect.

Uccello's fascination with such geometrical prob-

lems was very typical of fifteenth-century artists—and not only of those, like Uccello, of an experimental turn of mind. One of the most poetic, Piero della Francesca (c.1420–92), devoted much of his intellectual energy to them. He composed treatises on geometrical bodies (cube, sphere, cone, cylinder and polyhedron) and on perspective and even wrote a mathematical handbook on the abacus for merchants, with rules for assessing the cubic capacity of barrels and so on. Thus he covered the abstract, the pictorial and the practical application of geometry and mathematics. But numbers also had a religious, quasi-mystical significance. Hence the preoccupation of his time with the 'golden section', supposed to provide the key to the harmony of the heavens—a line divided in such a way that the smaller part is to the greater as the greater is to the whole, which sounds simple enough but cannot, in fact, be worked out mathematically as a numerical ratio.

Piero della Francesca's mathematical interests may well have sprung from his practice as a painter and his attempts to plumb the divine order beneath the surface of visual appearances. Even such a relatively early work as *The Baptism* (10, 37) seems to have been geometrically based on a grid of three equidistant horizontals and four verticals, against which the slightest movements vibrate like the gently struck strings of a musical instrument. His interest in optics is revealed by the reflection of the landscape and of the robes of the priests in the clear river, which also induces a mood of stillness and tranquillity. In later paintings Piero was to record architectural space and mass with scientific precision; but in *The Baptism* a sense of clear, clean air circulating between the figures is conveyed without the aid of emphatic guidelines. His whole art is fastidiously unemphatic: light is so evenly diffused that shadows are barely perceptible, and there are no strident contrasts between the beautiful, slightly powdery colours, which make the palettes of most other painters seem garish. Piero's unique colour harmonies enabled him to fuse the pattern on the surface of the panel with the representation of forms in the third dimension. In this way his work is not so much dependent on as analogous to the more mystical theories of mathematicians who found in numbers and geometrical diagrams a means of comprehending unity in the diversity of the universe.

Behind the figures of *The Baptism* there is a sun-drenched, wind-parched landscape inspired by the rough hilly country around Piero's home town Borgo S Sepolcro (its towers are visible beyond Christ's right hip). As we have already seen, Jan van Eyck incorporated a distant landscape in his *Madonna of Chancellor Rolin* (10, 25), and Piero may well have known Flemish paintings which had reached Florence. The landscape of *The Baptism* is not, however, a symbol glimpsed through a window: it surrounds the figures and, by implication, the spectators too. In Italian art such landscapes made their first appearance in the fifteenth century. Gold backgrounds, which had previously been so popular for devotional images, were suddenly abandoned, for a combination of reasons—economic (shortage of gold) and moral (hostility to conspicuous display), as well as aesthetic. The landscapes which took the place of these backgrounds enabled the figures to appear less hieratically remote from the world and more 'as if actually present'. They seem also to have been appreciated for their own sakes by both painters and their patrons. Thus, in 1485 Domenico Ghirlandaio (1449–94) signed a contract for frescoes he was to paint in S Maria Novella, Florence, agreeing to include 'figures, buildings, castles, cities, mountains, hills, plains, rocks, costumes, animals, birds and beasts of every kind'. Similarly, Pinturicchio (Bernardino di Betto, 1454–1513) undertook to paint 'landscapes and skies in the empty part—or more precisely the ground behind the figures—of the pictures' he was providing for a church in Perugia.

So there are no 'empty parts' in the paintings of Ghirlandaio and Pinturicchio: their backgrounds teem with activity, as in the Sassetti Chapel, where Ghirlandaio used both townscapes and landscapes (10, 36). The altarpiece itself is indebted to Flemish art in technique (oil painting) and also in other ways—two figures derive from Hugo van der Goes, for instance. But the landscape in which the Nativity takes place is Italianate and the triumphal arch through which the Magi pass, the Corinthian pilasters supporting the roof of the stable and a sarcophagus behind the Christ Child are all emphatically Classical. The setting of the frescoed scenes from the life of St Francis is specifically localized in Florence itself. Pope Honorius confirming the rule of the Franciscan Order, an event which took place in Rome in 1223, is set by Ghirlandaio in Florence, in front of the Loggia dei Lanzi, with Lorenzo de' Medici, his sons and their tutor, the humanist poet Poliziano, ascending the stairs to witness the event.

Ghirlandaio retained the 'strip cartoon' system traditional for fresco cycles—not until slightly later was it generally outmoded by large scenes on each wall, as in the cycle by Filippino Lippi (1457–1504) in the Strozzi Chapel in S Maria Novella in Florence, begun in 1487. Each scene in the Sassetti Chapel records a single incident without 'continuous narrative'. Past

events are set in the present, probably to suggest their continuing relevance, and this gives them a sense of immediacy which we still feel today and which must have been much more strongly felt by the painter's contemporaries. But Ghirlandaio or whoever was responsible for the iconographical program may have wished to go further and suggest how the Christian doctrine of eternity embraced both present and past, not excluding the Classical past. Four sibyls look down from the ceiling and in the side walls there are niches adorned with reliefs of centaurs, cupids and bacchantes, enclosing black marble sarcophagi carved with bulls' skulls. These images from the pagan cult of the dead adorn the tombs of the donors, who kneel so piously on either side of the altarpiece.

Secular painting

Throughout the fifteenth century, in Italy as in northern Europe, the figurative arts remained predominantly religious. Portraits were painted, modelled and carved, and no longer restricted to members of

10, 24 Florentine School, *Cassone*, c.1460. Overall length 80$\frac{7}{10}$ins (205cm). Royal Museum of Fine Arts, Copenhagen.

ruling houses, but they were still rare in comparison with, for instance, images of the Madonna and Child. Mythological scenes were hardly less rare and, as we shall see, were generally given a moral, if not an explicitly religious, significance. Surviving records written in Tuscany before 1550 name 500 or more religious paintings and sculptures and fewer than 40 secular ones; and although these writers mention only the more prominent artists and works of art (generally ignoring small devotional images and furniture paintings), the proportion is probably correct. There was almost certainly an increase in secular painting in the late fifteenth century, just as in Florence there was an increase in the number and size of large private houses built both in the city and as summer retreats in the surrounding hills.

Yet, as economic historians remind us, the fifteenth century was not a period of economic expansion so much as one of slow and incomplete recovery after a major depression in the mid-fourteenth century. It has, therefore, been suggested that merchants and bankers, who found trade stagnant and agriculture unremunerative, sometimes turned to investment in culture which, thanks to the humanists, had acquired prestige

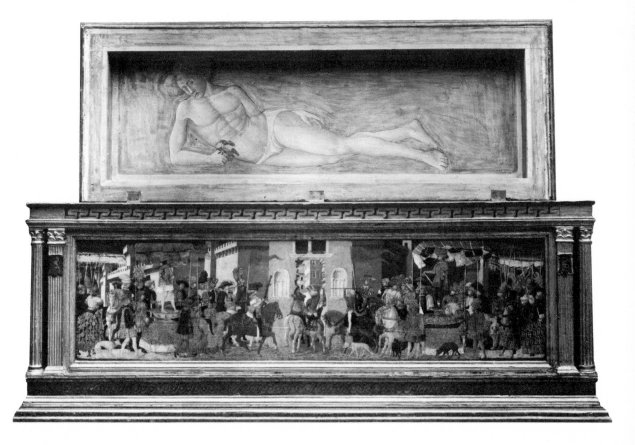

value. The hypothesis is as hard to prove as to disprove. The tendency towards simplicity and restraint in Florentine art and especially architecture may perhaps have been partly economic in origin. In terms of materials and man-hours, a building in the Renaissance style was certainly a less expensive undertaking than a Gothic one with its myriad decorations, and an altarpiece painted simply in tempera or oils than one with much use of gold and lapis lazuli (the costliest blue pigment) set in an elaborately carved and gilded frame.

The shift in attention from the value of materials to the skill of the artists coincided with, if it did not directly result from, a shortage of gold and silver, which became increasingly acute in the course of the century. Vasari stated that Antonio del Pollaiuolo abandoned a successful career as a goldsmith because he 'foresaw that his art did not promise a lasting fame', and took up painting. This was, of course, written with the benefit of hindsight after many of the finest Florentine works in gold and other precious metals had gone into the melting-pot during a crisis in 1529. But Pollaiuolo was not a unique case. Several other leading Florentine artists began their careers as goldsmiths and then turned to painting, notably Verrocchio, Botticelli and Domenico Ghirlandaio. Ironically, their work as painters has been preserved partly because the materials had little intrinsic value. If they had continued as goldsmiths their masterpieces would almost certainly have been melted down and their names forgotten.

Shortage of precious metals may, therefore, have played a part of seldom recognized importance in diverting talent to the art of painting. It certainly gave a fillip to the production of small objects made of humble materials yet designed and decorated with consummate skill—pottery painted as beautifully as enamelled gold vessels (10, 38) or little marriage coffers of wood covered with the molded paste called *pastiglia* and worked no less finely than caskets of gold or silver. Household furniture was generally simple—of plain wood covered on special occasions with woven silks or carpets from the eastern Mediterranean—except for the *cassone* or large chest used for storing clothes and linen and often made to hold the bride's trousseau and adorned with the coats of arms of her and her husband's families. *Cassoni* were sometimes very elaborate, reflecting the importance of marriage as a means of forging political and business alliances between leading families. Unfortunately few survive intact, but they reveal a preference for sober Classical ornamentation combined with brightly coloured, vivacious figurative scenes on the painted panels.

Many of these painted panels have been preserved as independent pictures after the *cassoni* they decorated were broken up. They usually depict scenes from ancient history or mythology—those with Christian subjects probably adorned the chests which nuns took with them when they entered convents. In style, however, they all maintain until well after the mid-fifteenth century the traditions of International Gothic art, packed with incident, crowded with figures related to one another in intricate surface patterns. Some of the stories come from Homer or Virgil, but the figures are always dressed in the height of contemporary fashion; they are, in fact, indistinguishable from those who enact scenes from the stories of Boccaccio. Greeks and Trojans are clad in shining armour like jousting knights. These paintings have a distinctly courtly air, which reminds one that the Florentines, though city-dwellers, merchants and nominally republicans, still paid lip-service to feudal ideals of chivalry. Some directly allude to marriage, the story of the Romans and the Sabines being among the most popular. The *cassone* illustrated here is one of a pair with paintings on this theme: the panel depicts the reconciliation between the two peoples after Romulus and his companions had carried off Sabine women to be their wives (10, 24). Inside the lids of these chests there are paintings of nudes, which would have been seen only by the bride and were probably intended as lucky charms for fair children of the marriage.

Much larger and finer mythological paintings were similarly expected to be charming in the original, magical sense of the word. *Primavera* (Spring) by Sandro Botticelli (Alessandro Filipepi, c.1445–1510) is one of the earliest (10, 39). Just under 6 feet (1.8m) high, it is painted on a scale previously reserved for religious pictures. The most notable earlier secular works of art of such a size intended for private houses—or rather the private apartments of palaces—are tapestries on chivalric themes woven in France and Flanders from early in the fifteenth century (10, 27). Tapestries were by far the most costly large-scale works of art—much more expensive than paintings—and the *Primavera* may well have been conceived originally as an inexpensive substitute. There is certainly something tapestry-like about its flat composition and especially the flower-strewn ground, recalling the 'thousand-flower' hangings, though the finest of these are slightly later in date. This affinity may partly account for the 'Gothic' quality often noted in Botticelli's exquisitely, almost preciously, graceful and rather weightless figures, so different from those of Masaccio, Piero della Francesca and Uccello. But whereas the figures in a fifteenth-century French or

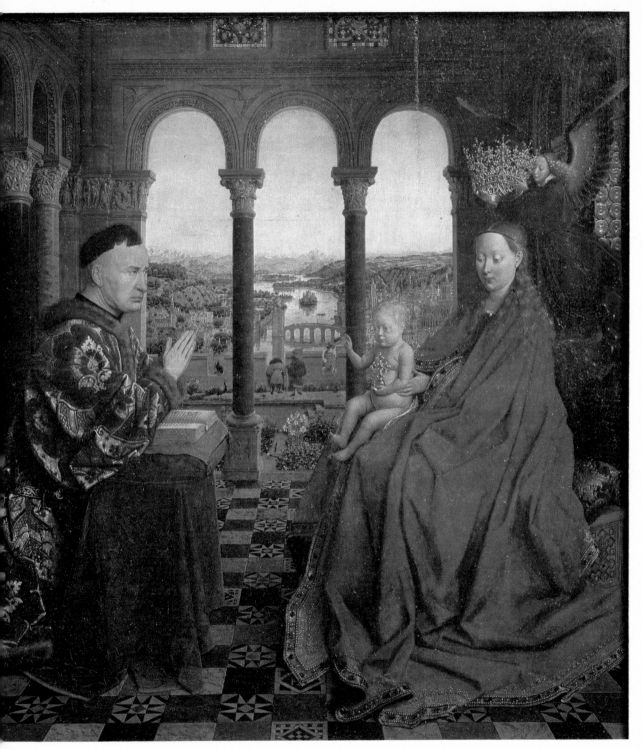

10, 25 Jan van Eyck, *The Madonna of Chancellor Rolin*,
c.1433–34. Oil on panel, 26 × 24⅜ins (66 × 61.9cm). Louvre,
Paris.

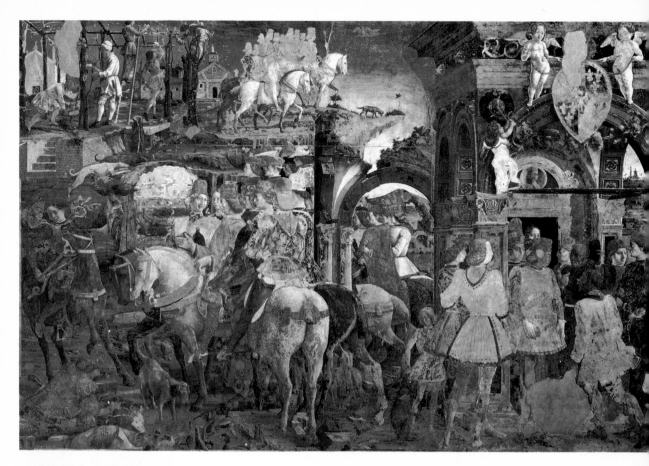

10, 26a & 26b *Top* Francesco Cossa, *The Month of March*,
1469–70; and *above*, detail. Fresco, Palazzo Schifanoia, Ferrara.
10, 27 *Above right* Detail of French or Flemish tapestry, *The
Rose Tapestry*, c.1435–40. Wool, total height 9ft 7ins (2.9m).
Metropolitan Museum of Art, New York.

Flemish tapestry belong to the medieval world of chivalry and courtly love, the figures in the *Primavera* come no less obviously from Classical mythology.

Venus stands in the centre, with the blindfolded Cupid hovering over her head. The other figures, reading from left to right, are Mercury, the three Graces, Flora, goddess of flowers and the spring, the earth nymph Chloris, and Zephyr, the west wind. They do not enact any specific scene from ancient mythology and a bewildering number of different interpretations has been put on them. As the messenger of the gods, Mercury had come to be regarded as the patron of those who sought to penetrate the mysteries of the ancient world—the Hermetic philosophers, who were called after his Greek name, Hermes. 'He calls the mind back to heavenly things through the power of reason', wrote Marsilio Ficino, one of the group of Florentine Neoplatonists. And there can be little doubt that the *Primavera* was strongly influenced by ideas current in this group. It seems to have been painted for Lorenzo di Pierfrancesco de' Medici (second cousin of Lorenzo the Magnificent) when he was no more than 14 or 15 years old and Ficino was taking a close interest in his education.

In 1478, the probable date of the picture, Ficino wrote the boy a letter in the form of a horoscope, urging him to fix his eyes on Venus, who represented Humanity, 'a nymph of excellent comeliness born of heaven and more than others beloved by God all-highest. Her soul and mind are Love and Charity, her eyes Dignity and Magnanimity, the hands Liberality and Magnificence, the feet Comeliness and Modesty …'. This mixture of astrology, Classical mythology and Christian morality typifies Florentine Neoplatonic thought. So, too, does the idea of presenting a didactic lesson in a form that was outwardly attractive yet yielded its inner message only to the initiated, for mysteries were supposed to lose their almost magic power when they were revealed to the profane. It is natural to ask how far Botticelli shared this outlook. The program of the *Primavera* was almost certainly devised for him. But it was Botticelli's individual genius that enabled him to translate the program into a sweetly poignant poetry no less characteristically Florentine – though he seems to have known Alberti's treatise on painting, which recommends that a pictorial narrative should have 'abundance and rarity of object', several figures, some fully clothed, others wholly or partly nude in different poses, frontal or profile 'with hand up and fingers apart' or 'arms relaxed and feet together', each having 'its own action and bending of limb'. He created the visual equivalent not so much of the obscurantist

treatises of Ficino as of the hedonistic songs of his patron Lorenzo the Magnificent, which epitomize all the freshness of the early Renaissance.

Interest in antiquity was complemented by a still deeper preoccupation with astrology. No court of the time was complete without an astrologer to cast horoscopes and decide on propitious moments for taking important decisions. Though condemned by the early Christians, astrology had been revived in Europe by the twelfth century and soon became so influential that it was tolerated by the Church. That the planets and constellations bore the names of pagan deities was unfortunate (attempts to provide Christian alternatives were ineffectual), but they were generally believed to reveal the will of God and in this way astrology, astronomy and Christian theology were reconciled. Above the altar of Brunelleschi's sacristy in S Lorenzo (see p. 319) the cupola is painted with an accurate map of the stars in the sky over Florence on 9 July 1422—the date of the altar's consecration—and there is a similarly placed celestial map in the Pazzi Chapel (10, 5). The signs of the zodiac, in which the pagan gods survived the Middle Ages, recur again and again in the art of the Renaissance, nowhere more prominently than in Palazzo Schifanoia, the summer palace of Borso d'Este, duke of Ferrara. Here, the walls of the great hall were divided into 12 vertical sections (only 7 of which remain intact) frescoed by the chief court painter, Cosimo Tura (1430–95) and a team of artists who were paid by the square yard. The erudite program, derived mainly from an astrological poem of the first century AD, was probably drawn up by one or more of the Classical scholars and astrologers whom Borso d'Este had gathered around him. Each section is devoted to one of the zodiacal months of the year, horizontally divided into three parts.

March (10, 26a), painted by Francesco Cossa (c.1436–78), has at the top the presiding deity Minerva seated on a triumphal chariot. As she was the patroness of learning and the crafts, scholars are ranged on one side of her, women engaged in embroidery and weaving on the other. The central band is devoted to the zodiac, with two bizarrely dressed figures representing decans, the spirits who ruled each period of ten days. We come down to earth in the lower register with activities appropriate to the month, courtiers hunting and peasants pruning their vines. In a handsome little Renaissance loggia on the right, Borso d'Este encourages the administration of justice. Each of the other months illustrates one of his virtues and thus the room as a whole celebrates the tiny dukedom of Ferrara as a microcosmic reflection of

celestial harmony in which peasants, scholars, women, courtiers and, above all, Borso d'Este have their appointed places. For astrology was regarded not simply as a way of predicting the future, but as a means of discovering the rules of cosmic order.

There were a few humanists who protested at the fatalism of astrology and proclaimed their belief in the power of man to be his own master, but all succumbed to the lure of the antique mysteries in which eternal truths were supposedly concealed. Notable literary and artistic expression is given to them in a strange rambling allegorical romance, *Hypnerotomachia Poliphili* (Love's Strife in a Dream of Poliphilo), written in about 1460 by a Dominican friar, Francesco Colonna, and published with elegant woodcuts in Venice in 1499 (10, 32). The combination of a darkly obscurantist text with typography of unprecedented clarity and illustrations in which forms are fully defined by a few confidently drawn lines could hardly be more characteristic of the period.

The art of printing with movable type, first developed in Europe in the mid-fifteenth century (though invented in China 400 years earlier), was initially employed to diffuse religious texts and these

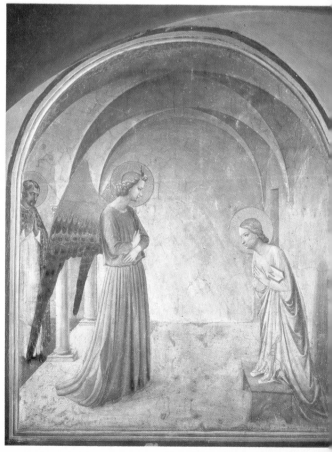

10, 28 *Opposite top right* Antico, *Venus Felix*, c.1500. Bronze, parcel-gilt and inlaid with silver, height 12⅜ins (32cm). Kunsthistorisches Museum, Vienna.

10, 29 *Opposite bottom left* Luca della Robbia, *Madonna and Child*, c. 1455–60. Enamelled terracotta, approx. 6ft (183cm) in diameter. Or San Michele, Florence.

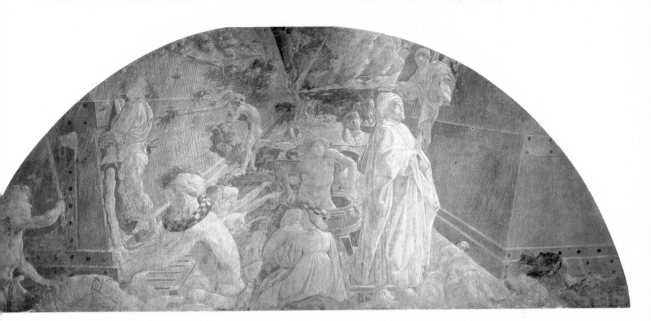

were to remain the staple products of printing presses for centuries. An edition of the Bible printed by Johann Gutenberg at Mainz in 1455 was the first major work. Early printed books were conceived as substitutes for manuscripts and many printers left space for illuminators to elaborate capital letters at the beginning of chapters. Humanists (some of whom disapproved of the new invention) and printers seem to have had little influence on one another until the last decade of the century, when Aldus Manutius set up his press in Venice and published the first accurately printed Greek texts and reliable editions of Latin authors, as well as such curiosities as the *Hypnerotomachia*. Not until this moment did printing begin to affect the intellectual life of Europe, which it was eventually to transform.

The Venetian synthesis

A small painting of St Sebastian by Andrea Mantegna (c.1431–1506), dating from about 1460, emphasizes many of the characteristic features which had gradually emerged in Italian art of the previous four decades—spatial clarity by means of perspective, naturalistic landscape background, antique architectural and decorative motifs and an idealized human being, harmoniously proportioned and all but nude (10, 33). It is signed, below the saint's right elbow, in Greek, as if to underline the painter's insistent

fangue che per dolore,& nimia formidine in fe era conftricto p troppo & inufitata læticia,laxare le uene il fentiua exhaufto, & tuta abforta,& attoni ta ignoraua che me dire,Si non che io agli ancora pallidati labri,cum foluta audacia,gli offerfi blandicula uno lafciuo & muftulento bafio, Ambi dui ferati,& conftrecti in amorofi amplexi,Quali nel Hermetico Caduceo gli intrichatamente conuoluti ferpi , & quale il baculo inuoluto del diuino Medico.

10, 30 *Opposite bottom right* Fra Angelico, *Annunciation*, c. 1440–45. Fresco, S Marco, Florence.

10, 31 *Top* Paolo Uccello, *The Flood*, c. 1445–47. Fresco, Chiostro Verde, S Maria Novella, Florence.

10, 32 Woodcut illustration to *Hypnerotomachia Poliphili*, Venice, 1499.

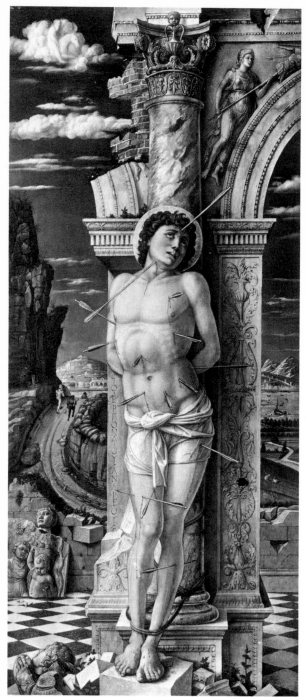

Classicism. The story of St Sebastian, an officer in Diocletian's imperial guard, converted to Christianity and condemned to be shot to death with arrows, justified an antique setting.

Mantegna was trained in Padua, where the university was one of the main centres for humanist studies in Italy—or for that matter in all Europe—though the local artistic style was still predominantly Gothic. Just after he finished his apprenticeship Donatello arrived in Padua to model the Gattamelata monument and the Classicizing reliefs for the altar of S Antonio (see pp. 328–9). Later, in Venice, Mantegna married the daughter of the painter Jacopo Bellini (c. 1400–70/71), whose drawings of Classical antiquities (Louvre and British Museum) are remarkable for their archeological precision and understanding. At this date, antique sculpture was nowhere more in evidence than in Venice, the Italian city with the closest contacts with Greece, much of which was a Venetian possession from the early thirteenth century until 1460. Four first-century AD bronze horses stood on the façade of S Marco and other bronze statues seem to have been brought to the city if only to be melted down to make cannons. Marble carvings were also to be seen there. On Mantegna all these antiquities must have made a deep impression and he began very early to develop a style of painting more explicitly indebted to Greek and Roman sculpture than that of any other artist of his time.

Vasari was to write that Mantegna 'always maintained that the good antique statues were more perfect and beautiful than anything in Nature. He believed that the masters of antiquity had combined in one figure the perfections which are rarely found together in one individual and had thus produced single figures of surpassing beauty.' Whether or not Mantegna ever made such an uncompromising statement of faith in idealization, these words are relevant to his *St Sebastian* (10, 33). The young saint's body looks as if it had been carved out of some unusually hard and flawless marble. It is placed against a Corinthian column (with a glancing allusion to Vitruvius's equation between architectural and bodily proportions). Yet in this, as in many other fifteenth-century religious pictures, the pagan world is shown symbolically in ruins. Fragments of statues and reliefs lie on the ground, the building (based on the arch of Septimius Severus in Rome) is fissured and broken. The apparent contradiction is, however, essential to the meaning of the painting—Christianity, personified by the saint, prevails over all human ills and disasters. St Sebastian was a patron of the sick and his intercession was evoked especially in times of plague,

10, 33 *Above* Andrea Mantegna, *St Sebastian*, c.1460. Panel, 26⅘ × 11⅘ins (68 × 30cm). Kunsthistorisches Museum, Vienna.
10, 34 *Opposite bottom* Albrecht Dürer, *St Eustace*, 1501. Engraving, 14 × 10⅛ins (35.5 × 25.9cm). British Museum, London.
10, 35 *Opposite top* Initial from a Venetian edition of Virgil of 1495.

of which there were outbreaks (probably bubonic) every 15 years or so in Venice throughout the century. This accounts for the frequency of his appearance in Venetian art.

St Sebastian, paired with Job as the Old Testament type of the pestilence-stricken, is included in the large altarpiece painted by Mantegna's brother-in-law Giovanni Bellini (c.1427–1516) for the church attached to the hospital of S Giobbe (Job) in Venice (10, 42). In this painting also there are crisply carved antique ornaments on pilasters and capitals. But the differences between the two works are striking although Bellini's shallow space is no less real for being restricted by the curved wall of the apse, his forms no less clearly defined for being painted with gentle fluid brush-strokes. The greatest Venetian painter of his time, Giovanni Bellini assimilated the technical and stylistic innovations of early Renaissance art, combin-

ing a spring-like freshness typical of the fifteenth century with a new self-confident mastery. Statuesque poses are no longer needed to indicate weight, nor guidelines to indicate perspective recession.

In the S Giobbe altarpiece the barrel vault recalls the architecture of Brunelleschi, but otherwise the setting is distinctly Venetian with inlays of precious marbles, very seldom used in Tuscany, and a half-dome of gold mosaic on which Byzantine seraphim flutter their wings, a reminder of Venetian contacts with Constantinople in the not-so-distant past. The picture is of a type called a *sacra conversazione* (holy conversation), evolved in the fifteenth century by Fra Angelico and others. No longer are the saints separated from one another as in a Gothic polyptych: they stand in an informal group on either side of the Madonna and Child, conversing or communing with each other within a single, unified space. Bringing the saints much closer to the spectator, and representing them much more 'as if actually present' (see p. 334), the *sacra conversazione* beautifully answered the spiritual need for a less remote, less hieratic religious art. On the left of the S Giobbe altarpiece St Francis looks straight out of the picture and with a gentle gesture of his right hand invites the devout to share in a celestial vision where angels play their musical instruments beneath the throne of the Madonna. Each of the saints is an individual, distinguishable by pose and expression as well as traditional attributes. They have a humanity which has little if anything to do with humanism. The most striking feature of the altarpiece and its greatest novelty is, however, its colour—not simply the resonance of the Madonna's lapis-lazuli robe or the shot silk of the dresses worn by the angelic musicians but the rich colour harmonies created by the whole work. Forms are, as it were, built out of colours which merge into one another; and the light which falls on them is no longer a ray of unearthly pallor, but is itself charged with glowing colour. It might be said that Bellini introduced 'atmosphere' into painting by

10, 36 *Opposite* Domenico Ghirlandaio, Sassetti family chapel, 1479–86. S Trinita, Florence.
10, 37 *Left* Piero della Francesca, *Baptism of Christ,* c.1445. Panel painting, 66 × 45¾ins (167.6 × 116.2cm). National Gallery, London.
10, 38 *Above* Maiolica plate, Deruta or Faenza, c.1476. Victoria and Albert Museum, London.
10, 39 *Below* Sandro Botticelli, *Primavera,* c.1478. Panel painting, 80 × 124ins (203 × 315cm). Galleria degli Uffizi, Florence.

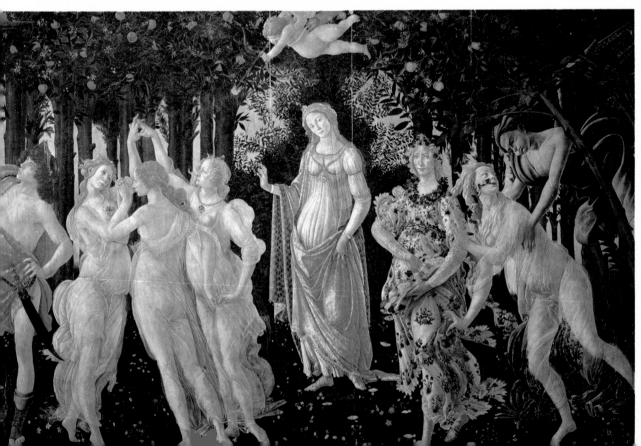

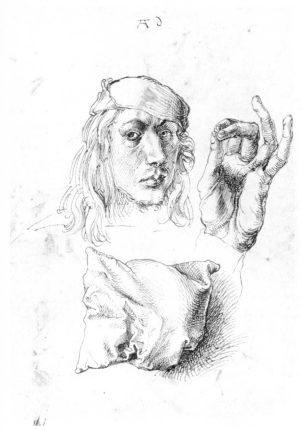

10, 40 Albrecht Dürer, *Self-Portrait*, 1493. Drawing, $10\frac{9}{10} \times 8$ins (27.6 × 20.2cm). Metropolitan Museum of Art, New York, Robert Lehman Collection, 1975.

opening the hermetically sealed perspective box invented in Florence to admit the glow of real Venetian sunlight, an achievement made possible by oil painting. In effect, Bellini had, so to speak, fused the innovations of Flemish and Florentine art, and it was perhaps for this reason that Albrecht Dürer was to call him in 1506 'still the supreme master'.

Albrecht Dürer

In the last decades of the fifteenth century, Italian influence gradually began to infiltrate Europe north of the Alps. Matthias Corvinus, king of Hungary (1458–90), not only acquired Renaissance works of art, including marble reliefs by Verrocchio, but employed an Italian architect to rebuild his palaces in the Tuscan manner and Italian sculptors and painters to decorate them with carved marble fountains and frescoes (of which only fragments survive). Such strongly marked Italianate tastes were unusual before the sixteenth century and may have been due partly to his wife, a daughter of the king of Naples, whose arms appear with his own on a spectacular maiolica table service painted with allegories at Faenza or Deruta (10, 38). But the little Renaissance court at Budapest was altogether exceptional at this date.

The new style was first carried across the continent by illuminated manuscripts of Classical texts, engravings of mythological subjects and printed books, mainly, it seems, along a network of personal contacts between humanists. The reader of a book printed in Italy might find his eye distracted by naked *putti* frolicking among the crisp fronds of acanthus which sprout from capital letters in many a woodcut initial (10, 35). These little figures insidiously established a link between learning and the visual language of the Renaissance long before Italian paintings and sculptures had reached northern Europe in any quantity.

It was in the context of international humanism that Albrecht Dürer (1471–1528) created a northern equivalent to the Italian Renaissance style of the fifteenth century. Like many Florentine artists, he began as a goldsmith (in his father's workshop). But he completed his apprenticeship under a Nuremberg painter, who was also a maker of woodcuts, and after journeyman travels in the Rhineland was employed for a while on book illustrations in Basel. In 1494 he went to Venice, then beginning to emerge as the most important centre for humanist book publishing. The reasons for this visit are, however, unknown and he may have gone there primarily to study works of art and to complete his artistic education, just as his life-long friend Willibald Pirckheimer was then completing his classical education at the University of Padua. Through Pirckheimer, the son of a patrician family of Nuremberg, he made and maintained contact with humanists, who in Germany tended to hold themselves aloof from artists and craftsmen. In these circles, probably, Dürer encountered engravings of mythological scenes by Pollaiuolo and Mantegna, which were quite unlike any northern works of art in that the figures were nude or clad in antique drapery (not modern costume) and thus reintegrated Classical subject-matter with Classical form. He set himself to copy them in pen and ink, soon mastering their style so perfectly that he could work in it independently. It was not, however, with Classical subjects that he established his reputation after returning to Nuremberg in 1495. Apart from portraits, all but one of his paintings are religious. So, too, are most of his many prints, the finest of which have never been surpassed in their concentration of religious thought and feeling— or in technical accomplishment.

The practice of making prints from metal plates, first developed in Germany and Italy in the mid-fifteenth century, was the result of combining two much older techniques —printing from carved wood-blocks and engraving silver ornamentally—facilitated by a great improvement in the quality of linen-rag paper. No artist was better fitted by training to bring the process to maturity than Dürer, and his large print of St Eustace is a masterpiece in point of technique alone (10, 34). Never before had an engraving suggested such subtle gradations of light and shade, such contrasts of texture and almost of colour. The story of St Eustace converted to Christianity, while out hunting, by the vision of a stag with a crucifix between its antlers was a popular one and demanded a landscape setting. And Dürer's landscape reveals the unprecedented sharpness of his eye and cunning of his hand in recording plants and animals—dogs with their alert, knowing look, the horse restively shifting his hind leg, tufts of grass springing from the earth, tree-trunks weatherbeaten into strange shapes, even a flight of birds (starlings to judge from its formation) circling the hilltop tower. Dürer delighted in drawing such things, which, in the St Eustace print, are invested with special meaning as a revelation of God in the beauty of nature and thus give universal relevance to the saint's miraculous vision. For this is no straightforward transcript of the visible world.

Kunst—a word which meant both knowledge and art in the modern sense of the term—'is embedded in nature; he who can extract it has it', wrote Dürer. 'No man can ever make a beautiful image out of his private imagination unless he have replenished his mind by much painting from life. That can no longer be called private but has become *Kunst* acquired and gained by study, which germinates, grows and becomes fruitful of its kind.' Drawings testify to his tireless application: more than 1,700 survive, a far larger number than can be attributed to any earlier artist or any contemporary except, significantly, Leonardo da Vinci (see p. 358). He seems to have had an insatiable urge to draw whatever he observed, including his own face and body.

Few previous artists had portrayed themselves at all, but Dürer painted three half-lengths (two of them lifesize) and made several drawings of himself. The first is a fairly large, meticulous silver-point made when he was no more than 13 (Albertina, Vienna). A sheet of sketches dating from his journeyman years includes his own face staring wistfully back from a mirror and beside it his elegantly long-fingered left hand held up to be drawn by the right, as if he wished to compare a reflection in a glass with directly observed reality (10,

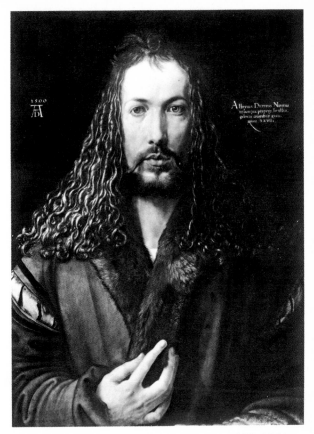

10, 41 Albrecht Dürer, *Self-Portrait*, 1500. Panel, $26\frac{2}{5} \times 19\frac{3}{10}$ins (67 × 49cm). Alte Pinakothek, Munich.

40). Below there is a crumpled cushion and there are more cushions on the back of the sheet, exercises in the technique of rendering an irregular object with hatched lines of varying density. At about the same date he drew his left leg in two positions (British Museum). It was not simply for want of other models that Dürer made these drawings. The self-portrait is marked with his initials—at a time when few artists signed even their most highly finished paintings, let alone sketches— which suggests that he was already highly conscious of himself and of his artistic uniqueness.

Dürer was much preoccupied with his status. Although he had friends in the upper strata of Nuremberg society, notably Willibald Pirckheimer, he ranked among craftsmen along with all other painters and together with carpenters, tailors and so on. Painters were more highly regarded only in Italy. There, as he wrote to Pirckheimer just before leaving Venice after his second visit in 1505–7, things were very different: 'here I am a gentleman'. A few years earlier he had, indeed, depicted himself very much as a well-

dressed, even dandified gentleman in what appears to be the first independent self-portrait ever painted (Prado, Madrid). But another self-portrait is still more extraordinary, for here he took up the hieratic frontal pose normally reserved for kings and for Christ, to whose features he assimilated his own (10, 41). This can be explained partly as a literal interpretation of the doctrine of the 'Imitation of Christ' and partly by Dürer's conviction that the artist's creative gift came from, and was at least to some extent part of, the creative power of God. In 1512 he was to write: 'This great art of painting has been held in high esteem by the mighty kings many hundred years ago. They made the outstanding artists rich and treated them with distinction because they felt that the great masters had an equality with God, as it is written. For, a good painter is full of figures, and if it were possible for him to live on forever he would always have to pour forth something new from the inner ideas of which Plato writes.'

The reference to Plato recalls the Florentine humanists; but Dürer's attitude was essentially different. He was not concerned with Plato's theory of ideas so much as with the God-given power of the artist to create. Towards the end of his life he wrote: 'Only the powerful artists will be able to understand this strange speech, that I speak the truth: one man may sketch something with his pen on half a sheet of paper in one day, or may cut it into a tiny piece of wood with his little iron, and it turns out to be better and more artistic than another's big work at which its author labours with the utmost diligence for a whole year. And this gift is miraculous. For God often gives the ability to learn and the insight to make something good to one man the like of whom nobody is found in his own days, and nobody has lived before him for a long time, and nobody comes after him very soon.' This remarkable statement of faith in the value of the individual could hardly have been made but for the great revolution in attitudes to the arts initiated by the Italian Renaissance, which had by the end of the fifteenth century achieved so much more than a revival of antique forms.

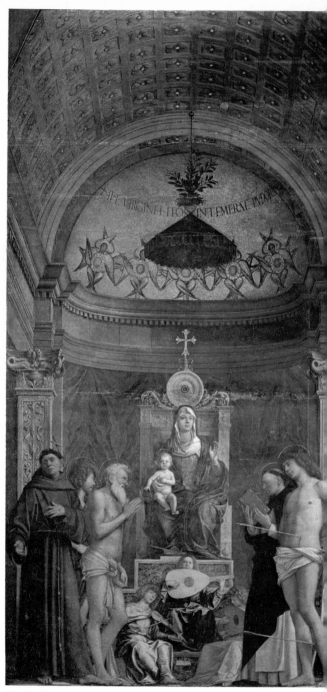

10, 42 Giovanni Bellini, *San Giobbe Altarpiece*, c.1485. Panel, 15ft 4ins × 8ft 4ins (4.67 × 2.54m). Gallerie dell'Accademia, Venice.

11 Harmony and reform

For the first time artists took their place among the great minds of the age—this is the outstanding feature in the history of sixteenth-century art. The century was dominated by a few artists of commanding personality, all Italians apart from Dürer, who was exceptional in other ways. Their fame and influence were international, spread by printed accounts of their careers and by reproductive engravings. They were courted by popes and emperors and princes, who competed with each other to possess examples of their work. Never before had individual artists won such extensive and exalted acclaim.

The idea that architecture, painting and sculpture were liberal arts, rather than branches of craftsmanship, was due mainly to Alberti (see p. 326). But Alberti had been primarily a writer. To him the knowledge and (strictly non-professional) practice of the visual arts were among the accomplishments of a 'universal man'. Now, with Leonardo, an artist had become a 'universal man'. The shift in emphasis is crucial. Leonardo da Vinci (1452–1519) was a scientist and daring experimental thinker, Michelangelo (1473–1564) a notable poet. It was, nevertheless, as supreme artists that they were extolled, together with Raphael (1483–1520) and Titian (c. 1490–1576), who had no other claims to fame. Their towering achievement overshadowed Western art until well into the nineteenth century.

In general history, however, the main event of the sixteenth century was the great movement for religious reform. By setting up the individual conscience as moral authority, the Protestant Reformation called into question not only the teachings and practices of the Catholic Church, but also the traditions and assumptions underlying European culture, including the visual arts. In spreading new ideas the recent invention of printing was instrumental, for it enabled the writings of the reformers to be disseminated both widely and quickly. What might otherwise have

11, 1 Pietro Torrigiano, Tomb of Henry VII, 1512–18. Gilt bronze figures, about life-size. Westminster Abbey, London.

349

remained a minor dispute among theologians or the heresy of a local sect (like those led by John Wyclif in England and Jan Hus in Bohemia in the late fourteenth and early fifteenth centuries) immediately became an international issue on which every thinking Christian was obliged to take sides. Within a decade of 1517, when Martin Luther (1483–1546) launched his first protest in the small German city of Wittenberg, Western Christendom was irreparably split.

The Protestant Reformation polarized beliefs that originated much earlier. Humanists of the fifteenth century had extolled the importance of the individual. They looked sceptically on the Aristotelianism of medieval theology. They probed the scriptures with the tools of Classical scholarship. And it was the exemplary humanist Desiderius Erasmus (1466–1536) of Rotterdam who was said, already in the sixteenth century, to have 'laid the egg which Luther hatched'. But there were other, complementary tendencies in religious thought like that which had inspired such deeply personal, emotional and undogmatic writings as the *Revelations of Divine Love* by Juliana of Norwich and found expression at a less intense level in what was called *Devotio moderna*—the new devotion. This was fostered by the Brethren of the Common Life, groups of pious laymen in the Netherlands and northern Germany who renounced private property to live a communal life without taking monastic vows. Its manual was the *Imitation of Christ* (probably by Thomas à Kempis, d. 1471), a work of anti-worldly and anti-intellectual piety uncomplicated by theological niceties and unencumbered by the popular medieval cults of saints, relics and pilgrimages. It was first printed in 1472; there were more than 20 editions before 1500, and it was repeatedly printed and reprinted in Latin, French, German and English versions in the early sixteenth century. It may have had almost as much influence as the vernacular translations of the Bible that proliferated at the same time. Admired by St Ignatius Loyola (c. 1491–1556), founder of the Society of Jesus, the *Imitation of Christ* testified to a movement for reform within the Roman Church, a movement which gathered strength in the early sixteenth century to become the self-transforming force of the so-called Counter-Reformation.

Luther, who also admired the *Imitation of Christ*, nevertheless followed the opposing tendency. By combining hostility to the ecclesiastical hierarchy and rejection of priestly mediation and outward forms with the widespread yearning for a more direct and personal religion, he evolved a new and distinctive theology of justification by faith—the main doctrinal point on which Protestants parted company from Catholics. It was a theology which placed the burden of deciding what is right and wrong on the individual conscience.

So far as the visual arts are concerned, humanism, the *Devotio moderna* and, later, the Counter-Reformation had a more positive influence than Protestantism. Luther's first protest was against the traffic in indulgences to raise money for rebuilding St Peter's (see p. 367). 'Cannot the Pope build one single basilica for St Peter out of his own purse rather than out of the money of the faithful poor?' he asked. But he was indifferent, rather than hostile, to painting and sculpture and opposed both the veneration and the destruction of religious images. There were, however, more extreme Protestants who thought them idolatrous and sinful, notably John Calvin (1509–64), who dominated the Protestant world after the mid-century. Luther did not promote Iconoclasm. 'I approached the task of destroying images by first tearing them out of my heart', he wrote in 1525; 'for when they are no longer in the heart they can do no harm when seen by the eyes.' Crucifixes and representations of saints were, he ruled, 'praiseworthy and to be respected', but only as 'images for memorial or witness'. Nevertheless, more than one great work of art was inspired by Protestantism during his lifetime (11, 5 & 8).

Reform and early sixteenth-century art in the north

Although the forms, motifs and techniques of Italian Renaissance art spread amazingly quickly, as we have seen (p. 346), they were only gradually accepted in northern Europe. During the first quarter of the sixteenth century the new style coexisted with a still-vigorous Gothic. The tomb of Henry VII and his queen in Westminster Abbey, London, is a case in point (11, 1). A conspicuous monument was needed to commemorate the founder of the Tudor dynasty, who had re-established royal power in England after 30 years of civil war, and his son Henry VIII looked to Italy for a sculptor. The commission went to the Florentine Pietro Torrigiano (1472–1528), a fellow student with Michelangelo (whose nose he broke in a fight) under Donatello's pupil Bertoldi di Giovanni (see p. 329). The tomb he created is very obviously Italian, with naked *putti* and delicate Classical pilasters surrounding the sarcophagus, angels with alert little Florentine faces seated at its corners, and the effigies of the king and queen sensitively modelled with controlled naturalism.

That the Italian Renaissance style should have been adopted for dynastic monuments in both France and England testifies to its prestige in the north. Already, it seems to have been associated not only with the new

humanist learning but also with the new ideal of a monarch who was a patron of scholarship and the arts as well as a military leader and a divinely appointed ruler. The tomb of Henry VII was, nevertheless, surrounded by a bronze screen in the English 'Perpendicular Gothic' style that echoes the flattened Gothic arches of the chapel in which it stands (begun 1503). Even after the tomb was finished, niches in the chapel's walls were filled with statues of saints which adhere so closely to Gothic conventions that they might be mistaken for work of at least a century earlier.

The 'Perpendicular' style is peculiar to England. First developed in the mid-fourteenth century, it persisted until late in the sixteenth (though mainly for secular buildings after the English Reformation in 1532). In fifteenth-century France, Gothic had been elaborated into the 'Flamboyant' style with intricate curvilinear tracery which was not outmoded until the mid-sixteenth century. A more robust but equally rich version of Gothic was evolved in the Low Countries. The Town Hall of Ghent is a notable example, one in which the opulence of a great trading centre found expression in an abundance of busy carving (11, 2). It was begun in 1518, one year after the regent of Flanders, Margaret of Austria, had an addition to her palace at Mechlin (Malines) built in a pure

11, 2 *Below* Town Hall, Ghent, Belgium, begun 1518.
11, 3 *Right* Hieronymus Bosch, *Hell* (right-hand panel of *The Garden of Earthly Delights*), c.1515, 86 × 36ins (218.5 × 91.5cm). Museo del Prado, Madrid.

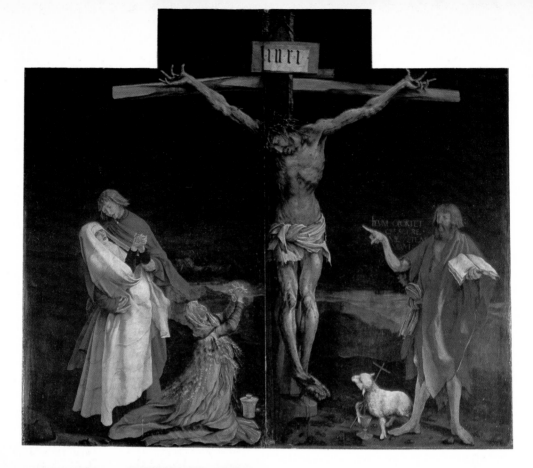

Renaissance style. There cannot be much doubt that in each instance the style was deliberately chosen—the wealthy citizens of Ghent clinging conservatively to the Gothic associated with their civic liberties, the regent adopting the new Classicizing style patronized by the ruling families in the south.

In Netherlandish painting the tradition established by Jan van Eyck (see p. 323) lived on into the second decade of the sixteenth century. But the most interesting painter of the time, Hieronymus Bosch (Jeroen van Aken, c. 1450–1516), had more distant artistic origins. Living in the provincial city of s'Hertogenbosch (generally called Den Bosch, hence his name) and apparently working in isolation— though conversant with a wide range of religious, astrological, astronomical and travel literature—he evolved an imagery of disturbing individuality. A large triptych more than 7 feet (215cm) high is perhaps the finest, but also the most perplexing, of his works. It is

11, 4 *Above* Matthias Grünewald, *Isenheim Altarpiece*, central panel, c.1510–15. Panel, 8ft × 10ft 1in (2.4 × 3m). Musée Unterlinden, Colmar.
11, 5 *Below* Albrecht Dürer, *The Four Apostles*, 1526. Panel, each 85 × 30ins (216 × 76.2cm). Alte Pinakothek, Munich.

now called *The Garden of Earthly Delights*, although its precise subject-matter and original function remain obscure (for it cannot have been intended as an altarpiece). In the late sixteenth century it was called *Lust* or *The Strawberry Painting*. The most convincing interpretation is that the outer panels, when closed, represent the world under the flood, the central panel the world before the flood, flanked by the Garden of Eden on the left and hell on the right, thus illustrating the origin, indulgence and punishment of sin (11, 3).

No paintings of the period are more remote from the spirit of the Italian Renaissance than those of Bosch, an almost exact contemporary of Leonardo da Vinci. Bosch stresses the frailty and wickedness, not the beauty and nobility, of humankind. The pleasures of the flesh, which Italian artists celebrated, he condemned as severely as the author of the *Imitation of Christ*—'O how brief, how false, how inordinate and filthy, are all those pleasures!' Musical instruments, which to Giorgione and other Italian artists symbolized a soothing and celestial harmony, were for Bosch the agents of the Devil. In his view of hell they surround the damned, one of whom is crucified on a harp. Perhaps he had in mind the words of Isaiah (5, 11–14):

Woe unto them that rise up early in the morning, that they may follow strong drink: that continue until night, till wine inflames them! And the harp, and the viol, the tabret, and pipe, and wine are in their feasts; but they regard not the work of the Lord ... Therefore hell hath enlarged herself, and opened her mouth without measure: and their glory, and their multitude and their pomp, and he that rejoiceth, shall descend into it.

Bosch's view of hell is not, however, as was that of medieval artists, a mere aggregate of symbols. His is truly a vision. A hallucinatory, unbounded, fluid space, seen from far away and above, is rendered with complete command of the new techniques of pictorial representation. In the chaotic area between the foreground and the burning buildings on the horizon, human figures, demons and various strange and incongruous objects seem to float, all depicted with a delicate precision and sense of form which give them a weird reality. Even the most bizarre are uncomfortably tangible presences. It is this that differentiates them from the demons and monsters abounding in medieval art (9, 15). 'He endeavoured to find for his fantastic pictures the most out-of-the-way things, but they were always true to nature', a Spaniard wrote of him in the mid-sixteenth century. Despite the prevalent Classicism of the time, his work was greatly admired and collected, by Philip II of Spain (Titian's patron) among others, and copied in costly tapestry.

The work of another German painter, Mathis Gothardt Neithardt (d. 1528), enjoyed so little posthumous renown that his very name was for long forgotten. Since the late seventeenth century he has been known as Grünewald. His masterpiece is the large polyptych he painted for the high altar of the hospital chapel in the monastery of St Anthony at Isenheim (Alsace). The Crucifixion (11, 4) is depicted on the outer side of doors which were opened on Sundays to reveal paintings of the Annunciation, Nativity and Resurrection and, on feast-days, the inner sculptured *corpus* (see p. 354). Of all the tortured Christs in the history of Western art, this makes the most violent impact. His body, torn and bruised by scourging and with a ragged stained cloth around the loins, hangs heavily on the cross, head slumped forwards, eyes closed and mouth open after the last breath of life has escaped. The fingers of the pierced hands strain convulsively upwards and blood flows from the wound in the contorted feet, but physical agony has ceased and the flesh has already begun to turn gangrenous. To suggest the weight of the body, Christ's arms have been disproportionately lengthened. He is also much larger than the four figures on the ground, St John the Baptist, St John the Divine, who supports the fainting Virgin, and St Mary Magdalen kneeling, hands clenched in a paroxysm of grief and prayer. A desolate stony landscape and louring sky close in and complete this harrowing image, painted in quivering brushstrokes, with anguished angularities of line and shrill contrasts of colour.

The iconographical program of the altarpiece seems to have been inspired by the mystical writings of St Bridget of Sweden (1303–73), first printed at the end of the fifteenth century. But the Crucifixion on its outer doors had a particular purpose and meaning, being permanently visible in the monastic hospital's chapel. There patients prepared themselves spiritually before undergoing medical treatment (mainly for diseases of the blood and skin, including syphilis, which had suddenly struck Europe in the late 1490s). Help for the sick was commonly invoked from the four saints below the cross and also from those on the flanking wings, St Sebastian (see p. 342) and St Anthony, patron of the religious order which ran this and many other hospitals. Grünewald's Crucifixion scene, however, transcends the popular cult of miracle-working saints and reflects profounder beliefs about the meaning of physical suffering. Although sickness was sometimes regarded as punishment for sin, it was also interpreted as an act of grace which could restore the health of the

soul. Nothing is 'more profitable to man's salvation than suffering', wrote the author of the *Imitation of Christ*; 'the more the flesh is wasted by affliction, so much the more is the spirit strengthened by inward grace.' Suffering had to be endured for Christ's sake, as the human equivalent of his Passion, and Grünewald's agonized image was intended in this way as a spiritual aid to the sick and infirm.

In form, the Isenheim altarpiece or retable (see Glossary) belongs to a type extremely popular in Germany in the second half of the fifteenth century and first quarter of the sixteenth. It consists of a central element called the *corpus* with sculptured figures, a high superstructure of interlaced Gothic tracery and a base like a predella. Except on feast-days, the *corpus* was concealed behind doors or wings often painted outside and carved in low relief inside. Pride of place was thus given to sculpture rather than painting. The favourite material in south Germany was light, close-grained and easily worked lime-wood, which permitted effects of the greatest delicacy, though it also imposed limitations since only the outer shell of the tree-trunk can be satisfactorily carved. Concave forms and strong verticals determined by the organic structure of the tree tend to predominate. The wood was either coated with gesso and painted naturalistically or, from the late fifteenth century, left plain and varnished.

The makers of these retables were independent artists, in social standing and organization more like panel painters than medieval sculptors and stone carvers who had been employed as day-labourers in the masons' lodges attached to the great cathedrals and churches. The emergence of these wood-carvers in the second decade of the fifteenth century marks the beginning of large-scale independent sculpture in northern Europe—that is, sculpture independent of architecture. Their carvings are among the outstanding products of the new urban culture of Germany which appeared on the recovery of industry and trade after the devastation of the Black Death (see p. 314). For although their major works were for churches, they were commissioned less frequently by the clergy than by rich merchants, city councils, guilds and lay confraternities. And much of their small-scale work was offered for sale ready-made, e.g. crucifixes and figurines of saints, often bought for private houses. Alongside other skilled craftsmen and tradesmen, they belonged to the middle rank of the society for which they worked and were members of guilds with a voice on the city council. One of the most successful, Tilman Riemenschneider (c. 1460–1531), became mayor of Würzburg in 1520–1. The changing social climate that permitted such independence also fostered

competitiveness; and this may largely account for the bravura displays of technical skill and the development of strongly marked workshop styles, as means of advertisement no less than self-expression. The long, lean faces and spiralling locks of hair in Riemenschneider's figures, for instance, might be regarded as his hallmarks.

Cross-currents of civic, religious and artistic ideas meet in an imposing retable commissioned by the corporation of Rothenburg-on-the-Tauber, an imperial free city (i.e. one that was self-governing under the emperor). Local craftsmen were entrusted with the framework, but Riemenschneider, working in Würzburg some 30 miles (48km) away, was engaged to carve the figures (11, 6). Its purpose, to enshrine a relic of Christ's blood which drew pilgrims to Rothenburg, links it with medieval Catholicism. But in other respects it reflects contemporary attitudes, especially the rising tide of hostility to elaborate religious images as being both temptations to idolatry and vain displays of wealth and pride rather than true piety. Riemenschneider's retable was relatively inexpensive, costing less than a fifth of the sum paid by a rich merchant to Veit Stoss (c. 1450–1533) for the Annunciation group in the church of St Lorenz in Nuremberg (10, 3). There is no showy paint or costly gilding on the retable at Rothenburg. The figures in the group of the Last Supper have a sober rustic simplicity. Airs and graces, the elegant Gothic play of curve and counter-curve have been renounced, and with them the complex theological symbolism of medieval art. Riemenschneider returned to the letter of St John's Gospel and gives a straightforward account of the moment when Christ answered the disciples' questioning as to which of them would betray him: '"He it is, to whom I shall give the sop when I have dipped it." And when he had dipped the sop he gave it to Judas Iscariot.' The figures communicate with one another, not with the spectator, and the central position normally reserved for Christ is occupied by Judas, as if to emphasize the illustrative and didactic, rather than devotional, function of the carving. Protestant objections to religious images could hardly have been more effectively forestalled, and this may account for the preservation of the retable after Rothenburg adopted the reformed faith in 1524.

Riemenschneider supported the peasants against the landed nobility and higher clergy in the Peasants' War of 1524–26, although he was not converted to Protestantism, as was Grünewald, who also sided with the peasants. In the following years both suffered, like other German artists, from a precipitous decline in patronage. A print of the 1530s illustrates the plight of

11, 6 Tilman Riemenschneider, *The Last Supper* from the Altar of the Holy Blood, 1499–1505. Limewood, figures up to 39ins (100cm) high. St Jakobskirche, Rothenburg-on-the-Tauber.

sculptors with the lamentable case of one who had been obliged to turn soldier for lack of work. Others were forced to emigrate, including even well-known artists such as Hans Holbein the Younger (1497–1543), who left Basel in 1526 with a letter of introduction from Erasmus saying, 'here the arts are freezing: he goes to England in order to scrape together a little money.' Holbein was welcomed in London and after 1532, when Henry VIII formally ousted the Pope as head of the Church of England, he settled there, eventually becoming court artist.

Born in Augsburg, Holbein spent his youth in Basel, one of the great centres of printing and book production, of humanism and, later, of Protestantism. At first he worked mainly as a religious artist. But he drew illustrations in a copy of Erasmus's sharp attack on the abuses of the Church, *In Praise of Folly* (1509). And after Erasmus settled in Basel in 1521 Holbein painted several portraits of him. One commissioned by Erasmus himself to send to a friend in England is almost emblematical of the great cause for which his name stood in the minds of his admirers (11, 7). It shows him standing beside a pilaster delicately carved with Classical motifs and resting his sensitive fingers on a book inscribed in Greek 'The Herculean Labours' and in Latin 'of Erasmus of Rotterdam'. The origins of his scholarship are thus made quite explicit, but the

purity and truth of his Christian humanism are also alluded to (in the decanter of clear water). It is the image of a new and peculiarly Renaissance type of man, the aristocrat of the intellect.

In Protestant countries there was a demand for portraits of reformers, including Erasmus (although his desire for Christian unity prevented him from abandoning the Catholic Church), and especially of Luther himself, of whom those by Lucas Cranach the Elder (1473–1553) are outstanding. They are the most numerous Protestant works of art produced in the sixteenth century, apart from satirical prints. Attempts were, however, made to express Lutheran ideas in a 'reformed' religious art by Lucas Cranach the Younger (1515–53) and others, above all by Holbein and Dürer. Holbein's *Allegory of the Old and New Testaments* is a doctrinally didactic work, which subtly transforms the significance of traditional Christian imagery (11, 8). Instead of presenting the Old Testament as a prefiguration of the New, he shows the two in antithesis to

11, 7 Hans Holbein the Younger, *Erasmus of Rotterdam*, c.1523. Panel, 30 × 20¼ins (76.2 × 51.4cm). Private collection.

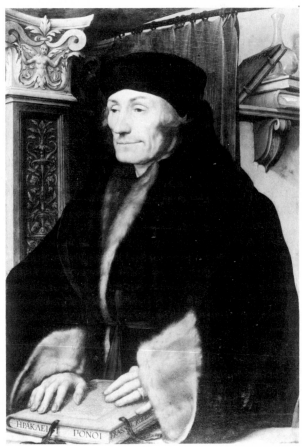

underline the differences between old (Roman Catholic) and new (Lutheran) teaching. Moses receiving the Law on Mount Sinai, for instance, is contrasted with the Virgin, towards whom the infant Christ descends bearing a cross. Adam and Eve repenting their sins, the consequence of which is death (a skeleton in a coffin), are contrasted with Christ teaching and, below, trampling on sin and death as he rises from the tomb—with the inscription 'our victory'. In the centre, beneath a tree dead on one side and in leaf on the other, a nude figure representing mankind is seated flanked by Isaiah and St John the Baptist, who direct his attention to the Incarnation, Crucifixion and Resurrection of Christ, which were, for Luther, the essentials of Christianity. In this overt way the Roman Catholic cult (symbolized by Law in various guises on the left side of the painting) is contrasted with Protestant belief in salvation by faith and grace.

Dürer's approach was less militant. In 1519 he underwent a spiritual crisis from which he emerged a fervent admirer of Luther, 'the Christian man who has helped me out of great anxieties' as he called him. The iconoclastic riots and the questioning of the value and function of art that accompanied Luther's preaching and writing deeply affected Dürer and for some years he pondered the uses and abuses of art. In 1526 he presented to the city council of Nuremberg *The Four Apostles*, probably at least partly in gratitude for the peaceful outcome of the religious crisis the city had just gone through when it accepted Lutheranism (11, 5). The paintings were to be hung in the city hall, not in a church. (They were never, as has sometimes been thought, intended to form part of a triptych.) Four saints or witnesses, three apostles and one evangelist, are depicted. In the left-hand panel St John, Luther's 'favourite evangelist', overshadows St Peter, the founder of the Roman See; in the other panel prominence is given to St Paul, often regarded as the spiritual father of Protestantism, who stands in front of the evangelist St Mark. The painting is unmistakably Protestant.

Dürer is known to have intended the figures to exemplify also the four humours or temperaments—sanguine, phlegmatic, choleric and melancholic—associated with the elements forming the basic substance of all creation. These humours were believed to have been perfectly balanced in Adam and Eve; but since the fall one predominated over the others in every human body and mind. In so far as the theory of the humours accounts for physical and psychological diversity, it embodied Protestant beliefs about human nature, and thus *The Four Apostles* expresses another aspect of Protestantism. But Dürer went further,

11, 8 Hans Holbein the Younger, *An Allegory of the Old and New Testaments*, c.1530. Oil on panel, 19¾ × 24ins (50.2 × 61cm). National Gallery of Scotland, Edinburgh.

illustrating Protestantism at a deeper level. His four figures constitute a divine whole greater than the sum of its parts, like the Lutheran conception of the Reformed Church, composed of equal individuals without a hierarchy.

Beneath the figures Dürer inscribed lengthy quotations from their writings, in Luther's translation of the New Testament (1522), beginning with a warning to the secular powers against taking 'human misguidance for the Divine word' in these perilous times. He was alluding not only to the Roman Church but also to extreme forms of Protestantism, which had recently come to the surface during the Peasants' War. These he firmly denounced, as did Luther. So the paintings may perhaps also be interpreted as a plea for balance and sanity in a world torn by dissension. Their dignified simplicity and restraint bear the same message. 'When I was young I craved variety and novelty', Dürer told his friend Melanchthon, a Protestant humanist; 'now in my old age, I have come to see ... that simplicity is the ultimate goal of art.' He eschewed all superfluous detail, rendering draperies in broad swathes of contrasting colours without ornament. There are no haloes. But the figures have a monumental stability and solidity, a serenity and nobility which sanctifies them more truly than would any outward sign of holiness.

In his last years Dürer almost totally abandoned

secular work, devoting himself mainly to prints of 'apostolic' simplicity illustrating themes so fundamental to Christian belief that they transcend sectarian differences. (Protestants who were wary of painted images had few objections to prints of sacred subjects.) Other artists with Lutheran sympathies were less rigorous. Albrecht Altdorfer (c. 1480–1538), who was instrumental in bringing a Protestant preacher to the city of Regensburg (of which he was a councillor), painted both sensuous mythological and traditional religious pictures. His drawings, etchings and oil paintings of the rolling hills, rocks, streams and pine-trees of the Danube valley may, nevertheless, have had new religious implications (11, 9). Without any figures or narrative content, they are among the earliest pure landscapes in European art and seem to reflect, as well, ideas then current among Protestant mystics. 'As the air fills everything and is not confined to one place', wrote Sebastian Franck in *Paradoxa* (1533), 'as the light of the sun overfloods the whole earth, is not on earth and nonetheless makes all things on earth

11, 9 Albrecht Altdorfer, *Danube landscape*, c.1530. Oil on parchment on beechwood, 11⅘ × 8⅜ins (30 × 22cm). Alte Pinakothek, Munich.

verdant, thus God dwells in everything, and everything dwells in Him.'

The High Renaissance in Italy

The first quarter of the sixteenth century was one of political stress and almost constant warfare in Italy. Florence, still an important artistic centre, passed from republicanism to the autocratic rule of the Medici. Northern Italy was twice invaded by the French, who occupied Milan from 1499 to 1512 and from 1515 to 1525. The Papacy was actively engaged in a struggle to extend its temporal power—Pope Julius II was almost continuously at the head of his troops on military campaigns—and was only checked by the intervention of the Holy Roman Emperor. In 1527 Rome itself was sacked by German and Spanish mercenaries of the army of Charles V. Yet it was during this extremely turbulent period that the art of the High Renaissance came into being, an art of serene and elevated conception, of great but controlled energy and, above all, of Classical balance. It was the creation of a small number of pre-eminent artists—pre-eminent in their own day as in ours—notably Leonardo da Vinci (1452–1519), Michelangelo Buonarroti (1475–1564) and Raphael (Raffaello Sanzio, 1483–1520). Each one was very much an individualist and although sparks of inspiration flashed between them they never formed a group. Supreme technical accomplishment, perfect co-ordination of mind, eye and hand, was attained by all three. Problems which had vexed earlier artists they effortlessly resolved. In their work artistic form is always beautifully adjusted to intellectual content.

Looking back from the mid-sixteenth century, the Florentine painter, architect and biographer of artists Giorgio Vasari (1511–74) described how the 'revival' of the arts led, under Leonardo, to what Vasari called the 'modern' style, notable for 'boldness of design, the subtlest imitation of all the details of nature, good rule, better order, correct proportions and divine grace, prolific and profound, endowing his figures with motion and breath'. The high position given to Leonardo is the more remarkable in view of the small number of works he completed. His first major painting, *The Adoration of the Magi* (Uffizi, Florence), begun in 1481, was left unfinished and so, too, was his large battle scene in the Palazzo Vecchio, Florence (1502–5, destroyed in the mid-sixteenth century). His equestrian monument to Francesco Sforza of Milan was never cast and the full-size clay model perished. None of the buildings he designed was erected. Nor did he ever prepare for publication his several thousand pages of illustrated notes on artistic theory, human anatomy, natural history, the flight of birds, the

properties of water and numerous mechanical contrivances. 'Great minds often produce more by working less, for with their intellect they search for conceptions and form those perfect ideas which afterwards they merely express with their hands,' he wrote. Such ideas presuppose that 'art' is much more than 'craft' and lead directly to the notion of a great artist as a 'man of genius'.

Leonardo grew up in the Florence of the humanists but took little interest in their Classical erudition and Neoplatonic speculations. He did not learn Latin until he was 40. So he was as independent of Classical as of medieval thought—perhaps the first thinker to be so. Trained as a painter and sculptor, almost certainly in the studio of Andrea del Verrocchio (see p. 332), his interests soon expanded to embrace not only all the arts, but all natural phenomena. His boundless curiosity and appetite for knowledge gradually focused on what Aristotle had called 'entelechy', the condition in which a potentiality becomes an actuality. Hence his preoccupation with the germinal stage in both nature and art, the moment a body is organically complete though still immature, or that in which a painting is fully realized though not yet finished. His passion to understand the structure of the human body led him to dissect corpses and make the first accurate anatomical drawings (11, 10). Leonardo developed his astonishingly bold empirical approach at a time when scientists still accepted as authorities such ancient Greek and Roman writers as the first-century AD Dioscorides and Galen. 'It seems to me that those sciences are vain and full of error which are not born of experience, mother of all certainty, first-hand experience which in its origins or means or ends has passed through one of the five senses,' he wrote. 'And if we doubt the certainty of everything that passes through the senses, how much more ought we to doubt things contrary to these senses such as the existence of God or of the soul or of similar things over which there is always dispute and contention.'

Leonardo's innovatory genius first found full expression in his *Last Supper* (11, 11). In order, presumably, to avoid the cramping limitations of fresco, which obliges a painter to finish one section of a wall at a time, he experimented with a medium which would allow him to work over the whole composition simultaneously, like an oil painting. Unfortunately the new medium proved not to be durable and there were already signs of decay during his lifetime. In general conception his composition follows recent Florentine precedents, with figures set in a pictorial space which extends the real space of the refectory. But the scene is defined more precisely and invested with a wholly new

11, 10 Leonardo da Vinci, *Anatomical studies*, 1510. Pen and ink, $11\frac{1}{8} \times 7\frac{3}{4}$ins (28.4 × 19.7cm). Royal Collection, Windsor Castle. Reproduced by Gracious Permission of Her Majesty The Queen.

animation. Instead of depicting the disciples in an undifferentiated line, he gathered them in threes, creating a network of formal and emotional connections binding each figure to his neighbours and to Christ in the centre. By selecting the pregnant moment in the Gospel story when the disciples ask Christ which of them would betray him—'Lord, is it I?'—he was able to depict each one as an individual reacting in a different and psychologically revealing way. He dispensed not only with all the discursive details in which earlier fifteenth-century painters had revelled, but also the emblems and inscriptions previously used

to identify the various figures. By facial expression and gesture the disciples identify themselves. They are all larger and—apart from Judas, whose head is in shadow—nobler than life, needing no haloes to indicate their sanctity, although Christ's divine aura is suggested by the natural light from the window framing his head. Leonardo was not a devout Christian, he might almost be called an agnostic, but by translating what had previously been represented as an hieratic ritual into a scene of human tragedy, he paradoxically deepened its religious significance. No more than a few years later, as we have seen, Riemenschneider in Germany represented the succeeding moment in the story of the Last Supper, also as a human drama but one enacted by peasants and lacking both the psychological subtlety and the sense of spiritual elevation conveyed by Leonardo's complex composition.

Careful study of plants and anatomy and the principles of organic growth led Leonardo to construct his paintings according to a similar system, with every part integrated in such a way that there are no apparent beginnings or ends, no sharp transitions. In his *Virgin and Child with St Anne*, for example, he entwined the three figures into a pyramid, within which forms grow out of one another as naturally as a leaf from its stem or a branch from a tree-trunk (11, 12).

11, 11 Leonardo da Vinci, *The Last Supper*, c.1495–98. Mural painting, 15ft 1⅛in × 28ft 10½in (4.6 × 8.56m). S Maria delle Grazie, Milan.

This picture also illustrates, much better than the *Last Supper*, the pictorial techniques which were either perfected or, in effect, invented by Leonardo and very soon transformed European painting into a form of art unlike any practiced elsewhere in the world: *chiaroscuro* (light and dark modulated to create effects of relief or modelling), *sfumato* (misty, soft blending of colours) and aerial perspective, which indicates distance by grading tones and muting colour contrasts. Comparison with such a masterpiece of the mid-fifteenth century as Piero della Francesca's *Baptism* (10, 37) marks the difference between two ways of seeing and painting. Whereas Piero's landscape background is rendered with telescopic vision and painted like the foreground in local colours (see Glossary), Leonardo's distant mountains melt into a grayish-blue haze. The figures in the *Baptism* have an adamantine solidity; those in the *Virgin and Child with St Anne* have no less weight yet breathe with a yielding softness. Leonardo's picture presents an image of figures in a landscape closer to visual experience, though veiled in a mysterious unworldly atmosphere. Calculated imprecision in rendering the most expressive facial features, the eyes and the corners of the mouths, gives to the faces strangely ambiguous half-smiles as remote and haunting as that of Leonardo's *Mona Lisa* (Louvre, Paris), the most famous portrait ever painted.

Leonardo opened the eyes of artists to great new possibilities in painting, even artists as tem-

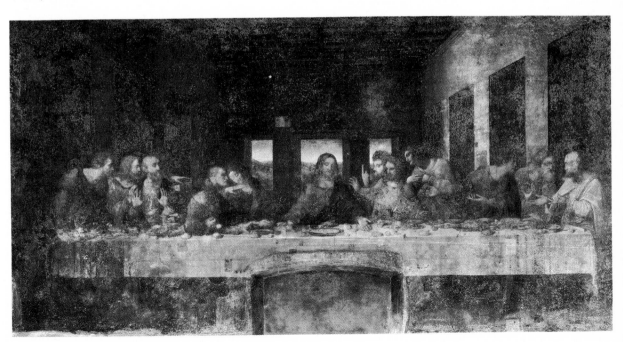

peramentally opposed to him as Fra Bartolommeo (1472–1517), 20 years his junior and a man of deeply pious character, who had been inspired by Savonarola to become a Dominican friar. Fra Bartolommeo's finest work is an altarpiece commissioned by Ferry Carondelet, the imperial ambassador to Rome, who is portrayed kneeling on the right, looking at the spectator and pointing to the Virgin and Child borne aloft by angels (11, 13). Figures are depicted as three-dimensional forms made visible by light, like Leonardo's, but without his hazy atmospheric effects. Their apparently natural poses are governed by the principle of *contrapposto*, whereby one part of a body is twisted in a direction opposite to another—a right arm counterpoising a left leg, for instance. Two angels in the upper corners are not only posed in this counterbalancing way but also, unlike the mirror-image pairs in earlier art, complement one another, introducing a rhythm of correspondence which runs through the whole composition and binds it together. One gesture echoes another across the panel, holding the gentle, unemphatic movements of the figures in an equilibrium which steadies and concentrates thought, creating a piously reflective mood. A similar holy calm pervades the tranquil landscape stretching far into the distance beyond the door, through which the Virgin and Child appear to have entered.

In painting this altarpiece, Fra Bartolommeo was confronted or confronted himself with the problem of reconciling three-dimensional naturalism with symmetry and poise—the natural with the contrived. The problem taxed the abilities of all High Renaissance artists, as can be seen in Raphael's many ingenious variations on the Madonna and Child theme. In more than one he reached a solution so convincing that it has the apparent simplicity and inevitability of a single axiomatic thought (11, 19). With figures as natural in pose as in gesture, yet forming a most unnaturally well-balanced design of soft, sweetly melting curves within the curved picture shape, the finest retain, none the less, all the spirituality of an icon. Circularity has complex implications in a devotional image for Christian prayer and meditation—like the cosmic diagrams in a Buddhist mandala (see p. 183). As the writer Baldassare Castiglione, who was a friend of Raphael at about this date, put it: 'Beauty is born of God, and is like a circle of which goodness is the centre: and, just as no circle can exist without a centre, so no beauty can exist without goodness.'

The idea of grouping the Virgin and Child with the infant St John the Baptist (an incident never mentioned in the Gospels) was Leonardo's. And it was from Leonardo that Raphael derived his organic

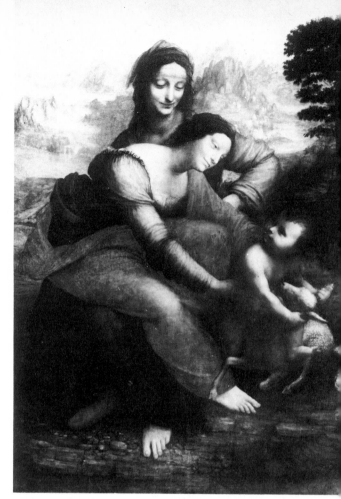

11, 12. Leonardo da Vinci, *Virgin and Child with St Anne*, 1508–10. Panel, $66\frac{1}{8} \times 51\frac{1}{4}$in (168×130cm). Louvre, Paris.

system of composition and his subtle use of *chiaroscuro*. Not for him, however, Leonardo's mysterious twilight. Raphael's figures are bathed in the even, limpid sunshine of a mellow summer's day and set in an untroubled landscape with an idyllic distant view of a farmstead and rolling hills. Nor is there any Leonardesque ambiguity in the loving expressions with which they gaze upon one another.

The same ideal of harmonious unity inspired architects as well as painters. Some 50 years later, Palladio wrote that Donato Bramante (1444–1514) was 'the first to bring to light good and beautiful architecture which from the time of the ancients to his day had been forgotten'. In view of the great achievements of Alberti, Brunelleschi and others of their time, this may seem a strange judgement. But Bramante was more radical than any of his predecessors and with the Tempietto (11, 14), to which

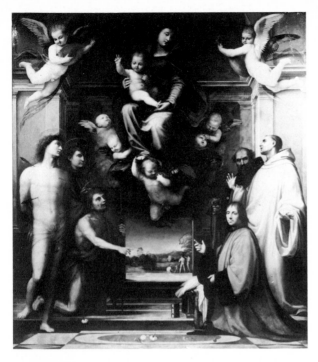

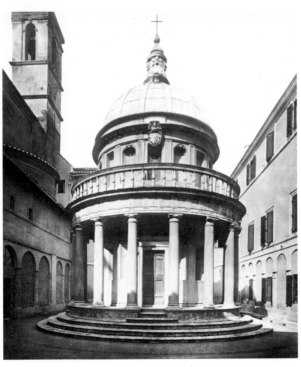

11, 13 *Top* Fra Bartolommeo, *Carondelet Altarpiece*, c.1511. Panel, 102⅜ × 90½ins (260 × 230cm). Cathedral, Besançon.
11, 14 *Above* Donato Bramante, The Tempietto, S Pietro in Montoria, Rome, c. 1502–3.

Palladio specifically referred, he initiated a new phase in Renaissance architecture. He renounced all superfluous decoration and restored the correct usage of the Classical orders in this little building—a tholos surrounded by a colonnade of equally-spaced Doric columns bearing a flat entablature with metopes and triglyphs, not arches, as had previously been used. It was intended to be set in the centre of a circular peristyle (never built), being conceived not in isolation but as the nucleus of an ordered environment, in which solids and voids, mass and volume, would be held in perfect equipoise.

The Tempietto is a monument rather than a place for congregational worship, for it can hold only a few people. But it embodied the idea of a free-standing, centrally planned church crowned by a hemispherical dome, an idea that had haunted the minds of Italian architects for more than half a century, as a symbol of the concentric cosmos, reflecting celestial harmony in its proportions and geometry of pure forms. Leonardo, a friend of Bramante, experimented with many sketches for churches combining cubes and spheres. And when Bramante was given the task of rebuilding St Peter's in Rome (partly in order to make the presbytery into a memorial to Pope Julius II), he designed the most grandiose centralized church he could conceive standing in the middle of an immense square. The foundation stone was laid in 1506. St Peter's was not to be built to Bramante's design, but he had, nevertheless, set a new standard of solemn, monumental grandeur.

Bramante was artistic adviser as well as architect to Pope Julius II (1503–13), under whom Rome became, for the first time since antiquity, the centre of European art. Bramante may well have been responsible for engaging Raphael to decorate the Pope's private apartments in the Vatican—generally known simply as *le stanze* (the rooms)—almost immediately after he arrived in Rome from Florence in 1508. Raphael was not yet 26 years old. It was a golden moment, a brief interval of apparent prosperity before the sack of Rome, and Raphael created visions of unequalled grandeur and serenity.

The Stanza della Segnatura (called after the supreme ecclesiastical tribunal which later met there) came first. Originally intended as a library, its paintings allude to the four 'faculties' or branches of humanist learning—theology, philosophy, poetry and jurisprudence—personified in roundels on the ceiling. On one side is the wall devoted to literature, with Classical and modern writers gathered around Apollo and the Muses on Mount Parnassus. Philosophy is illustrated on the other wall in a fresco of ancient Greek thinkers and

scientists, generally if somewhat inaccurately entitled the *School of Athens* (11, 24), with Plato and Aristotle enshrined in the centre—here, at the very heart of the Papacy. However, this celebration of human reason faces the wall on which Theology is represented by a congregation of saints and Catholic teachers called the *Disputa* or 'Debate on the Holy Sacrament'—the complementary path to truth, reached by faith and revelation. The fourth wall is divided into two parts (below the lunette), with civil law depicted on that adjoining the *School of Athens*, canon law next to the *Disputa*. Thus, a perfect balance is maintained between the different strands in Christian humanist culture.

The general iconographical program seems to have been devised before Raphael took charge in 1509, for a start had already been made on the ceiling. From then onwards he was given a free hand to work out the great compositions, as his numerous preliminary drawings testify. He abandoned the old system of allegorical personifications of abstract ideas (except in the roundels on the ceiling) in favour of scenes in which historical figures enact the subjects. For the *School of Athens* he conjured up an ideal gathering of thinkers actively engaged in philosophical discourse, teaching, learning, talking, pondering, with rapt expressions of mental concentration. In the centre Plato pointing upwards, perhaps to indicate the source of Platonic Ideas, stands next to Aristotle, whose downward gesture suggests his preoccupation with natural phenomena. Speculative thinkers are grouped on Plato's side: on the other there are 'scientists', including the geographer Ptolemy with Euclid (said to be a portrait of Bramante) demonstrating a geo-metrical theorem.

The device of placing the two main figures within a framing arch against the sky recalls Leonardo's *Last Supper*. Raphael's composition is, however, more complex than Leonardo's, with 52 figures in as many different poses, yet the same unity within diversity is attained without any deadening sense of symmetry. His insertion of the brooding man identified as Heraclitus in the foreground, just to the left of centre, was a masterly afterthought—as examination of the plaster has shown, for this section of the wall had to be chipped out and replastered to enable Raphael to make the alteration. (Heraclitus is perhaps a portrait of Michelangelo, and Plato of Leonardo.) Contrasts in colour, sharp greens, clear blues and a few shot reds and yellows create an animating pattern, which further relieves the formality and exalted solemnity of the general scheme. But the great innovation in the painting is the relationship between the figures and their architectural setting, a grandiose vaulted structure reminiscent of Bramante's unexecuted designs for St Peter's. Whereas in Leonardo's *Last Supper* the figures were set in a predetermined perspective box, here they determine the pictorial space, which is no longer conceived as an extension of the room but as one much larger and wholly independent, yet which neither constricts nor over-whelms. In Raphael's full-scale cartoon for the fresco (Ambrosiana, Milan) there is no indication of the architectural background, which was presumably conceived later and, as it were, built round and for the figures.

While Raphael was painting the Stanza della Segnatura, Michelangelo was at work on the ceiling of the Sistine Chapel (11, 25 & 29). Never before or since have two masterpieces of this order been created concurrently in such close proximity. They exemplify, however, two tendencies latent in the High Renaissance but soon to diverge and set off a conflict which has given later European art its stylistic volatility. The two artists were unlike one another in background, as in character. Raphael, the son of a painter, had begun in the medieval tradition of artist-craftsman, although he rapidly rose socially to end his brief life as a man of conspicuous wealth, the owner of a handsome palace in Rome, with a retinue of domestic servants and a still larger staff of assistants. In his style of life, as in his paintings, he acquired the *sprezzatura* or ease of manner so highly lauded by his friend Baldassare Castiglione in *The Book of the Courtier* (1528)—the quality that 'conceals art and shows that what is said and done is accomplished without difficulty and almost without thinking about it'. Michelangelo was the antithesis of the ideal courtier. Unsociable, mistrustful, moody, untidy, obsessed with his work and almost pathologically proud, he was the archetype of the 'man of genius', a poet as well as a sculptor, painter and architect. At odds with himself and with the world, his introspective imagination revolutionized everything he touched.

He came from an impoverished Florentine family with claims to nobility and always held himself aloof from other artists. 'I was never a painter or sculptor like those who set up shop,' he told his nephew in 1548. Although he served a brief apprenticeship to Domenico Ghirlandaio (see p. 334), his formative years were those he spent in the household of Lorenzo de'Medici (the Magnificent) around 1489 to 1492, studying sculpture under Bertoldi di Giovanni (see p. 329) and living on familiar terms with the young Medici, two of whom were later to become popes, Leo X and Clement VII. Here, too, he encountered the Classical scholar and poet Angelo Poliziano (see p.

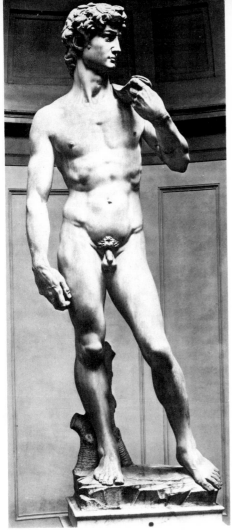

11, 15 Michelangelo, *David*, 1501–4. Marble, height approx. 18ft (5.5m). Galleria dell'Accademia, Florence.

the Medici in 1494. Whether this was uppermost, or present at all, in Michelangelo's mind when working on the figure may be questioned. (Originally the statue was intended for the cathedral exterior.) But as the first nude to be carved on this colossal scale since antiquity, it gave him the opportunity to measure his strength. The effect is audaciously un-Classical. The hands and feet are over-size, muscles and veins are swollen and the gangling limbs are not at rest. But already Michelangelo's conception of the body as the prison of the soul has endowed his heroic figure with an extraordinary sense of pent-up energy—outwardly calm, but inwardly tense and challenging.

The success of the *David* was such that Michelangelo was summoned to Rome to execute for Julius II a free-standing sepulchral monument, on a scale and of a complexity to outdo all others, as part of the new St Peter's designed by Bramante. This was to have been Michelangelo's masterpiece, combining and unifying architecture and sculpture, and he worked on it intermittently for 40 years, its scale being gradually reduced to that of a wall monument (S Pietro in Vincoli, Rome). He regarded it as the tragedy of his life. However, in 1508 Julius II persuaded him to paint the ceiling of the Sistine Chapel, of which the upper parts of the walls had been frescoed by leading artists of the late fifteenth century—Botticelli, Domenico Ghirlandaio and Raphael's master Pietro Perugino, among others. The vault measures roughly 133 by 43 feet (40 by 13m), with many curved surfaces, and presented an exceptionally difficult problem as a field for figurative paintings. Michelangelo's solution was one of daring originality. He probably had the advice of theologians for the iconographical program, though he claimed that the Pope had 'let him do what he wanted'. In two sessions, from winter 1508/9 to summer 1510 and February 1511 to October 1512, he painted the upper part of the walls and the whole ceiling in true fresco, almost single-handed.

Michelangelo conceived the ceiling as an imaginary architectural structure rising above the chapel and treated the areas of greatest curvature as continuations of the walls (11, 18 & 22). Separating off the concave triangles above the windows and at the corners, he painted the spandrels between them as thrones, joined by a cornice that marks the top of the fictive walls, and flanked by pilasters that support 'horizontal' ribs of stone spanning the centre. This imaginary structure provided three distinct zones for figurative paintings, which could thus be given a corresponding hierarchy of content. In the lowest—the lunettes surrounding the upper windows of the real wall and the small vaults above them—he painted the ancestors of Christ. The

334) and the philosopher Marsilio Ficino, who revived the Neoplatonic notion of 'Ideas' as metaphysical realities (see p. 339) which was to play an important part in sixteenth-century aesthetics.

In Florence in the autumn of 1504 the over-life-size statue of David on which Michelangelo had been working for the previous three years was set up outside the main entrance to the Palazzo Vecchio (now replaced by a copy) (11, 15). Unlike earlier representations, his *David* is not shown as the victor with his foot on Goliath's severed head, but as the champion of a just cause fearlessly confronting his physically stronger opponent. Placed in front of the seat of government, this provocative adolescent with his muscular torso, straining neck and defiant expression beneath knotted brows was seen by some Florentines as symbolizing their new republic, which had expelled

thrones of the second zone support magnificent figures of prophets alternating with Classical sibyls, who foretold the coming of Christ. All these are fore-shortened from the viewpoint of a spectator on the ground—as if they were within his space. But the figurative scenes of the uppermost zone, seen through the ribs of stone, present a higher reality and are painted according to their own perspectival laws as independent pictures. They illustrate the first of the three periods into which the history of the world was then divided, that before the tablets of the Law were given to Moses and called *ante legem*. (Those *sub lege* and *sub gratia* had already been depicted on the lateral walls.)

Above the altar Michelangelo recorded the beginning of all things, the androgynous figure of God with cloud-covered face dynamically emerging out of primal chaos, followed by the creation of the sun and moon, and the separation of land from water. In the next scene, Michelangelo's most sublime and justly famous image, God animates the languid clay of Adam through a tiny gap between their outstretched fingers, imparting the spirit that enables man to move, think and feel. The creation of Eve and a scene which combines the temptation of Adam and Eve with their expulsion from Eden come next. The three final scenes are devoted to Noah, the man chosen by God to continue the human race. Michelangelo began work at this end of the ceiling, proceeding towards the altar with an access of self-confidence, simplifying the compositions and enlarging his designs. (They were intended to be seen from the chancel, where the Pope sat on his throne. To the modern visitor entering the chapel, they read in reverse and upside down.)

Seated on the pilasters between the thrones of prophets and sibyls are nude adolescents—*ignudi* as they are called—flexing their muscles and showing off their athletic limbs with complete abandon, as if in praise of God's creation. Their pictorial function is to mask the join between the upper zones (they seem to belong to both), and they have been variously interpreted as wingless angels and symbols of the rational soul, though Michelangelo's homosexual leanings must partly account for them. Clearly related to the slaves intended for Julius II's tomb (11, 28), they are not, like them, held by the bonds of sin and death. They exult in their carnality. To Michelangelo the male body made in God's image represented the summit of physical and spiritual beauty and there can be little doubt that these sensuously painted nudes embodied his deepest longings.

Numerous attempts have been made to expound the meaning and program of the ceiling in interpretations ranging from Neoplatonic to orthodox theological allegory, without, however, accounting for its most striking feature, the complete freedom from convention with which every aspect of the great composition is treated. For Michelangelo's frenzied, whirlwind energy made everything seem superhuman and Olympian, creating a pantheon for the soul's most exalted aspirations, transforming a chapel at the centre of Western Christendom into a monument to his own genius. It is the most extreme instance of the independence that could be won by a great artist.

Raphael was the first artist to respond to the impact of the Sistine Chapel ceiling, and he was perhaps the only one to assimilate it without compromising his own artistic integrity. He must have seen part of it before completing the *School of Athens* with the Michelangelesque figure of Heraclitus. In 1515 he took account of the whole work when designing a set of tapestries to hang beneath it—they cost more than ten times as much as Michelangelo was paid for the ceiling! In Raphael's last great work, *The Transfiguration* (11, 16), Michelangelo's superhuman, demonic sculptural vision was translated into something much less overpowering but more painterly and dramatic in its rendering of natural and supernatural light, a masterpiece in which the combination of grandeur and humanity is unique. The contrast between the serene figures bathed in transcendental light in the upper part and the troubled gesturing of those in the shadows below who have witnessed the disciples' failure to cure a lunatic boy, enforces the picture's message that only Christ can heal the ills of the world. The words of the boy's father in the Gospel story link the painting with the spiritual crisis of the time: 'Lord, I believe; help thou my unbelief.'

After the Sistine Chapel ceiling Michelangelo returned to Florence, where the Medici had regained power in 1512 and, with the election of a Medici Pope (Leo X, 1513–21), took control of the Papal States. They were now the rulers of central Italy. The new Pope and his cousin (later Clement VII, 1523–34) set about converting the church of S Lorenzo into a dynastic monument by commissioning Michelangelo to design a new façade (never built) and subsequently a family mausoleum, the Medici Chapel (11, 17). In plan, in the use of a giant Corinthian order and in the dark-gray and white colour-scheme, Michelangelo followed Brunelleschi, whose sacristy matched the new chapel on the other side of the church. But in every other respect his design was revolutionary, especially in the way it broke free from the tyranny of the Classical orders. Windows taper, capitals vanish from pilasters which have recessed panels instead of fluting, taber-

wax model and then, with few if any assistants, to attack the marble block direct, all but finishing the front before removing the material on either side. For the statues in the Medici Chapel, however, he adopted the process which became normal for European sculptors during the next four centuries—making full-scale models from which assistants could rough out figures for him to finish. Even so, Michelangelo completed only one statue for the Medici Chapel, that of Giuliano de'Medici. This is an idealized image of a young patrician general in Roman military costume, not a likeness. Of the unfinished figures of Day and Night below, Michelangelo wrote a *concetto* or literary conceit of the type beloved by Renaissance writers (including Shakespeare at the end of the century), and its antithetical convolutions are echoed in the elaborate *contrapposto* of all three figures. But they transcend the ingenious artificiality of the *concetto*, just as they seem to burst through the restraining architectural framework, whose angular linearity offsets and heightens their roundness and weight. Iron-muscled Day, with his roughly worked face staring over a huge, beautifully modelled and smoothly carved shoulder, and heavy-limbed Night, with her tired

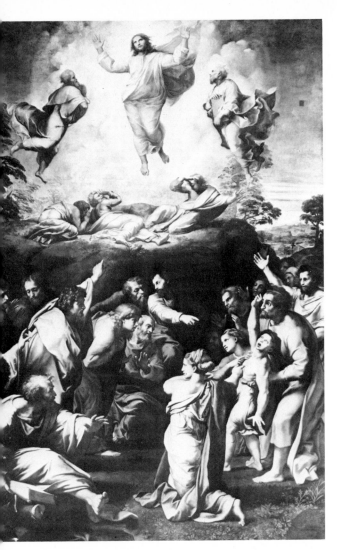

11, 16 Raphael, *The Transfiguration*, 1517. Panel, 15ft 1½ins × 9ft 1½ins (4.6 × 2.8m). Vatican Museum, Rome.

11, 17 Michelangelo, Medici Chapel, Florence, 1519–34.

nacles weigh down heavily on the voids beneath them. Many architectural elements have no structural function at all, the marble cladding simply being carved into simulated architectural forms. In this way Michelangelo evolved a new conception of architecture in which the wall is no longer an inert plane to which ornament may be applied, but a vital many-layered organism. His approach was that of a sculptor removing stone from a block rather than that of a builder raising one structural element on another.

'In hard and craggy stone the mere removal of the surface gives being to a figure, which ever grows the more the stone is hewn away', he wrote in one of his poems. His usual practice was to make a small clay or

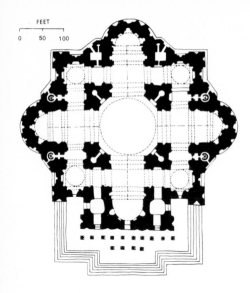

FEET

0 50 100

Plan of St Peter's.

breasts and creased belly, as if in troubled sleep or exhausted after frantic, impotent struggle, are only equalled by the unfinished Slaves for the tomb of Julius II (11, 28). Masterpieces of complex three-dimensional form, they are invested with the pathos of the human tragedy, the dualism of body and spirit. Outwardly calm, they seem stirred by some ever-present inward anguish.

Work on the Medici Chapel was interrupted by a political crisis precipitated by Medici ambitions, culminating in 1527, when the unpaid mercenaries of the imperial army—Spaniards and Germans, some of whom were Lutherans—sacked Rome, chasing the Pope out of the Vatican, desecrating churches, burning houses and slaughtering civilians with calculated brutality. It was the worst disaster to have befallen the city for nearly a thousand years. The Florentines took advantage of it to expel the Medici and proclaim a republic, enthusiastically supported by Michelangelo, who was later pardoned by the Pope on condition he resume work on the Medici Chapel. In 1534 he returned to Rome to paint the *Last Judgement* above the altar in the Sistine Chapel (11, 29).

The Last Judgement had usually been conceived as reflecting the eternal equity of divine justice. Michelangelo's vision was of a cosmic convulsion. Christ's gesture controls an irreversible and irresistible cyclical motion, raising up the blessed on his right and casting down the damned, towards whom his face is turned with a merciless expression. No attempt was made to give an illusion of depth. The figures are suspended in a single plane, each group being depicted

from a different viewpoint, those at the base much smaller than those higher up. This defiance of the normal laws of perspective construction has a deeply disturbing effect and adds to the force of the painting, which powerfully expressed that sublime and awesome quality in Michelangelo's art and personality called by contemporaries his *terribilità*.

Less pronounced is his Neoplatonism, though still present in his conception of divinity as light. He had recently made a drawing of Helios, the sun god, and used the same pose for Christ, beardless, nude and with the muscular physique of a Hellenistic statue, surrounded by an aureole like the sun. Perhaps he was also inspired by the Hellenistic notion of a heliocentric universe, then being given new and scientific validity by Copernicus (1473–1543). While painting the fresco, however, Michelangelo began his passionate friendship with the pious poet Vittoria Colonna, in whose circle he met religious thinkers who held that salvation depended wholly on God's mercy—a belief generically similar to the Protestant doctrine of justification by faith. These were the early years of the Counter-Reformation sponsored by Pope Paul III (1534–49). As a young cardinal he had fathered four illegitimate children: as Pope he became a zealous reformer and tried to steady the Church after the shock of Luther by enquiring into ecclesiastical abuses, sanctioning the Society of Jesus (1540) and convoking the Council of Trent, which, between 1545 and 1563, hardened the lines of doctrine, revised the liturgy, initiated the index of prohibited books and laid down rules for religious music and art. Michelangelo's *Last Judgement* reflected something of this new mood, as well as his own increasingly anguished piety—but not enough to satisfy the more literal-minded reformers.

The nude figures gave offence. Nudity in art had come to seem indecent, its antique precedents being pagan and its Neoplatonic justification heretical. The Christian humanism which had inspired the Sistine Chapel ceiling was now seen as the hot-bed of Protestantism. Michelangelo was denounced in 1549 as an 'inventor of filthiness, who cared more for art than for devotion'. After his death, loin-cloths were added to the figures and there were repeated proposals that the whole fresco be erased. Yet no one was more painfully aware of the conflict between art and piety than Michelangelo. 'Now know I well how that fond fantasy / which made my soul the worshipper of earthly art is vain', he wrote in a poem of 1554. He still had ten years to live but, apart from drawings of the Crucifixion and two unfinished groups of the Pietà, carved as a kind of religious exercise, he gave up art. His last years were devoted mainly to architecture.

In 1546 he had been appointed architect of St Peter's. As we have already seen, Bramante had designed a centrally planned church 40 years before, but funds soon ran out and the sale of indulgences (which provoked Luther's first protest, see p. 350) failed to raise enough. Although projects for less costly buildings had been prepared, by Raphael among others, little was achieved until Paul III became Pope. Work began in earnest in 1543 under the direction of Antonio da Sangallo (1483/5–1546), a pupil of Bramante. Within a few months of Sangallo's death Michelangelo made a clay model for a bolder, stronger and more tightly organized structure, and in the course of the next 18 years the two transepts and the drum of the dome were substantially completed according to his design—or, rather, designs, for he constantly modified his ideas as construction proceeded (11, 18). Much still remained to be done when he died. The dome was erected between 1588 and 1590 by Giacomo della Porta (c. 1522/33–1602) with considerable modifications, and the centralized plan of the whole building was converted into a Latin cross by Carlo Maderno (1556–1629), who also designed the façade built in 1608–15. Nevertheless, St Peter's owes more to

11, 18 Michelangelo, St. Peter's, Rome, 1546–64 (dome completed by Giacomo della Porta, 1590). View from the west.

Michelangelo than to any other architect. He created the internal continuum of space flowing round the massive piers that support the dome (13, 12). It is his exterior of the transepts, repeated round the apse and on either side of the nave, that articulates the huge mass of masonry with a supremely dignified rhythm.

On the exterior Michelangelo used giant pilasters of the same Corinthian order as those within but made little attempt to indicate the interior volume of the building, and none to suggest its structural form. Here, as elsewhere, he made a logical distinction between structure and decoration, the body and its clothes, which enabled him to treat the latter with imaginative freedom. His alternation of wide and narrow bays separated by the pilasters backed by strips, for example, creates deep shadows which lead the eye up to the paired columns around the drum of the dome and its prominent ribs (an element from his design preserved by della Porta). This vertical emphasis recalls the aspiring effect of a Gothic cathedral; but Michelangelo interrupted the insistent upward thrust with the strong horizontal of the cornice and unusually high attic, above and beyond which the dome seems to float—the symbol of Heaven being in this way visually detached from the world of mortal endeavour. Like all his works, St Peter's made an immediate impact on younger artists. But later sixteenth-century architects seem to have been attracted more by details which they could imitate (the surrounds of the attic windows, for instance) than by his new and dynamic principles of architectural composition.

The Venetian High Renaissance

Throughout the century Venice remained one of the richest cities in Europe, far richer than any other in Italy. It was a great entrepôt for trade with Asia (as yet little affected by the use of the sea route to India), a flourishing industrial centre for textiles and glass, and the capital of an overseas empire with territories on the mainland of Italy as well. Venice was the only important Italian city to resist political and economic domination by France, Spain or the Papacy, and one of the very few that retained a nominally republican, in fact oligarchic, system of government. Venetian art followed a similarly independent course, partly due to its particular pattern of patronage. The church did not enjoy in Venice the absolute predominance it did elsewhere in Italy. Both state and private patronage, on the other hand, were considerable, since the governing body of the Serenissima (the 'most serene' republic, as it was called) was intent on making a conspicuous display of power and prosperity as were the luxury-loving families at the top.

At the beginning of the century Giovanni Bellini (see p. 343) was, as Dürer wrote in 1506, 'still the best' painter in Venice. But two younger men, Giorgione and Titian, were already becoming known. Giorgione (c. 1476/8–1510) or Giorgio da Castelfranco, a small town on the Venetian mainland, is a very elusive figure, whose only surviving documented work is an all but totally obliterated fresco (Accademia, Venice). No more than six easel paintings can reasonably be attributed to him. And yet, there is abundant evidence of his fame. He introduced a new technique, a new style and a new type of picture. He was the first artist to exploit the luminous effects of the new Venetian technique of painting on canvas (rather than panel) with pigments mixed with oil and flexible resins (not the hard resins used in the Low Countries). Great freedom of brushwork with richly opaque and thick, juicy colours was now possible. Unlike the Florentines, Vasari noted, Giorgione made no detailed preparatory drawings on paper or on the canvas itself. He began by roughing out a composition in body-colour on the canvas and modified it as he proceeded, defining forms in gradations of tone. Softness of contour, atmospheric subtlety and an evanescent dream-like quality characterize his style—as also, indeed, his subject-matter or, one might almost say, his lack of it. The earliest writer to mention his paintings, the Venetian connoisseur and collector Marcantonio Michiel (d. 1552), might seem sometimes to have been deliberately vague about them—'a nude in a landscape', for instance. Another is described as 'depicting three philosophers in a landscape, two standing and one sitting looking at the rays of the sun with a sextant'. This survives and shows not only that Michiel's descriptions were accurate, but also that the ambiguous nature of the scene depicted was intentional and reflects Giorgione's very personal conception of the purpose and meaning of art (11, 30). So eloquently could he evoke atmosphere and mood that we do not need to know the precise meaning—the mood is all.

In this instance X-rays reveal that he began by painting the figures in the traditional guise of the Three Magi or 'wise men'—one black, another wearing a crown—not, as was usual, adoring the Christ Child but awaiting the appearance of the star that would announce his nativity. Legend identified the Magi as astronomers or astrologers—'philosophers' in the terminology of the time. But so effectively did Giorgione remove all traditional attributes of the Magi that they are open to more than one interpretation, for example that they refer to the main tendencies in Venetian thought, the bearded man being associated with Aristotelianism, the man in Oriental costume with Islamic Averroism and the youth with a sextant with the new natural philosophy. Unilluminating though such interpretations are, they invite comparison with Raphael's almost exactly contemporary School of Athens (11, 24) and emphasize the disparity between the two paintings. It is the mystery and magic, not the rationality, of Renaissance thought that is evoked by Giorgione.

The composition of the Three Philosophers is daringly asymmetrical, the figures being balanced by the dark entrance to a cave in the overhanging rock, while the centre opens out on to a warmly glowing landscape beneath the first convincing sunset sky in European art. The figures are in the classical triad of poses—profile, frontal and three-quarters—psychologically detached from one another as from the spectator, yet pictorially inseparable from this lyrically beautiful countryside, as if within a glade and not, as in most earlier paintings, placed in front of a backdrop. The whole painting with its rich colours of falling leaves, dark evergreens and the red of ripe berries is suffused with a hushed, autumnal atmosphere of vague apprehension, as the 'philosophers' await whatever revelation is to be vouchsafed to them.

Another Venetian painting of about the same date, entitled Concert Champêtre, is entirely secular and, what is more surprising, entirely without any discernible narrative content, mythological or otherwise (11, 20). A pastoral landscape, with a shepherd and his flock in the distance, recalls the Arcadian setting of Classical and Renaissance bucolic poetry. But one can only speculate as to who the foreground figures are and how and why they have come together—two nude women, one holding a flute, a very fashionably dressed lute-player and a bare-foot young rustic with tousled hair. The theme might possibly be harmony, though whether harmony between man and nature, or the sexes, or the classes of society or simply of musical instruments, we are left to guess. Only poets had hitherto captured this air of nostalgic erotic reverie in which everything is, like music, the 'food of love', and the Concert Champêtre is best understood as a visual poem. Indeed, Venetians were soon to begin calling such pictures poesie. Whether or not it was painted by Giorgione or by Titian, who, according to Vasari, imitated him 'so well that in a short time his works were taken for Giorgione's', this and similar Giorgionesque pictures established a new and immensely influential type, that of the small easel painting intended for the delectation of private collectors—'cabinet pictures' as they were later to be called. Nothing so sensuous and unintellectual was as yet being produced in Florence or

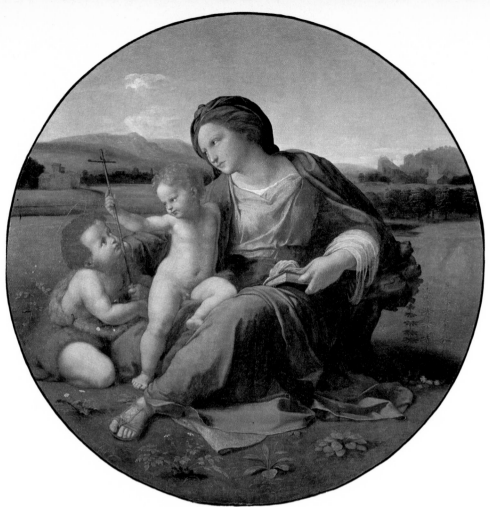

11,19 Raphael, *Alba Madonna*, c.1510. Canvas (originally panel), diameter 37¾in (94.5cm). National Gallery of Art, Washington DC.

Rome. Only in Venice could be found private patrons rich enough and sophisticated enough to create a demand for such works—patrons like the sybaritic Andrea Odoni, whom Giorgione's pupil Lorenzo Lotto (c. 1480–1556) portrayed in his 'cabinet', swathed in furs and toying with a statuette of Diana of Ephesus by a table strewn with antique gems and coins—an image of cultivated self-indulgence (11, 21).

Despite lavish private patronage, Venetian artists were dependent on public commissions for fame and fortune. Titian (Tiziano Vecelli, c. 1490–1576) was given his first chance to reveal the full force of his artistic energy when he was asked to paint a vast picture of the Assumption of the Virgin for the high altar of S Maria dei Frari (11, 22). Hitherto, Venetian altarpieces had been intended to be seen to best advantage from the altar steps: their figures were life-size or less and usually set within simulated archi-

tecture conceived as an extension of the church (10, 42). Titian's altarpiece, the largest ever painted in Venice, with heroic-scale figures, was designed to catch the eye of anyone entering the west door of the nave, nearly a hundred yards away. Its dynamic vertical impulse accords with the Gothic architecture of the church, though the amplitude of the forms, sumptuousness of colour and general sense of abundance and health lend its triumphant message a peculiarly Renaissance flavour. All the figures are caught in dramatically expressive movement, the apostles gesticulating on the ground, the Virgin with wind-blown draperies borne up in an aureole of golden light, and the Michelangelesque figure of God the Father with arms extended at a slight slant, as if soaring through the picture plane. Titian's uncompromising departure from Venetian conventions—the picture is said to have dismayed the friars of the church when they first saw it—seems to have been prompted by his knowledge of recent developments in Tuscan art, especially in drawings of the same subject by Fra Bartolommeo.

For the Virgin he used a typically Florentine *contrapposto* pose. But the manner of painting is Giorgione's, though much broadened. Contours are brushed in with sweeping strokes and the structure of the composition is created as much by colour as by form, with a great triangle of rich red pointing up from the two most prominent apostles to the Virgin's robe and God the Father.

The *Assumption of the Virgin* established Titian's reputation as the leading painter in Venice, with few rivals elsewhere. Indeed, he was perhaps the greatest Renaissance painter of all. He had none of Leonardo's scientific interests or Michelangelo's religious and poetic ones. Nor was he, like Raphael, an architect as well. It was Titian, however, who became in a real sense the founder of modern painting, for he made oil colour on canvas the main medium of later Western art. He exploited all its possibilities for the first time, from the animation of the picture surface with vigorous brushstrokes on the rough texture of the canvas to the contrast between rich, creamy highlights thickly laid on and deep, dark hues delicately modulated with glazes.

The *Assumption* was the first of several important altarpieces, but Titian was increasingly occupied with secular commissions, especially after 1532/3, when he painted the Emperor Charles V (Madrid, Prado). Ten years later he was asked to portray Pope Paul III (11, 23). The relaxed three-quarter length and three-quarter face pose was invented by Raphael, but Titian now developed it in his own more painterly way, absorbing everything into a composition of colours, the heightened flesh-tones of the face contrasting with the surrounding colour-scheme of deep values of the same tones. Forms and textures are rendered with amazing skill but only by gradations of tone and variety of touch. Similarly, the compelling impression of authority is conveyed by purely pictorial means. The seated figure with long bony fingers and shrewd lean face directs a steely gaze down towards the spectator.

Paul III tried to lure Titian to Rome. Charles V offered to make him a member of the imperial household, sending him a patent of nobility. But Titian refused. Though far from unworldly, he resisted all their blandishments and clung to his independence. Aided by his close friend, the brilliant, urbane and sometimes scabrous writer Pietro Aretino (1492–1556), he made himself the most sought-after painter in Europe. This unique position enabled him to work very largely for whom he wished, at his own pace and on subjects of his own choosing. No earlier artist had achieved such freedom, and the contrast between his career and that of the constantly thwarted and

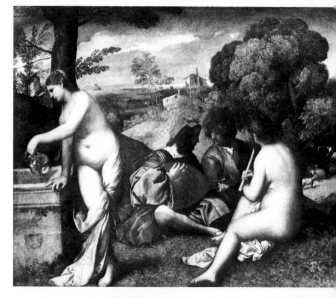

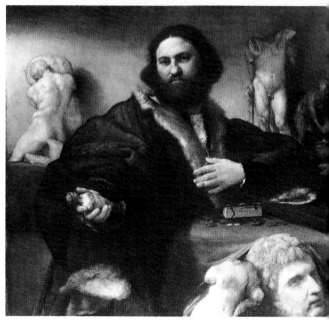

11, 20 *Top* Anonymous (Giorgione–Titian?), *Concert champêtre*, c.1508. Canvas, c.43 × 54in (109.2 × 137.2cm). Louvre, Paris.

11, 21 *Above* Lorenzo Lotto, *Andrea Odoni*, 1527. Canvas, 39⁴⁄₅ × 44⁹⁄₁₀ins (101 × 114cm). Hampton Court Palace, London. Reproduced by Gracious Permission of Her Majesty The Queen.

11, 22 *Opposite left* Titian, *Assumption of the Virgin*, 1516–18. Panel, 22ft 6ins × 11ft 10ins (6.9 × 3.6m). S Maria Gloriosa dei Frari, Venice.

11, 23 *Opposite right* Titian, *Pope Paul III*, 1543. Canvas, 41⁷⁄₁₀ × 33½ins (106 × 85cm). Museo e Gallerie Nazionali di Capodimonte, Naples.

disappointed Michelangelo is poignant.

A painting of a reclining woman, naked and as large as life, has for long been known as *The Venus of Urbino*, although it lacks all the attributes of a goddess (11, 26). Titian took the pose from Giorgione's more chaste *Sleeping Venus in a Landscape* (Dresden Gallery), with slight variations to show the figure not only awake but quite frankly inviting her lover (the spectator) with wide-eyed expectation. He also moved her from the fields to the bedroom, where she reclines on ruffled sheets with a pet dog curled up by her feet. In

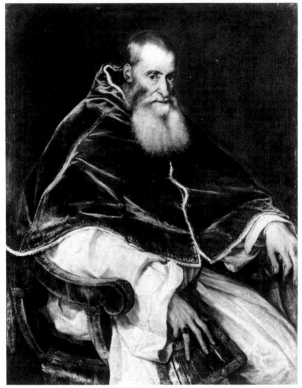

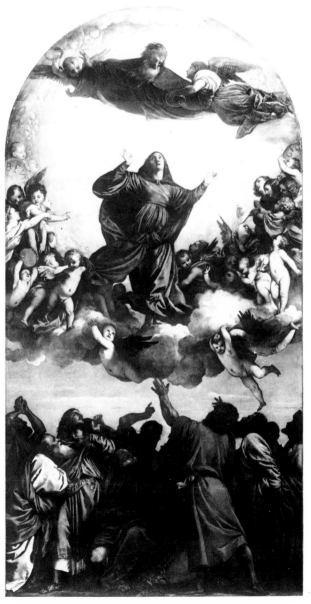

the background there are two attendants, one of whom looks into a chest of the type in which brides kept their trousseau, and it has been suggested that the picture was conceived as an allegory of married love. But Guidobaldo della Rovere, for whom it was painted, called it simply 'the naked woman' and there is no reason to suppose that more, or less, was intended. This image of a woman luxuriating in the warmth and voluptuous softness of her flesh is an uninhibited celebration of the erotic experience raised to the plane of great love-poetry.

Titian's attitude to his subject-matter becomes clearer in the series of *poesie* or erotic mythological scenes he painted for Philip II of Spain. In a letter of 1554 he wrote: 'Because the figure of Danae, which I have already sent to your Majesty, is seen entirely from the front, I have chosen in this other *poesia* to vary the appearance and show the opposite side, so that the room in which they are to hang will seem more agreeable. Shortly I hope to send you the *poesia* of *Perseus and Andromeda*, which will have a viewpoint different from these two.' Evidently, the subjects did not mean a great deal to him, though he had chosen them himself from Ovid's *Metamorphoses*, which he seems to have read in a popular Italian version (not in

the original). His aim was neither to illustrate a literary text nor to enrich it with variations, but to create autonomous works of art. His approach to Classical mythology was akin to that of sixteenth-century poets, who also used it simply as a pretext for new and original compositions—Christopher Marlowe's *Hero and Leander*, for example, or Shakespeare's *Venus and Adonis*. In the last picture in the series painted for Philip II Titian derived from the story of Jupiter

11, 24 *Above* Raphael, Stanza della Segnatura with *The School of Athens*, 1509–11. Vatican, Rome.
11, 25 *Right* Michelangelo, detail of the ceiling, Sistine Chapel, Vatican, Rome, 1508–12. Fresco.

transforming himself into a bull in order to abduct Europa a wonderful image of the ecstasy, as well as the mystery and fear, involved in the sexual act (11, 31). Europa's abandoned attitude reveals both her instinctual resistance and her irresistible urge to physical

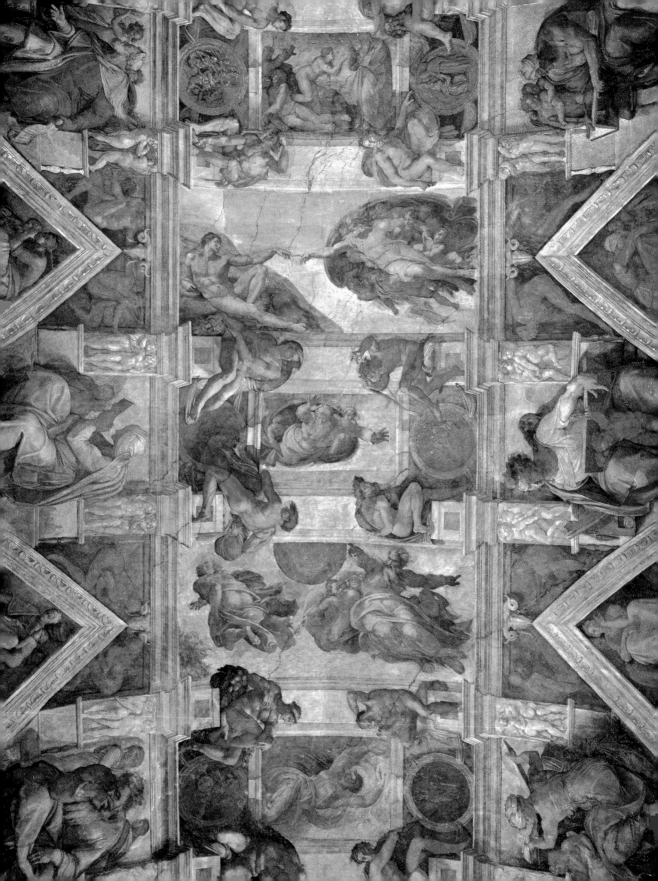

surrender, conveying the terror and the rapture of submission to natural, primal impulses. Her swirling red scarf has the effect of a convulsive cry and her ample flesh seems to quiver with voluptuous anticipation.

By the time he painted *The Rape of Europa* Titian had reached complete mastery of his highly individual handling of paint. The bold rhythm of his heavily loaded brush-strokes could evoke effects of the most sumptuous or the most iridescent colour. His early works had been executed with 'a certain finesse and incredible diligence, to be seen from near and far', Vasari remarked:

These last pictures are executed with bold strokes and smudges, so that nearby nothing can be seen but from a distance they seem perfect ... he went over them many times with his colours and one can appreciate how much labour was involved.

Another contemporary described his unorthodox way of finishing his paintings, 'moderating here and there the brightest highlights by rubbing them with his fingers, reducing the contrasts with middle tones and harmonizing one tone with another; at other times, using his finger he would place a dark stroke in a corner to strengthen it, or a smear, almost like a drop of blood, which would enliven some subtle refinement; and so he would proceed.' This method of working was not simply a new technique. It was the outcome of a new attitude to painting. For Titian established the autonomy of the picture as an equivalent—not a mere imitation—of the real world.

From the 1550s Titian worked mainly for Philip II of Spain, leaving his large staff of assistants to turn out pictures, often replicas of earlier works, for less discerning patrons. Although he was by far the most famous Venetian artist, he latterly painted little for the city. Public commissions went to younger painters, notably Tintoretto and Veronese. Tintoretto (Jacopo Robusti, 1518–94) is reputed to have begun in Titian's studio and probably learned his painterly technique there. But his fondness for sharp and often irrational perspective effects, violent foreshortening and gest-iculating figures in strenuous muscular movement reveal different susceptibilities, hence perhaps the legend that he aimed to combine the colouring of Titian with the drawing of Michelangelo. Fervently devout, volatile and unworldly, he was the reverse of Titian in character.

Tintoretto grew up in the heady climate of Counter-Reformation piety and his religious pictures have the emotional force of a revelation. An enormous *Cruci-fixion* he painted for a charitable confraternity engulfs

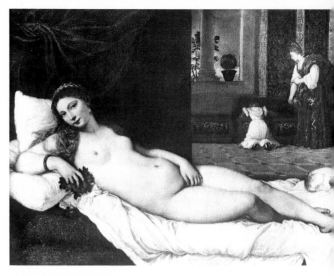

11, 26 Titian, *Venus of Urbino*, 1538. Canvas, 47 × 65ins (119.4 × 165.1cm). Gallerie degli Uffizi, Florence.

and overwhelms the spectator (11, 32). The huge panoramic canvas stretches from wall to wall and from wainscoting to ceiling with wide-angle enveloping effect, yet the multitude of tilting, twisting figures, of which those in the foreground are over life-size, coheres under the visionary lighting into a single dramatic unity. Great plunging diagonals meet and intersect in the body of Christ, isolated above the tumult. There is nothing episodic about this intensely dramatic painting: the eye is barely allowed time to take in the superb accomplishment with which individual figures are rendered before being directed to the dominating central cross.

Details, often irrelevant details, are just what catch the attention in a contemporary painting by Veronese (Paolo Caliari, 1528–88) of the Last Supper. When Veronese was called before the Inquisition to explain why he had included dogs, dwarfs, German soldiers and a fool with a parrot, he answered: 'My commission was to make this picture beautiful according to my judgement', adding that 'we painters use the same licence as poets and madmen'. A compromise was reached by calling it *The Feast in the House of Levi* (11, 35). Nothing could be further removed from the noble conception of Leonardo's *Last Supper* (11, 11) than this Venetian banquet, though Veronese was a devout Catholic, rather more devout, indeed, than Leonardo. Yet Veronese's is no mere decorative painting. With complete self-assurance he creates an imaginary world of elegance and grandeur, of marble, gold and costly fabrics, in which visual delight in the sumptuous and gorgeous can riot and exult.

The loggia in which Veronese's grandees are gathered is reminiscent of the upper floor of the library of S Marco (11, 27) designed by Sansovino (Jacopo Tatti, 1486–1570), who had left Rome at the time of the sack and settled in Venice. There he was taken up by Titian and Aretino, another refugee from Rome, and together they formed an artistic triumvirate. The library was conceived as part of a grandiose urban scheme for the republic's administrative and ceremonial centre, the vast L-shaped space flowing from the piazza in front of S Marco into the piazzetta outside the Doges' Palace, which the library faces (9, 54). One of Sansovino's problems was to marry their façades. He translated the palace's superimposed Gothic arcades, with their squat columns, pointed arches and elaborate tracery, into a true Roman idiom, compensating for the smaller height by adding an exceptionally rich entablature crowned by a balustrade on which statues and obelisks stand against the sky. Figurative carvings, in the spandrels and on the soffits of the lower arches, take the place of the costly inlays of coloured marble previously favoured by Venetians for buildings intended to display conspicuous wealth. The two orders used (and used correctly for the first time in Venice) are Doric and Ionic. Sansovino reserved the 'superior' Composite order for the nearby Loggetta built at the base of the Campanile as a meeting-place for the patricians of Venice—a nice example of the use of the language of Classical architecture to accord with the hierarchic social structure.

The library introduced High Renaissance architecture to Venice, and its admirers included Andrea Palladio (1508–80), whose most prominent Venetian building, the church of S Giorgio Maggiore, is on an island just across the water from the Piazzetta (11, 36). At S Giorgio Maggiore a solution was found to a problem which had vexed Italian architects ever since the beginning of the Renaissance, that of adapting a Classical temple front to a church with a nave and lower side-aisles. Façades had usually been divided into two stories, a wide one across the whole breadth and a narrower upper part corresponding to the nave. But Palladio conceived the façade as two interlocking temple fronts, one based on the height of the nave, the other on that of the aisles. At S Giorgio Maggiore the triangles on either side of the main block are the ends of a pediment, whose base is marked by the string-course between the tall half-columns. Pilasters supporting this structure visually (but not structurally) rise from low bases, whereas the half-columns in the centre are set on high pedestals, giving the façade a strong and un-Classical vertical thrust and at the same time uniting it with the interior, where the same two

orders are used in exactly the same way.

Most of the great sixteenth-century Italian architects were also painters or sculptors (Sansovino was primarily a sculptor), and it was said at the time that those who were neither could have 'no eye for what really makes the beauty of architecture'. Palladio was unusual in being a professional architect who practiced no other art. Trained in the building craft, he was enrolled in 1524 in the guild of stone-masons and brick-layers of Vicenza, some 40 miles (64km) west of Venice. A local nobleman, Giangiorgio Trissino— humanist, poet and amateur architect—noticing that he was 'a very spirited young man with an inclination to mathematics', undertook, so a contemporary tells us, 'to cultivate his genius by explaining Vitruvius to him and taking him to Rome'. The mathematical theories of the Renaissance, the writings of Vitruvius

11, 27 Jacopo Sansovino, Library of S Marco, Venice, begun 1536.

and the ruins of ancient Rome were to be the interrelated sources of his style. But his designs were saved from theoretical dogmatism and archeological pedantry by his early experience as a working builder.

His practice was mainly domestic—another novelty—ranging from palaces in Vicenza to villas distributed widely over the Venetian mainland. In the mid-sixteenth century, Venetian patricians had begun to turn their attention to farming as a means of maintaining the republic's economic independence from the great grain-producing countries of the north. They improved marshland by drainage, introduced modern methods of cultivation and experimented with new crops, notably maize, then only recently introduced into Europe after the discovery of America. The demand thus created for houses or 'villas' from which

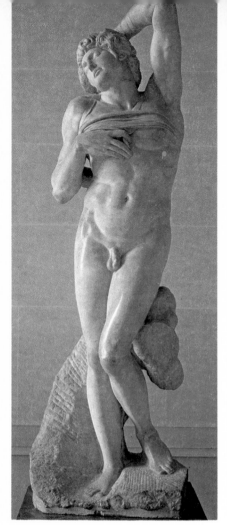

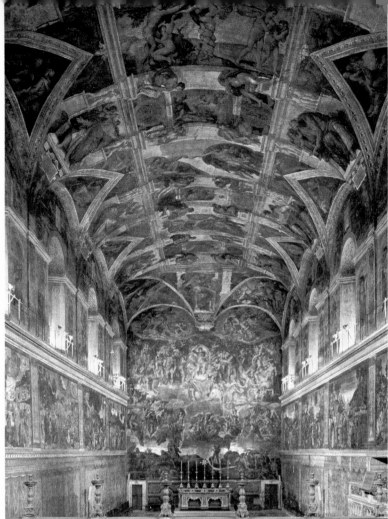

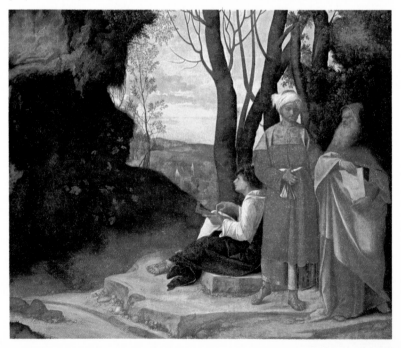

11, 28 *Above* Michelangelo, *The dying slave*, c.1513. Marble, height 90 ins (228.6cm). Louvre, Paris.

11, 29 *Above right* Michelangelo, Sistine Chapel, Rome, showing the ceiling (1508–12) and *Last Judgement* (1534–41).

11, 30 *Right* Giorgione, *The three Philosophers* (finished by Sebastiano del Piombo), c. 1509. Canvas 47⅝ × 55½in (121 × 141cm). Kunsthistorisches Museum, Vienna.

11, 31 *Opposite top* Titian, *The Rape of Europa*, 1559–62. Canvas, 73 × 81ins (185.4 × 205.7cm). Isabella Stewart Gardner Museum, Boston.

11, 32 *Opposite bottom* Tintoretto, *Crucifixion*, 1565. Canvas, 17ft 7ins × 40ft 2ins (5.36 × 12.3m). Scuola di San Rocco, Venice.

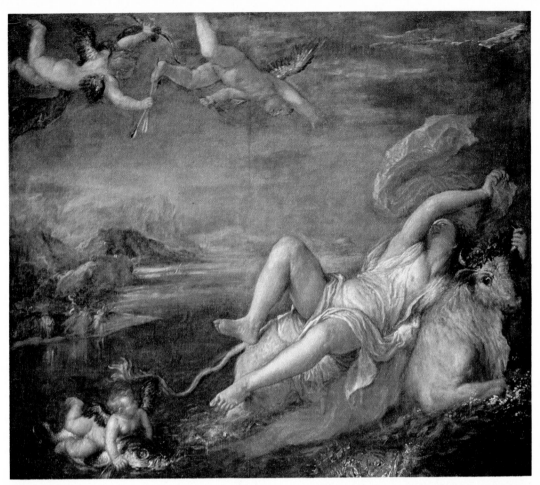

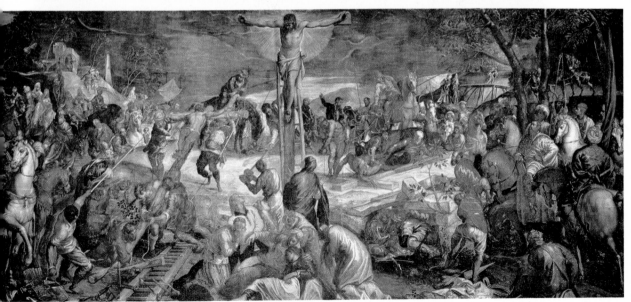

estates could be administered was met most success-fully by Palladio. He designed buildings of the utmost dignity which could, nevertheless, be constructed by local labour from the simplest and cheapest materials, rough brickwork covered with stucco and needing little if any carved stone. A seigneurial effect was created by the use of temple fronts to emphasize the main façades, in the mistaken belief that ancient Roman villas had them. La Rotonda outside Vicenza—a suburban retreat rather than a villa in the true sense—has four hexastyle porticoes and is perhaps the most perfect realization of the Renaissance ideal of a free-standing centrally planned building (11, 33). He designed it to take advantage of a site which he called (in words reminiscent of Pliny the Younger, see p. 158) 'one of the most agreeable and delightful that may be found, on a hillock with gentle approaches and surrounded by other charming hills, all cultivated, that give the effect of a huge theatre'. This sensitivity to landscape, which links Palladio with Giorgione and other Venetian painters, is equally evident in the siting of his other villas, 18 of which survive. They are simpler than the Rotonda, usually with attached farm buildings, and though no two are alike, all observe the laws of harmonic proportions.

To Palladio and his contemporaries, the phrase 'harmoniously proportioned' was no mere figure of speech. The ancient Greeks (traditionally Pythagoras) had discovered that if two chords are twanged, the difference in pitch will be an octave if one is half the length of the other, a fifth if one is two-thirds the length of the other, and a fourth if the relationship is 3:4. It was therefore assumed that a space or solid whose measurements followed the ratio 1:2, 2:3 or 3:4 would be visually harmonious. This belief persisted in the Middle Ages and seems to have been known to some Gothic architects. Indeed, these simple ratios were so often used that they came to condition, almost instinctively, the Western 'sense of proportion' and the Western idea of a well-proportioned building. As Palladio wrote, 'such harmonies usually please very much without anyone knowing why, apart from those who study their causes.' Measurements prominently inscribed on the plans of villas in his *Quattro libri dell'architettura* (1570, the first extensive publication by an architect about his own work) suggest that he had in mind also such subtler proportions as those of the major and minor third, 5:6 and 4:5. They were, however, more easily indicated on the drawing-board than observed on the building-site and, in fact, were rarely followed precisely in construction.

The laws of musical harmony were studied by sixteenth-century theorists and architects not simply to

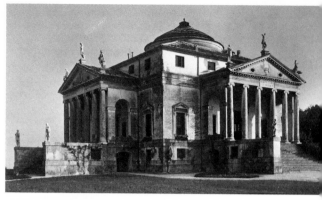

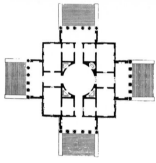

11, 33 Andrea Palladio, Villa Rotonda, Vicenza, begun 1567–69; plan of the Villa Rotonda.

create visually pleasing effects. Harmony had cosmic significance, to which Lorenzo, in Shakespeare's *Merchant of Venice*, refers when gazing at the starry sky from the garden of Belmont, a villa near Venice:

> Look how the floor of Heaven
> Is thick inlaid with patines of bright gold;
> There's not the smallest orb, which thou beholdest,
> But in his motion like an angel sings,
> Still quiring to the young-eyed cherubins:
> Such harmony is in immortal souls.

Observance of the laws of harmony was believed to attune all aspects of life on earth to a heavenly ideal. And in Venice particularly the polyphonic consonance of the many voices of the social orders was believed to be essential for the well-being of the most serene republic. Musical metaphors occur frequently in the political theory as well as in the art of the time.

Mannerism and mannerisms
The term 'Mannerist'—sometimes used in connection with Palladio and more often with Tintoretto—has acquired a bewildering range of meanings. It derives from the Italian word *maniera*, much used in sixteenth-century writings on social behaviour as well as on the

arts, to signify not simply a style or manner in the literal sense but also the highly prized quality of stylishness which implied ease of manner, virtuosity, fluency and refinement. This quality was found in the antique statues then most admired and in the works of Leonardo, Raphael and Michelangelo. A distinction was, however, drawn between the stylish and the mannered or affected, i.e. the adoption of another's mannerisms or, paradoxically, the self-conscious display of personal traits. It was in this derogatory sense that the word 'Mannerist' later came to be used for the work of mid- and late sixteenth-century artists, whose paintings in sharp acid colours, with figures writhing in curiously distorted perspective, looked contrived and over-refined to seventeenth-century eyes. The notion of Mannerism as an historical style, following that of the High Renaissance, is much more recent and there are various and contradictory definitions and interpretations of it. It has been construed as either a reaction against or an extension of the ideals of the High Renaissance, as an expression of the spiritual crises of the time or as a sophisticated art created solely for art's sake, a 'stylish style' exemplifying the aesthetic theories of the sixteenth century.

Evolving mutations in Renaissance style can be seen very clearly in the work of two artists, Correggio and Parmigianino, separated by a generation gap but working at the same time in Parma, some way from the main centres of artistic activity. Correggio (Antonio Allegri, c. 1489–1534) developed from the art of Mantegna and Leonardo, or his north Italian followers, a personal style of the utmost grace and suavity. Michelangelo's Sistine Chapel ceiling, Raphael's *Stanze* and Titian's *Assumption* enlarged his ideas, even though he may have known them only at second-hand from drawings. With his fresco in the cupola of Parma Cathedral he created a work of art no less influential, a new type of ceiling painting which breaks completely through the architecture to open a vision of figures swirling into the heavens and, as it were, whirling the spectator up into the vortex with them (11, 34). Instead of witnessing the scene as if through a proscenium arch (as in Titian's *Assumption*, 11, 22) the spectator is made part of it. Correggio's skill in depicting figures seen from below—*sotto in sù* is the technical term—displaying well-turned limbs as they gyrate in space, set a new standard for illusionism. But his mastery in rendering flesh—no artist has ever painted the blush of a perfect youthful complexion with greater sensitivity—was fully developed only in his oil paintings, whether of saints in graceful adoration or of elegantly amorous Olympians. In one

painting Jupiter is about to descend in a shower of gold on Danae, whose virginity her father tried to preserve by incarceration in a tower, as the view through the window indicates (11, 38). The subject had often been cited (by St Augustine among others) as one of dangerously provocative eroticism, but Correggio purged it of gross sensuality. Lubricity is held in check by the tenderness and sweetness of Danae's passively receptive attitude, by the gentleness with which Cupid lifts the drapery from her thighs and by the lithe and supple rhythm which the metrical rhyming of their limbs imposes on the composition.

Correggio's paintings perfectly express the early sixteenth-century notion of stylishness, and his idealized images of youthful beauty never pass beyond natural limits. Parmigianino (Francesco Mazzola, 1503–40) went further, pursuing grace and elegance to anomalous extremes in his painting known as the *Madonna with the Long Neck* (11, 39). He was much indebted to Correggio, whose pupil he may have been, and to such late works of Raphael as the *Transfiguration* (11, 16) (he spent three years in Rome from 1524 until the sack of the city). But his ideal of feminine beauty seems to have derived less from art and still less from nature than from literary conceits such as that which compared a woman's shoulders, neck and head with a perfectly formed vase (hence that carried by the long-legged angel on the left). Not only the Virgin's neck, but her hands, her right foot and the limbs of the Child are all elongated and refined to an unearthly

11, 34 Correggio, Detail of the *Assumption of the Virgin*, 1526–30. Fresco, dome of Parma Cathedral.

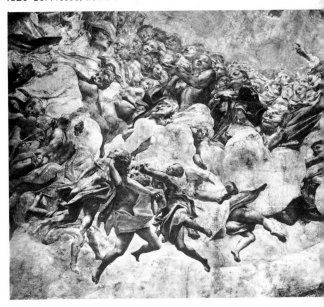

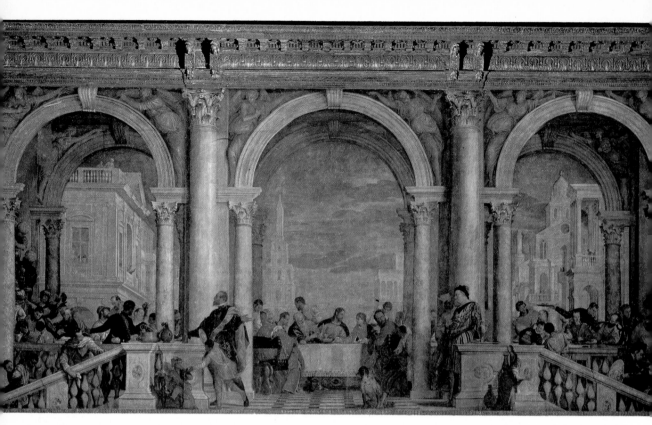

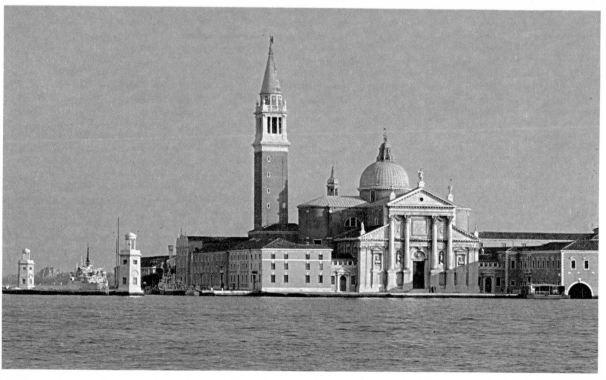

elegance. Far below and far away in space and time a tiny figure, probably St Jerome, unfolds a scroll in an echoing perspective space and introduces a slightly uncomfortable visionary quality into the otherwise very worldly atmosphere of the painting.

The wilful distortion of the human body in painting was paralleled in architecture by the manipulation of the Classical orders and their enrichments. Michelangelo had given a lead in the Medici Chapel (11, 17) and still more boldly in the vestibule to the Laurentian Library attached to the same church, of which Vasari remarked that all architects owed a debt to Michelangelo 'for having broken the chains which made them all work in the same way'. At exactly the same time

11, 35 *Left* Veronese, *The feast in the house of Levi*, 1573. Canvas, 18ft 3ins × 42ft (5.56 × 12.8m). Gallerie dell'Accademia, Venice.
11, 36 *Left below* Andrea Palladio, S Giorgio Maggiore, Venice, begun 1565.
11, 37 *Below* Pieter Bruegel the Elder, *Harvesters (The Month of August)*, 1565. Panel, 46½ × 63¼ins (118 × 160.7cm). Metropolitan Museum of Art, New York (Rogers Fund 1919).

Giulio Romano (1492/9–1546), formerly a pupil and assistant of Raphael, was indulging in similar 'licence'—a term of approval in the sixteenth century. In 1526 he began the Palazzo del Tè just outside Mantua (11, 40). As was appropriate for a building in the country, he used the Doric order and covered the walls from ground to entablature with rustication (originally less bulky than restorations have made it). But the spacing of the half-columns is most irregular and mid-way between each of them a triglyph slips unaccountably down from an otherwise correct frieze. On the side of the courtyard illustrated here windows are frameless, pushed up to the top of the wall and squeezed between the more closely spaced columns; prominence is given to niches below them and blind windows capped by bold pediments in the wider spaces. These contradictions are disturbing, but Giulio Romano's intention seems to have been less to dismay than delight those who knew enough of architectural theory to appreciate his ingenuity. They have an effect akin to that of a rhetorical oxymoron, such as Aretino

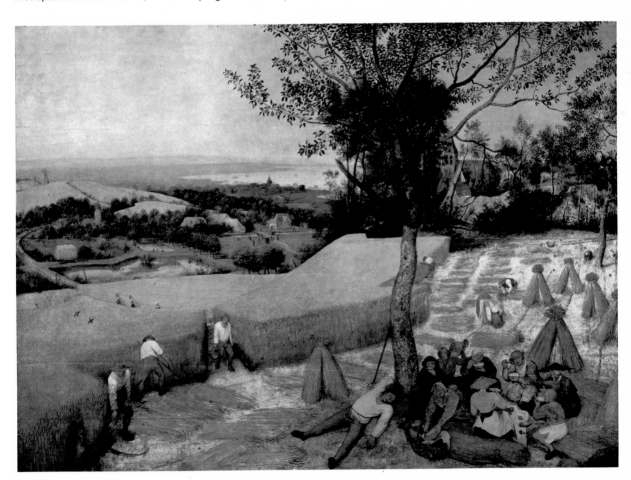

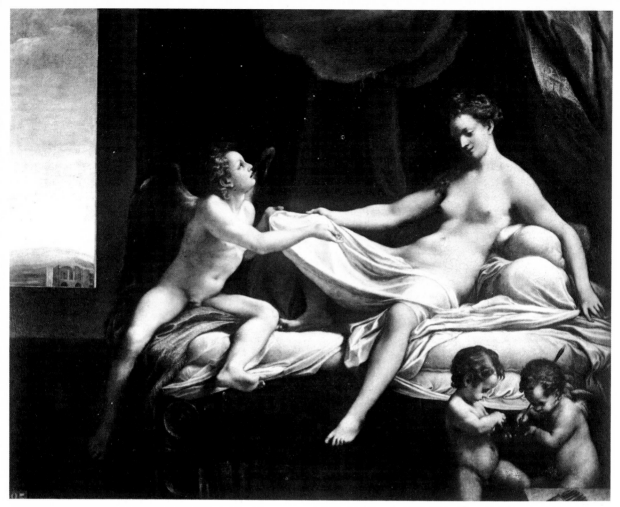

11, 38 Correggio, *Danae*, c.1532. Canvas, 64⅖ × 29ins
(163.5 × 74cm). Galleria Borghese, Rome.

used in a letter to Giulio Romano: 'always modern in
the antique way and antique in the modern way'.

The licence accorded to architects was dependent on
their knowledge of the rules they infringed. Treatises
codifying the Classical orders were published by two of
the most dashingly stylish architects, Sebastiano Serlio
(1475–1554) and Giacomo Barozzi da Vignola
(1507–73), an assistant of Michelangelo, whom he
succeeded at St Peter's. For his own most important
building, however, Vignola renounced all licence in
favour of severity and decorum. This was the first and
still the main church of the Society of Jesus in Rome
(11, 41). His brief was to accommodate as large a
congregation as possible within the limits of an oblong
site. 'The Church is to be entirely vaulted over,' he was

told; 'it is to have a single nave, not a nave with aisles,
and there are to be chapels on both sides.' By almost
completely shutting off the chapels flanking an
unusually spacious, 60-foot-wide (18m) nave he
successfully combined the centralized scheme of the
Renaissance with the longitudinal plan of the Middle
Ages. The demands of Counter-Reformation piety
were perfectly met by this lucid and simple interior—
originally gray and white without any further
enrichments—in which there was nothing to distract
from the words of the preacher or obstruct the view of
the ritual at the high altar. The strong eastward drive of
the great tunnel vault and cornice running right
through without a break was dramatically emphasized
by carefully contrived light effects, notably the

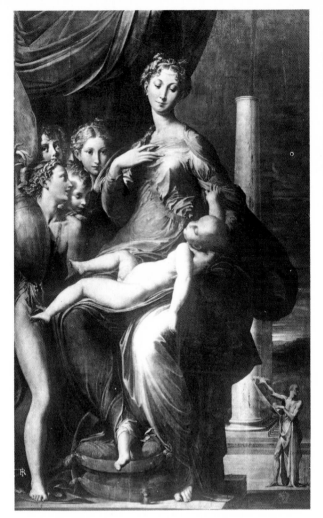

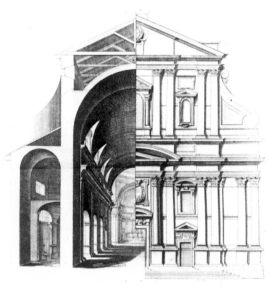

11, 39 *Above* Parmigianino, *Madonna with the long neck*, c.1535. Panel, approx. 85 × 52ins (216 × 132cm). Gallerie degli Uffizi, Florence.
11, 40 *Top right* Giulio Romano, Palazzo del Tè, Mantua, 1525–35.
11, 41 *Centre right* Vignola, Il Gesù, 1568. Façade by Giacomo della Porta, c. 1575–84 (engraving by Sandrart). *Bottom right* Plan of Il Gesù.

contraction and darkening of the last bay before the crossing to make a pause before the flood of light streaming down from the drum of the dome with a wonderful sense of glory and fulfilment. The façade was designed after Vignola's death by Giacomo della Porta (see p. 367), with correctly proportioned Classical elements combined in an entirely un-Classical way.

A sharpening of the distinction between what was deemed appropriate for, respectively, religious and secular art was an immediate consequence of the Counter-Reformation. Michelangelo's *Last Judgement* was censured from a religious viewpoint for the very qualities that most appealed to artists—for what his pupil and biographer Ascanio Condivi called his expression of 'all that the human figure is capable of in the art of painting, not leaving out any pose or action whatsoever'. Such virtuosity was brought to its highest pitch in secular work, often on a small scale and in precious materials, for example the gold salt-cellar by

11, 42 Benvenuto Cellini, Salt-cellar of Francis I, 1539–43. Gold with enamel, $10\frac{1}{4} \times 13\frac{1}{8}$in ($26 \times 33.3$cm). Kunsthistorisches Museum, Vienna.

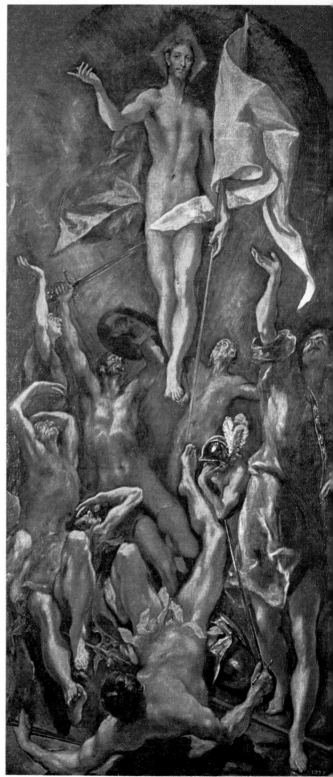

Benvenuto Cellini (1500–71) (11, 42). In his autobiography Cellini gave a full account of the genesis, production and meaning of this exquisitely refined *objet de luxe*, which might seem far removed from the exuberant rough and tumble, the fierce passions and jealousies, of the world Cellini lived in and also brilliantly described. The main figures represent Water and Earth 'fashioned like a woman with all the beauty of form, the grace and charm, of which my art was capable', he proudly declared. Their legs are interlaced, giving a sophisticated eroticism to his celebration of the fecundity of nature.

Cellini began this feat of virtuoso artistry in Rome, but completed it in France for Francis I (1515–47), who had made his court at Fontainebleau the most important centre of artistic activity north of the Alps. Italians, beginning with Leonardo, who spent his last years in France, were particularly favoured. French artists followed their lead, realizing Italian ideals in their own slightly different way. Water nymphs from a (dismembered) fountain by Jean Goujon (fl. 1540–62), for example, wear clinging draperies derived from Hellenistic carvings and dance to an Italian tune yet have a curiously bloodless, wraith-like quality quite foreign to the Mediterranean (11, 45). From France the principle of delicately poised *contrapposto* was transmitted to England and adopted for jewel-like

miniature portraits of Elizabethans by Nicholas Hilliard (c. 1547–1619), a student of both Italian artistic theory and of Castiglione's *Book of the Courtier*.

Contrapposto, which had been understood in the early sixteenth century simply as a means of articulation, was gradually developed to obtain an effect of continuous spiral movement almost as an end in itself. The Roman writer Quintilian's eulogy of the

11, 43 *Left* El Greco, *The Resurrection*, c.1597–1604. Canvas, 108¼ × 50in (275 × 127cm). Museo del Prado, Madrid.
11, 44 *Below* Giovanni Bologna, *Apollo*, 1573–5. Bronze, height 34⅝ins (88 cm). Palazzo Vecchio, Florence.
11, 45 *Right* Jean Goujon, Nymphs from the *Fountain of the innocents*, 1547–49. Stone, 92½ins (235cm) high. Louvre, Paris.

'distorted and elaborate attitude ... the novelty and difficulty' of Myron's Discobolus (4, 23a) was well known and, although no copy or version of this famous statue had as yet been discovered, sixteenth-century sculptors took to heart Quintilian's recommendation that effects of grace and charm involve 'departure from the straight line and have the merit of variation from the ordinary usage'. Statuettes by Giovanni Bologna (1529–1608) seem almost to have been conceived as essays in smoothly convoluted three-dimensional form, to be appreciated only when

385

they can be seen all round. That of Apollo (11, 44) was modelled to stand in a niche and Giovanni Bologna compensated for the restriction of viewpoints by the sway of the hips, the curve of the torso and the eurhythmic movement of the supple arms and legs to make it appear as if slowly revolving (in fact, there was originally a mechanism to rotate it in the niche). It was commissioned for Francesco de'Medici's *studiolo*, a small room described at the time as 'a cabinet of objects that are rare and precious both for their price and their art'. For another such sanctum of visual hedonism, that of the Emperor Rudolf II, a strangely introverted connoisseur of artistic preciosity, Bartholomäus Spranger (1546–1611) painted a series of small pictures in which the provocatively erotic nature of the twisted pose becomes explicit (11, 46). There are echoes of statues by Michelangelo, of paintings by Correggio and of Giulio Romano's illustrations to pornographic poems by Titian's friend Pietro Aretino in these works, which are Mannerist in every sense of the word and invest sexuality with a stylish perversity.

Giovanni Bologna was born at Douai, then in Flanders, but worked from about 1556 until his death in Florence. Spranger was a native of Antwerp who, after some years in Italy, settled in Prague as court painter to Rudolf II. Many other Flemish artists visited Rome and returned to the north, where they practiced an ostentatiously Italianate style favoured by Church and state. The great exception was Pieter Bruegel the Elder (c. 1525/30–69), who began by painting and drawing for engravers moralizing subjects of a disquieting strangeness looking back to Bosch (see pp. 352–3). Later he became more direct and straightforward, or apparently so, and was often misunderstood as a result. The biographer Karel van Mander (1548–1606) said that there were few of his works which the observer could contemplate 'with a straight face' and he was later nicknamed 'Peasant Bruegel' and 'Bruegel the jester'. But he was by no means a *naïf* painter. He knew Italy as well as any of the Flemish 'Romanists' and his rejection of their modish style was quite deliberate. In Antwerp, where he spent most of his life, he was a valued member of an intellectual circle which included Christophe Plantin, the great scientific publisher, and Abraham Ortelius, then preparing the first modern atlas of the world and later to become official geographer to Philip II of Spain. Bruegel worked for private collectors of educated taste and a large group of his paintings was bought shortly after his death by Rudolf II.

In an obituary tribute, Ortelius extolled Bruegel's fidelity to nature and went on to remark that 'in all his

11, 46 Bartholomäus Spranger, *Vulcan and Maia*, c.1590. Copper, $9 \times 7\frac{1}{8}$ins (23×18cm). Kunsthistorisches Museum, Vienna.

works more is always implied than is depicted'. This is fully borne out by a series of paintings recording the cycle of the seasons, subjects often represented in medieval art (9, 56) but treated by Bruegel in an entirely new way and on the large scale normally reserved for religious or mythological scenes. They are essentially paintings of landscape and atmosphere rather than illustrations of 'the labours of the months'. One evokes in rich browns and yellows the burning heat of August in a wide landscape so objectively factual in detail that it is difficult to realize that it is imaginary (11, 37). From Italians, especially Venetians, Bruegel had learnt much—notably aerial perspective and the advantage of a high viewpoint—but his figures are far removed from the poetic inhabitants of Arcadia: they are real-life farm labourers, of the earth earthy. Some are reaping and tying sheaves while others eat and drink; one lies in a stupor. The church half hidden behind the tree reappears in another work, his most disturbing, that of the *Blind leading the Blind* (Capodimonte, Naples). In this the moral is explicit, whereas in the harvest scene it

is implied in the contrast between the plenitude and generosity of nature and the insignificance of man. The vacuous faces and ungainly limbs of the yokels might suggest that Bruegel saw only their clownish aspects—they recall Shakespeare's rustics. But Bruegel made this lowest class of the social order stand for all humanity. In his paintings men are not, as they are in Italian Renaissance art, the lords of creation. They are almost incidental to his majestic conception of the annual cycle of growth and decay, of death and rebirth. He extols the grandeur of the universe by denying man's central position in it. His peasants are, none the less, individuals and the independent life with which he has endowed them reveals another seam of implied meaning which runs through all his mature work. He was in direct contact with the Dutch moralist Dirck Volckertszoon Coornheert, the leading exponent of an undogmatic tendency in religious thought called Libertinism or Spiritualism, centred on man's personal relationship with God and his duty to overcome sin, to which he is driven by folly. Bruegel probably remained a Catholic, like Coornheert, but he came closer to a Protestant view of the world than any great artist of the century, apart from Dürer and Holbein. Though he did not live to see the worst effects of the Spanish suppression of Protestantism in the Netherlands, he had his wife burn many of his engravings during his last illness. Their inscriptions might be thought 'too biting and too sharp' and he feared that 'most disagreeable consequences might grow out of them'.

The Italian mannerisms which Bruegel disregarded were painstakingly learned only to be transformed into a deeply emotional religious art by the last great European painter of the sixteenth century, El Greco (Domenicos Theotocopoulos, 1541–1614). He was born on Crete, then a Venetian possession, and went as a youth to Venice, where he began by painting icons in the Byzantine style for the Greek community there but soon succumbed to the influence of Titian, Tintoretto and, later, Michelangelo. When he visited Rome between 1570 and 1572 the Counter-Reformation was at its height and all religious art was being scrutinized in strict accordance with the decrees of the Council of Trent to eliminate any imagery which might be misconstrued as profane, pagan or heretical. When Michelangelo's *Last Judgement* (11, 29) was attacked and condemned, El Greco is said to have offered to paint something more 'decent and virtuous' as a replacement—a myth, no doubt, but one which indicates the direction of his ambition, to create an art as grandiose as Michelangelo's yet purged of all sensuality. In 1576/7 El Greco went to Spain, settling in Toledo, where he spent the rest of his life. Spain was then the leading power in Europe with dominions stretching from the Netherlands to Mexico and Peru. In 1571 it had scored a major victory for Christendom with the destruction of the Turkish fleet at the battle of Lepanto. And, of course, the Counter-Reformation was nowhere more ardently promoted by both Church and state than in Spain. The most profoundly spiritual of sixteenth-century Catholic mystics were Spanish, notable St Teresa of Avila (1515–82) and St John of the Cross (1542–91), as was also St Ignatius Loyola, the founder of the Society of Jesus.

The aim of El Greco's art was to arouse religious fervour and to elevate the spirit above the everyday world of sensory perceptions. But whereas St Teresa, for example, visualized her transcendental experiences in concrete imagery, he translated the physical into incandescent spirituality. In his late painting of the Resurrection lambent forms flicker upwards in parabolic curves (11, 43). The brushwork is ecstatically free, colours are used expressively, the white banner in Christ's hand being balanced by shimmering red drapery which has no other function than that of adding vibration to the upper parts of the picture. Figures are elongated to maximum tension, their arms being all but dislocated by emphatic gestures. Violent foreshortening is used to entirely non-illusionistic effect—for the body of the nude man falling backwards in the centre and for the shins and knees of the sleeping figure beside him. Lighting and spatial relationships are similarly irrational. And the traditional iconography of the subject has also been left behind. No tomb is visible. Indeed, the radiant figure of Christ suggests the Ascension as well as the Resurrection, and his feet are crossed as if still crucified.

El Greco was a visionary. Though described by a contemporary in 1611 as 'a great philosopher', he could have said, with St John of the Cross, that he had 'no light or guide other than that burning in the heart'. The books in his library at Toledo included two editions of the works of Dionysius whose concept of divine light had fired Abbot Suger more than four centuries earlier (see p. 292). And his painting of the Resurrection recalls Dionysius's metaphor for Christ as 'the first radiance' of God the Father. His art seems to have been inspired by the belief that if the human mind could abandon itself to the 'harmony and radiance' of true terrestrial beauty, it would be ineluctably guided upwards to the divine transcendent cause. He was the last European painter to express such transcendental ideals, and his work brings a great age of Christian art to its close.

12 Wider horizons

European knowledge of the rest of the world was dramatically and vastly expanded around the year 1500. Vasco da Gama opened up the sea-route round Africa to India in 1497–9 and in 1492–1504 Christopher Columbus's attempts to reach the spice islands of the Far East by sailing westwards led, totally unexpectedly, to the discovery and subsequent exploration of America. Finally, in 1519–22, came the first circumnavigation of the globe. The boundaries of Classical geography were shattered by all this—and there were also some disconcerting implications which could not be ignored. As the Florentine historian Francesco Guicciardini wrote in the 1530s, 'not only has this navigation confounded the affirmations of former writers about terrestrial things, but it has also given some anxiety to the interpreters of Holy Scripture.' A reluctance to take in or an inability to assimilate the new knowledge persisted until late in the sixteenth century, nowhere more obviously than in European reactions to non-European art.

Both Near Eastern and Far Eastern arts had been known in the West since ancient Roman times at least, as we have seen, and if not fully understood were often greatly prized. Motifs from Chinese and Islamic art had long been acclimatized in Europe. But American artifacts, when they first reached Europe, were regarded in quite a different light. Mexican gold, silver and featherwork, sent by Hernando Cortés to the Emperor Charles V, were displayed at Brussels in 1520 and seen by Dürer, who wrote in his diary of these 'wonderful works of art', but neither he nor anyone else seems to have made a visual record of them. Such visual imagery was, perhaps, too strange to be digested. Further examples of Mexican art were imported after the conquest in 1521—illustrated codices (12, 19), masks encrusted with turquoise (12, 18) and ingenious pieces of featherwork (12, 17). Some were preserved as 'curiosities', but the majority were destroyed—and so, too, was the civilization that had produced them. Still more ruthless was the destruction of work in gold or silver sent to Europe from Peru in 1534. Not a single piece survives.

The ease with which small forces of Spaniards conquered Mexico and Peru fostered the belief, summed up by an Italian shortly before the end of the sixteenth century, that Europe 'was born to rule over Africa, Asia and America'. This preposterous notion is implicit in numerous European paintings and other images of the four parts of the world (14, 15). While it prevailed, as it did until well into the nineteenth century, few Europeans were able to see more than a piquant exoticism in works of art from distant, alien traditions. So it is hardly a paradox that the great sixteenth-century expansion in knowledge of the world should have coincided with a resurgence of the Classical tradition in European art.

Meso-America and Peru

At the time of the Spanish invasion in 1519 Meso-America, from the desert just north of modern Mexico City to the tropical rain-forests of Guatemala (an area more extensive than western Europe from Portugal to Germany), was ruled by the Aztecs or Mexica, as they called themselves. They were recent arrivals from farther north whose empire had begun to expand less than a century before. But their pervasive artistic style, which incorporates elements from the earlier art of the region, might give the misleading impression that it was the product of a continuous process of evolution over the previous millennium and a half. In fact, the history of art in this region is quite complex, with many and various divergent styles which overlap chronologically and encroach on one another geographically.

Before the civilization of the Olmecs on the Gulf Coast disintegrated (see pp. 90–1), another, related to it, emerged in about 600 BC on the west of the central mountain chain. Its ceremonial centre was at Monte Albán (near present-day Oaxaca City), but most of the

surviving buildings at this site date from the first millennium AD, when it rose to its maximum importance under the Zapotecs, who spoke a language which survives to the present day. Some 200 miles (320 km) to the north-west, at a place on the Mexican plateau which the Aztecs later called Teotihuacán ('where one becomes a god'), another ceremonial centre was developed from about AD 400 into a true city, covering about 8 square miles (2072 hectares) and with a population of 50,000 or more at the height of its prosperity. The residential quarters were laid out on a grid system, but the plan of the whole city was fixed astronomically to provide an earthly reflection of the

12,1 Detail of Central Pyramid, Teotihuacán, Mexico, before 600.

movement of the heavenly bodies. At its heart an avenue, 130 feet (40m) wide and a mile and a half (2.4km) long, connected massive stepped platforms—so-called 'pyramids' but more like ziggurats in form as in function—each of which was originally crowned by a temple approached up a broad flight of stairs. The earliest, and also the largest not only here but in all Mexico (700 feet, 213m, wide and over 200 feet, 61m, high), was sited on axis with the point where the sun set on the day of its zenith passage. It is composed of layers of clay faced with rough stones. A more elaborate system of construction was adopted for the later pyramids—a skeleton framework of piers and slabs of tufa, to stabilize earth and rubble fillings, and finely dressed masonry on the exterior. That at the southern end of the avenue was exceptional in the richness of its relief carvings of plumed serpents and menacing heads composed of circles and squares,

perhaps derived from the Olmec jaguar mask but representing the rain god (12, 1). These sculptures were fortuitously preserved when the platform was enlarged and its surface was covered with painted plaster. Paintings came to be preferred for the decoration of both religious and secular buildings, and it is a strange irony that the subject-matter of those fragments that survive is devoted almost exclusively to farming scenes and the cult of the capricious rain god. For Teotihuacán appears to have outgrown the agricultural resources of the surrounding country when a climatic change to semi-desert conditions was brought about partly by deforestation to provide timber to burn lime for plaster. After a century of decline the city was sacked in about 750. And this first American experiment in urbanization had no sequel for many centuries.

The civilization of the Maya emerged at about the same time as Teotihuacán, but enjoyed a much longer life in the humid climate of the Yucatán peninsula (nowadays divided between Mexico, Guatemala and Belize). No cities were built there. A population of farmers living in scattered hamlets of mud huts was administered by a ruling caste of priests in association with a warrior aristocracy from grandiose ceremonial centres. That at Tikal sprawled over some 6 square miles (1554 hectares), with nine main courts surrounded by religious buildings on hillocks connected by causeways over the intervening swamps. The power of the priests derived largely from their supposed ability to ensure the continuance of time, or—to put it rationally—to predict astronomical phenomena. By the beginning of the fourth century AD, at the beginning of the so-called 'Classic Maya' period, they had developed a precise calendar reckoned from their day 0, which corresponds with 10 August 3113 BC. Preoccupation with time was the mainspring of their religion and of their art. Enough of their writing has been deciphered to reveal that the luxuriant carvings on megaliths refer mainly to the dates of the birth, accession to power, marriages and conquests of rulers (12, 2). They also recorded the legitimizing ancestry of the ruler, whose faces stare out from these impressive monuments. But sometimes the act of setting up the stone on a meticulously recorded day seems to have been of prime importance. Dates are no less prominent among the convolutions of serpents, birds and human figures carved on the irregular surfaces of boulders called zoomorphs. The few surviving Mayan manuscripts are similarly concerned with the calendar. Astronomical observations governed the siting of religious buildings. The rubber ball flying over the players' heads in the ritual ball-game, for which courts

were built in temple precincts, probably symbolized the sun—and the sacrifice of the leader of the losing team ensured that the sun continued on its daily course.

From the beginning of the 'Classic' period, the Maya built with stone and a remarkably durable burnt-lime cement, from which they subsequently developed concrete used for cores. They also discovered the technique of corbelled vaulting (see p. 25), hitherto unknown in America. But their temple architecture was predominantly one of exteriors, since all rituals were conducted in the open air. At Tikal two unusually steep pyramids topped by temples, rising to a height of some 230 feet (70m), each with an unbroken flight of steps climbing precipitously up its front, faced one another across a spacious square (12, 3). Here, as elsewhere, the height of each temple was increased by the vertical extension of its rear wall into what is called

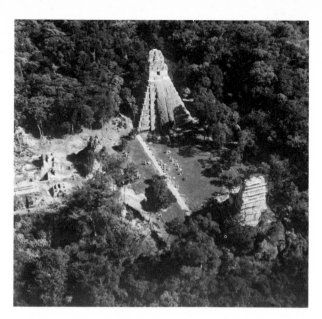

12, 3 Stepped pyramids at Tikal, Guatemala, before 800.

12,2 Megalith D, Quirigua, Guatemala, 766. Sandstone, 35ft (10.7m) high.

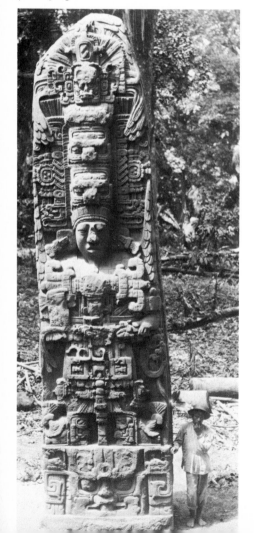

a 'roof comb', and the whole construction might be described as a high-backed throne set on a dais. Structures with a horizontal accent—usually called palaces, though their original purpose is unknown—were heightened by building up the front wall far above roof level, as a false or flying façade, and sometimes adding a second still higher wall behind it. These flat areas were articulated with relief carvings, at first figurative but later mainly geometrical, brightly painted and polished to a refulgent gloss.

The large-scale carvings on Mayan buildings, and on the surface of megaliths and zoomorphs, are in shallow relief, pictorial rather than sculptural. Outlines must have been drawn on the surface of the stone, details incised and the background cut away, sometimes with surprising delicacy in view of the fact that only stone tools were available. One of a set of overdoor panels from a building at Yaxchilán (Mexico) shows a woman, probably the ruler's wife, in penitential devotion, drawing blood—the most efficacious offering to the gods—by pulling through her tongue a cord into which thorns have been knotted, under the gaze of a figure wielding a ceremonial staff (12, 4). The stolid impassivity of the figures is set off by the hard-edged clarity and firmly weighted balance of the composition. Wall paintings were sometimes more naturalistic and a cycle of about AD 800 at Bonampak (Mexico) includes a battle scene and its aftermath, in which captives wait to be sacrificed with the resigned fatalism that characterizes so much of the figurative art

of the Maya. (There are similar paintings on fine pottery vessels.)

The structure of Mayan civilization began to crumble in the ninth century, and the 600-year-long sequence of dated inscriptions came to an end in 889. Meanwhile, a warlike people, the Toltecs, had extended their rule from central Mexico into Mayan territory. As a result, Mayan art was transformed in the service of new overlords and their gods. A ceremonial centre at Chichén Itza, in northern Yucatán, was taken over and greatly enlarged by the Toltecs, who employed local artists and craftsmen— they seem themselves to have constituted a warrior caste patronizing rather than practicing the arts. The observatory is an outstanding example of Mayan (rather than Toltec) architecture, enclosing two concentric annular passages with unusually high corbelled vaults and an upper story reached by a winding stair (a *caracol* in Spanish, after which the building is often named) (12, 5). It may have been

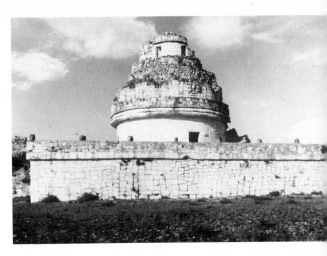

12, 5 The Observatory (*El Caracol*), Chichén Itza, Yucatán, before 1200.

begun in the eighth century before the arrival of the Toltecs but was completed under their rule and was apparently connected with the cult of Quetzalcoatl, the plumed serpent god of the Mexican highlands, represented earlier at Teotihuacán (12, 1). Shafts radiating from the centre of the upper story seem to have been directed to transit points of the sun and stars and also to the ball-courts below, thus permitting observation of cosmic movements and rituals on earth and making it possible to correlate earthly ceremonies with heavenly phenomena.

Other, more sinister, records of the Toltecs at Chichén Itza include relief carvings of warriors marching in procession, files of eagles and jaguars devouring human hearts, and rank upon rank of skulls on poles in front of a platform where the heads of sacrificial victims were displayed. There are also statues of a deity usually called Chacmool (though this is, in fact, a later Aztec name), a reduction of the human figure to severely impersonal geometry, resting on his elbows with knees up and holding an offering-tray in his lap but turning his head away from it with apparent indifference, as gods accept the lives of men (12, 6). Similar reliefs and statues have been found at the Toltec capital Tula (some 40 miles, 64km, north-east of Mexico City), a ceremonial centre surrounded by the habitations of the exclusive military aristocracy. Here the main temple, on top of a stepped pyramidal platform, was supported by columns in the form of warriors standing rigidly to attention as if on ceremonial parade (12, 7). Toltec art is very strongly marked by their militarism; but whether it originated in the Valley of Mexico or in Yucatán is an unresolved

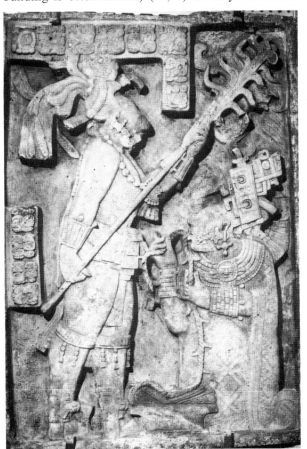

12, 4 *Penitential rite*, lintel from Yaxchilán, Mexico, c. 780. Limestone. British Museum, London.

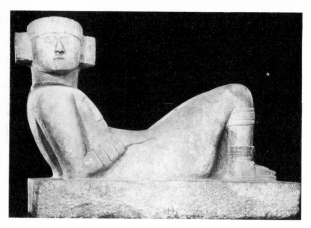

12, 6 *Chacmool* from Chichén Itza, Yucatán, before 1200. Limestone, height 41$\frac{5}{16}$ins (105cm). Museo Nacional de Antropologia, Mexico.

question. After Tula was sacked in 1168, the style was further developed at Chichén Itza and, some 50 miles (80km) away, at Mayapán, which was the Toltec capital from the thirteenth century until about 1450, when the Maya regained control of the region.

At about the time of the expansion of Toltec power, in the second half of the first millennium, southern Mexico also came under the rule of a military aristocracy, that of the Mixtecs. At Mitla, near the Zapotec ceremonial centre of Monte Albán (see p. 388), they had handsome palaces built round large square courtyards, still occupied by priests and members of the ruling class at the time of the Spanish invasion. The finest surviving Meso-American manuscripts are Mixtec, painted on sheets of parchment joined to make long strips that could be folded into book-like form—generally, if inaccurately, called codices. They are concerned with rituals, performed in accordance with the all-important astronomical calendar and with the genealogical history of the leading families (12, 19). Figures, firmly drawn in black outline filled with brilliant colour, are shown frontally or in profile, gesturing with hieratic gravity, and located in space and time by symbols. This is a purely informative art. But elaborate gold jewelry found in Mixtec tombs suggests appreciation of fine craftsmanship. And their craftsmen seem to have been extensively employed by the Aztecs, who conquered much of their territory in the fifteenth century. They are known to have excelled in featherwork, of which a surviving shield with a coyote is perhaps an example (12, 17). Mixtec craftsmen may also have been responsible for masks coated with turquoise, worn by Aztec priests. Concurrent tendencies towards naturalism and ab-stract symbolism, present in Meso-American art since early times, intersect in these minatory and disconcerting objects (12, 18).

The Aztecs

The Aztecs were imperialists able to draw on the artists and craftsmen of their subject peoples, and the art they sponsored combines elements from different traditions. There is a strong reminiscence of Olmec art, for instance, in the figure of a woman giving birth, carved in a greenish stone probably in the Valley of Mexico about 1500 (12, 8). The head of a full-grown man (not a baby) emerging from the womb is an indication that the carving had ritual significance as the symbol of the beginning of a time-period. But the straining and grimacing image of a mother in the agony of parturition, with the clammy surface of skin in cold sweat, has an expressiveness new to the art of Meso-America. A colossal statue of the earth goddess Coatlicue is expressive in a different way, completely dehumanized and yet oppressively real, a terrifying evocation of malignity in nature—with two confronted rattlesnake heads, serpent fangs at her elbows, a skull hanging from a necklace of human hands and hearts above her pendulous breasts and a skirt of entwined

12, 7 Atlantean figures on north pyramid, Tula, Mexico, before 1200. Basalt, height 15ft (4.57m).

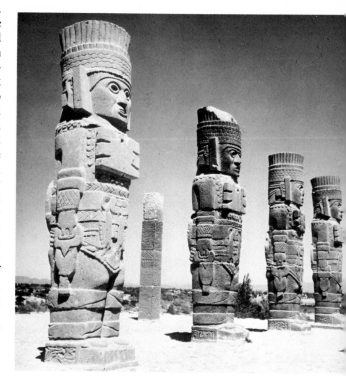

snakes. Her feet have feline claws (12, 9). Most other monsters in the art of the world are docile by comparison.

The last of a succession of northern tribes which infiltrated the Valley of Mexico, the Aztecs settled in about 1370 on the island of Tenochtitlán (where Mexico City now stands) in Lake Texcoco. Here they built the city of spacious palaces and gardens and temple-crowned pyramids which seemed like an enchantment to the first Europeans who saw it. The sanguinary rites performed in this beautiful setting, however, appalled even those hardened adventurers. Human sacrifice, practiced by most other Meso-Americans, had become the central rite of Aztec religion. According to beliefs which the Aztecs shared with the Toltecs, the first men were created out of bone-meal mixed with the sacrificial blood of gods and thus inherited godlike qualities with the responsibility for preserving the cosmos from constantly threatening cataclysms. To ensure the continuing life of the gods, and the world, the blood debt had to be repaid. On dates determined by the astronomical calendar they sacrificed their own people by the thousand—the hearts of 20,000 are said to have been torn out on a single occasion—and to obtain more victims they

12, 8 *Goddess in childbirth*, from the Valley of Mexico? c.1500. Stone (Wernerite), Dumbarton Oaks, Washington DC.

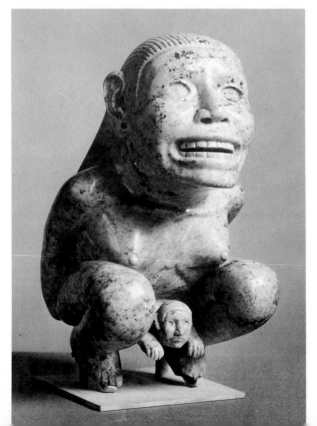

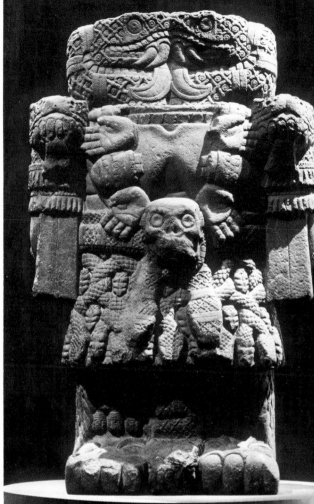

12, 9 *The goddess Coatlicue*, late 15th century. Adesite, height $99\frac{1}{4}$ins (252cm). Museo Nacional de Antropologia, Mexico.

embarked in the mid-fifteenth century on a campaign of imperial expansion, the success of which was largely due to their soldiers' disciplined willingness to confront death. As a result, Cortés was greeted as a liberator by the subject peoples who assisted him in the conquest of Mexico—promptly followed by the suppression of Aztec religion and the art it had inspired.

The Incas

In Peru the Spaniards found the empire of the Incas, which by one of the most extraordinary and inexplicable coincidences in history had begun to expand at almost exactly the same time as that of the Aztecs. It

was still more extensive, occupying, about 1500, the whole length of the Andes from modern Ecuador to Bolivia, Argentine and southern Chile. Technology was developed here in advance of Meso-America, weaving at a very early date (see p. 93), metallurgy before the first millennium AD (with the production of a gold and copper alloy, followed c. 700–1000 by bronze) and extensive schemes of agricultural terracing and irrigation. The people of the Andes appear to have had a much more practical bent than those of Meso-America, and it is significant that most of their finest artistic products were elaborate forms of useful objects, notably in textiles and pottery.

For want of written records, the early history of the area can be traced only from artifacts, which reveal a succession of more than local styles. As we have already seen (p. 92), the Chavín style is the earliest of which clear traces remain. Another style called Mochica originated perhaps as early as 400 BC in the valleys of the Moche and Chicama rivers and spread some hundred miles to the south. An aristocratic society living in walled towns built round hillocks seems to have governed a population of farmers working on land irrigated by long aqueducts and canals (still in use today). Its most distinctive artistic products are exceptionally well-made pottery vessels with stirrup-shaped spouts of a type peculiar to South America. Some have globular bodies with vivaciously painted figurative scenes, sometimes overtly erotic. Others are modelled like human heads, whole figures, animals or buildings. The heads are strongly characterized and startlingly realistic (12, 20). They ponder, frown or sneer in high disdain, some have enigmatic smiles with the hint of a twinkle in the eyes, and one has a broad grin which lights up his whole face. All the vessels were probably made for burial with the dead.

About the seventh century an entirely different style of pottery painting, with abstract designs or severely stylized natural forms, spread from the south and covered a far wider area, including the Moche valley. It is named after Tiahuanaco, high in the Bolivian Andes, where an ancient ceremonial centre was enlarged with massive stone buildings in the course of the first millennium AD. A deity holding two upright staffs, carved with geometric rectilinearity on a monolithic gateway at Tiahuanaco, is a recurrent motif in pottery painting and textiles, including featherwork. The diffusion of the style seems to have been due to the expansion of a religious cult whose devotees looked askance on the freedom and variety of Mochica art (and also on the lively, if less naturalistic, style of pottery painting and textile design centred on the Nazca valley, which likewise died out). There is, however, evidence of the growth of increasingly large political units, one with a populous capital city at Huari, which has given its name to a style allied with that of Tiahuanaco. On the coast further to the north Chanchan (near modern Trujillo), a city founded in about the twelfth century, became in the fourteenth the capital of the Chimú kingdom incorporated in the Inca empire in about 1460.

The Incas, a clan of unknown origin, founded their capital city Cuzco early in the thirteenth century and after some 200 years of local warfare became an imperial power. Their organizing genius was comparable only with that of the Romans. Like that of the Romans, it found expression in large-scale works of civil and military engineering and in an architecture of massive solidity. The great straight 'Royal Road of the Mountains', 30 feet (9m) wide and bordered with walls along its 3,750 miles (6000km), was the main line in a unifying system of communications which amazed the Spaniards, who had seen nothing like it in Europe. At Cuzco there were huge walls of polygonal masonry ingeniously tenoned and of regular courses of rectangular blocks fixed by grinding the surface of one against those beneath and beside it. Both methods of construction were used and have survived the storms of five centuries at the fortified town of Machu Picchu, built on a saddle of the Andes, with terraced fields on the slopes and a 2,000-foot (610m) drop to the valley below (12, 10). Types of building were simple and standardized throughout the Inca empire, rectangular or circular with windows and doors of uniform trapezoid shape. Architectural decoration was sparse. Geometrical patterns prevail on textiles and on pottery made in a very limited range of utilitarian shapes. Natural forms appear only in small carvings and in gold and silver, made by techniques of embossing and *cire perdue* casting which originated in the northern Andes and were perfected in the Chimú kingdom, whence craftsmen were transported to Cuzco. Llamas, the only beasts of burden, and alpacas, which provided wool for clothing, seem to have been the most popular subjects (12, 11). There is a rigidity in the art as in the structure of the Inca empire. It was ruled by a despot styled the 'Son of the Sun', administered by an interrelated nobility and populated by an inferior class paying tax by labour service (there was no money and officially no private property) and regimented with totalitarian thoroughness. Indeed, so rigid was the structure that Francisco Pizarro and his 180 Spanish followers were able to take over the whole system intact by deposing and strangling the last emperor in 1533.

12,10 *Top* Machu Picchu, Peru, c.1500.
12,11 *Above* Alpaca, Cuzco style, about 1500. Silver, height $9\frac{7}{16}$ins (24cm). American Museum of Natural History, New York.

Africa

Unlike America, Africa was never cut off from Europe and Asia. Long before Portuguese mariners sailed down the Atlantic coast as far south as the equator (1471), the cities of west Africa were linked to the Mediterranean by a network of trade routes with caravan trails across the Sahara. The maritime cities of east Africa had been trading for centuries with Arabia, Iran, India and beyond—coins of T'ang emperors of China have been dug up on their sites—and late fifteenth-century Portuguese explorers found that towns like Mombasa had 'many fair houses of stone and mortar, very well arranged in streets ... with doors of wood well carved and excellent joinery'. Religion followed commerce and Islam spread south of the Sahara into Mali before 1100, as well as down the east coast. But until the nineteenth century, Europeans were able to establish little more than coastal footholds. African states, jealous of one another and well able to resist intruding seafarers, generally maintained their independence culturally if not always economically.

The history of art in Africa is difficult to trace, not only for want of written records (apart from travellers' reports), but because the use of perishable materials condemned much to natural destruction. Probably the

only extant wood carvings earlier than the mid-seventeenth century are those brought to Europe by a German merchant, C. Weickmann, before 1659 (Ulm Museum) and thus preserved from the ravages of tropical termites. Works in stone, terracotta, ivory and metal appear to have been produced only in west and southern Africa, and even there they probably represent no more than a minute proportion of the total artistic output. They have artistic qualities, perhaps connected with their purpose and the choice of medium, which may not have been shared by contemporary cult images and masks made of perishable materials. (Traditions prevalent in later cult images are thought to reach back many centuries, however; see p. 93.)

In other parts of the world a bronze age was succeeded by an iron age. But in west Africa iron came first and was used before the end of the first millennium BC for making weapons, agricultural implements and perhaps also cult images, which have long since rusted away. Its introduction is celebrated in myths as a great cultural advance and its working was until recently accompanied by rituals of probably ancient origin. As the raw materials for bronze had to be imported, its use seems to have been limited from the beginning to the appurtenances of kings and priests. Complete mastery of the medium is, nevertheless, displayed in the earliest examples so far discovered (at the village of Igbo-

Ukwu in eastern Nigeria) and probably made in the ninth or tenth century. A ritual water-pot enclosed in a net of simulated rope is extremely accomplished and as elegant in design as in craftsmanship, a virtuoso feat of *cire perdue* casting (12, 24). Other objects from the same place are encrusted with brightly coloured beads or covered with intricate ornamental patterns in shallow relief and some, of the utmost miniaturist delicacy, are fashioned like snakes or shells. The alloy of copper, tin and a high proportion of lead is very unusual, if not unique, but it is not known where the metals came from, let alone how the skill of casting was acquired. This extraordinary Igbo-Ukwu art bursts into the archeological record without precedents and vanishes without a sequel.

An entirely different, predominantly figurative, style of sculpture was created at Ife, an important religious and political centre in south-western Nigeria. Here terracotta seems to have preceded metal as a medium and there may have been some, now submerged, link with the much earlier Nok culture (see p. 93). Ife sculpture has a self-assurance which could hardly have been attained without a long evolutionary period. The earliest surviving examples were modelled in the twelfth or thirteenth century, some 400 years after the foundation of the city—if their dating from scientific analysis (carbon-14 and thermoluminescence) is accurate. They include the head of a ruler which is a masterpiece of restrained naturalism, a distillation of human features into an image at once serene and intensely lifelike (12, 12). The elaborate head-dress is rendered in minute detail, but the sculptor departed from such strict verisimilitude in modelling the face with high, thoughtful brow and sensitive mouth. The full lips are emphasized by a slight ridge at their outer edges and the upper eyelids overlap the lower at the corners, with just a hint of a living flicker. Several other heads are in the same style, all youthful and probably intended to some extent as idealizations rather than as portraits, despite their being so strongly individualized. They are modelled in terracotta or cast in copper or brass (not bronze) (12, 25). There are also brass statuettes of kings with stocky bodies clad in elaborate regalia. A still more remarkable cast copper figure, found in the village of Tada on the Niger some 120 miles (192km) north of Ife, may be the work of a sculptor from a related though independent school (12, 13). It is rather over half life-size, natural in bodily proportions and features and in a pose of subtle rhythmic complexity which reveals both complete mastery of sculptural form and technical proficiency in casting. These naturalistic works were, however, produced at the same time as some in which human

Map of Africa.

forms are reduced to barely recognizable abstractions. And further up the Niger at Djenne (Mali), in about the thirteenth century, an entirely different, strenuously expressive, style was created in small figures provocatively thrusting out their chins and pointed beards (12, 16).

When terracotta and brass heads were first discovered at Ife at the beginning of this century, contact with the Mediterranean was assumed. But they are as close or closer in feeling to contemporary Buddhist art in India and south-east Asia (although there is no evidence of direct contact) as to the art of Europe. In fact, no sculpture of comparable technical accomplishment or spiritual poise and serenity was produced in Europe between the fall of the Roman empire and some centuries after the date of the finest Ife works. Metals may have been imported from beyond the Sahara and the processes of working them learned from Muslim craftsmen, who were the most skilled metalworkers of the time, though never naturalistic. There can, therefore, be little doubt that this west African art was an indigenous growth conditioned by the need for lifelike images of royalty for funerary rituals and the cult of ancestors from whom kings

12,12 *Below* Head of a queen, 12th–13th century. Terracotta, height 9¾ (25cm). Museum of Ife Antiquities, Ife, Nigeria.
12,13 *Right* Seated figure from Tada, late 13th–14th century. Copper, height 21⅛ins (53.7cm). National Museum, Lagos.

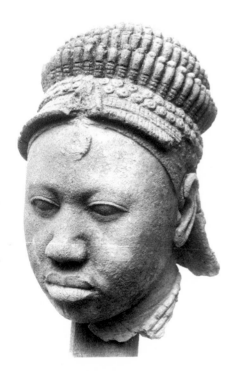

derived their authority. Significantly, the sculpture produced in the city of Benin after it began to trade with Portugal in the 1480s is more stylized than that of Ife.

Contradictory local traditions ascribe the founding of the Benin school of sculpture to a master from Ife and to the Portuguese. Some affinities with the art of Ife are evident in a powerful yet exquisitely carved ivory mask believed to have been made for the oba or king of Benin reigning at the time the Portuguese arrived (12, 14). (The long-haired and bearded heads of Portuguese are incorporated in the crown.) The Portuguese traded copper and brass for ivory and slaves and they are represented in a number of brass relief plaques and statuettes. Originally attached to columns in the oba's palace at Benin, the plaques formed a series illustrating the history and rituals of the realm and are of a rectangular format most unusual in African art. The introduction of this 'framing device' may have been due to European printed book illustrations, which could have reached Benin in the sixteenth century with the Portuguese. Stylistically, however, the plaques have little in common with

European art at the time. Isolated against delicately patterned flat backgrounds, the figures are frontally posed, stiff in gesture, steady in gaze, scaled according to importance, yet packed with compressed energy. One plaque shows an oba sacrificing or displaying his power over two leopards, which he swings by their tails (12, 15). His legs terminate in fish, associating him with the sea god Olokun and also, perhaps, alluding to a belief that the king's feet should not come into contact with the soil. The oba traced his ancestry to the son of an oni (or king) of Ife who was believed to be descended from a god, and this tradition set him apart from his subjects. He held a monopoly of sculpture in brass (chiefs were allowed ancestor figures only in terracotta) and metalworkers were servants of the oba. Benin art was thus predominantly royal and so closely

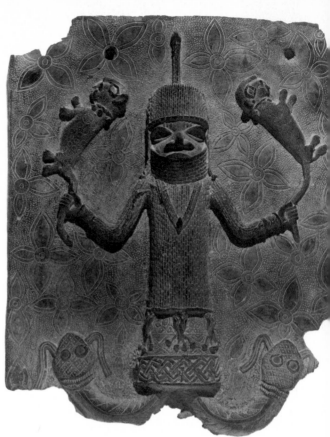

12, 15 The Oba of Benin in divine aspect, 16th century. Bronze, height 15½ins (40cm). British Museum, London.

12, 14 Pectoral or waist mask, early 16th century. Ivory, height 9¾ins (25cm). British Museum, London.

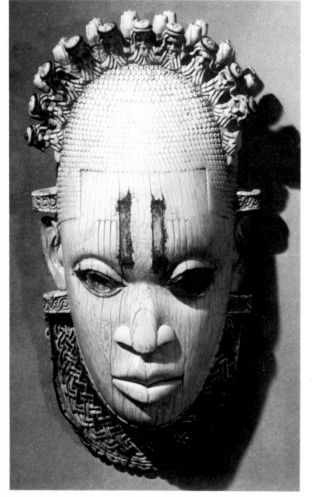

connected with the rituals in the service of divine kingship that it underwent few modifications. Some new types of object were produced in the early eighteenth century, when increased quantities of brass (mainly from trade in slaves) became available. But sculptors went on working according to their own time-honoured traditions, with some loss of vitality due to artistic inbreeding, until 1897, when a British punitive expedition deposed the oba, sacked his palace and carried off most of its works of art.

The palace of the oba, which sprawled over much of the city of Benin, was constructed of mud-brick and timber with metal facing and consisted of rooms ranged round courts with roofs sloping inwards to carry rainwater into cisterns—rather like a huge ancient Roman villa. Building with stone seems to have been practiced only in east Africa. At Zimbabwe massive walls survive from the capital city of a kingdom which extended from the Zambesi to the Limpopo—covering the main gold-bearing area—and reached its summit of power and wealth in the mid-

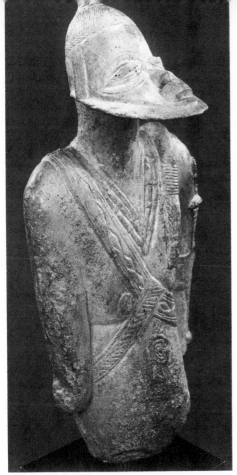

12, 16 Bearded male figure from Djenne, Mali, 14th century. Terracotta, height 15ins (38.1cm). Detroit Institute of Arts (Eleanor Clay Ford Fund for African Art).

fifteenth century. The remains of trading cities on the coast, including that of Kilwa, which the Muslim traveller Ibn Battuta described in 1331 as 'one of the most beautiful and well constructed towns in the world', show how deeply the art as well as the religion of Islam had penetrated this part of Africa.

The Islamic world

At the beginning of the diary he wrote on the voyage which led to the discovery of the New World, Columbus recorded how, a few months before setting sail in August 1492, he saw the Spanish royal banners 'victoriously raised on the towers of the Alhambra'. At the same moment the last Muslim emir of Granada came out of the city gates and kissed the hands of the Catholic sovereigns, Ferdinand and Isabella. Nearly seven centuries of war between Christians and Muslims in Spain had ended. As a result Ferdinand and Isabella took possession of what was perhaps the most luxurious palace in all Europe at that date. Begun

as the residence of a Jewish vizier in the mid-eleventh century, when a patchwork of semi-independent Islamic states covered three-quarters of present-day Spain and Portugal, the Alhambra was enlarged into a palace-city after Granada became the capital of an emirate in the late thirteenth century.

Islamic culture flowered under the emirs of Granada, and the Alhambra is the finest monument of the 'Hispano-Moresque' style. It also epitomizes the paradoxical character of Islamic architecture as a whole in its simultaneous appeal to the senses, to the intellect and to the spirit, and especially in its capacity to assimilate elements from other traditions and recast them in forms as distinctively Muslim as the turban and robe of a mullah. The Alhambra belongs to the same tradition of Mediterranean palatial building as the great imperial Roman palaces, of which very much less survives. At the Alhambra a forbiddingly austere and fortified exterior encloses a complex of cool rooms, ingeniously heated baths and sun-drenched courts overlaid with intricately devised and exquisitely wrought decorations to provide settings for a life of cultivated luxury—prominently displaying, however, inscriptions to the glory of Allah with appropriate allusions to the evanescence of all earthly things. There are colonnaded interior courts green with plants and running water as at Domitian's palace in Rome and Hadrian's villa at Tivoli, there are even domed halls of cosmic symbolism like that in Nero's Golden House, but at the Alhambra all these memorably imposing and symmetrically grouped spaces open unexpectedly out of one another, like successive incidents of some rambling story in the *Thousand and One Nights*.

The most elaborate part of the Alhambra, the Court of the Lions, is a Hellenistic peristyle given new life and a wider range of associations by Islamic thought and culture (12, 22). The slender columns on which the arches are lightly poised are not uniformly spaced, being sometimes single and sometimes coupled in irregular but rhythmical sequence, breaking forward gracefully to form pavilions at either end. Interpenetrating covered and open spaces modulate the light and eliminate harsh contrasts. As it varies in intensity and direction from dawn to dusk, the light subtly changes the structural appearance of the court and the rooms leading off from it, creating almost hallucinatory effects of insubstantiality. Stucco and tiled panels drape walls with abstract patterns of all-over ornamentation, whose predominant geometricity (even of vegetal forms) is profoundly Islamic in its underlying mathematical structure (12, 21). There is no background, every motif being an active and equal participant in the design. Like the cosmic symbolism of

the adjoining domed hall, which is made quite explicit in verse inscriptions, this ornamentation reflects in its myriad divisions and subdivisions certain essential characteristics and values of Islam and has even been interpreted as a visual translation of the cosmic view of Islamic mysticism. No less typically Islamic is its orientation—not outwards but inwards. Light and shade, stone and water, all are interwoven like the delicate motifs on the capitals of columns and on the walls—and like the various levels of meaning which sustain all this fragile sensual beauty. Water sparkles from the central fountain and ripples along four intersecting channels to give a foretaste of paradise, a specifically Islamic holy paradise as described for the faithful in the Koran—'gardens through which rivers flow, where they shall remain for ever'—as well as a more sensuous paradise of physical well-being, whose possible mystical associations did not eschew occasional orgiastic overtones. The four water channels also recall the rivers flowing out of Eden, as in the quadripartite gardens or *chahar baghs* of later Iran and India—and as in the complex symbolism surrounding the Fountain of Life in Christian art and thought. In Islamic art, however, symbolism is usually metaphorical rather than allegorical, with consequent ambiguities and sometimes even reversals of meaning. The 12 lions of the fountain, for example, were, according to an eleventh-century poem, originally associated with Solomon, the first great builder of palaces; but when they were re-used in the fourteenth century to form the centrepiece of the court they became 'lions of the Holy War', perhaps with allusion to the taking of Algeciras in 1369, the last triumph for Islam on Spanish soil.

The expulsion of the Muslims from Spain in 1492 was a very minor setback for Islam, which was then in the ascendant on every other sector of its immense frontier, from Africa to Indonesia and across central Asia to the Balkans. But it inspired Ferdinand and Isabella to finance Columbus's epoch-making voyage, the declared aim of which was to contact the 'Great Khan', traditionally believed to be the leading opponent of Islam in Asia. They seem to have been unaware of the changes that had taken place in the previous 300 years. The vast Mongol empire built by Genghis Khan (1167–1227) had been increased but also divided among his descendants. One grandson, Kubilai, founded the Yüan dynasty of emperors of China, whose rule came to an end after little more than a century in 1368 (see p. 411). Another grandson, Hulagu, who took the dynastic title of ilkhan, became ruler of the western territory from Iran through Mesopotamia to Syria, sacking Baghdad in 1258 (see p. 260). He was a violent anti-Muslim with Christian sympathies, but his great-grandson, who became the fifth ilkhan in 1295, was a Muslim convert. Thus Islam was re-established as the state religion of Iran, which once again became a major centre of Islamic art and culture (see below).

Under the Mongols the decorative arts of China and Iran were brought close together, with influences flowing in both directions, but the religious architecture of Iran maintained or reverted to Seljuk and earlier traditions, despite a hiatus in building activity which lasted almost a century. The *iwan*, which derived ultimately from Sassanian architecture (see p. 254), remained the most characteristic form, a large niche-like structure placed in the centre of one or more interior walls of a court and also used as a portal. At Yazd (some 200 miles, 320km, south-east of Isfahan) an exceptionally tall and fine *iwan*, crowned by minarets reminiscent of Seljuk funerary towers, provides the entrance to the court of the Friday Mosque (12, 28). This is purely decorative and demonstrative architecture, without any utilitarian purpose, erected with a complicated system of buttressing to support its height simply as an embellishment to the earlier mosque. The entire surface is coated with glazed tiles of a type which, from the early fourteenth century, had a dominant role in Iranian architecture, giving to the most substantial constructions an ephemeral fragility (12, 31).

The further development of art and architecture in Iran was little affected by changes in dynastic rule. In the early 1380s the area was incorporated in the empire of Timur Lang (1336–1405), a prince of Turko-Mongol descent whose armies swept across Asia, penetrating as far north as Moscow, south into India and west into Anatolia. He is the Tamburlaine of Western literature. But in addition to being a merciless conqueror, he was a notable, if hardly less ruthless, patron of the arts—when a building failed to please he had the architect beheaded! Calling on artists and craftsmen from all the territories he overran, he made his capital city, Samarkand, the wonder of the age. The sophisticated elegance of the mausoleum he had built for his son, and in which he also is buried, might seem to be at odds with his character (12, 29). The architect was a Persian from Isfahan. Here again coloured glazed tiles are used with wonderful effect on the ribbed melon-shaped dome, which gives prominence to the building by rising high above the domed ceiling of the interior chamber. An inscription in Kufic lettering round its drum declares that 'Allah is eternity'.

Ottoman architecture

Timur's empire shrank immediately after his death.

12, 17 *Top left* Shield from Tenochtitlán, before 1519.
Featherwork, Museum für Völkerkunde, Vienna.
12, 18 *Top right* The God Quetzalcoatl or Tonatiuh, c.1500.
Turquoise mosaic set in resinous gum over wood, with eyes of
pearl shell, height 6⅝ins (16.8cm). British Museum, London.
12, 19 *Bottom left* Page from the *Codex Zouche-Nuttall*,
c.1350–1500. Bodycolour on prepared deerskin. British
Museum, London.
12, 20 *Right* Portrait vessel, Mochica style, 200–500 AD.
Pottery, height 11⅜ins (28.9cm). Art Institute of Chicago,
Buckingham Fund.

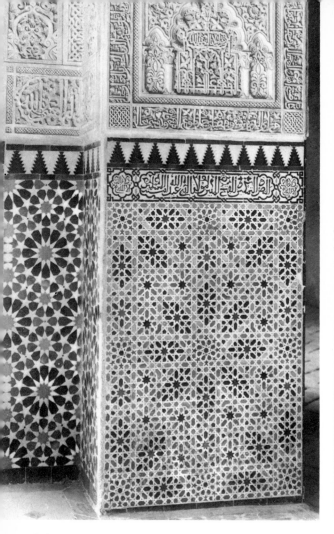

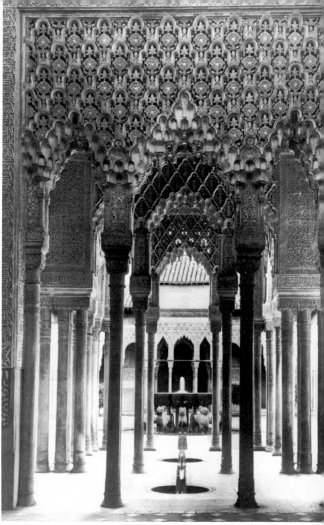

12, 21 Tile decoration in the Alhambra, Granada, 1354–91.

12, 22 The Court of the Lions, the Alhambra, Granada, 1354–91.

The petty rulers whom he had held in vassalage regained their independence and the Osmanli or Ottoman Turks resumed their expansion westwards, which Timur had interrupted. A clan from central Asia named after their first notable leader Osman (d.1324), who had seized control of the Seljuk sultanate in Anatolia (see p. 267), the Ottoman Turks crossed the Dardanelles into Europe in 1354, took Sofia in 1382, drew a noose round Constantinople, which fell to them in 1453, and then moved swiftly on to the conquest of Greece, Serbia and Albania. By 1520 the Ottoman empire had also spread to the south, covering Syria and Egypt, but the drive into Europe continued. Belgrade was taken in 1521, Buda in 1526 and Vienna besieged for the first time in 1529. They even glanced across the Atlantic. In 1513 a Turkish cartographer drew a map of the New World for his sultan, and in 1580 a Turkish historian of the Spanish colonization of America expressed the hope 'that these valuable lands will be conquered by the family of Islam, and will be inhabited by Muslims and become part of the Ottoman lands'. The peak of power had, in fact, been passed by that date, but Ottoman sultans ruled until 1922—it was the longest-lived dynasty in the history of Islam.

The first act of Mehmed the Conqueror on taking Constantinople—or Istanbul, as it was called in colloquial Greek—was to ride to Hagia Sophia (7, 18), claim it for Islam, leap on the altar slab and kneel in prayer to Allah. Muslims had always been ready to take over Christian churches. They had also, as we have seen, been adept at bending to their own purposes the architectural styles of the lands they occupied. Even before the Ottomans burst out of Asia their buildings incorporated Byzantine as well as Seljuk elements and had always shown a preference for stone rather than the brick of central Asia. But a new and

explicitly Ottoman style, not so much derivative from as challenging the Byzantine achievement, had reached maturity in the late fifteenth century and was crystallized in the sixteenth by Sinan (1489–1588)—Koca Mimar Sinan, 'the great architect Sinan', as he came to be known. Structural logic is its main characteristic, vast spaces vaulted by shallow domes with no dark corners or mysteriously shaded extensions, centralized planning and sober exteriors composed of wide-spreading masses set off by slender minarets like sharp-pointed pencils.

Sinan began his career as a soldier and not until 1538 was he appointed architect to the Sultan Suleyman the Magnificent (1520–66); but the sheer quantity of buildings he designed and saw through to completion in the following 50 years is the most vivid testimony to his genius and bounding energy—and to Ottoman wealth at this period. He is reliably credited with 81 Friday mosques for communal worship, 50 smaller mosques, 55 schools, 34 palaces, 33 public baths and 19 mausoleums, not to mention hospitals, soup kitchens, bridges and other utilitarian structures, notably hydraulic systems, making up a total of 334. The many that survive reveal consistently high standards of design and craftsmanship in execution with perfectly cut masonry, crisp detailing and exquisite glazed tiles made specially in the factories at Iznik and used for cladding interior walls. The contrast with the amount of building achieved by Michelangelo at about the same time, or by any other west European architect before the eighteenth century, is striking. Sinan was also able to realize on the grandest scale the idea of a free-standing centrally planned place of worship which had haunted the imagination of Italian Renaissance architects, most of whose projects remained on paper.

The functional demands for a mosque are, of course, much simpler than those for a Catholic or Orthodox church. All that is strictly necessary is a large hall; and Sinan took the opportunity to create an impressive variety of spaces conditioned only by the availability of building land and the financial resources of his patrons. He regarded as his masterpiece the Selimye mosque at Edirne (the first Ottoman capital in Europe) built for Suleyman's son and successor Selim II (12, 23). It had distressed him, he later declared, that nothing had been built to 'rival the dome of Hagia Sophia and it was thought too difficult to build another equally large'. The Selimye mosque has not only a slightly wider dome (more than 100 feet, 30m, in diameter) resting on eight elegant piers of pinkish sandstone but also, as it were, 'corrects' the design of Hagia Sophia with the axiomatic simplicity of its centralized plan—an octagon inscribed in a square—

with the clarity and evenness of the lighting, the sparseness of decoration and the monumental regularity of the exterior which perfectly expresses the interior volumes. He created, in fact, one of the world's masterpieces of architecture conceived as the molding of space. But he was hardly less successful when working on a smaller scale, as in the Sokollu Mehmed Pasha mosque built for the grand vizier's wife (a

Plan of the Selimye Mosque.
12, 23 Sinan, The Selimye Mosque, Edirne, Turkey, 1567–74.

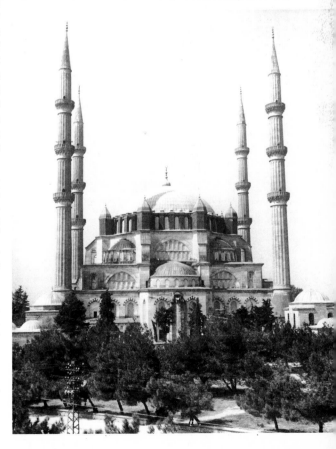

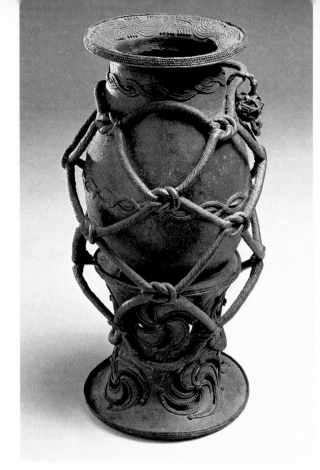

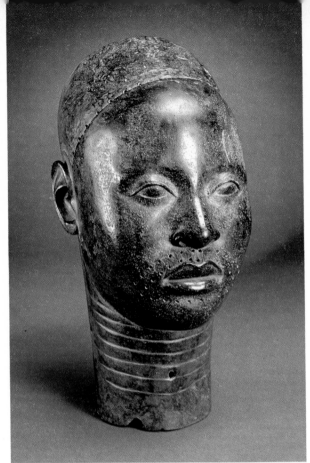

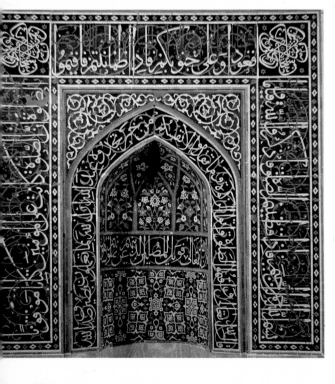

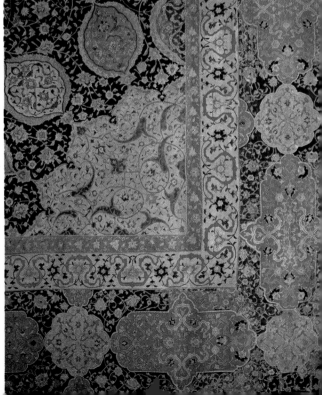

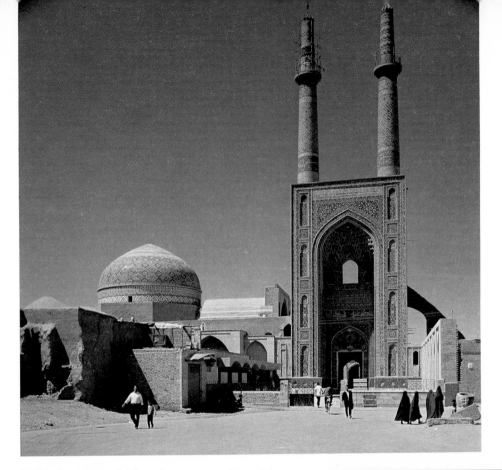

12, 24 *Opposite top left* Roped pot on a stand, from Igbo-Ukwu, 9th-10th century. Leaded bronze, height 12 11/16 ins (32.3cm). National Museum, Lagos.
12, 25 *Opposite top right* Head of an oni, 12th–15th century. Zinc brass, height 12 3/16 ins (31 cm). Museum of Ife Antiquities.
12, 26 *Opposite bottom left Mihrab* from Iran, early 16th century. Tin glazed earthenware tiles, 6ft 7ins (2m) high. Museum für Islamische Kunst, Berlin.
12, 27 *Opposite bottom right* The Ardebil carpet (detail), 1540. Woollen pile, 34½ × 17½ft (10.5 × 5.3m). Victoria & Albert Museum, London.

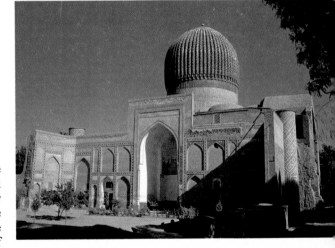

daughter of Selim II) on a difficult and limited hill-side site in Istanbul (12, 30). Its plan is a hexagon inscribed in a rectangle with a central dome counterbalanced by four half-domes (creating a spatial effect totally unlike anything in Byzantine architecture). For this more intimate building Sinan devised decorative effects of greater delicacy, with contrasted areas of white marble and panels of glazed tiles, which suffuse a turquoise light through the whole interior.

Safavid art
On the eastern frontier of the Ottoman empire the most powerful state was that ruled since 1502 by the

12, 28 *Top* The Great Mosque, Yazd, Iran, completed by 1330.
12, 29 *Above* The Gur-i-Mir of Timur Lang, Samarkand, USSR, 1403–5.

405

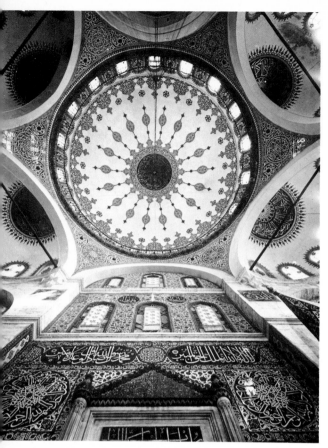

12, 30 Sinan, The Sokollu Mehmed Pasha Mosque, Istanbul, 1571.

they help to concentrate the worshipper's attention beyond the wall, which the tiles cover like a shimmering veil. Better than any other medium, tiles resolved the contradictory functions of the *mihrab*. To indicate the direction of prayer without becoming an object of devotion, it had simultaneously to proclaim physically and deny spiritually the importance of the *qibla* wall.

The only naturalistic motifs are floral and although they have no precise symbolical meanings (like the lily in Christian and the lotus in Buddhist art) they may reflect both the transience of life and mystical Sufi ideas of the immanence of the divine in the natural world. Floral patterns were, however, also used on tiles simply as colourful enrichments. So, too, were those on carpets, like that said to have come from Ardebil, where the Safavid dynasty originated (12, 27). Flowers similar to those on tiles are scattered over its surface with two mosque lamps suspended, as it were, from an 'arabesque' central motif. The art of making knotted carpets goes back to very distant prehistoric times, when it was practiced by the nomads of central Asia (see p. 123). Those produced in Anatolia (greatly prized in western Europe during the later Middle Ages and Renaissance) maintained ancient traditions, with foliage and animal forms reduced to geometrical shapes determined by the rectangular weave of the ground to which the tufts of woollen pile are knotted. The rectangularity was, of course, deeply congenial to Islamic artists with their predilection for geometrically based design. So much so, indeed, that textile patterns were transferred whole, as rectangular units, into tile decoration, so that the memory of textiles and carpets hanging on walls seems to lie behind even the finest and most elaborate Safavid architectural decoration (12, 31).

As we have already seen (p. 252), Muslim attitudes to figurative art had from the beginning been very loosely defined. (Only in religious contexts was there unanimity.) The Koran placed a ban only on idols, and traditions relating to the representation of human beings were diversely interpreted. Figurative scenes were often painted on the walls of palaces and appeared in Arabic manuscripts from at least as early as the ninth century. Korans were not illustrated, of course, but were often sumptuously illuminated with abstract ornament. It was from cross-fertilization of this type of work with Chinese Buddhist art, introduced by the Mongols, that Iranian miniature painting developed from its immediate origins in Mesopotamian painting. Already cultivated by Timur Lang's successors, especially at Herat (Afghanistan), it was brought into full bloom under the patronage of the Safavids at Tabriz.

Safavid dynasty, who claimed descent from both Cyrus the Great and the Prophet Muhammad, covering modern Iraq, Iran and much of Afghanistan. The area overlaps the main schism in Islam, the Ottoman lands being predominantly Sunnite, and Iran, as it still remains, Shi'ite (see p. 259); but in the arts the difference between them was due more to tradition and aesthetic preferences than to religious doctrine. Safavid art is epitomized in one of the finest early sixteenth-century *mihrabs* (12, 26). Scrolls and closely integrated floral patterns surround verses from the Koran in the beautiful flowing *thuluth* script—the text across is a warning to those who pray negligently or hypocritically, and that running round the arch reads: 'Be constant in prayer, and give alms; and what good ye have sent before for your souls, ye shall find it with Allah; surely Allah seeth that which ye do.' Such inscriptions fulfil the same function as visual imagery does in a Christian altarpiece and, incorporated in an apparent eternity of intricately woven motifs, without a focal point and conveying no sense of space or time,

A miniature of an angel warning Gayumarth, the legendary first shah of Iran, that the idyllic age in which he lives will soon come to an end, is from a manuscript of the Iranian national epic, the *Shah-nama* (book of kings) by the early eleventh-century poet Abu'l-Qasim Firdawsi (12, 35). The pose of Gayumarth, the attenuated elegance of the angel, the clouds and the gnarled branches recall Chinese art; but the general effect of jewel-like colours and the fluid rhythm of the composition are essentially Iranian in their synthesis of western (Tabriz) and eastern (Herat) traditions. The painting is attributed to Sultan-Muhammad (fl. c. 1510–45), the greatest painter of the Safavid period and largely responsible for bringing about this synthesis of styles. It is precious in every way, the work probably of several years, with much use of gold and blue lapis-lazuli pigment. Such paintings were intended primarily to delight the eye as it follows the curves of the design and lingers in admiration at the vividness of the smallest details, especially the animals. The many miniatures in the volume, commissioned by the first Safavid shah, Isma'il (1502–24), and finished for his bibliophile son Tahmasp (1524–76), were the work of several hands and the pleasure of looking at each one must always have been enhanced by that of comparing it with others. Monotony was avoided by shifts in type of subject, colour-scheme, composition and the way in which some scenes are tightly confined within a rectangle, while others burst out, so that the gold-speckled border is read as a background rather than as a frame. Shah Tahmasp employed a retinue of artists who observed the same basic conventions — recession indicated by position on the page rather than diminution of scale, flat colour with hatching but no shading — and satisfied the same demands for meticulous craftsmanship, yet were able to command an astonishing range of effects, from the lyrical and visionary to the humorous and delicately salacious.

Mughal art and architecture

From Iran the Safavid art of miniature painting was introduced into India. At the beginning of the sixteenth century the greater part of the sub-continent had for long been ruled by Muslim sultans. In 1526 two military adventurers from Turkestan, Babur (d. 1530) and his son Humayun (1508–56), seized power and founded the Mongol, or Mughal, empire. Humayun was, however, opposed and took refuge for 12 years in Iran at the court of Tahmasp, who aided his restoration. During his exile he acquired a taste for Iranian art, especially miniatures, and took into his service two of the best painters employed by the shah, who was beginning to lose interest in illustrated books.

Humayun's son Akbar (1542–1605), who consolidated and extended the Mughal empire to Bengal in the east and as far south as the river Godavari, was a still more active patron and assembled court ateliers at Agra, Delhi and Fatehpur-Sikri with artists from all parts of India, including many Hindus. As a result, Islamic art underwent its most radical transformation.

Although he was among the wisest of all rulers — perhaps the greatest in a century dominated by emperors, Charles V in western Europe and Suleyman in Turkey — Akbar was almost, if not entirely, illiterate. And this may partly account for his passion for paintings, especially for those with a strong and clearly expressed narrative content — unlike most Iranian miniatures. The history of his long reign was brilliantly illustrated in his own copy of his biography, written about 1586–90 by his minister Abu'l Fazl. One sheet by the Hindu painter Basawan (fl. 1590–1605), who created the classic Mughal narrative style, records a youthful exploit, Akbar's mounting a notoriously intractable elephant and setting it to fight another, which it chased across a pontoon bridge (12, 32). In technique the painting follows the Iranian practice of drawing in outline and filling with colour (draftsman and colourist sometimes being different artists), but the bold contrasts of red, blue, green and yellow owe more to Hindu art, and the suggestion of distance by diminution in scale was probably learned from Europeans, who were welcomed at Akbar's court. Although the subject might seem to be light and anecdotal, it had a symbolic meaning, which Basawan presented dramatically. Akbar told Abu'l Fazl that he had mounted dangerous elephants in order to put himself at God's mercy and the incident thus illustrates the origin of the vital power that enabled him to triumph over men as well as beasts.

Under Akbar painting was largely an 'official' art, confined almost entirely to the illustration of histories and chronicles and sometimes intended for display at public readings. Many paintings were quite large, for example the 1,400 commissioned in 1567 for the *Hamzanama* (The Tales of Hamza), which were 45 inches square (114.3cm) (only about 100 survive). They generally depict scenes of violence or boisterous energy — battles, sieges, hunts, etc. — and are very different in feeling from sybaritic Safavid painting. Akbar also commissioned portrait miniatures, but the great master of this famous type of Mughal painting, Abu'l Hasan (b.1589), worked for Akbar's successor Jahangir (1569–1627), under whom painting became more aristocratic and refined — smaller in scale, lighter in palette and more exquisite — intended for the connoisseur's private delectation. Narrative painting

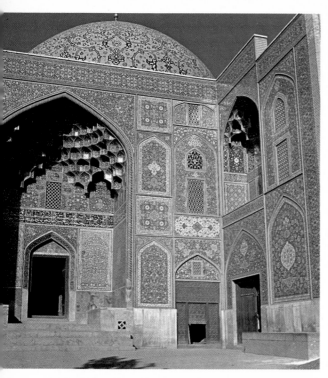

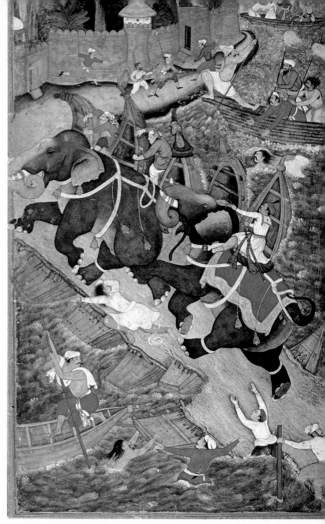

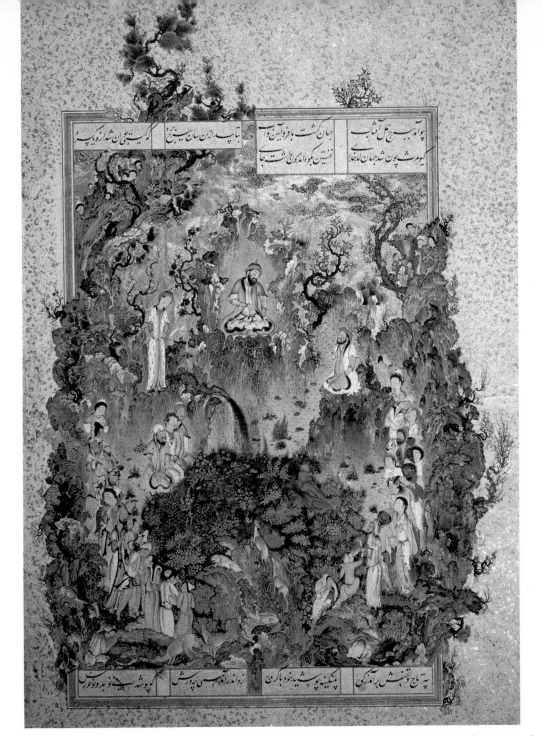

12, 31 *Opposite top left* The Lutfullah Mosque, Isfahan, Iran, 1602–16.

12, 32 *Opposite top right* Basawan, *Akbar restrains Hawa'i*, c.1590. Pigment on paper, 13½ × 8½ins (34.5 × 21.7cm). Victoria & Albert Museum, London.

12, 33 *Opposite bottom left* Mansur, *Turkey cock*, 1605–27. Pigment on paper, 5¼ × 5⅛ins (13.2 × 13cm). Victoria & Albert Museum, London.

12, 34 *Opposite bottom right* Anonymous, *Imayat Khan dying*, c.1618. Pigment on paper, 5 × 6ins (12.5 × 15.3cm). Curators of the Bodleian Library, Oxford, MS Ouseley Add. 1716, f. 4v.

12, 35 *Above* Anonymous (Sultan-Muhammad?), *The court of Gayumarth*, c.1525–35. Pigment and gold on paper, 18⅜ × 6¾ins (47.3 × 17cm). Metropolitan Museum of Art, New York.

declined and was superseded by album painting, i.e. paintings of animals, birds, flowers, genre scenes or portraits, made not as illustrations to a book but as individual works of art to be mounted in an album and enjoyed for their own sakes. Boasting of his connoisseurship in his memoirs, Jahangir claimed to be able to attribute not only whole paintings to their author but even the parts of a composite work—'if anyone has put in the eye and eyebrow of a face, I can perceive whose work the original face is and who has painted the eye and eyebrow'! When the Portuguese at Goa sent him a turkey—a species still rare in the Old World, to which it had been introduced from America a century before—Jahangir commissioned a picture of it from one of his favourite artists, al-Mansur, called 'The Wonder of the Age'. The result is among the most distinguished of all ornithological paintings, capturing the turkey's jauntiness as well as meticulously recording the colour and sheen of its plumage with sumptuous effect (12, 33).

But this detached approach could also lead to other and, to Western eyes, rather disturbing effects, in which the most refined artistic sensibilities are combined with complete and inhuman indifference to the implications of the subject. In 1618, for instance, one of Jahangir's courtiers, reduced to skin and bones as a result of opium addiction, was carried into his presence and, Jahangir wrote, 'as it was a very extraordinary case, I directed painters to take his portrait' (12, 34). No more coolly objective image of a man confronting death has ever been painted. The beauty of its austerely geometrical structure, its predominantly pallid tone lit only by the carefully placed patches of bright colour and the tiny strip of blue and red ornament in the right-hand margin, glows like a fading ember. Every link with the Iranian style of decorative miniature painting has been severed in this extraordinary work.

The early Mughal emperors were no less active as patrons of architecture and the decorative arts than of paintings, most notably Jahangir's successor Shah Jahan (1592–1666). The Taj Mahal at Agra (12, 37), one of the most famous buildings in the world, grandiose in scale, exquisite in its opalescent colour and its refinement of carved and inlaid detail and perfectly balanced in its proportions, was commissioned by Shah Jahan as a mausoleum for his favourite wife Mumtaz Mahal (1593–1631). A tomb for a wife on such a scale was entirely without precedent in Islam and it seems possible that the Taj Mahal was conceived also as an allegory in stone of the day of Resurrection, the Taj itself being a symbolical replica of the throne of God. Certainly the quadripartite lay-out of four

intersecting water channels in the great Persian *chahar bagh* garden, through which the Taj Mahal is approached, symbolized Paradise with its four flowing rivers as described in the Koran.

The architect seems to have been Ustad Ahmad Mu'ammar Nadir al-Asar (d. 1649), a Persian who later designed the palaces of the Red Fort at Delhi (1639–48). Yet the effect of the huge white marble octagonal structure of the Taj, culminating in its enormous dome with flanking minarets some 140 feet (43m) high, is not wholly Iranian, despite the prominence of Iranian forms such as the *iwan* and the bulbous double-dome like that of Timur Lang's tomb at Samarkand (12, 29). The general effect is entirely different from that of any building north of the Hindu Kush. The Taj Mahal is, indeed, the ultimate refinement and culmination of a style developed at Humayun's tomb at Delhi (completed c. 1570), refined at Akbar's new city of Fatehpur Sikri (1568–75) and later still at Akbar's tomb at Sikandra (completed 1613), all of which incorporate and reconcile Hindu and Islamic elements as a conscious expression of political and religious policy. For Akbar's success as a ruler was largely due to his winning over the Hindu princes and to his religious tolerance. He even attempted to found a new world-wide religion and had a hall built for discussions between Muslims of all sects, Hindus, Zoroastrians, Jains and Christians.

The architectural activities of the early Mughals were devoted mainly to mausoleums and palaces of rarefied opulence, not to mosques for the mass of the faithful. 'If there is heaven on earth, it is here, it is here, it is here', Shah Jahan had inscribed in his audience hall at Delhi. Yet this essentially courtly art reflects highly developed intellectual interests. The complexities of Indian theology particularly fascinated Shah Jahan's favourite son, the most cultivated member of the family, Dara Shikoh, and it was probably for him that a group of Hindu holy men was depicted (12, 38)—an amazingly objective record of spiritual experience, quite literally a brown study in colour as in subject. This painting also reveals the extent of European artistic influence on Indian art at this date, for the distant view is rendered with aerial perspective and the pose of the *chela* or neophyte in the foreground is taken from an Italian print.

A great change, not only in art, came about after 1658, when Aurangzeb (1618–1707) seized the throne, imprisoned his father Shah Jahan, had his brother Dara Shikoh executed for heresy, and attempted to impose the Sunnite Muslim faith throughout the empire, which he extended almost to the tip of the peninsula. Under his rule the art of miniature painting

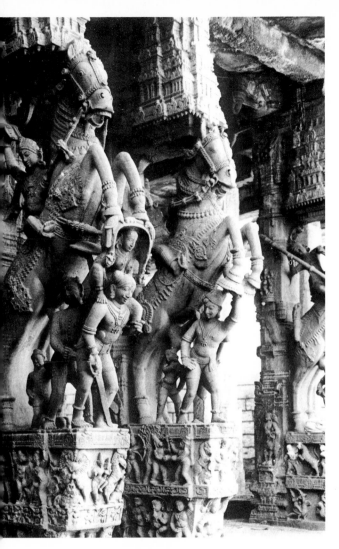

12, 36 Mandapa of temple, Srirangam, India, 17th century.

they appear as if made in Italy', a Portuguese traveller reported in about 1520! But in 1565 it fell to Muslims of the Deccan sultanate, who spent a whole year destroying it with gunpowder and crowbars. Its style of architecture and sculpture was taken further in the huge, mainly seventeenth-century temple at Srirangam, where from a line of pilasters exuberantly carved with deities a whole cohort of warriors on life-size horses rears up over men and tigers (12, 36). About the same time the great temple city of Madura was built with a hall of a thousand columns, each of which incorporates figures in high relief, and its tall *gopuras* (gateway towers) entirely covered with stacked friezes, on which the deities of the Hindu pantheon are carved in stucco. These structures make the most violent contrast with the smooth planes and clearly defined volumes, the abstract harmonies and subtleties of such Islamic buildings as the Taj Mahal. The sensuality and carnality of their mountains of writhing forms continue the ancient Indian conception of architecture as sculpture, as a living, organic mass.

Yüan and Ming China

The Mongol conquest of China, begun by Genghis Khan in 1210 and completed by his grandson Kubilai, who made himself the first emperor of the Yüan dynasty in 1279, brought the greater part of Asia under the rule of a single family. As a result, China briefly became more easily accessible to Europeans. Marco Polo, who travelled extensively in Asia from 1271 to 1295 and served as an official to Kubilai, and Friar Odoric of Pordenone, who went as a missionary to Peking in 1324, both recorded their experiences; and they were by no means the only European visitors to China. In 1340 an Italian merchants' manual declared the route from the Black Sea to Peking to be perfectly safe 'whether by night or by day'. In these circumstances greater quantities of silks and other artifacts crossed the continent and Chinese motifs were more frequently imitated by European artists and craftsmen than ever before. There are, for instance, dragons of Chinese ancestry on the embroidered mitre worn by St Louis of Toulouse in Simone Martini's painting of 1317 (9, 51). Chinese influence on the art of Iran was more profound, as we have seen (12, 35), and Iranian motifs also passed in the opposite direction to be incorporated in porcelain and metalwork made in China. The Mongols seem, indeed, to have promoted a kind of international Asian style in the decorative arts. But the major Chinese art form, landscape painting, remained largely unknown to the rest of the world (apart from Japan).

was virtually suppressed; he devoted himself to copying out the Koran and building mosques on the sites of Hindu temples which he had demolished. The result of his long reign was, however, divisive and after his death in 1707 India reverted to its pre-Mughal state of internal warfare, which, of course, opened the way to European colonization.

In the far south, never completely assimilated by the invaders who had poured into India from central Asia over the millennia, the tradition of Hindu art lived on, strengthened by an influx of refugees. Here in the early sixteenth century the 10-square-mile (2590 hectares) city of Vijayanagar had been built with huge temples richly adorned with sculpture, 'so well executed that

Although Marco Polo had nothing but praise for the

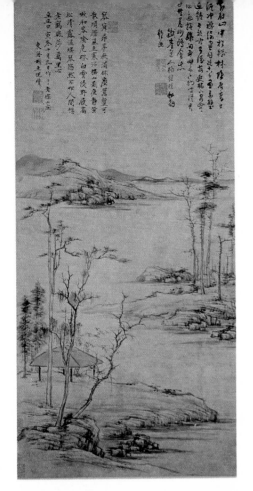

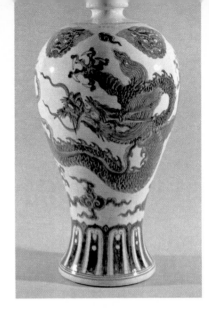

12, 37 *Opposite top left* The Taj Mahal, Agra, India, 1632–48.
12, 38 *Opposite top right* Anonymous (Govardhan?), *Hindu holy men*, c.1625. Pigment on paper, $9\frac{3}{8} \times 6$ins (23.8×15.2cm). Private collection.
12, 39 *Opposite bottom* Chao Meng-fu, *A sheep and goat*, c. 1300. Detail from a horizontal scroll, ink on paper, height $9\frac{7}{8}$ins (25cm). Freer Gallery of Art, Smithsonian Institution, Washington DC.
12, 40 *Left* Ni Tsan, *Autumn landscape*, early 14th century. Ink on paper. Nationalmuseum, Stockholm.
12, 41 *Above* Mei-p'ing Vase, 1426–35. Ming Dynasty (Hsüan-te era). Porcelain, height $21\frac{3}{4}$ins (55.2cm). Nelson Gallery–Atkins Museum, Kansas City.
12, 42 *Below* The Wang Shih Yüan garden, Suchou. 16th century. Ming Dynasty.

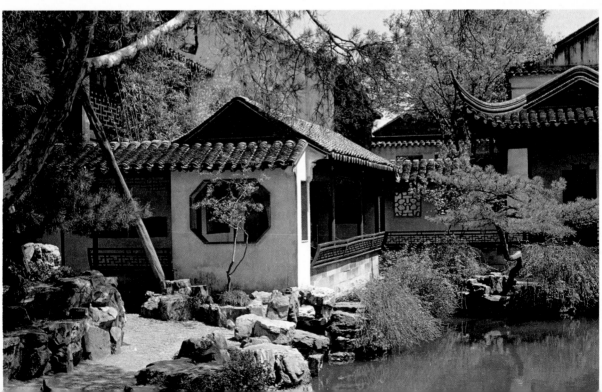

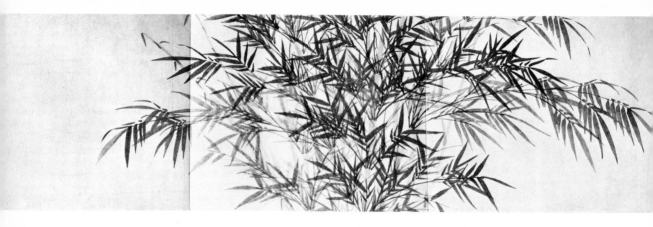

12, 43 Li K'an, *Bamboo*, c.1300. Detail from a horizontal scroll, ink on paper, height 13¾ins (34.9cm). Nelson Gallery–Atkins Museum, Kansas City.

splendour of Kubilai's court and the efficiency of his administration, the Chinese felt very differently, crushed beneath a burden of taxes which landowners could pay only by pressing on the peasants until they were reduced to serfdom. The country was devastated and a population estimated at 100,000,000 in the early Sung period had dwindled under the Mongols to 45,000,000, of whom 7,500,000 were officially reported to be starving. In 1325 there was a popular uprising against Chinese landlords and the Yüan regime, in 1348 rebellion broke out in the east and in 1368 the Mongols withdrew. The first emperor of the native Ming dynasty was installed on the Dragon Throne the same year.

Economically disastrous and relatively short though the Yüan period had been, it determined the future course of Chinese painting. A rift that was never to be bridged had opened between, on the one hand, professionals who worked in a decorative manner with much colour for the imperial court and wealthy patrons and, on the other hand, gentleman amateurs or scholar-painters or *literati*, as they are usually called, who cultivated painting, mainly in black and white, as an intensely personal and private form of art in accordance with the philosophical and religious ideals of an intellectual élite. With a few exceptions (12, 48) the former are now much less well known than the latter. Most professionals were thought little better than craftsmen by Chinese connoisseurs and writers on art—who were, of course, almost always scholar-painters themselves, which may partly account for the eclipse of the professional. Yüan scholar-painters were also, very often, poets and calligraphers, though rarely, as in former times, important government officials. They tended towards the contemplative and

introspective and looked back with reverence to the early art of China. Their paintings present convincing images of the natural world—always a prime aim for earlier Chinese artists—but are more concerned with the artist's inner vision. 'A painting is nothing but an idea', wrote Huang Kung-wang (1269–1354); 'what matters most when making a painting is the spirit of rightness'—and rightness implied adherence to tradition, both moral and artistic.

A painting of a sheep and goat by Chao Mêng-fu (1254–1322) illustrates the Yüan scholar-painters' dependence on the past, in this case early Sung realism, their sometimes almost defiant 'amateur' stance and their profound concern for art's inner meaning (12, 39). In his inscription Chao Mêng-fu stated that he had not previously painted these animals and did so now 'for amusement' to please a friend. A goat's characteristic movements are, in fact, brilliantly caught and the texture of its hair deftly suggested by a subtle mixture of wash and dry brush-strokes with very little use of outline. But to Chao Mêng-fu such naturalistic effects were no more than a means of capturing the rhythm of life or vital spirit, which can be sensed in natural forms. It could also be sensed in the works of old masters, but could not be injected into a painting simply by copying. Nevertheless, 'the spirit of antiquity' sometimes led, as in his case, to deliberate archaism. He was one of the leaders of a return to the styles of painting practiced under the T'ang and early Sung. He was also one of the few members of the intellectual aristocracy who accepted office under Kubilai and rose to a high position in the civil service—and his 'collaboration' was never entirely forgiven by other scholar-painters who wrote the history of Chinese art.

Both the life and the work of Ni Tsan (1301–74), on the other hand, were regarded as exemplary. He came from a rich merchant family, devoted himself exclusively to intellectual pursuits and, impoverished

by taxation, in 1352 disburdened himself of his remaining possessions to live on a small houseboat drifting around the beautiful rivers and lakes of south-eastern Kiangsu. Rejecting the delicacy and lyricism of late Sung painting (see p. 212), he created an art of austere detachment and understatement without any atmospheric effects or displays of virtuosity. His medium was black ink used with the utmost economy on absorbent paper, which was preferred at this period to glossy silk as a ground. Human figures very rarely appear in his landscapes, which are nearly always of the same imaginary scene, a group of sparsely leaved trees and a scholar's empty pavilion at the edge of a stretch of water with low hills rising from the farther shore (12, 40). 'Their air of supreme refinement and purity is so cold that it overawes men', wrote a late seventeenth-century Chinese painter who likened them to 'waves on the sandy beach, or streams between stones which roll and flow and issue by their own force'. His paintings have the moral qualities extolled by the Chinese, being firm without an undue display of strength, graceful without affectation, informal without being casual—very gentlemanly in their restraint and unpretentiousness and in the stern self-discipline and intense application which underlies them.

Some subjects had strong symbolic overtones for the scholar-painters. The resilient evergreen bamboo, for example, was likened to the perfectly educated gentleman who bends to circumstances, adapts himself to society yet preserves his integrity; and it is hardly a coincidence that the plant was more frequently painted than ever before under the oppressive Yüan dynasty, when these moral qualities were especially called for.

12, 44 Camel, 15th–16th century. Ming Dynasty. Stone, height c.98ins (250cm). Approach to the Ming tombs near Peking.

Bamboo painting became a distinct genre. Its stems and pointed leaves naturally had a particular fascination for artists who were also calligraphers, and its constantly changing appearance according to the season, time of day and humidity in the atmosphere presented a challenge to those who sought, in painting or in words, to grasp the vital spirit of nature. Li K'an (fl. 1260–1310) devoted his life to the plant, travelling as far as Assam to study different species, seeking out earlier bamboo paintings and writing a *Comprehensive Record of Bamboo*. He did not, however, advocate painting it direct from nature. The artist must, he wrote, accumulate his observations until he 'possesses' the bamboo completely in his mind and can depict what he holds in his mind's eye. Only in this way could its vital rhythm pass through the artist on to the paper and thence to the spectator. One of his few surviving scrolls shows two clumps of different species and a single stem painted with equal regard for botanical accuracy, for the naturalistic representation of growing leaves and gently swaying stems surrounded by warm air, and for the intricate organization of brush-strokes in a most carefully thought-out composition, which seems nevertheless to have been splashed on to the paper with spontaneous creative abandon (12, 43). By being cut at top and bottom, the image is brought up close to the picture plane and the spectator enters, as it were, into intimate relationship with it.

Although the Mongols provoked only a negative response from painters, they had a strong and lasting influence on the decorative arts by introducing new techniques. The blue-and-white colour-scheme so intimately associated with Chinese porcelain—especially in the West—was evolved under their rule by a marriage of Chinese and Iranian processes and materials. China provided the porcelain, which had been invented much earlier (p. 209), Iran the cobalt-oxide medium used for decorating Near Eastern earthenware. This was the most easily controllable medium for underglaze decorations and was at first used in China for motifs of an Iranian cast on porcelain vessels fashioned like the metalwork of the Mongols. During the Ming period the colour-scheme persisted, but all traces of foreign influence were expunged from the designs and Ming blue-and-white porcelain is as purely Chinese in decoration as in form (12, 41). Similarly, *cloisonné* enamelling introduced under the Mongols came to be used to enrich bronze vessels of shapes which hark back to the Shang period with brightly coloured T'ang style ornament.

The first Ming emperor, Hung-wu (1368–99), was a man of the people and won the throne by force of arms against a hated foreign oppressor. A return to ancient

12, 45 *Below* Anonymous, *Uesugi Shigefusa*, 14th century. Kamakura period. Painted wood, height 27½ins (70cm). Meigetsuin, Kamakura, Kanagawa prefecture, Japan.
12, 46 *Right* Anonymous, *Tales of the Heiji Insurrection*, detail, 13th–14th century. Kamakura period. Bodycolour and gold on paper, height c.16ins (41cm). Museum of Fine Arts, Boston.
12, 47 *Bottom* Nonomura Sotatsu, *Poppies* (detail), pre-1643. Edo period. Colour and gold leaf on paper, height 66ins (167.6cm). Museum of Fine Arts, Boston (gift of Mrs W. Scott Fitz).

national traditions was thus the order of the day. The civil service was restored with an even less flexible organization than before. Classical Chinese scholarship was revived and in 1403 the third Ming emperor, Yung-lo, initiated the compilation of all knowledge in an 11,095-volume encyclopedia. Respect for tradition was, however, tempered by a growing taste for ostentation. When Yung-lo moved his capital from Nanking to Peking in 1417, he had his palace laid out according to Chou dynasty ritual, which prescribed that the 'Son of Heaven' should rule from three courts. Raised on the site of Kubilai's palace and using some of the old foundations, it was also designed to outshine the splendour of buildings which Marco Polo had

thought 'so vast, so rich and so beautiful that no man on earth could design anything superior'. A 15-mile (24 km) wall surrounded the axially planned courts dominated by the three great halls of state, which were later rebuilt and refurbished but always in the same sacrosanct manner, with wooden columns and beams and wide-spreading roofs of shimmering glazed yellow tiles. Vast underground palaces built as tombs for the Ming emperors, some 30 miles (48km) outside Peking, were no less sumptuous. They are approached along a 'spirit road' flanked by large statues of men and monsters and of life-size camels and elephants carved with a bold realism recalling T'ang dynasty sculpture

12, 48 Lü Chi, *Winter*, c.1500. Ming Dynasty. Hanging scroll, ink and colour on silk, height 69ins (175.2cm). National Museum, Tokyo.

12, 49 Memorial pillar, 16th century. Ming Dynasty. Marble, Ceremonial gateway before the Ming tombs near Peking.

(12, 44). But a memorial pillar by one of the gates with a delicately cut relief of a dragon materializing out of a tight pattern of clouds is, perhaps, more typical of Ming taste (12, 49).

Conservatism, naturalism and opulence characterize the style of painting favoured at the Ming court. *Winter Scenery* by Lü Chi (1477–1521), with snow, water, rocks, gnarled trees, a brightly feathered cock pheasant, two small birds, flowers of prunus and bright-red camellias, derives from the bird and flower paintings of early Sung artists, who would, however, have contented themselves with two of its elements and half its colour (12, 48). The rushing torrent binds the composition together and gives the whole work a vigour conspicuously lacking in later renderings of similar subjects, which were exported in quantity to Europe and gave a misleading impression of Chinese art. Such a painting was intended to grace the wall of a princely palace, not to be scrutinized in the seclusion of a scholar's sanctum. It is a highly professional performance by one of the most gifted members of the imperial academy, who were, as already mentioned, despised as little better than craftsmen by the gentlemen amateurs.

The first Ming emperor was hostile to the scholar-

painters and they in turn were repelled by the court and court intrigues of his successors. The more exquisite and financially independent settled far away from the capital in the sunnier climate of Hang-chou and Su-chou, where they cultivated their talents and, quite literally, their gardens—designed as three-dimensional landscape paintings with trees and curiously shaped rocks framed by the columns and trellis-work of the covered walks (12, 42). Devoted exclusively to scholarship and the liberal arts of painting, calligraphy and poetry, they were amateurs only in the sense that they did not sell their work. A small album leaf on which Shên Chou (1427–1509) depicted himself standing aloof from the world on a mountain (12, 50) conveys their aims and attitudes as neatly as the wistful poem at which he gazes:

12, 50 *Top right* Shen Chou, *Poet on a mountain top*, late 15th century. Ming Dynasty. Album leaf, ink on paper, height 15¼ins (38.7cm). Nelson Gallery–Atkins Museum, Kansas City.
12, 51 *Above* Wên Chêng-ming, *Seven juniper trees*, 1532. Ming Dynasty. Detail of handscroll, ink on paper, height 11⅛ins (28.3cm). Honolulu Academy of Arts, Hawaii.

White clouds like a belt encircle the mountain's waist.
A stone ledge flying in space and the far, thin road.
I lean on my bramble staff and gazing into space
Make the note of my flute an answer to the surrounding torrent. (tr. R. Edwards)

In the Ming period the artist's poem was conceived more frequently than before as an integral part of the work of art both visually and intellectually, and as much attention was paid to its calligraphy as to the painting itself. Shên Chou was a close student and able imitator of the old masters, who now included Ni Tsan and other admired amateurs of the Yüan period, and he developed various styles, which he employed according to the mood of his subject. For the *Poet on a Mountain* he used his broad manner, with thick brush-strokes, dots of various sizes to represent vegetation and mark the main accents, united by graded ink washes. In his later years he attracted the friendship of Wen Cheng-ming (1407–1559), who took up painting seriously only after he had failed the civil service examination 28 times and held for a short while a minor post as an historian at the academy in Peking. Despite his late start, Wen Cheng-ming developed a highly personal style especially in paintings of juniper

trees, symbols of vitality in old age, and much more besides (12, 51). The scroll, from which a detail is illustrated here, has an inscription referring to the trees as 'flawless idols, spirits infinite' that 'hallow the Palace of the Stars, attendants subservient to Heaven's majesty'. But it demonstrates also an intense feeling for and grasp of pure form new to Chinese painting.

'Painting is no equal to mountains and water for the wonder of scenery, but mountains and water are no equal to painting for the sheer marvels of brush and ink', wrote Tung Chi'i-chang (1556–1646), summarizing a belief that had become prevalent among the scholar-painters and tended to remove art ever further from the direct representation of nature (12, 52). Conventional elements of landscape painting were pulled apart and reorganized in a monumental format, from which he rigorously excluded everything, including atmospheric effects, that might appeal to sentiment. Paramount importance was given to the brush-strokes dragging the ink thinly over the surface so that the paper shows through, concentrating densely in only a few areas. The effect is daunting in its austerity. Of the major painters of the Ming period he alone was a true *wen-jen* or scholar-official, and he rose to be president of the all-important Board of Ceremonies. As an examiner he was so severe that he provoked a student uprising and his treatment of his peasants was so autocratic that they revolted and burnt his house. Authoritarian also in his attitude to art, he wrote influential treatises enumerating the few painters of the Sung, Yüan and Ming periods who should be imitated—all of them scholars and constituting the core of what came to be called the Southern School. But the emphasis he placed on the spiritual qualities in works of art led him to make a proviso ignored by many later Chinese painters: 'Those who study the old masters and do not introduce some changes are as if closed in by a fence. If one imitates the models too closely, one is often still further removed from them.' In this way he justified his own bold originality—and also the still more radical individuality manifested by a few Chinese painters in the later seventeenth and eighteenth centuries (see Chapter 16).

Japan—Kamakura to Edo

Attempts by the Mongols to invade Japan in 1274 and 1281 were thwarted and the national style created more than a century earlier (see p. 215) continued to flourish in isolation throughout the Kamakura period (1185–1333). A tendency towards naturalism, more conspicuous in secular work than in religious images—which derived iconographically from the Buddhist art of China—is felt especially in portraiture, the art in which the Japanese had earlier shown pre-eminence (6, 47) and which now developed in both painting and sculpture, perhaps in connection with the cult of ancestors. A statue of Uesugi Shigefusa, for instance, is preserved in a temple built by his descendants (12, 45). Formal, frontally posed with only the slightest deviation from symmetry in the position of the hands, his body completely engulfed in the billowing drapery of court dress, which indicates his status in Japanese feudal society, it is, nevertheless, the portrait of an individual, a speaking likeness of a member of the ruling class. The realism of such works reflects a taste for the down-to-earth, a taste prevalent among the aristocracy at the time and perhaps more often expressed in painting, where it was combined with the Japanese flair for bold, decorative design.

The art of narrative painting on scrolls, originally introduced to Japan from China with Buddhism, was secularized in about the eleventh century, when works

12, 52 Tung Ch'i-ch'ang, *Autumn mountains*, early 17th century. Ming Dynasty. Detail of handscroll, ink on paper, height 15⅛ins (38.4cm). Cleveland Museum of Art.

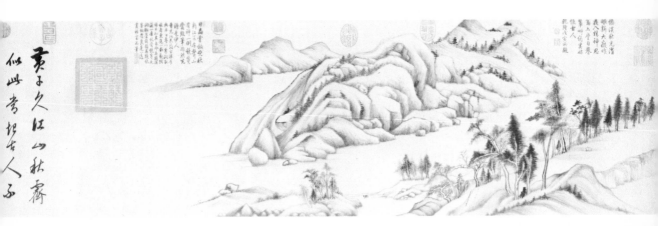

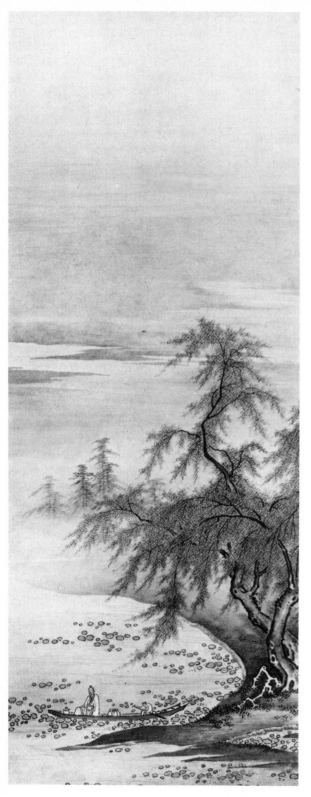

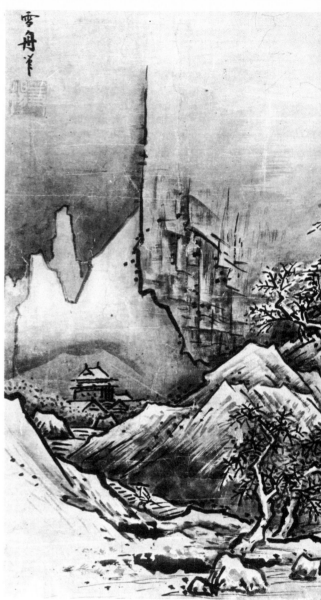

12, 53 *Left* Kano Masanobu, *Chou Mao-shu admiring the lotus*, c.1500. Muromachi period. Ink and faint colour on paper, 35⅜ × 12⅝ins (89.9 × 32cm). National Museum, Tokyo.
12, 54 *Above* Sesshu, *Winter landscape*, c.1495. Muromachi period. Ink and faint colour on paper, 17¾ × 10⅝ins (45 × 27cm). National Museum, Tokyo.

of fiction were illustrated, notably Lady Murasaki's famous *Tale of Genji*. Such paintings are called *Yamato-e*, 'Japanese paintings', to distinguish them from those in the Chinese manner. The scrolls, rarely as much as 15 inches (38cm) high but up to 30 feet (9.1m) long to include numerous scenes, differ from the

panoramic landscapes of Chinese painting both in format (narrower and much longer) and in style and subject-matter. As a Chinese writer of the time remarked, Japanese painters 'portray the natural objects, landscapes and intimate scenes of their own country. Their pigments are laid on very thick, and they make much use of gold and jade colours'. Dismayed by its complete lack of philosophical content, he was able to commend this type of painting only 'for the way it shows the people and customs of a foreign land in an unfamiliar quarter, a country which is rude and out of the way, uncivilized, lacking ceremonies and propriety'.

Recent events were recorded on several *Yamato-e* scrolls of the thirteenth century, such as the war between rival branches of the imperial family which broke out in Kyoto in 1159 and ended with the establishment of the dictatorship at Kamakura. A succession of scenes is presented in bright, sharply contrasting colours, all painted from a bird's eye viewpoint with architecture slanting diagonally across the paper and sometimes open to show interiors—a characteristic of *Yamato-e*. Emphasis is on telling circumstantial details, especially of military costume, and on swift energetic action which leads the eye excitedly forward from one turbulent episode to the next (12, 46). Bullocks draw carriages with whirling wheels, horses gallop, running soldiers rattle sabres and brandish long bows in a *mêlée*, which is, none the

less, composed with decorative aplomb and great narrative skill to suggest constant movement from right to left. Glorifying the thrill of battle and expressing a love of martial pageantry, which members of the Japanese upper class shared with contemporary chivalry in Europe, these scrolls are a very far cry from the reveries of Chinese scholar-painters of about the same time (6, 53). Before the end of the Kamakura period, however, the influence of Chinese painting was reasserted as a result of the spread of Ch'an Buddhism (see p. 210), known in Japan as Zen, and the leading artists turned to work in monochrome. A Zen tenet states that 'many colours blind the vision'.

Links with China were greatly strengthened in the course of the fifteenth century. In the Zen monasteries, which were now the main cultural centres, priests read and wrote nature poetry in Chinese. They also admired and practiced ink painting in the Chinese manner, as a means of attaining enlightenment by breaking through the barriers of the physical world to ultimate reality. These communities still preserve some of the finest early Chinese Ch'an paintings, including the *Six Persimmons* by Mu Chi and the imaginary *Portrait of Li Po* by Liang K'ai, two of the originators of the style and more highly regarded in Japan than in their own country (6, 50 & 51). The greatest Japanese master of ink painting, Sesshu (1420–1506), was trained in Zen monasteries and became a *gaso* or priest-painter—the existence of such a denomination indicates the importance given to painting by Zen Buddhists. Sesshu travelled in China in 1467–9, studying both art and the natural landscape, which was to be a permanent source

12, 55 Hasegawa Tohaku, *Pine trees*, 1539–1610. Momoyama period. Ink on paper, height 61ins (155cm). National Museum, Tokyo.

of inspiration for him. There is nothing imitative about his work, however, as his *Winter Landscape* shows (12, 54). Instead of the delicate brushwork and soft atmospheric effects of Chinese painting, his landscapes are firmly structured in bold, jagged linear designs. Conventional elements of Chinese landscape, gnarled trees, rocks, distant crags, jutting cliffs, a temple and a diminutive human figure climbing up to it, are rendered as if suddenly revealed in the cold, flattening illumination of a flash of lightning—a sudden vision corresponding to the mental spasm of transcendental Zen experience.

Ink painting was also practiced by artists less closely associated with Zen, notably Kano Masanobu (1434–1530), the founder of six generations of painters—one of the several dynasties which play a leading role in the history of Japanese art. His serene vision of the Chinese philosopher Chou Mao-shu admiring lotuses from a boat in a lake is an exemplary illustration of the Zen love of nature and of virtue, but it is painted with as much attention to subtle decorative effect as to literary or moral content (12, 53). It is a

hanging scroll of the format which became popular from the fifteenth century onwards with the introduction of the *toko-no-ma* or picture alcove, still a common feature of the Japanese interior. Screens were also painted in ink monochrome. A pair by Hasegawa Tohaku (1539–1610) of pine trees exploits the splashed ink technique used by Zen masters, including Sesshu, in a composition which takes to its limit Japanese daring and economy in asymmetrical design (12, 55).

Such exquisite and delicate effects were, however, rather unusual on screens, which were more often boldly painted with the brilliant colours of the *Yamato-e* palette and a great deal of gold. Painted screens and sliding panels were used to enliven the otherwise austere, bare and completely unfurnished rooms of the period, such as still survive in the castles built for the daimos or feudal lords. After the Muromachi period (1334–1573) of almost constant civil war, castles were built to combine elegance with strength and were sometimes sited with hardly less regard for the views they afforded of the surrounding landscape than for defence. At Himeji, massive stone fortifications are surmounted by a five-story structure of wood coated in white plaster, with a complex arrangement of gables and eaves tilted up at the

12, 56 Himeji Castle, Hyogo prefecture, Japan. Late 16th century. Momoyama period.

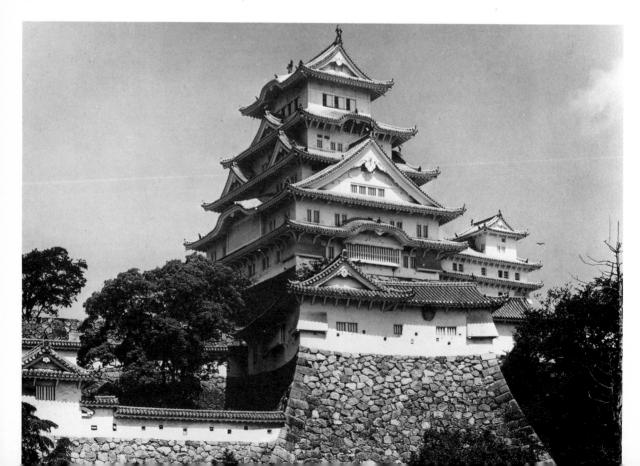

dominant faith of the ruling classes and began to permeate Japanese life and art. Undogmatic and unsystematic, anti-logical, intuitive, non-theological to the point of being almost irreligious, Zen made a direct appeal to the war lords and samurai. It provided a strenuous practical discipline to fortify the will in the individual's struggle for self-knowledge and against self-ness. Frugal simplicity of life and indifference to both sensual pleasure and physical pain were extolled.

12, 58 *Below* Tea Ceremony rooms, Daitokugi monastery, Kyoto, Japan, c.1573–1615. Momoyama period.
12, 59 *Bottom* Oribe ware plate, 17th century. Edo period. Stoneware with green and transparent glaze, submerged wheel decoration in brown slip. Diameter 8ins (20.3cm). Seattle Art Museum (Eugene Fuller Memorial Collection).

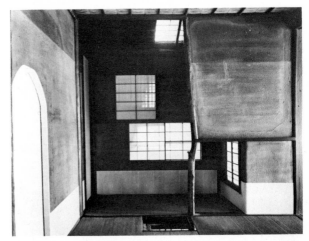

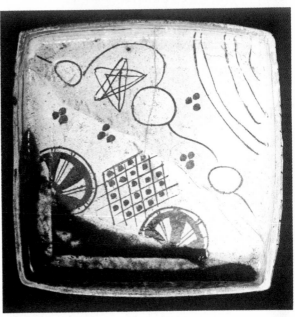

12, 57 Nonomura Sotatsu, *The Zen priest Choka*, pre-1643. Edo period. Ink on paper, 37¾ × 15¼ins (96 × 38.8cm). Cleveland Museum of Art (Norman O. Stone and Ella A. Stone Memorial Fund).

corners which gives it an almost weightless appearance (12, 56). The high base was made necessary by the introduction of fire-arms from Europe in the mid-sixteenth century, and the departure from the single story normal for secular buildings in Japan may also perhaps be due to Western influence. Religious architecture, on the other hand, underwent no significant change after the thirteenth century. Temples destroyed in the civil wars were reconstructed exactly as before.

During the Kamakura and Muromachi periods Zen Buddhism became—what it long remained—the

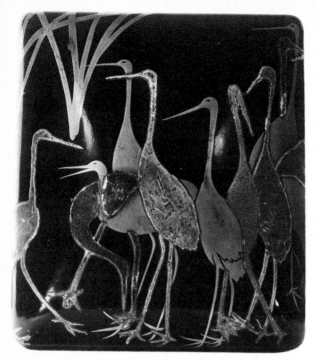

12, 60 Writing box, 17th century. Edo period. Black lacquer on wood, gold paint, inlaid lead and pewter, $8\frac{1}{2} \times 9\frac{1}{8}$ins (21.6 × 23.2cm). Seattle Art Museum (Gift of the late Mrs Donald E. Frederick).

Book learning, rational argument and philosophy were dismissed as valueless. Zen masters taught by baffling the disciple's mind with paradoxes of inconsequential discourse until it broke through to a direct vision of 'things as they are'—the ultimate reality. Warfare could be seen as a life-and-death struggle, uninhibited by fear, not only with the enemy but also with the self—for to the Zen Buddhist the self is the greatest enemy.

In the more peaceful climate of the Edo period (1615–1867, called after the capital, which was renamed Tokyo in 1868) Zen retained its hold. But a new decorative elegance appeared in Zen painting. Nonomura Sotatsu (d.1643), for instance, depicted with irreverent Zen humour a priest meditating up a tree. Fluid graceful brushwork is combined with a keen appreciation of the decorative possibilities of asymmetry (12, 57). On the other hand, a screen by the same artist with poppies on a gold ground that glints through their petals, reveals how a work of art with a mainly decorative purpose could yet be interfused with a Zen feeling for nature (12, 47).

Among the laity Zen ideals were most prominently expressed in the unceremonious ritual of the tea-ceremony or Cha-no-yu, with its formal informality, its

sophisticated cultivation of the unsophisticated, its artificial naturalness. Tea drinking, introduced from China with Buddhism, was a feature of social life in Zen monasteries. By the late sixteenth century rooms set apart for it had acquired a style, or rather a contrived non-style, being constructed of roughly worked natural materials, stripped tree-trunks, bamboos and reeds, rectangular in plan but with irregularly, one might think haphazardly, placed windows (12, 58). To capture this spirit in the city, small thatched tea-houses (chachitsu), surrounded by appropriately natural and apparently untended gardens with lichened stones, moss and fallen leaves, were erected in the grounds of palaces and upper-class houses. Here, under the guidance of a tea-master, who was both arbiter of taste and censor of behaviour, a select company would meet in an atmosphere of quiet harmony to drink tea and to admire and discuss poetry, paintings and arrangements of flowers. The vessels used were of coarse pottery, at first peasant wares imported from China but later pieces made expressly for the purpose in Japan, erratic in shape, uneven in surface and with decorations of seemingly artless spontaneity (12, 59). They were, and still are, admired for the correspondence of form, texture and weight according to an aesthetic which defies logical analysis. Appreciation of accidental effects, irregularity and asymmetry, which sharply distinguishes Japanese from Chinese attitudes to the arts, is nowhere more clearly reflected than in these little cups and bowls. Devotees of the tea-ceremony were, nevertheless, just as appreciative of the most exquisitely finished works of art and craftsmanship, such as lacquer boxes painted in gold and inlaid with metals (12, 60).

A similar, though less extreme, taste for simplicity

12, 61 Katsura palace, Kyoto, Japan, 16th century. Edo period.

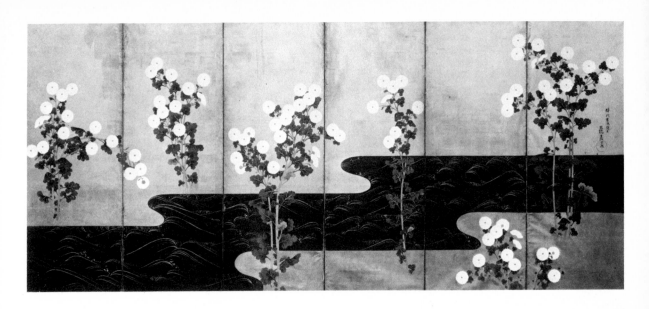

12, 62 Ogata Korin, *Chrysanthemums by a stream*, c.1700. Edo period. Colour and gold on paper, height 67ins (170cm). Cleveland Museum of Art (Gift of Hanna Fund).

and formal informality also governed the design of the finest example of seventeenth-century Japanese architecture, the Katsura Palace at Kyoto, built for a prince of the imperial family (12, 61). It is a single-story building with an asymmetrical, totally unmonumental plan. A succession of rooms opening out of one another vary in size but are all proportioned according to a module derived from the standard 6-by-3-foot (180 by 90cm) straw mat, which unobtrusively unites the separate rooms into a harmonious spatial flow. The exterior is uncompromisingly rectilinear in contrast to the garden setting, where all straight lines are carefully avoided. The module observed in the interior determines the proportions of the windows, which are likewise related asymmetrically to the gables of the roof. From every point of view—there is no main façade in the European or Chinese sense—a most delicate balance is maintained between horizontals and verticals, solids and voids, the linear and the spatial. Decoration is reserved for the interior walls, some of which are sliding panels and can be drawn back to unite rooms. Both inside and out the carving of the woodwork is of the utmost precision, satisfying a demand for meticulous workmanship complemented by that for rusticity in the nearby teahouse.

The peace brought to Japan by the centralized government of the Edo period encouraged trade and the rise of a prosperous merchant class. In these circumstances secular art flourished as never before. Painted screens for the domestic interior were produced in quantity and some are among the most beautiful examples of purely decorative art ever created. A pair by Ogata Korin (1658–1716), one of the leading painters of his period, combines mastery of both abstract patterning and naturalistic representation (12, 62). The gracefully swaying stems of the chrysanthemums are set off by the rigid rectilinear panels and the schematic rendering of the stream, and their blossoms grouped in twos and threes and fours create a kind of fugal rhythm. Colours are limited to azurite blue, emerald green, jade green, gold and, for the blossoms, pure white modelled in relief. Such screens were, of course, luxury products, but their opulence is restrained. They are quintessentially Japanese in form, style and subject-matter.

The integrity of this style of painting was preserved throughout the Edo period by conservatism and the isolationist policy of the government. Japan cut itself off from the rest of the world in 1638, when Portuguese traders, who had first arrived in 1542, were expelled. Christianity, introduced by St Francis Xavier, was proscribed. Therafter trade with Europe was carried on through the Dutch, whom the Japanese held at arm's length, allowing them no closer than an island off Nagasaki harbour. Exports, mainly lacquer and porcelain, were specially designed for the foreign market, and thus Europeans had for long a very partial and misleading impression of Japanese art, as they had, for similar reasons, of Chinese art.

13 The seventeenth century in Europe

The rise of the Dutch republic was the most momentous event in the history of seventeenth-century Europe, coinciding with the decline of Spain and the Thirty Years' War (1618–48), which devastated Germany and destroyed the authority of the Holy Roman Empire. Holland, and six other provinces of the Netherlands which rebelled against Spanish rule (1579–1609), became one of the richest of European states and by far the least intolerant. Its prosperity was founded on free enterprise at home and world-wide maritime trade. So, too, was that of England, where the principle of parliamentary government was gradually being accepted. Throughout Europe, but especially in the north, there was a revolt against long-established authority, most notably in scientific thought, where great advances were made in astronomy and mathematics. An experimental and inductive approach to the physical sciences proposed by Francis Bacon (1561–1626) at the beginning of the century was widely accepted by the end. Above all, Western philosophy was freed from two millennia of dependence on Plato and Aristotle by René Descartes (1596–1650), whose *Discourse on Method* (1637) set forth a new theory of knowledge, an extreme form of scepticism that led, by a systematic process of doubt, to the famous conclusion: 'I think therefore I am'. This made mind more certain than matter, and the individual mind the most certain of all, with subjective implications that were far-reaching. Though French and a Catholic, Descartes wrote and published his works in the Dutch republic.

This great explosion of speculative thinking did not have any immediate effect on the visual arts. (For a time art and thought moved 'out-of-phase', although the sudden flowering of Dutch painting followed relatively quickly, see p. 450.) Moreover, it coincided with the recovery of the Papacy from the blow of the Protestant Reformation so that Rome became once again a great artistic centre; while in France autocracy

triumphed and was given its most magnificent expression.

New beginnings in Rome

In Rome new life was breathed into old forms by two artists from northern Italy, Annibale Carracci (1560–1609) and Caravaggio (Michelangelo Merisi, 1571–1610). Although they were later to be seen as the founders of two irreconcilably divergent tendencies (idealism and naturalism), both were equally admired in their own time, often by the same people. In 1600, indeed, an ecclesiastical lawyer commissioned for his funerary chapel in S Maria del Popolo, Rome, an altarpiece from Annibale Carracci and two paintings for the side walls from Caravaggio.

In one of the latter, the *Conversion of St Paul*, naturalism has completely replaced the symbolism usual in religious painting (13, 1). There are none of the rhetorical antitheses and stylish 'figures of art' beloved by the Mannerists of the mid-sixteenth century. It has the directness of the spare New Testament account of how Saul the persecutor of the Christians was miraculously converted into an apostle, as if Caravaggio had accepted the robustness and conviction of High Renaissance art but rejected its idealism. St Paul is a coarse-featured young soldier with a first growth of beard, his horse a sturdy piebald held by an old man with wrinkled brow and balding head—one of the peasants whose prominence in later pictures by Caravaggio shocked some contemporaries. Rough textures are rendered with illusionistic skill. This is not, however, naturalism for its own sake. The painting effectively illustrates, as the contract specified, 'the mystery' of St Paul's conversion. His arms and hands are spread to embrace the divine light which blinds him and penetrates his heart. Caravaggio was almost certainly aware of the importance placed by St Ignatius Loyola's *Spiritual Exercises* on the senses rather than the intellect as a means of attaining spiritual under-

standing, and his picture, with its life-size and lifelike figures, is an open invitation to participate in the mystery of conversion. Significantly, it makes its most dramatic effect when seen from a kneeling position at the entrance to the chapel.

Only three years after this painting was completed the Dutch painter and writer Karel van Mander (1548–1606) published a report of the 'remarkable things' Caravaggio was doing in Rome:

He holds that all works are nothing but *bagatelles*, child's work, whatever their subject and by whomever painted, unless they be painted after life and that nothing could be good and nothing better than

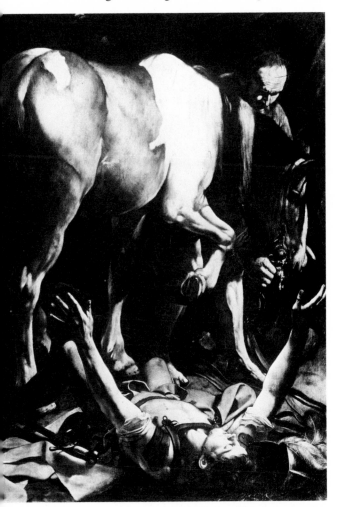

13, 1 Caravaggio, *Conversion of St Paul*, c. 1601. Canvas, 90½ × 68⅞ins (230 × 175cm). S Maria del Popolo, Rome.

to follow Nature. Whence it is that he will not do a single brush-stroke without close study from life which he copies and paints. Surely this is no wrong way to achieve a good end. For to paint after drawings, even though they be done after life, is nowise as reliable as to face life and to follow nature with all her different colours. (*Het Schilder-Boeck*, Haarlem 1604, trs W. Friedlaender)

This contradicts practically all the theoretical writings of the sixteenth century, yet van Mander called it 'an example for our young artists to follow'—and follow it they did. Within a decade Caravaggism, as it came to be called, had spread throughout Italy to Spain, France and the Netherlands. There was a proliferation of pictures with unidealized, boldly illuminated figures set against dark, mysterious backgrounds. But van Mander also spread the news of Annibale Carracci's recent work in Palazzo Farnese, Rome (13, 6).

Annibale Carracci broke with the immediate past no less decisively than Caravaggio. His first biographer, the influential art theorist Giovanni Pietro Bellori (c. 1615–96) claimed that he rescued painting from 'Mannerism'—a term which now took on its pejorative meaning (see p. 379). The Sistine Chapel ceiling (11, 29) was one source of inspiration for the Palazzo Farnese ceiling, but Carracci rationalized Michelangelo's scheme, clarifying the distinction between levels of reality. The decorative structure, with simulated stucco reliefs of Atlantes and bronze medallions, is painted illusionistically, skilfully foreshortened and lit as if from the real source of light below, whereas the narrative scenes, celebrating the divine power of love, are rendered like framed pictures (*quadri riportati*) placed in front of the decorative structure. They are painted in a style inspired by Raphael and antique sculpture, evenly lit, Classically composed with figures parallel to the picture plane.

Annibale Carracci also differed from Caravaggio in his working methods. Some 500 drawings were made in the process of working out his design for the Farnese ceiling. He, his brother Agostino (1557–1602) and their cousin Lodovico Carracci (1555–1619) were all indefatigable draftsmen. They drew everything, compositions for painting, models in the studio, people in the street, and the first caricatures (they invented the word). At meal-times they sat with bread in one hand and a piece of charcoal in the other. Their aim was fidelity to nature, but to a nature purified of all grosser elements, and in pursuing it they turned for guidance to antique sculpture and the masters of the High Renaissance. Annibale Carracci was no theorist, but his work soon came to be extolled as the exemplar of a

13, 2 David Teniers, *The Picture Gallery of Archduke Leopold Wilhelm of Austria*, c. 1647. Canvas, 41¾ × 50¾ins (106 × 129cm). Prado, Madrid.

rationalized version of sixteenth-century aesthetic theory, substituting for the Neoplatonic metaphysical 'Idea' (see p. 176) an ideal derived purely from art itself. For more than two centuries it was to provide the basis of all academic teaching.

In Bologna in the 1580s the Carracci had organized gatherings of artists called the *Accademia degli Incamminati* (academy of the initiated). It was one of several such informal groups that enabled artists to discuss problems and practice drawing in an atmosphere calmer and more studious than that of a painter's workshop. The term 'academy' was more generally applied at the time to literary associations, membership of which conferred intellectual rank. The first academy of artists was founded in Florence in 1563 and had similar social ambitions, together with the more practical purpose of freeing painters and sculptors from the restrictions of the craft guilds. The two types of academy were combined at the Academy of St Luke in Rome, which, from the early seventeenth

century, provided lectures on theory, instruction in design and facilities for life-classes to supplement the training given to an apprentice in a master's workshop. Similar academies sprang up elsewhere in Italy and in northern Europe, most notably in Paris, where art education was to be more highly organized than anywhere else (see p. 457).

Alongside, and perhaps not unconnected with, the rise of academies was the widespread growth of art-collecting in the seventeenth century, both of Old Masters and contemporary works, which naturally led to art dealing. This diverted attention from large-scale mural painting and other traditional forms towards the more easily transportable and negotiable easel painting, which now began to occupy in European art a place of prime importance. It was, and is, a unique phenomenon, without parallel in other cultures. Vast collections were made by Charles I of England, Philip IV of Spain, the self-exiled Queen Christina of Sweden, Cardinal Mazarin, the ruler of France during Louis XIV's long minority, not to mention minor noblemen and rich bankers. Part of the collection made by Archduke Leopold Wilhelm of Austria, governor of the Spanish Netherlands, is recorded visually—a room

stuffed with paintings by Giorgione (the *Three Philosophers* [11, 30] is visible on the right), Titian (the top row) and other Venetians (13, 2). Raphael's *St Margaret* is propped against a large sketch by Rubens for a *Circumcision*. In such surroundings devotional images were separated from portraits, still-life paintings, landscapes and mythological scenes only by their gilt frames and thus tended to lose whatever religious meaning they originally had. They were looked upon quite simply as works of art like all the others: pictures acquired mainly to demonstrate the owner's status, wealth and discriminating taste. A preference for the already rare and very expensive works by High Renaissance masters agreed with academic teaching, but there were also, by the mid-seventeenth century, perceptive collectors sensitive to qualities other than those stressed by theorists—such as freedom of handling and lubricity of subject-matter—and in the subsequent history of European painting their taste was to be increasingly important.

Baroque art and architecture

Like many other stylistic labels, 'Baroque' was first used as a term of critical abuse. It has a curious etymology, being derived from two words current in the sixteenth century, the Italian *barocco* referring to tortuous medieval pedantry, and the Portuguese *barrocco*, a deformed pearl. Both signified deviation from a norm, and in this sense mid-eighteenth-century theorists took them up to describe works of art, and especially architecture, which seemed to them impure and irrational. Although no longer pejorative, the term is still used to isolate a single strand from the tightly woven fabric of seventeenth-century art, that strand of predominantly religious emotionalism, dynamic energy and exuberant decorative richness which was generated in Rome and spread all over Europe and beyond, including the European colonies in America and India. The distinction between this so-called 'Baroque' and other seventeenth-century styles, such as those of the 'Naturalists' and 'Classicists', is not easy to define. Despite superficial differences, there are similarities which run deep, and the art of the seventeenth century is best understood as a whole, as a nexus of various stylistic impulses. Essentially, it was the creation of strong-minded individualists, among whom were some of the greatest of all European artists. Apart from Peter Paul Rubens (1577–1640), they were all born within a few years of each other: Nicolas Poussin (1594–1665), Gianlorenzo Bernini (1598–1664), Anthony van Dyck (1599–1641), Diego de Velázquez (1599–1660), Claude Lorraine (1600–82) and Rembrandt van Rijn (1606–69).

Rubens stands somewhat apart, not only because of his age but also because of his social background, for he was an active and high-ranking diplomat as well as a painter. The son of a prominent lawyer and alderman of Antwerp, Rubens was given a Classical education and then lived for a period in a noble household to acquire aristocratic manners before beginning his training as a painter. In 1598 he qualified as a master in the Antwerp artists' guild and two years later left for Italy, where he lived and travelled in some style while pursuing his artistic career at the little ducal court of Mantua. Back in Antwerp in 1609 he was appointed court painter to the Habsburg regent of the Netherlands and very soon he was the most highly esteemed artist in Europe, occupying a position analogous to that of Titian in the previous century.

No artist ever studied the works of the Italian masters more diligently and closely than Rubens—he copied them in literally hundreds of drawings and painted sketches. Although he copied them in order to learn by exploring the means of pictorial representation, his robust sensuality and fertile imagination stamped his copies, like everything that came out of his studio, with a strongly individual character. A painting of the gods Castor and Pollux carrying off the daughters of Leucippus (13, 3), for example, may well have been inspired partly by Titian's *Rape of Europa* (11, 31), which he had copied in Spain. There are also reminiscences of Veronese in the glossy silken draperies, and his debt to Flemish painters, especially Pieter Bruegel, is evident in the landscape. All these disparate influences have, however, been completely absorbed and transmuted in the heat of Rubens's imagination. A new and very personal ideal of female beauty, full-breasted, broad-waisted, more womanly than girlish, as natural in amplitude of figure as in innocent freedom from coquetry, is celebrated with full-blooded exuberance. The dimpling and puckered flesh of his female nudes is painted in pearly translucent colours both suggesting the smoothness and warmth of skin and enabling him to depict the blush on a cheek without so much as a hint of cosmetic artifice—a rare achievement in paint.

In the *Rape of the Daughters of Leucippus* the two women are in precisely complementary poses, the one presenting almost a mirror image of the other. Such antitheses were not uncommon in sixteenth-century paintings but Rubens used them without the usual rhetorical emphasis, simply in order to enhance the swirling impression of dynamic movement. Rejecting the stability of a pyramidal composition, he designed the picture as a diamond of intersecting diagonals within which the large swinging movement, the twist

and counter-twist of intertwined forms, so typical of 'Baroque' art and architecture, gives a sense of expansive ascension, a suggestion of rapture rather than rape. There is no violence; the central figure seems to float upwards, merely supported on the brawny arms of the two gods. Despite the theme, the effect is curiously unerotic—rather as Rubens's religious pictures are unmystical.

Whether he was painting a mythological or a sacred subject, Rubens concentrated on the vitality and corporeality of the figures, seeking in this way to bring the supernatural world within the grasp of human experience. Many of his religious paintings were for Jesuit churches, including a whole cycle for one in Antwerp, where, a contemporary wrote, 'the magnificence of the interior of the edifice turns the thoughts to the abode of heaven'. The original austerity of their mother-church in Rome (11, 41) was abandoned by the Jesuits in Antwerp, on a contested frontier of Catholicism, where they spared no pains to uplift the minds of beholders by dazzling their eyes. Two huge canvases depicting the first Jesuit saints, Ignatius Loyola and Francis Xavier, were placed alternately above the high altar. That of St Francis Xavier (1506–52), who had preached the gospel in India, Ceylon, south-east Asia and Japan, records the miracles he performed and celebrates the world-wide mission of the Society of Jesus (13, 4). It is very much a Eurocentric vision of the world. Only the recumbent Hindu with shaved head on the left is Oriental. The pagan temple from which the idol topples down has Corinthian columns, and the saint himself stands in the attitude of a Roman emperor addressing his troops—a motif taken from the Arch of Constantine. As several drawings reveal, Rubens made studies from life for individual figures but the final work is built up in colour and light rather than by line. The episodic nature of the subject enabled him to represent in subtly differentiated facial expressions a wide gamut of human emotions, for he shared to the full his contemporaries' interest in what were called the 'passions of the soul' and is said to have composed a treatise on the subject 'with appropriate illustrations after the best masters, especially Raphael'. In this respect, indeed, he may have sought to rival Raphael's *Transfiguration* (11, 16) in *The Miracles of St Francis Xavier*. His principal achievement was, however, to unify this 17-foot-high (5.2m) composition with a sweeping spiral which curls round the saint and his attendant in their black habits, silhouetted against the sky. The eye is led, and the mind follows, a line from the blind men groping their way forward in the lower right corner, to a man who has been raised from the

13, 3 *Above* Rubens, *Rape of the Daughters of Leucippus*, c. 1616–17. Canvas, $87\frac{1}{2} \times 82\frac{1}{4}$ins (222.3 × 209cm). Alte Pinakothek, Munich.
13, 4 *Right* Rubens, *The Miracles of St Francis Xavier*, 1616–17. Canvas, $210\frac{5}{8} \times 155\frac{1}{2}$ins (535 × 395cm). Kunsthistorisches Museum, Vienna.

dead, past the sick Hindu and along the beams of light striking the temple to the visionary personification of Faith in the heavens.

'I am by natural instinct better fitted to execute very large works than little curiosities', Rubens wrote in a letter of 1621. 'I have never lacked courage to undertake any design, however vast in size or diversified in subject'—as his twenty-one 12-foot-high (3.7m) canvases illustrating the life of Marie de Médici, queen of France, confirm. (Painted between 1621 and 1625, they are now in the Louvre, Paris.) Yet his small, intimate works are unsurpassed in their combination of delicacy and robustness. The head of his bright-eyed smiling first wife, Isabella Brant, is one of the most arresting (13, 5). It also exemplifies his essentially painterly vision, even in a chalk drawing. His prodigious ability to define form fully in a small rapid sketch had, however, a dubious side-effect: it enabled him to turn over to his staff of assistants much of the work commissioned from him. Often he would add no

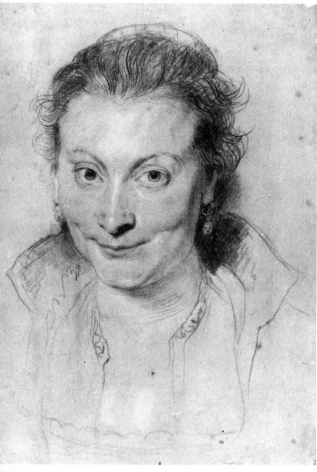

13, 5 *Above* Rubens, *Portrait of Isabella Brant*, c. 1622. Black, red and white chalk with light washes on light brown paper, the eyes strengthened with pen and black ink, 15 × 11⅝ins (38.1 × 29.5cm). British Museum, London.
13, 6 *Right* Annibale Carracci, ceiling frescoes, 1597–1600. Palazzo Farnese, Rome.

own sake and on a large scale (13, 11). Pride in land-ownership may have prompted these works, which he evidently painted for himself. But they seem to be still more deeply personal—celebrations, as it were, of the goodness and plenitude of creation on the part of a middle-aged man who had recently married a second wife, 27 years his junior, and was fathering a new family of children. Very vividly do they convey, in the generous all-embracing 'Baroque' rhythm of their great arcs and spirals, a sense of perpetual growth and change as the earth revolves in its diurnal course, and a sense, too, of an aging man's longing to catch and hold the fleeting moment, all of which gives them a deeply moving human dimension. Rainbows appear, storm-clouds roll away and through them sunlight, which always seems brighter after rain, strikes on patches of meadow land and glistens on wet leaves, while the workaday life of the farm goes on undisturbed—buxom milkmaids lead the cattle home to the byre, men build stacks of new-mown hay, geese paddle in the flowing stream.

Of Rubens's many assistants and followers, Anthony van Dyck (1599–1641) was the most notable. He painted both religious and mythological subjects, but it was as a portrait painter that he excelled and in 1632 he was appointed court painter to Charles I (1625–49) in England. In deference to Charles I's obsession with the idea of kingship van Dyck portrayed him some 20 times in a variety of richly symbolic roles—as the knight of St George and commander of armies, as the perfect Renaissance gentleman cultivated in mind and body, self-assured and unaffected in manner, as faithful husband and fond father both of his children and of the nation. Charles I, in fact of diminutive stature and rather plain features, was wonderfully transfigured in these por-traits. In one he appears in imperial guise mounted like Marcus Aurelius, but on a nobler horse and riding through a triumphal arch (13, 7). A low viewpoint silhouetting the king against the sky within a grandiose architectural framework—a device used to exalt saints in altarpieces—was here employed in the service of divinely appointed monarchy. It must have looked still more imposing in its original position, at the end of a long gallery hung with pictures of ancient Roman emperors by Giulio Romano and Titian, masterpieces in the great art collection Charles I amassed. The propagandist value of paintings by both old and modern masters was nowhere more fully exploited.

But despite the fame of Rubens and van Dyck, the works of art most eagerly sought by collectors were Italian. At the beginning of his reign Charles I had invited to England two painters of the Bolognese

more than the final touches to a painting (though he honestly adjusted his prices according to the extent of his own participation). The rate of production was such that his studio has been likened to a factory. This is rather misleading, for it was a studio directed by a genius, who, moreover, never let it slip from his control.

He made a fortune and in 1635 bought a country estate, the Château de Steen, a few miles south of Antwerp. But he did not retire. The surrounding country inspired a series of paintings which suddenly revealed, in his late fifties, a new aspect of his art. For although he had often sketched views from nature, only now did he depict the scenery of Flanders for its

13, 7 Anthony van Dyck, *Portrait of Charles I*, 1633. Canvas,
145 × 106¼ins (368.4 × 269.9cm). Buckingham Palace, London.
Reproduced by Gracious Permission of H. M. The Queen.

heroine may have added a sense of alarm. Artemisia
specialized in scenes in which women play a dominant
role. But although she had good reason to distrust
men—she was seduced by her teacher of perspective
and when her father brought him into court *she* was
tortured with the thumb-screw to ascertain the truth of
her evidence—her choice of subjects was probably
determined as much by the expectations of her patrons
as by her personal feelings. A rather cool, businesslike
character is revealed in her letters.

Artemisia Gentileschi worked for most of her career
in Naples, where naturalism flourished under the
patronage of Spanish rulers and the stimulus of such
Spanish painters as Jusepe de Ribera (1591–1652), who
lived there from 1616 onwards. In Rome, on the other
hand, despite the great popularity of small pictures of
peasants and beggars—usually by Flemish artists
settled in the city—idealization was demanded in large

13, 8 Artemisia Gentileschi, *Judith slaying Holofernes*, c. 1620.
Canvas, 78⅓ × 64ins (199 × 162.5cm). Uffizi Gallery, Florence.

school. They refused to undertake the journey and he
was obliged to make do with Orazio Gentileschi (1563–
1639), joined for a short time by his daughter
Artemisia (1593–1652), the first prominent woman
artist. She was a follower of Caravaggio, but such
works as her gory picture of *Judith Slaying Holofernes*
exploit *chiaroscuro* and an unidealized vision of
common humanity to such violent effect that his
canvases seem quite restrained in comparison (13, 8).
Slowly and deliberately carving off the head of
Holofernes, Judith holds her body back from the
spurting blood. The subject had often been represent-
ed, sometimes as an allegory of tyrannicide. But this
picture seems to have been intended simply as a vivid
reconstruction of the story told in the apocryphal *Book
of Judith* and as a virtuoso feat of dramatic naturalism
for inclusion in a collection of works of art—it was
bought by the grand duke of Tuscany on the advice of
Galileo. A late seventeenth-century Florentine de-
scribed it as arousing 'not a little terror' and the
conjunction of a woman painter with a homicidal

13, 9 Guido Reni, *Atalanta and Hippomenes*, c. 1625. Canvas, 75⅛ × 104ins (191 × 264cm). Gallerie Nazionali di Capodimonte, Naples.

the change, however, and in 1660 a Sicilian collector asked him to paint a canvas in his 'early powerful manner' as a pendant to a Rembrandt. That Rembrandt should have been held up as a model by a Sicilian patron at this date is noteworthy, as is the admiration for his etchings that Guercino declared in his reply. Guercino's own graphic work was almost as extensive as Rembrandt's and was likewise done mainly for his own pleasure or as working drawings, such as that illustrated here (13, 10)—a masterly study from life, entirely natural in attitude, the full form of the model's body being caught with a few swift strokes of the quill-pen and a very sparing application of wash. These drawings were not conceived as finished works of art, but as notes of visual ideas for his own use or the instruction of pupils and he was always reluctant to sell them.

Paradoxically, Guercino's stylistic regression towards a restrained Classicism in painting coincides with the rise to pre-eminence of the artist from whose work the idea of Baroque exuberance is mainly

religious and mythological works. Hence the success of Guido Reni (1575–1642), a Bolognese painter long resident in Rome who adopted Caravaggio's dramatic *chiaroscuro* to spotlight the nobility of his figures. He was an almost exact contemporary of Rubens and his first master was a Mannerist painter from Antwerp, but he soon moved into the circle of the Carracci. Even in such a mature work as *Atalanta and Hippomenes* the ballet-dancer poses of the figures, the delicately contrived pattern of their limbs and the fluttering ribbons of drapery, with no possible functional purpose, recall the stylishness of the sixteenth century (13, 9). These youthful bodies are, however, more substantial as well as more naturally proportioned, and the sensuous painting of their flesh declares a debt to Correggio. The picture is, furthermore, composed like an antique low relief—or like one of the *quadri riportati* on the ceiling of Palazzo Farnese—with movement parallel to the picture plane. Guido Reni took the subject from Ovid's story, overlooking its feminist implications to create, like Artemisia Gentileschi, what is essentially a collector's piece.

Another artist from the region of Bologna, known by his nick-name Il Guercino, the man with a squint (Giovanni Francesco Barbieri, 1591–1666), began by working in a rich painterly manner, but later adopted a lighter palette and less dramatic lighting in order, so he told a friend, 'to satisfy as well as he could most of the people, especially those who commissioned paintings and had the money to pay for them'. Some regretted

13, 10 Guercino, *Woman undressing*, c. 1620. Pen, ink and wash on paper, 10 × 8⅛ins (25.6 × 20.7cm). British Museum, London.

13, 11 *Above* Rubens, *Landscape with Rainbow*, c. 1635. Panel, 37¼ × 48½ins (94.6 × 123.2cm). Alte Pinakothek, Munich.
13, 12 *Right* Bernini, *Baldacchino* in St Peter's, Rome, 1624–33. Gilded bronze, height c. 100ft (30.5m).

derived, Gianlorenzo Bernini (1598–1680). Like Michelangelo a century before, Bernini regarded himself primarily as a sculptor, though he was no less gifted as an architect and was also a painter and poet. And he was similarly indebted to the patronage of artistically enlightened Popes. He was the first artist with the self-confidence to confront Michelangelo's achievement without flinching. But in character they were antithetical. Bernini was extrovert, sociable, witty in conversation, aristocratic in manner and way of life, a good family man, conformist in his no less profound piety, little interested in philosophical speculation and untroubled by doubts. He was an astonishingly fast worker with a demonic drive to complete whatever he

undertook, a systematic and extremely efficient organizer of large teams of assistants. For half a century he dominated the artistic scene in Rome and no single man contributed more to the city's present appearance. 'You are made for Rome and Rome is made for you', Pope Urban VIII is said to have told him.

Bernini was the son of a sculptor and first made his name with mythological groups and portrait busts. The latter he continued to carve throughout his career and none of his other works better displays his astonishing technical virtuosity, his ability to chisel and rasp white marble into the semblance of flesh, hair and drapery, even to give a suggestion of colour. The portrait of Francesco I d'Este, duke of Modena, is a triumph of art over that most artificial of all European conventions—the bust (13, 13). It succeeds in evoking the presence of a whole figure by means only of the head and armless shoulders. The lifelike impression is

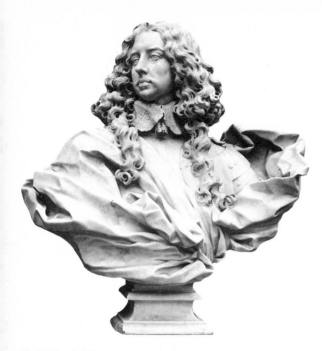

13, 13 Bernini, *Francesco I d'Este*, 1651. Marble, height with base 39⅜ins (100cm). Galleria e Museo Estense, Modena.

due not only to the illusionism of the carving but, still more, to balanced asymmetry in a composition of opposed diagonals. The face is to the left and the centre folds of the cloak to the right of the main axis, while the direction of the gaze is countered by that of the drapery, which descends from one shoulder to swirl up into a buoyant billow over the other. Bernini, who never saw the duke, complained of the difficulty of working from a painted portrait, but this may have helped him to attain that concentration on problems of form rather than of description which makes the bust memorable. In the process he created one of the most vivid images of regal hauteur, setting a new standard for royal portrait sculpture, which he was unable to surpass, even in his bust of Louis XIV at Versailles.

Bernini received his first Papal commission when only 26 years old. The newly elected Pope Urban VIII (1623–44) entrusted him with the task of creating a *baldacchino* for the main altar of St Peter's, above the tomb believed to contain the remains of St Peter and St Paul. This gigantic 95-foot-high (29m) structure, of bronze embellished with gilding, rose majestically to reaffirm the centrality of the crossing not only for the church but also for all Christendom (13, 12). The elements of the design were traditional but combined in a new way, which some contemporaries thought chimerical. Its twisted columns are greatly enlarged versions of those believed to have come from

Solomon's temple in Jerusalem (incorporated in Constantine's basilica and later re-used by Bernini, see below); the tasselled valance simulates the fabric of a canopy carried on staves, usually for a priest bearing the sacrament in a procession, and the superstructure recalls a type of ciborium often suspended over an altar. Symbolically, therefore, its message was plain to all believers and the triumphant visual flourish of its huge twisting columns, buoyant scrolls and dynamic sculpture epitomizes the grandeur, flamboyance and emotionalism of the Counter-Reformation.

Bernini's new conception of the crossing of St Peter's did not stop there, however. Michelangelo's great piers were transformed to allude to four famous relics enshrined within them. In the upper niches Bernini re-used the twisted columns from Constantine's basilica to flank reliefs of the relics borne by white marble angels set in golden yellow skies with purple clouds—an unprecedented use of colour. The lower niches were filled with colossal statues of the two men and two women associated with the relics, each expressing a different 'passion of the soul', the men gazing ecstatically towards the heavens, the women towards the sacrifice at the altar. In this way the whole crossing, with the *baldacchino* marking the centre, became a total work of art in which all the elements are conceptually and visually woven into a seamless fabric of associations—a grandiose conception celebrating the continuity of the Church and its triumph over the Reformation. The theme was brought to its climax outside when Bernini added, 1656–67, two great colonnades enclosing an oval piazza. These reach out and around it like, Bernini said, the motherly arms of the Church, 'which embrace Catholics to reinforce their beliefs, heretics to re-unite them with the Church, and unbelievers to enlighten them with the true faith.'

Bernini's aim at St Peter's was to proclaim the unity of the Catholic Church by combining all available artistic means, unifying architecture, sculpture and painting into what was called at the time *un bel composto*—a beautiful whole. On a less colossal scale he achieved the same unified effect in a chapel commissioned by Cardinal Federico Cornaro as his own burial-place and as a memorial to his family, dedicated to St Teresa of Avila (13, 14a). It is dazzlingly rich and sumptuous from inlaid floor to frescoed vault, the complex architectural elements built up of various coloured marbles (predominantly yellow and green) with flashes of gilt bronze and the shallow space lit with such ingenuity that it has often been likened, rather misleadingly, to a theatre. The central feature is a white marble group of the saint's ecstasy, illuminated from above by a hidden window

and carved with supreme illusionistic mastery (13, 14b)—as are also the half-figures of the Cornaro family behind their marble-draped praying desks (not theatre boxes) on the side walls. Such realism was entirely appropriate to St Teresa's visions of the angel as described by herself:

> In his hands I saw a long golden spear and at the end of the iron tip I seemed to see a point of fire. With this he seemed to pierce my heart several times so that it penetrated my entrails. When he drew it out, I thought he was drawing them out with it and he left me completely afire with love of God. The pain was so sharp that it made me utter several moans; and so excessive was the sweetness caused me by this intense pain that one can never wish to lose it, nor will one's soul be content with anything less than

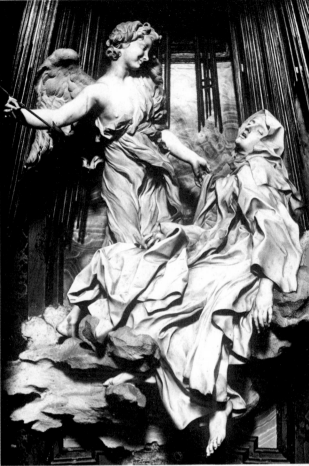

13, 14 Bernini, Cornaro Chapel, S Maria della Vittoria, Rome, 1645–52.
13, 14a *Left* Anonymous 18th-century painting. Staatliches Museum, Schwerin.
13, 14b *Above* Bernini, *Ecstasy of St Teresa*, detail of altar. Marble, height c 11ft 6ins (3.5m).

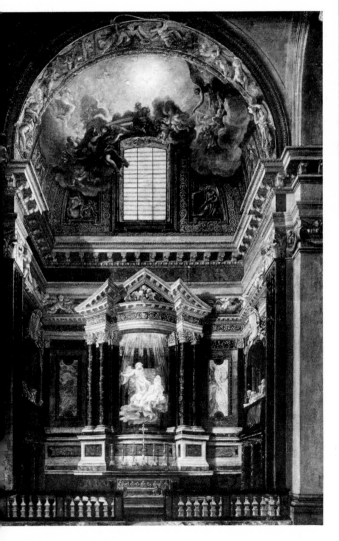

> God. It is not bodily pain, but spiritual, though the body has a share in it—indeed, a great share. (St Teresa, *Vida*, tr. E. A. Peers)

The pious Bernini, who worshipped each day at the Gesù and cherished the *Imitation of Christ* (see p. 350), responded instinctively to the sensual imagery of St Teresa's mystical writings and did not minimize the body's 'great share' in the spiritual experience. His angel, reminiscent of a cupid by Correggio (11, 34) and his St Teresa, head thrown back, mouth open and eyes closed in an attitude of physical abandon, have obvious erotic overtones and aroused adverse comment from contemporaries. But Bernini goes beyond a direct representation of her experience—so direct that

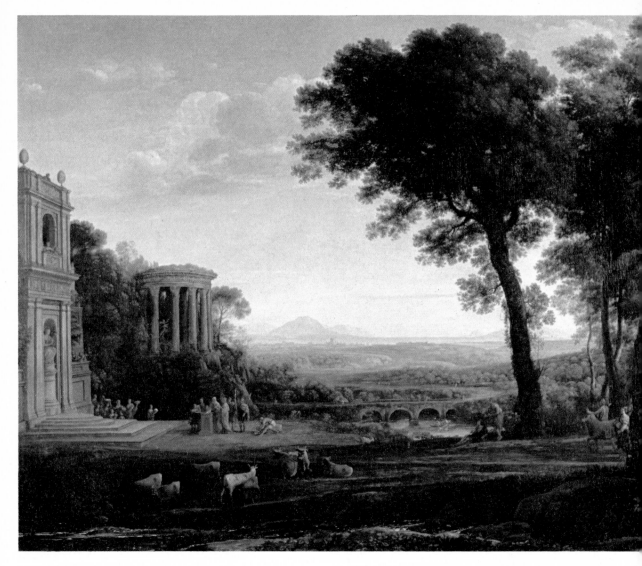

13, 15 Claude Lorraine, *Landscape with the Father of Psyche sacrificing to Apollo*, 1660–70. Canvas, 69 × 87¾ins (175 × 223cm). National Trust (Fairhaven Collection), Anglesey Abbey, Cambridgeshire.
13,16 *Right* Velázquez, *Las Meninas*, 1656. Canvas, 127 × 108½ins (323 × 276cm). Prado, Madrid.

her convulsive condition might almost be diagnosed by a twentieth-century psychologist—to hint at the phenomenon of her levitation after receiving communion and also her miraculous transformation into a beautiful young woman at the moment of her death, so that the group becomes a richly allusive image of that state, midway between heaven and earth, when spirit and matter meet.

The rest of the chapel sets the saint's individual salvation in a universal context. The institution of the Eucharist is shown in relief on the altar frontal, the dead rise from their graves on the inlaid floor, the Cornaro family meditate on and participate in the divine mysteries. High overhead, angels carry a scroll with the message of salvation in words spoken by Christ to St Teresa in a vision but addressed to every believer: 'If I had not created heaven already, I would create it for you alone.'

While work was proceeding on the chapel Bernini was also engaged on another of his major undertakings, the huge fountain in Piazza Navona, which has a cognate theme—even though, at first sight, it may seem an extravaganza (13, 17). It was designed as the base for an Egyptian obelisk, interpreted as a symbol

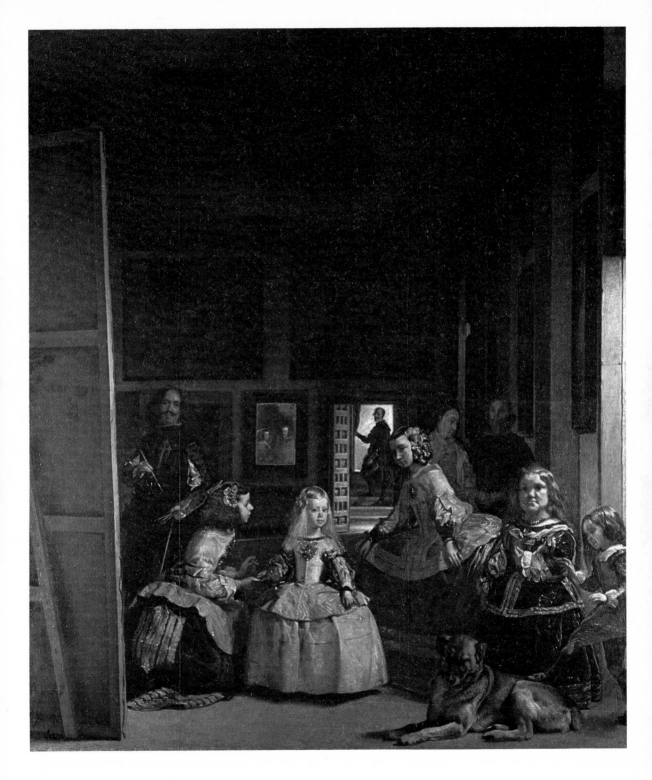

of divine light and eternity, crowned by the dove of the Holy Spirit, the personal emblem of Pope Innocent X (1644–55), who commissioned it. Four gigantic figures seated in contrasting poses personify the great rivers (the life-giving waters) of the four continents, each with a characteristic animal—the American River Plate has an armadillo. But they are also associated with the four rivers flowing out of Paradise and the central rock with the hill of Calvary. Thus the idea of salvation through the Church is interwoven with that of Catholic triumph over the four parts of the world in a complex *concetto* of the kind beloved by the seventeenth-century intelligentsia. Others were less enthusiastic, however, and verses posted nearby declared: 'We want bread more than obelisks and fountains—bread, bread, bread'.

The great church façade towering behind the fountain was designed mainly by Francesco Borromini (1599–1667), with concave centre and a dome not, as was usual, set back but seeming to rise up from it. Borromini was a stone carver by training and in 1619 came to Rome, where he was employed as a decorative sculptor and draftsman. Later he worked under Bernini, on the *baldacchino* at St Peter's among other projects, but temperamental incompatibility kept them apart. Borromini was morose, quarrelsome, frustrated and neurotic—eventually he committed suicide. The liberties he took with the rules laid down by Vitruvius prompted Bernini to remark that he had been 'sent to destroy architecture'. But he had, in fact, greater knowledge of ancient Roman architecture than Bernini and he was more deeply concerned with structural problems—and far more daring in solving them, often with thrilling spatial effects. His work makes a stronger intellectual than emotional appeal. He was an inspired geometrician and it is tempting to suggest that the new Galilean conception of the regular irregularity of the planetary orbits—though condemned by the Roman Church—emboldened him to reject the simple cubes, cylinders and spheres of earlier cosmic significance, on which so many architectural designs had been based.

His independent career began late, in 1634, and he succeeded in completing relatively few buildings, of which S Ivo della Sapienza is one of the finest (13, 18). His ingenious plan of intersecting equilateral triangles and circles creates a very unusual hexagonal central space. Built as the chapel of the Archiginnasio (later the university) of Rome, the main purpose of the new building was to provide suitable space for the preaching of sermons to the students. Borromini was thus freed from the restrictions of the usual Counter-Reformation church plan and devised a single large

13, 17 Bernini, Fountain of the Four Rivers, 1648–51. Travertine and marble. Piazza Navona, Rome.

enclosing shell of complex homogeneity. The dome is unprecedented in conception, being formed simply by the continuation of the walls upwards and inwards until they meet in the circle of light beneath the lantern. There are no intervening elements. Complete spatial unity is attained without any loss of variety or movement. Symbolism also played a part, however, in this remarkable design. It is said that the plan was based on a schematic drawing of a bee with folded wings from the Barberini family coat of arms of Pope Urban VIII, who was reigning when Borromini began work. The six-pointed 'star of David' made by the intersection of two triangles is a symbol of wisdom especially appropriate for a university chapel and as such it appears in the stucco decorations of the dome. The whole was, in fact, conceived as a symbol of wisdom (*sapienza*) associated with the descent of the Holy Ghost, which gave the apostles knowledge of tongues at Pentecost, and a gilded dove hovers in the

13, 18 Francesco Borromini, S Ivo della Sapienza, Rome, begun 1642.
13, 18a *Left* Section, engraving.
13, 18b *Below left* Interior of dome. *Above*, plan.

centre of the lantern. A curious feature of the exterior, a spiral ziggurat-like crown for the lantern, may allude to the confusion of tongues, which was interpreted as the Old Testament parallel to the Pentecostal gift of tongues.

For interiors Borromini used none of the rich materials in which Bernini delighted. That of S Ivo is entirely of stucco originally painted white or in shades of off-white. Many of the larger Roman churches were, however, decorated at this time with frescoed vaults opening into visions of heaven. In S Maria in Vallicella (known as the Chiesa Nuova), for which Rubens had painted the high altarpiece in 1608, the dome was frescoed with the Holy Trinity in Glory and the conch of the apse with the Assumption of the Virgin (13, 21). The influence of Correggio's cupola at Parma is obvious (11, 34): it had demonstrated how such an exhilarating sense of levitation could be conveyed. But the compositions are more forcefully articulated in great swirling scrolls, and what was more important at the time, the subjects are much more clearly legible. They are by Pietro da Cortona (Pietro Berrettini, 1596–1669), the leading Italian painter of his generation and also a notable architect, though overshadowed by the more inventive Borromini and the more grandiose Bernini.

The most distinguished painters working in Rome in the mid-seventeenth century were not Italian but French: Nicolas Poussin (1596–1665) and Claude Lorraine (1600–82), both of whom spent the greater part of their lives in the city. Poussin arrived in 1624. He was well educated, with a command of Latin literature that won the admiration of Roman men of letters, but as an artist he was slow in developing. For a while he worked in the studio of Domenichino

443

autumnal, elegiac mood of bucolic poetry. Shepherds are depicted reading the words on a sarcophagus, *Et in Arcadia Ego*—I, that is to say death, am present also in Arcadia. No Classical source for the inscription is known and Poussin probably invented it. The Classical concision and restraint of these lapidary words point up similar qualities in the painting and perfectly express his melancholy at the evanescence of pleasure.

By the time he painted *The Holy Family on the Steps* (13, 23) Poussin's art had almost reached its final stage of stoical severity. This grave painting unites Raphaelesque and Michelangelesque forms with the idea of the Virgin as the 'stairway to heaven' in a single image of still perfection. There are no merely decorative details: every element has both a symbolic meaning and a pictorial function in the deceptively simple balance of the composition. The exquisitely painted basket of apples, for instance, alludes to the forbidden fruit and the fall of man redeemed by Christ. Poussin wrote of one of his pictures that it should be framed so that 'in considering all its parts, the eye shall remain concentrated and not dispersed beyond the limits of the picture.' His paintings demand and reward such attention, like poems that must be learned by heart before they are fully understood. Poussin was, as Bernini remarked, pointing to his forehead, 'a painter who works up here'.

The name of Claude Gellée, known as Claude Lorraine, is often coupled with that of Poussin and the two artists certainly knew one another, though they were as different in character and in art as were the two great French dramatists of the same period, Corneille and Racine. Claude had no Classical education; he was trained as a pastry-cook in his native Lorraine and went in his early teens to Rome, where he learned to paint as an assistant to a decorative artist. He remained there for the rest of his life, apart from a few years in the 1620s. He appears to have read Latin poetry only in translation, yet his pictures fixed the image of its landscape indelibly on the European mind. The 'Classical landscape' was virtually his creation, and the idea of landscape as one of the higher art forms in the West was largely due to him. Until the mid-seventeenth century it had not even been recognized as an independent genre. Claude's landscapes were bought by kings, notably Philip IV of Spain, and the aristocracy of Europe—patrons of a different type and class from the intellectuals, lawyers and officials who admired Poussin's more intellectually demanding work. Claude's success was such that by 1635 his works were being so extensively forged that he began to keep records of the originals, drawing their compositions and noting their purchasers in a volume called the

13, 19 *Left* Rembrandt, *The Prodigal Son*, c. 1669. Canvas, 104½ × 82ins (265.4 × 208.3cm). The Hermitage, Leningrad.
13, 20 *Above* Jan Vermeer, *The Art of Painting*, c. 1670. Canvas, 47¼ × 39⅜ins (120 × 100cm). Kunsthistorisches Museum, Vienna.

(Domenico Zampieri, 1581–1641), a Bolognese who had assisted Annibale Carracci on the gallery in Palazzo Farnese. By 1628 Poussin had so far mastered their style that he was given the important commission for a large altarpiece in St Peter's. But his work did not please and he never painted again for a church or other public building in Rome. Instead he concentrated on relatively small pictures for the cabinets of collectors, especially those whose intellectual interests he shared. Turning away from contemporary Roman art, Poussin looked for inspiration first to the Venetians, as can be seen in a picture of about 1630 in which the robust, athletic figures, rich in colours, golden light and succulent, free handling of paint all recall Titian, several of whose finest works were then in Rome (13, 22). Titian's sensuous vitality has, nevertheless, been completely transmuted in this evocation of the

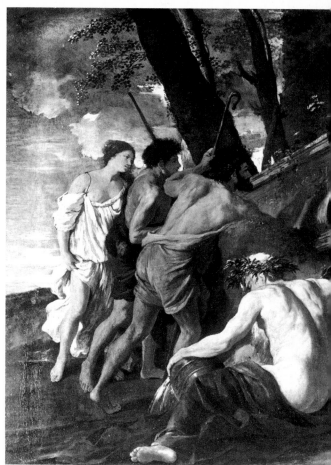

13, 21 Pietro da Cortona, *The Trinity in Glory* (dome), 1647–51; *The Assumption of the Virgin* (apse), 1655–60. Frescoes, S Maria in Vallicella, Rome.

13, 22 Nicolas Poussin, *The Arcadian Shepherds*, c. 1629–30. Canvas, $39\frac{3}{4} \times 32\frac{1}{4}$ins (101 × 82cm). The Chatsworth Settlement, Chatsworth, Derbyshire.

Liber Veritatis (now British Museum).

Claude's landscapes (13, 15) have acquired a timeless appearance, a kind of inevitability that makes it difficult to appreciate their novelty. They represent the pastoral world of a Classical Golden Age, a recurring theme in European literature and art, but Claude's immediate inspiration came from the countryside around Rome itself—the *campagna*—which, surprisingly, had not previously attracted painters apart from those in search of ancient ruins. He spent days on end with his sketchbooks in these miles and miles of solitary, gently undulating pastures, observing and registering their undramatic, almost monotonous features under varying effects of natural light. Ancient myth acquired a new reality in his pictures which are at once idealized and closely observed—wide views of subtle diversity, with an open foreground, prominently placed trees just off-centre or

to one side and here and there unobtrusive but skilfully placed features, such as a bridge or a copse, to lead the eye along a slowly winding path through the gentlest gradations of tone to the bright horizon. His principal innovation was in the treatment of light emanating from the horizon towards the spectator—reflected by water, absorbed by stone, penetrating the outer branches of the great oaks which throw shadows into the foreground, and unifying the whole composition. He generally avoided the blaze of noonday with its dramatic contrasts of sunshine and shade, preferring the more evenly diffused glow of morning and early evening. Nothing more closely links him with his contemporaries than this preoccupation with light, connecting him with artists as diverse in every other way as Caravaggio, Bernini, Rembrandt, Vermeer and Velázquez.

Diego de Velázquez (1599–1660) was among the

many artists who visited Rome in the mid-seventeenth century—he was there in 1630 and again in 1650–51—drawn, like most of the others, by the ruins of antiquity rather than by contemporary Roman art and architecture. He began in a style of solid, almost sculpturesque realism influenced, if only indirectly, by Caravaggio, whose work was then beginning to reach Spain. Spaniards responded instinctively to such straightforward realism. Miguel de Cervantes (1547–1616) in the prologue to *Don Quixote* (1605) significantly used a pictorial metaphor for the 'plain and simple' style of writing he strove for, and Velázquez's almost exact contemporary, Francisco de Zurbarán (1598–1664), began in the same way. Zurbarán's pictures of praying monks—painted mainly for monasteries in South America as well as Spain—combine to a unique degree down-to-earth actuality with the rapt intensity of Counter-Reformation mysticism (13, 26). The subsequent development of the

13,23 Nicolas Poussin, *The Holy Family on the Steps*, 1648. Canvas, 27 × 38½ins (68.6 × 97.8cm). National Gallery of Art, Washington DC (Samuel H. Kress Collection).

art of Velázquez was, however, quite different.

In 1623 Velázquez entered the service of the young king Philip IV (1621–65), who took a strong personal liking to him and almost monopolized his production for the rest of his life. The royal collection opened Velázquez's eyes to the splendour of Venetian art, especially Titian, whose great series of *poesie* adorned the palace in Madrid. They confirmed Velázquez in his natural predilection for the painterly—and his indifference to Raphael and the more linear tradition. Eventually he was to go beyond even Titian's subtle handling with broken and fluid brush-strokes, sometimes with such thinly applied paint that the texture of the canvas shows through.

The picture originally called 'The Family of Philip IV', better known as *Las Meninas* (the Maids of Honour), is Velázquez's supreme achievement, a highly self-conscious, calculated demonstration of what painting could achieve and perhaps the most searching comment ever made on the possibilities of the easel painting (13, 16). Already before the end of the seventeenth century an Italian artist called it 'the

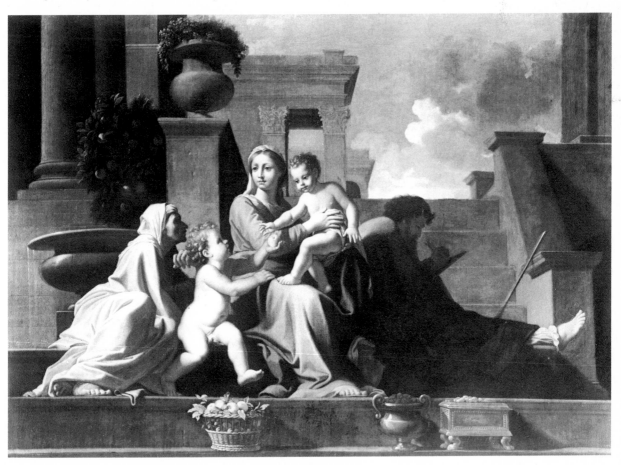

theology of painting' and it is indeed essentially a painting about painting. The central figure is the five-year-old Infanta Margarita, daughter of Philip IV and his second wife, who are reflected in the looking-glass on the far wall. She is attended by two maids of honour, from whom the picture takes its modern title. Two court dwarfs stand behind the large sleepy dog, a lady-in-waiting and a male official are engaged in conversation and a member of the queen's staff can be seen through the doorway at the end of the room. Velázquez himself, palette and brushes in hand, stands by a gigantic canvas. All the figures are members of the royal household including the painter, who had risen to the high rank of chamberlain. There were no precedents for such a picture, recording an apparently

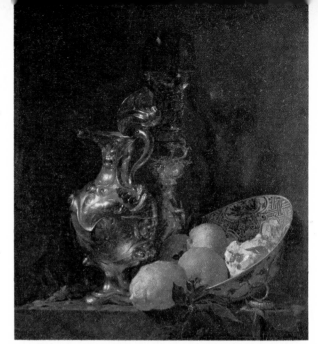

13, 24 *Right* Willem Kalf. *Still Life*, c. 1650–90. Canvas, 28⅛ × 24⅝ins (71.5 × 62cm). Rijksmuseum, Amsterdam.
13,25 *Below* Antoine Coysevox, *Louis XIV on Horseback*, 1683–85. Stucco relief, over life-size. Salon de la Guerre, Palace of Versailles.

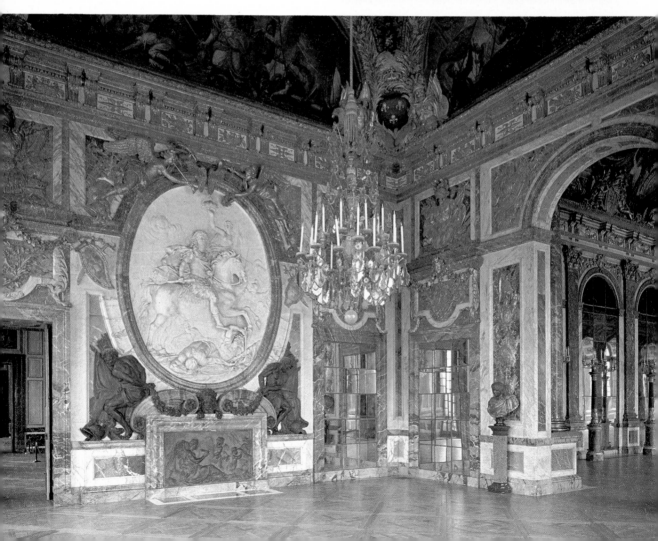

casual incident of no significance in the life of the court and painted on a scale hitherto reserved for full-length formal portraits and historical subjects. But behind what appears to be no more than a moment captured in the mirror of art there are several layers of meaning.

Las Meninas is, first of all, a demonstration of the painter's unique power to represent life as it takes place before our eyes and thus to arrest time, to stop the clock for ever at a certain moment. The apparently quite haphazard disposition of the figures and the artist's neutral, uninvolved attitude towards them are such that the effect of the painting has often been likened to that of a snapshot. In fact, of course, so convincing an illusion of reality can be created only by great and concealed artifice. Similarly, the completely dispassionate way in which the grotesque ugliness of the female dwarf is recorded makes us believe in the exquisite beauty of the infanta and her attendants. The naturalism of these figures is further set off by the contrast with the dim reflections in the looking-glass and the dimmer pictures on the wall above it. And the presence in the painting of the painter himself recalls the ingenious play with levels of reality in those passages in *Don Quixote* where the Don and Sancho Panza refer to the book in which they appear and to its author. Yet there is no trace at all of the contrived, of the meretricious, optical trickery of *trompe l'oeil* painting, in this greatest of all visual illusions. Velázquez's handling of paint was exceptionally free, and as one approaches *Las Meninas* there is a point at which the figures suddenly dissolve into smears and blobs of pigment. The long-handled brushes he used enabled him to stand back from the canvas and judge the total effect—an enclosed space naturally ill-uminated from the windows on the right wall, the door and, most important of all, the area in front of the picture plane, that is to say that part of the room in which the king and queen notionally stand. These three sources of light eliminate harsh and stagey shadows. Moreover, the rectangular pictorial space provides a framework within which the figures seem to have come together accidentally, without being 'composed' at all. They are unified by their relationship not to one another but to the spectator standing in the position apparently occupied by the king and queen, whose reflections appear in the looking-glass. In this way the spectator becomes part of the whole, being drawn into the picture just as the worshipper is involved in such a very different work of art of the same years as Bernini's chapel in S Maria della Vittoria in Rome (13, 14).

A secondary theme of *Las Meninas* is that of painting as a liberal art and, by extension, that of the status of the artist. The latter was very much on Velázquez's mind when painting the picture, for he was just then seeking admission to one of the orders of military knighthood which would have raised him to noble rank. Their ancient statutes, however, excluded all 'manual' workers as well as those of Moorish and Jewish ancestry and thus the question as to whether painting was a liberal or merely a mechanical art was crucial. The question had been hotly disputed in Spain for some time. Liberal status carried substantial practical advantages, such as exemption from taxes and military service. There were many, including the famous dramatist Lope de Vega (1562–1635), who supported the painters' claim and *Las Meninas* can be interpreted as the artist's contribution to the debate. The two paintings on the far wall of the room, for instance, are copies after works by the ennobled Rubens illustrating divine participation in the arts.

13, 26 Francisco Zurbarán, *St Francis in Meditation*, c. 1639. Canvas, 60 × 39in (152 × 99cm). National Gallery, London.

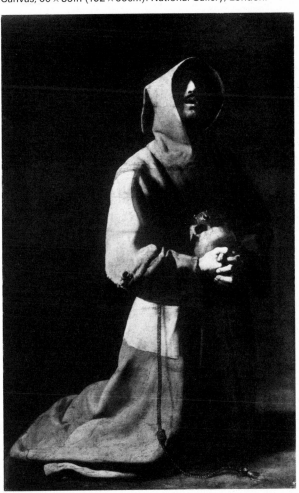

Moreover, Velázquez portrayed himself as a court official wearing his badge of office, the keys, in his belt. In fact, he was admitted two years later to the proudest of all the Spanish noble orders, that of S Iago (St James), whose cross was later, at the king's behest, painted onto his breast.

Dutch painting

The importance of the Dutch republic in the intellectual life of seventeenth-century Europe can hardly be exaggerated. It was the one country where there was freedom of speculation, the one country where Descartes from France and Spinoza, the heretical Jew from Portugal, could write and publish their revolutionary philosophical works. Although the revolt in the Spanish Netherlands had begun with the resistance of trading cities to Philip II's policy of centralizing the government of his empire, which threatened to deprive them of their ancient privileges, it soon became a struggle for religious as well as civic liberty. For the Spanish ideal of 'one king, one law, one faith' had led to the remorseless persecution of Protestants, thousands of whom took refuge in the seven United Provinces (usually, if inaccurately, called Holland after the richest of them), which, as already

13, 27 Frans Hals, *The Merry Drinker*, 1628–30. Canvas, 31⅞ × 26⅛ins (81 × 66.5cm). Rijksmuseum, Amsterdam.

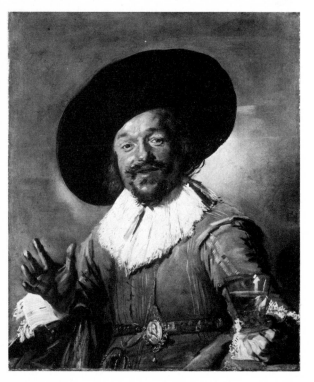

mentioned, formally renounced allegiance to Philip II in 1581 and were given tacit recognition of independence in 1609. Although attempts were made to impose Calvinism as the established faith, other Protestant sects were tolerated, asylum was given to Jews who had fled from persecution in Spain and Portugal, an official ban on Catholics was liberally interpreted and free-thinking was unchecked.

The Dutch republic was unique in other respects, a federation surrounded by unitary states, far more democratic than other nominal republics (Venice, for instance), defensive rather than aggressive in foreign policy, with an economy based not on agriculture but on commerce. Aristocracy went out with the Spaniards; the powers of the princes of Orange, who held the title of stadtholder (governor) for most of the century, were severely restricted. Bankers, merchants, shippers and manufacturers constituted the upper class and under their patronage secular painting flourished as never before and as nowhere else. 'As for the art of painting and the affection of the people to pictures, I think that none go beyond them', wrote an English visitor to Amsterdam in 1640:

> all in general striving to adorn their houses, especially the outer or street rooms, with costly pieces—butchers and bakers not much inferior in their shops, which are fairly set forth, yea many times blacksmiths, cobblers, etc. will have some picture or other in their forge and in their stalls. Such is the general notion, inclination and delight that these country natives have to paintings. (*The Travels of Peter Munday in Europe and Asia: 1608–1667*, spelling modernized)

It was, of course, exclusively easel paintings that were being bought. And by their development of all the various genres—landscapes, seascapes, portraits, low-life scenes, still life, etc.—the Dutch brought easel painting to its highest pitch. It could almost be claimed that European art found its most distinctive form in Dutch seventeenth-century painting. There was little or no demand for altarpieces or other large-scale devotional paintings, or for grandiose architecture or sculpture.

Frans Hals (c.1581/5–1666), generally regarded as the founder of the Dutch school of painting, specialized in portraits—usually of fellow citizens of Haarlem, singly or in groups—and in portrait-like pictures of figures from contemporary life. In the latter, which were primarily studies of expression and character, he was unrestricted by his sitters and free to work out his individual manner of painting. The picture known as *The Merry Drinker* (13, 27) was

probably conceived as an allegory of the sense of taste or of drinking, perhaps also with political overtones (a medal of Prince Maurice of Orange associates the drinker with the anti-burgher faction, which came near to converting the young republic into a monarchy). But whatever implications may have been intended, they are completely swallowed up by the immediacy of this image of forceful physical reality. With bibulously flushed face, eyes twinkling, mouth slightly open as if about to speak, one hand impetuously raised, the other clutching a glass of wine, the man seems surprised by the spectator's appearance before him. The impression of instantaneous life is created by the apparent spontaneity of the brushwork, flicks of dark paint for beard and mustaches, smears of white for reflections on the glass and the sweaty forehead, dark slashing strokes for the creases in the sleeve and a jagged outline suggesting sudden movement. Much of the animating sparkle comes from the highlights added as final touches, 'putting in his handwriting', Hals is reported to have said—and the phrase is significant. In the competitive Dutch art world a premium was set on individuality and also on novelty, with the result that painters' reputations swiftly rose and declined. Hals, whose broadly painted works caught so brilliantly the boisterous optimism of the first decades of the Dutch republic, fell out of favour in the 1640s, when smoother styles, influenced by van Dyck, were introduced to portray newly enriched citizens with their recently acquired aristocratic manners. Rembrandt, too, was not uninfluenced by this changing social situation, different though he was from Hals in almost every way.

Rembrandt Harmensz van Rijn (1609–69) began with small, very smoothly painted Biblical scenes, in which spiralling compositions learned from Rubens were painted with the strong *chiaroscuro* of the Dutch followers of Caravaggio. Throughout his life Rembrandt was to be unusually responsive to the work of other artists, notably Italians of the Renaissance and even, very exceptionally at this date, non-European artists—he owned and copied Mughal miniatures. But every influence was completely assimilated in his work, which reflects an uninterrupted course of development throughout his life, both artistic and spiritual. After 1631/2, when he moved from his native Leiden to more prosperous Amsterdam, the main commercial centre of the Dutch republic, he was soon recognized as the leading painter of the day, especially for portraits. The work traditionally called *The Night Watch*—though it is neither a night scene nor does it depict soldiers mounting a watch—was commissioned as a group portrait of a militia company and finished in 1642 (13, 28). By then Dutch militia companies had become little

more than male drinking and dining clubs. Frans Hals portrayed those of Haarlem seated around banqueting tables. But Rembrandt devised a more dramatic solution to the problem of integrating numerous portraits into a pictorial composition by showing the company issuing from its headquarters for a ceremonial parade, perhaps that on the occasion of Marie de Médici's official reception in Amsterdam in 1638. This enabled him to present an insignificant incident as a grand historical spectacle on a huge scale—the figures are life-size and the canvas was originally larger (it was cut down on all sides when it was removed to the Town Hall in 1715, with a serious loss on the left destroying the symmetry of the background architecture).

The whole vast canvas throbs with bustling activity: a drum beats, a dog barks, banners and pikes are raised, excited children run between the militiamen. Rembrandt pulled out every stop to create a resonantly thrilling atmosphere with rich contrasts of light and shade, brilliant and drab colour, a great variety of poses, gestures and facial expressions in opposed movements across and out of the picture plane, in a complex spatial design which leads the eye on a zigzag backwards and forwards. The composition is focused on the captain dressed in black with an orange-red sash and his lieutenant in lemon-yellow, colours which shimmer in other parts of the canvas. Frans Banning Cocq, the captain, was a wealthy merchant and the other militiamen, each of whom paid a subscription for the picture scaled according to the prominence he was given in it, probably came from the upper ranks of Amsterdam society. Militia companies kept alive memories of the heroic days of struggle against authoritarian Spain and some of the older men in the picture may well have been veterans. But it was, above all, the triumph of the Dutch republic with its loose (if by no means egalitarian) social structure and exaltation of private enterprise that is being celebrated. Rembrandt spared no pains to create as convincing an illusion of actuality as possible in this image of self-possessed and somewhat self-satisfied burghers walking out of the picture to meet us on their own terms.

The Night Watch was always regarded as Rembrandt's masterpiece. Subsequently, his reputation and prosperity declined for reasons quite unconnected with it. As a result of being less in demand as a portrait painter, he later came to depend for sitters on members of his own circle—and himself. No earlier artist had ever portrayed himself so frequently. He began in the 1620s and went on throughout his life, leaving some hundred or more self-portraits in paintings and etchings which constitute a unique pictorial autobio-

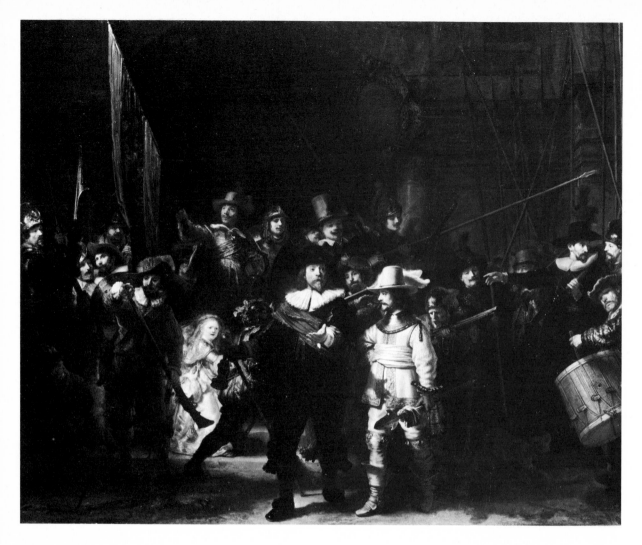

13, 28 Rembrandt, *The Night Watch* (*The Company of Captain Frans Banning Cocq*), 1642. Canvas, 146 × 175ins (3.7 × 4.45m). Rijksmuseum, Amsterdam.

graphy, though this is unlikely to have been his intention. Most were probably made as studies of character and expression and may well have been bought as such by collectors unaware of whom they represented. He takes on a variety of roles, as rebellious youth, bourgeois citizen, armed knight, eccentric in flamboyant Oriental costume, jovial reveller, saint and sage. His rough and powerful features, broad face and bulbous nose, appear in several pictures of himself as a painter. In one, dating from the last sad years after his bankruptcy in 1656, he is white-haired, deeply thoughtful, as if rising indomitably above a sea of troubles (13, 29). It is so completely dispassionate, so sublimely impartial, that Rembrandt

might almost seem to have shared with one of Descartes's followers, Arnold Geulincx (1624–69), then teaching at Leiden, the belief that the soul is neither stimulated by nor moves the body but simply observes it. Yet this burly, dishevelled figure conveys in its simple frontality and static pose a powerful impression of inwardness and sombre, deeply serious meditation. A great but unassuming dignity and natural nobility is inherent in its simple forms, emphasized by the two great arcs on the wall behind.

Despite his supreme gifts as a painter of portraits, Rembrandt seems to have thought of himself as, above all, a religious painter—not of devotional images, however, so he was able to give his own personal interpretation of sacred subjects. He was a Calvinist by upbringing but associated in Amsterdam with members of the undogmatic, pacifist Mennonite sect, which

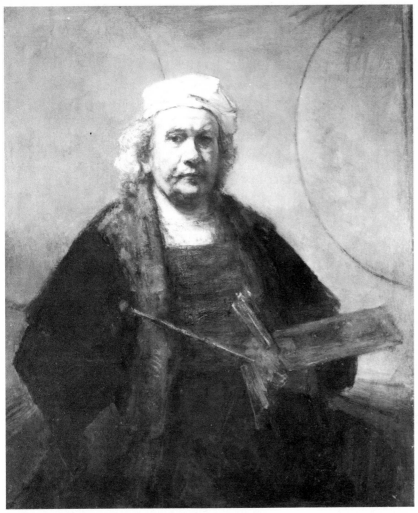

13, 29 Rembrandt, *Self-Portrait*, c. 1660. Canvas, 45 × 38ins (114.3 × 96.5cm). The Iveagh Bequest, Kenwood, London.

accepted no authority apart from the Bible and strove to follow the teaching of the Sermon on the Mount. Their ideals permeate his *Christ Healing the Sick* (13, 30), known as the 'hundred-guilder print' from the price allegedly paid for a fine impression in Rembrandt's lifetime. Although he made full use of Baroque compositional devices to lead the eye on an undulating three-dimensional course, it is far removed in spirit from a Baroque altarpiece or such Counter-Reformation displays of religious fervour as Rubens's *Miracles of St Francis Xavier* (13, 4). Both are complex figure compositions, but the miracle Rembrandt represents is one of spiritual not physical healing. No artist has ever depicted the poor and derelict, the outcasts of society, with greater sympathy than

Rembrandt and here they fill the entire right-hand half of the print: the well-dressed and healthy are on the other side. All are equally and deeply pensive, communicating with something within themselves that leads beyond themselves. Sombreness, mystery and a dark, flickering spirituality pervade the whole scene.

The 250 or more etchings which spread Rembrandt's fame across Europe were public works of art, even though they are small in size and often appear to be unfinished—he is said to have declared a work to be completed 'when the master has achieved his intention by it'. On the other hand, the large religious pictures of his later years are intensely private, as personal in their interpretations of scripture as in expression and technique. In that of *The Return of the Prodigal Son* his power of creating a palpable physical presence with broad, thick brushwork is undiminished (13, 19). The weary body of the kneeling son is sensed

beneath the tattered garments, and the slight pressure of his father's aged hands on his shoulders is felt as well as seen. Resonant, sombre colours have an interior warmth which glows like embers in the scarlet and gold of the father's garments. But Rembrandt concentrates attention on the relationship between the main figures, flooded in mysterious, supernatural light, which catches also the face and folded hands of the unbendingly virtuous elder brother. No display of emotion, no gestures, no movements even, disturb an atmosphere of absolute calm. The essential meaning of the parable is embodied in this remarkably simple but deeply felt and pondered image of humble repentance and tender fatherly forgiveness, of homecoming as a metaphor for death and man's innermost contact with the divine.

Still life, landscape and genre

Rembrandt's art was exceptional in its range as well as its profundity. Nearly all other Dutch artists of the time specialized, some very narrowly. A painter of still life, for instance, would often restrict himself to a single class of objects. Willem Kalf (1619–93), one of the most gifted, depicted group after group of almost identical luxury objects such as silver flagons, Turkish rugs and Chinese porcelain bowls with oranges and lemons (expensive fruits in northern Europe at this date). His sense of composition was no less sure than his illusionistic skill, enabling him to create sumptuous, restful harmonies of shapes, colours, textures, reflections and transparencies (13, 24). The immediate predecessors of this type of still life incorporated such symbols of mortality as a skull or a burnt-out candle as a *memento mori*, the reminder of death which is also an invitation to enjoy the pleasures of life. But the tradition of depicting household objects went back to the fifteenth century.

There were similar precedents for landscape painting, but an altogether new way of seeing, as well as depicting, landscape began with Jan van Goyen (1596–1656) and others of his generation working mainly in Haarlem. They made atmosphere the animating element in subdued, almost monochromatic pictures which are as much of drifting grey clouds as of land and water. Buildings and human figures are reduced to insignificance. Others specialized in nautical subjects. Aelbert Cuyp (1620–91), for instance, who lived in Dordrecht at the junction of two important commercial waterways, beautifully recorded the river traffic with great skies reflected in calm waters, the whole scene suffused with the golden light of a summer's afternoon (13, 33). These are no dreams of a lost paradise, such as Claude was then painting in Italy (13,

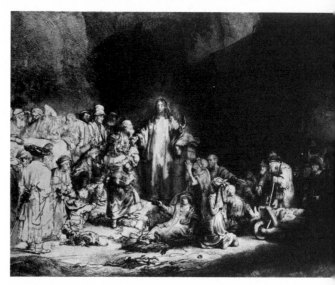

13, 30 Rembrandt, *Christ healing the Sick* ('The hundred-guilder print'), c. 1648–50. Etching, $109\frac{1}{2} \times 153\frac{1}{8}$ins ($278 \times 389$cm). British Museum, London.

15), but quite straightforward views of the present. Beneath their unruffled surfaces there is more than a suggestion of the Calvinist notion of trade being in harmony with universal laws. Jacob van Ruisdael (1628/9–82) had a wider range, his landscapes including views of the south-eastern provinces of Gelderland and northern Germany, as well as his native Holland. *The Windmill at Wijk* (13, 32) is at once the view of a particular place on the right bank of the Rhine—the church tower and bishop's palace of Wijk bij Duurstede can be identified in the background—and an epitome of the man-made Dutch landscape under a shifting pattern of clouds and with the mill itself, then a recent and wholly utilitarian structure, given a presence that is almost heroic. *The Avenue, Middelharnis* by Ruisdael's pupil Meyndert Hobbema (1638–1709) is also an accurate view but transcends topography as an unforgettable record of a tract of country which might seem to have in itself little interest and no pictorial possibilities, a striking instance of the artist's power to 'make something out of nothing' (13, 31). The device of placing the avenue of lanky trees dead centre is as unusual as it is effective in carrying the eye both into the picture and up to the calmly luminous sky.

In the favours of the Dutch art-buying public, scenes of ordinary everyday indoor life vied with landscape and still life. Such *genre* pictures (as they came to be called in the late eighteenth century), small in size, sharply detailed and representing a familiar world,

were perfectly adapted for the living-rooms of middle-class houses and accurately mirrored the outlook of their owners. They have often been seen, in fact, as prime examples of an art called into being by its patrons, in this instance hard-headed merchants who distrusted imagination and idealization. The realism of these paintings was not, however, an end in itself, for most if not all of them originally carried a moral message, sometimes expressed ambiguously as in *memento mori* still-life pictures. Many allude to sexual transgression, but so dispassionately that they offer the spectator a choice of luxuriating in its licence or ruminating on its iniquity, raising the problem of

13, 31 *Below* Meyndert Hobbema, *The Avenue, Middelharnis*, 1689. Canvas, $40\frac{3}{4} \times 55\frac{1}{2}$ins (103.5 × 141cm). National Gallery, London.
13, 32 *Right* Jacob van Ruisdael, *Windmill at Wijk*, c. 1665. Canvas, $32\frac{2}{3} \times 39\frac{3}{4}$ins (83 × 101cm). Rijksmuseum, Amsterdam.

13, 33 Aelbert Cuyp, *The Maas at Dordrecht*, 1650–90. Canvas, $38\frac{1}{2} \times 54\frac{1}{4}$ins (97.8 × 136.8cm). The Iveagh Bequest, Kenwood, London.

Christian free-will, which had not been allayed by the Calvinist doctrine of predestination. *The Linen Cupboard* by Pieter de Hooch (1629–after 1688), on the other hand, provides a glimpse of a perfectly ordered household with well-polished floors, a maid handing laundered linen to her mistress and a child quietly playing (13, 34). It is a rare image of domesticity invested with poetry by restrained warmth of colour, delicate gradations of light, and the spatial complexity of a view through another room and a door to the sunlit house on the far side of a canal.

Jan Vermeer (1632–75) also specialized in moralizing *genre* pictures. He painted very little—no more than 35 surviving pictures can be attributed to him—

and apparently supported his large family as an inn-keeper and art dealer. But he stands out from his contemporaries on account of his extreme, almost tremulous sensitivity in the rendering of light and his unusual, predominantly blue and yellow colour-schemes. The extraordinary luminosity of his paintings was achieved by a virtually new technique based partly on optical experiments but mainly on observation and an intuitive awareness of the subtleties of inter-penetrating reflected colours. His method of capturing the sparkle of light in minute pearl-like dots beyond the contours of objects is unique. And the evenness of focus in his pictures makes them seem so limpid and objective that they have the effect of panels of clear

glass—windows on to interiors in which all conflicts have been resolved. They have often been mistaken for straightforward renderings of daily life, and one was believed to represent the artist himself at work in his studio until it was discovered that his widow entitled it *De Schilderconst*—'The Art of Painting'. The painter is dressed in sixteenth-century Burgundian costume and the model is posed with the attributes of Clio, the Muse of History (13, 20). The rich curtain recalls the swathes of drapery used in official portraits (13, 7). On the wall there is a recently printed Dutch map of the Netherlands, such as were hung in many houses of the period and appear in other pictures by Vermeer. But the presumably allegorical meaning of *The Art of Painting* remains unknown. Was Vermeer perhaps making a claim for painting as a liberal art, as Velázquez did in *Las Meninas* (13, 16)? (Dutch as well as Spanish artists were then seeking recognition for their status and trying to dissociate themselves from the craft guilds.) If so, the claim went unheeded. Soon afterwards French influence became dominant throughout the Netherlands. Vermeer's name was omitted from the academically inspired histories of Dutch art and his work was almost entirely forgotten until rediscovered in the mid-nineteenth century.

England and France

There were close cultural links between the Dutch republic and England, despite differing political alliances which twice led to war. English books were translated into Dutch but in the visual arts influence was mainly, if not entirely, in the opposite direction. The English bought Dutch pictures and several Dutch artists, following Rubens and van Dyck, worked and sometimes settled in England. Dutch influence dominated the decorative arts and domestic architecture (brick with stone dressings). A more Italianate style had, however, been introduced early in the century for royal buildings by Inigo Jones (1573–1652) and it was to this tradition that the greatest English architect, Christopher Wren (1632–1723), turned when designing the cathedral and 51 parish churches in London to replace those destroyed in the great fire of 1666.

By training, Wren was a mathematician and astronomer—professor of astronomy at Oxford, 1661–73—with an eminently practical and experimental mind. For the cathedral, the first to be built for the Church of England, he was required 'to frame a Design handsome and noble, and suitable to all the ends of it, and to the Reputation of the City and the Nation' (13, 35). He approached the task in the empirical spirit of his fellow scientists in the Royal Society, who included Isaac Newton, gradually

13,34 Pieter de Hooch, *The Linen Cupboard*, 1663. Canvas, $28\frac{1}{3} \times 30\frac{1}{2}$ins (73 × 77.5cm). Rijksmuseum, Amsterdam.

working out the design like a series of experiments as the building went up. Although the foundations were laid in 1675 and the chancel completed in 1697, he did not settle on the definitive form of the dome and west towers until after 1700. In the course of the work he studied engravings of Bramante's design for St Peter's in Rome and the Tempietto (11, 14), also more recent Italian and French buildings. But his imagination or inventiveness, still more apparent in the ingenious variety of his parish church designs, was essentially practical, and St Paul's has none of the transcendent spirituality felt in even the most intellectual of Italian Baroque churches (13, 18). Imposing but not overpowering, it strikes a middle path between Classical puritanism and Baroque exuberance. St Paul's and the city churches were, however, the products of exceptional circumstances. In England, as in the Dutch republic, the arts owed little to Church or state patronage in the late seventeenth century.

Different artistic aims and ideals were pursued in France in the second half of the century. Here the visual arts were enrolled, ordered and paraded in the service of autocracy. No artistic style is more directly expressive of the political ambitions and achievements of a monarch than that named after Louis XIV (1643–1715), nor more clearly marked by the peculiar

circumstances of its conception. Before Louis XIV began his long personal rule in 1661, the main obstacles to the centralized organization of an absolutist state had already been removed. Under him the ancient feudal nobility were reduced to purely courtly functions, allowing recently ennobled families (the *noblesse de la robe*, as they were called) to become powerful and, eventually, to hold the principal ministries of state. It was among this section of the upper class that the greatest French painter of the time, Nicolas Poussin, found buyers for his late and most severely Stoical works; and it was for one of the richest of them, the finance minister Nicolas Fouquet, that the architect Louis Le Vau (1612–70) designed a luxurious château at Vaux-le-Vicomte, which prefigured Versailles. All the visual arts, including garden design, were exploited at Vaux-le-Vicomte in a style of Classical authority, logical clarity and imposing splendour well adapted to glorifying absolutism. Louis XIV was greatly impressed, so much so that he had Fouquet arrested for embezzlement and took over his architect, artists and craftsmen.

The organization of the arts in the service of the monarchy was one of the great administrative achievements of Jean-Baptiste Colbert (1619–83), a man of humble origin who became Louis XIV's adviser on political, economic, religious and artistic matters. He gathered the best tapestry weavers, furniture makers and other craftsmen into a single factory, the Gobelins, to produce furnishings for the royal palaces under the direction of Charles Lebrun (1619–90), a painter much influenced by Poussin. Colbert also reformed the Parisian Academy of painters, converting it almost into a part of the civil service and developing it as a teaching institution to provide the most thorough system of artistic training ever devised. Its inherent tendency to codify and regularize—as well as its authoritarian tone—is exemplified in Lebrun's lectures on how to represent the passions 'correctly', as well as by the practice of sending promising students to Rome to study and copy the masterpieces of antique sculpture and Renaissance painting.

In a memorandum to the king, Colbert wrote: 'Your Majesty knows that apart from striking actions in warfare, nothing is so well able to show the greatness and spirit of princes than buildings; and all posterity will judge them by the measure of those superb habitations which they have built during their lives.' The first task confronting the king was the completion of the Louvre, the royal palace in Paris. In 1665 Bernini was summoned to advise. But his designs were rejected. The king selected one of two alternative designs

13, 35 Christopher Wren, St Paul's Cathedral, London, 1675–1710.

presented by a committee consisting of Lebrun, Louis Le Vau and Claude Perrault (1613–88), a scientist and student of Classical architecture. With its correct Roman detailing, its clarity in the definition of masses and its dry, crisp elegance in articulation, the new east front is more strictly Classical than any earlier building in France (13, 37). There was, however, no precedent for the coupled columns or the segment-headed windows, which contribute so notably to its 'modernity'.

While the east front of the Louvre was being built Louis XIV decided to make his main residence outside Paris at Versailles. A relatively small château built by his father was enlarged first by Le Vau and then by Jules Hardouin-Mansart (1646–1708) into the largest and most grandiose palace of the world, set in a vast park laid out by André Le Nôtre (1613–1700) to extend its symmetry over the whole surrounding landscape

13, 36 *Top* Louis Le Vau and Jules Hardouin-Mansart, Palace of Versailles, 1669–85. Aerial view.
13, 37 *Above* Claude Perrault, Louis Le Vau and Charles Lebrun, the east front of the Louvre, Paris, 1667–70.

(13, 36). In addition to providing a complete environment for the unending ritual of court life, the palace of Versailles was a manifestation of Louis XIV's determination to shine as the greatest ruler in Europe. The work of several generations of designers, artists and craftsmen over nearly half a century, carried out piecemeal and not according to a single predetermined plan, the whole complex of buildings and gardens is, nevertheless, unusually consistent in conception. The king's personal approval was necessary for even minor decorative details—most of which alluded either directly or symbolically to himself.

A great series of state rooms was created after 1678, when the wars against Spain, the Dutch republic and the Holy Roman Empire came to an end with notable territorial advantages to France. On the ceiling of the Galerie des Glaces—the very long central gallery named after the tall mirrors lining the wall opposite large windows looking out on to a completely artificial man-made landscape as far as the eye can see—Lebrun

translated the history of the wars into the pictorial language of Classical mythology with the king figuring in the guise of Apollo. In the Salon de la Guerre, which leads into it, a huge stucco relief of the king, larger than life on horseback, by Antoine Coysevox (1640–1720), is set among panels of coloured marbles and gilt bronze reliefs beneath a painted ceiling, again by Lebrun (13, 25).

As Louis XIV intended, Versailles caught the attention of all Europe. It became the ideal for every royal household and even the sultan of Morocco competed with it at Meknes. Christopher Wren almost certainly had it in mind when enlarging Hampton Court Palace near London for Louis XIV's main antagonist, William of Orange, stadtholder of the Dutch republic and from 1688 king of England. In France, however, there was a reaction against its formality and towards the end of the century voices were raised against the dominant Classicism of the Academy. Admirers of Rubens contested the supremacy of Poussin and, for the first time, the taste of middle-class patrons who collected Dutch and Flemish *genre* paintings began to play a part in determining the course of French art.

14 Enlightenment and liberty

Almost everything that distinguishes the modern Western world from earlier centuries—industrialized production, bureaucratized government, the new conceptions that science introduced into philosophy, the whole climate of thought and opinion—overlapped during the eighteenth century with the old political and social order, the *ancien régime*. It was the last period in which it was widely believed that 'kings are by God appointed', the first in which it could be claimed as 'self-evident' that (in the words of the American Declaration of Independence, 1776), 'all men are created equal, that they are endowed by their Creator with certain unalienable Rights, that among these are Life, Liberty and the Pursuit of Happiness'. The incompatibility of these claims with traditional systems of monarchic or oligarchic government was not shown up until the last decade of the century, when the French Revolution gave a new and explosive meaning to ideas of 'liberty, equality and fraternity'. Yet, the revolution with which the century ended was by no means inevitable or even foreseen. Enlightened despots of the *ancien régime*—notably Frederick the Great of Prussia (1740–86) and Joseph II of Austria (1780–90), even to some extent Louis XVI of France (1774–93)—strove, together with their efficient administrators, to promote material progress and enforce justice, toleration and humanitarianism, often overriding the ancient privileges of the nobility, the clergy and the city corporations.

Until the end of the century Christianity retained its hold, unquestioned by the mass of the population in Protestant as well as in Catholic countries. This is clearly reflected in the arts. Despite the development of operatic and chamber music, much of the most memorable music was religious in the period beginning with Johann Sebastian Bach (1685–1750) and Georg Friedrich Handel (1685–1759) and ending with Wolfgang Amadeus Mozart (1756–91) and Joseph Haydn (1732–1809). In Catholic Europe there was no decline in the building and decoration of churches, monasteries and religious foundations. Secular works account for only a part of the total production of French, German, Spanish and Italian painters and sculptors—though it is the part that stands out in the perspective of history. Similarly, the thinkers of the Enlightenment who questioned Christian teaching were a tiny minority and very few of them rejected religion altogether. But the brilliance of their writing—and the force of their (often wishful) thinking—was such that the whole century is sometimes called 'the age of reason'.

The Enlightenment radiated out of the philosophical and scientific thought of the seventeenth century, especially that of Descartes (see p. 426), of John Locke (1632–1704), who propounded a philosophy based on empirical observation and common sense, and of Isaac Newton (1642–1727), who provided a rational explanation of the laws determining the structure and working of the universe. Despite many and profound differences, the leaders of the eighteenth-century Enlightenment shared a faith in the power of the human mind to solve every problem. They believed in human perfectibility and in the possibility of human omniscience. And in this optimistic belief all physical phenomena were studied and categorized and all aspects of human behaviour were scrutinized from a strictly rational viewpoint—political systems, social customs, religious practices. Everything that seemed to them worth knowing was ordered and encapsulated in the great French encyclopedia, which began to appear in 1751. It aimed to survey knowledge according to rational philosophical principles. '*Dare to know!* Have the courage to use your understanding; this is the motto of the Enlightenment', the German philosopher Immanuel Kant declared in 1784, although in his case it eventually led him to lay bare the inadequacies and fallacies of rationalism (see p. 481).

French Rococo art

The delicate, sensual and often capricious art of the first half of the eighteenth century, especially in France, seems at first sight to be at odds with the rational thought of the Enlightenment. Indeed, most contemporary theorists criticized it from this point of view. Later, in the revolutionary era, it was dubbed Rococo—a frivolous confection of shells and shell-like forms—and dismissed as an attempt to satisfy the whims of a dissipated upper class. But if it lacked a closely reasoned theory, it was not without a rationale. Demands for freedom from academic restrictions and 'rules', for an appearance of spontaneity and for novelty were its motivating forces. Its genius lay in nuances, subtle juxtapositions of forms, gentle gradations and minglings of colours, the elusive dancing rhythms of only slightly differentiated motifs. Classically inspired rules of pictorial compositions were light-heartedly infringed, the Vitruvian orders of architecture were abused or ignored. There was widespread recognition that—in the words of Alexander Pope's *Essay on Criticism* (1711)—'some beauties yet no Precepts can declare', and that there:

Are nameless graces which no methods teach
And which a master-hand alone can reach.

Such qualities could be judged only by 'taste', which Voltaire (François Marie Arouet, 1694–1778), the leading spirit of the Enlightenment in France, defined as 'a quick discernment, a sudden perception, which, like the sensations of the palate, anticipates reflexion; like the palate it relishes what is good with an exquisite and voluptuous sensibility, and rejects the contrary with loathing and disgust.' Without knowledge of the Classical rules, however, the man of taste could not savour the piquancy of deviations from them. Taste was an attribute of the educated class only.

The Rococo first developed in France, where Classicism had been made the guiding principle of a rigorous system of artistic instruction (see p. 457). In 1698 Louis XIV called for paintings more light-hearted and 'youthful' than those previously commissioned for Versailles, where work was still in progress. He also transferred his favours from artists who supported the official doctrine of the Academy to those who dissented from it. The quarrel between these two parties hinged on the relative importance of drawing and colour, epitomized by Poussin and Rubens, from whom they took their names. *Poussinistes*, led by Charles Lebrun (director of the Academy), declared that drawing, which appealed to the intellect, was superior to colour, which appealed only to the eye. *Rubénistes* argued that colour was necessary for a truthful imitation of nature, which they held to be the prime aim of art. That colour made an impression on the senses rather than on the intellect was for them an advantage. Philosophical support could be found in John Locke's influential *Essay Concerning Human Understanding* (1690), which claimed that all ideas derived ultimately from experience and that none was innate. The implications for aesthetics were soon realized, and in 1719 a leading French theorist, Jean-Baptiste Dubos (1670–1742), remarked that what was apprehended through the mind seemed pale and insipid in comparison with what was apprehended through the senses. Pictures affect people more deeply than poetry because they 'act upon us directly through the organ of sight; and the painter does not employ artificial signs to convey his effect . . . the pleasure we derive from art is a physical pleasure.'

The greatest of early eighteenth-century painters, Antoine Watteau (1684–1721), came from outside the circle of artists employed by the court and was not of a theoretical turn of mind. He was born at Valenciennes, which had been part of the Spanish Netherlands until six years before, and his training was that of an artist-craftsman. His admiration for Rubens and the great sixteenth-century Venetian colourists seems to have been instinctive. He painted a fairly wide range of subjects: religious pictures, portraits, military scenes and mythological pieces. But his individual genius found scope especially in *fêtes galantes*—fanciful visions of well-dressed men and women enjoying themselves in the open air. In them his contemporaries could catch a reflection of their own ideals of civilized life (14, 5). Pictures of this type were indebted to the early sixteenth-century Venetians, especially to the Giorgionesque *Concert* (11, 20), which was then in the royal collection at Versailles, though they are almost insistently up-to-date in other ways. *The Dance* (later named *Les fêtes Vénitiennes*) is set in a park of a type which had only recently been laid out, with much less constraint than hitherto in the treatment of plants and much more freedom in the design of stonework and statuary, striking a new balance, one might almost say creating a fusion, between the works of man and of nature. This balance between the artificial and the natural is equally apparent in the poses of Watteau's figures and, indeed, in the composition as a whole with its deceptive air of informality.

It may be questioned whether the picture is quite so simple and straightforward a celebration of the pleasures of this world as it seems. The man in fancy-dress Oriental costume on the left may be a portrait of the artist Nicolas Vleughels, the dancing young woman in the centre is perhaps an actress of the day

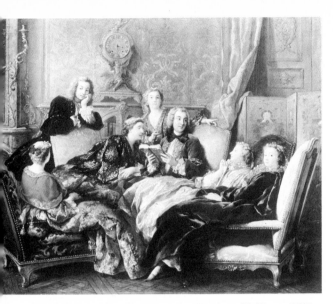

14, 1 Jean-François De Troy, *A Reading from Molière*, c.1728. Oil on canvas, $28\frac{1}{2} \times 35\frac{3}{4}$ins (72.4 × 90.8cm). Collection Marchioness of Cholmondeley.

ladies wear silks of a pattern woven at Lyons in 1728), but they are perfectly at ease in their finery. Five of them are absorbed in one another, two others stare out of the canvas as if to include the spectator in their cultivated circle. The varying, glancing directions of their gaze, as much as the contrasting colours and textures, break down what might otherwise have been too formal and self-consciously composed a group. For the accent is on informality and modish contemporaneity. The only link with the past is the volume of Molière, the great comic moralist who had satirized with supreme verve the pomposities, absurdities and pretences of society in the early years of the reign of Louis XIV.

The room in which the reading takes place is flooded with light, with looking-glasses playing a part in its diffusion (that over the chimneypiece reflecting one on the opposite wall). Every detail of decoration is of calculated, informal elegance: the tendril curves of the ormolu candle-sconces and similar motifs on the walls, the clock with figures signifying the triumph of love over time, the screen painted with decorations after Watteau, the carving on the lower rail of the chairs with their delicately turned cabriole feet. But the room is designed as much for comfort as for elegance: a screen stands in front of the door, which would have been a commanding as well as a draughty feature in a formal room, the chairs are lower and more thickly upholstered than hitherto, inviting their occupants to recline indolently.

Most French buildings of this period have been altered (if only by refurnishing) and none provides as vivid an impression of their original atmosphere of sophisticated and cultivated ease as De Troy's painting. The finest surviving French interior is probably the Princess's Salon in the Hôtel de Soubise, Paris (14, 2). It is on the upper floor of a pavilion (with a very reticent, almost plain, exterior typical of domestic architecture in France at the time) designed by Gabriel-Germain Boffrand (1667–1754) and completed in 1739–40. Even now this room seems to have been conjured up rather than constructed, so insubstantial are the walls, so effervescent the decorations, which hover above. The effect is due partly to the oval plan (very popular in France in these years), which creates a looser effect than the rectangle or circle, and partly to the manipulation of light, which floods into the room only just above floor level from tall arched windows reflected in corresponding looking-glasses. Boffrand provided the general design but the success of the decorative scheme is due to the team of artists and craftsmen who executed the various parts, interlocking with one another to create a total work of art. The

and the bagpipe player on the right is probably Watteau himself, dressed in peasant costume. Fantasy and reality and the interplay between them are the painting's theme. There was a deep strain of irony in Watteau's character—'he was born caustic', a contemporary remarked—and this gives his work its 'edge' and a sometimes haunting poignancy, a combination of sadness and sensuality. Few artists have more faithfully recorded the sheen of silk with such keen awareness that it is no more than a superficial evanescent effect of texture and light. The exquisite world he created in his *fêtes galantes* is largely a fantasy, but none the less poetically 'true'. That he had struck a penetrating chord is indicated by their vast progeny, not only in painting, but also in porcelain, lacquer, textiles, enamel, silver, even gold snuff-boxes. And his influence was even more pervasive than these might suggest: prints after his paintings and drawings proliferated all over Europe and inspired artists as diverse as Boucher, Gainsborough and Goya.

Another aspect of the early eighteenth-century French ideal of civilized life is recorded in *A Reading from Molière* (14, 1) by Jean-François De Troy (1679–1752). It probably illustrates a scene from a novel or a play, but the characterization of each individual is so sharp and the details of decoration in the room are depicted with such precision that it has often been thought to be a portrait group. The figures are dressed in the height of fashion of the late 1720s (two of the

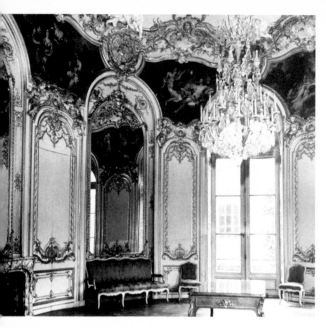

14, 2 Gabriel-Germain Boffrand, The Princess's Salon, Hôtel de Soubise, Paris, 1737–40.

curvilinear forms than a taste for whimsicality. Their organic character lends them a sensuality, a carnality almost, which becomes quite explicit in such a painting as *Hercules and Omphale* by François Boucher (1703–70), in which the gilded sofa with a cupid emerging out of its curved leg is so appropriate a piece of furniture for a scene of sensual rapture and abandon (14, 3). The picture is somewhat exceptional for Boucher, who usually left more to the imagination. But all his work, even his religious paintings, exults in the same voluptuous sensibility.

It seems a far cry from the paintings of Boucher to those of his contemporary Jean-Baptiste-Siméon Chardin (1699–1779). Boucher's scenes are often set in, and were probably intended for, the boudoir, his palette is light with an abundance of pearly flesh tints and a hint of cosmetics, his handling has an easy juicy fluency beneath a sparkling and highly finished

14, 3 François Boucher, *Hercules and Omphale*, c. 1730–40. Oil on canvas, $35\frac{1}{2} \times 29\frac{3}{8}$ins (90.2 × 74cm). Pushkin Museum, Moscow.

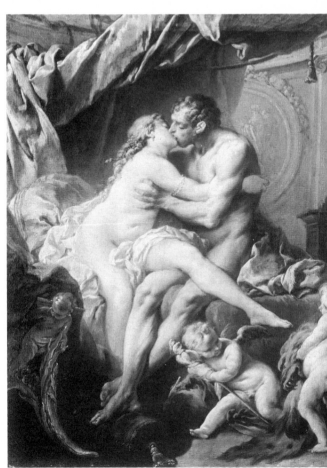

carved and painted woodwork of the walls, the delicate stucco decorations on the ceiling, and white reliefs of cupids above the 'openings' (door, windows and looking-glasses) have no less importance than the inset paintings of the fable of Cupid and Psyche by Charles-Joseph Natoire (1700–77), a leading Parisian artist of the day but one who was prepared to adapt his compositions to the unusually shaped cartouches determined by the window arches and the undulating curves of the cornice. It is a fairly large room for a private house, even by the standards of the previous century, but so airy and light as to seem intimate in scale. For the Rococo not only introduced a taste for small rooms—such as boudoirs—but answered a demand for rooms adapted to their human purposes and to a human scale. Tall pilasters and all other decorative elements which might dwarf the occupants were excluded.

The Salon in the Hôtel de Soubise is one of the masterpieces of what was called in France at the time the *genre pittoresque*—a style which subordinated architectonic to 'pictorial' motifs. Its repertory of ornament was of shells, flowers, wayward tendrils, sprouting leaves and patterns of scrolls. Lightness, elegance, gaiety and, of course, novelty were the aims of the designers who created this decorative style, Nicolas Pineau (1684–1754) and Juste-Aurèle Meissonier (c. 1693–1750). But there is more to their

surface. An air of perfumed and powdered artifice is pervasive. Chardin painted downstairs, often below stairs; his colours are subdued with the grays and browns of rough worsted to offset plain white linen; his paintings seem to have been built up slowly, methodically with thick blocks of pigment. Everything is simple and wholesome—not, as in Boucher, fancy and succulent. Yet both artists, if for totally different reasons, appealed to much the same patrons: both were, for instance, represented in the collections of Louis XV and his mistress Mme de Pompadour, the king of Sweden, the king of Prussia and Catherine the Great of Russia, not to mention numerous wealthy amateurs of art. *The Governess* (14, 7) was bought by a rich Parisian banker, who later sold it to the prince of Liechtenstein.

Chardin's paintings may have been appreciated by the rich simply because they provided a piquant contrast to their pampered lives. In many there are moral overtones of a reassuringly upper-class kind— the governess, with her work-basket beside her, reproves her young charge, whose idleness is indicated by the battledore, shuttlecock and cards on the floor. The picture is, indeed, in the moralizing tradition of Dutch seventeenth-century *genre* scenes, which were very popular with collectors (despite academic disapproval) throughout the eighteenth century. Chardin is often called the painter of the *bourgeoisie*, but the moral code he illustrated was extolled (if often infringed) by the upper as well as by the middle class. The low-life figures in his pictures are usually servants in what appear to be well-to-do households. But Chardin also appealed for his pictorial mastery, his almost miraculous power to evoke the substantial reality of objects. 'He is the one who understands the harmony of colours and reflections', wrote Denis Diderot, the most sensitive art critic of the century, in 1763. 'O Chardin! it is not red, white and black you mix on your palette: it is the very substance of objects, it is the air and the light you take with the tip of your brush and fix on the canvas.'

The robust sensitivity of Chardin and the tender sensuality of Boucher had some influence on Jean-Honoré Fragonard (1732–1806), who was apprenticed to the former for six months and to the latter for slightly longer before being absorbed into the official system of art education, in Paris and Rome. His first major painting, of 1765, was brought for the Crown and he was accepted for membership of the Academy, though he never became an Academician and rarely showed his work at the biennial Salons—the only important art exhibitions in eighteenth-century France. There were enough private collectors in Paris

who appreciated his genius as draftsman and painter for him to opt out of the official art world. His masterpiece, a series of large pictures of *The Progress of Love*, was commissioned by Louis XV's mistress Mme du Barry for a pavilion at Louveciennes.

The four scenes of *The Progress of Love* are set in a park with statues and stone balustrades amongst a luxuriant growth of flowers and free-growing trees. In the first, a girl as exquisite as porcelain is surprised by a youth climbing over a wall (14, 8). There is an ejaculatory force in the composition, echoing the subject-matter, with lines shooting upwards and outwards, and the girl in a pure white dress in the centre of it all. Everything has been set in motion by the precipitate arrival of the youth; flowers and leaves seem to tremble with excitement, even the statue is animated, preventing Cupid from snatching an arrow from her. And the whole canvas is painted with amorous energy in coruscating flecks of bright pigment. With Fragonard the Rococo took on palpitating new life; and that was probably why Mme du Barry found *The Progress of Love* unsuitable for her new pavilion. She returned the paintings to Fragonard and commissioned Joseph-Marie Vien (1716–1809)— an older and indifferent artist, but one more closely in touch with current developments in the arts—to paint a series of panels on the same theme, but with solemn Classical temples in the background, figures in antique not contemporary costume and greater emphasis on sentiment than on impulsive 'natural' urges. By this date the critical opposition to the Rococo, voiced periodically throughout the century, had grown too loud for anyone as fashion-conscious as Mme du Barry to ignore it.

The Rococo in Germany and Italy

In France the Rococo emerged in opposition to the teaching program of the Academy, which, nevertheless, continued to exert a restraining influence and forcefully reasserted its authority in the 1750s. German Rococo, on the other hand, although sometimes directly indebted to France, developed from an exuberantly Italianate Baroque. Borromini (p. 442) and the north Italian architect Guarino Guarini (1624–83), who were always regarded with suspicion by the French, inspired the spatial complexity, intricacy of form and elaboration of surface textures which German architects exploited to the point where architectonic verticals and horizontals all but dissolve. The distinction between Baroque and Rococo in Germany, as in Italy, is one of degree, which can be measured only subjectively. (The presence or absence of the Classical orders is no more than a convenient

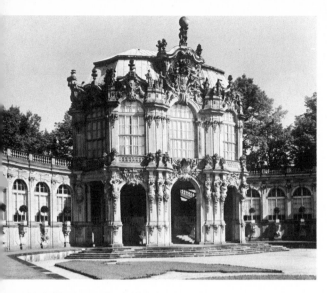

14, 4 Matthaeus Daniel Pöppelmann, Pavilion in the Zwinger, Dresden, 1711–22.

rule-of-thumb aid to categorization.)

The Zwinger in Dresden (14, 4) is of such light-hearted ebullience that it mocks stylistic classification. Incredible as it may seem, the architect Matthaeus Daniel Pöppelmann (1662–1736) claimed that he designed it according to the Vitruvian rules: he called it a 'Roman theatre'! Classical prototypes can be found for all the decorative elements which he distended and contracted, combined and dismantled and reassembled, without any inhibiting deference to the Roman sense of decorum. In conception, however, this extraordinary building goes back to ephemeral 'festival' architecture. Elaborate, open-air festivals had played an important part in European court life ever since the Renaissance, combining entertainment with instruction—about the magnificence, wisdom and power of princes. The Zwinger (the word means simply 'outer courtyard') replaced a wooden amphitheatre to provide a permanent setting for parades, carousels and other pageants.

The patron was Augustus the Strong (1694–1733) and the statue of Hercules crowning the 'grand stand' of the Zwinger symbolized both his strength and the burden he had assumed as king of Poland and elector of Saxony. Aspiring to build a palace to outshine all others, he despatched Pöppelmann on a study tour of Austria and Italy to pick up ideas, but the Zwinger was the only part to be erected. After his return Pöppelmann made a succession of designs which show him gradually moving away from the boldness and massiveness favoured in the late seventeenth century,

towards ever greater intricacy and richness, perhaps at the behest of Augustus, whose taste in art was for the exquisite and opulent. (He founded the Meissen factory in 1710, the first to produce true porcelain in Europe.) The Zwinger owes much of its enchanting effect to the unusually happy collaboration between architect and sculptor, Balthasar Permoser (1651–1732), under whose guiding hand the wall surfaces were animated with flowers and masks, leering satyrs and muscular term-figures. Together they produced a unique masterpiece in which architecture and sculpture are completely integrated. All that is lacking is colour, originally provided by the costumes of the performers in the festivities for which the Zwinger was created.

The Zwinger is exterior architecture (the rooms in the pavilions were something of an anticlimax even before they were burnt out in 1944), though of a very unusual kind. For the vast courtyard was conceived as if it were an interior, an enclosed space which can be fully appreciated only by walking through it or looking down into it from the upper windows of the pavilions. Early eighteenth-century architects were generally more concerned with the manipulation of space than with form. This is equally apparent in French town-houses and south German churches, which seldom give an external hint of the splendours within.

The Wieskirche (or 'church of the meadow'), in open country near Füssen and Oberammergau in southern Bavaria, has an undistinguished exterior. Inside is a miracle of light and colour and swirling all-encompassing decorative motifs, giving the visitor coming through the door an extraordinary feeling of welcome and joy (14, 9). This was, of course, the intended effect, for it is a pilgrimage church. The architect, Dominikus Zimmermann (1685–1766), was by training a craftsman—a worker in stucco—who retained throughout his life a peasant vitality and unquestioning piety. But he had a highly sophisticated understanding of architectural space and a feeling of the utmost refinement for ornament. In the Wieskirche the rather broad oval of the nave flows into an oblong chancel, drawing the visitor towards the altar not only by the curvature of the walls and the disposition of the columns but also by the intensification of colour and the richness of the decoration—from the predominantly white nave, with motifs picked out in gold, pinks and blues, to the glowing pink chancel, with details in shining white. Structure dissolves, leaving the decorative motifs as if suspended in space; even the

14, 5 Right Antoine Watteau, Fête Champêtre, c. 1717–18. Oil on canvas, 21½ × 17¾ins (54.6 × 45cm). National Gallery of Scotland, Edinburgh.

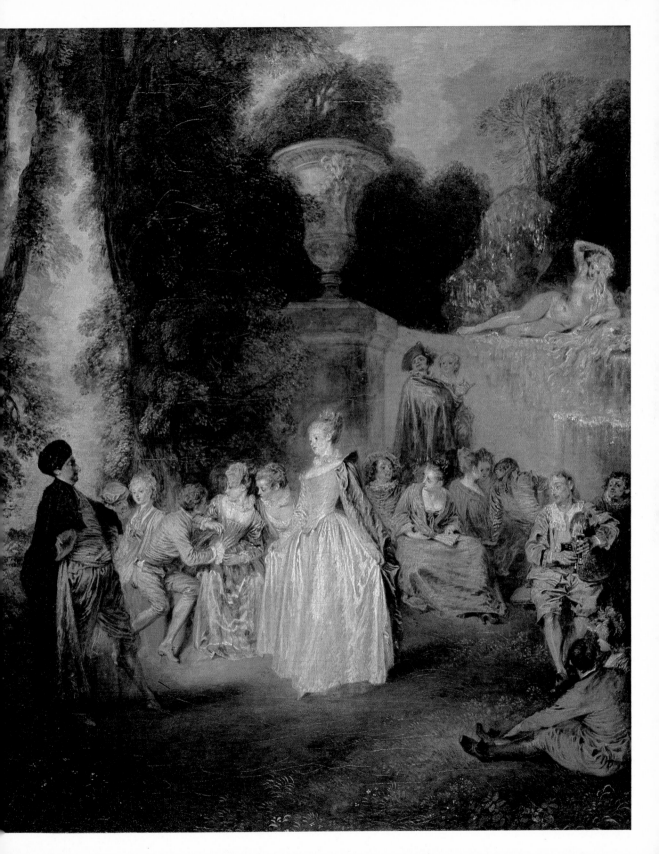

large and elaborate pulpit seems to hover in mid-air.

Such church interiors—and there are many in central Europe—gave the visitor and especially the peasant pilgrim a vision of heaven. This was their main purpose. At Ottobeuren the prior of the abbey asked Johann Michael Fischer (1692–1766) to design a church that would be 'new, splendid and worthy of the King of Heaven and Earth'. Yet their ostentatious decorations, even their colours, have religious significance as well. The Wieskirche, for instance, is dedicated to Christ Scourged and the red columns in the chancel symbolize his blood. It is without the slightest sense of impropriety that simple piety is combined with a taste for the mondaine and fantastical. No hint of secularization is implied, rather the reverse—the sanctification of the secular.

Among the sculptors who worked for the churches in Bavaria, Ignaz Günther (1725–75) was outstanding. His statues are of wood, often painted in naturalistic colours, but the rusticity of the medium is offset by the preternatural grace of his tall, light-footed figures, which perfectly blend sophistication with guileless innocence. The two are contrasted and combined in the group of a very chubby, earthy peasant-boy Tobias clutching the hand of a delicately poised and rather superior angel from the court of heaven (14, 12). Günther had studied late sixteenth-century statues in Munich, and the influence of Italian Mannerism, especially the serpentine figure (p. 379), is very evident in his, as in many other Rococo, sculptures. But he was also heir to the German tradition of naturalistic wood-carving, which reached back to the Middle Ages, when the idea of saints and angels dressed in the height of fashion had seemed no more untoward or irreligious than it did to him. Although he was appointed sculptor to the elector of Bavaria in 1754, the unmistakably Germanic and religious character of his work set him apart from other artists employed at the court.

In the mid-eighteenth century the courts of the many German principalities looked to France for leadership in fashion; in some even the language spoken was French. The genre pittoresque, diffused by engraved designs, influenced architectural decorations and the furnishings made to accompany them. The Bavarian court architect François Cuvilliés (1695–1768) had been trained in Paris and introduced into Germany a kind of hyper-Rococo version of French interior design. But in painting (as in operatic music) Italy still retained its prestige. Thus, when the prince-bishop of Würzburg wished to add the crowning touch of magnificence to his vast palace, he called in the greatest (and most expensive) fresco painter of the time, the Venetian Giovanni Battista Tiepolo (1696–1770).

At Würzburg Tiepolo painted the ceiling of the Kaisersaal—the main state room, suitable for the entertainment of the Holy Roman Emperor—and the ceiling above the staircase that leads up to it. The staircase is itself an imposingly dramatic creation by Johann Balthasar Neumann (1687–1753), the most gifted and prolific German architect of his time, a master of elegant and ingenious spatial compositions of great intellectual and visual complexity. Here Tiepolo was required to record the fame of the prince-bishop Carl Philip von Greiffenklau, trumpeted to the corners of the earth and beyond to the gods on Olympus—an unpromising program, which he made, nevertheless, the vehicle for what is perhaps his finest work, sparkling with Venetian light and colour (14, 15). Unlike most previous ceiling paintings, it was intended to be seen from a succession of viewpoints. The eye of a visitor climbing the first flight of the staircase from the rather cavernous ground floor is caught immediately by a nude woman with feathers in her hair symbolizing America—the New World, source of prodigious natural riches. A turn to right or left on the half-landing brings into view bizarrely dressed figures and exotic animals representative of Asia and Africa. Ascending either of the twin flights leading to the main floor the visitor is finally confronted with Europe and the portrait of the prince-bishop suspended in a sky teeming with gods and goddesses and cupids and figures of fame. The whole ceiling, a vast area of nearly 6,000 square feet (557sq.m), is painted with astonishing illusionistic bravura and a complete command of the fresco painter's resources. It is also enlivened by flashes of Tiepolo's visual wit. The architect, Neumann, for instance, in the uniform of an artillery officer with a svelte dog beside him, is portrayed reclining on the trompe-l'oeil cornice which connects the frescoed surface of the ceiling with the relief decorations on the walls. Painting, architecture and sculpture (stucco figures and huge shells in the corners) interpenetrate to create a total environment masking the frontier between reality and fiction.

The ceiling presents a view of the world cherished by Enlightenment thinkers who were fascinated by distant countries—their flora and fauna, their peculiar artifacts, and the customs and religious beliefs of their strangely beautiful people—but unquestioning in their faith in European superiority. On Tiepolo's ceiling Africa, America and Asia produce the goods to be enjoyed by Europe in civilized comfort. There are enticing bundles and casks on the shore of Asia, where merchants examine ropes of pearls held out by a turbaned Oriental. Europeans, on the other hand, are

able to devote themselves to the arts of music, architecture, sculpture and painting. But Tiepolo's view of the world was not only Eurocentric—it was Venetocentric. The ceiling is a tribute to his own Venetian school and especially the art of Paolo Veronese (p. 375). The livery of the page-boys, who appear in several parts of the ceiling, is sixteenth-century Venetian and the throned female figure symbolizing Europe (to the left of the musicians) is almost directly copied from one of Veronese's allegories of the city of Venice.

Local patriotism is apparent in much of the art of eighteenth-century Italy. Italians had already begun to live on their artistic past. The Bolognese clung tenaciously to their early seventeenth-century masters. Rome was dominated by the Classicism of the High Renaissance. Venetians looked back to the richness and colour of Titian, the elegance of Veronese and the dramatic lighting effects of Tintoretto (pp. 370–5). Francesco Guardi (1712–93) is perhaps best understood as the last exponent of a tradition initiated by Tintoretto. He began as a figurative painter working with his brother Gianantonio (1699–1760). But his fame rests mainly on his views of Venice, which beautifully capture the sparkle of sunshine on domes and towers and the eerie mystery of its dark canals and passages (14, 13). Very few are dated nor is much known of the public for which he painted them. He certainly did not have the success with rich foreign visitors to Venice enjoyed by Canaletto (1697–1768),

whose cool clear views of the city were much to the taste of the English. Under the lightning brilliance of Guardi's flicks and dabs of colour, buildings, gondolas, sailing ships, men and women in flurrying cloaks, all seem to dissolve into aerial fantasies. That the government of Venice was also on the point of dissolution may be no more than a coincidence: only four years after Guardi's death the city fell to the French republican army of Napoleon.

English sense and sensibility

The Italian Baroque, which inspired German architects, was viewed askance in Great Britain from the early eighteenth century. 'How affected and licentious are the works of Bernini' wrote the Scottish architect Colen Campbell (1676–1729). 'How wildly Extravagant are the designs of Borromini, who has endeavoured to debauch Mankind with his odd and chimerical Beauties' (*Vitruvius Britannicus*, 1715). This combination of rational and moral disapproval isolated Great Britain from the rest of Europe in artistic matters. Campbell was the spokesman for a group of architects, including the earl of Burlington (1694–1753) and other wealthy amateurs, who advocated a return to Classical principles by way of Andrea Palladio (p. 375). Burlington indeed built for himself at Chiswick near London one of the several English versions of Palladio's La Rotonda. Houses in the Neo-Palladian style, created in England and taken up in the American colonies, make an effect of robust self-assurance, unaffected good manners and very solid prosperity. They also had political and social implications. Their Classicism was Roman and seemed to embody the republican virtues extolled by Cicero and for many years thrashed into every English schoolboy, but never more highly valued than after the development of constitutional monarchy which, under George I (1714–27), gave political power to a land-owning oligarchy. A Neo-Palladian house declared its owner's respect for propriety and decorum and with its dressed stonework, columns and pediment, marked his social standing far more obviously than the seventeenth-century brick-built gentleman's house.

This social aspect of the style is well brought out in paintings by William Hogarth (1697–1764). In the second scene of his *Marriage à la Mode* series an ill-matched couple (young viscount and city merchant's daughter) are shown in a typical Neo-Palladian room with columns and Classical ornament (14, 6). Italianate pictures on the walls indicate upper-class taste. But there are also some telling 'frivolities', Chinese porcelain figures on either side of a Roman bust on the chimneypiece and a preposterous Rococo

14, 6 William Hogarth, *Marriage à la Mode II*, 1743. Oil on canvas, 27½ × 35¾ins (69.9 × 90.8cm). National Gallery, London.

14, 7 *Left* Jean-Baptiste-Siméon Chardin, *The Governess*, 1738. Oil on canvas, $18\frac{1}{3} \times 14\frac{3}{4}$ins ($46.5 \times 37.5$cm). National Gallery of Canada, Ottawa.
14, 8 *Bottom* Jean-Honoré Fragonard, *The Surprise*, 1771–2. Oil on canvas, 125×96ins (317.5×243.8cm). Frick Collection, New York.
14, 9 *Right* Dominikus Zimmermann, The Wieskirche, Bavaria, 1745–54; *below*, plan of the church.

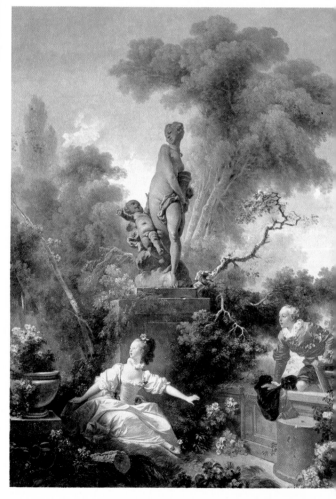

clock on the right. To Hogarth such objects symbolized heartlessness or affectation—deviance from nature in life and art. Yet his attitude to the Rococo was equivocal. He was closely associated with the decorative designers who cultivated an English version of the *genre pittoresque*, for furniture, metalwork and the title-pages of books. The wonderfully free brush-strokes of his paintings suggest the influence of contemporary French artists. And he chose French engravers active in England for the prints which made him and his paintings famous.

Hogarth was most sharply set off from his contemporaries on the continent by moral attitudes which were secular rather than Protestant, derived from common sense as much as from bourgeois values. This was the morality preached by the two leading journalists and writers of the time, Joseph Addison and Richard Steele. Hogarth's satire on the fashionable marriage of convenience, which leads to unhappiness and immorality, may well have been inspired by an essay Addison wrote for the *Spectator* in 1712, celebrating the ideal of marriage based on love—in comfortable financial circumstances, of course. The theme was taken up by countless English novelists and playwrights. Love was presented as a 'natural' passion, but one which should be restrained within a reasonable

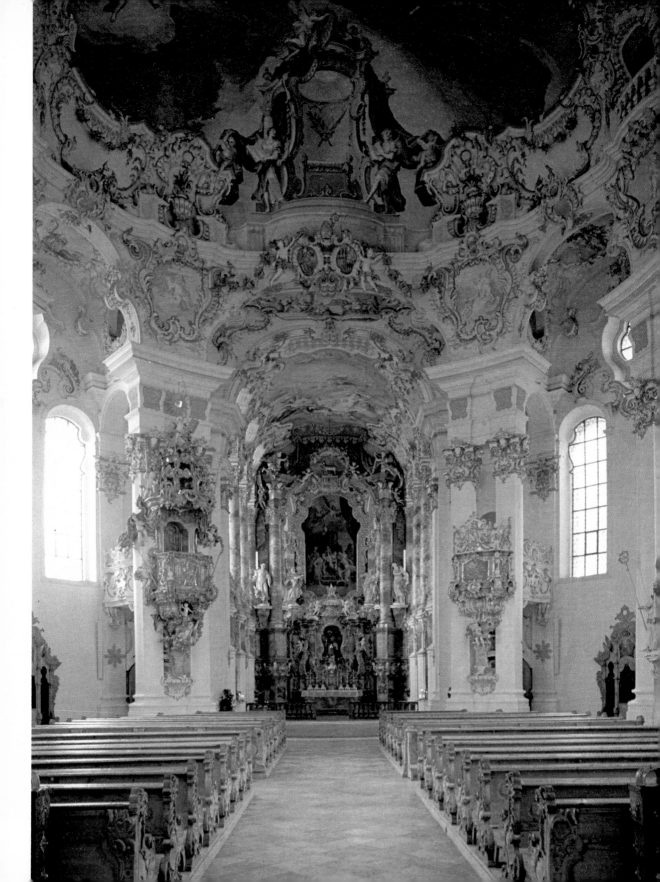

framework of social conventions. Addison in his essays and Alexander Pope in his poetry extolled the related ideas of nature and liberty—words which then had meanings different from those they were to acquire at the end of the century and retain to the present day. The natural was then understood simply as the opposite of the artificial, the affected, the aberrant. Nature signified not the wild and lawless, but the divinely ordered universe, as revealed by Newton, in which everything had its appointed place. Liberty could be regarded as 'natural' only within this structure, which provided the model for the social system.

These ideas, or rather these assumptions, lie behind one of the most eloquent English pictures of the mid-century, the portrait of the Suffolk squire Robert Andrews and his wife Mary—a well-matched couple from the same stratum of county society—painted shortly after their wedding in 1748 by the young Thomas Gainsborough (1727–88) (14, 14). This wonderfully fresh little painting is eminently natural, especially the very precisely rendered background, clearly the record of an actual place. Despite their fine clothes, there is more than a touch of rustic provincial gaucherie in Mr and Mrs Andrews, who make as striking a contrast with the figures in French outdoor scenes as does the Suffolk landscape with the balustraded, be-statued gardens of France (depicted by Watteau and Fragonard, 14, 5 & 8). The landscape in which the pair are shown, presumably at their request, is their own estate. They are placed at the point where their park with its clumps of trees merges into their well-cultivated farm-land with its neat hedges and gates, stooks of recently cut grain in the foreground and sheep grazing a distant meadow.

The landscape park, perhaps the most important British contribution to the visual arts of the eighteenth century, was often regarded as a symbol of liberty, in contrast with the rigidly formal gardens of Versailles, in which the domination of nature could be equated with autocracy. A park often had a monument to British liberty—in the form of a ruin recalling the Barons' Wars and *Magna Carta* or a temple of British worthies—liberty as defined by Locke and enjoyed by the propertied class. The ditch or 'ha-ha', which separated a gentleman's park from the surrounding world of unimproved nature, was a most discreet, indeed almost invisible barrier, although one no less firmly set and effective than that dividing the owners from other ranks of society. An ideal of self-assured informality, unostentatious wealth, untyrannical power and unpedantic learning is reflected in these parks and landscape gardens. Like the Neo-Palladian

country-house, they were the product of a Classically based culture, created by and for the well-bred and well-read. Sometimes it was directly associated with ancient Rome. At Stourhead in Wiltshire Henry Hoare (the son of a banking family which had made a vast fortune after the revolution of 1688) transformed his estate into a Virgilian landscape of running brooks, lakes, groves of mixed trees, Classical temples and a sibyl's grotto. The effect is reminiscent of paintings by Claude (14, 10 & 13, 15). As in other English parks, there is a note of nostalgia for youthful days on the Grand Tour to Italy, which completed a Classical education. But the main purpose of the makers of these landscape gardens was more serious: to penetrate and, as it were, to liberate an ideal lying beneath the common face of nature.

The Classical past permeated British culture throughout the eighteenth century. Deviations into Gothic and Chinese architectural styles merely afforded amusing contrasts to emphasize the supremacy of the Classical norm. But attitudes began to change in the mid-century. When the architect Robert Adam (1728–92) went to Italy on his Grand Tour in 1754 he quickly realized that the Neo-Palladian houses he had previously built in Scotland bore scant resemblance to the monuments of ancient Rome. Like the Italian engraver and architect Giovanni Battista Piranesi (1720–78), he responded to the richness, variety and magnificence of imperial Roman architecture. These were the qualities he strove to recapture in the houses he began to design soon after setting up his practice in London in 1758. The ancient Roman baths (p. 172) inspired him to make imaginative use of contrasted shapes and sizes of rooms and to plan an interior as a series of dilating and contracting spaces. At Syon House near London, where he remodelled the shell of an early seventeenth-century building, a severe entrance hall, accented horizontally, opens into a seemingly lofty square room of imperial Roman splendour with great gilt trophies of arms on the walls and tall green marble columns topped by gilded statues (14, 11). The following two rooms are oblong but with contrasted decor, a dining-room with copies of famous antique statues in niches, and a drawing-room where the unit and scale of the decorations is decreased to create a more intimate, relaxed effect.

Not only the wall surfaces but also the furniture, the carpets, even the door-knobs and key-hole guards were designed in Adam's office. In his interiors the architect rules supreme: craftsmen became merely the mechanics executing designs as precisely as possible. The style he created therefore lent itself well to industrial production. Pottery designed in his manner and made

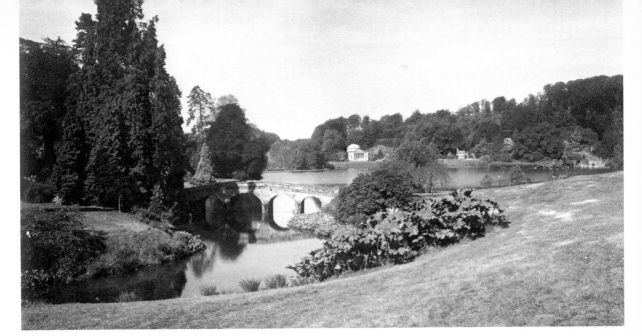

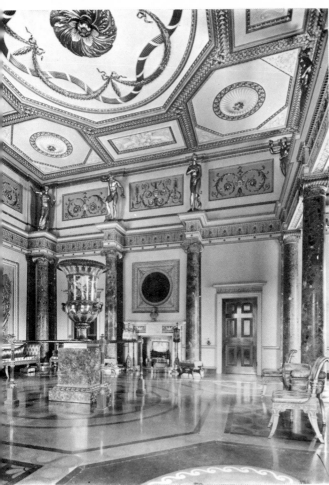

14, 10 *Above* The Park at Stourhead, Wiltshire, laid out 1743.
14, 11 *Left* Robert Adam, Anteroom, Syon House, Middlesex, 1760-9.

in the Staffordshire factory of Josiah Wedgwood (1730–95), for instance, was the work of simple artisans following predetermined patterns. The craftsman's individual touch was no longer needed. One of the results was a widening of the gap between artists and craftsmen, especially in England, where industrialization was more advanced than elsewhere. For this and other reasons artists demanded recognition of their superior status and this was partly achieved by the foundation of the Royal Academy in 1768.

The first president of the Royal Academy, Sir Joshua Reynolds (1723–92), knighted the year after its foundation, was obsessed by status, personally, professionally and nationally. The son of a clergyman-schoolmaster, he came from a social stratum above most English artists of his day and, as a youth, declared his ambition to be more than an 'ordinary painter'. Like Robert Adam he made the Grand Tour to Rome, where he saturated himself in the work of Raphael, Michelangelo and the seventeenth-century Bolognese masters. His desire was to emulate the 'grand style', but he was shrewd enough to see that the market for 'history pictures' (mythological as well as religious) was very limited in England, where the Old Masters were much collected but living painters were patronized mainly as portraitists. He therefore devoted himself to elevating the art of portraiture. Male sitters were posed by him in the attitudes of antique statues;

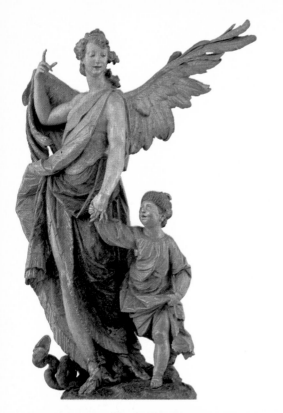

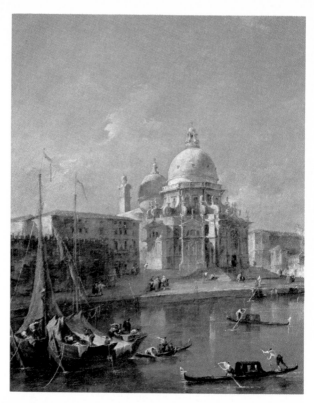

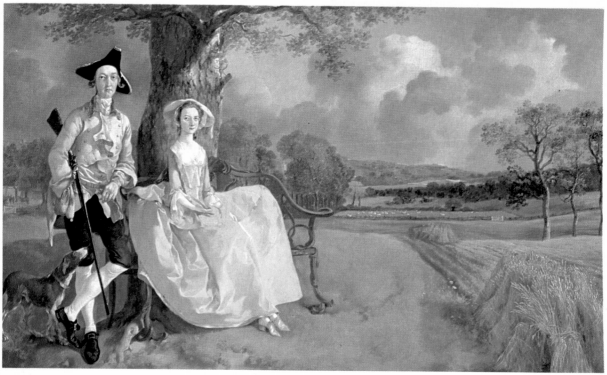

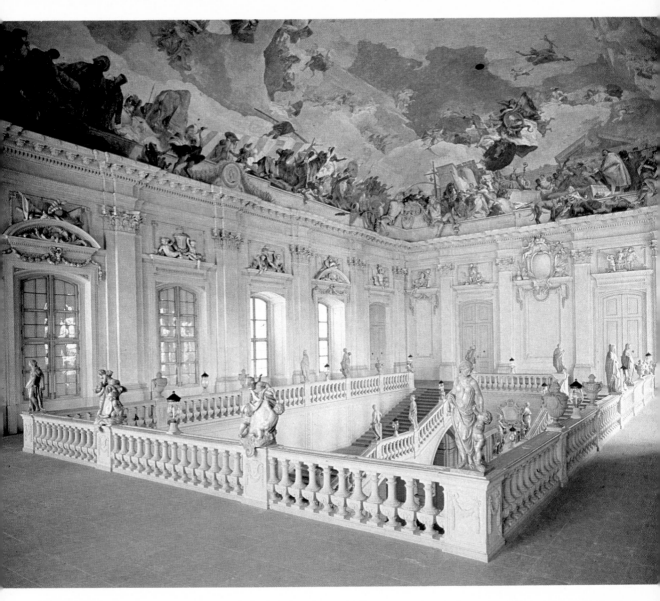

14,12 *Opposite top left* Ignaz Günther, *Tobias and the Angel*, 1763. Limewood, height 69⅝ins (177cm). Burgersaal-Kirche, Munich.
14,13 *Opposite top right* Francesco Guardi, *Santa Maria della Salute*, Venice, c. 1765. Oil on canvas, 19 × 15⅛ins (48.3 × 38.4cm). National Gallery of Scotland, Edinburgh.
14,14 *Opposite bottom* Thomas Gainsborough, *Mr and Mrs Andrews*, c. 1749. Oil on canvas, 27½ × 47ins (69.8 × 119.4cm). National Gallery, London.
14,15 *Above* Giovanni Battista Tiepolo, Staircase ceiling of the Residenz, Würzburg, Germany, 1752–3.

ladies were treated almost like figures in mythological compositions. Lady Sarah Bunbury (one of the most famous beauties of the day, whom George III had wanted to marry) he depicted as a priestess sacrificing to the Graces (14,16). This grand style was reserved, however, for his socially grander sitters: men of letters, such as Dr Johnson, were portrayed in more natural poses and in the clothes they normally wore. Although he became the most fashionable English portrait painter of his time, Reynolds despised fashion, exhorting young artists to rise above it. In 1771 he declared in one of the *Discourses* he delivered year after year at the Royal Academy: 'If a portrait painter is

desirous to raise and improve his subject, he has no other means than by approaching it to a general idea'. He should change 'the dress from a temporary fashion to one more permanent, which has annexed to it no ideas of meanness from its being familiar to us.'

Reynolds is said to have been shocked when he first heard that Benjamin West (1738–1820), an American settled in London, was painting an historical subject in contemporary dress. It represented the death of General James Wolfe as victor over the French at the battle of Quebec, a turning-point in the war that made Canada a British colony (14,17). There were accepted traditions for the depiction of such a scene. It could be treated as an allegory with personifications of victory, war and so on; or as an heroic scene with the figures in Classical costume; or as straight reportage. Although the latter was denigrated by theorists, West combined it with the others: the costumes suggest reportage, the poses Classicism, while the figures are at the same time symbols and flesh-and-blood individuals who might have been present when Wolfe died. The pensive Indian in the foreground, for instance, is both a personification of America and a 'portrait' of one of the British Mohawk auxiliaries. The picture was conceived in the grand style with echoes of the Old Masters—Wolfe is in the attitude of Christ in a *Deposition* by van Dyck. Only the costumes would have to be changed to convert it all into a scene from Biblical, Classical or medieval history.

But contemporary costume was important for another reason. The sense of reality it gave reinforced the truth of a painting's moral message. West drew from the particular incident a general significance: the calm courage with which the hero faces death. And his picture also reflects the current shift in emphasis from the concept of divine judgement and eternal life to that of judgement by posterity and immortality on earth. Wolfe, it is suggested by West, will live in the memory of those around him; and through them the story of his heroic death will be transmitted to future ages. The painting is a secular apotheosis, a rationalization of a Renaissance or Baroque altarpiece, with the angel carrying a crown of martyrdom replaced by a soldier who cries: 'they run, I protest, they run', and the martyr by a hero (a Protestant, of course, for the war in Canada was against a Catholic power). It also made

14, 16 *Above right* Sir Joshua Reynolds, *Lady Sarah Bunbury sacrificing to the Graces*, 1765. Oil on canvas, 94 × 60ins (238.8 × 152.4cm). Art Institute of Chicago (W. W. Kimball Collection).
14, 17 *Right* Benjamin West, *Death of General Wolfe*, c. 1770. Oil on canvas, 59½ × 84ins (151.1 × 213.4cm). National Gallery of Canada, Ottawa (Gift of the Duke of Westminster 1918).

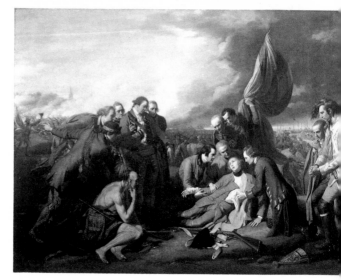

an appeal to 'sensibility', that proneness to emotion, more particularly the emotion of sympathy, which led to the cult of the tender heart and 'generous tear', complementing hard-headed rationalism among the cultivated in the eighteenth century. The 'man of sensibility' was much admired.

The prodigious popularity enjoyed by prints of West's *Death of Wolfe* (the engraver is said to have earned £15,000) was, however, largely due to a turn of political events. Only five years after the picture was exhibited in London the Declaration of Independence was signed in Philadelphia and North America suddenly became the promised land of the Enlightenment. Both the Declaration and the constitution of the United States were based on the rational principles of natural law—the 'self-evident' rights to which we have already alluded (p. 459). And when Americans wished to give artistic expression to these political ideals they turned to the masterpieces of Classical antiquity, not because they were fashionable in Europe, but because they embodied—or seemed to embody—aesthetic principles no less eternally and universally valid. Thus, Thomas Jefferson (1743–1826) selected the Maison Carrée at Nîmes (5, 27)—'without contradiction . . . the most perfect and precious remain of antiquity in existence', he called it—as the model for the state capitol of Virginia, designed by him in collaboration with the French architect Charles-Louis Clérisseau (1721–1820), formerly drawing-master to Robert Adam.

Neo-Classicism or the 'true style'

The founders of the United States were often seen, and sometimes represented, as figures from the ancient world. Benjamin Franklin was portrayed wearing a toga like a Roman senator. But Jefferson wears modern dress in his bust (14, 18) as does George Washington in the statue carved on Jefferson's recommendation for the state capitol of Virginia. The author of these works was Jean-Antoine Houdon (1741–1828), the leading French portrait sculptor of his day. Houdon combined unusual directness, almost an innocence, of vision with great dexterity of hand. In one bust after another he brings us jowl to jowl, eye to illusionistically sculptured eye with a large number of his most eminent contemporaries—Voltaire, Diderot, Rousseau and other luminaries, as well as the leaders of the American Revolution. Repetitions of these portraits were produced in Houdon's studio in various sizes and media as images for the cult of great men of modern times that was promoted by thinkers of the Enlightenment. Whether the sitters are shown wearing their own hair or wigs, whether bare-necked with

stylized antique drapery around their shoulders or with cravats and contemporary clothes, these busts have an air of being perfectly natural. And in this way they answered the call to renounce Rococo affectation and 'return to nature' that was reiterated with increasing vehemence in the second half of the eighteenth century.

Reaction against the Rococo set in almost simultaneously in France, Germany and England in the 1750s, though from diverse and complex intellectual motives. Thinkers of the Enlightenment played an important part with their demand for logic, clarity, simplicity and moral rectitude. Jean-Jacques Rousseau (1712–78), the fiercest critic of the evils of contemporary social life and the most impassioned advocate of the cultivation of natural sentiments, called in 1750 for a didactic art—for statues and paintings of 'the men who have defended their country or those still greater who have enriched it by their genius'. In words that bring to mind paintings by Boucher (14, 3), he condemned 'images of every perversion of heart and mind, drawn ingeniously from ancient mythology'. Simultaneously a less high-minded, more general nostalgia for the glory of the 'great century' of Louis XIV led to condemnation of

14, 18 Jean-Antoine Houdon, *Thomas Jefferson*, 1789. Marble, height 21½ins (54.6cm). Library of Congress, Washington DC.

the style which had flourished in its aftermath. There was also a demand for a 'new' art, the retrieval or creation of what was called at the time the 'true style' and, much later, Neo-Classicism. In England this demand reflected national self-consciousness and the ambition of artists, such as Reynolds, to found a national school on a par with those of sixteenth-century Italy. In Germany it was coloured by bourgeois hostility to the Francophile culture of the princely courts.

The term 'Neo-Classical', coined in the mid-nineteenth century, gives a misleading impression, implying a style devoted essentially to the revival of antique forms. Ancient Roman buildings and antique statues had, in fact, been admired, imitated and sometimes directly copied throughout the first half of the eighteenth century. Their pre-eminence had never been seriously doubted. But they were revealed in a new light by Johann Joachim Winckelmann (1717–68), who effected a complete reappraisal of the art of antiquity (as understood since the Renaissance) and suggested the means for the regeneration of that of his own time. His first book, *Thoughts on the Imitation of Greek Works of Art* (Dresden 1755, translated into English 1765), broke away from the dry antiquarianism of earlier Classical scholarship. Writing from the point of view of an aesthete, a 'man of sensibility' and a man of the Enlightenment, he understood and discussed Greek statues as living works of art of eternal relevance (albeit without realizing how many of them were not originals). To him they embodied the essence of the Greek spirit, its liberty and love of the good, the beautiful and the true. 'The only way to become great and, if possible, inimitable', he wrote, 'is by imitation of the ancients'—not by the straightforward copying of antiquities, of course, but by emulating their essential aesthetic and moral qualities, which he defined in a famous phrase as 'noble simplicity and calm grandeur'. Winckelmann's fusion of the ideas of the Enlightenment with the art of antiquity set such familiar works as the *Apollo Belvedere* (5, 4b) in a new perspective, together with the recent discoveries at Herculaneum from 1738 and Pompeii from 1748 (see p. 147). But Winckelmann went further than that. He gave a sense of aspiring purpose to the reaction against the Rococo. And his shift in emphasis from form to spiritual essence contributed to the creation of a new theory of the arts which was expressive rather than mimetic (or imitative in Aristotle's sense), with still more far-reaching consequences.

Winckelmann's influence was pervasive but it was most strongly felt in Rome, where he lived from 1755 to 1768 and where most of the statues he extolled were to be seen. Here it was that the sculptor Antonio Canova (1757–1822) and the painter Jacques-Louis David (1748–1825) underwent a kind of artistic revelation and conversion. Canova began his career in the Venice of Guardi, carving figures which have the graceful lightness and sensuous charm of those in Tiepolo's frescoes. Before he was 20 he had astonished Venetian connoisseurs with his technical virtuosity. But in 1779 he visited Rome, where he settled permanently next year, fell in with an international (predominantly British) set of artists, archeologists and theorists, and began to evolve a new sculptural style of revolutionary severity and uncompromising idealistic purity. His austere monument to Pope Clement XIV (SS Apostoli, Rome), completed in 1787, won him international renown and also numerous

14, 19 Jacques-Louis David, *The Dead Marat*, 1793. Oil on canvas, approx. 63 × 49ins (160 × 124.5cm). Musées Royaux des Beaux-Arts de Belgique, Brussels.

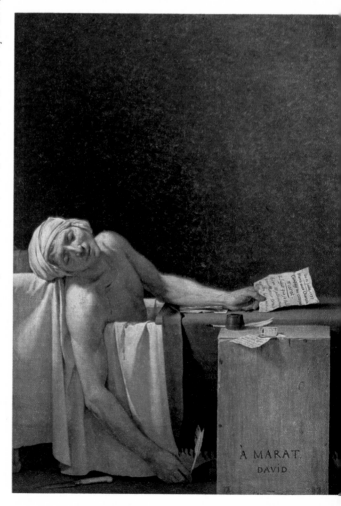

commissions. He was hailed as the continuer of the ancient Greek tradition, the modern Phidias.

The free-standing statues and groups Canova went on to carve in a gentler, less impersonal style were even more widely acclaimed. Their subjects were drawn from Classical mythology, sometimes challenging comparison with the most highly admired antiquities. But they are always suffused with the sensibility of his own time. His *Cupid and Psyche* is as far removed in feeling from Greek or Roman sculptures as from those of the earlier eighteenth century (14, 21). Representing the moment, in the version of the fable by Apuleius, when Cupid revives the dying Psyche, it is a complex image of love and death, of eroticism purged of sensuality, of idealism made tangible and accessible by human passion. Nor is it less complex when viewed

solely as a three-dimensional composition of inter-locking forms in contrapuntal harmony, revolving through a series of mellifluous and apparently effortless transitions. The figures, wholly absorbed in one another without so much as a glance towards the spectator, form a self-contained entity and demand to be seen as such. The group has to be shown in a central position. In addition to 'reviving' the art of sculpture (in the eyes of his contemporaries), Canova liberated it from the architectural settings to which most works, apart from portraits, had been bound since the early seventeenth century. It is also a sign of the times that some of his new statues were intended for museums— the first great works of art to be created specifically for this purpose. Museums were now regarded for the first time as institutions for public education.

Jacques-Louis David, like Canova, began in a distinctly mid-eighteenth-century manner. He was a product of the French system of artistic education

14, 20 Jacques-Louis David, *The Oath of the Horatii*, 1784–85. Oil on canvas, approx 14 × 11ft (4.27 × 3.35m). Louvre, Paris.

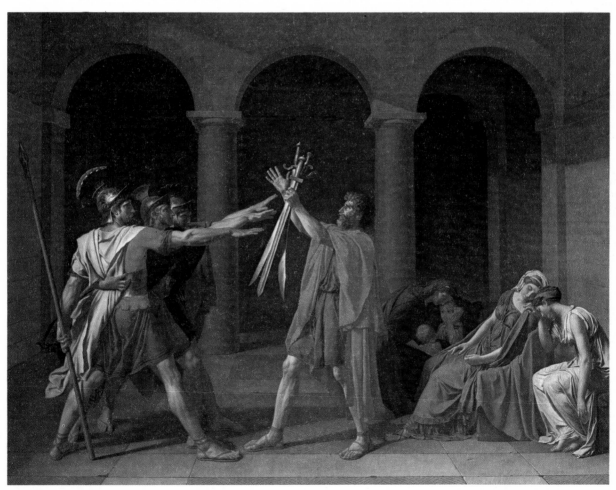

shortly after it had been made more rigorous, a student at the Academy in Paris and then from 1775 to 1780 at the French Academy in Rome. He went back to Rome in 1784 to paint his first great masterpiece, *The Oath of the Horatii* (14, 20). It was commissioned for the Crown as one of a number of pictures with the didactic purpose of improving public morality through the visual arts. The subject was probably proposed and certainly approved by Louis XVI's minister for the arts. But David himself was responsible for selecting, one might say inventing, the particular scene or incident, which is not described in ancient or later literature. The three Horatii brothers are shown selflessly resolving to sacrifice their lives for their country, a premonitory overture stating the great themes of a story from the early history of ancient Rome told by Livy and dramatized by the seventeenth-century French tragedian Pierre Corneille. (To settle a political dispute the three Roman Horatii fought three brothers from the neighbouring city of Alba; the only survivor was one of the Horatii who, on returning victorious to Rome, killed his sister for lamenting the death of one of the Alban brothers, her betrothed lover.)

The nobility of ancient Roman stoicism and patriotism is the message, which David conveyed with an appropriately stoic directness and economy of visual means. Style is fused with subject-matter in this evocation of an heroic world of simple, uncomplicated passions and blunt, uncompromising truths. Masculine courage and resolve is contrasted with feminine tenderness and acquiescence: the taut muscles of the brothers, vibrant with an almost electric energy, are balanced, across the noble aspiring stance of their father, by the softly pliant draperies and meltingly compassionate gestures of their mother and sisters. Compositional lucidity is reinforced by the limpid early morning clarity of the lighting and the pristine purity of colour, as well as by the rudimentary simplicity of the shallow box-like space with its primitive Doric columns and semicircular arches. David followed up this work with another on the same vast scale (more than 10 feet, 3m, high) and still more severe in subject—the ancient Roman consul Brutus seated in his house while lictors carry in the bodies of his two sons, who have been executed at his command for treasonable conspiracy (Louvre, Paris). It was also painted for the Crown and exhibited at the Salon in 1789, a few weeks after the Bastille had been stormed. Both pictures are revolutionary in an artistic sense; but whether they were so politically, as was later only too easily assumed, is uncertain.

The events of 1789—the demolition of the Bastille,

which demonstrated that the king had lost control of Paris, the formation of a national assembly and its declaration of the Rights of Man, the nationalization of Church property, the abolition of feudal rights, riots throughout the land—forced on every Frenchman a political choice of the utmost gravity. David threw in his lot with the revolutionary extremists of the Jacobin club. He was elected to the Convention in 1792 and voted for the death of the king, he became a member of the police committee of 'General Security', which was mainly responsible for administrating the Terror, and when more moderate views began to prevail in 1794 he was imprisoned. During the Jacobin years he devoted his art to the new republic, finding the style he had forged for pictures of ancient virtue to be the perfect vehicle for commemorating the 'martyrs' of the Revolution in paintings hung in the Convention—the journalist Jean-Paul Marat murdered in his bath by Charlotte Corday, the young Joseph Barra shot by royalist troops, and Lepeletier de Saint-Fargeau, a fellow member of the Convention, killed by a royalist during the trial of Louis XVI. *The Dead Marat* is the most deeply moving of David's works and perhaps the greatest 'political' picture ever painted (14, 19). The

14, 21 Antonio Canova, *Cupid and Psyche*, 1787–93. Marble, height 61ins (155cm). Louvre, Paris.

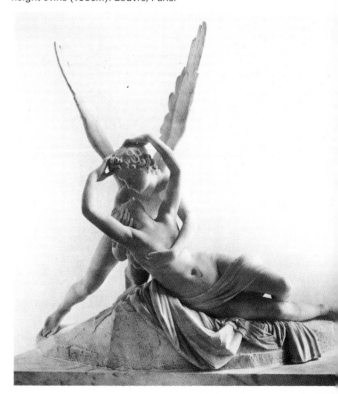

absolute minimum of detail necessary to recreate the historical moment is used. For the painting's significance is universal, a stark image of the finality of death in which the unrelenting horizontality of the composition is broken only by the downward accent of the right arm, which seems to deny any hope of redemption above. The upper part of the canvas is a limitless, empty void. It is a revolutionary icon, a secular Pietà, intended to immortalize Marat in the memory of his fellow men, as ruthless in its logic and unyielding in its austerity as the political ideals of the Jacobins—a fitting memorial to the writer who had extolled 'the despotism of Liberty'.

Architectural parallels to David's radical style of the 1790s, but without the political significance he gave it, may be found in the designs of Etienne-Louis Boullée (1728–99) and Claude-Nicolas Ledoux (1736–1806). In the work of both the mid-century reaction against the Rococo was given a positive direction, a return to the antique leading to the creation of a new architecture of astonishing boldness and simplicity. They participated in a general movement to reject the Baroque system of architectural composition, that process of fusing and interlocking of parts so that one flows almost imperceptibly into those adjacent to it, together with the mesh of decoration which made such an organic unification possible. Stark contrasts between the various masses of a building or group of buildings were emphasized with interior volumes clearly expressed on the exterior. A marked preference was shown for unbroken contours, clear-cut lines, right-angles, openings of simple shape punched in the walls with no surrounds to soften the impact. Emphasis shifted from free-flowing space to static mass and what the English poet Mark Akenside (1721–70) called 'the pure forms/Of Triangle or Circle, Cube or Cone'.

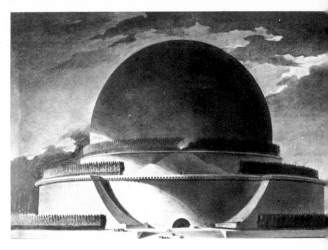

14, 22 Etienne-Louis Boullée, *Design for Monument to Isaac Newton*, 1784. Ink and wash on paper, $15\frac{7}{16} \times 25\frac{5}{8}$ins ($39.2 \times 65$cm). Bibliothèque Nationale, Paris.

Such an architecture of pure geometry could be taken to its logical conclusion only on paper, as in Boullée's project for a monument to that great hero of the Enlightenment, Isaac Newton (14, 22). The exterior was intended to suggest a planet, the interior the night sky with stars lit by holes bored through the shell. Like the Pantheon in Rome, it is composed of a cylinder and sphere; but Boullée went back beyond antiquity to the primal Platonic essences. The monument has no antique elements apart from the sarcophagus. The architect 'ought not to make himself the slave of the ancients', Boullée wrote: he should become the 'slave of nature'—but of nature as understood by Newton and subsequent thinkers, an orderly structure, not the impenetrable mystery which was soon to fire the imagination and trouble the souls of the Romantics.

15 Romanticism to Realism

In the last decade of the eighteenth century and the first of the nineteenth, attitudes to the arts, as to life in general, underwent a profound change which has influenced Western thought to the present day. Out of the turbulence of the revolutionary epoch there emerged ideas which soon became basic assumptions for artists, architects, writers, musicians and the public for whom they worked—ideas about the artist's individual creativity, the uniqueness of his work and his relationship to the rest of society, about artistic sincerity and integrity, about the relative importance of expression and representation and, above all, about the power of the artist to transcend logical processes of thought and break through to states of mind beyond or below man's conscious control. An art based on the optimism of the Enlightenment and on its faith in reason and human perfectibility could not long survive the French Revolution. The insufficiency of reason, the power of fanaticism and the role of chance in human affairs, the bewildering internal contradictions which make such rational concepts as those of liberty and equality irreconcilable had all been made painfully apparent by the course the Revolution took. Initial, eminently reasonable reforms installing a constitutional monarchy had led to republicanism and thence, uncontrollably, to the Terror and the 'despotism of Liberty', followed by the autocracy of Napoleon's imperial rule.

These political events coincided with almost equally revolutionary changes in philosophy. Science now seemed to make the universe more, rather than less, mysterious. Isaac Newton's mechanistic conception of creation—an orderly system set in motion by 'a divine clock-maker'—gave way to one that was dynamic and organic. The classification of natural species by Linnaeus (Carl von Linné, 1707–78) and others led to the dawning realization that they had not been created in definitive form but were the products of a long evolutionary process. Speculative theories of evol-

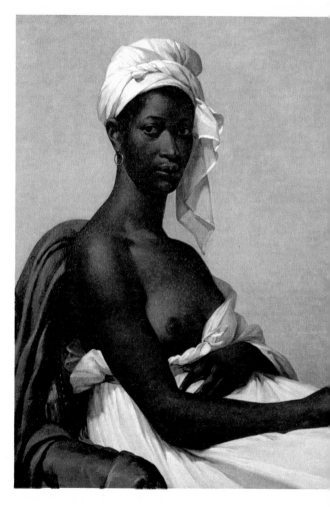

15, 1 Marie Guillemine Benoist, *Portrait of a black woman*, 1800. Oil on canvas, 32 × 25½ins (81 × 65cm). Louvre, Paris.

embittered and violent by 1814 to permit any relief or distraction from the horror of the subject by delicacy of brushwork or harmony of colours such as had 'neutralized' savage subjects in earlier art.

The shift in emphasis from heroism to suffering, from victors to victims, is also apparent in the work of the French painter Théodore Géricault (1791–1824). His first exhibited work, of 1812, was a painting of a cavalry officer thrilling to the music of battle, the boom of cannon and the whistle of grape-shot—his next, of 1814, was of a wounded cuirassier retiring from the field (both in the Louvre). He was a painter of a socially new type: middle-class with a private income large enough to enable him to work without commissions. (Such financial independence helped to establish the notion of artistic independence.) When he set out to make his reputation at the Paris Salon of 1819 he took a subject very much of his own choosing and painted it on a vast scale: the survivors from the wreck of a

French government frigate, *La Méduse*, in the Atlantic in 1816 (15, 5). When the ship foundered, the captain and the senior officers took the only seaworthy life-boats and cast 150 passengers and crew adrift on a makeshift raft on which only 15 survived a horrifying ordeal of 13 days.

The men on the raft were not heroes in any accepted sense of the word. Neither courageous endurance nor stoic self-control was displayed by any of them: they behaved as men all too frequently do in moments of crisis, those who survived did so simply from a crude animal urge to live. They suffered atrociously but in no good or noble cause; they were victims of incompetence, not of human or divine malevolence. But Géricault raised their plight to a level of universal significance. His picture questions conventional attitudes to the perennial problems of heroism, hope, despair and suffering, providing only a disturbingly equivocal answer. When the picture was first exhibited, comments in the press were strongly coloured by the scandal of *La Méduse* (the captain was a returned royalist émigré). By elevating a topical 'low-life'

15, 5 Théodore Géricault, *The raft of the 'Medusa'*, 1819. Oil on canvas, 16ft × 23ft 6ins (4.91 × 7.16m). Louvre, Paris.

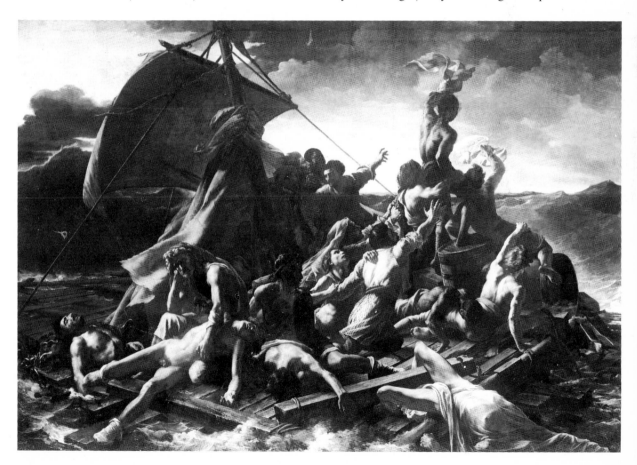

subject to such a colossal and heroic scale, Géricault might seem to have been attacking by implication not only the long-established hierarchy of genres but also the recent Bourbon restoration. Later it came to be regarded as a political allegory of a more profound type. 'France herself, our whole society is on that raft', the historian Jules Michelet wrote in 1847, when the clouds of revolution were again gathering over the country.

Despite its provocative subject, *The Raft of the Medusa* was well received by the artistic establishment. Géricault was awarded a gold medal and given a commission for a large religious painting, which he passed on to the young Delacroix (see p. 487). His pyramidal composition was of an academically approved type. Individual figures were depicted with the healthy physique of Greek athletes and not at all realistically—not, as they appeared when rescued, bearded, emaciated, covered with sores and wounds. In the Salon of 1819 it was Jean-Auguste-Dominique Ingres (1780–1867) who was censured for daring innovations in his paintings of an odalisque and of a scene from Ariosto's epic of chivalry.

The *Odalisque* of 1819 was the first of the many nudes in Near Eastern settings which Ingres painted in the course of his long career, including the *Odalisque with a Slave* (15, 18) and the *Turkish Bath* (Louvre) of 1862, on which he proudly inscribed his age—82. The poses and background 'props' vary from one to another; but all reveal the same fleshy, erotic sensuality expressed with the utmost refinement of line, often in bright, rather acid colours. It is, in fact, the un-expectedness of the contrast between the warm voluptuousness of the subject-matter and the cool, sharp precision of the painting, between the languorous atmosphere and the carefully worked smooth surface, which gives these pictures their unnerving hold on our imagination. The composition of the *Odalisque with a Slave* is as tightly integrated as the pattern on a Persian carpet, with one element echoing another, the coil of the hookah's tube and the ripple of the odalisque's arms, the slant of her torso and of the lute, the two left feet one above the other. Colours are sharply juxtaposed and repeated with different effects of contrast over the canvas, a bright scarlet recurring in such a way as to suggest the twanging notes of the lute. The blonde complexion of the odalisque is set off by the swarthy slave girl and the black eunuch, the soft smoothness of her boneless body by the caressing silks and satins on which she wallows with sensuous abandon, her nakedness enhanced by the thin drapery around her legs and thighs, her pearl necklace and jewelled bracelets.

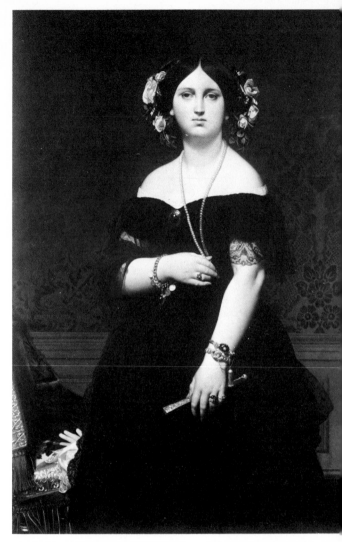

15, 6 Jean-Auguste-Dominique Ingres, *Madame Moitessier*, 1851. Oil on canvas, 57¾ × 39½ins (146.7 × 100.3cm). National Gallery of Art, Washington DC (Samuel H. Kress Collection, 1946).

Ingres seems almost to have believed that a woman's place was in the harem. The fashionable ladies in his portraits are often loaded with golden chains, decked out to accentuate the opulence of well-rounded shoulders and plump arms, frequently posed against mirrors as if to suggest that such expensive and delectable objects should be seen, as well as fondled, in the round. Mme Moitessier, dressed in black lace and tulle with roses in her hair, standing in front of a damask, silk or paper wall-covering the colour of Parma violets, exudes a hot-house luxuriance (15, 6). She slightly looks down on the spectator, with a

devouring expression of sexual superiority. After his early years in Rome, where he was obliged to earn his living from portraiture—mainly by exploiting his supreme gift as a draftsman in drawings of northern visitors to the city—Ingres would depict only those sitters with whom he felt some *rapport*. The Junoesque Mme Moitessier appealed to him for what he called her 'terrible beauty' and he gave her the air of an inscrutable goddess, her arms placed almost—but significantly not quite—in the pudic gesture of an antique Venus (see p. 112). Paradoxically, she acquires a timeless quality from the fashionable decor, which might seem to have been included gratuitously but which, in fact, plays an important part in the composition. The appearance and personality of the sitter, like the real-life original of a character in some great novel, provided Ingres with no more than a point of departure for a complex work of art. Mme Moitessier becomes part of a pattern of curving lines. The composition is much subtler than it may seem at first sight—the bold vertical axis running down from the parting of the hair provides a central line against which Ingres plays off gentle asymmetries—and so is the predominantly black, pink and violet colour-scheme, made vibrant by a tiny patch of turquoise in the chair.

A pupil of David in the late 1790s, albeit an unruly one, Ingres became by the mid-nineteenth century the self-appointed guardian of the Classical tradition—the devotee of Raphael, the champion of 'line' and the great opponent of the colourist Eugène Delacroix (1798–1863). A caricaturist pictured them in single combat, one wielding a pencil, the other a paintbrush. Delacroix, born after the Revolution, was almost a generation younger than Ingres. As a student he was swept off his feet by Géricault, with whom he struck up a friendship, posing for one of the figures in *The Raft of the Medusa* (the dead youth lying on his face in the centre foreground). His ambition was to paint large history pictures in the grand manner, in the tradition of Michelangelo and Rubens. And he succeeded so well that his first exhibited work (*The Bark of Dante*, 1822, now in the Louvre) was bought for the crown—he was always to be favoured by the state, receiving more and also more important official commissions than Ingres. But he developed an increasingly personal style of dynamic energy and richness of colour, applied in great sweeps and splashes, which reached a climax in his *Death of Sardanapalus* (15, 21). Even his admirers quailed before this vast canvas.

Depicting the story of the king of Nineveh, who, when besieged, ordered the massacre of his entire retinue before he too was immolated in his palace, the *Death of Sardanapalus* was inspired by (though not taken directly from) a tragedy by Byron, the most famous poet of the day. An intoxicating atmosphere of violence and sexual licence hangs over this voluptuous picture. It pulsates with colour and flashes with light which glances off gold and pearls and precious stones. The sinewy virility of the black slave killing a horse, and the beautiful passionate bodies of the women in attitudes of frenzied exhaustion, or of pain which is almost rapture, give an orgiastic appearance to the scene of carnage. Although the subject is antique, and details in the painting are taken from antique art, nothing could be further removed from the Neo-Classical ideal of 'noble simplicity and calm grandeur'. It is also a far cry from the torpid world of the harem pictured with such cool and calculating eroticism by Ingres. The *Death of Sardanapalus* is composed in bold masses, which roll like clouds of smoke from a furnace across the canvas. Spatial relationships are ambiguous, conventional rules of perspective are disregarded, anatomy is wilfully distorted, an illusion of solidity is created by daring colour relationships, flecks of blue and grey on flesh tones, not by firm contours and carefully graded modelling. The picture is a kind of manifesto of artistic autonomy and of the Romantic belief in the painter as creator and destroyer, of both art and life.

The picture was shown in 1828 in the last Salon held under the Restoration, at a moment when Romanticism in the arts was being equated with liberalism in politics. Delacroix's next major work *The 28th July: Liberty Leading the People* (15, 7) commemorated the revolution of July 1830 and was shown in the first Salon of the new régime under Louis-Philippe. For this evocation of fighting on the barricades—perhaps the most famous visual image of revolution ever created—he returned to the combination of grand style and reportage, allegory and real life. It is more idealized than the many other representations of the July days, but also more vivid and much more disturbing—as contemporaries seem to have appreciated. Bought by the state, it was judged too inflammatory to be exhibited for long and was withdrawn until immediately after the 1848 revolution, though not made permanently accessible to the public until 1861. Accompanied by an urchin brandishing pistols, a high-hatted bourgeois and a proletarian with a sabre, Liberty herself, with bayoneted rifle in one hand, tricolour in the other, advances inexorably towards the spectator, from whom she turns her head to rally her followers. Her attitude and the life-size corpses underfoot—one recalling a figure in *The Raft of the Medusa* (15, 5)—suggest that Delacroix was aware of

15, 7 Eugène Delacroix, *The 28th July: Liberty leading the people*, 1830. Oil on canvas, 8ft 6ins × 10ft 7ins (2.59 × 3.25m). Louvre, Paris.

her two-faced nature, of the distinction between negative liberty, or freedom from oppression, and positive liberty, or freedom to impose an ideal way of life. Indeed, the picture brings to mind a remark made by the French novelist and liberal politician Benjamin Constant (1767–1830): 'Human beings are sacrificed to abstractions; a holocaust of individuals is offered up to "the people".'

For committed and unequivocally political images one must turn to the caricaturists of the day, who worked for the increasing number of newspapers. A new reproductive technique, lithography (invented in 1798), was widely used—a process of print-making, from drawings on stone in greasy chalk, which calls for no intermediary engraver and preserves the artist's

individual touch. Typically Romantic effects of spontaneous fluency could be obtained. In one caricature lithograph after another the painter and sculptor Honoré Daumier (1808–79) satirized the absurdities and pomposities of the newly rich bourgeois, especially judges and lawyers and reactionary politicians, sometimes recording the horrific results of their actions. Daumier was deeply committed to liberalism and yet, when he drew *Freedom of the Press: Don't Meddle with It* (15, 8) he was perhaps almost as much concerned with artistic as with political freedom. Press censorship had been one of the immediate causes of the revolution of 1830 in France and in this print of 1834 the printer who has knocked out the last Bourbon king stands ready to take on Louis-Philippe. The muscular working man, fists clenched, sleeves rolled up and open shirt revealing a hairy chest, is certainly no pallid abstraction. He is an individual prepared to

defend the integrity and independence of his craft, 'true, formidable and sincere'—as Daumier himself was to be described by Victor Hugo (1802–85), the leader of the French Romantic movement in literature.

The value of sincerity in art and literature is now so generally assumed that it is often forgotten how recently it was recognized. Its appreciation as a desirable artistic quality is essentially Romantic. (None of Tiepolo's contemporaries would have bothered to ask whether he was 'sincere' in extolling the prince-bishop of Würzburg!) The value of sincerity was implicit in the Romantic conception of the work of art as being, above all, an expression of the artist's feelings and convictions, especially those which seemed to lie beyond the bounds of logical discourse. In 1824 the young Delacroix wrote in his journal: 'I find precisely in Mme de Staël the development of my ideas about painting. This art, like music, is *higher than thought*; and both are superior to literature—in their vagueness.' He was referring to Germaine de Staël, the French writer whose book on Germany (*De l'Allemagne*, 1813) was the main channel through which the ideas of German philosophers and poets reached both France and England.

Romanticism and philosophy

German Romanticism was very much a home-grown product, strongly coloured by the ideas of nationalism developed by the philosopher Johann Gottfried Herder (1744–1803) and by the new concept of *Deutschheit* or Germanness, which crystallized during the War of Liberation against Napoleonic France in 1813–15. Painters were much more closely associated with poets and philosophers in Germany than in France, especially with those who, in the wake of Immanuel Kant, began to question accepted Enlightenment views about human reason, religion, nature and the meaning and purpose of the arts. Caspar David Friedrich (1774–1840) was attacked by a critic of the old guard partly because his paintings were supposed to reflect the transcendental ideas of the new school of philosophy. The relationship was not simple or direct; nor was it supposed to be so. Critics did not imagine that Friedrich's paintings were based on programs drawn up for him by philosophers (as had been the case with Botticelli and the *Primavera*, see p. 336). Friedrich sought to express in paint thoughts and emotions which could not be put into words. What he said of a fellow artist's works applies perfectly to his own: 'Just as the pious man prays without speaking a word and the Almighty hearkens unto him, so the artist with true feelings *paints* and the sensitive man understands and recognizes it.'

Friedrich came from a pious north German Protestant background which conditioned his attitude to art as well as to religion. His refusal to make the art student's traditional pilgrimage to Rome may well have been prompted by anti-Catholic sentiments. He was opposed to the notion of authority in any form, whether of the Academy or the Church. His firm faith in the inner light and his insistence on the 'private judgement' of the individual as the only valid guide to the interpretation of the 'Bible of nature' are at once artistic and religious in a quintessentially Protestant way. Hence the tone of intimacy and mystery, the strange and moving power of his landscapes, which seem to be the product of strenuous solitary self-examination. Crystal-clear precision of detail and an even, flat surface emphasize this withdrawn quality. But their simultaneously sharp focus and vague, dissolving air of unreality, their literalness combined with the heightened 'mood' of poetry make us almost painfully aware of an element of uncertainty that lies at the heart of Friedrich's work and his grappling with the problems of art and reality—with the agonizing doubts of the man of faith confronted with a natural world in which divine order could no longer be seen. His figures are usually extraneous to the landscape—like the man in *The Wanderer above the Mists* (15, 9)—neither of its world nor of ours, standing on the edge of reality. Motionless, isolated, they seem to be both within and yet somehow outside nature, at once at home in it and estranged—symbols of ambiguity and alienation. Great visual subtlety, a unique manner of seeing and representing, gives his paintings an

15, 8 Honoré Daumier, *The freedom of the press: Don't meddle with it*, 1834. Lithograph, 12 × 17ins (30.7 × 43.1cm).

15, 9 Caspar David Friedrich, *The wanderer above the mists*, c. 1817–18. Oil on canvas, 29½ × 37¼ ins (74.8 × 94.8cm). Kunsthalle, Hamburg.

that 'in the midst of the highest flights of fancy or imagination, reason ought to preside from first to last', Blake commented: 'If this is True, it is a devilish Foolish Thing to be an Artist.'

Blake's art and writings (which cannot be fully understood independently of one another) reflect his burning need to resolve the agonizing conflicts in his own mind—to reconcile imagination with understanding, the ideal of man with the experience of men, and, above all, his intuitions of the divine with accepted ideas of god, whether as the jealous God of the Old Testament or as the rationalists' 'prime mover' of a mechanistic universe—whom he called Mr Nobodaddy. In some of his finest prints, executed in series with a dialectical inner logic, an irreconcilability is, however, acknowledged and accepted. That of Newton, for example, a nude of flawless Classical beauty, immersed in the waters of materialism, turned in on himself as he studies geometrical ratios, is accompanied by a print of Nebuchadnezzar, the man who abandoned reason—one of Blake's most terrifyingly memorable images (15, 30). Reason may be insufficient, as the Newton print suggests, but Nebuchadnezzar's bestial sensuality is no better.

The figures in both these prints were derived from earlier artists whom Blake admired, Newton from Michelangelo and Nebuchadnezzar from Dürer. Both are drawn with the firm outlines advocated by Neo-Classical theorists and filled in with watercolour (they are engravings from which very few prints were pulled,

extraordinary power. The viewpoint is rarely that of a naturalistic painter with his feet on the ground: we are, as it were, suspended in mid-air when we look at his pictures. *The Wanderer above the Mists* is depicted from a point in space on a level with his head.

The art of the great English mystic, poet and painter William Blake (1757–1827), like that of Friedrich, confronts a world in which the certainties of both Christianity and the Enlightenment had been clouded over. Blake accepted much of Enlightened thought, subscribing to its demand for tolerance and social justice, welcoming the revolutions in America and France. But like other Romantics, he found that Enlightenment thinkers had failed to answer some vital questions and left a void at the centre of their system. His attitude to Neo-Classical artistic theory was similar: he accepted its demands for high seriousness, universality and purity, but rejected its submission of the imagination to reason. The God-given faculty of imagination should control the fallible human understanding, he believed, and not vice versa. When Reynolds (see p. 471) wrote in his *Discourses*

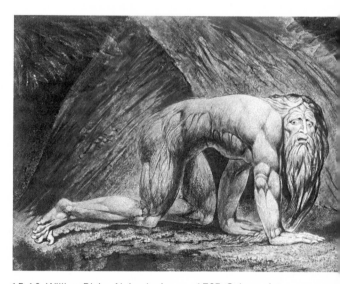

15, 10 William Blake, *Nebuchadnezzar*, 1765. Colour print finished in watercolour, 17¼ × 24¼ ins (44 × 61.5cm). Tate Gallery, London.

15, 11 John Constable, *The vale of Dedham*, 1814–15. Oil on canvas, 21 ¾ × 30¾ ins (55.3 × 78.1 cm). Museum of Fine Arts, Boston.

each being coloured by hand). But the prototypes have been given a new and intensely personal significance in Blake's wholly individual mythology, and the method of representation suggests that their philosophical meaning was more important to Blake than their tangibility. 'The Nature of my Work is Visionary and Imaginative,' he wrote in 1810:

> This world of Imagination is the world of Eternity; it is the divine bosom into which we shall all go after the death of the Vegetated body. The World of Imagination is Infinite & Eternal, whereas the world of Generation, or Vegetation, is Finite & Temporal. There Exist in that Eternal World the Permanent Realities of Every Thing which we see reflected in this Vegetable Glass of Nature. ('A vision of the Last Judgement', in *The Complete Writings of William Blake*, ed. Geoffrey Keynes, 1957)

This idea can be traced back by way of the Protestant mystics (see p. 357) to the Neoplatonists (see p. 175). But Blake's religious and artistic thought was too deeply personal to be systematized or categorized.

Romantic landscape painting

The 'vegetable glass of nature' was just what appealed most to John Constable (1776–1837), who declared his ambition to be, above all, 'a natural painter'. One of his most beautiful paintings of his native Vale of Dedham shows men at work on a dunghill (15, 11). No painter ever represented the English countryside with greater fidelity, the sparkle of dew on grass, the glint of sunshine on sappy leaves, the noble form of great elms, the enthralling intricacies of the hedgerow, and as a result his paintings are very much more than straightforward topographical records. He sought to recapture in them a childhood vision of the harmony of nature in all its innocent purity and to re-examine it in the light of mature reflection—to use it as a touchstone against which all experience, of nature and art and his sense of being part of creation, might be tested. In this

his affinity with William Wordsworth (1770–1850), whom he knew and whose profoundly reflective autobiographical poetry he loved, is very evident.

Constable, the son of a fairly prosperous farmer and mill-owner, was brought up in the flat lands of East Anglia. His native landscape was not wild. It had been formed by the labour of his relations and their neighbours over many generations. He preferred painting man-made canals and dams, he said, to the mountain brooks and waterfalls that inspired Romantic poets. 'The sound of water escaping from mill-dams, etc., willows, old rotten planks, slimy posts and brickwork, I love such things,' Constable wrote in 1821. 'As long as I do paint, I shall never cease to paint such places.' In nearly all his pictures the land is worked. The dung which fertilized the fields, no less than the rain that watered them, the mills in which the grain was ground, the boats in which it was transported by canal to the city, all played their parts in the divine harmony of the physical world as he understood it. The tower of Dedham parish church recurs constantly in his Suffolk landscapes, a reminder rather than a symbol of the presence of God. In the picture illustrated here, he placed it immediately above the dunghill.

Constable's vision of the English landscape culminates in a series of seven large pictures—'six-foot canvases' he called them—of scenes near his childhood home, a landscape so unspectacular that it had not previously been thought worth recording at all, let alone on this grand scale. Each one of them represents the harmony of the elements, epitomized by the reflection of sky in water. The pulse-beat of the universe can be felt in the movement of the clouds, the ripples on the stream and the shimmer of leaves on the great trees as a summer breeze passes over them, as well as in the bustle of human figures and animals. Each picture is centred on some workaday occurrence, sometimes of a slightly unexpected kind—a lumbering cart-horse rearing to leap a barrier, for instance— which links it with a particular moment of vision. In this way they form pictorial equivalents to the 'spots of time' of Wordsworth's *The Prelude*—those vividly remembered moments of childhood that 'retain a renovating virtue' and through which in later life 'our minds are nourished and invisibly repaired'. Constable prepared these pictures with great care, proceeding from drawings to full-size sketches. To modern eyes, the sketches strike first and deepest, by their apparent spontaneity and truth to nature, the bravura of handling, with heavily loaded brush-strokes and pigments dashed on and worked with a palette knife, the bold massing of forms, the sparkling highlights and

15,12 Joseph Mallord William Turner, *Glacier and source of the Aveyron*, 1802–3. Watercolour on paper, 27 × 40ins (68.5 × 101.5cm). Paul Mellon Collection, Yale Center for British Art, New Haven, Connecticut.

rich shadows (15, 22). The quietly contemplative finished pictures seem deliberate, perhaps over-elaborated. But Constable would not have agreed. He wrote of a sketch as something which 'will not serve more than one state of mind & will not serve to drink at again & again'. His six-foot sketches were attempts to recapture the original moment of vision, the finished pictures his mature reflections. The relationship is akin to that between a diary and an autobiography.

The mature landscapes by Constable's contemporary Joseph Mallord William Turner (1775–1851) are no less obsessively personal, though in a very different and often ambiguous manner. The artist is literally at the centre of an elemental vortex in the *Snow Storm: Steam Boat off a Harbour's Mouth*, of which he remarked: 'I did not paint it to be understood' (15, 23). In some ways Turner was more of a 'natural observer' than Constable, less reflective, more impulsive, more concerned with visual appearances and especially with fleeting effects of light. He was also more concerned with the practice of painting as an end in itself. Mists which transform and unite disparate objects visually, and skies in shot reds and yellows with the deep radiance of the rising or setting sun, are natural paradigms of the art of painting, and eventually Turner seems almost to have identified the pigments which he applied to paper or canvas with the atmospheric colouring which hangs between the artist and the object depicted. For he conceived painting neither as the composition of clearly defined solid forms nor as the imitation of nature, but simply as the manipulation of opaque and translucent pigments on a flat surface. He sought to recreate rather than represent effects of light—in his own words 'admiring

Nature by the power and practicability of his Art, and judging his Art by the perceptions drawn from Nature'.

He began (like Constable and Friedrich) with topographically accurate views in watercolour, a medium of great antiquity and much used in the Orient but only occasionally in Europe, notably by Dürer, before the second half of the eighteenth century, when it was extensively taken up for small-scale landscapes, especially in England. Prodigiously gifted, he very soon attracted official recognition and was elected associate of the Royal Academy in 1799 and a full member in 1802 (Constable had to wait for associate-ship until 1819 and did not become an Academician for another ten years). His early style is seen at its best in such large watercolours as *Glacier and Source of the Aveyron, Chamonix*, painted immediately after his first Continental tour in 1802 (15, 12). It is a 'Romantic landscape' in the eighteenth-century meaning of the phrase. There is not so much as a hint of the transcendental overtones which were to hang over the paintings of Friedrich (15, 9), nor of the Words-worthian 'joy of elevated thoughts' emanated by Constable's. The viewpoint has been carefully selected so that the scene can be portrayed accurately within the well-established conventions for sublime prospects.

15, 13 Jean-Baptiste-Camille Corot, *Volterra*, 1834. Oil on canvas, $1\frac{7}{8} \times 3\frac{1}{4}$ins (4.7 × 8.2cm). Louvre, Paris.

Only in its slightly broader technique does it differ from mountain views by John Robert Cozens (1752–97), which Turner had studied. Turner's oil paintings of the same period, with pigment dashed on to the canvas and much use of the palette knife and heavy scumbling (see Glossary), depart more radically from accepted academic manners and shocked con-servative critics. The Swiss painter known as John Henry Fuseli (1741–1825), professor of painting at the Royal Academy in London, formulated an axiom that 'the less the traces appear of the means by which a work has been produced, the more it resembles the operations of nature'. The nature Turner perceived could rarely be smoothly rendered by an art which conceals art. His technique responded with increas-ingly violent colour and handling to his ever more pessimistic preoccupation with the clash of elemental forces in natural cataclysms. The conventional compo-nents of landscape diminish in importance. Everything becomes transmuted into light and water, as in *Snow Storm: Steam Boat off a Harbour's Mouth* (15, 23), where the compositional vortex seems to suck the struggling ship back into primal chaos. This astonish-ing picture, shown at the Royal Academy in 1842 to a bewildered public, is both a record of a storm which Turner had experienced (he had himself lashed to the mast of a ship in order to do so) and a more general comment on the impotence of man confronting the elements. But in many of his other late paintings

(which he did not exhibit) there are no signs of humanity at all, just seas and skies of lambent colour charged with the mysterious energy of a creative force.

In France the transformation of the art of landscape painting in the Romantic period was more gradual than in Germany and England, but perhaps more far-reaching. If less affected by the transcendental ideas of Romantic poets and thinkers, it was no less deeply influenced by the new demands for spontaneity, emotional authenticity and artistic freedom. Jean-Jacques Rousseau (see p. 475) had already, in the late eighteenth century, extolled the beauty and morally improving power of uncorrupted nature. Still more influential was the cult of the individual sensibility he promoted. But French landscape painting did not, as might be supposed, develop in conflict with academic theory and practice. Indeed, landscape was given an academic respectability it had previously lacked by the institution in 1817 of a scholarship at the French Academy in Rome for a painter of 'historic land-scapes'—that is to say idealized Italianate views based on the precedents of Claude and Poussin (see pp. 443–6). Close study of nature was, nevertheless, required. Drawing and painting in the open country-side became the equivalent of the figurative painter's studies in the life-class. Precise records of trees and rocks, of the effects of light and atmosphere, made out of doors for their own sake (not as preparatory sketches) were seen as prerequisites for the creation of imaginative compositions painted in the studio. They were called studies or *études*. The practice was by no means confined to France. Constable worked in much the same way and Turner referred to 'pictures of bits' and 'pictures made up of bits'. The impact one of Constable's 'six-foot canvases' made when shown in Paris in 1824 was due to his having preserved the freshness of an *étude* in a large exhibition piece.

Jean-Baptiste-Camille Corot (1796–1875), the greatest French landscape painter of his time, was trained under a 'historical landscape' painter, though he soon 'took up the study of nature all on my own'. Like Géricault and other Romantic artists, he had sufficient independent means for his modest needs, and this enabled him to devote more time to *études* than most artists could and rather less to exhibition pieces (though he regularly contributed landscapes with Biblical or mythological subjects to the Paris Salon). Many small views of the Italian and French landscape, freely painted with a loaded brush, display Corot's unique sensitivity to the varying quality of light and atmosphere and to the subtlest gradations of tone. Tone, rather than line and colour, indicates form, suggests distance and unites the various components of

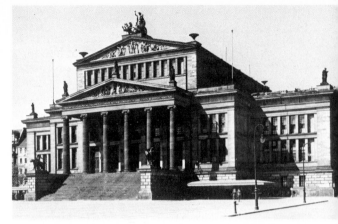

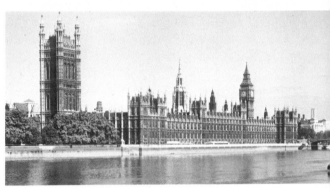

15,14 *Top* Carl Friedrich Schinkel, Theatre in Gendarmenmarkt, Berlin, 1818–21.
15,15 *Above* Sir Charles Barry and Augustus Welby Northmore Pugin, Houses of Parliament, London, 1839–52.

a landscape into an artistic whole. His aim, he said, was 'to reproduce as conscientiously as possible what I see before me'. So entirely convincing is the naturalism of these *études*, so free are they from artificial framing and other devices, that his compositions seem to have been determined simply by choice of viewpoint—like that of a photographer. In one of Corot's views of Volterra, for instance, a hillock covered with nondescript scrub is given greater prominence and no less pictorial importance than the distant citadel, which is the main object of interest (15, 13). It dates from just four years before 1839, when Louis-Jacques-Mandé Daguerre (1787–1851), a painter by training, publicly announced his invention of photography.

The several attempts made independently in the early nineteenth century to fix images photographi-cally (Thomas Wedgwood 1802, Nicéphore Niepce 1826, William Henry Fox Talbot 1835) seem to have been motivated by an urge akin to that of contempor-ary landscape painters in their *études*: to capture single

spots of space and time. For Corot, however, and perhaps for others as well, an artist's record of visual appearances was not purely objective and scientific. 'In striving conscientiously to imitate, I do not lose for a moment the emotion that possessed me', Corot wrote in one of his notebooks. 'If we have been truly touched, the sincerity of our emotion will be transmitted to others'.

In which style should we build?

Romantic ideas put a heavy burden on architects, who were far more dependent than painters on the demands of patrons and much more constrained by stylistic conventions and technical possibilities. But the need for a 'new architecture' to embody the ideals of the nineteenth century was keenly felt and repeatedly expressed from the 1820s onwards, following the precipitate decline of the 'Empire Style' promoted by Napoleon. *In which style should we build?* was the title of a book published in 1829 by the German critic Heinrich Hübsch. 'Every epoch has left its own style of architecture', wrote the leading Prussian architect Carl Friederich Schinkel (1781–1841). 'Why should we not try whether a style of our own might also be found?'

Schinkel was trained under the brilliant but short-lived Friedrich Gilly (1772–1800), whose designs have a geometrical purity and rational severity akin to those of Boullée (14, 22). Subsequently Schinkel adopted and adapted a number of historical styles—Greek, Roman, Romanesque, Gothic, Italian Renaissance—and sometimes made precocious use of cast iron for decoration as well as construction. But his buildings always have an individual feeling for mass, for the delicate balance of proportions and for sharp, clean detailing which gives a precision-tooled rather than hand-carved effect, though without any sense of the mechanical. His theatre in Berlin (badly damaged in 1945) consists of rectangular forms compactly interlocked in such a way that it presents a visually exciting composition from whatever point of view it is seen—not just four façades to be confronted head-on (15, 14). An Ionic portico marks the entrance with an appropriately dramatic gesture, but other antique elements are reduced to simple geometry. Ornament is minimized throughout. In later buildings Schinkel reduced his means almost to proportional relationships alone. 'The scope of architecture is to render beautiful what is usable, useful, purposeful', he wrote; adding elsewhere, however, that 'mere need cannot give us beauty'. Qualities which he called 'the historic and the poetic' were necessary in architecture.

Schinkel was unusual in his concern with architectonic, rather than stylistic, problems. Most of his

contemporaries tended to equate architecture with the use of period styles, which were imitated, or rather re-lived, with ever greater fidelity as information about them became more detailed and more widely diffused. Once Neo-Classical faith in the 'true' style underlying all others had faltered, an ever widening choice opened before architects and their patrons. Eclecticism was, however, discountenanced: a building was expected to conform in all its parts to a single style. Before the beginning of the nineteenth century Classical architecture had been divided into Greek and Roman. Now medieval architecture, which had been termed 'Gothic' in eighteenth-century England, was divided and subdivided into chronological and local styles,

15,16 Richard Upjohn, Trinity Church, New York City, 1841–52.

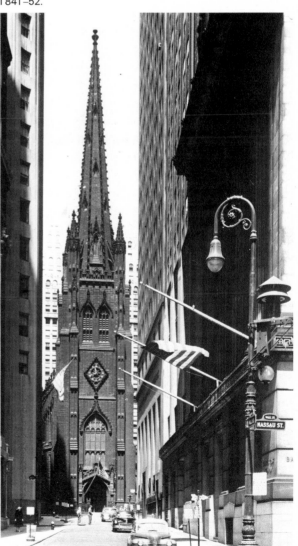

each with its own rules and historical associations.

In England, Gothic had survived longer and was revived earlier than elsewhere in Europe, survival overlapping revival in the early eighteenth century. Nevertheless, the decision taken in 1836 to rebuild the recently burnt-out Houses of Parliament in London in a medieval rather than a Classical style was the flashpoint for violent controversy. Classicists stressed the rationality of Greek and Roman architecture. But Gothic had for some time been regarded as a national style, evolved at the time of the Barons' Wars which had led to the granting of Magna Carta—the supposed foundation stone of British liberties. Something of a compromise was reached in the building eventually erected (15, 15), to the general design of Charles Barry (1795–1860) with profuse Gothic ornament inside and out by Augustus Welby Northmore Pugin (1812–52). For, although the silhouette, with the massive Victoria Tower providing a robust vertical accent at one corner and the more delicate clock-tower (Big Ben) piercing the skyline at the other, is eminently picturesque (as many painters were to discover), the plan is quite logical in its clarity, ornaments are regular and repetitive, and each section of the building is strictly symmetrical. Pugin himself is said to have complained that the river front was 'all Greek'—a Classical structure in medieval costume.

In 1836, the year of the first design for the Houses of Parliament, John Constable condemned the Gothic Revival as a 'vain endeavour to reanimate deceased art, in which the utmost that can be accomplished will be to reproduce a body without a soul'. This was a highly Romantic idea. In the eighteenth century no one had questioned the principle of imitation in architecture, nor had buildings been expected to have souls. But Pugin turned the anti-revivalist argument to his advantage. For him, Gothic art had never died, it had merely fallen into disuse after the Renaissance and Reformation. Gothic, he proclaimed, was not a style, but a principle as eternally valid as the teaching of the Roman Church, to which he had been converted. He propounded two 'great rules': 'first, that there should be no features about a building which are not necessary for convenience, construction or propriety; second, that all ornament should consist of enrichment of the essential structure of the building.' These principles were fulfilled in Gothic architecture and only in Gothic architecture, he declared. Greek temples were marble copies of prototypes in wood, and therefore shams. Gothic was the perfect expression of construction in stone or brick and, therefore, true. By a nimble shift in emphasis from styles to principles, from the integrity and the imaginative faculty of the architect to the nature and potentialities of his media, Pugin freed the Gothic Revival building from the stigma of being a deception, and his ideas were to be given far wider circulation by the militant anti-Papist John Ruskin (1819–1900), a writer of genius and a social reformer as well as an art critic.

Pugin's principles were widely accepted by architects throughout the English-speaking world (also to some extent in France and Germany). But Gothic was adopted for its historical associations as much as for its structural rectitude. Thus, Richard Upjohn (1802–78)—born in England but trained in America—admitted a 'deceptive' plaster vault to his otherwise correctly stone-built Trinity Church, New York (15, 16). It is in the English early-fourteenth-century style particularly dear to High Church Anglicans and to Episcopalians, partly as the 'classic' phase of Gothic (richer than Early English, purer than Flamboyant and Perpendicular) and partly, it seems, because it had been evolved before John Wyclif's propositions for reform had been condemned in 1382. Upjohn built Gothic churches only for Episcopalians. For Congregationalists he adopted a round-arched Early Christian or Romanesque style.

Historicism and Realism

History dominated not only architecture, but nearly every aspect of Western thought throughout the nineteenth century, very largely taking the place occupied by reason in the eighteenth. (The German term *Historismus* or Historicism was coined to describe this tendency.) Political, social and economic as well as artistic problems were referred to historical precedents and principles. Both Hegel and Marx founded their philosophies on historical studies. Where eighteenth-century naturalists had classified species, those of the nineteenth sought to trace their evolution—notably Charles Darwin (1809–82) in *The Origin of Species* (1859). 'When we regard every production of nature as one which has had a history', he wrote, 'how far more interesting, I speak from experience, will the study of natural history become!' In literature historical novels such as those by Walter Scott in Great Britain, James Fenimore Cooper in the United States, Victor Hugo in France and Alessandro Manzoni in Italy attained unprecedented popularity. The majority of operas had historical settings, Giuseppe Verdi's *Il Trovatore* (1853), *Don Carlos* (1867) and *Aida* (1871) being among the most famous. The exhibition halls of Europe and America were crammed with statues of figures from medieval and later history, and with pictures of historical events over an ever widening time-range—from the very dawn of human life with

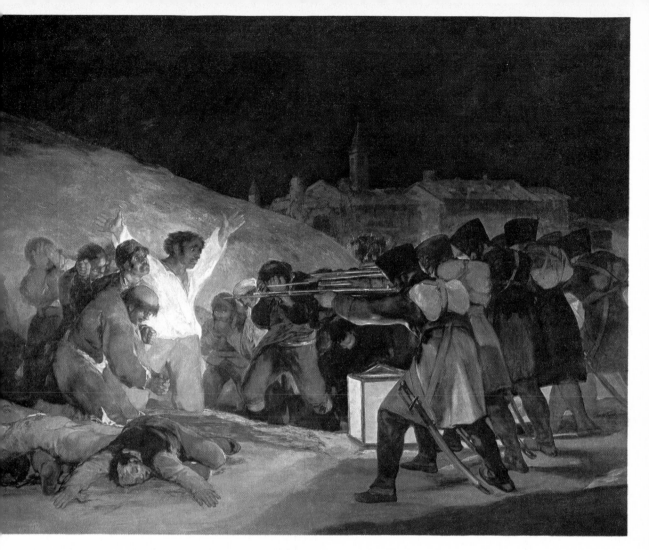

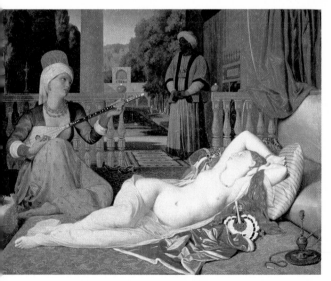

15,17 *Above* Francisco de Goya, *The third of May 1808*, 1814. Oil on canvas, 8 ft 6 ins × 11 ft 4 ins (2.60 × 3.45m). Prado, Madrid.

15,18 *Left* Jean-Auguste-Dominique Ingres, *Odalisque with a slave*, 1842. Oil on canvas, 28 × 39⅜ ins (71 × 100cm). Walters Art Gallery, Baltimore.

the ape-men of popular science to the French Revolution and its heroes, and victims.

Late eighteenth-century painters had used medieval as well as antique historical subjects as moral exemplars. Historical anecdotes with few didactic overtones were more to the taste of the nineteenth century, telling and touching glimpses of how people had lived and loved and died in former days: the past recorded for its own colourful sake. Although such subjects were painted by Ingres and Delacroix, the artists who scored the greatest popular success were those who held to a middle course, avoiding all extremes. They were called the painters of the *juste milieu* (happy medium), a phrase popularized in a

political sense by Louis-Philippe, who announced in 1831 his wish to avoid both an excess of popular power and the abuse of royal power. The genre demanded detail—local colour in a literary as well as in an artistic sense—and detail rendered with illusionistic veracity: the button-hole of a cloak, the pommel of a dagger. Artists were obliged to engage in historical research to guard themselves against anachronisms. *The Execution of Lady Jane Grey* by Paul Delaroche (1797–1856), the acknowledged leader of the *juste milieu* in France, was one of the most famous of these historical pictures, clearly composed and painted with consummate technical ability (15, 19). The lighting is dramatic, concentrated on the heroine in her shimmering white silk dress, with an effect comparable to that of the final scene of a play or opera, a tragedy vividly enacted by substantial flesh-and-blood figures. The subject is eminently pathetic—the death on the scaffold of the hapless Lady Jane Grey, unwillingly elevated to the English throne (in 1553) in opposition to Mary Tudor—and would have been quite familiar to a French middle-class public alert to any possible parallels between English history and their own. Choice of subject was, indeed, all-important for such paintings, to catch popular attention when first exhibited and later to secure a wide and very profitable diffusion of prints after them.

Pictures of this type were produced in every European country and also in the United States of America. Sometimes they had overt political overtones, especially in Italy, where subjects alluding to the *Risorgimento* or struggle for national unification and independence were as popular for paintings as for operas—the battle of Legnano, for instance, at which the German emperor was defeated by the Milanese in 1176. Despite, or perhaps because of, their appeal to the general public, they were, however, scorned by the more serious critics and painters. If they reflected Romantic notions of history, they seldom answered Romantic demands for artistic authenticity, for originality of vision and individuality of touch, and for the expression of the painter's own feelings and intimate convictions. It was against their superficial Romanticism—which helped to give the whole Romantic movement a bad name—that a number of young artists in France, England and Germany rebelled in the mid-century.

In England a group of artists—William Holman Hunt (1827–1910), John Everett Millais (1829–96), Dante Gabriel Rossetti (1828–82) and four others—founded the Pre-Raphaelite Brotherhood in 1848. The name is somewhat misleading, for they did not advocate a return to the art of the period before

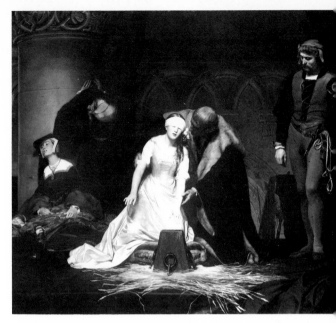

15, 19 Paul Delaroche, *The execution of Lady Jane Grey*, 1833. Oil on canvas, 96¾ × 117ins (2.46 × 2.97m). National Gallery, London.

Raphael (as a group of German painters known as 'Nazarenes' had done nearly half a century earlier), nor did they know very much about it. Their declared aim was a 'return to Nature' and a renunciation of academic practices which they traced back by way of Joshua Reynolds ('Sir Sploshua', as they called him) and the seventeenth-century Bolognese school to the first imitators of Raphael. The name was chosen, Holman Hunt said, 'to keep in our minds our determination ever to do battle against the frivolous art of the day'. He was soon drawn to religious subjects, though of a highly allusive type (15, 25). *Our English Coasts 1852* is a comment on the defencelessness of the English Church against attacks from the Papacy (Pope Pius IX had just proclaimed the re-establishment of the Roman Catholic hierarchy in England). But it is also, and more notably, a wonderfully faithful, naturalistic view of the Sussex coastal landscape, diligent in its attention to details of natural forms clearly lit by bright cold seaside sunlight. The picture was, in fact, painted in the open air, a practice occasionally adopted by Constable but rare, except for *études* like those of Corot (15, 13), before the mid-century. Informality of composition and a curious evenness of focus give it a kind of 'snapshot' immediacy. The original title was soon forgotten and it came to be regarded as a pure landscape without any ulterior meaning.

A much greater painter in France, Gustave Courbet (1819–77), reacted against the 'frivolous art of the day' in a very different manner. He began with portraits, including more than one of himself in medieval costume, but soon discarded what he called the 'trappings of Romanticism'. After the exhibition of his first major work, *A Burial at Ornans* (15, 20) in 1850–1, he was called a Realist, just as, he wrote, the title of Romantic was imposed on 'the men of 1830'. The remark occurs in Courbet's preface to the catalogue of the one-man show he set up in 1855 to display pictures which had been excluded from the international exhibition in Paris. This revealing document, which constitutes a manifesto of Realism, continues:

> I have studied, outside system and without prejudice, the art of the ancients and the art of the moderns. I no more wanted to imitate the one than to copy the other; nor, furthermore, was it my intention to attain the trivial goal of *art for art's sake*. No! I simply wanted to draw forth from a complete acquaintance with tradition the reasoned and independent consciousness of my own individuality. To know in order to be able to create, that was my idea. To be in a position to translate the customs, the ideas, the appearance of my epoch, according to my own estimation; to be not only a painter, but a man as well; in short, to create a living art—this was my goal.

15, 20 Gustave Courbet, *A burial at Ornans*, 1849–50. Oil on canvas, 10ft 3ins × 21 ft 9ins (3.14 × 6.63m). Louvre, Paris.

Courbet had not cast off all Romantic ideas along with the trappings of Romanticism. But his paintings show better than his writings how his forceful personality and the circumstances of his life led him to create an art far removed from that of Delacroix, not to mention Delaroche. He was the son of a fairly well-to-do farmer at Ornans, near the Swiss border, and went in 1839 to Paris, where he taught himself to paint by studying in the Louvre and in the *ateliers libres* (open studios), which for a small fee provided a model but had no formal curriculum. His circle of friends included Baudelaire and Pierre-Joseph Proudhon (1809–65), originator of the phrase 'property is theft', whose Socialist views he shared.

Painting of Human Figures, Historical Record of a Burial at Ornans, as Courbet himself entitled it, is a painting on the same grand scale as Gros's *Plague House at Jaffa* (15, 2), Géricault's *Raft of the Medusa* (15, 5), Delacroix's *Sardanapalus* (15, 21) and *Liberty leading the People* (15, 7). But the grand style which survives in those great canvases—*grandes machines*, as they came to be called—is lacking, although there is a distant and perhaps significant echo of the 'bourgeois' group portraits of Dutch seventeenth-century art. There are no heroic gestures. There is no firm centre to the vast composition. The group of figures looking in different directions, each absorbed in his or her sad thoughts, seems hardly to have been composed at all; yet it is very subtly organized, with breaks which give the frieze-like arrangement a slow threnodic rhythm, and a masterly use of a limited range of colours, so that the blue stockings of the man by the dog and the red

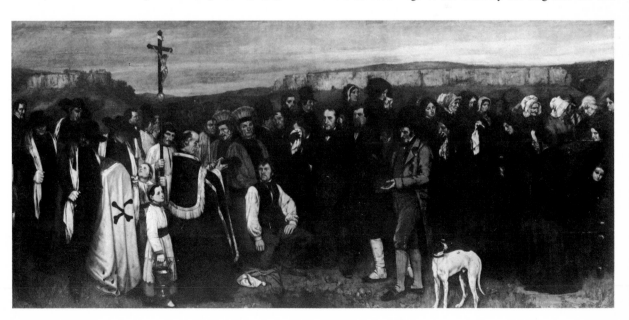

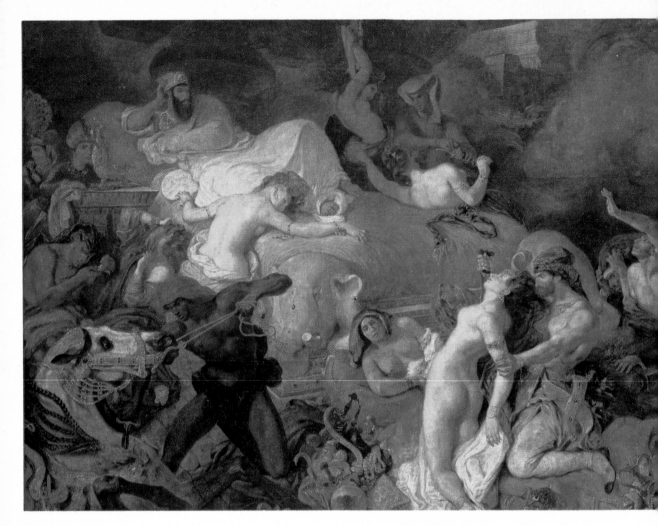

costumes of the men who have carried the coffin lend the russet and black-and-white scheme a sombre autumnal resonance.

The subject is insistently commonplace—just *a* burial at Ornans, no matter whose. Death is a leveller in more than one sense, uniting round the grave members of the various strata of rural society, the priest, the mayor, farmers and farm-labourers with their wives and children. Courbet set the scene in the new cemetery at Ornans, opened the year before he began the picture. And he painted the figures, including among them his father and sisters, as large as life and just as plain, with such frankness that his Parisian critics supposed that he had intended to ridicule the priest with his slightly inane expression, the red-nosed coffin-bearers, the gaunt-faced women. Courbet's aim was simply to record the most solemn act in the life of any community as it really takes place

and his calm and straightforward honesty of purpose is felt throughout the great painting and gives it its continuing power. The scene is dominated by the crucifix. As a socialist, Courbet would hardly have questioned its importance, for life in the French countryside was still dominated by the Church. Socialism and Christianity were never so closely allied as they were at this moment in France, on the eve of

15, 21 *Above* Eugène Delacroix, *The death of Sardanapalus*, 1828. Oil on canvas, 12ft 10ins × 16ft 3ins (3.92 × 4.96m). Louvre, Paris.
15, 22 *Above right* John Constable, *The leaping horse*, sketch, 1804–5. Oil on canvas, 51 × 74ins (129.4 × 188cm). Victoria & Albert Museum, London.
15, 23 *Right* Joseph Mallord William Turner, *Snow storm: steam-boat off a harbour's mouth*, 1842. Oil on canvas, 36 × 48ins (91.5 × 122cm). Tate Gallery, London.

Napoleon III's seizure of power. But later, in 1873, after his political and anti-clerical ideas had hardened and he was an exile in Switzerland as a result of his involvement in the Paris Commune in 1871, Courbet said that *A Burial at Ornans* was 'worth nothing'. By this time he had come to share Marx's view that 'Christian Socialism is but the holy water with which the priest consecrates the heart-burnings of the aristocrat'.

The main figures in Courbet's picture were members of the rural bourgeoisie, to which his own family belonged. His near-contemporary Jean-François Millet (1814–75) specialized in depicting the rural proletariat, the people who had no possessions. But he, too, was misunderstood. As the painter Camille Pissarro (1830–1903), a convinced Anarchist, later remarked:

> Because of his painting *The Man with a Hoe*, the Socialists thought Millet was on their side, assuming that an artist who had undergone so much suffering, this peasant of genius who had expressed the sadness of peasant life, would necessarily have to be in agreement with their ideas. Not at all ... He was just a bit too Biblical. Another one of those blind men, leaders or followers, who unconscious of the march of modern ideas, defend the idea without knowing it, despite themselves! (Letter to his son, 2 May 1887, tr. T.J. Clark)

Millet's obstinate refusal to accept the Socialist interpretations put on his work was part of the myth he created about himself as the uneducated peasant who had worked on the land until he was 21. In fact, he was the son of a far from indigent farmer who sent him (aged 18) to study art at Cherbourg. In 1837 he went to Paris, where he became a favourite pupil of Delaroche (see p. 498), but was embittered by failure to win a scholarship to the French Academy in Rome. From 1849 he lived at Barbizon, a village on the fringe of the forest of Fontainebleau (south of Paris), where a group of naturalist landscape painters led by Théodore Rousseau (1812–67) — the so-called Barbizon School — had settled.

But if Millet the 'peasant painter' is largely a myth he was not politically disingenuous. The peasants he depicted belonged to the class which still accounted for more than half the French population yet had benefited least from the growing mid-century prosperity. In Marx's view of society they were no more than dim background figures, destined to form the rank and file of 'industrial armies for agriculture'. But *The Man with the Hoe* (15, 24), brutalized by toil, stopping for a moment in his task of hacking the stubborn soil,

15, 24 Jean-François Millet, *The man with the hoe*, 1852–62. Oil on canvas, 32 × 39½ins (81 × 100cm). Private Collection, San Francisco.

personifies a more fatalistic and pessimistic view in an image of eternal human labour and poverty. It recalls a description of a peasant by the sixteenth-century essayist Michel de Montaigne, one of Millet's favourite authors. But the image goes back further, to the first Book of Genesis and God's judgement on Adam: 'Cursed is the ground for thy sake; in sorrow shalt thou eat of it all the days of thy life; thorns also and thistles shall bring forth to thee, and thou shalt eat the herb of the field. In the sweat of thy face shalt thou eat bread, till thou return unto the ground ...'. Millet's view of life was deeply fatalistic, redeemed only by his power to express it with an epigrammatic terseness and force of composition, a tautness of line combined with great delicacy and refinement in handling of paint. Yet the tillers and sowers and gleaners he depicted with an uncompromising realism that seemed shocking to many contemporaries soon came to be veiled in a nostalgia which gave the innumerable reproductions of them an irresistible sentimental appeal to city-dwellers. For the rural world was on the eve of a momentous change as a result of the mechanization of agriculture (already well under way by this date in the United States).

The realities of contemporary life were given a different and more straightforward interpretation by Edouard Manet (1832–83), who outlived Courbet and Millet by less than a decade but seems to belong to

another, later period, being often hailed as the 'first modern painter'. He claimed no more than the simple merit of having 'merely tried to be himself and not someone else'. As he wrote in the catalogue of the one-man show he organized when excluded from the International Exhibition in Paris in 1862: 'The artist does not say today, "Come and see faultless work", but "Come and see sincere work". This sincerity gives the work its character of protest, albeit the painter merely thought of rendering his impressions.' Rebelliousness and conformism are found side by side in Manet. He was both a convinced Socialist and a respectable bourgeois (from an upper-middle-class family). Few artists have leaned more heavily and obviously on masters of the past—Raphael, Giorgione, Titian, Velázquez, Hals, Watteau, Chardin, Goya—yet made a clearer break with traditional ways of painting. He wanted to be accepted by the Salon, and to shock its organizers and visitors. Hankering after official recognition, he aspired to paint a monumental public work in the great French tradition. But the nearest he came to realizing this ambition was with *The Execution of Maximilian* (15, 26), which was debarred from public exhibition until 1879 because of its subject.

The death of the Archduke Maximilian of Austria in 1867 was the last event in the tragic story of Napoleon III's ill-starred attempt to create a client state in the New World. Maximilian had been made emperor of Mexico with the support of French troops, and when they were withdrawn he was captured and shot by Mexican nationalists. In Manet's picture, however, the firing-squad is dressed not in Mexican but in French uniforms, and in this way Maximilian is made to appear an innocent victim of the imperial régime, which Manet hated (the point was taken by the censors who banned the publication of his lithograph of the composition). The device also made it easier for Manet to adhere strictly to his 'realist' aims. Photographs (which were much used as visual 'aids' by Courbet and other artists at this date) provided him with a record of the event. But he employed as models soldiers from a nearby barracks so that he need trust only his own eyes to depict their stance and the blue serge and pipe-clay of their uniforms. And his eyes told him that most previous artists had falsified visual appearances. Just as Delacroix found that shadows are not simply darkened local colours, so Manet perceived that the half-tones of academic painters were merely a pictorial convention. He strove to eliminate them from his work. His constant study of the Old Masters, and also of Japanese prints (see pp. 526–8), and his practice of incorporating elements from them in his paintings were methods of testing his vision against theirs.

When Manet painted *The Execution of Maximilian* he clearly had in mind Goya's *The Third of May 1808* (15, 17), which he knew from a print, but the two pictures are essentially dissimilar. Manet's picture lacks the drama and pathos of Goya's masterpiece. It is dispassionate: contemporaries thought it unfeeling. There is no indication of where his sympathies lay, with the nationalists or with their victims, no pictorial suggestion of anything above or beyond the ostensible subject. The matter-of-fact attitude and expression of the captain of the squad, cocking his rifle on the right, sets the tone of the scene, which the painter seems to observe with the same disinterested, almost casual, curiosity as the figures looking over the wall (a kind of mirror-image of the picture's viewers). It is an example of the way in which Manet redefined the Romantic notion of sincerity to signify not so much emotional integrity as artistic honesty—direct painting from the motif without studio tricks and subterfuges. He made another attempt to work on the grand scale in 1879 by offering to paint murals of socially significant scenes (markets, railways and docks) for the council chamber of the Hôtel de Ville in Paris. But his proposal was turned down and thereafter he worked on medium or small-sized pictures for private collectors (see p. 525).

The motto of the Realists, *il faut être de son temps*—one must be of one's own time—was in origin a Romantic idea, the counterpart of the new sense of history or historicism. Justifying a rejection of superficially Romantic themes, it encouraged artists and writers to select unpicturesque, unconventional and sometimes sordid subject-matter. But this did not necessarily involve any break with the past in the manner of painting as sharp as that made by Courbet and Manet, nor did it inevitably imply a rebellious attitude towards the social system. The picture of an iron rolling-mill by Adolf Menzel (1815–1905) is a case in point (15, 28). Menzel's sympathy with the spirit of the 1848 revolution is commemorated in his unfinished painting of the funeral of those killed in the March uprising in Berlin (Kunsthalle, Hamburg). But most of his work is divided between freshly painted studies from life, either landscapes or domestic interiors, and large historical pictures, often scenes from the life of Frederick the Great, almost pedantic in their dependence on research and fully approved by the Prussian state and the Berlin Academy (where he became a professor in 1856). Despite the industrial subject, the *Iron Rolling-Mill* is painted with the same studied accuracy of detail, the same virtuoso command of oil paint and the same ability in organizing large figurative compositions to give an impression of

15, 25 *Above* William Holman Hunt, *Our English coasts, 1852.* Oil on canvas, 17 × 23ins (43.2 × 58.2cm). Tate Gallery, London.
15, 26 *Opposite top* Edouard Manet, *The execution of the Emperor Maximilian,* 1867. Oil on canvas, 8ft 3ins × 10ft (2.52 × 3.05m). Kunsthalle, Mannheim.
15, 27 *Opposite bottom* Winslow Homer, *Long Branch, New Jersey,* 1869. Oil on canvas, 16 × 21¾ins (40.6 × 55.2cm). Museum of Fine Arts, Boston.

spontaneity. It is a highly dramatic and at the same time realistic celebration of what Menzel called the 'Cyclopean world of modern engineering', a description of, rather than a comment on, man's relationship with the machine.

In the United States, artists equated being of their own time with being of their own country. Historical subjects—apart from the American Revolution—were little favoured. Portraits, genre scenes, still lifes and,

especially, landscape were preferred. The painter Thomas Cole (1801–48) declared that artists who depicted American scenery had 'privileges superior to any other. All nature here is new to art'. There were no stretches of country like the Roman Campagna, which had been painted over and over again for several centuries. Paradoxically, however, while Constable and others in Europe were freeing themselves from such visual clichés and seeking out new and unpicturesque types of landscape, Cole and his contemporaries in America generally found New World equivalents to the 'beauty spots' of the Old and painted them in accordance with European formulas, though they tended to be of a Titanic scale and extent unknown in Europe—the Niagara Falls, for example, or the gigantic canyons and chasms of the Far West, a truly 'Cyclopean world' beyond anything envisaged

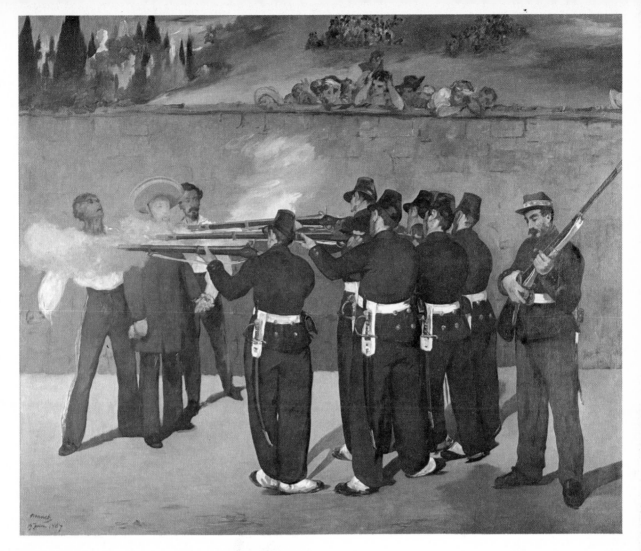

by European artists. Frederick Edwin Church (1826–1900) and Albert Bierstadt (1830–1902) took this megalomaniac strain to its extreme. It was in less melodramatic, though equally and uniquely American, outdoor genre scenes, with very prominent, solid figures—by William Sidney Mount (1807–68) and George Caleb Bingham (1811–79)—that American painters made fullest use of their 'privileges'.

The American school of painting reached maturity in the aftermath of the Civil War (1861–5), which provoked the most anxious heart-searching on the problem of national identity. Winslow Homer (1836–1910), the first painter of international standing to be born and trained and to work almost exclusively in America, began his career as an illustrator for various periodicals. During the Civil War he was sent to the front to make drawings for *Harper's Weekly* and there found himself alongside photographers record-

15, 28 *Above* Adolph von Menzel, *Iron rolling-mill*, 1875. Oil on canvas, 62¼ × 100ins (1.58 × 2.54m). Staatliche Museen, East Berlin.
15, 29 *Right* Thomas Eakins, *The Gross clinic*, 1875. Oil on canvas, 96 × 78ins (244 × 198cm). The Jefferson Medical College, Philadelphia.

ing the same events. Photography suggested new ways in which three-dimensional reality might be projected on to a flat surface, but the highly individual style Homer began to evolve, when he took up painting after the war, owed at least as much to American artists of the previous two or three decades. In 1867 he visited France and his view of *Long Branch, New Jersey* (15, 27), a popular resort with fashionably dressed figures, is a kind of scene often painted by such French artists as Eugène Boudin (see p. 522). In its asymmetry, its silhouetted forms and its light, bright colour-scheme (white, pale blues, fresh greens and sandy yellows) it is also quite close to contemporary work by Manet. But this may be no more than a coincidence. The way in which the composition is cut (especially in the lower left-hand corner) and the flattening of perspective could have been learned either from Japanese prints (see pp. 526–8) or from photographs. The picture has a distinctly American air, an insistence on the plain,

solid and wholesome reality of everyday things—the beach-hut with its uncompromisingly geometrical blank wall—and also a sense of open spaciousness in which figures are all individually distinct, sometimes almost estranged from one another. The similarity of stance of the two women in the foreground only emphasizes the absence of connection between them. They even look in different directions. As in other paintings by Homer, there are undercurrents of psychological tension, and the sharpness of focus suggests also the detachment of the artist as an observing eye. Sometimes they recall passages from the fiction of Henry James (1843–1916), who admired Homer, though in rather simple terms. 'He is a genuine painter; that is, to see and to reproduce what he sees, is his only care', James wrote of him in 1875. 'He not only has no imagination, but he contrives to elevate this rather blighting negative into a blooming and honourable positive.'

Homer's paintings are small in size (he was also a master of watercolour). His near-contemporary Thomas Eakins (1844–1916) worked on a grander scale, and his masterpiece, *The Gross Clinic* (15, 29), has life-size figures in the foreground. As a youth in Philadelphia he had attended anatomy classes at a medical college as well as drawing at the academy. Then he went to Paris and studied under Jean-Léon Gérôme (1824–1904), a pupil of Delaroche and a highly finished painter of historical subjects (mainly antique). But it was Rembrandt, Velázquez and Ribera who inspired him to create a nineteenth-century American equivalent to their 'realism'. He may even have intended to rival Rembrandt's *Anatomy Lesson of Dr Tulp* (Mauritshuis, The Hague) with *The Gross Clinic*, which shows a celebrated American surgeon, Dr Samuel Gross, directing an operation on a man's thigh in front of a class of students. Eakins depicted not the investigatory dissection of a corpse (as Rembrandt had done), but remedial surgery on an anaesthetized patient—one of the triumphs of modern science. Skilful control of light, which falls on Dr Gross's forehead and hand and the patient's naked limb, makes it also a highly dramatic composition, showing how far Eakins's debt to Rembrandt went beyond choice of subject-matter. For this is no casual record of a daily event in the life of a busy surgeon. The concentrated expression of concern on Dr Gross's face, the dramatic lighting and the imposing composition give the picture the solemnity of a meditation on the mysteries of science.

Eakins's quest for scientific realism led him to photography. The instantaneous photographs which Eadweard Muybridge (1830–1904), an English photographer in United States government service, began to take in 1872 prompted Eakins to devise his own apparatus for recording the human figure in movement. This helped him to depict spontaneous gestures and expressions with greater naturalism. The sequence of shots published by Muybridge in *Animal Locomotion* (1887) revealed movements too swift to be registered by the naked eye. He showed, for instance, that the flying gallop in which horses had been depicted since ancient Egyptian times, with all four legs off the ground, was the result of an optical illusion. Naturalistic painters almost immediately took account of Muybridge's discoveries. But the shortcomings of photography were as quickly recognized. The abrupt suspension of time in a photograph often results in unreal effects. 'The artist is truthful and photography lies,' Rodin (see p. 535) was later to remark. Photography helped to define the relations between art and the visual, phenomenal world, but much more is involved in the realization of an artist's individual vision.

16 Eastern traditions

'The Great Exhibition of the Works of Industry of All Nations' held in London in 1851 was an apotheosis of material progress. According to the Prince Consort, who presided over the organizing committee, it presented 'a living picture of the point of development at which the whole of mankind has arrived' and marked 'the new starting point from which all nations will be able to direct their further exertions'. More than 100,000 exhibits were brought together from all parts of the world, specimens of raw materials, hand-tools and handicrafts, machines and their products both utilitarian and decorative, to form a celebration of Europe's still continuing colonial expansion together with the Industrial Revolution. The unprecedented display was housed in the Crystal Palace designed by Joseph Paxton (1803–65), itself a marvel of the new technology, being constructed almost entirely of cast-iron and glass (16, 5). It was 1,848 feet (563m) long and 408 feet (124m) wide. The great novelty, little appreciated at the time, was its prefabrication, all the component parts having been mass-produced in factories and then assembled on the site, thus greatly reducing the need for skilled workmen—and saving time. It was the Industrial Revolution's answer to a construction deadline of nine months. The length of the largest manufacturable pane of glass (4 feet 1 inch, 124.5cm) provided the module for the whole building. Nothing could have been more remote from all earlier principles of design than this purely utilitarian module. The Crystal Palace was the first major building to exploit metal construction and prefabrication, themselves closely linked not only with the Industrial Revolution but also with colonial expansion—e.g. with the 'portable' houses of the Australian pioneers and the Californian Forty-Niners and with the prefabricated metal churches of colonial missionaries. But it was only with the development of the skyscraper in the United States (p. 542) that the new technology found expression in great architecture.

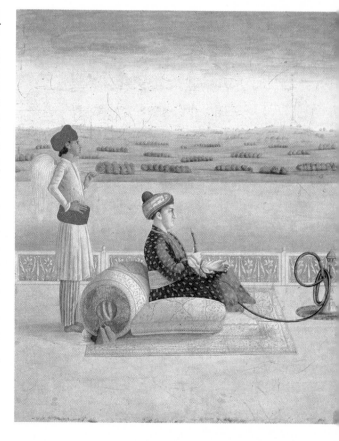

16, 1 *Above* Anonymous, *Dr George Wombwell, Lucknow*, c.1790. Gouache on paper, $1\frac{1}{4} \times 1$ ins (3.23 × 2.55cm). Fondation Custodia, Collection Frits Lugt, Paris.
16, 2 *Opposite top* T'ai-ho-tien (main audience hall) in the Forbidden City, Peking, mid-18th century.
16, 3 *Opposite bottom left* Throne of the Emperor Ch'ien Lung, c.1740. Red lacquer, height 47ins (119.3cm). Victoria & Albert Museum, London.
16, 4 *Opposite bottom right* Kitagawa Utamaro, *The hour of the boar*, c.1790. Polychrome woodblock print, $9\frac{1}{2} \times 15$ins (24.5 × 38cm). British Museum, London.

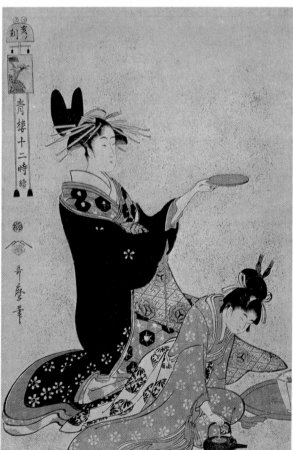

16, 5 George Paxton, *The Crystal Palace, London*, 1851.
Engraving (R. P. Cuff after W. B. Brounger), $18\frac{1}{4} \times 25\frac{1}{4}$ins
(46.5×64cm). Drawings Collection, Royal Institute of British
Architects, London.

At the time the Crystal Palace was little admired by
architects—indeed most of them refused to regard it as
'architecture' at all. A few high-minded critics also
condemned the vulgarity and overwrought ingenuity
of many of the examples of Western decorative art on
show, reserving their praise for works of hand-
craftsmanship which harked back to pre-industrial
traditions, especially those assembled in a 'medieval
court' under the direction of A.W.N. Pugin (see p.
496). But no dissident voice seems to have been raised
against the exhibition's resounding declaration of faith
in the triumph of man over nature and of Europeans
over the rest of the world, both of which were blandly
assumed to be providential. The commemorative
catalogue's account of the Indian exhibits—'the works
of people whom many conceive as placed beyond the
pale of civilization'—conceded that some techniques
had originated in Asia, while adding that they had, of
course, 'matured' in Europe! Subsequent international
exhibitions in Paris and Vienna gave greater space to
non-European countries but made similar claims for
European superiority in the arts as well as in tech-
nology—claims which went unquestioned at the time.

By 1851 a very large part of the inhabitable world
was ruled by Europeans or by men of European
descent, and throughout this vast area European
artistic ideals gradually infiltrated. In India, for
instance, the art of miniature painting had a brief but
very beautiful reflowering at the courts of Hindu rulers
in Rajputana and the Punjab and among the British
nabobs and their retainers from the mid-eighteenth
century to the 1820s, but slowly faded with the
extension of British control (16, 1). Not only did
British officials demand work in European styles, but
the semi-independent princes who were the only other
patrons followed their example. Western art also
penetrated the politically autonomous states of Asia.
The Ottoman sultans of Turkey, for instance, built
palaces and even mosques which owed as much to
French as to Islamic architecture. Shahs of the Qajar
dynasty, who ruled Iran from 1794 onwards, en-
couraged the imitation of European models, including
portraiture in oils. Examples of Chinese decorative art
shown at the Great Exhibition incorporated Italian
Renaissance motifs; but these were very uncharacter-
istic and were made exclusively 'for export'. Indigen-
ous traditions were studiously maintained in China
itself, as also in Japan.

Ch'ing-dynasty China

The alien Ch'ing or Manchu dynasty, from Manchuria north of the Great Wall, displaced the last of the Ming emperors in 1644 and in 1682 completed the conquest of China, which they ruled until 1911. As Manchuria had for some time been a cultural province of China, the advent of the Ch'ing made a much less violent impact on life and art than that of the Yüan four centuries earlier. They brought with them no new artistic style. Before the beginning of this period, however, Chinese painting had already become quite eclectic with a wide range of styles, both conservative and original.

Yün Shou-p'ing (1633–90) worked in a tradition of flower painting which went back many centuries and had been popular at the Sung court (where an emperor had been among its masters), probably originating in Buddhist art. His album-leaf of a lotus is a superbly accomplished essay in what the Chinese call 'boneless' painting—colour washes with no outlines (16, 6). The forms and textures of the waxy leaves and fragile translucent petals are recorded with the greatest fidelity in a composition so delicately balanced as to seem entirely natural, the movement of reeds swirling round the flower being steadied and closed on the left by two columns of free, strong calligraphy. This is not, however, a straightforward botanical illustration. The symbolism with which Buddhists endowed the lotus has been subsumed in a more general feeling for the creative force or *tao* immanent in all nature. The painting is a product of the concentrated meditation which Yün Shou-p'ing admonished artists to cultivate

16, 6 Yün Shou-p'ing, *Lotus flower*, late 17th century (Ch'ing Dynasty). Watercolour on paper, Osaka Museum, Osaka, Japan.

before putting brush to paper. 'You must exclude all human presence', he wrote, 'then the creative dynamism is imparted to your hand and the original inspiration spreads in abundant measure.' He preserved, in fact, the ideals of the scholar-painters, although he was obliged to sell his work—an indignity to which they had never been reduced—in order to support himself and his father, a former Ming official. His album-leaves won him recognition as the last of the great flower painters and they were extensively copied in later years, sometimes, it seems, at second if not third hand, with a conspicuous slowing down of 'creative dynamism'.

Opposition to the new régime was not necessarily accompanied by a nostalgic return to the art of earlier times. Kung Hsien (1617/18–89), who seems to have gone underground during the first years of Manchu rule, was perhaps the most notable of the individualist landscape painters. Dissociating himself from acknowledged schools, he remarked, 'there has been nobody before me and there will be nobody after me'. His was a distinctly bleak personal view of the world and he invested traditional subject-matter with a sadness sometimes close to despair. There are no human figures in his hand-scroll of a ghostly landscape with a tomb-like temple and forbidding cliffs, which rise sheer out of glazed preternaturally still waters (16, 8). The technique he developed was also unorthodox, with much use of heavy masses of black ink broken by occasional glints of light, uniform short brush-strokes and a profusion of small dots which give an effect of haziness. In an inscription on one of his works he summed up an attitude to art which had been developing during the previous century. In antiquity there were pictures but no paintings, he wrote.

> A picture represents objects, portrays persons, describes events. In a painting this is not necessarily so. (tr. Max Loehr)

Of course, painting was never thought of as being other than representational, but the emphasis changed. Subject-matter was of less importance than handling, and subject-matter was in any case rather limited— 'clouded mountains, mist-enveloped trees, steep rocks, cool springs, plank bridges and rustic dwellings', according to Kung Hsien; he added: 'there may be figures or there may be none'. Similar distinctions were to be made independently in Europe in the nineteenth century (see p. 522), though their implications were not fully realized until the twentieth.

This attitude led the most gifted painters of the Ch'ing period to an almost obsessive concern with technique. *Conversation in Autumn* by Hua Yen (1682–

16, 7 *Left* Ando Hiroshige, *Maple leaves at the Tekona shrine, Mamma*, 1857. Polychrome woodblock print, 13¾ × 9⅜ins (35 × 24cm). British Museum, London.
16, 8 *Above* Kung Hsien, *Landscape* (detail), late 17th century (Ch'ing Dynasty). Ink on paper, height 10½ins (26.7cm). Nelson-Atkins Gallery of Art, Kansas City.

c. 1762) is a virtuoso performance with colour-washed mountains in the 'boneless' manner, contrasts of wet and dry ink, quick flicks of the brush, and slow, steady, well-loaded strokes (16, 9). Yet it very vividly conveys both the love of mountain scenery and the ideal of disinterested intellectual companionship which had been recurrent themes in Chinese literature and art for more than a millennium. Hua Yen was regarded as an eccentric, even though he did not go to such extremes as Kao Ch'i-p'ei (c. 1672–1734), who painted with the tips of his fingers and with his long nails split into quill-like pens. The inscription claims *Conversation in Autumn* to have been 'inspired by the ideas of Yüan masters', but it is a very free interpretation rather than a direct imitation. Most eighteenth-century Chinese painters were content to imitate the old masters in scrolls and album-leaves which are often pleasing and almost invariably competent as a result of intensive training, but very rarely have any sense of the profound religious and philosophical ideas which lay behind the masterpieces of the past. They seem often to have resorted to such books as *The Painting Manual of the Mustard Seed Garden* (1679–1701) with woodcut illustrations showing how to depict trees, rocks, waterfalls and so on in the approved styles of the Sung, Yüan and Ming periods. Such painters were, none the

less, most favoured at the imperial court.

Despite, or perhaps because of, their foreign origins, the first Ch'ing emperors enforced the strictest observance of ancient Chinese traditions in the complicated rituals of the court, the elaborate system of administration, in education, literature and the visual arts. At the imperial palace—the Forbidden City within the city of Peking—the great audience hall, called the Hall of Supreme Harmony, built in 1627 but damaged by the peasant rebellion which preceded the Manchu seizure of power, was promptly restored in 1645. In the complete reconstructions of 1669–99 and 1765 and in subsequent refurbishings there appear to have been no significant deviations from the original form and decoration, including the double roof with yellow glazed tiles which shone like gold, red lacquer and gilt woodwork, all of which followed much more ancient prototypes (16, 2). There was no more potent symbol of the continuing authority of the Son of Heaven.

This building is one of three (all with much the same history of construction and reconstruction) at the focal point of three concentric rectangles in the Forbidden City. Chou dynasty ritual of the late second millennium BC had prescribed that the emperor should rule from 'three courts'. It also appointed the hour of dawn for his audiences, and it was in the gray twilight, when the buildings must have looked most dauntingly impressive, that those who were to be received passed along the straight processional way through monumental gate-houses, over bridges spanning canals and through wide bare courtyards. The audience hall

stands on a high platform of white marble approached up flights of stairs. It is a large columned hall about 200 feet (61m) wide and 100 feet (30·5m) deep, very richly decorated with much red lacquer and gilding, the imperial throne being placed on a dais against the back wall. In the smaller Hall of Middle Harmony, behind it, the emperor performed various ancient rituals, notably at the New Year when he inspected seeds and agricultural implements. The third building, nearly as large as the audience hall, was used for more select receptions, including that of scholars who had won high honours in the civil service examinations and were destined for administrative posts.

The three buildings were the heart of an empire which, in Chinese eyes, spread over the entire world—foreign ambassadors were received there only as tribute-bearers from vassals until well into the nineteenth century. The buildings lie on the south-north axis of the celestial meridian which determined the lay-out of the whole palace. Thus the emperor, who ruled by the mandate of heaven, looked south and down on the world of men as from the pole star. And the rituals he performed were intended to ensure harmony on earth in tune with the harmony of the cosmos. Although cosmic symbolism had been a feature of palatial architecture from a very early date and throughout the world, nowhere was it more strictly adhered to than in China. It even guided the planning of private residences, which always had their main buildings facing south. The imperial palace was, furthermore, a kind of model of the administrative structure of the aptly named Celestial Empire, both palace and empire being divided and subdivided into units of identical form.

Veneration for ancient Chinese traditions—so evident in the main buildings of the imperial palace—is less strongly felt in the decorative arts which the Ch'ing emperors patronized very lavishly. K'ang-hsi (1662–1722) rejuvenated the Ming imperial porcelain factories and established in the palace precincts workshops for lacquer, glass, enamel and jade. Their products set standards of excellence which other craftsmen strove to emulate in household objects for an increasingly large public of government officials and merchants, who prospered under Manchu rule. Chinese preoccupation with technical refinement, which could have so deadening an effect on painting, was more propitious when directed towards the decorative arts. In perfection of craftsmanship the finest examples of eighteenth-century Chinese porcelain have never been surpassed, even though they may lack the subtleties of surface texture which distinguish T'ang and Sung wares. (The differences are

16, 9 Hua Yen, *Conversation in autumn*, 1732. Hanging scroll, ink and colour on paper, 45¾ × 15⅝ins (115.3 × 39.7cm). Cleveland Museum of Art, Cleveland, Ohio (John L. Severance Fund).

most clearly apparent in the imitations of earlier wares which began to proliferate under the Ch'ing emperors.) Nor have jade and lacquer ever been carved with more delicate precision.

A lacquer throne (16, 3) demonstrates the skill of the imperial craftsmen in this extremely exacting process

(see p. 88). It was made for the emperor Ch'ien-lung (1736–96) with the decorative elaboration that became increasingly prevalent during his long reign. Motifs include the imperial dragon in sinuous pursuit of a fiery pearl signifying the sun, but quite without the menacing vigour of Ming dragons. Symbols are, in fact, so closely interwoven that they are almost lost in a blaze of opulence. Their devaluation was perhaps partly a result of contact with the West, for by this date many Chinese craftsmen were working largely for the European market, crowding fanciful decorations on porcelain, lacquer and enamels to satisfy a European craving for exoticism. Ch'ien-lung himself acquired a taste for European art, albeit one no better informed than the taste of contemporary European monarchs for Chinese art. While they were raising fragile *chinoiserie* pavilions at Potsdam and elsewhere, he had

a summer palace built in the European Rococo style (almost totally destroyed in 1860). He also employed a Jesuit missionary, Giuseppe Castiglione (1688–1766), who lived in China from 1716 onwards, to paint for him in a hybrid Sino-Italian manner with linear perspective and shading. Yet he seems never to have doubted the supremacy of Chinese culture, and he assembled the largest of all collections of works by earlier Chinese artists as well as by contemporaries who imitated them.

As the Western powers forced their way into China in the nineteenth century, obtaining trading concessions by warfare, Chinese artists and their patrons became ever more inflexible in the maintenance of their own traditions. A kind of artistic paralysis ensued. After the 1911 revolution, which deposed the last Ch'ing emperor, attempts were made to bring Chinese art into conformity with the West. Academies were founded and students were obliged to draw from casts and, to the horror of conservatives, from nude models.

16,10 Torii Kiyonaga, *Bath-house scene*, c.1800. Woodblock print. Museum of Fine Arts, Boston.

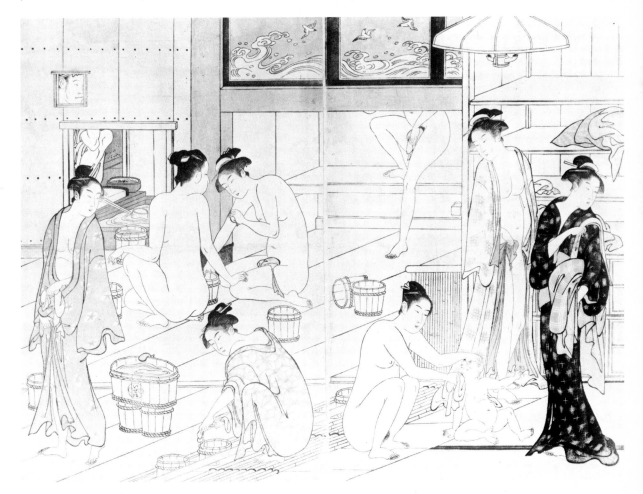

Jupéon (Hsü Pei-hung, 1895–1953) is the best known of those who sought a compromise between their own traditions and the realism of late nineteenth-century Western art. There were, however, a number of artists who looked neither to European nor to Chinese traditionalists but followed the lead of their own 'individualists' of the early Ch'ing period in confronting the challenge of Western culture in the twentieth century without relapsing into a synthetic Sino-Western style—such artists as Huang Pin-hung (1864–1955) and Fu Pao-shih (1904–65). Later the influence of certain European twentieth-century artists, notably Paul Klee (1879–1940), whose sensibilities were akin to the Chinese in their delicacy and extreme refinement, were absorbed into new forms of Chinese painting by Chao Wu-chi (Zao Wouki, b. 1921) and others.

Japan in the Edo period

A late eighteenth-century Japanese print of the type known as *Ukiyo-e* (see below) is a very far cry from any Chinese work of art (16, 10). Indeed, it would not have been thought a work of art at all in China—nor were such prints so regarded by upper-class Japanese. They were essentially a popular art. Subject-matter is all-important and often of an extremely plebeian and important and often of an extremely plebeian and unelevating nature. Forms are indicated by firm, curving or rigidly straight lines and there can have been no sense of spontaneity in handling, no subtle variations of brushwork, even in the drawings from which such prints were made.

The scene depicted is one of common everyday life: a group of women in a communal bath-house with a squatting man, whose head and knees are glimpsed through openings into an adjoining room—perhaps the voyeur artist himself. Extremes of realism and stylization, of awkwardness and elegance, are combined in the naked and dressed figures. Throughout the emphasis is on recording a casual moment. Figures are informally grouped and posed, the upper body of the woman in the background is cut off by the wall on which there are prints of birds flying over the sea, suggesting another level of artistic reality. However, the effect of unsophisticated artlessness is contrived with a consummate skill, which astonished European artists when they first saw *Ukiyo-e* in the second half of the nineteenth century. Edgar Degas (p. 525) hung the specimen illustrated here over his bed (16, 10).

Japan was effectively isolated from the rest of the world from the 1630s, when Christianity was suppressed and Portuguese traders were expelled. So eighteenth- and nineteenth-century Japanese art is exclusively the product of Japan's peculiar political, social and economic structure. Throughout the Edo period (1615–1867) the role of the emperors in their palace at Kyoto was no more than ceremonial. Power had shifted into the hands of the shoguns (dictators) of the Tokugawa family, who ruled from Edo (later renamed Tokyo). Although they paid lip-service to Neo-Confucian ideals of wise government, the dominant class below them was not one of scholars but of *daimyos* and their *samurai* (feudal lords and knights). There were four distinct social strata, with the military at the top, then farmers, followed by artisans with merchants below. Officially, all occupations were determined by heredity, the art of painting thus being limited to the sons or adopted sons of painters (though exceptions were made and some members of the military families voluntarily relinquished their privileges to become artists). But laws which precluded upward social mobility permitted development within the classes so long as they did not threaten the authority of the military caste. During the long period of peace following two centuries of civil war, the *samurai* were, in fact, impoverished. Merchants, on the other hand, prospered and increasingly commanded the services of artists and craftsmen. They quite consciously maintained the high standards reached in the seventeenth century in screen painting and lacquer and went on indulging the traditional and peculiarly Japanese taste for complementary extremes— exquisite porcelain (made in Japan since 1616) of elegant form and refined decoration being produced side by side with rough tea-ceremony pottery wares of ostensibly artless simplicity. Chinese influence was rarely felt except in landscape painting, patronized exclusively by the intelligentsia and sometimes practiced by them as well in emulation of the scholar-gentlemen painters of earlier times in China.

The principal innovation was the *Ukiyo-e* print created for and mainly by the lower ranks of society, especially the urban lower class in Edo (Tokyo) itself, which grew into a huge bustling prosperous city under the rule of the shoguns. *Ukiyo-e* expressed the tastes and interests of a sub-culture with an artistic mastery unequalled anywhere else in the world at any time. No other art form comparably secular, plebeian (sometimes explicitly anti-aristocratic) and strictly topical has ever attained the distinction of the *Ukiyo-e* popular print. The word 'Ukiyo-e' was originally applied to a 'painting of the floating world', that is to say the

16, 11 Saito Sharaku, *The actor Segawa Tomisaburo as Yadorigi*, 1794. Polychrome woodblock print, $14\frac{1}{4} \times 9\frac{1}{4}$ins (36.2 × 23.5cm). Art Institute of Chicago (Clarence Buckingham Collection).

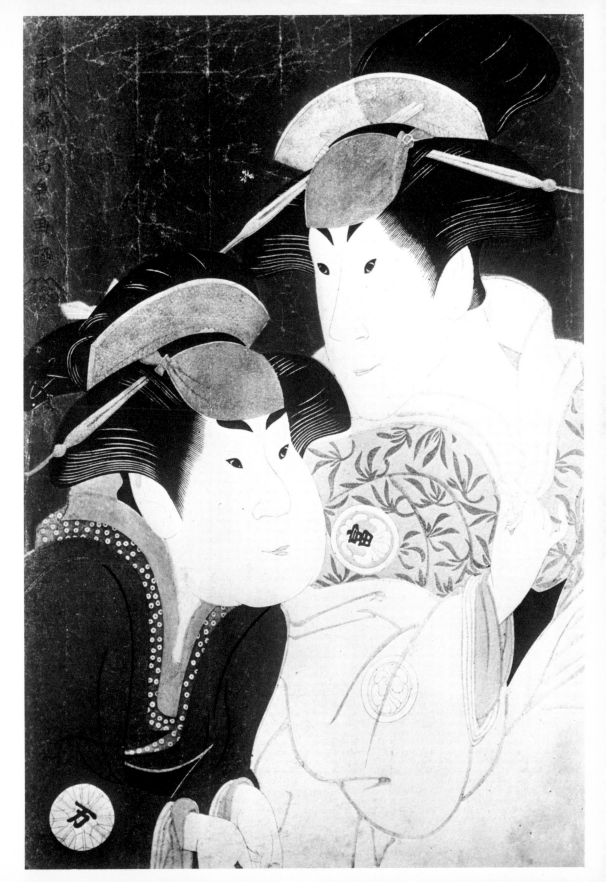

changing or fashionable scene. But the print-makers of the late eighteenth and early nineteenth centuries gave it a wider meaning, equivalent to 'modern'. The most gifted of them were able to invest the grossest and most trivial subject-matter with a strangely haunting beauty as well as to inject a new proletarian vigour into traditional themes.

The origins of *Ukiyo-e* can be traced back to two diverse sources, to popular religious prints and to *Yamato-e* or 'Japanese-style paintings' of scenes from daily, though usually courtly, life (see pp. 419–21). The technique of wood-block printing had been introduced from China with Buddhism in the eighth century and was later developed for the illustration of printed Buddhist texts and, from the early seventeenth century, of love poems and romances. Printed books were at first regarded as substitutes for the expensive hand-written and painted scrolls which they imitated— sometimes printed sheets were joined to form scrolls. But picture books for the masses were also produced, most notably by Hishikawa Moronobu (c. 1625–95), generally regarded as the founder of *Ukiyo-e*. Although he had been trained in the most conservative traditions, he turned to representing popular subjects, especially of the Yoshiwara or brothel district of Edo. In the 1670s he also began to design single-leaf prints, which evidently enjoyed enough popularity for his lead to be followed. Subjects ranged from the flowers and birds that had for so long delighted the Japanese to portraits of beautiful women, usually the flaunting 'queens' of Yoshiwara, to scenes of furious fornication. Most of them are small and were probably intended to be kept in albums, but the larger ones could be mounted on hanging scrolls. They were printed in black on white paper, and colour had to be added by hand. But in the second half of the eighteenth century the technique of polychrome printing was very rapidly developed, and further widened the appeal of *Ukiyo-e*. The first multicoloured prints were fairly expensive and their buyers probably the richer merchants, rather than artisans. The process of making them was cooperative and differed from that used in Europe. An artist's drawing was pasted on to a panel of pear or cherry wood and all but the fine lines was cut away to make a block from which to print sheets used in the cutting of other blocks, sometimes as many as 15, one for each colour, brushed on to it in a water-soluble pigment. Impressions were taken not with a press but by placing the paper on the block and rubbing the back with a circular tool, skilful manipulation of which could produce subtle variations of tone.

In the fully developed *Ukiyo-e*, women have pride of

16,12 Katsushika Hokusai, page from *Manga*, volume 8, 1817. Woodcut, 9 × 5¾ins (22.8 × 14.6cm). British Museum, London.

place, young, elegant in deportment, dressed in the height of urban fashion from the tips of tiny feet to jet black hair beset with combs and bodkins. They figure singly, clutching exquisitely patterned kimonos to their slender forms with an air of mild surprise, and in groups, in the bath-house (16, 10), idling away an afternoon on a river-boat, watching the moon rise or catching fireflies on a warm summer's night. They are invariably creatures of sensual pleasure, often recognizable as the highly sophisticated prostitutes for whom Edo became famous. One is shown daintily handing to her unseen client a saucer of warm *sake* which her apprentice assistant has prepared (16, 4). It is entitled *The Hour of the Boar* (9 to 11 pm) and comes from a set depicting 'Twelve Hours of the Green Houses' (i.e. brothels) by Kitigawa Utamaro (1753– 1806), one of the first and greatest masters of the genre. The Kabuki theatre, a form of entertainment more popular and thrilling than the formal and intricately

symbolical *No* dramas favoured by the aristocracy, provided numerous subjects for print-makers. Saito Sharaku (fl. 1794–5) specialized during his very brief career in portraits of actors, notably the star female impersonators (16,11). Realism merges into caricature in these prints and it is hard to tell whether the exaggeratedly arch expression on Segawa Tomisaburo's face is a record or a criticism of his performance. Sharaku was himself a *No* actor in the

16, 13 Katsushika Hokusai, *The great wave off Kanazawa*, 1823–29. Polychrome woodblock print, 10 × 14¾ins (25.5 × 37.5cm). Victoria & Albert Museum, London.

service of a *daimyo*. His work reveals, none the less, the full decorative possibilities of the medium, with bold patterns of colour set off by the metallic sheen of a mica background, a substitute for the gold which the lower classes were not allowed.

The greatest *Ukiyo-e* master of the early nineteenth century, Katsushika Hokusai (1760–1849), was a pupil of a theatrical print-maker, like Sharaku, but set no limits to his own subject-matter. As prolific as he was gifted, he made some 30,000 drawings, most of which were reproduced as book illustrations. An unparalleled record of the life of his time, especially street life in and around Edo, is presented in the 15 volumes of his *Manga*, which he began to publish in 1814. No human activity seems to have escaped his sharp observant eye and expressive brush. His line is sinewy, his style virile, his view of humanity humorously objective. He made no attempt to disguise the physical gracelessness of, for instance, acrobats caught unaware of their observer (16, 12). Late in life he signed himself 'the old man mad about drawing'. His most important contribution to the art of the polychrome

print was, however, in landscapes quite unlike any previously depicted in Japan or China: very strongly coloured views which are instantly recognizable yet are neither realistic nor idealized. Mount Fuji's snow-covered cone recurs in them, glimpsed in the most famous from the trough of a great wave breaking into spray like dragon-claws over fragile boats (16, 13). His prints reveal the intense response to natural forms and the genius for decorative pattern-making which has always characterized Japanese art when least dependent on China. The same can be said of the landscape prints by his younger contemporary Ando Hiroshige (1797–1858), which came to epitomize Japan for the Japanese as well as for Westerners. They are more realistic and less stylized than Hokusai's, yet often more poetic in feeling. In many he adopted the novel device of depicting distant views through a 'framing' foreground of plants, irises in one, maple leaves in another (16, 7).

Four years after Hokusai died the isolation of Japan was broken and his prints were almost immediately imported into Europe, where they had an electric effect on painters attempting to find a way out of the conventions of Western art (see pp. 526–8). In 1854 the American naval commodore Matthew Calbraith Perry forced the Japanese to open their ports to foreign traders. Radical internal changes quickly followed. In 1867 the dictatorship of the shoguns was suppressed, government passed once again to the emperor and his court in Kyoto, Western technology was rapidly assimilated and the process of transforming feudal Japan into an industrial nation began. The *Ukiyo-e* print was one of the many victims. By the end of the nineteenth century the main distinction in the arts of the world was no longer that between West and East but between the industrialized and unindustrialized— notably in Africa and Oceania (Chapter 18).

17 Impressionism to Post-Impressionism

Only three years after the great Universal Exhibition of 1867 (see p. 510), which had celebrated the still expanding French colonial empire and established Paris in Western eyes as the artistic capital of the world, France suffered the most humiliating defeat in her long history. The Franco-Prussian War ended in surrender, followed by political collapse and revolution. The first German emperor was crowned at Versailles in 1871, while in Paris the Commune was repressed with a ferocity far exceeding anything witnessed in 1830 or 1848. Yet these traumatic events left remarkably little trace. A bourgeois empire was succeeded by a bourgeois republic. 'Plus ça change plus c'est la même chose' was a quip of the time. 1871 was not a turning point, hardly even a date in French intellectual or artistic history. Apart from the now ageing Courbet, who was imprisoned and heavily fined for his part in the Commune, most artists were unengaged if not indifferent. Monet and Sisley, for example, avoided the troubles at home by going to London for some months. Their friend, the critic Théodore Duret, went off on a world tour.

As if to celebrate bourgeois stability the most typically Second Empire monument in Paris—the Opéra, designed in 1861 by Charles Garnier (1825–98)—opened some years after the Second Empire had been succeeded by the Third Republic (17, 1). The flamboyant opulence and ostentation, the meaningless eclecticism of this Neo-Renaissance Neo-Baroque extravaganza, with its lavish sculptural decorations, luxurious display of costly materials and ample, buxomly curved furnishings, epitomizes the tone of both régimes and periods and the showy pomposity of officially sponsored art. Among the life-size sculptural groups on the façade was one of a frenetic bacchanalian dance by Jean-Baptiste Carpeaux (1827–75)—a virtuoso display of naturalistic, painterly sculpture. Carpeaux's verve and lightness of handling combines with a vigorously sensual feeling

17,1 *Above* Charles Garnier, Opéra grand staircase, Paris, 1861–74.
17,2 *Opposite* Jean-Baptiste Carpeaux, *The dance*, 1867–69. Plaster, about 15ft × 8ft 6ins (4.6 × 2.6m). Musée de l'Opéra, Paris.

for human form in this joyously rhythmical, freely swinging and whirling composition of solids and voids (17, 2).

It was, however, the one feature of the building to be severly criticized—for indecency. The rendering of naked flesh was too lifelike for the prudish and attempts were made to deface it.

Impressionism

Attacks on artists by an outraged public were a regular feature of mid-nineteenth-century life, not only in France. But it was in Paris that the situation became acute with the opening in 1863 of a Salon des Refusés for works rejected by the official Salon, and later with the holding of independent exhibitions, notably by the Impressionists. These marked the first stage in an attempt to evade the tyranny of the official art-world, which controlled, through the Salons, the only road to professional acceptance and success for an artist in France. Hostility to these initiatives was of an intensity that is now difficult to comprehend. Even at the time, Manet was never able to understand why such paintings as his *Déjeuner sur l'herbe* (1863) had been refused by the Salon, still less why it and others aroused such a storm of abuse. Of course, the general public, accustomed to the smooth brushwork and careful finish of Salon painting, had some difficulty in 'reading' Impressionist paintings with their rough handling and broken colour patches spotted all over the surface, as if they were casual sketches. The few critics who noticed the early Impressionist exhibitions pointed this out, though not all of them were unfavourable. 'By Michalon', one critic wrote,

'What on earth is that?'
'You see ... a hoarfrost on deeply ploughed furrows.'
'Those furrows? That frost? But they are palette-scrapings placed uniformly on a dirty canvas.
It has neither head nor tail, top nor bottom, front nor back.'
'Perhaps ... but the impression is there.'
'Well, it's a funny impression!' (Louis Leroy in *Charivari*, 25 April 1874)

The Impressionists never completely won over the official art-world, but they were recognized by the cultivated intelligentsia. Eventually Monet was so successful that he could employ six gardeners at his country house at Giverny. Yet even as late as 1900 the Academician Jean-Léon Gérôme (1824–1904) is said to have stopped the French president from entering the Impressionist room at the Universal Exhibition with the words: 'Arrêtez, monsieur le Président, c'est ici le déshonneur de la France'! Such anecdotes fuelled a Romantic myth about the artist's 'alienation' from society.

Few, if any, of the Impressionists ever thought of themselves in these terms. So far from being rebels, some of them were, like Manet, of good, solid bourgeois origins and enjoyed to the full the advantages of their position. Their paintings embody precisely those values which true rebels would have scorned. They convey a quintessentially middle-class vision of happiness—unintentionally, of course, for the Impressionists claimed to be quite uninvolved emotionally with their subject-matter. Theirs is a sunny, friendly, convivial world in which everyone

enjoys robust good health and relaxes out of doors during a perpetual midsummer weekend. Carefree and extrovert, with more than enough to eat and drink, they while away the hours with music and laughter and casual flirtation (17, 3).

This can already be seen in the huge, life-size painting of a picnic which Claude Monet (1840-1926) hoped would make his name at the 1866 Salon but which he never finished (17, 8). Like many other young Parisians, Monet and his friends passed summer weekends picnicking at Fontainebleau and with this painting he tried to answer Baudelaire's demand for an art of 'modern life' by recording an everyday theme in a strictly objective, dispassionate spirit of on-the-spot observation. In its dual concern for contemporaneity of subject and optical truth, Monet's painting sums up the aims of young avant-garde artists in mid-nineteenth-century Paris. But it was not until 1869, when Monet and Pierre-Auguste Renoir (1841–1919) spent the summer together at Bougival on the Seine, that Impressionism may be said to have been born. So closely did they work together that some of their paintings can scarcely be distinguished one from another, notably those of the restaurant and swimming place 'La Grenouillère' (17, 9). No paintings had ever before shown such innocent, unquestioning joy in the visible world.

Impressionism had no aesthetic theory nor any definable program—both Monet and Renoir detested theorizing—but it may be thought of, in broad terms, as the final stage of Realism (see pp.499–504). It reflects the positivist, scientific attitudes of the mid-century, when the study of optics and the psychological principles of visual perception were being intensively pursued by Hermann L. F. von Helmholtz (1821–94), the colour theorist Michel Eugène Chevreul (1786–1809) and others (see below). Positivism, as a philosophical system, was largely the creation of Auguste Comte (1798–1857), who taught that non-scientifically verifiable explanations of natural phenomena, including human life, are inadmissible—that our sense perceptions are the only acceptable basis of knowledge. The influence of these ideas was already apparent in the Realists' rejection of the past (and future) as a source of subject-matter. They believed that an artist should deal only with the world around him. He should invent nothing. His concern should be solely with the truth and actuality of contemporary experience. For the Impressionists this meant that the artist should restrict himself to what lay within his range of vision at the place and time he was painting. They sought to give a totally objective transcription of the everyday world, to escape from the studio and academy into the streets and open air and capture their immediate, momentary impressions with the greatest possible fidelity. For them the present became the instant of consciousness in which one is aware of existence. Had not Baudelaire said that 'modernity is the transitory, the fleeting, the contingent'? Yet a degree of artifice inevitably entered into their work, even some of the most apparently spontaneous of Monet's 'impressions' being dependent on devices learnt from Japanese prints.

The archetypal Impressionist painting is a landscape or other out-of-doors subject, comparatively small in scale and painted largely or entirely on the spot and not in the studio, with a high-toned palette of clear, bright colours applied with varied, broken brushwork to a canvas primed with white (not the traditional brown). They tried to catch the prismatic character of natural light by using spectrum colours evenly and in small touches so that they blend optically when seen from the right distance. The composition, apparently as casual as a snapshot, is constructed entirely with colour (optical colours in place of local colours) and relies as little as possible or not at all on tonal contrasts. All these elements had been anticipated separately by earlier painters to a greater or lesser degree but their combination was new. Many had even been taught at the academies, though only for sketches or *études* (see p. 495). Monet's friend and teacher Eugène Boudin (1824–98) specifically recommended this, and Baudelaire, writing in 1859, singled out Boudin's *études* for praise while recognizing the gulf that separated them from 'finished' pictures. Now, however, it was not just the sketch but the finished picture which was painted in the open air, so that the truth of the first immediate impression of the scene would not be lost. Other artists had occasionally painted complete, finished canvases out of doors from at least as early as the 1820s, notably Corot, the Barbizon School painters (see p. 502) and Charles-François Daubigny (1817–78), the Dutch artist Johan Barthold Jongkind (1819–91) and, in England, Constable and later Ford Madox Brown (1821–93) and Holman Hunt (15, 25), who pursued a Ruskinian conception of truth to nature (see p. 498). But the Impressionists went much further.

Impression – Sunrise (17, 12)—the painting which gave the movement its name when it was exhibited in 1874—is a good example of how Monet constructed a whole composition in terms of colour alone (blues and greens setting off yellows and orange instead of contrasting dark and light tones) and of his exploitation of a high viewpoint to eliminate the foreground and, usually, the horizon as well. Outlines have also been eliminated. In fact, nothing is clear-cut and solid.

For Monet experienced nature as distant things veiled in atmosphere, as vibrations or sensations of light and colour rather than as shapes and forms. All 'content' or subject-matter, in the traditional sense, has gone, too. Light and atmosphere are the subject—the visual effects of mist, smoke and murky reflections in the dirty water of a harbour. This is simply the record of a fleeting moment, a glimpse of the sun as it rises through the rapidly dissolving mists of dawn. A few minutes, a few seconds later the sun will have climbed higher and changed colour, the small boat will have moved, everything will look different.

Monet tried to recreate in pigment an equivalent for his optical sensations or (as the scientists who were just then exploring the problems of visual perception would have said) the neurological reactions of the retina to stimuli received from light rays reflected by the phenomenal world. Monet told a young American artist in 1889, '"When you go out to paint, try to forget what objects you have before you—a tree, a house, a field, or whatever. Merely think, here is a little square of blue, here an oblong of pink, here a streak of yellow, and paint it just as it looks to you, the exact colour and shape, until it gives you your own naive impression of the scene before you." He said he wished he had been born blind and then had suddenly gained his sight so that he could have begun to paint in this way without knowing what the objects were that he had before him. He held that the first real look at the *motif* was likely to be the truest and most unprejudiced one.' For this reason his pictures are usually without any sense of deep space. To the innocent eye, it was thought, the world would look flat. As his contemporary, Hermann von Helmholtz, the founder of a physiological theory of perception, pointed out: 'The instant we take an unusual position and look at the landscape with the head under one arm, let us say, or between the legs, it all appears to be like a flat picture.' In fact, according

17, 3 Pierre-Auguste Renoir, *The boating party*, 1881. Oil on canvas, 51 × 68ins (130 × 173cm). Phillips Collection, Washington DC.

to the scientific theory of the time, we do not see the third dimension. All we see is a medley of colour patches. Monet's conviction that it is our knowledge of what we see which falsifies our vision eventually led him to pursue what he called 'instantaneity' by painting series of views of the same subject—whether a haystack or a cathedral didn't matter to him—at different times of day, in varying conditions of light and atmosphere, and later to explore ever more fleeting and evanescent effects of light, on and through water especially. Cézanne is reported to have said: 'Monet is only an eye but, my God, what an eye!' Monet was, indeed, gifted with a uniquely sensitive instrument for recording the subtlest gradations of tone, the most exquisite sensations of colour. He expressed the quality of light in terms of paint on canvas more brilliantly than any artist before or since. But he was not unaware of the ambiguities and contradictions inherent in Impressionism (see p. 528)—nor was his vision quite so innocent as he claimed.

Alfred Sisley (1839–99), the purest if also the simplest Impressionist of them all, remained true to the movement's original impulse, though its inspiration flagged in his later work. Renoir began to feel he had exhausted its possibilities by the early 1880s. He had 'wrung Impressionism dry', he said. Although he had initially taken the lead with his 'rainbow palette', Renoir had always been more traditional than Monet in his concern with the human figure, and his *Boating Party* of 1881 is still fully Impressionist (17, 3). Its diaphanous brushwork beautifully catches the trembling leaves and shimmering water and quivering vibrations of air inundated with blazing summer light filtered through canvas awnings on to clean white linen and cut glass and soft human flesh. But by 1882, after a trip to Italy, Renoir had serious doubts about Impressionism's lack of form and composition, and lack of content, and he sought renewal in developing

17, 4 Edouard Manet, *A bar at the Folies-Bergère*, 1881–82. Oil on canvas, 37½ × 51 ins (95.2 × 129.5cm). Courtauld Institute Galleries, University of London.

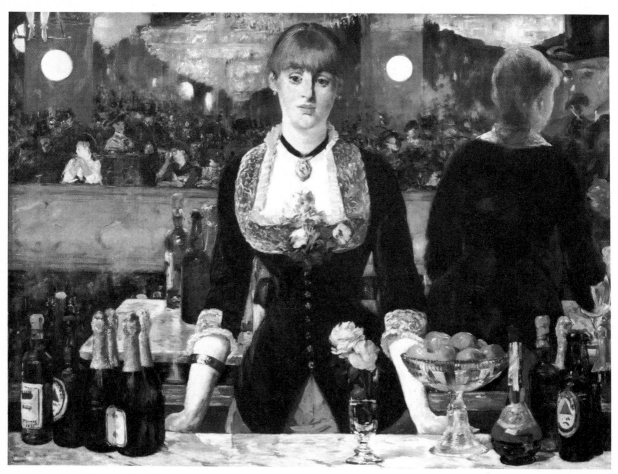

more traditional forms and methods.

Manet's *Bar at the Folies-Bergère* was finished the same year (17, 4). He never exhibited with the Impressionists, but from the early 1870s onwards he associated himself with them and their illusionistic innovations, experimenting with spectrum palette while retaining the firm structure of his earlier, more broadly handled, flat manner. Manet often worked at Argenteuil in 1874, painting idyllic, hedonistic riverside scenes together with Monet and Renoir. But his *Bar at the Folies-Bergère*, painted shortly before he died, is a masterpiece of a different kind. Urban nightlife and the anonymous vitality of the streets and cafés, bars and cabarets, appealed to the Impressionists as to Naturalist writers like Zola and Maupassant and the recognition of its visual interest for a painter was one of Impressionism's greatest discoveries. The combination of the artificial and the natural, of illusion and reality, in this nocturnal world provided pre-eminently 'modern' images of contemporary life. Manet's painting is one of the most subtle and evocative of

17, 5 Edgar Degas, *Ballet rehearsal*, 1874. Canvas, 23 × 33ins (58 × 84cm). Burrell Collection, Glasgow Museums & Art Galleries.

them. It is largely a reflection of a reflection, the entire background being a mirror. We look into a reflection of the cabaret behind us. The picture has virtually no depth at all, indeed by cutting off the bar along the bottom edge of the canvas Manet indicates that it extends outwards rather than inwards. This complex conception is, however, slightly ambiguous (why are we not reflected in the mirror? and who is the top-hatted gentleman talking to the barmaid?)—but Manet also caught, in the barmaid's empty stare,

something of the loneliness and disillusion of city life, of that sense of isolation and alienation so typical of the modern sensibility.

The painter most deeply involved in the representation of urban life was Edgar-Hilaire Degas (1834–1917). Although he exhibited with the Impressionists, his relationship to them is problematical, for landscapes did not interest him and he painted in the studio, seldom if ever on the spot. Moreover, he was consistently concerned with drawing and with the art of the past. But his sense of actuality was as authentic as that of any of the Impressionists and in some ways he was more radical than they were. He preferred the tawdry and seedy night-life of gas-lit streets and cafés to the fresh and jolly open-air world painted by Monet and Renoir. 'For you natural life is necessary; for me, artificial life', he remarked to an Impressionist friend one evening at the Cirque Fernando while an acrobat, Miss La La—the subject of one of his finest paintings—was literally hanging by her teeth high above them.

Degas had 'fallen in love with modern life', wrote Edmond de Goncourt apropos of the paintings of laundresses and ballet-dancers he saw stacked against Degas's studio walls in 1874. Illusion and reality—the tinselly disguise and the naked truth—are artfully contrasted in these deceptively informal compositions (17, 5). All the gossamer prettiness and glitter seen 'out front' vanish backstage. There the dancers go through backbreaking work-outs at the bar or squat, breathless with fatigue, their features sagging, muscles bulging, as their bodies relax gracelessly, with legs sprawling wide apart, totally devoid of erotic or any other charm. Even more cynical in observation are the paintings of laundresses and washerwomen, yawning and scratching their backs.

It is largely these paintings and his later pastels of women bathing and drying themselves after their morning tub that gave rise to the idea of Degas the misogynist. But his detachment was artistic rather than emotional. 'The nude', he told the Irish writer George Moore, 'has always been represented in poses which presuppose an audience, but these women of mine are honest, simple folk, unconcerned by any other interest than those involved in their physical condition. Here is another, she is washing her feet. It is as if you looked through a keyhole.' Certainly, it is this so-called keyhole aesthetic that gives his work such biting reality, most of all in his sculpture. Although Degas exhibited only one sculpture during his lifetime—the *Little Dancer of Fourteen* (1881)—he was deeply and continually involved with sculptural problems and was certainly as great an artist in plastic as in pictorial

17, 6 Edgar Degas, *Dancer looking at the sole of her right foot*, after 1896. Bronze, height 19⅛ins (48.5cm). Metropolitan Museum of Art (Bequest of Mrs H. O. Havemeyer, 1929. H. O. Havemeyer Collection).

media. Renoir always insisted that Degas was the greatest sculptor of the nineteenth century. Such figures as that of the dancer looking at the sole of her right foot are conceived so completely and fully in three dimensions that they cannot be appreciated from one viewpoint only (17, 6). They must be seen from various positions as the spectator moves round them, as with the most sophisticated and accomplished sculptures of the past, such as Giovanni Bologna's *Apollo* (11, 44).

Degas goes beyond Giovanni Bologna, however, not only by concealing his virtuosity more completely, but also by his interpretation of sculptural form itself. This has been described as 'sculpture from within'. For his conception of the human form surpasses mere nakedness. For him the human body was an infinitely complex and malleable organism, never still, endlessly changing. So the materiality of his figures sometimes seems almost provisional, as if their bodies had not yet quite taken on their final form. Created in privacy and never cast until after Degas died, these astonishing sculptures lack the revolutionary use of real materials

(muslin, satin, human hair) which made one critic claim that the *Little Dancer of Fourteen* had 'overthrown the tradition of sculpture' at one stroke. But they are perhaps even more radically modern. And they rival the most exquisite of his pastels and mixed-media paintings in sensitivity of handling.

By the late 1870s Degas had given up oil painting for pastel or a mixture of oil paint and pastel and sometimes other media as well—gouache, ink and watercolour—even combining them with monotypes or other print media as in *Women on the Terrace* (17, 13). This masterpiece is small in scale only, for it sums up many aspects of his art, not least his extraordinary ability to disguise the artificiality of a picture's construction by making it all appear an effect of chance. 'A painting', he said, 'is an artificial work existing outside nature and it requires as much cunning as the perpetration of a crime.' The women sitting at a café seem to have been caught as in a snapshot by someone strolling along the boulevard or passing by in a bus or tram. In fact, the composition is ingeniously contrived, with carefully judged cut-offs and croppings of figures to give an effect of discontinuity. Some of these devices Degas had learnt from Japanese prints. Though by no means the first in Europe to admire and collect Japanese art, he was deeply interested in it from the 1870s onwards and a Kiyonaga bathhouse scene always hung over his bed (16, 10). But so completely and with such understanding and tact did he assimilate Japanese influence into his own art that its presence is almost unrecognizable.

Japonisme

Japanese prints dramatically affected the whole course of Western art in the latter half of the nineteenth century. They provided a catalyst which helped painters to throw off the spell of the Classical tradition, free themselves from the authority of the Old Masters and seek new conceptions in art, new ways of seeing. 'Looking at them', wrote Edmund de Goncourt in 1863, 'I think of Greek art, boredom in perfection, an art that will never free itself from the curse of being academic.' Japanese prints were usually popular, if not vulgar, in subject-matter, unorthodox in their viewpoint and as fresh and brilliant in colour as they were vivacious in form. It was from them, Degas confessed, that he had learnt what drawing really meant—that it was 'a way of seeing form'. Without them Monet and the Impressionists would not have been able to realize so quickly and so completely their new vision of the world. 'Well, it may seem strange to say it', wrote Théodore Duret, author of the first serious discussion of Impressionism (1878), 'but it is none the less true

that before the arrival among us of Japanese books, there was no one in France who dared to seat himself on the banks of a river and put side by side on his canvas a roof frankly red, a white-washed wall, a green poplar, a yellow road, and blue water.' Almost certainly Japanese prints were more influential than photography (p. 507), as we have already suggested in connection with Degas (himself a keen photographer). Indeed, the influence may well have moved as much or more in the opposite direction, from Japanese prints and naturalistic painters to photographers.

Nineteenth-century *Japonisme* was completely different from earlier Orientalisms—seventeenth- and eighteenth-century *Chinoiserie*, for instance. That had been essentially an art of fantasy and exoticism, of sophisticated caprice and elegant mockery. No attempt was made to understand Chinese art or the principles on which it was based. Not until the mid-nineteenth century did Western artists approach any non-Western art in a sufficiently receptive and humble frame of mind to learn from it. And so potent was the impact when they did that every major late-nineteenth-century painter (with the possible exception of Cézanne) was to be influenced by it, often fundamentally. Indeed, the history of modern art in the West is to a much greater extent than is commonly realized that of the liberating and vitalizing effect of successive waves of discovery by Western artists of alien cultures, first Oriental and then the so-called 'primitive'.

Japanese wood-block prints became widely accessible after 1854, when Japan was reopened to foreigners by the United States—it had been closed

17, 7 James Abbot McNeill Whistler, *Nocturne in blue and silver, Cremorne lights*, c. 1870. Oil on canvas, $19\frac{3}{4} \times 29\frac{1}{4}$ins (40 × 74cm). Tate Gallery, London.

since 1638, though the Dutch were allowed a trading station at Nagasaki—and the first artists to evince Japanese influence in their work were American, John La Farge (1835–1910) and James Abbott McNeill Whistler (1834–1903). Whistler lived in London from 1859 onwards and became the most radical of the aesthetes, an apostle of Art for Art's Sake. At first his *Japonisme* amounted to little more than the use of Japanese motifs, but by the early 1860s he had begun to immerse himself in Oriental art and was trying to absorb it creatively into his own. Complete assimilation was achieved a few years later in such works as *Nocturne in Blue and Silver, Cremorne Lights* (17, 7), in which all explicitly Oriental borrowings have been eliminated. An empty expanse of smooth water with a very high skyline almost becomes an undefined space, with here and there delicate hints of objects floating freely in it. Though naturalistically conceived, the exquisite adjustment of lines and intervals approaches some abstract 'arrangement' of colours so that the painting is, in effect, a translation into Western terms of Japanese art.

Whistler's *Nocturne in Blue and Silver* was painted the same year as Monet's *Impression – Sunrise* (17, 12) and comparison between them reveals how much both were indebted to Japan. Impressionism might seem to be the antithesis of Japanese art, and Monet, as Impressionism's purest exponent, the painter least open to Oriental influence. Yet he was closely caught up in it from the day he first bought a Japanese print when a 17-year-old student to his last great paintings of water-lilies in his Japanese garden (19, 3). The freshness and brightness of colour, the unorthodoxy of design and subject-matter all appealed to him. More important, Japanese art indicated a way to solve the problem which increasingly obsessed him, that of how to combine and reconcile pictorial three-dimensional illusionism with the flat painted surface as a field for invention. This became a central concern for all late-nineteenth-century painters and it was in connection with it that Japanese influence is most strongly felt, especially in the work of artists like Lautrec, who confronted the problem directly and in its simplest terms.

Henri-Marie-Raymond de Toulouse-Lautrec (1864–1901) revolutionized the art of poster-making by flattening illusionistic space in the Japanese manner and uniting the pattern of the pictorial elements with that of the lettering. The development of lithography into a polychrome medium converted posters, which had earlier been confined mainly to typographic announcements, into a new form of public art, which Lautrec brought to sudden maturity. In his *Jane Avril*

au Jardin de Paris (17, 14) the lack of modelling, the economy of line and the integration of blank paper into the composition all derive from Japan, as does the truncation of the boldly foreshortened cello and its use as a framing device. The pictorial elements merge with the frame and the lettering into a flat pattern so that the dancer's vivacious, gawky body makes a Hokusai-like calligraphic flourish on the same frontal plane as the uptilted perspective of the stage and footlights.

Japanese influence is hardly less strong in the work of Symbolist painters, especially Paul Gauguin (see pp. 532–5), who enthusiastically collected Japanese prints, decorated his primitive studio in the South Seas with them and combined their influence with that of other non-European cultures in his own work. In his first completely Symbolist painting, *The Vision after the Sermon* (17, 17), the 'vision' of Jacob wrestling with the angel is derived from Hokusai's *Manga*. But Japanese influence goes deeper. It is felt in the whole conception of the picture, in the flattened forms with dark contours, the absence of shadows, the unmodulated areas of pure, sometimes unnaturalistic colours, as in the dominant red ground. With van Gogh (see pp. 533–4) the debt to Japan also went far beyond the occasional use of Japanese motifs, remarkable though van Gogh's copies after Hiroshige and his other directly Japanese-inspired paintings are. Van Gogh's involvement with Japanese art during the last four years of his life was perhaps more extensive and more complex than that of any other artist of the period.

Neo-Impressionism

The crisis within Impressionism, to which we have already alluded (p. 524), became a conscious reaction by the mid-1880s, when young artists sought to move away from and beyond it. Impressionism's dependence on nature and on the objective recording of visual appearances, its concentration on the fleeting and casual at the expense of the enduring and monumental, seemed to them to be self-imposed limitations which had led to formlessness, sketchiness and the lack of any sense of elevation or deeper meaning. The latter especially—the triviality of content—was deplored, although earlier it had been thought one of Impressionism's virtues. To Renoir what had seemed most significant about Impressionism was that it had 'freed painting from the importance of the subject (under Louis XV I would have been obliged to paint nothing but specified subjects). I am at liberty to paint flowers and call them simply flowers, without their needing to tell a story.' Now artists wanted art to have, once again, some avowed and significant purport, to be more 'meaningful'.

Of course, their reaction oversimplified the issues. Impressionism was deeply ambivalent, hence the difficulty the Impressionists had in defining their aims. Their concept of the 'impression' was both objective and subjective, going some way beyond a straightforward 'accurate view of nature' to include the individual and unique 'sensation' of a particular artist. Monet, for example, would talk about 'my very own impression' and said he always worked better in solitude according to 'just the impression of what I felt, I, all alone'. Similarly, Pissarro referred to his own 'sensation' as being 'the only thing that counts'.

One solution to the crisis was indicated by Georges Seurat (1859–91) in his *Bathers at Asnières* (17, 10). This huge and monumental rendering of a weekend riverside scene near Paris is a combination of opposites, of Impressionist contemporaneity and naturalism with academic gravity and formality. It is as joyous a celebration of sunlight as anything by Monet or Renoir, but the transitoriness and sketchiness of their renderings of similar, typically Impressionist, subjects (17, 9) have been replaced with a sense of timeless universality—as in some mythological scene by Pierre Puvis de Chavannes (1824–98), an academic painter whose subtlety and refinement was admired by artists despite his rather pallid idealizing imagery. Comparison of the *Bathers* with Puvis's *Pastoral* (17, 11), exhibited at the Salon the previous year, shows that Seurat's relation to this academic master went deeper than might be supposed. But Seurat was a great deal more than just a 'modernizing Puvis'. Based on numerous small impressionistic sketches done quickly on the spot, the *Bathers* was composed in the studio and painted slowly and methodically in a new technique invented by Seurat to impose logic and discipline on Impressionist discoveries. He called it 'chromo-luminarism', but it is better known as 'Divisionism' (or 'Pointillism'). The *Bathers* is painted evenly all over with short brush-strokes uniformly separated and not directional—in later works these became dots like the tesserae in mosaics—each a pure colour juxtaposed (or 'divided') instead of being mixed on the palette, so as to fuse optically in the eye of the spectator when seen at the right distance. Increased luminosity would, it was hoped, result, especially when the juxtaposed colours were complementary (red-green, yellow-violet, orange-blue, etc). Divisionism was a systematization of Impressionist practice (from

17, 8 *Above right* Claude Monet, sketch for *The picnic*, 1865–66. Canvas, $51\frac{1}{4} \times 71\frac{1}{4}$ins ($130 \times 181$ cm). Pushkin Museum, Moscow.

17, 9 *Right* Pierre-Auguste Renoir, *La Grenouillère*, c.1869. Canvas, $26 \times 31\frac{7}{8}$ins (66×81 cm). Nationalmuseum, Stockholm.

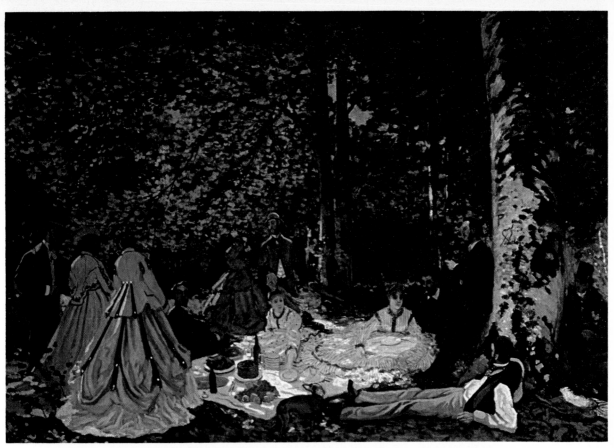

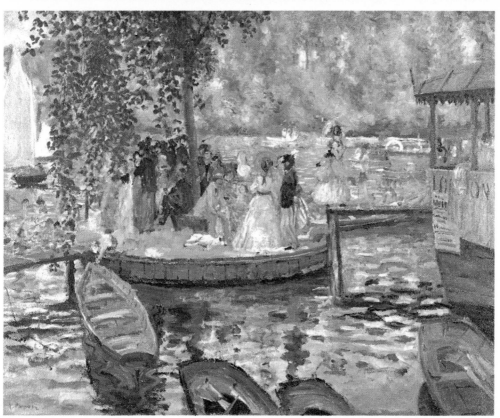

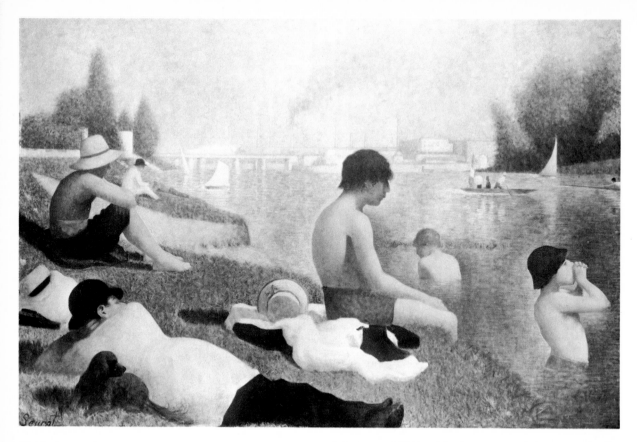

17, 10 Georges Seurat, *Bathers, Asnières*, 1883–84. Canvas, $79\frac{1}{8} \times 118\frac{1}{8}$ ins (201 × 300cm). National Gallery, London.

the colour and other theories of Michel Eugène Chevreul, Ogden N.Rood and Charles Henry especially), but its laborious, painstaking application contrasts with the spontaneity and freshness of Impressionist brushwork. Similarly, the sharp hard-edged outlines of Seurat's figures and their arrangement along parallel diagonals, combined with the predominant horizontality implied by the left-right direction in which all but one of the figures gaze, create a firm structural effect very different from the evanescent atmospheric imprecision of Impressionist painting.

Seurat's scenes of modern urban life also differ from those of the Impressionists in being less bourgeois and more working-class. His political stance is uncertain, but several of his followers, notably Paul Signac (1863–1935), who became the spokesman for the Divisionists or Neo-Impressionists as they were called from 1866 onwards, were active supporters of the Socialist-Anarchist movement in France. Signac was quite explicit about the social and political inspiration

of their art. While abjuring any crudely propagandist intentions, the Neo-Impressionists, he wrote, bore witness with paintings of proletarian subjects to 'the great social struggle that is now taking place between the workers and capital'. It would be an error, he went on, 'to require a precise socialist tendency in works of art'. But 'pure aesthetes, revolutionaries by temperament', who painted 'what they see, as they feel it' do very often 'give a hard blow of the pick-axe to the old social structure ...' ('Impressionnistes et Révolutionnaires' in *La Révolte*, June 1891, trs.L.Nochlin).

Neo-Impressionist paintings by Signac, Pissarro, Henri-Edmond Cross and other members of the group now seem more lyrical and carefree than politically provocative. But socialism played a very positive role in the work of the Italian *Divisionisti*, who developed independently of the French. In such paintings as *For Eighty Cents* (17, 15) by Alessandro Morbelli (1853–1919), a social message is very forcefully conveyed without any attempt at pathos and without any loss in subtlety of colour, handling or composition. It depicts peasants weeding rice-fields near Casale Monferrato in Piedmont and was recognized immediately as a powerful indictment of the appalling conditions in

which women were condemned to work—'in the asphyxiating heat' and 'stench of the waters of the rice fields under the blaze of the June sun'. Yet this social protest is combined with exquisite visual effects of transparency and luminosity rendered with a very personal Divisionist technique, in which the predominant greens are opposed not by their complementary (red) but by their contrast in terms of light rays (purple). The intricately woven brush-strokes of Morbelli's specially devised three-pointed brush run in parallel threes.

During the last few years of his tragically short life, Seurat began to explore the expressive possibilities of line and colour in a systematic, scientific manner and, had he lived, his ideas would probably have resulted in a kind of scientific 'synthetism' parallel to the more intuitive synthetism of Gauguin and the Symbolist painters of the Pont-Aven school. For Symbolism, in varying forms, was to be the main subjective current of anti-Impressionism during the last two decades of the century.

Symbolism

Many young artists, seeking ways of escape from objective naturalism, turned to imagination and fantasy, to the intimate private world of the self, which Baudelaire had made into a cult, as well as to Baudelaire's theory of 'correspondences' and expressive equivalences. The idea that colour might have a directly expressive rather than a merely descriptive function was traced back to Delacroix and the Romantic painters; similar potentialities were now found in line and form though without going so far as to suggest that emotion and subjective experience might be communicated with abstract pictorial means.

The movement was heralded for poets by the Symbolist Manifesto (1886) of Jean Moréas, who rejected the naturalism of Zola and other writers in favour of a totally new school, whose aim was 'to clothe the *Idea* in sensual, perceptible form'. A further declaration by the Symbolist poet Gustave Kahn was more explicit.

> We are tired of the everyday, the near-at-hand and the contemporaneous; we wish to be able to place the development of the symbol in any period, even in dreams (dreams being indistinguishable from life). … The essential aim of our art is to objectify the subjective, [the externalization of the Idea] in place of subjectifying the objective [nature seen through the eyes of a temperament]. Thus we carry the analysis of the Self to the extreme. (G.Kahn in *L'Evénement*, 1886)

17,11 Pierre Puvis de Chavannes, *Pastoral*, 1882. Canvas, $10\frac{1}{8} \times 15\frac{5}{8}$ins (25.7 × 39.7cm). Yale University Gallery (Mary Gertrude Abbey Fund).

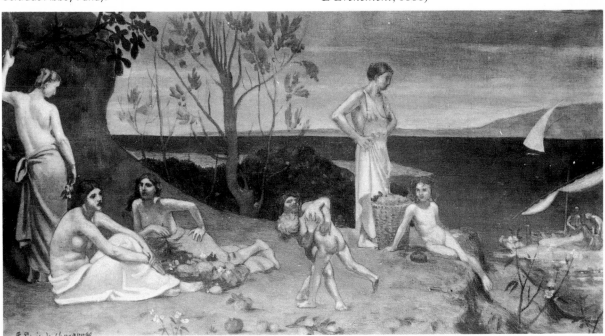

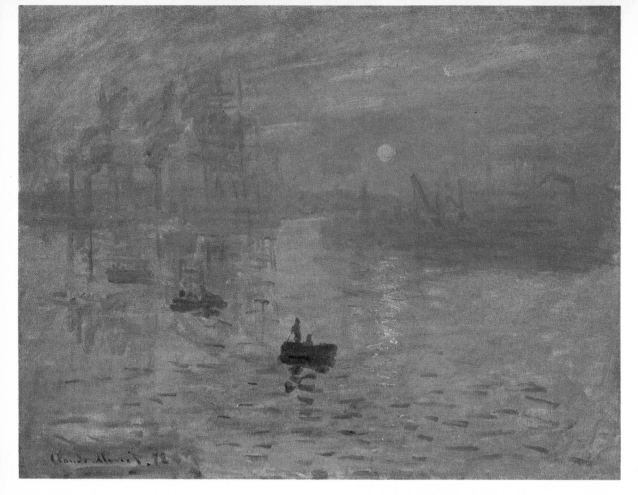

17,12 Claude Monet, *Impression – sunrise*, 1872. Canvas, 19½ × 25½ins (49.5 × 64.8cm). Musée Marmottan, Paris.

The relationship of the poet and artist to his subject was reversed: instead of seeking their motifs in the tangible, external world, they now looked inwards so that feelings and ideas became the starting-point of works of art. Rejection of Impressionism and Neo-Impressionism followed, quite consciously and explicitly in the case of the painter Emile Bernard (1868–1941). Until 1886 Bernard had been painting in a Neo-Impressionist manner. That autumn he visited Signac's studio to 'obtain the latest word on the chromatic researches of the theoreticians of optics'. Experiencing a sudden revulsion, he abandoned Neo-Impressionism in order, as he later wrote, 'to allow ideas to dominate the technique of painting'. He destroyed all his Neo-Impressionist work and left Paris for Brittany, a backward area where village life was still untainted by urban civilization. There, at Pont-Aven mainly, he experimented with rustic, archaic subjects and anti-naturalistic techniques until he reached a simplified style of bold outline and flat colour (called 'Cloisonnism'), which, he claimed, became the catalyst for his friend Gauguin's *Vision after the Sermon* (17, 17), the first major example of Synthetism or pictorial Symbolism.

Paul Gauguin (1848–1903) had given up a profitable career as a stockbroker in 1883 in order to paint and had twice exhibited with the Impressionists before settling in Brittany in 1886. By that date he had already formulated—in letters and no doubt also in conversation—the essence of his new style, but it was Bernard's pictorial innovations that finally released him from the last vestiges of Impressionism and enabled him to realize paintings in which dream and memory predominate. 'Art is an abstraction,' he wrote from Pont-Aven in 1888, 'extract it from nature, dreaming before it, and think more of the creation which will result than of nature.' Gauguin had probably seen Breton village festivals, including one with wrestling matches, red banners and bonfires, before painting the *Vision after the Sermon*, but this painting is essentially of something not seen. It is the

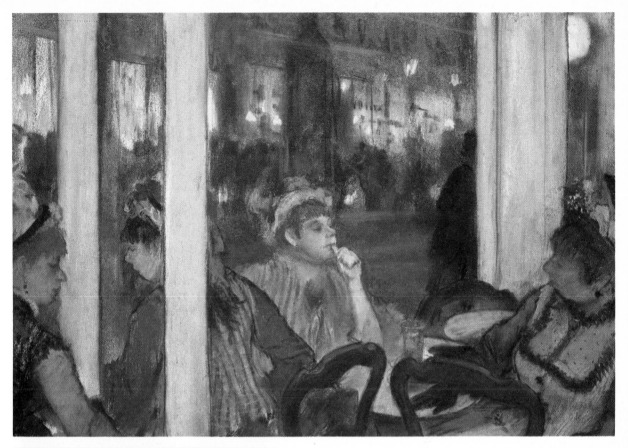

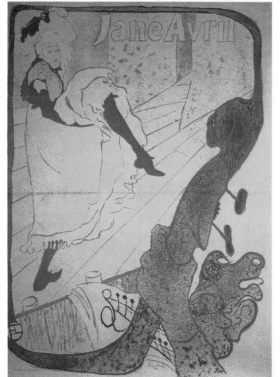

17,13 *Above* Edgar Degas, *Women on the terrace*, c. 1877. Pastel over monotype on paper, $15\frac{3}{4} \times 23\frac{1}{2}$ins ($40 \times 60$cm). Louvre, Paris.

17,14 *Left* Henri de Toulouse-Lautrec, *Jane Avril au jardin de Paris*, 1893. Lithograph, $51\frac{3}{16} \times 37$ins (130×94cm). Victoria & Albert Museum, London.

record of something imagined and interpreted in visual metaphors. At first glance, too, it might seem to present both an outward and an inner experience—the priest and the peasants and their recollection of the sermon they have just heard (on Jacob wrestling with the angel)—but the 'vision' is a double one, the religious vision of the Breton women and the artist's imaginary vision of them and of the power of the faith that moves them.

Gauguin's Symbolist, expressive aims were shared by the Dutch painter Vincent Willem van Gogh (1853–90), for whom art was a means of personal, spiritual redemption. Van Gogh's is a unique case. He did not become an artist until 1881 and for him it was truly a 'calling'. He threw himself into it with all the fervour of a religious convert. 'To try to understand the real significance of what great artists, the serious

masters, tell us in their masterpieces, that leads to God,' he wrote in 1880. Between then and 1890, when he committed suicide after intermittent periods of insanity and several months as a voluntary inmate of an asylum, he painted over 800 pictures—not to mention drawings and his voluminous correspondence with his brother Theo and others, one of the most tormented and relentless accounts of the search for self in literary history and one of the fullest expositions ever given by an artist of his ideas about the meaning and purpose of art. During the last 70 days of his life he painted 70 canvases. Of all these hundreds of fully realized, if hastily executed, pictures he succeeded in selling only one, though the effect on him of this neglect and of the poverty and obscurity in which he lived should not be overstressed. His reaction, shortly before his suicide, to the one favourable mention his work received in the press during his lifetime was remarkably level-headed.

Van Gogh had studied theology to become a pastor in a depressed coal-mining area of Belgium. In becoming an artist he satisfied his craving for spiritual fulfilment in work which, he believed, could and should be socially useful. 'I am good for something, my life has a purpose after all,' he told his brother Theo in 1880. 'How can I be useful, of what service can I be? There is something inside of me, what can it be?' Each of his paintings became a cry of anguish as he struggled to release his violent, frustrated passions. 'I have a terrible lucidity at moments,' he wrote in 1888. 'I am not conscious of myself any more, and the picture comes to me as in a dream.' Writhing, flame-like forms and agitated brushwork transmit with almost hallucinatory power the convulsions of his tormented sensibility and, in such baleful works as *Night Café* (17, 18), the state of almost permanent anxiety and sense of instability which threatened to engulf him. It is painted in disharmonies of red, green and yellow, he wrote, 'to express the terrible passions of humanity ... the idea that the café is a place where one can ruin oneself, go mad or commit a crime. So I have tried to express, as it were, the powers of darkness in a low public house, by soft Louis XV greens and malachite, contrasting with yellow-green and harsh blue-greens, and all this in an atmosphere like the devil's furnace, of pale sulphur. And all with an appearance of Japanese gaiety.'

The concept of art as a new religion, as a way of life to which the artist is called and to which he gives himself up utterly, was an article of faith for Gauguin as much as for van Gogh. Both were inspired by a similar quest to recover the sincerity and purity of simple, unspoilt people, uncorrupted by civilization and modern urban life. Such myths of the primitive

17, 15 Alessandro Morbelli, *For eighty cents*, 1895. Canvas, $48\frac{3}{4} \times 27\frac{1}{2}$ins (124 × 70cm). Civico Museo Antonio Borgogna, Vercelli.

have haunted the Western imagination ever since Classical times, going back far beyond Romantic ideas of the 'noble savage' to that of an earthly paradise where men lived in a state of nature. But no artist before Gauguin had ever tried to put it into practice and go native himself. Gauguin turned his back on Europe and sailed for the South Seas in 1891, settling in a native village in Tahiti.

Innocence and knowledge, the savage and the civilized, became central themes for Gauguin after he left Europe, though he found that he was no more able to shed Western civilization in Tahiti than he had been in Pont-Aven. In fact, his paintings became less, rather than more, 'primitive' in the South Seas. Though more exotic in subject and colour, the essential elements of his style remained unchanged. And since he had taken with him a stock of photographs and reproductions— of ancient Egyptian reliefs, the Parthenon frieze, a Rembrandt drawing, Borobudur reliefs, and so on— and drew on them as freely as he had previously on Japanese prints and rustic Breton sculptures, his South Seas paintings are often more obviously eclectic. His synthetic method of constructing a picture became quite self-conscious after the shock and stimulus of his new surroundings wore off, as he revealed in his description of the genesis of the *Spirit of the Dead Watching* (17, 19). It began by his being 'captured by a form, a movement' of a young Tahitian, of whom he made a carefully rendered drawing with 'no other preoccupation than to execute a nude'. He then felt impelled to 'imbue it with the native feeling, character and tradition' and introduced the bright *pareo* and yellow bark-cloth which would 'arouse something unexpected in the spectator'. To suggest a background of 'terror', he added some purple. In this way 'the

musical part of the picture' was all set out. The 'idea' of the picture, however, which had come to him as he worked on it and which is incipient in his use of the word 'terror', had not yet been made visual. To do that he had to reconsider the whole work once again. 'I see only fear. What kind of fear?' he asked himself.

> Certainly not the fear of Susanna surprised by the Elders. That does not exist in Oceania. The *Tupapau* (Spirit of the Dead) is clearly indicated. For the natives it is a constant dread. Once I have found my *Tupapau* I attach myself completely to it, and make it the motif of my picture. The nude takes second place.
>
> What can a spirit be for a Maori? … she thinks necessarily of some she has seen. My spirit can only be an ordinary little woman.
>
> The title has two meanings, either she thinks of the spirit: or, the spirit thinks of her. (From Gauguin's manuscript 'Cahier pour Aline', tr. R.Goldwater)

The *Spirit of the Dead Watching* illustrates Gauguin's Synthetist-Symbolist creative process—and, by implication, the reasons for the failure of his quest to become a savage himself. But his achievement was, none the less, great. His anti-naturalism and emphasis on poetic and rhythmical effects, on purity of line and creative autonomy of colour, his appeal to the imagination, to dreams, to the unconscious and to the primitive, all these were to be enormously influential. 'I wanted to establish the right to dare everything,' he said. 'The public owes me nothing, since my pictorial *oeuvre* is but relatively good; but the painters who today profit from this liberty owe me something.'

Gauguin's largest work, *Where do we come from? What are we? Where are we going?* (Boston Museum of Fine Arts), painted as a kind of personal testament before he attempted suicide in 1897, is less daring than many of his earlier paintings but more typically Symbolist in its subject-matter, an allegory of human life from infancy to old age. Allegories also preoccupied several other artists of the period, notably Edvard Munch (1863–1944) and Auguste Rodin (1840–1917). Munch left Norway in 1889 to study in Paris, where he felt the impact of Impressionism and of Seurat, van Gogh and Gauguin. But he belonged essentially to a dark Northern world of brooding introspection and neurotic obsessions, the deeply pessimistic, fatalistic world of Ibsen's and Strindberg's plays, and his paintings and lithographs are similarly expressive of states of mind—often unbalanced and bordering on the pathological—in sequences having a continuous, cumulative effect. The theme of his *Frieze of Life*, which occupied him over many years, is

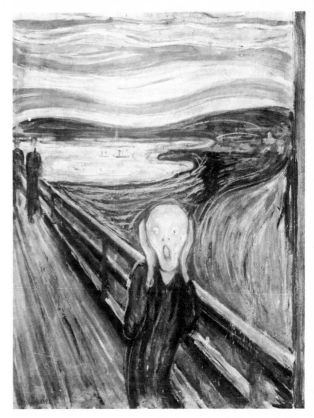

17, 16 Edvard Munch, *The scream*, 1893. Oil, pastel and casein on cardboard, $35\frac{3}{4} \times 29$ins (91×73.5cm). National Gallery, Oslo.

suffering through love. A cycle of intensely subjective images re-enacts the emotional states of attraction, union, disenchantment, jealousy and despair. Though never completed, it forms the most powerful statement left by any artist of *fin-de-siècle* disillusion and culminates in Munch's most famous painting, *The Scream* (17, 16). 'I stood there, trembling with fear', he wrote. 'And I felt a loud, unending scream piercing nature.' The despair and terror experienced by the foreground figure is made visible in the landscape and sky, which writhe with agonized streaks of arbitrary colour—red, yellow and green—as if the scream was expanding in waves of neurotic, unreasoning fear.

Rodin objected to being called a Symbolist and distrusted his visionary powers. He always worked from nature like an Impressionist painter and, in fact, one of his early works was so realistic that he was accused of having made it up from casts taken from a living model. Yet his sculptures are much more than just naturalistic feats of descriptive modelling: they portray states of mind and feeling. His one-time

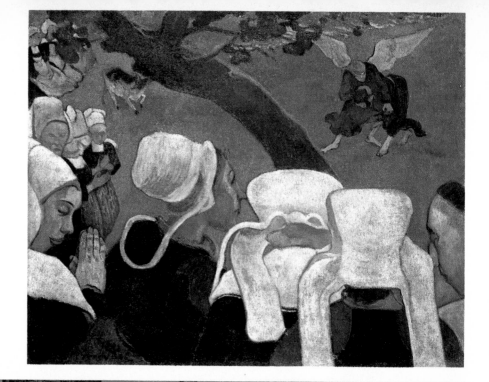

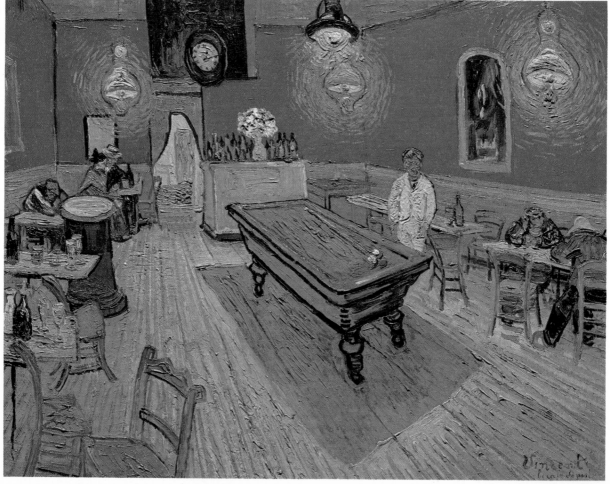

secretary, the Austrian poet Rainer Maria Rilke, said that Rodin's was an art 'to help a time whose misfortune was that all its conflicts lay in the invisible'. In his most ambitious work, *The Gates of Hell* (17, 21), which occupied him for 20 years and was never finished, the pessimism and anxiety and psychic distress of the *fin-de-siècle* period take on material

form and become visible with the same immediacy as in Munch's and van Gogh's paintings. Indeed, some figures in the *Gates of Hell* closely parallel Munch's, notably the kneeling youths with arms upstretched and heads thrown back, emitting, as Rodin said, 'cries lost in the heavens' (17, 22). If less obsessive, less pathologically expressive, they are quite as powerful images of despair as Munch's *The Scream* (17, 16), and the spectator's delayed awareness that they are casts from the same model only adds to the unnerving effect. Moreover, in its whole conception as a modern Inferno of perpetual flux, this huge monumental portal with its amorphous indeterminate composition, inconsistencies of scale and dizzying shifts of direction, is a disturbing symbol of psychic instability. Rodin may not have been as great or as innovatory a sculptor as

17,17 *Opposite top* Paul Gauguin, *The vision after the sermon*, 1888. Canvas, 28¾ × 36¼ins (73 × 92cm). National Gallery of Scotland, Edinburgh. .
17,18 *Opposite bottom* Vincent Van Gogh, *The night café*, 1888. Oil on canvas, 28½ × 36¼ins (72.4 × 92.1 cm). Yale University Art Gallery (Bequest of Stephen C. Clark, 1903).
17,19 *Below* Paul Gauguin, *The spirit of the dead watching (Mamao Tapapau)*, 1892. Canvas, 28¾ × 36¼ins (73 × 92cm). Albright Knox Art Gallery (A. Conger Goodyear Collection).

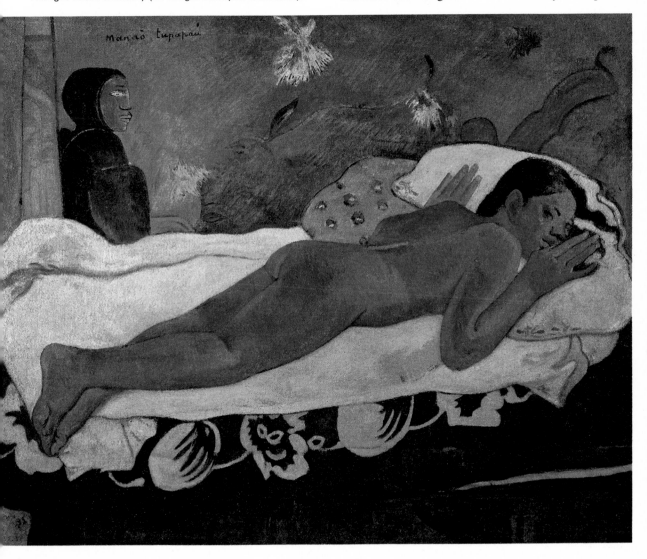

Degas. He was the last great exponent of an old tradition, rather than the first of a new. But the imaginary world he created is comparable in power with the tormented visions of van Gogh.

Art Nouveau

Munch's *The Scream* is exactly contemporary with the Tassel House in Brussels (17, 20) by Victor Horta (1861–1947), and three years later, in 1896, Munch's first exhibition in Paris was held in a recently opened gallery called 'Art Nouveau', which gave the new style its name and had been designed by another Belgian architect, Henry van de Velde (1863–1957). These

17, 20 *Left* Victor Horta, Tassel House, Brussels, 1892–3.
17, 21 *Above* Auguste Rodin, *The gates of Hell*, 1880–1917. Bronze, height 18ft (5.49m). Musée Rodin, Paris.
17, 22 *Opposite* Auguste Rodin, *The gates of Hell*, detail.

coincidences are not irrelevant. For the slithery, undulating, plant-like curvilinear patterns of the Tassel House interior, so characteristic of Art Nouveau, have affinities with the swelling and writhing lines of *The Scream* and other works by Symbolist painters, including Gauguin and van Gogh.

The connection between Symbolism and Art Nouveau is, however, formal only. Whereas the tortured lines of *The Scream* have great suggestive and expressive force, the linear patterns of the Tassel House are smooth and relaxed and purely decorative. The same superficial similarities and radical differences can be seen very clearly in two small, but masterly, designs by van de Velde (17, 25 a, b). In one, the woodcut title-page for a volume of poems, *Dominical*, by Max Elskamp, the design is expressive as in Symbolist painting. Suggestions of both space and mood are vividly conveyed without either modelling or fore-

17, 23 Paul Cézanne, *Mont Sainte-Victoire*, 1885–87.
25¾ × 32⅛ins (64.5 × 81.6cm). Metropolitan Museum of Art
(Bequest of Mrs H. O. Havemeyer, 1929. H. O. Havemeyer
Collection).

shortening. The poster for Tropon tinned foods, on the
other hand, though equally linear, lacks any sug-
gestion of depth nor are there any emotional overtones
or hints of further meaning, or indeed of any meaning
at all. The design is flat and ornamental. Its extreme
economy of means and non-representational character
relate it, rather, to early attempts at industrial design
being made in Germany at about the same date by
Peter Behrens (see p. 571).

Despite the odour of decadence which hangs about a
great deal of Art Nouveau, the movement was, in fact,
a positive one, the last of several earnest endeavours to
achieve a truly contemporary and 'modern', i.e. non-
period-imitation, style. Historicism (pp. 496–8) and
the revival of historical styles had repeatedly pro-
voked, as a reaction, a demand for a 'style of the
nineteenth century'. But buildings which exploited new
industrial materials and methods and attempted to
answer the call to be 'of one's own time', taken over
from the Romantics by the mid-century Realists, were
seldom accepted as 'architecture' by their contempor-
aries (16, 5). Art Nouveau was the first conscious and
successful attempt to halt the succession of historical
revivals (Greek, Roman, Gothic, Byzantine, Early

Christian, Romanesque, Italian Renaissance, French Renaissance, Jacobean, Elizabethan, and so on) and replace them with something which had no links, or at any rate no obvious links, with the past. Connections with Rococo ornament and Celtic ornament can be traced, as well as debts to the Pre-Raphaelite painters and to the English designer, poet and theorist William Morris (1834–96) and the Arts and Crafts Movement. But an essentially 'new' style was certainly achieved by the more extreme Art Nouveau designers, notably the Spanish architect Antoni Gaudí (1852–1926), some of whose buildings in Barcelona combine entirely free, asymmetrical, jagged plans with fiercely extravagant and arbitrary forms so that there are no straight walls, no right-angles and everything undulates in an unprecedentedly organic interplay of exterior and interior.

The rapid diffusion of Art Nouveau all over Europe

was due largely to another late-nineteenth-century phenomenon—the lavishly illustrated art magazine made possible by new reproduction processes following the invention of photography. Art magazines now had international circulations and they, together with the international exhibitions which were also a feature of the 1890s, could make an artist's work known very quickly and widely. Thus the Scottish Art Nouveau architect Charles Rennie Mackintosh (1868–1928) was better appreciated and more influential in Vienna than in Glasgow. In the same way, the style soon reached the United States, where, however, an indigenous type of proto-Art Nouveau ornament had already been created by the architect Louis Henry Sullivan (1856–1924), though this was not to be of great significance. Sullivan's importance lies elsewhere, in an architecture far more radically contemporary than anything conceived by Art Nouveau architects in Europe. Already in 1892 Sullivan had written that 'it would be greatly for our aesthetic good if we should refrain entirely from the use of ornament for a period of years in order that our thought might concentrate acutely

17, 24 Paul Cézanne, *Mont Sainte-Victoire seen from Les Lauves*, 1902–4. Canvas, 27½ × 35¼ins (69.8 × 89.5cm). Philadelphia Museum of Art (George W. Elkins Collection).

17, 25a *Top* Henry van de Velde, *Dominical*, 1892. Lithograph, 12¾ × 10¼ins (32.5 × 26cm).
17, 25b *Above* Henry van de Velde, *Tropon*, 1898. Lithograph, 11½ × 8½ins (29 × 21.5cm).

upon the production of buildings well formed and comely in the nude'.

Sullivan worked in Chicago, not hitherto a centre of architectural achievement. But a devastating fire in 1871 was followed by a building boom and this induced a sudden and extraordinary outburst of architectural invention, which Sullivan brought to maturity by giving the skyscraper its classic form. Office buildings in New York had reached 10 or 12 stories by the 1870s and to go beyond this was impossible with traditional materials. Further development depended on the introduction of metal framing, which took place in Chicago in 1883 when William Le Baron Jenney (1832–1907) built the Home Insurance Building (demolished). Skeleton construction free from load-bearing walls soon followed with Holabird & Roche's Tacoma Building in Chicago of 1886–9, though the new principle of construction was not expressed externally. It was Sullivan who made the classic statement of it with his masterpiece, the Guaranty (Prudential) Building in Buffalo (17, 26). In this monumental building the underlying grid of the structural steel frame dominates and controls the whole design so that complete independence from all period styles is reached. The façades become simple but rhythmically beautiful patterns of windows and sills between elegantly slender vertical members, the whole being read as a protective skin stretched between the corner piers, attics and mezzanine floors. The latter, together with the ground story, are conceived as forming a huge pedestal with the main piers isolated by slightly setting back the shop windows. These great piers seem to lift the building right off the ground, allowing space to flow under and into it. Moreover, the building's purpose as well as its hollow-cage structure is expressed in a way that illustrates and interprets Sullivan's famous words, 'form follows function', without any of the doctrinaire rigidity of later functionalists who made his remark their slogan.

Skyscrapers were American, but another architectural phenomenon had meanwhile occurred on both sides of the Atlantic almost simultaneously—the medium-sized middle-class architect-designed detached house. No aspect of nineteenth-century art and architecture is so quintessentially bourgeois. Up to this date the history of domestic architecture had been little concerned with that of any but the upper classes. If architects designed domestic buildings on a small scale they did so only as picturesque 'retreats' or follies or as adjuncts (vicarages, etc) to some noble mansion on a large estate. Now middle-class clients began commissioning architects independently to serve their own particular needs. In England a 'picturesque' tradition

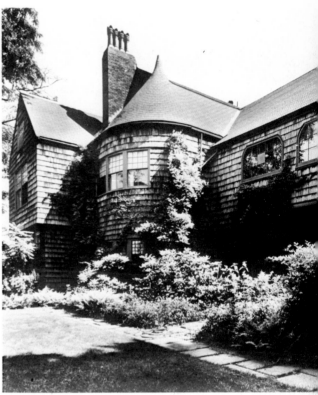

17, 26 *Left* Louis H. Sullivan, Guaranty Building, Buffalo, N.Y., 1894–5.
17, 27 *Below* H. H. Richardson, Stoughton House, Cambridge, Mass., 1882–3.
17, 28 *Bottom* C. F. A. Voysey, Norney, near Shackleford, Surrey, 1897.

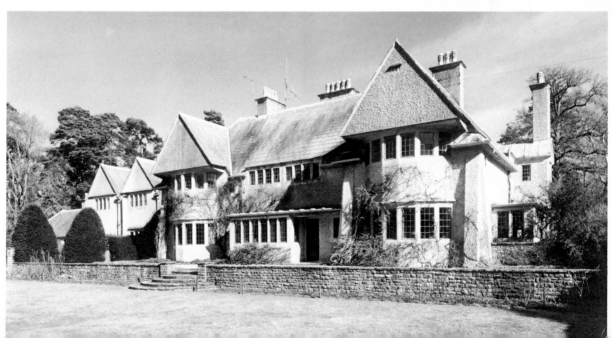

for the small detached house had begun with John Nash (1752–1835), and the famous Red House at Bexley Heath which Philip Webb (1831–1915) built for William Morris in 1859–60 was still in this tradition, simple and comfortable but with an individual plan to suit the client's special requirements. In the United States a comparable development took place in New England and culminated with the Shingle-style houses of Henry Hobson Richardson (1838–86), which are remarkable for their open internal planning and free compositions (17, 27), qualities which made Richardson's neo-Romanesque but no less idiosyncratic public buildings influential in Europe. In England towards the end of the century, Charles Francis Annesley Voysey (1857–1941) brought this informal rustic trend in domestic architecture to its unassuming, but masterly, conclusion with such houses as Norney in

Surrey (17, 28). Voysey's houses were never grand or imposing, never representative in any sense, but were most sensitively planned in intimate relation to nature, with perhaps an old tree preserved near the front door and surrounded by ample and rambling gardens. They spread with ease and have low, comfortable, cosy rooms. All is reasonable and friendly and wholesome— the perfect expression of the middle-class city-worker's dream of a lost rural felicity.

Cézanne

The same post-Industrial Revolution nostalgia for country life inspired much nineteenth-century art, Impressionism above all, and it profoundly informed that of the greatest late-nineteenth-century artist, Paul Cézanne (1839–1906). Cézanne, however, was to go far beyond Monet's and Renoir's celebrations of the sunlit natural world. No painter understood so well the limitations and inner contradictions of Impressionism. 'One must reflect,' he is recorded as saying. 'The eye is

17, 29 Paul Cézanne, *Cardplayers*, c.1890–95. Canvas, 18¾ × 22½ins (47.5 × 57cm). Louvre, Paris.

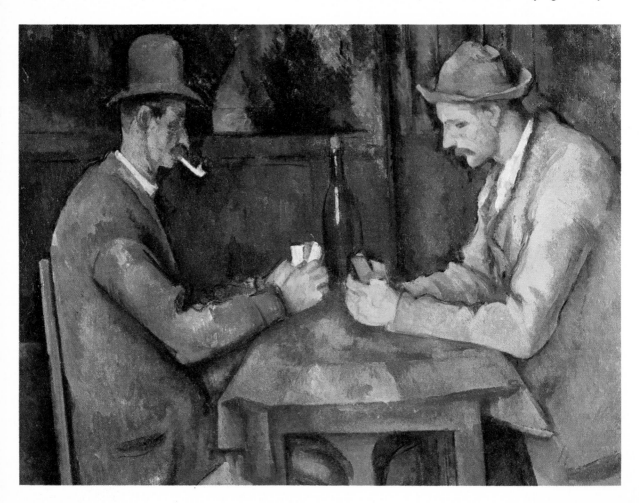

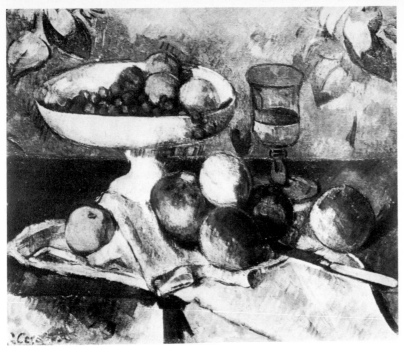

17, 30 Paul Cézanne, *Fruit bowl, glass and apples*, 1879–82. Canvas, 18 × 21½ins (45.7 × 54.6cm). Private Collection, Paris.

not enough, reflection is needed.' His paintings are the result of prolonged meditation in front of nature, not of the instantaneous recording of its fleeting effects. He wanted to make 'something solid and enduring' out of Impressionism, which seemed to him to lack simplicity, grandeur and, especially, that sense of underlying structural unity that can transform into a whole even the most fragmentary view.

'Art is a harmony parallel to nature', he wrote in an often quoted phrase. The problem was how to adapt the discoveries of Impressionism to this end; how to remain faithful to the truth of visual sensations without sacrificing all sense of order, how to regain form and solidity without losing the brilliance of Impressionist colour; indeed, how to regain it by colour alone and, in addition, reconcile the flat surface of the canvas with an illusion of depth. For Cézanne had to a unique degree the faculty of seeing both depth and pattern at the same time and he felt that a picture should exist as a flat design before it creates a three-dimensional illusion. To young artists around the turn of the century, when his work was first becoming known, the magnitude and loneliness of his quest seemed heroic.

Cézanne had exhibited with the Impressionists in 1873 and 1877 but left Paris after a few years and returned to his home town, Aix-en-Provence, where his father was a prosperous banker. There he dedicated himself to his art in isolation and solitude. Of independent means, he had no need to find buyers for his paintings and was almost completely forgotten and unknown until 1895, when his first one-man show was held in Paris at the instigation of Camille Pissarro, with whom Cézanne had worked many years earlier. Thereafter his work gradually won recognition, though widespread knowledge of it—even among avant-garde artists and collectors—came only with the memorial exhibition of 56 paintings at the 1907 Salon.

From the first, Cézanne was attracted by still life. He could set it up in the studio and keep it almost indefinitely for contemplation, apples and other long-lasting fruits being favourites, though they sometimes had to be replaced by wax replicas before he finished painting them. Completely absorbed in what lay before his eyes, he would go on organizing and re-organizing his visual responses until he saw his subject 'correctly'. 'If only I could realize' was a phrase repeatedly on his lips and the term 'realize' was evidently of central importance to his conception of his goal. By it he seems to have meant the process of transforming nature into something amenable to the closed and artificial world of the painted canvas. And to his mind this could be done by making visible that unifying harmony which unveils itself little by little to the artist in answer to some profound demand of the spirit.

It was the agonizing difficulty he had in 'realizing' combined with the constant struggle to integrate his natural sense of flat pattern with his consciousness of solid form that led to what were sometimes thought to be awkwardnesses and clumsy distortions in his work.

In one of his best known still-life paintings, for instance, the horizontal surfaces seem to tilt upwards and there are other features which make the perspective appear incorrect (17, 30). Yet an extraordinary sense of monumental gravity and grandeur, of everything having found its duly appointed place as in some sonorous Bach chorale, is evoked by this quite modest depiction of a commonplace subject. The design is very closely-knit, every part of the canvas being equally worked. Moreover, apart from the bowl and glass, everything has been reduced to its essential form, either spherical or rectangular, which enforces a great sense of weight and mass. The same heavily rounded curves echo each other across the canvas, creating rhythms of such momentum and pull that all the objects depicted take on the same elementary shapes—like rocks and stones ground smooth into cognate forms by the endless motion of the tides. Thus, the ellipses of the bowl and glass become rounded oblongs and the bowl's stem is set very slightly off-centre to accord with the general design. Evenly worked with thick, regular brush-strokes slanting from right to left as they descend without regard to the contours of the objects, the whole surface of the painting is united into a rich consistency, like enamel or lacquer, and saturated with colour.

Cézanne's voluptuous sense of colour and passion for solid construction produced unprecedented effects of mass and volume in still-life painting. With the more evasive subject of landscape the problem of rendering depth in space by colour became crucial. Linear perspective and tonal modelling would detract from the truth of his optical impressions and were therefore to be avoided. 'Colour must reveal every interval in depth', he said, through the recession of cool colours, the advance of warm colours and variations in intensity. The challenge this presented released all the boldness and largeness of his vision. It was partly in response to it that he began, after about 1882, to paint more thinly with a restricted palette of pale greens, earth colours and a wide range of blues, with which limited means the scenery of his native Provence—scenery which had hardly ever been painted before—was endowed with all the nobility of a Classical landscape. The seeming simplicity and straightforwardness of his views of Mont Sainte-Victoire conceal most complex and refined constructions (17, 23).

Parallel lines, echoing forms, balancing contrasts unite into a surface pattern elements that also represent things in depth so that complete integration of his dual vision is attained. We look out across the valley, past an evergreen pine, towards Mont Sainte-Victoire. He was to paint this great rocky outcrop near Aix again and again, in all seasons and at all times of day, until, towards the end of his life, its odd, almost unreal contours came to symbolize the exaltation he experienced before, as he put it, 'the depth and breadth of nature or, if you prefer, the spectacle that the Pater Omnipotens Aeterne Deus spreads out before our eyes'. The spirituality inherent in Cézanne's work is felt most deeply in his last majestic, but sombre, paintings of this strange mountain—remote, unchanging, divine in its intimations of eternity—silhouetted against a serene or lowering sky (17, 24).

The absence of figures or of any 'human interest' in Cézanne's landscapes and still-life paintings should not be understood as implying in any way an impersonal attitude or that he was concerned mainly with formal artistic problems. His portraits, especially of his own household, are among the finest of all his works. Those of his gardener Vallier and of an old woman with a rosary—said to have been an aged nun who had escaped from a convent, and was found wandering and taken in as a servant by Cézanne—have all the monumental gravity of his landscapes, as well as a deeply-felt and pondered humanity. Though anonymous, his groups of card-players in a local café are equally intimate and filled with human warmth. One of the last depicts two of his peasant neighbours facing each other in silent concentration across a rickety café table (17, 29). It sums up his achievement in a totally unconventional image of bold frontality and horizontality broken right down the middle by a vertical line which would have been anathema to an academician. The extreme refinement of its resonant harmonies of purples, deep blues, black, reddish brown and yellow tan combine with its restraint and directness and unpretentious simplicity to convey all the moral dignity of Cézanne's single-minded pursuit of an ideal. With such masterpieces he gave an answer—not the only answer but a wonderfully coherent one—to the basic questions Impressionism had raised about art and nature, perception and reality, and about the nature of reality itself.

18 'Primitive' alternatives

The term 'primitive art' was coined at the beginning of the present century to categorize objects which had not previously been regarded in the West as 'works of art' at all, that is to say objects from areas on the margin of or beyond the cultural influence of Europe, the Near East, India, China and Japan. In a pioneer study of *Primitive Culture* (1871) Edward Tylor, the first professor of anthropology at Oxford, mentioned the arts only in so far as they illuminated his problem of 'determining the relation of the mental condition of savages to that of civilized man'. Ethnographical museums founded in the nineteenth century—Copenhagen 1841, Berlin 1856, Leiden 1864, Cambridge, Mass., 1866, Dresden 1875, Paris 1878 among others—all

Map of Oceania.

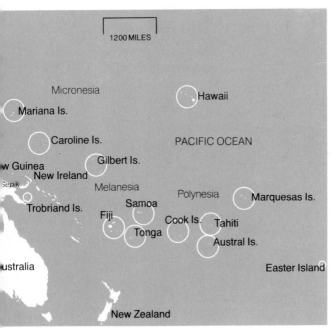

adopted the same attitude. Their aim was to illustrate the ground base from which Western civilization had supposedly ascended and they can now be seen as monuments to that cult of progress enshrined in Charles Darwin's *The Origin of Species* (1859), subtitled *The Preservation of Favoured Races in the Struggle for Life*.

Objects formerly preserved as odd and isolated examples of human ingenuity in cabinets of 'natural and artificial curiosities'—*Wunderkammern*, as they were called in Renaissance Germany (see p. 388)—were set together with prehistoric artifacts in the context of the evolution of material culture. Their alien strangeness was neutralized to some extent by incorporation into that cult of history or 'historicism' which became one of the dominant preoccupations of Western thought in the nineteenth century. The majority of exhibits in ethnographical museums were weapons and other utensils brought back by explorers, traders and missionaries from Africa, America and, after the mid-eighteenth century, the islands of the South Pacific. More specialized collections were built up by the colonial powers. Colonial exhibitions were also held (Amsterdam 1883, London 1887, Tervuren, outside Brussels, 1897), their aim being quite clearly indicated in the entrance to the museum at Tervuren by contemporary European sculptures personifying Belgium bringing peace, prosperity and Christianity to the Congo!

Although the ideas and assumptions on which these museums were based have fallen into disrepute, together with the colonialism they celebrated, the word 'primitive' is still applied to the objects exhibited in them (although nowadays 'tribal' is sometimes preferred). The term 'primitive' has positive as well as negative overtones with reference to urban man's regression from the primal state of nature—a recurrent theme in Western art and literature (pastoral poetry being among its finest expressions), and one of special

relevance in the heavily urbanized and industrialized West of the late nineteenth century, as we have seen (p. 534). The heterogeneous carvings, paintings and compositions in various materials which the term has been stretched to cover have little in common except their divergence from Western conceptions, especially of naturalism, and the fact that they evolved—like nearly all major artistic forms at all times and places— in intimate association with religion and magic. They are expressions of humanity's common and unending endeavour to live in harmony with, or to control, natural and supernatural forces; very seldom are they merely decorative in intention. They were, however, products of widely dissimilar social groups which integrated the arts into complex structures of laws, customs, morals, knowledge and beliefs. And, unlike the illustrative art of the proselytizing world-wide religions, 'primitive art' tends towards the deliberately arcane. The precise significance of a cult object, the mask worn in a ritual, the carving on the support of a house, or the painting on a shield, was limited to the initiated, sometimes to no more than a single sector of the community, and it has become ever less accessible as the structures of these societies have been transformed, if not completely disrupted, by contact with the West.

18,1 Monolithic images, 400–1680 AD, on the slopes of Rano-raraku, Easter Island.

Oceania

The vast stretch of the Pacific known as Oceania is conventionally divided into three geographical and cultural areas: Polynesia, a triangle with sides some 4,000 miles (6,400 km) long from New Zealand to Hawaii in the north and Easter Island in the east; Melanesia, comprising New Guinea and a group of islands stretching to the western limits of Polynesia; and Micronesia, a scattering of small islands north of Melanesia. The original populations immigrated from Asia. After about 26,000 BC a succession of groups settled in Melanesia, which has remained multilingual. Polynesia was the last part of the world to be populated—Fiji by 1300 BC, Tonga by 1200 BC and Samoa by 1000 BC. Not until shortly before the beginning of the Christian era did people occupy the westerly Fiji islands and then spread to Hawaii and Easter Island in about AD 300–600, and to New Zealand in about AD 750–1000. They were horticulturalists, fishermen and expert canoe-builders with an hereditary hierarchy and spoke a single Austronesian language. The dialects subsequently developed in the various sub-groups of islands thus had the same origin, and the arts similarly branched from a single rootstock.

After the initial settlement, however, Polynesia remained isolated from the rest of the world until the mid-eighteenth century. Although Fiji had been visited by A.J.Tasman in 1643 and Easter Island by another

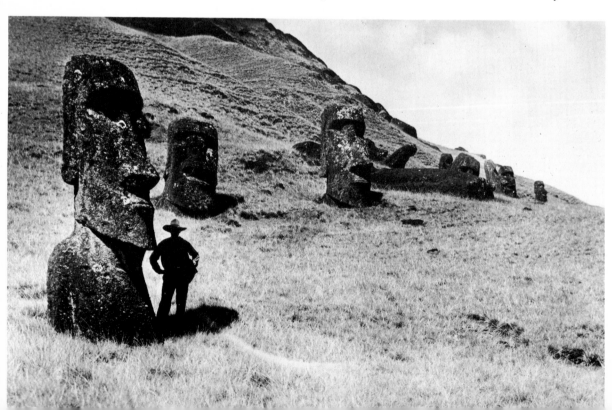

Dutch sailor, Jacob Roggeveen, in 1722, it was only in the 1760s that Europeans reached Tahiti in the centre of the Polynesian triangle—an English naval captain, Samuel Wallis, in 1767, the French scientist and explorer Louis de Bougainville next year and James Cook on his three voyages of discovery (1768–79). To these explorers, especially the observant Cook with his trained naturalists and artists, we owe most of our knowledge of Polynesian culture. For contact with the outside world was fatal for the Polynesians, who soon succumbed to diseases carried from Europe, especially syphilis. Their way of life was changed by the introduction of metal tools and firearms; their traditional beliefs and rituals were undermined by Christian missionaries.

Easter Island's great monolithic heads and half-length figures, up to 60 feet (18.3 m) high, are the most imposing Polynesian sculptures (18, 1). More than 600 survive, carved over a long period from about AD 400 to 1680, when the majority were thrown down, probably in a tribal war, and others were left unfinished in the volcanic crater where they were quarried. Bodies are summarily rendered and the heads are no more than giant masks, all with the same forceful features, prominent noses, pursed lips, long ears, massive brows and deep sunken eye-sockets. Some, wearing cylindrical crowns of red rock, were set with their backs to the sea on stone platforms beneath which the dead were buried near the shore. Others are thought to have marked three long avenues across the interior. By the time of Cook's visit the islanders seemed to have lost interest in them; but Cook recognized their connection with the cult of ancestors of a ruling caste. They are now known to have been symbols of the power which, throughout Polynesia, ruling chiefs were believed to inherit from the gods and retain after death when they were themselves deified. In this way they are comparable with other images of divine kingship—the faces inscrutably staring out from the towers of Angkor Thom (contemporary with some Easter Island statues, p. 195), for instance, or the much earlier ancient Egyptian royal statues and the Great Sphinx (see p. 41)—and are likewise the expressions of an hereditary politico-religious structure. Their peculiar jutting, block-like form is probably due mainly to the nature of the only material available for large-scale work, a grainy, easily worked tufa. But only stone, shell and bone implements were available.

Elsewhere in Polynesia stone sculptures were carved, though not on so gigantic a scale nor in such quantity.

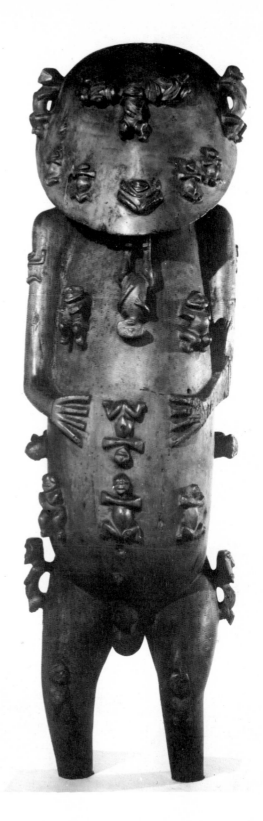

18, 2 The god A'a from Rurutu, pre-1821. Iron and wood, height 44ins (112cm). British Museum, London.

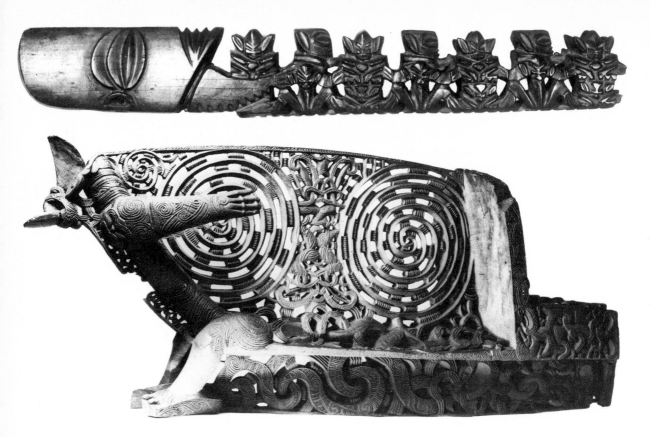

18, 3 *Top* Staff-god from Rarotonga, pre-1823. Wood, length 28½ins (72.5cm). University Museum of Archaeology and Anthropology, Cambridge (UK).
18, 4 *Above* Canoe prow, Maori, pre-1835. Wood, 70⅞ × 29½ins (180 × 75cm). Musée d'Histoire Naturelle, Ethnographie et Préhistoire, Rouen.

Greater use was made of wood, which was scarce on Easter Island and could be used only for small figures and the plaques on which hieroglyphics were incised (perhaps related to an early Chinese script, but as yet only beginning to be deciphered). In the Hawaiian Islands some images of gods were composed of basketry covered with red, yellow and black feathers, dog's teeth in their mouths and pearly shells for eyes (18, 21). Priests carried them in religious ceremonies and also in battles, which were almost a ritual, attended by chiefs wearing similarly made helmets and capes of the finest featherwork—a prerogative of the gods and the ruling clans descended from them. The example illustrated here was one of several collected by Cook in 1779 when he was hailed as a god by the Hawaiians (although they later killed him). They are the earliest examples known (now widely dispersed in museums). Basketry and featherwork quickly perish in the tropics, and so also does wood.

Few extant wood carvings date from much before the arrival of Europeans, and the vast majority of those produced in the following decades were destroyed as Christianity spread across Polynesia in the nineteenth century. Only a few were saved, mainly by missionaries who sent them to Europe for exhibition as trophies of their victory over heathenism. One of the most remarkable was collected in 1821 by an English missionary who recorded its significance (18, 2). A'a, the deified ancestor of the ruling clan on the island of Rurutu (in the Austral group south of Tahiti) is shown with his progeny, tiny figures in relief, which take the place of his physical features, and a number of statuettes enclosed in a cavity in the back. The phallic shape of the figure emphasizes its procreative symbolism. Other cult figures called staff-gods, from Rarotonga (in the Cook Islands west of Tahiti) similarly combine images of gods with their descendants (18, 3). They ranged in length between 30 inches (76 cm) and 18 feet (5.5 m) and were carried and displayed horizontally. At one end there is a highly schematized blade-shaped head and arms of the progenitive god with a succession of little figures rising from his body, alternately full-face and in profile—those in profile with penis erect. The staff itself terminated in a phallus.

But this elaborately carved sexual imagery had less importance for the Rarotongans than the feathers and pieces of shell representing the soul of the god and enclosed in yards of bark-cloth wound round the centre of the staff. Missionaries called them idols, though the Polynesians regarded cult images as no more than temporary 'receptacles' into which the spirit of a god might be induced by rituals. (Idolatry, the worship of man-made objects rather than of the spirits they represent, is, in fact, a very rare phenomenon in any part of the world.) Simpler figures, always naked, usually male, sometimes intended to stand on the prows of canoes, were carved elsewhere in Polynesia in a remarkably wide variety of local styles. All of them expressed similar beliefs in religion and magic.

The Maori, whose forebears were probably canoe parties from central Polynesia driven to the shores of New Zealand by storms, created an art conditioned by a colder climate, different natural resources and a social structure based on kinship rather than on class hierarchy. They excelled in relief carving, often on a large scale, for canoes and for the lintels, barge-boards and posts of assembly houses, communal storehouses and stockades protecting villages. The indigenous *totara* and *kauri* pine, light, tough, durable and much softer than the types of wood found in tropical Polynesia, permitted effects of greater elaboration and curvilinear vitality. Whole surfaces were intricately worked with spirals (a favourite motif), scrolls and chevrons. A large relief of an ancestor, club in hand, tongue protruding from open mouth, joints of limbs rendered as spirals which suggest the capability of movement, is characteristic (18, 5). It is one of a series attached to supports in an assembly house, the physical embodiment of a tribe, where its members were surrounded and protected by the benevolent spirits of ancestors—menacing only to outsiders. The face is strikingly reminiscent of bronze ritual vessels made in Shang dynasty China about two millennia before New Zealand was populated. Other Maori carvings are still closer to the *t'ao-t'ieh* masks in their combination of two profiles with a frontal view (2, 40).

No direct connection can be established, but perhaps the tattooing with which the Maori, like other Polynesians, covered their bodies may provide a clue. (The word tattoo is, like the word taboo, of Polynesian origin, introduced into European languages by Cook but now, of course, used for a very widespread and ancient practice in many cultures, see p. 123). Body painting, from which tattooing developed, is probably the oldest of the arts of mankind and the one which most obviously distinguished human beings from other creatures. Lasting no more than a single lifetime,

18, 5 Ancestor figure, c. 1842. Wood, $55 \times 25\frac{1}{5}$ins (139.5 × 64cm). National Museum of New Zealand.

it is also the least permanent and yet, paradoxically, so strongly regulated by traditions passed from one generation to another that it may well have kept alive motifs which appear in other, more enduring media widely separated in time and space. Tattooing in the most intricate designs, clearly of remote origin, was and still is practiced all over the area between China, Indonesia and the South Pacific (18, 23).

18, 6 Asmat memorial poles from Irian Jaya, south-west New Guinea, early 20th century. Wood, paint and sago-palm leaves, height 17–18ft (5.2–5.5m). Metropolitan Museum of Art, New York (Michael C. Rockefeller Memorial Coll. of Primitive Art, Gift of Nelson A. Rockefeller and Mrs Mary C. Rockefeller, 1965).

The decoration of the living human body is closely associated with that of the shield made to protect it. Shields are perhaps the most telling instances of the various ways in which art has been used to give additional meaning or magic power to a utilitarian object. Reliefs and paintings applied to them seem to have been seldom merely ornamental, even if they indicated no more than the bearer's membership of a group or his status within it. The precise significance of

such designs is, nevertheless, often elusive. The painting on a shield from the Trobriand Islands off New Guinea has been variously interpreted by well-informed anthropologists as the representation of a witch—a Melanesian Medusa intended to petrify an enemy with fear—or a copulating couple (18, 22)! There are several other shields from the same area, similarly painted with symmetrical curvilinear forms, derived apparently from parts of the human body, which suggest not only an arcane symbolism but also aesthetic preferences peculiar to Trobriand Islanders.

In Melanesia a still wider range of artistic styles was evolved than in the scattered islands of Polynesia. They can be broadly grouped, just as the 800 or so languages spoken on New Guinea have been categorized in linguistic groups called phyla—though, strangely, these and the artistic styles are not coterminous. Their diversity reflects the corporate individuality of the many small tribes which were until very recently in a state of almost constant warfare. The Asmat on the marshy coastal plain of south-western New Guinea, for instance, developed their own kind of memorial for victims of head-hunting raids: tall poles, up to 37 feet (11.3 m) high and carved from single tree-trunks with human figures balanced precariously on top of one another, from which heads taken in revenge were suspended (18, 6). As head-hunting had a ritualistic sexual significance, these poles were also believed to promote fertility and the elaborately worked project-ing member is phallic. Poles with the same function and significance were carved by the neighbouring Mimika but in a different style, more solid and much less elegant and dynamic. In the valley of the Sepik river in northern New Guinea a rich variety of styles of carving was and still is practiced. Masks intended to be worn or carried in rituals or hung on the wall of a hut are the most striking products, brilliantly coloured and often embellished with shells, boar-tusks, feathers and locks of human hair (18, 24). A long-nosed face recurs in many and they all incorporate symbolic elements (the chin extended into a phallus), displaying amazing ingenuity in the assemblage of materials to create images of supernatural vitality. Large wooden hooks, made to be hung from roof-beams to carry baskets for food, clothing and precious objects, are often intricate works of sculpture incorporating human figures or long-nosed heads similar to those of masks (18, 7).

On the island of New Ireland, north-east of New Guinea, artistic attention centred on the *malanggan*, a term that covers ceremonies commemorating the dead as well as the statues, masks, carved and painted boards, and string instruments used in them. Many of these objects were made for a single, particular

ceremony and thrown away afterwards. Ancestor figures, on the other hand, were preserved for a time in huts built specially for them (18, 25). They are of an impersonal, collective character, not, apparently, representations of individuals. Usually symmetrical in structure, they are carved with great intricacy from single blocks of wood, painted in bright colours, sometimes inlaid with shells and usually provided with plant fibres for hair. Although they are recognizably human in inspiration, the extensive use of open-work in the carving and the complex painted patterns on the surface reduce their solidity, giving them an insubstantial, perhaps intentionally 'spiritual' rather than corporeal appearance. Diverse styles of carving were practiced in different parts of the island, although it is no more than 200 miles (320 km) long and very narrow. These sculptures from New Ireland have, none the less, a generic similarity which sets them apart from other types or styles of Melanesian art.

There were few hereditary chieftainships in Melanesia, so there is little or no dynastic art. Power within a tribe was acquired by individual prowess (in head-hunting or other ways) and this goes far to explain the lack of interest in objects intended to endure for more than a short while. Few surviving examples of Melanesian art can be dated earlier than the mid-nineteenth century. And although traditional ways of tribal life survive in New Guinea and masks continue to be made much as before, even if with metal tools, the rituals for which they are made have, with the pacification of the island, lost much of their power. In the Sepik region the building of a ceremonial house is nowadays marked by the killing of pigs, instead of men, and their skulls are now hung from its roof. Paradoxically, however, the population has declined since head-hunting was virtually suppressed. In 1932 the great anthropologist Bronislaw Malinowski, who devoted his life to the study of Melanesia, remarked: 'Ethnology is in a sadly ludicrous, not to say tragic, position, that at the very moment when it begins to put its workshop in order ... the material of its study melts away with hopeless rapidity.'

The American north-west

The 1,000-mile stretch of the north-west coast of America—the north-east of the Pacific—from southern Alaska to the state of Washington, provided an ideal environment for the growth of stable communities. Despite the northerly latitude, the climate is

18, 7 Double-ended suspension hook from Middle Sepik, New Guinea, early 20th century. Carved and painted wood, height 29$\frac{1}{8}$ins (74cm). Musée de l'Homme, Paris.

temperate. Natural resources were originally so rich that the inhabitants could subsist by fishing, hunting and gathering, without the need to domesticate stock or cultivate the land. Forests yielded abundance of wood for buildings, for boats and also for sculpture, sometimes on a large scale. Beyond them the Rocky Mountains were an impenetrable barrier against marauders. The history of the area is obscure until the 1770s, when exploration by Europeans began—James Cook was among the first and collected the earliest surviving examples of its art. It appears to have been settled in the mid-first millennium AD by tribes of diverse origins speaking languages which are still mutually unintelligible: the Tlingit in the north, the Haida on Queen Charlotte Island, the Tsimshian, the Kwakiutl, the Bella-Coola and the Nootka. The culture to which they contributed has, nevertheless, an underlying homogeneity and a visual character as distinct from that of the Polynesians as from that of the nomads of the North American plains and forests.

The peoples of the American north-west engaged in trade as well as warfare with one another, and this may partly account for the diffusion of cultural traits and artistic motifs throughout the area. They were also linked by belief in shamanism, that most ancient form of magic which they shared with the hunting tribes of Siberia and had probably inherited from common forebears in the remote past. Despite very different myths of creation and ideas of supreme deities, all acknowledged the power of shamans to make contact with the spirits of the forests and the waters, to heal the sick and predict the future. Much of their art was concerned with the shaman's equipment of masks and other ritual objects. But the rest is secular and springs from a preoccupation with the hereditary basis of their complex social structures.

The Tlingit and other 'nations' or language groups were aggregates of autonomous village communities composed of one or more families, each with its own chief, who inherited his position through matrilineal descent. They had no centralized political or religious organization, but cohesion was given by extensive networks of kinship established through marriage, both men and women being obliged to marry outside the larger divisions of clans and moieties (or halves) into which they were born and into which the social group was divided by matrilineal or patrilineal descent. Thus families built up riches by marriage without any one family acquiring a dominant position. Although politically on a par with one another, their

18, 8 Tlingit 'totem-pole' at Sitka, Alaska, late 19th century. Carved and painted wood.

chiefs competed in displays of riches, especially in the potlatch, a feast accompanied by exchanges of gifts and the dramatic performance of myths connected with the history of the family. The so-called 'totem-poles', the most distinctive artistic product of the north-west, were similarly conspicuous declarations of prestige and the genealogy by which it had been attained, equivalents to the coats of arms of the European nobility (18, 8). These magnificent sculptures up to 90 feet (27.4 m) high and carved from single tree-trunks probably originated as funerary monuments, but by the nineteenth century were more often

18, 9 *Below* Tlingit bear screen, c. 1840. Wood and paint, 15 × 9ft (4.57 × 2.74m). Denver Art Museum, Denver, Colorado.
18, 10 *Right* Tlingit war helmet from south-east Alaska, early 19th century. Wood, height 12ins (30.5cm). American Museum of Natural History, New York.
18, 11 *Below right* Tlingit mask, mid-19th century. Carved and painted wood with shell, height 9¼ins (23.5cm). Musée de l'Homme, Paris.

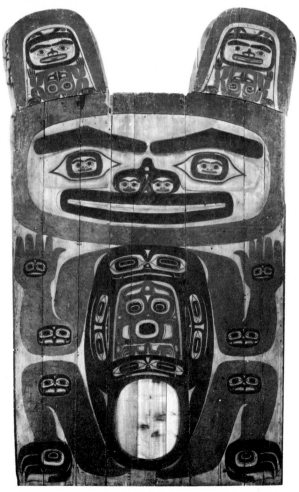

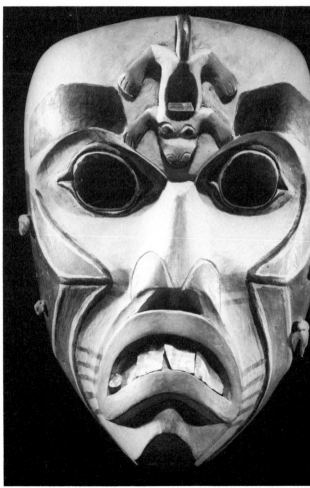

set up outside the houses of chiefs. Their superimposed figures—eagles, bears, beavers, whales, sea-monsters and so on—were crests which a chief inherited from his lineage, his clan and his moiety. They were not objects of worship, nor were the animals carved on them totems with which a group of people had a super-natural relationship.

Poles were designed according to a governing principle of bilateral symmetry, with their various elements interlocked so that they seem to grow organically out of one another. They have a unity of symbolism, form and surface. In their manner of representation the carvings range from almost abstract symbolism to a realism bordering on caricature—taken to its furthest extreme in Tlingit war helmets (18, 10). Masks are similarly varied, including represen-tations of the shamans' spirit helpers and also the faces of ancestors (with their crests), worn at commemor-ative potlatches, but all carved with the same feeling for bold sculptural forms (18, 11). Paintings, on the other hand, are emphatically flat and non-naturalistic. They are mainly of animals rendered by devices which mysteriously recur in the arts on both sides of the Pacific. Sometimes the animals are, as it were, split open and their features rearranged so that all can be shown on a flat surface. This device was used by the ancient Chinese and also by the Maori in New Zealand (18, 5). Physical features were also incorporated inside one another, as in the Animal style of the ancient Scythians (4, 37 & 38). Faces stare out from the ears, eyes, nostrils, paws and limb-joints in a painting of a brown bear (18, 9). The large scale (15 feet, 4.6 m, high), the broad sweep of the general design and the simple colour-scheme combine to give imposing monumentality to an image conjured up from a world contingent to that of reality. The brown bear was a Tlingit clan crest and this painting was executed in about 1840 on the interior wall of a chief's house in Wrangell, Alaska, but is said to have been copied from an earlier prototype.

Africa

The art of Africa south of the Sahara permits no generalizations that are not equally applicable to the art of mankind as a whole. It has a diversity of functions, media and styles as great as that of any of the other continents. Nor did it evolve in complete isolation from Europe and Asia. Africans were trading overseas with Europe and Asia long before Europeans penetrated the interior. Materials were imported and techniques assimilated. On the west coast objects were made for export (mainly ivory carvings) from at least as early as the sixteenth century. (The widespread

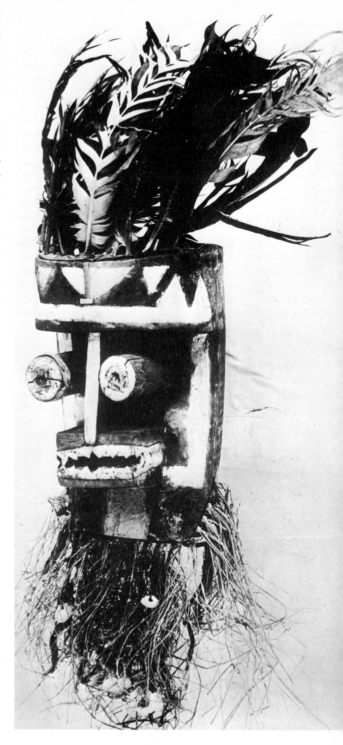

18, 12 Ceremonial mask from Wobé or Grebo, Ivory Coast, late 19th century. Painted wood, feathers and fibres, height 11 ins (28cm). Musée de l'Homme, Paris.

production of 'airport art' for tourists is, of course, a very recent phenomenon.) Otherwise, the visual arts were practiced in Africa mainly in the context of religious rituals, which included cults of ancestors and divine kingship, or to satisfy a need for symbols of wealth and status. Religious beliefs were localized. There was no unifying religion with a clearly defined iconography. Even in areas where Islam has been the official creed since the Middle Ages and in those where there has been a Christian majority since the mid-nineteenth century, animistic and pantheistic cults have survived. African art is, furthermore, the product of many ethnic groups with their own languages. It was created within diverse social organizations ranging from small tribal communities to the centrally organized kingdoms of, for instance, Benin, Dahomey and Asante.

18, 13 Bakota ancestor figure from Gabon, late 19th century. Wood and copper sheeting, height 26¾ins (68cm). British Museum, London.

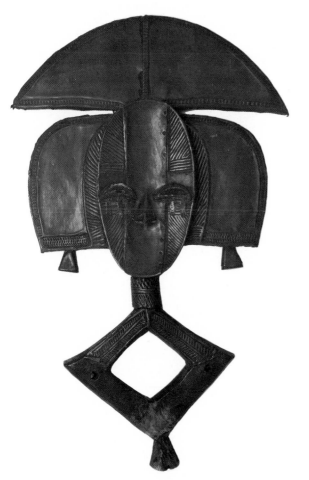

All the usual materials for artistic production were employed in Africa, stone, metals, wood, ivory, many different pigments, as well as the horns and teeth of animals, feathers, shells and dried grasses (18, 12). Many, though by no means all, African images were created to inspire terror or wonder or to mediate with the elemental spirits, often as part of a ritual. Some are serene in their beauty to Western eyes. Laborious craftsmanship was lavished on those intended to endure, while others were roughly assembled to serve for no more than a short time—among the Dogon, for instance, a type of mask was made to be worn only once and then discarded. Styles range from a spare geometrical symbolism—as in ancestral reliquaries made by the Bakota (18, 13)—to the naturalism of Benin and Asante heads (3, 41) with a preference, however, for what the Yoruba of Nigeria call *jijora*, i.e. moderate resemblance to the subject, something between absolute abstraction and absolute likeness. There are, nevertheless, certain modes of artistic expression which have been developed in Africa perhaps more fully than anywhere else, especially in sculpture. Figurative paintings appear sporadically throughout the continent and over a very long time-span, from the prehistoric rock art of the Sahara (1, 10) to that which the Bushmen (or San as they are now often called) practiced in the south until well into the nineteenth century. Woven fabrics from many areas reveal great feeling for colour and flat patterning. But the major contribution of Africa to the arts of the world has been made in sculpture—sculpture including, of course, assemblages and all works of art in three dimensions—produced largely by groups of settled cultivators in the areas drained by the Niger and Congo rivers (the migratory cattle herders of the east almost entirely limited their material arts to shields and items of nomad's gear).

As we have already seen, very fine examples of west African sculpture survive from the early Nok culture (p. 93), from probably the ninth- to tenth-century culture at Igbo-Ukwu and from twelfth- to fifteenth-century Ife (p. 396). The art of brass sculpture was practiced at the court of the obas in Benin (pp. 397–8) from the fifteenth century until the city was sacked by a British punitive expedition in 1897 and its treasures were dramatically revealed to the world. After the seventeenth century, however, forms tended to lose their vitality as a result of artistic inbreeding. In the kingdom of Asante, which rose to power and wealth in the eighteenth century, a secular art of small-scale sculpture flourished. Here little weights, for measuring gold dust, were cast in brass in the form of lively human figures and animals. Some appear to illustrate

proverbs and thus have a verbal or narrative content comparatively rare in African art. But in the general context of west African sculpture the bronzes of Ife and Benin are also exceptional in their naturalism, as well as being examples of a court art in an enduring medium. The majority of works were connected with popular religious cults and magic practices and appear to have been of iron, which soon rusts away in the tropics, or of wood, which usually perishes in less than a century. Our knowledge of the history of this art before the nineteenth century is therefore scanty and incomplete.

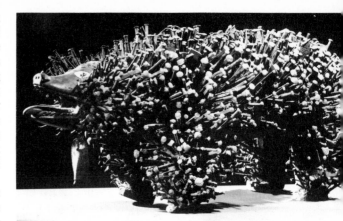

There is evidence to show that some symbolic motifs remained unchanged over long periods in African, as in European and Asian, art. A wooden divining tray acquired by a German collector in the early seventeenth century (Ulm Museum) is almost identical with those carved by the Yoruba some 300 years later. But there are indications of change as well as of continuity. African art of the nineteenth and early twentieth centuries is the product of a long process of development, conditioned by extensive folk migrations, by the rise and fall of states, by the introduction of materials and techniques from outside, and by the work of individual artists. Wooden fetish figures known as *konde* bristling with nails driven into them by *ngangas* or medicine men for magic effect, both to cure and to kill, are among the most distinctive cult objects of the Lower Congo, but obviously they cannot have antedated the introduction of European iron nails (18, 14). (There may, of course, have been earlier fetish figures of this kind in a slightly different form.) It has even been suggested that the idea of investing nails with supernatural power came from crucifixes— Christianity was the state religion of the kingdom of Kongo (Angola) from the early sixteenth to the late seventeenth century.

Iron had a much older symbolical significance in Africa, derived from its use in both agriculture and warfare, antedating any possible symbolism acquired from or through Christianity. Although it had been smelted since very early times on the Jos plateau (northern Nigeria, p. 93), the rituals associated with its working, which appear to be of equally ancient origin, may have tended to inhibit large-scale production. Increasingly large quantities were imported and it was, indeed, partly to obtain iron that Africans became embroiled in the vicious spiral of the transatlantic

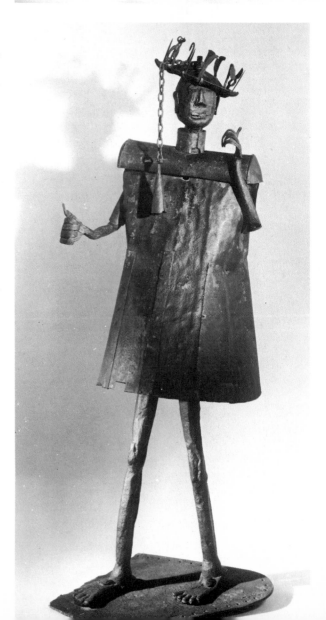

18, 14 *Above right* Magic animal from Loango, Congo Brazzaville, late 19th or early 20th century. Wood with iron nails and blades, length 35ins (88cm). Musée de l'Homme, Paris.
18, 15 *Right* Gu, god of iron and war, from Dahomey, late 19th century. Iron, height 78ins (165cm). Musée de l'Homme, Paris.

slave-trade, selling captives for iron bars which could be forged into weapons used in wars to obtain more captives. Among the Yoruba, users of iron implements—woodcarvers, hunters, farmers and warriors, as well as blacksmiths—worship the god Ogun, who introduced the metal to their ancestors, and wear iron amulets (formerly including miniature slave manacles). Gu, the god of iron and of war of the neighbouring Fon tribe, is the subject of one of the most compelling African images—an iron man constructed partly of European scrap (18, 15). Divinities were, however, seldom represented as directly as this in African art, which is focused on the spirit they conceived as 'residing' in matter rather than on the spirit's physical manifestation. It is in this essential way

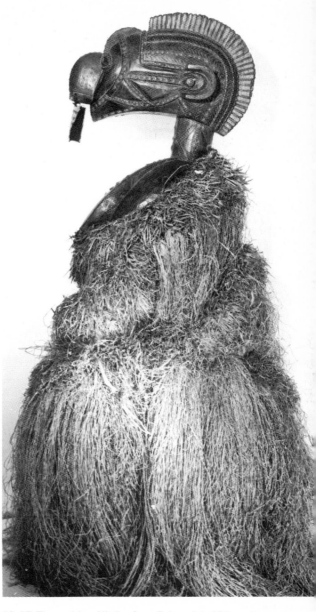

18, 17 The goddess Nimba, from Guinea, late 19th century. Carved wood with copper nails and natural fibres, height 86⅝ins (220cm). Musée de l'Homme, Paris.

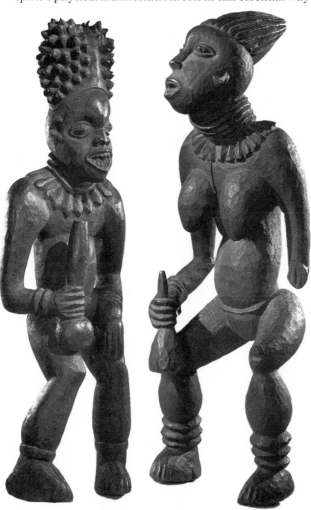

18, 16 Dancing royal couple from the kingdom of Bangwa, Cameroun, late 19th or early 20th century. Wood, heights 34½ and 34¼ins (87.6 and 87cm). Harry A. Franklin Family, on loan to the Los Angeles County Museum of Art.

that African sculpture differs from Greek sculpture. The angularity and asymmetrical pose of the figure are also unusual. It is, in fact, unique: a solitary masterpiece of an individual sculptor-smith hammering and bending rods and sheets into an image of destructive force in which the symbolism of the material itself and the form it is given have equal importance.

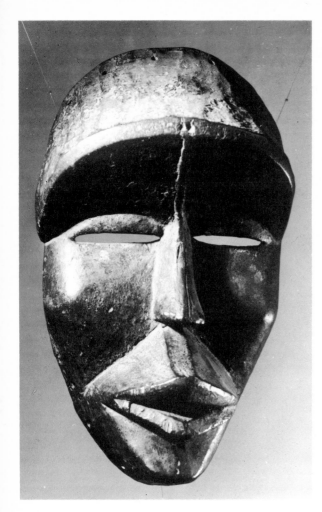

grasslands of Cameroun (18, 16). The youthful appearance which these dancers share with nearly all African figurative carvings reflects a preoccupation with the process of growth (perhaps also evident in ancestor figures with large heads and infantile bodies). Although they do not come from the Yoruba region, these two figures also have the qualities valued by the Yoruba in sculpture, qualities which can only be called aesthetic: modified naturalism, 'visibility' or clear articulation of parts, shining surfaces which afford a play of flickering light and shade, as well as *odo* or the representation of the prime of life. The woman

18, 19 Dogon 'Black Monkey' mask, from Mali, late 19th century. Carved wood, height 14½ins (37cm). Musée de l'Homme, Paris.

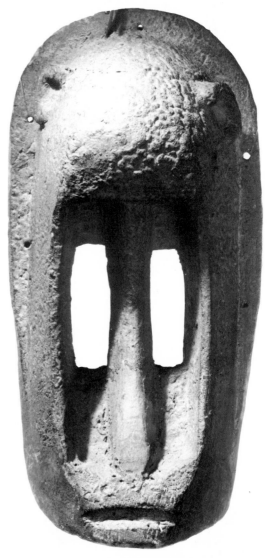

18, 18 Dan ceremonial mask from Ivory Coast or Liberia, late 19th century. Wood, height 9⅝ins (24.5cm). Musée de l'Homme, Paris.

The sculpture of wooden cult images was in many parts of Africa hedged round with rituals, from the felling of a tree and the propitiation of its spirit to their completion by the incorporation of magic substances (medicine), and the application of non-naturalistic colouring, or by some form of sacrifice to invest them with supernatural power. Their predominantly curving forms seem, furthermore, to express the widespread dynamistic belief in the energy immanent in all nature, the principle of growth or a life-force which integrates and reconciles the cults of gods, ancestors and impersonal fetishes by which men seek to exert control over nature. Organic forms are thus ordered and controlled by simplification and symmetry even in representations of figures in motion, like those of a dancing couple from the Bangwa kingdom in the

especially has the flexibility of body and that 'coolness' or detachment of expression which Africans particularly admire in dancers.

Cult images, many of which were rarely and some of which were never seen once they had been completed, did not have the prominence in African art that they had in European art. In Europe literacy has tended to destroy the instinctive orchestration of the senses and to focus attention on the static image as on a statement in black and white. In Africa, as in Melanesia (though curiously not in Polynesia), much sculptural activity was devoted to masks made to be seen in movement as part of a ceremonial, often accompanied by music. They were worn in rites with various purposes: to gain security and survival, fertility and increase of food supply in a world where uncertainty was always a menacing presence, and to ensure the continuity and stability of a social group by initiating the young into its ancestral traditions and preserving its myths by dramatic presentation. Occasionally masks were worn on top of the head so that they could be seen only by the spirits above, but generally they were visible to all participants and set off by elaborate costumes concealing the wearer so that the whole became an animated image. Among the Baga in Guinea, heavy carved wood busts of Nimba, goddess of maternity, were at the time of the rice harvest carried on the shoulders of dancers who could see out through holes in the breasts but were completely concealed by a rustling skirt of fibres (18, 17). The forms of masks were determined by the ceremonies in which they were used. The Dogon mask of the 'Black Monkey', for instance—a carving of sombre power—was worn in funeral dances which terminated periods of mourning (18, 19). A very elaborate helmet mask embellished with copper, cowrie shells and beads represents a royal ancestor, and was used in all-important initiation rites for boys of the Bakuba in the Kanai river region of the central Congo (Zaire) (18, 26). Some masks provided channels through which the spirits of ancestors could be addressed as intermediaries between the living and the higher gods. Others were simply intended to entertain, charm or terrify the living. But none was conceived as a static object: all were intended to be seen in movement.

A mask from the Sassandra river area of the Ivory Coast is one of many made for the Poro society, a male initiatory organization which directs diverse public functions, civic, religious, administrative, judicial and social (18, 12). It is roughly made up of unnaturalistic and non-representational forms which are given the appearance of a terrifying human head by their arrangement—a flat oblong panel with a semicircular

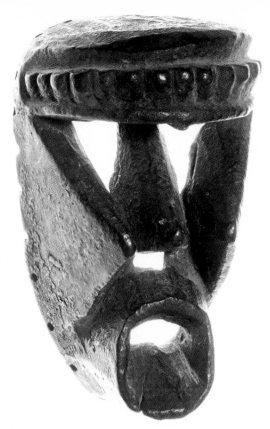

18, 20 Mask from Liberia, late 19th–early 20th century. Wood, height 9ins (22.9cm). Yale University Art Gallery (Gift of Mr and Mrs James M. Osborn for the Linton Collection of African Art).

block for a brow, cylinders for eyes, a vertical strip for a nose, and a block with a horizontal incision for a mouth—painted gray, white and blue with a feather crown and a beard of raffia. Similar masks were made, assembled rather than sculpted, by the Dan on the Ivory Coast. Masks in a very different style, embodying an ideal of feminine beauty and intended to be handed down from one generation to the next, were also carved of hard wood and given a high black polish (18, 18). Both types were valued for their efficacy both supernatural and 'natural' in arousing emotional effects. But the latter also correspond with aesthetic preferences stated by Dan carvers and others and recorded in conversations with sympathetic ethnologists—symmetry about a vertical axis, with balance, rhythm and harmony between the various masses, surfaces and lines. These three-dimensional qualities, which appealed so strongly to several European artists in the early twentieth century, survive even when such a mask is shown in isolation. But the arts of

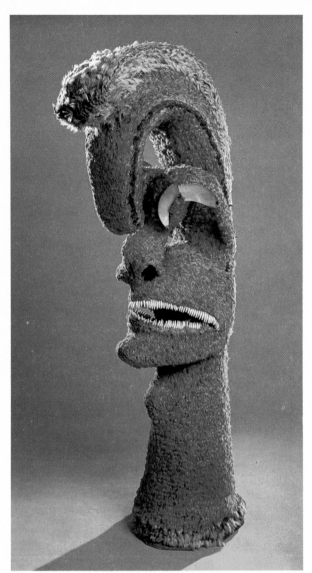

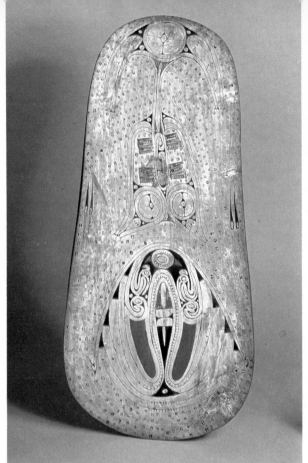

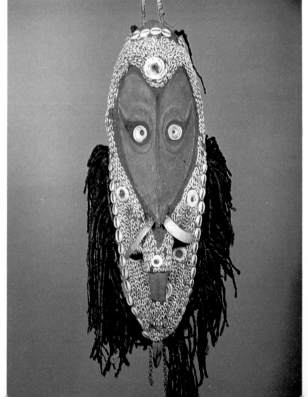

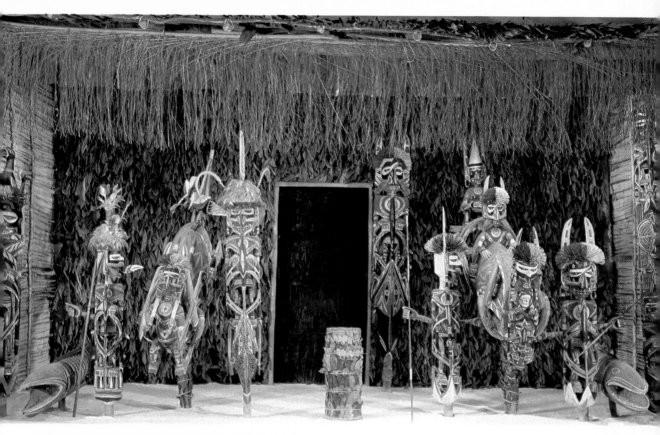

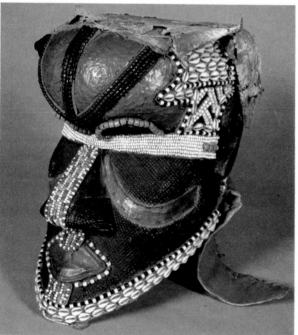

18, 21 *Opposite top left* The war-god Kukailimoku, from Hawaii, pre-1779. Feathers over wickerwork, pearl shells and dog teeth, height 40¾ins (103.5cm). British Museum, London.
18, 22 *Opposite top right* Shield from the Trobriand Islands, late 19th century. Painted wood and cane, height c. 33ins (84cm). University Museum of Archaeology and Anthropology, Cambridge (UK).
18, 23 *Opposite bottom left* Tattoo patterns used by the Iban of Sarawak.
18, 24 *Opposite bottom right* Mask from Kanganaman, Middle Sepik, New Guinea, collected 1950–3. Wood with overmodelling, cowrie inlays and boar tusks, height 23¼ins (59cm). Tropical Museum, Amsterdam.
18, 25 *Above* Malanggan masks and figures, New Ireland. Bamboo, palm and croton leaves and painted wood. Museum für Völkerkunde, Basel.
18, 26 *Left* Mboom helmet mask from Bakuba (Zaire). Wood, brass, cowrie shells, beads and seeds, height 13ins (33cm). Musée royale de l'Afrique Centrale, Tervuren, Belgium.

Africa, like those of Oceania and the American north-west, lose their all-important fourth dimension when uprooted and taken out of their ritual contexts—just as people living in urbanized and industrialized societies tend to lose their sixth sense.

19 Art from 1900 to 1919

By the beginning of the twentieth century the revolt against all forms of naturalism was in full swing and the decade before the First World War was to be one of the most daring and adventurous in the whole history of Western art. Fundamentally new ideas and methods were put forward—in painting, sculpture and architecture, in literature and music and in philosophy and science as well—and the radical innovations of these years underlie all later developments, even today. Two opposing tendencies which had been increasingly felt towards the end of the nineteenth century, the subjectivism of the Symbolists and the objectivism and transcendent 'otherness' sought by Cézanne, were intensified and explored ever more self-consciously. Each was to be taken to its ultimate extreme, bringing to an end artistic traditions going back to Giotto and the early fourteenth century. Already by about 1912 the limits had been reached in one direction with the first completely abstract work of art. Artists then found themselves confronted by an insoluble dilemma as they oscillated frantically between the cult of pure form and the cult of inner truth—though the dilemma was more apparent than real.

The search for new ways of looking at the world, combined with an urge to break down all accepted conventions and preconceptions, is characteristic generally of the period around the turn of the century. Quite close parallels between innovations in the arts and in philosophy and thought—notably in Henri Bergson (1859–1941) and Benedetto Croce (1866–1952)—can be found. But the theories which were to have the profoundest effect on Europeans and others generally were those of the Viennese psychologist Sigmund Freud (1856–1939), whose *Interpretation of Dreams* was published in 1900. Freud's revolutionary theories about the role of the subconscious, especially of the sexual urge, transformed early twentieth-century attitudes and values. His emphasis on the importance of understanding the instinctual side of

man's nature, his assertion that the emotions and sensations, especially the unconscious urges, are more important than rational thought as a key to human behaviour, were to have profound effects, in art no less than in other fields.

This climate of ideas naturally favoured primitivism—that so-called 'myth of the primitive' to which we have already alluded in connection with Gauguin (p. 534), the belief that a superior spontaneity, energy and sincerity resides in the ethos of indigenous peoples. As a result, artists now became aware for the first time of primitive art as 'art', all the more stimulating for being so completely at odds with Western traditions. It could still be seen only in ethnographical and anthropological museums, not in art galleries. But in their search for directness and immediacy of instinctual response, artists increasingly turned away from civilized 'fine art' in favour of the primitive, especially 'Negro' sculpture (African was not distinguished from Oceanic); and they went on to embrace naive and folk art, even the art of children. In 1911 the writer André Gide declared, in a phrase already in circulation, that 'the time for gentleness and dilettantism is past. What are needed now are barbarians.' By 1915 African sculpture was being claimed as among the greatest ever created. As Braque, an artist little influenced by it overtly, confessed: 'Negro masks also opened a new horizon for me. They permitted me to make contact with instinctive things, direct manifestations that ran counter to a false traditionalism which I abhorred.'

As if by coincidence, the first decade of the century witnessed the culmination of *le Douanier* Rousseau's unique career. Henri Rousseau (1844–1910), a retired customs collector, hence his nickname, was the only naive artist of undoubted genius who has ever lived. And it is significant that his genius was recognized only by the few other artists and writers of genius of the day, notably by Picasso, who owned several of his paintings

and gave a now famous banquet in his honour in 1908. Rousseau had started to paint in middle age without training of any kind, though he went to public art exhibitions and was aware of recent developments. But his technical and conceptual naiveté endowed him with the innocent eye of a savage without his ever leaving Paris. His imagination teemed with exotic images of

19, 1 Emil Nolde, *Masks*, 1911. Canvas, 28¾ × 30½ins (73 × 77.5cm). Nelson Gallery–Atkins Museum, Kansas City.

mysterious and menacing tropical jungles—true landscapes of the unconscious (19, 2). The poet Guillaume Apollinaire (1880–1918) wrote that while painting such scenes Rousseau felt their imaginative reality so intensely that he had to throw open the window to escape from his self-induced spells. Though depicted with obsessive exactness and particularity, his extraordinary natural gift for design subordinated every detail to the hypnotic drum-beat rhythm of the interweaving verticals and diagonals of his compositions. Violence and terror are completely exteriorized in them.

Jostling the enormous canvases by Rousseau in Picasso's studio were numerous African masks and Oceanic sculptures. Picasso was not the first artist in Paris to discover African sculpture, but it was for him, as he later acknowledged, a creative revelation and source of liberating energy. It impelled him on a

headlong course, the immediate effect of which can be seen in the *Demoiselles d'Avignon* (19, 3). The two right-hand figures were repainted after he had felt the emotive power of African sculpture (though he claimed not to have seen the ethnographic collection at the Trocadéro until later). This monumental composition marks a decisive turning-point, for with it Picasso made a revolutionary break with traditional, Western, illusionistic art. Instead of treating the picture as a window opening on to the visible world beyond, he conceived it simply as a painting, as a complex of invented forms, flat or nearly so. 'It was my first exorcism painting', Picasso told the writer André Malraux. 'Yes, absolutely.' It exorcised the past and made a fresh start.

In painting the *Demoiselles* Picasso quite deliberately set out to produce a major work—he had the huge canvas specially lined—probably in response to two challenges: Matisse's *Joy of Life* (19, 5), which had caused a stir at the 1906 Salon, and Cézanne's late monumental figure compositions, which were just then becoming known and seemed to represent a last noble attempt to re-create the Classical tradition. 'Around 1906 Cézanne's influence gradually flooded everything', Picasso is reported as saying in 1930. The *Demoiselles d'Avignon* (named after a red-light district in Barcelona, Picasso's home town), began as a brothel scene with allegorical overtones suggested by a sailor seated among the naked women and a student holding a skull. Picasso eliminated these figures at an early stage, and with them any symbolical, iconographical or anecdotal significance he may have originally intended the painting to carry. Its eroticism, however, became ever more aggressive and savage the more radically he absorbed primitive images and forms into it—a ravening eroticism at the very opposite pole of sensuality to that of the Salon painters or to that of Ingres, whose *Turkish Bath* (Louvre) may well have been an initial source for one or more of the *Demoiselles*.

Picasso had turned to various sources for inspiration, notably to Cézanne and Iberian (pre-Roman Spanish) sculpture, before African art opened his eyes to new ways of regarding the visual world. African art struck him as being *plus raisonnable*, he explained—that is, more conceptually structured than the art of the West, more dependent on 'knowing' than on 'seeing'. So, abandoning the single viewpoint and normal proportions, reducing anatomy largely to geometrical lozenges and triangles, he completely re-ordered the human image. It is this total departure from long-accepted Western conventions that makes the *Demoiselles* so revolutionary a work of art. Its creation

19, 2 Henri Rousseau, *The snake-charmer*, 1907. Canvas,
66½ × 74⅜ins (169 × 189.5cm). Louvre (Jeu de Paume), Paris.

involved a major intellectual 'breakthrough', opening
up new approaches not only to the treatment of space
and form (see pp. 576–7) but also to the evocation of
previously unexpressed emotions and states of mind
and the rejection of all the comfortable, contrived
coherences of representational art. He may even have
gone so far as to reject stylistic unity. Was the painting
abandoned unfinished, as is usually assumed? It seems
quite likely that the stylistic rupture on the right-hand
side was left intentionally unresolved.

Monet is seldom mentioned in this context,
although it was during these years that he began his
last great series of paintings. Impressionism cul-
minated with these—his *Nymphéas* (*Water Lilies*)—
and if the new concept of painting embodied in the
Demoiselles had a single origin it could be identified as
a reaction against Impressionism's illusionistic aesthe-
tic and air of civilized refinement. Certainly, nothing
could be further from the rough handling and harsh
and jagged forms of the *Demoiselles*, its shrieking lack
of harmony, its flat, unmodulated colour areas and
violent centripetal composition, than the delicate
brushwork, exquisitely subtle colour harmonies and
expansive centreless compositions of the *Water Lilies*
Monet was painting at the very same moment (19, 4).

Monet's aim was still the presentation of an immediate experience of nature, but his water-lily garden at Giverny held for him intimations of infinity and his contemplative visions of it give the illusion of a glimpse into an endless whole. His almost spaceless views downwards, on to and through the surface of the pool become shimmering, impalpable curtains of colour. The natural world disappears into near-abstract patterns of vibrating light and atmosphere. The implications of such paintings were, in fact, quite as radical as those of Picasso's, albeit Monet's approach had been along an alternative route.

If Picasso was a pioneer in the appreciation of African art for its formal qualities, other artists, who had discovered primitive art as early or even earlier, responded more emotionally. The Fauve painters (see below), to whom Picasso probably owed his introduction to African sculpture, were less overtly influenced by it, but by 1904 in Germany artists were recognizing as 'art' much of the contents of their ethnographic museums and German artists were to be perhaps more deeply influenced by it than were any others. For them it meant essentially a sensual

19, 4 Claude Monet, *Water lilies*, 1907. Canvas, diameter 31½ins (80cm). Musée d'Art et d'Industrie, Saint-Etienne.

19, 3 Pablo Picasso, *Demoiselles d'Avignon*, 1907. Canvas, 96 × 92ins (244 × 234cm). Museum of Modern Art, New York (Lillie P. Bliss Bequest).

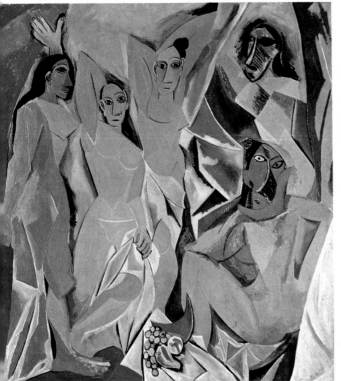

awakening. What fascinated them was its power and directness and immediacy. As the painter Emil Nolde said, it was 'its absolute primitiveness, its intense, often grotesque expression of strength and life in the very simplest form' that impressed them. In his series of *Masks* (19, 1) Nolde began the process by which these qualities were to be absorbed and interiorized by twentieth-century artists. A few years later the Expressionist painters of *Der Blaue Reiter* group in Munich (see below) were exploring an even wider range of aboriginal and other primitive art. In their 'almanac' of 1912 they illustrated examples from New Caledonia, the Malay Peninsula, Easter Island, the Cameroons, Brazil and Mexico as well as Russian and Bavarian folk art and children's drawings and paintings. Renaissance art was omitted altogether except for one El Greco. As the painter Franz Marc, co-author of the almanac with Kandinsky, wrote earlier that same year: 'We must be bold and turn our backs upon almost everything that until now good Europeans like ourselves thought precious and indispensable.' By that time Kandinsky had already made the second great twentieth-century artistic breakthrough—comparable with that of Picasso— when he painted the first of his abstract *Improvisations*. In them his debt to primitive art was as great as Picasso's had been in the *Demoiselles*, but in his case it was instinctive. Of his sympathy and 'spiritual

relationship' with primitive art and artists Kandinsky said that 'like ourselves, these artists sought to express in their work only internal truths, renouncing in consequence all considerations of external forms.'

The Fauves and Expressionism

Paris was still the cultural capital of Western civilization, and it was there that an exhibition, which has since come to be regarded as the first 'event' in twentieth-century art, took place in 1905. At the Salon d'Automne that year a group of young painters headed by Henri Matisse (1869–1954) exhibited a roomful of works of such strident colours, rough handling and distorted anti-naturalistic drawing that they were dubbed *Les Fauves* (Wild Beasts). The art historian Elie Faure referred to them as young 'primitives' in his introduction to the catalogue and their spiritual

affinity with naive art was emphasized by hanging in the same room with their paintings one of the Douanier Rousseau's more disturbing jungle visions, *Hungry Lion*.

Matisse was the oldest of the group and the only major artist among them. Of the others, André Derain (1880–1954) and Maurice Vlaminck (1876–1958) were the most gifted. Derain's views of London of 1905 and 1906 summarize the Fauve achievement in their exploitation of violent and quite arbitrary colour, what Derain called 'deliberate disharmonies' (19, 6). The clashing yellows, purples, blues, greens and reds are expressive of his emotional reaction to the subject, asserting with the utmost intensity his own personal vision. All naturalistic effects have been abandoned. By freeing colour from its traditional descriptive role in representation, the Fauves led the way to its use as an expressive end in itself. The great Fauve masterpiece is Matisse's *The Joy of Life* (19, 5), in which colour is used even more subjectively than by Derain, while the

19, 5 Henri Matisse, *The joy of life*, 1906. Canvas, 68¾ × 94ins (174.6 × 239cm). Barnes Foundation, Merion, Pa.

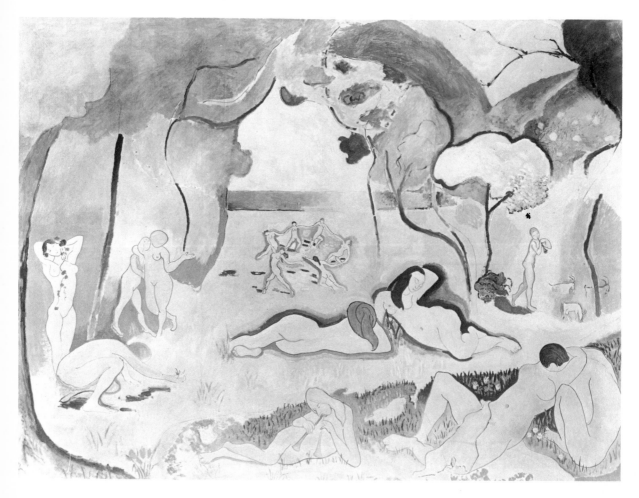

forms are so drastically simplified that they become a pure linear pattern unifying the picture surface into a single spatial plane, not without some lingering reminiscences of Art Nouveau.

The Joy of Life has an ostensible subject and one which might even seem to look back to the Classical pastoral tradition of Arcadia. Such references were avoided in future. In the *Red Room* (19, 7) Matisse summed up and completed the Fauve revolution with a vibrant composition of line and flat areas of colour, a brilliant essay in pure, childlike creative play with the simplest possible pictorial means—a few contrasting warm and cool colours and some curving and some straight lines. Perspective and modelling have gone completely; space is reduced to a minimum; light has become simply a function of flat colour, not a reflection from a lighted surface. Above all, a child's simplicity and innocence bordering on the gauche is combined with an almost barbaric sense of decoration. Colour floods the room and turns into something elemental, enveloping the spectator so that we begin to share in the exhilaration of the artist's self-identification with his medium.

'What I am after, above all, is expression', wrote Matisse in his *Notes of a Painter* in 1908. 'The whole arrangement of my picture is expressive. The place occupied by figures or objects, the empty spaces around them, the proportions, everything plays a part.' *Notes of a Painter* was widely read and immediately translated into German and Russian, but although Matisse set out the method he proposed for an art intended to express emotional responses with apparent spontaneity and vividness, he avoided saying anything that might be taken for a program. Perhaps his most revealing comment was that his 'choice of colours does not rest on any scientific theory; it is based on observation, on feeling, on the very nature of each experience', and that his goal was 'to reach that state of condensation of sensations which constitutes a picture.' He also described how slowly and how laboriously his paintings were achieved. Their apparently impetuous spontaneity is quite misleading. They were, in fact, created by a long, progressive process of continual small adjustments until the relationships of colour to colour, shape to shape and colour to shape reached what he felt to be exactly the 'right' balance. The process was self-observant and introverted. His art grew out of art. As he painted he watched his reactions to every brush-stroke, and his reactions to his reactions, and went on painting and repainting until the process gathered its own momentum and the picture emerged of itself, as if out of his subconscious. When painting, he wrote, he was 'conscious only of the forces I am using and I am driven on by an idea that I grasp only as it grows with the picture.'

The Fauves never became a movement, never developed a consistent artistic theory, and by 1908 their loose association began to dissolve. It had been very short-lived. Some members had broken away even earlier, notably Georges Rouault (1871–1958) who was to become the finest religious painter of the twentieth century. He had, in fact, very little in common with the Fauves apart from the deliberate cultivation of coarse pictorial means for ardent emotional ends, in his case glowing colours separated by thick dark outlines recalling fragments of early medieval stained-glass windows. (He began as a stained-glass painter and restorer.) His pictures are personal confessions of spiritual anguish and of faith in a revitalized Catholicism, his position being analogous to that of polemical French Catholic writers of his day, such as Léon Bloy, Charles Péguy and Jacques Maritain, who became his friends and admirers. Like Bloy, he found the truths of religious experience and, like van Gogh, the inspiration for his most 'sacramental' images among the poor and destitute and other outcasts and rejects of industrial society. The typical Fauve painting is, of course, quite devoid of social comment. Rouault was an Expressionist in the wider European sense and was perhaps closer to German painters such as Emil Nolde than to any of his French contemporaries.

The German Expressionists

Emile Nolde (1867–1956) was a lonely figure in whose work deeply religious and intensely human feelings are conveyed. He regarded himself as a kind of mystic evangelist. Though a good deal older than most German Expressionists, he matured late and his full artistic powers were not revealed until after 1900. By then, largely under the influence of the nihilist philosopher Friedrich Wilhelm Nietzsche (1844–1900), a whole generation of writers and artists in central Europe was awaiting a violent change, their work exuding a heavy, oppressive atmosphere of unease, guilt and foreboding. The novels and stories of Franz Kafka (1883–1924) are the supreme example. In the visual arts, too, the Germans were concerned with the psychological situation of contemporary man, and Expressionist painting originated in a revolt in favour of a new spontaneity and intensity of inner vision. They felt impelled to confess their moods of anxiety, frustration and resentment towards the modern world. Even more subjective than the Fauves, they sought *Durchgeistigung* or the charging of everything with spiritual significance, with soul, their fervent national-

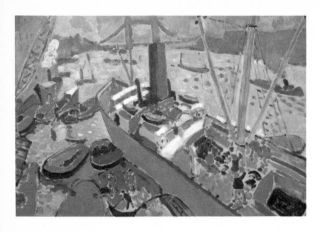

ism and self-consciously anti-French bias making such painters as Grünewald (11, 4) seem especially valid. For them primitive art was primarily an emotional and spiritual experience and Nolde, for instance, was able to absorb the impact of African and Oceanic art into his own, deeply personal Christian images, which acquired almost ecstatic force from their brutal simplifications and raw colours. When a critic told him to soften his work he replied, 'It is exactly the opposite that I am striving for, strength and inwardness.'

The first organized group of German Expressionists, *Die Brücke* (The Bridge), was formed in Dresden in 1905, but its goals had been foreshadowed in the work of Munch (see p. 535), who was living in Berlin during these years. In the *Brücke* manifesto the leading painter in the group, Ernst Ludwig Kirchner (1880–1938), wrote that, 'He who renders his inner convictions as he knows he must, and does so with spontaneity and sincerity, is one of us.' However, the

19, 6 *Above* André Derain, *The Pool of London*, 1906. Canvas, $25\frac{7}{8} \times 39$ins (65.7×99cm). Tate Gallery, London.
19, 7 *Below* Henri Matisse, *The red room*, 1908–9. Canvas, 71×97ins (180×246cm). Hermitage, Leningrad.

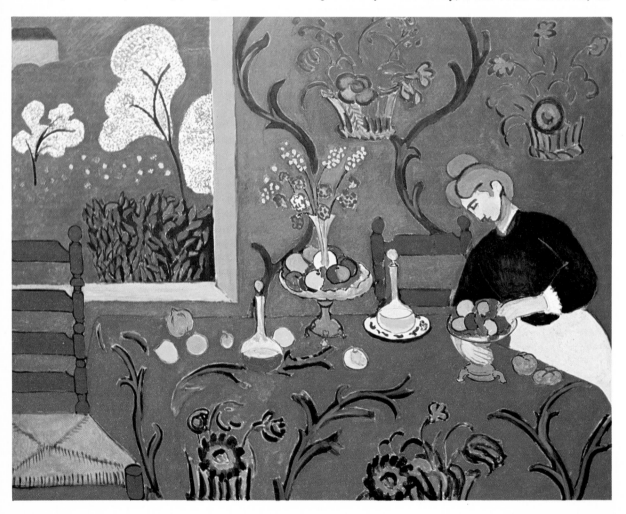

group did not move far beyond its origin in avant-garde protest against academic naturalism, even in Kirchner's Berlin street scenes with their dandies and prostitutes (19, 9), compelling images though they are of the modern city as the devourer of human souls and fermenter of anxiety. The group's most striking achievement was in graphic art. Rejecting all the delicate atmospheric subtleties achieved with such enormous technical skill and ingenuity by the Impressionists and Post-Impressionists in lithography and various complicated mixtures of graphic media, the *Brücke* artists exploited the simplest and crudest methods of wood-block and lino-cut with brutal but often very powerful effect (19, 10). In them their primitivism found a perfect vehicle for distilling the

19, 8 Vassily Kandinsky, *Improvisation no. 30*, 1913. Canvas, 43¼ × 43¼ins (110 × 110cm). Art Institute of Chicago (Arthur Jerome Eddy Memorial Collection).

ferment of introspective emotions.

The term 'Expressionist' was first used in 1911 by Wilhelm Worringer (1881–1965), author of *Form in Gothic* and *Abstraction and Empathy*, see p. 573) in connection with van Gogh and Matisse. Soon it was being quite widely applied to artists and even to architects, though Expressionist architecture is not easy to define. However, in Germany and northern Europe, where Expressionists could find roots in their native (Gothic) traditions, organic Art Nouveau forms coalesced with the anti-Classical simplifying trend in industrial building in ways which enabled architects to mold buildings 'expressively' and mark every form with their creative will. They went some way towards that 'total transposition of a personal idea into a work' which Kirchner had demanded of artists, and in this sense such architects as Hans Poelzig (1869–1936) and Erich Mendelsohn (1887–1953) may be called Expressionist. The most obviously Expressionist buildings are the former's Grosse Schauspielhaus in Berlin (1918–19 destroyed) and the latter's Einstein Observatory at Potsdam (1919, destroyed). The Schauspielhaus especially, with its fantastic cavernous stalactite-ceilinged interior round a central circular stage, was a truly innovatory conception inaugurating a new departure in theatre design. But other pre-war buildings in Germany were also and perhaps more essentially, though less obviously, Expressionist. The famous AEG turbine factory in Berlin of 1908–9 by Peter Behrens (1868–1940), for example, is not functional in any simple utilitarian sense but rather monumentally expressive of the energy it houses, both in its form (like a giant piece of machinery) and in its application of the latest technologies (glass and steel) (19, 11). Similarly expressive is the great Centennial Hall of 1911 at Wroclaw (formerly Breslau) by Max Berg. And it was among architects, it should be noted, that the alliance in these years of a leftist political utopianism with the artistic avant-gardes was most pronounced. Their ideology of individual creativity and the autonomy of the imagination led naturally to forms of anarchism.

Whereas the Fauves and the artists allied to the *Brücke* group had all been in varying degrees representational, those of the slightly later *Der Blaue Reiter* (The Blue Rider) group in Munich between 1912 and 1916 took the crucial step beyond the world of visual appearances and created some of the first completely abstract or non-objective works of art. The question of who painted the first abstract picture may be endlessly debated. Certainly Kandinsky, the leading *Blaue Reiter* painter, was not the only artist who began, around 1910–12, to eliminate all references to objective reality in his work. There were others in France, Italy, Russia, Holland and elsewhere (see pp. 605–6). But Kandinsky was different in that he did so in order to strengthen the imaginative and emotional and spiritual content of his paintings. There is nothing of the coldly theoretical and geometric about his first abstract pictures. On the contrary, they are warmly

19, 9 Ernst Ludwig Kirchner, *Berlin street scene*, 1913. Canvas,
78¾ × 59ins (200 × 150cm). Brücke Museum, Berlin.

spontaneous and organic. Discerning critics and others were immediately persuaded by them. 'I cannot any longer doubt the possibility of emotional expression by such abstract visual signs', wrote Roger Fry in 1913 after seeing one of Kandinsky's *Improvisations* in London. 'They are pure visual music.'

As Fry realized, the origins of abstract art go back to Romantic theories that in their essential nature all the arts—music, poetry, painting, sculpture and architecture—are one and that the ultimate artistic experience would be synaesthetic, a Wagnerian *Gesamtkunstwerk* or total art work. Stimulated by their awareness of the directly affective character of music, which communicates without the aid of description or narrative or any appeal to anything outside itself, the Romantics were already conscious of the expressive power of shapes and colours, of brushstrokes and textures, of size and scale, and of the possibility that the visual arts might become as autonomous as music. In this way the trend towards abstraction began. During the later nineteenth century, artists successively approached and withdrew

from the threshold of non-representational art, though the Symbolists and others such as Whistler in his *Nocturnes* (17, 7) came close to crossing it with their use of colours and forms to evoke sensations.

The Russian painter Vassily Kandinsky (1866–1944) lived in Munich from 1896 until war broke out in 1914, with lengthy visits to Italy and Paris. A highly educated and widely cultivated man, he had given up a university professorship in law in order to become an artist. In his early work he adopted the flat patterns, broad colour areas and rhythmic lines of German Art Nouveau; but around 1910 his paintings began to move towards abstraction as his lyrical and resonantly Slav sense of colour—he said he had always experienced music in terms of colour and colour primarily as an emotional effect—gradually lost its descriptive function and became detached from form. Yet he approached abstraction cautiously. He himself dated his full understanding of its possibilities to an evening in 1910 when he accidentally failed to recognize one of his own canvases which was stacked the wrong way up and saw a picture 'of extraordinary beauty, glowing with inner radiance'. This revelation of the inherent expressive properties of colour and form convinced him that the representation of nature was quite superfluous for his art. It also accorded with the predominantly anti-materialist, mystical bent of his

19, 10 Karl Schmitt-Rottluff, *Die Brücke* membership card,
1911. Woodcut on orange card, 6¾ × 5ins (17 × 12.7cm).
Brücke Museum, Berlin.

mind, for he was deeply interested in the occult and the theosophical theories of Rudolf Steiner (1861–1925), who believed that art and artistic experiences were the best stimulant for an understanding of the spiritual. Steiner was living in Munich during these pre-war years and Kandinsky probably knew him and certainly attended his lectures. He may even have been influenced by theosophical drawings of 'thought forms'. In other ways, too, his 'revelation' of abstract art was in keeping with much of the advanced thought

of the day, for example that of the French philosopher Bergson, who insisted on the importance of the intuitive in the apprehension of truth, or that of the pioneer *gestalt* psychologists who asserted that shape, size, colour, spatial orientation, etc. regularly produce certain perceptual effects, from whence it follows that there are 'meanings' intrinsic within forms and colours by which they convey themselves directly, irrespective of the context. The publication in Munich in 1908 of Worringer's *Abstraction and Empathy*, in which abstract tendencies in art are attributed to man's need to withdraw from the materialist world and find a 'resting-place in the flight of phenomena' was also more than a coincidence.

In 1910 Kandinsky finished writing his own book *Concerning the Spiritual in Art*, though it was not published until 1912. In it he formulated his concept of non-representational art as one originating in some 'inner necessity' of the artist to find a 'spiritual' art form free from all references to the external world. In themselves abstract formal qualities were of as little importance to Kandinsky as representational qual- ities: they became meaningful only in so far as they expressed the artist's innermost feelings and anti- materialist values and thus created a true spiritual reality. He was keenly aware of the danger that abstract art might be misunderstood and would be seen as mere decoration—indeed, of the danger that an art of pure colours and forms might degenerate into meaningless decorative patterns—'something like a necktie or a carpet', as he wrote.

So in his early abstract paintings of 1911 to 1913 he retained hints and suggestions of recognizable subject- matter, hidden or disguised images, in order to lead the spectator into his spiritual world and apoca- lyptic visions, as in *Improvisation No. 30* (19, 8). Kandinsky's 40-odd *Improvisations* were, he said, 'largely unconscious, spontaneous expressions of inner character, non-material in nature.' In No. 30, however, two cannons are quite clearly recognizable in the right- hand bottom corner and indeed the painting acquired the sub-title *Cannons*. When questioned about this in 1914 Kandinsky replied: 'The designation *Cannons* selected by me *for my own use*, is not to be understood as indicating the "contents" of the picture. These contents are indeed what the spectator *lives*, or *feels* while under the effect of the *form and colour* combinations of the picture. ... which I have painted rather subconsciously in a state of strong inner tension. So intensively did I feel the necessity of some of the forms that I remember having given loud-voiced directions to myself, as for instance, "But the corners must be heavy!"'

Kandinsky seems to be implying that the cannons had taken shape while he painted without his consciously intending them and that the spectator should similarly allow his subconscious free play when looking at the picture. How far he actually went in such paintings towards the automatic creative processes of later twentieth-century artists is uncertain. His more

19, 11 Peter Behrens, AEG turbine factory, Berlin, 1909.

fully evolved *Compositions* of these same years were certainly consciously planned and carefully worked out in preliminary drawings and sketches; and it was with his *Compositions* that he finally succeeded in suppressing representational elements altogether. He described them in 1912 as 'expressions of a slowly formed inner feeling, tested and worked over re- peatedly, and almost pedantically. ... Reason, con- sciousness, purpose play an overwhelming part. But of calculation nothing appears: only feeling.' A work such as *Composition VII* (19, 16) constitutes a true landmark in the history of painting, for the forms, the coloured shapes, have no equivalents in the world of appearances at all. Moreover, there is no perspective and thus no spatial relations as we normally apprehend them: the coloured shapes float and gyrate in a continuously expanding and contracting space un- known to our conscious selves but akin to that of dreams.

Franz Marc (1880–1916) was the only other important member of *Der Blaue Reiter* group, though it was not until shortly before he was killed in the First World War that he approached Kandinsky's degree of

symbolic abstraction. His work is dominated by passionate feelings for animals, which he thought more beautiful than human beings and through which he believed humans could experience closer affinities with nature. It was a need to find symbolic forms to convey his emotions on 'submerging himself in the soul of the

19, 12 *Opposite* Georges Braque, *The Portuguese*, 1911. Canvas, $45\frac{7}{8} \times 32$ins (117×81.5cm). Kunstmuseum, Basel.
19, 13 *Above left* Robert Delaunay, *Windows open simultaneously*, first part, third motif, 1912. Canvas, $18 \times 14\frac{3}{4}$ins (45.7×37.5cm). Tate Gallery, London.
19, 14 *Left* Giacomo Balla, *Abstract speed the car has passed*, 1913. Canvas, $19\frac{3}{4} \times 25\frac{3}{4}$ins ($50 \times 65.3$cm). Tate Gallery, London.
19, 15 *Above* Pablo Picasso, *Harlequin*, 1915. Canvas, $72\frac{1}{4} \times 41\frac{3}{8}$ins ($183.5 \times 105.1$cm). Museum of Modern Art, New York (Lillie P. Bliss Bequest).

animals' that impelled his search for a non-representational art echoing what he called the 'absolute rhythms of nature'. By 1911, the year in which he and Kandinsky formed *Der Blaue Reiter* group in Munich, Marc had already abandoned local colour in such paintings as his famous *Red Horses* and *Blue Horses*. The following year he saw examples of Futurist and Orphic paintings in Paris (see p. 584). Inspired by their dynamic innovations, he embarked on his last works, notably *Animal Destinies* (1913, Kunstmuseum, Basel) and the almost completely non-representational *Fighting Forms* (19, 17), painted early in 1914 but left unfinished when war broke out and he was called up. Two whirling embryonic forms, one expanding red, the other a contracting dark blue, seem to be on the point of impact, symbolizing the universal psychic energy animating both human and non-human creation.

Cubism

The word Cubism is a misnomer and hinders rather than helps the understanding of a subject which has always resisted precise definition. Neither Picasso nor Braque would ever say what they meant or intended in inventing Cubism—no doubt for much the same reason that T. S. Eliot always refused to explain *The Waste Land*. It has no meaning beyond or outside itself. As the poet Archibald MacLeish wrote: 'A poem should not mean but be'. However, 'Cubism' became the label of a movement in 1911 when a group of artists (not including Picasso and Braque, from whom they all derived) exhibited together in Paris and were written about as Cubists. The following year exhibitions were held all over Europe—again without Picasso and Braque—and a book entitled *Du Cubisme* was published by two of the painters, Albert Gleizes (1881–1953) and Jean Metzinger (1883–1956). In 1913 the Armory Show in New York made Cubism known in America.

If Picasso and Braque held themselves aloof from the movement they had initiated, they were probably better aware than any of their contemporaries of its implications; for it raised the question of figuration as against abstraction as a conscious and serious issue. On this matter Picasso's views are known. 'There is no such thing as abstract art', he is reported to have said. 'You must always start with something.' So whatever later abstract artists were to derive from Cubism—and it became the immediate source of a stream of abstract movements such as Orphism, De Stijl, Constructivism, etc. (see pp. 584–6)—it was certainly never intended by its creators to be non-representational.

Pablo Picasso (1881–1973) was an infant prodigy.

19, 16 *Top* Vassily Kandinsky, *Composition VII no. 186*, 1913. Canvas, 78¾ × 118⅛ins (200 × 300cm). Tretyakov Gallery, Moscow.
19, 17 *Above* Franz Marc, *Fighting forms*, 1914. Canvas, 35¾ × 51¾ins (91 × 129cm). Bayerische Staatsgemäldesammlungen, Munich.

Already in 1900 when he first came to Paris from Barcelona, he had mastered every trick in the academic painter's repertoire and several of his Blue Period paintings of 1903 to 1906 are masterpieces of wistful poetry and extreme delicacy and refinement of colour and handling. The *Demoiselles d'Avignon* (19, 3) was a complete and deliberate *volte-face*. Its crudity and apparent clumsiness were intentional. Moreover, it posed the pictorial problems with which Cubism was to wrestle and illustrates very clearly the influences of its two main sources—first of all Cézanne, whose late

works (17, 24) foreshadowed Cubism even more profoundly than his famous injunction to treat nature in terms of the sphere, the cylinder and the cone would suggest; and secondly, African sculpture, in which Picasso recognized the key to his problem of creating an art simultaneously representational and anti-naturalistic. This is, perhaps, as near a simple definition as is possible of so slippery a concept as Cubism, and it is significant that Picasso's debt to African art should be most obvious in the most Cubist features of the painting, for example the squatting figure on the right in which he abandoned perspective and the single viewpoint in order to combine several views in a single image. Cubism is adumbrated in other ways as well, notably in the way figures are broken up into flat surfaces meeting at sharp angles (later called 'faceting'); in the way light is used arbitrarily and anti-perspectively, different forms being lit from different directions as required by the general design; in the way space has been almost completely eliminated, as if the figures were being projected forwards out of the picture by the stiff but pliable metallic material behind, which seems to buckle out between them while taking on a correspondingly angular, faceted form from the pressure of their bodies against it so that the foreground merges into the background; and above all

19, 19 Pablo Picasso, *Three women*, 1908–9. Canvas, 78¾ × 70½ins (200 × 179cm). Hermitage, Leningrad.

19, 18 Georges Braque, *Houses and trees*, 1908. Canvas, 28¾ × 23⅜ins (73 × 59.5cm). Kunstmuseum, Berne (Hermann and Margrit Rupf Foundation).

in the way the whole picture is conceived as an independent construction—what the Cubists were later to call a *tableau-objet* or picture-object.

Very soon after painting the *Demoiselles* Picasso met Georges Braque (1882–1963), who was at first as shocked as everyone else by its wilful ugliness. But shortly afterwards his own painting began moving, more coolly and soberly, in a parallel manner to Picasso's and from 1908 until 1914, when Braque was called up for military service, they worked together. Cubism was invented jointly by them. Theirs was a uniquely close and intimate collaboration, closer and more prolonged than that of Monet and Renoir in the early years of Impressionism. They were, Braque once said, 'like mountaineers roped together'. Indeed, at one point (in 1911) their works can hardly be distinguished and they themselves were uncertain later who had painted which pictures.

At first Braque seems to have taken the lead, but by late 1908 both he and Picasso were on the threshold of Cubism with such works as *Houses and Trees* (19, 18) and *Three Women* (19, 19). Cézanne was now the predominant influence, most obviously in the geometrical simplifications of the Braque, where natural forms have been broken up into a semi-abstract all-over design of tilting, overlapping planes compressed

into so shallow a space that they seem to move outwards towards the spectator instead of inwards towards a vanishing point. But the Picasso is hardly less indebted to Cézanne. It was originally conceived in his 'African' manner, with brashly contrasted colours articulated with vigorously brushed striations, as in the right-hand figures of the *Demoiselles*. He then completely repainted it in a more controlled and consistent way with a very narrow range of close-valued colours (mainly terracottas and muted greens) so that the whole picture has a faceted surface without intervals or gaps, the figures and the ground forming a single, rock-like mass. It is less spatial, more volumetric and sculptural than the Braque. The huge figures are palpably bulky, while the picture itself remains flat, like a stone relief—and static, as if filled with a primordial stillness.

From 1910 onwards Picasso's paintings gradually became less sculptural, their fragmented contours and transparent planes hovering in indeterminate yet somehow shallow, luminous space, so that his and Braque's work during these years of so-called Analytical Cubism—1910 to 1912—might be described as a painterly dissolution of their 1908/9 manner. The term Analytical Cubism, introduced some years later by the Spanish Cubist painter Juan Gris (1887–1927), is another misnomer in so far as it implies any rational process of dissection. But forms were increasingly fragmented and Picasso and Braque both tended not to work from any visual model, not even a still life set up in the studio, and this inevitably led towards abstraction and a more intellectual kind of painting in which the depicted objects were to disintegrate to a point only just short of total unrecognizability. How far and how quickly they were to move away from anything like verisimilitude can be seen in Picasso's *Female Nude* and Braque's *The Portuguese* of 1910 and 1911 respectively (19, 20 & 12).

In the *Female Nude* the effect is hardly sculptural at all any longer, for it is quite massless, a configuration of floating, overlapping and eliding planes open to space and suggesting a flimsy tower built of pieces of cardboard leaning against or propped on top of each other. The tilting of these planes, combined with the lines, which sometimes form their edges and sometimes do not, create a delicately poised spiral of ambiguities. In *The Portuguese* the traditional relationship between figure and ground has given way to a unified pictorial configuration in which the shapes seem to float close to the picture plane in a sharply contracted space. In both

19, 20 Pablo Picasso, *Female nude*, 1910. Canvas, 73¾ × 24ins (187 × 61cm). National Gallery of Art, Washington DC (Ailsa Mellon Bruce Fund, 1972).

paintings the near monochrome colour (predominantly ochres and silvery grays), the dry, matt surface, the non-descriptive rippling horizontal brush-strokes and the extreme degree of fragmentation are all characteristic of Analytical Cubism. So, too, is the way the ostensible subjects hover like after-images behind the geometrical structures. Braque left only just enough clues for his to be recognized, Picasso went further. His subject may not, in fact, have been a female nude but a mother and child, and this uncertainty emphasizes how unimportant subject-matter was for the Cubists—seldom more than a pretext, in fact, and always extremely limited and studio-centred.

It was this introversion, this concentration on pictorial structure and language at the expense of subject-matter which led to the Cubists' assertion of the essentially autonomous nature of the work of art—all of which, combined with their fastidious restraint and good taste in handling, might suggest some latent Art for Art's Sake and Symbolist affinities. Much of Picasso's earlier work had been strongly Symbolist in tone. And it is in Symbolist writings that comparable conjunctions to those of Cubist paintings can be found, mysterious verbal structures which afford only the most partial glimpses of external reality.

That the artists themselves realized how dangerously near they had come to total abstraction is shown by their beginning to include small but easily recognizable details, such as the stencilled lettering in *The Portuguese*, in their later Analytical Cubist pictures. And it was probably this, too, which led to the next and perhaps the most important step of all in Cubism as a source for later developments in twentieth-century art—the invention of *collage* (paste-up). In a still life of May 1912 Picasso incorporated a ready-made facsimile, a piece of commercial oilcloth printed with imitation chair-seat caning, to indicate the chair on which the still life rested. In a sense this was the logical outcome of Cubism. Certainly, the Cubist aesthetic could go only one step further, which Picasso duly took when he began incorporating actual objects or parts of them into his pictures. In doing this he went beyond the play with natural and artistic reality in his first *collage* with chair-seat caning, for he now introduced 'real' elements in such a way that they could be understood in either sense or in both senses simultaneously.

A further refinement of *collage* was invented by Braque when he limited the pasted-on elements to pieces of paper. *Papiers collés*, as they are called, are necessarily and absolutely flat and with them illusionistic space was finally eliminated altogether, though

19, 21 Georges Braque, *Le Courrier*, 1913. Pasted paper and charcoal, 20 × 22½ins (51 × 57cm). Philadelphia Museum of Art (A. E. Gallatin Collection).

spatial relationships might still be indicated by overlapping. The virtue of *papiers collés*, however, lay in the method's ambivalence. The strips of pasted paper could be arranged according to an aesthetically independent (or abstract) scheme, while still signifying the colour and form of the objects drawn over them. The breathtaking skill with which this duality could be manipulated by Braque is beautifully displayed in *Le Courrier* (19, 21). The carafe, wine-glass, cigarette packet, newspaper and playing-card, which provide the subject, seem to hover over the square table-top like disembodied presences. They can be sensed rather than seen through the gossamer web of an abstract 'arrangement' of pasted-on planes of colour.

Whereas Braque used *collage* logically and soberly as an instrument on which to draw out tender and sonorous chords of visual harmony, Picasso delighted in the opportunities it gave him to display his audacity in paradox and visual wit, turning one substance into another as if by visual alchemy—newspapers into violins and so on—and extracting new meanings out of old forms by combining them in unexpected ways or in unusual contexts. It also enabled him to attain the ultimate Cubist ideal of the *tableau-objet*—a constructed object independent of, but recreating, the external world. 'The purpose of the *papier collé*', he later said, 'was to give the idea that different textures can enter into a composition to become the reality in the painting that competes with the reality in nature. We tried to get rid of *trompe l'oeil* to find a *trompe*

l'esprit. . . . If a piece of newspaper can become a bottle, that gives us something to think about in connection with both newspapers and bottles, too. This displaced object has entered a universe for which it was not made and where it retains, in a measure, its strangeness. And this strangeness was what we wanted to make people think about because we were quite aware that our world was becoming very strange and not exactly reassuring.'

The words printed on the newspaper cuttings, cigarette packets, bottle labels, etc. used in *collages* may have had some urban associative value for the artists but seldom if ever any other verbal significance, and it is misleading to read any into them. Indeed, the importance of *collages* lies in the fact that, divorced from their artistic context, the individual elements used to create their imagery are quite meaningless and of no intellectual or aesthetic value—a supreme demonstration, in fact, of the artist making something beautiful and meaningful out of nothing.

The first Cubist sculpture also dates from 1912 and, Picasso claimed, slightly preceded *collage*. Braque had for some time been making cardboard models of objects as aids in working out his Cubist paintings and Picasso followed him. But it was Picasso who saw in them the possibility of Cubist sculpture. He remade one in sheet metal and wire and thereby effected a sculptural revolution (19, 22). It is impossible to exaggerate the radical nature of Picasso's impact on sculpture: it was more radical even than on painting. With the *Guitar* he changed, at one stroke, the whole nature of sculpture. Until now all Western sculpture had been carved in stone or wood or modelled in clay and cast in bronze or other metal. Picasso's sculptures were made of wood, tin, cardboard, paper, string and other materials, sometimes of a distinctly ready-made character, and they were constructed or put together by the same process of assemblage as were his *collages*—though his debt to African sculpture, particularly to a Wobé mask he owned, is obvious (18, 12). Sculpture was liberated by him from its traditional materials and techniques and subject-matter and was given a new intellectual dimension—as was appreciated at the time, notably by Boccioni and Tatlin (pp. 583, 595). And since Picasso's constructed objects themselves represent objects they attained in a high degree that autonomy which the Cubists sought. The *Guitar* also manages to retain some of the

19, 22 *Above left* Pablo Picasso, *Guitar*, 1912. Sheet metal and wire, $30\frac{1}{2} \times 13\frac{1}{8} \times 7\frac{5}{8}$ins (77.5 × 35 × 19.3cm). Museum of Modern Art, New York (Gift of the artist).
19, 23 *Left* Pablo Picasso, *Still life with fringe*, 1914. Painted wood with fringe, height 10ins (25.4cm). Tate Gallery, London.

ambiguities and contradictions of Cubist paintings, being flat yet not quite flat, half spatial and half solid, decorative yet austere and harsh. Later his constructions were more light-hearted or seemingly so. The *Still Life with Fringe* (19, 23) hangs a snack on the wall with wooden salami, slices of bread, knife and a half-full wine glass (the latter rendered as a rather crude three-dimensional planar model of an Analytical Cubist painting of a glass). A dark wood-grained strip of dado with carved motifs painted in *trompe l'oeil* and, below, a piece of real golden-thread fringe complete this apparently rough and simple, but in fact most sophisticated, compound image. Cubist sculpture of a few years later by Jacques Lipchitz (1890–1941), Henri Laurens (1855–1954) and Alexander Archipenko (1887–1964) is tame by comparison. Most sculptors, such as Aristide Maillol (1861–1944), went on using the traditional techniques and materials and subject-matter (nude figures).

The last, or Synthetic, phase of Cubism developed alongside *collage* and became in a sense the mirror image of Analytical Cubism, for the artists now worked back from abstraction to representation, not the other way round. As in *collage*, the object was depicted with forms not originally derived from it. Flat and coloured shapes were arranged decoratively on the canvas, creating a substructure through which the object was made visible by subsequent adjustment and added signs. The pictorial surface remains an arrangement of flattened forms bearing no relation to the shape of the figure or object portrayed and looking almost as if they had been cut out and pasted on to the canvas. Yet the subject is clearly recognizable. At the time Picasso thought his Synthetic Cubist *Harlequin* (19, 15) the 'best thing I have done', and it epitomizes the style in its daring simplicity, its bright, almost dazzlingly decorative colour and its unconcealed disunities. By this date Picasso was again working on his own, for Braque, who was invalided out of the French army in 1917, never resumed his collaboration with Picasso after they had parted on his being called up in 1914.

Although Cubism had been the invention and creation of Picasso and Braque alone, there were already by 1914 a number of deviant or subsidiary Cubisms, of which the first to emerge as a new and identifiable movement was Orphism or Orphic Cubism. This was heralded in 1912 by Apollinaire, a close friend of Picasso, as a form of 'pure painting' in which the subject would no longer count at all. The painters involved were Robert Delaunay (1885–1941), Fernand Léger (1881–1955), Marcel Duchamp (1884–1968) and Francis Picabia (1879–1953).

19, 24 Fernand Léger, *Contrast of forms*, 1913. Canvas, $51\frac{3}{8} \times 38\frac{3}{8}$ins (130.5 × 97.5cm). Philadelphia Museum of Art (Louise and Walter Arensberg Collection).

Delaunay was interested mainly in colour, at that date banished by Picasso and Braque from their work, but Delaunay nevertheless adopted a Cubist planar structure for his 'Windows' series (19, 13). They are compositions of prismatic colours dispersed evenly across the canvas in simultaneous contrast and change. Their subject and that of his 'Circular Forms' series of 1913 is light and its source, the solar disc, also the source of life itself—for life springs like colour from a prism, Delaunay believed, from a differentiation of some all-pervasive energy. His conception of colour is quite remote from that of Kandinsky, for whom it was a vehicle of indefinable emotions. But the vibrancy of Delaunay's colour conveys a dynamism consonant with the dynamism of life if not quite fulfilling the claims made for Orphism by Apollinaire: 'Works of the Orphic artist must simultaneously give a pure aesthetic pleasure, a structure which is self-evident, and a sublime meaning, that is, a subject. This is pure art.'

Léger's relationship to Cubism was more personal

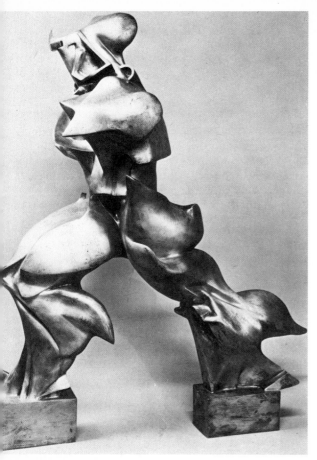

19, 25 Umberto Boccioni, *Unique forms of continuity in space*, 1913. Bronze (cast 1931), $43\frac{7}{8} \times 34\frac{7}{8} \times 15\frac{3}{4}$ins ($111 \times 88.5 \times 40$cm). Museum of Modern Art, New York (Lillie P. Bliss Bequest).

contemporary life and technology, for everything up-to-date and dynamic, so that he became, after his release from military service in 1917, the artist *par excellence* of the Machine Age.

Futurism

Unlike other modern movements, Futurism was not concerned solely with the arts. It was less a style than an ideology. Launched in Milan in 1908 by the Italian poet Filippo Tommaso Marinetti, the publication of the Futurist Manifesto in Paris the following year gave it an immediate international impact and a series of further manifestos and public appearances spread the Futurist idea throughout Europe, from Italy to Tsarist Russia and even to the United States. Futurism became better and more widely known than Cubism — a phenomenon quite out of proportion to the value of all but very few of its achievements.

Exhilarated by the noise and speed and mechanical energy of the modern city, Marinetti wanted to obliterate the past, especially the cult and culture of the Italian past—'Burn the museums! Drain the canals of Venice!'—and replace it with a new society, a new poetry and a new art based on new dynamic sensations. 'We declare', he wrote in the Manifesto, 'that the splendour of the world has been increased by a new beauty: the beauty of speed. ... A screaming automobile that seems to run like a machine-gun is more

19, 26 Raymond Duchamp-Villon, *The horse*, 1914. Bronze, height 40ins (101.6cm). Museum of Modern Art, New York.

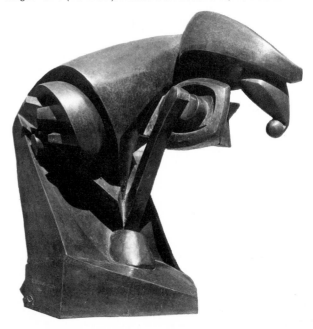

and closer than Delaunay's and he created what might be described as a genuine alternative. Already in 1910 he had begun to emphasize in his work the hard, gleaming geometric forms of his subjects, reducing figures to tubular structures in increasingly mechanized compositions. Like Delaunay, he believed that painting should be concerned with contrasts, but contrasts not only of colour, but of line and form. Instead of the dynamism of light, his paintings are about the dynamism and dissonance of modern urban life. Gradually he eliminated nearly all representational elements until his compositions reached, around 1913/14, what he called 'Contrasts of Forms', tubular forms and flat areas being rhythmically set off against each other so as to achieve the maximum contrast and plastic vigour (19, 24). The result came close to abstraction, but Léger's concern with formal values was always combined with a passion for

19, 27 Constantin Brancusi, *Prodigal son*, 1915. Oak on stone base, height 17½ins (44.5cm), base height 12½ins (31.3cm). Philadelphia Museum of Art (Louise and Walter Arensberg Collection).

not only in their emphasis on intuition and action but also in their rejection of centralized, static compositions in favour of what they called 'simultaneity'. Their pictures were conceived as small sections only of continuous wholes. The action which is the subject of the painting passes through it and has no centre, as in Balla's *Abstract Speed the Car has Passed* (19, 14), a typical Futurist work. Giacomo Balla (1871–1958) painted the famous *Dog on a Leash* (1912, Albright-Knox Art Gallery, Buffalo, NY) based on Eadweard Muybridge's multiple-exposure photographic studies of movement, but in his other works the dynamism is less superficial and in his studies called *Iridescent Interpretations*, begun in 1912, he created some of the earliest non-objective paintings.

Boccioni's paintings were more naturalistic and his triptych entitled *States of Mind* (1911–12) has considerable poetic power, but it was as a sculptor that he excelled and in *Unique Forms of Continuity in Space* (19, 25) he succeeded in giving full expression to the movement's aims in memorable form. The figure does not so much symbolize movement as realize it through a sequence of surfaces which seem to be constantly dissolving and reforming. He here achieved what he had been seeking, 'not pure form, but *pure plastic rhythm*; not the construction of the body, but the construction of the *action* of the body.'

Boccioni went even further in his *Technical Manifesto of Futurist Sculpture* of 1912, which parallels, if it does not anticipate, the breakthrough made that year by Picasso with his first constructed sculptures (19, 22). Boccioni proclaimed the 'absolute and complete abolition of the finite line and closed-form sculpture. Let us tear the body open and let us enclose the environment in it.' And he went on to suggest that 'transparent planes of glass, of sheet metal, wires, electric lighting outside and inside, could indicate the planes, the directions, the tones and half-tones of a new reality.' Other untraditional materials are later proposed—cardboard, iron, cement, horse-hair, leather, cloth, mirrors, even built-in motors to give sculpture actual movement. The only surviving example of Boccioni's constructions is, however, rather less revolutionary than his Manifesto. He was killed in the First World War and in 1916 Futurism came to an end. An attempt to revive it after the war foundered in its alliance with Fascism.

Futurism was a short-lived, meteoric episode, but it had more lasting effects and a much wider influence than is sometimes thought. In America its exuberance and optimism were reflected in such works as Joseph Stella's *Battle of Lights, Coney Island* (Yale University Art Gallery, New Haven, Conn.) of 1914. Nearly all

beautiful than the Victory of Samothrace.' Of the artists who rallied to Marinetti's call, the most articulate as well as the most gifted, both as painter and sculptor, was Umberto Boccioni (1882–1916). He was mainly responsible for the manifestos of Futurist painting in 1910, in which it was proclaimed 'that universal dynamism must be rendered as dynamic sensations; that movement and light destroy the substance of objects.' Later, after he and the other Futurist painters had been to Paris and seen Cubist painting, he formulated their aim as being 'to represent not the optical or analytical impression but the psychical and total experience.' As this suggests, they were as close to the Expressionists as to the Cubists. But they borrowed freely from the Cubist vocabulary of broken forms and, in fact, could not have realized their 'dynamic' visions without them. Their fundamental divergence from Cubism is, however, evident

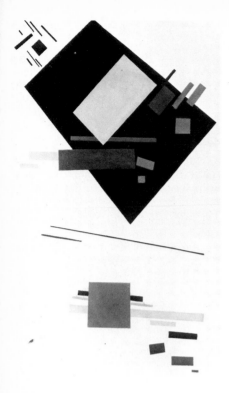

19, 28. Kasimir Malevich, *Suprematist composition, black trapezium and red square*, after 1915. Canvas, $24\frac{3}{8} \times 39\frac{3}{4}$ins (62 × 101.5cm). Stedelijk Museum, Amsterdam.

contemporary European movements in the arts were touched by it, including Cubism in its last, synthetic phase, which may not have been uninfluenced by Futurism's anarchic vitality. The brilliant young Duchamp brothers in Paris certainly were. The extraordinary dynamism of *The Horse* (19, 26) by Raymond Duchamp-Villon (1876–1918), brother of Marcel Duchamp (see p. 589), clearly owes something to Boccioni and Futurist painting. This remarkable work, in which vital animal energies are given mechanistic forms symbolizing the locomotive apparatus or machinery of a horse, is outstanding in its relentless, though not quite complete, abstraction. The tendons and muscles are just recognizable, coiled in upon themselves in an image compact of potential energy—of mechanical horse-power.

The Rumanian sculptor Constantin Brancusi (1876–1957), who settled in Paris in 1904, may also have been stimulated by the Futurists, although he never became involved with them in any way. At least one of his early sculptures seems to have been at least partly prompted by their dynamism and machine aesthetic (19, 27). The 'primitive' and folkloric origins

of Brancusi's art—tribal African sculpture and the peasant artifacts of his native Rumania—were, of course, completely at odds with Futurist aspirations and tend to conceal his affinities with them. Brancusi's unique sense of form, of form cut rather than modelled or carved or constructed in space, and his almost rapturous feeling for surface textures and the inherent qualities of his medium, all found expression in wood sculptures such as *The Prodigal Son*. Wood's tensile strength and its amenability to different types of handling (chopping and sawing, as well as carving) are exploited in this small work and give it an organic, hand-made quality of a kind the Futurists abhorred. However, Brancusi's later and most famous sculpture (20, 18) embodies glistening, precision-tooled, high-speed effects more eloquently than any Futuristic work of the pre-First World War period.

Abstract or non-objective art

One of the implications of Cubism—an implication that Picasso and Braque always resisted—was that, since the shapes within a painting could be conceived and seen as existing independently of whatever they stood for in the world of appearances, art could therefore be—perhaps should be—abstract, an absolutely self-sufficient entity of value entirely in and for itself. Such ideas were not new. They go back to Romantic theories of the early nineteenth century, as has been mentioned in connection with Kandinsky, who was embarking on his exploration of the non-objective in about 1910–12. The abstract art to which Cubism gave the creative impulse was, however, ideologically different from Kandinsky's. The Cubists had broken down their subjects into abstract or semi-abstract shapes which were predominantly geometrical. This seemed to confirm the belief that the underlying laws of art correspond to those of geometry and mathematics, although they played only an incidental role in Orphic Cubism (19, 13), which became completely abstract as we have seen. But there were to be others who aspired to embody universal laws in their art and believed that this could be achieved only with abstract forms originating in the artist's mind. Despite the rarefied, intellectual nature of this approach, it led to abstract art being conceived as a kind of model for an ideal harmony between man and his environment. It thus acquired a sense of social destiny linking it with contemporary political and social theory.

Avant-garde art could be seen in pre-war Tsarist Russia almost as well and as easily as in Paris, for exhibitions of contemporary Western art were regularly held in Moscow and St Petersburg from 1910

onwards. In fact, the chief patrons of both Picasso and Matisse were at that time wealthy Moscow merchants whose collections were open to the public. Russian artists were thus *au courant* with all the latest trends and in 1912/13 the first Russian abstract movement emerged, led by Mikhail Larionov (1881–1964) and Natalia Goncharova (1881–1962). It was called Rayonism by Larionov because his abstract paintings resembled rays of light, but its importance was mainly as a focus of artistic theory and inspiration for their

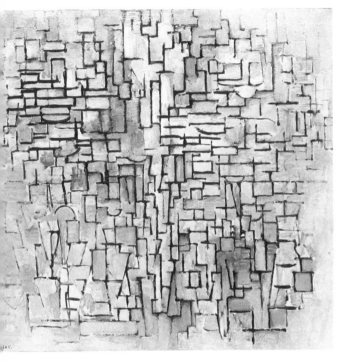

19, 29 Piet Mondrian, *Composition VII*, 1913. Canvas, $41\frac{1}{8} \times 44\frac{3}{4}$ ins (104.5 × 113.7cm). Solomon R. Guggenheim Museum, New York.

contemporaries, above all for Kasimir Malevich (1878–1935) and a younger generation who were to form the Constructivist movement during and after the Revolution (see pp. 595–7).

In 1912 Malevich was painting in a style he called Cubo-Futurist, which indicates his sources accurately enough. In 1913, however, he had gone far beyond them towards an absolutely pure and geometric form of total abstraction. This he called Suprematism and the first Suprematist picture, a black square on a white square, he claimed to have painted in 1913, though the movement was not publicly proclaimed until the following year. Malevich had much in common with Kandinsky and his theosophical speculations, though

he was a devout Christian of a deeply mystical cast of mind. By Suprematism he meant 'the supremacy of feeling in creative art' and this, he believed, could be best expressed by the simplest, most elemental visual forms, such as the square, which convey the supremacy of mind over matter, over the chaos of nature. In his *Black Square on a White Ground*, he wrote, 'all reference to ordinary objective life has been left behind and nothing is real except feeling ... the feeling of non-objectivity.' In his most famous painting, *White on White* of about 1918, the square has shed even this vestigial materiality and merges with infinity. Abstraction can go no further, at any rate in theory.

However, Malevich also developed a progression of shapes, the square being followed by the circle, the triangle, two equal squares side by side, squares unequal in size but balanced by colour, and so on. It was the more dynamic and complex compositions he was able to create with these elements, such as *Black Trapezium and Red Square* (19, 28), that influenced Alexander Rodchenko, El Lissitzky, Vladimir Tatlin and others who turned his pure and lofty conceptions to practical use in the post-Revolutionary period (see pp. 595–7). Despite his belief in art as a spiritual and strictly non-utilitarian activity, Malevich welcomed the Revolution and stayed on in Russia. But in 1922 he announced the end of Suprematism.

The most cerebral and at the same time most idealistic of the abstract movements was the Dutch group *De Stijl* (The Style), founded in Amsterdam in 1917 by the painters Piet Mondrian (1872–1944) and Theo van Doesburg (1883–1931) and the architect Jacobus Johannes Pieter Oud (1890–1963). They felt, Mondrian said later, that Cubism had not accepted 'the logical consequences of its own discoveries; it was not developing abstraction towards its ultimate goal.' Mondrian, who had passed from Impressionism through Symbolism, settled in Paris in 1911 and lived there until war broke out in 1914. He knew the Cubists and their work very well, but from the first pursued an individual and solitary path towards a more spiritual form of art. Though obviously indebted to Cubist painting for his subtle ochre and gray colour harmonies and his firmly centralized compositions fading out towards the edges, Mondrian's pre-war paintings were already so abstract that it was sometimes impossible to detect their subjects. These were often, unlike the studio subject-matter of the Cubists, organic structural forms such as trees, and it is perhaps for this reason that his work is so dynamic, so close-textured and vibrant (19, 29). 'It took me a long time', he wrote, 'to discover that particularities of form and natural colour evoke subjective states of feeling which obscure

pure reality. The appearance of natural form changes, but reality remains. To create pure reality plastically, it is necessary to reduce natural forms to constant elements of form, and natural colour to primary colour. The aim is not to create other particular forms and colours, with all their limitations, but to work toward abolishing them in the interest of a larger unity.'

High-minded ideals of absolute purity, harmony and sobriety inspired all the *De Stijl* artists—and also provided a model for the perfectly balanced organism they believed it possible for man to become both as an individual and in society as a whole. The markedly ethical overtones of all this reflect their sternly Calvinist background, which also accounts for their sense of dedication and mission. Van Doesburg is reported to have said that 'the square is to us as the cross was to the early Christians.' However, the great achievements of *De Stijl*—the buildings of Rietveld and the mature work of Mondrian—belong to the years after 1918 and are discussed in the next chapter.

Architecture

The course of architecture in the first two decades of this century paralleled in many ways that of the other arts, except in one respect. The United States moved for the first time to a central position with the buildings of Frank Lloyd Wright (1869–1959), the greatest American architect to date. Wright began in the office of Louis Sullivan (see pp. 541–2), whom he revered and with whose Guaranty Building in Buffalo (17, 26) steel-skeleton skyscraper construction achieved its classic statement. Sullivan had allowed the underlying grid of the structural steel frame to dominate and control his whole design so that complete independence of all period styles was at last reached, the façades being reduced to a simple, totally unornamented but

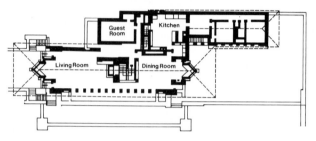

19, 30 Frank Lloyd Wright, Robie House, Chicago, 1907–9; (*right*) plan.

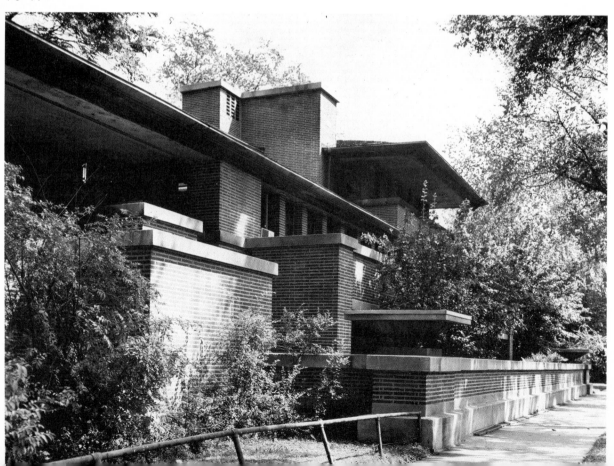

rhythmically beautiful pattern of mullions and sills. This represented quite as radical a break with the past as that made a few years later in Europe by young artists and architects, and it was comparable in its direction. Indeed, Sullivan anticipated much of the most advanced architectural thought in Europe around the turn of the century. It is not without significance that the Austrian architect Adolf Loos (1870–1933), whose famous *Ornament and Crime* of 1908 was to become the gospel of functionalism and the modern movement in architecture, was studying in Chicago in the 1890s, where he doubtless became familiar with Sullivan's slogan 'Form follows Function'.

Frank Lloyd Wright came from this same background but his genius carried him far beyond it. He had an instinctual, an almost animal, sense of architecture as shelter and of its relation to nature, of the possible affinities between man-made and natural structures, so that his buildings grow out of their environments in a way and to a degree not to be found in the work of any other architect anywhere. He aimed at what he called 'organic architecture', by which he meant 'an architecture that develops from within outwards in harmony with the conditions of its being.' This can be felt already in his early 'prairie houses', which reflect in their ground-hugging design the long, low-lying far horizons of the great plains of the Middle West, where the slightest vertical projection is instantly visible. His prairie houses culminated in the extended horizontality and free-flowing interior-exterior spaces of the Robie House, Chicago (19, 30). The precise detailing and good workmanship—it is built of fine Roman brick—tend to conceal the extreme radicality of this masterpiece. Symmetry has gone completely, as has the controlling conception of the façade, the main entrance being tucked away far off-centre. Instead, the interior spaces, which are not at all articulated but unified and interpenetrating, are allowed to determine the form. Walls have become mere screens and the whole design is dominated by the long lines of the parapeted balconies and cantilevered roofs projecting far out without vertical supports (hip roofs but so low that they look like slab roofs). These and other clean-cut rectangular features elaborate the composition plastically in a way that is very suggestive of Cubism. Even more so is Wright's handling of space—sometimes closed, sometimes open—and the way he played with voids and solids as design equivalents.

Wright did not aim simply to design a house. His 'organic architecture' was also conceived as a polemic in favour of cultural integration. 'An organic entity, this modern building', he wrote in 1910, 'as contrasted

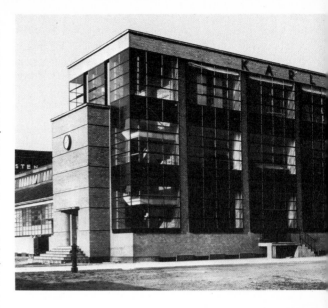

19, 31 Walter Gropius and Adolf Meyer, Fagus Works, Alfeld, 1911–14.

with the former insensate aggregation of parts. Surely we have here the higher ideal of unity as a more intimate working out of the expression of one's life in one's environment. One thing instead of many things; a great thing instead of a collection of small ones.... In organic architecture, then, it is quite impossible to consider the building as one thing, its furnishings another and its setting and environment still another.' He had already gone some way towards realizing this ideal integration in his Larkin Building at Buffalo, NY, in which all the furniture and office equipment and fittings were designed by him. The furniture is of steel.

Wright's fame was international by 1910, partly as a result of a magnificent folio publication of his work issued in Berlin that year. His influence, however, was less great. Germany was by then approaching the pre-eminent position it was to hold in Europe for the next few decades in architecture and architectural theory. In the Fagus Shoe Factory at Alfeld near Hanover (19, 31) Walter Gropius (1883–1969) and Adolph Meyer (1881–1929) anticipated to an amazing extent the International Style of the post-war years—glass curtain-walling, flat roof without cornice, an unrelieved cubic block with the corners left free of any support, ornament limited to the simplest horizontal banding. The total effect is one of transparent volume, not solid mass. Yet it remains bound, by its modular grid, to the past and to a traditional feeling for symmetry.

20 Between the two World Wars: 1920–40

The First World War made a deeper mark on Western culture than did the Napoleonic Wars a century earlier. It brought to an end a long period of almost uninterrupted material progress and prosperity in Europe, cutting short a great outburst of creative genius in the late nineteenth and early twentieth centuries. Western civilization has never fully recovered from it. Fine paintings and works of art went on being produced in the 1920s and 1930s, notably by Picasso, Braque and Matisse, but they were much less adventurous and innovative than before. The rigour and force of the great Cubist and Fauve masterpieces are quite lacking in Braque's and Matisse's post-war paintings, exquisite though they often are. Both painters increasingly indulged their extraordinary gifts in displays of extreme 'good taste' and refinement in colour, texture, handling and all those purely painterly qualities valued and highly cultivated in Paris. The relaxed tension is reflected in their subject-matter: oysters and lemons and sunny Riviera landscapes, languorous nudes and beach scenes, exotic fruits and flowers and all the undemanding and soothing delights of bourgeois comfort which had so miraculously survived the war. Picasso, too, had lost the relentless single-mindedness of his Cubist years and succumbed to the multiple opportunities his pictorial intelligence had opened up, sometimes painting in two or three different styles at the same time (20, 4a; 4b; 4c). Throughout the inter-war period Paris remained the capital of Western art—as of *haute couture* and fashion design—though it had begun to lose its influential position in most other cultural and scientific fields.

Dada and Surrealism

Dada and Surrealism, the two related movements which dominated the inter-war years, had already been prefigured before 1914, but, as Lenin wrote from his Swiss exile in 1917, war is 'a great accelerator of events'. Its impact was felt as quickly in the arts as in social, political and economic life, for example, in Dada, which was launched from a cabaret in Zürich almost next door to Lenin's lodgings. Not that Lenin had anything to do with Dada. So far as is known, he was quite unaware of it. The cafés and cabarets of Zürich teemed with revolutionary exiles, not all of them political revolutionaries. Writers such as James Joyce, musicians such as Igor Stravinsky, as well as artists and intellectuals of every kind, congregated in wartime Switzerland. They went there—or to the United States, which remained neutral until 1917—to avoid the war and protest against the society which had unleashed it. It was early in 1916, when the German and Allied armies were stalemated in the trenches at Verdun on the Western Front, that Dada emerged.

A state of mind rather than a literary or artistic movement, according to its spokesman the Rumanian poet Tristan Tzara (1886–1963), Dada was anarchic, nihilistic and disruptive. Dadaists mocked all established values, all traditional notions of good taste in art and literature, the culture symbols of a society based, they believed, on greed and materialism and now in its death agony. The name Dada—a nonsense, baby-talk word—means nothing, so was well suited to Dada's wholly negative nature. Dada even denied the value of art, hence its cult of non-art, and ended by negating itself. 'The true Dadaist is against Dada.'

The Zürich Dadaists were mainly writers and poets, as was also the only notable artist among them, Jean (Hans) Arp (1887–1966), whose experiments with automatism and the laws of chance led him to create some remarkable and quite fortuitously beautiful *papiers collés*. He tore up coloured papers and let the pieces fall haphazardly, fixing them (sometimes after slight adjustments) in the abstract patterns they had formed. Much more radically non-art, however, were Duchamp's ready-mades, first exhibited in 1915 in New York, where he spent most of the war years.

Marcel Duchamp (1887–1968), the younger brother

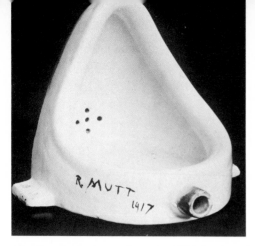

20, 1 Marcel Duchamp, *Fountain*, 1917. Readymade. Height 24ins (61cm).

of the sculptor Duchamp-Villon (see p. 584), was perhaps the most stimulating intellectual to be concerned with the visual arts in this century—ironic, witty and penetrating. He was also a congenital anarchist. Like his brother, he began (after some exploratory years in various current styles) with a dynamic Futurist version of Cubism, of which his painting *Nude Descending a Staircase* (1912, Philadelphia Museum of Art) is the best known example. It caused a scandal at the famous Armory Show of modern art in New York in 1913. Duchamp's readymades are everyday manufactured objects converted into works of art simply by the artist's act of choosing them. Duchamp did nothing to them except present them for contemplation as 'art'. They represent in many ways the most iconoclastic gesture that any artist has ever made—a gesture of total rejection and revolt against accepted artistic canons. For by reducing the creative act simply to one of choice 'ready-mades' discredit the 'work of art' and the taste, skill, craftsmanship—not to mention any higher artistic values—which it traditionally embodies. Duchamp insisted again and again that his 'choice of these ready-mades was never dictated by an aesthetic delectation. The choice was based on a reaction of visual *indifference*, with at the same time a total absence of good or bad taste, in fact a complete anaesthesia.' However, he may be thought to have protested too much about this. His ready-mades do have, willy-nilly, a certain visual attraction and distinction.

The earliest was a bicycle-wheel mounted on a kitchen stool (1913); the most outrageous was the *Fountain* (20, 1), an industrial porcelain-fitting for a public urinal, set sideways and signed 'R.Mutt'. When it was rejected by the New York Independents in 1917 it was defended (anonymously but probably by Duchamp himself) as follows: 'Whether Mr Mutt with

his own hands made the fountain or not has no importance, he CHOSE it. He took an ordinary article of life, placed it so that its useful significance disappeared under the new title and point of view— created a new thought for that object.' In other words, the significance of ready-mades as 'art' lies not in any aesthetic qualities that may or may not be discovered in them, but in the aesthetic questions they force one to contemplate.

Together with a wealthy Cuban painter, Francis Picabia (1879–1953), Duchamp formed a New York wartime Dada group—Dada in spirit if not in name. Picabia's satirically simplified drawings of actual or

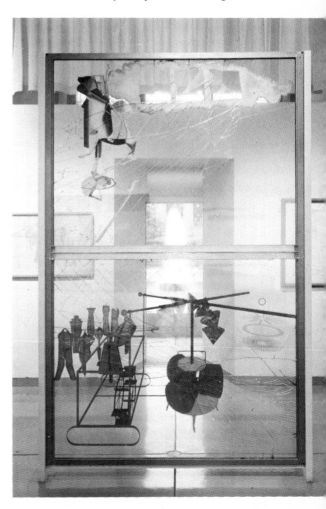

20, 2 Marcel Duchamp, *The bride stripped bare by her bachelors, even*, 1915–23. Oil and lead foil between glass, $109\frac{1}{4} \times 69\frac{1}{8}$ins (277.5 × 175.6cm). Philadelphia Museum of Art (Bequest of Katherine S. Dreier).

589

invented mechanical forms conveying private symbolic meanings—in deliberate contrast to Futuristic machine aesthetics—paralleled the most extreme and baffling of Duchamp's works, *The Bride Stripped Bare by Her Bachelors, Even*, often known as the *Large Glass* (20, 2). Duchamp had been evolving this extraordinary configuration in his mind since 1912 and worked intermittently on the actual construction, in oil paint, lead wire and foil, dust and varnish between two sheets of glass, in New York between 1915 and 1923, when he abandoned it unfinished. In 1927 it was shattered on returning from an exhibition in Brooklyn. The glass cracked in complementary directions due to its being transported in two halves, one on top of the other, and this entirely fortuitous effect 'completed' his masterpiece, Duchamp declared.

The *Large Glass* is an insoluble enigma and was intended to be so. It is an illusion of an illusion, all the more disorienting because the changing 'real world' on the other side of the glass forms part of it, as well as the viewer, who is occasionally caught in its reflectivity. It can be deciphered only in the most general terms. In the upper half the bride, a fusion of mechanical and biological functions that Duchamp had evolved separately in an oil painting of 1912, is shown undressing while she both attracts and repulses her suitors, whose orgasmic frustrations are indicated diagrammatically in the bottom half. Is it simply a joke?—a complicated and meaningless visual puzzle? When questioned about it Duchamp once said that 'there is no solution because there is no problem.' Whatever its meaning may be—and it has inspired the most varied and abstruse interpretations ranging from Hindu mysticism to medieval alchemy—it has been enormously influential. For painters and artists of every kind it has become a talisman. They have recognized in it the most fully committed and radical opposition to a purely visual conception of art. It asserts the value of the work of art as a 'sign', as a 'machine for producing meanings' and for compelling the active contemplation and creative participation of the viewer. Duchamp was quite explicit about this. It was not his intention, he said, to make 'a painting for *the eyes*.' He wanted to put painting once again at the service of the mind. If his work was dubbed 'literary' and 'intellectual' that wouldn't bother him, he said. The term 'literature' has a very vague meaning. 'And in fact until the last hundred years all painting had been literary or religious: it had all been at the service of the mind.' This quality was only lost during the nineteenth century—culminating in Impressionism and Cubism. Dada had been for him, he went on, an extreme protest against such purely visual attitudes to painting.

Duchamp always kept on the margin of politics but the Dada movement had obvious political implications, especially during the immediate post-war years in Berlin. The German painter Max Ernst (1891–1976), for instance, held a notorious exhibition in Cologne in 1920, entered through a public lavatory. Visitors to a Surrealist exhibition were met by a young girl in communion dress reciting obscene poems and were then handed an axe with which to destroy the exhibits. By such provocative gestures against the pomposities of respectable bourgeois society, by mocking everything that was taken seriously, especially everything that was revered as 'art' and 'culture', Dadaists might seem to have been preparing the way for a new social, intellectual and artistic order. Few of them had any such positive intentions, of course. But their successors, the Surrealists, did have. The Surrealists had close links with political revolution and, for a time, with the Communist Party. They were even welcomed by the Soviets. Lenin's commissar for education and the arts, Lunacharsky, is reported as saying: 'The Surrealists have rightly understood that the task of all revolutionary intellectuals in a capitalist régime is to denounce bourgeois values. This effort deserves to be encouraged.' However, the alliance did not last long. After four years those Surrealists who had joined the party left it.

Bourgeois values, it should be remembered, were being celebrated during these same years by two of the acknowledged masters of modern art, Braque and Matisse, in paintings of supreme accomplishment and sensual beauty. Such works as Braque's *Le Guéridon* (20, 3) and Matisse's *The Moorish Screen* (20, 10) express, or at any rate imply, an ideal of physical and psychological well-being—of well-heeled comfort and ease—that represents everything the Dadaists and Surrealists most disliked. They had to admit, reluctantly, the sheer beauty of Matisse's work, but they deplored his influence and everything he stood for. With consummate and apparently effortless skill Matisse had finally achieved that 'art of balance, of purity and serenity devoid of troubling or depressing subject-matter' of which he had long dreamed—an art which would appease and soothe 'like a good armchair' and embody all those qualities of good taste and well-bred refinement and restraint so prized by the bourgeoisie. Even Picasso succumbed for a time—though patently without conviction—to the post-war call to order promoted by the supremely versatile poet, playwright, film-maker and artist, Jean Cocteau (1889–1963), with whom he had already collaborated in designing sets and costumes for Diaghilev's Russian Ballet. Suave and immensely adroit but insipid

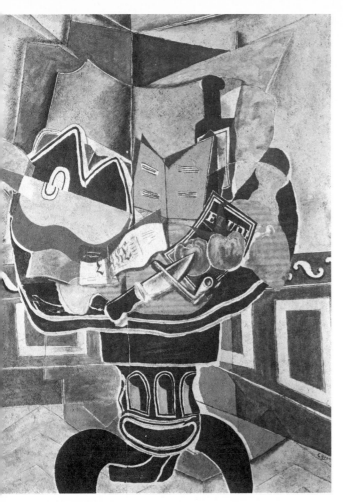

20, 3 Georges Braque, *Le guéridon*, 1929. Canvas, 58 × 45ins (147.3 × 114.3cm). Phillips Collection, Washington DC.

Ingresque portraits now alternated with gigantic, inflated Pompeiian evocations of the Classical Mediterranean world and a highly decorative and brilliantly coloured form of flat-patterned Cubism. No other major artist had ever before painted in several utterly different styles simultaneously (20, 4, a, b, c). Such heterogeneous displays go beyond mere stylistic versatility. But it was only some years later that an all-consuming sensuality and physical passion once again fired Picasso's powers of metamorphosis to create works comparable in impact with those of the pre-war years (20, 5).

Surrealism was as anti-bourgeois and as consciously disruptive generally as Dada, but it lacked Dada's anarchic spontaneity. It had a theory and a program and eventually became almost doctrinaire. However,

most Dadaists rallied to it when the poet André Breton (1896–1966), who became the leader and theorist of the movement, issued the first Surrealist Manifesto in Paris in 1924. This was concerned almost exclusively with poetry and imaginative literature (hardly at all with the visual arts), but it made an eloquent appeal for the total emancipation of writers and artists from all restraints. The aim was to explore the world of psychic experience revealed by Freud and by psychoanalytic research and to transmute 'those two seemingly contradictory states, dream and reality, into a sort of absolute reality, of surreality ...'

Breton had had some experience as a military psychiatrist during the war and had later visited Freud in Vienna. Surrealism's ideological origins clearly lie in Freud's theories, and Freud's methods became the model for writers' and artists' explorations of the unconscious, at first with automatic writing, which released the mind from conscious control so that images from the subconscious could float to the surface. Although Breton later thought his early definition of Surrealism had been too narrow it is worth recalling his main points: 'pure psychic automatism, by which we propose to express verbally, in writing, or by any other means, the real process of thought. ... Surrealism is based on the belief in the superior reality of certain forms of association neglected heretofore, in the omnipotence of the dream, in the disinterested play of thought.'

Breton named Freud as one of the three great precursors of Surrealism—one of three men who had, he said, revolutionized modern life from its roots. The other two were Trotsky and, curiously but rather typically, an obscure author known as the Comte de Lautréamont (but really Isidore Ducasse), who had written a collection of evil and sadistic prose poems entitled *Les Chants de Maldoror* (1868), from which the Surrealists took their motto—'As beautiful as the chance meeting on a dissecting table of a sewing-machine and an umbrella.' Various other precursors were mentioned, all of them writers. Painters and sculptors were notable for their absence. However, it was to be mainly through the visual arts that Surrealism reached a wide public and Breton later acknowledged its debt to several artists, notably de Chirico, whom he called 'the supreme Surrealist painter'.

Giorgio de Chirico (1888–1978) was a perplexing figure. Between 1911 and 1919 he created some of the most powerful and disturbing images in modern art—ominous evocations of desolate Italian piazzas in which the key to some impending catastrophe seems to be forever locked (20, 6). They are all the more

disturbing for being so apparently naive and bland. De Chirico was by no means naive. Yet he abandoned the world of dreams and nightmares in 1919 for a succession of increasingly contrived and academic styles which greatly embarrassed the Surrealists. He was equally embarrassed by their adulation and when they denounced his later work he retaliated by denying the authorship of his early and best paintings, and by executing inferior copies to confuse them! In this, if in nothing else, he revealed himself to be a true Surrealist after all.

The first Surrealist exhibition was held in Paris in 1925, the same year as another, much larger, exhibition in which Le Corbusier and exponents of both the International Modern and Art Deco styles were present (see p. 603). The Surrealist exhibition included the former Dadaists Hans Arp and Max Ernst as well as Joan Miró and several others, the only notable absentees being René Magritte and Salvador Dali, who joined the movement later. Ernst was the first and most successful practitioner of what might be called artistic Freudianism. The Freudian idea of the inner dictation of messages from the subconscious in dreams or psychic, dream-like states and of the possibility, therefore, of attaining complete liberation of the unconscious mind in art so that the writer and artist would simply stand by as spectators at the birth of their works (as Ernst himself was to put it), led Surrealist poets to automatic or unconscious writing. Ernst now invented a visual equivalent which he called *frottage* (rubbing). By taking rubbings with black lead from worn floor-boards and other surfaces, as children do with paper and pencil on coins, Ernst created some mysteriously beautiful and suggestive images. 'I was surprised', he wrote, ' by the sudden intensification of my visionary capacities and by the hallucinatory succession of contradictory images superimposed, one upon the other.' In theory his method avoided conscious control and thus bypassed all questions of taste or skill, but in practice, of course, the surfaces to be rubbed had to be selected and the rubbings were usually cut and arranged, so that *frottage* is not wholly comparable to automatic writing.

The alternative route to Surrealism, according to Breton, is the recording or '*trompe l'oeil* fixing' of dreams and this was taken by Ernst in his collage novels. These brilliantly exploit that principle of chance juxtaposition which disorientates and disrupts our sense of reality—as epitomized in Lautréamont's metaphor quoted above. By means of such unexpected combinations and confrontations a new sense of reality or surreality is created. Ernst's first collage novel *La Femme 100 têtes* of 1929—untranslatable

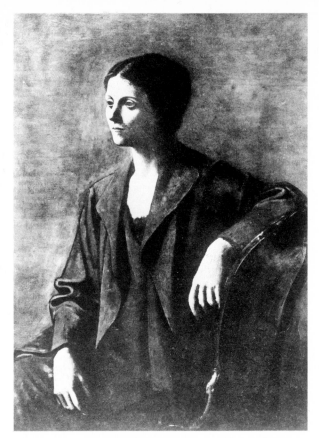

20, 4a Pablo Picasso, *Olga Picasso*, 1923. Canvas, 51$\frac{1}{4}$ × 38$\frac{1}{4}$ins (130 × 97cm). Private Collection.

since '100' means either 'a hundred' or 'without' when spoken in French—contains 149 collage images or 'ready-made realities'. These were put together by Ernst mainly from nineteenth-century wood-engraved book illustrations, cut out and recomposed by free association. The narrative thus created is convincingly dream-like and frequently borders on the nightmare (20, 9). Only very rarely did Ernst achieve the same dead-pan, enigmatic and compelling quality in his paintings.

The Spanish painter Salvador Dali (b. 1904) also tried to capture the hallucinatory clarity of dreams in his so-called 'hand-painted dream photographs', of which *The Persistence of Memory* is perhaps the most unnerving (20, 7). Time stands still within the dreamer's mind, as in Freud's timeless unconscious, so that in Dali's arid, airless landscape the metal watches go limp and stop forever. They even melt and decompose, attracting iridescent insects as they take

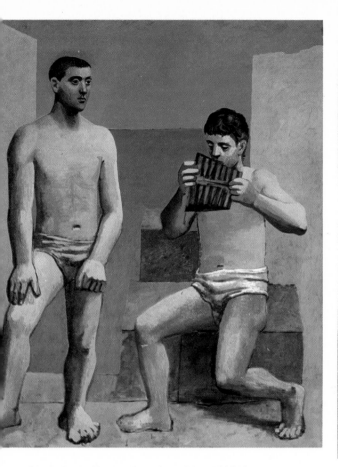

20, 4b Pablo Picasso, *The pipes of Pan*, 1923. Canvas, 80¾ × 68¾ins (205 × 174.5cm). Musée Picasso, Paris.

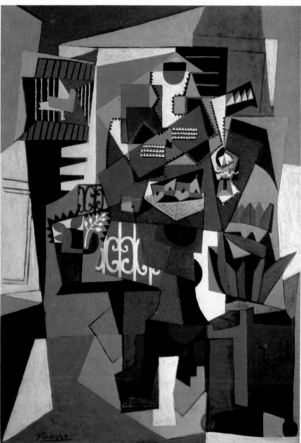

20, 4c Pablo Picasso, *The bird-cage*, 1923. 79⅛ × 55¼ins (200.7 × 140.4cm). Collection Mr & Mrs Victor W. Ganz, New York.

on organic shapes such as that of the watch drooping like some rotting fruit on the bare branch of a dead tree. Dali outlined his creative method in his book *La Femme Visible* (1930). It went a stage beyond that of the most radical Surrealists so far, and for their passive automatism he substituted what he called a 'paranoiac and active advance of the mind'. He proposed a state of mind that would be permanently disoriented. The only difference between himself and a madman, he said, was that he wasn't mad! 'I believe that the moment is near when by a procedure of active paranoiac thought it will be possible to systematize confusion and contribute to the total discrediting of the world of reality.' The paranoia which he claimed to be responsible for his visual images—especially his double images—has little or nothing to do with medical paranoia, but some of them are genuinely disquieting and quickly became famous. However, Dali's cynical self-promotion eventually led to his excommunication by Breton.

Freudian symbolism—phallic noses, fetishistic hair—is very obvious in Dali's work and pervades Surrealist imagery generally. The Belgian painter René Magritte (1898–1967) used it especially. Whereas Dali's paintings were disturbing, Magritte's are truly disruptive—all the more so for being executed with an intentionally banal technique used by Magritte when he worked as a designer of posters, advertisements and wallpapers. They challenge our assumptions about art and reality and, furthermore, they are totally without any meaning in so far as they resist explication as distinct from interpretation. Their titles are striking but the connection of their titles with the visual image almost always turns out to be ambiguous, or non-existent. *Le Viol* (20, 11) is typical. The super-imposition on a head of a female torso with pubic mouth, above a swollen and suggestively phallic neck, would be, without the title, no more than an image in bad taste. By adding *Le Viol*—a word whose sug-

gestiveness is lost when translated as 'The Rape'—Magritte intimates some 'meaning', which in fact doesn't exist. But it has the effect of a slow fuse. *Le Viol* was recognized by the Surrealists as a powerful statement of their aims and Breton used a drawing for it as the cover of his *What is Surrealism?* in 1934. Breton appreciated Magritte as an artist 'who detected what could result from relating concrete words of great resonance . . . with forms which deny or at least do not rationally correspond to them.'

It was another Spaniard, however, the Catalan painter Joan Miró (b.1893), who Breton thought (correctly) would turn out to be 'the most Surrealist of [us] all.' Miró had undergone several conversions before being drawn to Surrealism—to Fauvism, to Cubism in 1919 after he met Picasso, and to Dada a few

years later. Surrealism offered a new direction for his art and helped him to free himself from previous influences. He evolved what Breton called a 'pure psychic automatism', allowing his subconscious full play in the creation of semi-abstract forms. 'I begin painting,' he said, 'and as I paint the picture begins to assert itself, or suggest itself, under my brush. The form becomes a sign for a woman or a bird as I work.' Many of his early Surrealist paintings have a wonderful child-like innocence of fantasy and gaiety of free invention. But with the outbreak of the Spanish Civil War and the looming probability of another world war his vision darkened. His forms became increasingly sinister and amoeba-like—or 'biomorphic' as they were called—floating in an immaterial space like medical specimens in a jar of spirits. Such works as his *Head of a Woman* (20, 8) gave savage expression to the sense of impending horror widely felt in Europe at the time and equalled in intensity only by Picasso's *Guernica* (20, 20). When war broke out in 1939 most of the Surrealists, including Breton, took refuge in New York. They went on working, holding exhibitions and

20, 5 *Below* Pablo Picasso, *Head of a woman*, 1930–31. Painted iron, sheet metal, springs and found objects (colanders), height 39¾ins (100cm). Musée Picasso, Paris.
20, 6 *Below right* Giorgio de Chirico, *Mystery and melancholy of a street*, 1914. Canvas, 34¼ × 28⅛ins (87 × 71.4cm). Private Collection.

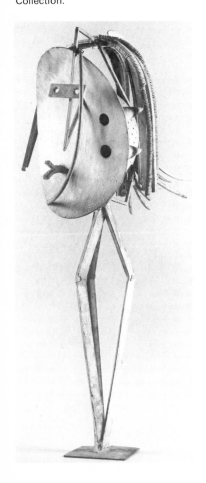

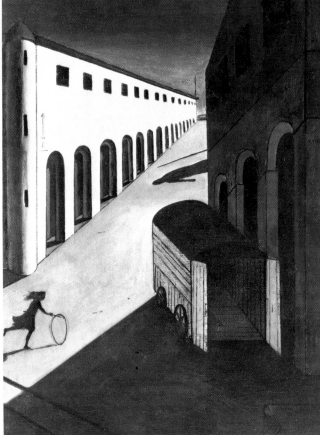

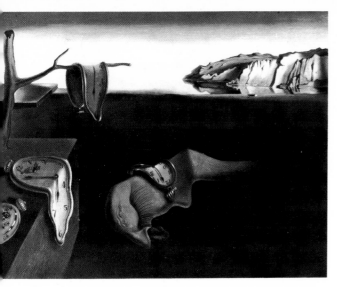

20, 7 Salvador Dali, *The persistence of memory*, 1931. Canvas, $9\frac{1}{2} \times 13$ins (24×33cm). Museum of Modern Art, New York.

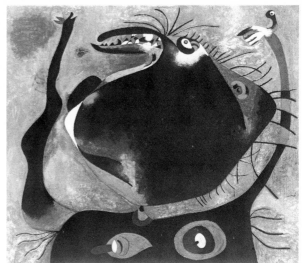

20, 8 Joan Miró, *Head of a woman*, 1938. Canvas, $18\frac{1}{8} \times 21\frac{5}{8}$ins ($46 \times 55$cm). Minneapolis Institute of Arts.

other public manifestations, attracting into their orbit such artists as the Armenian-born Arshile Gorky (see p. 607), and helped to sow the seeds of post-war American movements, notably Abstract Expressionism.

Constructivism, De Stijl and the International Style

As we have already seen, Malevich and other artists in Russia welcomed the Revolution in 1917, and during the confused and turbulent years that followed a number of them, among whom were some of the most original and radical artists and architects of the time, enjoyed a brief honeymoon of official recognition. The avant-garde seemed to have come into its own at last. Lunacharsky, a writer and playwright long resident in Paris, and the first commissar for education and the arts, gave them full support and encouragement, as did also Trotsky. Lenin was indifferent.

Among the painters Malevich, Marc Chagall (b. 1889) and Kandinsky (see p. 572) were prominent. But the leaders of the most progressive new movement, Constructivism, were the architects, sculptors and designers Vladimir Tatlin (1885–1953) and El (Eleazar Markevich) Lissitzky (1890–1941). Tatlin had seen Picasso's assemblages in Paris in 1913 and after his return to Russia he went on to make similar constructions out of various everyday materials, but without any representational elements so that they were completely abstract—among the first of their kind anywhere. They later took on architectural significance in his décor for the Moscow Café

20, 9 Max Ernst, plate from *Les femmes 100 têtes*, 1929.

Pittoresque of 1917. In 1919 he began his Monument to the Third International, a gigantic double skew spiral of openwork girders with revolving halls suspended at different levels, the whole construction to be a third of a mile high. Though it was never realized, Tatlin's design became a symbol of revolutionary modernism and of the Constructivist spirit of util-

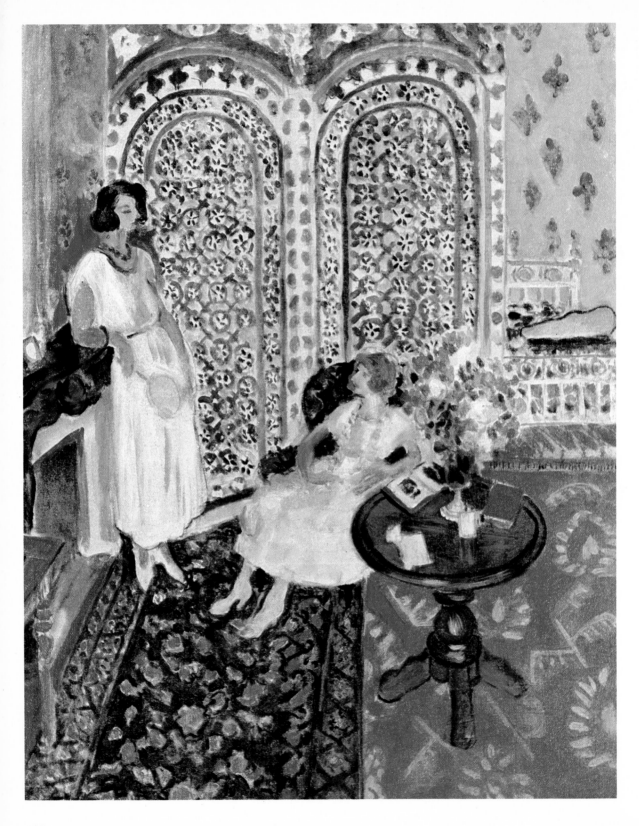

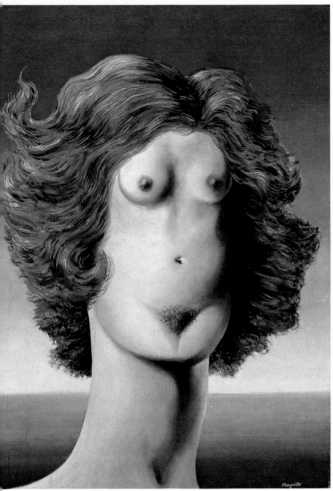

20, 10 *Left* Henri Matisse, *The Moorish screen*, 1921–22.
Canvas, $36\frac{1}{4} \times 29\frac{1}{4}$ins (92 × 74.3cm). Philadelphia Museum of
Art (Bequest of Lisa Norris Elkins).
20, 11 *Above* René Magritte, *Le viol*, 1934. Canvas,
$28\frac{3}{4} \times 21\frac{1}{4}$ins (73 × 54cm). Menil Foundation, Houston.

El Lissitzky's best-known Constructivist work, his Lenin Tribune project of 1920, failed, like Tatlin's, to get off the drawing-board. But his paintings, which he called Prouns—an invented word meaning 'For the New Art'—are strongly architectural in character and fully express his vision. He described a Proun as 'a station for changing from architecture to painting', and they often seem to hover halfway between an isometric projection and an abstract composition (20, 12). The one illustrated here is typical in its cool precision, like that of an engineer's drawing, of the Constructivist machine aesthetic. A cube is suspended in space above a grid of perspective lines and in front of a slightly off-centre bar of colour anchored top and bottom by semicircles. The subtle play with intervals and weight and balance is essentially architectural.

However, the Constructivist utopia was short-lived. After the introduction of Lenin's New Economic Policy in 1921 the movement's usefulness began to be seriously questioned and several of its members hastened to leave Russia. In 1922 Lissitzky went to Germany, where he remained for the next nine years. It was largely through him that Constructivist ideas reached the West. In Russia their legacy remained mainly on paper, the Moscow workers' clubs by Constantin Melnikov (1890–1974) and Ilia Golossov (1883–1945) being the outstanding Constructivist buildings to survive, especially the latter's club, Zoniev, Moscow, of 1926–7. The suppression of artistic groupings in 1932 signalled a radical change in Soviet artistic policy and finally eliminated all modernist tendencies in favour of various revival styles in architecture and of Social Realism in the figurative arts—attempts to bridge the gap between avant-garde and working-class culture, between the artist and the masses, which foundered in a banal official style lacking both the creative originality of élitist work and the genuine vitality of popular art.

In post-war Germany, too, there were many who believed that the artist could help to bring about new social conditions through the creation of new visual environments. The Bauhaus at Weimar became the centre of such aspirations not only in Germany, but in Europe generally. It had been launched in 1919 by Gropius (see p. 587) with a fervently Expressionist manifesto as a school where artists and architects could work together towards the great goal of 'the building of the future'. The Expressionist mood changed, however, in about 1922 through contact with *De Stijl* (see pp. 585–6), which Lissitzky had joined on leaving Russia and which became under his influence ever more austere and purposeful. The Bauhaus moved in a similar direction towards stark cubic

itarian simplicity and respect for the logic of materials. Constructivist ideology was largely anti-aesthetic, reflecting Marx's contention that the mode of production of material life determines social, political and intellectual processes. Its aims were primarily social, utilitarian and materialist. The artist's mission was to express the aspirations of the revolutionary proletariat and enhance the physical and intellectual conditions of society as a whole—hence the Constructivists' eager acceptance of machine production, architectural engineering, manufactured materials, photographic and other modern means of mass communication. Much of their best and most influential work, apart from architecture, was to be in typography and publicity and exhibition design.

simplicity and functionalism, notably in industrial design, as outlined by Gropius in his memorandum *Art and Technology—A New Unity*.

De Stijl's theorist, the painter Theo van Doesburg (1883–1931), lectured to Bauhaus students at Weimar in 1922, and *De Stijl*'s leading architect Gerrit Thomas Rietveld (1888–1964) completed in the early 1920s his paradigmatic masterpiece, the Schröder House in Utrecht (20, 13). This small semi-detached suburban villa foreshadowed all the features which were to distinguish the style advocated at the Bauhaus and later throughout Europe and America, where it was to be called the International Style—asymmetrical composition, unrelieved cubic shapes of clean-cut precision, slab roofs often cantilevered out at the corners, large windows in continuous horizontal strips, a complete absence of moldings and other ornamentation and a predilection for white rendering. Solidity gave way to transparent volume. Skeletal construction, free from load-bearing walls and oppressive monumental openings, enabled architects to realize that feeling of openness and apparent weightlessness which is the International Style's most attractive characteristic.

The Schröder House might almost seem to be a realization in three dimensions of a painting by Mondrian. Piet Mondrian (see p. 585) became the greatest painter of the inter-war years—that is to say he was the greatest to reach maturity during these years. And it is no coincidence that the greatest sculptor of the time, Constantin Brancusi (see p. 584), should have been nominated to succeed him when he resigned from *De Stijl* in 1924. Mondrian resigned, needless to say, on a question of principle. He carried the high-minded Calvinist purity of the movement to such lengths that even van Doesburg could not follow him. Mondrian would not allow the use of diagonals! This may seem absurd. But Mondrian's asceticism and single-mindedness were inseparable from the intensity of his vision and of his Utopian outlook. The universal harmony his art celebrated would one day, he believed, control all forms and activities of life.

His task he conceived as being primarily that of discovering 'pure means' whereby the universal harmony, the ultimate reality behind appearances, could be made clear. Cubism, he said, had stopped short of complete fulfilment. It had failed to realize the implications of its discoveries and thus had not gone on towards abstraction. Mondrian totally renounced the world of physical appearances. Identifying a picture firmly with the foreground plane and limiting himself to lines and rectangles and to the primary colours and black and white, he strove to create 'an art

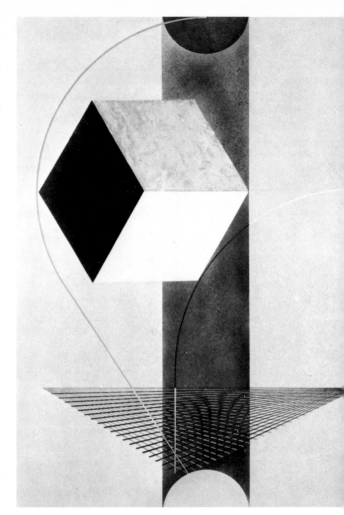

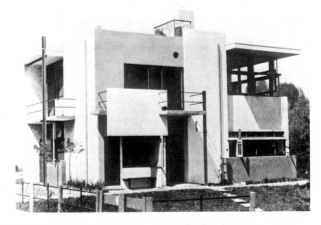

20, 12 *Top* El Lissitzky, *Proun 99*, 1924–25. Canvas, $50\frac{3}{4} \times 39$ins (129×99cm). Yale University Art Gallery, New Haven (Gift of the Société Anonyme).

20, 13 *Above* Gerrit Rietveld, Schröder House, Utrecht, 1924.

of pure relations'. By this he meant not something static but dynamic, not a symmetry and balance but a life-giving tension. And the effect is sometimes almost lyrically intense. In one of his most stark and challenging paintings, *Fox Trot A* (20, 14), this is achieved with only three straight black lines on white—an economy of means unsurpassed even by the Chinese. Of course, the simplicity is quite deceptive. The longer we look at this apparently elementary diamond-shaped configuration, the more complex and ambiguous it becomes.

Mondrian's economy of means included denying himself the aid of modelling and perspective, yet one is made immediately and very acutely aware of depth and

20, 14 Piet Mondrian, *Fox trot A*, 1930. Canvas, diagonal 43¾ins (109.8cm). Yale University Art Gallery, New Haven (Gift of the Société Anonyme).

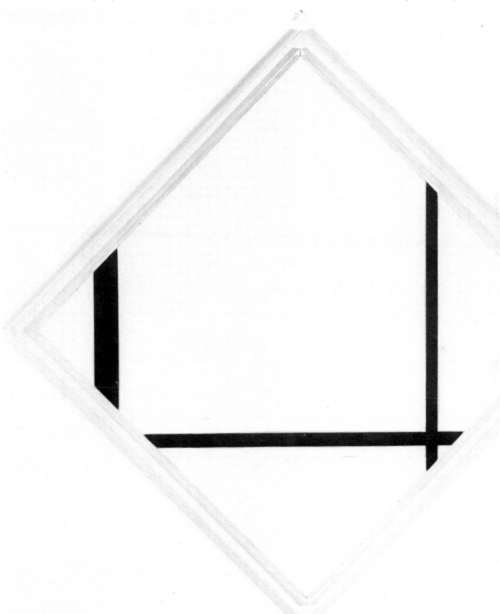

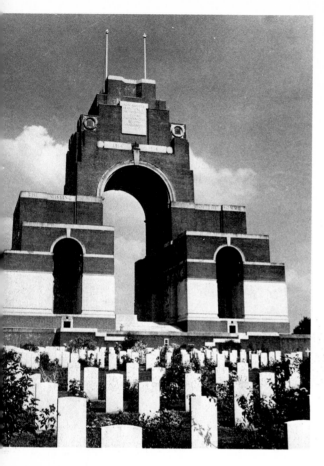

space in this painting. Depth—even if only a hair's breadth—is implied by the overlapping of lines and forms on the flat plane of the canvas. The edges of the up-turned square or 'diamond' seem to have cropped the rectangular forms created by the lines, which thus appear to recede below the surface, passing under the edges and continuing into space—or rather they would appear to do so were it not that the edges are slightly raised. (The framing-strip is set back twice, thus emphasizing the surface and the graphic power of the exposed edges, round which the black lines continue down the sides to the first framing-strip.) The ambiguity this creates is not the only one, however. The crossing of the vertical and horizontal lines near the right-hand bottom edge implies a similar crossing beyond the edge on the left, and the grid pattern thus formed could be indefinitely prolonged in all directions so that what we see is part of a larger whole, perhaps an infinity—were it not, once again, for an ambiguity. For no clear indication is given at the top, corresponding to that at the bottom, as to the formation of the lines beyond the top edges. Yet these ambiguities only sharpen our awareness of the spatial harmonies implied in this great painting.

Of course, the painting need not be read in this way at all. It can be looked at simply as a limited plane surface with flat marks on it making an asymmetrical design complete in itself, a design of four triangles of unequal size and a large five-sided polygon. The three lines are of unequal thickness, however, and this introduces another ambiguity. Is the central area to be read as a space, or as a solid set slightly at an angle.

These ambiguities combine with the uncertain sense of balance or symmetry (although a hidden geometric stability is suggested by, for example, the right vertical

20, 15 *Above* Sir Edwin Lutyens, War memorial to those who fell at the Battle of the Somme, Thiepval, 1925.
20, 16 *Below* Le Corbusier, Villa Savoie, 1928–30, Poissy, France.

which is so strongly felt in the work of progressive architects and designers during these years.

It is this straightforward, no-nonsense quality that marks the buildings of the two leading architects of the time, the Swiss painter-architect Charles-Edouard Jeanneret (1887–1965), known by his pseudonym Le Corbusier, and the German architect-designer Ludwig Mies van der Rohe (1886–1969), who became director of the Bauhaus in 1930. It even had a tonic effect on some well-established architects such as Auguste Perret (1874–1954) in France and, in England, Edwin Lutyens (1869–1944), whose reputation had been based on moderate-sized suburban and country houses around 1900, houses of great originality in their sense

20, 17 *Above* William van Alen, The Chrysler Building, New York, 1928–30, spire of stainless steel.
20, 18 *Above right* Constantin Brancusi, *Bird in space*, 1928. Bronze, ht 54ins (137.2cm). Museum of Modern Art, New York.
20, 19 *Right* Ludwig Mies van der Rohe, Living-room, single family house project, 1931.

exactly bisecting the right diagonal edges) and, above all, with the lack of centrality to set up a most subtle tension distributed across the whole picture surface. There is no fading away at the edges, as in traditional pictures, even in Cubist pictures. The edges are as important as any other area. But although there is no focus, nothing is inert. Everything is irregular. No two spaces are the same size or shape. Even the tonal values of the white areas are not quite even, for the pigment is most delicately brushed, reminding one of the vividly sensuous response to the art of painting displayed by Mondrian in his early work, before he renounced all such physical delights (19, 29). Austere it may be, but *Fox Trot A* is filled with a sense of liberation, of emancipation even. It has that frankness and openness

of massing and house-and-garden integration. But his First World War memorials strike a deeper note (20, 15). They reflect in their simplicity and gravity an awareness of those reductionist trends in contemporary architecture which were quite alien to his immediately previous and later work (e.g. the Viceroy's House, New Delhi, of 1921–31, whose architectural rhetoric now rings as hollow as that of the declining empire it celebrated).

Le Corbusier's famous definition of a house as 'a machine for living in' has often been misunderstood and misused in order to denigrate him. He did not mean that a house ought to be an artless, soulless mechanical capsule fit only for robots to inhabit. For him, as for the Russian Constructivists and the Bauhaus architects, the machine was something wholly beneficial. He thought that a house ought to be conceived, designed and produced in a rational manner (as were motor cars and aeroplanes) and that traditional, irrationally planned and designed houses simply frustrated the promise of the new age and the

20, 20 Pablo Picasso, *Guernica*, 1937. Canvas, 11ft 5½ins × 25ft 5¾ins (3.5 × 7.8m). Prado, Madrid.

good life for all that the machine could bring. Many other gifted young architects and designers were inspired by the same generous ideals. Our aim, said Gropius of the teachers and students at the Bauhaus, is a 'clear organic architecture, whose inner logic will be radiant and naked, unencumbered by lying façades and trickeries; we want an architecture adapted to our world of machines, radios and fast motor cars, an architecture whose function is clearly recognizable in the relation of its forms.'

This vision came near to realization in Le Corbusier's Villa Savoie of 1928–30 just outside Paris (20, 16) and in Mies van der Rohe's Berlin project the following year for a single-family suburban house, complete with furniture (20, 19). Mies van der Rohe was essentially an architect of steel and glass, Le Corbusier of ferro-concrete, but both exploited to the full the possibilities offered by skeleton construction for a spatially free and open architecture. The Villa Savoie is a cube on stilts or pillars of reinforced concrete called *pilotis*. This was a favourite device of Le Corbusier, and by allowing space to flow under and through the building, it very strongly enhanced that look of volume as opposed to mass which we have already noted in Rietveld (20, 13). Le Corbusier went some way further than Rietveld, for the cubic volume

of Villa Savoie is hollowed out on three sides, mainly on the south-east and south-west so that sunlight can flood right into the centre of the building. And since load-bearing walls had been eliminated the interior could be left quite free. One wall facing the interior terrace is glazed its whole length from top to bottom. Being open on every side, moreover, there is no façade, no front and no back. That the building should be impossible to comprehend from any single viewpoint only confirms how completely Le Corbusier had achieved his objective of total interpretation of outer and interior space.

The same principles underlie Mies van der Rohe's 1931 Berlin project, in which the walls are very obviously just screens to be moved or walked around as is convenient (20, 19). Here, however, the machine aesthetic finds expression also in the furniture which has the elegance of a finely adjusted precision tool— the famous 1929 Barcelona chair in the foreground and tubular steel cantilever chairs of 1926 in the background, all breaking decisively with the Arts and Crafts tradition in favour of design for standardized mass production. Mies van der Rohe's tubular steel chairs were not the first of their kind. The Dutch architect Mart Stam (b.1899) had introduced the cantilever principle in 1924 and the Hungarian-born architect Marcel Breuer (1902–81) evolved the first chromium-plated steel chairs at the Bauhaus in 1925. But Mies van der Rohe's chairs, with their immaculate

finish, poise and elegance, are the classic statement of this revolutionary design concept. They are deceptive, however, for despite their appearance of having been designed for mass production they, in fact, require careful hand-finishing in order to produce the desired 'machine-made' look.

A similar ambivalence can be felt in the sculpture of Constantin Brancusi (see p. 584) during these years, though he approached the ideal of absolute form from an entirely different point of view to that of the Bauhaus. By this date Brancusi's point of view had become ever more subjective and spiritual, almost mystic. And, unlike most sculptors before and since, he executed all his works himself by hand. He believed in old-fashioned hand-craftsmanship. Direct carving, he said, was 'the true road to sculpture'. Yet not only did he frequently have his marble works cast in bronze— thus denying the autonomy of the medium—but the extremely subtle and refined surfaces, on which he worked for days and weeks in solitude like a secular monk, carefully conceal all trace of his hand so that they look as if they had been machine-tooled.

There are many versions of most Brancusi sculptures, for he was constantly refining on the original idea. He made some 15 versions of *Bird in Space* from 1923 onwards, of which the one illustrated here is the tenth (20, 18). Although it neither resembles a flying bird nor suggests the aerodynamics of bird flight, there are analogies which powerfully suggest a continuous rising motion and the poetry of flight. The shining immaculate surface of the highly polished bronze and the streamlined form convey a euphoria of speed and of effortless elevation and ascent. A sense of release from gravity and from everything earthly and confining is imparted so that all our aspirational yearnings seem to be voluptuously fulfilled as in a dream of flight.

Streamlining became one of the hallmarks of an unfunctional modernism taken up by architects and designers of the late twenties and thirties and only recently has it become possible, with the passage of time, to recognize this—Art Deco, as it is now called— as having been an authentic style of the period parallel with the International Style. The vigour and vitality of popular culture, which the International Style had sacrificed to purism, found exuberant release in Art Deco. It is significant that the 1925 Paris exhibition of decorative art, after which the style is named, included Le Corbusier's Pavillon de l'Esprit Nouveau, in which some of his most brilliant and forward-looking concepts were displayed, but this attracted very little attention and was relegated to the periphery by the exhibition organizers. In architecture Art Deco found its most notable expression in New York, where the Chrysler Building (20, 17) and Radio City Music Hall with its jazz-age furniture and fittings by Donald Deskey epitomize the style. It was, in fact, only in New York—at Rockefeller Center, of which Radio City Music Hall forms part—that one of the great new urban planning conceptions of the twenties came anywhere near realization on the grandiose scale envisaged by Le Corbusier and others. Le Corbusier published a number of total plans for cities with a centre of glass curtain-wall skyscrapers symmetrically arranged in a park setting, with lower buildings and complex traffic circulation systems in between—his Contemporary City for 3 Million Inhabitants of 1922 is the most dazzling. Rockefeller Center is a group of 14 buildings occupying three blocks cut out of the narrow-scale gridiron street system of mid-town Manhattan. The buildings are disposed and co-ordinated as a unit. Of course, the park setting, which was all-important to Le Corbusier, is sadly lacking as well as a good deal else of his utopian scheme for a modern city. But it introduced for the first time into a living city centre a unified planning concept on the large scale he had imagined.

While the Rockefeller Center was going up in New York the lights were already beginning to grow dim once more in Europe. By the end of 1936 the Spanish Civil War had broken out and in April of the following year the first in a new catalogue of atrocities took place when the small, unprotected Basque village of Guernica was destroyed by Nazi bombers in the service of Spanish fascists. Picasso's most famous painting commemorates this inhuman act of criminal brutality (20, 20). It is by far his largest and in many ways his most ambitious work, for his aim was to press into ideological service all the sophisticated pictorial techniques of modern art. Such an enterprise might seem impossible. But his rage and indignation at the merciless slaughter of defenceless refugees and un-armed civilians so fuelled his visual imagination that images which he had created in earlier paintings for their privately expressive or purely formal qualities were now transformed into symbols which could be understood by everyone. The dying horse which had been the tragic protagonist in many of his bull-fight paintings here takes on universal significance, as does the implacable bull which he had recently drawn as the Minotaur for a Surrealist periodical to embody all the irrational forces in man and nature. But the agonized heads of mothers and the cruel malformations of wounded limbs and hands welled up spontaneously from his subconscious under the impact of this terrible and premonitory event.

21 Contemporary art

Although the United States had been in the forefront of developments in Western architecture ever since the late nineteenth century and, with Frank Lloyd Wright, had played a leading role in the early twentieth century, it was not until after the Second World War that New York superseded Paris as the focal point of new art in the West. The meeting of the American and Russian armies on the River Elbe in Germany in 1945 symbolized much more than the end of the war in Europe. It marked the end of European imperialism and of European rule overseas and, with the loss of

21, 1 Jackson Pollock, *Autumn rhythm*, 1950. Canvas, 105 × 207ins (267 × 526cm). Metropolitan Museum of Art, New York (George A. Hearn Fund 1957).

political and economic power, the end of European cultural predominance in the West.

The exodus of intellectuals and artists from Europe to America in the 1930s was symptomatic of this impending decline. They went as refugees from political and racial persecution, mainly from Nazi Germany. The greatest scientist of the twentieth century, Albert Einstein, fled to the United States in 1933 and he was followed by many other intellectuals including musicians such as Béla Bartok, Arnold Schoenberg and Igor Stravinsky, and numerous artists, of whom Hans Hofmann (1880–1966) was the first. Hofmann left Germany for America in 1932 just before the Nazis came to power. A few years later Max

21, 2 *Above* Richard Estes, *The Solomon R. Guggenheim Museum*, 1979. Canvas, 31⅛ × 55½ins (79 × 140cm). Solomon R. Guggenheim Museum, New York.
21, 3 *Right* Mark Rothko, *Green on blue*, 1956. Canvas, 89¾ × 63¼ins (228.2 × 160.8cm). University of Arizona Museum of Art (Gift of Edward J. Gallagher Jr).
21, 4 *Below right* Barnett Newman, *Broken obelisk*, 1963–67. Steel, height 25ft 1in (7.65m). Institute of Religion and Human Development, Houston, Texas.

Beckmann (1884–1950), George Grosz (1893–1959) and some of the leading Bauhaus figures (including Gropius, Mies van der Rohe, Marcel Breuer, Ludwig Hilbersheimer, Laszlo Moholy-Nagy, Josef Albers) escaped to the United States, and a new Bauhaus, later called the Institute of Design, was opened in Chicago. After the fall of France in 1940 a further influx of refugees arrived from Paris, among them several of the most notable painters and sculptors of the time— Léger, Mondrian, Gabo, Max Ernst, Dali, Chagall, Lipchitz and others, most of whom settled in New York.

Thus the two major European movements of the inter-war years were transferred to New York, the rational, formalistic Purist-Abstract trend being represented by Mondrian, Léger and the Bauhaus designers, the anti-rational, emotional, expressive trend by the Surrealists, Ernst, Dali and André Breton (as well as by Marcel Duchamp, who had been a semi-permanent resident in New York ever since 1915). In Paris these two movements had usually been thought antithetical if not mutually exclusive. But American artists, quite oblivious of this, were open and receptive to both. There had been, in fact, a small but strong and steady current in America towards abstraction ever since the first decade of the century, for emotional and expressive rather than formal ends. The artists who explored this vein were usually loners—America has always been rich in gifted mavericks—and it is only now that they can be seen as having in some ways foreshadowed post-Second World War painting in

New York. Of these forerunners Arthur Dove (1880–1946) was the first; indeed, his 1910 'extractions' from nature, as he called them, are among the earliest abstract paintings anywhere (see p. 571). That he was aware of the Romantic origins of his art is revealed by his remarking that his ambition was to take nature in its most elemental aspects, wind and water and sand, and simplify everything to 'color and force lines and substances, just as music has done with sound'—a highly Romantic analogy illustrated by such paintings as *Fog Horns*, 1929 (Colorado Springs Fine Arts Center). Though less consistently abstract, Georgia O'Keeffe (b.1887) created a vocabulary of personal forms which often hover ambiguously between representation and abstraction as they are transmuted into symbols. Filmy, quivering and sometimes extremely sensuous and voluptuous, they seem to take on a life of their own. But remarkable though Dove, O'Keeffe and one or two other isolated American artists were—and O'Keeffe became for a time a modern culture heroine, like the dancer Isadora Duncan and the writer Gertrude Stein, for the new liberated woman—it was the Surrealists from Paris in wartime New York who, with automatism and other techniques for releasing the unconscious, were to point the way ahead into the world confronting young American artists in 1945.

Abstract Expressionism

The New York painters who came to notice in the late 1940s and 1950s did not form a movement, though they all knew each other and were close contemporaries in age. Jackson Pollock (1912–56) was one of the youngest, with Franz Kline (1910–62), Ad Reinhardt (1913–67) and Robert Motherwell (b.1915). The others, a few years older, were all born within three years of each other—Adolph Gottlieb (b.1903), Mark Rothko (1903–70), Willem de Kooning (b.1904), Clyfford Still (1904–80) and Barnett Newman (1905–70). Their work has no uniform stylistic traits. Some of them painted with apparently uncontrolled and quite haphazard spontaneity, others with the most austere self-restraint. Superficially they might seem to have very little in common. They had no program. They issued no manifestos. But they all brought to their work a febrile energy and extremism as typically American as their taste for the colossal—and they all felt themselves to be in the same human predicament, all equally subject to the same complex fate of being Americans in the aftermath of the Second World War. The painter Barnett Newman wrote in 1945: 'The war, as the Surrealists predicted, has robbed us of our hidden terror, as terror can only exist if the forces of tragedy are unknown. We now know the terror to expect. Hiroshima showed it to us. We are no longer in the face of a mystery. After all, wasn't it an American boy who did it?'

But what they all thought and felt in common found expression in highly personal works of art. It was the critics who gave them a label—Abstract Expressionists or Action Painters. They never used and probably never thought of themselves in these terms. Their aims were unformulated, except by critics, one of whom, Harold Rosenberg, became their unofficial spokesman. 'At a certain moment', he wrote in 1952:

the canvas began to appear to one American painter after another as an arena in which to act—rather than as a space in which to reproduce, re-design, analyze or 'express' an object, actual or imagined. What was to go on the canvas was not a picture but an event.

The painter no longer approached his easel with an image in his mind; he went up to it with material in his hand to do something to that other piece of material in front of him. The image would be the result of that encounter.

Abstract Expressionism or Action Painting differed from other phases of modern art because, as Harold Rosenberg put it, it had a different 'motive for extinguishing the object.'

The new American painting is not 'pure' art, since the extrusion of the object was not for the sake of the aesthetic. The apples weren't brushed off the table in order to make room for perfect relations of space and color. They had to go so that nothing would get in the way of the act of painting. In this gesturing with materials the aesthetic, too, has been subordinated. Form, color, composition, drawing, are auxiliaries, any one of which—or practically all, as has been attempted logically, with unpainted canvas—can be dispensed with. What matters always is the revelation contained in the act. ('The American Action Painters', 1952, repr. in *The Tradition of the New*, 1959).

It was the business of putting paint on canvas that alone counted for the Action Painters and led them to abstraction. They did not represent their emotions or sensations but enacted them before the canvas.

A crucial figure in the evolution of Abstract Expressionism was the painter Hans Hofmann. He had an intimate, first-hand experience of Cubism, Fauvism and Expressionism, having lived between 1904 and 1914 in Paris, where he knew Picasso and Matisse among others, and later in Munich where he had in his keeping during the First World War most of

21, 5 Arshile Gorky, *The betrothal II*, 1947. Canvas, 50¾ × 38ins (129 × 96.5cm). Whitney Museum of American Art, New York.

Kandinsky's early, transitional paintings, transitional between Expressionism and abstraction. In New York Hofmann's art-school became the centre from which a synthesis of Cubism and Fauvism, a new unity of colour and form reflecting his belief in the duality of the world of art and the world of appearances, was propagated. He himself was a strong personality and he achieved in his own work an unusual combination of painterliness and abstraction, especially in the early 1940s when he experimented with 'drip' techniques and mixed media—oil paint, India ink, casein, aluminum paint, etc. For him painting meant creating form with colour and his definition of composition—a 'push-pull' of formal and colour tensions across the surface of the canvas—became celebrated. His teaching was very influential. But it was the Armenian painter Arshile Gorky (1905–48), whose family had emigrated to America in 1920, who became the effective catalyst between European and the new American painting.

Whether Gorky is best understood as the last Surrealist or the first Abstract Expressionist may be

endlessly debated. He spent many years working patiently through a series of obsessive master-pupil relationships, culminating with Kandinsky and Miró, before, in the last years of his short life, he suddenly came into full command of his extraordinary gifts. He succeeded in reconciling the previously irreconcilable, the abstract painterliness propagated by Hofmann with Surrealist imagery as well as with something of the literariness of André Breton, who admired and encouraged him. In Gorky's last attenuated, tortured paintings the embryonic forms seem about to melt and fuse with the gauzy, mysteriously coloured flux in which they float, so that they hang forever in suspense in an indeterminate world of being and not-being (21, 5). They are private myths. 'I do not paint in front of nature', Gorky said, 'but from within nature.'

The role of leading Abstract Expressionist painter, which Gorky would probably have taken had he lived, was filled by an even more disturbed and melancholy artist, Jackson Pollock, an archetypal American loner—raw, violent and consumed by neuroses and frustrations. He was born in Cody, Wyoming—the home of Buffalo Bill—spent his childhood in Arizona and grew up in southern California; his familiarity with south-west Indian art, especially sand painting, was to remain with him always and re-emerged as a seminal influence in his great Abstract Expressionist paintings. However, nothing in his early life prepares one for his paintings of the early 1950s—his admiration for the intense, subjective landscapes of Albert Pinkham Ryder (1847–1917), his apprenticeship to the mural painter Thomas Hart Benton (1889–1975), his acceptance and later rejection of Social Realism, especially that of the Mexicans David Alfaro Siqueiros (1898–1974) and José Clemente Orozco (1883–1949), his veneration for Picasso and especially for *Guernica* (20, 20), his familiarity with Surrealist automatism and Jungian analysis—all these may have contributed to, but they do little to explain or account for, the totally unprecedented nature of such paintings as *Autumn Rhythm* (21, 1).

Pollock's finest work belongs to a relatively brief period, 1947 to 1951. He was not a naturally gifted painter and wrestled in rage and fury at his inability to master traditional techniques. Suddenly it seems to have come to him, as if in a revelation, that he could find fulfilment by exteriorizing this struggle, by making the act of painting its own subject. Abandoning easel and palette—even brushes—he began to drip, to pour and spatter and fling the paint on to canvas laid out like a piece of sailcloth on the floor. In this way the marks on the canvas were liberated from any possible representational significance; they simply recorded his

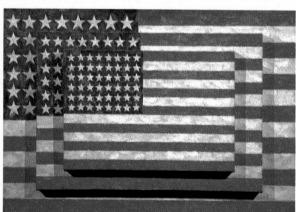

21, 7 *Above* Jasper Johns, *Three flags*, 1958. Encaustic on canvas, $30\frac{7}{8} \times 45\frac{1}{2}$ ins (78.4×115cm). Whitney Museum of American Art, New York (50th Anniversary Gift of the Gilman Foundation, Inc., the Lauder Foundation, A. Alfred Taubman).

engagement with the medium, forming a graph, as it were, of his emotions as he struggled with the viscosity of paint. 'My painting does not come from the easel', he wrote in 1947.

> I hardly ever stretch my canvas before painting. I prefer to tack the unstretched canvas to the hard wall or the floor. I need the resistance of a hard surface. On the floor I am more at ease. I feel nearer, more part of the painting, since this way I can walk around it, work from the four sides and literally be *in* the painting. This is akin to the method of the Indian sand painters of the West. ...
>
> When I am in my painting, I'm not aware of what I'm doing. It is only after a sort of 'get acquainted' period that I see what I have been about. I have no fears about making changes, destroying the image, etc. because the painting has a life of its own. I try to let it come through. ('My Painting', in *Possibilities*, I, 1947/8).

Indian sand paintings were executed rhythmically by trickling sand of different colours to form ephemeral symbolic images, as part of a religious rite, and a similar state of transport accompanied the creation of Pollock's paintings. He would gyrate freely round the canvas or into it, spilling and pouring and flinging the colours from cans of Duco and other aluminum and enamel paints as he spun round whirling his arms in

21, 6 *Opposite top* Henri Matisse, *The snail*, 1953. Painted, cut and pasted paper, 112¾ × 113ins (286.4 × 287cm). Tate Gallery, London.
21, 8 *Opposite below right* Christo, *56 barrels*, 1968. Rijksmuseum Kröller-Müller, Otterlo, Holland.
21, 9 *Below* Giorgio Morandi, *Still life*, 1957. Oil on canvas, 13¾ × 9⅞ins (35 × 25cm). Private Collection, Milan.

great arcs and hemicycles in a kind of dervish dance. His whole body was involved, not just his hands and arms. (He was filmed while painting.) But despite the frenzy, his movements were not completely uncontrolled, as he later admitted. 'When I am painting I have a general notion as to what I am about. I *can* control the flow of paint. There is no accident, just as there is no beginning and no end.'

This indeterminateness and sense of limitlessness is one of the most striking characteristics of Pollock's work. He used extremely large canvases—'portable murals' they were sometimes called—so large that the spectator has the sensation of being enveloped and engulfed by them as his eye moves from one swirling vortex of colour to the next. The nets and skeins of paint he dribbled and poured, one over the other from edge to edge across the huge expanse of the picture field, form an endlessly rhythmical palimpsest of repetitive patterns, interpenetrating and partaking of each other like some great Islamic composition of *thuluth* lettering (12, 26), and with a similar exquisiteness of surface expanding into infinity beyond the painting itself. The spectator's vision oscillates between the near and the far, between the microscopic and the telescopic, as if he were witnessing some galactic or atomic explosion. Whether this sublime effect of pure creative force was consciously intended is uncertain. Pollock said his all-over method was simply 'the natural growth out of a need.'

Pollock remained an isolated figure. He joined no groups or societies of artists and had no pupils or followers. Willem de Kooning was the closest to him artistically if not temperamentally, and they now tend to be seen together as the leaders of the Action Painting wing of Abstract Expressionism. De Kooning had emigrated from Holland to the United States in 1926, became a friend of Gorky, with whom he shared a studio for a time, and by the late 1940s was already recognized as one of the major Abstract Expressionists. He was the only one to remain to some extent representational, even making the human figure a principal theme. But his abstract work is perhaps more intense (21, 10). Aggressive and harsh, often rather raw in colour with juicy, fleshy pinks and lurid yellows and tart greens, the texture thick and heavy as if it had been relentlessly worked and reworked over again and again, his pictures have none of the delicacy and neurotic volatility of Pollock's. Moreover, they are never completely abstract. The shapes are always vaguely suggestive, pressing against each other with charged brush-strokes in dense and crowded compositions which almost burst out of the picture field.

The other notable exponent of this type of gestural

painting was Franz Kline (1910–62). He began in the late 1930s by painting city scenes in New York, and his later, almost wholly abstract black and white oil paintings were also inspired by the dynamism and violence of urban America. In them, he insisted, he was 'painting experiences': he was not creating formal abstractions, any more than he was painting 'bridge constructions or skyscrapers'. However, his work is often very evocative of just such urban configurations.

Abstract Expressionist painting divides into two groups: that of the gestural or 'Action' painters, whose work is discussed above, and that of the colour-field painters, of whom Clyfford Still, Mark Rothko and Barnett Newman were the outstanding exponents. Still was in some ways a comparable figure to Pollock and mediates between the two groups. Born in North Dakota and brought up in the Far West and in Canada, he was another loner and solitary, even in New York, where he lived during the 1940s and 1950s. He wrote then of the 'journey that one must make, walking straight and alone. ... Until one has crossed the darkened and wasted valleys and come at last into clear air and could stand on a high and limitless plain.' The religious, almost Messianic tone of this and other statements by Still is characteristic.

In 1943 he joined Rothko and Adolph Gottlieb in writing a now-famous letter to the *New York Times* in which the Abstract Expressionist point of view was first adumbrated. 'To us art is an adventure into an unknown world which can be explored only by those willing to take risks', they wrote. 'We favour the simple expression of the complex thought. We are for the large shape because it has the impact of the un-equivocal. We wish to reassert the picture plane. We are for flat forms because they destroy illusion and reveal truth ... we profess spiritual kinship with primitive and archaic art.'

Still was a pioneer, like Pollock, of the very large-size canvas—the 'portable mural'. He also, more consciously perhaps than the others, initiated that reorientation away from European and especially French culture and traditions which was shared to some extent by Rothko, Newman and others. (Still described the Armory Show, which introduced 'modern' art to the United States in 1913, as having 'dumped upon us the combined and sterile conclusions of western European decadence.') By 1946 his vision had found its natural form of expression and his work was to remain remarkably consistent from then onwards. Large asymmetrically placed, jagged planes or planar formations—for the paint is so thickly laid on in great slabs of colour that the surface can be, and often is, worked over like a relief—extend right across

21, 10 Willem de Kooning, *Excavation*, 1950. Canvas, 80⅛ × 100⅛ins (203.5 × 254.3cm). Art Institute of Chicago.

the canvas without overlaying or standing out against each other. There is a feeling of density but very little, if any at all, of space. The shapes are usually suggestive of tawny hides or tattered bill-boards or of the fissured rock-face or shale in deep gorges and canyons, the colossal elemental detritus of some geological 'fault'. The paint surface is strangely dry and scaly, and this, combined with Still's rawly assertive palette of earth browns and maroons, acid yellows and chalky whites, lends his enormous abstract compositions a primitive power akin in some almost Whitmanesque way with the wide and incommensurable landscapes of the American West.

Mark Rothko was born in Russia and emigrated to the United States with his family in 1913. As melancholy and misanthropic as Pollock and Still, his paintings became increasingly sombre and in 1970 he committed suicide. But he was perhaps the greater artist. Certainly he was more fully aware of the spiritual dimensions attainable in abstract art and his mature works are deeply religious. They are objects for contemplation. They demand silence and the spectator's complete absorption in them.

'I am not interested in relationships of colour or form or anything else', Rothko is reported as saying in 1957:

I am interested only in expressing the basic human emotions—tragedy, ecstasy, doom and so on—and the fact that lots of people break down and cry when confronted with my pictures shows that I *communicate* with those basic human emotions. The people

who weep before my pictures are having the same religious experience I had when I painted them. And if you, as you say, are moved only by their color relationships, then you miss the point. (S. Rodman, *Conversations with Artists*, New York, 1957).

Although Rothko did not make so aggressive a rejection of the easel painting as did Pollock and Still, his work is equally enveloping in scale. Soft, hovering, cloudy forms with frayed edges fill almost the entire surface of his pictures. But whereas with Pollock it is the texture of the paint that becomes expressive, with Rothko the texture of the canvas is allowed to remain as if it had been dyed rather than painted. He soaked his paints into the canvas and the two or three banks of colours which form the composition are scumbled over the other very thinly painted areas, creating an effect of luminous grandeur unique to Rothko. In contrast with the austere simplicity of the forms the colour is very opulent and subtle; the forms glow and throb as the spectator stands before them on the brink, as it were, of an enormous luminous void (21, 3).

Like Rothko, whose ambitions ultimately went beyond the subjectivity of Abstract Expressionism, Barnett Newman sought a new form of art which could carry some general human significance. Though his paintings may appear to be no more than arrangements of colour and space, his many statements reveal the importance Newman gave to subject-matter. For him art was a quest to attain the unknowable and the sublime. 'I believe that here, in America', he wrote:

Some of us, free from the weight of European culture, are finding the answer, by completely denying that art has any concern with the problem of beauty and where to find it. ... We are reasserting man's natural desire for the exalted, for a concern with our relationship to the absolute emotions. ... We are freeing ourselves of the impediments of memory, association, nostalgia, legend, myth, or what have you, that have been the devices of Western European painting. Instead of making *cathedrals* out of Christ, man, or 'life', we are making it out of ourselves, out of our own feelings. ('The Sublime is Now' in *Tiger's Eye*, no. 6, 1948).

By the 1950s he was painting the kind of picture he was writing about—*Vir Heroicus Sublimis* (Museum of Modern Art, New York), for example, a huge canvas covered with an even flat field of red divided by four narrow, sharp-edged stripes or 'zips', as he called them, running from top to bottom and varying slightly in colour and width. Such paintings went further even than Mondrian in reducing pictorial language to its basic elements, though whether they can bear the weight of meaning their titles sometimes suggest may be doubted. In 1966 Newman entitled a series of 14 such canvases *The Stations of the Cross* (1958–66). Rothko, too, was working on a great (his last) series of paintings at this time for a chapel designed and built specially for them at Houston, Texas, approached past a memorable sculpture by Newman. In this Newman's exalted and tragic conception of art found a form more readily accessible than in painting—a great burnished pyramid of steel (symbol of timeless stability) bearing at the point of perfect intersection and balance the tip of an upturned and broken obelisk (symbol of man's flawed but perennial aspirations) (21, 4).

Abstract configurations carrying implications akin to meaning and with references to human hopes and anxieties were created by the sculptor David Smith (1905–65), who shared many of the interests of the Abstract Expressionists without being publicly associated with them. He was trained as a painter in New York and his sculptures tend to be conceived frontally, built up in a pictorial manner that defies gravity (21, 11). They are constructed sculptures of metal owing something to Picasso's welded pieces of the 1930s, but more to Smith's own experiences as a welder on an automobile assembly line and in a tank factory during

21, 11 David Smith, *Cubi XVIII* and *Cubi XVII*, 1963–64. Stainless steel, heights 116 and 108ins (295 and 274.3cm). Museum of Fine Arts, Boston, and Dallas Museum of Fine Arts.

the war. He felt a strange affinity with large, heavy machinery. And the surfaces of his sculptures were always carefully roughened so that they take the colours, without reflections, of the open landscape settings in which he visualized them. Delicacy and strength, the natural and the manufactured, are combined with an almost Hemingwayesque sensitivity.

Abstract Expressionism with its great achievements, despite its sometimes overweening transcendentalist claims, was a uniquely American phenomenon. Nothing comparable emerged in Europe in the immediate aftermath of the war. During these same years of the late 1940s and early 1950s, however, Matisse, by then in his eighties and partly bed-ridden, created some of the most lyrically ebullient and joyous of all his works. In 1947 he had finished a book, *Jazz*, with pages of hand-written text and illustrations made with cut and coloured papers. This was to be the technique which sparked off the last phase of his long artistic evolution, the most serene and perhaps the most fully resolved of all—'a flowering after 50 years of effort', he called it. Papers were coloured in gouache and prepared by him, then cut and arranged. 'Cutting into colour reminds me of the direct action of the sculptor carving stone', he said, and the method had for him more than just physical advantages. In it he conceived an extraordinary variety and richness of composition in colour, from designs for stained-glass windows and wall decorations to book-jackets. In the year before he died, his art reached its consummation in such large-scale cut-outs as *A Memory of Oceania* and *The Snail* (21, 6), which sums up his life-long quest to regain that innocence he had first discovered around the turn of the century in primitive art. 'Seeing is of itself a creative operation, one that demands effort', he wrote in 1953.

> Everything we see in our ordinary life undergoes to a greater or lesser degree the deformation given by acquired habits, and this is perhaps especially so in an age like ours, when cinema, advertising and magazines push at us a daily flood of images which, all ready-made, are to our vision what prejudice is to our intelligence. The necessary effort of detaching oneself from all that calls for a kind of courage, and this courage is indispensable to the artist who must see all things as if he were seeing them for the first time. All his life he must see as he did when he was a child. (*Le Courrier de l'UNESCO*, vol. VI, no. 10, 1953).

21, 12 *Top* Roy Lichtenstein, *Big painting no. 6*, 1965. Canvas, 92 × 129ins (233.7 × 327.7cm). Kunstsammlung Nordrhein-Westfalen, Düsseldorf.

21, 13 *Above* Richard Hamilton, *Just what is it makes today's homes so different, so appealing?*, 1956. Collage, $10\frac{1}{4} × 9\frac{1}{4}$ins (26 × 23.5cm). Kunsthalle, Tübingen.

Pop Art

By the early 1960s Abstract Expressionism had reached its apogee and the artistic climate in both the United States and western Europe was rapidly changing. Post-war austerity and constraint was being succeeded by consumer-society affluence and prosperity and the short-lived optimism of the Kennedy years. Analyzing the situation, the critic and champion of the Abstract Expressionists, Clement Greenberg, ruminated on the various possibilities the future held for artists. After the 'turgidities of Abstract Expressionism', he wrote, what was needed was a more disciplined, formalist art, one which recognized and concentrated on essentials and, he went on, 'the irreducibility of pictorial art consists in but two constitutive conventions or norms, flatness and the delimitation of flatness'. The artists whose work attained the desired coolness, restraint and elegance in pursuing the rather limited aims of Post-Painterly Abstraction, as it was called, were Morris Louis (1912–62), Kenneth Noland (b.1924) and Jules Olitski (b. 1922), and their paintings were highly esteemed throughout the 1960s. However, the main reaction provoked by Abstract Expressionism was to be of a much more brash and positive nature.

Big Painting No. 6 by Roy Lichtenstein (b.1923) represents this reaction—Pop Art—at its most blatant (21, 12). The Abstract Expressionist brush-stroke is treated by Lichtenstein impersonally, even ironically, to make a visual comment on the excessive subjectivity of their cult of the gestural manipulation of paint as a means of unfettered, spontaneous self-expression. He renders it as if he were painting a still life of some graphic material for a paint manufacturer's display stand. 'We think the last generation, the Abstract Expressionists, were trying to reach into their subconscious, and more deeply than ever before, by doing away with subject matter', he wrote in 1966.

> When we consider what is called Pop Art—although I don't think it is a very good idea to group everybody together and think we are all doing the same thing—we assume these artists are trying to get outside the work. Personally, I feel that in my own work I wanted to look programmed or impersonal but I don't really believe I am being impersonal when I do it. ... But the impersonal look is what I wanted to have. (*Artforum*, 1966).

Pop Art—defined as 'making impersonality a style' by using the imagery of commercial art and other mass media sources—emerged simultaneously but quite independently in Britain and the United States. The collage *Just What is it Makes Today's Homes So Different, So Appealing?* by the English painter Richard Hamilton (b.1922) may be considered the first truly Pop work of art (21, 13). It incorporates or alludes to male and female pin-ups, TV, pulp romance, consumer durables, packaging, the movies, automobile heraldry—even the word Pop on the muscleman's racket. When first exhibited in London, it was misconstrued as an attack on art or on the consumer society. On the contrary, Hamilton explained, he was aiming at a new art which would be 'popular, transient, expendable, low cost, mass produced, young, witty, sexy, gimmicky, glamorous and big business.' It was not intended as 'a sardonic comment on our society', he said. 'I should like to think of my purpose as a search for what is epic in everyday subjects and everyday attitudes.'

But whereas mass media imagery had an exotic glamour for Europeans, it was simply banal and commonplace to American artists. American Pop Art

21, 14 Andy Warhol, *Disaster 22*, 1964, Silkscreen enamel on canvas, 106 × 82ins (269.2 × 208.3cm).

therefore had from the beginning an ambivalence and complexity lacking in its European counterparts. Works by Robert Rauschenberg (b.1925) and Jasper Johns (b.1930) were sometimes called 'Assemblage' or 'Neo-Dada' to call attention to their use of ready-made or junk objects and to their works' implicit questioning of the concept and value of 'art' itself. Jasper Johns's

Three Flags, for instance, is painted in encaustic, an Old Master technique of great antiquity which gives an elaborately and sensitively worked and an unmistakably 'fine-art' surface to a very edgy subject for the sophisticated public to which such paintings were primarily addressed (21, 7). Was Johns mocking the flag? or art? Similarly awkward and provocative questions were posed in 1962 by the *Giant Hamburger* (Art Gallery of Ontario, Toronto) of Claes Oldenburg (b. 1929). Made of painted sailcloth, grossly inflated in scale (it measures some 7 feet, 2m, across) and stuffed with foam so that it is disturbingly soft, like a feather bed, the *Giant Hamburger* denies all traditional notions of sculpture in which surface generates volumes and it widened the boundaries of art by making the spectator aware of something as art that doesn't look like a work of art at all. Oldenburg felt passionately the need to bring art back into ordinary life after the hushed solemnities and high seriousness of Abstract Expressionism. He sold his works in simulated stores with other miscellaneous goods as if they were intended for the supermarket, not an art gallery. 'I am for an art that embroils itself with the everyday crap and still comes out on top,' he said.

If Lichtenstein and Oldenburg represent Pop Art at its most brash, Andy Warhol (b. 1928) represents its most extreme and subversive form. Warhol was a successful commercial artist on Madison Avenue,

21, 15 Francis Bacon, *Three studies for a Crucifixion*, 1962. Oil with sand on canvas, each panel 78 × 57ins (198.2 × 144.8cm). Solomon R. Guggenheim Museum, New York.

working for *Glamour* and other magazines, before he became a painter and later a film-maker, sculptor, writer, director of a pop group and the creator of a Pop life-style. He stood all theories of mass culture on their heads, notably Walter Benjamin's Marxist predictions of the suffocation of art in the glut of commercial images. Warhol said he liked mechanical repetition and wanted to be a machine himself. 'I think it would be terrific if everybody was alike.' He made a cult of being boring and banal and superficial—'just look at the surface of my paintings and films and me, and there I am. There's nothing behind it.' His paintings were done for him by assistants—with a silk-screen technique he was the first to use for painting—and even his subjects were pre-selected, for they were the most popular (Campbell's soup, Marilyn Monroe, etc). This extreme form of non-choice also governed his compositions or non-compositions, which reduce everything to nullity by repetition and trivialization. However, a degree of motivation clearly entered into the most powerful, his various Disaster series, in which the real horror lies in the refinement of taste with which the mindless repetition and banality of the conception is treated rather than in the grisly subject itself (21, 14).

Though a generation older, the Anglo-Irish painter Francis Bacon (b. 1909) was the only European artist creating works of comparable power in the 1960s and since he too relied largely on existing images (press photographs, films, etc) his paintings have some, albeit distant, connections with current artistic developments in America. For Bacon art is a 'method of

21, 16 Robert Morris, Exhibition at the Green Gallery, New York, 1964.

opening up areas of feeling rather than merely an illustration of an object.' The Crucifixion becomes an ambiguous horror enacted in a shoddy, claustrophobic hotel bedroom, with bodies like partially dismembered carcases grappling in some unnamable sexual embrace (21, 15). There are beautiful, even exquisite passages of paint in this 'triptych' and it is the incongruity, or rather the total disassociation, of theme and handling which, as with Warhol, conveys that sense of obsessional guilt which is the painting's real subject. In the United States, however, Bacon's work seemed merely decadent, irrelevantly European.

Minimal and Conceptual art to Photo-Realism

The most self-consciously American of all post-war artistic movements was Minimalism, which aimed at complete purity and integrity, the reduction of art to that which is intrinsic to its medium and the elimination of all that is not. By reducing the artist's means to an apparent minimum, it was hoped that an absolutely unitary activity would result—as well as a unitary experience for the spectator. 'All I want anyone to get out of my paintings … is the fact that you can see the whole *idea* without any confusion', the painter Frank Stella (b.1936) remarked. 'What you see is what you see.' Yet the reductive essence of the mechanically precise forms and bare surfaces of Stella's 'unitary' paintings of the mid-1960s and of the equally self-sufficient Minimal sculptures of about the same date by Donald Judd (b.1928), Robert Morris (b.1931) and Carl Andre (b.1932) harks back to Malevich (19, 28) and the non-art of Duchamp as well

as, more specifically, to the teaching of the former Bauhaus designer Josef Albers (1888–1976) and his *Homage to the Square* paintings of the late 1950s. The Minimalists, however, were perhaps more keenly aware than their precursors of some of the implications of their extreme position. As Robert Morris observed: 'A single, pure sensation cannot be transmissible because one perceives simultaneously more than one as parts of any given situation: if colour, then also dimension; if flatness, then texture, etc.' And he doubtless had his own recent work in mind (21, 16) when he went on to remark:

> Simplicity of shape does not necessarily equate with simplicity of experience. Unitary forms do not reduce relationships. They order them. If the predominant, hieratic nature of the unitary form functions as a constant, all those particularizing relations of scale, proportion, etc, are not thereby cancelled. Rather they are bound more cohesively and indivisibly together. The magnification of this single most important sculptural value, shape, together with greater unification and integration of every other essential sculptural value makes on the one hand, the multipart, inflected formats of past sculpture extraneous, and on the other, establishes both a new limit and a new freedom for sculpture. (*Artforum*, February 1966).

Minimal art was anticipated in Europe by the French artist Yves Klein (1928–62), who began his series of monochrome blue paintings in 1956 and two years later held a notorious exhibition entitled *Le Vide* in Paris consisting of a completely bare art gallery painted white inside and blue outside. The Bulgarian artist Christo (Christo Jachareff, b.1935) settled in Paris the same year and began his stacking and wrapping pieces—so-called 'transient works'—of which *56 Barrels* is one of the few to have been preserved (21, 8). Many were never realized, such as a two-million barrel *mastaba* project for Abu Dhabi, though the most spectacular of his wrapping pieces was—a million square feet of the Australian coastline wrapped in plastic sheeting in 1969–70. At the time such works were thought to have extended the frontiers of art to their limit. But it may be questioned whether they went very much further, except in scale, than the work of Giorgio Morandi (1890–1964), whose paintings of discarded tins and empty bottles huddled together as if in self-protection should not be seen only within a European tradition of still-life painting (21, 9). Their implications are much wider and they are not open to the criticism levelled at Minimalism by Clement Greenberg, of being 'too much a feat of

ideation, and not enough of anything else. Its idea remains an idea, something deduced instead of felt and discovered.'

The extreme purism and formalism of Minimalist art did not fail to arouse reactions, of which Photo-Realism (Super-Realism or Sharp Focus Realism) was the most obvious, though it is often misunderstood. So far from being a revival of academic realism this style is as objective and object-oriented as Minimalism itself. Naturalistic imagery and illusionistic space are presented in the form of flat snapshots or colour slides rendered with *trompe l'oeil* virtuosity. Richard Estes (b. 1936) is the best-known exponent (21, 2). Other reactions were more rugged and anti-aesthetic—Process Art, Land Art, Body Art, all evolving towards the elimination of the work of art, which was finally achieved in the late 1960s with Conceptual Art and the 'dematerialization of the art object'. The central theory of Conceptual Art is that the work of art is essentially an idea which may (or may not) generate a visible form. It had been foreshadowed by the American composer John Cage, whose 1954 piece entitled *4' 33"* consisted of 4 minutes and 33 seconds without music—just silence broken by whatever sounds happened to occur during the indicated period of time. Similarly, Klein's *Le Vide* exhibition had in effect asserted the artist's power to take possession of an experience without converting it into a physical work of art.

The premise of all Post-Minimal and Conceptual Art is that the artist's product is of less significance than the process which brought it into being and of which it is only the record. As the Swiss painter Paul Klee (1879–1940) had stressed, 'the work of art is above all a process of creation: it is never experienced as a mere product.' In the 1960s this concept coincided with a deepening revulsion among artists against the art market and the whole system into which they were

inevitably drawn. By insisting that art is not to be identified with a special kind of object (an exhibitable, reproducible kind of object which could become a commercial commodity) or with a special location (art gallery or museum) they hoped to find a way of eluding the system—especially the system's elaborate structures for endowing their work with an exclusiveness, rarity value and luxury character they did not want it to have.

Modernism and Post-Modernism

It was during the seventies that the purist trends from Post-Painterly Abstraction to Minimalism came to be seen as the last stage of Modernism. And they seemed increasingly to lay the whole modern movement open to the charge of artistic narcissism, especially in the United States, where Minimalism was at its most extreme. Certainly they were self-referential to an unusual degree. Sculpture looked more and more like architecture, the Minimal grid becoming a characteristic form, almost an emblem, as, for example, in *Untitled Cube (6)* by Sol LeWitt (b. 1928) (21, 17). 'Presently', wrote a young American painter, John Perrault, in 1979, 'we need more than silent cubes, blank canvases and gleaming white walls. We are sick to death of cold plazas and monotonous "curtain wall" skyscrapers.' Architecture, much more clearly and consistently than painting and sculpture, had displayed the modern movement's high-minded austerity and self-abnegation and it now invited relaxation with hedonistic 'impurities'. And it was in architecture that the current situation was first polarized as Modernism and Post-Modernism.

Although purely European in origin, the International Style had come to be seen as characteristically American. Gropius and other leading members of the Bauhaus staff emigrated to America in the late 1930s and it was there, in the immediate post-Second World War years, that the style found its greatest exponent in Mies van der Rohe (p. 601). Very few of his designs had been executed in Europe. In those optimistic post-war years, however, no statement of pure, ideal form was too Platonic for realization in America and the clean, healthy and, above all, rational beauty of Mies van der Rohe's designs seemed to symbolize the new technology and its utopianism. Such 'ideal' solutions to design problems as the Farnsworth House (21, 19) and the Lake Shore Drive Apartments (21, 18) combine cubic simplicity with elegant precision of detail and immaculate finish in 'compositions of supreme poise and balance. A progeny of curtain-walled metal and glass skyscrapers proliferated, especially in the United States, beginning with the Lever House, New York

21, 17 Sol LeWitt, *Untitled cube (6)*, 1968. Painted steel, $15\frac{1}{4} \times 15\frac{1}{4} \times 15\frac{1}{4}$ ins ($39 \times 39 \times 39$cm). Whitney Museum of American Art, New York (Gift of the Howard and Jean Lipman Foundation, Inc.)

prominent works by Frank Lloyd Wright (pp. 586–7) and Le Corbusier (p. 601). Of course, Wright had always gone his own way and never subscribed to any movement or 'style', but his circular ramp design for the Guggenheim Museum in New York of 1943–59 (intended originally for a drive-in planetarium) was taken as a deliberate affront by functionalists and, indeed, it did assert the value of idiosyncrasy,

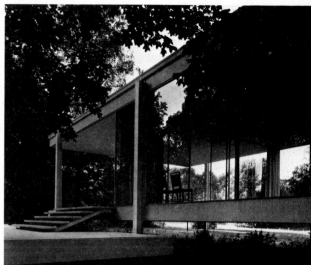

21, 19 Mies van der Rohe, Farnsworth House, Fox River, Illinois, 1945–50.

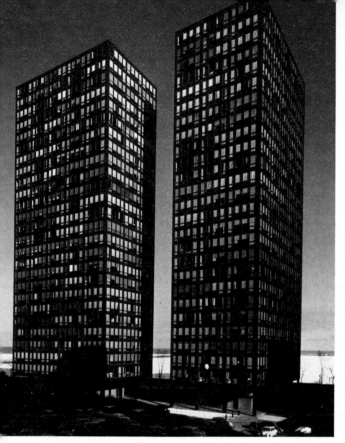

21, 18 Mies van der Rohe, Lake Shore Drive apartment houses, Chicago, 1950–52.

(1951–2), by Gordon Bunshaft (b.1909) of the firm Skidmore, Owings and Merrill. However, there were those who judged even Mies van der Rohe's masterly designs to have been sublime failures. (Dr Farnsworth found her house far too expensive to live in and tried, unsuccessfully, to sue the architect.) The critic Lewis Mumford probably spoke for many when he wrote that:

> Mies van der Rohe used the facilities offered by steel and glass to create some elegant monuments of nothingness. They had the dry style of machine forms without the contents. His own chaste taste gave these hollow glass shells a crystalline purity of form; but they existed alone in the Platonic world of his imagination and had no relation to site, climate, insulation, function, or internal activity; indeed, they completely turned their backs upon these realities just as the rigidly arranged chairs of his living rooms openly disregarded the necessary intimacies and informalities of conversation. (*The Case against 'Modern Architecture'*, 1964)

Hostility to the purism and impersonality of the International Style was felt soon after 1945 in

especially in an urban context (21, 2). Le Corbusier had abandoned Purism in his paintings some years before the Second World War—he was both painter and architect—but it was not until about 1950 that Expressionism made itself felt in his architecture with amoeboid curves, biomorphic forms and irregular plans. The pilgrimage chapel on a hill-top near Ronchamp in central France (21, 20) flouts all the geometrical, rational principles of his earlier work. Though he disclaimed any specific religious inspiration, this small building is richly suggestive of meaning and goes beyond architectural symbolism to intimate a new architectural language of metaphor. In the High Court Building he designed a few years later as part of his new government centre at Chandigarh in India, the conflict between plasticity and geometricality, which makes the Ronchamp chapel so dynamic, was resolved with powerful monumentality on a heroic scale (21, 21).

These works sparked off a number of equally sculptural, almost irrational, aggressively rough and chunky, so-called Brutalist buildings by young architects all over the world in the late 1950s and early 1960s—Paul Rudolph (b.1918) in America, James

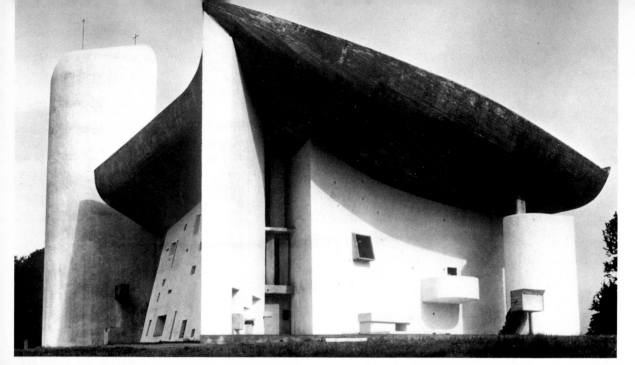

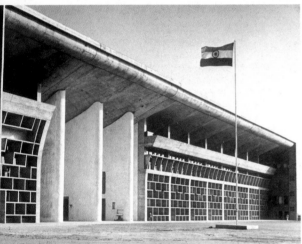

21, 20 *Above* Le Corbusier, Notre Dame du Haut, Ronchamp, France, 1950–54, from the south-east.
21, 21 *Left* Le Corbusier, Court of Justice, Chandigarh, India, 1956.

Stirling (b. 1926) in Britain, Kenzo Tange (b. 1913) and several others in Japan. But it was only in the 1970s, following the publication of *Complexity and Contradiction in Architecture* and *Learning from Las Vegas* by the architects Robert Venturi (b. 1925) and Denise Scott Browne (b. 1931) that a more radical and fully articulate reaction to the still flourishing International Style emerged. Called Post-Modernism, it is the creation of architects, most of whom were trained in the austere discipline of the International Style, which they have sought to transform by extending its élitist language 'into the vernacular, towards tradition and the commercial slang of the street' (Charles Jencks, *The Language of Post-Modern Architecture*, 1978).

The utopian, collectivist, revolutionary, technological and functional ideology which was supposed to have sustained Modernism in architecture—and gave it a single rationally determined goal—was rejected in favour of something deliberately less idealistic and earnest but, it was hoped, more democratic. The eclecticism to which this led ranged from Pop imagery to a piquant historicism notably in Venturi's own buildings. The house he designed for his mother (21, 22) revives traditional principles and characteristic forms of pre-Modern architecture—symmetry, for instance, and the gable like a Mannerist broken pediment—but they are set in opposition to the Modernism of flat planes and standard detailing, so that the contradiction gives the building meaning. Later manifestations of Post-Modernism have been less sophisticated and more stagey, not always unintentionally. In 1964, Charles Willard Moore (b. 1925) praised Disneyland as one of America's outstanding public spaces and an embodiment of the American Dream which inspired his own work. The Piazza d'Italia he designed for the Italian-American community in New Orleans (1978–9) is rich in colour, some of which is provided by neon lighting, with

columns, a temple front, and a fountain spilling into a map of Italy. The most monumental example of Post-Modernism to date is the Public Service Building by Michael Graves (b. 1934) in Portland, Oregon (21, 23). Here International Modernism, exemplified by huge areas of plate glass, is treated as one of several 'historical' styles, together with skyscraper imagery, Art Deco and Art Nouveau trimmings (fluttering fibreglass garlands), the purist 'revolutionary' architecture of late eighteenth-century France, and such transformed Classical elements as huge pilasters and a gigantic red keystone. 'Discipline, the backbone of architecture as a civic art is ridiculed', a practitioner of International Modernism complained — in words which vividly recall the objections raised by traditionalists half a century earlier to the work of Le Corbusier! But Graves's aim has been to create in a city of impersonal concrete and steel-and-glass boxes a building that exploits the metaphorical riches of the language of architecture with multiple layers of form, space and symbolism. It is a building that speaks not

housing project 'Les Arcades du Lac', near Versailles, openly challenges comparison with the Château de Versailles itself. Commenting on it, Bofill remarked that it takes 'without copying, different themes from the past, but in an eclectic manner, seizing certain moments in history and juxtaposing them, thereby prefiguring a new epoch.' The forms of Aldo Rossi's buildings are often taken from Boullée (p. 479), but are raised to what he calls 'an exalted rationalism, emotional and metaphorical', and have mostly, like Boullée's, remained on paper. The generous hopes for a richer, more allusive and vivacious architecture which inspire Post-Modernism have perhaps been best attained in Japan, where the combination of popular 'content' and sophisticated 'form' had once before been realized in art. Post-Modern architects such as Arata Isozaki (b. 1931), Kisho Kurokawa (b. 1934) and Minoru Takeyana (b. 1934) have some of the same

21, 22 Robert Venturi, Chestnut Hill House, Pennsylvania, 1965.

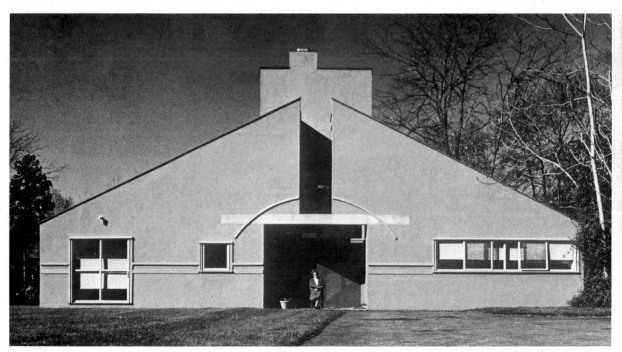

only to a professional élite, but also to the man in the street.

In Europe the best-known Post-Modern or 'revisionist' architects are the Spaniard Ricardo Bofill (b. 1939) and the Italian Aldo Rossi (b. 1931), whose ostensibly autonomous architecture is manifestly derived from the past. Bofill's extensive and grandiose

elegance (without gentility) and proletarian taste (without vulgarity) of the great masters of the *Ukiyo-e* prints (16, 12). Isozaki's highly personal use of even the simplest forms, especially cylinders and cubes, achieves an effect of internationalism quite distinct from that of the International Modern style in its allusions to the architectural heritage of the world (21,

24). That he should acknowledge debts to Palladio, Sinan and Boullée, as well as his own Japanese cultural background, is a sign of our own pluralist times.

In the present century, the enormously increased facilities for travel, combined with the vast expansion of the 'imaginary museum' of works of art and architecture known from photographs and reproductions, have greatly enlarged and modified attitudes of both artists and the general public. For the first time an artist is inevitably, unavoidably aware of the art of the whole world from prehistoric times to the present day, and this has provoked anxious and often introspective enquiry into the meaning and purpose of art. In the past the question hardly arose—art, as we have seen, was predominantly sacred. Today art has largely lost this religious function and nothing comparable has taken its place, unless it be a preoccupation with the problem of the artist's and art's role. (This has, indeed, increasingly become the subject of art itself.) As a result many of the assumptions on which art had previously been based, especially in the West, have been revised if not abandoned. The idea of 'progress' in art and the related concepts of an 'avant-garde' and forward-looking 'movements' have all been

questioned—together with the desirability of permanence, not to mention artistic 'quality' and 'taste'. Yet in every known human society art remains an essential part of the cultural structure, itself constantly regenerated as a result of internal and external pressures. Attempts by late twentieth-century artists to relate their own traditions to those of other cultures, their quest for means to express reactions to the mixed blessings of technology as well as the conflicting nationalist and internationalist, transcendental and materialist ideologies, reflect the dominant concerns of our time. The German sculptor Joseph Beuys (b. 1921) is in this respect one of the most significant living artists, the creator of intensely personal but widely relevant, transient yet haunting images. His 1965 Düsseldorf performance or 'social sculpture' entitled *How to explain pictures to a dead hare*—head covered with honey and gold leaf, muttering inaudibly for three hours to a dead hare in an empty art gallery—was an examination in complex tableau form of the problems of thought and communication, with reference also to ritual, magic and myth, including his own semi-mythical biography. Above all, it reflected our anxious need for explanations. 'My objects are to be seen as stimulants for the transformation of the idea of sculpture or of art in general', he said in an interview in 1978. 'They should provoke thought about what

21, 23 Michael Graves, Portland Public Office Building, Portland, Oregon, 1980.

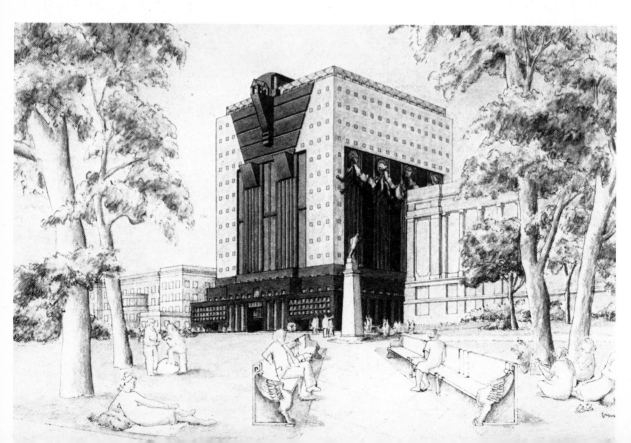

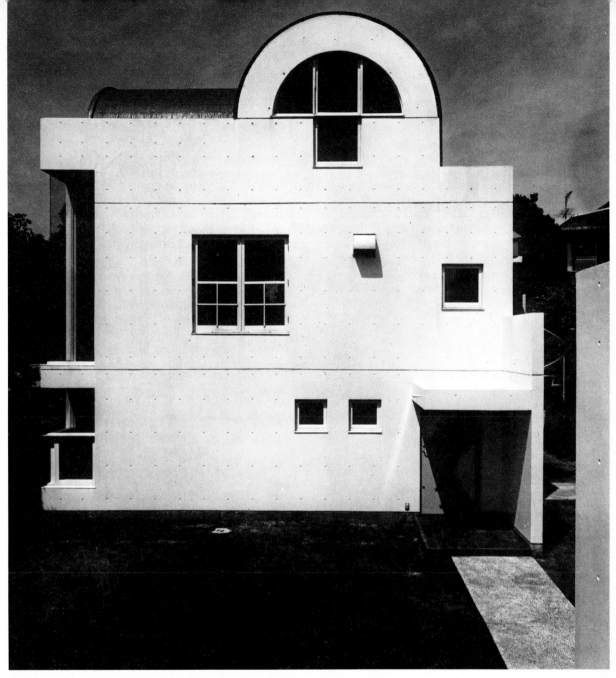

sculpture *can* be and how the concept of sculpting can be extended to the invisible materials used by everyone.' His aim is to create what he calls 'Social Sculpture' based on how we mold and shape the world in which we live. As a teacher, his guiding principle is that: 'One can no longer start from the old academic concept of educating great artists—that was always a happy coincidence. What one can start from is the idea that art and experience gained from art can form an element that flows back into life.'

21, 24 Arata Isozaki, Kaijima House, Kichijoji, Musashino City, Tokyo, 1974–6.

Glossary

ACANTHUS Mediterranean plant with thick, prickly leaves, the supposed source of much foliage ornament as on Corinthian capitals (4,31).

ACRYLIC PAINT A synthetic medium developed c.1960, quick-drying and retaining brightness. It permits effects of transparency and IMPASTO but is generally used for work in flat colour (21,12).

ADOBE Mud brick, sun-dried but not fired.

AERIAL PERSPECTIVE, see PERSPECTIVE.

ALTARPIECE, see p. 302.

AMBULATORY An aisle surrounding the choir or chancel of a (usually medieval) Catholic church (9,28).

ANASTASIS Byzantine painting of Christ's harrowing of Hell (9,41).

ANG In Chinese roof construction a long transverse bracket arm with the function of a lever. An *ang tou* is placed directly under a roof sloping downwards to the eaves.

APADANA The columned (hypostyle) audience-hall of Persian kings, e.g. at Persepolis, see p. 80.

APSARAS Heavenly maidens of the Buddhist paradises; in Hindu art, members of Indra's seraglio (6,30).

APSE Vaulted semicircular termination of a building, usually a church (7,5; 7,16; 9,12).

ARABESQUE Intricate surface decoration of plant forms, spirals, knots etc. without human figures (see also GROTESQUE).

ARCHITRAVE The lowest part of an ENTABLATURE, see ORDERS.

ARCHIVOLT The continuous molding on the face of an arch, also the underside of an arch.

ARCUATED A building dependent structurally on arches as distinct from one constructed on the post-and-lintel or TRABEATED principle.

ARMATURE Framework on which sculpture in clay is supported.

ASHLAR Hewn rectangular blocks of stone laid in regular courses.

ATRIUM Inner courtyard of Etruscan and ancient Roman house (5,22), also the forecourt of an Early Christian church, see p. 221.

BALDACCHINO Canopy over a throne, altar etc. (13,12).

BASILICA, see pp. 221–2.

BATTER The inclined face of a wall.

BAY Vertical division of the exterior or interior of a building marked by fenestration, an order, buttresses, units of vaulting, etc.

BODHISATTVA, see p. 184.

BUTTRESS Masonry or brickwork projecting from or built against a wall to give additional strength, usually to counteract the lateral thrust of an arch, roof or vault.

CALLIGRAPHY Fine (literally 'beautiful') handwriting (8,1).

CAMEO A gem, hardstone or shell having two layers of colour the upper of which can be carved in relief and the lower used as a ground (5,24).

CAPITAL The upper member of a column, see ORDERS.

CARTOON A full-size drawing for a painting. (In modern usage, a satirical or comic drawing, especially one in a newspaper.)

CAST Reproduction of a sculpture in plaster or metal from a mold.

CELLA The chamber in a temple, usually for a cult image.

CENTERING Wooden framework used in construction of arches and vaults, removed (or 'struck') when the mortar has set.

CHAITYA An Indian, Buddhist or Hindu, temple or shrine. A chaitya hall has an apsidal end and aisles like a BASILICA (6,6). The chaitya arch was originally a stone version of the gable of a thatched hut but developed into a horse-shoe shape.

CHALK Calcium carbonate, a white substance used for drawing, ground to powder and mixed with pigments for PASTELS, also a component of GESSO.

CHAMPLEVÉ, see ENAMEL.

CHASHITSU A small Japanese building, or room, for the tea ceremony (12,58).

CHATTRA A honorific Indian umbrella or canopy, also one simulated in stone as on the mast of a Buddhist STUPA (6,5), in Hindu temple architecture or Indian palace architecture.

CHEVET French term for the east end of a church, comprising the choir, ambulatory, apse and radiating chapels if there are any (9,12; 9,28).

CHIAROSCURO In painting, the manipulation of light and shade to give the effect of modelling.

CHIGI Japanese name for the scissors-like finials on the roof of a Shinto temple.

CIBORIUM A type of BALDACCHINO, a canopy supported on columns over the altar of a church.

CIRE PERDUE Lost wax – a process of making a cast from a model in wax by enclosing it in clay, melting the wax out and filling the resulting mold with molten metal (usually bronze) or plaster.

CLERESTORY The upper stage of the nave walls of a BASILICA or church, rising above the aisle roofs and pierced with windows (9,29).

CLOISONNÉ, see ENAMEL.

CLOISTER An enclosed space, usually an open court surrounded by covered passages, in a Christian monastery.

CODEX A manuscript composed of pages bound together as distinct from a scroll or rotulus.

COLLAGE A composition made by glueing pieces of paper, cloth etc. on a canvas or other ground (19,21).

COLOSSAL ORDER A Classical ORDER of giant columns rising from the ground through more than one story (11,18).

COLOSSUS A statue very much more than life-size.

COLOUR The sensation produced on the eye by light rays. The seven main rays which make up the visible spectrum are subdivided into three primary colours or hues: red, yellow and blue, each of which has a complementary colour composed of the other two. Colour values are determined by the amount of light different hues reflect (yellow has a high, blue a low value), irrespective of the saturation or purity of the hue. See also LOCAL COLOUR.

COLUMN An upright member, circular in cross-section and usually intended as a support, see ORDERS.

CONCRETE, see pp. 160–1.

CONTRAPPOSTO A pose in which one part of the body is twisted in an opposite direction to another, see p. 360.

CORBELLING Masonry courses each built out above the one below as a bracket or to form a rough arch, vault or dome.

CORINTHIAN ORDER, see ORDERS.

CORNICE In Classical architecture the top, projecting section of an entablature, also any projecting ornamental molding along the top of a wall, arch etc.

CRAYON Powdered pigment mixed with wax or paraffin and made into a stick for drawing.

CROSS One of the most ancient of symbols. Two main types have been used for plans of Christian churches, the Greek cross with equal arms and the Latin cross with the horizontal shorter than the vertical. Other types used as symbols and ornaments include the Maltese cross with wedge-shaped arms meeting at the points.

CROSS-HATCHING A method of shading in drawings and engravings by superimposing HATCHING in opposite directions.

CROSSING The space at the intersection of the nave, choir and transepts of a church (13,12).

CRYPT A chamber or vault beneath the main floor of a church.

CUPOLA A dome, see VAULTING.

CYCLOPEAN MASONRY Masonry composed of very large irregular blocks (2,38).

DEËSIS A representation of Christ enthroned in majesty between the Virgin and St John the Baptist, as found in Byzantine art.

DIPTERAL TEMPLE A Classical temple with two rows of columns on each side.

DIPTYCH A picture or relief on two hinged panels.

DOME, see VAULTING.

DORIC, see ORDERS.

ELECTRUM A natural alloy of silver and gold.

ELEVATION An external face of a building, also a drawing of one made in projection on a vertical plane (11,41).

ENAMEL A vitreous substance that can be fused to a metal surface under heat. *Champlevé* enamel is poured into grooves engraved on metal (9,37). *Cloisonné* enamel is poured into *cloisons* or compartments formed by a network of metal bands the tops of which remain exposed dividing one colour area from another (9,10).

ENCAUSTIC An ancient technique of painting with pigmented wax fused with the support by the application of hot irons.

ENGRAVING An incised design, also a print made from an engraved metal plate (10,34); see also ETCHING and WOODCUT.

ENTABLATURE, see ORDERS.

ENTASIS The slight convex curve in the shaft of a column, see p. 106.

ETCHING A print from a metal plate on which the design has been etched or eaten away by acid (13,30).

FAÇADE The architecturally emphasized front or face of a building.

FAIENCE Pottery with a tin-glaze (a glaze composed of oxides of lead and tin combined with silicate of potash) called in Italy *maiolica* (10,38); also a glassy substance made from powdered quartz in the ancient Near East and Aegean.

FERROCONCRETE A modern development of CONCRETE reinforced by the insertion of steel mesh or rods. Also called reinforced concrete.

FETISH An object to which magic power is attributed.

FLUTING Shallow concave grooves running vertically on the shaft of a column, pilaster or other surface.

FLYING FAÇADE The continuation of the FAÇADE wall of a building above the roof-line, especially in Mayan architecture.

FORESHORTENING Perspective applied to a single form, e.g. a foot represented as pointing out of, not in line with, a pictorial plane (4,13; 4,14).

FRESCO Wall and ceiling painting on fresh (*fresco*) moist lime plaster with pigments ground in water so that they are absorbed into the plaster. Pigments added after the plaster has dried are said to be applied *a secco*, see p. 310, 9,50.

FRIEZE The middle division of an entablature, see ORDERS, also loosely any sculptured or decorated horizontal band.

FUSUMA-E Japanese paintings on sliding screens.

GABLE A basically triangular portion of a wall at the end of a pitched roof.

GENRE PAINTING A picture of everyday life (13,34).

GENRES The various categories of painting, e.g. history, landscape, portrait, still-life etc.

GESSO A composition of gypsum or chalk and size sometimes with other materials. Applied to a panel it provides a smooth absorbent white GROUND for painting, usually in TEMPERA. It can also be modelled in relief. The term gesso is sometimes used for plaster of Paris, a white gypsum powder that forms a paste when mixed with water and hardens into a solid, used by sculptors for molds and casts.

GLAZE On pottery a glossy waterproof surface produced by the vitrification of silica (present in most clays) with a flux e.g. oxide of lead, tin etc. In painting a transparent film of oil paint which modifies the solid colour over which it is applied.

GOPURAM Monumental gateway to a Hindu temple.

GOUACHE Opaque WATERCOLOUR paint.

GRAPHIC ARTS The arts which depend on drawing rather than colour but generally including all forms of print-making.

GROTESQUE Fanciful decoration similar to but distinct from ARABESQUE in that it includes human figures, animals and architectural elements.

GROUND The surface on which a painting is executed.

GUTTAE, see ORDERS.

HATCHING Parallel lines indicating shadow in a drawing, engraving etc.

HISTORIATED Ornament incorporating human or animal figures.

HISTORY PAINTING In European academic theory a figurative painting of a scene from classical mythology, the Bible, the lives of saints or an historical event.

HUA In Chinese roof construction a bracket, usually one of several comprising a TOU KUNG.

HUE, see COLOUR.

HYPOSTYLE HALL A large space over which the roof is supported by rows of columns.

ICON, see p. 241.

ICONOCLASM, see p. 241.

ICONOSTASIS The screen separating the sanctuary from the nave of a Byzantine church, usually covered with icons.

ILLUMINATED MANUSCRIPT A manuscript decorated with drawings or paintings; see also MINIATURE PAINTING (7,20; 7,28; 7,38).

IMPASTO Oil paint thickly applied.

IONIC, see ORDERS.

INTAGLIO A gem with incised carving, as distinct from a CAMEO.

ITALIC The peoples of ancient Italy and their cultures, usually excluding Etruscan, Roman and colonial Greek.

IWAN In Near-Eastern architecture, a large porch or shallow hall with a pointed barrel vault, as in the Sassanian palace at Ctesiphon (8,2) and many later Islamic buildings where it may serve as an entrance (12,28) or face a courtyard (12,31).

KAKEMONO Japanese painting mounted to be hung vertically. A print made as a substitute is called a Kakemono-e.

KEYSTONE The central stone of an arch or rib vault.

KONDO The main hall of a Japanese Buddhist monastery (6,55).

LACQUER A waterproof substance made from the sap of a Chinese tree (*Rhus verniciflua*) used mainly as a protective and decorative covering (p. 88 and 3,27). Large but light-weight sculptures made in China and Japan by the *dry lacquer* process are composed of pieces of hemp cloth soaked in lacquer and covered with further coats of lacquer, over a wooden armature or clay core which could be removed to leave a hollow shell.

LINGAM Phallic emblem of the Hindu god Siva, usually a simple cylinder with rounded top (6,13).

LINTEL A horizontal beam or stone bridging an opening.

LITHOGRAPHY A process of print-making from a drawing in oily crayon on stone (15,8, and p. 488). Invented 1798.

LOCAL COLOUR An object's actual colour when seen close up in clear light, as distinct from the colour it appears to have when seen from a distance, or takes on by reflection from other objects or from the

atmosphere, e.g. at sunset.

LOST WAX, *see* CIRE PERDUE.

LUNETTE A semicircular shape.

MADRASSA Islamic college for teaching theology and canon law.

MAESTÀ Italian name for a painting of the Madonna and Child enthroned in 'majesty'.

MAGNA Trade name for a brand of ACRYLIC colours.

MAIOLICA, *see* FAIENCE.

MALANGGAN A ritual performed in New Ireland (Melanesia) and the objects used in it (18,25).

MANDALA Diagram of the Buddhist cosmos (p. 196).

MANDAPA A large open hall, especially one in a Hindu temple complex (12,36).

MANDORLA An almond-shaped glory of light surrounding a figure, usually the Risen Christ or Virgin.

MASTABA Superstructure of an ancient Egyptian tomb: a massive brick or stone mound with battered walls on a rectangular plan.

MBIS Carved wood memorial pole erected by the Asmat of New Guinea (18,6).

MEGALITH A large piece of stone of irregular shape, roughly dressed or left as found (1,17).

METOPE, *see* ORDERS.

MIHRAB A niche or flat slab in the QIBLA

WALL of a MOSQUE.

MINARET A tall tower from which Muslims can be called to prayer, attached to a MOSQUE (8,11; 12,23).

MINBAR The high pulpit from which an imam leads communal prayers and addresses the congregation in a MOSQUE.

MINIATURE PAINTING A painting with figures outlined in *minium* (a red pigment), usually an ILLUMINATED MANUSCRIPT; by extension any manuscript illumination. More loosely, any very small painting, often a portrait head.

MODULE A unit of measurement used to regulate the proportions of a building.

MONTAGE A picture composed of prints, photographs etc. cut out and mounted (20,9).

MOSAIC A pictorial composition made of small coloured stones (pebble mosaic) or cubes of stone, glass etc. set in plaster (5,16; 7,13).

MOSQUE Islamic building for communal prayer, *see* pp. 254–6.

NAMBAN A Japanese painting of foreigners, usually Europeans.

NARTHEX A porch or vestibule at the main entrance of a church.

NAVE The congregational area of a church, usually its western limb flanked by aisles.

OCULUS A circular opening in a wall or dome (5,33).

OGEE Double curved lines made up of a concave and convex part (S or inverted S), two such lines constituting an ogee arch.

ORDERS In Classical architecture an order consists of a column with base (usually), shaft, capital and entablature decorated and proportioned according to

one of the five accepted modes, *see* fig. below.

ORTHOGONALS Lines running into space at right angles to the picture plane in a painting or relief, observing the laws of linear perspective, *see* p. 319.

ORTHOSTAT A slab of stone set upright at the base of a wall and sometimes carved in relief, *see* pp. 65 and 75.

OIL PAINT Pigments mixed with oil, usually linseed, *see* pp. 322–3.

PAGODA European name for a Far Eastern Buddhist temple tower, called in Chinese a *t'a* (6,54), in Japanese a *shoro* if it serves as a bell-tower (6,46) or a *tahoto* if it has a single room with elaborate superstructure.

P'AI-LOU A Chinese monumental gateway usually of stone.

PAINT Pigments ground and mixed with a liquid vehicle, *see* ACRYLIC, FRESCO, OIL PAINT, TEMPERA, WATERCOLOUR.

PAINTERLY Characteristic of a painting in which forms are defined by tone rather than line.

PANTOCRATOR Byzantine representation of Christ as universal ruler, usually in the dome or apse of a church (7,36).

PASTEL Dry powdered colour mixed with a little gum as a binding agent.

PEDIMENT A low pitched gable over a portico, door or window.

PENDENTIVE A concave SPANDREL leading from the angle of two walls to the base of a circular dome (7,18).

PERIPTERAL TEMPLE A temple surrounded by a single row of columns.

PERISTYLE A colonnade around the inside of a court or room, also the space

Order

A Entablature	D Frieze	G Shaft
B Column	E Architrave	H Base
C Cornice	F Capital	I Plinth

1 Guttae	4 Abacus	7 Fluting
2 Metope	5 Echinus	8 Dentils
3 Triglyph	6 Volute	9 Fascia

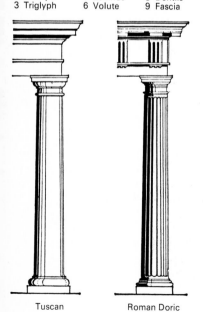

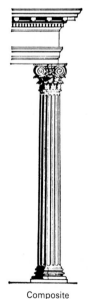

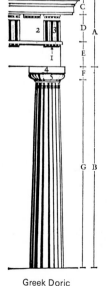

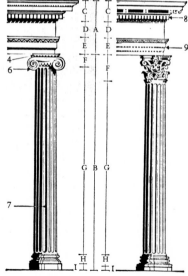

Tuscan Roman Doric Composite Greek Doric Ionic Corinthian

surrounded by such a colonnade.

PERSPECTIVE Systems of representing objects in spatial recession, *see* p. 319 (linear perspective) and p. 359 (aerial perspective).

PICTURE PLANE The flat surface of a picture. If painted according to Western ideas of perspective it is conceived as a transparent plane (or window) between the spectator and the pictorial space.

PIER A solid masonry support, as distinct from a column.

PIETÀ An image of the Virgin with the dead Christ on her lap.

PILASTER A shallow pier projecting only slightly from a wall, in Classical architecture a rectangular column conforming to one of the ORDERS.

POINTING APPARATUS A device for measuring volumetric proportions to enable carvers of marble and other stone (rarely wood) sculptures to make accurate copies, enlargements or reductions of models (usually in clay or plaster). The model is marked at its extremities with points and the distances between them and a plumb-line or wooden framework measured so that holes can be drilled at corresponding points to corresponding depths and a copy of the model thereby roughed out. Various instruments which can measure the relationship of any part of a model to three fixed points have been developed, e.g. the misleadingly named 'pointing machine' used in Europe from the early nineteenth century, with one adjustable and three fixed points. (They are not to be confused with hydraulically or electrically operated carving machines developed since the mid-nineteenth century.)

POLYPTYCH A painting or relief, usually an altarpiece on more than three panels, *see* TRIPTYCH.

POST AND LINTEL, see TRABEATED.

PREDELLA The platform on which an altar is set or a small step at the back of an altar, often below an altarpiece, also the paintings or carvings on either of these areas.

PRIMING A coating applied to a surface which is to be painted. A canvas for OIL PAINTING is usually coated with size (a thin solution of a gluey or resinous substance) and then primed with white lead.

PROGRAM The predetermined and often literary 'subject' of a work of art, e.g. the story illustrated in a narrative or history painting, or the theme of an allegorical painting.

PURLIN A horizontal longitudinal timber in a roof.

PUTTO Italian for a male child, especially one shown naked in Renaissance and later art (10,35).

PYLON A pair of truncated pyramidal towers flanking a gateway in ancient Egyptian temple architecture (3,13).

QIBLA WALL The wall of a mosque facing Mecca to which Muslims must turn when praying.

RADIOCARBON DATING A method of estimating the age of organic material (wood, bone, etc) by measuring its residue of the radioactive isotope of carbon or C-14. C-14 is produced by nitrogen-14 in the atmosphere by cosmic radiation and taken into the compounds of all living matter. It was discovered in 1946 that when living matter dies its C-14 content begins to decay. Measurement of the radioactivity of a specimen gives an indication of the time that has elapsed since the death of its material with a 68% probability that this is within 130 years, plus or minus, a 95% probability that it is within 260 years, and a 99.5% probability that it is within 390 years. Pottery is not susceptible to radiocarbon dating but thermoluminescence tests (also based on radioactivity) indicate the lapse of time, plus or minus 10%, since the mineral crystals in the clay were last heated.

REINFORCED CONCRETE, *see* FERRO-CONCRETE.

REPOUSSÉ Relief decoration on metal (mainly gold, silver and copper) produced by hammering from the underside (2,36).

REREDOS, *see* RETABLE.

RESPOND A half-pier bonded into a wall and carrying one end of an arch.

RETABLE The structure behind an altar (also called a reredos), especially one with carved figures in the *corpus* or central part, flanked by carved and/or painted wings (11,6).

RIDGE A horizontal longitudinal timber at the apex of a pitched roof supporting the ends of rafters.

ROOF COMB The ornamental extension of the rear wall above the roof level in a Mayan building (12,3).

RUSTICATION Massive blocks of masonry with roughened surfaces and sunk joints, often simulated in plaster (10,10a; 11,40).

SACRA CONVERSAZIONE The Virgin and Child with saints depicted in such a way that they occupy a single pictorial space, *see* p. 343.

SATURATION, *see* COLOUR.

SCUMBLING A layer of opaque or semi-opaque oil paint applied over another which it only partly conceals, giving a broken effect, softening hard lines.

SECTION A diagrammatic drawing of a vertical plane cut through a building, *see* p. 163.

SERIGRAPHY, *see* SILK-SCREEN.

SFUMATO A soft misty effect attained in oil painting mainly by the use of GLAZES to create delicate transitions of colour and tone, *see* p. 359.

SHAFT GRAVE A deep narrow pit for burial of the dead.

SHAMAN A priest believed to have contact with and ability to control good and evil spirits, especially in north-east Asian and north-west American cultures.

SHORO, *see* PAGODA.

SIKHARA The spire or tower over the shrine of an Indian temple (6,25).

SILK-SCREEN A process of making prints by squeezing paint through a piece of silk parts of which have been masked, exploited by commercial artists since the 1930s. One impression can be made to differ from another by varying the density of paint. Also called serigraphy.

SINOPIA A reddish brown pigment. The under-drawing for a FRESCO, often made in this medium, is also called a *sinopia*.

SLIP A mixture of fine clay and water used as a covering for vessels made from coarser and more porous clay, and fired together. Slip was often used decoratively.

SPANDREL A triangular area between the side of an arch with the horizontal drawn from its apex and the vertical from its springing, or that between two arches in an arcade, or that of a vault between ribs.

SQUINCH An arch or system of concentrically wider and gradually projecting arches placed diagonally to support a polygonal or round superstructure on a square base.

STAFF GOD Polynesian cult image of carved wood wrapped in cloth (18,3).

STELE An upright slab with an inscription or relief carving, usually commemorative (4,30).

STEREOTOMY The art of cutting stone into sections of geometric solids.

STOA A covered colonnade, in ancient Greek and Roman cities, flanking the agora or open market- and meeting-place.

STRING COURSE A continuous horizontal band in or more usually projecting from an exterior wall.

STUCCO Various types of plaster used as a protective and decorative covering for walls. A mixture including lime and powdered marble has been extensively used for relief decorations on ceilings and interior walls since the sixteenth century in Europe (14,15).

STUPA An Indian sacred mound, originally sepulchral but later of a type erected by Buddhists to enshrine a relic or mark a holy site (6,5).

SURINOMO A Japanese presentation print on special paper.

SUTRA A book of the Buddhist canon.

T'A, *see* PAGODA.

TAHOTO, *see* PAGODA.

T'AO-T'IEH Chinese term for the dragon mask on Shang dynasty bronze vessels (2,40; 2,41).

TEMPERA Painting with powdered pigments made workable (tempered) by egg-yolk and water, a technique practiced in Europe from the early Middle Ages until the sixteenth century (9,42).

TERM A pedestal tapering towards the base and usually supporting a bust; also a pedestal merging at the top into a human bust or animal figure and similarly tapering towards the base.

TERRACOTTA Baked or fired but unglazed clay.

THERMOLUMINESCENCE, *see* RADIOCARBON DATING.

THOLOS Greek term for a building on a circular plan, usually a temple or tomb.

TOKO-NO-MA The alcove in which a painting or print is hung and a flower vase placed in a Japanese house.

TOTEM The emblem of an individual family or clan, usually an animal. The word is in origin American Indian (Ojibwa) though used in a different sense.

TORANA Indian gateway, especially one on the enclosure of a Buddhist STUPA (6,5).

TOU KUNG Chinese term for a cluster of brackets cantilevered out from the top of a column to carry the rafters and overhanging eaves of a roof.

TRABEATED Construction based mainly on upright members supporting horizontals, as in an ancient Greek temple. Also called *post and lintel*. To be distinguished from ARCUATED.

TRACERY Ornamental intersecting work in the upper part of a Gothic window, screen or panel, or on the surface of a vault. There are two main types: *plate tracery* consisting of decoratively shaped openings cut through the solid stone infilling above an early Gothic window with two or more lights; *bar tracery* consisting of ribwork made, as it were, by bending and interweaving the tops of the mullions within the window frame.

TRANSEPT The transverse arms of a cross-shaped church.

TRIBHANGA Literally 'three bends', the sinuous pose in Indian art and dance (6,4).

TRIFORIUM An arcaded wall passage facing on to the nave of a Romanesque or Gothic church, above the arcade and below the CLERESTORY.

TRIGLYPH, *see* ORDERS.

TRIPTYCH A painting on three panels.

TRILITHON Two upright MEGALITHS supporting a horizontal one.

TRIUMPHAL ARCH A free-standing monumental gateway of a type originated in Rome in the early second century BC (5,37). Also the transverse arch at the east end of a medieval church, framing the altar and apse and marking them off from the rest of the interior.

TROMPE L'OEIL An illusionistic painting

intended to 'deceive the eye', *see* p. 150.

TROPHY A carving or painting of a group of arms and armour such as were erected as memorials to victories by ancient Romans (5,24) and, by extension, similar groups of other objects.

TRUMEAU A stone mullion supporting the middle of a TYMPANUM (9,19).

TYMPANUM The area between the lintel of a doorway and the arch above it (9,18); also the triangular or segmental space enclosed by the moldings of a pediment.

TS'UN Chinese term for brush-strokes which indicate modelling and suggest texture within the outline or contour of a form—rocks, mountains, trees, etc., in landscape painting.

UKIYO-E Japanese representations of everyday life, usually prints but also paintings (16,10).

Vault

a Tunnel vault
b Groin vault
c Rib vault
d Fan vault

1 Transverse rib

2 Diagonal rib
3 Transverse ridge-rib
4 Longitudinal ridge-rib
5 Tiercerons
6 Liernes
7 Boss

VAULTING A masonry roof or ceiling constructed on the principle of the arch. The simplest form is a tunnel or barrel vault of continuous semicircular or pointed section

unbroken by cross-vaults (9,13). The intersection of two tunnel vaults of identical shape produces a groin vault. A rib vault has a framework of arched diagonal ribs between which the cells are filled with lighter stone (9,26). It is called *quadripartite* if each bay is divided into four quarters or cells, *sexpartite* if divided transversely into two parts so that each bay has six compartments (9,27). A *dome* is a vault of even curvature on a circular plan and of segmental, semicircular, pointed or bulbous section. The simplest form is constructed by CORBELLING, *see* p. 57. If a dome is erected on a square base PENDENTIVES or SQUINCHES must be interpolated at the corners to mediate between square and circle. *See* fig. below left.

VITRUVIAN SCROLL A band of repeated wave-like scrolls often used in friezes in Classical architecture.

VOLUTE The spiral scroll on capitals of the Ionic and, less prominently, Corinthian and Composite ORDERS.

VOUSSOIR A wedge-shaped brick or stone forming one of the units of an arch.

WATERCOLOUR Pigments mixed with a gum which dissolves in water providing a transparent stain for application to an absorbent surface, usually paper.

WEN-JEN-HUA Chinese term for the style of painting practiced by literary men or scholar-artists, *see* pp. 211–2 and 414–5.

WESTWORK The west end of a Carolingian or Romanesque church, crowned by a broad tower (sometimes flanked by turrets) with internally a large room opening onto the nave above a low entrance hall (9,4).

WOODCUT A print made from a block of wood from the surface of which all areas not intended to carry ink have been cut away (10,32; 10,35). The block is cut from a smoothed plank of fairly soft wood with the grain running parallel to the surface. A print made from a block of very hard wood cut across the grain and worked with a graving tool is called a *wood engraving*.

YAKSHI Indian nature spirit (6,4).

YAMATO-E Japanese term for paintings in Japanese—as distinct from Chinese—styles (12,46).

ZIGGURAT A rectangular mound built in stepped-back stages and crowned by a temple (2,9).

ZOOMORPH, *see* p. 389.

For further reading

The following list is limited to books in English (only one place of publication being given, although most were published in both England and the USA. The date of first publication is given in brackets). For the most up-to-date bibliography, covering works in the European languages, see E. Arntzen and R. Rainwater, *Guide to the Literature of Art History*, Chicago, 1980. The 15-volume *Encyclopedia of World Art*, New York, 1959–68, presents an exceptionally full and well-illustrated world-wide survey. Handy single-volume dictionaries of artistic terms with brief biographies of artists (mainly Western) include P. and L. Murray, *A Dictionary of Art and Artists* (1959), Harmondsworth, 1976; J. Fleming, H. Honour and N. Pevsner, *Penguin Dictionary of Architecture* (1966), Harmondsworth, 1980; J. Fleming and H. Honour, *Penguin Dictionary of Decorative Arts*, London, 1977. For the history of techniques, there are K. Whelte, *The Materials and Techniques of Painting* (1952), New York, 1975; W. Verhelst, *Sculpture: Tools and Techniques*, Englewood Cliffs, NJ, 1973; R. J. Mainstone, *Developments in Structural Form*, London, 1975.

Chapter 1

C. L. Bruce, *The Stages of Human Evolution*, Englewood Cliffs, NJ, 1968; G. Clark, *World Prehistory in New Perspective* (1961), Cambridge, 1977; J. D. Evans, *Prehistoric Antiquities of the Maltese Islands*, London, 1971; S. Giedion, *The Eternal Present: The Beginning of Art*, New York, 1962; K. M. Kenyon, *Archaeology in the Holy Land*, London, 1960; A. Leroi-Gourhan, *The Art of Prehistoric Man*, London, 1968; A. Marshak, *The Roots of Civilization*, London, 1971; J. Mellaart, *Catal Hüyük: a neolithic town in Anatolia*, London, 1967; P. Phillips, *The Prehistory of Europe*, London, 1980; C. Renfrew, *Before Civilization: the radio-carbon revolution and prehistoric Europe* (1973), Harmondsworth, 1976; N. K. Sandars, *Prehistoric Art in Europe*, Harmondsworth, 1968; P. Ucko & A. Rosenfeld, *Palaeolithic Cave Art*, London, 1967.

Chapters 2 and 3

H. Frankfort, *The Art and Architecture of the Ancient Orient* (1954), Harmondsworth, 1970; R. Ghirshman, *Persia from the Origins to Alexander the Great*, London, 1964; H. A. Groenwegen-Frankfort, *Arrest and Movement*, London, 1951; S. A. Matheson, *Persia: An Archaeological Guide*, London, 1972; A. Parrot, *Sumer and the Dawn of Art* and *The Arts of Assyria*, London, 1960–1.
Indus Valley B. & R. Allchin, *The Birth of Indian Civilization*, Harmondsworth, 1968. E. J. H. Mackay, *Early Indus Civilization*, London, 1948; R. E. M. Wheeler, *The Indus Civilization*, Cambridge, 1968.
Ancient Egypt A. Badawy, *A History of Egyptian Architecture*, 3 vols, Berkeley, 1954–68; I. E. S. Edwards, *The Pyramids of Egypt*, Harmondsworth, 1979; T. G. H. Jones, *An Introduction to Ancient Egypt*, London, 1979; H. Schäfer, *Principles of Egyptian Art* (1918), Oxford, 1974; E. B. Smith, *Egyptian Architecture as Cultural Expression* (1938), New York, 1968; W. Stevenson Smith, *The Art and Architecture of Ancient Egypt* (1958), Harmondsworth, 1980; J. A. Wilson, *The Burden of Egypt*, Chicago, 1951.
Aegean J. Boardman, *Pre-classical: from Crete to Archaic Greece* (1967), Harmondsworth, 1979; S. Hood, *The Arts in Prehistoric Greece*, Harmondsworth, 1978; E. T. Vermueule, *Greece in the Bronze Age*, Chicago, 1972; S. Marinatos & M. Hirmer, *Crete and Mycenae*, London, 1960 (Munich ed, 1973, includes Akrotiri).
Hittites E. Akurgal, *The Art of the Hittites*, London, 1962.
China Wen Fong, ed., *The Great Bronze Age of China*, New York, 1980; M. Loehr, *Ritual Vessels of Bronze Age China*, New York, 1968; J. Rawson, *Ancient China, Art and Archaeology*, London, 1980; W. Watson, *Ancient Chinese Bronzes*, London, 1962; W. Willetts, *Chinese Art*, vol 1, Harmondsworth, 1958.
America G. H. S. Bushnell, *Ancient Arts of the Americas*, London, 1965; G. Kubler, *The Art and Architecture of Ancient America*, Harmondsworth, 1962.
Africa B. F. B. Fagg, *Nok Terracottas*, Lagos & London, 1977.

Chapter 4

S. Adam, *The Technique of Greek Sculpture*, London, 1966; J. Boardman, *The Greeks Overseas*, Harmondsworth, 1964; R. Carpenter, *The Esthetic Basis of Greek Art* (1921), Bloomington, 1963, and *Greek Art*, Philadelphia, 1962, and *The Architects of the Parthenon*, Harmondsworth, 1970; K. Clark, *The Nude*, London, 1956; R. M. Cook, *Greek Art* (1972), Harmondsworth, 1976; A. W. Lawrence, *Greek Architecture* (1957), Harmondsworth, 1967; J. J. Pollitt, *The Art of Greece 1400–31 BC: Sources and Documents*, Englewood Cliffs, NJ, 1965; G. Richter, *A Handbook of Greek Art* (1959), London, 1969; M. Robertson, *A History of Greek Art*, Cambridge, 1975.
Scythian E. C. Bunker, C. B. Chatwin & A. R. Farkas, *Animal Style Art from West to East*, New York, 1970; K. Jettmar, *Art of the Steppes*, London, 1967.
Celtic P. Jacobsthal, *Early Celtic Art*, Oxford, 1944; N. K. Sandars, *Prehistoric Art in Europe*, Harmondsworth, 1968.
Iberian A. Arribas, *The Iberians*, London, 1964.
Etruscan A. Boethius, *Etruscan and Early Roman Architecture* (1970), Harmondsworth, 1979; O. J. Brendel, *Etruscan Art*, Harmondsworth, 1978; M. Cristofani, *The Etruscans: A New Investigation*, London, 1979.

Chapter 5

See K. Clark, R. M. Cook, A. W. Lawrence and M. Robertson above; R. Bianchi Bandinelli, *Rome: the Centre of Power*, London, 1970, and *Rome: the Late Empire*, London, 1971; M. Bieber, *The Sculpture of the Hellenistic Age*, New York, 1961; O. G. Brendel, *Prolegomena to the Study of Roman Art* (1953), New Haven, 1979; R. Brilliant, *Roman Art from the Republic to Constantine*, London, 1974; P. Brown, *The World of Late Antiquity*, London, 1971; A. Burford, *Craftsmen in Greek and Roman Society*, London, 1972; J. Charbonneaux, R. Martin & F. Villard, *Hellenistic Art*, London, 1973; G. Hanfmann, *Roman Art*, Greenwich, Conn, 1964; C. M. Havelock, *Hellenistic Art*, New York, 1971; M. Lyttelton, *Baroque Architecture in Classical Antiquity*, New York, 1974; W. L. Macdonald, *The Architecture of the Roman Empire*, New Haven, 1965 and *The Pantheon*, London, 1976; J. Onians, *Art and Thought in the Hellenistic Age*, London, 1979; J. J. Pollitt, *The Art of Rome c.753 BC–AD 337: Sources*

and Documents, Englewood Cliffs, NJ, 1966;
D. E. Strong, *Roman Art*, Harmondsworth,
1976; J. B. Ward-Perkins, *Roman Imperial
Architecture* (1970), Harmondsworth, 1981.

Chapter 6

P. Brown, *Indian Architecture (Buddhist &
Hindu)* (n.d.), Bombay, 1971; R. C. Craven,
A Concise History of Indian Art, London,
1976; S. Kramrisch, *The Art of India* (1955),
London, 1965; S. E. Lee, *A History of Far
Eastern Art* (1964), New York, 1973;
M. Loehr, *The Great Painters of China*,
Oxford, 1980; R. T. Paine & A. Soper, *The
Art and Architecture of Japan* (1955),
Harmondsworth, 1975; B. Rowland, *The
Art and Architecture of India* (1953),
Harmondsworth, 1971 and *The Evolution of
the Buddha Image*, New York, 1963;
L. Sickman & A. Soper, *The Art and
Architecture of China* (1956),
Harmondsworth, 1971; M. Sullivan, *The
Arts of China* (1967), Berkeley, 1978 and
Symbols of Eternity, Oxford, 1979;
W. Watson, *Style in the Arts of China*,
Harmondsworth, 1974; H. R. Zimmer, *The
Art of Indian Asia* (1955), Princeton, 1960.

Chapter 7

C. Davis-Weyer, *Early Medieval Art
300–1150: Sources and Documents*,
Englewood Cliffs, NJ, 1971; A. Grabar,
Early Christian Art, London, 1968 and
Christian Iconography, Princeton, 1968;
A. Grabar & C. Nordenfalk, *Early Medieval
Painting from the Fourth to the Eleventh
Century*, New York, 1957; F. Henry, *Irish
Art*, Ithaca, 1965–70; R. Hinks, *Carolingian
Art* (1935), Ann Arbor, 1962; J. Hubert, *The
Carolingian Renaissance*, London, 1970;
E. Kitzinger, *Early Medieval Art in the
British Museum* (1940), Bloomington, 1964
and *Byzantine Art in the Making*, London,
1977; R. Krautheimer, *Early Christian and
Byzantine Architecture* (1965),
Harmondsworth, 1975; C. Mango, *The Art
of the Byzantine Empire 312–1453: Sources
& Documents*, Englewood Cliffs, NJ, 1972;
G. Matthews, *Byzantine Aesthetics*,
London, 1963; S. Runciman, *Byzantine
Style and Civilization*, Harmondsworth,
1975; D. M. Wilson & O. Klindt-Jensen,
Viking Art, London, 1966.

Chapter 8

K. A. C. Creswell, *Early Islamic
Architecture* (1932–40), abridged ed.,
Harmondsworth, 1958, rev. ed., vol I,
Oxford, 1969; R. Ettinghausen, *Arab
Painting* (1962), New York, 1977; D. Hill,
*Islamic Architecture and its Decoration
AD 800–1500*, London, 1964; O. Grabar,
The Formation of Islamic Art, New Haven,
1973; E. J. Grube, *The World of Islam*, New
York, 1967; E. Kühnel, *Islamic Art and*

Architecture, Ithaca, 1960; M. Rogers, *The
Spread of Islam*, Oxford, 1976.

Chapter 9

E. Borsook, *The Mural Painters of Tuscany*
(1960), Oxford, 1981; K. G. Conant,
*Carolingian and Romanesque Architecture
800–1200* (1959), Harmondsworth, 1974;
O. Demus, *Byzantine Art and the West*, New
York, 1970; C. R. Dodwell, *Painting in
Europe 800–1200*, Harmondsworth, 1971;
J. F. Fitchen, *The Construction of Gothic
Cathedrals* (1961), London, 1981;
H. Focillon, *The Art of the West in the
Middle Ages* (1938), London, 1963;
P. Frankl, *Gothic Architecture*,
Harmondsworth, 1962; T. G. Frisch, *Gothic
Art 1140–1450: Sources & Documents*,
Englewood Cliffs, NJ, 1971; J. H. Harvey,
The Medieval Architect, New York, 1972;
G. Henderson, *Early Medieval*,
Harmondsworth, 1972, and *Gothic*,
Harmondsworth, 1967; A. Katzenellen-
bogen, *The Sculptural Programs of Chartres
Cathedral* (1959), New York, 1964;
P. Lasko, *Ars Sacra 800–1200*,
Harmondsworth, 1972; E. Mâle, *Religious
Art in France: the twelfth century* (1922),
Princeton, 1978, and *Religious Art in
France, XIII century* (1898), New York,
1973; M. Meiss, *Painting in Florence and
Siena after the Black Death* (1951), New
York, 1964, and *French Painting in the time
of Jean de Berry*, New York, 1968–74;
E. Panofsky, *Abbot Suger and the Abbey
Church of St Denis* (1946), Princeton, 1978,
and *Renaissance and Renascences in Western
Art* (1960), New York, 1972; J. Pope-
Hennessy, *Italian Gothic Sculpture* (1955),
London, 1972; W. Sauerländer, *Gothic
Sculpture in France 1140–1270*, New York,
1973; M. Schapiro, *Romanesque Art*, New
York, 1977; O. G. von Simson, *The Gothic
Cathedral*, Princeton, 1974; H. Swarzenski,
Monuments of Romanesque Art (1954),
Chicago, 1967; J. White, *Art and Architecture
in Italy 1250–1400*, Harmondsworth, 1966;
G. Zarnecki, *Art of the Medieval World*,
Englewood Cliffs, NJ, 1975.

Chapters 10 & 11

J. Ackerman, *The Architecture of
Michelangelo* (1961), Harmondsworth,
1970, and *Palladio*, Harmondsworth, 1967;
M. Baxendall, *Painting and Experience in
Fifteenth-Century Italy* (1972), Oxford,
1974, and *The Limewood Sculptors of
Renaissance Germany*, New Haven, 1980;
B. Berenson, *The Italian Painters of the
Renaissance* (1894–1907), London, 1968;
O. Benesch, *The Art of the Renaissance in
Northern Europe* (1945), Hamden, Conn,
1964; A. Blunt, *Artistic Theory in Italy
1450–1600* (1940), London, 1962; J. C.
Burckhardt, *The Civilization of the*

Renaissance in Italy (1860), London, 1950;
A. Chastel, *The Age of Humanism*, London,
1963, and *The Crisis of the Renaissance
1520–1600*, Geneva, 1968; K. Clark,
Leonardo da Vinci (1939), Harmondsworth,
1967; S. J. Freedberg, *Paintings of the High
Renaissance in Rome and Florence* (1961),
New York, 1972 and *Painting in Italy 1500–
1600* (1971), Harmondsworth, 1975;
C. Gilbert, *History of Renaissance Art*, New
York, 1973; E. H. Gombrich, *Norm and
Form: Studies in the Art of the Renaissance*,
London, 1966, and *Symbolic Images*,
London, 1972; T. Helton ed., *The
Renaissance, a reconsideration of the theories
and interpretations of the age* (1961),
Madison, 1964; L. H. Heydenreich &
W. Lotz, *Architecture in Italy 1400 to 1600*,
Harmondsworth, 1974; R. Klein &
H. Zerner, *Italian Art 1500–1600: Sources
and Documents*, Englewood Cliffs, NJ, 1966;
M. Levey, *The Early Renaissance*,
Harmondsworth, 1967, and *High
Renaissance*, Harmondsworth, 1975;
T. Müller, *Sculpture in the Netherlands,
Germany, France and Spain 1400–1500*,
Harmondsworth, 1966; G. von der Osten &
H. Vey, *Painting and Sculpture in Germany
and the Netherlands 1500–1600*,
Harmondsworth, 1969; E. Panofsky, *Early
Netherlandish Painting* (1953), New York,
1971, and *The Life and Art of Albrecht
Dürer* (1943), Princeton, 1967; J. Pope-
Hennessy, *Italian Renaissance Sculpture*
(1958), London, 1971, and *Italian High
Renaissance and Baroque Sculpture* (1963),
London, 1970; F. Saxl, *Lectures*, London,
1957, and *A Heritage of Images*,
Harmondsworth, 1970; J. Shearman,
Mannerism, Harmondsworth, 1967; W.
Stechow, *Northern Renaissance Art 1400–
1600: Sources and Documents*, Englewood
Cliffs, NJ, 1966; R. Wittkower,
*Architectural Principles in the Age of
Humanism* (1949), New York, 1971.

Chapter 12

O. Aslanapa, *Turkish Art and Architecture*,
London, 1971; D. Barrett & B. Gray,
Painting in India (1963), New York, 1978;
A. Boyd, *Chinese Architecture and Town
Planning*, Chicago, 1962; P. Brown, *Indian
Architecture: The Islamic Period*, Bombay,
1942; G. H. S. Bushnell, *Ancient Arts of the
Americas*, London, 1965, and with
A. Digby, *Ancient American Pottery*,
London, 1956; P. J. C. Dark, *An
Introduction to Benin Art and Technology*,
Oxford, 1973; E. Eyo & F. Willett,
Treasures of Ancient Nigeria, New York,
1980; W. Fagg, *Divine Kingship in Africa*
(1970), London, 1978; G. Goodwin, *A
History of Ottoman Architecture*, London,
1971; O. Grabar, *The Alhambra*, London,
1978; B. Gray, *Persian Painting* (1961), New

York, 1977; R. d'Harcourt, *Textiles of Ancient Peru* (1934), Seattle, 1974; M. Keswick, *The Chinese Garden*, London, 1978; G. Kubler, *The Art and Architecture of Ancient America* (1962), Harmondsworth, 1975; S. E. Lee, *Japanese Decorative Style* (1961), New York, 1972; J. E. S. Thompson, *The Rise and Fall of Maya Civilization* (1954), Norman, Okla, 1970; A. Upham-Pope, *Persian Architecture*, New York, 1965; S. C. Welch, *The Art of Mughal India*, New York, 1964, and *Royal Persian Manuscripts*, New York, 1976; F. Willett, *Ife in the History of West African Sculpture*, London, 1967, and *African Art: An Introduction*, London, 1971. For China and Japan, see also works by S. E. Lee, L. Sickman & A. Soper, R. T. Paine & A. Soper, M. Sullivan and M. Loehr under Chapter 6.

Chapters 13 & 14

A. Blunt, *Art and Architecture in France, 1500–1700* (1953), Harmondsworth, 1973; J. Burke, *English Art 1714–1800*, Oxford, 1976; L. Eitner, *Neoclassicism and Romanticism 1750–1850: Sources and Documents*, vol I, Englewood Cliffs, NJ, 1970; R. Engass & J. Brown, *Italy and Spain 1600–1750: Sources and Documents*, Englewood Cliffs, NJ, 1970; F. Haskell, *Patrons and Painters* (1963), New Haven, 1980; E. Hempel, *Baroque Art and Architecture in Central Europe*, Harmondsworth, 1965; H.-R. Hitchcock, *Rococo Architecture in Southern Germany*, London, 1968; H. Honour, *Neoclassicism* (1968), Harmondsworth, 1977; W. G. Kalnein & M. Levey, *Art and Architecture of the Eighteenth Century in France*, Harmondsworth, 1972; F. Kimball, *The Creation of the Rococo* (1943), New York, 1964; G. A. Kubler & M. Soria, *Art and Architecture in Spain and Portugal and their American Dominions 1500–1800*, Harmondsworth, 1959; M. Levey, *Painting in XVIII century Venice* (1959), London, 1980; D. Mahon, *Studies in Seicento Art and Theory* (1947), Westport, Conn, 1971; J. R. Martin, *Baroque*, New York, 1977; H. H. Rhys ed., *Seventeenth Century Science and the Arts*, Princeton, 1961; J. Rosenberg, S. Slive & E. H. ter Kuile, *Dutch Art and Architecture 1600–1800* (1966), Harmondsworth, 1972; R. Rosenblum, *Transformations in Late Eighteenth Century Art*, Princeton, 1967; W. Stechow, *Dutch Landscape Painting in the Seventeenth Century* (1966), Oxford, 1981; J. Summerson, *Architecture in Britain 1530–1850* (1953), Harmondsworth, 1977; M. Whinney & O. Millar, *English Art 1553–1625*, Oxford, 1957; R. Wittkower, *Art and Architecture in Italy 1600–1750* (1958), Harmondsworth, 1973.

Chapters 15 & 17

A. Boime, *The Academy and French Painting in the Nineteenth Century*, London, 1971; T. J. Clark, *The Absolute Bourgeois* and *Image of the People*, London, 1973; P. Galassi, *Before Photography: Painting and the Invention of Photography*, New York, 1981; S. Giedion, *Space, Time and Architecture* (1941), Cambridge, Mass, 1967, and *Mechanization takes Command* (1948), New York, 1955; R. Goldwater, *Symbolism*, London, 1979; H.-R. Hitchcock, *Architecture Nineteenth and Twentieth Centuries* (1958), Harmondsworth, 1968; W. Hofmann, *The Earthly Paradise: Art in the Nineteenth Century*, London, 1961; H. Honour, *Romanticism* (1979), Harmondsworth, 1981; L. Nochlin, *Realism*, Harmondsworth, 1971 and *Realism and Tradition in Art 1848–1900: Impressionism and Post-Impressionism 1874–1904: Sources & Documents*, Englewood Cliffs, NJ, 1966; B. Novak, *American Painting in the Nineteenth Century*, New York, 1969; F. Novotny, *Painting and Sculpture in Europe 1780–1880* (1960), Harmondsworth, 1971; N. Pevsner, *Pioneers of Modern Design* (1936), Harmondsworth, 1964; J. Rewald, *The History of Impressionism* (1946), New York, 1973, and *Post-Impressionism from Van Gogh to Gauguin* (1962), New York, 1978; A. Scharf, *Art and Photography*, London, 1968; J. C. Sloane, *French Painting between the Past and the Present* (1951), Princeton, 1973; G. P. Weisberg *et al, Japonisme*, Cleveland, 1975; J. Wilmerding, *American Art*, Harmondsworth, 1976.

Chapter 16

R. A. Crichton, *The Floating World: Japanese Popular Prints 1700–1900*, London, 1973; J. R. Hillier, *The Japanese Print: a new approach* (1960), Rutland, Vermont, 1975; R. D. Lane, *Masters of the Japanese Print*, London, 1962; for general studies of art in China and Japan, see works cited under Chapters 6 and 12 above.

Chapter 18

F. Boas, *Primitive Art* (1927), New York, 1955; A. Buhler, T. Barrow & C. P. Mountford, *The Art of the South Sea Islands*, New York, 1962; R. T. Coe, *Sacred Circles*, exh. cat., London, 1976; P. Drucker, *Indians of the Northwest Coast* (1955), Garden City, NY, 1963; V. Ebin, *The Body Decorated*, London, 1979; D. Fraser, *Primitive Art*, Garden City, NY, 1962; P. Gathercole, A. L. Kaeppler & D. Newton, *The Art of the Pacific Islands*, exh. cat., Washington DC, 1979; I. Guiart, *The Arts of the South Pacific*, New York, 1963; M. Leiris & J. Delange, *African Art*,

London, 1968; C. Lévi-Strauss, *The Savage Mind* (1962), London, 1976; C. Schmutz, *Oceanic Art*, New York, 1969; R. F. Thompson, *African Art in Motion*, Los Angeles, 1974; F. Willett, *African Art: an Introduction*, London, 1971.

Chapters 19, 20 & 21

D. Ades *et al, Dada and Surrealism Reviewed*, exh. cat., London, 1978; R. Banham, *Theory and Design in the First Machine Age*, London, 1960; H. B. Chipp, *Theories of Modern Art*, Berkeley, 1968; P. Daix & J. Rosselet, *Picasso: The Cubist Years 1907–1916*, London, 1981; J. Elderfeld, *The Wild Beasts: Fauvism and its Affinities*, exh. cat., New York, 1976; E. F. Fry, *Cubism*, New York, 1966; J. Golding, *Cubism* (1959), London, 1968; R. Goldwater, *Primitivism in Modern Art* (1938), New York, 1967; C. Gray, *The Russian Experiment in Art 1863–1922*, London, 1971; C. Greenberg, *Art and Culture*, Cambridge, Mass, 1961; W. Haftmann, *Painting in the Twentieth Century* (1957), New York, 1980; G. H. Hamilton, *Painting and Sculpture in Europe 1880–1940* (1967), Harmondsworth, 1972; R. Hughes, *The Shock of the New*, London, 1980; S. Hunter, *American Art of the Twentieth Century*, Englewood Cliffs, NJ, 1973; H. L. C. Jaffé, *De Stijl*, New York, 1971; C. Jencks, *Modern Movements in Architecture*, Garden City, NJ, 1973, and *The Language of Post-Modern Architecture* (1977), London, 1978, and *Post-Modern Classicism*, London, 1980; P. Kaplan & S. Manso ed., *Major European Art Movements 1900–1945*, New York, 1977; L. Lippard, *Pop Art*, London, 1966, and *Surrealists on Art*, Englewood Cliffs, NJ, 1970, and *Six Years: The Dematerialization of the Art Object*, London, 1973; N. Lynton, *The Story of Modern Art*, Oxford, 1980; M. W. Martin, *Futurist Art and Theory 1909–1915* (1968), New York, 1977; U. Meyer, *Conceptual Art*, New York, 1972; R. Poggioli, *The Theory of the Avant Garde*, Cambridge, Mass, 1968; B. Rose, *American Art since 1900*, New York, 1967; W. S. Rubin, *Dada and Surrealist Art*, New York, 1968; W. Rubin ed., *Cézanne: The Late Work*, New York, 1977; J. Russell, *The Meanings of Modern Art*, London, 1981; I. Sandler, *The Triumph of American Painting: A History of Abstract Expressionism*, New York, 1970, and *The New York School: The Painters and Sculptors of the Fifties*, New York, 1978; M. Schapiro, *Modern Art, 19th and 20th Centuries*, New York, 1978; L. Steinberg, *Other Criteria Confrontations with Twentieth Century Art*, New York, 1972; W. Tucker, *The Language of Sculpture*, London, 1977; H. M. Wingler, *The Bauhaus* (1968), Cambridge, Mass, 1978.

Index

(Numbers in italic indicate illustrations)

Index